Praise for
Artist's & Graphic Designer's Market

"One of the most valuable books for the professional artist as well as those who wish to find a market for their work." **—Artbeat**

"This annual publication is an excellent marketing resource for artists and illustrators trying to sell their work. This is a practical, well-thought-out reference source that is useful for practicing artists."
—American Reference Books Annual

"I couldn't plan my year without *Artist's & Graphic Designer's Market*. I appreciate knowing what the companies want to see, so I don't waste their time and mine if the work isn't appropriate."
—Ellen Leonard, illustrator

"Great book! Great job! Great help to me. *Artist's & Graphic Designer's Market* took a part-time money maker for me and turned it into a full-time career!" **—Michael Mace, airbrush artist**

D1129043

If you are an editor, art director, creative director, art publisher or gallery director and would like to be considered for a listing in the next edition of *Artist's & Graphic Designers Market*, send a SASE (or SAE and IRC) with your request for a questionnaire to *Artist's & Graphic Designer's Market*—QR, 1507 Dana Ave., Cincinnati OH 45207. Questionnaires received after March 13, 1999, will be held for the 2001 edition.

Managing Editor, Annuals Department: Cindy Laufenberg;
Supervising Editor: Barbara Kuroff
Production Editors: Donya Dickerson, Alice P. Buening

Writer's Digest website: http://www.writersdigest.com

International Standard Serial Number 1075-0894
International Standard Book Number 0-89879-852-3

Attention Booksellers: This is an annual directory of F&W Publications. Return deadline for this edition is December 31, 1999.

1999
ARTIST'S & GRAPHIC DESIGNER'S MARKET

2,500 PLACES TO SELL YOUR ART & DESIGN

EDITED BY
MARY COX

WRITER'S DIGEST BOOKS
CINCINNATI, OHIO

Contents

© Mary Engelbreit Ink

Page 6

© C.F. Payne

Page 607

© 1997 Darryl Daniels

Page 279

© 1998 by Warner Bros.

Page 551

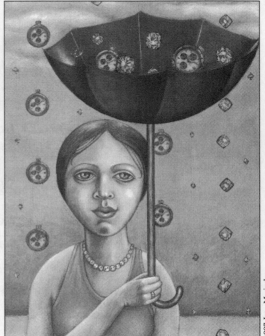

1997 Jane Marinsky

Page 195

From the Editor

For nearly twenty-five years, *Artist's & Graphic Designer's Market* has helped artists identify potential buyers and venues. As I browse through the past editions on my shelf, I'm amazed at how the art market has grown since our first edition. There are more opportunities than ever before.

With the expansion of technology, art is needed even more to brighten, enrich and humanize our world. And, thanks to technology, talented artists living in small towns can work with clients and galleries in far-flung cities through faxes and modems.

Many artists use this book every year with great results. (See our feature, *Artist's & Graphic Designer's Market Success Stories*, on page 10 to find out how some of your fellow artists use this book to sell their work.)

If you are a first-time reader, welcome! I have one important request: please do *not* use this book as a mailing list! You must *read* listings and only send samples to places that want the type of art *you* create. Sending inappropriate submissions hurts not only you, but your fellow artists. Art directors and gallery dealers sometimes remove their listings when they receive inappropriate submissions—and that hurts everyone's chances! So be considerate. Read **How to Use This Book to Sell Your Work**, on page 3, and learn how to identify and target the best opportunities for you.

If you're a regular buyer of *AGDM*, welcome back! You'll notice a few new features this year. We added a checkmark to listings that reported changes in contact information from our 1998 edition. You'll notice eight new indexes to speed up your search for clients and venues.

Most of the improvements from year to year are suggested by readers. This is *your* book. We absolutely depend on your feedback. So, please help us out by photocopying and filling out the "reply card" on the following page. Mail, fax or e-mail it back to me. With your help, *AGDM* will be an even more valuable resource next year!

It will be great hearing from you. Without a doubt, the best part of my job as editor of *Artist's & Graphic Designer's Market* is talking to artists and the people who work with them. This year we interviewed more artists and experts than ever before.

Whether you admire the homespun, illustrative style of **Mary Engelbreit** or prefer the cutting edge designs of **Chip Kidd**, the interviews and articles in this year's edition offer ideas and inspiration. It is a thrill to include greeting card artist **Jackie Frerichs** as an "Insider Report." Jackie is an *AGDM* reader who I've known as a friendly voice on the phone for the past few years. As I watched her career grow, I realized she would make a great "Insider"!

Be sure to read *all* the interviews in this book. (It's a great way to take a break from marking listings.) You'd be amazed how advice pertaining to fine art also applies to graphic art and vice versa. The down-to-earth advice of gallery dealer **Paul Klein** is helpful whether showing in a gallery is your dream or not.

Until the 2000 edition (can you believe it?), I'll leave you with some of Paul Klein's wisdom: "You are an artist. Apply your artistic creativity to other facets of your life and particularly your career . . . Don't expect miracles overnight. Follow your instincts. Above all, be who you are."

Mary Cox

Mary Cox, Editor
artdesign@fwpubs.com

Artist's & Graphic Designer's Market
Reply Card

To: Mary Cox, editor *Artist's & Graphic Designer's Market*

☐ Yes! I have a suggestion to improve *AGDM*:

☐ Yes! I'm willing to participate in a focus group in my city.

☐ Yes! I'm willing to fill out a short survey by mail or on-line to provide feedback
 on *AGDM* or other books about art/design.

How did you hear about AGDM?

How do you use AGDM to sell your work?

Name: _____

Address: _____

City: _____ State: _____ Zip _____

Phone: _____ Fax: _____

E-mail: _____ Url: _____

I am
 ☐ a graphic designer ☐ a fine artist
 ☐ an illustrator ☐ other: _____

Mail to: Mary Cox, Editor
 Artist's & Graphic Designer's Market
 1507 Dana Ave., Cincinnati, OH 45207

Fax to: (513) 531-7107

**Note: When you send me your reply card, please include a sample of your work. I'd love
to see what you're up to!**

How to Use This Book to Sell Your Work

This book contains listings of companies that buy artwork and design services, and galleries that exhibit and sell fine art. Information is grouped under headings, allowing you to scan for key elements. Symbols such as the double-dagger preceding new listings are used to conserve space. (Refer to the Key to Symbols and Abbreviations on page 50 for a complete list).

HOW TO READ LISTINGS

Each listing contains a description of the artwork and/or services it prefers. The information often reveals how much freelance material is used by each market, whether computer skills are needed, and which software programs are preferred.

In some sections, additional subheads help you identify potential markets. Magazine listings specify needs for cartoons and illustrations. Galleries specify media and style.

Editorial comments, denoted by bullets (•), give you extra information about markets, such as company awards, mergers and insight into a listing's staff or procedures.

ALERTS YOU TO CHANGES IN CONTACT INFORMATION FROM LAST YEAR'S EDITION

YOUR CHANCES OF ACCEPTANCE

WHAT TYPE OF WORK THEY'RE SEEKING

THEIR PRODUCTS AND SPECIALTIES

WHO TO CONTACT

H. GEORGE CASPARI, INC., 35 E. 21st St., New York NY 10010. (212)995-5710. Contact: Lucille Andriola. Publishes greeting cards, Christmas cards, invitations, giftwrap and paper napkins. "The line maintains a very traditional theme."
Needs: Buys 80-100 illustrations/year. Prefers watercolor and other color media. Produces seasonal material for Christmas, Mother's Day, Father's Day, Easter and Valentine's Day.
First Contact & Terms: Send samples to Lucille Andriola to review. Prefers unpublished original illustrations, slides or transparencies. Art Director will contact artist for portfolio review if interested.
Pays on acceptance; negotiable. Pays flat fee of $400 for design. Finds artists through word of mouth, magazines, submissions/self-promotions, sourcebooks, agents, visiting artist's exhibitions, art fairs and artists' reps.
Tips: "Caspari and many other small companies rely on freelance artists to give the line a fresh, overall style rather than relying on one artist. We feel this is a strong point of our company. Please do not send verses."

WHAT TO SEND

TIPS STRAIGHT FROM THE ART DIRECTORS

HOW MUCH THEY PAY AND WHEN

WHICH LISTINGS ARE BEST FOR YOU?

Listings are divided into sections such as Book Publishers or Magazines. Your talents could be marketable in several sections. Scan this list for opportunities in your area of interest:

Fine art. Galleries; Posters & Prints; and Greeting Cards, Gifts & Products will be your main markets, but Book Publishers; Magazines; Advertising, Design & Related Markets; and Record Labels seek illustration with a fine art feel.

Sculpture and crafts. Galleries is an obvious choice, but Advertising Design & Related Markets list companies that hire sculptors to create models and displays. Products manufacturers located in the Greeting Cards, Gifts & Products section hire sculptors to create ornaments and

figurines. You can market your work as 3-D illustrations to companies listed in Magazines and Book Publishers.

 Cartoons and comic strips. Greeting Cards, Gifts & Products; Magazines; Book Publishers; Advertising Design & Related Markets include listings that seek humorous illustrations and cartoons. Comic strip creators should look under Syndicates & Cartoon Features.

 Illustration. Check Greeting Cards, Gifts & Products; Magazines; Book Publishers; Record Labels; Stock Illustration & Clip Art Firms; Advertising, Design & Related Markets.

 Architectural rendering, medical and fashion illustration. Check Magazines, Book Publishers and Advertising, Design & Related Markets.

 Calligraphy. Look under Book Publishers; Greeting Cards, Gifts & Products; and Advertising, Design & Related Markets.

 Airbrush art. Look under Greeting Cards, Gifts & Products; Posters & Prints; Magazines; Book Publishers; and Advertising, Design & Related Markets.

 Storyboards. Look under Advertising, Design & Related Markets.

 Design and production. Check Greeting Cards, Gifts & Products; Magazines; Posters & Prints; Book Publishers; Record Labels; and Advertising, Design & Related Markets.

 Multimedia design and animation. Check the Animation & Computer Games section. The Multimedia Index will steer you to additional listings in need of your skills.

 T-shirts, mugs and toys. Check Greeting Cards, Gifts & Products; and Advertising, Design & Related Markets.

USING THE INDEXES

 Sixteen indexes are provided to help you narrow your search for markets seeking specific styles and genres. Refer to the Special Indexes starting on page 684. They'll lead you to listings looking for **Calendars**; **Calligraphy**; **Collectibles**; **Fashion**; **Humor & Cartoons**; **Informational Graphics**; **Licensing**; **Medical Illustrations**; **Multimedia Skills**; **Religious Art**; **Science Fiction & Fantasy Art**; **Sport Art**; **T-shirts**; **Textiles**; and **Wildlife Art**.

Mary Engelbreit: From Fledgling Artist to Marketing Phenomenon

BY ANNE BOWLING

Mary Engelbreit

Illustrator Mary Engelbreit had a big decision to make back in 1977. She could ignore the rejection of a New York art director who said her drawings would not work for children's books, or she could take his advice that she try to illustrate greeting cards.

At the time, she took the recommendation as an insult. But she carted her fledgling's portfolio back to her hometown of St. Louis, and employed an adage that she later popularized in her work—"If your ship doesn't come in, swim out to it."

"I was kind of crushed," Engelbreit says. "But once I realized there was a market for these bizarre little one-shot illustrations I'd always done, I really liked it."

As it turns out, her decision was sound. Since that rejection in New York, she has cultivated a one-woman cottage industry selling 14 million greeting cards each year. With some 1,000 product licenses to her name, Engelbreit's work shows up on everything from teapots to pillows and watches to kitchen accessories, not to mention the more conventional outlets of stationery and calendars.

Engelbreit's work is sold in five retail outlets of her own, in St. Louis, Chicago, Atlanta, Dallas and Denver, and in 1996 she launched a magazine, *Mary Engelbreit's Home Companion*, which features decorating and lifestyle articles. She has also published a series of decorating books, and began a decorating column syndicated in newspapers throughout the U.S. In 1997, Engelbreit put a final, triumphant touch on her success story with publication of a children's picture book, her illustrated Hans Christian Andersen's *The Snow Queen*.

Crayolas were Engelbreit's medium of choice when she first began drawing at four. "I used to sit at the window and draw all afternoon," she says. "I thought it was a lovely way to spend the day. I still do." Engelbreit went to work straight out of high school at an art supply store in St. Louis, where she found an unexpected source of inspiration: "All these working artists would

ANNE BOWLING *is a production editor for Writer's Digest Books and a Cincinnati-based freelance writer.*

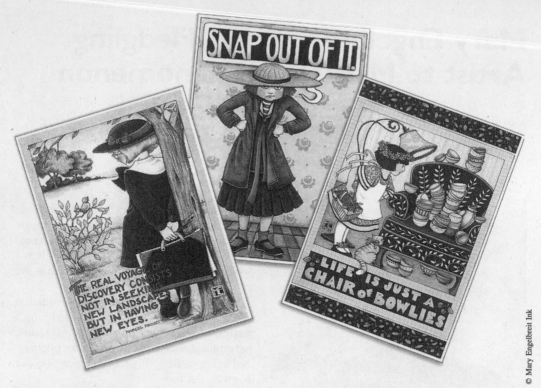

Illustrator Mary Engelbreit's whimsical, home-spun illustrations appear on products from greeting cards to jewelry to kitchen accessories. Several years after breaking into card design as a contract artist for Portal Publications, Engelbreit struck out on her own and parlayed designs like these into a multi-million dollar success story. Her greeting cards often feature bits of wisdom culled from Engelbreit's experiences or literary luminaries such as Marcel Proust and T.S. Eliot. Licensed for use on some 1,000 products, Engelbreit's art works hard: for example, border art from greeting cards is reformatted to appear on gift bags.

come in and buy their supplies, so I got to meet people who were making a living at art," she says. "It was very inspiring and exciting. I had no idea there were so many jobs involving art."

Engelbreit got one of her first breaks in greeting card design with California-based Portal Publications. After several years working as a contract artist, she decided to launch her own company. Step one was a 12-card exhibit at the 1985 National Stationery Show in New York. Tucked among displays featuring hundreds of designs, her presentation has been described as "laughably tiny," but it was big enough to attract attention, and she contracted with a publisher for a calendar and a licensing deal.

From its modest beginnings in Engelbreit's basement, her company has grown to occupy a renovated Greek Orthodox church in St. Louis, and employ a staff of 40 in admistration and, of course, the art department. But despite the company's growth, Engelbreit maintains strict controls on quality. "Mary herself hatches every concept in her head and draws every original piece of art with her hand," says lead designer Stephanie Barken. Engelbreit's work is later reformatted to be used on the company's many different products. "The border art from a greeting card illustration will become the pattern on a gift bag," Barken explains, "but we don't create anything new. All of this is Mary Engelbreit art."

Engelbreit credits children's illustrators from the 1920s and '30s as her stylistic tutors—Johnny Gruelle, creator of Raggedy Ann and Andy, Jessie Wilcox Smith and Joan Walsh Anglund. She later incorporated the works of poster art masters Peter Max, Seymour Chwast and

Milton Glaser into her work, which is immediately recognizable with its cherub-faced children, cherry-and-checker borders and homespun, hand-lettered adages such as 'Life is Just a Chair of Bowlies,' 'Home is Where the Heart Is' and 'The Queen of Everything.'

Here Engelbreit shares inspiration for aspiring artists, and passes along some lessons she learned on the road to success.

Your first break in greeting cards was selling 3 card designs for $50. To whom did you make the first sale, and were there lessons you learned from it?

I had approached a couple of different publishing houses before I found the now-defunct card company called Family Line, where I made my first sale. They paid me $50 for the originals, and unfortunately, I never got those originals back. A couple of weeks later, I got a contract from a company offering me an advance and royalties—that's the way to do it.

Your career path is unusual in that you were not formally educated in art. Do you recommend this route to other aspiring illustrators? Why or why not?

By the time I had reached my senior year in high school, I was ready to get to work, Besides, as a result of being on my own, no one was telling me that this was or wasn't the way to do it, so I just drew the way I wanted, and it happened to be different than anything else that was out there. This route was better for me, because I don't do very well in a structured setting. I do much better on my own, but for others it may be different. It's a personal decision.

Your company was headquartered in your basement when you first started. Describe those early days.

I started my own business because the first company I worked with just wasn't doing what I wanted to do—and I knew my stuff would sell really well if I could just get it out there. Plus, I'm a control freak, and I just wanted to do it myself. I didn't want to wait. Now I don't recommend that route to everybody. It took a lot of time and a lot of money. You really have to be dedicated.

We just walled off part of the basement, and it was really tiny. On one side of the room, we stacked up all the cards, and on the other side of the room we had a desk. We were only there for about six months. When you consider that 12 years later we have 40 employees in a converted Greek Orthodox church, the growth is amazing.

The key to any successful business is a trustworthy business partner. Phil Delano is just that— he's also my husband. Together, we built this business by trusting our instincts.

Your first big exhibit, at the 1985 National Stationery Show, attracted a lot of attention for your work. Was that a turning point for you?

Oh, definitely. And the reason it attracted attention was that we had already been out there. I don't think we would have gotten so much attention had we gone out there cold. People recognized the artwork and they knew that my artwork would sell.

We got a licensing agent at that show—I don't think we could have gotten our foot in the door otherwise. Sure, agents take a percentage of what you make, but they know the business. Licensing may go even more slowly without one.

How do you balance the demands of a family and your multi-million dollar business? Did you anticipate the size of your business?

Well, when we started the business, Will was just an infant, so I drew during his naptime. Plus, I have always liked to work at night. I just fit work in whenever I could in the early days. It's always been kind of a day-to-day thing, but I never imagined a magazine or anything like that. I just go after things that I'm interested in and that I would like to see my designs on. I love magazines and wasn't finding one that I really wanted, so I decided to create my own.

What's essential to success in licensing your artwork?

I would say to always try to keep your copyright—which you might not be able to do in the beginning. Ask a really good attorney to look over your contracts. Get specific about what the licensee is buying your drawing for, which products they plan to put it on, and how long they plan to use it.

Research the potential licensee and don't jump into anything. You have to spend a little time with these people before you go into business with them. Make sure that the licensee understands why you do the art that you do, how much it means to you, and how important it is that it looks good on a product. It's worth taking the time to get to know the people you're doing business with a little bit before you sign the contract. Life's too short to deal with jerks.

How do you manage to solely produce all the artwork that bears your name?

I have an excellent art staff. A lot of times, one of my core designs needs to be adapted to fit a product. The staff artists help do that by adding borders or changing the shape of the design to fit the product. We work with each company to re-format the designs to better suit their products.

Do you keep a schedule for drawing now?

I don't make myself draw every day. There's nothing more demoralizing than sitting down in front of a piece of paper and having nothing come out. I'd rather just go off and do something else. Then all of a sudden I'll get an idea. It usually happens at inconvenient moments, so I have to quickly scramble to write it down.

You use words instead of a sketch?

My work is very word-oriented, so it's the best way for me to capture an image. I get a lot of ideas from reading too—that's obvious with all the Proust, Goethe and Emerson quotes sprinkled in my work. But I'm just as enthusiastic about reading the backs of cereal boxes.

How have the greeting card and licensing markets changed since you entered them?

Nowadays, those companies are always looking for new artists. Even thought they may do just a few cards, I think it's a great way to get your work out there to show people.

What advice would you share with other aspiring artists who have unique talents and big dreams?

Proper timing is overrated. There's always a reason not to do things—it's too expensive, or it's not the best time, or this or that—but I believe there are wonderful opportunities sailing by, and you have to be ready to grab them.

ADVICE ON SUCCESS FROM "THE QUEEN OF EVERYTHING"

On developing your style: "Experiment. Be adventurous. Try a lot of different things. Who cares if it doesn't work out? It's only paper! I was exposed early to the work of classic children's book illustrators . . .and for a long time I practiced recreating something of their styles and, as a result, they are certainly influences."

On growing as an artist: "I don't think it's a coincidence that I found my audience at the time I started having kids, in the early '80s. Before that, I was drawing fantasy, fairy tales, castles, dragons, bizarre things like that. After kids . . .the things happening were more interesting to me than unicorns and castles. So I started illustrating them . . .I just started depicting the events, ideas and values that were important to me."

On licensing agreements, spiritual: "You have to remember that you're the one with the talent who's offering the licensees the gift to be cashed in on. You're certainly bringing something to the table, too, which you're entitled to be paid for."

On licensing agreements, practical: "Always try to keep your copyright. Retaining the copyright is crucial. Plus, it's important to sign the contract for the shortest time period possible. That gives you more control if the product isn't as nice as you had hoped."

On running a business: "Have an attorney. Don't think you're saving money by having your dad or your husband or friend look at the contract. It's important to have an attorney and you have to operate as a business from the word go."

–Anne Bowling

When she was young, people told artist Mary Engelbreit that being an artist was not a realistic way to make a living, but Engelbreit says she was not discouraged. "I believed in myself," she says, "and now I'm living my dream."

Artist's & Graphic Designer's Market Success Stories

BY MARY COX

In last year's edition, we asked you to mail us your samples and describe how you use *Artist's & Graphic Designer's Market* to sell your work.

There's not enough room in this book to publish all the success stories we received. But we thought you'd enjoy reading about some of your fellow freelancers and how they sell their work.

We hope you take inspiration from their stories, and send us yours for next year's edition!

HOW THEY DID IT

The freelancers on the following pages work in all different markets (and some work in several markets). Their marketing habits are as varied as their styles. Some are fine artists, some are illustrators, but all submitted samples to listings in *Artist's & Graphic Designer's Market*. In the following pages, they tell us how they use this and other resources to plan their promotional strategies.

A friendly cup of cocoa, then "dive right in."

Andi Butler, a Michigan freelancer whose lively promotional material sports the logo "Nut Lab Illustrations," wrote us that she sold 12 pieces to NovoCard Publishers last November. Andi reports NovoCard art director Molly Morawski was "wonderful to work with! NovoCard returned my artwork and sent my payment promptly."

Butler's been using *Artist's & Graphic Designer's Market* for several years. "My ritual when I'm planning on sending out new promotions is to get comfortable with a friendly cup of cocoa and dive right into the book. I let my mind wander a bit as I read the information and I come up with lots of new ideas that way."

Butler highlights more than one section, but only sends out a few mailers at a time. "By sending out groups of 10 or 12, you allow yourself to concentrate on sending the next group out instead of waiting by the mailbox!" Butler advises fellow freelancers to stay focused on marketing their work. "I shop the markets often to see what's being carried in the stores and note the companies using artwork that has something in common with my style. I read all the interviews in *AGDM*, *Step-by-Step*, and *HOW*, absorbing as much information as I can." She also watches children's television. "What's popular with children sometimes transcends into other areas [greeting cards, magazines]." She also advocates joining a professional organization to stay informed.

Butler urges fellow freelancers to stay focused and positive. "I set realistic, achievable goals (that get progressively higher as I conquer the previous hurdle) and I never give up! It's crucial to keep a positive attitude and have as much fun as possible, being careful not to confuse that with being unprofessional or unreliable." Butler is such a positive force she even sends thank-you notes to art directors who send rejection letters. "They still took the time to get back with me, so it counts!"

Andi Butler

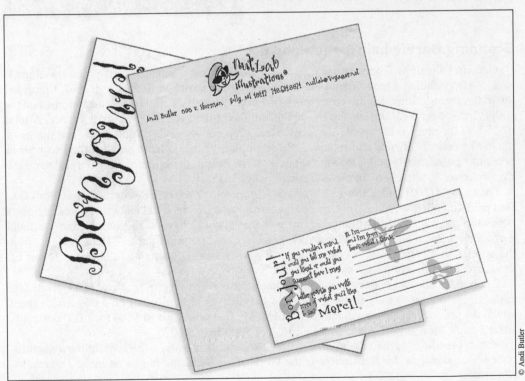

Andi Butler's promotional material, which she designs as well as illustrates, is bright and witty and shows off her fun illustration style. Her "Nut Lab Illustrations®" logo features a cartoon of herself wearing a pink beret and sunglasses. Like many other illustrators, Butler includes a return card art directors can use to let her know if they want to continue receiving samples. She also designed labels featuring her logo and address, which she places on the back of all original artwork. Having a total look for her invoices, envelopes, return cards and labels really sends a message to art directors that Butler will be just as thorough when completing freelance assignments.

Octavio Diaz

Scanning Barbie hair for fun and profit

Octavio Diaz of Melbourne Beach, Florida, reported great results from his promotional mailings. "After sending a promotional mailing to *Forbes* magazine, a listing in *AGDM*, I received the assignment to illustrate the cover story of *Forbes* as well as six inside illustrations. For the cover, I was paid $2,500. [For the inside illustrations] I received $500 to $650 a piece. A total of $5,800 for one week's worth of work." Diaz's hip collage style includes bits and pieces of photos he takes of friends and relatives. He often places his real hand on top of the scanner in order to "pose" hands on his collage subjects. "The hair of the blindfolded lady justice on the *Forbes* cover is actually a Barbie doll's hair," says Diaz.

Diaz uses *AGDM* and *Children's Writer's & Illustrator's Market* (Writer's Digest Books) to find potential clients. "*IEEE Spectrum*, a trade magazine for electrical and electronics engineers contacted me for an illustration assignment. I never would have seen this magazine without *Artist's & Graphic Designer's Market*, since it is not sold on newsstands." He also learns from the articles in *AGDM*. "I always read the interviews featuring artists and illustrators. I just eat those up! They always have lots of great tips."

Diaz offers his own hot tip for saving printing costs when preparing samples: he sends four pages of his images to the printer at once and has them printed together on a poster-size sheet, which the printer then cuts down into postcards. "My first printing cost $200 for 1,000 postcards. Later I went for a glossy stock, and the cost was $300 for 1,000."

Besides sending out mailings, Diaz placed 12 of his illustrations on *theispot* (http://www.theispot.com), a showcase for illustration on the World Wide Web, and has an ad in the *Directory of Illustration*.

This computer-generated collage was one of six Octavio Diaz created to illustrate a *Forbes* cover story on unlikely lawsuits—like the suit brought by an employee who was fired after staying home from work due to an ingrown toenail!

© Octavio Diaz

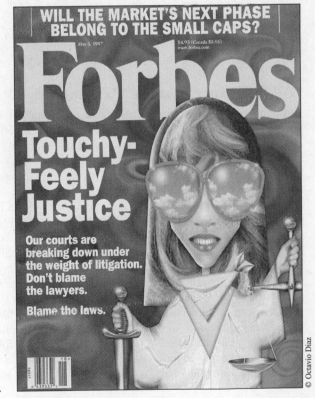

Octavio Diaz's hip collage style landed him a dream assignment: the cover of *Forbes* magazine.

© Octavio Diaz

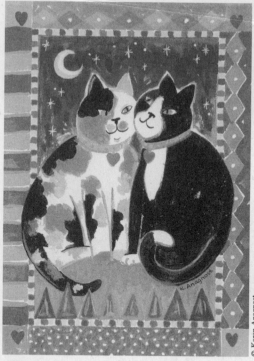

Karen Anagnost

Here's one of the cards Karen Anagnost created for Design Design.

"All things are possible. Pass the word."

Encino, California-based illustrator Karen Anagnost wrote us one of her favorite "how I got hired" stories—a tale that demonstrates the power of perseverance: "I keep index cards of every client or potential client, so I can accurately tell you the first time I sent samples to Design Design was in November 1994. I called the art director in October just to ask if he was taking submissions and to see what he was looking for. He was nice enough to talk with me, as most art directors have been. I called him back in February as a follow-up. Almost one year later, I received my samples back with a note saying he was not interested." In the meantime, Anagnost took a class in illustration at Art Center Night School to learn about painting techniques, and spent most of her free time painting greeting cards. "I sent Design Design four new samples in August of 1995. In February of 1996, the art director called to say he liked my work and asked to see more. In June of 1996, Design Design accepted my first painted freelance greeting cards. I now have 13 cards produced by Design Design. It's been a wonderful relationship. It definitely pays not to give up and to focus on the solution rather than the problem of being rejected."

Anagnost, who teaches a class on designing and illustrating greeting cards, is constantly taking drawing classes herself to hone her skills. "I tell all my students to get in their basics, choose the arena they want to make art in, and always follow their heart's desire. My aunt once sent me a greeting card that said, 'All things are possible. Pass the word . . .'. That's my mantra, and that is the simple truth. I've had a fun and artistic journey."

"Wacky" promotion gives serious career boost

Lew Azzinaro

Illustrator Lew Azzinaro of Reston, Virginia, sent us a color copy of a job he received after sending samples to listings in *AGDM*. "This fairly large commission ($3,500) was for a double-page color spread about the concept of 'play' for the Spring 1995 issue of *Notre Dame* magazine. I targeted listings that seemed to have a fairly good budget for illustration. I sent off my promo brochure "Lew's Wacky World" and got quite a few bites. I had three weeks to render the art—one and a half weeks for rough art and one and a half weeks for the final art. As you can see, I have used this job as a sample in my newest promo brochure 'Lew's Enormous Brain'." Azzinaro continues to use *AGDM* for listings, as well as lists he purchases from mailing houses (*American Showcase, Creative Access,* etc.). He also advertises in numerous directories (*American Showcase, The Workbook, Directory of Illustration, Black Book,* etc.) "I choose one book to advertise in each year and rotate the books."

Investing in a promotional brochure was a turning point in Azzinaro's career. At a time when he relied on mostly local assignments, the struggling illustrator was on the verge of giving up his dreams. As a last-ditch effort, he decided to take the plunge and go full speed ahead on his career. Azzinaro noticed some of his fellow

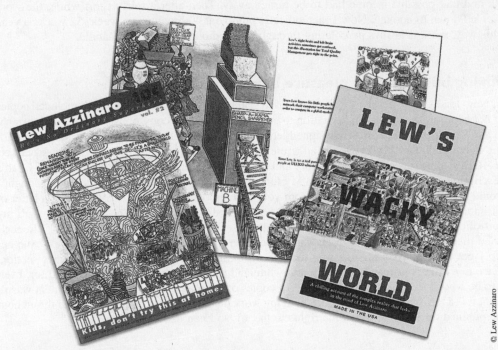

Azzinaro's booklets "Lew's Wacky World" and "Lew's Enormous Brain" caught the eye of *Notre Dame* magazine's art director.

© Lew Azzinaro

illustrators in the D.C. area hired a designer to help them create "truly spectacular and memorable marketing materials that had a 'stand out from the crowd' factor." Azzinaro observes that when you think of how much material comes across the average art director's desk, you realize why that factor is so important. "I summoned up the courage to call Chris Noel, of Chris Noel Design, and told him I admired how his promotional material truly launched my fellow artists out onto the national stage. I told him I wanted a brochure that would do that for me—something to introduce me to a national audience. Noel designed a booklet that highlighted Azzinaro's greatest asset—his wacky sense of humor. Though printing and mailing the brochure was costly ("even though Chris Noel was kind enough to wave the design fee in exchange for a piece of art"), it boosted both Azzinaro's confidence and visibility. After mailing the brochure, his phone rang off the hook "with jobs I had always wanted and dreamed of doing. Now I realize dreams don't cut it. [You have to] do something about it. I should have done it much earlier, but I truly was very intimidated by the level of talent out there. It took me a long time to find my courage and level of proficiency to compete on a national level. My promotional brochures have truly sent my career in a totally different direction, from flat and treading water—probably sinking—to cruising along at a nice steady clip. There are still some bumps in the road every now and again, but at least I'm not thinking of becoming a shoe salesman, a lá Al Bundy, which I was seriously entertaining during my lowest ebb back in 1991-92."

Don Nelson, the art director of *Notre Dame* magazine, was impressed by the brochure. "Lew sent me a nicely done four-color book to show his work. I always notice a promotional piece this ambitious. I still have it in my samples collection, even though it came to me three to four years ago. I am most interested in an artist's work, though, and a less expensive promotion could just as easily get my attention. In addition to his humorous drawings, Lew has an ability to do conceptual work. He is an original."

Another lesson Lew learned is to stagger his mailings. "When I did push them all out at one time, I was swamped with work right off the bat, which was thrilling, except I couldn't take it all, and that possible income had to be turned away. Then after a fairly short while, the work trickled down to nothing. Now I methodically pump out 40 brochures a week, 52 weeks a year. This way, work is always percolating through my studio at a pace I can handle."

Mixing business with pleasure in Hawaii

New Jersey artist Caren Belle Loebel-Fried sent us a packet of material which included copies of her haunting woodcuts, an invitation to an art opening and a copy of *The Carolina Quarterly*. In a letter typed on beautifully designed letterhead (which featured a smaller version of one of her woodcuts at the top), Loebel-Fried wrote that she was able to take advantage of three markets in *AGDM*: magazines, book publishers and galleries. Especially delightful was Loebel-Fried's description of two recent successes. "My family was planning a trip to Hawaii, and I thought I would approach one of the galleries from your listings: Wailoa Center in Hilo. I sent a letter of introduction to the director, Mrs. Pudding Lassiter, before going. I went to meet her with my portfolio while I was there and she offered me an exhibition for the following year!" Loebel-Fried made an additional trip to Hawaii to hang the show and had a wonderful time. "Another job I got through your listings was for *The Carolina Quarterly*, from the magazines section. Since my work is primarily in black and white and that was what their listing called for, I felt it to be a good shot. I received $50 plus 10 copies of the magazine. Though the payment wasn't high, it is a terrific promotional piece with my work on the front and back covers and throughout the publication. I also retained the rights to the art, so I can use the pieces again."

Caren Belle Loebel-Fried

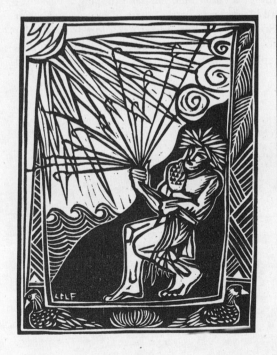

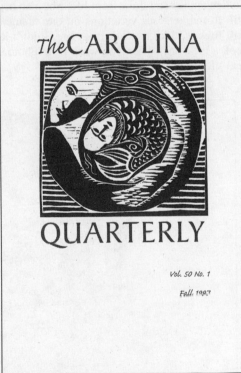

Loebel-Fried's woodcut was perfect for the cover and interior of *The Carolina Quarterly*. She now uses copies of the literary journal as part of her promotional package. Her exhibition at The Wailoa Center in Hawaii included her powerful woodcuts depicting the mythology of the islands.

The fine art of marketable watercolors

Audrey Ascenzo, a Torrington, Connecticut, artist who divides her time between fine art, illustration and calligraphy, sent us a set of four lovely country-themed posters produced by Angel Graphics. "Angel Graphics, a division of Angel Gifts, Inc., bought poster/print rights to the images," says Ascenzo. "Each image was printed in 8×10 and 16×20 sizes. Payment was $200 for each piece."

Though she is a fine artist who often enters her watercolors in competitions (and has won over 30 awards for her work), Ascenzo decided to market her work to the decorative market. In researching the market in *Artist's & Graphic Designer's Market*, she learned she'd have to be a little more conscious of trends and popular colors when creating work for the decorative market. Another tip she learned was to "watch the catalogs—especially Martha Stewart and Pottery Barn, to pick out popular colors." After picking up on blue and yellow as up-and-coming colors, and learning that gardening is a popular trend, Ascenzo set up a still life of a china blue bandana draping a basket of golden apples and drew from life. She also heard it's easier to market pairs of images and easier still to market four variations on one theme. So she created several watercolors from similar still lifes. "I like to work from life. I don't know how it looks to others, but I think paintings look a little stiff when you work from photograph. You pick up a lot of colors and shadows in real life you just can't see in a photo."

Audrey Ascenzo

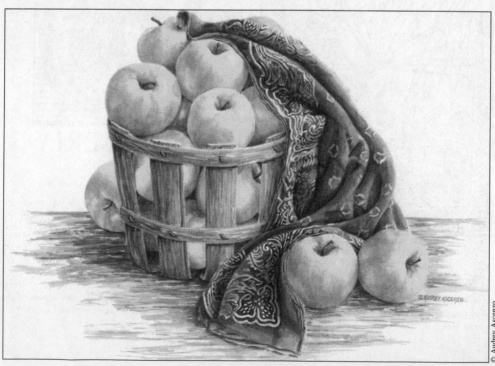

This watercolor of golden apples is one of a series of posters Ascenzo created for Angel Graphics.

© Audrey Ascenzo

Ascenzo learned a lot from her experience with Angel Graphics—mostly about how long the process of getting a print to market can be. She has since begun a working arrangement with a licensing agency, Rights International Group, and hopes to negotiate royalty arrangements on future poster, print and product projects.

Ascenzo reveals a tip that has helped the busy artist stay organized and keep track of all her projects. "I purchased some organizational systems for artists from Creative Systems for Creative People. One system, The Studio Log, is excellent for keeping track of artwork. Each piece is assigned an ID number and the artist fills in the title, size, medium, price, etc. Slide stickers and identification labels for paintings make the task of organizing much easier. The systems are reasonably priced (approximately $25) and can be ordered through Creative Systems for Creative People, 374 MacEwen Dr., Osprey FL 34229-9233."

Good news: greeting card industry is growing

Maria Vaci

Maria Vaci writes: "I thought you might like to see the enclosed Courage Center card catalog with two of my colorful (paper cut-out technique) greeting cards. I am very pleased to see my designs included. I was in contact with Laura Brooks, Courage Center's art director. She is wonderful to work with. I received $350 for reproduction rights for the card." Vaci also sent us samples of her fashion illustration. "I always liked to draw. I have been freelancing for the past 25 years for retail stores. It was great, but as time went by the demand for fashion illustration has almost disappeared. The good news is

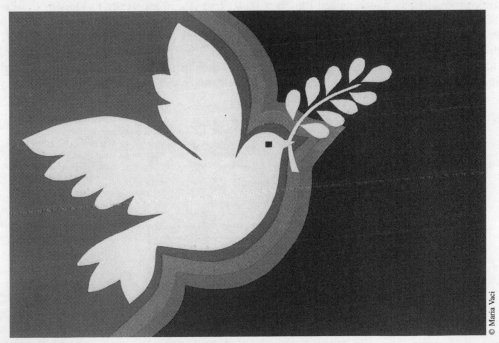

© Maria Vaci

"Dove of Peace" is one of the designs Maria Vaci created for Courage Center.

that the greeting card industry is growing . . . and so is the demand for freelance art. Yes! It is possible to get your art published. But one has to be patient! It may take some months to get your art sold and receive payment . . . Don't rush it. I started designing greeting cards approximately 14 years ago, while I was still doing fashion illustration. It was always a pleasure to see my art published. I especially like to design for silkscreen printing and like to do full-color, paper cut-out art which reproduces very well. I hope to get more into designing greeting cards, giftwraps, etc. One has to work at it, but it's well worth it!'' Vaci also sent us a Christmas card she designed for Frederick Beck, and another she created for the Crocket Collection.

From math teacher to working illustrator

Kathryn Vierra sent us some printed stationery from a pastel commissioned by The Paper Company. Vierra's success story is amazing. After teaching high school mathematics for 20 years, she signed up for an adult school class called "So You Thought You Couldn't Draw." At the time Vierra thought she couldn't draw. "Stick figures were my level of expertise. But something clicked with instructor Sandra Angelo (now owner of Discover Art in San Diego). I took three or four more classes in colored pencil from her over the course of a year. In 1992, I moved over to Palomar College in San Marcos to study with nationally known illustrator Mike Steinage. In two years, I completed one drawing class, a pastel technique class and three illustration classes with him. At that point he told me to put together a portfolio and get out there!

"The first thing I did was pick up a copy of *Artist's & Graphic Designer's Market*. I read the articles garnering tips for my portfolio and interview, reviewed the listings, and started to put together a mailing list. At first, I only included book publishers and magazines, but as time went on I included greeting cards. I would advise people getting started not to overlook markets which don't intrigue them."

Vierra goes through *AGDM* and marks listings appropriate for her skills. "I immediately input my chosen listings into my computer and generate mailing labels. Then after having my work professionally photographed (this is a must) I send a transparency to Modern Postcard (800-959-8365) and have 500 postcards made for approximately $100. I do a mass promotion three to four times a year. I usually mail out 350-400 cards at a time. In addition to *AGDM*, I also go to the yellow pages for local advertising agencies and graphic design firms. I have made hundreds of calls to these companies to determine if they use illustration and to see if my style fits their needs. And don't overlook passing out postcards to family and friends who are always

Kathryn Vierra

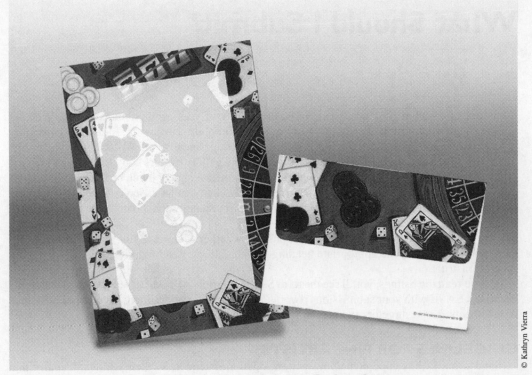

This pastel stationery design by Kathryn Vierra was commissioned by The Paper Company.

interested in seeing what you are doing. My biggest commission last year came from a postcard passed on by a friend."

Vierra thinks illustrators with computer skills have a distinct advantage. "Although my illustrations are done traditionally either in colored pencil or pastel, I can scan my artwork to create pages of samples. Eventually, I will put my portfolio on CD-ROM. I not only use the computer for mailing lists, I also design and print my stationery and business cards on the computer; do correspondence and keep financial records on the computer.

"Since I purchase *AGDM* every year, I always make a note on my mailing list as to which year I found the listing so I can refer back to it and easily review information on a company when I get 'the call.' When the new edition comes out, I look at the new listings first, and then go back and update the entries on my mailing list with any new information, new art directors, addresses and telephone numbers. I also carry the new edition around with me. Most artists hate to spend time on marketing. I find having my *AGDM* with me when I'm waiting to have my car fixed or waiting for an appointment is an efficient way to do my marketing research. By the time the new edition comes out, my old edition is full of notes and Post-Its!"

Stay tuned for more success stories

Well, that's all the room we have for success stories this year—although you'll find many more scattered throughout this book. The majority of the art reproduced in each section was created by artists who got their assignments as a result of seeing a listing in this book.

Please write and tell me about assignments *you've* landed—either from this book or some other promotional effort—and let *AGDM* readers in on *your* favorite marketing tips and shortcuts. I'd love to include you in *AGDM*'s 2000 edition! Send your success stories to: Mary Cox, Editor, *Artist's & Graphic Designer's Market*, 1507 Dana Ave., Cincinnati, OH 45207

What Should I Submit?

Your success as an artist depends largely on the quality of your promotional samples. Whether you are beginning your career or are a pro at self-promotion, review the following guidelines before sending samples. Like anything else, policies change and evolve. We've noticed a definite trend toward streamlined submissions. Art directors and gallery owners don't have time to review bulky submissions. Many art directors who formerly requested query letter, brochure and samples now say they'd rather see a simple postcard. Similarly, many galleries have reduced the number of slides they need to see. Increasingly, art buyers ask for samples that do not have to be returned so they can just keep them on file.

We divided this article into three sections, so whether you are a fine artist, illustrator or designer, check under the appropriate heading for guidelines. Read individual listings for more specific instructions.

As you read the listings, you'll see the term SASE, short for self-addressed, stamped envelope. Enclose a SASE with your submissions if you want your material returned. If you send postcards or tearsheets for art directors to keep on file, no return envelope is necessary.

GUIDELINES FOR FINE ARTISTS

Send a 9×12 envelope containing material galleries request in their listings. Usually that means a query letter, slides and résumé, but check each listing. Some galleries like to see more. Here's an overview of the various components you can include:

- **Slides.** Send 8 to 12 slides of your work in a plastic slide sleeve (available at art supply stores). To protect slides from being damaged in the mail, insert slide sheets between two pieces of cardboard. Ideally, slides should be taken by a professional photographer, but if you must take your own slides, refer to *Photographing Your Artwork*, by Russell Hart (North Light Books). Label each slide with your name, the title of the work, media, and dimensions of the work and an arrow indicating the top of the slide. Provide gallery directors with a list of titles and suggested prices they can refer to as they review slides. Make sure the list is in the same order as the slides. Type your name, address and phone number at the top of the list.
- **Query letter or cover letter.** Type one or two paragraphs expressing your interest in showing at the gallery, and include a date and time when you will follow up.
- **Résumé or bio.** Your résumé needn't list every job you've ever had—concentrate on your art-related experience. List any shows your work has been included in and the dates. A bio is a paragraph describing where you were born, your education, the work you do and where you have shown in the past.
- **Artist's statement.** Some galleries require a short statement about your work and the themes you are exploring. A few paragraphs are all that is necessary.
- **Brochures and business cards.** Some artists design brochures showing color samples of their artwork and biographical information. Business cards are another professional touch. These extras make a good impression in your submission package, but are optional.
- **SASE.** If you need material back, don't forget to include your SASE.

Gallery directors look for a sense of vision or direction and a body of work to demonstrate this. It's not enough to show a collection of unrelated work. You'll need to show you are capable of cultivating an idea into an entire exhibition's worth of work.

What makes a great promotional piece?

Pamela Hobbs, a San Francisco illustrator, has the right idea. The above sample is just a taste of her many promotions. Whether it's an accordian-folded sample in a see-through envelope, a T-shirt or a clip-on button showing Hobbs' website address, you can be sure it will be admired and saved (or quite possibly worn) by art directors. Hobbs, who is represented by Maslov/Weinberg, has served on the faculty at The School of Visual Arts, Parsons School of Design and The California College of Arts and Crafts. Her clients include *The New York Times*, MTV, Absolut vodka, *Wired* and others. You can see more of Hobbs's style on her website, http://www.pamorama.com.

GUIDELINES FOR ILLUSTRATORS AND CARTOONISTS

Illustrators have several choices when submitting to markets. Many freelancers send a cover letter and one or two samples in initial mailings. Others prefer a simple postcard showing their illustrations. Here are a few of your options:

- **Postcard.** Choose one (or more) of your illustrations that is representative of your style, then have the image printed on postcards. Have your name, address and phone number printed on the front of the postcard, or in the return address corner. Somewhere on the card should be printed the word "Illustrator." If you use one or two colors you can keep the cost below $200. Art directors like postcards because they are easy to file or tack on a bulletin board. If the art director likes what she sees, she can always call you for more samples.
- **Promotional sheet.** If you want to show more of your work, you can opt for an 8×12 color or black and white photocopy of your work. (See Greg Maxson's promotional sheet on page 26.)
- **Tearsheets.** After you complete assignments, acquire copies of any printed pages on which your illustrations appear. Tearsheets impress art directors because they are proof that you are experienced and have met deadlines on previous projects.
- **Photographs and slides.** Some illustrators have been successful sending photographs or slides, but printed or photocopied samples are preferred by most art directors.
- **Query or cover letter.** A query letter is a nice way to introduce yourself to an art director for the first time. One or two paragraphs stating you are available for freelance work is all you need. Include your phone number, samples or tearsheets. (See example on page 28.)

If you send 8×12 photocopies or tearsheets, do not fold them in thirds. It is more professional to send them flat, not folded, in a 9×12 envelope, along with a typed query letter, preferably on your own professional stationery.

Humorous illustrators and cartoonists should follow the same guidelines as illustrators when submitting to publishers, greeting card companies, ad agencies and design firms. Professional looking photocopies work well when submitting multiple cartoons to magazines. When submitting to syndicates, refer to the introduction for that section on page 523.

GUIDELINES FOR DESIGNERS AND COMPUTER ARTISTS

Plan and create your submission package as if it were a paying assignment from a client. Your submission piece should show your skill as a designer. Include one or both of the following:

- **Cover letter.** This is your opportunity to show you can design a beautiful, simple logo or letterhead for your own stationery. Have the stationery printed on good paper. Then write a simple cover letter stating your experience and skills.
- **Sample.** Your sample can be a copy of an assignment you have done for another client, or a clever self-promotional piece. Design a great piece to show off your capabilities. For ideas and inspiration, browse through *Fresh Ideas in Promotion*, edited by Lynn Haller (North Light Books). Another great title from North Light is *Creative Self-Promotion on a Limited Budget*, by Sally Prince Davis.

ARE PORTFOLIOS NECESSARY?

You do not need to send a portfolio when you first contact a market. But after buyers see your samples they may want to see more, so have a portfolio ready to show.

Many successful illustrators started their careers by making appointments to show their portfolios. But it is often enough for art directors to see your samples. Gallery directors sometimes ask to see your portfolio, but they can usually judge from your slides whether your work would be appropriate for their galleries. Never visit a gallery to show your portfolio without first setting up an appointment.

Some markets in this book have drop-off policies, accepting portfolios one or two days a week. You will not be present for the review and can pick up the work a few days later, after they've had a chance to look at it.

Most businesses are honorable and you don't have to worry about your case being stolen. However, since things do get lost, include only duplicates that can be insured at a reasonable cost. Only show originals when you can be present for the review. Label your portfolio with your name, address and phone number.

WHAT SHOULD I INCLUDE IN MY PORTFOLIO?

The overall appearance of your portfolio affects your professional presentation. Your portfolio need not be made of high-grade leather to leave a good impression. Neatness and careful organization are essential whether you are using a three-ring binder or a leather case. The most popular portfolios are simulated leather with puncture-proof sides that allow the inclusion of loose samples. Choose a size that can be handled easily. Avoid the large, "student" size books which are too big and bulky to fit easily on an art director's desk. Most artists choose 11×14 or 18×24. If you are a fine artist and your work is too large for a portfolio, bring your slides and a few small samples.

Don't include everything you've done in your portfolio. Select only your best work and choose pieces germane to the company or gallery you are approaching. If you're showing your book to an ad agency, for example, don't include greeting card illustrations.

In reviewing portfolios, art directors look for consistency of style and skill. They sometimes like to see work in different stages (roughs, comps and finished pieces) to see the progression of ideas and how you handle certain problems.

When presenting your portfolio, allow your work to speak for itself. It's best to keep explanations to a minimum and be available for questions if asked. Prepare for the review by taking along notes on each piece. If the buyer asks a question, take the opportunity to talk a little bit about the piece in question. Mention the budget, time frame and any problems you faced and solved. If you are a fine artist, talk about how the piece fits into the evolution of a concept, and how it relates to other pieces you've shown.

Don't ever walk out of a portfolio review without leaving the buyer a business card or sample to remember you by. A few weeks after your review, follow up by sending a small promo postcard or other sample as a reminder.

For more information, see *The Ultimate Portfolio*, by Martha Metzdorf and *The Fine Artist's Guide to Showing and Selling Your Work*, by Sally Prince Davis, both published by North Light Books.

SELF-PROMOTION STRATEGIES

Self-promotion is an ongoing process of building name recognition and reputation by introducing yourself to new clients and reminding past clients you are still available.

Experts suggest artists spend about one-third of each week and up to 10 percent of their gross income on self-promotion. Whether you decide to invest this much time is up to you, but it is important to build time into your schedule for promotional activities.

It's a good idea to supplement your mailings with other forms of self-promotion. There are many additional strategies to make prospective clients aware of you and your work. Consider some of these options:

- **Talent directories.** Many graphic designers and illustrators buy pages in illustration and design annuals such as *Black Book*, *The American Showcase* and *RSVP*. These go to thousands of art directors and many keep their directories for up to five years.

 A page in one of these directories can run from $2,000 to $3,500 and you have no control over who receives them. Yet, some artists who buy pages claim they make several times the amount they spend. One bonus to these directories is they provide you with up

Help art directors remember your name and style

Promotional samples don't have to be expensive to be effective. Technical illustrator Greg Maxson finds quarterly mailings especially effective. First he sends postcards printed inexpensively by Modern Postcard (800-959-8365). Then, he follows up with a four- or five-image promo sheet copied on his color laser printer. Using Adobe Illustrator, he customizes images to specific publishers; *Popular Science* and *Today's Homeowner* don't receive the same samples. Maxson first stumbled across *Artist's & Graphic Designer's Market* (then called *Artist's Market*) in 1988. "I have purchased every edition since, and my freelance work continues to grow each year."

to 2,000 loose pages, depending on the book, to use as samples.

- **Media relations.** The media is always looking for good public interest stories. If you've done something unique with your work, send a press release to magazines, newspapers and radio stations. This kind of exposure is free and will help increase public awareness of you and your work.

- **Pro bono work.** Donating your design or illustration services to a favorite charity or cause not only makes you feel good—it can be good public relations. These jobs can offer you added exposure and an opportunity to acquaint potential clients with your work. For example, a poster designed for your local ballet company may put your work in front of area business communicators, gallery directors and shop owners in need of artistic services. If you design a brochure for a charity event, you'll reach everyone on the charity's mailing list. Only donate free services to nonprofit organizations in need of help—don't give away work to a client who has the means to pay.

- **Networking.** Attending seminars, organization meetings, trade shows, gallery openings and fundraisers is a good way to get your name out. It doesn't hurt to keep a business card on hand. Volunteering to work on committees gives you an even better opportunity to make contacts.

- **Contests and juried shows.** Even if you don't win, contests provide good exposure. Judges of design and illustration contests are usually art directors and editors who may need work in the future. Winners of competitions sponsored by design magazines like *HOW* and *Print* are published in awards annuals that result in national exposure. Since there are many categories and levels of awards there are many chances to win. Judges of fine art shows are often gallery directors. Entering a juried show will also allow you to show your work to the community.

- **Home shows.** If you are a fine artist and have a body of work nearly complete, go over your mailing list and invite a select number of people to your home to preview the work. (Before pursuing this option, however, make sure you are not violating any contracts you already have with galleries.)

HOW TO STAND OUT FROM THE CROWD

Your potential clients are busy! Piles of samples cross their desks each day. They might spend only a few seconds glancing at each sample while making their way through the "slush" pile (an industry term for unsolicited submissions). Make yourself stand out in simple, yet effective ways:

- **Tie in your query letter with your sample.** When sending an initial mailing to a potential client, include a query letter of introduction with your sample. Type it on a great-looking letterhead of your own design. Make your sample tie in with your query letter by repeating a design element from your sample onto your letterhead. List some of your past clients within your letter.

- **Send artful invoices.** After you complete assignments, a well-designed invoice (with one of your illustrations or designs strategically placed on it, of course) will make you look professional and help art directors remember you (and hopefully, think of you for another assignment!)

- **Follow-up with seasonal promotions.** Holiday promotions build relationships while reminding past and potential clients of your services. So get out your calendar now and plan some special promos for one of this year's holidays!

To see how other freelancers use the above strategies to make their work stand out, see the examples on the following pages.

What's a query letter?

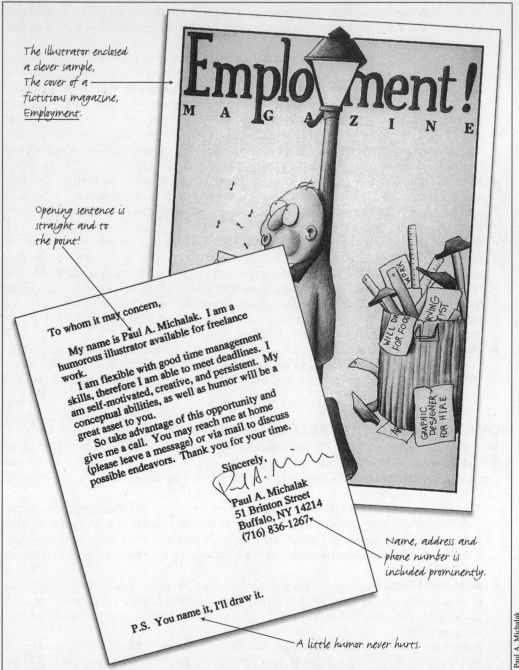

The Illustrator enclosed a clever sample, The cover of a fictitious magazine, Employment.

Opening sentence is straight and to the point!

To whom it may concern,

My name is Paul A. Michalak. I am a humorous illustrator available for freelance work.

I am flexible with good time management skills, therefore I am able to meet deadlines. I am self-motivated, creative, and persistent. My conceptual abilities, as well as humor will be a great asset to you.

So take advantage of this opportunity and give me a call. You may reach me at home (please leave a message) or via mail to discuss possible endeavors. Thank you for your time.

Sincerely,

Paul A. Michalak
51 Brinton Street
Buffalo, NY 14214
(716) 836-1267

Name, address and phone number is included prominently.

P.S. You name it, I'll draw it.

A little humor never hurts.

© Paul A. Michalak

A query letter, or cover letter, is a short letter introducing yourself and your artistic talent to potential clients. Query letters should be to-the-point, no more than one page long, and should include one or more samples of your work. Above, humorous illustrator Paul A. Michalak simply describes his abilities and encloses a very creative sample. Notice that he includes his name, address and phone number prominently. Michalak sent this query letter and sample to listings in *AGDM* and to advertising agencies in his city. He reports that "besides a lot of positive responses, this piece just landed me an assignment with Octameron Press."

Design a "total look" for your promotions

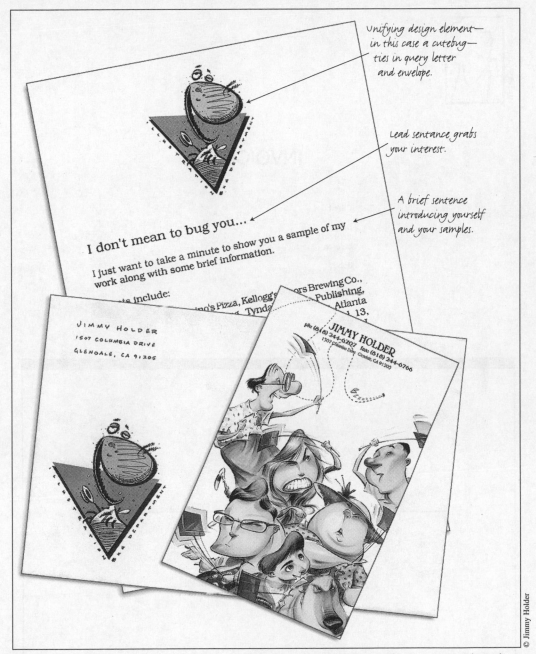

Unifying design element—
in this case a cutebug—
ties in query letter
and envelope.

Lead sentance grabs
your interest.

A brief sentence
introducing yourself
and your samples.

I don't mean to bug you...

I just want to take a minute to show you a sample of my
work along with some brief information.

...ts include:

...no's Pizza, Kellogg's ...ors Brewing Co.,
... Tynda... Publishing,
Atlanta ... l 13.

JIMMY HOLDER
1507 COLUMBIA DRIVE
GLENDALE, CA 91205

ph (818) 244-0707 fax (818) 244-6766
JIMMY HOLDER
1507 Columbia Drive, Glendale, CA 91205

© Jimmy Holder

Illustrator Jimmy Holder's promotional packet is one of the best we've seen. His query letter, promotional sample, envelope and postcard all connect with a unifying design concept: a bug! Jimmy's wife and marketing partner, Suzanne, wrote: "We were happy to send you some of his promotional mailers, especially since we use *AGDM* like a bible. We have been using it for the last couple of years and it has proven to be a huge success! You will be happy to know we booked the following clients in one year alone: *The Artist's Magazine, Baltimore Magazine, Entrepreneur Magazine, Covering Magazine, The Toastmaster, Wildlife Conservation, World Trade* and *Zymurgy*." Now there's a client list!

Even your invoices should make a statement

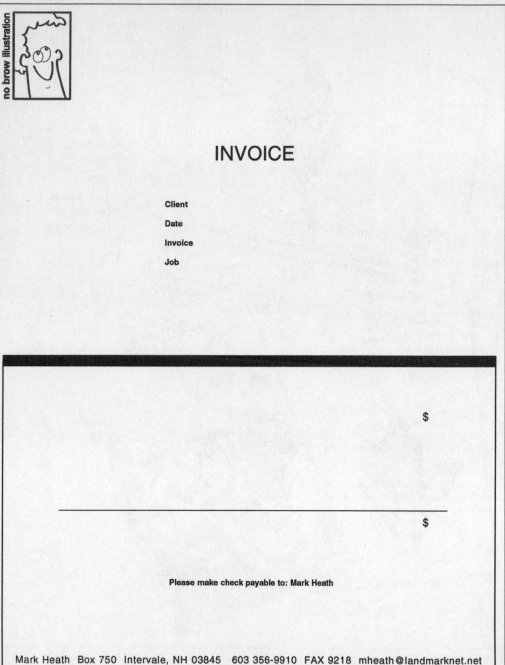

Does your invoice say "Pro"? Humorous illustrator Mark Heath designed invoices that not only get him paid, but reinforce his humor and professionalism with his clients. Notice how the invoice, with a funny cartoon at the top, gets across the idea that Heath is a thorough professional, an artist with a sense of humor who is also dependable, reliable and accustomed to sending out invoices to clients. No wonder Heath is remembered, and called again. Are your invoices as professional?

INVOICE

Make all checks payable to Pamela Hobbs
S S № 243-37-4641

Send To:

Pamela Hobbs
4150 Hana Hwy.
Haiku HI 96708
Tel: 415-550-8899
Fax: 808-573-0037

Date of Invoice

Today's date

Invoice Nº

Commissioned by

Billed to

Number of artworks () & Titles.

First reproduction rights only: payment of the reproduction fee listed on this invoice and only the payment constitutes license for pamela hobbs to use the artwork designated below in the manner described. terms net 30 days of invoice date. over due payments will be charged additional 8 % per day.

Reproduction:
lease rights are granted for one-time first North American reproduction rights only. Any use of this artwork in a manner other than exactly described is a violation of © and will be treated accordingly. In the event of cancellation of this assignment, the © shall be retained by the artist, and a cancellation fee of 50% of the full contract price and expenses already incurred, shall be paid by the client.

Alterations:
Alterations to artwork (Digital computer disk format included) shall not be made without written consent of the artist, and the artist shall be allowed the first option to make all alterations when possible. After acceptance of artwork, if alterations are requested, a payment shall be charged over the original amount.

Sales Tax
(if in the state of California) _____

Balance Due _____

Thank you for your prompt payment.

Signed

Pamela Hobbs

Enhance your image while protecting your rights. Concerned about rights? A well-designed invoice can show off your style and contain language to protect your rights and address reproduction considerations. Pamela Hobbs, whose sample appears on page 23, also sends an invoice showing one of her drawings to reinforce her name and style in clients' minds. As a computer illustrator whose work frequently appears on the World Wide Web, Hobbs is very aware of reproduction rights, so she includes paragraphs detailing how her illustration can be used.

Follow up with seasonal promotions

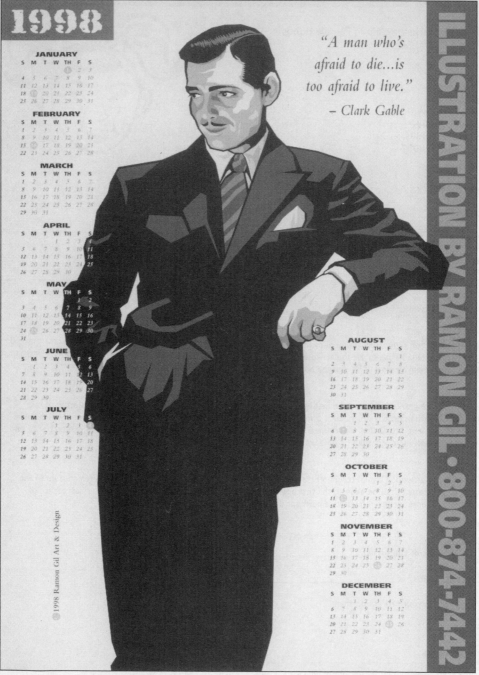

"A man who's afraid to die...is too afraid to live."
– Clark Gable

ILLUSTRATION BY RAMON GIL • 800-874-7442

© Ramon Gill

What a keeper! A "keeper" is any sample that art directors or other potential clients will keep on their desks or post to their bulletin boards. This calendar, by Ramon Gil, is just that. Gil made sure his design included his name and phone number prominently as well as a nifty calendar showing all 12 months on one card. All that—and Clark Gable, rendered in Gil's sophisticated style—add up to a sample art directors are likely to hold onto! For more examples of seasonal cards and calendars that double as promotional material, consult *The Best Seasonal Promotions* by Poppy Evans (North Light Books).

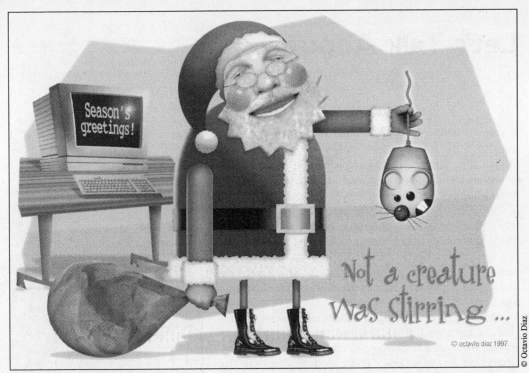

Season's greetings!

Not a creature was stirring ...

© octavio diaz 1997

© Octavio Diaz

Holiday promos are a surefire way to build relationships and name recognition. What better way to keep in touch with clients and potential clients, than by designing promotional cards for appropriate holidays? Octavio Diaz, whose work is also featured on page 13, designed this humorous card to wish "Season's Greetings" to all those on his mailing list. Not only did he get to wish them a happy holiday, but he reinforced his name, his style and his professionalism, too!

Let's Talk About Art

If you go gallery hopping in Chicago you surely won't want to miss a world-class gallery on North Morgan Street called Klein Art Works. Once there, you're likely to see an installation by Michael Kessler, paintings by Sam Gilliam or sculpture by Tony Berlant or Jun Kaneko. If you're lucky, you may even get to chat with the gallery's founder, an energetic force known as Paul Klein. But if you can't get to Chicago, Klein and his artists are as close as the nearest computer. For the past several years, Klein has been a pioneer of sorts. He is one of the first gallery dealers to take to the World Wide Web with a vengeance.

Along with fast-loading installation shots and biographies of his artists, Klein has made himself available to anyone who visits his homepage and wants to discuss the artwork or art in general. The award-winning site has attracted artists and collectors from all over the world. Quite naturally, artists want to know about how to get gallery representation. For each question, Klein offers

Paul Klein

down-to-earth and often inspiring advice. He never talks down to artists and never discourages anyone who wants to make art a career. "Maybe I am biased, but I think being an artist is among the most demanding professions one can choose," says Klein. "It is honest and satisfying. And it is hard. If you want to be an artist, by all means do it. It is an exciting and fulfilling existence."

The following are questions artists from all over the world have asked Klein about the artist/gallery relationship. For the sake of space, we've left off the questioners' names and condensed some of the answers. But first, Klein offers the following disclaimer: "I have been an art dealer for over 20 years, and by this time I kind of assume I know a fair amount about art and the art market. However, I speak only for myself." Klein points out that his relationships with artists may be very different than that between other dealers and their artists. "But, one of the nice things about the art world," says Klein, "is that there is no monopoly on truth."

People say if you want to be an artist you MUST move to L.A. or New York. Do you agree?

Hogwash. We represent about 20 artists—maybe 5 live in the Chicago area. The others live in L.A., Omaha, Sante Fe, southern Texas, Minnesota, Ohio, upstate New York, Washington, D.C. and all over the United States. None of them is from New York City.

I went to a large gallery in town, and no one would speak to me. I felt like I was in a hospital. How do I engage someone in a discussion about artwork?

Don't bother with stuffy galleries. Their heads are not into art. They are solely interested in capitalism—and that is not enough to make them a good gallery.

Young artists should not be intimidated by galleries and should be eager to take their work there, if only to say "Hey, I am going to get somewhere someday, and I would be flattered if

you would have a look at my work. I don't want you to represent me yet, I just want you to look at it and tell me anything you feel like saying.''

How can I get a gallery to represent me?

Proceed *very* slowly. I see the artist/gallery relationship as being very similar to dating. You don't walk up to somebody and say, "Let's do it—tonight!" And you don't walk up to a gallery director and say, "Here are my slides. Do something." There is a courtship. Thomas Wolfe talked about the "Boho Dance." It's a process.

It is a whole lot better if the dealer asks to look at your work first. Two or three artists I work with now used to stop by every month or so, ask a question or two and leave. After a while we started talking about the art in the gallery. I respected their opinions about what I showed. Eventually, I asked and was told they were artists—though it wasn't hard to tell. I asked if I could see what they were up to.

So I would advise you to first go visit galleries. Find a gallery that feels right to you—where the aesthetic is compatible and where you feel comfortable with the staff. Look around. Leave. Go back again. Say something sincere. Leave. Go back to see a third exhibit. Start slow and say something that indicates you like the gallery. Give the staff the opportunity to warm up to you. Try to find a way to let them ask you about your work. Don't expect miracles overnight. Follow your instincts. Above all, be who you are.

What if you are not local and can't make all those visits?

A recommendation helps. Write a letter that says something like, "I have heard/seen a lot about your gallery that I really like, and (if possible) my friend (who is known to the gallery) says you might be interested in my art."

What if a gallery doesn't want to show my work? How do I handle the rejection?

Get over the fear of showing your work. If you get the opportunity to show your slides, do so. But know this: good dealers do not pass judgment on the quality of your work—even though they may act like it. They are trying to determine if it fits their vision. It is about agreement. If they identify with what you are doing, a relationship is possible. If they don't, it isn't.

Think about the dating analogy again. Not everything or everyone is for everybody. If it doesn't work, it does not mean you are not worthy, nor does it mean they don't like you. It simply means your work is not for them at this moment.

Go through the steps. If they make you feel rejected I would conclude that they are jerks. It is not hard to find someone's work inappropriate for a given gallery without making the person feel rejected. It is not unusual that you will show your work to galleries for years before someone has the right response.

Isn't there an awful lot of politics in the art world? Shouldn't talent be enough? I don't think I should have to play the game.

There are a lot of rules/conventions/b.s. that govern the art world. It has a bunch of attitudes that seem to propel it. The art world is comprised of significant galleries (like we think we are) that have a bunch of rules to prop themselves up. It's all a bunch of baloney, but if you buy into you are part of it.

My own attitude is that it's beneficial to know the "rules" and then sometimes play into them and sometimes play off of them. For example, the art world says it is important for artists to have dealers, that if they do not they are not part of the mainstream and they won't be taken seriously. The fact of the matter is, many artists don't need dealers. They sell plenty of stuff without shows. They don't really care about being validated by the museum structure and never gave it much thought anyway. No problem. So be it—just don't expect the so-called establish-

ment to jump up and down and salute you because you can get by handsomely without them (but they might).

To a large extent the artworld is about relationships. Develop them. Know other artists. Know dealers. Know museum people. You will have the opportunity to help one another. Relationships will open doors for you. We do not exist in a vacuum. We are influenced by people we like.

It is important to realize that talent is not enough. Meet other artists. Go out drinking with them—share ideas, meet curators, be real, be a human, don't kiss ass too much, be yourself—and realize everyone has something to offer.

You do not need to be successful overnight, and it is probably a mistake to want to be. Overnight success is scary. It is too easy to be a one-trick pony. What are you going to do for an encore? It is not sufficient to do the same thing over again.

You are an artist. Be creative. Apply your artistic creativity to other facets of your life, and particularly your career. Use what you've got and use it well.

What should I include in my submission packet to galleries?

I am only interested in looking at a limited number of images of current stuff—the last 6 months, maybe 12. I don't want to see old stuff. I want to see what you're doing now. One page of slides—no more than 20 images—is more than enough. Slides are the norm, but snapshots are OK, and 4×5's are all right, too, or even a disk with jpeg files.

Don't show everything you've ever done. Don't reveal your whole life history. (Think about the dating analogy again.) Let galleries ask for more instead of showing too much and letting them lose interest. Always, always, *always* include a self-addressed, stamped envelope so the gallery does not feel imposed upon in returning your slides.

Only send work you are proud of. If I am interested in that, I may want to see more, i.e., earlier work, or ask that you submit more images in six months or so. Send along a résumé—even if it doesn't say much. I look at it, but have taken on artists who have recently completed school and have essentially no résumé, as well as established artists whose résumés are impressive. The résumé just gives me a sense of context.

What factors influence you when deciding whether or not to represent an artist?

I show art I believe in, art I wish I could have created. If you visit the Klein Art Works web page, you'll see we are interested in contemporary abstraction. But regardless of the aesthetic my gallery prefers, when looking at art I want to be able to get a sense of the artist who made the work. If the art is any good, I learn a lot about the artists who make it—their issues, concerns, and what makes them tick. And in the process I learn about myself.

Besides responding to and liking the artwork, I've also got to anticipate liking what the artist is going to do for the next ten years. In addition, I've still got to like the person, and Judith (my co-director) has got to like the person.

There have been many instances where I became interested in artists' work because I liked them before I even saw their work. Liking them got me into a frame of mind where I was receptive to their vision. There have also been times I have liked artists and not responded to their work, but remained a friend and supporter— though I have no desire to exhibit their artwork.

I like sincerity. I like artists who believe in what they are doing—not artists who are trying to be *au currant*—but artists who truly give a damn about what they are creating.

I also consider a whole lot of nebulous factors—like do I want an established artist whose work is pricey; a young, local artist who doesn't yet have a following; or someone in between? How does the artist's aesthetic compare to mine? Will my clients respond to the work? Beyond that, I look for commitment on the artist's part. I have to mentally make the jump from what they are doing now to what they are likely to be doing at some point far off in the future. If the work is not focused it is hard to extrapolate.

I am always open to looking at slides. I look all the time. If you don't look you don't see it. I look at all the work that is submitted. Not much of what I get do I do anything about. Out of a thousand sets of slides mailed to me per year, I'd say maybe I take on one or two new artists a year. When I like the work but it doesn't fit the type of work I show, I sometimes steer artists to more appropriate galleries.

I never put out a call for slides (well almost never). Artists send them in all the time. There are times when I put out the word that we are doing a group show and I get a lot more slides than I usually do. In the process I discover some new people.

What do you find lacking in the slides you see?

When I review slides I often sense artists are hedging, holding back—they are reluctant to put themselves in their art. This is a big mistake.

To be successful, you must allow yourself to be vulnerable and to share that vulnerabilty with an unknown audience. A difficult task. Art needs content. If there are no issues, if there is no content, it is not art—it's decoration.

It also hurts artists not to have a background in art history. You've got to know the artwork of the past, as well as what is going on now so as not to be derivative—not a good thing in the art biz. When you begin making your art—not theirs—progress happens. By digesting the art of the past, you will also answer questions about who you are by gauging your response to other artists' work. You can just be you and make art. Make it honest. Make it sincere. Make it good.

I like art that is fresh. Fresh does not mean earth-shattering. It means unique, interesting, honest. The art relates to what has gone on before, takes it a step or two further and introduces some new ideas—some of it technical, some of it concept. Rarely do I see art I consider fresh—but it happens.

How do I know if I am ready for gallery representation?

It frequently takes two years from the time an artist is out of school until a gallery dealer can feel pretty confident that the artist is making his own work as opposed to responding to various stimuli and/or assignments from school.

Many artists who come out of college or graduate school feel they are ready to make a difference. In many cases I think that is a rushed judgment. Frequently they need to have more time making art before a dealer can look at the work and feel confident the artist is committed to it.

Some young artists I see, in my mind, are ready. They're focused. They've benefited from their school experience and are making their own art, not somebody else's. As it happens, sometimes the artists I think are ready aren't; or artists I think are ready think they aren't. It's a delicate timing. Whether or not you're ready to show your work, the important thing is to find yourself and your vision—not worry about getting into the marketplace.

I am not convinced there are many artists under 30 who should be in a gallery. Their work is in a state of flux—as it should be. Every young artist should have the opportunity to create good art, bad art, goofy art, without the pressure of having it be successful.

When a gallery enters into a relationship with an artist, what role does the gallery play in guiding that artist?

When we begin a relationship with an artist, I look at it as being a minimum of a ten-year relationship. The relationship with a young artist is different from a relationship with an established artist who has a track record. Once an artist is established, the gallery's strategy tends to be in place. You can have discussions about changing and tweaking it, or modifying it slightly. With the more successful (older) artists there is a periodical exchange of ideas, sometimes strong friendships and sometimes just a boring business relationship—but we are excited by the art.

With younger artists there is a lot more hand holding—advising and discussing. I avoid

suggesting that an artist change his or her vision to accommodate mine. Too many dealers do this and destroy relationships. I am, however, very willing to discuss strategy, which I construe to be "how do we take this artist's vision/aesthetic and make some money?"

I see the relationship as a team effort—the gallery and the artist applying our distinct and occasionally overlapping abilities and connections to augment the career of the artist, and by extension, ourselves. If an out-of-town dealer approaches one of my (local and probably younger) artists, I expect the artist to consult me so that together we can reach a consensus about the wisdom of the potential relationship. If the artist makes deals without consulting us, sells work from the studio without consulting us, I am offended and the relationship is in trouble.

When I have questions about what is good for an artist, I remember my priorities: 1. Do what is good for the art; 2. Do what is good for the artist; 3. Do what is good for the gallery. Seems to solve a lot of problems before they happen.

Most of the younger artists we show tend to be local. We try to have them in the gallery more often and encourage them to talk to our other artists. We invite them to talk to collectors or introduce them to other folks, so they can get the kind of knowledge they didn't get in school. We try to give them a greater sense of the big picture and just be supportive.

Which responsibilities fall to the artist and which to the gallery?

Your job is to make good art. It's your gallery's job to do everything else. There is some latitude about who pays shipping, although in no case should you pay over 50 percent of the total of getting the work to and from the gallery—in most cases the gallery should cover it all. But if it is cheap it is not a big deal for the artist to pay for getting it to the gallery. Advertising and promotion are up to the gallery. If you don't feel like they have done a good job for you once the show is over, get your stuff and leave.

Do you help artists with pricing their work?

In the beginning it is far more important to get work out than to get big money for it—far more important to make art than to be concerned with selling it.

Pricing is really only an issue with young artists—those who have never shown or have essentially no track record. If they sell, prices go up. If they don't, prices remain the same. From then, it is merely a question of extrapolating from previous prices— and size (square inches) has a lot to do with it.

When thinking about pricing your art, do not think about what you deserve for it. Think about what IT deserves. Get objective. Envision your art as if it were made by someone else who has a comparable résumé. Odds are that it is far less than the value you would assign it if you had to stick a meager per-hour price on it for how long it took you to make it. Hopefully, by the time 10 years are up, the equation will be totally flipped and you will be getting far more than $100 per hour for your efforts.

What are the qualities that make a good artist?

The basic prerequisites are having talent and having something to say. Talent is easier to accomplish than vision. Talent you can learn in school. Talent you can learn from other artists. It comes from knowing one's media. It is very important to be fluent in your media and explore its nuances. Learn everything you can about what you are doing.

Having something to say comes from living life and having the guts to express yourself. Part of the problem here is that the artworld wants what you have to say to be unique, fresh and new. It is not enough to paint an Impressionist painting. That has already been done. Don't repeat what has already been done.

Gimmicks are shallow—trying to figure out what someone else will buy is very tricky. Come from yourself, your experiences, what you know, what you love. Seek to either reveal or discover yourself. It is best, easiest, and most genuine to do what one believes in.

As a human being, you are unique, somehow different than anyone else on the planet. Strive to be who you are. Look for yourself in your artwork. Become one with your art.

How can artists do this—become one with their art?

DO IT. Make art. Do it again. Make more. Seek to discover yourself in your art. Put everything of yourself into it. Be vulnerable, be honest, be real, take chances. Notice that I did not say sell it or exhibit it. This matters some—but not as much as all the other stuff. Ultimately, sales only need to be sufficient enough to let you keep doing what you want to do!

Editor's note: *This article was condensed from material on the Klein Art Works homepage. For more of Paul Klein's frank advice, visit the Klein Art Works homepage on the World Wide Web at http://www.kleinart.com.*

An installation at Klein Art Works of the paintings of artist Michael Kessler. This is representative of the type of work usually showcased at the Chicago gallery.

Organizing Your Business for Success

Like many artists, you might shy away from the word "business." But let's face facts, you must have business savvy in order to survive and prosper. Luckily, it's not that hard to set up a few simple systems that will keep you on track.

YOUR MOST VALUABLE RECORD-KEEPING TOOL

Visit an office supply store and pick out a journal, ledger or computer software to use in keeping a daily record of your business expenses and sales. If you are an illustrator or designer, assign a job number to each assignment. Record the date of the project, the client's name, any expenses incurred, sales tax and payments due.

A simple system for fine artists consists of two folders—one for expenses and one for sales. Every time you purchase art supplies, place the receipt in your "expenses" folder. When you make a sale, photocopy the check or place a receipt in your "sales" folder.

It doesn't matter what system you choose, but you must keep a record of every artwork you sell or every commercial assignment you undertake, along with receipts for every business expense. Keep all receipts, canceled checks, contracts and sales records. Record your expenses daily, showing what was purchased, from whom, for how much and the date. Log automobile expenses separately showing date, mileage, gas purchased and reason for trip.

BILLING YOUR CLIENTS

If you are a designer or illustrator, you will be responsible for sending out invoices for your services. Clients generally will not issue checks without them. Most graphic designers arrange to be paid in thirds, billing the first third before starting the project, the second after the client approves the initial roughs, and the third upon completion of the project. Illustrators are generally paid in full either upon receipt of illustration, or on publication. So mail or fax an invoice as soon as you've completed the assignment.

Standard invoice forms allow you to itemize your services. The more you spell out the charges, the easier it will be for your clients to understand what they are paying for. Most designers charge extra for changes made after approval of the initial layout. Keep a separate form for change orders and attach it to your invoice.

If you are an illustrator, your invoice can be much simpler, as you'll generally be charging a flat fee. It's helpful, in determining your quoted fee, to itemize charges according to time, materials and expenses (the client need not see this itemization—it is for your own purposes).

Most businesses require your social security number or tax ID number before they can cut a check so include this information in your bill. Be sure to put a due date on each invoice, include the phrase "payable within 30 days" (or other preferred time frame) directly on your invoice. Most freelancers ask for payment within 10-30 days.

Sample invoices are featured in *The Designer's Commonsense Business Book*, by Barbara Ganim (North Light Books) and *Business and Legal Forms for Illustrators*, by Tad Crawford (Allworth Press).

If you are working with a gallery, you will not need to send invoices. The gallery should send you a check each time one of your pieces is sold (generally within 30 days). To ensure that you are paid promptly, call the gallery periodically to touch base. Let the director or business

manager know that you are keeping an eye on your work. When selling work independently of a gallery, give receipts to buyers and keep copies for your records.

FEE-SETTING IN COMMERCIAL MARKETS

It's difficult to make blanket statements about what to charge for illustration and design. Every slice of the market is somewhat different. Nevertheless, there is one recurring pattern: hourly rates are generally only paid to designers working inhouse on a client's equipment. (Clients are more likely to pay hourly if they can easily keep track of the hours freelancers work.) Freelancers working out of their own studios (this is nearly always the arrangement for illustrators) are almost always paid a flat fee or an advance against royalties.

If you are unsure about what to charge for a job, begin by devising an hourly rate, taking into consideration the cost of your materials and overhead and whatever you think your time is worth. (If you are a designer, determine what the average salary would be for a fulltime employee doing the same job.) Then estimate how many hours the job will take and quote a flat fee based on these calculations. *Setting the Right Price for Your Design & Illustration*, by Barbara Ganim (North Light Books), includes easy-to-use worksheets to help you set prices for 33 kinds of projects.

There is a distinct difference between giving the client a job estimate and a job quotation. An estimate is a "ballpark" figure of what the job will cost, but is subject to change. A quotation is a set fee which, once agreed upon, is pretty much set in stone. Make sure the client understands which you are negotiating. Estimates are often used as a preliminary step in itemizing costs for a combination of design services such as concepting, typesetting and printing. Flat quotations are usually used by illustrators, as there are fewer factors involved in arriving at fees.

For recommended charges for different services, refer to the *Graphic Artist's Guild's Handbook of Pricing & Ethical Guidelines*. Many artists' organizations have hotlines you can call to find out standard payment for the job you're doing.

As you set fees, certain stipulations call for higher rates. Consider these bargaining points:
- **Usage (rights)**. The more rights bought, the more you can charge. For example, if the client asks for a "buyout" (to buy all rights), you can charge more because by relinquishing all rights to future use of your work you will be losing out on resale potential.
- **Turnaround time**. If you are asked to turn the job around in a short amount of time, charge more.
- **Budget**. Don't be afraid to ask a project's budget before offering a quote. You won't want to charge $500 for a print ad illustration if the ad agency has a budget of $40,000 for that ad. If the budget is that big, ask for higher payment.
- **Reputation**. The more well-known you are, the more you can charge. As you become established, periodically raise your rates (in small steps) and see what happens.

PRICING YOUR FINE ART

There are no hard and fast rules for pricing your fine artwork. Most artists and galleries base prices on market value—what the buying public is currently paying for similar work. Learn the market value by visiting galleries and checking prices of works similar to yours. When you are starting out don't compare your prices to established artists, but to emerging talent in your region. Consider these when determining price:
- **Medium**. Oils and acrylics cost more than watercolors by the same artist. Price paintings higher than drawings.
- **Expense of materials**. Charge more for work done on expensive paper than for work of a similar size on a lesser grade paper.
- **Size**. Though a large work isn't necessarily better than a small one, as a rule of thumb you can charge more for the larger work.
- **Scarcity**. Charge more for one-of-a-kind works like paintings and drawings, than for lim-

ited editions, such as lithographs and woodcuts.
- **Status of artist**. Established artists can charge more than lesser-known artists.
- **Status of gallery**. It may not be fair but prestigious galleries can charge higher prices.
- **Region**. Although this is changing, works sell for more in larger cities like New York and Chicago.
- **Gallery commission**. The gallery will charge from 30 to 50 percent commission. Your cut must cover the cost of materials, studio space, taxes and perhaps shipping and insurance, and enough extra to make a profit. If materials for a painting cost $25; matting, framing cost $37; and you spent five hours working on it, make sure you get at least the cost of material and labor back before the gallery takes their share. Once you set your price, stick to the same price structure wherever you show your work. A $500 painting by you should cost $500 whether it is bought in a gallery or directly from you. To do otherwise is not fair to your gallery and devalues your work.

As you establish a reputation, begin to raise your prices—but do so cautiously. Each time you "graduate" to a new price level, you will not be able to come back down.

CONTRACTS

Contracts are simply business tools to make sure everyone is in agreement. Ask for one any time you enter into a business agreement. Even if you take an assignment by phone, arrange for the specifics in writing, or provide your own. A letter stating the terms of agreement signed by both parties can serve as an informal contract. Several excellent books such as *The Artist's Friendly Legal Guide* (North Light Books) provide sample contracts you can copy*Business and Legal Forms for Illustrators*, by Tad Crawford (Allworth Press), contains negotiation checklists and tear-out forms. The sample contracts in these books cover practically any situation you might run into from renting your fine art to spelling out royalties in a contract with a book publisher.

The items specified in your contract will vary according to the market you are dealing with and the complexity of the project. Nevertheless, here are some basic points you'll want to cover:

Commercial contracts
- **A description of the service you are providing**.
- **Deadlines for finished work**.
- **Rights sold**.
- **Your fee**. Hourly rate, flat fee or royalty.
- **Kill fee**. Compensatory payment received by you if the project is cancelled.
- **Changes fees**. Penalty fees to be paid by the client for last-minute changes (these are most often imposed by designers).
- **Advances**. Any funds paid to you before you begin working on the project.
- **Payment schedule**. When and how often you will be paid for the assignment.
- **Statement regarding return of original art**. Unless you are doing work for hire, your artwork should always be returned to you.

Gallery contracts
- **Terms of acquisition or representation**. Will the work be handled on consignment? What is the gallery's commission?
- **Nature of the show(s)**. Will the work be exhibited in group or solo shows or both?
- **Time frames**. At what point will the gallery return unsold works to you? When will the contract cease to be in effect? If a work is sold, when will you be paid?
- **Promotion**. Who will coordinate and pay for promotion? What does promotion entail? Who pays for printing and mailing of invitations? If costs are shared, what is the breakdown?

- **Insurance**. Will the gallery insure the work while it is being exhibited?
- **Shipping**. Who will pay for shipping costs to and from the gallery?
- **Geographic restrictions**. If you sign with this gallery, will you relinquish the rights to show your work elsewhere in a specified area? If so, what are the boundaries of this area?

GOOD NEWS ABOUT INCOME TAX

You have the right to take advantage of deducting legitimate business expenses from your taxable income. Art supplies, studio rent, advertising and printing costs, and other business expenses are deductible against your gross art-related income. It is imperative to seek the help of an accountant or tax preparation service in filing your return. In the event your deductions exceed profits, the loss will lower your taxable income from other sources.

To guard against taxpayers fraudulently claiming hobby expenses as business losses to offset other income, the IRS requires taxpayers to demonstrate a "profit motive." As a general rule, you must show a profit three out of five years to retain a business status. This is a guideline, not a rule. The IRS looks at nine factors when evaluating your status and examines losses closely. If you are audited, the burden of proof will be on you to demonstrate your work is a business and not a hobby.

The nine criteria the IRS uses to distinguish a business from a hobby are: the manner in which you conduct your business, expertise, amount of time and effort put into your work, expectation of future profits, success in similar ventures, history of profit and losses, amount of occasional profits, financial status, and element of personal pleasure or recreation. If the IRS rules that you paint for pure enjoyment rather than profit, they will consider you a hobbyist. Complete and accurate records will demonstrate to the IRS that you take your business seriously.

Even if you are a "hobbyist," you can deduct expenses such as paint, canvas and supplies on a Schedule A, but you can only take art-related deductions equal to art-related income. That is, if you sold two $500 paintings, you can deduct expenses such as art supplies, art books, magazines and seminars only up to $1,000. Itemize deductions only if your total itemized deductions exceed your standard deduction. You will not be allowed to deduct a loss from other sources of income.

How to deduct business expenses

To deduct business expenses, you or your accountant will fill out a regular 1040 tax form (not 1040EZ) and prepare a Schedule C. Schedule C is a separate form used to calculate the profit or loss from your business. The income (or loss) from Schedule C is then reported on the 1040 form. In regard to business expenses, the standard deduction does not come into play as it would for a hobbyist. The total of your business expenses need not exceed the standard deduction.

There is a shorter form called Schedule C-EZ for self-employed people in service industries. It can be applicable to illustrators and designers who have receipts of $25,000 or less and deductible expenses of $2,000 or less. Check with your accountant to see if you qualify.

Deductible expenses include advertising costs, brochures, business cards, professional group dues, subscriptions to trade journals and arts magazines, legal and professional services, leased office equipment, office supplies, business travel expenses and many other expenses. Your accountant can give you a list of all 100 percent and 50 percent deductible expenses (such as entertainment).

As a self-employed "sole proprieter" there is no employer regularly taking tax out of your paycheck. Your accountant will help you put money away to meet your tax obligations and may advise you to estimate your tax and file quarterly returns.

Your accountant also will be knowledgeable about another annual tax called the Social Security Self-Employment tax. You must pay this tax if your net freelance income is $400 or more, even if you have other employment.

HOME OFFICE DEDUCTION

If you freelance fulltime from your home, and devote a separate area to your business, you may qualify for a home office deduction. If eligible you can deduct a percentage of your rent and utilities, expenses such as office supplies and business-related telephone calls.

The IRS does not allow deductions if the space is used for reasons other than business. A studio or office in your home must meet three criteria:

- The space must be used exclusively for your business.
- The space must be used regularly as a place of business.
- The space must be your principle place of business.

The IRS might question a home office deduction if you are employed fulltime elsewhere and freelance from home. If you do claim a home office, the area must be clearly divided from your living area. A desk in your bedroom will not qualify. To figure out the percentage of your home used for business, divide the total square footage of your home by the total square footage of your office. (To determine square footage, multiply length by width.) This will give you a percentage to work with when figuring deductions. If the home office is 10 percent of the square footage of your home, deduct 10 percent of expenses such as rent, heat and air conditioning.

The total home office deduction cannot exceed the gross income you derive from its business use. You cannot take a net business loss resulting from a home office deduction. Your business must be profitable three out of five years. Otherwise, you will be classified as a hobbyist and will not be entitled to this deduction.

Consult a tax advisor before attempting to take this deduction, since its interpretations frequently change.

Refer to IRS Publication 587, Business Use of Your Home, for additional information. *Homemade Money*, by Barbara Brabec (Betterway Books), provides formulas for determining deductions and provides checklists of direct and indirect expenses.

The fees of tax professionals are relatively low, and they are deductible. To find a good accountant, ask colleagues for recommendations, look for advertisements in trade publications or ask your local Small Business Association. And don't forget to deduct the cost of this book.

Independent contractor or employee?

Some clients automatically classify freelancers as employees and require them to file Form W-4. If you are placed on employee status, you may be entitled to certain benefits, but a portion of your earnings will be withheld by the client until the end of the tax year and you could forfeit certain deductions. In short, you may end up taking home less than you would if you were classified as an independent contractor.

The IRS uses a list of 20 factors to determine whether a person should be classified as an independent contractor or an employee. This list can be found in Publication 937. Note, however, that your client will be the first to decide whether or not you will be so classified.

The $600 question

If you bill any client in excess of $600, the IRS requires the client to provide you with a form 1099 at the end of the year. Your client must send one copy to the IRS and a copy to you to attach to your income tax return. Likewise, if you pay a freelancer over $600, you must issue a 1099 form. This procedure is one way the IRS cuts down on unreported income.

Report sales tax on art sales

Most states require a 2 to 7 percent sales tax on artwork you sell directly from your studio or at art fairs or on work created for a client, such as art for a logo. You must register with the state sales tax department, which will issue you a sales permit or a resale number, and send you appropriate forms and instructions for collecting the tax. Getting a sales permit usually involves filling out a form and paying a small fee. Reporting sales tax is a relatively simple procedure. Record all sales taxes on invoices and in your sales journal. Every three months, total the taxes collected and send it to the state sales tax department.

In most states, if you are selling to a customer outside of your sales tax area, you do not have to collect sales tax. However, this may not hold true for your state. You may also need a business license or permit. Call your state tax office to find out what is required.

Save money on art supply sales tax

As long as you have the above sales permit number, you can buy art supplies for paintings and assignments without paying sales tax. You will probably have to fill out a tax-exempt form with your permit number at the sales desk where you buy materials. The reason you do not have to pay sales tax on your art supplies is that sales tax is only charged on the final product. However, you must then add the cost of materials into the cost of your finished painting or the final artwork for your client. Keep all of your purchase receipts for these items in case of a tax audit. If the state discovers that you have not collected sales tax, you will be liable for tax and penalties.

If you sell all your work through galleries they will charge sales tax, but you will still need a tax exempt number so you can get a tax exemption on supplies.

Some states claim "creativity" is a non-taxable service, while others view it as a product and therefore taxable. Be certain you understand the sales tax laws to avoid being held liable for uncollected money at tax time. Write to your state auditor for sales tax information.

HOW TO GET FREE TAX ADVICE

Most IRS offices have walk-in centers open year-round and offer over 90 free IRS publications to help taxpayers. Some helpful booklets available include Publication 334—Tax Guide for Small Business; Publication 505—Tax Withholding and Estimated Tax; and Publication 533—Self Employment Tax. Order by phone at (800)829-3676. There's plenty of great advice on the Internet, too. Check out the official IRS website: http://www.irs.ustreas.gov/prod/cover.html. Fun graphics lead you to information and you can even download tax forms.

If you don't have access to the web, the booklet that comes with your tax return forms contains addresses of regional Forms Distribution Centers you can write to for information. The U.S. Small Business Administration offers seminars on taxes, and arts organizations hold many workshops covering business management, often including detailed tax information. Inquire at your local arts council, arts organization or university to see if a workshop is scheduled.

PACKAGING AND SHIPPING YOUR WORK

Send your submissions via first class mail for quicker service and better handling. Package flat work between heavy cardboard or foam core, or roll it in a cardboard tube. Include your business card or a label with your name and address on the outside of the packaging material in case the outer wrapper becomes separated from the inner packing in transit.

Protect larger works—particularly those that are matted or framed—with a strong outer surface, such as laminated cardboard, masonite or light plywood. Wrap the work in polyfoam,

heavy cloth or bubble wrap and cushion it against the outer container with spacers to keep from moving. Whenever possible, ship work before it is glassed. If the glass breaks en route, it may destroy your original image. If you are shipping large framed work, contact a museum in your area for more suggestions on packaging.

The U.S. Postal Service will not automatically insure your work, but you can purchase up to $600 worth of coverage. Artworks exceeding this value should be sent by registered mail. Certified packages are logged in at each destination en route. They travel a little slower, but are easier to track.

Consider special services offered by the post office, such as Priority Mail, Express Mail Next Day Service and Special Delivery. For overnight delivery, check to see which air freight services are available in your area. Federal Express automatically insures packages for $100 and will ship art valued up to $500. Their 24-hour computer tracking system enables you to locate your package at any time.

UPS automatically insures work for $100, but you can purchase additional insurance for work valued as high as $25,000 for items shipped by air (there is no limit for items sent on the ground). UPS cannot guarantee arrival dates but will track lost packages. It also offers Two-Day Blue Label Air Service within the U.S. and Next Day Service in specific zip code zones.

Before sending any original work, make sure you have a copy (photostat, photocopy, slide or transparency) in your files. Always make a quick address check by phone before putting your package in the mail.

Copyright Basics

Because copyright is frequently misunderstood, you must know your rights and make sure your clients do, too. As creator of your artwork, you have certain inherent rights over your work and can control how it is used. When a client buys "rights" to your work, he buys the right to reproduce it for a certain duration of time. Unless all rights are purchased, you temporarily "lease" your work to the client for reproduction or publication. The artwork must be returned to you unless otherwise specified. Once the buyer has used the rights purchased, he has no further claim to your work. If he wants to use it a second or third time, he must pay additional fees.

Copyright isn't a singular right. It is actually one or more of a number of rights and privileges guaranteed to you as the creator of an original artwork. The more rights you sell to one client, the more money you should receive. Negotiate this upfront with your client before agreeing on a price. Find out how long he intends to use it and where so that you will not relinquish too many rights. If the work is going to be used internationally, for example, you can charge a higher fee. Here is a list of rights typically sold in the art marketplace:

- **One-time rights**. The artwork is "leased" for one use. The buyer has no guarantee he is the first to use the piece. Rights revert back to you after use.
- **First rights**. This is generally the same as purchase of one-time rights though the art buyer is paying a bit more for the privilege of being the first to use the image. He may use it only once unless other rights are negotiated.
- **Exclusive rights**. These guarantee the buyer's exclusive right to use the artwork in his particular market or for a particular product. A greeting card company, for example, may purchase exclusive rights to an image with the stipulation that it not be sold to a competing card company for a certain time period. You retain rights to sell the image to other, noncompeting markets.
- **Second serial (reprint) rights**. These give a newspaper or magazine the opportunity to print your work after it has already appeared in another publication.
- **Subsidiary rights**. This category covers additional rights purchased. Each right must be specified in the contract. For example, a publisher might want to include the right to use your illustration for the second printing or paperback edition of a book. Most U.S. magazines ask for "first North American serial rights" which gives them the right to publish your work in North America.
- **Promotion rights**. Such rights allow a publisher to use your work for promotion of a publication in which the artwork appeared. You can charge more if the agreement asks for promotional use in addition to the rights first sold to reproduce the image.
- **Works for hire**. Under the Copyright Act of 1976, section 101, a "work for hire" (as applied to artwork) is defined as: "a work prepared by an employee within the scope of his or her employment; or a work specifically ordered or commissioned for use as a contribution to a collective work, as part of a motion picture or audiovisual work, or as a supplementary work if the parties expressly agree in a written instrument signed by them that the work shall be considered a work made for hire." Proceed with caution if a client requests this arrangement. You could be losing possible royalties and the work you create could make your employer very, very rich. Consult *Graphic Artist's Guild's Handbook of Pricing & Ethical Guidelines* before signing anything.
- **All rights**. This involves selling or assigning all rights to a piece of artwork for a specified

period of time. It differs from work for hire, which means the artist surrenders all rights to an image and any claims to royalties or other future compensation. Terms for all rights—including time period of usage and compensation—should always be negotiated and confirmed in a written agreement with the client.

ASK THE EXPERTS

For further information on copyright, refer to *The Legal Guide for the Visual Artist*, by Tad Crawford (Allworth Press) and *The Artist's Friendly Legal Guide* (North Light Books); or visit the Copyright Office's web page at http://www.loc.gov/copyright. This site even allows you to download the necessary copyright forms. You can also call the Copyright Office information line at (202)707-3000.

COPYRIGHT FAQ's

What can you copyright? You can copyright any work that has sprung from your creative efforts and is fixed on paper or any other tangible medium such as canvas or even in computer memory. Reproductions are copyrightable under the category of compilations and derivative works.

What can't be copyrighted? Ideas are not copyrightable. To protect an idea, you must use nondisclosure agreements or apply for a patent. Copyright protects the form but not the mechanical aspects of utilitarian objects. While you can copyright the form of your "Wally the Whale" lamp, you can't stop other people from making lamps. You can also copyright the illustration of Wally painted on the lamp.

What is copyright notice? A copyright notice consists of the word "Copyright" or its symbol ©, the year the work was created or first published and the full name of the copyright owner. It must be placed where it can easily be seen, preferably on the front of your work. You can place it on the back of a painting as long as it won't be covered by a backing or a frame. Always place your copyright notice on slides or photographs sent to potential clients or galleries. Affix it on the mounts of slides and on the backs of photographs (preferably on a label).

If you omit the notice, you can still copyright the work if you have registered it before publication and you make a reasonable effort to add the notice to all copies. If you've omitted the notice from a work that will be published, you can ask in your contract that the notice be placed on all copies.

When is a work "published"? Publication is the distribution of multiple copies to the public by sale, lease or lending. Public display in a gallery does not constitute publication. (Artwork published in a catalog does.)

How do you get copyright protection? Although you will own the copyright from the time your work is expressed in tangible form, you must register your copyright with the U.S. Copyright Office in order to be able to enforce your rights against infringers. You can register copyright "after the fact," that is, after the work has been shown or published. But while there is no deadline for filing a copyright registration application, you may lose important recourse to infringement if the copyright for an artwork is not registered within 90 days of publication or before infringement begins.

How do I register a work? Call the Copyright Form Hotline (202)707-9100 and ask for package 115 and circulars 40 and 40A. (Cartoonists should ask for package 111 and circular 44.) You can also write to the Copyright Office, Library of Congress, Washington DC 20559, Attn: Information and Publications, Section LM-455. Whether you call or write, they will send you a package containing Form VA (for visual artist). After you fill out the form, return it to the Copyright Office with a check or money order for $20, a deposit copy or copies of the work and a cover letter explaining your request. For almost all artistic work, deposits consist of

transparencies (35mm or 2¼ × 2¼) or photographic prints (preferably 8 × 10). For unpublished works, send one copy; send two copies for published works.

You can register an entire collection of your work rather than one work at a time. That way you will only have to pay one $20 fee for an unlimited number of works. For example, if you have created 100 works in your studio since 1994, you can send a copyright form VA to register "The collected work of Jane Smith; 1994-1998." But you will have to send either slides or photocopies of each of those works.

How does registration protect the artist? If you have registered a copyright you can legally sue for an injunction to prevent infringers from continuing to use infringed work and prevent distribution of the infringing material. You can sue for actual damages—what would have been earned (you must prove how much money you've lost). You can also sue for a percentage of the infringer's profits resulting from unauthorized use of your work. Or, you can sue for statutory damages of between $200-20,000 from innocent infringers to between $500-100,000 from willful infringers. If you win your case, the infringers can be forced to pay legal costs, and sometimes, attorney's fees.

What constitutes an infringement? Anyone who copies a protected work owned by someone else or who exercises an exclusive right without authorization is liable for infringement.

How long does copyright protection last? Once registered, copyright protection lasts for the life of the artist plus 50 years. For works created by two or more people, protection lasts for the life of the last survivor plus 50 years. For works created anonymously or under a pseudonym, protection lasts for 100 years after the work is completed or 75 years after publication, whichever is shorter.

What is a transfer of copyright? Ownership of all or some of your exclusive rights can be transferred by selling, donating or trading them and signing a document as evidence that the transfer has taken place. When you sign an agreement with a magazine for one-time use of an illustration, you are transferring part of your copyright to the magazine. Transfers are usually limited by time, place or form of reproduction, such as first North American serial rights.

What is a licensing agreement? A license is an agreement by you to permit another party to reproduce your work for specific purposes for a limited amount of time in return for a fee or royalty. For example, you can grant a nonexclusive license for your polar bear design, originally reproduced on a greeting card, to a manufacturer of plush toys, to an art publisher for posters of the polar bear, or a manufacturer of novelty items for a polar bear mug. For more information on licensing, see the articles on Mary Engelbreit and Jackie Frerichs in this edition.

IMPORTANT NOTE ON THE MARKETS

• The majority of markets listed in this book are those which are actively seeking new talent. Some well-known companies which have declined complete listings are included within their appropriate section with a brief statement of their policies. In addition, firms which have not renewed their listings from the 1998 edition are listed in the General Index with a code to explain the reason for their absence.

• Listings are based on editorial questionnaires and interviews. They are not advertisements (markets do not pay for their listings), nor are listings endorsed by the *Artist's & Graphic Designer's Market* editor.

• Listings are verified prior to the publication of this book. If a listing has not changed from last year, then the art buyer has told us that his needs have not changed—and the previous information still accurately reflects what he buys.

• Remember, information in the listings is as current as possible, but art directors come and go; companies and publications move; and art needs fluctuate between the publication of this directory and when you use it.

• *Artist's & Graphic Designer's Market* reserves the right to exclude any listing that does not meet its requirements.

KEY TO SYMBOLS AND ABBREVIATIONS

‡ New listing in all sections and all indexes
• Comment from *Artist's & Graphic Designer's Market* editor
✔ Change in either the address or contact information since the 1998 edition
✤ Canadian listing
* Listing outside U.S. and Canada
ASAP As soon as possible
b&w Black and white
IRC International Reply Coupon
P-O-P Point-of-purchase display
SASE Self-addressed, stamped envelope
SAE Self-addressed envelope

COMPLAINT PROCEDURE

If you feel you have not been treated fairly by a listing in *Artist's & Graphic Designer's Market*, we advise you to take the following steps:

• First try to contact the listing. Sometimes one phone call or a letter can quickly clear up the matter.

• Document all your correspondence with the listing. When you write to us with a complaint, provide the details of your submission, the date of your first contact with the listing and the nature of your subsequent correspondence.

• We will enter your letter into our files and attempt to contact the listing.

• The number and severity of complaints will be considered in our decision whether or not to delete the listing from the next edition.

The Markets
Greeting Cards, Gifts & Products

The greeting card companies listed here contain some great potential clients for you. (According to our readers, this is the most popular section in this book.) And, although greeting card companies make up the bulk of the listings, you'll also find find hundreds of other opportunities in the areas of gifts and other image-bearing products.

Businesses need images for all kinds of products; including the following:

balloons	shopping bags	personal checks
banners	stationery	games
party favors	T-shirts	mugs
paper plates	school supplies	limited edition plates
napkins	calendars	postage stamps
tablecloths	diaries	

Because the same images for greeting cards are often used for products and gifts, the most successful freelancers diversify and learn the ins and outs of licensing their work. (Read the article about savvy artist Jackie Frerichs on page 66 to find out more about licensing.)

BREAKING INTO THE MARKET

☐ Go through the listings in the following section and keep a highlighter handy.

☐ Read each listing carefully and note the products each company makes and the specific types of images they look for.

☐ Highlight listings of companies that might use the type of images you create.

☐ Send samples to your target listings.

Submitting to greeting card companies

☐ Do NOT send originals. Companies want to see photographs, photocopies, printed samples, computer printouts, slides or tearsheets.

☐ Before you make copies of your sample, render the original artwork in watercolor or gouache on illustration board in the standard industry size, $4\frac{5}{8} \times 7\frac{1}{2}$ inches.

☐ Artwork should be upbeat, brightly colored, and appropriate to one of the major categories or niches popular in the industry (see sidebar).

☐ Leave some space at the top or bottom of the artwork, because cards often feature lettering there. Check stores to see how much space to leave. It is not necessary to add lettering, because companies often prefer to use staff artists to create lettering.

☐ Have photographs, photocopies or slides made of your completed artwork.

☐ Make sure each sample is labeled with your name, address and phone number.

☐ Send three to five appropriate samples of your work to the contact person named in the listing.

☐ Include a brief (one to two paragraph) cover letter with your initial mailing.

☐ Enclose a self-addressed stamped envelope if you need your samples back.

☐ Within six months, follow-up with another mailing to the same listings.

Submitting to gift & product companies

☐ Send samples similar to those you would send to greeting card companies, only don't be concerned with leaving room at the top of the artwork for a greeting. Some companies prefer you send postcard samples or color photocopies. Check the listings for specifics.

☐ Read how freelancer Jackie Frerichs tailors her submissions to match a company's needs, on page 66.

☐ Consult books on the product industries, such as *Great T-Shirt Graphics* (Rockport) and *How to Write & Sell Greeting Cards, Bumper Stickers, T-Shirts and Other Fun Stuff* by Molly Wigand (Writer's Digest Books) for more ideas.

GREETING CARDS 101

• **Seasonal cards** express greetings for holidays, like Christmas, Easter or Valentine's Day.

• **Everyday cards** express non-holiday sentiments. **Birthday cards** are the most popular everyday cards. The "everyday" category includes everything from sympathy cards to notes that just say "Hi."

• Categories are further broken down into the following areas: **traditional, humorous** and **"alternative"** cards. "Alternative"cards feature quirky, sophisticated or offbeat humor.

• The Greeting Card Industry is also called the "Social Expressions" industry.

• According to the Greeting Card Association, the most popular card-sending holidays are, in order:

1. Christmas	7. Halloween	13. Passover
2. Valentine's Day	8. St. Patrick's Day	14. Secretary's Day
3. Mother's Day	9. Jewish New Year	15. National Boss's Day
4. Father's Day	10. Hannukkah	16. April Fool's Day
5. Graduation	11. Grandparent's Day	17. Nurses Day
6. Thanksgiving	12. Sweetest Day	

• Women buy 85 to 90 percent of all cards

• The average person receives eight birthday cards a year.

INDUSTRY TRADE SHOWS AND JOURNALS GIVE YOU AN EDGE

• *Greetings Today* is the official publication of the Greeting Card Association. Subscriptions are reasonably priced. To subscribe call 1-800-627-0932.

• *Party & Paper* is a trade magazine focusing on the party niche. Visit their website at http://www.partypaper.com for industry news and subscription information.

• The National Stationery Show, the "main event" of the greeting card industry, is held each May at New York City's Jacob K. Javits Center. Other important industry events are held across the country each year. For upcoming trade show dates, check *Greetings Today* or *Party & Paper*.

SET THE RIGHT PRICE

Most card and paper companies have set fees or royalty rates that they pay for design and illustration. What has recently become negotiable, however, is rights. In the past, card companies almost always demanded full rights to work, but now some are willing to negotiate for other arrangements, such as greeting card rights only. If the company has ancillary plans in mind for your work (calendars, stationery, party supplies or toys), they will probably want to buy all rights. In such cases, you may be able to bargain for higher payment.

THE PLATES AND COLLECTIBLES MARKET

Limited edition collectibles—everything from Elvis collector plates to porcelain lighthouses—appeal to a wide audience and are a lucrative niche for artists. To do well in this field, you have to be flexible enough to take suggestions. Companies test market to find out which images will sell the best, so they will guide you in the creative process. For a collectible plate, for example, your work must fit into a circular format or you'll be asked to extend the painting out to the edge of the plate.

Popular images for collectibles include Native American, wildlife, animals (especially kittens and puppies), children, religious (including madonnas and angels), stuffed animals, dolls, TV nostalgia, Egyptian and sports images. You can submit slides to the creative director of companies specializing in collectibles. See our collectibles index on page 684. For special insight into the market, attend one of the industry's trade shows held yearly in South Bend, Indiana; Secaucus, New Jersey; and Anaheim, California.

ACME GRAPHICS, INC., 201 Third Ave. SW, Box 1348, Cedar Rapids IA 52406. (319)364-0233. Fax: (319)363-6437. President: Stan Richardson. Estab. 1913. Produces printed merchandise used by funeral directors, such as acknowledgments, register books and prayer cards. Art guidelines available.
 • Acme Graphics manufactures a line of merchandise for funeral directors. Floral subjects, religious subjects, and scenes are their most popular products.
Needs: Approached by 30 freelancers/year. Considers pen & ink, watercolor and acrylic. "We will send a copy of our catalog to show type of work we do." Looking for religious, church window, floral and nature art. Also uses freelancers for calligraphy and lettering.
First Contact & Terms: Designers should send query letter with résumé, photocopies, photographs, slides and transparencies. Illustrators send postcard sample or query letter with brochure, photocopies, photographs, slides and tearsheets. Accepts submissions on disk. Samples are not filed and are returned by SASE. Reports back within 10 days. Call or write for appointment to show portfolio of roughs. Originals are returned. Requests work on spec before assigning a job. Pays by the project, $50 minimum or flat fee. Buys all rights.
Tips: "Send samples or prints of work from other companies. No modern art or art with figures. Some designs are too expensive to print. Learn all you can about printing production."

ADVANCE CELLOCARD CO., INC., 2203 Lively Blvd., Elk Grove Village IL 60007-5209. President: Ron Ward. Estab. 1960. Produces greeting cards.
Needs: Considers watercolor, acrylic, oil and colored pencil. Art guidelines for SASE with first-class postage. Produces material for Valentine's Day, Mother's Day, Father's Day, Easter, graduation, birthdays and everyday.
First Contact & Terms: Send query letter with brochure and SASE. Accepts disk submissions compatible with Mac formatted Adobe Illustrator 5.5, Adobe Photoshop 3.0 or Power Mac QuarkXPress 3.0. Samples not filed are returned by SASE. Reports back within weeks. Originals are not returned. Pays average flat fee of $75-150/design. Buys all rights.
Tips: "Send letter of introduction, and samples or photostats of artwork."

ALASKA MOMMA, INC., 303 Fifth Ave., New York NY 10016. (212)679-4404. Fax: (212)696-1340. President: Shirley Henschel. "We are a licensing company representing artists, illustrators, designers and established characters. We ourselves do not buy artwork. We act as a licensing agent for the artist. We license artwork and design concepts to toy, clothing, giftware, textiles, stationery and housewares manufacturers and publishers."
Needs: "We are looking for people whose work can be developed into dimensional products. An artist must have a distinctive and unique style that a manufacturer can't get from his own art department. We need art that can be applied to products such as posters, cards, puzzles, albums, etc. No cartoon art, no abstract art, no b&w art."
First Contact & Terms: "Artists may submit work in any form as long as it is a fair representation of their style." Prefers to see several multiple color samples in a mailable size. No originals. "We are interested in artists whose work is suitable for a licensing program. We do not want to see b&w art drawings. What we need to see are transparencies or color photographs or color photocopies of finished art. We need to see a consistent style in a fairly extensive package of art. Otherwise, we don't really have a feeling for what the artist can do. The artist should think about products and determine if the submitted material is suitable for licensed product. Please send SASE so the samples can be returned. We work on royalties that run from 5-10% from our licensees. We require an advance against royalties from all customers. Earned royalties depend on whether the products sell."
Tips: "Publishers of greeting cards and paper products have become interested in more traditional and conservative styles. There is less of a market for novelty and cartoon art. We need artists more than ever as we especially need fresh talent in a difficult market."

‡ALEF JUDAICA, INC., 8440 Warner Dr., Culver City CA 90232. (310)202-0024. Fax: (310)202-0940. President: Guy Orner. Estab. 1979. Manufacturer and distributor of a full line of Judaica, including menorahs, Kiddush cups, greeting cards, giftwrap, tableware, etc.

Needs: Approached by 15 freelancers/year. Works with 10 freelancers/year. Buys 75-100 freelance designs and illustrations/year. Prefers local freelancers with experience. Works on assignment only. Uses freelancers for new designs in Judaica gifts (menorahs, etc.) and ceramic Judaica. Also for calligraphy, pasteup and mechanicals. All designs should be upper scale Judaica.

First Contact & Terms: Mail brochure, photographs of final art samples. Art director will contact artist for portfolio review if interested, or portfolios may be dropped off every Friday. Sometimes requests work on spec before assigning a job. Pays $300 for illustration/design; pays royalties of 10%. Considers buying second rights (reprint rights) to previously published work.

✔**ALPHABETICA**, 1271 LaQuinta Dr., #4, Orlando FL 32809. (407) 240-1091. Fax: (407) 240-1951. E-mail: joanne @alphabetica.com. Art Director: Joanne-Kathy Amish. Estab. 1996. Alphabetica publishes inspirational calligraphic art for framed prints.

Needs: Approached by 30 freelancers/year. Works with 15 freelancers/year. Buys 50 freelance designs and illustrations/year. "We also buy a lot of lettering." Art guidelines free for SASE with first-class postage. Works on assignment only. Uses freelancers mainly for illustration and lettering. Considers watercolor, gouache, pastel and colored pencil. Looking for high-end calligraphic art. 20% of freelance design work demands knowledge of Adobe Photoshop, Adobe Illustrator and QuarkXPress. Produces material for everyday.

First Contact & Terms: Designers send brochure. Illustrators send query letter with photocopies, photographs, photostats, tearsheets and SASE. "No original art please." Send follow up postcard sample every 4 months. Samples are filed or returned by SASE. Reports back within 6 weeks. Company will contact calligraphers for portfolio review if interested. Portfolio should include color final art, slides, tearsheets and transparencies. Rights purchased vary according to project. Pays "either royalties or a flat fee. The artist may choose." Finds freelancers through SURTEX, word of mouth and calligraphy societies.

Tips: "Read the trade magazines, *GSB*, *G&D*, *GN* and *Greetings Today*."

AMBERLEY GREETING CARD CO., 11510 Goldcoast Dr., Cincinnati OH 45249-1695. (513)489-2775. Fax: (513)489-2857. Art Director: Dave McPeek. Estab. 1966. Produces greeting cards. "We are a multi-line company directed toward all ages. We publish conventional as well as humorous cards."

• Art director told *AGDM* that soft inspirational and lightly religious themes are becoming a trend.

Needs: Approached by 20 freelancers/year. Works with 10 freelancers/year. Buys 250 illustrations/year. Art guidelines not available. Works on assignment only. Considers any media.

First Contact & Terms: Send query letter with brochure, color photocopies and SASE. Calligraphers send photocopies of lettering styles. Samples are filed or returned by SASE if requested by artist. Reports back to artist only if interested. Call for appointment to show portfolio of original/final art. Pays illustration flat fee $75-80; pays calligraphy flat fee $20-30. Buys all rights.

Tips: "Send appropriate materials. Go to a card store or supermarket and study the greeting cards. Look at what makes card art different than a lot of other illustration. Caption room, cliché scenes, "cute" animals, colors, etc. Buy some samples and re-execute them in your style (as an exercise only—don't try to re-sell them!). Research publishers and send appropriate art! I wish artists would not send a greeting card publisher art that looks unlike any card they've ever seen on display anywhere."

AMCAL, 2500 Bisso Lane, Bldg. 500, Concord CA 94520. (510)689-9930. Fax: (510)689-0108. Licensing: Valerie Weeks. Publishes calendars, notecards, Christmas cards and other book and stationery items. AMCAL Licensing is also a full-service licensing agency representing a variety of artists. Main focus is in the area of tabletop, textile, collectibles, gifts and stationery. "Markets to better gift, book and department stores throughout U.S. Some sales to Europe, Canada and Japan. We look for illustration and design that can be used many ways—calendars, note cards, address books and more so we can develop a collection. We buy art that appeals to a widely female audience." No gag humor or cartoons.

• Also has listing in Posters & Prints section.

Needs: Needs freelancers for design and production. Prefers work in horizontal format. Art guidelines for SASE with first-class postage or "you can call and request."

First Contact & Terms: Designers send query letter with brochure, résumé and SASE. Illustrators send query letter with brochure, résumé, photographs, SASE, slides, tearsheets and transparencies. Include a SASE for return of submission. Art director will contact artist for portfolio review if interested. Pays for illustration by the project, advance against royalty.

Tips: "Research what is selling and what's not. Go to gift shows and visit lots of stationery stores. Read all the trade magazines. Talk to store owners."

✔**AMERICAN GREETINGS CORPORATION**, One American Rd., Cleveland OH 44144. (216)252-7300. Director of Creative Recruitment: Steven Tatar. Estab. 1906. Produces greeting cards, stationery, calendars, paper tableware products, giftwrap and ornaments—"a complete line of social expressions products."

Needs: Prefers local artists with experience in illustration, decorative design and calligraphy. Usually works from a list of 100 active freelancers. Guidelines available for SASE.

First Contact & Terms: Send query letter with résumé. "Do not send samples." Pays $200 and up based on complexity of design. Does not offer royalties.

AMERICAN TRADITIONAL STENCILS, 442 First New Hampshire Turnpike, Northwood NH 03261. (603)942-8100. Fax: (603)942-8919. E-mail: amtrad@ici.net Website: http://www.Amtrad-stencil.com. Owner: Judith Barker. Estab. 1970. Manufacturer of brass and laser cut stencils and 24 karat gold finish charms. Clients: retail craft, art and gift shops. Current clients include Williamsburg Museum, Old Sturbridge and Pfaltzgraph Co., Henry Ford Museum and some Ben Franklin stores.

Needs: Approached by 1-2 freelancers/year. Works with 1 freelance illustrator/year. Assigns 2 freelance jobs/year. Prefers freelancers with experience in graphics. Art guidelines not available. Works on assignment only. Uses freelancers mainly for stencils. Also for ad illustration and product design. Prefers b&w camera-ready art.

First Contact & Terms: Send query letter with brochure showing art style and photocopies. Samples are filed or are returned. Reports back in 2 weeks. Call for appointment to show portfolio of roughs, original/final art and b&w tearsheets. Pays for design by the hour, $8.50-20; by the project, $15-150. Pays for illustration by the hour, $6-7.50. Rights purchased vary according to project.

Tips: "Join the Society of Craft Designers—great way to portfolio designs for the craft industry. Try juried art and craft shows—great way to see if your art sells."

AMPERSAND PRESS, 750 Lake St., Port Townsend WA 98368. (360)379-5187. Fax: (360)379-0324. Website: http://www.ampersandpress.com. President: Amy Mook. Estab. 1994. Produces games, t-shirts and rubber stamps. Specializes in nature themes, gardening and wild animals.

Needs: Approached by 10+ freelancers/year. Works with 2-3 freelancers/year. Buys 40-100 freelance designs and illustrations/year. No cartoons or cutsey. Works on assignment only. Uses freelancers mainly for illustrating games (gameboard cards and box). Considers watercolor, color pencil, pen & ink, wood cut, scratch board, computer. Computer experience not required, but knowledge of Adobe Photoshop, Adobe Illustrator and QuarkXPress is helpful. Produces material for everyday.

First Contact & Terms: Designers send query letter with brochure, photocopies, résumé and photographs. Illustrators send query letter with photocopies, photographs, photostats and résumé. Send follow-up postcard every year. Accepts disk submissions compatible with PC format, Adobe Illustrator 4.0, QuarkXPress 3.2 or higher or PageMaker 6.0. Samples are filed. Reports back only if interested. Will contact for portfolio review of b&w, color and final art if interested. Rights purchased vary according to project; negotiable. Pays 3% royalties plus $50-150/small card illustration, $300-2,000/large illustration. Finds freelancers through word of mouth and submissions.

AMSCAN INC., 80 Grasslands Rd., Elmsford NY 10523. (914)345-2020. Senior Vice President of Creative Development: Diane D. Spaar. Estab. 1954. Designs and manufactures paper party goods. Extensive line includes paper tableware, invitations, giftwrap and bags, decorations. Complete range of party themes for all ages, all seasons and all holidays.

Needs: "Ever-expanding department with incredible appetite for fresh design and illustration. Subject matter varies from baby, juvenile, floral, type-driven and graphics. Designing is accomplished both in the traditional way by hand (i.e., painting) or on the computer using a variety of programs like Aldus FreeHand, Adobe Illustrator, Fractal Design Painter and Adobe Photoshop."

First Contact & Terms: "Send samples or copies of artwork to show us range of illustration styles. If artwork is appropriate, we will pursue." Pays by the project $300-2,000 for illustration and design.

ANGEL GRAPHICS, 903 W. Broadway, Fairfield IA 52556. (515)472-5481. Fax: (515)472-7353. Project Manager: Julie Greeson. Estab. 1981. Produces full line of posters for wall decor market.
- Also has listing in Posters & Prints section.

Needs: Buys 50-100 freelance designs and illustrations/year. Uses freelancers mainly for posters. Also "may consider your design for use in our line of wall decor." Considers any media. Looking for realistic artwork.

First Contact & Terms: Send query letter with photographs, slides or reproductions; not originals. Samples are not filed and are returned by SASE. Company will contact artist for portfolio review if interested. Negotiates rights purchased. Pays by the project, competitive prices. Can use previously published works.

APPLE ORCHARD PRESS, P.O. Box 240, Dept. A, Riddle OR 97469. Art Director: Gordon Lantz. Estab. 1988. Produces greeting cards and book products. "We manufacture our products in our own facility and distribute them nationwide. We make it a point to use the artist's name on our products to help them gain recognition. Our priority is to produce beautiful products of the highest quality."

Needs: Works with 4-8 freelancers/year. Buys 50-75 designs/year. Uses freelancers mainly for note cards and book covers. All designs are in color. Considers all media, but prefers watercolor and colored pencil. Looking for florals, cottages, gardens, gardening themes, recipe book art, Christmas themes and animals. "We are not interested in Halloween or in anything 'off color.' We usually produce four or more images from an artist on the same theme at the same time." Produces material for Christmas, Valentine's Day and everyday. Submit seasonal material 9-12 months in advance, "but will always be considered for the next release of that season's products whenever it's submitted."

First Contact & Terms: Submit photos, slides, brochure or color copies. Must include SASE. "If we are not interested in a submission without SASE, it will be discarded. We only file samples if we are interested." Reports back quarterly. Company will contact artist for portfolio review if interested. Portfolio should include slides and/or photographs. Pays one-time flat fee/image. Amount varies. Rights purchased vary according to project.

Tips: "Please do not send pictures of pieces that are not available for reproduction. We must eventually have access to either the original or an excellent quality transparency. If you must send pictures of pieces that are not available in

order to show style, be sure to indicate clearly that the piece is not available. We work with pairs of images. Sending quality pictures of your work is a real plus."

‡**APPLEWOOD SEED & GARDEN CORP.**, 5380 Vivian St., Arvada CO 80002. (303)431-6283. Fax: (303)431-7981. Graphics Manager: Karen Ducall. Estab. 1967. Produces gifts, flower pot baking kits, herb and flower growing kits. "We create innovative growing kits for herbs and flowers, the ideal gift for any occasion."
Needs: Approached by 25 freelancers/year. Works with 3-5 freelancers/year. Buys 3-5 freelance designs and illustrations/year. Prefers local designers and illustrators only with experience in packaging design. Works on assignment only. Uses freelancers mainly for packaging design and illustration. Considers any media. No restrictions on style. 100% of freelance design work demands knowledge of Adobe Photoshop, Adobe Illustrator and Quark XPress. Produces materials for all holidays and everyday.
First Contact & Terms: Designers send query letter with brochure, tearsheets and SASE. Illustrators send query letter with tearsheets and SASE. Samples are filed. Reports back only if interested. Portfolio review not required. Rights purchased vary according to project. Pays by the project, $100-1,000. Finds freelancers through referrals, artist submissions, ads run in local newspapers.
Tips: "Attend gift shows regularly and subscribe to trade magazines in the gift and toy industry."

AR-EN PARTY PRINTERS, INC., 3252 W. Bryn Mawr, Chicago IL 60645. (773)539-0055. Fax: (773)539-0108. E-mail: terry@als.com Website: http://ar-en.com. Vice President: Terry Morrison. Estab. 1978. Produces stationery and paper tableware products. Makes personalized party accessories for weddings, and all other affairs and special events.
Needs: Works with 2 freelancers/year. Buys 10 freelance designs and illustrations/year. Art guidelines not available. Works on assignment only. Uses freelancers mainly for new designs. Also for calligraphy. Looking for contemporary and stylish designs. Prefers small (2×2) format.
First Contact & Terms: Send query letter with brochure, résumé and SASE. Samples are filed or returned by SASE if requested by artist. Reports back within 2 weeks. Company will contact artist for portfolio review if interested. Rights purchased vary according to project. Pays by the hour, $60 minimum; by the project, $1,000 minimum.
Tips: "My best new ideas always evolve from something I see that turns me on. Do you have an idea/style that you love? Market it. Someone out there needs it."

ARTISTS TO WATCH, 500 N. Robert St., #302, St. Paul MN 55101. (612)222-8102. (800)945-5454. Fax: (612)290-0919. E-mail: artwatch@bitstream.net. Owner: Kathryn Shaw. "Full-service licensing agency and manufacturer of high-quality greeting cards featuring the work of contemporary international artists. We have international distribution—great exposure for new artists."
 ● Artists to Watch has a growing list of licensing partners including Disney, Rug Barn, Dayton Hudson Corporation, Antioch Publishing, Landmark Calendars, Ink-a-Dink-a-Doo, Computer Expressions, Rivertown Trading and Rizzoli.
Needs: Seeks emerging artists with distinctive style, visual appeal, and mature skills. Art guidelines available. Considers all media and all types of prints.
First Contact & Terms: Send query letter with slides, bio, brochure, photographs, business card, artist's statement and résumé. Call for appointment. Replies in 6 weeks. "File anything that is representative of artist's work that artist will allow us to keep. Use of artwork is compensated with royalty payments."
Tips: Owner offers the following advice, condensed from guidelines. "Artists to Watch licenses the work of artistically mature individuals chosen for their progressive style and the spiritual, social or cultural message in their work. We are honored and excited to introduce our artists to the world. Our card lines are renowned for their distinctive designs, striking images, spiritual appeal and poignant greetings. Our cards convey a consistent message through artwork, text and form. Please do not send original work! Be sure to include a broad enough sample of your work to clearly demonstrate your range, style and ability."

‡**ARTVISIONS**, 12117 SE 26th St., Suite 202A, Bellevue WA 98005-4118. (425)746-2201. Owner: Neil Miller. Estab. 1993. Markets include publishers, manufacturers and others who may require fine art.
Handles: Fine art licensing of greeting cards, gifts and products. See listing in Artists' Reps section.

ARTWORKS LICENSING, 107 Monument Ave., Old Bennington VT 05201. (802)442-3831. Fax: (802)447-3180. E-mail: decamp@bennington.edu. Owner/Licensing Agent: Kate Philbin. Estab. 1996. Art licensing agency. "We market artists' work and negotiate rights for reproduction to a variety of manufacturers including stationery products, giftware, housewares, clothing and textiles."
 ● Owner told AGDM that licensing fine art to the commercial art market is a growing trend because many manufacturers are using only outside artists for their products, and computer technology has made it easy to apply art to many products with good results.
Needs: Approached by over 150 freelancers/year. Works with 25 freelancers/year. Art guidelines free for SASE with first-class postage. Considers all media in color except photography. "We look for representational art in color that has a popular appeal and is appropriate for use on consumer products such as greeting cards, posters, giftware, calendars, etc."
First Contact & Terms: Artists should request submission guidelines first. Submissions should include 12-24 labeled photographs, slides or color copies; and bio. "No originals." Samples are not filed and are returned by SASE. Reports

Applewood Seed & Garden Group's "sof-pots" herb garden planter kits "are window gardens that grow culinary herbs indoors, and the blue, white and yellow color scheme is on-trend for kitchen decor," says Graphics Manager Karen Duvall. The artwork was created directly on a computer, except for a few pencil sketches, by artist Jeanne Hyland. Hyland feels it's important illustrators learn the technical side of the trade—computers and printing—"so you can create cost-effective and reproducible designs," and advises illustrators to be aware of the client's needs and concerns. "Too many designers don't listen to clients and go off on tangents."

back within 1 month. Company will contact artist for portfolio review if interested. Rights purchased vary according to project; negotiable. "The artist receives 50% commission for each contract we negotiate for them. There are no fees for the artist." Finds freelancers through submissions, galleries, word of mouth and shows.
Tips: "For licensing, artists should have a substantial body of work (25-50 images) in a representational style. It's an asset to have popular themes—holidays, cats, dogs, etc."

THE ASHTON-DRAKE GALLERIES, 9200 N. Maryland Ave., Niles IL 60714. (847)581-8107. Senior Manager of Artists' Relations and Recruitment: Andrea Ship. Estab. 1985. Direct response marketer of collectible dolls. Clients: consumers, mostly women of all age groups.
Needs: Approached by 300 freelance artists/year. Works with 250 freelance doll artists, sculptors, costume designers and illustrators/year. Works on assignment only. Uses freelancers for illustration, wigmaking, porcelain decorating, shoemaking, costuming and prop making. Prior experience in giftware design and doll design a plus. Subject matter includes babies, toddlers, children, brides and fashion. Prefers "cute, realistic and natural human features."
First Contact & Terms: Send query letter with résumé and copies of samples to be kept on file. Prefers photographs,

tearsheets or photostats as samples. Samples not filed are returned. Reports within 7 weeks. Pays by the hour, $25-50 or by the project, $50-300. Concept illustrations are done "on spec." Sculptors receive contract for length of series on royalty basis with guaranteed advances.

BALLOON WHOLESALERS INTERNATIONAL, 5733 E. Shields Ave., Fresno CA 93727-7822. (209)294-2170. Fax: (209)294-1800. Vice President: T. Adishian. Estab. 1983. Manufacturer of balloons for adults and children.
Needs: Approached by 2-3 freelance artists/year. Uses freelance artists mainly for balloon and gift design. Prefers bright, contemporary, upbeat styles. Also uses freelance artists for P-O-P displays, package and header card displays.
First Contact & Terms: Send query letter with brochure showing art style or résumé, tearsheets, photostats, photographs and SASE. Samples are filed or are returned by SASE only if requested by artist. Reports back within 4-6 weeks. Request portfolio review in original query. Art Director will contact artist for portfolio review if interested. Portfolio should include roughs, photostats, tearsheets and dummies. Requests work on spec before assigning a job. Rights purchased vary according to project.

BARTON-COTTON INC., 1405 Parker Rd., Baltimore MD 21227. (410)247-4800. Contact: Art Buyer. Produces religious greeting cards, commercial all occasion, Christmas cards, wildlife designs and spring note cards.
Needs: Buys 150-200 freelance illustrations/year. Submit seasonal work any time. Free guidelines for SASE with first-class postage and sample cards; specify area of interest (religious, Christmas, spring, etc.).
First Contact & Terms: Send query letter with résumé, tearsheets, photocopies or slides. Submit full-color work only (watercolor, gouache, pastel, oil and acrylic). Previously published work and simultaneous submissions accepted. Reports in 1 month. Pays by the project, $300-2,500 for illustration and design. **Pays on acceptance.**
Tips: "Good draftsmanship is a must. Spend some time studying current market trends in the greeting card industry. There is an increased need for creative ways to paint traditional Christmas scenes with up-to-date styles and techniques."

✔FREDERICK BECK ORIGINALS, 27 E. Housatonic, P.O. Box 989, Pittsfield MA 01201-0989. (818)998-0323. Fax: (818)998-5808. Art Director: Mark Brown. Estab. 1953. Produces silk screen printed Christmas cards, traditional to contemporary.
 ● This company is under the same umbrella as Editions Limited and Gene Bliley Stationery. One submission will be seen by all companies, so there is no need to send three mailings. Frederick Beck and Editions Limited designs are a little more high end than Gene Bliley designs. The cards are sold through stationery and party stores, where the customer browses through thick binders to order cards, stationery or invitations imprinted with customer's name. Though some of the same cards are repeated or rotated each year, all companies are always looking for fresh images. Frederick Beck and Gene Bliley's sales offices are still in Chatsworth, CA, but art director works from Pittsfield ofice.

BEISTLE COMPANY, 1 Beistle Plaza, Box 10, Shippensburg PA 17257. (717)532-2131. Fax: (717)532-7789. E-mail: beistle@cvn.net; Website: http://www.beistle.com. Product Manager: C.M. Luhrs-Wiest. Estab. 1900. Manufacturer of paper and plastic decorations, party goods, gift items, tableware and greeting cards. Targets general public, home consumers through P-O-P displays, specialty advertising, school market and other party good suppliers.
Needs: Approached by 250-300 freelancers/year. Works with 50 freelancers/year. Prefers artists with experience in designer gouache illustration. Also needs digital art (Macintosh platform or compatible). Art guidelines available. Looks for full-color, camera-ready artwork for separation and offset reproduction. Works on assignment only. Uses freelance artists mainly for product rendering and brochure design and layout. Prefers designer gouache and airbrush technique for poster style artwork. 50% of freelance design and 50% of illustration demand knowledge of QuarkXPress, Adobe Illustrator, Adobe Photoshop or Fractal Design PAINTER. Also uses freelance sculptors.
First Contact & Terms: Send query letter with résumé, brochure, SASE and slides. Samples are filed or returned by SASE. Art Director will contact artist for portfolio review if interested. Sometimes requests work on spec before assigning a job. Pays by the project. Considers buying second rights (reprint rights) to previously published work. Finds artists through word of mouth, magazines, submissions/self-promotions, sourcebooks, agents, visiting artists' exhibitions, art fairs and artists' reps.
Tips: "Our primary interest is in illustration; often we receive freelance propositions for graphic design—brochures, logos, catalogs, etc. These are not of interest to us as we are manufacturers of printed decorations. Send color samples rather than b&w. There is a move toward brighter, stronger designs with more vibrant colors and bolder lines. We have utilized more freelancers in the last few years than previously. We predict continued and increased consumer interest—greater juvenile product demand due to recent baby boom and larger adult market because of baby boom of the '50s." Advises freelancers to learn to draw well first and study traditional illustration.

BEPUZZLED, 22 E. Newberry Rd., Bloomfield CT 06040. (860)769-5723. Fax: (860)769-5799. Creative Services Manager: Sue Tyska. Estab. 1986. Produces games and puzzles for children and adults. "Bepuzzled mystery jigsaw games challenge players to solve an original whodunit thriller by matching clues in the mystery with visual clues revealed in the puzzle."
 ● BePuzzled now publishes a newspaper as part of the new product line "Extra Extra." They buy eight to ten humorous or editorial cartoons/year. Cartoonists should call and send a query letter with tearsheets. Pays $150-300 for black-and-white cartoons; $200-400 for color.
Needs: Works with 20 freelance artists/year. Buys 20-40 designs and illustrations/year. Prefers local artists with experi-

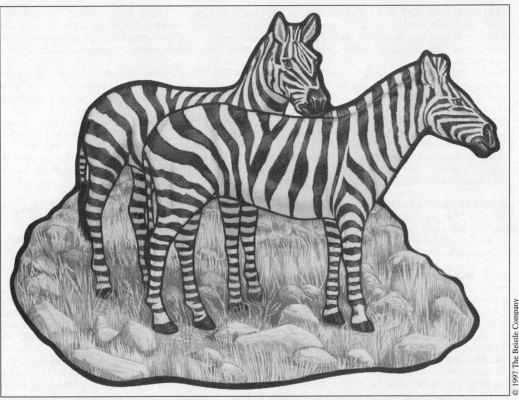

When the Beistle Company needed art for a line of animal cutouts, they approached the Wayne, Pennsylvania-based Brookins Group right away, says Beistle's C. Michelle Luhrs-Weist. "We've been happy with the variety and versatility provided by the numerous artists they represent," she says. This pair of zebras illustrates the element of decorative realism required by the project, and appeared in cut-out kits of both Noah's Ark and zoo animals to be marketed to schools and churches.

ence in children's book and adult book illustration. Uses freelancers mainly for box cover art, puzzle images and character portraits. All illustrations are done to spec. Considers many media.

First Contact & Terms: Send query letter with brochure, résumé, SASE, tearsheets, photographs and transparencies. Samples are filed. Reports back within 2 months. Art Director will contact artist for portfolio review if interested. Portfolio should include original/final art and photographs. Original artwork is returned at the job's completion. Sometimes requests work on spec before assigning a job. Pays by the project, $300-3,000. Finds artists through word of mouth, magazines, submissions, sourcebooks, agents, galleries, reps, etc.

Tips: Prefers that artists not "ask that all material be returned. I like to keep a visual in my files for future reference. New and fresh looking illustration styles are key."

BERGQUIST IMPORTS, INC., 1412 Hwy. 33 S., Cloquet MN 55720. (218)879-3343. Fax: (218)879-0010. E-mail: bbergqu106@aol.com. President: Barry Bergquist. Estab. 1948. Produces paper napkins, mugs and tile. Wholesaler of mugs, decorator tile, plates and dinnerware.

Needs: Approached by 5 freelancers/year. Works with 5 freelancers/year. Buys 50 designs and illustrations/year. Prefers freelancers with experience in Scandinavian and wildlife designs. Works on assignment only. Also uses freelancers for calligraphy. Produces material for Christmas, Valentine's Day and everyday. Submit seasonal material 6-8 months in advance.

First Contact & Terms: Send query letter with brochure, tearsheets and photographs. Samples are not filed and are returned. Reports back within 2 months. Request portfolio review in original query. Artist should follow-up with a letter after initial query. Portfolio should include roughs, color tearsheets and photographs. Rights purchased vary according to project. Originals are returned at job's completion. Requests work on spec before assigning a job. Pays by the project, $50-300; average flat fee of $50 for illustration/design; or royalties of 5%. Finds artists through word of mouth, submissions/self-promotions and art fairs.

BERNARD FINE ART, Box 1582, Historic Route 7A, Manchester Center VT 05255. (802)362-0373. Fax: (802)362-1082. Vice President: Michael Katz. Licenses art for balloons, bookmarks, calendars, CD-ROMs, collectible figurines, decorative housewares, decorations, games, giftbags, gifts, giftwrap, greeting cards, limited edition plates, mugs, ornaments, paper tableware, party supplies, personal checks, posters, prints, school supplies, stationery, T-shirts, textiles, toys, wallpaper, etc.

Needs: Approached by hundreds of freelancers/year. Works with 50-100 freelancers/year. Buys 1,200-1,500 designs and illustrations/year. Art guidelines free for SASE with first class postage. Considers all media and all styles. Prefers final art under 24×36, but not required. Produces material for all holidays. Submit seasonal material 6 months in advance.

First Contact & Terms: Designers send brochure, photocopies, photographs, slides, tearsheets, transparencies and SASE. Illustrators send query letter with photocopies, photographs, photostats, transparencies, tearsheets, résumé and SASE. Send follow-up postcard every 3 months. Accepts disk submissions compatible with Photoshop, Quark or Illustrator. Samples are filed or returned by SASE. Reports back in 1 month. Company will contact artist for portfolio review if interested. Portfolio should include color final art, photographs, photostats, roughs, slides, tearsheets, thumbnails and transparencies. Buys all rights. Pays royalties.

✔**GENE BLILEY STATIONERY**, 27 E. Housatonic, P.O. Box 989, Pittsfield MA 01201-0989. (818)998-0323. Fax: (818)998-5808. Art Director: Mark Brown. General Manager: Gary Lainer. Sales Manager: Ron Pardo. Estab. 1967. Produces stationery, family-oriented birth announcements and invitations for most events and Christmas cards.
 ● This company also owns Editions Limited and Frederick Beck Originals. One submission will be seen by both companies. See listing for Editions Limited/Frederick Beck.

BLISS HOUSE INC., 380 Union St., Suite 232, W. Springfield MA 01089. (413)737-0757. Fax: (413)781-3770. E-mail: blisshouse@aol.com. President: Jerry Houle. Estab. 1984. Licenses balloons, bookmarks, calendars, CD-ROMs, collectible figurines, decorative housewares, decorations, games, giftbags, gifts, giftwrap, greeting cards, limited edition plates, mugs, ornaments, paper tableware, school supplies, stationery, t-shirts, textiles, toys, wallpaper and licensed product services. Licensing agency representing: Charlie Chaplin, Curious George, Marx Brothers, Matchbox, Velveteen Rabbit, Ship of Dreams, Victory Garden, Samuel Adams, Davey & Goliath, Kids Say the Darndest Things and The Royal County of Berkshire Polo Club.

Needs: Approached by 10-20 freelancers/year. Works with 20+ freelancers/year. Licensed properties are responsible for hundreds of freelance designs and illustrations, 12 sculptures/year. Prefers freelancers with experience in upmarket children's designs and whimsical designs. Art guidelines available. Works on assignment only. Uses freelancers mainly for licensed art. Also for desktop publishing, brochures. Considers brochures, products. Looking for work exclusively with product illustration and sculpting for our licensed properties. 50% of freelance design work demands knowledge of Aldus PageMaker, Adobe Photoshop and Adobe Illustrator. Produces material for all holidays and seasons and everyday. Submit seasonal material 15 months in advance.

First Contact & Terms: Designers send query letter with photocopies, photographs and résumé. Illustrators and cartoonists send query letter with photocopies, photographs and follow-up postcard every 3 months. Sculptors send letter with photographs. Accepts disk submissions compatible with Adobe Illustrator. Samples are filed. Reports back in 1-2 weeks. Will contact for portfolio review of color, photographs, photostats and roughs if interested. Rights purchased vary according to project. Finds freelancers through word of mouth.

BLUE SKY PUBLISHING, 6395 Gunpark Dr., Suite M, Boulder CO 80301. (303)530-4654. Fax: (303)530-4627. E-mail: bsp cards@aol.com. Art Director: Theresa Brown. Estab. 1989. Produces greeting cards. "At Blue Sky Publishing, we are committed to producing contemporary fine art greeting cards that communicate reverence for nature and all creatures of the earth, that express the powerful life-affirming themes of love, nurturing and healing, and that share different cultural perspectives and traditions, while maintaining the integrity of our artists' work."
 ● Blue Sky is expanding its Christmas line. Art director told *AGDM* she sees reptiles and bugs as the new trend in toys and art. Sunflowers, dalmations and angels are out.

Needs: Approached by 500 freelancers/year. Works with 30 freelancers/year. Licenses 80 fine art pieces/year. Works with freelancers from all over US. Prefers freelancers with experience in fine art media: oils, oil pastels, acrylics, calligraphy, vibrant watercolor and fine art photography. "We primarily license existing pieces of art or photography. We rarely commission work." Looking for colorful, contemporary images with strong emotional impact. Art guidelines for SASE with first-class postage. Produces cards for all occasions. Submit seasonal material 1 year in advance.

First Contact & Terms: Send query letter with SASE, slides or transparencies. Samples are filed or returned. Reports back within 2-3 months only if interested. Transparencies are returned at job's completion. Pays royalties of 3% with a $250 advance per image. Buys greeting card rights for 5 years (standard contract; sometimes negotiated).

Tips: "We're interested in seeing artwork with strong emotional impact. Holiday cards are what we produce in biggest

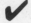 **A CHECKMARK PRECEDING A LISTING** indicates a change in either the address or contact information since the 1998 edition.

volume. We are looking for joyful images, cards dealing with relationships, especially between men and women, with pets, with Mother Nature and folk art. Vibrant colors are important."

BONITA PIONEER PACKAGING, 500 Bonita Rd., Portland OR 97224. (503)684-6542. Fax: (503)639-5965. E-mail: parker@bonitapioneer.com. Creative Director: Jim Parker. Estab. 1928. Produces giftwrap, shopping bags, boxes and merchandise bags.
Needs: Approached by 20 artists/year. Works with 10-20 artists/year. Buys 30-50 designs and illustrations/year. Prefers artists with experience in giftwrap, fabric or textile design. Considers acrylic, computer design, process and flat color design. Seeks upscale, traditional and contemporary styles. Prefers 15″ or 20″ cylinder repeats. Produces material for all occasions. 70% of design purchases are Christmas motifs. Considers submissions year-round.
First Contact & Terms: Send query letter with brochure, tearsheets and slides. Samples are not filed and are returned only if requested by artist. Reports back within 3 weeks. To show a portfolio, mail thumbnails, roughs, slides and photographs. Original artwork is not returned to the artist after job's completion. Pays average flat fee of $200-750/design. Buys all rights.
Tips: "Know the giftwrap market and be professional. Understand flexographic printing process limitations."

✔THE BRADFORD EXCHANGE, 9333 Milwaukee Ave., Niles IL 60714. (847)581-8015. Fax: (847)581-8770. Art Acquisition Manager: Susan Collier. Estab. 1973. Produces and markets collectible plates. "Bradford produces limited edition collectors plates featuring various artists' work which is reproduced on the porcelain surface. Each series of 6-8 plates is centered around a concept, rendered by one artist, and marketed internationally."
Needs: Approached by thousands of freelancers/year. Works with approximately 100 freelancers/year. Prefers artists with experience in rendering painterly, realistic, "finished" scenes; best mediums are oil and acrylic. Art guidelines by calling (847)581-8671. Uses freelancers for all work including border designs, sculpture. Considers oils, watercolor, acrylic and sculpture. Traditional representational style is best, depicting scenes of children, pets, wildlife, homes, religious subjects, fantasy art, florals or songbirds in idealized settings. Produces material for all occasions. Submit seasonal material 6-9 months in advance.
First Contact & Terms: Designers send brochure, transparencies, tearsheets, photographs, photocopies or slides. Illustrators and sculptors send query letter with brochure, photocopies, photographs, SASE, slides, tearsheets and transparencies. Samples are filed and are not returned. Art Director will contact artist only if interested. Originals are returned at job's completion. Pays by project. Pays royalties. Rights purchased vary according to project.

BRAZEN IMAGES, INC., 269 Chatterton Pkwy., White Plains NY 10606-2013. (914)949-2605. Fax: (914)683-7927. Website: http://www.brazenimages.com. President/Art Director: Kurt Abraham. Estab. 1981. Produces greeting cards and postcards. "Primarily we produce cards that lean towards the erotic arts; whether that be of a humorous/novelty nature or a serious/fine arts nature. We buy stock only—no assignments."
Needs: Approached by 10-20 freelancers/year. Works with 10 freelancers/year. Buys 10-30 freelance designs and illustrations/year. Uses freelancers mainly for postcards. Considers any media "I don't want to limit the options." Prefers 5×7 (prints); may send slides. Produces material for Christmas, Valentine's Day, Hanukkah, Halloween, birthdays, everyday and weddings.
First Contact & Terms: Send query letter with photographs, slides, SASE and transparencies. Samples are filed or returned by SASE if requested by artist. Reports back ASAP depending on workload. Company will contact artist for portfolio review if interested. Portfolio should include final art, photographs, slides and transparencies. Buys one-time rights. Originals are returned at job's completion. Pays royalties of 2%. Finds artists through artists' submissions.

BRILLIANT ENTERPRISES, 117 W. Valerio St., Santa Barbara CA 93101. Art Director: Ashleigh Brilliant. Publishes postcards.
Needs: Buys up to 300 designs/year. Freelancers may submit designs for word-and-picture postcards, illustrated with line drawings.
First Contact & Terms: Submit 5½×3½ horizontal b&w line drawings and SASE. Reports in 2 weeks. Buys all rights. "Since our approach is very offbeat, it is essential that freelancers first study our line. Ashleigh Brilliant's books include *I May Not Be Totally Perfect, But Parts of Me Are Excellent*; *Appreciate Me Now and Avoid the Rush*; and *I Want to Reach Your Mind. Where Is It Currently Located?* We supply a catalog and sample set of cards for $2 plus SASE." Pays $60 minimum, depending on "the going rate" for camera-ready word-and-picture design.
Tips: "Since our product is highly unusual, familiarize yourself with it by sending for our catalog. Otherwise, you will just be wasting our time and yours."

BRISTOL GIFT CO., INC., P.O. Box 425, 6 North St., Washingtonville NY 10992. (914)496-2821. Fax: (914)496-2859. E-mail: bristol@ny.frontiercomm.net. President: Matt Ropiecki. Estab. 1988. Produces posters and framed pictures for inspiration and religious markets.
 ● Bristol's president sees birdhouses and lighthouses as the next commercial art trend.
Needs: Approached by 5-10 freelancers/year. Works with 2 freelancers/year. Buys 15-30 freelance designs and illustrations/year. Works on assignment only. Uses freelancers mainly for design. Also for calligraphy, P-O-P displays and mechanicals. Prefers 16×20 or smaller. 10% of design and 60% of illustration require knowledge of Aldus PageMaker or Adobe Illustrator. Produces material for Christmas, Mother's Day, Father's Day and graduation. Submit seasonal material 6 months in advance.

First Contact & Terms: Send query letter with brochure and photocopies. Samples are filed or are returned. Reports back within 2 weeks. Company will contact artist for portfolio review if interested. Portfolio should include roughs. Requests work on spec before assigning a job. Originals are not returned. Pays by the project $30-50 or royalties of 5-10%. Rights purchased vary according to project. Interested in buying second rights (reprint rights) to previously published artwork.

BRUSH DANCE INC., 100 Ebbtide Ave., Bldg. #1, Sausalito CA 94965. (415)331-9030. Fax: (415)331-9059. E-mail: brushdan@nbn.com. Website: http://www.brushdance.com. Contact: Production Director. Estab. 1989. Produces greeting cards, calendars, postcards, candles, bookmarks, blank journal books and magnets. "Brush Dance creates products that help people express their deepest feelings and intentions. We combine humor, heartfelt sayings and inspirational writings with exceptional art."
Needs: Approached by 200 freelancers/year. Works with 5 freelancers/year. Art guidelines for 9×11 SASE with $1.50 postage. Uses freelancers mainly for illustration and calligraphy. Looking for non-traditional work conveying emotion or message. Prefers 5×7 or 7×5 originals or designs that can easily be reduced or enlarged to these proportions. Produces material for all occasions.
First Contact & Terms: Call or write for artist guidelines before submitting. Send query letter. Samples are filed or returned by SASE. Reports back only if interested. Buys all rights. Originals are returned at job's completion. Pays royalty of 5-7.5% depending on product. Finds artists through word of mouth, submissions, art shows.
Tips: "Please read guidelines first, then call with any questions."

BURGOYNE, INC., 2030 E. Byberry Rd., Philadelphia PA 19116. (215)677-8962. Fax: (215)677-6081. Contact: Christine Cathers Donohue. Estab. 1907. Produces greeting cards. Publishes Christmas greeting cards geared towards all age groups. Style ranges from traditional to contemporary to old masters' religious.
Needs: Approached by 150 freelancers/year. Works with 25 freelancers/year. Buys 50 designs and illustrations/year. Prefers freelancers with experience in all styles and techniques of greeting card design. Art guidelines available free for SASE with first-class postage. Uses freelancers mainly for Christmas illustrations. Also for lettering/typestyle work. Considers watercolor and pen & ink. Produces material for Christmas. Accepts work all year round.
First Contact & Terms: Send query letter with slides, tearsheets, transparencies, photographs, photocopies and SASE. Samples are filed. Creative Director will contact artist for portfolio review if interested. Pays flat fee. Buys first rights or all rights. Sometimes requests work on spec before assigning a job. Interested in buying second rights (reprint rights) to previously published work, first rights or all rights.
Tips: "Send us fewer samples. Sometimes packages are too lengthy. It is better to send one style that is done very well than to send a lot of different styles that aren't as good."

CANETTI DESIGN GROUP INC., P.O. Box 57, Pleasantville NY 10570. (914)238-1076. Fax: (914)238-3177. Marketing Vice President: M. Berger. Estab. 1982. Produces greeting cards, stationery, games/toys and product design.
Needs: Approached by 50 freelancers/year. Works with 20 freelancers/year. Works on assignment only. Uses freelancers mainly for illustration/computer. Also for calligraphy and mechanicals. Considers all media. Looking for contemporary style. Needs computer-literate freelancers for illustration and production. 80% of freelance work demands knowledge of Adobe Illustrator, Adobe Photoshop, Aldus FreeHand, Form 2/Strata.
First Contact & Terms: Send postcard-size sample of work and query letter with brochure. Samples are not filed. Portfolio review not required. Buys all rights. Originals are not returned. Pays by the hour. Finds artists through agents, sourcebooks, magazines, word of mouth and artists' submissions.

✔CAPE SHORE, INC., division of Downeast Concepts, 20 Downeast Dr., Yarmouth ME 04096. (207)846-3726. Creative Director: Janet Ledoux. Artist Contact: Betsy Abbott. Estab. 1947. "Cape Shore is concerned with seeking, manufacturing and distributing a quality line of gifts and stationery for the souvenir and gift market."
Needs: Approached by 100 freelancers/year. Works with 50 freelancers/year. Buys 200 freelance designs and illustrations/year. Prefers artists with experience in illustration. Uses freelance artists mainly for illustrations for boxed notes, Christmas card designs, ceramics and other paper products. Considers watercolor, gouache, acrylics, tempera, pastel, markers, colored pencil. Looking for traditional subjects rendered in a realistic style, stylized realistic looks and humor in good taste. Prefers final artwork on flexible stock for reproduction purposes.
First Contact & Terms: Send query letter with photocopies and slides. Samples are filed or are returned by SASE. Art Director will contact artist for portfolio review if interested. Portfolio should include slides, finished samples, printed samples. Pays by the project, $150 minimum. Buys reprint rights or varying rights according to project.
Tips: "Cape Shore is looking for realistic detail, good technique, bright clear colors and fairly tight designs, traditional themes or very high quality stylized looks for the souvenir and gift market. Proven success in the giftware field a plus, but will consider exceptional unpublished illustrators. If you have a great idea, we will consider it."

CARDMAKERS, Box 236, High Bridge Rd., Lyme NH 03768. Phone/fax: (603)795-4422. E-mail: diebold@sover.net. Website: http://www.cardmakers.com. Principle: Peter Diebold. Estab. 1978. Produces greeting cards. "We produce special cards for special interests and greeting cards for businesses—primarily Christmas. We have now expanded our Christmas line to include 'photo mount' designs, added designs to our everyday line for stockbrokers and are have recently launched a new everyday line for boaters."
Needs: Approached by more than 100 freelancers/year. Works with 5-10 freelancers/year. Buys 10-20 designs and

Using watercolor, pen & ink and an antique map, Barbara Schaffer created a fun take on Santa's yearly jaunt around the world, representative of "the whimsical nature of all our holiday cards," says Peter Diebold of Cardmakers. Schaffer, who found Cardmakers through their listing in *Artist's & Graphic Designer's Market*, retains all rights except greeting card rights to the illustration, so she can sell the design for use on mugs, paper products and other holiday items.

illustrations/year. Prefers professional-caliber artists. Art guidelines for SASE with first-class postage. Works on assignment only. Uses freelancers mainly for greeting card design, calligraphy and mechanicals. Also for paste-up. Considers all media. "We market 5×7 cards designed to appeal to individual's specific interest—golf, tennis, etc." Prefers an upscale look. Submit seasonal ideas 6-9 months in advance.

First Contact & Terms: Designers send query letter with SASE and brief sample of work. Illustrators send postcard sample or query letter with brief sample of work. "One good sample of work is enough for us. A return postcard with boxes to check off is wonderful. Phone calls are out; fax is a bad idea." Samples are filed or are returned by SASE. Reports back to artist only if interested. Portfolio review not required. Pays flat fee of range of $100-300 depending on many variables. Rights purchased vary according to project. Interested in buying second rights (reprint rights) to previously published work, if not previously used for greeting cards. Finds artists through word of mouth, exhibitions and *Artist's & Graphic Designer's Market* submissions.

Tips: "We like to see new work in the early part of the year. It's important that you show us samples *before* requesting submission requirements. Getting published and gaining experience should be the main objective of freelancers entering the field. We favor fresh talent (but do also feature seasoned talent). PLEASE be patient waiting to hear from us!"

CAROLE JOY CREATIONS INC., 107 Mill Plain Rd., #200, Danbury CT 06811. (203)798-2060. Fax: (203)748-5315. President: Carole Gellineau. Estab. 1986. Produces greeting cards. Specializes in cards, notes and invitations by and for people who share an African heritage.

Needs: Approached by 200 freelancers/year. Works with 5-10 freelancers/year. Buys 100 freelance designs, illustrations and calligraphy/year. Prefers artists "who are thoroughly familiar with, educated in and sensitive to the African-American culture." Art guidelines available. Works on assignment only. Uses freelancers mainly for greeting card art. Also for calligraphy. Considers full color only. Looking for realistic, traditional, Afrocentric, colorful and upbeat style. Prefers 11×14. 20% freelance design work demands knowledge of Adobe Illustrator, Adobe Photoshop and QuarkXPress. Also produces material for Christmas, Easter, Mother's Day, Father's Day, graduation, Kwanzaa, Valentine's Day, birthdays and everyday. Also for sympathy, get well, romantic, thank you, serious illness and multicultural cards. Submit seasonal material 1 year in advance.

First Contact & Terms: Designers send query letter with brochure, photocopies, photographs and SASE. "No phone calls, please. No slides." Illustrators and cartoonists send query letter with photocopies and photographs. No phone calls or slides. Calligraphers send samples and compensation requirements. Samples are not filed and are returned.

Reports back only if interested. Portfolio review not required. Buys all rights. Pays for illustration by the project.
Tips: "Excellent illustration skills are necessary and designs should be appropriate for African-American social expression. Writers should send verse that is appropriate for greeting cards and avoid lengthy, personal experiences. Verse and art should be uplifting."

CASE STATIONERY CO., INC., 179 Saw Mill River Rd., Yonkers NY 10701. (914)965-5100. President: Jerome Sudnow. Vice President: Joyce Blackwood. Estab. 1954. Produces stationery, notes, memo pads and tins for mass merchandisers in stationery and housewares departments.
Needs: Approached by 10 freelancers/year. Buys 50 designs from freelancers/year. Works on assignment only. Buys design and/or illustration mainly for stationery products. Uses freelancers for mechanicals and ideas. Produces materials for Christmas; submit 6 months in advance. Likes to see youthful and traditional styles, as well as English and French country themes. 10% of freelance work requires computer skills.
First Contact & Terms: Send query letter with résumé and tearsheets, photostats, photocopies, slides and photographs. Samples not filed are returned. Reports back. Call or write for appointment to show a portfolio. Original artwork is not returned. Pays by the project. Buys first rights or one-time rights.
Tips: "Find out what we do. Get to know us. We are creative and know how to sell a product."

✔H. GEORGE CASPARI, INC., 35 E. 21st St., New York NY 10010. (212)995-5710. Contact: Lucille Andriola. Publishes greeting cards, Christmas cards, invitations, giftwrap and paper napkins. "The line maintains a very traditional theme."
Needs: Buys 80-100 illustrations/year. Prefers watercolor and other color media. Produces seasonal material for Christmas, Mother's Day, Father's Day, Easter and Valentine's Day.
First Contact & Terms: Send samples to Lucille Andriola to review. Prefers unpublished original illustrations, slides or transparencies. Art Director will contact artist for portfolio review if interested. **Pays on acceptance**; negotiable. Pays flat fee of $400 for design. Finds artists through word of mouth, magazines, submissions/self-promotions, sourcebooks, agents, visiting artist's exhibitions, art fairs and artists' reps.
Tips: "Caspari and many other small companies rely on freelance artists to give the line a fresh, overall style rather than relying on one artist. We feel this is a strong point of our company. Please do not send verses."

‡CATCH PUBLISHING, INC., 456 Penn St., Yeadon PA 19050. (610)626-7770. Fax: (610)626-2778. Contact: Michael Markowicz. Produces greeting cards, stationery, giftwrap, blank books and posters.
Needs: Approached by 200 freelancers/year. Works with 5-10 freelancers/year. Buys 25-50 freelance designs and illustrations/year. Art guidelines for SASE with first-class postage. Works on assignment only. Uses freelancers mainly for design. Considers all media. Produces material for Christmas, New Year and everyday. Submit seasonal material 1 year in advance.
First Contact & Terms: Send query letter with brochure, tearsheets, résumé, slides, SASE and transparencies. Samples are not filed and are returned by SASE if requested by artist. Reports back within 2-6 months. Company will contact artist for portfolio review if interested. Portfolio should include final art, slides or large format transparencies. Rights purchased vary according to project. Originals are returned at job's completion. Pays royalties of 10-12% (may vary according to job).

‡CATHEDRAL ART METAL CO., INC., 25 Manton Ave., Providence RI 02909-3349. (401)273-7200. Website: http://cathedralart.com. Art Director: Fritzi Frey. Estab. 1920. Produces collectible figurines, gifts and ornaments. Specializes in giftware and jewelry.
Needs: Approached by 20-30 freelancers/year. Works with 10 freelances/year. Buys 100 freelance designs and illustrations/year. Uses freelancers mainly for product development and execution. Considers work in metal, pewter, etc. Looking for traditional, floral, sentimental, cute animals, adult contemporary, religious. Produces material for Christmas, Easter, Mother's Day, Father's Day, graduation, Halloween, Hanukkah, New Year, Thanksgiving, Valentine's Day, birthdays and everyday. "Open to any submissions." Submit seasonal material 1 year in advance.
First Contact & Terms: Designers send photocopies and photographs. Illustrators send photocopies. Accepts disk submissions compatible with Mac Photoshop. Send TIFF or EPS files. Samples are not filed and are not returned. Reports back in 2 weeks only if interested. Portfolios required from illustrators and sculptors; will contact artist for portfolio review of photographs if interested. Rights purchased vary according to project.

✔CEDCO PUBLISHING CO., 100 Pelican Way., San Rafael CA 94901. E-mail: sales@cedco.com. Website: http://www.cedco.com. Contact: Art Department. Estab. 1982. Produces 215 upscale calendars and books.
Needs: Approached by 500 freelancers/year. Works with 5 freelancers/year. Buys 48 freelance designs and illustrations/year. Art guidelines for SASE with first-class postage. "We never give assignment work." Uses freelancers mainly for stock material and ideas. "We use either 35mm slides or 4×5s of the work."
First Contact & Terms: "No phone calls accepted." Send query letter with photographs and tearsheets. Samples are filed. "Send non-returnable samples only." Reports back to the artist only if interested. To show portfolio, mail thumbnails and b&w photostats, tearsheets and photographs. Original artwork is returned at the job's completion. Pays by the

project. Buys one-time rights. Interested in buying second rights (reprint rights) to previously published work. Finds artists through art fairs and licensing agents.
Tips: "Full calendar ideas encouraged!"

CENTRIC CORP., 6712 Melrose Ave., Los Angeles CA 90038. (213)936-2100. Fax: (213)936-2101. E-mail: centric@juno.com. Vice President: Neddy Okdot. Estab. 1986. Produces fashion watches, clocks, mugs, frames, pens and T-shirts for ages 13-60.
Needs: Approached by 40 freelancers/year. Works with 6-7 freelancers/year. Buys 50-100 designs and illustrations/year. Prefers local freelancers only. Works on assignment only. Uses freelancers mainly for watch and clock dials, frames, mugs, T-shirts and packaging. Also for mechanicals. Considers graphics, computer graphics, cartoons, pen & ink, photography. 95% of freelance work demands knowledge of QuarkXPress, Adobe Illustrator, Adobe Photoshop and Adobe Paintbox.
First Contact & Terms: Send postcard sample or query letter with appropriate samples. Accepts submissions on disk. Samples are filed if interested. Reports back only if interested. Originals are returned at job's completion. Requests work on spec before assigning a job. Pays by the project. Pays royalties of 1-10% for design. Rights purchased vary according to project. Finds artists through submissions/self-promotions, sourcebooks, agents and artists' reps.
Tips: "Show us your range."

‡CHRISTY CRAFTS, INC., P.O. Box 492, Hinsdale IL 60521. (630)323-6505. President: Betty Christy. Produces gifts, greeting cards and mail-order craft kits and supplies of the 1800s.
Needs: Approached by many freelancers/year. Works with 10-20 freelancers/year. Prefers freelancers with experience in crafts. Art guidelines available by phone or mail. Uses freelancers mainly for craft kits and projects that fit 1800s. Looking for crafts of the 1800s. 50% of freelance design demands computer skills. Produces material and craft kits for all holidays and seasons. Submit seasonal material 6 months in advance.
First Contact & Terms: Send query letter or phone with idea. Samples are not filed and are returned. Reports back within days. Portfolio review not required. Negotiates rights purchased or rights vary according to project. Pays for design by the project; pays flat fee for illustration or by the project. Finds freelancers through submissions and craft organizations.
Tips: "Get an idea and call or write. I am always willing to listen and refer if I can't use."

CITY MERCHANDISE INC., 68 34th St., P.O. Box 320081, Brooklyn NY 11232. (718)832-2931. Fax: (718)832-2939. E-mail: citymdse@aol.com. Production Manager: Joanne Oleary. Produces calendars, collectible figurines, gifts, mugs, souvenirs of New York.
Needs: Works with 6-10 freelancers/year. Buys 50-100 freelance designs and illustrations/year. "We buy sculptures for our casting business." Prefers freelancers with experience in graphic design. Works on assignment only. Uses freelancers for most projects. Considers all media. 50% of design and 80% of illustration demand knowledge of Adobe Photoshop, QuarkXPress, Adobe Illustrator. Does not produce holiday material.
First Contact & Terms: Designers send query letter with brochure, photocopies, résumé. Illustrators and/or cartoonists send postcard sample of work only. Sculptors send résumé and copies of their work. Samples are filed. Reports back within 2 weeks. Portfolios required for sculptors only if interested in artist's work. Buys all rights. Pays by project.

CLARKE AMERICAN, P.O. Box 460, San Antonio TX 78292-0460. (210)697-1377. Fax: (210)561-8276. E-mail: jeanan_beisel@caradon.com. Product Development Manager: Jeanan Beisel. Estab. 1874. Produces checks and other products and services sold through financial institutions. "We're a national printer seeking original works for check series, consisting of five, three, or one scene. Looking for a variety of themes, media, and subjects for a wide market appeal."
Needs: Uses freelancers mainly for illustration and design of personal checks. Considers all media and a range of styles. Prefers art twice standard check size.
First Contact & Terms: Send postcard sample or query letter with brochure and résumé. "Indicate whether the work is available; do not send original art." Samples are filed and are not returned. Reports back to the artist only if interested. Rights purchased vary according to project. Payment for illustration varies by the project.
Tips: "Keep red and black in the illustration to a minimum for image processing."

CLAY ART, 239 Utah Ave., S. San Francisco CA 94080-6802. (650)244-4970. Fax: (650)244-4979. Art Director: Thomas Biela. Estab. 1979. Produces giftware and home accessory products: cookie jars, teapots, salt & peppers, mugs, magnets, pitchers, masks, platters and canisters.
Needs: Approached by 70 freelancers/year. Works with 10 freelancers/year. Buys 30 designs and illustrations/year. Prefers freelancers with experience in 3-D design of giftware and home accessory items. Works on assignment only.

‡ **MARKETS NEW TO THIS EDITION** are marked with a double dagger.

INSIDER REPORT

Licensing your work for fun and profit

Jackie Frerichs knows how to keep several plates in the air at once—plates and mugs and two kinds of napkins. She's been juggling her designs on a variety of products since 1991, and it's a trick she feels every artist should master.

Learning any new skill takes time and practice, but the rewards can be worth it. According to Frerichs, once you master the art of licensing, your income will multiply. "So many artists sell an illustration and think 'that's the end of it.' It's not—or at least it doesn't have to be."

You can parlay one illustration or design into sales on several different products—as long as you remember to retain the rights to your image. What's more, if you negotiate a royalty agreement, you can continue to receive a percentage of the product's sales for years to come.

Jackie Frerichs

As an example, Frerichs tells how after selling a Santa illustration to a greeting card company, she transformed the same design into a Christmas plate by simply adding a circular border of candy canes. She then sold her "new" design to a company that makes party goods. By transforming her card into a plate design she earned—and continues to earn—a hefty sum. "In addition to a $1,000 advance for the plate design, I earned $6,000 in royalties the first year. It was my first plate and I was surprised it did so well."

That doesn't mean you can just take any of your designs, slap a circular border on it and "Presto!" you've got a paper plate design. It takes some forethought at the designing stage to plan an image that's versatile enough to make the transition. "In the back of my mind when I'm designing I'm always thinking about the potential for other uses," says Frerichs. So, when designing a rectangular image such as a greeting card, she tries to imagine how she could turn it into a circular composition.

Frerichs's greatest trick to date is changing one card design into a place setting of 18. One of her Halloween designs, a scarecrow sitting among pumpkins, was originally sold as a greeting card. Now it's with another company and will be used as paper plates and party goods. "As I was creating the original card, I could see the potential. I thought, 'If I add more pumpkins, this would make a cute plate.' " But even Frerichs didn't imagine the variety of party goods and favors Contempo Coulours came up with using her scarecrow motif. Frerichs is still amazed to see her lovable scarecrow and his jack-o-lanterns smiling back at her from party bags, placemats, stickers, napkins, bowls, cups and party invitations. Contempo even made swizzle sticks using an element from Frerichs's original design.

To profit the most from your work, says Frerichs, you should be very mindful of the terms of your contracts with clients. Usually the forms are clear and straightforward, and most companies try to be fair. But she does have one warning: read your contract carefully. "If there's a clause asking for an exclusive right, or all rights, you don't want to agree to that." A request for an "exclusive" to anything deserves scrutiny, says Frerichs.

INSIDER REPORT, *Frerichs*

Most greeting card companies have standard rates for images for cards. That's fine, but remember to read the fine print and know which rights you are selling. "I sell greeting card rights only. I would never sell my designs outright to a company, because I [can] see the possibilities down the road for some other product."

When signing contracts, try to obtain a royalty agreement—especially if you think your design could be a best-seller. A royalty just means that you will earn a percentage of the product's sales in the future. On most of her projects, Frerichs will ask for and receive an advance on royalties. For an advance, she likes to—at the very least—make enough money to pay for her time, art materials, labor and expenses. Her typical advances range between $200-400 for a design.

Royalties vary, but Frerichs says five to ten percent is the usual range. However, she will agree to reduce the royalty to three percent or in some cases forfeit the advance against royalties if she believes the potential for mass market sales is especially promising. "If I were selling to a factory card outlet—they have tons of stores—3 percent could be a lucrative royalty, even if they sold the card for 39 cents."

The best-case scenario is to obtain an advance against royalties, says Frerichs, but all companies do not offer royalties. Here's where it gets a little confusing, because some artists think every licensing agreement comes with a royalty. "That's not true," says Frerich. "Every licensing agreement does not necessarily come with a royalty. But every royalty agreement is a licensing agreement."

If you cannot get a company to agree to a royalty, you should at least try to negotiate a licensing agreement that limits the time period the company is allowed to use your work.

Contempo® © Jackie Frerichs

This Halloween party ensemble, "Scarecrow & Pals," was produced by Contempo Colours using a design by Jackie Frerichs. There are 18 pieces in all to the set.

INSIDER REPORT, *continued*

Somewhere within your contract, you should also limit the types of products a company may use your work for. The more products a company hopes to manufacture from your design, the more it should pay you for it.

All a licensing agreement means is that you, as sole owner, are "licensing" a company to use your work for a finite amount of time and/or for a specific purpose or purposes. After that finite amount of time expires, the rights to the artwork revert to you. In a typical contract you might grant a company the right to reproduce your design on mugs for three years. Even during the period when your artwork is licensed to that company for mugs, you still retain the right to license that same artwork to different companies as long as it's used on products other than mugs.

Some artists sell all rights to their designs and illustrations abecause the company offers

© Papel Giftware®

Jackie Frerichs sold rights to the above valentine designs to Papel Giftware for the manufacture of mugs only. "The mugs have done really well," said Tina Merola, design manager at Papel. Papel made decals from Jackie's designs which were then fired onto the mugs. The mugs are sold through gift shops, florists and specialty stores.

INSIDER REPORT, *Frerichs*

an attractive payment. But Frerichs has found it better to negotiate a licensing agreement, even if the amount isn't as high as immediate payment for all rights would be. "It's more important to me that I retain the rights to a design, as long as the advance is reasonable."

Most companies are willing to negotiate on the percentage of royalties you will earn on sales, depending on whether the product will be sold by the mass market or in gift shops or department stores. Sometimes, companies offer what's called a "mid-tier" contract, meaning the product is sold initially in mass market stores at a lower royalty, and later sold through gift shops or specialty stores at a higher royalty (or vice versa). Often, companies stipulate that they receive the option to renew when the contract is up. On your end of the negotiating table, it may be important for you to have some control over the quality of materials used to manufacture a product and how profits are tabulated. Be sure to incorporate your concerns somewhere in the contract. Some artists even outline how they expect the company to track sales, so they are sure royalties are reported accurately.

Every contract is different, says Frerichs, and some she's signed have been up to 12 pages long. But when clauses sprout subclauses don't hesitate to find legal advice. "I have a lawyer who deals specifically with artists' contracts. An illustrator friend gave me the name," says Frerichs. If you can't get a referral from another artist, ask the Graphic Artist Guild or the National Cartoonist Society for recommendations.

With your rights intact, your next step is to find markets for your work. While many artists send the same package to dozens of companies, Frerichs tailors submissions to specific buyers. She leaves nothing to the client's imagination. She'll redo a card design to favor the wrap-around panorama of a mug. She'll add or subtract design elements to make her artwork fit the products of the company she's shooting for. "Right now I'm putting together a portfolio mailing for a company that does giftwrap and giftbags." But, instead of just sending card samples and tearsheets, she purchased a giftbag then pulled it apart and cut it down, and is using it as a template to make her own bag to submit to the company.

Where to begin? Frerichs suggests you start with the store's most conspicuous inventory. "Greeting cards are a very creative outlet. It's a lot of hard work, a lot of deadlines, but it's good training." In addition to welcoming new talent, she says, greeting card art directors will often offer advice on the essentials of producing work for reproduction.

If Frerichs is not familiar with a company, she'll make a few phone calls. "I'll call the Better Business Bureau of that city, or have the library do a search. They can find sales figures and credit histories. One business was going through bankruptcy; they had a phone number but it was the wrong phone number. I didn't submit to them."

In the beginning, Frerichs wasn't always so diligent. "I didn't research as much as I should have. Now I go to card stores and look for a specific company's product, see what type of quality they have, and [check out] their criteria before wasting my time and theirs submitting inappropriate work."

If you think all Frerichs's product juggling is impressive, she has plans to toss more items into circulation. "I don't think you should limit yourself. Don't be afraid of new markets. I'd like to see my work as figurines. And I haven't really submitted to textile markets, or wallpaper companies."

Keeping your work aloft takes skill and dedication, but don't be intimidated. Pick a company. Even the best jugglers begin with one toss.

—*Mark Heath*

JACKIE FRERICHS'S LICENSING TIPS

• **Keep on top of the industry.** Browse stores and malls often to study what's popular on shelves. Don't forget to peruse gift catalogs, too. Frerichs recommends a subscription to *Greetings Today*, a quarterly magazine that covers the giftware industry. Attend a stationery or gift show, such as the annual show at the Javits Center in New York. (You'll find a calendar of upcoming shows in *Greetings Today*). Or you can save your soles with a trip online. Many card companies offer their wares on the Web, and digital card shops may display the work of those who don't.

• **Read more about it.** Frerichs found *Greeting Card Design*, by Joanne Fink (PBC International), inspirational. If you can't find it, your local library should have copies. She also recommends *Business and Legal Forms for Illustrators* (North Light Books).

• **Research companies.** Read the listings in the Greeting Cards, Gifts & Products section of *Artist's & Graphic Designer's Market* carefully, so you know exactly what products each company manufactures—then, tailor your submissions to fit target markets. *Thomas's Registry of American Manufacturers* isn't a reference to set on your shelf—it's 21 volumes, but your library should have them. Caryn Leland directs you to the first 12 volumes, which list 50,000 manufacturers by product.

• **Consider signing with an agent.** Fifteen to twenty-five percent is a typical cut—pruned from your average royalty of five to ten percent. But if browsing through the aforementioned 12 volumes is daunting, pay the price and let an expert find the best markets for your style of artwork.

• **Keep the ball rolling.** After one company accepts your artwork, don't wait until the card or product is actually manufactured before submitting the same artwork to additional companies for other product categories.

—*Mark Heath*

Uses freelancers mainly for illustrations, 3-D design and sales promotion. Also for P-O-P displays, paste-up, mechanicals and product design. Seeks humorous, whimsical, innovative work. 60% of freelance work demands knowledge of Aldus PageMaker, Aldus FreeHand, Adobe Illustrator, Adobe Photoshop.
First Contact & Terms: Send query letter with brochure, résumé, SASE, tearsheets and photocopies. Samples are filed. Reports back to the artist only if interested. Call for appointment to show portfolio of thumbnails, roughs and final art and color photostats, tearsheets, slides and dummies. Negotiates rights purchased. Originals are returned at job's completion. Pays by project.

‡**CLEAR CARDS**, 11054 Ventura Blvd., #207, Studio City CA 91604. (818)980-4120. Fax: (818)980-0771. Director of Marketing: André Cheeks. Estab. 1989. Produces greeting cards, CD packaging, collectibles, promotional and advertising products. "Clear Cards produces and markets greeting cards using PVC and high-end graphics. The buying group is women 25-55. The unique concept lends itself to promotional and advertising products."
Needs: Approached by 5-10 freelancers/year. Works with 3-4 freelancers/year. Buys 30-50 freelance designs and illustrations/year. Looking for a humorous style (sketch, ideas and image); cartoonists welcome. Prefers 9×12 images with 1″ margins left/right. 70% of work demands knowledge of Adobe Illustrator, Adobe Photoshop and QuarkXPress. Produces material for Christmas, Valentine's Day, Mother's Day, New Year, birthdays and everyday. Submit seasonal material 4 months in advance.
First Contact & Terms: Send postcard sample of work. Samples are filed. Reports back with 15 working days. Company will contact artist for portfolio review if interested. Portfolio should include final art and photographs. Negotiates rights purchased. Originals are not returned. Pays by the project, $100-500. Finds artists through submissions, via referrals and local art schools.

CLEO, INC., 4025 Viscount Ave., Memphis TN 38118. (901)369-6661. Fax: (901)369-6376. Director of Creative Arts: Harriet Byall. Estab. 1953. Produces greeting cards, calendars, giftwrap, gift bags, valentines (kiddie packs). "Cleo is the world's largest Christmas giftwrap manufacturer. Also provides extensive all occasion product line. Cards are boxed only (no counter cards) and only Christmas. Other product categories include some seasonal product. Mass market for all age groups."
Needs: Approached by 25 freelancers/year. Works with 40-50 freelancers/year. Buys more than 200 freelance designs

and illustrations/year. Uses freelancers mainly for giftwrap and greeting cards (designs). Also for calligraphy. Considers most any media. Looking for fresh, imaginative as well as classic quality designs for Christmas. Prefers 5×7 for cards; 30″ repeat for giftwrap. Art guidelines available. Submit seasonal material at least a year in advance.

First Contact & Terms: Send query letter with slides, SASE, photocopies, transparencies and speculative art. Accepts submissions on disk. Samples are filed if interested or returned by SASE if requested by artist. Reports back to the artist only if interested. Rights purchased vary according to project; usually buys all rights. Pays flat fee. Finds artists through agents, sourcebooks, magazines, word of mouth and submissions.

Tips: "Understand the needs of the particular market to which you submit your work."

COMSTOCK CARDS, INC., 600 S. Rock Blvd., Suite 15, Reno NV 89502. (702)856-9400. Fax: (702)856-9406. Production Manager: David Delacroix. Estab. 1987. Produces greeting cards, notepads and invitations. Styles include alternative and adult humor, outrageous, shocking and contemporary themes; specializes in fat, age and funny situations. No animals or landscapes. Target market predominately professional females, ages 25-55.

Needs: Approached by 250-350 freelancers/year. Works with 10-12 freelancers/year. "Especially seeking artists able to produce outrageous adult-oriented cartoons." Uses freelancers mainly for cartoon greeting cards. Art guidelines for SASE with first-class postage. No verse or prose. Gaglines must be brief. Prefers 5×7 final art. Produces material for all occasions. Submit holiday concepts 11 months in advance.

First Contact & Terms: Send query letter with SASE, tearsheets or photocopies. Samples are not usually filed and are returned by SASE if requested. Reports back only if interested. Portfolio review not required. Originals are not returned. Pays royalties of 5%. Pays by project, $50-150 minimum; may negotiate other arrangements. Buys all rights.

Tips: "Make submissions outrageous and fun—no prose or poems. Outrageous humor is what we look for—risque OK, mile risque best."

CONCORD LITHO GROUP, 92 Old Turnpike Rd., Concord NH 03301. (603)225-3328. Fax: (603)225-6120. Vice President/Creative Services: Lester Zaiontz. Estab. 1958. Produces greeting cards, stationery, posters, giftwrap, specialty paper products for direct marketing. "We provide a range of print goods for commercial markets but also supply high-quality paper products used for fundraising purposes."

Needs: Buys 300 freelance designs and illustrations/year. Works on assignment only but will consider available work also. Uses freelancers mainly for greeting cards, wrap and calendars. Also for calligraphy and computer-generated art. Considers all media but prefers watercolor. Art guidelines available for SASE with first-class postage. "Our needs range from generic seasonal and holiday greeting cards to religious subjects, florals, nature, scenics, inspirational vignettes. We prefer more traditional designs with occasional contemporary needs." Prefers original art no larger than 10×14. Produces material for all holidays and seasons: Christmas, Valentine's Day, Mother's Day, Father's Day, Easter, Hanukkah, Passover, Rosh Hashanah, Thanksgiving, New Year, birthdays, everyday and other religious dates. Submit seasonal material 6 months in advance.

First Contact & Terms: Send introductory letter with résumé, brochure, photographs, slides, photocopies or transparencies. Accepts submissions on disk. Samples are filed. Reports back within 3 months. Portfolio review not required. Rights purchased vary according to project. Originals are returned at job's completion. Pays by the project, $200-800. "We will exceed this amount depending on project."

Tips: "Keep sending samples or color photocopies of work to update our reference library. Be patient. Send quality samples or copies."

CONTEMPO COLOURS, 1 Paper Place, Kalamazoo MI 49001. (616)349-2626. Fax: (616)349-6412. Design Manager: Kathleen Pavlack. Produces paper-tableware products; general and seasonal, birthday, special occasion, invitations, stationery, wrapping paper, thank you notes, T-shirts, mugs, confetti and party accessories for children and adults.

Needs: Approached by 200 freelance artists/year. Uses artists for product design and illustration. Art guidelines for SASE with first-class postage. Prefers flat 4-color designs; but will also accept 4-color pieces. Produces seasonal material for Christmas, Mother's Day, Thanksgiving, Easter, Valentine's Day, St. Patrick's Day, Halloween and New Year's Day. Submit seasonal material before June 1; everyday (not holiday) material before March

First Contact & Terms: Send query letter with 9×12 SASE so catalog can be sent with response. Accepts submissions on Mac disk. Disclosure form must be completed and returned before work will be viewed. Call or write to schedule an appointment to show portfolio. Portfolio should include original/final art and final reproduction/product. Previously published work OK. Originals are returned to artist at job's completion. "All artwork purchased becomes the property of Beach Products. Items not purchased are returned." Pays average flat fee of $500 or royalties of 3-5% for illustration and design; license fees negotiable. Considers product use when establishing payment.

Tips: "Artwork should have a clean, professional appearance and be the specified size for submissions, as well as a maximum of four flat colors."

✒COTTAGE ART, a licensed division of The Crockett Collection, P.O. Box 1428, Manchester Center, VT 05255. Owner: Jeanette Robertson. Estab. 1994. Produces greeting cards and notecards. "All of our designs are one color, silk screened, silhouette designs. Most cards are blank notes. They appeal to all ages and males! They are simple yet bold."

Needs: Uses freelancers mainly for design. Considers flat b&w; ink, marker, paint. Looking for silhouette designs only. Any subject considered. Art guidelines for SASE with first-class postage. "Remember they are only one color, solid, no tones." Prefers no larger than $8\frac{1}{2} \times 11$.

First Contact & Terms: Send query letter with SASE and photocopies. Samples are returned by SASE. "If no SASE,

they are disposed of. When an ad says SASE—do it!" Reports back within 2 weeks with SASE. Portfolio review not required. Pays $1-50 and free cards. Finds artists through submissions.
Tips: "Being a new company we are interested in artists who are willing to work with us and grow with us. Our company seeks out industry 'holes.' Things that are missing, such as designs that appeal to men. We like 'Victorian' paper cut out look in wildlife, sports, country, coastal, flowers and bird designs."

COURAGE CENTER, 3915 Golden Valley Rd., Golden Valley MN 55422. Fax: (612)520-0299. E-mail: artsearch@-courage.org. Website: http://www.couragecards.org. Art and Production Manager: Laura Brooks. Estab. 1970. "Courage Cards are holiday cards that are produced to support the programs of Courage Center, a nonprofit provider of rehabilitation services that helps people with physical, communication and sensory disabilities live more independently."
Needs: In searchof holiday art themes including: traditional, child art, diversity, winter scenes, nostalgic, religious, Americana, non-denominational, business-appropriate, ethnic, world peace and "earthly" holiday designs. Features artists with disabilities, but all artists are encouraged to enter the annual Courage Card Art Search.
First Contact & Terms: Send query letter, fax or e-mail with name and address to receive Art Search application and guidelines. Art Search information is sent in August. Entry deadline is December 1st. Receipt of entries is acknowledged immediately. Selections are decided 3 months after deadline. Entries are returned if requested. Artist retains ownership of the art. Pays $350 honorarium in addition to nationwide recognition through distribution of more than 500,000 catalogs and promotional pieces, TV, radio and print advertising.
Tips: "Do not send originals. We prefer that entries arrive as a result of the Art Search. The Selection Committee chooses art that will reproduce well as a card—colorful contemporary and traditional images for holiday greetings and all-occasion notecards. Participation in the Courage Cards Art Search is a wonderful way to share your talents and help people live more independently."

CREATIF LICENSING, 31 Old Town Crossing, Mount Kisco NY 10549. (914)241-6211. E-mail: creatiflic@aol.com. Website: http://members@aol.com/creatiflic. President: Paul Cohen. Licensing Manager. "Creatif is a licensing agency that represents artists and concept people." Licenses art for commercial applications for consumer products in gift stationery and home furnishings industry.
Needs: Looking for unique art styles and/or concepts that are applicable to multiple products. "The art can range from fine art to cartooning."
First Contact & Terms: Send query letter with brochure, photocopies, photographs, SASE and tearsheets. Pays royalties of 50%. Negotiates payment based on artist's recognition in industry. "If we are interested in representing you, we will present your work to the appropriate manufacturers in the clothing, gift, publishing, home furnishings, paper products (cards/giftwrap/party goods, etc.) areas with the intent of procuring a license. We try to obtain advances and/or guarantees against a royalty percentage of the firm's sales. We will negotiate and handle the contracts for these arrangements, show at several trade shows to promote your style and oversee payments to ensure that the requirements of our contracts are honored. Artists are responsible for providing us with materials for our meetings and presentations and for protection of copyrights, trademarks. For our services, as indicated above, we split revenues from any licenses we negotiate. Royalty rate varies depending on the experience and marketability of the artist. We also vary advance structure depending on if the artwork is existing vs. new. If the artist has a following we are more flexible. There are no fees if we are not productive."
Tips: Common mistakes illustrators make in presenting samples or portfolios are "sending oversized samples mounted on heavy board and not sending appropriate material. Color photocopies and photos are best."

CREATIVE CARD CO., (formerly Century Engravings), 1500 W. Monroe St., Chicago IL 60607. Wedding Art Director: Nanci Barsevick. Estab. 1955. Produces wedding invitations and announcements, Christmas cards and stationery.
Needs: Approached by 30 freelancers/year. Works with 10 freelancers/year. Buys 60 freelance designs and illustrations/year. "Prefers freelancers with experience in our production techniques (embossing, die-cutting and foil stamping)." Art guidelines free for SASE with first-class postage. Uses freelancers mainly for design and illustration of wedding invitations. Considers all media. Produces material for personalized Christmas, Rosh Hashanah, New Year, graduation, wedding invitations and birth announcements. Submit seasonal material 1 year in advance.
First Contact & Terms: Send query letter with SASE. Samples are not filed and are returned by SASE. Reports back within 3 weeks. Artist should follow-up with letter after initial query. Pays average flat fee of $250/design; pays more for full color or complicated artwork. Pays by the project for calligraphy. Buys reprint rights or all rights. No royalties.
Tips: "Send in any roughs or copies of finished ideas you have, and we'll take a look. Write for specs on size first (with SASE) before submitting any material. In wedding invitations, we seek an elegant card featuring embossing, foil stamping and die-cutting. Have a look at what is out there."

CREEGAN CO., INC., 510 Washington St., Steubenville OH 43952. (614)283-3708. Fax: (614)283-4117. E-mail: creegans@weir.net. Website: http://www.weir.net/Creegans. President: Dr. G. Creegan. Estab. 1961. "The Creegan Company designs and manufactures animated characters, costume characters and life-size audio animatronic air-driven characters. All products are custom made from beginning to end."
Needs: Approached by 10-30 freelance artists/year. Works with 3 freelancers/year. Prefers local artists with experience in sculpting, latex, oil paint, molding, etc. Artists sometimes work on assignment basis. Uses freelancers mainly for design comps. Also for mechanicals. Produces material for all holidays and seasons, Christmas, Valentine's Day, Easter,

Thanksgiving, Halloween and everyday. Submit seasonal material 3 months in advance.
First Contact & Terms: Send query letter with résumé. Samples are filed. Does not report back. Write for appointment to show portfolio of final art, photographs. Originals returned. Rights purchased vary according to project.

THE CROCKETT COLLECTION, P.O. Box 1428, Manchester Center VT 05255-1428. (802)362-0641. Fax: (802)362-5590. E-mail: sscheirer@aol.com. President: Sharon Scheirer. Estab. 1929. Publishes mostly traditional, some contemporary, humorous and whimsical silk screen Christmas and everyday greeting cards, postcards, notecards and bordered stationery on recycled paper. Christmas themes are geared to sophisticated, upscale audience.
Needs: Approached by 50 freelancers/year. Works with 20-30 freelancers/year. Buys 20-40 designs/year. Produces products by silk screen method exclusively. Considers cut and pasted paper designs and gouache. Prefers 5×7 or $4\frac{1}{2} \times 6\frac{1}{2}$. Art guidelines free for SASE with first-class postage. Produces material for Christmas and everyday. Submit seasonal material 1 year in advance.
First Contact & Terms: Send query letter with SASE. Request guidelines which are mailed out once a year in February, one year in advance of printing. Submit unpublished, original designs only. Art should be in finished form. Art not purchased is returned by SASE. Reports back in 3 months. Buys all rights. Pays flat fee of $90-150 for illustration/ design. Finds artists through *Artist's & Graphic Designer's Market* submissions.
Tips: "Designs must be suitable for silkscreen process. Airbrush, watercolor techniques and pen & ink are not amenable to this process. Bold, well-defined designs only. Our look is traditional, mostly realistic and graphic. Request guidelines and follow instructions. Don't submit inappropriate work."

CRYSTAL CREATIVE PRODUCTS, INC., P.O. Box 42450, Middletown OH 45042. Art Director: Mary Jo Recker. Estab. 1894. Produces giftwrap, gift bags, printed giftwrapping tissues and decorative accessories. "Crystal produces a broad range of giftwrapping items for the mass market. We especially emphasize our upscale gift bags with coordinating specialty tissues and giftwrap. Our product line encompasses all age groups in both Christmas and all occasion themes."
• Refer to the 1997 edition of *AGDM* for an interview with Mary Jo Recker about the giftwrap and giftbag market.
Needs: Approached by 200 freelancers/year. Works with 300 freelancers/year. Buys 200 freelance designs and illustrations/year. Prefers freelancers with experience in greeting cards or giftwrap markets. Works on assignment and "we also purchase reproduction rights to existing artwork." Uses freelancers mainly for gift bag and tissue repeat design. Also for calligraphy, mechanicals (computer only), b&w line illustration and local freelancers for design and production. 100% of design and 10% of illustration require knowledge of QuarkXPress, Adobe Illustrator, Aldus FreeHand, Aldus PageMaker and Adobe Photoshop. Produces seasonal material for Christmas, Valentine's Day, Easter, Hanukkah, Halloween, birthdays and everyday. "We need a variety of styles from contemporary to traditional—florals, geometric, country, whimsical, juvenile, upscale, etc."
First Contact & Terms: Send query letter with 10 or more color examples (not original art) and SASE. Submit samples anytime. Samples are filed or returned by SASE. Reports back in 1 month. Company will contact artist for portfolio review if interested. Originals returned depending on rights purchased. Pays by project, $400-1,200. Negotiates rights purchased.
Tips: "Send a packet of samples of what you do best. We'll keep your work on file if it has potential for us, and return it if it doesn't. No phone calls please. Study the illustration work currently being applied to the product you are interested in (in the marketplace). Be sure your style and subjects are appropriate before sending. Pay attention to trends. Garden themes are still strong. Angels are still important—especially at Christmas and in non-traditional handlings. Old-fashioned roses are growing in popularity and there is an increasing interest in pets. Photographic images and typographic solutions are also increasing."

∠CUSTOM STUDIOS INC., 6118 N. Broadway St., Chicago IL 60660-2502. (773)761-1150. President: Gary Wing. Estab. 1960. Custom T-shirt manufacturer. "We specialize in designing and screen printing custom T-shirts for schools, business promotions, fundraising and for our own line of stock."
Needs: Works with 10 freelance illustrators/year. Assigns 20 freelance jobs/year. Especially needs b&w illustrations (some original and some from customer's sketch). Uses artists for direct mail and brochures/fliers, but mostly for custom and stock T-shirt designs.
First Contact & Terms: Send query letter with résumé, photostats, photocopies or tearsheets. "We will not return originals." Reports in 3-4 weeks. Mail b&w tearsheets or photostats to be kept on file. Pays for design and illustration by the hour, $28-35; by the project, $50-150. Considers turnaround time and rights purchased when establishing payment. For designs submitted to be used as stock T-shirt designs, pays 5-10% royalty. Rights purchased vary according to project.
Tips: "Send 5-10 good copies of your best work. We would like to see more black & white, camera-ready illustrations—copies, not originals. Do not get discouraged if your first designs sent are not accepted."

DALEE BOOK CO., 129 Clinton Place, Yonkers NY 10701. (914)965-1660. Vice President: Charles Hutter. Estab. 1964. "We manufacture photo albums, scrapbooks, telephone address books and desk sets. Custom manufacturing for the industry and private labeling."
Needs: Approached by 5 freelance artists/year. Works with 1 feelance artist/year. Buys 1-3 designs and illustrations/ year from freelance artists. Prefers local artists only. Works on assignment only. Uses freelance artists mainly for labels and mechanicals. Considers any media.

Linda Malkus-Easler was going for a subdued, peaceful holiday feel while creating this airbrush and gouache design for The Crockett Collection, one of five greeting card companies she found through *Artist's & Graphic Designer's Market* and works with regularly. In addition to using *AGDM* (which has gotten her "100%" of her jobs—over 100 cards), Malkus-Easler recommends artists starting out "be willing to spend a little money on postage in the beginning. Be persistent. Ask for guidelines before submitting your artwork, so you don't waste your time mailing to companies that are not compatible with your style."

First Contact & Terms: Send query letter with photocopies. Samples are not filed and are returned by SASE if requested by artist. Reports back to the artist only if interested. Write to schedule an appointment to show a portfolio or mail roughs and color samples. Original artwork is not returned at the job's completion. Pays by the project, $200-500 average. Buys all rights.

DECORCAL, INC., 165 Marine St., Farmingdale NY 11735. (516)752-0076 or (800)645-9868. Fax: (516)752-1009. President: Walt Harris. Produces decorative, instant stained glass, as well as sports and wildlife decals.
Needs: Buys 50 designs and illustrations from freelancers/year. Uses freelancers mainly for greeting cards and decals; also for P-O-P displays. Prefers watercolor.
First Contact & Terms: Send query letter with brochure showing art style or résumé and photographs. Samples not filed are returned. Art director will contact artist for portfolio review if interested. Portfolio should include final reproduction/product and photostats. Originals are not returned. Sometimes requests work on spec before assigning a job. Pays by project. Buys all rights. Finds artists through word of mouth, magazines, submissions/self-promotions, sourcebooks, agents, visiting artists' exhibitions, art fairs and artists' reps.
Tips: "We predict a steady market for the field."

DESIGN DESIGN, INC., P.O. Box 2266, Grand Rapids MI 49501. (616)774-2448. Fax: (616)774-4020. Creative Director: Tom Vituj. Produces humorous and traditional fine art greeting cards, stationery, journals, address books, magnets, sticky notes and giftwrap.
Needs: Uses freelancers for all of the above products. Considers most media. Produces cards for everyday and all holidays. Submit seasonal material 1 year in advance.
First Contact & Terms: Send query letter with appropriate samples and SASE. Samples are not filed and are returned by SASE if requested by artist. To show portfolio, send color copies, photographs or slides. Do not send originals. Pays royalties.

DESIGNER GREETINGS, INC., Box 140729, Staten Island NY 10314. (718)981-7700. E-mail: designer@planet.earthcom.net. Art Director: Fern Gimbelman. Produces all types of greeting cards. Produces alternative, general, informal, inspirational, contemporary, juvenile and studio cards.
Needs: Works with 16 freelancers/year. Buys 250-300 designs and illustrations/year. Works on assignment only. Also uses artists for calligraphy, airbrushing and pen & ink. No specific size required. Produces material for all seasons; submit seasonal material 6 months in advance.
First Contact & Terms: Send query letter with brochure or tearsheets and photostats or photocopies. Samples are filed or are returned only if requested. Reports back within 3-4 weeks. Call or write for appointment to show portfolio of original/final art, final reproduction/product, tearsheets and photostats. Originals are not returned. Pays flat fee. Buys all rights.
Tips: "We are willing to look at any work through the mail (photocopies, etc.). Appointments are given after I personally speak with the artist (by phone)."

DIMENSIONS, INC., 641 McKnight St., Reading PA 19601. (610)372-8491. Fax: (610)372-0426. Designer Relations Coordinator: Pamela Keller. Produces craft kits and leaflets, including but not limited to needlework, stained glass, painting projects, iron-on transfer, printed felt projects. "We are a craft manufacturer with emphasis on sophisticated artwork and talented designers. Products include needlecraft kits and leaflets, wearable art crafts, baby products. Primary market is adult women but children's crafts also included."
Needs: Approached by 50-100 freelancers/year. Works with 200 freelancers/year. Develops more than 400 freelance designs and illustrations/year. Uses freelancers mainly for the original artwork for each product. In-house art staff adapts for needlecraft. Considers all media. Looking for fine art, realistic representation, good composition, more complex designs than some greeting card art; fairly tight illustration with good definition; also whimsical, fun characters. Produces material for Christmas; Valentine's Day; Easter; Halloween; everyday; birth, wedding and anniversary records. Majority of products are everyday decorative designs for the home.
First Contact & Terms: Send cover letter with color brochure, tearsheets, photographs or photocopies. Samples are filed "if artwork has potential for our market." Samples are returned by SASE only if requested by artist. Reports back within 1 month. Portfolio review not required. Originals are returned at job's completion. Pays by project, royalties of 2-5%; sometimes purchases outright. Finds artists through magazines, trade shows, word of mouth, licensors/reps.
Tips: "Current popular subjects in our industry: florals, country/folk art, garden themes, ocean themes, celestial, Southwest/Native American, Victorian, juvenile/baby and whimsical."

JOHN DIXON, INC., 24000 Mercantile Rd., Beachwood OH 44122-5913. (216)831-7577. Fax: (216)831-6793. President: Michael Wieder. Estab. 1979. Produces window treatments. Fabricator and distributor of quality custom window treatments.
Needs: Approached by 1-2 freelancers/year. Works with 1-2 freelancers/year. Buys 1-2 freelance designs and illustrations/year. Prefers freelancers with experience in working with window treatments. Works on assignment only. Uses freelancers mainly for custom painting window treatments. Looking for all styles. Produces material for everyday.
First Contact & Terms: Send query letter with brochure, photographs and résumé. Samples are not filed and are returned if requested. Reports back within 1 week. Portfolio review required only if interested in artist's work. Artist

should folow-up with call or letter after initial query. Pays for design by the project. Finds freelancers through word of mouth.

DLM STUDIO, 3158 Morley Rd., Shaker Heights OH 44122. (216)721-4444. Fax: (216)721-6878. E-mail: pat@dlmstudio.com. Website: http://www.dlmstudio.com. Vice President: Pat Walker. Estab. 1984. Produces fabrics/packaging. Specializes in wallcovering design, entire package with fabrics.
Needs: Approached by 10-15 freelancers/year. Works with 10-20 freelancers/year. Buys hundreds of freelance designs and illustrations/year. Art guidelines free for SASE with first-class postage. Works on assignment only. Uses freelancers mainly for designs, color work. Also for photo styling. Looking for traditional, floral, texture, woven, menswear, children's and novelty styles. Prefers 20½″ repeats. 10% of freelance design work demands computer skills. Wallcovering CAD experience a plus. Produces material for everyday.
First Contact & Terms: Illustrators send query letter with photocopies, résumé and SASE. Accepts disk submissions compatible with Illustrator or Photoshop files (Mac), SyQuest, Jaz or Zip. Samples are filed or returned by SASE on request. Reports back within 2-4 weeks. Request portfolio review of color photographs and slides in original query, follow-up with letter after initial query. Rights purchased vary according to project. Pays by the project, $500-1,500, "but it varies." Finds freelancers through agents and local ads, word of mouth.
Tips: "Send great samples, especially traditional patterns."

✔**THE DUCK PRESS**, P.O. Box 1147, San Marcos CA 92069. (760)749-6282. Fax: (760)749-6654. E-mail: duckpress @home.com. Owner: Don Malm. Estab. 1982. Produces greeting cards, calendars and posters for the golfing market only.
Needs: Approached by 12 freelance artists/year. Works with 5 freelance artists/year. Buys 50-100 freelance designs and illustrations/year. Prefers artists with experience in humorous sport art—especially golf. Works on assignment only. Uses freelance artists mainly for illustrations for greeting cards. Considers all media. Looking for full color illustration. Prefers final art scaled to 5×7. Produces material for Christmas and Father's Day. Submit seasonal material 6 months in advance.
First Contact & Terms: Send query letter with brochure, tearsheets, photostats and photographs. Samples are not filed and are returned. Reports back within 2 weeks. To show portfolio, mail thumbnails, roughs and color tearsheets. Original artwork is not returned at job's completion. Pays royalties of 4-6%. Negotiates rights purchased.

DUNCAN DESIGNS, 1141 S. Acacia St., Fullerton CA 92631. (714)879-1360. Fax: (714)879-4611. President: Catherine Duncan. Estab. 1969. Produces collectible figurines, decorative housewares, gifts, giftwrap, greeting cards. Specializes in historical figurines.
Needs: Approached by 50 freelancers/year. Works with 10 freelancers/year. Uses freelancers mainly for sculpture/graphic arts. Also for mechanicals, P-O-P displays, paste-up. Considers all media. Prefers historical, traditional. Art guidelines available. Works on assignment only.
First Contact & Terms: Send query letter with photocopies, photographs, résumé. Send follow-up postcard every month. Samples are not filed and are returned. Reports back within 1 month. Portfolio review required. They may be dropped off Monday through Friday and should include color final art, photographs, photostats. Request portfolio review in original query. Rights purchased vary according to project. Payment varies.

‡**EDITIONS LIMITED/FREDERICK BECK**, 27 E. Housatonic, P.O. Box 989, Pittsfield MA 01201-0989. (413)443-0973. Fax: (413)445-5014. Art Director: Mark Brown. Estab. 1958. Produces holiday greeting cards, personalized and box stock and stationery.
● Editions Limited joined forces with Frederick Beck Originals last year. The company also runs Gene Bliley Stationery. See editorial comment under Frederick Beck Originals for further information. Mark Brown is the art director for all three divisions.
Needs: Approached by 100 freelancers/year. Works with 20 freelancers/year. Buys 50-100 freelance designs and illustrations/year. Prefers freelancers with experience in silkscreen. Art guidelines available. Uses freelancers mainly for silkscreen greeting cards. Also for separations and design. Considers offset, silkscreen, thermography, foil stamp. Looking for traditional holiday, a little whimsy, contemporary designs. Size varies. Produces material for Christmas, graduation, Hannukkah, New Year, Rosh Hashanah and Valentine's Day. Submit seasonal material 15 months in advance.
First Contact & Terms: Designers send query letter with brochure, photocopies, photographs, résumé, tearsheets. Samples are filed. Reports back within 1 month. Will contact artist for portfolio review of b&w, color, final art, photographs, photostats, roughs if interested. Buys all rights. Pays $150-300/design. Finds freelancers through through word of mouth, past history.

● **SPECIAL COMMENTS** within listings by the editor of *Artist's & Graphic Designer's Market* are set off by a bullet.

ELEGANT GREETINGS, INC., 2330 Westwood Blvd., Suite 102, Los Angeles CA 90064-2127. (310)446-4929. Fax: (310)446-4819. President: S. Steier. Estab. 1981. Produces greeting cards, stationery and children's novelties; a traditional and contemporary mix, including color tinted photography; geared toward children 8-18, as well as school-teachers and young adults 18-35.
Needs: Approached by 15 freelance artists/year. Works with 3 freelance artists/year. Buys varying number of designs and illustrations/year. Prefers local artists only. Sometimes works on assignment basis only. Uses freelance artists mainly for new designs, new concepts and new mediums. Also uses freelance artists for P-O-P displays, paste-up and mechanicals. Looking for "contemporary, trendy, bright, crisp colors." Produces material for all holidays and seasons. Submit 1 year before holiday.
First Contact & Terms: Send query letter, brochure, photocopies, photographs and SASE. Samples are not filed and are returned. Reports back within 1 month. To show a portfolio, mail appropriate materials. Original artwork returned at the request of the artist. Pay is negotiable. Rights purchased vary according to project.
Tips: "We are currently looking for stuffed animal designs as well as home decor product including table and desk accessories. We review everything. We look for an almost finished product."

✔ENCORE STUDIOS, INC., 17 Industrial West, Clifton NJ 07012. (800)526-0497. Phone/fax: (973)472-3005. E-mail: encore17@aol.com. Website: http://www.encorestudios.com. Art Director: Ceil Benjamin. Estab. 1979. Produces personalized wedding, bar/bat mitzvah, party and engraved invitations, birth announcements, stationery, Christmas and Chanukah cards and Jewish New Year.
Needs: Approached by 50-75 freelance designers/year. Works with 20 freelancers/year. Prefers freelancers with experience in creating concepts for holiday cards, invitations, announcements and stationery. Art guidelines available for SASE with first-class postage. "We are interested in designs for any category in our line. Looking for unique type layouts, textile designs and initial monograms for stationery and weddings, holiday logos, flowers for our wedding line, Hebrew monograms for our bar/bat mitzvah line, religious art for Bar/Bat Mitzvah and Chanukah." Considers b&w or full-color art. Looking for "elegant, graphic, sophisticated contemporary designs." 20% of freelance work demands knowledge of Macintosh: QuarkXPress, Adobe Illustrator, Adobe Photoshop. Submit seasonal material all year.
First Contact & Terms: Send query letter with brochure, résumé, SASE, tearsheets, photographs, photocopies or slides. Samples are filed or are returned by SASE if requested by artist. Reports back within 2 weeks only if interested. Write for appointment to show portfolio, or mail appropriate materials. Portfolio should include roughs, finished art samples, b&w photographs or slides. Pays by the project. Negotiates rights purchased.

ENESCO CORPORATION, 225 Windsor Dr., Itasca IL 60143. (630)875-5300. Fax: (630)875-5349. Contact: New Submissions/Licensing. Producer and importer of fine gifts and collectibles, such as ceramic, porcelain bisque and earthenware figurines, plates, hanging ornaments, bells, thimbles, picture frames, decorative housewares, music boxes, dolls, tins, crystal and brass. Clients: gift stores, card shops and department stores.
Needs: Works with 300 freelance artists/year. Assigns 1,000 freelance jobs/year. Prefers artists with experience in gift product and packaging development. Uses freelancers for rendering, illustration and sculpture. 50% of freelance work demands knowledge of Adobe Photoshop, QuarkXPress or Adobe Illustrator.
First Contact & Terms: Send query letter with brochure, résumé, tearsheets, photostats and photographs. Samples are filed or are returned. Reports back within 2 weeks. Pays by the project.
Tips: "Contact by mail only. It is better to send samples and/or photocopies of work instead of original art. All will be reviewed by Senior Creative Director, Executive Vice President and Licensing Director. If your talent is a good match to Enesco's product development, we will contact you to discuss further arrangements. Please do not send slides. Have a well thought-out concept that relates to gift products before mailing your submissions."

EPIC PRODUCTS INC., 17395 Mt. Herrmann, Fountain Valley CA 92708. (714)641-8194. Fax: (714)641-8217. President: Steve DuBow. Estab. 1978. Produces paper tableware products and wine and spirits accessories. "Epic Products manufactures products for the gourmet/housewares market; specifically products that are wine-related. Many have a design printed on them."
Needs: Approached by 50-75 freelance artists/year. Works with 10-15 freelancers/year. Buys 25-50 designs and illustrations/year. Prefers artists with experience in gourmet/housewares, wine and spirits, gift and stationery.
First Contact & Terms: Send query letter with résumé and photocopies. Samples are filed. Reports back within 1 week. Write for appointment to show portfolio. Portfolio should include thumbnails, roughs, final art, b&w and color. Buys all rights. Originals are not returned. Pays by the project.

EQUITY MARKETING, INC., 131 S. Rodeo Dr., Suite 300, Beverly Hills CA 90212-2428. (310)887-4300. Fax: (310)887-4400. Studio Director: Sue Davis. Specializes in design, development and production of promotional, toy and gift items, especially licensed properties from the entertainment industry. Clients include Tyco, Applause, Avanti and Ringling Bros. and worldwide licensing relationships with Disney, Warner Bros., 20th Century Fox and Lucas Film.
Needs: Needs product designers, sculptors, packaging and display designers, graphic designers and illustrators. Prefers whimsical and cartoon styles. Products are typically targeted at children. Works on assignment only.
First Contact & Terms: Send résumé and non-returnable samples. Will contact for portfolio review if interested. Rights purchased vary according to project. Pays for design by the project, $50-1,200. Pays for illustration by the project, $75-3,000. Finds artists through word of mouth, network of design community, agents/reps.
Tips: "Gifts need to be simply made, priced right and of quality design to compete with low prices at discount houses."

EVERTHING METAL IMAGINABLE, INC. (E.M.I.), 401 E. Cypress, Visalia CA 93277. (209)732-8126 or (800)777-8126. Fax: (209)732-5961. E-mail: webmaster@emiartbronze.com. Website: http://www.emiartbronze.com. Artists' Liaison: Renee Robbins. Estab. 1967. Wholesale manufacturer. "We manufacture lost wax bronze sculpture." Clients: wholesalers, premium incentive consumers, retailers.

Needs: Approached by 10 freelance artists/year. Works with 20 freelance designers/year. Assigns 5-10 jobs to freelance artists/year. Prefers artists that understand centrifugal casting, bronze casting and the principles of mold making. Uses artists for figurine sculpture and model making. Prefers a tight, realistic style.

First Contact & Terms: Send query letter with brochure or résumé, tearsheets, photostats, photocopies and slides. Samples not filed are returned only if requested. Reports back only if interested. Call for appointment to show portfolio of original/final art and photographs "or any samples." Pays for design by the project, $500-20,000. Buys all rights.

Tips: "Artists must be conscious of detail in their work, be able to work expediently and under time pressure and be able to accept criticism of work from client. Price of program must include completing work to satisfaction of customers."

FANTAZIA MARKETING CORP., 65 N. Chicopee St., Chicopee MA 01020. President: Joel Nulman. Estab. 1979. Produces games/toys and high-end novelty products. Produces novelty, lamps, banks and stationery items in over-sized form.

Needs: Approached by 3 freelance artists/year. Works with 1 freelancer/year. Buys 1 design and illustration/year. Prefers artists with experience in product development. "We're looking to increase our molded products." Uses freelancers for P-O-P displays, paste-up, mechanicals. 50% of design requires computer skills.

First Contact & Terms: Send query letter with résumé. Samples are filed. Reports back within 2 weeks. Call for appointment to show portfolio. Portfolio should include roughs and dummies. Rights purchased vary according to project. Originals not returned. Pays by project. Royalties negotiable.

FINE ART PRODUCTIONS, RICHIE SURACI PICTURES, MULTIMEDIA, INTERACTIVE, 67 Maple St., Newburgh NY 12550-4034. Phone/fax: (914)561-5866. E-mail: rs7.fap@mhv.net or richie.suraci@bbs.mhv.net. Websites: http://www.mhv.net/~rs7.fap/networkerotica.html. or http://www.audionet.com/books or http://homepages.munich. netsurf.de/Sebastian.Ruell (click on Updates + News, click on Doc Kunda). Contact: Richie Suraci. Estab. 1994. Produces greeting cards, stationery, calendars, posters, games/toys, paper tableware products, giftwrap, CD-ROMs, video/film backgrounds, magazine, newspaper print. "Our products are fantasy, New Age, sci-fi, outer space, environmental, adult erotica."

Needs: Prefers freelancers with experience in sci-fi, outer space, adult erotica, environmental, fantasy and mystical themes. Uses freelancers for calligraphy, P-O-P displays, paste-up and mechanicals. Art guidelines for SASE with first-class postage. Considers all media. 50% of freelance work demands knowledge of Adobe Illustrator, Adobe Photoshop, QuarkXPress, Aldus FreeHand, Aldus PageMaker, SGI and ImMix. Produces material for all holidays and seasons and Valentine's Day. Submit seasonal material 1 year in advance.

First Contact & Terms: Send postcard sample or query letter with brochure, tearsheets, résumé, photographs, slides, SASE, photocopies and transparencies. Accepts submissions on disk (Macintosh). "If sending disks send 3½″ disks formatted for Apple computers." Samples are filed or returned by SASE if requested by artist. Reports back within 3-4 months if interested. Company will contact artist for portfolio review if interested. Portfolio should include thumbnails, roughs, final art, photostats, tearsheets, photographs, slides and transparencies. Rights purchased vary according to project. Originals are returned at job's completion. Pays by the project. Finds artists through agents, sourcebooks, magazines, word of mouth and submissions.

Tips: "Send unique material that is colorful. Send samples in genres we are looking for."

FISHER-PRICE, 636 Girard Ave., E. Aurora NY 14052. (716)687-3983. Fax: (716)687-5281. Director, Product Art: Henry Schmidt. Estab. 1931. Manufacturer of toys and other children's products.

Needs: Approached by 10-15 freelance artists/year. Works with 25-30 freelance illustrators and sculptors and 15-20 freelance graphic designers/year. Assigns 100-150 jobs to freelancers/year. Prefers artists with experience in children's style illustration and graphics. Works on assignment only. Uses freelancers mainly for product decoration (label art). Prefers all media and styles except loose watercolor. Also uses sculptors. 25% of work demands knowledge of Aldus FreeHand, Adobe Illustrator, Adobe Photoshop.

> • This company has two separate art departments: Advertising and Packaging, which does catalogs and promotional materials; and Product Art, which designs decorations for actual toys. Be sure to specify your intent when submitting material for consideration. Art Director told *AGDM* he has been receiving more samples on disk or through the Internet. He says it's a convenient way for him or his staff to look at work.

First Contact & Terms: Send query letter with samples showing art style or slides, photographs and transparencies. Samples are filed. Reports back to the artist only if interested. Call to schedule an appointment to show a portfolio. Portfolio should include original, final art and color photographs and transparencies. Pays for design and illustration by the hour, $25-50. Buys all rights.

FOTOFOLIO, INC., 536 Broadway, New York NY 10012. (212)226-0923. Fax: (212)226-0072. E-mail: fotofolio@aol.com. Website: http://www.fotofolio.com. Editorial Coordinator: Cindy Williamson. Estab. 1976. Produces greeting

cards, calendars, posters, T-shirts, postcards and a line of products for children including a photographic book, Keith Haring coloring books and notecards.

Needs: Buys 5-60 freelance designs and illustrations/year. Reproduces existing works. Primarily interested in photography. Produces material for Christmas, Valentine's Day, birthday and everyday. Submit seasonal material 8 months in advance. Art guidelines for SASE with first-class postage.

First Contact & Terms: Send query letter with SASE c/o Editorial Dept. Samples are filed or are returned by SASE if requested by artist. Editorial Coordinator will contact artist for portfolio review if interested. Originals are returned at job's completion. Pays by the project, 7½-15% royalties. Rights purchased vary according to project. Finds artists through word of mouth, magazines, submissions/self-promotions, sourcebooks, agents, visiting artist's exhibitions, art fairs and artists' reps.

Tips: "When submitting materials, present a variety of your work (no more than 40 images) rather than one subject/genre."

THE FRANKLIN MINT, Franklin Center PA 19091-0001. (610)459-6629. Fax:(610)459-7270. Artist Relations Managers: Kate Zabriskie, illustration; Ellen Caggiula, sculpture and dolls. Estab. 1964. Direct response marketing of high-quality collectibles. Produces collectible porcelain plates, prints, porcelain and coldcast sculpture, figurines, fashion and traditional jewelry, ornaments, precision diecast model cars, luxury board games, engineered products, heirloom dolls and plush, home decor items and unique gifts. Clients: general public worldwide, proprietary houselist of 8 million collectors and 55 owned and operated retail stores. Markets products in 20 countries worldwide including: USA, Canada, United Kingdom, France, Germany, Australia, New Zealand and Japan.

Needs: Approached by 3,000 freelance artists/year. Contracts 500 artists/sculptors per year to work on 7,000-8,000 projects. Buys approximately 400 sculptures/year. Art guidelines free for SASE with first class postage. Uses freelancers mainly for illustration and sculpture. Considers all media. Considers clay for sculpture; clay or wax for dolls. Considers all styles. 80% of freelance design and 50% of illustration demand knowledge of Aldus PageMaker, Aldus FreeHand, Adobe Photoshop, Adobe Illustrator, QuarkXPress and 3D Studio Eclipse (2D). Accepts work in SGI format. Produces material for Christmas and everyday. Submit seasonal material 6-8 months in advance.

First Contact & Terms: Send query letter, biography, SASE and samples (clear, professional full-color photographs, transparencies, slides, greeting cards and/or brochures and tearsheets). Sculptors send photographic portfolios. "Please do not send original artwork." Samples are filed or returned by SASE. Reports back within 3 months. Portfolio review required for illustrators and sculptors. Reviews portfolios weekly. Company gives feedback on all portfolios submitted. Portfolios should include color photographs, photostats, slides, tearsheets or transparencies of final art. Buys all rights. Payment varies. Finds artists through word of mouth.

Tips: "In search of artists and sculptors capable of producing high quality work. Those willing to take art direction and to make revisions of their work are encouraged to submit their portfolios."

FRAVESSI GREETINGS, INC., 11 Edison Place, Springfield NJ 07081. (201)564-7700. Fax: (201)376-9371. Art Director: Janet Thomassen. Estab. 1930. Produces greeting cards, packaged goods, notes.

Needs: Approached by 25 freelancers/year. Works with 12 freelancers/year. Uses freelancers for greeting card design. Art guidelines available. Considers watercolor, gouache and pastel. Especially needs seasonal and everyday designs; prefers cute and whimsical imagery. Produces seasonal material for Christmas, Mother's Day, Father's Day, Thanksgiving, Easter, Valentine's Day, St. Patrick's Day, Halloween, graduation, Jewish New Year and Hanukkah. Submit seasonal art 1 year in advance.

First Contact & Terms: Send query letter and samples of work. Include SASE. Reports in 2-3 weeks. Provide samples to be kept on file for possible future assignments. Art Director will contact artist for portfolio review if interested. Originals are not returned. Requests work on spec before assigning a job. **Pays on acceptance**, flat fee of $125-250/illustration or design. Buys all rights. Finds artists through word of mouth and submissions.

Tips: Must now implement "tighter scheduling of seasonal work to adapt to changing tastes. There is an emphasis on lower-priced cards. Check the marketplace for type of designs we publish."

✒GALISON BOOKS/MUDPUPPY PRESS, 28 W. 44th St., New York NY 10036. (212)354-8840. Fax: (212)391-4037. E-mail: gmanola@galison.com. Website: http://www.galison.com. Design Director: Gina Manola. Estab. 1978. Produces boxed greeting cards, puzzles, address books and specialty journals. Many projects are done in collaboration with museums around the world.

Needs: Works with 10-15 freelancers/year. Buys 20 designs and illustrations/year. Art guidelines for SASE with first-class postage. Works on assignment only. Uses freelancers mainly for illustration. Considers all media. Also produces material for Christmas and New Year. Submit seasonal material 1 year in advance. 100% of design and 5% of illustration demand knowledge of QuarkXPress.

First Contact & Terms: Send postcard sample, photocopies, résumé and tearsheets (no unsolicited original artwork) and SASE. Accepts submissions on disk compatible with Adobe Photoshop, Adobe Illustrator or QuarkXPress (but not preferred). Samples are filed. Reports back to the artist only if interested. Request portfolio review in original query. Art Director will contact artist for portfolio review if interested. Portfolio should include color photostats, slides, tearsheets and dummies. Originals are returned at job's completion. Pays by project. Rights purchased vary according to project. Finds artists through word of mouth, magazines and artists' reps.

Tips: "Looking for great presentation and artwork we think will sell and be competitive within the gift market."

GALLANT GREETINGS CORP., P.O. Box 308, Franklin Park IL 60131. (847)671-6500. Fax: (847)671-7500. E-mail: sales@gallantgreetings.com. Website: http://www.gallantgreetings.com. Vice President Sales and Marketing: Chris Allen. Estab. 1966. Produces greeting cards, packaged invitations and thank you notes. Creator and publisher of seasonal and everyday greeting cards.
Needs: Looking for traditional and humorous. Produces material for Christmas, Easter, Mother's Day, Father's Day, graduation, Halloween, Thanksgiving, Valentine's Day, birthdays, everyday and most card-giving occasions.
First Contact & Terms: Samples are not filed or returned. Reports back only if interested. Portfolio review not required. Negotiates rights purchased.

‡GALLERY GRAPHICS, INC., P.O. Box 502, Noel MO 64854. (417)475-6191. Fax: (417)475-3542. Art Director: Donna Schwegman. Estab. 1979. Produces bookmarks, calendars, giftbags, gifts, giftwrap, greeting cards, stationery, prints, notepads, notecards. Gift company specializing primarily in Victorian and country designs.
Needs: Approached by 100 freelancers/year. Works with 5 freelancers/year. Buys 36 freelance illustrations/year. Art guidelines available. Uses freelancers mainly for illustration. Considers any 2-dimensional media. Looking for country, teddy bears, florals, traditional. Prefers 16×20 maximum. Produces material for Christmas, Valentine's Day, birthdays, sympathy, get well, thank you. Submit seasonal material 8 months in advance.
First Contact & Terms: Accepts disk submissions compatible with Photoshop or FreeHand. Send TIFF or EPS files. Samples are filed or returned by SASE. Reports back within 3 weeks. Will contact artist for portfolio review of color photographs, photostats, slides, tearsheets, transparencies if interested. Payment negotiable. Finds freelancers through submissions and word of mouth.

GIBSON GREETINGS, INC., 2100 Section Rd., Cincinnati OH 45237. (513)841-6600. Design Director: Gwent Markley. Estab. 1850. Produces greeting cards, giftwrap, stationery, calendars and paper tableware products. "Gibson is a leader in social expression products."
Needs: Approached by 300 freelancers/year. Works with 200 freelancers/year. Buys 3,500 freelance designs and illustrations/year. Prefers freelancers with industry experience in social expression. Alternative designs accepted. Works on assignment only. Uses freelancers mainly for greeting cards. Considers any media and a wide variety of styles. 40% of freelance work demands knowledge of Adobe Illustrator, Adobe Photoshop and QuarkXPress. Produces material for all holidays and seasons. Submit seasonal material 1 year in advance.
First Contact & Terms: Send query letter with résumé, SASE, tearsheets, photographs, photocopies, photostats, slides, transparencies. Do not submit original work! Samples are filed if accepted or returned by SASE. Reports back within 2-3 weeks. Company will contact artist for portfolio review if interested. Portfolio should include final art, tearsheets, photographs, transparencies. "Artwork is bought outright—all rights and art belong to company." Originals are not returned. Pays by the project, or flat fee, varies.
Tips: "Excellent drawing skills are essential. Must be diversified in all media; experience in social expression field is a definite advantage."

‡THE GIFTED LINE, 999 Canal Blvd., Port Richmond CA 94804. (510)215-4777. Fax: (510)215-4772. E-mail: jay@thegiftedline.com. Production Manager: Jay Young. Estab. 1988. Produces CD-ROMs, giftbags, greeting cards, stickers, wrap. "Currently our market is mostly middle-aged women, mid to upper education and income."
Needs: Approached by 20-30 freelancers/year. Works with 5 freelancers/year. Prefers local designers only. Prefers freelancers with experience in photoshop production. Art guidelines available. Works on assignment only. Uses freelancers mainly for production of products. Also for design. Looking for traditional, flora, sentimental, cute animals. 60% of freelance design work demands knowledge of Adobe Photoshop, Adobe Illustrator. Produces material for all holidays and seasons, everyday, get well, romantic, thank you.
First Contact & Terms: Send email or fax of résumé/cover. Samples are filed and not returned. Will contact artist for portfolio review if interested. Pays production artists $20-30/hour. Finds freelancers through Internet, local newspapers.
Tips: "Be proficient in computer skills."

GLITTERWRAP, INC., 701 Ford Rd., Rockaway NJ 07866. (973)625-4200. Fax: (973)625-9641. Art Director: Danielle Grassi. Estab. 1987. Produces giftwrap, totes, ribbons, bows, wrap accessories (enclosure cards) for all ages—party and special occasion market.
Needs: Approached by 30-50 freelance artists/year. Works with 10-15 freelancers/year. Buys 10-30 designs and illustrations/year. Art guidelines available. Prefers artists with experience in textile design who are knowledgable in repeat patterns or surface. Uses freelancers mainly for design. Also for calligraphy and mechanicals. Considers gouache, oil, acrylic, cut paper, watercolor and mixed media. Style varies with season and year. Consider trends and designs already in line, as well as up and coming motifs in gift market. 80% of freelance work demands knowledge of QuarkXPress, Aldus FreeHand, Adobe Illustrator and Adobe Photoshop. Produces material for Christmas, graduation, birthdays, Valentine's Day, Hanukkah and everyday. Submit seasonal material 6-8 months in advance.
First Contact & Terms: Send query letter with brochure, tearsheets, photographs, slides, transparencies or color copies of work. Samples are filed or are returned by SASE if requested. Reports back in 2-3 weeks. Write for appointment to show portfolio or mail appropriate materials, which should include slides, color tearsheets, dummies, mechanicals and finished art samples. Rights purchased vary according to project. Pays by the hour, $10-25; or royalties of 5-6%.
Tips: "Giftwrap generally follows the fashion industry lead with respect to color and design. Adult birthday and baby

shower/birth are fast-growing categories. There is a need for good/fresh/fun typographic birthday designs in both adult and juvenile categories."

GOES LITHOGRAPHING COMPANY SINCE 1879, 42 W. 61st St., Chicago IL 60621-3999. (773)684-6700. Fax: (773)684-2065. Contact: W.J. Goes. Estab. 1879. Produces stationery/letterheads to sell to printers and office product stores.
Needs: Approached by 1-2 freelance artists/year. Works with 2-3 freelance artists/year. Buys 4-30 freelance designs and illustrations/year. Uses freelance artists mainly for designing holiday letterheads. Considers pen & ink, color, acrylic, watercolor. Prefers final art 17 × 22. Produces material for Christmas and Thanksgiving.
First Contact & Terms: Contact W.J. Goes. "I will send examples for your ideas." Samples are not filed and are returned by SASE. Reports back within 1-2 months. Pays $125-$300 on final acceptance. Buys first rights and reprint rights.

GOTTA GET UP PRODUCTIONS, 111 Maiden Lane, Oakland CA 94108. (415)982-4487. Fax: (415)982-4493. CEO: Lisa Tomlinson. Estab. 1992. Produces greeting cards and stationery.
Needs: Approached by 20 freelancers/year. Works with 5-6 freelancers/year. Freelance designs and illustrations purchased per year varies. Works on assignment only. Uses freelancers mainly for new greeting card images. Also for mechanicals or P-O-P. Looking for contemporary style. Computer experience not required for designers or illustrators, but knowledge of QuarkXPress is helpful. Produces material for Christmas, Easter, Mother's Day, Father's Day, graduation, Halloween, Kwanzaa, New Year, Thanksgiving, Valentine's Day, birthdays, everyday, sympathy, thank you and get well. Submit seasonal material 4-6 months in advance.
First Contact & Terms: Designers send query letter with brochure, photocopies, photographs, résumé and tearsheets. Illustrators send query letter with photocopies and photographs. Samples are not filed and are returned. Reports back within 10 days. Will contact for portfolio review of b&w, color, photographs, slides and tearsheets if interested. Rights purchased vary according to project. Payment negotiable.

GRAHAM & BROWN, 2031 Rt. 130, Suite K, Monmouth Junction NJ 08852. (732)940-0887. Fax: (732)940-2318. E-mail: bwoods.gbinc@worldnet.att.net. General Manager: Bill Woods. Estab. 1946. Produces residential wallpaper and borders.
Needs: Prefers freelancers with experience in wallpaper. Uses freelancers mainly for designs. Also for artwork. Looking for traditional, floral styles. Produces material for everyday.
First Contact & Terms: Designers send query letter with photographs. Illustrators send postcard sample of work only. Samples are filed or returned. Reports back only if interested. Buys all rights. For illustration pays a variable flat fee. Finds freelancers through shows (Surtex, etc.).

GREAT AMERICAN PUZZLE FACTORY INC., 16 S. Main St., S. Norwalk CT 06854. Fax: (203)838-2065. Art Director: Anne Mulligan. Estab. 1975. Produces jigsaw puzzles and games for adults and children.
Needs: Approached by 150 freelancers/year. Works with 15 freelancers/year. Buys 50 designs and illustrations/year. Uses freelancers mainly for puzzle material. Art guidelines for SASE with first-class postage. Looking for "fun, involved and colorful" work. 100% of design requires knowledge of QuarkXPress, Adobe Illustrator or Adobe Photoshop.
First Contact & Terms: Send postcard sample or query letter with brochure, tearsheets and photocopies. Do not send originals or transparencies. Samples are filed or are returned. Art Director will contact artist for portfolio review if interested. Original artwork is returned at job's completion. Pays flat fee of $800-1,000, work for hire. Royalties of 5-6% for licensed art (existing art only). Interested in buying second rights (reprint rights) to previously published work.
Tips: "All artwork should be *bright*, cheerful and eye-catching. 'Subtle' is not an appropriate look for our market. Go to a toy store and look at what is out there. Do your homework! Send a professional-looking package to appropriate potential clients. Presentation means a lot. We get a lot of totally inappropriate submissions."

GREAT ARROW GRAPHICS, 2495 Main St., Suite 432, Buffalo NY 14214. (716)836-0408. Fax: (716)836-0702. E-mail: grtarrow@aol.com. Art Director: Alan Friedman. Estab. 1981. Produces greeting cards and stationery. "We produce silkscreened greeting cards—seasonal and everyday—to a high-end design-conscious market."
Needs: Approached by 80 freelancers/year. Works with 20 freelancers/year. Buys 150-200 images/year. Art guidelines for SASE with first-class postage. Prefers freelancers with experience in hand-separated art. Uses freelancers mainly for greeting card design. Considers all 2-dimensional media. Looking for sophisticated, classic, contemporary or cutting edge styles. Requires knowledge of QuarkXPress, Adobe Illustrator or Adobe Photoshop. Produces material for all holidays and seasons. Submit seasonal material 1 year in advance.
First Contact & Terms: Send query letter with photocopies and SASE. Accepts submissions on disk compatible with QuarkXPress, Adobe Illustrator or Adobe Photoshop. Samples are filed or returned if requested. Reports back within 1 month. Art Director will contact artist for portfolio review if interested. Portfolio should include color roughs, final art, photographs and transparencies. Originals are returned at job's completion. Pays royalties of 5% of net sales. Rights purchased vary according to project.
Tips: "We are most interested in artists familiar with hand-separated process and with the assets and limitations of screenprinting. Be original—be complete with ideas—don't be afraid to be different . . . forget the trends . . . do what you want."

✓JAN HAGARA COLLECTABLES, INC., 40114 Industrial Park, Georgetown TX 78626. (512)863-8187. Fax: (512)869-2093. Art Director: Eric Welch. Estab. 1975. Produces limited-edition collectibles (e.g. prints, plates, figurines, dolls, notecards and stationery products). "We design and market a line of collectible giftware with a romantic Victorian theme. Our products appeal to women in an 'empty nest' situation who prefer 'pretty' things of uniqueness and value."
Needs: Approached by 100 freelance artists/year. Works with 7 or more freelancers/year. Buys 20 designs and illustrations/year. Prefers watercolor or clay or wax sculpture. Works on assignment only. Uses freelancers mainly for executing concepts in two and three dimensions—packaging, inserts, line drawings that resemble old-fashioned engravings and sculpture. Also for calligraphy, P-O-P displays, T-shirt art (mechanical separations), jewelry sculpting (charm bracelets), coffee mug art (mechanical separations), cloisonné pin art, cross-stitch development. For 2-D work, prefers watercolor/colored pencil and pen & ink. For 3-D work, prefers wax, Sculpey, clay. "We're in need of Romantic Victorian work—turn-of-the-century nostalgia. Our subjects are children, flowers, ribbons and bows. We're also interested in the amusements of childhood: toys, dolls, teddy bears."
First Contact & Terms: Send query letter with photostats, photographs, slides, transparencies and SASE. "Do not send original work." Samples are filed or are returned by SASE if requested by artist. Reports back only if interested. To show portfolio, mail photostats of lettering or one-color artwork and tearsheets or photographs of color work. Originals usually not returned at job's completion. Pays by the project, $35-2,000. Rights purchased vary according to project.
Tips: "Show, don't tell. We don't require 'professionalism,' lawyers, or agents. We simply want creative people with a feel for our style. The only way to know if you've got what we need is to let us see your work. Although we don't require computer skills for our freelancers, we have moved to inhouse prepress ourselves. We have virtually eliminated photography by using a digital studio camera which feeds directly into our computer system. Artists should be aware that digital prepress is very much the trend and should become familiar with software for graphics, particularly QuarkXPress and Adobe Photoshop. We also see a development in prototyping of sculpted items using computers. We are experimenting with x-ray technology and CAD software to develop plastic prototypes out of laser scintering. Sculptors interested in this trend should become familiar with STL files and CAD/CAM."

HALLMARK CARDS, INC., P.O. Box 419580, Drop 216, Kansas City MO 64141-6580.
● Because of Hallmark's large creative staff of fulltime employees and their established base of freelance talent capable of fulfilling their product needs, they are not accepting freelance submissions.

HAMPSHIRE PEWTER COMPANY, 43 Mill St., Box 1570, Wolfeboro NH 03894-1570. (603)569-4944. Fax: (603)569-4524. Website: http://www.steele@worldpath.net. President: Bob Steele. Estab. 1974. Manufacturer of hand-cast pewter tableware, accessories and Christmas ornaments. Clients: jewelry stores, department stores, executive gift buyers, tabletop and pewter speciality stores, churches and private consumers.
Needs: Works with 3-4 freelance artists/year. "Prefers New-England based artists." Works on assignment only. Uses freelancers mainly for illustration and models. Also for brochure and catalog design, product design, illustration on product and model-making.
First Contact & Terms: Send query letter with photocopies. Samples are not filed and are returned only if requested. Call for appointment to show portfolio, or mail b&w roughs and photographs. Pays for design and sculpture by the hour or project. Considers complexity of project, client's budget and rights purchased when determining payment. Buys all rights.
Tips: "Inform us of your capabilities. For artists who are seeking a manufacturing source, we will be happy to bid on manufacturing of designs under private license to the artists, all of whose design rights are protected. If we commission a project, we intend to have exclusive rights to the designs by contract as defined in the Copyright Law and we intend to protect those rights."

HANNAH-PRESSLEY PUBLISHING, 1232 Schenectady Ave., Brooklyn NY 11203-5828. (718)451-1852. Fax: (718)629-2014. President: Melissa Pressley. Estab. 1993. Produces calendars, giftwrap, greeting cards, stationery, murals. "We offer design, illustration, writing and printing services for advertising, social and commercial purposes. We are greeting card specialists."
Needs: Approached by 10 freelancers/year. Works on assignment only. Uses freelancers mainly for pattern design, invitations, advertising, cards. Also for calligraphy, mechanicals, murals. Considers primarily acrylic and watercolor, but will consider others. Looking for upscale, classic; rich and brilliant colors; traditional or maybe Victorian; also adult humor. Produces material for Christmas, Mother's Day, Father's Day, graduation, Kwanzaa, Valentine's Day, birthdays, everyday, ethnic cards (black, hispanic, Caribbean), get well, thank you, sympathy, Secretary's Day.
First Contact & Terms: Send query letter with slides, color photocopies, résumé, SASE. Samples are filed or returned by SASE. Reports back only if interested. Company will contact artist for portfolio review if interested. Portfolio should include b&w, color, final art, slides. Rights purchased vary according to project. Payment varies according to project. Finds freelancers through submissions, *Creative Black Book.*

SASE MEANS SELF-ADDRESSED, STAMPED ENVELOPE. Send SASEs when requesting return of your samples.

Tips: "Please be honest about your expertise and experience."

‡**HEARTPRINT**, 2660 Bullock Rd., Medford OR 97504. Produces bookmarks, giftbags, giftwrap, greeting cards, mugs, ornaments, stationery, framed art.
Needs: Approached by 40-50 freelancers/year. Prefers local designers only (illustrators need not be local). Prefers illustrators with experience in watercolor. Art guidelines are available. Uses freelancers mainly for reproduction for our paper and giftware. Also for calligraphy, paste-up, P-O-P. Looking for traditional, floral, sentimental, cute animals. Prefers 5×7. 80% of freelance design and 20% of freelance illustration demands knowledge of Adobe Photoshop, Adobe Illustrator, QuarkXPress. Produces material for Christmas, Mother's Day, Father's Day, everyday, sympathy, get well, thank you, wedding. Submit seasonal material 6 months in advance.
First Contact & Terms: Designers send query letter with brochure. Illustrators send query letter with photocopies, photostats. Accepts disk submissions from illustrators if compatible with Adobe Photoshop or QuarkXPress files. Zip disks OK. Samples are filed. Reports back within 2 weeks. Portfolios may be dropped off Monday-Friday. Artist should follow-up with letter after initial query. Will contact artist for portfolio review if interested. Rights purchased vary according to project. Pays for design by the hour, $30-75. Pays for illustration flat fee, $500/design. Finds freelancers through submissions.
Tips: "Color, color, color!"

HERITAGE COLLECTION, 79 Fifth Ave., New York NY 10003. (212)647-1000. Fax: (212)647-0188. President: Reginald Powe. Estab. 1988. Produces greeting cards, gift bags, giftwrap, mugs, placemats, etc., for the African-American.
Needs: Approached by 20-30 freelance artists/year. Works with 3-5 freelance artists/year. Buys 40-80 new freelance designs and illustrations/year. Uses freelance artists mainly for card art and verse. Considers all media. Produces material for all holidays and seasons, birthdays and Kwanzaa. Submit seasonal material 1 year in advance.
First Contact & Terms: Send query letter with SASE, tearsheets, photographs, photocopies and photostats. Samples are filed or are returned by SASE. Reports back within 1 month. Call for appointment to show portfolio of original/final art, color tearsheets. Originals are returned at job's completion. Pays royalty or buys all rights on work-for-hire basis.

HIGH RANGE GRAPHICS, 365 N. Glenwood, P.O. Box 3302, Jackson WY 83001. President: Jan Stuessl. Estab. 1989. Produces T-shirts. "We produce screen-printed garments for recreational sport-oriented markets and resort markets, which includes national parts. Subject matter includes, but is not limited to, skiing, climbing, hiking, biking, fly fishing, mountains, out-of-doors, nature and rafting, Native American, wildlife and humorous sayings that are text only or a combination of text and art. Our resort market customers are men, women and kids looking to buy a souvenir of their vacation experience or activity. People want to identify with the message and/or the art on the T-shirt."
 ● According to High Range Graphics' art guidelines, it is easiest to break into HRG with designs related to fly fishing, downhill skiing, snowboarding or river rafting. The guidelines suggest that your first submission cover one or more of these topics. The art guidelines for this company are detailed and include suggestions on where to place design on the garment.
Needs: Approached by 20 freelancers/year. Works with 3-8 freelancers/year. Buys 10-20 designs and illustration/year. Prefers artists with experience in screen printing. Uses freelancers mainly for T-shirt ideas and artwork and color separations. Art guidelines for SASE with first-class postage.
First Contact & Terms: Send query letter with résumé, SASE and photocopies. Accepts submissions on disk compatible with Aldus FreeHand. Samples are filed or are returned by SASE if requested by artist. Reports back within 6 months. Company will contact artist for portfolio review if interested. Portfolio should include b&w thumbnails, roughs and final art. Originals are returned at job's completion. Pays by the project, licensing fee of $300 in addition to royalties of 5% based on actual sales. Buys garment rights.
Tips: "Familiarize yourself with screen printing and T-shirt art that sells. Knowledge of color separations a plus. We look for creative design styles and interesting color applications. Artists need to be able to incorporate the colors of the garments as part of their design thinking, as well as utilize the screen printing medium to produce interesting effects and textures. However, sometimes simple is best. Four-color process will be considered if highly marketable. Be willing to work with us on design changes to get the most marketable product. Know the industry. Art that works on paper will not necessarily work on garments. No cartoons please."

✔**HIXON & FIERING, INC.**, 9219 Quivira Rd., Overland Park KS 66215. (800)964-4002. Fax: (913)438-5515. Website: http://www.hfproducts.com. Art Director: Susan Crilley. Estab. 1987. Produces birth announcements and invitations. "We started out as a birth announcement company, branched off into children's party invitations and now do party invitations for adults as well."
Needs: Approached by 30 freelancers/year. Works with 5 freelancers/year. Buys 20-30 freelance designs and illustrations/year. Uses freelancers for card design. Art guidelines available. Buys art outright and by assignment. "If the artist has a style we like and is a good conceptualizer, we will approve a sketch, then he gives us the final product." Considers watercolor, acrylic (soft) and pastels. Also interested in computer generated art using Adobe Illustrator. Prefers high quality, whimsical, but not cartoonish artwork for the baby and children's lines. Nothing that could be construed as negative or off-color in any way. Prefers work that is soft, happy and colorful. Produces seasonal material for Christmas, New Year, Valentine's Day, Halloween, graduation and birthdays.

First Contact & Terms: Send query letter with color copies of work. Samples are filed or are returned. Reports back in 2 months. Pays flat fee, $250-1,000.

Tips: "We are starting to work on some lines of elegant, embossed and foil stamped cards for birth, christening and adult invitations. So, we need the soft, warm and cuddly children's things as well as elegant formal designs. We look for refined talent with a sweet look for our birth announcement line. Consider the product the company produces before sending samples. For instance: don't send pictures of dragons, monsters and skeletons to a birth announcement company."

HOFFMASTER, 2920 N. Main St., Oshkosh WI 54903. (920)235-9330. Fax:(920)235-1642. Senior Marketing Manager: Ralph Rich or Creative Managers. Produces decorative paper tableware, placemats, plates, tablecloths and napkins for institutional and consumer markets. Printing includes up to 6-color flexographic napkin printing.

Needs: Approached by 20-30 freelancers/year. Works with 5-10 freelancers/year. Prefers freelancers with experience in paper tableware products. Art guidelines and specific design needs based on current market are available from Creative Managers. Looking for trends and traditional styles. Prefers 9″ round artwork with coodinating 6.5″ square image. Produces material for all holidays and seasons and everyday.

First Contact & Terms: Send query letter with photocopies, résumé, appropriate samples by mail or fax only. Ideas may be sent in a color rough sketch. Accepts disk submissions compatible with Adobe Illustrator and Aldus FreeHand. Samples are filed or returned by SASE if requested by artist. Reports back in 90 days only if interested. "Will provide feedback to artists whose designs could be adapted, but are not currently acceptable for use without additional work and a resubmission." Creative Manager will contact artist for portfolio review if interested. Portfolio should include thumbnails, roughs, finished art samples, color photostats, tearsheets, photographs and dummies. Prefers to buy artwork outright. Rights purchased vary according to project. Pays by the project $350-1,500. Amounts vary according to project. May work on a royalty arrangement for recognized properties. Finds freelancers through art fairs and artists' reps.

Tips: Looking for new trends and designs appropriate for plates and napkins.

‡**HOME INTERIORS & GIFTS**, 4550 Spring Valley Rd., Dallas TX 75244. (972)386-1000. Fax: (972)233-8825. Artist Representative: Robbin Allen. Art Director: Louis Bazan. Estab. 1957. Produces decorative framed art in volume to public by way of shows in the home. "H.I.& G. is a direct sales company. We sell nationwide with over 35,000 consultants in our sales force. We work with artists to design products for our new product line yearly. We work with some publishers now, but wish to work with more artists on a direct basis."

Needs: Approached by 75 freelance artists/year. Works with 25-30 freelancers/year. "We carry approximately 450-500 items in our line yearly." Prefers artists with knowledge of current colors and the decorative art market. "We give suggestions but we do not dictate exacts. We would prefer the artists express themselves through their individual style. We will make correction changes that will enhance each piece for our line." Uses freelance artists mainly for artwork to be framed (oil and watercolor work mostly). Also for calligraphy. Considers oil, watercolor, acrylic, pen & ink, pastels, mixed media. "We sell to middle America for the most part. Our art needs to be traditional with a sense of wholesomeness to it. For example: a hunter with dog, but no gun. We sell Victorian, country, landscapes, still life, wildlife. Art that tells a story. We also sell a mild contemporary." Produces material for Father's Day, Halloween, Christmas, Easter, graduation, Thanksgiving, Mother's Day. Submit seasonal material 10 months in advance.

First Contact & Terms: Send query letter with résumé, SASE, photographs, slides and transparencies. Samples are filed or are returned by SASE. Art Director will contact artist for portfolio review if interested. Portfolio should include color slides, photographs. Requests work on spec before assigning a job. Pays royalties. Royalties are discussed on an individual basis. Buys reprint rights. Finds artists through word of mouth, magazines, submissions, sourcebooks and visiting artist's exhibitions.

Tips: "This is a great opportunity for the artist who is willing to learn our market. Paint for women because women are our customers. Paintings need softness in form—not rugged and massive/strong or super dark. Jewel tones are great for us. Study Monét—good colors there. Our art demands are unique. The artist will work with our design department to stay current with our needs."

✔**HURLIMANN ARMSTRONG STUDIOS**, Box 1246, Menlo Park CA 94026. (650)594-1876. Fax: (650)594-9211. E-mail: hascards@aol.com. Website: http://www.hascards.com. Managing General Partner: Mary Ann Hurlimann. Estab. 1987. Produces greeting cards and enclosures, mugs, portfolios and placemats.

Needs: Approached by 60 freelance artists/year. Works with 6 freelancers/year. Buys 16 designs/year. Considers watercolor, oil and acrylic. No photography. Prefers rich color, clear images, no abstracts. "We have some cards that use words as the central element of the design." Not interested in computer-generated art.

First Contact & Terms: Send query letter with slides. Samples are filed. Art Director will contact artist for portfolio review if interested. Originals are returned at job's completion. Requests work on spec before assigning a job. Pays by the project, $100-300; royalties of 5% or fixed fee. Buys all rights.

Tips: "Send good quality slides of your work. We are attracted to a strong sense of individual style, technical competence, and a sense of whimsy is great."

IGPC, 460 W. 34th St., 10th Floor, New York NY 10001. (212)629-7979. Contact: Art Department. Agent to foreign governments. "We produce postage stamps and related items on behalf of 40 different foreign governments."

Needs: Approached by 50 freelance artists/year. Works with 75-100 freelance illustrators and designers/year. Assigns several hundred jobs to freelancers/year. Prefers artists within metropolitan New York or tri-state area. Must have

"Chuck was able to simply, humorously and effectively give personality to cheese!" says The Imagination Association's Ellise Lovelady of Charles Somerville's clever apron design. "He was able to keep it bright and colorful and still limit the design to four colors." Lovelady says the "I've Got a Friend in Cheeses" apron has been popular in upscale gourmet markets and wine and cheese shops. Somerville, who's had a working relationship with The Imagination Association for several years, does mailings to a well-researched list of markets, advertises in sourcebooks, and is launching two websites. "Do tons of work, be yourself and avoid compromise," he advises illustrators. "Never, ever undercharge just to get work."

excellent design and composition skills and a working knowledge of graphic design (mechanicals). Artwork must be focused and alive (4-color) and reproducible to stamp size (usually 4 times up). Works on assignment only. Uses artists for postage stamp art. Prefers airbrush, acrylic and gouache (some watercolor and oil OK).

First Contact & Terms: Send samples. Reports back within 5 weeks. Art Director will contact artist for portfolio review if interested. Portfolio should contain "4-color illustrations of realistic, tight flora, fauna, technical subjects, autos or ships. Also include reduced samples of original artwork." Sometimes requests work on spec before assigning a job. Pays by the project, $1,000-4,000. Consider government allowance per project when establishing payment.

Tips: "Artists considering working with IGPC must have excellent drawing abilities in general or specific topics, i.e., flora, fauna, transport, famous people, etc.; sufficient design skills to arrange for and position type; the ability to create artwork that will reduce to stamp size and still hold up with clarity and perfection. Must be familiar with printing process and print call-outs. Generally, the work we require is realistic art. In some cases, we supply the basic layout and reference material; however, we appreciate an artist who knows where to find references and can present new and interesting concepts. Initial contact should be made by phone for appointment."

THE IMAGINATION ASSOCIATION, 1073 Colony St., Flower Mound TX 75028. (972)355-7685. Fax: (972)539-7505. E-mail: ia4cs@aol.com. Website: http://www.aprons-tees.com. Creative Director: Ellice Lovelady. Estab. 1992. Produces greeting cards, T-shirts, mugs, aprons and magnets. "We are primarily a freelance design firm that has been quite established with several major greeting card and T-shirt companies who, in fact, produce our work. We have a sub-division that manufactures cutting edge, contemporary aprons and T-shirts for the gourmet food market."

Needs: Works with 12 freelancers/year. Artists must be fax accessible and able to work on fast turnaround. Uses freelancers for everything. Considers all media. "We're open to a variety of styles." 10% of freelance work demands knowledge of Adobe Illustrator, Adobe Photoshop and QuarkXPress. "That is rapidly increasing as many of our publishers are going to disk." Produces material for all holidays and seasons. Submit seasonal material 18 months in advance.

First Contact & Terms: Send query letter with brochure, photographs, SASE and photocopies. Samples are filed or returned by SASE if requested by artist. Company will contact artist for portfolio review if interested. Portfolio should include final art, photographs or any material to give indication of range of artist's style. Negotiates rights purchased. Originals are returned at job's completion. Pays royalties—the amount is variable depending on assignment. Finds artists via word of mouth from other freelancers or referrals from publishers.

Tips: Looking for artist "with a style we feel we can work with and a professional attitude. Understand that sometimes our publishers and manufacturers require several revisions before final art and all under tight deadlines. Be persistent! Stay true to your creative vision and don't give up!"

INCOLAY STUDIOS INCORPORATED, 520 Library St., San Fernando CA 91344. Fax: (818)365-9599. Art Director: Shari Bright. Estab. 1966. Manufacturer. "Basically we reproduce antiques in Incolay Stone, all handcrafted

here at the studio. There were marvelous sculptors in that era, but we believe we have the talent right here in the U.S. today and want to reproduce living American artists' work."

• Art director told *AGDM* that hummingbirds and cats are popular subjects in decorative art, as are angels, cherubs, endangered species and artwork featuring the family, including babies.

Needs: Prefers local artists with experience in carving bas relief. Uses freelance artists mainly for carvings. Also uses artists for product design and model making.

First Contact & Terms: Send query letter with résumé, or "call and discuss; 1-800-INCOLAY." Samples not filed are returned. Reports back within 1 month. Call for appointment to show portfolio. Pays 5% of net. Negotiates rights purchased.

Tips: "Let people know that you are available and want work. Do the best you can Discuss the concept and see if it is right for 'your talent.' "

‡INSPIRATIONS UNLIMITED, P.O. Box 9097, Cedar Pines Park CA 92322. (909)338-6758 or (800)337-6758. Fax: (909)338-2907. Owner: John Wiedefeld. Estab. 1983. Produces greeting cards and gift enclosures.

Needs: Approached by 15 freelancers/year. Works with 4 freelancers/year. Buys 48 freelance designs and illustrations/year. Uses freelancers mainly for greeting cards. Will consider all media, all styles. Prefers 5×7 vertical only. Produces material for Christmas, Mother's Day, graduation, Valentine's Day, birthdays, everyday, sympathy, get well, romantic, thank you, serious illness. Submit seasonal material 1 year in advance.

First Contact & Terms: Designers and illustrators send photocopies and photographs. Samples are filed and are not returned. Reports back in 1 week. Company will contact artist for portfolio review if interested. Buys reprint rights; rights purchased vary according to project. Pays $100/piece of art. Finds freelancers through artists' submissions, art galleries and shows.

INTERCONTINENTAL GREETINGS LTD., 176 Madison Ave., New York NY 10016. (212)683-5830. Fax: (212)779-8564. Creative Marketing Director: Robin Lipner. Sells reproduction rights on a per country, per product basis. Licenses and syndicates to 4,500-5,000 publishers and manufacturers in 50 different countries. Products include greeting cards, calendars, prints, posters, stationery, books, textiles, heat transfers, giftware, china, plastics, toys and allied industries, scholastic items and giftwrap.

Needs: Approached by 500-700 freelancers/year. Assigns 200-300 jobs and 1,500 designs and illustrations/year. Buys illustration/design mainly for greeting cards and paper products. Also buys illustration for giftwrap, calendars, giftware and scholastic products. Uses traditional as well as humorous and cartoon-style illustrations. Art guidelines available for SASE with first-class postage. Accepts airbrush, watercolor, colored pencil, acrylic, pastel, marker and computer illustration. Prefers "clean work in series format. All card subjects are considered." 30% of freelance work demands knowledge of Adobe Illustrator, Aldus FreeHand or Adobe Photoshop.

First Contact & Terms: Send query letter and/or résumé, brochure, tearsheets, slides, photocopies, photographs and SASE. Request portfolio review in original query. Artist should follow-up after initial query. Portfolio should include color tearsheets and photographs. Pays for original artwork by flat fee. Pays 20% royalties upon sale of reproduction rights on greeting cards, giftwrap and gift items. Contractual agreements made with artists and licensing representatives; will negotiate reasonable terms. Provides worldwide promotion, portfolio samples (upon sale of art) and worldwide trade show display. Finds artists through word of mouth, self-promotions, visiting artists' exhibitions and artists' reps.

Tips: "More and more of our clients need work submitted in series form, so we have to ask artists for work in a series or possibly reject the odd single designs submitted. Make as neat and concise a presentation as possible with commercial application in mind. Artists often send too few samples, unrelated samples or sloppy, poor quality reproductions. Show us color examples of at least one finished piece as well as roughs."

THE INTERMARKETING GROUP, 29 Holt Rd., Amherst NH 03031. (603)672-0499. President: Linda L. Gerson. Estab. 1985. Licensing agent for greeting cards, stationery, calendars, posters, paper tableware products, tabletop, dinnerware, giftwrap, eurobags, giftware, toys, needle crafts. The Intermarketing Group is a full service merchandise licensing agency representing artists' works for licensing with companies in consumer goods products including the paper product, greeting card, giftware, toy, housewares, needlecraft and apparel industries.

Needs: Approached by 100 freelancers/year. Works with 6 freelancers/year. Licenses work as developed by clients. Prefers freelancers with experience in full-color illustration. Uses freelancers mainly for tabletop, cards, giftware, calendars, paper tableware, toys, bookmarks, needlecraft, apparel, housewares. Will consider all media forms. "My firm generally represents highly illustrated works, characters and humorous illustrations for direct product applications. All works are themed." Prefers 5×7 or 8×10 final art. Produces material for all holidays and seasons and everyday. Submit seasonal material 6 months in advance.

First Contact & Terms: Send query letter with brochure, tearsheets, résumé, slides, SASE or color copies. Samples are not filed and are returned by SASE. Reports back within 3 weeks. Originals are returned at job's completion. Requests work on spec before assigning a job. Pays royalties of 2-7% plus advance against royalties. Buys all rights. Considers buying second rights (reprint rights) to previously published work. Finds new artists "mostly by referrals and via artist submissions. I do review trade magazines, attend art shows and other exhibits to locate suitable clients."

Tips: "Companies today seem to be leaning towards the tried and true traditional art approach. Economic times are tough so companies are selective in their licenses. A well-organized presentation is very helpful."

JILLSON & ROBERTS, 5 Watson Ave., Irvine CA 92618. (714)859-8781. Fax: (714)859-0257. Art Director: Josh Neufeld. Estab. 1974. Produces giftwrap and giftbags using more recycled/recyclable products.
Needs: Works with 10 freelance artists/year. Prefers artists with experience in giftwrap design. Considers all media. "We are looking for colorful graphic designs as well as humorous, sophisticated, elegant or contemporary styles." Produces material for Christmas, Valentine's Day, Hanukkah, Halloween, graduation, birthdays, baby announcements and everyday. Submit 3-6 months before holiday.
First Contact & Terms: Send query letter with brochure showing art style, tearsheets and slides. Samples are filed or are returned. Reports back within 3 weeks. To show a portfolio, mail thumbnails, roughs, final reproduction/product, color slides and photographs. Originals not returned. Pays average flat fee of $250; or pays royalties (percentage negotiable).

J-MAR, INC., P.O. Box 23149, Waco TX 76702-3149. (817)751-0100. Fax: (817)751-0054. Marketing Manager: Kelly Shivers. Estab. 1984. Produces bookmarks, calendars, decorative housewares, decorations, giftbags, gifts, giftwrap, greeting cards, mugs, stationery, pocket-size and 5×7 name and verse cards. J-Mar produces inspirational Christian giftware and related products.
Needs: Approached by 200 freelancers/year. Works with approximately 10 freelancers/year. Buys 10 freelance designs and illustrations/year. Prefers freelancers with experience in PC-Adobe Photoshop. Works on assignment only. Uses freelancers mainly for illustrating, rendering. Also for paste-up, P-O-P. Considers all media. Looking for inspirational/Christian, floral, bright colors, collage/quilt effects, prints. Prefers 5×7 or $8\frac{1}{2} \times 11$. 50% of freelance design work demands knowledge of Aldus PageMaker 6, Adobe Photoshop 3, Adobe Illustrator. 50% of freelance illustration demands knowledge of Aldus PageMaker 6, Adobe Photoshop 3, Adobe Illustrator. Produces material for Christmas, Easter, Mother's Day, Father's Day, graduation, New Year, Passover, Thanksgiving, Valentine's Day, birthdays, everyday, motivational, family, sympathy, get well, thank you, pastor/church thank you, christenings, juvenile, adult, love, friendship, humor, birthday, seasonal.
First Contact & Terms: Send query letter with photocopies, photographs, photostats, résumé, SASE, tearsheets. "We accept work on disk that is compatible with PC-based versions of Adobe PageMaker or PhotoShop." Samples are filed and are not returned. Reports back only if interested within 2 months. Company will contact artist for portfolio review of color, final art, photographs, photostats, roughs, tearsheets, thumbnails if interested. Buys all rights. Pays by the project. Finds freelancers through sourcebooks and artists' submissions.
Tips: "Please contact J-Mar via mail only. It is better to send samples and/or copies of art rather than originals. If your talent matches our needs, we will contact you to make further arrangements."

‡KALAN LP, 97 S. Union Ave., Lansdowne PA 19050. (610)623-1900. Fax: (610)623-0366. E-mail: chrisdee@pond.com. Art Director: Chris Wiemer. Estab. 1973. Produces giftbags, greeting cards, school supplies, stationery and novelty items such as keyrings, mouse pads, shot glasses and magnets.
Needs: Approached by 50-80 freelancers/year. Buys 10 freelance designs and illustrations/year. Art guidelines are available. Uses freelancers mainly for fresh ideas, illustration and design. Considers all media and styles. 80% of freelance design and 50% of illustration demands knowledge of Adobe Photoshop 4 and Adobe Illustrator 7. Produces material for major holidays such as Christmas, Mother's Day, Valentine's Day; plus birthdays and everyday. Submit seasonal material 9-10 months in advance.
First Contact & Terms: Designers send query letter with photocopies, photostats and résumé. Illustrators and cartoonists send query letter with photocopies and résumé. Accepts disk submissions compatible with Illustrator 7 or Photoshop 4.0. Send EPS files. Samples are filed. Reports back within 1 month if interested in artist's work. Will contact artist for portfolio review of final art if interested. Buys first rights. Pays by the project, $75 and up. Finds freelancers through submissions and newspaper ads.

KOGLE CARDS, INC., 1498 S. Lipan St., Denver CO 80223-3411. President: Patricia Koller. Estab. 1982. Produces greeting cards and postcards for all business situations.
Needs: Approached by 500 freelancers/year. Buys 250 designs and 250 illustrations/year. Art guidelines for SASE with first-class postage. Works on assignment only. Considers all media for illustration. Prefers 5×7 or $8\frac{1}{2} \times 11$ final art. Produces material for Christmas and all major holidays plus birthdays and all occasion; material accepted year-round. Send Attention: Art Director.
First Contact & Terms: Send query letter with brochure, photocopies, photographs and slides. Samples not filed are returned only if SASE included. Reports back within 1 month. To show portfolio, mail color and b&w photostats and photographs. Originals not returned. Pays by the project on royalty basis. Buys all rights.
Tips: "Include $8\frac{1}{2} \times 11$ color copies of your work—they are easy to view and to keep on file for quick reference. Ignore 'trends.' Develop your own style and characters."

L.B.K. MARKETING, 7800 Bayberry Rd., Jacksonville FL 32256-6893. (904)737-8500. Fax: (904)737-9526. Art Director: Barbara McDonald. Estab. 1940. "Four companies feed through L.B.K.: NAPCO and INARCO are involved with manufacturing/distributing for the wholesale floral industry; First Coast Design produces collectible giftware; Brinn's produces collectible dolls and seasonal giftware." Clients: wholesale.
 ● L.B.K. Marketing has a higher-end look for their floral market products. They are doing very little decal, mostly dimensional pieces.
Needs: Works with 15 freelance illustrators and designers/year. 50% of work done on a freelance basis. Prefers local

freelancers for mechanicals for sizing decals; no restrictions on artists for design and concept. Art guidelines available for SASE with first-class postage. Works on assignment only. Uses freelancers mainly for mechanicals and product design. "Need artists that are highly skilled in illustration for three-dimensional products. 75% of our work is very traditional and seasonal. We're also looking for a higher-end product, an elegant sophistication." 10% of freelance work requires computer skills.

First Contact & Terms: Designers send query letter with brochure, résumé, photocopies, photographs, SASE, tearsheets and "any samples we can keep on file." Illustrators send brochure, résumé, photocopies, photographs and SASE. If work is in clay, send photographs. Samples are filed or returned by SASE. Reports back in 2 weeks. Artist should follow-up with letter after initial query. Portfolio should include samples which show a full range of illustration style. Sometimes requests work on spec before assigning a job. Pays for design by the project, $50-500. Pays by the project for illustration, $50-2,000. Pays $15/hour for mechanicals. Buys all rights. Considers buying second rights (reprint rights) to previously published work. Finds artists through word of mouth and self-promotions.

Tips: "We are very selective in choosing new people. We need artists that are familiar with three-dimensional giftware and floral containers. We have recently merged with Brinn's. We now will be producing dolls and seasonal giftware. Our market is expanding and so are our needs for qualified artists."

✔**THE LANG COMPANIES: Lang Graphics, Main Street Press, Bookmark and R.A. Lang Card Co.**, 514 Wells St., Delafield WI 53018. (414)646-3399. Fax: (414)646-4678. Product Development: Joyce Quandt. Estab. 1982. Produces high quality linen-embossed greeting cards, stationery, calendars, giftbags, and many more fine paper goods.

Needs: Approached by 300 freelance artists/year. Art guidelines available. Works with 40 freelance artists/year. Buys 600 freelance designs and illustrations/year. Uses freelancers mainly for card and calendar illustrations. Considers all media. Looking for traditional and non-abstract country, folk and fine art styles. Produces material for Christmas, birthdays and everyday. Submit seasonal material 6 months in advance.

First Contact & Terms: Send query letter with SASE and brochure, tearsheets, photostats, photographs, slides, photocopies or transparencies. Samples are filed or are returned by SASE if requested by artist. Reports back within 6 weeks. Pays royalties based on net wholesale sales. Rights purchased vary according to project.

Tips: "Research the company and submit a compatible piece of art. Be patient awaiting a response. A phone call often rushes the review and work may not be seriously considered."

‡**LEADER PAPER PRODUCTS**, 2738 S. 13th St., Milwaukee WI 53215. (414)383-0414. Fax: (414)383-0760. Creative Team Leader: Shanna dela Cruz. Estab. 1901. Produces stationery, holiday cards, invitations and scrapbook supplies. Specializes in stationery from 8½×11 to social writing and related paper products.

Needs: Approached by 20 freelancers/year. Works with 10 freelancers/year. Buys 24 freelance illustrations/year. Prefers freelancers with experience in illustration/fine art who create detailed but not necessarily realistic art. Art guidelines available. Works on assignment only. Uses freelancers mainly for illustrations. Considers any medium that is scannable. Looking for traditional, floral, some humorous, sentimental, animals, contemporary, children's book styles. Produces material for holidays and seasons, birthdays, everyday, wedding, baby, events, trends, home decor and multicultural. Submit seasonal material 6 months in advance.

First Contact & Terms: Designers send query letter with photocopies and résumé. Illustrators send query letter with color photocopies and résumé. Send follow-up postcard or call every 3 months. Accepts disk submissions compatible with Adobe Illustrator 6.0, Adobe Photoshop and Quark. Send EPS files. Samples are filed. Artist should follow-up with call and/or letter after initial query. Will contact artist for more samples and to discuss project if interested. Buys all rights. Pays for illustration by the project, $300 and up. Finds freelancers through newspaper ads in various cities and by referrals.

Tips: "Send lots of samples, showing your best neat and cleanest work with a clear concept. Be flexible."

LIFE GREETINGS, P.O. Box 468, Little Compton RI 02837. (401)635-8535. Editor: Kathy Brennan. Estab. 1973. Produces greeting cards. Religious, inspirational greetings.

Needs: Approached by 25 freelancers/year. Works with 5 freelancers/year. Uses freelancers mainly for greeting card illustration. Also for calligraphy. Considers all media but prefers pen & ink and pencil. Prefers 4½×6¼—no bleeds. Produces material for Christmas, religious/liturgical events, baptism, first communion, confirmation, ordination.

First Contact & Terms: Send query letter with photocopies. Samples are filed or returned by SASE if requested by artist. Reports back to the artist only if interested. Portfolio review not required. Buys all rights. Originals are not returned. Pays by the project, $25-45. **"We pay on acceptance."** Finds artists through submissions.

‡**LOVE GREETING CARDS, INC.**, 1717 Opa Locka Blvd., Opa Locka FL 33054-4221. (305)685-5683. Fax: (305)685-0903. Vice President: Norman Drittel. Estab. 1984. Produces greeting cards, posters and stationery. "We produce cards for the 40- to 60-year-old market, complete lines and photography posters."

● This company has found a niche in targeting middle-aged and older Floridians. Keep this audience in mind when developing card themes for this market. One past project involved a line of cards featuring Florida's endangered wildlife.

Needs: Works with 2 freelancers/year. Buys 20 designs and illustrations/year. Prefers freelancers with experience in greeting cards and posters. Also buys illustrations for high-tech shopping bags. Uses freelancers mainly for greeting cards. Considers pen & ink, watercolor, acrylic, oil and colored pencil. Seeks a contemporary/traditional look. Prefers 5×7 size. Produces material for Hanukkah, Passover, Rosh Hashanah, New Year, birthdays and everyday.

First Contact & Terms: Send query letter, brochure, résumé and slides. Samples are filed or are returned. Reports back within 10 days. Call or write for appointment to show portfolio of roughs and color slides. Originals are not returned. Pays average flat fee of $150/design. Buys all rights.
Tips: "Most of the material we receive from freelancers is of poor quality. We use about 5% of submitted material. We are using a great deal of animal artwork and photographs."

✔**MADISON PARK GREETINGS**, 1407 11th Ave., Seattle WA 98122-3901. (206)324-5711. Fax: (206)324-5822. Art Director: Sarah McHale. Estab. 1984. Produces giftwrap, greeting cards, stationery.
Needs: Approached by 250 freelancers/year. Works with 15 freelancers/year. Buys 400 freelance designs and illustrations/year. Art guidelines available. Works on assignment only. Uses freelancers mainly for greeting cards. Also for calligraphy, reflective art. Considers all paper related media. Prefers finished card size 4⅛×7. 100% of design and 30% of illustration demand knowledge of Aldus PageMaker, Aldus FreeHand, Adobe Photoshop, QuarkXPress, Adobe Illustrator. Produces material for Christmas, Easter, Mother's Day, Father's Day, graduation, New Year, Valentine's Day, birthdays, everyday, sympathy, get well, anniversary, baby congratulations, wedding, thank you, expecting, friendship. Submit seasonal material 10 months in advance.
First Contact & Terms: Designers send photocopies, slides, transparencies. Illustrators send postcard sample or photocopies. Accepts submissions on disk compatible with Adobe Illustrator 5.0. Send EPS files. "Good samples are filed; rest are returned." Company will contact artist for portfolio review of color, final art, roughs if interested. Rights purchased vary according to project. Pays royalty of 5%.
Tips: "Study European and classic art."

FRANCES MEYER, INC., 104 Coleman Blvd., Savannah GA 31408. (912)748-5252. Fax: (912)748-8378. Stationery Manager: Katherine Rosenblum. Estab. 1979. Produces giftwrap, stationery and party supplies. "We produce a number of items for the gift and party industry as well as an ever-growing number of stationery-related products. Our products are directed to consumers of all ages. We have everything from birth announcements to shower and wedding invitations."
Needs: Works with 5-6 freelance artists/year. Commissions 100 freelance illustrations and designs/year. Works on assignments only. Uses freelancers mainly for stationery-related products. "Most of our artists work in either watercolor or acrylic. We are open, however, to artists who work in other media." Looking for "everything from upscale and sophisticated adult theme-oriented paper items, to fun, youthful designs for birth announcements, baby and youth products. Diversity of style, originality of work, as well as technical skills are a few of our basic needs." Produces material for Christmas, graduation, Thanksgiving (fall), New Year's, Halloween, birthdays, everyday, weddings, showers, new baby, etc. Submit seasonal material 2-3 months in advance.
First Contact & Terms: Send query letter with tearsheets, slides, SASE, photocopies, transparencies and "as much information as is necessary to show diversity of style and creativity." "No response or return of samples by Frances Meyer, Inc. *without SASE!*"Reports back within 2-3 months. Company will contact artist for portfolio review if interested. Originals are returned at job's completion. Pays royalty (varies).
Tips: "Generally, we are looking to work with a few talented and committed artists for an extended period of time. Our outside artists are given ample coverage in our catalog as we tend to show collections of each design. We do not 'clean out' our line on an annual basis just to introduce new product. If an item sells, it will remain in the line. Punctuality concerning deadlines is a necessity."

‡**MILLIMAC LICENSING CO.**, 188 Michael Way, Santa Clara CA 95051. (408)984-0700. Fax: (408)984-7456. E-mail: bruce@clamkinman.com. Website: http://www.clamkinman.com. Owner: Bruce Ingrassia. Estab. 1978. Produces collectible figurines, mugs, T-shirts and textiles. Produces a line of cartoon characters called the Clamkin® Family directed towards "children and adults young at heart."
Needs: Approached by 10 freelancers/year. Works with 2-3 freelancers/year. Buys 30-40 freelance designs and illustrations/year. Prefers freelancers with experience in cartooning. Works on assignment only. Uses freelancers mainly for line art, color separation, Mac computer assignments. Considers computer, pen & ink. Looking for humorous, "off the wall," cute animals, clever and cute. 50% of freelance design/illustration demands knowledge of Adobe Photoshop, Adobe Illustrator, Aldus FreeHand (pencil roughs OK). "Computer must be Mac." Produces material for everyday.
First Contact & Terms: Designers/cartoonists send query letter with photocopies. Sculptors send photos of work. Accepts disk submissions compatible with Mac Adobe Illustrator files. Samples are filed. Will contact artist for portfolio review if interested. Rights purchased and pay rates vary according to project. Finds freelancers through submissions. "I also find a lot of talent around town—at fairs, art shows, carnivals, students—I'm always on the lookout."
Tips: "Get a computer—learn Adobe Illustrator, Photoshop. Be clever, creative, open minded and responsible."

MIXEDBLESSING, P.O. Box 97212, Raleigh NC 27624-7212. (914)723-3414. President: Elise Okrend. Estab. 1990. Produces interfaith greeting cards combining Jewish and Christian as well as multicultural images for all ages.
Needs: Approached by 10 freelance artists/year. Works with 2-3 freelancers/year. Buys 20 designs and illustrations/year. Provides samples of preferred styles upon request. Works on assignment only. Uses freelancers mainly for card illustration. Considers watercolor, pen & ink and pastel. Prefers final art 5×7. Produces material for Christmas and Hanukkah. Submit seasonal material 10 months in advance.
First Contact & Terms: Send query letter with brochure, photocopies, photographs and SASE. Samples are filed. Reports back only if interested. Artist should follow-up with letter after initial query. Originals are returned at job's

completion. Sometimes requests work on spec before assigning a job. Pays flat fee of $125-500 for illustration/design. Buys all rights. Finds artists through visiting art schools.
Tips: "I see growth ahead for the industry."

✔**THE JOHN MORRIS COMPANY**, 729 Knickerbocker Rd., San Angelo TX 76903. (915)655-7787. Fax: (915)653-9447. E-mail: jmorris@wcc.net. President: John S. Pearcy. Estab. 1993. Produces T-shirts, textiles and silk neckties. "We produce high-quality art, nature and conversational T-shirts, neckties, caps and other apparel and accessories."
Needs: Approached by 15-20 freelancers/year. Works with 5-6 freelancers/year. Buys 20-40 freelance designs and illustrations/year. Art guidelines available. Uses freelancers mainly for new designs of ties and T-shirts. Considers all media. Looking for new ideas. Produces material for Christmas and everyday.
First Contact & Terms: Call for submission information and/or to request portfolio review. Accepts disk submissions. Samples are filed or returned by SASE. Reports back within 2 days. Portfolio review required. Portfolio should include color samples. Rights purchased vary according to project. Payment negotiable based on the market. Finds artists through word of mouth, postings and art schools.

J.T. MURPHY CO., 200 W. Fisher Ave., Philadelphia PA 19120. (215)329-6655. Fax: (800)457-5838. President: Jack Murphy. Estab. 1937. Produces greeting cards and stationery. "We produce a line of packaged invitations, thank you notes and place cards for retail."
Needs: Approached by 12 freelancers/year. Works with 4 freelancers/year. Buys 8 freelance designs and illustrations/year. Prefers local freelancers with experience in graphics and greeting cards. Uses freelancers mainly for concept, design and finished artwork for invitations and thank yous. Looking for graphic, contemporary or traditional designs. Prefers 4×5⅛ but can work double size. Produces material for graduation, birthdays and everyday. Submit seasonal material 9 months in advance.
First Contact & Terms: Designers send query letter with brochure. Illustrators send query letter with photocopies. Samples are filed and returned with SASE. Reports back within 1 month. Company will contact artist for portfolio review if interested. Rights purchased vary. Originals not returned. Payment negotiated.

NALPAC, LTD., 1111 E. Eight Mile Rd., Ferndale MI 48220. (248)541-1140. Fax: (248)544-9126. President: Ralph Caplan. Estab. 1971. Produces coffee mugs and T-shirts for gift and mass merchandise markets.
Needs: Approached by 10-15 freelancers/year. Works with 2-3 freelancers/year. Buys 70 designs and illustrations/year. Works on assignment only. Considers all media. Needs computer-literate freelancers for design, illustration and production. 60% of freelance work demands computer skills.
First Contact & Terms: Send query letter with brochure, résumé, SASE, photographs, photocopies, slides and transparencies. Samples are filed or are returned by SASE if requested by artist. Reports back within 1 month. Call for appointment to show portfolio. Usually buys all rights, but rights purchased may vary according to project. Pays for design and illustration by the hour $10-25; or by the project $40-500, or offers royalties of 4-10%.

‡**NATIONAL DESIGN CORP.**, 16885 Via Del Campo Court, #300, San Diego CA 92127-1724. (619)674-6040. Fax: (619)674-4120. Art Director: Steven Duncan. Estab. 1985. Produces gifts, writing instruments and stationery accoutrements. Multi markets include gift/souvenir, mass market and premium markets.
Needs: Works with 3-4 freelancers/year. Buys 3 freelance designs and illustrations/year. Prefers local freelancers only. Must be Macintosh proficient. Works on assignment only. Uses freelancers mainly for design illustration. Also for prepress production on Mac. Considers computer renderings to mimic traditional medias. Prefers children's and contemporary styles. 100% of freelance work demands knowledge of Aldus PageMaker 6.0, Aldus FreeHand 5.5, Adobe Photoshop 3.0, QuarkXPress 3.0, Adobe Illustrator 5.5. Produces material for Christmas and everyday.
First Contact & Terms: Send query letter with photocopies, résumé, SASE. Accepts submissions on disk. "Contact by phone for instructions." Samples are filed and are returned if requested. Company will contact artist for portfolio review of color, final art, tearsheets if interested. Rights purchased vary according to project. Payments depends on complexity, extent of project(s).
Tips: "Must be well traveled to identify with gift/souvenir markets internationally. Fresh ideas always of interest."

NCE, New Creative Enterprises Inc., 401 Milford Pkwy., Milford OH 45150. (513)248-1144. Fax: (513)248-7520. Design & Art Director: Dave J. Griffiths. Estab. 1979. Produces low-medium priced giftware and decorative accessories. "We sell a wide variety of items ranging from magnets to decorative flags. Our typical retail-level buyer is female, age 30-50."
Needs: Approached by 5-10 freelancers/year. Works with 2-5 freelancers/year. Buys 10-50 designs and illustrations/year. Prefers local freelancers only with experience in giftware/decorative accessory design, concept development and illustration and concept sketching. Most often needs ink or marker illustration. Seeks heart-warming and whimsical designs and illustrations using popular (Santa, Easter Bunny, etc.) or unique characters. Final art must be mailable size. Needs computer-literate freelancers for design, illustration and production. 50% of freelance work demands knowledge of Adobe Illustrator. Produces material for Christmas, Valentine's Day, Easter, Thanksgiving and Halloween. Submit seasonal material 10 months in advance.
First Contact & Terms: Send query letter with tearsheets, photographs, photocopies, photostats, slides and transparencies. Samples are filed and are returned by SASE if requested by artist. Reports back within 3-5 weeks. Call for appointment to show portfolio if local or mail appropriate materials. Portfolio should include thumbnails, roughs, finished

art samples, b&w and color tearsheets, photographs, slides and dummies. Originals are returned at job's completion. Pays average flat fee of $75 for illustration/design; or by the hour, $9-15. Rights purchased vary according to project.

Tips: "Familiarity and experience with the industry really helps, but is not imperative. Yard and garden decoration/accessories are very popular right now."

✔THOMAS NELSON GIFTS, INC.—C.R. GIBSON, CREATIVE PAPERS, PRETTY PAPER, 404 BNA Drive, Building 200, Suite 600, Nashville TN 37217. (615)889-9000. Fax: (615)391-3166. Creative Director: Ann Cummings. Producer of stationery and gift products and giftbook publisher. Specializes in baby, children, feminine, wedding, sports and kitchen-related subjects. 85-90% require freelance illustration; 50% require freelance design. Gift catalog free by request.

Needs: Approached by 150-200 freelance artists/year. Works with 10-30 illustrators and 10-30 designers/year. Assigns 20-30 design and 20-30 illustration jobs/year. Uses freelancers mainly for covers, borders and spots. 50% of freelance work demands knowledge of QuarkXPress, Aldus FreeHand and Adobe Illustrator. Works on assignment only.

First Contact & Terms: Send query letter with brochure, résumé, tearsheets and photocopies. Samples are filed or are returned. Reports back only if interested. Request portfolio review in original query. Portfolio should include thumbnails, finished art samples, color tearsheets and photographs. Whether originals returned to the artist depends on contract. Sometimes requests work on spec before assigning a job. Interested in buying second rights (reprint rights) to previously published work. "Payment varies due to complexity and deadlines." Finds artists through word of mouth, magazines, artists' submissions/self-promotions, sourcebooks, agents, visiting artist's exhibitions, art fairs and artists' reps.

Tips: "The majority of our mechanical art is executed on the computer with discs and laser runouts given to the engraver instead of paste up boards."

‡NEW DECO, INC., 23123 Sunfield Dr., Boca Raton FL 33433. (800)543-3326. President: Brad Hugh Morris. Estab. 1984. Produces greeting cards, posters, fine art prints and original paintings.

● See also the listing for New Deco, Inc. in Posters & Prints section.

Needs: Approached by 50-100 artists/year. Works with 5-10 freelancers/year. Buys 8-10 designs and 5-10 illustrations/year. Uses artwork for original paintings, limited edition graphics, greeting cards, giftwrap, calendars, paper tableware, poster prints, etc.

First Contact & Terms: Send query letter with brochure, résumé, tearsheets, slides and SASE. Samples not filed are returned by SASE. Reports back within 10 days only if interested. To show portfolio, mail color slides. Originals are returned at job's completion. Pays royalties of 5-10%. Negotiates rights purchased.

Tips: "Do not send original art at first."

NEW ENGLAND CARD CO., Box 228, Route 41, West Ossipee NH 03890. (603)539-5095. Owner: Harold Cook. Estab. 1980. Produces greeting cards and prints of New England scenes.

Needs: Approached by 75 freelancers/year. Works with 10 freelancers/year. Buys more than 24 designs and illustrations/year. Prefers freelancers with experience in New England art. Art guidelines available. Considers oil, acrylic and watercolor. Looking for realistic styles. Prefers art proportionate to 5×7. Produces material for all holidays and seasons. "Submit all year."

First Contact & Terms: Send query letter with SASE, photocopies, slides and transparencies. Samples are filed or are returned. Reports back within 2 months. Artist should follow-up after initial query. Pays by project. Rights purchased vary according to project, but "we prefer to purchase all rights."

Tips: "Once you have shown us samples, follow up with new art."

N-M LETTERS, INC., 125 Esten Ave., Pawtucket RI 02860. (401)247-7651. Fax: (401)245-3182. President: Judy Mintzer. Estab. 1982. Produces birth announcements and party invitations.

Needs: Approached by 2-5 freelancers/year. Works with 2 freelancers/year. Prefers local artists only. Works on assignment only. Produces material for graduation and everyday. Submit seasonal material 5 months in advance.

First Contact & Terms: Send query letter with résumé. Reports back within 1 month only if interested. Call for appointment to show portfolio of b&w roughs. Original artwork is not returned. Pays by the project.

NORSE PRODUCTS, 1000 S. Second St., Plainfield NJ 07063. (908)754-6330. Fax: (908)757-5241. Vice President Marketing: David Rubin. Estab. 1979. Produces acrylic barware, serveware, placemats and tabletop products.

● Also owns Stotter. See listing in this section.

Needs: Buys 20 designs and illustrations/year. Works on assignment only. Uses freelancers mainly for product design. Seeking trendy styles. Final art should be actual size. Produces material for all seasons. Submit seasonal material 6 months in advance.

First Contact & Terms: Send query letter with brochure and résumé. Samples are filed. Reports back within 1 month or does not report back, in which case the artist should call. Call for appointment to show portfolio. Negotiates rights purchased. Originals returned at job's completion if requested. Pays flat fee and royalties; negotiable.

✔❋NORTHERN CARD PUBLISHING, INC., 5692 Ambler Dr., Mississauga, Ontario L4W 2K9 Canada. (905)625-4944. Fax: (905)625-5995. E-mail: nclcards@aol.com. Product Coordinator: Jane Donato. Estab. 1992. Produces greeting cards.
Needs: Approached by 200 freelancers/year. Works with 25 freelancers/year. Buys 75 freelance designs and illustrations/year. Uses freelancers for "camera-ready artwork and lettering." Looking for traditional, sentimental, floral and humorous styles. Prefers 5½×7¾ or 5×7. Produces material for Christmas, Easter, Mother's Day, Father's Day, graduation, Valentine's Day, birthdays and everyday. Also sympathy, get well, someone special, thank you, friendship, new baby, good-bye and sorry. Submit seasonal material 6 months in advance.
First Contact & Terms: Designers send query letter with brochure, photocopies, slides, résumé and SASE. Illustrators and cartoonists send photocopies, tearsheets, résumé and SASE. Lettering artists send samples. Samples are filed or returned by SASE. Reports back only if interested. Pays flat fee, $150 (CDN). Finds freelancers through newspaper ad.

‡THE NOTEWORTHY COMPANY, 100 Church St., Amsterdam NY 12010. (518)842-2660. Fax: (800)866-8317. Vice President Development: Steve Smeltzer. Estab. 1954. Produces bags and coloring books. Advertising specialty manufacturer selling to distributors with clients in the health, real estate, banking and retail fields.
Needs: Buys 25 illustrations/year. Prefers freelancers with experience in designing for flexographic printing. Works on assignment only. Uses freelancers mainly for stock bag art and coloring book themes.
First Contact & Terms: Send query letter with brochure, résumé, samples and SASE. Samples are filed. Pays $200 for bag design.

✔NOVO CARD PUBLISHERS INC., 3630 W. Pratt Ave., Lincolnwood IL 60645. (847)763-0077. Fax: (847)763-0022. Art Directors: Molly Morwaski and Tom Benjamin. Estab. 1927. Produces all categories of greeting cards.
Needs: Approached by 200 freelancers/year. Works with 30 freelancers/year. Buys 300 or 400 pieces/year. Art guidelines free for SASE with first-class postage. Uses freelancers mainly for illustration and text. Also for calligraphy. Considers all media. Prefers crop size: 5×7¾, bleed 5¼×8. Knowledge of Adobe Photoshop 4.0, Adobe Illustrator 6.0 and QuarkXPress helpful. Produces material for all holidays and seasons and everyday. Submit seasonal material 8 months in advance.
First Contact & Terms: Designers send brochure, photocopies, photographs and SASE. Illustrators and cartoonists send photocopies, photographs, tearsheets and SASE. Calligraphers send b&w copies. Accepts disk submissions compatible with Macintosh Quark and Windows 95. Art samples are not filed and are returned by SASE only. Written samples retained on file for future assignment with writer's permission. Reports back within 2 months. Pays for design and illustration by the project, $75-200.

OATMEAL STUDIOS, Box 138, Rochester VT 05767. (802)767-3171. Fax: (802)767-9890. Creative Director: Helene Lehrer. Estab. 1979. Publishes humorous greeting cards and notepads, creative ideas for everyday cards and holidays.
Needs: Approached by approximately 300 freelancers/year. Buys 100-150 freelance designs and illustrations/year. Considers all media. Produces seasonal material for Christmas, Mother's Day, Father's Day, Easter, Valentine's Day and Hanukkah. Submit art in May for Christmas and Hanukkah; in January for other holidays.
First Contact & Terms: Send query letter with slides, roughs, printed pieces or brochure/flyer to be kept on file; write for artists' guidelines. "If brochure/flyer is not available, we ask to keep one slide or printed piece; color or b&w photocopies also acceptable for our files." Samples returned by SASE. Reports in 3-6 weeks. No portfolio reviews. Sometimes requests work on spec before assigning a job. Negotiates payment.
Tips: "We're looking for exciting and creative, humorous (not cutesy) illustrations for our everday lines. If you can write copy and have a humorous cartoon style all your own, send us your ideas! We do accept work without copy too. Our seasonal card line includes traditional illustrations, so we do have a need for non-humorous illustrations as well."

✔P.S. GREETINGS, INC., 5060 N. Kimberly Ave., Chicago IL 60630. (800)334-2141. Fax: (773)725-8655. Art Director: Jennifer Dodson. Manufacturer of boxed greeting and counter cards.
Needs: Receives submissions from 300-400 freelance artists/year. Works with 20-30 artists/year on greeting card designs. Prefers illustrations be 5×7¾ with ⅛″ bleeds cropped. Publishes greeting cards for everyday and holidays. 20% of work demands knowledge of QuarkXPress, Adobe Illustrator and Adobe Photoshop.
First Contact & Terms: Send query letter requesting artist's guidelines. All requests as well as submissions must be accompanied by SASE. Samples will *not* be returned without SASE! Reports within 1 month. Pays flat fee. Buys exclusive worldwide rights for greeting cards and stationery.
Tips: "Our line includes a whole spectrum: from everyday needs (florals, scenics, feminine, masculine, humorous, cute) to every major holiday (from New Years to Thanksgiving) with a huge Chrismas line as well. We continue to grow every year and are always looking for innovative talent."

❋ **CANADIAN LISTINGS** are marked with a maple leaf.

PAINTED HEARTS & FRIENDS, 1222 N. Fair Oaks Ave., Pasadena CA 91103. (818)798-3633. Fax: (818)798-7385. E-mail: teri@paintedhearts.com. Sales Manager: Richard Crawford. President: Susan Kinney. Estab. 1988. Produces greeting cards, stationery, invitations and notecards.
● This company also needs freelancers who can write verse. If you can wear this hat, you'll have an added edge.
Needs: Approached by 75 freelance artists/year. Works with 6 freelancers/year. Art guidelines free for SASE with first-class postage or by e-mail. Works on assignment only. Uses freelancers mainly for design. Produces material for all holidays and seasons, birthdays and everyday. Submit seasonal material 1 year in advance.
First Contact & Terms: Send Art submissions Attn: David Mekelburg, send Writer's submissions Attn: Michelle Gomez or or use e-mail. Send query letter with résumé, SASE and color photocopies. Samples are returned with SASE. Reports back only if interested. Write for appointment to show portfolio, which should include original and published work. Rights purchased vary according to project. Originals returned at job's completion. Pays flat fee of $150-300 for illustration. Pays royalties of 5%.
Tips: "Familiarize yourself with our card line." This company is seeking "young artists (in spirit!) looking to develop a line of cards. We're looking for work that is compatible but adds to our look, which is bright, clean watercolors. We need images that go beyond just florals to illustrate and express the occasion."

PANDA INK, P.O. Box 5129, Woodland Hills CA 91308-5129. (818)340-8061. Fax: (818)883-6193. E-mail: ruthluv-ph@worldnet.att.net. Art Director: Ruth Ann Epstein. Estab. 1982. Produces greeting cards, stationery, calendars and magnets. Products are Judaic, general, everyday, anniversay, etc.
● This company has added a metaphysical line of cards.
Needs: Approached by 8-10 freelancers/year. Works with 1-2 freelancers/year. Buys 3-4 freelance designs and illustrations/year. Art guidelines for SASE with first-class postage. Uses freelancers mainly for design, card ideas. Art guidelines free for SASE with first-class postage. Considers all media. Looking for bright, colorful artwork, no risqué, more ethnic. Prefers 5×7. Produces material for all holidays and seasons, Christmas, Valentine's Day, Mother's Day, Father's Day, Easter, Hanukkah, Passover, Rosh Hashanah, graduation, Thanksgiving, New Year, Halloween, birthdays and everyday. Submit seasonal material 6 months in advance.
First Contact & Terms: Send query letter with résumé, SASE, tearsheets and photocopies. Samples are filed. Reports back within 1 month. Portfolio review not required. Rights purchased vary according to project. Originals are returned at job's completion. Pay is negotiable; pays flat fee of $20; royalties of 2% (negotiable). Finds artists through word of mouth and submissions.
Tips: "Looking for bright colors and cute, whimsical art. Be professional. Always send SASE. Make sure art fits company format."

✔**PAPEL GIFTWARE**™, (formerly Papel Freelance), 30 Engelhard Dr., Cranbury NJ 08512. (609)395-0022. Design Manager: Tina M. Merola. Estab. 1955. Produces everyday and seasonal giftware items and home decor items: mugs, photo frames, magnets, figurines, plush collectible figurines, candles and novelty items. Paper items include giftbags, journals, plaques and much more.
Needs: Approached by about 125 freelancers/year. Buys 250 illustrations/year. Uses freelancers for product design, illustrations on product, calligraphy, computer graphics and mechanicals. Looks for artwork that is "very graphic, easy to interpret, bold, clean colors, both contemporary and traditional looks." Produces material for Halloween, Christmas, Valentine's Day, Easter, St. Patrick's Day, Mother's Day, Father's Day, Secretary's Day, personalized, inspirational, birthday, teacher, mid-life crisis, golf, wedding. Freelancers should be familiar with Adobe Illustrator, Adobe Photoshop and QuarkXPress.
First Contact & Terms: Designers send query letter with photocopies. Illustrators send postcard sample or query letter with photocopies and SASE to be kept on file. Samples not filed are returned by SASE. Will contact for portfolio review if interested. Portfolio should include final reproduction/product and b&w and color tearsheets, photostats and photographs. Originals not returned. Sometimes requests work on spec before assigning a job. Pays by project, $125 minimum; or royalties of 3%. Buys all rights.
Tips: "I look for strong basic drawing skills with a good color sense. I want an artist who is versatile and who can adapt their style to a specific product line with a decorative feeling. Please submit as many styles as you are capable of doing. Clean, accurate work is very important and mechanicals are important to specific jobs. New ideas and 'looks' are always welcome. Keep our files updated with your future work as developed."

THE PAPER COMPANY™, 731 S. Fidalgo St., Seattle WA 98108. (206)762-0982. Fax: (206)762-9128. Website: http://www.thepaperco.com. Contact: Art Director. Estab. 1979. Manufacturer of fine contemporary stationery and related products. "We produce a wide array of designs from sophisticated florals to simple, fun graphics and everything in between."
Needs: Prefers to work with 8 freelance artists and in-house design staff. Buys approximately 40 designs/year. Art guidelines are available. Produces material for everyday and Christmas. "There are no restrictions to media usage, however please note that we do not use cartoon illustration/design."
First Contact & Terms: Send a query letter including previous work assignments/experience with printed samples and/or color photocoies to indicate style. Reports in 1 month. Art Director will contact artist for portfolio review if interested. Sometimes requests work on spec before assigning a job. Samples are returned upon request. No phone calls accepted. Pays flat fee rate, $300-800; no licensing considerations. Finds artists through submissions and word of mouth.
Tips: "This is a constantly changing field, new products, new trends; etc. Imprintables will be making a huge impact

© 1998 The Paper Company

Working on a tight deadline in watercolor and ink applied with a watercolor brush, Sam Day created this collection of canines for stationery from The Paper Company. "Sam's expressive line work and coloring really give this piece a fun, playful quality, which, combined with the textured background, keep it upscale in feeling," says Art Director Scott Church. The Paper Company is one of about 2,500 companies Day mails promotional material to each year. The illustrator also advertises in *Showcase* and *RSVP* and has his own website (www.samday.com). He advises illustrators just starting out to "keep your day job. It can take years to establish yourself as a freelancer. Make sure you're marketing a style that appeals to current trends but try to be unique enough to distinguish yourself from others."

shortly (if not already). Do lots of research and observe what kind of artwork sells. Work hard to develop your own look and style and then only show your best work. Research trends and colors as well as what a company does before contacting them."

✓**PAPER MAGIC GROUP INC.**, 401 Adams Ave., Scranton PA 18510. (717)961-3863. Fax: (717)341-9098. Creative Director for Winter Division: Peg Cohan. Estab. 1984. Produces greeting cards, stickers, vinyl wall decorations, 3-D paper decorations. "We are publishing seasonal cards and decorations for the mass market. We use a wide variety of design styles with an emphasis on traditional and cute."
Needs: Works with 60 freelance artists/year. Prefers artists with experience in greeting cards. Work is by assignment only. Designs products for Christmas, Valentine's Day, Easter, Halloween and school market. Also uses freelances for lettering and art direction.
First Contact & Terms: Send query letter with résumé, samples and SASE. Color photocopies are acceptable samples. Samples are filed or are returned by SASE only if requested by artist. Reports back within 2 months. Originals not returned. Pays by the project, $350-2,000 average. Buys all rights.
Tips: "Please, experienced illustrators only."

PAPER MOON GRAPHICS, INC., Box 34672, Los Angeles CA 90034. (310)287-3949. Contact: Creative Director. Estab. 1977. Produces greeting cards and stationery. "We publish greeting cards with a friendly, humorous approach—dealing with contemporary issues."
● Paper Moon is a contemporary, alternative card company. Traditional art is not appropriate for this company.
Needs: Works with 40 artists/year. Buys 200 designs/illustrations/year. Buys illustrations mainly for greeting cards and stationery. Art guidelines for SASE with first-class postage. Produces material for everyday, holidays and birthdays. Submit seasonal material 6 months in advance.
First Contact & Terms: Send query letter with brochure, tearsheets, photostats, photocopies, slides and SASE. Samples are filed or are returned only if requested by artist and accompanied by SASE. Reports back within 8-10 weeks. To show a portfolio, mail color roughs, slides and tearsheets. Original artwork is returned to the artist after job's completion. Pays average flat fee of $350/design; $350/illustration. Negotiates rights purchased.
Tips: "We're looking for bright, fun style with contemporary look. Artwork should have a young 20s and 30s appeal." A mistake freelance artists make is that they "don't know our product. They send inappropriate submissions, not professionally presented and with no SASE."

❦**PAPERPOTAMUS PAPER PRODUCTS INC.**, Box 310, Delta, British Columbia V4K 3Y3 Canada. (604)270-4580. Fax: (604)270-1580. E-mail: paperpotamus@paperpotamus.com. Website: http://www.paperpotamus.com. Director of Marketing: George Jackson. Estab. 1988. Produces greeting cards for women ages 18-60.
Needs: Works with 8-10 freelancers/year. Buys 75-100 illustrations from freelancers/year. Also uses freelancers for P-O-P displays, paste-up and inside text. Prefers watercolor and computer created, but will look at all color media; no b&w except photographic. Especially seeks detailed humorous cartoons, fairies, wizards, dragons etc. and country style color artwork. Will use some detailed nature drawings of items women are attracted to i.e. cats, flowers, teapots etc. especially in combination. Also wants whales, eagles, tigers, wolves and other wildlife. Would like to see "cute" cats, Teddy bears, kids etc. Produces material for Christmas. Submit seasonal work at least 18 months before holiday. Has worked with artists to produce entire lines of cards but is currently most interested in putting selected work into existing or future card lines and will possibly develop line based on success of the selected pieces. Prefers 5¼×7¼ finished artwork.
First Contact & Terms: Send brochure, résumé, roughs, photocopies and SASE. No slides. Samples are not filed and are returned by SASE only if requested by artist. Reports back within 2 months. Original artwork is not returned if purchased. Pays average flat fee of $100-150/illustration or royalties of 5%. Prefers to buy all rights. Company has a 20-page catalog you may purchase by sending $4 with request for artist's guidelines. You can also check website for guidelines. Please do not send IRCs in place of SASE. "Do not phone or fax to inquire about your artwork. It will be returned if you send an SASE with it. If sending samples from USA, put US postage on SASE. Your samples will be mailed back to you from USA post office."
Tips: "Know who your market is! Find out what type of images are selling well in the card market. Learn why people buy specific types of cards. Who would buy your card? Why? Who would they send it to? Why? Birthdays are the most popular occasions to send cards. Understand the time frame necessary to produce cards and do not expect your artwork to appear on a card in a store next month. Send only your best work and we will show it to the world, with your name on it."

✔**PAPERPRODUCTS DESIGN U.S. INC.**, 60 Galli, Novato CA 94949. (415)883-1888. Fax: (415)883-1999. President: Carol Florsheim. Estab. 1990. Produces giftwrap, greeting cards, paper tableware. Specializes in high end design, fashionable designs.
Needs: Approached by 20-30 freelancers/year. Works with 10 freelancers/year. Buys 30 freelance designs and illustrations/year. Art guidelines available. Uses freelancers mainly for designer paper napkins. Looking for very stylized/clean designs and illustrations. Prefers 6½×6½. Produces material for Christmas, Easter, everyday and birthday (most are blank). Submit seasonal material 6 months in advance.
First Contact & Terms: Designers send brochure, photocopies, photographs, tearsheets. Samples are not filed and are returned. Reports back within 3 weeks. Request portfolio review of color, final art, photostats in original query. Rights purchased vary according to project. Pays for design and illustration by the project in royalties. Finds freelancers through agents, *Workbook*.
Tips: "Shop the stores, study decorative accessories. Read European magazines."

PARAMOUNT CARDS INC., 400 Pine St., Pawtucket RI 02860. (401)726-0800. Fax: (401)727-3890. Contact: Art Coordinator. Estab. 1906. Publishes greeting cards. "We produce an extensive line of seasonal and everyday greeting cards which range from very traditional to whimsical to humorous. Almost all artwork is assigned."
Needs: Works with 50-80 freelancers/year. Uses freelancers mainly for finished art. Also for calligraphy. Considers watercolor, gouache, airbrush and acrylic. Prefers 5½×8⁵⁄₁₆. Produces material for all holidays and seasons. Submit seasonal holiday material 1 year in advance.
First Contact & Terms: Send query letter résumé, SASE (important), photocopies and printed card samples. Samples are filed only if interested, or returned by SASE if requested by artist. Reports back within 1 month if interested. Company will contact artist for portfolio review if interested. Portfolio should include photostats, tearsheets and card samples. Buys all rights. Originals are not returned. Pays by the project, $200-450. Finds artists through word of mouth and submissions.
Tips: "Send a complete, professional package. Only include your best work—you don't want us to remember you from one bad piece. Always include SASE with proper postage and *never* send original art—color photocopies are enough for us to see what you can do. No phone calls please."

PATTERN PEOPLE, INC., 10 Floyd Rd., Derry NH 03038. (603)432-7180. President: Janice M. Copeland. Estab. 1988. Design studio servicing various manufacturers of consumer products. Designs wallcoverings and textiles with "classical elegance and exciting new color themes for all ages."
Needs: Approached by 5 freelancers/year. Works with 2 freelance designers/year. Prefers freelancers with professional experience in various media. Uses freelancers mainly for original finished artwork in repeat. "We use all styles but they must be professional." Special needs are "floral (both traditional and contemporary), textural (faux finishes, new woven looks, etc.) and geometric (mainly new wave contemporary)."
First Contact & Terms: Send query letter with photocopies and transparencies. Samples are filed. Art Director will contact artist for portfolio review if interested. Portfolio should include original/final art and color samples. Sometimes requests work on spec before assigning a job. Pays for design by the project, $100-1,000. Buys all rights. Finds artists through sourcebooks and other artists.

PHUNPHIT DESIGNS, LTD., 56 Lynncliff Rd., Hampton Bays NY 11946. (516)723-1899. Fax: (516)723-3755. E-mail: nolinguini@phunphit.com. Website: http:///www.phunphit.com. President: Barbara A. Demy. Estab. 1995. Purchases art for T-shirt and sweatshirt designs.
Needs: Works with 6-8 freelancers/year. Buys 10-12 freelance designs and illustrations/year. Art guidelines available. Uses freelancers mainly for product illustration. Looking for colorful and distinctive designs.
First Contact & Terms: Illustrators send query letter with photocopies, photographs, tearsheets, SASE. Samples are filed or are returned by SASE only. "No SASE, no reply." Reports back within 6-8 weeks. Rights purchased vary according to project. Pays average flat fee of $300 for illustration; royalties of 5%.
Tips: "Over the next few years, we plan to expand the number of themes we have on the market. We prefer working with several talented individuals who can anticipate our needs and grow with us."

‡PICTURA INC., 4 Andrews Dr., W. Paterson NJ 07424-7058. (973)890-1070. Fax: (800)453-3319. Art Director: Nando Caldarone. Estab. 1982. Produces decorations, giftbags, gifts, greeting cards, mugs, ornaments. Specializes in birthday cards and holiday products.
Needs: Approached by 100 freelancers/year. Works with 2 freelancers/year. Buys 10 freelance designs and illustrations/year. Art guidelines available. Works on assignment only. Uses freelancers mainly for illustration of greeting cards. Looking for traditional, floral, humorous, "off the wall," sentimental, cute animals, adult contemporary designs and illustrations. Produces material for all holidays and seasons. Submit seasonal material 1 year before the holiday.
First Contact & Terms: Send photocopies, résumé, follow-up postcard every year. Accepts disk submissions. Samples are filed. Reports back within 2 months if interested. Portfolio review not required. Buys all rights. Payment negotiable.

PLUM GRAPHICS INC., Box 136, Prince Station, New York NY 10012. (212)337-0999. Contact: Yvette Cohen. Estab. 1983. Produces greeting cards. "They are full-color, illustrated, die-cut; fun images for young and old."
Needs: Buys 12 designs and illustrations/year. Art guidelines not available. Prefers local freelancers only. Uses freelancers for greeting cards only. Considers oil, acrylic, watercolor and computer generated medias.
First Contact & Terms: Send query letter with photocopies. Samples are filed or are returned by SASE if requested by artist. Reports back only if interested. "We'll call to view a portfolio." Portfolio should include final art and color tearsheets. Originals are returned at job's completion. Pays average flat fee of $100-450 for illustration/design. Pays an additional fee if card is reprinted. Considers buying second rights (reprint rights) to previously published work; "depends where it was originally published." Finds artists through word of mouth, submissions and sourcebooks.
Tips: "I suggest that artists look for the cards in stores to have a better idea of the style. They are sometimes totally unaware of Plum Graphics and submit work that is inappropriate."

PLYMOUTH MILLS, INC., Dept. AM, 330 Tompkins Ave., Staten Island NY 10304. (718)447-6707. President: Alan Elenson. Manufacturer of imprinted sportswear: T-shirts, sweatshirts, fashionwear, caps, aprons and bags. Clients: mass merchandisers/retailers.
Needs: Approached by 100 freelance artists/year. Works with 20 freelance illustrators and 8 freelance designers/year. Assigns 100 jobs to freelance artists/year. Uses freelance artists mainly for screenprint designs. Also uses freelance artists for advertising and catalog design, illustration and layout and product design.
First Contact & Terms: Send brochure and résumé. Reports back only if interested. Pays for design and illustration by the hour or by the project. Considers complexity of the project and how work will be used when establishing payment.

MARC POLISH ASSOCIATES, P.O. Box 3434, Margate NJ 08402. (609)823-7661. E-mail: sedonamax@aol.com. President: Marc Polish. Estab. 1972. Produces T-shirts and sweatshirts. "We specialize in printed T-shirts and sweatshirts. Our market is the gift and mail order industry, resort shops and college bookstores."
Needs: Works with 6 freelancers/year. Designs must be convertible to screenprinting. Produces material for Christmas, Valentine's Day, Mother's Day, Father's Day, Hanukkah, graduation, Halloween, birthdays and everyday.
First Contact & Terms: Send query letter with brochure, tearsheets, photographs, photocopies, photostats and slides. Samples are filed or are returned. Reports back within 2 weeks. To show portfolio, mail anything to show concept. Originals returned at job's completion. Pays royalties of 6-10%. Negotiates rights purchased.
Tips: "We like to laugh. Humor sells. See what is selling in the local mall or department store. Submit anything suitable for T-shirts. Do not give up. No idea is a bad idea. It sometimes might have to be changed slightly to fit into a marketplace."

THE POPCORN FACTORY, 13970 W. Laurel Dr., Lake Forest IL 60045. E-mail: nancy.hensel@fgcorp.com. Website: http://www.thepopcornfactory.com. Vice President, Merchandising and Marketing: Nancy Hensel. Estab. 1979. Manufacturer of popcorn cans and other gift items sold via catalog for Christmas, Valentine's Day, Easter and year-round gift giving needs.
Needs: Works with 6 freelance artists/year. Assigns up to 20 freelance jobs/year. Works on assignment only. Art guidelines available. Uses freelancers mainly for cover illustration, can design, fliers and ads. Occasionally uses artists for advertising, brochure and catalog design and illustration. 100% of freelance catalog work requires knowledge of QuarkXPress and Adobe Photoshop.
First Contact & Terms: Send query letter with photocopies, photographs or tearsheets. Samples are filed. Reports back within 1 month. Write for appointment to show portfolio, or mail finished art samples and photographs. Pays for design by the hour, $50 minimum. Pays for catalog design by the page. Pays for illustration by project, $250-2,000.

Considers complexity of project, skill and experience of artist, and turnaround time when establishing payment. Buys all rights.

Tips: "Send classic illustration, graphic designs or a mix of photography/illustration. We can work from b&w concepts—then develop to full 4-color when selected. Do not send art samples via E-mail."

✔PORTAL PUBLICATIONS, LTD., 201 Alameda del Prado, Suite 200, Novato CA 94949. (415)884-6200. E-mail: artsub@portalpub.com. Vice President of Creative: Pamela Prince. Estab. 1954. Produces calendars, giftbags, greeting cards, stationery, T-shirts, mugs, posters and prints. "All Portal products are image-driven, with emphasis on unique styles of photography and illustration. All age groups are covered in each product category, although the prime market is female, ages 18 to 45."

Needs: Approached by 1,000 + freelancers (includes photographers and illustrators)/year. Freelance designs and illustrations purchased per year varies, 12 + calligraphy projects/year. Prefers freelancers with experience in "our product categories." Art guidelines free for SASE with first-class postage. Works on assignment only. Uses freelancers mainly for primary image, photoshop work and calligraphy. Considers any media. Looking for "not too high-end, but unique illustration—humorous illustration is a growth category in our card division." 90% of freelance design demands knowledge of the most recent versions of Adobe Illustrator and QuarkXPress. Submit seasonal material 12 months in advance.

First Contact & Terms: Send query letter with photocopies and SASE and follow-up postcard every 6 months. Prefers color copies to disk submissions. Samples are filed or returned by SASE. Reports back only if interested. Will contact for portfolio review of b&w, color and final art if interested. Rights purchased vary according to project.

Tips: "Send color copies of your work that we can keep in our files—also, know our product lines."

PORTERFIELD'S, 12 Chestnut Pasture Rd., Concord NH 03301. (800)660-8345 or (603)228-1864. Fax: (603)228-1888. E-mail: ljklass@aol.com. Website: http://www.porterfields.com. President: Lance Klass. Estab. 1994. Produces collector plates and other limited editions. Also functions as a full-service licensing representative for individual artists wishing to find publishers or licensees. "We produce high-quality limited-edition collector plates and prints sold in the U.S. and abroad through direct response and retail. Seeking excellent representational art on all subjects including children, florals, landscapes, baby wildlife, foreign and domestic (cats/kittens, puppies/dogs), cottages and English country scenes. Also looking for artists who can create realistic representational works from references supplied to them."

Needs: Approached by 100 freelancers/year. Buys or licenses many freelance designs and illustrations/year. Prefers representational artists "who can create beautiful pieces of art that people want to look at and look at." Art guidelines not available. Considers existing works first. Considers any media—oil, pastel, pencil, acrylics. "We want artists who have exceptional talent and who would like to have their art and their talents introduced to the broad public."

First Contact & Terms: Send query letter with tearsheets, photographs, slides, SASE, photocopies and transparencies. Samples are filed or returned by SASE. Reports back within 2 weeks. Will contact for portfolio review if interested. Portfolio should include tearsheets, photographs and transparencies. Rights purchased vary. Pays royalties for licensed works and/or flat fee for commissioned single works; royalty for products produced directly by Porterfield's. Generally pays advance against royalties when work accepted, royalties/sale paid after product sales are made.

Tips: "We are impressed first and foremost by level of ability, even if the subject matter is not something we would use. Thus a demonstration of competence is the first step; hopefully the second would be that demonstration using subject matter that we feel would be marketable. We work with artists to help them with the composition of their pieces for particular media. We treat artists well, and actively represent them to potential licensees. Instead of trying to reinvent the wheel yourself and contact everyone 'cold,' get a licensing agent or rep whose particular abilities complement your art. For example, we specialize in the application of art of all kinds to limited and open-edition collectibles and also to print media such as cards, stationery, calendars, prints, lithographs and even fabrics. Other licensing reps and companies specialize in decorative art, cartoons, book illustrations, etc.—the trick is to find the right rep whom you feel you can work with, who really loves your art whatever it is, and whose specific contacts and abilities can help further your art in the marketplace."

PORTFOLIO GRAPHICS, INC., 4060 S. 500 W., Salt Lake City UT 84123. (801)266-4844. Fax: (801)263-1076. Creative Director: Kent Barton. Estab. 1986. Produces greeting cards, fine art posters, prints, limited editions. Fine art publisher and distributor world-wide. Clients include frame shops, galleries, gift stores and distributors.

● Portfolio Graphics also has a listing in the Posters & Prints section of this book.

Needs: Approached by 200-300 freelancers/year. Works with 30 freelancers/year. Buys 50 freelance designs and illustrations/year. Art guidelines free for SASE with first-class postage. Considers all media. "Open to large variety of styles." Produces material for Christmas, everyday, birthday, sympathy, get well, anniversary.

First Contact & Terms: Illustrators send résumé, slides, tearsheets, SASE. "Slides are best. Do not send originals." Samples are filed "if interested" or returned by SASE. Reports back in 2-3 weeks. Negotiates rights purchased. Pays 10% royalties. Finds artists through galleries, word of mouth, submissions, art shows and exhibits.

Tips: "Open to a variety of submissions, but most of our artists sell originals as fine art home or office decor. Keep fresh, unique, creative."

✔POTPOURRI DESIGNS, 4411 W. Market St., Suite 301, Greensboro NC 27419. Mailing address: Box 19566, Greensboro NC 27407. (910)852-8961. Fax: (910)852-1402. Vice President of New Product Development: Richard Moser. Estab. 1968. Produces paper products including bags, boxes, stationery and tableware; tins; stoneware items;

and Christmas and home decor products for gift shops, the gourmet shop trade and department stores. Targets women age 25 and older.

Needs: Buys 10-20 freelance designs and 10-20 illustrations/year. "Our art needs are increasing. We need freelancers who are flexible and able to meet deadlines." Works on assignment only. Uses freelancers for calligraphy, mechanicals and art of all kinds for product reproduction. Prefers watercolor and acrylic. Also needs mechanical work. Seeking traditional, seasonal illustrations for Christmas introductions and feminine florals for everyday. Submit seasonal material 1-2 years in advance.

First Contact & Terms: Send query letter with résumé and tearsheets, slides or photographs. Samples not filed are returned by SASE. Will contact for portfolio review if interested. Pays average flat fee of $300; or pays by project, $1,000-5,000 average. Buys all rights. Finds artists through word of mouth, magazines, submissions/self-promotions, sourcebooks, agents, visiting artist's exhibitions, art fairs and artists' reps.

Tips: "Our audience has remained the same but our products are constantly changing as we continue to look for new products and discontinue old products. I often receive work from artists that is not applicable to our line. I prefer that artists learn more about the company before submitting work."

PRATT & AUSTIN COMPANY, INC., Dept. AGDM, 642 S. Summer St., Holyoke MA 01040. (413)532-1491. Fax: (413)536-2741. President: Bruce Pratt. Art Director: Lorilee Costello. Estab. 1931. Produces envelopes, children's items, stationery and calendars. Does not produce greeting cards. "Our market is the modern woman at all ages. Design must be bright, cute busy and elicit a positive response." Using more recycled paper products and endangered species designs.

Needs: Approached by 100-200 freelancers/year. Works with 20 freelancers/year. Buys 100-150 designs and illustrations/year. Art guidelines available. Uses freelancers mainly for concept and finished art. Also for calligraphy.

First Contact & Terms: Send non-returnable samples, such as postcard or color copies. Samples are filed or are returned by SASE if requested. Will contact for portfolio review if interested. Portfolio should include thumbnails, roughs, color tearsheets and slides. Pays flat fee. Rights purchased vary. Interested in buying second rights (reprint rights) to previously published work. Finds artists through submissions and agents.

PRE-EMPTIVE PRODUCTS, INC.-3 CENTURY DESIGNS, 2048 Elm St., Stratford CT 06497. (203)378-6725. Fax: (203)380-0456. E-mail: thomas.berquist@gte.net. President: Tom Berquist. Estab. 1985. Produces children's picture books, greeting cards and framed prints. Specializes in decorative framed art prints sold to gift catalogs, retail museum shops, schools, etc. All ages mostly female.

Needs: Approached by 15-20 freelancers/year. Works with 3-5 freelancers/year. Buys 300-500 freelance designs and illustrations/year. Considers art, acrylic and watercolor. Looking for mostly traditional/stylistic with mass-market romantic human interest. Seasonal or topical subjects as accent piece for kitchens, bath, den, etc. Prefers 11×14 or smaller. Produces material for Christmas, everyday, office occasions-retirement, promotion, achievement, maternity. Submit seasonal material 1 year in advance.

First Contact & Terms: Designers and cartoonists send query letter with photocopies. Samples are filed and are not returned. Reports back only if interested. Rights purchased vary according to project. Pays royalties of 3-5% for original art. Finds freelancers through word of mouth.

‡❧PRESENCE OF MINE GREETINGS, 6656 Thornberry Crescent, Windsor, Ontario N8T 2X2 Canada. (519)944-1633. Fax: (519)944-2874. E-mail: jlees@wincom.net. Art Director: Frank D'Angelo. Estab. 1995. Produces greeting cards, giftwrap, stationery, gift boxes. "Our company is proudly comprised of a select group of highly innovative designers and artists. Diligently crafted by hand (absolutely no printed work), the products we carry are one of a kind numbered editions, signed by the creator. Framing of cards is encouraged by the purchaser. Clients include museums, gallery shops, paperies and speciality gift and bookstores."

● A percentage of this company's sales goes to support the arts at the college and university levels.

Needs: Approached by 150 freelancers/year. Works with 18 freelancers/year. Art guidelines available for SASE with first-class postage. Works on assignment only. Considers oil, watercolor, acrylic, found objects, collage, fabrics, organic materials, Japanese papers, etc. "Anything that works! Very high-end elegant, contemporary, extremely unique designs— but must be 'do-able' in quantity by the artist." Prefers verticle formats. Produces material for all holidays and seasons, 75% are all occasion cards, all cards blank inside. Submit seasonal material 1 year in advance.

First Contact & Terms: Send query letter with résumé, SASE, samples of finished cards at appropriate size. "Package should be professionally put together, as this will determine your committment to high standards, quality control and interest in being successful." Samples are filed or returned by SASE if requested by artist. Reports back within 2 months. Negotiates rights purchased. Pays "40% of the wholesale cost of the card, stationery or gift packaging. Wholesale prices are established by the company." Finds freelancers through advertising in graphic design trade magazines obtaining members' lists of art organizations, through universities and college-degreed art programs, part-time study programs and word of mouth.

Tips: "Send a professionally put together package meeting all specs and only what you love. Put your best piece first and your second best piece last. Only put your best work in when you're showing your portfolio. Bad work or poor work or work you are not confident with will show in your expressions and in your mannerisms."

THE PRINTERY HOUSE OF CONCEPTION ABBEY, Conception MO 64433. (660)944-2632. Fax: (660)944-2582. Website: http://www.msc.net/cabbey/. Art Director: Rev. Norbert Schappler. Estab. 1950. Publishes religious

greeting cards. Specializes in religious Christmas and all-occasion themes for people interested in religious, yet contemporary, expressions of faith. "Our card designs are meant to touch the heart. They feature strong graphics, calligraphy and other appropriate styles."

Needs: Approached by 75 freelancers/year. Works with 25 freelancers/year. Art guidelines available for SASE with first-class postage. Uses freelancers for product illustration. Prefers acrylic, pastel, oil, watercolor, line drawings and classical and contemporary calligraphy. Looking for dignified styles and solid religious themes. Produces seasonal material for Christmas and Easter "as well as the usual birthday, get well, sympathy, thank you, etc. cards of a religious nature. Creative general message cards are also needed." Strongly prefers calligraphy to type style. 2% of freelance work requires knowledge of Adobe Photoshop or Adobe Illustrator.

First Contact & Terms: Send query letter with résumé, photocopies, photographs, SASE, slides or tearsheets. Calligraphers send any printed or finished work. Non-returnable samples preferred—or else samples with SASE. Accepts submissions on disk compatible with Adobe Photoshop or Adobe Illustrator. Send TIFF or EPS files. Reports back usually within 3 weeks. To show portfolio, mail appropriate materials only after query has been answered. "In general, we continue to work with artists once we have accepted their work." Pays flat fee of $150-300 for illustration/design, and $50-100 for calligraphy. Usually buys exclusive reproduction rights for a specified format; occasionally buys complete reproduction rights.

Tips: "Abstract or semi-abstract background designs seem to fit best with religious texts. Color washes and stylized designs are often appropriate. Remember our specific purpose of publishing greeting cards with a definite Christian/religious dimension but not piously religious. It must be good quality artwork. We sell mostly via catalogs so artwork has to reduce well for catalog." Sees trend towards "more personalization and concern for texts."

PRISMATIX, INC., 333 Veterans Blvd., Carlstadt NJ 07072. (201)939-7700. Fax: (201)939-2828. Vice President: Miriam Salomon. Estab. 1977. Produces novelty humor programs. "We manufacture screen-printed novelties to be sold in the retail market."

Needs: Works with 3-4 freelancers/year. Buys 20 freelance designs and illustrations/year. Works on assignment only. 90% of freelance work demands computer skills.

First Contact & Terms: Send query letter with brochure, résumé. Samples are filed. Reports back to the artist only if interested. Portfolio should include color thumbnails, roughs, final art. Payment negotiable.

PRODUCT CENTRE-S.W. INC./THE TEXAS POSTCARD CO., Box 860708, Plano TX 75086. (972)423-0411. Fax: (972)578-0592. Art Director: Susan Grimland. Produces postcards. Themes range from nostalgia to art deco to pop/rock for contemporary buyers.

Needs: Buys 25 designs from freelancers/year. Uses freelancers for P-O-P display, paste-up and mechanicals. Considers any media, but "we do use a lot of acrylic/airbrush designs." Prefers contemporary styles. Final art must not be larger than 8×10. "Certain products require specific measurements. We will provide these when assigned."

First Contact & Terms: Send résumé, business card, slides, photostats, photographs, photocopies and tearsheets to be kept on file. Samples not filed are returned only by request with SASE including return insurance. Reports within 4 months. Originals are not returned. Call or write to show portfolio. Pays by the project, $100-200. Buys all rights.

Tips: "Artist should be able to submit camera-ready work and understand printer's requirements. The majority of our designs are assigned. No crafty items or calligraphy. No computer artwork."

PRODUCT CONCEPT CONSULTING, INC, 3334 Adobe Court, Colorado Springs CO 80907. (719)632-1089. Fax: (719)632-1613. President: Susan Ross. Estab. 1986. New product development agency. "We work with a variety of companies in the gift and greeting card market in providing design, new product development and manufacturing services."

● This company has recently added children's books to its product line.

Needs: Works with 20-25 freelancers/year. Buys 400 designs and illustrations/year. Prefers freelancers with 3-5 years experience in gift and greeting card design. Works on assignment only. Buys freelance designs and illustrations mainly for new product programs. Also for calligraphy, P-O-P display and paste-up. Considers all media. 25% of freelance work demands knowledge of Adobe Illustrator, Adobe Streamline, QuarkXPress or Aldus FreeHand. Produces material for all holidays and seasons.

First Contact & Terms: Send query letter with résumé, tearsheets, photostats, photocopies, slides and SASE. Samples are filed or are returned by SASE if requested by artist. Reports back within 1 month. To show portfolio, mail color and b&w roughs, final reproduction/product, slides, tearsheets, photostats and photographs. Originals not returned. Pays average flat fee of $250; or pays by the project, $250-2,000. Buys all rights.

Tips: "Be on time with assignments." Looking for portfolios that show commercial experience.

‡PRUDENT PUBLISHING, 65 Challenger Rd., Ridgefield Park NJ 07660. (201)641-7900. Fax: (201)641-5248. Marketing: Mary Patton. Estab. 1928. Produces calendars and greeting cards. Specializes in business/corporate all-occasion and holiday cards.

Needs: Buys calligraphy. Art guidelines available. Uses freelancers mainly for card design, illustrations and calligraphy. Considers traditional media.. Prefers no cartoons or cute illustrations. Prefers $5\frac{1}{2} \times 7\frac{7}{8}$ (or proportionate to those numbers). Produces material for Christmas, Thanksgiving, birthdays, everyday, sympathy, get well and thank you.

First Contact & Terms: Designers, illustrators and calligraphers send query letter with brochure, photostats, photocopies, tearsheets, photocopies. Accepts disk submissions compatible with Adobe Illustrator 7.0 and Photoshop 4.0. Samples

are filed or returned by SASE if requested. Reports back ASAP. Portfolio review not required. Buys all rights. Pay is negotiable. Finds freelancers through artist's submissions, magazines, sourcebooks, agents and word of mouth.
Tips: "No cartoons."

RAGNAROK GAMES, P.O. Box 140333, Austin TX 78714. (512)472-6535. Fax: (512)472-6220. E-mail: ragnarokgc @aol.com. Websites: http://www.ccsi.com/~graball/quest and http://www.ccsi.com/~graball/ragnarok. Editorial Director: David Nallie. Estab. 1979. Produces games and books.
 ● Also see listing for Ragnarok in the Book Publishers section, and *Abyss* in the Magazines section. Company has formed partnership with Stone Ring Games. David Nallie told *AGDM* they are actively seeking good color artists for spot art and game cards.
Needs: Approached by 80-100 freelancers/year. Works with 15-20 freelancers/year. Buys 150-500 designs and illustrations/year. Uses freelancers mainly for color and b&w topical illustrations. Also for playing card illustrations. 60% of freelance illustration demands knowledge of Adobe Photoshop, Aldus PageMaker, QuarkXPress.
First Contact & Terms: Send postcard sample or query letter with brochure, tearsheets, photostats, photographs, slides, SASE, photocopies, transparencies or e-mail. Samples are filed, or are returned by SASE. Company will contact artist for portfolio review in 2 months if interested. Artist should follow-up with call and/or letter after initial query. Portfolio should include roughs, photostats, tearsheets, photographs, slides, transparencies. Negotiates rights purchased. Originals returned at job's completion. Pays by the project, $20-4,000.

RAINBOW CREATIONS, INC., 216 Industrial Dr., Ridgeland MS 39157. (601)856-2158. Fax: (601)856-5809. President: Steve Thomas. Estab. 1976. Produces wallpaper.
Needs: Approached by 10 freelancers/year. Works with 5 freelancers/year. Buys 45 freelance designs and illustrations/year. Prefers freelancers with experience in Illustrator, Photoshop. Art guidelines available on individual project basis. Works on assignment only. Uses freelancers mainly for new border designs. Also for setting designs in repeat. Considers Mac and hand painted media. 50% of freelance design work demands knowledge of Adobe Photoshop and Adobe Illustrator. Produces material for everyday.
First Contact & Terms: Designers send query letter with photocopies, photographs and résumé. Illustrators send postcard sample of work only. "We will accept disk submissions if compatible with Adobe Illustrator 5.0." Samples are returned. Reports back within 7 days. Buys all rights. Pays for design and illustration by the project, $200-500.
Tips: "If experienced in the field of textile/wallcovering call me directly."

RECO INTERNATIONAL CORPORATION, Collector's Division, Box 951, 138-150 Haven Ave., Port Washington NY 11050. (516)767-2400. E-mail: recoint@aol.com. Manufacturer/distributor of limited editions, collector's plates, lithographs and figurines. Sells through retail stores and direct marketing.
Needs: Works with freelance and contract artists. Uses freelancers under contract for plate and figurine design and limited edition fine art prints. Prefers romantic and realistic styles.
First Contact & Terms: Send query letter and brochure to be filed. Write for appointment to show portfolio. Art Director will contact artist for portfolio review if interested. Negotiates payment. Considers buying second rights (reprint rights) to previously published work.
Tips: "Have several portfolios available. We are very interested in new artists. We go to shows and galleries, and receive recommendations from artists we work with."

✔RECYCLED PAPER GREETINGS INC., 3636 N. Broadway, Chicago IL 60613. (773)348-6410. Fax: (773)281-1697. Art Director: Melinda Gordon. Art Coordinator: Gretchen Hoffman. Publishes greeting cards, adhesive notes and mugs.
Needs: Buys 1,000-2,000 freelance designs and illustrations. Considers b&w line art and color—"no real restrictions." Looking for "great ideas done in your own style with messages that reflect your own slant on the world." Prefers 5×7 vertical format for cards; 10×14 maximum. "Our primary interest is greeting cards." Produces seasonal material for all major and minor holidays including Jewish holidays. Submit seasonal material 18 months in advance; everyday cards are reviewed throughout the year.
First Contact & Terms: Send SASE to Gretchen Hoffman for artist's guidelines. "Please do not send slides or tearsheets. We're looking for work done specifically for greeting cards."Reports in 2 months. Portfolio review not required. Originals returned at job's completion. Sometimes requests work on spec before assigning a job. Pays average flat fee of $250 for illustration/design with copy. Some royalty contracts. Buys all rights.
Tips: "Remember that a greeting card is primarily a message sent from one person to another. The art must catch the customer's attention, and the words must deliver what the front promises. We are looking for unique points of view and manners of expression. Our artists must be able to work with a minimum of direction and meet deadlines. There is a renewed interest in the use of recycled paper—we have been the industry leader in this for more than two decades."

RED FARM STUDIO, 1135 Roosevelt Ave., P.O. Box 347, Pawtucket RI 02862-0347. (401)728-9300. Fax: (401)728-0350. Contact: Creative Director. Estab. 1955. Produces greeting cards, giftwrap and stationery from original watercolor art. Also produces coloring books and paintable sets. Specializes in nautical and traditional themes. Approached by 150 freelance artists/year. Buys 200 freelance designs and illustrations/year. Uses freelancers for greeting cards, notes, Christmas cards. Considers watercolor artwork for cards, notes and stationery; b&w linework and tonal pencil drawings for coloring books and paintable sets; will also consider other media (oils, pastel, etc.) for specialty lines. Looking for

accurate, detailed, realistic work, though some looser watercolor styles are also acceptable. Produces material for Christmas and everyday occasions. Also interested in traditional, realistic artwork for religious line: Christmas, Easter, Mother's and Father's Day and everyday subjects, including realistic portrait and figure work, such as the Madonna and Child.

First Contact & Terms: First send query letter and #10 SASE to request art guidelines. Submit printed samples, transparencies, color copies or photographs with a SASE. Samples not filed are returned by SASE. Art Director will contact artist for portfolio review if interested. Pays flat fee of $250-350 for card or note illustration/design, or pays by project, $250-1000. Buys all rights.

Tips: "We are interested in clean, bright watercolor work of traditional subjects like florals, birds, kittens, some cutes, puppies, shells and nautical scenes. No photography. Our guidelines will help to explain our needs."

‡REEDPRODUCTIONS, 52 Leveroni Court, Suite 3, Novato CA 94949. (415)883-1851. E-mail: reedpro@earthlink.net. Owner/Art Director: Susie Reed. Estab. 1978. Produces celebrity postcards, key rings, magnets, address books, etc. Specializes in products related to Hollywood memorabilia.

Needs: Approached by 20 freelancers/year. Works with few freelancers/year. Art guidelines are not available. Prefers local freelancers with experience. Works on assignment only. Artwork used for paper and gift novelty items. Also for paste-up and mechanicals. Prefers color or b&w photorealist illustrations of celebrities.

First Contact & Terms: Send query letter with brochure or résumé, tearsheets, photostats, photocopies or slides and SASE. Samples are filed or are returned by SASE. Art Director will contact artist for portfolio review if interested. Portfolio should include color or b&w final art, final reproduction/product, slides, tearsheets and photographs. Originals are returned at job's completion. Payment negotiated at time of purchase. Considers buying second rights (reprint rights) to previously published work.

RENAISSANCE GREETING CARDS, Box 845, Springvale ME 04083. (207)324-4153. Fax: (207)324-9564. Art Director: Janice Keefe. Estab. 1977. Publishes greeting cards; "current approaches" to all-occasion cards, seasonal cards, Christmas cards including nostalgic themes. "Alternative card company with unique variety of cards for all ages, situations and occasions."

Needs: Approached by 500-600 artists/year. Buys 350 illustrations/year. Occasionally buys calligraphy. Art guidelines available free for SASE with first-class postage. Full-color illustrations only. Produces materials for all holidays and seasons and everyday. Submit art 18 months in advance for fall and Christmas material; approximately 1 year in advance for other holidays.

First Contact & Terms: Send query letter with SASE. To show portfolio, mail color copies, tearsheets, slides or transparencies. Packaging with sufficient postage to return materials should be included in the submission. Reports in 2 months. Originals are returned to artist at job's completion. Sometimes requests work on spec before assigning a job. Pays for design by the project, $150-300 advance on royalties or flat fee, negotiable. Finds artists mostly through submissions/self-promotions.

Tips: "Do some 'in store' research first to get familiar with a company's product/look in order to decide if your work is a good fit. It can take a lot of patience to find the right company or situation. Especially interested in trendy styles as well as humorous concepts and illustration. Start by requesting guidelines and then send a small (10-12) sampling of 'best' work, preferably color copies or slides (with SASE for return). Indicate if the work shown is available or only samples. We're doing more designs with special effects like die-cutting and embossing."

RIGHTS INTERNATIONAL GROUP, 463 First St. #3C, Hoboken NJ 07030. (201)963-3123. Fax: (201)420-0679. E-mail: hazaga@aol.com. Contact: Robert Hazaga. Estab. 1996. Agency for cross licensing. Licenses images for manufacturers of giftware, stationery, posters, home furnishing.

● This company also has a listing in the Posters & Prints section.

Needs: Approached by 50 freelancers/year. Uses freelancers mainly for creative, decorative art for the commercial and designer market. Also for textile art. Considers oil, acrylic, watercolor, mixed media, pastels and photography.

First Contact & Terms: Send brochure, photocopies, photographs, SASE, slides, tearsheets or transparencies. Accepts disk submissions compatible with Adobe Illustrator. Reports back within 1 month. Will contact for portfolio review if interested. Negotiates rights purchased and payment.

RITE LITE LTD./THE JACOB ROSENTHAL JUDAICA-COLLECTION, 260 47th St., Brooklyn NY 11220. (718)439-6900. Fax: (718)439-5197. E-mail: ritelite@aol.com. President: Alex Rosenthal. Estab. 1948. Manufacturer and distributor of a full range of Judaica ranging from mass-market commercial goods, such as decorative housewares, to exclusive numbered pieces, such as limited edition plates. Clients: department stores, galleries, gift shops, museum shops and jewelry stores.

● Company is looking for new menorah, mezuzah, children's Judaica, Passover and matza plate designs.

Needs: Approached by 15 freelancers/year. Works with 4 freelancers/year. Art guidelines not available. Works on assignment only. Uses freelancers mainly for new designs for Judaic giftware. Must be familiar with Jewish ceremonial objects or design. Prefers ceramic, brass and glass. Also uses artists for brochure and catalog design, illustration and layout mechanicals, P-O-P and product design. 25% of freelance work requires knowledge of Adobe Illustrator and Adobe Photoshop. Produces material for Hannukkah, Passover, Hasharah. Submit seasonal material 1 year in advance.

First Contact & Terms: Designers send query letter with brochure or résumé and photographs. Illustrators send photocopies. Do not send originals. Samples are filed. Reports back within 1 month only if interested. Portfolio review

Sherry Schmidt's design uses "folk art and friendly motifs for a very sendable card, which works well for a lot of situations," says Janice Keefe of Renaissance Greeting Cards. Here the design is used as a cheery "Get Well Soon" greeting in the company's Soft Sentiments line. "Sherry is great at taking rough concepts we supply and coming up with timely, trendy card designs," says Keefe. "With a big line of cards, it's a challenge for us to come up with new and unique designs and formats."

not required. Art Director will contact for portfolio review if interested. Portfolio should include color tearsheets, photographs and slides. Pays flat fee of $500/design or royalties of 5-6%. Buys all rights. "Works on a royalty basis." Finds artists through word of mouth.

Tips: "Be open to the desires of the consumers. Don't force your preconceived notions on them through the manufacturers. Know that there is one retail price, one wholesale price and one distributor price."

SANGHAVI ENTERPRISES PVT LTD., (formerly Greetwell), D-24, M.I.D.C., Satpur, Nasik 422 007 India. Fax: 91-253-351381. Chief Executive: H.L. Sanghavi. Produces greeting cards, calendars and posters.

Needs: Approached by 50-60 freelancers/year. Buys 50 designs/year. Uses freelancers mainly for greeting cards and calendars. Prefers flowers, landscapes, wildlife and general themes.

First Contact & Terms: Send query letters and photocopies to be kept on file. Samples not filed are returned only if requested. Reports within 1 month. Originals are returned at job's completion. Pays flat fee of $25 for design. Buys reprint rights.

Tips: "Send color photos. Do not send originals. No SASE."

SANGRAY CORPORATION, 2318 Lakeview Ave., Pueblo CO 81004. (719)564-3408. Fax: (719)564-0956. President: James Stuart. Estab. 1971. Produces refrigerator magnets, trivets, wall decor and other decorative accessories—all using full-color art.

Needs: Approached by 30-40 freelancers/year. Works indirectly with 6-7 freelancers/year. Buys 25-30 freelance designs and illustrations/year. Prefers florals, scenics, small animals and birds. Uses freelancers mainly for fine art for products. Considers all media. Prefers 7×7. Submit seasonal material 10 months in advance.

First Contact & Terms: Send query letter with examples of work in any media. Samples are filed. Reports back within 30 days. Company will contact artist for portfolio review if interested. Buys first rights. Originals are returned at job's completion. Pays by the project, $250-400. Finds artists through submissions and design studios.

✔*SCANDECOR INC., Box 656, S-751 27 Uppsala Sweden. Contact: Helena Westman. Produces posters, calendars, greeting cards and art prints.

● Scandecor has offices in the United States and Europe. All artwork is now being chosen out of Sweden Office. Scandecor no longer owns Opus One, which is now a division of the New York Graphic Society. Scandecor's U.S. office is located in Southampton PA, but that office is not currently taking submissions.

Needs: Looking for cute and trendy designs mainly for posters for boys, girls and teens. Prefers illustrations and airbrush work. Art prints needs are fine art in floral, traditional and contemporary styles.

First Contact & Terms: Samples not filed are returned by SASE. Artist should follow-up after initial query. Art Director will contact artist for portfolio review if interested. Portfolio should include color slides, photostats and photographs. Originals are sometimes returned at job's completion. Requests work on spec before assigning a job. Negotiates rights purchased. Finds artists through magazines, submissions, gift shows and art fairs. Advises artists to attend local gift shows.

SEABRIGHT PRESS INC., P.O. Box 7285, Santa Cruz CA 95061. (408)457-1568. Fax: (408)459-8059. E-mail: artcards@cruzio.com. Editor: Jim Thompson. Estab. 1990. Produces greeting cards and journals.

Needs: Approached by 20-30 freelancers/year. Works with 5-10 freelancers/year. Licenses 10-20 freelance designs and illustrations/year. Uses freelancers mainly for notecard designs. Art guidelines available for SASE with first-class postage. Considers any media. Produces material for all holidays and seasons. Submit seasonal material 4-6 months in advance.

First Contact & Terms: Send query letter with brochure, tearsheets, photographs, photocopies and SASE. Do not submit artwork via e-mail. Samples are not filed and are returned by SASE if requested by artist. Reports back within 2 months. Portfolio review not required. Negotiates rights purchased. Originals are returned at job's completion. Pays royalties of 5-7%.

Tips: "Be familiar with the notecard market before submitting work. Develop contemporary illustrations/designs that are related to traditional card themes."

SEABROOK WALLCOVERINGS, INC., 1325 Farmville Rd., Memphis TN 38122. (901)320-3500. Fax: (901)320-3675. Marketing Product Manager: Barbara Brower. Estab. 1910. Developer and distributor of wallcovering and coordinating fabric for all age groups and styles.

Needs: Approached by 10-15 freelancers/year. Works with approximately 15 freelancers/year. Buys approximately 400 freelance designs and illustrations/year. Prefers freelancers with experience in wall coverings. Art guidelines available. Works on assignment only. Uses freelancers mainly for designing and styling wallcovering collections. Considers gouache, oil, watercolor, etc. Prefers $20\frac{1}{2} \times 20\frac{1}{2}$. Produces material for everyday.

HUMOR & CARTOON markets are listed in the Humor & Cartoon Index located at the back of this book

First Contact & Terms: Designers send query letter with color photocopies, photographs, résumé, slides, transparencies and sample of artists' "hand." Illustrators send query letter with color photocopies, photographs and résumé. Samples are filed or returned. Reports back within 2 weeks. Company will contact artist for portfolio review of final art, roughs, transparencies and color copies if interested. Buys all rights. Pays for design by the project. Finds freelancers through word of mouth, submissions, trade shows.
Tips: "Attend trade shows pertaining to trends in wall covering. Be familiar with wallcovering design repeats."

PAULA SKENE DESIGN, 1250 45th St., Suite 240, Emeryville CA 94608. (510)654-3510. Fax: (510)654-3496. President: Paula Skene. Produces and markets greeting cards, stationery and corporate designs to meet specific client needs featuring foil stamping and embossing.
Needs: Works with 1-2 freelancers/year. Works on assignment only. Produces material for all holidays and seasons, everyday.
First Contact & Terms: Designers send tearsheets and photocopies. Illustrators send sample, call for appointment. Samples are returned. Reports back within 3 days. Company will contact artist for portfolio review of b&w, color final art if interested. Buys all rights. Pays for design and illustration by the project.

SMART ART, P.O. Box 661, Chatham NJ 07928. (973)635-1690. Fax: (973)635-2011. E-mail: smartart@juno.com. President: Barb Hauck-Mah. Vice President: Wesley Mah. Estab. 1992. Produces photo frame cards. "Smart Art creates unique, premium-quality cards for all occasions. We contribute a portion of all profits to organizations dedicated to helping our nation's kids."
 • Smart Art is continuing to expand its photo frame card line, so they are looking for artists who can do great watercolor, collage or mixed media border designs. The cards are ready-to-use "frames" customers can slip photos into and mail to friends.
Needs: Approached by 40-50 freelancers/year. Works with 6 freelancers/year. Buys 20-25 illustrations/year. Art guidelines available for SASE with first-class postage. Works on assignment only. Uses freelancers for card design/illustration. Considers watercolor, pen & ink and collage or mixed media. Produces material for most holidays and seasons, plus birthdays and everyday. Submit seasonal material 10-12 months in advance.
First Contact & Terms: Send query letter with tearsheets, photocopies, résumé and SASE. Samples are filed or returned by SASE. Reports back within 8-10 weeks. Portfolio review not required. Sometimes requests work on spec before assigning a job. Originals are returned at job's completion. Pays royalties of 5%, based on wholesale money earned. Negotiates rights purchased. Finds artists through word of mouth and trade shows.
Tips: "Send us rough color samples of potential greeting cards or border designs you've created."

‡SPARROW & JACOBS, 2870 Janitell Rd., Colorado Springs CO 80906. (719)579-9011. Fax: (719)579-9007. Art Director: Peter Schmidt. Estab. 1986. Produces calendars, greeting cards, postcards. Publisher of greeting cards and other material for businesses to send for prospecting, retaining and informing clients.
Needs: Approached by 60-80 freelancers/year. Works with 30 freelancers/year. Buys 50 freelance designs and illustrations/year. Art guidelines not available. Works on assignment only. Uses freelancers mainly for illustrations for postcards and greeting cards. Also for calligraphy and computer work. Considers all media. Looking for humorous, sophisticated cartoons and traditional homey and warm illustrations of sweet animals, client/business communications. Prefers 8×10 size. 100% of design and 20% of illustration demands knowledge of Adobe Photoshop, Adobe Illustrator, QuarkXPress. Produces material for Christmas, Easter, Mother's Day, Father's Day, graduation, Halloween, New Year, Thanksgiving, Valentine's Day, birthdays, everyday, "just listed/just sold," time change, doctor-to-patient reminders. Submit seasonal material 1 year in advance.
First Contact & Terms: Send query letter with color photocopies, photographs, slides or tearsheets. Accepts Mac-compatible disk submissiions. Samples are filed or returned. Reports back only if interested. Portfolios of color final art may be dropped off every Monday-Friday. Buys all rights. Pays for design by the hour or by the project, $15-25. Pays for illustration by the project, $300-500.

SPENCER GIFTS, INC., 6826 Black Horse Pike, Egg Harbor Twp. NJ 08234-4197. (609)645-5526. Fax: (609)645-5651. E-mail: jamesstevenson@spencergifts.com. Art Director: James Stevenson. Estab. 1965. Retail gift chain located in approximately 500 malls in 43 states. Includes a new retail chain of 20 stores named "DAPY" (upscaled unique gift items).
 • Products offered by this chain include posters, T-shirts, games, mugs, novelty items, cards, 14k jewelry, neon art, novelty stationery. Art Director says Spencer's is moving into a lot of different product lines, such as custom lava lights and Halloween costumes. Visit a store if you can to get a sense of what they offer.
Needs: Assigns 10-15 freelance jobs/year. Prefers artists with professional experience in advertising. Uses artists for illustration (hard line art, fashion illustration, airbrush). Uses a lot of freelance computer art. 50% of freelance work demands knowledge of Aldus FreeHand, Adobe Illustrator, Adobe Photoshop and QuarkXPress. Also needs color separators, production and packaging people. "You don't necessarily have to be local for freelance production."
First Contact & Terms: Send postcard sample or query letter with *nonreturnable* brochure, résumé and photocopies including phone number where you can be reached during business hours. Accepts submissions on disk. Art director will contact artist for portfolio review if interested. Will contact only upon job need. Considers buying second rights (reprint rights) to previously published work. Finds artists through sourcebooks.

‡**STONE GINGER PRESS, INC.**, 2907 Summerfield Dr., Louisville KY 40220-2832. (502)493-4890. Fax: (502)493-4893. E-mail: rhaines@stoneginger.com. Website: http://www.stoneginger.com. Executive Director: Jodi Michel. Estab. 1988. Produces greeting cards, stationery and line of crafty everyday notecards.
• This company plans to expand into holiday cards with a craft theme. Many of their designs are quilt related. Check out their website. It is extremely well designed and gives of great idea of what they do.
Needs: Approached by 5 freelancers/year. Works with 5 freelancers/year. Buys 8-12 freelance designs and illustrations/year. Art guidelines available for SASE with first-class postage. Uses freelancers mainly for new designs. Looking for traditional style. Prefers 5×7. 80% of freelance design works demands knowledge of Adobe Photoshop, QuarkXPress. Produces material for all holidays and seasons, everyday. Submit seasonal material 5 months in advance.
First Contact & Terms: Send query letter with brochure, slides. Samples are filed. Reports back only if interested. Portfolio review not required. Rights purchased vary according to project. Finds freelancers through word of mouth and submissions.

STOTTER, 100 Second St., Plainfield NJ 07063. (908)754-6330. Fax: (908)757-5241. V.P. Marketing: David Rubin. Estab. 1979. Produces, barware, serveware and a broad range of tabletop products.
• The same company also owns Norse Products. See listing this section.
Needs: Buys 20 designs and illustrations/year. Art guidelines not available. Works on assignment only. Uses freelancers mainly for product design. Seeking trendy styles. Final art should be actual size. Produces material for all seasons. Submit seasonal material 6 months in advance.
First Contact and Terms: Send query letter with brochure and résumé. Samples are filed. Reports back within 1 month or does not report back, in which case the artist should call. Call for appointment to show portfolio. Negotiates rights purchased. Originals returned at job's completion if requested. Pays flat fee and royalties; negotiable.

STUART HALL CO., INC., P.O. Box 200915, Kansas City MO 64120-0915. Website: http://www.stuarthall.com. Director of Creative Development: Judy Riedel. Produces stationery, school supplies and office supplies.
Needs: Approached by 30 freelancers/year. Buys 40 freelance designs and illustrations/year. "Artist must be experienced—no beginners." Art guidelines free for SASE with first-class postage. Works on assignment only. Uses freelance artists for design, illustration, calligraphy on stationery, notes and tablets, and paste-up and mechanicals. Considers pencil sketches, rough color, layouts, tight comps or finished art; watercolor, gouache, or acrylic paints are preferred for finished art. Avoid fluorescent colors. "All art should be prepared on heavy white paper and lightly attached to illustration board. Allow at least one inch all around the design for notations and crop marks. Avoid bleeding the design. In designing sheet stock, keep the design small enough to allow for letter writing space. If designing for an envelope, first consult us to avoid technical problems." 100% of design and 50% of illustration demand knowledge of QuarkXPress, Adobe Illustrator, Adobe Photoshop and Aldus FreeHand.
First Contact & Terms: Send query letter with résumé, tearsheets, photostats, slides and photographs. Samples not filed are returned by SASE. Reports only if interested. Will contact for portfolio review if interested. Portfolio should include roughs, original/final art, final reproduction/product, color, tearsheets, photostats and photographs. Originals are not returned. "Stuart Hall may choose to negotiate on price but generally accepts the artist's price." Pays by project. Buys all rights. Finds artists primarily through word of mouth.

✓**SUNSHINE ART STUDIOS, INC.**, Denslow Rd., East Longmeadow MA 01028. (413)781-5500. Creative Art Director: Jeanna Lane. Estab. 1921. Produces greeting cards, stationery, calendars and giftwrap that are sold in own catalog, appealing to all age groups.
Needs: Works with 100-125 freelance artists/year. Buys 200-250 freelance designs and illustrations/year. Prefers artists with experience in greeting cards. Art guidelines available for SASE with first-class postage. Works on assignment only. Uses freelancers for greeting cards, giftwrap, stationery and gift items. Also for calligraphy. Considers all media. Looking for traditional or humorous look. Prefers art 4½×6½ or 5×7. Produces material for Christmas, Easter, birthdays and everyday. Submit seasonal material 6-8 months in advance.
First Contact & Terms: Send query letter with brochure, résumé, SASE, tearsheets and slides. Samples are filed or are returned by SASE if requested by artist. Reports back to the artist only if interested. Portfolio should include finished art samples and color tearsheets and slides. Originals not returned. Pays by the project, $250-400. Pays $25-75/piece for calligraphy and lettering. Buys all rights.

CURTIS SWANN, Division of Burgoyne, Inc., 2030 E. Byberry Rd., Philadelphia PA 19116. (215)677-8000. Fax: (215)677-6081. Contact: Christine Cathers Donohue. Produces greeting cards. Publishes everyday greeting cards based on heavily embossed designs. Style is based in florals and "cute" subjects.
• See also listing for Burgoyne, Inc. in this section.
Needs: Works with 10 freelancers/year. Buys 20 designs and illustrations. Prefers freelancers with experience in greeting card design. Art guidelines free for SASE with first-class postage. Considers designs and media that work well to enhance embossing. Produces material for everyday designs as well as Christmas, Valentine's, Easter, Mother's Day and Father's Day. Accepts work all year round.
First Contact & Terms: Send query letter with brochure, tearsheets, slides, transparencies, photographs, photocopies and SASE. Would like to see a sample card with embossed features. Samples are filed. Creative Director will contact artist for portfolio review if interested. Sometimes requests work on spec before assigning a job. Pays flat fee. Buys first rights or all rights.

Tips: "It is better to show one style that is done very well than to show a lot of different styles that aren't as good."

✔**SYRACUSE CULTURAL WORKERS**, Box 6367, Syracuse NY 13217. (315)474-1132. Fax: (315)475-1277. Art Director: Karen Kerney. Estab. 1982. Produces notecards, postcards, greeting cards, posters, T-shirts and calendars. "SCW is a nonprofit publisher of artwork that inspires and supports social change. Our *Tools for Change* catalog is distributed to individuals, stores, co-ops and groups in North America."

• SCW is specifically seeking artwork celebrating diverstiy, people's history and community building. Themes include environment, positive parenting, positive gay and lesbian images, multiculturalism and cross-cultural adoption.

Needs: Approached by many freelancers/year. Works with 50 freelancers/year. Buys 40-50 freelance fine art images and illustrations/year. Considers all media (in slide form). Art guidelines free for SASE with first-class postage. Looking for progressive, feminist, liberating, vital, people- and earth-centered themes. "December and January are major art selection months."

First Contact & Terms: Send query letter with slides, brochures, photocopies, photographs, SASE, tearsheets and transparencies. Samples are filed or returned by SASE. Reports back within 1 month with SASE. Will contact for portfolio review if interested. Buys one-time rights. Pays by project, $85-400; royalties of 6% of gross sales. Finds artists through word of mouth, its own artist list and submissions.

Tips: "Please do NOT send original art or slides. Rather, send photocopies, printed samples or duplicate slides. Also, one postcard sample is not enough for us to judge whether your work is right for us. We'd like to see at least three or four different images."

‡**T.V. ALLEN**, 27 N. Mentor Ave., Pasadena CA 91106. (626)795-6764. Fax: (626)795-4620. Art Director: Richard Adamson. Estab. 1912. Produces greeting cards, stationery. Specializes in Christmas cards and stationery featuring illustration, foil stamping and engraving. Supplier of all major department stores and fine card and gift stores.

Needs: Approached by 20 freelancers/year. Works with 10-12 freelancers/year. Buys 20-35 freelance designs and illustrations/year. Also buys some calligraphy. Use freelancers mainly for Christmas cards. Considers all media except sculpture. Looking for traditional, humorous, cute animals and graphic designs. Prefers multiple size range. 30% of freelance work demands knowledge of Adobe Photoshop, QuarkXPress. Produces material for Christmas, Hannukkah and Valentine's Day. Submit seasonal material 8-12 months in advance.

First Contact & Terms: Send query letter with photocopies. Samples are filed. Will contact artist for portfolio review of color photographs and slides if interested. Negotiates rights purchased. Pays flat fee by the project. Will also license with option to buy out after license is completed. Finds freelancers through word of mouth, submissions, Surtex show.

‡**THE TOY WORKS, INC.**, Fiddler's Elbow Rd., Middle Falls NY 12848. (518)692-9665. Fax: (518)692-9186. E-mail: thetoyworks@juno.com. Art Director: Maria Riera. Estab. 1974. Produces decorative housewares, gifts, T-shirts, toys, silkscreened toys, pillows, totes, backpacks, soft sculpture and doormats.

Needs: Works with 5 freelancers/year. Buys 50 freelance designs and illustrations/year. Works on assignment only. Uses freelancers mainly for design and illustration. Looking for traditional, floral, humorous, cute animals, adult contemporary. 50% of freelance design demands knowledge of Adobe Photoshop, Adobe Illustrator and Quark XPress. Produces material for Christmas, Easter, Mother's Day, Valentine's Day, birthdays and everyday. Submit seasonal material 20 weeks in advance.

First Contact & Terms: Designers and illustrators send query letter with photostats, résumé, photocopies, photographs. Accepts disk submissions compatible with Postscript. Samples are filed or returned. Reports back in 1-2 weeks. Portfolio review not required. Rights purchased vary according to project. Pays for design by the project; $400-1,000; pays for illustration by the project, $400-1,200.

VAGABOND CREATIONS INC., 2560 Lance Dr., Dayton OH 45409. (937)298-1124. Art Director: George F. Stanley, Jr. Publishes stationery and greeting cards with contemporary humor. 99% of artwork used in the line is provided by staff artists working with the company.

Needs: Works with 4 freelancers/year. Buys 30 finished illustrations/year. Prefers local freelancers. Seeking line drawings, washes and color separations. Material should fit in standard-size envelope.

First Contact & Terms: Query. Samples are returned by SASE. Reports in 2 weeks. Submit Christmas, Mother's Day, Father's Day, Valentine's Day, everyday and graduation material at any time. Originals are returned only upon request. Payment negotiated.

Tips: "Important! Currently we are *not* looking for additional freelance artists because we are very satisfied with the work submitted by those individuals working directly with us. We do not in any way wish to offer false hope to anyone, but it would be foolish on our part not to give consideration. Our current artists are very experienced and have been associated with us for in some cases over 30 years."

VERMONT T'S, Main St., Chester VT 05143. (802)875-2091. President: Thomas Bock. Commercial screenprinter, specializing in T-shirts and sweatshirts. Vermont T's produces custom as well as tourist-oriented silkscreened sportwear. Does promotional work for businesses, ski-resorts, tourist attractions and events.

Needs: Works with 5-10 freelance artists/year. Uses artists for graphic designs for T-shirt silkscreening. Prefers pen & ink, calligraphy and computer illustration.

First Contact & Terms: Send query letter with brochure. Samples are filed or are returned only if requested. Reports

back within 10 days. To show portfolio, mail photostats. Pays for design by the project, $75-250. Negotiates rights purchased. Finds most artists through portfolio reviews and samples.

Tips: "Have samples showing rough through completion. Understand the type of linework needed for silkscreening."

WANDA WALLACE ASSOCIATES, Box 436, Inglewood CA 90306. (310)419-0376. Fax: (310)675-8020. Website: http://www.sensorium.com. President: Wanda. Estab. 1980. Produces greeting cards and posters for general public appeal. "We produce black art prints, posters, originals and other media."

Needs: Approached by 10-12 freelance artists/year. Works with varying number of freelance artists/year. Buys varying number of designs and illustrations/year from freelance artists. Prefers artists with experience in black art subjects. Uses freelance artists mainly for production of originals and some guest appearances. Considers all media. Produces material for Christmas. Submit seasonal material 4-6 months in advance.

First Contact & Terms: Send query letter with any visual aid. Some samples are filed. Policy varies regarding answering queries and submissions. Call or write to schedule an appointment to show a portfolio. Rights purchased vary according to project. Original artwork is returned at the job's completion. Pays by the project.

✔WARNER PRESS, INC., 1200 E. Fifth St., Anderson IN 46018. (765)644-7721. Creative Director: John Silvey. Estab. 1884. Produces church bulletins and church supplies such as postcards and children's materials. Warner Press is the publication board of the Church of God. "We produce products for the Christian market. Our main market is the Christian bookstore. We provide products for all ages."

● This company has gone through a restructuring since our last edition and their freelance needs have changed. They no longer publish greeting cards or posters. Their main focus is now church bulletin supplies.

Needs: Approached by 50 freelancers/year. Works with 35-40 freelancers/year. Buys 300 freelance designs and illustrations/year. Works on assignment only. Uses freelancers for all products, coloring books. Also for calligraphy. "We use local Macintosh artists with own equipment capable of handling 40 megabyte files in Photoshop, FreeHand and QuarkXPress." Considers all media and photography. Looking for bright florals, sensitive still lifes, landscapes, wildlife, birds, seascapes; all handled with bright or airy pastel colors. 100% of production work demands knowledge of QuarkXPress, Aldus FreeHand, Adobe Illustrator or Adobe Photoshop. Produces material for Father's Day, Mother's Day, Christmas, Easter, graduation and everyday. Submit seasonal material 18 months in advance.

First Contact & Terms: Send query letter with brochure, tearsheets and photocopies. Samples are filed and are not returned. Creative manager will contact artist for portfolio review if interested. Portfolio should include b&w and color final art, tearsheets, photographs and transparencies. Originals are not returned. Pays by the project, $250-350. Pays for calligraphy pieces by the project. Buys all rights (occasionally varies).

Tips: "Subject matter must be appropriate for Christian market. Most of our art purchases are for children's material. We prefer palettes of bright colors as well as clean, pretty pastels."

‡WELLSPRING, 339 E. Cottage Place, York PA 17403. (717)846-5156. Fax: (717)757-3242. E-mail: scotta@wellspring-gift.com. Art Director: Scotta Magnelli. Estab. 1980. Produces giftbags, stationery, notepads and recipe books. Specializes in quality art images reproduced on magnetic notepads, ceramic tile magnets, giftbags, notecards, recipe cards and recipe books for use primarily in the kitchen.

Needs: Approached by 15-20 freelancers/year. Works with 2-3 freelancers/year. Buys 90-100 freelance designs and illustrations/year. Prefers freelancers with experience in full-color illustration. Prefers local, but will look at work outside area. Art guidelines not available. Works on assignment only. Uses freelancers mainly for full-color illustration for use on products. Also for mechanicals, photo manipulation. Considers watercolor, acrylics, oils, gouache, electronic, pastels. Looking for traditional, floral, wildlife (realistic) art no larger than 5×6. 5% of freelance design works demands knowledge of Aldus PageMaker 6.5, Adobe Photoshop 4.0, Adobe Illustrator 7.0. Produces material for Christmas and everyday. Submit seasonal material 2-3 months in advance.

First Contact & Terms: Designers send query letter with brochure, photographs, résumé, SASE, tearsheets. Illustrators send query letter with photographs, tearsheets, SASE. Accepts disk submissions in Photoshop 4.0 EPS files, Illustrator 7.0. Files accepted on CD, Jazz or Zip disks. Samples are filed. Will contact artist for portfolio review of color final art, tearsheets, transparencies if interested. Buys all rights. Pays for illustration by the project, $125-150. Payment of $50 each for every product line the art is used on after the initial line. Finds freelancers through magazines, trade shows, local art shows, artist's submissions, word of mouth.

Tips: "Keep up with trends by paying attention to what is happening in the fashion industry, attending trade shows and reading trade publications."

✔WEST GRAPHICS, 1117 California Dr., Burlingame CA 94010. (800)648-9378. Website: http://www.west-graphics.com. Contact: Production Department. Estab. 1980. Produces greeting cards. "West Graphics is an alternative greeting card company offering a diversity of humor from 'off the wall' to 'tastefully tasteless.' Our goal is to publish cards that challenge the limits of taste and keep people laughing."

● West Graphics' focus is 'adult' humor.

Needs: Approached by 100 freelancers/year. Works with 40 freelancers/year. Buys 150 designs and illustrations/year. Art guidelines free for SASE with first-class postage. Uses freelancers for illustration. "All other work is done inhouse." Considers all media. Looking for outrageous contemporary illustration and "fresh new images on the cutting edge." Prefers art proportionate to finished vertical size of 5×7, no larger than 10×14. Produces material for all holidays and everyday (birthday, get well, love, divorce, congratulations, etc.) Submit seasonal material 1 year in advance.

First Contact & Terms: Send query letter with SASE, tearsheets, photocopies, photostats, slides or transparencies. Samples should relate to greeting card market. Samples are not filed and are returned by SASE. Reports back within 6 weeks. Rights purchased vary. Offers royalties of 5%.

Tips: "We welcome both experienced artists and those new to the greeting card industry. Develop art and concepts with an occasion in mind such as birthday, etc. Your target should be issues that women care about: men, children, relationships, sex, religion, aging, success, money, crime, health, etc. Increasingly, there is a younger market and more cerebral humor. Greeting cards are becoming a necessary vehicle for humorously communicating genuine sentiment that is uncomfortable to express personally."

WHITEGATE FEATURES SYNDICATE, 71 Faunce Dr., Providence RI 02906. (401)274-2149. Contact: Eve Green.
- This syndicate is looking for fine artists and illustrators. See their listing in Syndicates for more information about their needs.

✓WIZARDS OF THE COAST, P.O. Box 707, Renton WA 98057. Website: http://www.wizards.com. Attn: Artist Submissions. Estab. 1990.

Needs: Approached by 300 freelancers/year. Works with 150 freelancers/year. Buys 1,000 freelance designs and illustrations/year. Prefers freelancers with with experience in fantasy art. Art guidelines available for SASE with first class postage. Works on assignment only. Uses freelancers mainly for cards, posters, books. Considers all media. Looking for fantasy, science fiction portraiture art. 100% of design demands knowledge of Adobe Photoshop, Adobe Illustrator, Aldus FreeHand, QuarkXPress. 30% of illustration demands computer skills.

First Contact & Terms: Illustrators send query letter with 6-10 non-returnabale full color pieces. Accepts submissions on disk. Samples are filed or returned by SASE. Reports back within 1 month. Artist should follow-up with letter after initial query. Will contact for portfolio review if interested. Portfolios should include color, final art, photographs and tearsheets. Rights purchased vary according to project. Pays for design by the project, $300 minimum. Payment for illustration and sculpture depends on project. Finds freelancers through conventions, submissions and referrals.

Magazines

Art directors look for the best visual element to hook the reader into the story. A whimsical illustration can set the tone for a humorous article and a caricature might dress up a short feature about a celebrity. Smaller illustrations, called spot illustrations, are needed to break up text and lead the reader from feature to feature.

Attractive art isn't enough to grab assignments. Your work must not only convey the tone and content of a writer's article, it also must fit in with a magazine's "personality." For example, *Rolling Stone* illustrations have a more edgy quality to them than the illustrations in *Reader's Digest*, which tends to publish more conventional illustrations. Chances are with a little honing, your artwork would do well in several magazines.

Target your market

- **Read each listing carefully.** Within each listing are valuable clues. Knowing how many artists approach each magazine will help you understand how stiff your competition is. (At first, you might do better submitting to art directors who aren't swamped with submissions.) Look at the preferred subject matter to make sure your artwork fits the magazine's needs. Note the submission requirements and develop a mailing list of markets you want to approach.
- **Visit newsstands and bookstores.** Look for magazines not listed in *Artist's & Graphic Designer's Market*. Check the cover and interior. If illustrations are used, flip to the masthead (usually a box in one of the beginning pages) and note the art director's name. While looking at the masthead, check the circulation figure. As a rule of thumb, the higher the circulation the higher the art director's budget. When an art director has a good budget, he tends to hire more illustrators and pay higher fees. Look at the illustrations and check the illustrator's name in the credit line in small print to the side of the illustration. Notice which illustrators are used often in the publications you wish to work with. Art directors need diversity in their publications. They like to show several styles within the same issue. After you have studied the illustrations in dozens of magazines, you will understand what types of illustrations are marketable.

Send samples that get you noticed

- **Focus on one or two *consistent* styles to present to art directors in sample mailings.** See if you can come up with a style that is different from every other illustrator's style, if only slightly. No matter how versatile you may be, limit styles you market to one or two. That way, you'll be more memorable to art directors. Pick a style or styles you enjoy and can work quickly in. Art directors don't like surprises. If your sample shows a line drawing, they expect you to work in that style when they give you an assignment.
- **Create a sample showing not only a definite style, but the ability to illustrate abstract ideas.** It's not enough just to draw or paint a pretty picture. Your sample must convey a mood—whether happy, somber, playful or dignified. If you create caricatures, make sure your drawing captures the celebrity's *personality*, not just the face.
- **Send simple, polished samples to the right contact person.** After you choose an illustration for your sample, get some good color photocopies made, or make an investment in printed postcards or promotional sheets. Each sample must show your name, address and phone number. (See What Should I Submit?, page 4.) Send your samples to as many art directors as your budget permits. Be sure to use the art director's name in the address line, and spell it correctly!
- **Don't rely on one mailing to win assignments.** Wait a few months and create another sample

in the same style to send to the art directors on your original mailing list. Successful illustrators report that promotional mailings are cumulative. As a general rule, it takes about three mailings for your name to sink into art directors' brains.

• **Develop a spot illustration style in addition to your regular style.** "Spots"—illustrations that are half-page or smaller—are used in magazine layouts as interesting visual cues to lead readers through large articles, or to make filler articles more appealing. Though the fee for one spot is less than for a full layout, art directors often assign five or six spots within the same issue to the same artist. Because spots are small in size, they must be all the more compelling. So send art directors a sample showing several power-packed small pieces along with your regular style. *Note: each year the Society of Publication Designers sponsors an annual juried competition called, appropriately, SPOTS. The winners are featured in a prestigious exhibition. If you would like information about the annual competition, contact the Society of Publication Designers at (212)983-8585.*

MORE MARKETING TIPS

• **Tap industry sources.** A great source for new leads is in the business section of your local library. Ask the librarian to point out the business and consumer editions of the *Standard Rate and Data Service (SRDS)*. The huge directory lists thousands of magazines by category. While the listings contain mostly advertising data and are difficult to read, they do give you an idea of the magnitude of magazines published today. Another good source is a yearly directory called *Samir Husni's Guide to New Consumer Magazines* also available in the business section of the public library. Also read *Folio* magazine to find out about new magazine launches and redesigns.

• **Invest in a fax machine and/or modem.** Art directors like to work with illustrators who own faxes, because they can quickly fax a layout with a suggestion. The artist can fax back a preliminary sketch or "rough" the art director can OK. More and more illustrators are sending images via computer modem, which also makes working with art directors easier.

• **Get your work into competition annuals and sourcebooks.** The term "sourcebook" refers to the creative directories published each year showcasing the work of freelancers. Art directors consult these publications when looking for new styles. If an art director uses creative directories, we include that information in the listings to help you understand your competition. Some directories like *Black Book*, *The American Showcase* and *RSVP* carry paid advertisements costing several thousand dollars per page. Other annuals, like the *Print Regional Design Annual* or *Communication Art Illustration Annual* feature award winners of various competitions. An entry fee and some great work can put your work in a competition directory and in front of art directors across the country. (Consult Publications of Interest, page 678, for directory addresses.)

• **Join an artists' organization.** Networking with fellow artists and art directors will help you find additional success strategies. There are many great organizations out there—the Graphic Artist's Guild, The American Institute of Graphic Artists (AIGA), your city's Art Director's Club or branch of the Society of Illustrators, which hold monthly lectures and networking functions. Attend one event sponsored by each organization in your city to find a group you are comfortable with. Then join and become an active member.

• **Consider hiring a rep.** If after working successfully on several assignments you decide to make magazine illustration your career, consider hiring an artists' representative to market your work for you. (See the Artists' Reps section, page 653.)

BEST BETS: TRADE MAGAZINES AND REGIONAL PUBLICATIONS

While they may not be as glamorous as national consumer magazines, some trade and regional publications are just as lavishly produced. Most pay fairly well and the competition is not as fierce. Every assignment is valuable. Until you can get some of the higher circulation magazines to notice you, take assignments from smaller magazines. Despite their low payment, there are many advantages. You learn how to communicate with art directors, develop your signature style and learn how to work quickly to meet deadlines. Once the assignments are done, the tearsheets become valuable samples to send to other magazines.

ATTENTION DESIGNERS

Some magazines also hire freelance designers and production people to assist with layouts or create and maintain websites. If you are a designer, look for listings featuring a separate heading for design. Needed computer skills and submission preferences vary from magazine to magazine, so read each listing carefully before you approach art directors.

‡ABSOLUTE MAGNITUDE, SF, P.O. Box 910, Greenfield MA 01302-0910. (413)722-0725. Fax: (413)772-0725. E-mail: absmag@shaysnet.com. Art Director: Warren Lapine. Estab. 1993. Quarterly 4-color cover, b&w interior literary magazine featuring science fiction. Circ. 6,000. Sample copies for $5, postage paid.
Illustration: Approached by 20 illustrators/year. Buys 7 illustrations/issue. Has featured illustrations by Bob Eggleton, Kelly Frease. Features illustrations for fiction. Prefers bright covers, pen & ink interiors. Assigns 25% of illustrations to well-known or "name" illustrators; 50% to experienced, but not well-known illustrators; 25% to new and emerging illustrators. Send query letter with photocopies. Samples are filed. Reports back within 60 days. Will contact artist for portfolio review if interested. Pays $100-400 for color cover; $50-75 for b&w inside. Finds illustrators through samples.
Tips: "We assume that you are only as good as your weakest portfolio piece. Art director has recently changed and we need new artists now!"

ABYSS MAGAZINE, RAGNAROK PRESS, Box 140333, Austin TX 78714. Fax: (512)472-6220. E-mail: ragnarokg c@aol.com. Editor: David F. Nalle. Estab. 1979. Black and white quarterly emphasizing fantasy and adventure games for adult game players with sophisticated and varied interests. Circ. 1,800. Does not accept previously published material. Returns original artwork after publication. Sample copy for $5. Art guidelines free for SASE with first-class postage. 25% of freelance work demands computer skills.
 • Ragnarok Press is also a book and game publisher. See its listing in the Greeting Card, Gifts & Products section for website information and additional needs.
Illustration: Approached by 100 illustrators/year. Works with 10-20 illustrators/year. Buys 200-300 illustrations/year. Need editorial, horror, historical and fantasy in tradition of H.J. Ford and John D. Batten. Uses freelancers mainly for covers and spots. Prefers science fiction, fantasy, dark fantasy, horror or mythology themes. Send query letter with samples. Write for appointment to show portfolio. Prefers photocopies or photographs as samples. Samples not filed are returned by SASE. Reports within 1 month. Buys first rights. Pays on publication; $20-40 for b&w, $50-300 for color cover; $3-10 for b&w inside; $10-20 for b&w spots.
Tips: Does not want to see "Dungeons and Dragons-oriented cartoons or crudely created computer art." Notices "more integration of art and text through desktop publishing. We are now using all scanned art in layout either as provided by artists or scanned inhouse. Knowledge of Photoshop helpful."

ACCENT ON LIVING, Box 700, Bloomington IL 61702. Fax: (309)378-4420. E-mail: cheeverpub@aol.com. Editor: Betty Garee. Estab. 1956. Quarterly magazine with emphasis on success and ideas for better living for the physically handicapped. 5×7 b&w with 4-color cover. Original artwork returned after publication if requested. Sample copy $3.50.
 • Also publishes books for physically disabled adults under Cheever Publishing.
Cartoons: Approached by 30 cartoonists/year. Buys approximately 12 cartoons/issue. Receives 5-10 submissions/week from freelancers. Interested in seeing people with disabilities in different situations. Send finished cartoon samples and SASE. Reports in 2 weeks. **Pays on acceptance;** $20 b&w; $35 full page. Buys first-time rights (unless specified).
Illustration: Approached by 20 illustrators/year. Features humorous illustration. Uses 3-5 freelance illustrations/issue. Works on assignment only. Send SASE and postcard samples to be kept on file for future assignments. Accepts disk submissions compatible with QuarkXPress. Send TIFF or EPS files. Samples not filed are returned by SASE. Reports in 2 weeks. **Pays on acceptance**; $50-100 for color cover; $10-50 for b&w and color inside. Buys first-time rights.

‡*ACTIVE LIFE, Aspen Publishing Christ Church, Cosway St., London NW1 5NJ United Kingdom. Phone: (0171)2622622. Fax: (0171)7064811. Managing Editor: Helene Hodge. Estab. 1990. Bimonthly lively lifestyle consumer magazine for the over 50s. Circ. 300,000.
Illustration: Approached by 200 illustrators/year. Buys 12 illustration/issue. Features humorous illustration. Preferred subject: families. Target group 50+. Prefers pastel and bright colors. Assigns 20% of illustration to well-known or "name" illustrators; 60% to experienced, but not well-known illustrators; 20% to new and emerging illustrators. Send non-returnable samples. Accepts Mac-compatible disk submissions. Samples are filed. Reports back within 1 month. Will contact artist for portfolio review if interested. Buys all rights. Pays on publication. Finds illustrators through promotional samples.

ADVENTURE CYCLIST, 150 E. Pine, Missoula MT 59802. (406)721-1776. Fax: (406)721-8754. E-mail: acaeditor@ aol.com. Website: http://www.adv-cycling.org. Art Director: Greg Siple. Estab. 1974. Published 9 times/year. A journal of adventure travel by bicycle. Circ. 26,000. Originals returned at job's completion. Sample copies available.
Illustration: Buys 1 illustration/issue. Works on assignment only. Send printed samples. Samples are filed. Publication will contact artist for portfolio review if interested. Portfolio should include color photocopies. Pays on publication; $350 for color cover; $50 and up for color inside. Buys one-time rights.

ADVOCATE, PKA'S PUBLICATION, 301A Rolling Hills Park, Prattsville NY 12468. (518)299-3103. Art Editor: C.J. Karlie. Estab. 1987. Bimonthly b&w literary tabloid. "*Advocate* provides aspiring artists, writers and photographers the opportunity to see their works published and to receive byline credit toward a professional portfolio so as to promote careers in the arts." Circ. 12,000. "Good quality photocopy or stat of work is acceptable as a submission." Sample copies available for $4. Art guidelines for SASE with first-class postage.
Cartoons: Open to all formats except color washes. Send query letter with SASE and submissions for publication. Samples are not filed and are returned by SASE. Reports back within 2-6 weeks. Buys first rights. Pays in contributor's copies.
Illustration: Buys 10-15 illustrations/issue. Considers pen & ink, charcoal, linoleum-cut, woodcut, lithograph, pencil or photos, "either b&w or color prints (no slides). We are especially looking for horse-related art and other animals." Also needs editorial and entertainment illustration. Send query letter with SASE and photos of artwork (b&w or color prints only). No simultaneous submissions. Samples are not filed and are returned by SASE. Portfolio review not required. Reports back within 2-6 weeks. Buys first rights. Pays in contributor's copies. Finds artists through submissions and from knowing artists and their friends.
Tips: "Please remember SASE for return of materials. We hope to continue publishing 6 times per year and will need 10-15 illustrations per issue."

AGING TODAY, 833 Market St., San Francisco CA 94103. (415)974-9619. Fax: (415)974-0300. Editor: Paul Kleyman. Estab. 1979. "*Aging Today* is the bimonthly black & white newspaper of The American Society on Aging. It covers news, public policy issues, applied research and developments/trends in aging." Circ. 15,000. Accepts previously published artwork. Originals returned at job's completion if requested. Sample copies available.
Cartoons: Approached by 50 cartoonists/year. Buys 1-2 cartoons/issue. Prefers political and social satire cartoons; single, double or multiple panel with or without gagline, b&w line drawings. Send query letter with brochure and roughs. Samples returned by SASE. Reports back only if interested. Buys one-time rights. Pays $15-25 for b&w.
Illustration: Approached by 50 illustrators/year. Buys 1 illustration/issue. Works on assignment only. Prefers b&w line drawings and some washes. Considers pen & ink. Needs editorial illustration. Send query letter with brochure, SASE and photocopies. Samples are not filed and are returned by SASE. Reports back only if interested. To show portfolio, artist should follow-up with call and/or letter after initial query. Buys one-time rights. Pays on publication; $25 for b&w cover; $25 for b&w inside.
Tips: "Send brief letter with two or three applicable samples. Don't send hackneyed cartoons that perpetuate ageist stereotypes."

AGONYINBLACK, VARIOUS COMIC BOOKS, (formerly *Nightcry*), 360-A W Merrick Rd., Suite 350, Valley Stream NY 11580. (516)285-5545, (518)877-4908. E-mail: chntngmnks@aol.com. Website: http://www.loginet.com/ cfd. Editor: Pamela Hazelton. Estab. 1994. Bimonthly "illustrated magazine of horror" for mature readers. Circ. 4-6,000. Art guidelines for #10 SASE with first-class postage.
Illustration: Approached by 200-300 illustrators/year. Buys 5 illustrations/issue. Has featured illustrations by Bernie Wrightson, Louis Small and Ken Meyer. Features realistic and spot illustration. Assigns 50% of illustrations to well-known or "name" illustrators; 30% to experienced, but not well-known illustrators; 20% to new and emerging illustrators. Prefers horror, disturbing truth. Considers all media. Send query letter with printed samples, photocopies, SASE or tearsheets. Send follow-up samples every 3 months. Accepts disk submissions compatible with Photoshop, PageMaker

‡ **MARKETS NEW TO THIS EDITION** are marked with a double dagger.

files only or TIFFS, GIFS, JPG; no e-mail uploads. Samples are filed. Reports back within 6-9 weeks. Buys first North American serial rights. Pays on publication; $50-300 for b&w cover; $100-500 for color cover; $20-100 for b&w inside; $50-100 for color inside; $50-250 for 2-page spreads; $25-50 maximum for spots. Will discuss payment for spots. Finds illustrators through conventions—referrals.

Tips: "We publish comic books and occasionally pinup books. We mostly look for panel—sequential art. Please have a concept of sequential art."

THE AGUILAR EXPRESSION, 1329 Gilmore Ave., Donora PA 15033. (412)379-8019. Editor/Publisher: Xavier F. Aguilar. Estab. 1989. Biannual b&w literary magazine/newsletter. Circ. 150. Originals not returned. Sample copies available for $6. Art guidelines for SASE with first-class postage.

Illustration: Approached by 5-10 illustrators/year. Buys 1-2 illustrations/issue. Has featured illustrations by Barbara J. McPhail. Features caricatures of celebrities and politicians, humorous, realistic illustration and computer illustrations. Assigns 25% of illustrations to experienced, but not well-known illustrators; 75% to new and emerging illustrators. Considers pen & ink. Also needs creative illustrations with 1 line caption. Send query letter with SASE and photocopies. Samples are not filed and are not returned. Reports back within 1 month. Portfolio review not required. Sometimes requests work on spec. Acquires one-time rights. No payment. Artist receives 1 copy and byline. Finds artists through submissions.

Design: Needs freelancers for multimedia design. Send query letter with photocopies and SASE.

Tips: "Study sample copy of publication before submitting artwork. Follow guidelines."

✔**AIM**, Box 1174, Maywod IL 60153. (312)874-6184. Editor-in-Chief: Ruth Apilado. Managing Editor: Dr. Myron Apilado. Estab. 1973. 8½×11 b&w quarterly with 2-color cover. Readers are those "wanting to eliminate bigotry and desiring a world without inequalities in education, housing, etc." Circ. 7,000. Reports in 3 weeks. Accepts previously published, photocopied and simultaneous submissions. Sample copy $5; artist's guidelines for SASE.

Cartoons: Approached by 12 cartoonists/week. Buys 10-15 cartoons/year. Uses 1-2 cartoons/issue. Prefers education, environment, family life, humor in youth, politics and retirement; single panel with gagline. Especially needs "cartoons about the stupidity of racism." Send samples with SASE. Reports in 3 weeks. Buys all rights on a work-for-hire basis. Pays on publication; $5-15 for b&w line drawings.

Illustration: Approached by 4 illustrators/week. Uses 4-5 illustrations/issue; half from freelancers. Prefers pen & ink. Prefers current events, education, environment, humor in youth, politics and retirement. Provide brochure to be kept on file for future assignments. Samples not returned. Reports in 1 month. Prefers b&w for cover and inside art. Buys all rights on a work-for-hire basis. Pays on publication; $25 for b&w cover illustrations.

Tips: "We could use more illustrations and cartoons with people from all ethnic and racial backgrounds in them. We also use material of general interest. Artists should show a representative sampling of their work and target the magazine's specific needs. Nothing on religion."

AKC GAZETTE, 51 Madison Ave., 19th Floor, New York NY 10010-1603. (212)696-8370. Fax: (212)696-8299. E-mail: info@akc.org. Website: http://www.akc.org. Creative Director: Tilly Grassa. Estab. 1889. Monthly consumer magazine about "breeding, showing, and training pure-bred dogs." Circ. 58,000. Sample copy available for 9×12 SASE.

Illustration: Approached by 200-300 illustrators/year. Buys 6-12 illustrations/issue. Considers all media. 25% of freelance illustration demands knowledge of Adobe Photoshop, Adobe Illustrator, Aldus FreeHand and QuarkXPress. Send query letter with printed samples, photocopies and tearsheets. Send follow-up postcard every 6 months. Accepts Mac platform submissions—compatible with QuarkXPress (latest revision). Send EPS or TIFF files at a high resolution (300 dpi). Samples are filed. Reports back only if interested. Rights purchased vary according to project. Pays on publication; $500-1,000 for color cover; $50-150 for b&w, $150-800 for color inside. Pays $75-300 for color spots. Finds illustrators through artist's submissions.

Design: Needs freelancers for design, production and multimedia projects. Prefers local designers with experience in QuarkXPress, Photoshop and Illustrator. 100% of freelance work demands knowledge of Adobe Photoshop, Adobe Illustrator and QuarkXPress. Send query letter with printed samples, photocopies, tearsheets and résumé.

Tips: "Although our magazine is dog-oriented and a knowledge of dogs is preferable, it is not required. Creativity is still key."

‡**ALASKA MAGAZINE**, 4220 B St., Anchorage AK 99513. (907)561-4772. Fax: (907)561-5669. Art Director: Linda Lockhart. Production Assistant: Deb Bruesch. Estab. 1935. Monthly 4-color regional consumer magazine featuring Alaskan issues, stories and profiles exclusively. Circ. 250,000.

Cartoons: Approached by 500 cartoonists/year. Buys 2 cartoons/year. Prefers single panel, humorous color washes. Samples are filed and not returned. Does not report back. Buys first North American rights or rights purchased vary according to project. Pays on publication; $75-150 for b&w, $125-300 for color.

Illustration: Approached by 200 illustrators/year. Buys 1-4 illustration/issue. Has featured illustrations by James Havens, Lance Lekander, Victor Juhaz, Debra Dubac, Bob Parsons. Features humorous and realistic illustrations. Assigns 50% to experienced, but not well-known illustrators; 50% to new and emerging illustrators. 50% of freelance illustration demands knowledge of Adobe Illustrator, Adobe Photoshop and QuarkXPress. Send postcard or other non-returnable samples. Accepts Mac-compatible disk submissions. Samples are not returned. Reports back only if interested. Will contact artist for portfolio review if interested. Buys first North American serial rights or rights purchased vary according

to project. Pays on publication; $125-300 for color inside; $400-600 for 2-page spreads; $125 for spots.
Tips: "We work with illustrators who grasp the visual in a story quickly and can create quality pieces on tight deadlines."

‡ALTERNATIVE THERAPIES IN HEALTH AND MEDICINE, 101 Columbia, Aliso Viejo CA 92656. (714)362-2000. Fax: (714)632-2020. Art Director: LeRoy Hinton. Estab. 1995. Bimonthly trade journal. *"Alternative Therapies* is a peer-reviewed medical journal established to promote integration between alternative and cross-cultural medicine with conventional medical traditions." Circ. 20,000. Accepts previously published artwork. Originals returned at job's completion. Sample copies available.
Cartoons: Prefers alternative or conventional medicine themes. Prefers single panel, political and humorous, b&w washes and line drawings with gagline. Send query letter with roughs. Samples are filed. Reports back within 10 days. Buys one-time rights.
Illustration: Buys 6 illustrations/year. "We purchase fine art for the covers, not graphic art." 50% of freelance work demands knowledge of Adobe Illustrator, QuarkXPress and Adobe Photoshop. Send query letter with slides. Samples are filed. Reports back within 10 days. Publication will contact artist for portfolio review if interested. Portfolio should include photographs and slides. Buys one-time and reprint rights. Pays on publication; negotiable. Finds artists through agents, sourcebooks and word of mouth.

AMELIA, 329 E St., Bakersfield CA 93304. (805)323-4064. Editor: Frederick A. Raborg, Jr. Estab. 1983. Quarterly magazine. Also publishes 2 supplements—*Cicada* (haiku) and *SPSM&H* (sonnets) and illustrated postcards. Emphasizes fiction and poetry for the general review. Circ. 1,750. Accepts some previously published material from illustrators. Original artwork returned after publication with SASE. Sample copy $9.95; art guidelines for SASE.
Cartoons: Buys 3-5 cartoons/issue for *Amelia*. Prefers sophisticated or witty themes (see Ford Button's, Earl Engleman's and Vahan Shirvanian's work). Prefers single panel b&w line drawings and washes with or without gagline (will consider multipanel on related themes). Send query letter with finished cartoons to be kept on file. Material not filed is returned by SASE. Reports within 1 week. Usually buys first rights. **Pays on acceptance**; $5-25 for b&w. Occasionally uses captionless cartoons on cover; $50 b&w; $100 color.
Illustration: Buys 80-100 illustrations and spots/year for *Amelia;* 24-30 spots for *Cicada*; 15-20 spots for *SPSM&H* and 50-60 spots for postcards. Considers all themes. "No taboos, except no explicit sex; nude studies in taste are welcomed, however." Prefers pen & ink, pencil, watercolor, acrylic, oil, pastel, mixed media and calligraphy. Send query letter with résumé, photostats and/or photocopies to be kept on file. Unaccepted material returned immediately by SASE. Reports in 1 week. Portfolio should contain "one or two possible cover pieces (either color or b&w), several b&w spots, plus several more fully realized b&w illustrations." Buys first rights or one-time rights (prefers first rights). **Pays on acceptance**; $50 for b&w, $100 for color, cover; $5-25 for b&w inside. "Spot drawings are paid for on assignment to an issue."
Tips: "In illustrations, it is very difficult to get excellent nude studies. Everyone seems capable of drawing an ugly woman; few capture sensuality, and fewer still draw the nude male tastefully. (See male nudes we've used by Susan Moffett and Miguel Angel Reyes for example.)"

AMERICA WEST AIRLINES MAGAZINE, 4636 E. Elwood St., Suite 5, Phoenix AZ 85040-1963. Estab. 1986. Monthly inflight magazine for national airline; 4-color, "conservative design. Appeals to an upscale audience of travelers reflecting a wide variety of interests and tastes." Circ. 130,000. Accepts previously published artwork. Original artwork is returned after publication. Sample copy $3. Art guidelines for SASE with first-class postage. Needs computer-literate illustrators familiar with Adobe Photoshop, Adobe Illustrator, QuarkXPress and Aldus FreeHand.
Illustration: Approached by 100 illustrators/year. Buys 5 illustrations/issue from freelancers. Buys illustrations mainly for spots, columns and feature spreads. Uses freelancers mainly for features and columns. Works on assignment only. Prefers editorial illustration in airbrush, mixed media, colored pencil, watercolor, acrylic, oil, pastel, collage and calligraphy. Send query letter with color brochure showing art style and tearsheets. Looks for the "ability to intelligently grasp idea behind story and illustrate it. Likes crisp, clean colorful styles." Accepts disk submissions. Send EPS files. Samples are filed. Does not report back. Will contact for portfolio review if interested. Sometimes requests work on spec. Buys one-time rights. Pays on publication; $500-700 for color cover; $75-250 for b&w; $150-500 for color inside; $150-250 for spots. "Send lots of good-looking color tearsheets that we can keep on hand for reference. If your work interests us we will contact you."
Tips: "In your portfolio show examples of editorial illustration for other magazines, good conceptual illustrations and a variety of subject matter. Often artists don't send enough of a variety of illustrations; it's much easier to determine if an illustrator is right for an assignment if we have a complete grasp of the full range of abilities. Send high-quality illustrations and show specific interest in our publication."

‡THE AMERICAN ATHEIST, Box 140195, Austin TX 78714-0195. (512)458-1244. Director: Spike Tyson. Estab. 1958. Monthly for atheists, agnostics, materialists and realists. Circ. 30,000. Simultaneous submissions OK. Sample copy for 9 × 12 envelope or label.
Cartoons: Buys 5 cartoons/issue. Especially needs 4-seasons art for covers and greeting cards. Send query letter with résumé and samples. Pays $15 each.
Illustration: Buys 1 illustration/issue. "Send samples to be kept on file. We do commission artwork based on the samples received. All illustrations must have bite from the atheist point of view and hit hard." Prefers pen & ink, then

airbrush, charcoal/pencil and calligraphy. To show a portfolio, mail final reproduction/product and b&w photographs. **Pays on acceptance**; $75-100 for cover; $25 for inside.

Tips: "*The American Atheist* looks for clean lines, directness and originality. We are not interested in side-stepping cartoons and esoteric illustrations. Our writing is hard-punching and we want artwork to match. The American Atheist Press (parent company) buys book cover designs and card designs. I would like to see a sample of various styles, but since we can't print in color, I need to know if the artist can design/illustrate for offset printing."

AMERICAN BANKERS ASSOCIATION-BANKING JOURNAL, 345 Hudson St., New York NY 10014. (212)620-7256. E-mail: ababj@aol.com. Website: http://www.banking.com. Art Director: Wendy Williams. Estab. 1908. 4-color; contemporary design. Emphasizes banking for middle and upper level banking executives and managers. Monthly. Circ. 42,000. Accepts previously published material. Returns original artwork after publication.

Illustration: Buys 4-5 illustrations/issue from freelancers. Has featured illustrations by Scott Swales and Kurt Varg. Features charts & graphs, computer, humorous and spot illustration. Assigns 50% of illustrations to well-known or "name" illustrators; 30% to experienced, but not well-known illustrators; 20% to new and emerging illustrators. Themes relate to stories, primarily financial, from the banking industry's point of view; styles vary, realistic, cartoon, surreal. Uses full-color illustrations. Works on assignment only. To send a portfolio, send query letter with brochure and tearsheets, promotional samples or photographs. Negotiates rights purchased. **Pays on acceptance**; $250-950 for color cover; $250-450 for color inside; $250-450 for spots.

Tips: "Look at what the art director has used for illustration in the past. And create three illustrations that would fit the style and concept for the publication."

AMERICAN BREWER MAGAZINE, Box 510, Hayward CA 94543-0510. (510)538-9500 (mornings). E-mail: ambre w@aol.com. Website: http://www.ambrew.com. Publisher: Bill Owens. Estab. 1985. Quarterly trade journal in b&w with 4-color cover focusing on the microbrewing industry. Circ. 18,000. Accepts previously published artwork. Original artwork returned after publication. Sample copies for $5; art guidelines not available. 80% of freelance work demands knowledge of Aldus PageMaker.

• Bill Owens formerly published *BEER, The Magazine*, which has been discontinued, but may be sold to another publisher.

Cartoons: Approached by 6-8 cartoonists/year. Buys 2 cartoons/issue. Prefers themes related to drinking or brewing handcrafted beer; single panel. Send query letter with roughs. Samples not filed are returned. Reports back within 2 weeks. Buys reprint rights. Pays $150-200 for color cover; $25-50 for b&w.

Illustration: Approached by 6-10 illustrators/year. Buys 2 illustrations/issue. Features caricatures of celebrities. Works on assignment only. Prefers themes relating to beer, brewing or drinking; pen & ink. Send postcard sample or query letter with photocopies. Samples are not filed and are returned. Reports back within 2 weeks. Pays $200-500 for b&w or color cover; $50-150 for b&w or color inside. Buys reprint rights.

Design: Needs freelancers for design. 100% of design requires knowledge of Adobe Photoshop. Send query letter. Pays by project.

Tips: "I prefer to work with San Francisco Bay Area artists. Work must be about microbrewing industry."

AMERICAN CAREERS, 6701 W. 64th St., Overland Park KS 66202. (913)362-7788 or (800)669-7795. Fax: (913)362-4864. E-mail: ccinfo@carcom.com. Publisher: Barbara Orwig. Estab. 1990. Quarterly career awareness magazine for students in middle/high school. Circ. 500,000. Accepts previously published artwork. Original artwork returned at job's completion on request. Sample copies available. 90% of freelance work demands knowledge of QuarkXPress, Aldus FreeHand and Adobe Photoshop.

Illustration: Works on assignment only. Prefers editorial illustration or career-related cartoons. Send query letter with brochure or résumé and tearsheets or proof of work. Show enough to prove work experience. Samples are filed or are returned by SASE if requested by artist. Reports back only if interested. Negotiates rights purchased. **Pays on acceptance**; $100 for b&w cover; $300 for color cover; $100 for b&w inside; $200 for color inside.

AMERICAN FITNESS, 15250 Ventura Blvd., Suite 200, Sherman Oaks CA 91403. (818)905-0040. Editor-at-Large: Peg Jordan. Managing Editor: Rhonda J. Wilson. Bimonthly magazine emphasizing fitness, health and exercise "for sophisticated, college-educated, active lifestyles." Circ. 36,000. Accepts previously published material. Original artwork returned after publication. Sample copy $3.

Illustration: Approached by 12 illustrators/month. Assigns 2-4 illustrations/issue. Works on assignment only. Prefers "very sophisticated" 4-color line drawings. Send query letter with thumbnails, roughs or brochure showing art style. Reports back within 2 months. Acquires one-time rights.

Tips: "Excellent source for never-before-published illustrators who are eager to supply full-page lead artwork."

THE AMERICAN LEGION MAGAZINE, Box 1055, Indianapolis IN 46206. Contact: Cartoon Editor. Emphasizes the development of the world at present and milestones of history; 4-color general-interest magazine for veterans and their families. Monthly. Original artwork not returned after publication.

Cartoons: Uses 2-3 freelance cartoons/issue. Receives 100 freelance submissions/month. Especially needs general humor in good taste. "Generally interested in cartoons with broad appeal. Those that attract the reader and lead us to read the caption rate the highest attention. Because of tight space, we're not in the market for spread or multipanel cartoons but use both vertical and horizontal single-panel cartoons. Themes should be home life, business, sports and

everyday Americana. Cartoons that pertain only to one branch of the service may be too restricted for this magazine. Service-type gags should be recognized and appreciated by any ex-service man or woman. Cartoons that may offend the reader are not accepted. Liquor, sex, religion and racial differences are taboo. No roughs. Send final product for consideration." Usually reports within 1 month. Buys first rights. **Pays on acceptance**; $150.
Tips: "Artists should submit their work as we are always seeking new slant and more timely humor. Black & white art is what we seek. Note: Cartoons are separate from the art department."

AMERICAN MOTORCYCLIST, American Motorcyclist Association, Box 6114, Westerville OH 43081-6114. (614)891-2425. Executive Editor: Greg Harrison. Managing Editor: Bill Wood. Circ. 190,000. Monthly 4-color for "enthusiastic motorcyclists investing considerable time and money in the sport." Sample copy $1.50; art guidelines free for SASE with first-class postage.
Illustration: Buys 1-2 illustrations/issue, almost all from freelancers. Receives 1-3 submissions/week. Interested in motorcycling themes. Send query letter with photocopies to be kept on file. Samples returned by SASE. Reports in 3 weeks. Buys first North American serial rights. Pays on publication; $250 minimum for b&w cover; $350 minimum for color cover; $50-300 for b&w and color inside.

AMERICAN MUSCLE MAGAZINE, Box 6100, Rosemead CA 91770. Art Director: Michael Harding. Monthly 4-color magazine emphasizing bodybuilding, exercise and professional fitness. Features general interest, historical, how-to, inspirational, interview/profile, personal experience, travel articles and experimental fiction (all sports-related). Circ. 356,440. Accepts previously published material. Original artwork returned after publication.
Illustration: Buys 5 illustrations/issue. Send query letter with résumé, tearsheets, slides and photographs. Samples are filed or are returned. Reports back within 1 week. Buys first rights, one-time rights, reprint rights or all rights. **Pays on acceptance**.
Tips: "Be consistent in style and quality."

✔**THE AMERICAN SPECTATOR**, Box 549, Arlington VA 22216-0549. (703)243-3733. Fax: (703)243-6814. Executive Editor: Wladyslaw Meszczynski. Art Director: Deborah Clark. Monthly political, conservative, newsworthy literary magazine. "We cover political topics, human interest items and book reviews." Circ. 258,000. Original artwork returned after publication. Sample copies available; art guidelines not available.
Illustration: Uses 5-10 illustrations/issue. Interested in "realism with a comic twist." Works on assignment only. Has featured illustrations by Dan Adel, Jack Davis, Phillipe Weisbecker and Blair Drawson. Features caricatures of celebrities and politicians; humorous and realistic illustration; informational graphics; spot illuastration. Prefers pen & ink, watercolor, acrylic, colored pencil, oil and pastel. Samples are filed or returned by SASE. Reports back on future assignment possibilities. Provide résumé, brochure and tearsheets to be kept on file for future assignments. No portfolio reviews. Reports in 2 weeks. Buys first North American serial rights. Pays on publication; $1,500-2,000 for color cover; $150-1,750 for color inside; $1,250-2,000 for 2-page spreads.
Tips: "We only take on about one new artist each year."

‡**AMERICAN WOMAN MOTORSCENE**, 1510 11th St., Suite 201-B, Santa Monica CA 90401-2906. (310)260-0192. Fax: (310)260-0175. E-mail: courtney@americanwomanmag.com. Website: http://www.americanwomanmag.com. Editor-in-Chief: Courtney Caldwell. Estab. 1988. Bimonthly automotive and recreational motorsports magazine for today's active women. Feature oriented for women of achievement. Circ. 150,000. Accepts previously published artwork. Originals returned at job's completion only if requested. Sample copies available for 9×12 SASE and 10 first-class stamps. 20% of freelance work demands knowledge of QuarkXPress or Aldus PageMaker.
Cartoons: Approached by 3-5 cartoonists/year. Prefers women in automotive—"classy, no bimbo stuff"; single/double panel humorous cartoons with gaglines. Send query letter with roughs and finished cartoons. Samples are filed. Reports back within 1 month by SASE or if interested. Rights purchased vary. Pays $50 for b&w.
Illustration: Approached by 3-5 illustrators/year. Works on assignment only. Features humorous illustration. Assigns 50% of illustrations to experienced, but not well-known illustrators; 50% to new and emerging illustrators. Prefers women of achievement. Open/flexible to all media. Send query letter with résumé, SASE, tearsheets and photocopies. Samples are filed or are returned by SASE. Reports back within 1 month by SASE. Will contact for portfolio review if interested. Portfolio should include b&w tearsheets, roughs, photocopies, final art and photographs. Rights purchased vary according to project. Pays on publication; $50 minimum for b&w inside. Finds artists through submissions, *Artist's & Graphic Designer's Market*.
Tips: "Must have knowledge of cars, trucks, motorcycles, hot rods and how today's women think!"

✔**AMERICA'S COMMUNITY BANKER**, 900 19th St. NW, Washington DC 20006. (202)857-3100. Fax: (202)857-5581. Art Director: Jon C. Bock. Estab. 1993. Monthly trade journal targeting senior executives of community banks. Circ. 12,000. Accepts previously published artwork. Originals returned at job's completion.
Illustration: Approached by 200 illustrators/year. Buys 2 illustrations/issue. Works on assignment only. Considers all media and any style. Send postcard-size sample. Samples are filed. Reports back only if interested. "Artists should be patient and continue to update our files with future mailings. We will contact artist when the right story comes along." Publication will contact artist for portfolio review if interested. Portfolio should include mostly finished work, some sketches. Buys one-time rights. Pays on publication; $800-1,200 for color cover; $400-600 for color inside; $250-400 for spots. Finds artists primarily through word of mouth.

Blair Drawson worked in acrylic on gessoed paper to convey "brash satire" in this illustration of Saddam Hussein accompanying an article in the January 1998 *American Spectator*. Art Director Deborah Clark appreciates Drawson's "ability to render the subject accurately yet with a sense of humor, while creating a strong concept." Clark found the illustrator through an ad in *Communication Arts*, which Drawson advertises in every two or three years.

✓**ANALOG**, 1270 Avenue of the Americas, New York NY 10020. (212)698-1313. Fax: (212)698-1198. Creative Director: Victoria Green. Junior Designer: Shirley Chan Levi. All submissions should be sent to Shirley Chan Levi, assistant art director. Estab. 1930. Monthly consumer magazine. Circ. 80,000 Art guidelines free for #10 SASE with first-class postage.
Cartoons: Prefers single panel cartoons. Send query letter with photocopies and/or tearsheets and SASE. Samples are not filed and are returned by SASE. Reports back only if interested. Buys one-time rights. **Pays on acceptance**; $35 minimum for b&w cartoons.
Illustration: Buys 8 illustrations/issue. Prefers science fiction, hardwre, robots, aliens and creatures. Considers all media. Send query letter with printed samples or tearsheets and SASE. Send follow-up postcard sample every 4 months. Accepts disk submissions compatible with QuarkXPress 7.5/version 3.3. Send EPS files. Fileees samples of interest, others are returned by SASE. Reports back only if interested. "No phone calls." Portfolios may be dropped off every Tuesday and should include b&w and color tearsheets and transparencies. "No original art please, especially oversized." Buys one-time rights. **Pays on acceptance;** $1,200 for color cover; $125 minimum for b&w inside; $35-50 for spots. Finds illustrators through *Black Book*, *LA Workbook*, *American Showcase* and other reference books.

ANGELS ON EARTH MAGAZINE, 16 E. 34th St., New York NY 10016. (212)251-8127. Fax: (212)684-0679. Website: http://www.guideposts.org. Director of Art & Design: Lawrence A. Laukhuf. Estab. 1995. Bimonthly magazine featuring true stories of angel encounters and angelic behavior. Circ. 1,000,000.
● Also publishes *Guideposts*, a monthly magazine. See listing in this section.
Illustration: Approached by 500 illustrators/year. Buys 5-8 illustrations/issue. Features computer, humorous, realistic and spot illustration. Assigns 30% of illustrations to well-known or "name" illustrators; 40% to experienced but not well-known illustrators; 30% to new and emerging illustrators. Prefers conceptual/realistic, "soft" styles. Considers all media. 2% of illustration demands computer skills. Call for submission information. Accepts disk submissions compatible with Adobe Photoshop, Adobe Illustrator. Samples are filed or returned by SASE. Art director will contact artist for portfolio review of color slides and transparencies if interested. Rights purchased vary. **Pays on acceptance**; $2,500-3,500 for color cover; $1,500-2,400 2-page spreads; $300-1,000 for spots. Finds artists through reps, *American Showcase*, *Society of Illustrators Annual*, submissions.
Tips: "If you submit work, know our publications! Tailor your portfolio or samples to each publication so the Art Director is not looking at one or two that fit his needs. Call me and tell me you've seen recent issues and how close your work is to some of the pieces in the magazine."

ANIMALS, 350 S. Huntington Ave., Boston MA 02130. (617)522-7400. Fax: (617)522-4885. Contact: Molly Lupica. Estab. 1868. "*Animals* is a national bimonthly 4-color magazine published by the Massachusetts Society for the Prevention of Cruelty to Animals. We publish articles on and photographs of wildlife, domestic animals, conservation, controversies involving animals, animal-welfare issues, pet health and pet care." Circ. 90,000. Original artwork usually returned after publication. Sample copy $3.95 with SAE (8½×11); art guidelines not available.
Illustration: Approached by 1,000 illustrators/year. Works with 5 illustrators/year. Buys 5 or less illustrations/year from freelancers. Uses artists mainly for spots. Prefers pets or wildlife illustrations relating to a particular article topic. Prefers pen & ink, then airbrush, charcoal/pencil, colored pencil, watercolor, acrylic, oil, pastel and mixed media. Needs editorial and medical illustration. Send query letter with brochure or tearsheets. Samples are filed or are returned by SASE. Reports back within 1 month. Publication will contact artist for portfolio review if interested. Portfolio should include color roughs, original/final art, tearsheets and final reproduction/product. Negotiates rights purchased. **Pays on acceptance**; $300 maximum for color cover; $150 maximum for b&w, $200 for color inside.
Tips: "In your samples, include work showing animals, particularly dogs and cats or humans with cats or dogs. Show a representative sampling."

‡**ANTHOLOGY**, P.O. Box 4411, Mesa AZ 85211-4411. Phone/fax: (602)461-8200. E-mail: anthology@juno.com. Website: primenet.com/~inkwell. Art Director: Sandy Nelson. Executive Editor: Sharon Skinner. Estab. 1991. Bimonthly b&w literary magazine featuring poetry, prose and artwork. Circ. 2,000. Sample copies for $3.95. Art guidelines free for #10 SASE with first-class postage.
Illustration: Approached by 3-5 illustrators/year. Buys 6-10 illustrations/issue. Has featured illustrations by Donald Fronheiser, Shane Howerton. Features humorous, realistic and spot illustrations of sci-fi, fantasy objects. Prefers b&w ink. Assigns 100% of illustrations to new and emerging illustrators. 100% of freelance illustration demands knowledge of Aldus PageMaker or Corel Draw. Send query letter with photocopies and SASE. Accepts Window-compatible disk submissions. Send TIFF, BMP, PCX or GIF files. Samples are not filed, returned by SASE. Reports back within 3 months. Buys one-time rights. Pays on publication $5 for b&w cover or inside. Finds illustrators through word of mouth.
Tips: "Illustration is a valuable yet overlooked area for many literary magazines. The best chance illustrators have is to show the publication how their work will enrich its pages."

‡**AOPA PILOT**, 421 Aviation Way, Frederick MD 21701-4798. (301)695-2371. Fax: (301)695-2381. E-mail: mike.kline @aopa.org. Website: http://www.aopa.org. Creative Director: Art Davis. Art Director: Michael Kline. Estab. 1958. Monthly 4-color trade publication for the members of the Aircraft Owners and Pilots Association. The world's largest aviation magazine. Circ. 340,000. Sample copies free for 8½×11 SASE.
Illustration: Approached by 50 illustrators/year. Buys 3 illustrations/issue. Has featured illustrations by Jack Pardue, Byron Gin. Features charts & graphs, informational graphics, realistic, computer, aviation-related illustration. Prefers

variety of styles ranging from technical to soft and moody. Assigns 75% of illustration to experienced, but not well-known illustrators; 25% to new and emerging illustrators. 10% of freelance illustration demands knowledge of Adobe Illustrator, Adobe Photoshop, Aldus FreeHand or 3-D programs. Send postcard or other non-returnable samples, such as photocopies and tearsheets. Accepts Mac-compatible disk submissions. Send EPS files. Samples are filed and are not returned. Will contact artist for portfolio review if interested. Rights purchased vary according to project; negotiable. **Pays on acceptance.** Finds illustrators through agents, sourcebooks, online services and samples.
Tips: "We are looking to increase our stable of freelancers. Looking for a variety of styles and experience."

APPALACHIAN TRAILWAY NEWS, Box 807, Harpers Ferry WV 25425. (304)535-6331. Fax: (304)535-2667. Editor: Judith Jenner. Emphasizes the Appalachian Trail for members of the Appalachian Trail Conference. 5 issues/year. Circ. 26,000. Sometimes accepts previously published material. Returns original artwork after publication. Sample copy $3 (no SASE); art guidelines for SASE with first-class postage.
Illustration: Buys 2-5 illustrations/issue. Prefers pen & ink, charcoal/pencil, colored pencil, watercolor, acrylic, oil, pastel and calligraphy. Original artwork must be related to the Appalachian Trail. Send query letter with samples to be kept on file. Prefers photostats, photocopies or tearsheets as samples. Samples not filed are returned by SASE. Reports within 2 months. Negotiates rights purchased. **Pays on acceptance;** $25-200 for b&w, occasional color. Also buys 1-2 cartoons/year; pays $25 and up. Finds most artists through references, word of mouth and samples received through the mail.

AREA DEVELOPMENT MAGAZINE, 400 Post Ave., New York NY 11590. (516)338-0900. Fax: (516)338-0100. E-mail: marta777@aol.com. Art Director: Marta Sivakoff. Estab. 1965. Monthly trade journal regarding economic development and site selection issues. Circ. 40,000.
Illustration: Approached by 60 illustrators/year. Buys 1-2 illustrations/issue. Features charts & graphs; informational graphics; realistic, medical and computer illustration. Assigns 50% of illustrations to well-known or "name" illustrators; 50% to experienced, but not well-known illustrators. Prefers business/corporate themes with strong conceptual ideas. Considers all media. 50% of freelance illustration demands knowledge of Adobe Photoshop, Adobe Illustrator and QuarkXPress. Send postcard sample. Accepts disk submissions compatible with QuarkXPress 3.31 for the Mac. Send EPS, TIFF files. Art director will contact artist for portfolio review of b&w, color tearsheets if interested. Rights purchased vary according to project. Pays on publication; $500-1,200 for color cover.
Tips: "Must have corporate understanding and strong conceptual ideas. We address the decision-makers' needs by presenting their perspectives. Create a varied amount of subjects (business, retail, money concepts). Mail color self promotions with more than one illustration."

ARMY MAGAZINE, 2425 Wilson Blvd., Arlington VA 22201. (703)841-4300. Art Director: Patty Zukerowski. Estab. 1950. Monthly trade journal dealing with current and historical military affairs. Also covers military doctrine, theory, technology and current affairs from a military perspective. Circ. 115,000. Originals returned at job's completion. Sample copies available for $2.25. Art guidelines available.
Cartoons: Approached by 5 cartoonists/year. Buys 1 cartoon/issue. Prefers military, political and humorous cartoons; single or double panel, b&w washes and line drawings with gaglines. Send query letter with brochure and finished cartoons. Samples are filed or are returned by SASE if requested by artist. Reports back to the artist only if interested. Buys one-time rights. Pays $50 for b&w.
Illustration: Approached by 1 illustrator/year. Buys 1-3 illustrations/issue. Works on assignment only. Prefers military, historical or political themes. Considers pen & ink, airbrush, acrylic, marker, charcoal and mixed media. "Can accept artwork done with Illustrator or Photoshop for Macintosh." Send query letter with brochure, résumé, tearsheets, photocopies and photostats. Samples are filed or are returned by SASE if requested by artist. Publication will contact artist for portfolio review if interested. Portfolio should include b&w and color tearsheets, photocopies and photographs. Buys one-time rights. Pays on publication; $300 minimum for b&w cover; $500 minimum for color cover; $50 for b&w inside; $75 for color inside; $35-50 for spots.

THE ARTIST'S MAGAZINE, 1507 Dana Ave., Cincinnati OH 45207. E-mail: tamedit@aol.com. Contact: Editor. Monthly 4-color magazine emphasizing the techniques of working artists for the serious beginning, amateur and professional artist. Circ. 275,000. Occasionally accepts previously published material. Returns original artwork after publication. Sample copy $3.50 US, $4.50 Canadian or international; remit in US funds; art guidelines available.
● Sponsors annual contest. Send SASE for more information. Also publishes a quarterly issue called *Watercolor Magic*.
Illustration: Contact: Art Director. Buys 1-2 illustrations/issue. Has featured illustrations by: Brenda Grannan, Sean Kane, Darryl Ligasan, Loren Long and Brad Walker. Features humorous and realistic illustration. Assigns 10% of illustrations to well-known or "name" illustrators; 60% to experienced, but not well-known illustrators; 30% to new and emerging illustrators. Works on assignment only. Send postcard sample or query letter with brochure, photocopies, photographs and tearsheets to be kept on file. Prefers photostats or tearsheets as samples. Samples not filed are returned by SASE. Buys first rights. **Pays on acceptance;** $275-600 for color inside; $100-275 for spots. "We're also looking for b&w spots of art-related subjects. We will buy all rights; pay $25 per spot."
Tips: "Research older issues of publication and send samples that fit the subject matter and style of target publication."

‡ART:MAG, P.O. Box 70896, Las Vegas NV 89170-0896. (702)734-8121. Art Director: Peter Magliocco. Estab. 1984. Quarterly b&w small press literary arts zine. Circ. 100. Art guidelines for #10 SASE with first-class postage.

Cartoons: Approached by 5-10 cartoonists/year. Buys 5 cartoons/year. Prefers single panel, political, humorous and satirical b&w line drawings. Send query letter with b&w photocopies, samples, tearsheets and SASE. Samples are filed. Reports back within 3 months. Rights purchsed vary according to project. Pays on publication. Pays 1 contributor's copy.

Illustration: Approached by 5-10 illustrators/year. Buys 3-5 illustrations/year. Has featured illustrations by Jeffrey Bullock, Mary Fancher, Ho Baron, Stepan Chapman. Features caricatures of celebrities and politicians and spot illustrations. Preferred subjects: art, literature and politics. Prefers realism, hip, culturally-literate collages and b&w line drawings. Assigns 95% of freelance illustrations to new and emerging illustrators. Send query letter with photocopies, SASE. Reports back within 3 months. Portfolio review not required. Buys one-time rights. Pays on publication; 1 contributor's copy. Finds illustrators through magazines, word of mouth.

Tips: "*Art:Mag* is basically for new or amateur artists with unique vision and iconoclastic abilities whose work is unacceptable to slick mainstream magazines."

‡ARTS INDIANA, 47 S. Pennsylvania, #701, Indianapolis IN 46204-3622. (317)632-7894. Fax: (317)632-7966. Editor-in-Chief: Julie Pratt McQuiston. Estab. 1979. Monthly arts magazine. Circ. 12,000. Sample copies available for $4.95. 25% of freelance work demands computer knowledge of Quark XPress.

Cartoons: Approached by 5-10 cartoonists/year. Buys up to 2 cartoons/year by Indiana-connected illustrators. Prefers arts-related (all arts) and humorous cartoons; single panel b&w washes and line drawings with or without gaglines. Send query letter with roughs and finished cartoons. Samples are not filed. Reports back within 2 months. Buys one-time rights. Pays $35 for b&w.

Illustration: Approached by 5-10 illustrators/year. Buys up to 2 illustrations/year by Indiana-connected illustrators. Prefers any line drawings for illustrating columns. Considers pen & ink. Send query letter with SASE and photocopies. Reports back within 2 months. Portfolio review not required. Buys one-time rights. Pays on publication; $25-35 per line drawing; $35 for spots.

Tips: "Anticipate lead time better with submissions."

✔ISAAC ASIMOV'S SCIENCE FICTION MAGAZINE, 1270 Avenue of the Americas, New York NY 10020. (212)698-1313. Fax: (212)698-1198. Art Director: Victoria Green. Junior Designer: Shirley Chan Levy. All submissions should be sent to Shirley Chan Levi, assistant art director. Estab. 1977. Monthly b&w with 4-color cover magazine of science fiction and fantasy. Circ. 61,000. Accepts previously published artwork. Original artwork returned at job's completion. Art guidelines available for #10 SASE with first-class postage.

Cartoons: Approached by 20 cartoonists/year. Buys 1-2 cartoons/issue. Prefers science fiction and fantasy themes, humorous cartoons. Prefers single panel, b&w washes or line drawings with and without gagline. Send query letter with finished cartoons, photocopies and SASE. Samples are filed or returned by SASE. Reports back only if interested. Buys one-time rights or reprint rights. **Pays on acceptance**; $35 minimum.

Illustration: Buys 4 illustrations/issue. Works on assignment only. Prefers photorealistic style. Considers all media. Send query letter with printed samples, photocopies and/or tearsheets and SASE. Accepts disk submissions compatible with QuarkXPress 7.5 version 3.3. Send EPS files. Accepts illustrations done with Adobe Illustrator, Adobe Photoshop and Aldus FreeHand. Reports back only if interested. Portfolios may be dropped off every Tuesday and should include b&w and color tearsheets. Buys one-time and reprint rights. **Pays on acceptance**; $1,000-1,200 for color cover; $100-125 for b&w inside; $50 for spots.

Tips: No comic book artists. Realistic work only, with science fiction/fantasy themes. Show characters with a background environment.

‡ASPCA ANIMAL WATCH, 424 E. 92nd St., New York NY 10128. (212)876-7700, ext. 4441. Art Director: Sibylle von Fischer. Estab. 1960. Quarterly company magazine. Circ. 90,000. Accepts previously published artwork. Original artwork returned at job's completion.

Illustration: Approached by 20 illustrators/year. Buys 3 illustrations/issue. Prefers animal-related themes or styles. Considers all media. Send photocopies. Samples are filed. Reports back within 2 weeks. Rights purchased vary. Pays on publication; $150 for color cover; $75 for b&w inside; and $100 for color inside.

‡ASPEN MAGAZINE, Box G-3, Aspen CO 81612. (970)920-4040. Fax: (970)920-4044. Art Director: Andrew Snider. Bimonthly 4-color city magazine with the emphasis on Aspen and the valley. Circ. 12,000. Accepts previously published artwork. Original artwork returned at job's completion. Samples copies and art guidelines available.

Illustration: Approached by 15 illustrators/year. Buys 2 illustrations/issue. Themes and styles should be appropriate for editorial content. Considers all media. Send query letter with tearsheets, photostats, photographs, slides, photocopies and transparencies. Samples are filed. Reports back only if interested. Call for appointment to show a portfolio, which

 A CHECKMARK PRECEDING A LISTING indicates a change in either the address or contact information since the 1998 edition.

should include thumbnails, roughs, tearsheets, slides and photographs. Buys first, one-time or reprint rights. Pays on publication.

ASSOCIATION OF COLLEGE UNIONS-INTERNATIONAL, One City Centre, 120 W. Seventh St., Bloomington IN 47404-3925. (812)855-8550. Fax: (812)855-0162. E-mail: avest@indiana.edu. Website: http://www.indiana.edu/~acui. Assistant Director of Publishing and Marketing: Ann Vest. Estab. 1914. Professional education association journal covering "multicultural issues, creating community on campus, union and activities programming, managing staff, union operation, professional development and student development." Needs computer-literate freelancers with knowledge of CorelDraw for illustration.
 • Also publishes hardcover and trade paperback originals. See listing in the Book Publishers section for more information.
Illustration: Works on assignment only. Considers pen & ink, pencil, and computer illustration. Send query letter with résumé, photocopies, tearsheets, photographs and color transparencies of college student union activities. Samples are filed. Reports back only if interested. Negotiates rights purchased.
Design: Needs designers for production. Send query letter with résumé and photocopies. Pays by project.
Tips: "We are a volunteer-driven association. Most people submit work on that basis. We are on a limited budget."

‡ATLANTIC CITY MAGAZINE, 100 W. Washington Ave., Pleasantville NJ 08232-1324. (609)272-7907. Fax: (609)272-7910. Director of Design & Production: Michael L.B. Lacy. Estab. 1979. 4-color monthly that emphasizes the growth, people and entertainment of the Atlantic City/South Jersey region for residents and visitors. Circ. 50,000.
Illustration: Approached by 1,000 illustrators/year. Works with 20 illustrators/year. Buys 36 illustrations/year. Uses artists for spots, department and feature illustration. Uses mainly 4-color and some b&w. Works on assignment only. Send query letter with brochure showing art style, tearsheets, slides and photographs to be kept on file. Call or write for appointment to show portfolio of printed samples, final reproduction/product, color and b&w tearsheets and photographs. Buys first rights. Pays on publication; $250 for b&w and $500 for color cover; $125 for b&w inside; $225 for color inside.
Tips: "We are looking for intelligent, reliable artists who can work within the confines of our budget and time frame. Deliver good art and receive good tearsheets. We are produced completely electronically and have more flexibility with design. Now illustrators who can work with and provide electronic files are a plus."

AUTHORSHIP, 1450 S. Havana, Suite 424, Aurora CO 80012. (303)751-7844. Fax: (303)751-8593. Executive Director: Sandy Whelchel. Estab. 1937. Bimonthly magazine. "Our publication is for our 3,000 members, and is cover-to-cover about writing."
Cartoons: Samples are returned. Reports back in 4 months. Buys first North American serial and reprint rights. **Pays on acceptance**; $25 minimum for b&w.
Illustration: Accepts disk submissions. Send TIFF files.
Tips: "We only take cartoons slanted to writers."

AUTOMOBILE MAGAZINE, Dept. AGDM, 120 E. Liberty, Ann Arbor MI 48104. (313)994-3500. Art Director: Lawrence C. Crane. Estab. 1986. Monthly 4-color "automobile magazine for upscale lifestyles." Traditional, "imaginative" design. Circ. 650,000. Original artwork is returned after publication. *Art guidelines specific for each project*.
Illustration: Buys illustrations mainly for spots and feature spreads. Works with 5-10 illustrators/year. Buys 2-5 illustrations/issue. Works on assignment only. Considers airbrush, mixed media, colored pencil, watercolor, acrylic, oil, pastel and collage. Needs editorial and technical illustrations. Send query letter with brochure showing art style, résumé, tearsheets, slides, photographs or transparencies. Show automobiles in various styles and media. "This is a full-color magazine, illustrations of cars and people must be accurate." Samples are returned only if requested. "I would like to keep something in my file." Reports back about queries/submissions only if interested. Request portfolio review in original query. Portfolio should include final art, color tearsheets, slides and transparencies. Buys first rights and one-time rights. Pays $200 and up for color inside. Pays $2,000 maximum depending on size of illustration. Finds artists through mailed samples.
Tips: "Send samples that show cars drawn accurately with a unique style and imaginative use of medium."

‡AUTOMUNDO, 2960 SW Eighth St., 2nd Floor, Miami FL 33135-2827. (305)541-4198. Fax: (305)541-5138. E-mail: jorgek@automundo.com. Website: http://www.automundo.com. Editor: Jorge Koechlin. Estab. 1982. Monthly 4-color Spanish automotive magazine. Accepts previously published artwork. Originals returned at job's completion. Sample copies and art guidelines available.
Cartoons: Approached by 2 cartoonists/year. Buys 1 cartoon/issue. Prefers car motifs. Prefers cartoons without gagline. Send query letter with brochure and roughs. Accepts disk submissions. Samples are filed. Reports back only if interested. Rights purchased vary. Pays $10 for b&w cartoons.
Illustration: Will contact for portfolio review if interested. Portfolios may be dropped off every Monday. Needs editorial illustrations.
Design: Needs freelancers for design with knowledge of Adobe Photoshop and Adobe Illustrator. Send brochure.

‡AWARE COMMUNICATIONS, INC., 305 SW 140th Terrace, Newberry FL 32669. (352)378-3879. E-mail: scottgolf@bigfoot.com. Vice President-Creative: Scott M. Stephens. Estab. 1984. Semi-annual, annual 4-color company maga-

zines and posters for Fortune 100 companies. Circ. 500,000 to 6.5 million. 30% of freelance work demands knowledge of QuarkXPress, Adobe Photoshop and CorelDraw. Original artwork is not returned. Art guidelines not available.

Illustration: Has featured illustrations by Randy Hamblin, Scott Ross and Larry Winberg. Features computer, realistic, medical and spot illustration. Assigns 90% of illustrations to experienced, but not well-known illustrators; 10% to new and emerging illustrators. Works on assignment only. Needs editorial, medical and technical illustration. Prefers realistic styles; very graphic and educational. Send brochure, tearsheets and photostats. Samples are filed or returned by SASE. Will contact for portfolio review if interested. Portfolio should include printed samples, color tearsheets, photostats, photographs, slides and photocopies. Buys all rights. **Pays on acceptance.**

Tips: "Have a universal, appealing style. We deal with medical and educational publications, so abstract images and style will not be considered." Must be able to illustrate people and be anatomically accurate.

❧B.C. OUTDOORS, 780 Beatty St., Suite 300, Vancouver, British Columbia V6B 2M1 Canada. (604)606-4644. Fax: (604)687-1925. 4-color magazine, emphasizing fishing, hunting, RV camping, wildlife/conservation in British Columbia. Published 8 times/year. Circ. 40,000. Original artwork returned after publication unless bought outright. Prefers inquiring freelancers to be familiar with Adobe Illustrator and QuarkXPress.

Illustration: Approached by more than 10 illustrators/year. Buys 16-20 illustrations/year. Prefers local artists. Interested in outdoors, creatures (BC species only) and activities as stories require. Format: b&w line drawings and washes for inside and color washes for inside. Works on assignment only. Samples returned by SAE (nonresidents include IRC). Reports back on future assignment possibilities. Arrange personal appointment to show portfolio or send samples of style. Subject matter and the art's quality must fit with publication. Reports in 6-8 weeks. Buys first North American serial rights or all rights on a work-for-hire basis. **Pays on acceptance;** $40 minimum for spots.

Tips: "Send us material on fishing and hunting. We generally just send back non-related work."

BABYBUG, 315 Fifth St., Peru IL 61354-0300. (815)223-2520. Fax: (815)224-6675. Art Director: Suzanne Beck. Estab. 1994. Magazine published every six weeks "for children six months to two years." Circ. 44,588. Sample copy for $4; art guidelines for SASE.

Illustration: Approached by about 85 illustrators/month. Buys 23 illustrations/issue. Considers all media. Send query letter with printed samples, photocopies and tearsheets. Samples are filed or returned if postage is sent. Reports back within 45 days. Buys one-time rights. Pays 30 days after acceptance. Pays $500 minimum for color cover; $250 minimum per page inside. Finds illustrators through agents, *Creative Black Book*, magazines, word of mouth, artist's submissions and printed children's books.

BABY'S WORLD, 16 Peniston Ave., E. Hanover NJ 07936. (201)503-0700. Fax: (201)887-6801. E-mail: info@babys world.com. Editor: Taylor Scott. Quarterly consumer magazine focusing on new and expecting parents and on issues such as health, safety, medical concerns, nutrition. Circ. 100,000. Sample copies free for $9 × 11$ SASE and 5 first-class stamps. Art guidelines with first-class postage.

Cartoons: Buys 2 cartoons/issue. Prefers baby and parents. Prefers single panel, humorous, with gaglines. Send query letter with finished cartoons, photographs, photocopies, roughs, tearsheets. Samples are filed and not returned. Reports back only if interested. Buys first North American serial rights. Pays on publication; $5-20 for b&w, $10-30 for color.

Illustration: Buys 5 illustrations/issue. Prefers baby, parents, medical, exercise. Considers all media. 25% of freelance illustration demands computer skills. Send postcard sample, query letter with printed samples, photocopies and tearsheets. Send follow-up postcard sample every month. Samples are filed and are not returned. Reports back only if interested. Art director will contact artist for portfolio review of b&w, color tearsheets if interested. Buys first North American serial rights. Pays on publication; $75-150 for b&w cover; $200-500 for color cover; $5-15 for b&w inside; $20-30 for color inside.

Design: Needs freelancers for design. Prefers designers with experience in QuarkXPress. 100% of freelance design work demands knowledge of Adobe Photoshop, Adobe Illustrator, QuarkXPress. Send query letter with printed samples, photocopies, tearsheets.

Tips: "We want fun materials with the latest on baby care and new parents' issues."

BACKPACKER MAGAZINE, 33 E. Minor St., Emmaus PA 18098. (610)967-5171. Fax: (617)967-8181. E-mail: jpepper1@earthlink.net. Website: http://www.bpbasecamp.com. Art Director: John Pepper. Estab. 1973. Consumer magazine covering non-motorized wilderness travel. Circ. 250,000. Art guidelines free for SASE with first-class postage.

Illustration: Approached by 200-300 illustrators/year. Buys 10 illustrations/issue. Considers all media. 60% of freelance illustration demands knowledge of Aldus FreeHand, Adobe Photoshop, Adobe Illustrator, QuarkXPress. Send query letter with printed samples, photocopies and/or tearsheets. Send follow-up postcard sample every 6 months. Accepts disk submissions compatible with QuarkXPress, Illustrator and Photoshop. Samples are filed and are not returned. Artist should follow up with call. Art director will contact artist for portfolio review of color photographs, slides, tearsheets and/or transparencies if interested. Buys first rights or reprint rights. Pays on publication; $200 minimum for b&w or color inside or spots. Finds artists through submissions and other printed media.

Tips: *Backpacker* does not buy cartoons. "Know the subject matter, and know *Backpacker Magazine.*"

BALLAST QUARTERLY REVIEW, 2022 X Ave., Dysart IA 52224-9767. Contact: Art Director. Estab. 1985. Quarterly literary and graphic design magazine. "*Ballast* is an acronym for Books Art Language Logic Ambiguity Science and Teaching. It is a journal of verbal and visual wit. Audience consists mainly of designers, illustrators, writers and

teachers." Circ. 600. Accepts previously published artwork. Originals returned at job's completion. Sample copies available for 5 first-class stamps; art guidelines not available.

Illustration: Approached by 30 illustrators/year. Publishes 5 illustrations/issue. Has featured illustrations by Gary Kelley, Steven Guarnaccia and Beth Bartholomew. Features humorous illustration. Seeks b&w line art—no halftones. Send postcard sample or query letter with photocopies and SASE. Samples are sometimes filed or returned by SASE. Reports back only if interested. Payment is 5-10 copies of issue. Finds artists through books, magazines, word of mouth, other illustrators.

Tips: "We rarely use unsolicited artwork. Become familiar with past issues."

BALLOON LIFE MAGAZINE, 2336 47th Ave. SW, Seattle WA 98116-2331. (206)935-3649. Fax: (206)935-3326. E-mail: blnlife@scn.org. Website: http://www.balloonlife.com. Editor: Tom Hamilton. Estab. 1985. Monthly 4-color magazine emphasizing the sport of ballooning. "Contains current news, feature articles, a calendar and more. Audience is sport balloon enthusiasts." Circ. 4,000. Accepts previously published material. Original artwork returned after publication. Sample copy for SASE with 8 first-class stamps. Art guidelines for SASE with first-class postage.

● Only cartoons and sketches directly related to gas balloons or hot air ballooning are considered by *Balloon Life*.

Cartoons: Approached by 20-30 cartoonists/year. Buys 1-2 cartoons/issue. Seeks gag, editorial or political cartoons, caricatures and humorous illustrations. Prefers single panel b&w line drawings with or without gaglines. Send query letter with samples, roughs and finished cartoons. Samples are filed or returned. Reports back within 1 month. Buys all rights. Pays on publication; $25 for b&w and $25-40 for color.

Illustration: Approached by 10-20 illustrators/year. Buys 1-3 illustrations/year. Has featured illustrations by Charles Goll. Features humorous illustration; informational graphics; spot illustration. Needs computer-literate illustrators familiar with Aldus PageMaker, Adobe Illustrator, Adobe Photoshop, Colorit, Pixol Paint Professional and Aldus FreeHand. Send postcard sample or query letter with business card and samples. Accepts submissions on disk compatible with Macintosh files. Send EPS files. Samples are filed or returned. Reports back within 1 month. Will contact for portfolio review if interested. Buys all rights. Pays on publication; $50 for b&w or color cover; $25 for b&w inside; $25-40 for color inside.

Tips: "Know what a modern hot air balloon looks like! Too many cartoons reach us that are technically unacceptable."

‡**BAY AREA PARENT/BAY AREA BABY**, 401 Alberto Way, Suite A, Los Gatos CA 95032. Fax: (408)356-4903. Production Manager: Patrick. Estab. 1983. Monthly family and parenting resource magazine. Circ. 75,000. Accepts previously published artwork. Originals are returned at job's completion. Freelance work demands knowledge of Page-Maker, QuarkXPress and Photoshop.

Tips: "Start out cheap, get us hooked, be reliable, work fast. Keep in mind that the work will be printed on newsprint. This can be very muddy. Artist has to compensate for this."

‡**BAY WINDOWS**, 631 Tremont St., Boston MA 02118. (617)266-6670. E-mail: epperly@baywindows.com or Rudy K@aol.com. Editor: Jeff Epperly. Arts Editor: Rudy Kikel. Estab. 1983. A weekly newspaper "targeted to politically-aware lesbians, gay men and other political allies publishing non-erotic news and features"; b&w with 2-color cover. Circ. 60,000. Accepts previously published artwork. Original artwork returned after publication. Sample copies available. Needs computer illustrators familiar with Adobe Illustrator or Aldus FreeHand.

Cartoons: Approached by 25 freelance cartoonists/year. Buys 1-2 freelance cartoons/issue. Buys 50 freelance cartoons/year. Preferred themes include politics and life-styles. Prefers double and multiple panel, political and editorial cartoons with gagline, b&w line drawings. Send query letter with roughs. Samples are returned by SASE if requested by artist. Reports back to the artist within 6 weeks only if interested. Rights purchased vary according to project. Pays on publication; $50-100 for b&w only.

Illustration: Approached by 60 freelance illustrators/year. Buys 1 freelance illustration/issue. Buys 50 freelance illustrations/year. Artists work on assignment only. Preferred themes include politics—"humor is a plus." Considers pen & ink and marker drawings. Send query letter with photostats and SASE. Samples are filed. Reports back within six weeks only if interested. Portfolio review not required. Rights purchased vary according to project. Pays on publication; $100-125 for cover; $75-100 for b&w inside; $75 for spots.

‡***BBC LEARNING IS FUN MAGAZINE**, 80 Woodlane, Woodlands Room A1130, London W12 0TT United Kingdom. Phone: (0181)5762558. Fax: (0181)5762941. Art Editor: Maria Goodspeed. Estab. 1996. Monthly 4-color learning magazine covering all subjects of national curriculum for children aged 5-7.

Illustration: Approached by 52 illustrators/year. Buys many illustrations/year. Features computer, humorous and realistic illustrations of children. Prefers bright colors. Send query letter with photocopies. Accepts Mac-compatible disk submissions. Samples are filed. Will contact artist for portfolio review if interested. Buys all rights. Pays on publication. Finds illustrators through sourcebooks.

BECKETT PUBLICATIONS, 15850 Dallas Pkwy., Dallas TX 75248. (972)991-6657. Fax: (972)991-8930. E-mail: jsmalling@beckett.com. Website: http://www.beckett.com. Art Editor: Judi Smalling. Estab. 1984. Publishes monthly consumer magazines emphasizing sports card and memorabilia collecting (baseball, football, basketball, hockey and auto racing). "Our readers particularly enjoy sports art of superstar athletes." Circ. 1 million. Art guidelines for #10 SASE with first-class postage.

Illustration: Approached by 150-250 illustrators/year. Buys 1-2 illustrations/issue. Features humorous and realistic illustration; informational graphics; spot illustration. Assigns 80% to experienced, but not well-known illustrators. Prefers sports art with good likeness, vertical format. Considers all media. Send query letter with SASE or contact by e-mail. Accepts disk submissions. Send high resolution, 5-file EPS files. Samples are filed. Reports back within 1 month. Will contact for portfolio review of slides and transparencies if interested. Buys first North American serial rights, with option for reprint and electronic rights. **Pays on acceptance**; $300 minimum for color cover; $150 maximum for b&w inside; $200 maximum for color inside. Finds illustrators through art contests, word of mouth, the Beckett magazines.
Design: Needs freelancers for design and production. Prefers local designers with experience in editorial design. 100% of freelance work demands knowledge of Adobe Photoshop 3.0, Adobe Illustrator 5.0, QuarkXPress 3.3. Send query letter with photocopies.
Tips: "Read our magazines to determine which superstar athletes are desirable to paint. Vertical format preferred. Submit 4×5 transparencies or 35mm slides. Label submissions. Call or write for our current 'Want List.' "

BEST'S REVIEW, Ambest Rd., Oldwick NJ 08858. (908)439-2200. Fax: (908)439-3363. Website: http://www.ambest.-com. Art Director: John M. Onuschak. Estab. 1930. Monthly insurance trade journal. Circ. 50,000. Sample copies and art guidelines available.
Illustration: Approached by 50 illustrators/year. Buys 3 illustrations/issue. Considers all media. 75% of freelance illustration demands knowledge of Adobe Photoshop and Adobe Illustrator. Send postcard sample. Accepts disk submissions. Samples are filed and are not returned. Reports back within 1 month. Buys one-time rights. Pays on publication; $900-1,000 for b&w cover; $1,000-1,500 for color cover; $250-500 for b&w inside; $500-750 for color inside; $100-250 for spots.

BLACK BEAR PUBLICATIONS/BLACK BEAR REVIEW, 1916 Lincoln St., Croydon PA 19021-8026. E-mail: bbreview@aol.com. Website: http://members.aol.com/bbreview/index.htm. Editor: Ave Jeanne. Associate Editor: Ron Zettlemoyer. Estab. 1984. Publishes semiannual b&w magazine emphasizing social, political, ecological and environmental subjects "for mostly well-educated adults." Circ. 500. Also publishes chapbooks. Accepts previously published artwork. Art guidelines for SASE with first-class postage. Current copy $5 postpaid in U.S., $8 overseas.
Illustration: Works with 20 illustrators/year. Buys 10 illustrations/issue. Has featured illustrations by James P. Lennon. Prefers collage, woodcut, pen & ink. Send camera-ready pieces with SASE. Samples not filed are returned by SASE. Portfolio review not required. Reports within 2 weeks. Acquires one-time rights or reprint rights. Pays on publication with sample copy for the magazine and $3-10 for cover illustration work. Pays cash on acceptance for chapbook illustrators. Chapbook illustrators are contacted for assignments. Average pay for chapbook illustrators is $20-50 for one-time rights. Does not use illustrations over 4×6. Finds artists through word of mouth, submissions and on the Internet.
Tips: "Read our listing carefully. Be familiar with our needs and our tastes in previously published illustrations. We can't judge you by your résumé—send signed copies of b&w artwork. Include title and medium. Send pieces that reflect social concern. No humor please. If we are interested, we won't let you know without a SASE."

‡THE BLACK LILY, 8444 Cypress Circle, Sarasota FL 34243-2006. (941)351-4386. E-mail: gkuklews@ix.netcom.com. Chief Editor: Vincent Kuklewski. Estab. 1996. Quarterly b&w zine featuring fantasy and medieval short stories and poetry (pre-1600 world setting). Circ. 150.
 ● This publisher is launching a science fiction zine in early 1999.
Cartoons: Buys 2 cartoons/year. Prefers fantasy—elves, dragons, princess, knights. Prefers: single or multiple panel, humorous, b&w line drawings. Send query letterr with b&w photocopies and SASE. Samples are filed. Reports back within 1 month. Rights purchased vary according to project. **Pays on acceptance.** Pays $5-25 for b&w and comic strips.
Illustration: Approached by 50 illustrators/year. Buys 15 illustrations/issue. Has featured illustrations by Bill Reames, Richard Dahlstrom, Virgil Barfield, Cathy Buburuz. Features humorous and realistic illustrations portraying high fantasy and pre-1600 historical subjects. Prefers pen & ink. Assigns 25% to experienced, but not well-known illustrators; 75% to new and emerging illustrators. Send query letter with photocopies, SASE. Accepts Windows-compatible disk submissions. Send TIFF files. Samples are filed. Reports back within 1 month. Will contact artist for portfolio review if interested. Buys one-time rights or vary according to project. **Pays on acceptance.** Pays $25-50 for b&w cover; $5-50 for b&w inside. Pays $5 for spots.
Tips: Submit "crisp, clear black & white line drawings. Shading by stipiling preferred. Need more pre-1600 AD western Europe work, but also need Chinese/Japanese and Islamic designs. Especially interested in art with Northwoods Forest/animal/villagers/Lappland/fairy tale work. Commonly used size work is 'one-column' 3½×9. Always need cover art. We seek to never repeat the same artist on covers."

BLACK WARRIOR REVIEW, Box 862936, University of Alabama, Tuscaloosa AL 35486-0027. (205)348-4518. Website: http://www.sa.ua.edu/osm/bwr. Editor: Christopher Chambers. Biannual 4-color literary magazine publishing contemporary poetry, fiction and nonfiction by new and established writers. Circ. 2,000. Accepts previously published artwork. Original artwork is returned at job's completion. Sample copy $8.
Illustration: Approached by 30 illustrators/year. Buys 1-2 illustrations/issue. Has featured illustrations by John Westmark, Santiago Uceda, Kathleen Fetters and Robert Cox. Themes and styles vary. Considers color and b&w photography, pen & ink, watercolor, acrylic, oil, collage and marker. Send postcard sample. Samples are not filed. Pays on publication; $150 for b&w or color cover; $25 for b&w inside.

‡**BLOOMBERG PERSONAL MAGAZINE**, Bloomberg Business Park, 100 Business Park Dr., Princeton NJ 08542-0888. (609)279-4604. Fax: (609)279-7150. E-mail: personal@bloomberg.com. Website: http://www.bloomberg.com. Art Director: Carol Layton. Estab. 1994. Monthly consumer magazine. "Currently a Sunday supplement, we plan to re-launch as a subscriber-based magazine fall 1996. Our audience will be consumers interested in money, markets and lifestyle, and will offer enhanced information from the Bloomberg database for serious investors." Circ. 150,000. Art guidelines not available.

Illustration: Approached by 500 illustrators/year. Buys 300 illustrations/year. Has featured illustrations by B. Blitt, B. Cronin, W. Linn, M. Witte, J. Wooley, W. Schumaker and B. Drawson. Features informational graphics; computer, spot and conceptual illustration. Assigns 85% of illustrations to well-known or "name" illustrators; 15% to experienced, but not well-known illustrators. Prefers conceptual, editorial, humorous, highly stylized. Considers all media. 20% of freelance illustration demands knowledge of Adobe Photoshop and Adobe Illustrator. Send printed samples and tearsheets. "We will accept work compatible with QuarkXPress 7.5/version 3.3. Send EPS files. Samples are filed and are not returned. Reports back only if interested. Will contact for portfolio review of color photographs, tearsheets and transparencies if interested. Buys one-time rights. **Pays on acceptance**; $1,500-2,000 for color cover; $250-500 for b&w (use very little); $300-1,500 for color inside. Payment for spots depends on size and how many are required for a story. Finds illustrators through *Creative Black Book*, *American Showcase*, *Graphis*, *Print*, *How*, *Step By Step*, *Communication Arts Directory of Illustration*, *Illustrator's Annual*, *Society of Publication Design Annual*, magazines and submissions.

Tips: "Illustrators must have ability to conceptualize ideas for financial, consumer audience without being cliché."

↙**THE B'NAI B'RITH INTERNATIONAL JEWISH MONTHLY**, B'nai B'rith, 1640 Rhode Island Ave. NW, Washington DC 20036. (202)857-6645. E-mail: erozenman@bnaibrith.org. Editor: Eric Rozenman. Estab. 1886. Specialized magazine published 6 times a year, focusing on issues of interest to the Jewish family. Circ. 200,000. Originals returned at job's completion. Sample copies available for $2; art guidelines for SASE with first-class postage.

Illustration: Approached by 100 illustrators/year. Features caricatures of celebrities and politicians; humorous and realistic illustration; charts & graphs; informational graphics. Buys 1-2 illustrations/issue. Works on assignment only. Considers pen & ink, airbrush, colored pencil, mixed media, watercolor, acrylic, oil, pastel, collage, marker, charcoal. Send query letter with brochure and SASE. Samples are filed. Reports back only if interested. Request portfolio review in original query. Portfolio should include final art, color, tearsheets and published work. Buys one-time rights. Pays on publication; $50 for b&w cover; $400 maximum for color cover; $50 for b&w inside; $100 maximum for color inside. Finds artists through word of mouth and submissions.

Tips: "Have a strong and varied portfolio reflecting a high degree of professionalism. Illustrations should reflect a proficiency in conceptualizing art—not just rendering. Will not be held responsible for unsolicited material."

BOSTONIA MAGAZINE, 10 Lenox St., Brookline MA 02146. (617)353-9711. Art Director: Douglas Parker. Estab. 1900. Quarterly 4-color alumni magazine of Boston University. Audience is "highly educated." Circ. 200,000. Sample copies free for #10 SASE with first-class postage. Art guidelines not available.

Cartoons: Approached by 100 cartoonists/year. Buys 5 cartoons/issue. Prefers single panel, humorous, b&w line drawings with gagline. "Would be interested in creative ideas appropriate for highly educated audience." Send photocopies of unpublished work regularly. Do not send originals. Samples are filed and not returned. Reports back within weeks only if interested. Buys first North American serial rights. Pays $200.

Illustration: Approached by 500 illustrators/year. Buys 7 illustrations/issue. Has featured illustrations by Mark Fisher, Jeff Smith, Tim Foley, Anna Kang and Mark Eliot. Features humorous and realistic illustration; charts & graphs; informational graphics, medical, computer and spot illustration. Assigns 10% of illustrations to well-known or "name" illustrators; 80% to experienced, but not well-known illustrators; 10% to new and emerging illustrators. Considers all media. Works on assignment only. Send query letter with photocopies, printed samples and tearsheets. Samples are filed and not returned. Reports back within weeks only if interested. Will contact for portfolio review if interested. Portfolio should include color and b&w roughs, final art and tearsheets. Buys first North American serial rights. "Payment depends on final use and size." **Pays on acceptance**. Payment varies for cover and inside; pays $200-400 for spots. "Liberal number of tearsheets available at no cost." Finds artists through magazines, word of mouth and submissions.

Tips: "Portfolio should include plenty of tearsheets/photocopies as handouts. Don't phone; it disturbs flow of work in office. No sloppy presentations. Show intelligence and uniqueness of style." Prefers original illustrations "meant to inform and elucidate."

BOWLING MAGAZINE, 5301 S. 76th St., Greendale WI 53129. (414)423-3232. Fax: (414)421-7977. Editor: Bill Vint. Estab. 1933. Bimonthly 4-color magazine covering the sport of bowling in its many facets. Circ. 140,000. Sample copies for 9×12 SAE with 5 first-class stamps. Art guidelines for SASE with first-class postage.

Illustration: Approached by 12 illustrators/year. Buys 1-2 illustrations/issue. Works on assignment only. Send query letter with tearsheets, SASE and photocopies. Samples are filed or are returned by SASE. Reports back within 10 days. Rights purchased vary. **Pays on acceptance**; $250-500 for color cover; $75-250 for color inside; $25-75 b&w spots (instructional themed material).

Tips: "We do not publish cartoons as a matter of policy. Have a thorough knowledge of bowling. We have a specific interest in instructional materials that will clearly illustrate bowling techniques."

BOYS' QUEST, 103 N. Main St., Bluffton OH 45817. (419)358-4610. Assistant Editor: Becky Jackman. Estab. 1995. Bimonthly consumer magazine "geared for elementary boys." Circ. 5,000. Sample copies $3 each; art guidelines for SASE with first-class postage.
Cartoons: Buys 1-3 cartoons/issue. Prefers wholesome children themes. Prefers: single or double panel, humorous, b&w line drawings with gagline. Send finished cartoons. Samples are filed or returned by SASE. Reports back in 2 months. Buys first rights. Pays on publication; $5-25 for b&w.
Illustration: Approached by 100 illustrators/year. Buys 6 illustrtions/issue. Has featured illustrations by Chris Sabatino, Gail Roth and Pamela Harden. Features humorous illustration; realistic and spot illustration. Assigns 60% of illustrations to experienced, but not well-known illustrators; 40% to new and emerging illustrators. Prefers childhood themes. Considers all media. Send query letter with printed samples. Samples are filed or returned by SASE. Reports back within 2 months. To arrange portfolio review of b&w work, artist should follow-up with call or letter after initial query. Buys first rights. Pays on publication; $200-250 for color cover; $25-35 for b&w inside; $50-70 for 2-page spreads; $10-25 for spots. Finds illustrators through artist's submissions.
Tips: "Read our magazine. Send in a few samples of work in pen & ink."

‡BROOKLYN BRIDGE, 388 Atlantic Ave., Brooklyn NY 11217. (718)596-7400. Fax: (718)852-1290. Contact: Art Director. Estab. 1995. Monthly Brooklyn regional magazine with an emphasis on culture, politics and human interest. Circ. 60,000.
Cartoons: Buys 1 cartoon every 6 issues. Prefers urban life themes. Send query letter with finished cartoons. Samples are filed or returned by SASE. Does not report back. Cartoonist should call. Rights purchased vary according to project. Pays $100-200 for b&w, $200-400 for color.
Illustration: Approached by 200 illustrators/year. Buys 10-15 illustrations/issue. Considers all media. Send postcard sample. Accepts disk submissions. Samples are filed. Reports back only if interested. To arrange portfolio review artist should follow-up with a call. Portfolio should include b&w, color, final art, photographs, slides, tearsheets and transparencies. Buys one-time rights. Pays on publication; $600-1,000 for color cover; $200-400 for color inside. Pays $150 for spots.
Design: Needs freelancers for design and production. Prefers local designers only. 100% of freelance work demands knowledge of Adobe Photoshop, Adobe Illustrator, QuarkXPress. Phone art director.
Tips: "Looking for local talent with an understanding of Brooklyn's diverse cultural makeup."

‡BUCKMASTERS WHITETAIL MAGAZINE, 10350 Hwy. 80 E., Montgomery AL 36117. (205)215-3337. Fax: (334)215-3535. Vice President of Production: Dockery Austin. Estab. 1987. Magazine covering whitetail deer hunting. Seasonal—6 times/year. Circ. 300,000. Accepts previously published artwork. Originals are not returned. Sample copies and art guidelines available. 80% of freelance work demands knowledge of Adobe Illustrator, QuarkXPress, Adobe Photoshop or Aldus FreeHand.
Cartoons: Approached by 5 cartoonists/year. Buys 1 cartoon/issue. Send query letter with brochure and photos of originals. Samples are filed or returned by SASE. Reports back within 3 months. Rights purchased according to project. Pays $25 for b&w.
Illustration: Approached by 5 illustrators/year. Buys 1 illustration/issue. Works on assignment only. Considers all media. Send postcard sample. Accepts submissions on disk. Samples are filed. Call or write for appointment to show portfolio. Portfolio should include final art, slides and photographs. Rights purchased vary. Pays on publication; $500 for color cover; $150 for color inside.
Design: Needs freelance designers for multimedia. 100% of freelance work requires knowledge of Adobe Photoshop, QuarkXPress or Adobe Illustrator. Pays by project.
Tips: "Send samples related to whitetail deer or turkeys."

BUILDINGS MAGAZINE, 427 Sixth Ave. SE, Cedar Rapids IA 52406. (319)364-6167. Fax: (319)364-4278. E-mail: elisa-geneser@stamats.com. Website: http://www.buildingsmag.com. Art Director: Elisa Geneser. Estab. 1906. Monthly trade journal; magazine format; "information related to current approaches, technologies and products involved in large commercial facilities." Circ. 56,500. Original artwork returned at job's completion. Sample copies available; art guidelines for SASE with first-class postage.
● *Buildings* has nearly doubled its pay for black & white and color illustration.
Illustration: Works on assignment only. Has featured illustrations by Jonathan Macagba and Pamela Harden. Features informational graphics; computer and spot illustration. Assigns 50% of illustrations to experienced, but not well-known illustrators; 50% to new and emerging illustrators. Considers all media, themes and styles. Send postcard sample. Accepts submissions on disk compatible with Macintosh, Adobe Photoshop 4.0 or Adobe Illustator 7.0. Samples are filed. Will contact for portfolio review if interested. Portfolio should include thumbnails, b&w/color tearsheets. Rights purchased vary. **Pays on acceptance**, $250-500 for b&w, $500-1,000 for color cover; $25-200 for b&w inside; $100-350 for color inside; $30-75 for spots. Finds artists through word of mouth and submissions.
Design: Needs freelancers for design. 60% of freelance work demands knowledge of Adobe Photoshop, Adobe Illustrator. Send query letter with brochure, photocopies and tearsheets. Pays by the project.
Tips: "Send postcards with samples of your work printed on them. Show us a variety of work (styles), if available. Send only artwork that follows our subject matter: Commercial Buildings."

BULLETIN OF THE ATOMIC SCIENTISTS, 6042 S. Kimbark, Chicago IL 60637. (773)702-2555. Fax: (773)702-0725. E-mail: bullatom.sci@apc.igc.org. Website: http://neog.com/atomic/. Managing Editor: Linda Rothstein. Estab. 1945. Bimonthly magazine of international affairs and nuclear security. Circ. 15,000. Sample copies available.
Cartoons: Approached by 5-10 cartoonists/year. Buys 6-10 cartoons/issue. Prefers single panel, humorous, b&w washes and line drawings. Send photocopies. Samples are not filed and are returned. Reports back within 10 days. Buys one-time rights. **Pays on acceptance**; $35-150 for b&w.
Illustration: Approached by 20-25 illustrators/year. Buys 4-6 illustrations/year. Send postcard sample and photocopies. Samples are filed. Reports back only if interested. Buys first rights. **Pays on acceptance**; $300-500 for color cover; $100-150 for b&w inside.
Tips: "We're eager to see cartoons that relate to our editorial content, so it's important to take a look at the magazine before submitting items."

‡BUSINESS INGENUITY, 125 Walnut St., Watertown MA 02172. (617)926-7077. Fax: (617)926-7013. Production/Art Manager: Jennifer Fenuccio. Estab. 1998. Quarterly trade publication sent to top CEOs, presidents, etc., produced by the state of Massachusetts, promoting itself as a great place to keep or bring your business.
 • See listing for *Contract Professional*.

BUSINESS LAW TODAY, 750 N. Lake Shore Dr., 8th Floor, Chicago IL 60611. (312)988-6050. Fax: (312)988-6035. E-mail: nowakt@staff.abanet.org. Art Director: Tamara Nowak. Estab. 1992. Bimonthly magazine covering business law. Circ. 56,000. Sample copies available; art guidelines not available.
Cartoons: Buys 20-24 cartoons/year. Prefers business law and business lawyers themes. Prefers single panel, humorous, b&w line drawings with gaglines. Send photocopies and SASE. Samples are not filed and are returned by SASE. Reports back within several days. Buys one-time rights. Pays on publication; $150 minimum for b&w. Please send cartoons to the attention of Ray DeLong.
Illustration: Buys 6-9 illustrations/issue. Has featured illustrations by Justin Diggle, Sean Kane, Slug Signorino and Charlene Potts. Features humorous, realistic and computer illustrations. Assigns 10% of illustrations to well-known or "name" illustrators; 80% to experienced, but not well-known illustrators; and 10% to new and emerging illustrators. Prefers editorial illustration. Considers all media. 10% of freelance illustration demands knowledge of Adobe Photoshop, Adobe Illustrator and QuarkXPress. Send query letter with printed samples. "We will accept work compatible with QuarkXPress 7.5/version 3.3. Send EPS or TIFF files." Samples are filed and are not returned. Reports back only if interested. Art director will contact artist for portfolio review of b&w, color tearsheets if interested. Buys one-time rights. Pays on pubication; $650-800 for color cover; $400 for b&w inside, $500 for color inside; $150 for b&w spots.
Tips: "Although our payment may not be the highest, accepting jobs from us could lead to other projects, since we produce many publications at the ABA. Sometimes sending samples (three to four pieces) works best to get a sense of your style; that way I can keep them on file."

‡BUSINESS NASHVILLE, 2817 West End Ave., Suite 216, Nashville TN 37203. (615)843-8000. Fax: (615)843-4300. E-mail: horton@nashmags.com. Creative Director: Thomas Horton. Art Coordinator: Donna Norfleet. Estab. 1993. Twice-monthly local business magazine. Circ. 15,000.
 • Also owns *Nashville Life*; same creative director for both magazines.
Cartoons: Approached by 2 cartoonists/year. Buys 2-3 cartoons/year. Prefers whimsical single panel, political color washes and b&w line drawings. Send query letters with samples. Samples are filed and not returned. Reports back only if interested. Rights purchased vary according to project. **Pays on acceptance.** Pays $50-150 for b&w; $60-200 for color cartoons.
Illustration: Approached by 25 illustrators/year. Buys 2-3 illustrations/issue. Has featured illustrations by Lori Bilter, Pashur, Mike Harris, Dar Maleki, Kurt Lightner. Features caricatures of celebrities and politicians; charts & graphs; computer and spot illustrations of business subjects and country music celebs. Prefers bright colors and pastels, "all styles welcome except 'grunge.' " Assigns 50% of illustrations to experienced, but not well-known illustrators; 50% to new and emerging illustrators. 10% of freelance illustration demands knowledge of Adobe Illustrator, Adobe Photoshop, Aldus FreeHand, QuarkXPress. Send query letter with non-returnable samples. Accepts Mac-compatible disk submissions. Send EPS files. Samples are filed and are not returned. Will contact artist for portfolio review if interested. Rights purchased vary according to project. **Pays on acceptance**; $200-1,000 for color cover; $50-300 for b&w inside; $60-500 for color inside; $150-800 for 2-page spreads; $30 for spots. Finds freelancers through other publications.
Tips: "I'm looking for folks who can deal with my simple needs and handle all three legs of the 'quick-cheap-good' triangle. And leave your attitudes at the door."

BUSINESS NH MAGAZINE, 404 Chestnut St., Suite 201, Manchester NH 03101-1831. (603)626-6354. Fax: (603)626-6359. E-mail: bnhmag@aol.com. Senior Art Director: Nikki Bonenfant. Estab. 1982. Monthly magazine with focus on business, politics and people of New Hampshire. Circ. 13,000. Accepts previously published artwork. Originals returned at job's completion. Sample copies free for 9×12 SASE and 5 first-class stamps.
Illustration: Buys 1-4 illustrations/year. Works on assignment only. Has featured illustrations by Gregor Bernard and Jim Roldan. Features computer, humorous and spot illustration. Assigns 100% of illustrations to new and emerging illustrators. Prefers bold, contemporary graphics. Considers pen & ink, airbrush, colored pencil and computer-generated illustration. 10% of freelance work demands knowledge of Adobe Illustrator or QuarkXPress. Send postcard sample or query letter with résumé and tearsheets. Samples are filed or are returned by SASE. Will contact for portfolio review

if interested. Portfolio should include b&w and color thumbnails, tearsheets, slides and final art. Buys one-time rights and reprint rights. Pays on publication; $50-100 for b&w inside; $75-150 for color inside; $25-50 for spots.
Design: Needs freelancers for design production. 75% of freelance work requires knowledge of Adobe Photoshop 3.0, QuarkXPress 3.32 or Adobe Illustrator 5.0. Send query letter with résumé.
Tips: Art Director hires freelancers mostly to illustrate feature stories and for small icon work for departments. Does not use cartoons. "Looking for fast, accurate, detail-oriented work."

‡**BUSINESS TRAVEL NEWS**, 1 Penn Plaza, New York NY 10119. Contact: Art Director. Estab. 1984. Bimonthly 4-color trade publication focusing on business and corporate travel news/management. Circ. 50,000.
Illustration: Approached by 300 illustrators/year. Buys 3-5 illustrations/issue. Has featured illustrations by Robert Pizzo, Bruce Lennon, Lisa Cangemi. Features charts & graphs, computer illustration, conceptual art, humorous illustration, informational graphics and spot illustrations. Preferred subjects: business and travel. Assigns 30% of illustrations to well-known or "name" illustrators; 40% to experienced, but not well-known illustrators; 30% to new and emerging illustrators. 30% of freelance illustration demands knowledge of Adobe Illuatrator or Adobe Photoshop. Send postcard or other non-returnable samples. Samples are filed. Buys first rights. **Pays on acceptance**; $600-900 for color cover; $250-350 for color inside; $300 for spots. Finds illustrators through artist's promotional material and sourcebooks.
Tips: "Send your best samples suitable for the publication. We want interesting concepts and print a variety of styles, however our audience is a somewhat conservative. We serve a business market."

‡**BUTTERICK CO., INC.**, 161 Avenue of the Americas, New York NY 10013. (212)620-2500. Art Director: Joe Vior. Associate Art Director: Lauren Angheld. Quarterly magazine and monthly catalog. "*Butterick Magazine* is for the home sewer, providing fashion and technical information about our newest sewing patterns through fashion illustration, photography and articles. The Butterick store catalog is a guide to all Butterick patterns, shown by illustration and photography." Magazine circ. 350,000. Catalog readership: 9 million. Originals are returned at job's completion.
Illustration: "We have two specific needs: primarily fashion illustration in a contemporary yet realistic style, mostly depicting women and children in full-length poses for our catalog. We are also interested in travel, interior, light concept and decorative illustration for our magazine." Considers watercolor and gouache for catalog art; all other media for magazine. Send query letter with tearsheets and color photocopies and promo cards. Samples are filed or are returned by SASE if requested by artist. Does not report back, in which case the artist should call soon if feedback is desired. Portfolio drop off every Monday or mail appropriate materials. Portfolio should include final art, tearsheets, photostats, photocopies and large format transparencies. Rights purchased vary according to project.
Tips: "Send non-returnable samples several times a year—especially if style changes. We like people to respect our portfolio drop-off policy. Repeated calling and response cards are undesirable. One follow-up call by illustrator for feedback is fine."

‡**CAFE EIGHTIES MAGAZINE**, 1562 First Ave., Suite 180, New York NY 10028. (212)802-4528. Fax: (212)861-0588. Creative Director: Kimberly Brittingham. Creative Assistant: John Welsh. Estab. 1993. Quarterly b&w consumer magazine mixing identifiable images of '80s and topics of current interest for 25-35 readership. Circ. 2,500. Art guidelines free for #10 SASE with first-class postage.
Cartoons: Approached by 40 cartoonists/year. Buys 6 cartoons/year. Prefers single, double or multiple panel humorous b&w line drawings. Send query letter with b&w photocopies and SASE. Samples are filed. Reports back within 2 weeks. Buys one-time rights. Pays on publication; $5-50 for b&w cartoons or comic strips.
Illustration: Approached by 20 illustrators/year. Buys 2-10 illustrations/issue. Features caricatures of celebrities, computer, humorous, realistic and spot illustrations. Prefers realism, unique approaches, mixed-media. Assigns 20% of illustrations to experienced, but not well-known illustrators; 80% to new and emerging illustrators. Send query letter with photocopies. Accepts Windows-compatible disk submissions. Samples are filed. Reports back within 2 weeks. Portfolio review not required. Buys one-time rights. Pays on publication; $50-100 for b&w cover; $5-50 for b&w inside; $5 for spots. Finds freelancers through sourcebooks, word of mouth.
Tips: "*Cafe Eighties Magazine* has a special need for caricatures of '80s celebrities, clever and detailed comic strips in 'soap opera' or 'sitcom' styles, celebrity paper dolls of New Wave icons, and illustrations to accompany short works of fiction. We're always open to artists who are inspired to carve out their own creative niche in the magazine with a unique regular feature."

CALIFORNIA JOURNAL, 2101 K St., Sacramento CA 95816. (916)444-2840. Fax: (916)444-2339. Website: http://www.statenet.com. Contact: Art Director. Estab. 1970. Monthly magazine "covering politics, government and independent analysis of California issues." Circ. 15,000. Sample copies available. Art guidelines not available. Call.
Cartoons: Approached by 10 cartoonists/year. Buys 10-20 cartoons/year. Prefers political/editorial. Prefers single or double panel political, humorous, b&w washes, b&w line drawings without gagline. Send query letter with photocopies and samples. Samples are filed and not returned. Reports back only if interested. Buys all rights. **Pays on acceptance**; $100-300 for b&w, $300-400 for color.
Illustration: Approached by 10-30 illustrators/year. Buys 30-40 illustrations/year. Has featured illustrations by Santiago Uceda. Features caricataures of politicians; realistic, computer and spot illustration. Assigns 5% of illustrations to well-known or "name" illustrators; 50% to experienced, but not well-known illustrators; 25% to new and emerging illustrators. Prefers editoral. Considers all media. 10% of freelance illustration demands knowledge of Adobe Photoshop. Send postcard sample or query letter with photocopies. Send follow-up postcard sample every 4 months. Accepts disk

submissions compatible with Mac Photoshop/Syquest on 3.5 or Zip disk. Samples are filed and not returned. Reports back only if interested. Art director will contact artist for portfolio review if interested. Buys all rights. **Pays on acceptance**; $350 minimum for color cover; $150 minimum for b&w inside; $100 minimum for spots. Finds illustrators through magazines, word of mouth and artist's submissions.
Design: Prefers California design freelancers only.
Tips: "We like to work with illustrators who understand editorial concepts and are politically current."

‡**CAMPUS LIFE**, 465 Gundersen Dr., Carol Stream IL 60188. Art Director: Doug Johnson. Monthly 4-color publication for high school and college students. "Though our readership is largely Christian, *Campus Life* reflects the interests of all kids—music, activities, photography and sports." Circ. 100,000. Original artwork returned after publication. "No phone calls, please. Send mailers." Uses freelance artists mainly for editorial illustration.
Cartoons: Approached by 50 cartoonists/year. Buys 100 cartoons/year from freelancers. Uses 3-8 single-panel cartoons/issue plus cartoon features (assigned) on high school and college education, environment, family life, humor through youth and politics; applies to 13-18 age groups; both horizontal and vertical format. Prefers to receive finished cartoons. Reports in 1 month. **Pays on acceptance**; $50 for b&w, $75 for color.
Illustration: Approached by 175 illustrators/year. Works with 10-15 illustrators/year. Buys 2 illustrations/issue, 50/year from freelancers. Styles vary from "contemporary realism to very conceptual." Works on assignment only. 10% of freelance work demands knowledge of Aldus FreeHand and Adobe Illustrator. Send promos or tearsheets. Please no original art transparencies or photographs. Samples returned by SASE. Publication will contact artist for portfolio review if interested. Buys first North American serial rights; also considers second rights. **Pays on acceptance**; $75-350 for b&w; $350-500 for color inside.
Tips: "I like to see a variety in styles and a flair for expressing the teen experience. Keep sending a mailer every couple of months."

✓❋**CANADIAN GARDENING**, 340 Ferrier St., Markham, Ontario L3R 2Z5 Canada. (905)475-8440. Fax: (905)475-9560. E-mail: camar@the-wire.com. Art Director: Bonnie Summerfeldt. Estab. 1990. Special interest magazine published 7 times/year. "A down-to-earth, indispensable magazine for Canadians who love to garden." Circ. 135,000.
Illustration: Approached by 50 illustrators/year. Buys 3 illustrations/issue. Considers all media. 50% of freelance illustration demands knowledge of Adobe Photoshop, Adobe Illustrator and QuarkXPress. Send query letter with tearsheets. Accepts disk submissions compatible with Slide Show, QuarkXPress, Illustrator or Photoshop (Mac). Samples are filed and are not returned. Does not report back. Artist should follow up. Buys first rights. Pays within 45 days, $50-600 (CDN) for color inside. Pays $50-250 (CON) for spots.
Tips: Likes work that is "earthy and hip."

‡❋**CANADIAN PHARMACEUTICAL JOURNAL**, 21 Concourse Gate #13, Nepean, Ontario K2E 754 Canada. (613)727-1364. Fax: (613)727-3757. Editor: Andrew Reinbold. Estab. 1867. Trade journal. Circ. 17,500. Accepts previously published artwork. Originals are returned at job's completion. Sample copies available.
Illustration: Approached by 20 illustrators/year. Works on assignment only. "Stories are relative to the interests of pharmacists—scientific to life-style." Considers all media. Send query letter with photostats and transparencies. Samples are filed. Reports back only if interested. Call for an appointment to show a portfolio, which should include slides, photostats and photographs. Rights purchased vary. **Pays on acceptance**; $600-1,200 for color cover; $200-1,000 for color inside.

‡**CAREER FOCUS**, 3100 Broadway St., Suite 660, Kansas City MO 64111. (816)960-1988 Fax: (816)960-1989. Contact: Editorial Department. Estab. 1985. Bimonthly educational, career development magazine. "A motivational periodical designed for Black and Hispanic college graduates who seek career development information." Circ. 250,000. Accepts previously published artwork. Originals are returned at job's completion. Sample copies and art guidelines for SASE with first-class postage.
Illustration: Buys 1 illustration/issue. Send query letter with SASE, photographs, slides and transparencies. Samples are filed. Reports back to the artist only if interested. Buys one-time rights. Pays on publication; $20 for b&w, $25 for color.

CAREERS AND COLLEGES, 989 Sixth Ave., New York NY 10018. (212)563-4688. Fax: (212)967-2531. Contact: Art Director. Estab. 1980. Quarterly 4-color educational magazine published September-May. "Readers are college-bound high school juniors and seniors and college students. Besides our magazine, we produce educational material (posters, newsletters) for outside companies." Circ. 100,000. Accepts previously published artwork. Original artwork is returned at job's completion.
Illustration: "We're looking for contemporary, upbeat, sophisticated illustration. All techniques are welcome." Send query letter with samples. "Please do not call. Will call artist if interested in style." Buys one-time rights.

‡**CAREERS AND MAJORS MAGAZINE**, P.O. Box 14081, Gainesville FL 32604-2081. (352)373-6907. Fax: (352)373-8120. E-mail: oxendine@compuserve.com. Art Director: Jeff Riemersma. Estab. 1990. 4-color magazine "targeted toward graduating college seniors, emphasizing career and higher-education opportunities." Publishes 2 issues/year. Circ. 18,000. Sample copies for 8½×11 SASE and 4 first-class stamps. Art guidelines for #10 SASE with first-class postage.

● Oxendine Publishing also publishes *Student Leader Magazine, Florida Leader Magazine* and *Florida Leader Magazine for High School Students.*

Illustration: Approached by hundreds of illustrators/year. Buys 4-5 illustrations/issue. Prefers "satirical or humorous, student or job-related themes." Considers all media. 10% of freelance illustration demands computer skills. Disk submissions must be PC-based TIF or EPS files. Samples are filed and are not returned. Reports back only if interested. Rights purchased vary according to project. Pays on publication; $75 for color inside. Finds illustrators through sourcebooks and artist's submissions.

Tips: "Be very talented, have a good sense of humor, be easy to work with."

CAT FANCY, Fancy Publications Inc., Box 6050, Mission Viejo CA 92690. (714)855-8822. Editor: Jane Calloway. Monthly 4-color magazine for cat owners, breeders and fanciers; contemporary, colorful and conservative. Readers are mainly women interested in all phases of cat ownership. Circ. 303,000. No simultaneous submissions. Sample copy $5.50; artist's guidelines for SASE.

Cartoons: Buys 12 cartoons/year. Seeks single, double and multipanel with gagline. Should be simple, upbeat and reflect love for and enjoyment of cats. "Central character should be a cat." Send query letter with photostats or photocopies as samples and SASE. Reports in 2-3 months. Buys first rights. Pays on publication; $35 for b&w line drawings.

Illustration: Buys 2-5 b&w spot illustrations/issue. Send query letter with brochure, high-quality photocopies (preferably color), SASE and tearsheets. Article illustrations assigned. Portfolio review not required. Pays $20-35 for spots; $20-100 for b&w; $50-300 for color insides; more for packages of multiple illustrations. Needs editorial, medical and technical illustration and images of cats.

Tips: "We need cartoons with an upbeat theme and realistic illustrations of purebred and mixed-breed cats. Please review a sample copy of the magazine before submitting your work to us."

CED, 600 S. Cherry St., Suite 400, Denver CO 80222. (303)393-7449. Fax: (303)393-6654. E-mail: druth@chilton.net. Website: http://cedmagazine.com. Art Director: Don Ruth. Estab. 1978. Monthly trade journal dealing with "the engineering aspects of the technology in Cable TV. We try to publish both views on subjects." Circ. 20,000. Accepts previously published work. Original artwork not returned at job's completion. Sample copies and art guidelines available.

Cartoons: Approached by 5-10 freelance illustrators/year. Perfers cable-industry-related themes; single panel, color washes without gagline "or b&w line drawing that we colorize." Contact only through artist rep. Samples are filed. Rights purchased vary according to project. Pays $200 for b&w; $400 for color.

Illustration: Buys 1 illustration/issue. Works on assignment only. Features caricatures of celebrities; realistic illustration; charts & graphs; informational graphics and computer illustrations. Assigns 10% of illustrations to well-known or "name" illustrators; 80% to experienced, but not well-known illustrators; 10% to new and emerging illustrators. Prefers cable TV-industry themes. Considers watercolor, airbrush, acrylic, colored pencil, oil, charcoal, mixed media, pastel, computer disk through Adobe Photoshop, Adobe Illustrator or Aldus FreeHand. Contact only through artist rep. Samples are filed. Call for appointment to show portfolio. Portfolio should include final art, b&w/color tearsheets, photostats, photographs and slides. Rights purchased vary according to project. **Pays on acceptance**; $400-800 for color cover; $125-400 for b&w and color inside; $250-500 for 2-page spreads; $75-175 for spots.

Tips: "Be persistent; come in-person if possible. Be willing to change in mid course; be willing to have finished work rejected. Make sure you can draw and work fast."

‡CHEMICAL ENGINEERING, 1221 Avenue of the Americas, New York NY 10020. (212)512-3377. Fax: (212)512-4762. Art Director: M. Gleason. Estab. 1903. Monthly 4-color trade journal featuring chemical process, industry technology, products and professional career tips. Circ. 80,000. Accepts previously published artwork. Original artwork returned at job's completion. Sample copies available. "Illustrators should review any issue for guidelines."

Illustration: Approached by 1,000 illustrators/year. Buys 100 illustrations/year. Features humorous and realistic illustration; charts & graphs; informational graphics; and computer illustrations. Assigns illustrations to well-known or "name" illustrators; to experienced, but not well-known illustrators; to new and emerging illustrators. Works on assignment only. Prefers technical information graphics in all media, especially computer art. 80-90% of freelance work demands knowledge of QuarkXPress, Aldus FreeHand, Adobe Illustrator or Adobe Photoshop. Send query letter with samples and SASE. Samples are filed or are returned by SASE. Reports back only if interested. To show a portfolio, mail appropriate representative materials. Buys first rights, reprint rights, global rights, all media, including possible Internet exposure. Call for details. Pays on publication; $750-1,500 for color cover; $75-200 for b&w inside; $75-300 for color inside; $75-300 for spots.

Tips: "Have a style and content appropriate to the business of engineering and a fit with our limited budget. Develop your unique vision, palette and composition and most importantly, conceptual interpretation. Get the best Mac you can and practice, practice, practice!"

‡CHESAPEAKE BAY MAGAZINE, 1819 Bay Ridge Ave., Annapolis MD 21403. (410)263-2662. Fax: (410)267-6924. Art Director: Karen Ashley. Estab. 1972. Monthly 4-color magazine focusing on the boating environment of the Chesapeake Bay—including its history, people, places and ecology. Circ. 35,000. Original artwork returned after publication upon request. Sample copies free for SASE with first-class postage. Art guidelines available. "Please call."

Cartoons: Approached by 12 cartoonists/year. Prefers single panel, b&w washes and line drawings with gagline. Cartoons are nautical and fishing humor or appropriate to the Chesapeake environment. Send query letter with finished

cartoons. Samples are filed. Reports back to the artist only if interested. Buys one-time rights. Pays $25-30 for b&w.
Illustration: Approached by 12 illustrators/year. Buys 2-3 technical and editorial illustrations/issue. Considers pen & ink, watercolor, collage, acrylic, marker, colored pencil, oil, charcoal, mixed media and pastel. Usually prefers watercolor or oil for 4-color editorial illustration. "Style and tone are determined by the artist after he/she reads the story." Send query letter with résumé, tearsheets and photographs. Samples are filed. Reports back only if interested. Publication will contact artist for portfolio review if interested. Portfolio should include "anything you've got." No b&w photocopies. Buys one-time rights. "Price decided when contracted." Pays $50-175 for b&w inside; $75-275 for color inside.
Tips: "Our magazine design is relaxed, fun, oriented toward people having fun on the water. Style seems to be loosening up. Boating interests remain the same. But for the Chesapeake Bay—water quality and the environment are more important to our readers than in the past. Colors brighter. We like to see samples that show the artist can draw boats and understands our market environment. Send tearsheets or call for an interview—we're always looking. Artist should have some familiarity with the appearance of different types of books."

‡❤**CHICKADEE**, 179 John St., Suite 500, Toronto, Ontario M5T 3G5 Canada. (416)340-2700. Fax: (416)340-9769. Creative Director: Tim Davin. Estab. 1979. 9 issues/year. Children's science and nature magazine. Chickadee is a "hands-on" science, nature and discovery publication designed to entertain and educate 6-9 year-olds. Each issue contains photos, illustrations, an easy-to-read animal story, a craft project, puzzles, a science experiment, and a pull-out poster. Circ. 150,000 in North America. Originals returned at job's completion. Sample copies available. Uses all types of conventional methods of illustration. Digital illustrators should be familiar with Adobe Illustrator, CorelDraw or Adobe Photoshop.
 • The same company that publishes *Chickadee* now also publishes *Chirp*, a science, nature and discovery magazine for pre-schoolers two to six years old, and *OWL*, a similar publication for children over eight years old.
Illustration: Approached by 500-750 illustrators/year. Buys 3-7 illustrations/issue. Works on assignment only. Prefers animals, children, situations and fiction. All styles, loaded with humor but not cartoons. Realistic depictions of animals and nature. Considers all media and computer art. No b&w illustrations. Send postcard sample, photocopies and tearsheets. Accepts disk submissions compatible with Adobe Illustrator 5.0. Send EPS files. Samples are filed or returned by SASE. Will contact for portfolio review if interested. Portfolio should include final art, tearsheets and photocopies. Buys all rights. Pays within 30 days of invoice; $500 for color cover; $100-750 for color/inside; $100-300 for spots. Finds artists through sourcebooks, word of mouth, submissions as well as looking in other magazines to see who's doing what.
Tips: "Please become familiar with the magazine before you submit. Ask yourself whether your style is appropriate before spending the money on your mailing. Magazines are ephemeral and topical. Ask yourself if your illustrations are: A. editorial and B. contemporary. Some styles suit books or other forms better than magazines." Impress this art director by being "fantastic, enthusiastic and unique."

CHILD LIFE, Children's Better Health Institute, 1100 Waterway Blvd., Box 567, Indianapolis IN 46206. (317)636-8881. Fax: (317)684-8094. Website: http://www.satevepost.org/kidsonline. Contact: Art Director. Estab. 1921. 4-color magazine for children 9-11. Monthly, except bimonthly January/February, April/May, July/August and October/November. Sample copy $1.25. Art guidelines for SASE with first-class postage.
 • Art Director reports *Child's Life* has gone through a format change from conventional to nostalgic. She is looking for freelancers whose styles lend themselves to a nostalgic look. This publisher also publishes *Children's Digest*, *Children's Playmate*, *Humpty Dumpty's Magazine*, *Jack and Jill*, *Turtle Magazine* and *U.S. Kids Weekly Reader Magazine*.
Illustration: Approached by 200 illustrators/year. Works with 15 illustrators/year. Buys approximately 20 illustrations/year on assigned themes. Features humorous, realistic, medical, computer and spot illustration. Assigns 50% of illustrations to experienced, but not well-known illustrators; 50% to new and emerging illustrators. Especially needs health-related (exercise, safety, nutrition, etc.) themes, and stylized and realistic styles of children 9-11 years old. Uses freelance art mainly with stories and medical column and activities poems. Send postcard sample or query letter with tearsheets or photocopies. "Please send SASE and comment card with samples." Especially looks for an artist's ability to draw well consistently. Reports in 2 months. Buys all rights. Pays $275 for color cover; $35-90 for b&w inside; $70-155 for color inside; $210-310 for 2-page spreads; $35-80 for spots. Pays within 3 weeks prior to publication date. "All work is considered work for hire." Finds artists through submissions, occasionally through a sourcebook.
Tips: "Artists should obtain copies of current issues to become familiar with our needs. I look for the artist's ability to illustrate children in group situations and interacting with adults and animals, in realistic styles. Also use unique styles for occasional assignments—cut paper, collage or woodcut art. No cartoons, portraits of children or slick airbrushed advertising work."

‡**CHILDREN'S DIGEST**, Children's Better Health Institute, 1100 Waterway Blvd., Box 567, Indianapolis IN 46206. (317)636-8881. Fax: (317)684-8094. Website: http://www.satevepost.org/kidsonline. Art Director: Penny Rasdall. 4-color magazine with special emphasis on book reviews, health, nutrition, safety and exercise for preteens. Published 8 times/year. Sample copy $1.25; art guidelines for SASE.
 • Also publishes *Child Life*, *Children's Playmate*, *Humpty Dumpty's Magazine*, *Jack and Jill*, *Turtle Magazine* and *U.S. Kids Weekly Reader Magazine*.
Illustration: Approached by 200 illustrators/year. Works with 10 illustrators/year. Buys 15-20 illustrations/year. Has

featured illustrations by Len Ebert, Tim Ellis and Kathryn Mitter. Features humorous, realistic, medical, computer and spot illustrations. Assigns 90% of illustrations to experienced, but not well-known illustrators; 10% to new and emerging illustratoars. Uses freelance art mainly with stories, articles, poems and recipes. Works on assignment only. Send query letter with brochure, résumé, samples and tearsheets to be kept on file. "Send samples with comment card and SASE." Portfolio review not required. Prefers photostats, slides and good photocopies as samples. Samples returned by SASE if not kept on file. Reports within 2 months. Buys all rights. Pays $275 for color cover; $35-90 for b&w inside; $60-120 for 2-color inside; $70-155 for 4-color inside; $35-70 for spots. Pays within 3 weeks prior to publication date. "All artwork is considered work for hire." Finds artists through submissions and sourcebooks.

Tips: Likes to see situation and storytelling illustrations with more than 1 figure. When reviewing samples, especially looks for artist's ability to bring a story to life with illustrations and to draw well consistently. No advertising work, cartoon styles or portraits of children. Needs realistic styles and animals.

THE CHRISTIAN CENTURY, 407 S. Dearborn, Chicago IL 60605. (312)427-5380. Fax: (312)427-1302. Production Coordinator: Matthew Giunti. Estab. 1888. Religious magazine; "a weekly ecumenical magazine with a liberal slant on issues of Christianity, culture and politics." Circ. 35,000. Accepts previously published artwork. Original artwork returned at job's completion. Art guidelines for SASE with first-class postage.
● Also publishes *The Christian Ministry*, a bimonthly magazine of practical ministry.
Cartoons: Buys 1 cartoon/issue. Prefers religious themes. Seeks single panel, b&w line drawings and washes. Send query letter with finished cartoons. Samples are filed or are returned by SASE if requested by artist. Reports back within 3 weeks. Buys one-time rights. Pays $25 for b&w cover; $50 for color cover.
Illustration: Approached by 40 illustrators/year. Buys 30 illustrations/year. Works on assignment only. Needs editorial illustration with "religious, specifically Christian themes and styles that are inclusive, i.e., women and minorities depicted." Considers pen & ink, pastel, watercolor, acrylic and charcoal. Send query letter with tearsheets. Samples are filed or returned by SASE. Reports back within 1 month. Buys one-time rights. Pays on publication; $100-200 for b&w cover; $50 for b&w inside; $25-50 for spots.

CHRISTIAN HOME & SCHOOL, 3350 E. Paris Ave. SE, Grand Rapids MI 49512. (616)957-1070. Fax: (616)957-5022. Website: http://ChristianSchoolsInt.com. Senior Editor: Roger W. Schmurr. Emphasizes current, crucial issues affecting the Christian home for parents who support Christian education. 4-color magazine; 4-color cover; published 6 times/year. Circ. 61,000. Sample copy for 9×12 SASE with 4 first-class stamps; art guidelines for SASE with first-class postage.
Cartoons: Prefers family and school themes. Pays $50 for b&w.
Illustration: Buys approximately 2 illustrations/issue. Has featured illustrations by Patrick Kelley, Rich Bishop and Pete Sutton. Features humorous, realistic, computer and spot illustration. Assigns 75% of illustrations to experienced, but not well-known illustrators; 25% to new and emerging illustrators. Prefers pen & ink, charcoal/pencil, colored pencil, watercolor, collage, marker and mixed media. Prefers family or school life themes. Works on assignment only. Send query letter with résumé, tearsheets, photocopies or photographs. Show a representative sampling of work. Samples returned by SASE, or "send one or two samples art director can keep on file." Will contact if interested in portfolio review. Buys first rights. Pays on publication; $250 for 4-color full-page inside; $75-125 for spots. Finds most artists through references, portfolio reviews, samples received through the mail and artist reps.

THE CHRISTIAN MINISTRY, 407 S. Dearborn, Suite 1405, Chicago IL 60605. (312)427-5380. Fax: (312)427-1302. Art Director: Matthew Giunti. Estab. 1974. Bimonthly magazine "of practical ministry, primarily Protestant with a center-left slant." Circ. 8,000. Sample copies and art guidelines available.
Cartoons: Buys 3-6 cartoons/issue. Prefers religious/focus on ministry. Prefers single panel, humorous, b&w washes or line drawings with gaglines. Send finished cartoons and SASE. Samples are filed or returned by SASE. Reports back within one month. Buys first rights. Pays on publication; $35-50 for b&w.
Illustration: Approached by 25 illustrators/year. Buys 5-10 illustrations/issue. Considers all media. Send query letter with printed samples and SASE. Accepts disk submissions. Samples are filed or returned by SASE. Reports back within one month. Buys first rights. Pays on publication; $100-200 for color cover; $25-60 for both b&w and color inside. Pays $25-60 for spots. Finds illustrators through submissions.

‡CHRISTIAN PARENTING TODAY MAGAZINE, 4050 Lee Vance View, Colorado Springs CO 80918. (719)531-7776. Fax: (719)535-0172. E-mail: cptcolin@aol.com. Art Director: Colin Miller. Estab. 1988. Bimonthly 4-color consumer magazine featuring advice for parents raising kids to become Christians. Circ. 150,000.
Illustration: Approached by 100 illustrators/year. Buys 25 illustrations/issue. Has featured illustrations by Al Hirschfeld, Ken Westphal, Daniel Baxter, Marcie Wolf-Hubbard, Lori Oseicki, Emily Thompson, Nathan Ota, Janet Hamlin. Features charts & graphs, commputer, humorous and spot illustrations. Assigns 10% of illustrations to well-known or "name" illustrators; 70% to experienced, but not well-known illustrators; 20% to new and emerging illustrators. Send postcard or other non-returnable samples or tearsheets. Accepts Mac-compatible disk submissions. Send EPS or TIFF files. Samples are filed. Will contact artist for portfolio review if interested. Buys first rights one-time rights or vary according to project. Pays on publication. Pay varies. Finds illustrators through agents, self promos.

CHRISTIAN READER, Dept. AGDM, 465 Gundersen Dr., Carol Stream IL 60188. (630)260-6200. Fax: (630)260-0114. Art Director: Jennifer McGuire. Estab. 1963. Bimonthly general interest magazine. "A digest of the best in

Christian reading." Circ. 220,000. Accepts previously published artwork. Originals returned at job's completion. Sample copies and art guidelines for SASE with first-class postage.

Illustration: Buys 12 illustrations/issue. Works on assignment only. Has featured illustrations by Rex Bohn, Ron Mazellan and Donna Kae Nelson. Features humorous, realistic and spot illustration. Prefers family, home and church life. Considers all media. Samples are filed. Reports back only if interested. To show a portfolio, mail appropriate materials. Buys one-time rights. **Pays on acceptance**.

Tips: "Send samples of your best work, in your best subject and best medium. We're interested in fresh and new approaches to traditional subjects and values."

‡THE CHRISTIAN SCIENCE MONITOR, Mailstop C-17, 1 Norway St., Boston MA 02115. Contact: Design Director. Estab. 1910. International 4-color daily newspaper. Originals returned at job's completion. Freelancers should be familiar with Adobe Illustrator, QuarkXPress and Adobe Photoshop.

Cartoons: Prefers international news, commentary and analysis cartoons.

Illustration: Approached by 30-40 illustrators/year. Buys 100-150 illustrations/year. Works on assignment only. Needs editorial illustration. Prefers local artists with color newspaper experience. Uses freelancers. Send query letter with brochure, photocopies and photostats. Samples are filed. Publication will contact artist for portfolio review if interested. Copyright agreement to be signed before publication. Fee negotiated per job. Requires print and electronic rights and national syndication rights. Finds artists through artists' submissions and other publications.

CICADA, 329 E St., Bakersfield CA 93304. (805)323-4064. Editor: Frederick Raborg. Estab. 1984. A quarterly literary magazine "aimed at the reader interested in haiku and fiction related to Japan and the Orient. We occasionally include excellent Chinese and other Asian poetry forms and fiction so related." Circ. 600. Accepts previously published artwork. Originals returned at job's completion. Sample copies available for the cost of $4.95. Art guidelines for SASE with first-class postage.

Cartoons: Approached by 50-60 cartoonists/year. Buys 2 cartoons/issue. Prefers the "philosophically or ironically funny. Excellent cartoons without gaglines occasionally used on cover." Prefers single panel b&w washes and line drawings with or without gagline. Send good photocopies of finished cartoons. Samples are filed or returned by SASE. Reports back within 2 months. Buys first rights. **Pays on acceptance**; $10 for b&w; $15 if featured.

Illustration: Approached by 150-175 illustrators/year. Buys 2 illustrations/issue. Prefers Japanese or Oriental, nature themes in pen & ink. Send query letter with photostats of finished pen & ink work. Samples are filed or returned by SASE. Reports back within 2 months. Buys first rights and one-time rights. Pays $15-20 for b&w cover; $10 for b&w inside. Pays on publication for most illustrations "because they are dictated by editorial copy." Finds artists through market listings and submissions.

✓CINCINNATI MAGAZINE, 705 Central Ave., Suite 370, Cincinnati OH 45202. (513)421-4300. E-mail: colleen@c intimag.emmis.com. Art Director: Colleen Lanchester. Estab. 1960. Monthly 4-color lifestyle magazine for the city of Cincinnati. Circ. 30,000. Accepts previously published artwork. Original artwork returned at job's completion.

• This magazine has been recently redesigned (June 1998). It now has new ownership, new staff and is taking a new direction from past editions.

Illustration: Approached by 20 illustrators/year. Works on assignment only. Send postcard samples. Samples are filed or returned by SASE. Reports back only if interested. Buys one-time rights or reprint rights. Pays on publication; $200-800 for features; $40-150 for spots.

Tips: Prefers traditional media with an interpretive approach. No cartoons or mass-market computer art, please.

CIRCLE K MAGAZINE, 3636 Woodview Trace, Indianapolis IN 46268. (317)875-8755. Fax: (317)879-0204. Art Director: Dianne Bartley. Estab. 1968. Kiwanis International's youth magazine for college-age students emphasizing service, leadership, etc. Published 5 times/year. Circ. 12,000. Originals and sample copies returned to artist at job's completion.

Illustration: Approached by more than 30 illustrators/year. Buys 1-2 illustrations/issue. Works on assignment only. Needs editorial illustration. "We look for variety." Send query letter with photocopies, photographs, tearsheets and SASE. Samples are filed. Will contact for portfolio review if interested. Portfolio should include tearsheets and slides. **Pays on acceptance**; $100 for b&w cover; $250 for color cover; $50 for b&w inside; $150 for color inside.

‡*CLASSIC CD, Future Publishing, 30 Monmouth St., Bath BA1 2BW United Kingdom. Phone: 01225 442244. Fax: 01225 732 396. Art Director: David Eachus. Estab. 1990. Monthly 4-color consumer magazine to help introduce new listeners to classical music. Circ. 40,000.

Illustration: Approached by 30 illustrators/year. Buys 3 illustrations/issue. Has featured illustrations by Andrew Kingham, Chris Burke, Jake Abrahms. Features caricatures of celebrities, computer, realistic and abstract illustrations. Preferred subjects: composers, history. Assigns 80% of illustrations to well-known or "name" illustrators; 10% to experienced, but not well-known illustrators; 10% to new and emerging illustrators. Send postcard sample and follow-up postcard every 3 months. Accepts Mac-compatible disk submissions. Samples are filed. Will contact artist for portfolio review if interested. Buys one-time rights. Pays on publication; $200-350 for color cover; $100-300 for color inside; $450 maximum for 2-page spreads. Finds illustrators through postcards, samples, other magazines.

Tips: "I look for 100% confidence and strong well-defined images, whether abstract, montage or realistic. A good

striking sense of color and an obvious understanding of the brief must reflect within the finished piece. Finally, I am attracked to originality."

CLEANING BUSINESS, Box 1273, Seattle WA 98111. (206)622-4241. Fax: (206)622-6876. E-mail: wgriffin@seanet .com. Website: http://www.cleaningconsultants.com. Publisher: Bill Griffin. Submissions Editor: Jeff Warner. Monthly magazine with technical, management and human relations emphasis for self-employed cleaning and maintenance service contractors. Circ. 6,000. Prefers first publication material. Simultaneous submissions OK "if to noncompeting publications." Original artwork returned after publication if requested by SASE. Sample copy $3.
Cartoons: Buys 1-2 cartoons/issue. Must be relevant to magazine's readership. Prefers b&w line drawings.
Illustration: Buys approximately 12 illustrations/year including some humorous and cartoon-style illustrations. Send query letter with samples. "*Don't* send samples unless they relate specifically to our market." Samples returned by SASE. Buys first publication rights. Reports only if interested. Pays for illustration by project $3-15. Pays on publication.
Tips: "Our budget is extremely limited. Those who require high fees are really wasting their time. We are interested in people with talent and ability who seek exposure and publication. Our readership is people who work for and own businesses in the cleaning industry, such as maid services; janitorial contractors; carpet, upholstery and drapery cleaners; fire, odor and water damage restoration contractors; etc. If you have material relevant to this specific audience, we would definitely be interested in hearing from you. We are also looking for books, games, videos, software, books and reports related to our specialized subject matter."

‡THE CLERGY JOURNAL, (formerly Church Management—The Clergy Journal), 6160 Carmen Ave. E., , Inver Grove Heights MN 55076. (612)451-9945. Fax: (612)457-4617. Assistant Editor: Sharilyn Figuerola. Art Director: Doug Thron. Magazine for professional clergy and church business administrators; b&w with 4-color cover. Monthly (except June and December). Circ. 10,000. Original artwork returned after publication if requested.
Cartoons: Buys 4 single panel cartoons/issue from freelancers on religious themes. Send SASE. Reports in 2 months. Pays $40-75; on publication.

CLEVELAND MAGAZINE, Dept. AGDM, 1422 Euclid Ave., Suite 730, Cleveland OH 44115. (216)771-2833. Fax: (216)781-6318. E-mail: clevemag@aol.com. Contact: Gary Sluzewski. Monthly city magazine, b&w with 4-color cover, emphasizing local news and information. Circ. 45,000.
Illustration: Approached by 100 illustrators/year. Buys 5-6 editorial illustrations/issue on assigned themes. Sometimes uses humorous illustrations. 40% of freelance work demands knowledge of QuarkXPress, Aldus FreeHand or Adobe Photoshop. Send postcard sample with brochure or tearsheets. Accepts disk submissions. Please include application software. Call or write for appointment to show portfolio of printed samples, final reproduction/product, color tearsheets and photographs. Pays $300-700 for color cover; $75-200 for b&w inside; $150-400 for color inside; $75-150 for spots.
Tips: "Artists used on the basis of talent. We use many talented college graduates just starting out in the field. We do not publish gag cartoons but do print editorial illustrations with a humorous twist. Full-page editorial illustrations usually deal with local politics, personalities and stories of general interest. Generally, we are seeing more intelligent solutions to illustration problems and better techniques. The economy has drastically affected our budgets; we pick up existing work as well as commissioning illustrations."

‡CLUBHOUSE, Box 15, Berrien Springs MI 49103. (616)471-9009. Fax: (616)471-4661. Editor: Krista Phillips Hainey. Bimonthly b&w magazine emphasizing stories, puzzles and illustrations for children ages 9-15. 8½×11 format, amply illustrated. Circ. 2,000. Accepts previously published material. Returns original artwork after publication if requested. Sample copy for SASE with postage for 3 oz.
Illustration: Approached by over 100 illustrators/year. Buys 4-5 illustrations/issue from freelancers on assignment only in style of Debora Weber/Victoria Twichell-Jensen. Prefers pen & ink, charcoal/pencil and all b&w media. Assignments made on basis of samples on file. Send query letter with résumé and samples to be kept on file. Portfolio should include b&w final reproduction/product, tearsheets and photostats. Usually buys one-time rights. **Pays on acceptance** according to published size: $30 for b&w cover; $25 full page; $18 for ½ page; $15 for ⅓ page; $12 for ¼ page b&w inside. Finds most artists through references/word-of-mouth and mailed samples received.
Tips: Prefers "natural, well-proportioned, convincing expressions for people, particularly kids. Children's magazines must capture the attention of the readers with fresh and innovative styles—interesting forms. I continually search for new talents to illustrate the magazine and try new methods of graphically presenting stories. Samples illustrating children and pets in natural situations are very helpful. Tearsheets are also helpful. I do not want to see sketchbook doodles, adult cartoons or any artwork with an adult theme. No fantasy, dragons or mystical illustrations."

‡COBBLESTONE, AMERICAN HISTORY FOR KIDS, Cobblestone Publishing, Inc., 30 Grove St., Suite C, Peterborough NH 03458. (603)924-7209. Fax: (603)924-7380. Art Director: Ann Dillon. Assistant Art Director: Lisa

HOW TO USE THIS BOOK TO SELL YOUR WORK offers suggestions for understanding and using the information in these listings. Read this and other articles in the front of this book for important business tips.

Brown. Monthly magazine emphasizing American history; features nonfiction, supplemental nonfiction, fiction, biographies, plays, activities and poetry for children ages 8-14. Circ. 38,000. Accepts previously published material and simultaneous submissions. Sample copy $3.95 with 8×10 SASE; art guidelines for SASE with first-class postage. Material must relate to theme of issue; subjects and topics published in guidelines for SASE. Freelance work demands knowledge of Adobe Illustrator and Adobe Photoshop.

● Other magazines published by Cobblestone include *Calliope* (world history), *Faces* (cultural anthropology) and *Odyssey* (science). All for kids ages 8-15.

Illustration: Buys 2-5 illustrations/issue. Prefers historical theme as it pertains to a specific feature. Works on assignment only. Has featured illustrations by Annette Cate, Tony Anthony, Tim Foley, Richard Schlecht, Mark James, Wenhai Ma, Rich Harrington and Cheryl Jacobsen. Features caricatures of celebrities and politicians, humorous, realistic illustration, informational graphics, computer and spot illustration. Assigns 33% of illustrations to well-known or "name" illustrators; 33% to experienced, but not well-known illustrators; 33% to new and emerging illustrators. Send query letter with brochure, résumé, business card and b&w photocopies or tearsheets to be kept on file or returned by SASE. Write for appointment to show portfolio. Buys all rights. Pays on publication; $20-125 for b&w inside; $40-225 for color inside. Artists should request illustration guidelines.

Tips: "Study issues of the magazine for style used. Send samples and update samples once or twice a year to help keep your name and work fresh in our minds. Send non-returnable samples we can keep on file—we're always interested in widening our horizons."

‡COLLEGE BROADCASTER MAGAZINE, Brown University, Box 1824, Providence RI 02912-1824. (401)863-2225. Fax: (401)863-2221. Editor: Mike Russo. Estab. 1989. Quarterly 2-color trade journal; magazine format; "for college radio and television stations, communication and film depts.; anything related to student station operations or careers in electronic media." Circ. 4,000. Accepts previously published artwork. Original artwork is returned at job's completion if requested upon submission. Sample copies available for SASE with first-class postage. Needs computer literate freelancers familiar with Aldus PageMaker, Aldus FreeHand and Adobe Photoshop.

Illustration: Approached by 1-3 freelance illustrators/year. Needs editorial and technical illustrations. Prefers all "cartoons and funky covers." Considers pen & ink and marker. Contact through artist rep or send query letter with tearsheets and photographs. Samples are filed. Reports back only if interested. Publication will contact artist for porfolio review if interested. Portfolio should include photocopies. Buys one-time rights. Pays 5 copies.

Tips: "Be aware of what's happening in the media, especially what's hot in college radio and/or TV. Keep it topical."

‡❀COMMON GROUND, Box 34090, Station D, Vancouver, British Columbia V6J 4M1 Canada. (604)733-2215. Fax: (604)733-4415. Contact: Art Director. Estab. 1982. 10 times/year consumer magazine and holistic personal resource directory. Accepts previously published artwork. Original artwork is returned at job's completion. Sample copies for SASE with first-class postage.

Illustration: Approached by 10-20 freelance illustrators/year. Buys 1-2 freelance illustrations/issue. Prefers all themes and styles. Considers pen & ink, watercolor, collage and marker. Send query letter with brochure, photographs, SASE and photocopies. Samples are filed or are returned by SASE if requested by artist. Reports back to the artist only if interested. Buys one-time rights. Payment varies; on publication.

Tips: "Send photocopies of your top one-three inspiring works in black & white or color. Can have all three on one sheet of $8\frac{1}{2} \times 11$ paper or all in one color copy. I can tell from that if I am interested."

‡COMMUNICATION WORLD, One Hallidie Plaza, Suite 600, San Francisco CA 94102. (415)433-3400. E-mail: ggordon@iahc.com. Website: http://www.iabc.com. Editor: Gloria Gordon. Emphasizes communication, public relations for members of International Association of Business Communicators: corporate and nonprofit businesses, hospitals, government communicators, universities, etc. who produce internal and external publications, press releases, annual reports and customer magazines. Monthly except June/July combined issue. Circ. 14,000. Accepts previously published material. Original artwork returned after publication. Art guidelines available for SASE with first-class postage.

Cartoons: Approached by 6-10 cartoonists/year. Buys 6 cartoons/year. Considers public relations, entrepreneurship, teleconference, editing, writing, international communication and publication themes. Prefers single panel with gagline; b&w line drawings or washes. Send query letter with samples of style to be kept on file. Material not filed is returned by SASE only if requested. Reports within 2 months only if interested. To show portfolio, write or call for appointment. Buys first rights, one-time rights or reprint rights; negotiates rights purchased. Pays on publication; $25-50, b&w.

Illustration: Approached by 20-30 illustrators/year. Buys 6-8 illustrations/issue. Features humorous and realistic illustration; informational graphics; computer and spot illustration. Assigns 75% of illustrations to experienced, but not well-known illustrators; 25% to new and emerging illustrators. Theme and style are compatible to individual article. Send query letter with samples to be kept on file. To show a portfolio, write or call for appointment. Accepts tearsheets, photocopies or photographs as samples. Samples not filed are returned only if requested. Reports back within 1 year only if interested. To show a portfolio, write or call for appointment. Buys first rights, one-time rights or reprint rights; negotiates rights purchased. Pays on publication; $300 for b&w cover; $200-500 for color cover; $200 for b&w or color inside; $350 for 2-page spreads; $200 for spots..

Tips: Sees trend toward "more sophistication, better quality, less garish, glitzy—subdued, use of subtle humor."

COMPUTERWORLD, 500 Old Connecticut Path, Framingham MA 01701. (508)820-8198. Fax: (508)875-8931. E-mail: janell_genovese@cw.com. Website: computerworld.com. Associate Art Director: Janell Genovese. Weekly

newspaper for the information technology leaders. Circ. 150,000. Sample copies and art guidelines available.
Illustration: Approached 150 illustrators/year. Buys 2 illustrations/issue. Prefers business/professional. Considers all media. 30% of freelance illustration demands knowledge of Adobe Photoshop, Aldus FreeHand and QuarkXPress. Send postcard sample or query letter with printed samples. Accepts disk submissions, EPS files are the best. Samples are filed. Reports back only if interested. Art director will contact artist for portfolio review of b&w, color, final art, photographs, tearsheets and transparencies. Buys one-time rights. Pays on publication. Pays $1,000-2,000 for color cover; $100-250 b&w inside; $400-500 for color inside; $300-400 for spots.
Design: Needs freelancers for design. Prefers local design freelancers only. 100% of freelance work demands knowledge of Adobe Photoshop, Aldus FreeHand and QuarkXPress. Send query letter with printed samples and résumé.
Tips: "Send a sample regularly. No phone calls please."

‡CONDÉ NAST TRAVELER, 360 Madison Ave., 10th Floor, New York NY 10017. (212)880-2142. Fax: (212)880-2190. Design Director: Robert Best. Estab. 1987. Monthly travel magazine with emphasis on "truth in the travel industry." Geared toward upper income 40-50 year olds with time to spare. Circ. 1 million. Originals are returned at job's completion. Freelance work demands knowledge of QuarkXPress, Adobe Illustrator and Adobe Photoshop.
Illustration: Approached by 5 illustrators/week. Buys 5 illustrations/issue. Works on assignment only. Considers pen & ink, collage, oil and mixed media. Send query letter with tearsheets. Samples are filed. Does not report back, in which case the artist should wait for assignment. To show a portfolio, mail b&w and color tearsheets. Buys first rights. Pays on publication; fees vary according to project.

CONSERVATORY OF AMERICAN LETTERS, Box 298, Thomaston ME 04861. (207)354-0753. Editor: Bob Olmsted. Estab. 1986. Quarterly Northwoods journal emphasizing literature for literate and cultured adults. Original artwork returned after publication.
Cartoons: Pays $5 for b&w cartoons.
Illustration: Approached by 30-50 illustrators/year. "Very little illustration used. Find out what is coming up, then send something appropriate. Unsolicited 'blind' portfolios are of little help." Portfolio review not required. Buys first rights, one-time rights or reprint rights. **Pays on acceptance**; $5 for b&w cover; $30 for color cover; $5 for b&w inside; $30 for color inside.

CONSTRUCTION DIMENSIONS, 307 E. Annandale Rd., #200, Falls Church VA 22042-2433. (703)534-8300. Fax: (703)534-8307. E-mail: editorcd@ix.netcom.com. Website: http://www.awci.org. Editor: Laura M. Porinchak. Monthly magazine "for contractors, manufacturers, suppliers and allied trades in the wall and ceiling industry." Circ. 25,000. Sample copies available.
Cartoons: Would like to start buying cartoons. Prefers single panel b&w line drawings. Send query letter with tearsheets. Samples are not filed and are returned. Reports back only if interested. Buys first North American serial rights. **Pays on acceptance**; negotiable. Has featured illustrations by Jim Patterson. Assigns 50% of illustrations to experienced, but not well-known illustrators; 50% to new and emerging illustrators.
Illustration: Buys 3-5 illustrations/year. Considers all media. Send query letter with tearsheets. Accepts disk submissions. Samples are not filed and are returned. Reports back only if interested. Buys first North American serial rights. **Pays on acceptance**; $300-800 for b&w inside; $500-1,000 for color cover; $100-400 for b&w inside; $300-500 for color inside; $50-200 for spots. Finds illustrators through queries, word of mouth.
Tips: "We don't buy a lot of freelance artwork, but when we do, we usually need it fast. Prompt payment and extra copies are provided to the artist. Try to develop more than one style—be able to do cartoons as well as realistic drawings. Editors want different 'looks' for different articles. Keep sending samples (postcards), promotions, etc. to keep your name (and phone number) in front of the buyer as often as possible."

✒CONSUMERS DIGEST, 8001 N. Lincoln Ave., 6th Floor, Skokie IL 60077. (847)763-9200. E-mail: bceisel@consumersdigest.com. Corporate Art Director: Beth Ceisel. Estab. 1961. Frequency: Bimonthly consumer magazine offering "practical advice, specific recommendations, and evaluations to help people spend wisely." Circ. 1,100,000. Art guidelines available.
Illustration: 50-60% of freelance illustration demands knowledge of Aldus FreeHand, Adobe Photoshop, Adobe Illustrator. Send postcard sample or query letter with printed samples, tearsheets. Accepts disk submissions compatible with Macintosh System 8.0. Samples are filed or are returned by SASE. Reports back only if interested. Buys first rights. **Pays on acceptance**, $400 minimum for b&w inside; $300-1,000 for color inside; $300-400 for spots. Finds illustrators through *American Showcase* and *Workbook*, submissions and other magazines.

CONTACT ADVERTISING, Box 3431, Ft. Pierce FL 34948. (561)464-5447. E-mail: nietzche@cadv.com. Website: http://www.cadv.com. Editor: Herman Nietzche. Estab. 1971. Publishes 26 national and regional magazines and periodicals covering adult-oriented subjects and alternative lifestyles. Circ. 1 million. Sample copies available. Art guidelines for SASE with first-class postage.
 • Some titles of publications are *Swingers Today* and *Swingers Update*. Publishes cartoons and illustrations (not necessarily sexually explicit) which portray relationships of a non-traditional number of partners.
Cartoons: Approached by 9-10 cartoonists/year. Buys 3-4 cartoons/issue. Prefers sexually humorous cartoons. Send query letter with finished cartoons. Samples are filed or returned by SASE if requested by artist. Reports back within 30 days. Rights purchased vary according to project. Pays $15 for b&w.

"Receiving artwork digitally, we're able to work more efficiently and at less cost," says Beth Ceisel, art director of *Consumers Digest*. Illustrator Marina Thompson electronically created a series of four illustrations for an article on top seasonal travel destinations, getting a lot of detail in a small amount of space. Ceisel found the artist through her ad in *The Black Book*. "The majority of my work comes from advertising in illustration directories," says Thompson. "*The Graphic Artists Guild Directory of Illustration* is a good place to start."

Illustration: Approached by 9-10 illustrators/year. Buys 2-4 illustrations/issue. Has featured illustrations by Bill Ward, Larry Loper, Dan Rosandich and Gary Roberts. Prefers pen & ink drawings to illustrate adult fiction. Send query letter with photocopies and SASE. Accepts ASCII formatted disk submissions. Samples are filed or are returned by SASE. Reports back within 30 days. Will contact for portfolio review if interested. Portfolio should include final art. Rights purchased vary. Pays $15-35 for b&w. Finds artists through word of mouth, referrals and submissions.
Tips: "Meet the deadline."

‡**CONTRACT PROFESSIONAL**, 125 Walnut St., Watertown MA 02172. (617)926-7077. Fax: (617)926-7013. Production/Art Manager: Jennifer Fenuccio. Estab. 1996. Bimonthly 4-color consumer magazine for I.T. workers ("computer geeks") who work on a contract basis. Circ. 50,000.
 • Also publishes *Business Ingenuity*.
Cartoons: Approached by 0-2 cartoonists/year. Buys 6 cartoons/year. Prefers humorous color washes. Send query letter with color photocopies and tearsheets. Samples are filed. Reports back only if interested. Buys one-time rights or rights purchased vary according to project. Pays on publication.
Illustration: Approached by 10 illustrators/year. Buys 1 illustration/issue. "Hoping to purchase more in future." Features charts & graphs, computer and humorous illustration, informational graphics and spot illustrations of business subjects. Send query letter with printed samples. Accepts Mac-compatible disk submissions. Samples are filed. Will contact artist for portfolio review if interested. Buys one-time rights. Pays on publication. Finds illustrators online and through promotional samples.
Tips: "Both magazines are fairly conservative. I find sometimes we like to stick with that approach, but often we need humor to affect it."

COOK COMMUNICATIONS MINISTRIES, 4050 Lee Vance View, Colorado Springs CO 80918. Design Manager: Scot McDonald. Publisher of teaching booklets, take home papers, visual aids and filmstrips for Christians, "all age groups." Art guidelines available for SASE with first-class postage.
Illustration: Buys about 20 full-color illustrations/month. Features humorous and realistic illustration; charts & graphs; computer and spot illustration. Assigns 20% of illustrations to well-known or "name" illustrators; 70% to experienced, but not well-known illustrators; 10% to new and emerging illustrators. Send tearsheets, slides or photocopies of previously published work; include self-promo pieces. No samples returned unless requested and accompanied by SASE. Works on assignment only. **Pays on acceptance**; $400-700 for color cover; $150-250 for b&w inside; $250-400 for color inside; $500-800 for 2-page spreads; $10-50 for spots. Considers complexity of project, skill and experience of artist and turnaround time when establishing payment. Buys all rights..
Tips: "We do not buy illustrations or cartoons on speculation. We welcome those just beginning their careers, but it helps if the samples are presented in a neat and professional manner. Our deadlines are generous but must be met. We send out checks as soon as final art is approved, usually within two weeks of our receiving the art. We want art radically different from normal Sunday School art. Fresh, dynamic, the highest of quality is our goal; art that appeals to preschoolers to senior citizens; realistic to humorous, all media."

COPING, P.O. Box 682268, Franklin TN 37068. (615)790-2400. Fax: (615)794-0179. Editor: Kay Thomas. Estab. 1987. "*Coping* is a bimonthly, nationally-distributed consumer magazine dedicated to providing the latest oncology news and information of greatest interest and use to its readers. Readers are cancer patients, their loved ones, support group leaders, oncologists, oncology nurses and other allied health professionals. The style is very conversational and, considering its sometimes technical subject matter, quite comprehensive to the layman. The tone is upbeat and generally positive, clever and even humorous when appropriate, and very credible." Circ. 80,000. Accepts previously published artwork. Originals returned at job's completion. Sample copy available for $2.50. Art guidelines for SASE with first-class postage.
 • All writers and artists who contribute to this publication volunteer their services without pay for the benefit of cancer patients, their loved ones and caregivers.

CORPORATE REPORT, 105 S. Fifth St., Suite 100, Minneapolis MN 55402-9018. (612)338-4288. Fax: (612)373-0195. E-mail: jonathanh@corpreport.com. Website: http://www.corpreport.com. Art Director: Jonathan Hankin. Estab. 1969. Monthly magazine covering statewide business news for a consumer audience. Circ. 18,000. Samples available.
Illustration: Approached by 50 illustrators/year. Buys 2 illustrations/issue. Has featured illustrations by Victor GAD, Chuck Nendza, Joe Sorren, Darren Thompson and Jeff Tolbert. Assigns 70% of illustrations to experienced, but not well-known illustrators; 30% to new and emerging illustrators. Prefers strong graphical content; business metaphors and editorial themes. Considers all media. Send postcard sample. After initial mailing, send follow-up postcard sample every 2 months. "We will accept work compatible with QuarkXPress 3.3., Adobe Illustrator 6.0, Adobe Photoshop." Samples are filed. Reports back only if interested. To arrange portfolio review art should follow-up with call after initial query. Portfolio should include b&w, color roughs, slides, tearsheets and transparencies. Buys one-time rights. **Pays on acceptance**; $600-1,200 for b&w and color cover; $200-600 for b&w and color inside; $100-150 for spots. Finds illustrators through agents, submissions, creative sourcebooks, magazines.
Design: Needs freelancers for production. Prefers local designers with experience in QuarkXPress magazine publication. 100% of freelance work demands knowledge of Adobe Photoshop 3.0, Adobe Illustrator 6.0, QuarkXPress 3.3. Send query letter with printed samples.
Tips: "I like work which has strong graphic qualities and a good sense of mood and color. Develop a consistent style

and present work in a professional manner. Too many different styles are confusing; I like to know what to expect from an artist. The main advice I have for an illustrator trying to get work from *Corporate Report* is 'look at our publication.' I get many promo pieces from artists whose work doesn't fit our design. Decide for yourself if you are an advertising or an editorial illustrator."

‡**COUNTRY AMERICA**, 1615 Locust St., Des Moines IA 50309-3023. (515)284-3023. Fax: (515)284-3035. Art Director: Mick Schnepf. Estab. 1989. Consumer magazine "emphasizing entertainment and lifestyle for people who enjoy country music." Bimonthly 4-color magazine. Circ. 900,000.
Illustration: Approached by 10-20 illustrators/year. Buys 5-6 illustrations/issue, 20-30 illustrations/year from freelancers on assignment only. Contact through artist rep or send query letter with brochure, tearsheets, slides and transparencies. Samples are filed. Reports back only if interested. **Pays on acceptance**; negotiable.

‡**CRAFTS 'N THINGS**, 2400 Devon, Suite 375, Des Plaines IL 60018-4618. (847)635-5800. Fax: (847)635-6311. President and Publisher: Marie Clapper. Estab. 1975. General crafting magazine published 10 times yearly. Circ. 305,000. Originals returned at job's completion. Sample copies available. Art guidelines for SASE with first-class postage.
• *Crafts 'n Things* is a "how to" magazine for crafters. The magazine is open to crafters submitting designs and step-by-step instruction for projects such as Christmas ornaments, cross-stitched pillows, stuffed animals and quilts. They do not buy cartoons and illustrations.
Design: Needs freelancers for design. Send query letter with photographs. Pays by project $50-300. Finds artists through submissions.
Tips: "Our designers work freelance. Send us photos of your *original* craft designs with clear instructions. Skill level should be beginning to intermediate. We concentrate on general crafts and needlework. Call or write for submission guidelines."

CRICKET, Box 300, Peru IL 61354. Senior Art Director: Ron McCutchan. Estab. 1973. Monthly magazine emphasizes children's literature for children ages 10-14. Design is fairly basic and illustration-driven; full-color with 2 basic text styles. Circ. 78,000. Original artwork returned after publication. Sample copy $4; art guidelines for SASE with first-class postage.
Cartoons: "We rarely run cartoons, but we are beginning to look at wordless ½ page (4½×6½ dimension) cartoons—1-3 panels; we have more short picture stories rather than traditional cartoons; art styles are more toward children's book illustration."
Illustration: Approached by 800-1,000 illustrators/year. Works with 75 illustrators/year. Buys 600 illustrations/year. Has featured illustrations by Alan Marks, Trina Schart Hyman, Kevin Hawkes and Deborah Nourse Lattimore. Features humorous, realistic and spot illustration. Assigns 25% of illustrations to well-known or "name" illustrators; 50% to experienced, but not well-known illustrators; 25% to new and emerging illustrators. Needs editorial (children's) illustration in style of Trina Schart Hyman, Charles Mikolaycak, Troy Howell, Janet Stevens and Quentin Blake. Uses artists mainly for cover and interior illustration. Prefers realistic styles (animal or human figure); occasionally accepts caricature. Works on assignment only. Send query letter with SASE and samples to be kept on file, "if I like it." Prefers photocopies and tearsheets as samples. Samples not kept on file are returned by SASE. Reports within 4-6 weeks. To show a portfolio, include "several pieces that show an ability to tell a continuing story or narrative." Does not want to see "overly slick, cute commercial art (i.e., licensed characters and overly sentimental greeting cards)." Buys reprint rights. Pays 45 days from receipt of final art; $750 for color cover; $50-150 for b&w inside; $75-250 for color inside; $250-350 for 2-page spreads; $50-75 for spots.
Tips: "We are trying to focus *Cricket* at a slightly older, preteen market. Therefore we are looking for art that is less sweet and more edgy and funky. Since a large proportion of the stories we publish involve people, particularly children, *please* try to include several samples with *faces* and full figures in an initial submission (that is, if you are an artist who can draw the human figure comfortably). It's also helpful to remember that most children's publishers need artists who can draw children from many different racial and ethnic backgrounds. Know how to draw the human figure from all angles, in every position. Send samples that tell a story (even if there is no story); art should be intriguing."

‡**CURIO**, 81 Pondfield Rd., Suite 264, Bronxville NY 10708. (914)961 8649. Fax: (914)779-4033. E-mail: qenm20b@p rodigy.com. Art Director: Michael G. Stonoha. Estab. 1996. Quarterly 4-color magazine "best described as a salon; a place where people come to exchange ideas." Audience age 25-35 urban professionals with artistic tendencies. Circ. 50,000. Sample copies for $6. Guidelines free for #10 SASE.
Cartoons: Approached by 200 cartoonists/year. Buys 10 cartoons/year. Prefers single panel, political, humorous b&w line drawings. Send b&w, color photocopies and SASE. Samples are filed. Reports back within 3 months if interested. Buys first rights, first North American serial rights; negotiable. Pays on publication in contributor copies or rates up to $140/page.
Illustration: Approached by 300 illustrators/year. Buys 20 illustrations/issue. Prefers to work with students for illustration. Features caricatures of celebrities and politicians, charts & graphs, computer, fashion and humorous illustration, informational graphics, realistic and spot illustrations. Prefers 4-color. Assigns 20% to experienced, but not well-known illustrators; 80% to new and emerging illustrators. 50% of freelance illustration demands knowledge of Adobe Illustrator, Adobe Photoshop, Aldus FreeHand, QuarkXPress. Send postcard sample and follow-up postcard every 3 months. Accepts Mac-compatible disk submissions. Send EPS files. Samples are filed. Reports back only if interested. Negotiates rights purchased. Pays on publication; $140-350 for b&w cover; $140-500 for color cover; pays in contributor copies

or rates up to $140 for inside art. Finds illustrators through promotional samples, word of mouth, art fairs and visits to art schools throughout the country.

Tips: "*Curio* provides two to four pages to illustrators to design illustration essays based on our theme issues. The essays may be travelogues as appeared in our August 1996 issue, or personal essays that portray 'a simple celebration of the illustrator's work.' The pay is a $100 flat fee, but the 4 pages are yours!"

CURRICULUM VITAE, Grove City Factory Stores, P.O. Box 1309, Grove City PA 16127. (814)671-1361. E-mail: simpub@hotmail.com. Website: http://www.geocities.com/SOHO/CAFE/2550. Editor: Michael Dittman. Estab. 1995. Quarterly literary magazine. "We're a Gen-X magazine dedicated to intellectual discussion of pop culture in a satirical vein." Circ. 2,500. Sample copies available for $4 (includes postage). Art guidelines available for #10 SASE with first-class postage.

Cartoons: Approached by 50 cartoonists/year. Buys 5 cartoons/year. Prefers satirical but smart (not *New Yorker*) style. Must be topical but timeless, twisted also works." Prefers single, double, or multiple panel, political and humorous, b&w washes or line drawings, with or without gaglines. Send query letter with photocopies and SASE. Samples are filed or returned by SASE. Reports back in 2 months. Negotiates rights purchased. Pays on publication; $5-25.

Illustration: Approached by 75 illustrators/year. Buys 5 illustrations/year. Has featured illustrations by Jason McElwain and Allison McDonald. Features realistic illustration. Assigns 50% of illustrations to experienced, but not well-known illustrators; 50% to new and emerging illustrators. Open to all themes and styles. Considers all media. Send query letter with photocopies and SASE. Samples are filed or returned by SASE. Reports back within 2 months. Negotiates rights purchased. Pays on publication; $25-100 for cover; $5-15 for b&w inside. Finds illustrators through word of mouth and submissions.

Tips: "Read our magazines. We like edgy, smart new-looking art. We love first timers and black & white work. We're eager to work with young artists. Be willing to work with us. Too many times young illustrators want more money than we can provide. We get great artwork all the time from young people, but many times they don't want to negotiate."

‡THE DAIRYMAN, 14970 Chandler St., Box 819, Corona CA 91718. (909)735-2730. Fax: (909)735-2460. E-mail: mabise@aol.com. Website: http://www.hfw.com. Art Director: Maria Bise. Estab. 1922. Monthly trade journal with audience comprised of "Western-based milk producers (dairymen), herd size 100 and larger, all breeds of cows, covering the 13 Western states." Circ. 23,000. Accepts previously published artwork. Samples copies and art guidelines available.

Illustration: Approached by 5 illustrators/year. Buys 1-4 illustrations/issue. Works on assignment only. Preferred themes "depend on editorial need." Considers pen & ink, airbrush, watercolor, computer, acrylic, collage and pastel. Send query letter with brochure, tearsheets and résumé. Samples are filed or are returned by SASE if requested by artist. Reports back within 2 weeks. Write for appointment to show portfolio of thumbnails, tearsheets and photographs. Buys all rights. Pays on publication; $100 for b&w, $200 for color cover; $50 for b&w, $100 for color inside.

Tips: "We have a small staff. Be patient if we don't get back immediately. A follow-up letter helps. Being familiar with dairies doesn't hurt. Quick turnaround will put you on the 'A' list."

‡DAKOTA COUNTRY, Box 2714, Bismark ND 58502. (701)255-3031. Publisher: Bill Mitzel. Estab. 1979. *Dakota Country* is a monthly hunting and fishing magazine with readership in North and South Dakota. Features stories on all game animals and fish and outdoors. Basic 3-column format, b&w and 2-color with 4-color cover, feature layout. Circ. 13,200. Accepts previously published artwork. Original artwork is returned after publication. Sample copies for $2; art guidelines for SASE with first-class postage.

Cartoons: Likes to buy cartoons in volume. Prefers outdoor themes, hunting and fishing. Prefers multiple or single cartoon panels with gagline; b&w line drawings. Send query letter with samples of style. Samples not filed are returned by SASE. Reports back regarding queries/submissions within 2 weeks. Negotiates rights purchased. **Pays on acceptance**; $10-20, b&w.

Illustration: Features humorous and realistic illustration of the outdoors. Portfolio review not required. Pays $20-25 for b&w inside; $12-30 for spots.

Tips: "Always need good-quality hunting and fishing line art and cartoons."

DAKOTA OUTDOORS, P.O. Box 669, Pierre SD 57501-0669. (605)224-7301. Fax: (605)224-9210. Website: http://dakoutdoor.com. Editor: Kevin Hipple. Managing Editor: Rachel Engbrecht. Estab. 1978. Monthly outdoor magazine covering hunting, fishing and outdoor pursuits in the Dakotas. Circ. 7,500. Accepts previously published artwork. Original artwork is returned at job's completion. Sample copies and art guidelines for SASE with first-class postage.

Cartoons: Approached by 10 cartoonists/year. Buys 1-2 cartoons/issue. Prefers outdoor, hunting and fishing themes. Prefers cartoons with gagline. Send query letter with appropriate samples and SASE. Samples are not filed and are returned by SASE. Reports back within 1-2 months. Rights purchased vary. Pays $5 for b&w.

Illustration: Approached by 2-10 illustrators/year. Buys 1 illustration/issue. Features spot illustration. Prefers outdoor, hunting/fishing themes, depictions of animals and fish native to the Dakotas. Prefers pen & ink. Accepts submissions on disk compatible with Macintosh in Adobe Illustrator, Aldus FreeHand and Adobe Photoshop. Send TIFF, EPS and PICT files. Send postcard sample or query letter with tearsheets, SASE and copies of line drawings. Reports back within 1-2 months. To show a portfolio, mail "high-quality line art drawings." Rights purchased vary according to project. Pays on publication; $5-50 for b&w inside; $5-25 for spots.

Tips: "We especially need line-art renderings of fish, such as the walleye."

DATA COMMUNICATIONS MAGAZINE, 1221 Avenue of the Americas, New York NY 10020. Fax: (212)512-4135. Website: http://www.data.com. Design Director: Ken Surabian. Associate Art Director: Scot Sterling. Estab. 1972. Monthly trade journal emphasizing global enterprise networking for corporate network managers. Circ. 120,000. Art guidelines not available.

Illustration: Approached by 250 illustrators/year. Buys 125 illustrations/year. Features realistic illustration; charts & graphs; informational graphics; and computer and spot illustration. Assigns 33% of illustrations to well-known or "name" illustrators; 33% to experienced, but not well-known illustrators; 33% to new and emerging illustrators. Prefers conceptual style. Considers all media. 75% of freelance illustration demands computer skills. Send postcard sample. Accepts disk submissions compatible with QuarkXPress version 3.3. Send EPS files. Samples are filed. Does not report back. Will contact for portfolio review if interested. Buys worldwide rights. **Pays on acceptance**; $750-1,500 for color cover; $125-250 for b&w inside; $250-1,000 for color inside; $1,000-1,500 for 2-page spreads; $125-350 for spots.

Design: Needs freelancers for design, production. 100% of freelance work demands knowledge of Adobe Photoshop, Adobe Illustrator, QuarkXPress. Send query letter with printed samples.

Tips: "Tell the art director that you need a break. We've all needed help in the beginning. If you're good, you'll get work eventually. Be persistent."

DATAMATION, Dept. AGDM, 275 Washington St., Newton MA 02158. (617)558-4682. Fax: (617)558-4506. Senior Art Director: Susan Pulaski. Monthly trade journal; magazine format, "computer journal for corporate computing professionals worldwide." Circ. 200,000. Accepts previously published artwork. Original artwork is returned at job's completion. Sample copies available.

Cartoons: Approached by 60 cartoonists/year. Buys 2 cartoons/issue. Prefers "anything with a computer-oriented theme; people in businesses; style: horizontal cartoons"; single panel, b&w line drawings and washes. Send query letter with finished cartoons. "All cartoons should be sent *only* to Eileen Roche, Assistant Managing Editor." Samples are not filed and are returned by SASE. Reports back within 1 month. Buys first rights. Pays $125 for b&w.

Illustration: Approached by 100-200 illustrators/year. Buys 2-5 illustrations/issue. Has featured illustrations by James Yang and Judy Miller. Features charts & graphs; computer and spot illustration. Assigns 25% of illustrations to well-known or "name" illustrators; 60% to experienced, but not well-known illustrators; 15% to new and emerging illustrators. Works on assignment only. Open to most styles. Considers pen & ink, watercolor, collage, airbrush, acrylic, marker, colored pencil, mixed media, computer and pastel. Send query letter with non-returnable brochure, tearsheets and photocopies. Samples are filed and are not returned. Does not report back. To show a portfolio, mail b&w/color tearsheets, photostats and photocopies. Buys first rights. **Pays on acceptance**; $800-1,500 for b&w cover; $1,000-2,500 for color cover; $100-600 for b&w inside; $250-1,000 for color inside; $1,000-2,000 for 2-page spreads; $250-500 for spots.

Tips: "Send non-returnable samples only by mail; do not wish to meet and interview illustrators." No phone calls please.

DC COMICS, Time Warner Entertainment, Dept. AGDM, 1700 Broadway, 5th Floor, New York NY 10019. (212)636-5990. Fax: (212)636-5977. Design Director: Georg Brewer. Monthly 4-color comic books for ages 7-25. Circ. 6,000,000. Original artwork is returned after publication.

 • See DC Comics's listing in Book Publishers section.

DECORATIVE ARTIST'S WORKBOOK, 1507 Dana Ave., Cincinnati OH 45207. E-mail: fwart@eos.net. Art Director: Amy Schneider. Estab. 1987. "A step-by-step bimonthly decorative painting workbook. The audience is primarily female; slant is how-to." Circ. 89,000. Does not accept previously published artwork. Original artwork is returned at job's completion. Sample copy available for $4.65; art guidelines not available.

Cartoons: Buys 1-5 cartoons/year. Prefers themes and styles related to the decorative painter; single panel b&w line drawings with and without gagline. Send query letter with finished cartoons. Samples are not filed and are returned by SASE if requested by artist. Reports back within 1 month. Buys first rights. Pays $50 for b&w.

Illustration: Buys occasional illustration; 3-4/year. Works on assignment only. Has featured illustrations by Barbara Maslen and Annie Gusman. Features humorous, realistic and spot illustration. Assigns 50% of illustrations to experienced, but not well-known illustrators; 50% to new and emerging illustrators. Prefers realistic and humorous themes and styles. Prefers pen & ink, watercolor, airbrush, acrylic, colored pencil, mixed media and pastel. Send postcard sample or query letter with tearsheets. Accepts disk submissions compatible with the major programs. Send EPS or PICT files. Samples are filed. Reports back to the artist only if interested. Buys first or one-time rights. Pays on publication; $50-100 for b&w inside; $100-350 for color inside.

✔**DELICIOUS! MAGAZINE**, 1301 Spruce St., Boulder CO 80302. (303)939-8440. Fax: (303)440-8884. E-mail: delicious@newhope.com. Website: http://www.delicious~online.com. Art Director: Maryl Swick. Estab. 1984. Monthly magazine distributed through natural food stores focusing on health, natural living, alternative healing. Circ. 400,000 guaranteed. Sample copies available.

Illustration: Approached by hundreds of illustrators/year. Buys approximately 2 illustrations/issue. Prefers positive, healing-related and organic themes. Considers acrylic, collage, color washed, mixed media, pastel. 30% of illustration demands knowledge of Adobe Photoshop and Adobe Illustrator. Send postcard sample, query letter with printed samples, tearsheets. Send follow-up postcard sample every 6 months. Accepts disk submissions compatible with QuarkXPress 3.32 (EPS or TIFF files). Samples are filed and are not returned. Art director will contact artist for portfolio review of color, final art, photographs, photostats, tearsheets, transparencies, color copies. Rights purchased vary according to

project. **Pays on acceptance**; $1,000 maximum for color cover; $250-700 for color inside; $250 for spots. Finds illustrators through *Showcase Illustration*, SIS, magazines and artist's submissions.
Design: Needs freelancers for design, production. Prefers local designers with experience in QuarkXPress, Illustrator, Photoshop and magazines/publishing. 100% of freelance work demands knowledge of Adobe Photoshop, Adobe Illustrator, QuarkXPress. Send query letter with printed samples, photocopies, tearsheets and résumé.
Tips: "We like our people and designs to have a positive and upbeat outlook."

‡**DERMASCOPE**, 3939 E. Hwy. 80, Suite 408, Mesquite TX 75150. (972)682-9510. Fax: (972)686-5901. Graphic Artist: Ted Gregory. Estab. 1978. Bimonthly magazine/trade journal, 128-page magazine for dermatologists, plastic surgeons and stylists. Circ. 8,000. Sample copies and art guidelines available.
Illustration: Approached by 5 illustrators/year. Prefers illustrations of "how-to" demonstrations. Considers all media. 100% of freelance illustration demands knowledge of Adobe Photoshop, Adobe Illustrator, QuarkXPress, Fractil Painter. Accepts disk submissions. Samples are not filed. Reports back only if interested. Rights purchsed vary according to project. Pays on publication.

‡**DISCOVER**, 114 Fifth Ave., New York NY 10011. (212)633-4400. Fax: (212)633-4817. Art Director: Richard Boddy. Estab. 1980. Monthly general interest science magazine. Circ. 1 million.
Illustration: Buys illustrations for covers, spots and feature spreads. Buys 10 illustrations/issue. Considers all media including electronic. Send query letter with brochure showing art style, or nonreturnable tearsheets. Samples are filed. Reports back within 1 month. To show a portfolio, phone Art Director. Buys first rights. **Pays on acceptance**.

DISCOVERIES, 6401 The Paseo, Kansas City MO 64131. (816)333-7000. Editor: Rebecca S. Raleigh. Estab. 1974. Weekly 4-color story paper; "for 8-10 year olds of the Church of the Nazarene and other holiness denominations. Material is based on everyday situations with Christian principles applied." Circ. 40,000. Originals are not returned at job's completion. Sample copies and art guidelines for SASE with first-class postage.
Cartoons: Approached by 15 cartoonists/year. Buys 52 cartoons/year. "Cartoons need to be humor for children—not about them." Spot cartoons only. Prefers artwork with children and animals; single panel. Send finished cartoons. Samples not filed are returned by SASE. Reports back in 6-8 weeks. Buys all rights. Pays $15 for b&w.
Illustration: Approached by 30-40 illustrators/year. Buys 52 illustrations/year. Works on assignment only. Has featured illustrations by Ron Wheeler, Keith Alexander, Jason Piel and Mike Streff. Features children's and realistic illustration. Assigns 10% of illustrations to well-known or "name" illustrators; 80% to experienced, but not well-known illustrators; 10% to new and emerging illustrators. Needs cover illustrations. Considers watercolor, acrylic and other mediums on request. Send query letter with brochure and résumé. Samples are filed. Reports back only if interested. Request portfolio review in original query. To show a portfolio, mail tearsheets. Buys all rights. **Pays on acceptance**; $75 for color cover; $40 for b&w cover; $40 maximum for b&w inside; $75 maximum for color inside. Finds artists through submissions/ self-promotions and word of mouth.
Tips: No "fantasy or science fiction situations or children in situations not normally associated with Christian attitudes or actions. Our publications require more full-color artwork than in the past."

DIVERSION MAGAZINE, 1790 Broadway, 6th Floor, New York NY 10019. (212)969-7500. Fax: (212)969-7557. Cartoon Editor: Shari Hartford. Estab. 1976. Monthly travel magazine for physicians. Circ. 176,000.
Cartoons: Approached by 50 cartoonists/year. Buys 100 cartoons/year. Prefers travel, food/wine, sports, lifestyle, family, animals, technology, art and design, performing arts, gardening. Prefers single panel, humorous, b&w line drawings, with or without gaglines. Send query letter with finished cartoons. "SASE must be included." Samples are not filed and are returned by SASE. Reports back in 5 days. Buys first North American serial rights. **Pays on acceptance**; $100.

‡**DREAMS OF DECADENCE**, P.O. Box 910, Greenfield MA 01302-0910. Phone/fax: (413)772-0725. E-mail: dream s@shaysnet.com. Art Director: Angela Kessler. Estab. 1995. Quarterly, 4-color b&w interior literary gothic fiction zine. Circ. 3,000. Sample copies and art guidelines available.
Illustration: Approached by 10 illustrators/year. Buys 15 illustrations/issue. Has featured illustrations by Lee Seed, Lori Albrech. Features realistic and moody gothic illustrations for fiction pieces. Prefers bright colors for covers and pen & ink for interiors. Assigns 75% of illustrations to experienced, but not well-known illustrators; 25% to new and emerging illustrators. Send query letter with photocopies, SASE and tearsheets. Samples are filed or returned. Reports back within 60 days. Will contact artist for portfolio review if interested. Buys first rights and reprint rights. Pays $100-300 for color cover; $10-50 for b&w inside; $5 for spots. Finds illustrators through samples.
Tips: "You are only as good as your weakest piece. We need quick turnaround and we do need new artists."

‡**THE EDGE**, 111 Guinness Bldgs., Fulham Palace Rd., London W6 8BQ United Kingdom. Phone: (0181)741 7757. E-mail: houghtong@globalnet.co.uk. Website: http://users.globalnet.co.uk/~houghtong/edsel.htm. Editor: Graham Evans. Assistant Editor: Gerald Houghton. Estab. 1996. Bimonthly b&w literary magazine featuring modern imaginative fiction and articles on films, books and popular culture. Circ. 10,000. Sample copies available for £250 UK, $6 US. Guidelines are free for #10 SASE (UK only); 2 IRCs outside Europe, 1 IRC Europe.
Cartoons: Buys 10-20 cartoons/issue. Prefers single, double or multiple panel political, humorous (satire), b&w washes and line drawings. Send query letter with b&w photocopies, samples or tearsheets and SASE (SAE UK only, 1 IRC

Europe, 2 IRCs outside Europe). Samples are either filed or returned. Pays on publication; $40-100 for b&w cartoons or comic strips.

Illustration: Approached by 50-100 illustrators/year. Has featured illustrations by Kris Guidio, Dave Mooring, Jason Hurst, Dave McKean, John Coulthart. Features humorous (satirical) and realistic illustrations. Send query letter with printed samples, photocopies, SASE, tearsheets (SAE in UK; 2 IRCs outside Europe; 1 IRC in Europe) Samples are filed. Reports back within 3 weeks. Portfolio review not required. Buys first rights. Pays on publication; $40-100 for color cover or b&w inside.

Tips: "The only way you'll know what we publish is by looking at the magazine. If you want to send samples without looking first, that's fine, but you could be miles wide of the mark. We're always open to new talent."

ELECTRICAL APPARATUS, Barks Publications, Inc., 400 N. Michigan Ave., Suite 900, Chicago IL 60611-4198. (312)321-9440. Fax: (312)321-1288. Contact: Cartoon Editor. Estab. 1948. Monthly 4-color trade journal emphasizing industrial electrical/mechanical maintenance. Circ. 16,000. Original artwork not returned at job's completion. Sample copy $4.

Cartoons: Approached by several cartoonists/year. Buys 3-4 cartoons/issue. Prefers themes relevant to magazine content; with gagline. "Captions are typeset in our style." Send query letter with roughs and finished cartoons. "Anything we don't use is returned." Reports back within 2-3 weeks. Buys all rights. Pays $15-20 for b&w and color.

Illustration: "We have staff artists so there is little opportunity for freelance illustrators, but we are always glad to hear from anyone who believes he or she has something relevant to contribute."

✒EMERGENCY MEDICINE MAGAZINE, 26 Main St., Chatham NJ 07928. Website: http://www.emedmag.com. Art Director: Diane Villarreal. Estab. 1969. Emphasizes emergency medicine for primary care physicians, emergency room personnel, medical students. Bimonthly. Circ. 140,000. Returns original artwork after publication. Art guidelines not available.

Illustration: Works with 30 illustrators/year. Buys 3-12 illustrations/issue. Has featured illustrations by Teri McDermott, Todd Buck and Kevin Somerville. Features realistic, medical and spot illustration. Assigns 70% of illustrations to well-known or "name" illustrators; 30% to experienced, but not well-known illustrators. Works on assignment only. Send postcard sample or query letter with brochure, photocopies, photographs, tearsheets to be kept on file. Samples not filed are not returned. Accepts disk submissions. To show a portfolio, mail appropriate materials. Reports only if interested. Buys first rights. **Pays on acceptance**; $800-1,200 for color cover; $200-500 for b&w inside; $500-1,000 for color inside; $150-600 for spots.

✒ENTREPRENEUR MAGAZINE, 2392 Morse Ave., Irvine CA 92614. Fax: (714)261-2325. Fax: (714)755-4200. Creative Director: Mark Kozak. Photo Editor: Chrissy Borgatta. Estab. 1978. Monthly 4-color magazine offers how-to information for starting a business, plus ongoing information and support to those already in business. Circ. 650,000. Art guidelines free for #10 SASE with first-class postage.

Illustration: Approached by 500 illustrators/year. Buys 5-15 illustrations/issue. Has featured illustrations by Chris Spollen, Neil Shigley, Scott Pollack, Jimmy Holder and Brian Razka. Features computer, humorous, realistic and spot illustration. Themes are business, financial and legal. Prefers realism, watercolors and bright colors. Assigns 80% of illustrations to well-known or "name" illustrators; 10% to experienced, but not well-known illustrators; 10% to new and emerging illustrators. 35% of freelance illustration demands knowledge of Adobe Illustrator, Adobe Photoshop, Adobe FreeHand and Adobe PageMaker. Needs editorial illustration "some serious, some humorous depending on the article. Illustrations are used to grab readers' attention." Send non-returnable postcard samples or query letter with printed samples, photocopies and tearsheets. Will contact artist for portfolio review if interested. Buys first rights. **Pays on acceptance**; $200-300 for b&w inside; $200-400 for color inside; $600 for 2-page spreads; $275 for spots.

ENVIRONMENT, 1319 18th St. NW, Washington DC 20036. (202)296-6267, ext. 236. Fax: (202)296-5149. E-mail: env@heldref.org. Art Director: Jennifer Bascug. Estab. 1958. Emphasizes national and international environmental and scientific issues. Readers range from "high school students and college undergrads to scientists, business, and government leaders and college and university professors." 4-color magazine with "relatively conservative" design Published 10 times/year. Circ. 12,500. Original artwork returned after publication. Sample copy $7; art guidelines for SASE with first-class postage.

Cartoons: Buys 1-2 cartoons/issue. Receives 5 submissions/week. Interested in single panel line drawings or b&w washes with or without gagline. Send finished cartoons and SASE. Reports in 2 months. Buys first North American serial rights. Pays on publication; $50 for b&w cartoon.

Illustration: Buys 1-2/year. Features humorous illustration, informational graphics and computer illustrations. Uses illustrators mainly for cover design, promotional work, feature illustration and occasional spots. Send postcard sample, SASE, tearsheets and photocopies. Accepts disk submissions compatible with Mac. Will contact for portfolio review if interested. Portfolio should include printed samples. Pay is negotiable.

Tips: "Send illustrations regularly to different publications to increase chances of being published. Regarding cartoons, we prefer witty or wry comments on the impact of humankind upon the environment. Stay away from slapstick humor." For illustrations, "we are looking for an ability to communicate complex environmental issues and ideas in an unbiased way."

EQUILIBRIUM[10], Box 162, Golden CO 80402-0162. E-mail: equilibrium10@compuserve.com. Website: http://www.ourworld.compuserve.com/homepages/equilibrium10. Graphic Coordinator: Brent Allan. Estab. 1984. Monthly magazine

emphasizing philosophy, ideology and equilibrium: balance, opposites and antonyms for all ages. Accepts previously published material.

Cartoons: Buys 200 cartoons/year. Buys 30 cartoons/issue from freelancers. Accepts any format. Send query letter with samples and finished cartoons. Samples not filed are returned by SASE. Reports back within 3 months. Rights purchased vary. Pays on publication; $40-80, color.

Illustration: Works with 75 illustrators/year. Buys 40 illustrations/issue from freelancers. Send scanned work with GIF extension as a file attachment to e-mail address. Send query letter with brochure and samples. Samples are filed or are returned by SASE. Reports back within 3 months. Negotiates rights purchased. Pays on publication; $50 b&w cover.

Tips: "Letters and queries arriving at our office become the property of our firm and may be published 'as is'. We sometimes publish your material with another author to show contrast. Whatever our needs are, we are flexible."

✔ERO'S ERRANT, % Aguilar Expression, 1329 Gilmore Ave., Donora PA 15033. (412)379-8019. Editor: Xavier R. Aguilar. Estab. 1997. Biannual magazine of fiction, poetry and art dealing with adult sexual themes. Circ. 100. Art guidelines for SASE with first-class postage.

Illustration: Has featured illustrations by Steve Lawes. Features humorous and realistic illustration. Assigns 25% of illustration to experienced, but not well-known illustrators; 75% to new and emerging illustrators. Considers 5×7 b&w line drawings. Send query letter with photocopies. Samples are not returned. **Pays on acceptance**; $10 plus 1 free copy for b&w cover; inside pages paid in free copy only.

Design: "Artwork must depict adult sexual themes. Follow guidelines."

‡ETCETERA, P.O. Box 8543, New Haven CT 06531. E-mail: iedit4you@aol.com. Art Director: Mindi Englart. Estab. 1996. 2 times/year b&w literary magazine. Circ: 500. Sample copies available for $3. Art guidelines free for #10 SASE with first-class postage.

Cartoons: Prefers single, double or multiple panel humorous b&w washes. Send query letter with b&w photocopies, roughs and SASE. Samples are returned by SASE. Reports back in 5 months. Buys one-time rights. Pays on publication; 1 issue and a 1-year subscription.

Illustration: Approached by 20 illustrators/year. Buys 8-10 illustrations/issue. Has featured illustrations by: Barbara Kagan, Jonathan Talbot and Michael McCurdy. Features fine art illustration. Prefers b&w only. Assigns 25% of illustrations to well-known or "name" illustrators; 50% to experienced, but not well-known illustrators; 25% to new and emerging illustrators. Send postcard sample or send query letter with printed samples, photocopies, tearsheets and SASE ("no originals, please"). Accepts Mac-compatible disk submissions. Send EPS files. Samples are filed or are returned by SASE. Reports back in 5 months. Will contact artist for portfolio review if interested. Buys one-time rights. Pays on publication; 1 issue plus a 1-year subscription. Finds illustrators through the Internet and word of mouth.

Tips: "We're always open to new talent. Professional, clean quality black & white work. We are open to many forms including: collage, abstract, line drawings, prints, woodcuts, images that incorporate text, avant garde. Stark, funky, understandable work that will reproduce well via offset printing."

‡✦EYE FOR THE FUTURE, 594 Christie St., Toronto, Ontario M6G 3E2 Canada. (416)654-5858. Fax: (416)654-5898. E-mail: eyefuture@eyefuture.com. Website: http://www.eyefuture.com. Contact: Peter Diplaros. Estab. 1995. Monthly b&w consumer magazine focusing on health and self development. Circ. 40,000.

Illustration: Features humorous, realistic and medical illustration. Open to all subjects except children, teens, pets. Send postcard or other non-returnable samples. Accepts Mac-compatible disk submissions. Send EPS files. Reports back only if interested. Portfolio review not required. Buys one-time rights. Pays on publication.

Tips: "Looking for art that can add emotional depth to entice a reader to read and article in its entirety. Our magazine is about personal growth and we do articles on psychology, image, health, New Age, humor and business. We are looking for emotional appeal—not intellect."

FACTSHEET FIVE, P.O. Box 170099, San Francisco CA 94117-0099. (415)668-1781. Publisher: R. Seth Friedman. Estab. 1982. Magazine published 3 times/year "that provides a complete guide to zines and the underground press by printing reviews of over 2,000 zines in every issue." Circ. 16,000. Sample copies available.

Cartoons: Approached by 60 cartoonists/year. Buys 5 cartoons/issue. Prefers political/humorous/cutting-edge. Prefers single panel, political and humorous b&w line drawings. Send query letter with photocopies. Samples are filed or returned by SASE. Reports back only if interested. Buys one-time rights. Pays on publication; $10-40 for b&w.

Illustration: Approached by 20 illustrators/year. Buys 1 illustration/issue. Prefers quirky/humorous/topical. Considers all media. Send postcard sample. Samples are not filed and are not returned. Reports back only if interested. Buys one-time rights. Pays on publication; $100-300 for b&w, $100-500 for color cover.

Tips: "We use cartoons for illustrations and prefer unique underground styles that work for youth-oriented publications."

FASHION ACCESSORIES, 65 W. Main St., Bergenfield NJ 07621. (201)384-3336. Fax: (201)384-6776. Publisher: Sam Mendelson. Estab. 1951. Monthly trade journal; tabloid; emphasizing costume jewelry and accessories. Publishes both 4-color and b&w. Circ. 10,000. Accepts previously published artwork. Original artwork is returned to the artist at the job's completion. Sample copies for $3.

Cartoons: Pays $75 for b&w cartoons.

Illustration: Works on assignment only. Needs editorial illustration. Prefers mixed media. Freelance work demands knowledge of QuarkXPress. Send query letter with brochure and photocopies. Samples are filed. Reports back within

2 weeks. Portfolio review not required. Rights purchased vary according to project. **Pays on acceptance**; $50-100 for b&w cover; $100-150 for color cover; $50-100 for b&w inside; $100-150 for color inside.

FAST COMPANY, 77 N. Washington St., Boston MA 02114-1927. (617) 973-0350. Fax: (617)973-0373. E-mail: rrees@fastcompany.com. Website: http://www.fastcompany.com. Art Director: Patrick Mitchell. Estab. 1996. Bimonthly cutting edge business publication supplying readers with tools and strategies for business today.
Illustration: Approached by "tons" of illustrators/year. Buys approximately 20 illustrations/issue. Considers all media. Send postcard sample or printed samples, photocopies. Accepts disk submissions compatible with QuarkXPress for Mac. Send EPS files. Samples are filed and not returned. Reports back only if interested. Rights purchased vary according to project. **Pays on acceptance**, $300-1,000 for color inside; $300-500 for spots. Finds illustrators through submissions, illustration annuals, *Workbook* and *Alternative Pick*.

‡**FAULTLINE**, P.O. Box 599-4960, Irvine CA 92716-4960. (714)824-6712. E-mail: faultline@uci.edu. Creative Director: Cullen Gerst (1998-99 rotating director).
 ● Even though this is not a paying market, this high-quality literary magazine would be an excellent place for fine artists to gain exposure.

‡**FEDERAL COMPUTER WEEK**, 3141 Fairview Park Dr., Suite 777, Falls Church VA 22042. (703)876-5131. E-mail: jeffrey_langkau@fcw.com. Website: http://www.fcw.com. Art Director: Jeff Langkau. Associate Art Director: Kristina Owlett. Estab. 1987. Four-color trade publication for federal, state and local government information technology professionals. Circ. 120,000.
 ● Also publishes *CIVIC.COM* and *Government Best Buys*.
Illustration: Approached by 50-75 illustrators/year. Buys 5-6 illustrations/month. Features charts & graphs, computer illustrations, informational graphics, spot illustrations of business subjects. Assigns 5% of illustrations to well-known or "name" illustrators; 85% to experienced, but not well-known illustrators; 10% to new and emerging illustrators. Send postcard or other non-returnable samples. Accepts Mac-compatible disk submissions. Samples are filed. Will contact artist for portfolio review if interested. Buys one-time rights. Rights purchased vary according to project. Pays $800-1,200 for color cover; $600-800 for color inside; $200 for spots. Finds illustrators through samples and sourcebooks.
Tips: "We look for people who understand 'concept' covers and inside art, and very often have them talk directly to writers and editors."

FINESCALE MODELER, 21027 Crossroads Circle, Waukesha WI 53187. Fax: (414)796-1383. Art Director: Lawrence Luser. Estab. 1972. Magazine emphasizing plastic modeling. Circ. 73,000. Accepts previously published material. Original artwork is returned after publication. Sample copy and art guidelines available.
 ● Published by Kalmbach Publishing. Also publishes *Classic Toy Trains*, *Astronomy*, *Model Railroader*, *Model Retailer*, *Nutshell News* and *Trains*.
Illustration: Prefers technical illustration "with a flair." Send query letter with "samples, either postcard, 8×10 sheet, color copy or photographs. Currently running Illustrator 5.0. Accepts submissions on disk." Samples are filed or returned only if requested. Reports back only if interested. Write for appointment to show portfolio or mail color and b&w tearsheets, final reproduction/product, photographs and slides. Negotiates rights purchased.
Tips: "Show black & white and color technical illustration. I want to see automotive, aircraft and tank illustrations."

‡**FIRST FOR WOMEN**, 270 Sylvan Ave., Englewood Cliffs NJ 07632. (201)569-6699. Fax: (201)569-6264. Art Director: Rosemarie Wyer. Estab. 1988. Mass market consumer magazine for the younger woman published every 3 weeks. Circ. 1.4 million. Originals returned at job's completion. Sample copies and art guidelines not available.
Cartoons: Buys 10 cartoons/issue. Prefers women's issues. Prefers humorous cartoons; single panel b&w washes and line drawings. Send query letter with photocopies. Samples are filed. Reports back to the artist only if interested. Buys one-time rights. Pays $150 for b&w.
Illustration: Approached by 100 illustrators/year. Buys 1 illustration/issue. Works on assignment only. Preferred themes are humorous, sophisticated women's issues. Considers all media. Send query letter with any sample or promo we can keep. Publication will contact artist for portfolio review if interested. Buys one-time rights. **Pays on acceptance**; $200 for b&w, $300 for color inside. Finds artists through promo mailers and sourcebooks.
Tips: Uses humorous or conceptual illustration for articles where photography won't work. "Use the mail—no phone calls please."

‡**FISH DRUM MAGAZINE**, P.O. Box 966, New York NY 10156. Editor: Suzi Winson. Estab. 1988. "*Fish Drum* is an eclectic ('funky to slick') literary magazine, including poetry, prose, interviews, essays, scores and black & white art. We've upgraded the production of the magazine, and are now larger, perfect bound, offset printed." Publishes 1-2 issues yearly. Circ. 1,000. Original artwork returned at the job's completion.
Cartoons: "We have accepted and published a few cartoons, though we aren't offered many. Cartoons need to be literary, underground, Buddhist or political." Prefers single, multiple panel and b&w line drawings. Send query letter with finished cartoons. Samples are not filed and are returned by SASE if requested. Reports back within 2 months. Acquires one-time rights. Pays in copies.
Illustration: Prefers abstract, humorous or emotional art. Prefers any b&w offset-reproducible media. Send query letter

with SASE and photocopies. Samples are not filed and are returned by SASE. Reports back within 2 months. Portfolio review not required. Acquires one-time rights. Pays in copies.
Tips: "We're interested in original, personal, arresting art and have a bias toward non-mainstream New Mexico artists, underground and abstract art."

THE FLICKER MAGAZINE, P.O. Box 660544, Birmingham AL 35266-0544. (205)324-7111. Fax: (205)324-4035. E-mail: yellowhamr@aol.com. Website: http://www.flickermag.com. Production Manager/Art Director: Jimmy Bass. Estab. 1994. Bimonthly magazine geared toward children 8-13 years. Educational, fun stuff, exclusive interviews, safety tips, conservation awareness, 4-H and more. Samples copies available; art guidelines free for #10 SASE with first-class postage.
Cartoons: Approached by 20 cartoonists/year. Buys 2-4 cartoons/issue. Themes and styles are open with the exception of demonic or supernatural. Prefers humorous color washes without gagline. Send query letter with photocopies, SASE and tearsheets. Samples are filed or returned by SASE. Reports back only if interested. Negotiates rights purchased. "We prefer all rights, but will consider negotiations." Pays on publication; $50-250 for color.
Illustration: Approached by 25 illustrators/year. Buys 2-3 illustations/issue. Has featured illustrations by Toni Wall, Shellie Reese and Chris Sabatino. Features humorous, realistic and computer illustrations. Assigns 75% of illustrations to experienced, but not well-known illustrators; 25% to new and emerging illustrators. Preferred themes vary. Considers airbrush, color washed, marker, pastel and watercolor. 35% of freelance illustration demands knowledge of "at least" Adobe Photoshop 3.0, Aldus FreeHand 5.0 and QuarkXPress 3.3. Send query letter with printed samples, photocopies, SASE and tearsheets. Accepts disk submissions compatible with QuarkXPress 7.5/version 3.3. Send EPS files. Samples are filed or returned by SASE. Reports back only if interested. Art director will contact artist for portfolio review of color final art, tearsheets if interested. Negotiates rights purchased. Pays on publication; $50-250 for color inside. Finds illustrators through artist's submissions.
Design: Needs freelancers for design, production and multimedia projects. 75% of freelance work demands knowledge of Adobe Photoshop 3.0, Aldus FreeHand 5.0 and QuarkXPress 3.3. Send printed samples, photocopies, SASE and tearsheets.
Tips: "You must have a knack for doing kid-type art. We prefer colorful exciting art—not something that will put you to sleep. Send samples showing your strong points. Keep it simple, yours is not the only mail being received."

FLORIDA LEADER MAGAZINE, P.O. Box 14081, Gainesville FL 32604-2081. (352)373-6907. Fax: (352)373-8120. E-mail: oxendine@compuserve.com. Art Director: Jeff Riemersma. Estab. 1983. 4-color magazine for college and high school students. Publishes 3 issues/year. Circ. 23,000. Sample copies for 8½×11 SASE and 4 first-class stamps. Art guidelines for #10 SASE with first-class postage.
 • Oxendine Publishing also publishes *Careers & Majors Magazine* and *Student Leader Magazine*.
Illustration: Approached by hundreds of illustrators/year. Buys 4 illustrations/issue. Considers all media. 10% of freelance illustration demands computer skills. Send postcard sample. Disk submissions must be PC-based TIF or EPS images. Samples are filed and are not returned. Reports back only if interested. Rights purchased vary according to project. Pays on publication; $75 for color inside. Finds illustrators through sourcebooks and artist's submissions.
Tips: "We need responsible artists who complete projects on time and have a great imagination. Also must work within budget."

✔FOLIO: MAGAZINE, COWLES BUSINESS MEDIA, 11 Riverbend Dr. S., P.O. Box 4949, Stamford CT 06907-0949. (203)358-9900. Fax: (203)358-5811. Website: http://www.foliomag.com. Contact: Art Director. Trade magazine covering the magazine publishing industry. Sample copies for SASE with first-class postage.
 • This company publishes a total of 24 magazines. Also uses Mac-literate freelancers for production work on catalogs and direct mail pieces. Send SASE for more information.
Illustration: Approached by 200 illustrators/year. Buys 150-200 illustrations/year. Works on assignment only. 75% of freelance work demands knowledge of Adobe Illustrator, QuarkXPress, and Adobe Photoshop. Send postcard samples and/or photocopies or other appropriate samples. No originals. Samples are filed and returned by SASE if requested by artist. Reports back to the artist only if interested. Call for appointment to show portfolio of tearsheets, slides, final art, photographs and transparencies. Buys one-time rights. Pays by the project.
Tips: "Art director likes to see printed 4-color and b&w sample illustrations. Do not send originals unless requested. Computer-generated illustrations are used but not always necessary. Charts and graphs must be Macintosh-generated."

FOOD & SERVICE, Box 1429, Austin TX 78767. (512)472-3666. E-mail: qwilson@tramail.org. Art Director: Gina Wilson. Estab. 1940. Official trade publication of Texas Restaurant Association. Seeks illustrations (but not cartoons) dealing with business issues of restaurant owners and food-service operators, primarily in Texas, and including managers of clubs, bars and hotels. Published 8 times/year. Circ. 6,500. Simultaneous submissions OK. Originals returned after publication. Sample copy for SASE, art guidelines for SASE with first-class postage.
Illustration: Works with 15 illustrators/year. Buys 12-15 illustrations/year. Has featured illustrations by Walter Stanford, Edd Patton and AJ Garces. Features computer and spot illustration. Assigns 10% of illustration to well-known or "name" illustrators; 45% to experienced, but not well-known illustrators; 45% to new and emerging illsutrators. Uses artwork mainly for covers and feature articles. Seeks high-quality b&w or color artwork in variety of styles (airbrush, watercolor, pastel, pen & ink, Adobe Illustrator, Photoshop). Seeks versatile artists who can illustrate articles about food service industry, particularly business aspects. Works on assignment only. Send postcard or other non-returnable samples.

Accepts disk submissions compatible with Adobe Ilustrator 5.0. Send EPS files on Zip disk. Will contact for portfolio review if interested. Pays $350-500 for color cover; $150-250 for b&w inside; $250-350 for color inside; $75-150 for spots. Negotiates rights and payment upon assignment. Finds artists through submissions and other magazines.

‡**FOODSERVICE DIRECTOR MAGAZINE**, 355 Park Ave., S., 3rd Floor, New York NY 10010-1789. (212)592-6537. Fax: (212)592-6539. Website: http://www.fsdmag.com. Contact: Art Director. Computer Graphic Designer: Jim Haines. Estab. 1988. Monthly 4-color trade publication covering cafeteria-style food in colleges, schools, hospitals, prisons, airlines, business and industry. Circ. 45,000.
Illustration: Approached by 75 illustrators/year. Buys 1-2 illustrations/issue. Features humorous illustration, informational graphics, spot illustrations of food and kitchen art and business subjects. Prefers solid colors that reproduce well. No neon. Assigns 50% of illustration to experienced, but not well-known illustrators; 50% to new and emerging illustrators. 10% of freelance illustration demands knowledge of Adobe Illustrator, Adobe Photoshop, Aldus FreeHand, QuarkXPress. Send postcard or other non-returnable samples or query letter with photocopies. Send follow-up postcard every 6 months. Accepts Mac-compatible disk submissions. Send EPS or TIFF files. Samples are filed. Will contact artist for portfolio review if interested. Pays on publication; $350-550 for color inside; $150 for spots. Finds illustrators through samples, sourcebooks.

FORBES MAGAZINE, 60 Fifth Ave., New York NY 10011. (212)620-2200. E-mail: ehalvorsen@forbes.com. Art Director: Everett Halvorsen. Five associate art directors. Established 1917. Biweekly business magazine. Circ. 765,000. Art guidelines not available. "*Forbes* is a magazine for executives who are interested in business and investing. Most stories use photography. However, we use illustrations in any medium, when they are the more appropriate visual solution. We do not use, nor are we liable for ideas or work that we didn't assign. *Forbes* does not use cartoons."
Illustration: Contacted by 100 illustrators/year. Buys 5-6 illustrations/issue. "We prefer contemporary illustrations that are lucid and convey an unmistakable idea with wit and intelligence. Illustration must be rendered on a material and size that can be separated on a drum scanner or digitally. After discussion, we are prepared to receive art on zip, scitex, CD and floppy disk, or downloaded via e-mail or the Web." **Pays on acceptance** whether reproduced on not. Pays up to $3,000 for a cover assignment and an average of $450 to $700 for an inside illustration depending on complexity and reproduction size. "Discuss the specifications and fee before you accept an assignment." Portfolios: "We discourage appointments with illustrators or their reps, unless out-of-town travel requires a meeting. Call Roger Zapke, the Deputy Art Director for an appointment. Dropping a portfolio off is encouraged and it has its advantage, in that it permits more people to see it. Plan to leave your portfolio for few hours or overnight. It's helpful that portfolios be delivered by 11 a.m., to permit time for the art directors to review the work. Call first, to make sure someone in the art department is available. Address the label to the attention of the individual you want to reach in *Forbes*'s art department. Attach your name and local phone number to the outside of the portfolio. If you need the portfolio returned the same day, include a note stating when you need it. Robin Regensberg, the art traffic coordinator, will make every effort to call you to arrange for your pickup. Samples: Do not mail original artwork. Send printed samples, scanned samples or photocopies of samples. Include enough samples as you can spare in a portfolio for each person on our staff. If interested, we'll file them. Otherwise they are discarded. Samples are returned only if requested."
Tips: "Look at the magazine to determine if your style and thinking are suitable. The art director, associate art directors and the photo editors are listed on the masthead, normally located within the first ten pages. The art directors make assignments for illustration. However, it is important that you include Everett Halvorsen in your mailings. We get a large number of requests for portfolio reviews, and many mailed promotions daily. This many explain why, when you follow up with a call we may not be able to acknowledge receipt of your samples. If the work is memorable and we think we can use your style, we'll file samples for future consideration."

FOREIGN SERVICE JOURNAL, 2101 E St. NW, Washington DC 20037. (202)338-4045. Contact: Graphic Designer. Estab. 1924. Monthly magazine emphasizing foreign policy for foreign service employees; 4-color with design in "*Harpers*' style." Circ. 11,000. Returns original artwork after publication. Art guidelines available.
Illustration: Works with 10 illustrators/year. Buys 35 illustrations/year. Needs editorial illustration. Uses artists mainly for covers and article illustration. Works on assignment only. Send postcard samples. Accepts disk submissions. "Mail in samples for our files." Publication will contact artist for portfolio review if interested. Buys first rights. Pays on publication; $500 for color cover; $100 and up for b&w inside. Finds artists through sourcebooks.

GALLERY MAGAZINE, Dept. AGDM, 401 Park Ave. S., New York NY 10016. (212)779-8900. Website: http://www.gallerymagazine.com. Creative Director: Mark DeMaio. Emphasizes "sophisticated men's entertainment for the upper middle-class, collegiate male; monthly 4-color with flexible format, conceptual and sophisticated design." Circ. 375,000.
Cartoons: Approached by 100 cartoonists/year. Buys 3-8 cartoons/issue. Interested in sexy humor; single, double or multiple panel, color and b&w washes, b&w line drawings with or without gagline. Send finished cartoons. Enclose SASE. Contact: J. Linden. Reports in 1 month. Buys first rights.
Illustration: Approached by 300 illustrators/year. Buys 30 illustrations/year. Works on assignment only. Needs editorial illustrations. Interested in the "highest creative and technical styles." Especially needs slick, high-quality, 4-color work. 100% of freelance work demands knowledge of QuarkXPress and Adobe Illustrator. Send flier, samples and tearsheets to be kept on file for possible future assignments. Prefers prints over transparencies. Samples returned by SASE. Publication will contact artist for portfolio review if interested. Negotiates rights purchased. Pays on publication; $350

for b&w inside; $250-1,000 for color inside; $250-500 for spots. Finds artists through submissions and sourcebooks.
Design: Needs freelancers for design and production. 100% of freelance work demands knowledge of Adobe Photoshop, Adobe Illustrator, QuarkXPress. Prefers local freelancers only. Send query letter with résumé, SASE and tearsheets. Pays by the hour, $25.
Tips: A common mistake freelancers make is that "often there are too many samples of literal translations of the subject. There should also be some conceptual pieces."

GAME & FISH PUBLICATIONS, 2250 Newmarket Pkwy., Marietta GA 30067. (770)953-9222. Fax: (770)933-9510. Graphic Artist: Allen Hansen. Estab. 1975. Monthly b&w with 4-color cover. Circ. 540,000 for 30 state-specific magazines. Original artwork is returned after publication. Sample copies available.
Illustration: Approached by 50 illustrators/year. Buys illustrations mainly for spots and feature spreads. Buys 1-8 illustrations/issue. Considers pen & ink, watercolor, acrylic and oil. Send query letter with photocopies. "We look for an artist's ability to realistically depict North American game animals and game fish or hunting and fishing scenes." Samples are filed or returned only if requested. Reports back only if interested. Portfolio review not required. Buys first rights. Pays 2½ months prior to publication; $25 minimum for b&w inside; $75-100 for color inside.
Tips: "We do not publish cartoons, but we do use some cartoon-like illustrations which we assign to artists to accompany specific humor stories. Send us some samples of your work, showing as broad a range as possible, and let us hold on to them for future reference. Being willing to complete an assigned illustration in a 4-6 week period and providing what we request will make you a candidate for working with us."

GARDEN GATE MAGAZINE, 2200 Grand Ave., Des Moines IA 50312. (515)282-7000. Fax: (515)283-2003. Art Director: Steven Nordmeyer. Estab. 1995. Bimonthly consumer magazine on how-to gardening for the novice and intermediate gardener. Circ. 300,000.
Illustration: 90% of illustration needs are conventional/watercolor illustrations. Other styles require knowledge of Adobe Photoshop 3.0, QuarkXPress 3.31 and Corel Draw 5.0. Send postcard sample, query letter with tearsheets. Accepts disk submissions compatible with QuarkXPress 7.5/version 3.31. Send EPS files. Samples are filed and are not returned. Reports back only if interested. Art director will contact artist for portfolio review of slides, tearsheets if interested. Buys all rights. Finds illustrators through artist submissions, *Black Book*, word of mouth.
Design: Prefers designers with experience in publication design. 98% of freelance work demands knowledge of Adobe Photoshop 3.0, QuarkXPress 3.31, Corel Draw 5.0. Send query letter with printed samples and tearsheets.
Tips: "Become familiar with our magazine and illustration style that is compatible."

GENTRY MAGAZINE, 618 Santa Cruz Ave., Menlo Park CA 94025. (415)324-1818. Fax: (415)324-1888. E-mail: gentry@aol.com. Art Director: Jessica Grimes. Estab. 1994. Bimonthly community publication for affluent audience of designers and interior designers. Circ. 35,000. Sample copies and art guidelines available for 9×10 SASE.
Cartoons: Approached by 200 cartoonists/year. Buys 4 cartoon/issue. Prefers political and humorous b&w line drawings without gaglines. Send query letter with tearsheets. Samples are filed. Reports back only if interested. Buys first rights. Pays on publication; $50-100 for b&w; $75-200 for color.
Illustration: Approached by 100 illustrators/year. Buys 6 illustrations/issue. Features informational graphics and computer and spot illustration. Assigns 50% of illustrations to experienced, but not well-known illustrators; 50% to new and emerging illustrators. Prefers financial and fashion themes. Considers all media. Knowledge of Adobe Photoshop, Adobe Illustrator and QuarkXPress helpful. Send postcard sample. Accepts disk submissions if Mac compatible. Send EPS files. Samples are filed. Art director will contact artist for portfolio review if interested. Buys one-time rights. Pays on publication; $200-500 for color inside; $100-500 for spots. Finds illustrators through submissions.
Design: Needs freelancers for design and production. Prefers local designers. 100% of freelance work demands knowledge of Adobe Photoshop, Adobe Illustrator and QuarkXPress. Send query letter with printed samples, photocopies or tearsheets.
Tips: "Read our magazine. Regional magazines have limited resources but are a great vehicle for getting your work printed and getting tearsheets. Ask people and friends (honest friends) to review your portfolio."

GEORGIA MAGAZINE, P.O. Box 1707, Tucker GA 30085-1707. (770)270-6950. Fax: (770)270-6995. E-mail: ann.elstad@opc.com. Editor: Ann Elstad. Estab. 1945. Monthly consumer magazine promoting electric co-ops (largest read publication by Georgians for Georgians). Circ. 270,000 member.
Cartoons: Approached by 10 cartoonists/year. Buys 2 cartoons/year. Prefers electric industry theme. Prefers single panel, humorous, b&w washes and line drawings. Send query letter with photocopies. Samples are filed and not returned. Reports back within 1 month if interested. Rights purchased vary according to project. **Pays on acceptance**; $50 for b&w, $50-100 for color.
Illustration: Approached by 10 illustrators/year. Prefers electric industry theme. Considers all media. 50% of freelance illustration demands knowledge of Adobe Illustrator and QuarkXPress. Send postcard sample or query letter with photocopies. Accepts disk submissions compatible with QuarkXPress 7.5. Samples are filed or returned by SASE. Reports back within 1 month if interested. Rights purchased vary according to project. **Pays on acceptance**; $50-100 for b&w, $50-200 for color. Finds illustrators through word of mouth and artist's submissions.
Design: Needs freelancers for design and production. Prefers local designers with magazine experience. 80% of design demands knowledge of Adobe Photoshop, Adobe Illustrator and QuarkXPress. Send query letter with printed samples and photocopies.

GIRLFRIENDS MAGAZINE, 3415 Cesar Chavez, #101, San Francisco CA 94110. (415)648-9464. Fax: (415)648-4705. E-mail: staff@gfriends.com. Website: http://www.gfriends.com. Managing Editor: Diane Anderson. Estab. 1994. Bimonthly consumer magazine, "America's fastest growing lesbian magazine for women 25-38." Circ. 60,000. Sample copies available for $4.95. Art guidelines for #10 SASE with first-class postage.
Cartoons: Approached by 20 cartoonists/year. Buys 2 cartoons/issue. Prefers single panel, lesbian culture, any style, humorous, b&w line drawings with gagline. Send query letter with photocopies, SASE, tearsheets. Samples are filed. Reports back within 6-8 weeks. Rights purchased vary according to project. Pays on publication; $30-50 for b&w.
Illustration: Approached by 50 illustrators/year. Buys 2-3 illustrations/issue. Has featured illustrations by Joanna Goodman, Christopher Buzelli, Adam Guszauson and Jennifer Mazzueo. Features caricatures of celebrities and realistic, computer and spot illustration. Assigns 10% of illustrations to well-known or "name" illustrators; 50% to experienced, but not well-known illustrators; 40% to new and emerging illustrators. Prefers any style. Considers all media. 10% of freelance illustration demands knowledge of Adobe Illustrator, QuarkXPress. Send query letter with printed samples, tearsheets, résumé, SASE and color copies. Accepts disk submissions compatible with QuarkXPress (JPEG files). Samples are filed or returned by SASE on request. Reports back within 6-8 weeks. To show portfolio, artist should follow-up with call and/or letter after initial query. Portfolio should include color, final art, tearsheets, transparencies. Rights purchased vary according to project. Pays on publication; $50-200 for color inside; $150-300 for 2-page spreads; $30-50 for spots. Finds illustrators through word of mouth and submissions.
Tips: "Read the magazine first; we like colorful work; ability to turn around in two weeks."

GLAMOUR, 350 Madison Ave., New York NY 10017. Art Director: Kati Korpijaakko. Monthly magazine. Covers fashion and issues concerning working women (ages 20-35). Originals returned at job's completion. Sample copies available on request. 5% of freelance work demands knowledge of Adobe Illustrator, QuarkXPress, Adobe Photoshop and Aldus FreeHand.
Cartoons: Buys 1 cartoon/issue. Prefers feminist humor. Prefers humorous b&w line drawings with gagline. Send postcard-size sample. Samples are filed and not returned. Reports back to the artist only if interested. Rights purchased vary according to project.
Illustration: Buys 7 illustrations/issue. Works on assignment only. Considers all media. Send postcard-size sample. Samples are filed and not returned. Publication will contact artist for portfolio review if interested. Freelancers can also call to arrange portfolio drop-off. Portfolio should include final art, color photographs, tearsheets, color photocopies and photostats. Rights purchased vary according to project. Pays on publication.

‡GOLF ILLUSTRATED, P.O. Box 5300, Jenks OK 74037-5300. (918)491-6100. Fax: (918)491-9424. Website: http://www.Golfillustrated.com. Managing Editor: Jason Sowards. Estab. 1914. Bimonthly golf lifestyle magazine with instruction, travel, equipment reviews and more. Circ. 300,000. Sample copies free for 9×11 SASE and 6 first-class stamps. Art guidelines available for #10 SASE with first-class postage.
Cartoons: Approached by 25 cartoonists/year. Prefers golf. Prefers single panel, b&w washes or line drawings. Send photocopies. Samples are filed. Reports back in 1 month. Buys first North American serial rights. **Pays on acceptance**; $50 minimum for b&w.
Illustration: Approached by 50 illustrators/year. Buys 10 illustrations/issue. Prefers instructional, detailed figures, course renderings. Considers all media. 30% of freelance illustration demands knowledge of Adobe Photoshop, Adobe Illustrator and QuarkXPress. Send query letter with photocopies, SASE and tearsheets. Accepts disk submissions. Samples are filed. Reports back within 1 month. Portfolios may be dropped off Monday-Friday. Buys first North American serial and reprint rights. **Pays on acceptance**; $100-200 for b&w, $250-400 for color inside. Finds illustrators through sourcebooks, magazines, word of mouth and submissions.
Tips: "Read our magazine. We need fast workers with quick turnaround."

‡GOLF TIPS MAGAZINE, 12121 Wilshire Blvd., Suite 1200, Los Angeles CA 90025-1175. (310)820-1500. Fax: (310)820-2793. Art Director: Warren Keating. Designer: Janet Webb. Estab. 1986. Monthly 4-color consumer magazine featuring golf instruction articles. Circ. 300,000.
Illustration: Approached by 100 illustrators/year. Buys 3 illustrations/issue. Has featured illustrations by Phil Franké, Scott Matthews, Ed Wexler. Features charts & graphs, humorous illustration, informational graphics, realistic and medical illustration. Preferred subjects: men and women. Prefers realism or expressive, painterly editorial style or graphic humorous style. Assigns 30% of illustrations to well-known or "name" illustrators; 50% to experienced, but not well-known illustrators; 20% to new and emerging illustrators. 15% of freelance illustration demands knowledge of Adobe Illustrator, Adobe Photoshop and Aldus FreeHand. Send postcard or other non-returnable samples. Accepts Mac-compatible disk submissions. Send EPS or TIFF files. Samples are filed. Will contact artist for portfolio review if interested. Rights purchased vary according to project. Pays on publication; $500-700 for color cover; $100-200 for b&w inside; $250-500 for color inside; $500-700 for 2-page spreads. Finds illustrators through *LA Workbook*, *Creative Black Book* and promotional samples.
Tips: "Look at our magazine and you will see straightforward, realistic illustration, but I am also open to semi-abstract, graphic humorous illustration, gritty, painterly, editorial style, or loose pen & ink and watercolor humorous style."

THE GOLFER, 21 E. 40th St., New York NY 10016. (212)696-2484. Fax: (212)696-1678. Art Director: R. Delgado. Estab. 1994. 6 times/year "sophisticated golf magazine with an emphasis on travel and lifestyle. Circ. 250,000.
 ● Also publishes *Racquet*. Both publications are beautifully designed with superior illustrations.

Illustration: Approached by 200 illustrators/year. Buys 6 illustrations/issue. Considers all media. Send postcard sample. "We will accept work compatible with QuarkXPress 3.3. Send EPS files." Samples are not filed and are not returned. Reports back only if interested. Rights purchased vary according to project. Pays on publication. Payment to be negotiated.

Tips: "I like sophisticated, edgy, imaginative work. We're looking for people to interpret sport, not draw a picture of someone hitting a ball."

GOVERNING, 1100 Connecticut Ave. NW, Suite 1300, Washington DC 20036. (202)862-1446. Fax: (202)862-0032. E-mail: rsteadham@governing.com. Website: http://www.governing.com. Art Director: Richard Steadham. Estab. 1987. Monthly magazine. "Our readers are executives of state and local governments nationwide. They include governors, mayors, state legislators, county executives, etc." Circ. 86,000.

Illustration: Approached by hundreds of illustrators/year. Buys 5-10 illustrations/issue. Prefers conceptual editorial illustration dealing with public policy issues. Considers all media. 10% of freelance illustration demands knowledge of Adobe Photoshop, Adobe Illustrator, Aldus FreeHand. Send postcard sample with printed samples, photocopies and tearsheets. Send follow-up postcard sample every 3 months. "No phone calls please. We work in QuarkXPress, so we accept any format that can be imported into that program." Samples are filed. Reports back only if interested. Art director will contact artist for portfolio review if interested. Buys one-time rights. Pays on publication; $700-1,200 for cover; $350-700 for inside; $350 for spots. Finds illustrators through *Blackbook*, *LA Workbook*, online services, magazines, word of mouth, submissions.

Tips: "We are not interested in working with artists who can't take some direction. If your work is that precious, take it to a gallery. If you can collaborate with us in communicating our words visually, then we can do business. Also, please don't call asking if we have any work for you. When I'm ready to use you, I'll call you."

‡GRAND RAPIDS MAGAZINE, Gemini Publications, 549 Ottawa Ave., Grand Rapids MI 49503. (616)459-4545. Editor: Carole Valade. Monthly for greater Grand Rapids residents. Circ. 13,500. Original artwork returned after publication. Local artists only.

Cartoons: Buys 2-3 cartoons/issue. Prefers Michigan, Western Michigan, Lake Michigan, city, issue or consumer/household themes. Send query letter with samples. Samples not filed are returned by SASE. Reports within 1 month. Buys all rights. Pays $25-40 for b&w.

Illustration: Buys 2-3 illustrations/issue. Prefers Michigan, Western Michigan, Lake Michigan, city, issue or consumer/household themes. Send query letter with samples. Samples not filed are returned by SASE. Reports within 1 month. To show a portfolio, mail printed samples and final reproduction/product or call for an appointment. Buys all rights. Pays on publication; $100-$150 for color cover; $20-40 for b&w inside; $30-75 for color inside.

Tips: "Approach us only if you have good ideas."

GRAPHIC ARTS MONTHLY, 245 W. 17th St., New York NY 10011. (212)463-6579. Fax: (212)463-6530. E-mail: r.levy@gam.cahners.com. Website: http://www.gammag.com/. Creative Director: Rani Levy. Estab. 1930. Monthly 4-color trade magazine for management and production personnel in commercial and specialty printing plants and allied crafts. Design is "direct, crisp and modern." Circ. 95,000. Accepts previously published artwork. Originals returned at job's completion. Needs computer-literate freelancers for illustration.

Illustration: Approached by 150 illustrators/year. Buys 6 illustrations/issue. Works on assignment only. Considers all media, including computer. Send postcard-sized sample to be filed. Accepts disk submissions compatible with Adobe Photoshop 3.0, Adobe Illustrator 6.0 or EPS/TIFF files. Will contact for portfolio review if interested. Portfolio should include final art, photographs, tearsheets. Buys one-time and reprint rights. **Pays on acceptance**; $750-1200 for color cover; $250-350 for color inside; $250 for spots. Finds artists through submissions.

GRAY AREAS, P.O. Box 808, Broomall PA 19008-0808. Website: http://www.grayarea.com/gray2.htm. Publisher: Netta Gilboa. Estab. 1991. Magazine examining gray areas of law and morality in the fields of music, law, technology and popular culture. Accepts previously published artwork. Originals not returned. Sample copies available for $8; art guidelines not available.

Cartoons: Approached by 15 cartoonists/year. Buys 2-5 cartoons/issue. Prefers "illegal subject matter" humorous cartoons; single, double or multiple panel b&w line drawings. Send query letter with brochure, roughs, photocopies or finished cartoons. Samples are filed. Reports back within 1 week only if SASE provided. Buys one-time rights.

Illustration: Works on assignment only. Has featured illustrations by Dennis Preston, Jeff Wamples and Wes Wilson. Features humorous and computer illustration. Assigns 50% of illustrations to experienced, but not well-known illustrators; 50% to new and emerging illustrators. Prefers "illegal subject matter like sex, drugs, computer criminals." Considers "any media that can be scanned by a computer, up to 8½×11 inches." 50% of freelance work demands knowledge of Aldus PageMaker 6.0 or CorelDraw 6.0. Send postcard sample or query letter with SASE and photocopies. Accepts disk submissions compatible with IBM/PC. Samples are filed. Reports back within 1 week only if SASE enclosed. Portfolio review not required. Buys one-time rights. Pays on publication; $500 for color cover; negotiable b&w. Pays 5 copies of issue and masthead listing for spots.

Design: Needs freelancers for design. 50% of freelance work demands knowledge of Aldus PageMaker 6.0, Aldus FreeHand 5.0 or CorelDraw 6.0. Send query letter with photocopies. Pays by project.

Tips: "Most of the artists we use have approached us after seeing the magazine. All sections are open to artists. We are only interested in art which deals with our unique subject matter. Please do not submit without having seen the

magazine. We have a strong 1960s style. Our favorite artists include Robert Crumb and Rick Griffin. We accept all points of view in art, but only if it addresses the subject we cover. Don't send us animals, statues or scenery."

GREENPRINTS, P.O. Box 1355, Fairview NC 28730. (704)628-1902. Editor: Pat Stone. Estab. 1990. Quarterly magazine "that covers the personal, not the how-to, side of gardening." Circ. 13,000. Sample copy for $4; art guidelines free for #10 SASE with first-class postage.
Illustration: Approached by 6 illustrators/year. Works with 15 illustrators/issue. Prefers plants and people. Considers b&w only. Send query letter with photocopies, SASE and tearsheets. Samples are filed or returned by SASE. Reports back within 2 months. Buys first North American serial rights. Pays on publication; $250 maximum for color cover; $75-100 for b&w inside; $25 for spots. Finds illustrators through word of mouth, artist's submissions.
Tips: "Read our magazine. Can you do both plants and people? Can you interpret as well as illustrate a story?"

GREENWICH MAGAZINE, 39 Lewis St., Greenwich CT 06830. (203)869-0009. Fax: (203)869-2549. E-mail: grnwchmag@aol.com. Contact: Art Director. Lifestyle magazine covering the people, places, celebrities and town issues of Greenwich. Circ. 10,000
Cartoons: Approached by 10 cartoonists/year. Buys 2 cartoons/year. Prefers political and humorous, b&w washes and line drawings. Send query letter with tearsheets. Samples are filed. Reports back only if interested. Buys one-time rights. Pays on publication, $50-300 for b&w, $100-500 for color.
Illustration: Approached by 5 illustrators/year. Features caricatures of politicians, humorous and computer illustrations. Prefers light, esoteric themes. Considers all media. 50% of illustration demands knowledge of Adobe Photoshop 4.0, Adobe Illustrator 6.0 and QuarkXPress 3.32. Send query letter with printed samples, photocopies and tearsheets. Send follow-up postcard every 6 months. Accepts disk submission compatible with QuarkXPress 4.0, Illustrator 7.0 and Photoshop 4.0. Samples are filed. Reports back only if interested. Art director will contact artist for portfolio review of b&w and color slides and tearsheets if interested. Buys one-time rights. Pays on publication, $100-200 for b&w covers; $100-400 for color covers; $50-300 for b&w inside; $50-500 for color inside; $50 for spots.
Design: Needs freelancers for design and production. Prefers local designers only. 100% of freelance design demands knowledge of Adobe Photoshop 4.0, Adobe Illustrator 6.0 and QuarkXPress 3.32. Send query letter with tearsheets.
Tips: "Unfortunately, with our small circulation, we have little or no budget for artwork. Artists should probably be just starting out and need to have printed pieces for their portfolio."

✔**GROUP PUBLISHING—MAGAZINE DIVISION**, 1515 Cascade Ave, Loveland CO 80538. (970)669-3836. Fax: (970)679-4372. Publishes *Group Magazine*, Art Director: Joel Armstrong (6 issues/year; circ. 50,000; 4-color); *Children's Ministry Magazine*, Art Director: RoseAnne Buerge (6 issues/year; 4-color) for adult leaders who work with kids from birth to 6th grade; *Vital Ministry Magazine*, Art Director: Joel Armstrong (6 issues; 4-color) an interdenominational magazine which provides innovative and practical ideas for pastors. Previously published, photocopied and simultaneous submissions OK. Original artwork returned after publication. Sample copy $1 with 9×12 SAE.
 • This company also produces books. See listing in Book Publishers section.
Cartoons: Generally buys one spot cartoon per issue that deals with youth or children ministry. Pays $50 minimum. Submit cartoon samples to Joel Armstrong.
Illustration: Buys 2-10 illustrations/issue. Send postcard samples, SASE, slides or tearsheets to be kept on file for future assignments. Accepts disk submissions compatible with Mac. Send EPS files. Reports only if interested. **Pays on acceptance**; $35-450, from b&w/spot illustrations (line drawings and washes) to full-page color illustrations inside. Buys first publication rights and occasional reprint rights.
Tips: "We prefer contemporary, nontraditional (not churchy), well-developed styles that are appropriate for our innovative, youth-oriented publications. We appreciate artists who can conceptualize well and approach difficult and sensitive subjects creatively."

GUIDEPOSTS FOR KIDS, 1050 Broadway, Suite #6, Chesterton IN 46304. (219)929-4429. Fax: (219)926-3839. E-mail: gp4k@netnitco.net. Website: http://www.guideposts.org. Art Director: Michael C. Lyons. Estab. 1990. Bimonthly magazine "for children ages 8 to 12, value centered." Circ. 200,000.
Illustrtion: Approached by 40 illustrators/year. Buys 10 illustrations/issue. Considers acrylic, collage, color washed, colored pencil, marker, mixed media, oil, pastel, watercolor and electronic. 25% of freelance illustration demands knowledge of Adobe Photoshop and Adobe Illustrator. Send postcard sample or send query letter with printed samples, photocopies and tearsheets. Accepts disk submissions. Samples are filed or returned by SASE. Reports back only if interested. Art director will contact artist for portfolio review of color, final art, photographs, roughs, tearsheets and thumbnails if interested. Buys first and reprint rights. **Pays on acceptance**; $300-1,000 for color inside; $120-300 for spots. Finds illustrators through submissions, invitations from guilds, exhibitions.
Design: Needs freelancers for design. Prefers designers with experience in teen or preteen age group. 25% of freelance work demands knowledge of Adobe Photoshop, Adobe Illustrator and QuarkXPress. Send query letter with printed samples, photocopies and tearsheets.
Tips: "No adults in magazine . . . kids only. Focus on 12-year-olds not 8-year-olds. Colorful and on the funky side."

GUIDEPOSTS MAGAZINE, 16 E. 34th St., New York NY 10016. (212)251-8127. Fax: (212)684-0679. Website: http://www.guideposts.org. Art Director: Lawrence A. Laukhuf. Estab. 1945. Monthly nonprofit inspirational, consumer magazine. *Guideposts* is a "practical interfaith guide to successful living. Articles present tested methods for developing

courage, strength and positive attitudes through faith in God." Circ. 4 million. Sample copies and guidelines are available.
- Also publishes *Angels on Earth*, a bimonthly magazine buying 4-7 illustrations/issue. They feature more eclectic and conceptual art, as well as realism.

Illustration: Buys 4-7 illustrations/issue. Works on assignment only. Features humorous, realistic, computer and spot illustration. Assigns 30% of illustrations to well-known or "name" illustrators; 40% to experienced, but not well-known illustrators; 30% to new and emerging illustrators. Prefers realistic, reportorial. Considers watercolor, collage, airbrush, acrylic, colored pencil, oil, mixed media and pastel. Send postcard sample with SASE, tearsheets, photocopies and slides. Accepts disk submissions compatible with QuarkXPress, Adobe Illustrator, Adobe Photoshop (Mac based). Samples are returned by SASE if requested by artist. To arrange portfolio review artist should follow up with call after initial query. Portfolio should include 8×10 color transparencies. Buys one-time rights. **Pays on acceptance**; $2,500-3,500 for color cover; $1,500-2,400 for 2-page spreads; $300-1,000 for spots. Finds artists through sourcebooks, other publications, word of mouth, artists' submissions and Society of Illustrators' shows.

Tips: Sections most open to freelancers are illustrations for action/adventure stories. "Do your homework as to our needs. At least see the magazine! Tailor your portfolio or samples to each publication so our Art Director is not looking at one or two that fit his needs. Call me and tell me you've seen recent issues and how close your work is to some of the pieces in the magazine."

GUITAR MAGAZINE & GUITAR SHOP, 10 Midland Ave., Port Chester NY 10573. (914)935-5251. Fax: (914)937-0614. E-mail: swarzecha@cherrylane.com. Art Director: Stephanie L. Warzecha. Monthly consumer magazine for practicing musicians with news on products and artists in the industry. Sample copies and art guidelines available.

Illustration: Approached by 35 or more illustrators/year. Buys 6-9 illustrations/issue. Bright, energetic and edgy is the usual style of art. Considers all media. Some freelance illustration demands knowledge of Adobe Photoshop, Adobe Illustrator and QuarkXPress. Send postcard sample or send query letter with printed samples and photocopies. Accepts disk submissions compatible with QuarkXPress 3.32. Photoshop files should be EPS-266 resolution and CMYK. Samples are filed or returned. Reports back only if interested. Art director will contact artist for portfolio review of color, photographs, slides, tearsheets if interested. Buys first rights. **Pays on acceptance**, negotiable depending on experience. Finds illustrators through *Creative Black Book* and samples.

Design: Prefers designers with experience in magazine publications. 100% of freelance design work demands knowledge of Aldus FreeHand, Adobe Photoshop, Adobe Illustrator, QuarkXPress. Send query letter with printed samples and photocopies.

Tips: "We need fast workers that work well under pressure while still creating dynamic designs."

GUITAR PLAYER, 411 Borel Ave., Suite #100, San Mateo CA 94402. (415)358-9500. Fax: (415)358-9527. Website: http://www.guitarplayer.com. Art Director: Richard Leeds. Estab. 1975. Monthly 4-color magazine focusing on technique, artist interviews, etc. Circ. 150,000. Original artwork is returned at job's completion. Sample copies and art guidelines not available.

Illustration: Approached by 15-20 illustrators/week. Buys 3 illustrations/issue. Works on assignment only. Features caricature of celebrities; realistic, computer and spot illustration. Assigns 33% of illustrations to well-known or "name" illustrators; 33% to experienced, but not well-known illustrators; 33% to new and emerging illustrators. Prefers conceptual, "outside, not safe" themes and styles. Considers pen & ink, watercolor, collage, airbrush, computer based, acrylic, mixed media and pastel. Send query letter with brochure, tearsheets, photographs, photocopies, photostats, slides and transparencies. Accepts disk submissions compatible with Mac. Samples are filed. Reports back only if interested. Will contact for portfolio review if interested. Buys first rights. Pays on publication; $200-400 for color inside; $400-600 for 2-page spreads; $200-300 for spots.

‡HABITAT MAGAZINE, 928 Broadway, New York NY 10010. (212)505-2030. Editor-in-Chief: Carol J. Ott. Art Director: Bernie Hossman. Estab. 1982. "We are a how-to magazine for cooperative and condominium boards of directors and home owner associations in New York City, Long Island, New Jersey and Westchester." Published 12 times a year; b&w with 4-color cover. Circ. 18,000. Original artwork is returned after publication. Sample copy $5. Art guidelines free for SASE with first-class postage.

Cartoons: Cartoons appearing in magazine are "line with some wash highlights." Pays $75-100 for b&w.

Illustration: Approached by 50 illustrators/year. Buys illustrations mainly for spots and feature spreads. Buys 1-3 illustrations/issue from freelancers. Needs editorial and technical illustration that is "ironic, whimsical, but not silly." Works on assignment only. Prefers pen & ink. Considers marker. Send query letter with brochure showing art style, résumé, tearsheets, photostats, photocopies, slides, photographs and transparencies (fee requirements). Looks for "clarity in form and content." Samples are filed or are returned by SASE. Reports back about queries/submissions only if interested. For a portfolio review, mail original/final art and b&w tearsheets. Pays $75-125, b&w.

Tips: "Read our publication, understand the topic. Look at the 'Habitat Hotline' and 'Case Notes' sections." Does not want to see "tired cartoons about Wall Street board meetings and cute street beggars."

⊮HADASSAH MAGAZINE, 50 W. 58th St., New York NY 10019. (212)688-0227. Fax: (212)446-9521. E-mail: hadamag1@aol.com. Estab. 1914. Consumer magazine. *Hadassah Magazine* is a monthly magazine chiefly of and for Jewish interests—both here and in Israel. Circ. 340,000.

Cartoons: Buys 1-2 freelance cartoons/issue. Preferred themes include the Middle East/Israel, domestic Jewish themes

and issues. Send query letter with sample cartoons. Samples are filed or returned by SASE. Buys first rights. Pays $50, b&w; $100, color.

Illustration: Approached by 50 freelance illustrators/year. Works on assignment only. Has featured illustrations by Dick Codor and Ilene Winnlederer. Features humorous, realistic, computer and spot illustration. Prefers themes of Jewish/family, Israeli issues, holidays. Send postcard sample or query letter with tearsheets. Samples are filed or are returned by SASE. Write for appointment to show portfolio of original/final art, tearsheets and slides. Buys first rights. Pays on publication; $400-600 for color cover; $100-200 for b&w inside; $200-250 for color inside; $100 for spots.

‡HARPER'S MAGAZINE, 666 Broadway, 11th Floor, New York NY 10012. (212)614-6500. Fax: (212)228-5889. Art Director: Angela Riechers. Estab. 1850. Monthly 4-color literary mgazine covering fiction, criticism, essays, social commentary and humor.

Illustration: Approached by 250 illustrators/year. Buys 5-10 illustrations/issue. Has featured illustrations by Steve Brodner, Ralph Steadman, Polly Becker, Edmund Guy, Mark Ulriksen, Victoria Kann, Peter de Seve. Features intelligent concept-oriented illustration. Preferred subjects: literary, artistic, social, fiction-related. Prefers intelligent, original thought and imagery in any media. Assigns 50% of illustrations to well-known or "name" illustrators; 25% to experienced, but not well-known illustrators; 25% to new and emerging illustrators. 10% of freelance illustration demands knowledge of Adobe Photoshop. Send non-returnable samples. Accepts Mac-compatible disk submissions. Samples are filed and are not returned. Will contact artist for portfolio review if interested. Portfolios may be dropped off and picked up the last Thursday of every month. Buys first North American serial rights. Pays on publication; $250-300 for b&w inside; $350-700 for color inside; $300 for spots. Finds illustrators through samples, annuals, reps, other publications.

Tips: "Intelligence, originality and beauty in execution are what we seek. A wide range of styles is appropriate; what counts most is content."

HEALTHCARE FINANCIAL MANAGEMENT, 2 Westbrook Corp. Center, Suite 700, Westchester IL 60154-5700. (708)531-9600. Fax: (708)531-0032. E-mail: cstachura@hfma.org. Publisher: Cheryl Stachura. Estab. 1946. Monthly association magazine for chief financial officers in healthcare, managers of patient accounts, healthcare administrators. Circ. 35,000. Sample copies available; art guidelines not available.

Cartoons: Buys 1 cartoon/issue. Prefers single panel, humorous b&w line drawings with gaglines. Send query letter with photocopies. Samples are filed or returned. Reports back only if interested. Pays on publication.

Illustration: All freelance illustration should be sent to James Lienhart Design, 155 N. Harbor Drive, Suite 3008, Chicago IL 60601. Considers acrylic, airbrush, color washed, colored pencil, marker, mixed media, oil, pastel, watercolor. Send query letter with printed samples, photocopies and tearsheets. Samples are filed. Will contact artist for portfolio review if interested.

HEALTHCARE FORUM JOURNAL, 425 Market St., 16th Floor, San Francisco CA 94105-2406. (415)356-4300. Fax: (415)356-9300. Art Director: Bruce Olson. Estab. 1936. Bimonthly trade journal for healthcare executive administrators, a publication of the Healthcare Forum Association. Circ. 25,000. Accepts previously published artwork. Originals are returned at job's completion.

Illustration: Approached by 25-30 illustrators/year. Buys 3-5 illustrations/issue. Works on assignment only. Has featured illustrations by Tana Powell and Whitney Sherman. Features charts & graphs; computer illustration. Assigns 5% of illustrations to well-known or "name" illustrators; 80% to experienced, but not well-known illustrators; 15% to new and emerging illustrators. Preferred styles vary, usually abstract and painterly; watercolor, collage, acrylic, oil and mixed media. Send query letter with SASE, tearsheets, photostats and photocopies. Samples are filed and returned by SASE if requested by artist. Reports back only if interested. Buys one-time rights. **Pays on acceptance**; $800-1,200 for color cover; $600-800 for color inside.

HEARTLAND USA, 1 Sound Shore Dr., Suite 3, Greenwich CT 06830-7251. (203)622-3456. Fax: (203)863-5393. E-mail: husaedit@aol.com. Editor: Brad Pearson. Estab. 1990. Quarterly 4-color magazine of U.S. Tobacco. Audience is composed of blue-collar men. Circ. 1 million. Accepts previously published artwork. Originals are returned at job's completion. Sample copies for SASE with first-class postage.

Cartoons: Approached by 60 cartoonists/year. Buys 6 cartoons/issue. Preferred themes are blue-collar life-style, "simple style, light humor, nothing political or controversial"; single panel, b&w line drawings and washes with or without gagline. Send query letter with roughs. Samples are filed. Reports back within 2 weeks. Rights purchased vary according to project. Pays $150 for b&w.

Illustration: Approached by 36 illustrators/year. Buys 2 illustrations/issue. Preferred themes are blue-collar lifestyle. Prefers flexible board. Send query letter with tearsheets. Samples are filed. Reports back within 2 weeks. Call for appointment to show portfolio of printed samples, tearsheets and slides. Rights purchased vary according to project. Pays on publication; $150 for b&w or color.

HEAVEN BONE, Box 486, Chester NY 10918. (914)469-9018. E-mail: poetsteve@compuserve.com. Editor: Steve Hirsch. Estab. 1987. Annual literary magazine emphasizing poetry, fiction reviews, and essays reflecting spiritual, surrealist and experimental literary concerns. Circ. 2,500. Accepts previously published artwork. Original artwork is returned after publication if requested. Sample copies $6; art guidelines for SASE with first-class postage.

Cartoons: Approached by 5-7 cartoonists/year. Cartoons appearing in magazine are "humorous, spiritual, esoteric, ecologically and politically astute." Pays in 2 copies of magazine, unless other arrangements made.

Illustration: Approached by 25-30 illustrators/year. Buys illustrations mainly for covers and feature spreads. Buys 2-7 illustrations/issue, 4-14/year from freelancers. Considers pen & ink, mixed media, watercolor, acrylic, oil, pastel, collage, markers, charcoal, pencil and calligraphy. Needs computer literate illustrators familiar with Adobe Illustrator, QuarkXPress, Aldus FreeHand and Adobe Photoshop. Send query letter with brochure showing art style, tearsheets, SASE, slides, transparencies, photostats, photocopies and photographs. "Send samples of your most esoteric and nontraditional work, inclusive of but not exclusively literary—be outrageous." Accepts disk submissions compatible with Adobe Illustrator 6.0, Adobe Photoshop 4.0 or any Mac compatible format. Samples are returned by SASE. Reports back within 4-6 months. To show a portfolio, mail b&w tearsheets, slides, photostats and photographs. Buys first rights. Pays in 2 copies of magazine.
Tips: "Please see sample issue before sending unsolicited portfolio."

‡THE HERB QUARTERLY, P.O. Box 689, San Anselmo CA 94960. (415)455-9540. E-mail: herbquart@aol.com. Editor and Publisher: James Keough. "Quarterly magazine emphasizing horticulture for middle to upper class men and women with an ardent enthusiasm for herbs and all their uses—gardening, culinary, crafts, etc. Most are probably home owners." Unusual design with 2 main text columns flanked by mini-columns. Uses original artwork extensively. Circ. 40,000. Original artwork returned after publication. Sample copy $5.
Illustration: Accepts pen & ink illustrations, pencil, washes and 4-color watercolors. Needs illustrations of herbs, garden designs, etc. Send query letter with brochure showing art style or résumé, tearsheets, slides and photographs. Samples not filed are returned by SASE only if requested. Reports within weeks. Buys reprint rights. Pays on publication; $200 for full page; $100 for half page; $50 for quarter page; $25 for spots.
Tips: "Artist should be able to create illustrations drawn from themes of manuscripts sent to them."

HERBALGRAM, P.O. Box 201660, Austin TX 78720-1660. (512)331-8868. Fax: (512)331-1924. E-mail: gingerhm@h erbalgram.org. Website: http://www.herbalgram.org. Art Director: Ginger Hudson-Maffei. Estab. 1983. Quarterly journal. "We're a non-commercial education and research journal with a mission to educate the public on the uses of beneficial herbs and plants. Fairly technical. For the general public, pharmacists, educators and medical professions." Circ. 33,000. Accepts previously published artwork. Originals are returned at job's completion.
Cartoons: Buys 3-4 cartoons/year. Prefers medical plant, general plant, plant regulation themes; single panel, political, humorous b&w line drawings with gaglines. Send query letter with brochure or roughs. Samples are filed. Buys one-time rights. Pays $50-100 for b&w.
Illustration: Approached by 20 illustrators/year. Buys 2 illustrations/year. Works on assignment only. Has featured illustrations by Regan Garrett and Michelle Vrentas. Features humorous, realistic and computer illustrations. Assigns 15% of illustrations to experienced, but not well-known illustrators; 85% to new and emerging illustrators. Prefers plant/drug themes. Considers acrylic, mixed media, collage or computer-generated images. 90% of freelance work demands knowledge of Adobe PageMaker, Adobe Photoshop, Freehand or Adobe Illustrator.Send query letter with photographs, tearsheets, photocopies and transparencies. Accepts disk submissions compatible with PageMaker, QuarkXPress and Adobe Illustrator. Samples are filed. Will contact artist for portfolio review if interested. Portfolio should include final art, tearsheets and photocopies. Buys one-time rights. **Pays on acceptance**; $50-200 for b&w inside; $150-700 for color inside; $50-300 for spot illustrations. Finds artists through submissions, word of mouth and *Austin Creative Directory*.
Design: Needs freelancers for production and multimedia. 95% of design demands knowledge of Aldus PageMaker, FreeHand, Adobe Photoshop, QuarkXPress or Adobe Illustrator. Send query letter with photocopies, photographs or transparencies. Pays $50-300 by project.
Tips: Have a "good knowledge of CMYK process, good knowledge of computer to service bureau process. We are nonprofit, any work donated is tax deductible. Please preview *HerbalGram* before submitting work. To get started, create a beautiful portfolio, create some hypothetical art for a publication or house you admire and use it as a tool to get in. Familiarize yourself with the companies you are soliciting. Try to know what their market and needs are. Send art that is relative to the recipient."

✔HIGHLIGHTS FOR CHILDREN, 803 Church St., Honesdale PA 18431. (717)253-1080. Fax: (717)251-7847. Art Director: Janet Moir McCaffrey. Cartoon Editor: Rich Wallace. Monthly 4-color magazine for ages 2-12. Circ. 3 million. Art guidelines for SASE with first-class postage.
Cartoons: Receives 20 submissions/week. Buys 2-4 cartoons/issue. Interested in upbeat, positive cartoons involving children, family life or animals; single or multiple panel. Send roughs or finished cartoons and SASE. Reports in 4-6 weeks. Buys all rights. **Pays on acceptance**; $20-40 for line drawings. "One flaw in many submissions is that the concept or vocabulary is too adult, or that the experience necessary for its appreciation is beyond our readers. Frequently, a wordless self-explanatory cartoon is best."
Illustration: Buys 30 illustrations/issue. Works on assignment only. Prefers "realistic and stylized work; upbeat, fun, more graphic than cartoon." Pen & ink, colored pencil, watercolor, marker, cut paper and mixed media are all acceptable. Discourages work in fluorescent colors. Send query letter with photocopies, SASE and tearsheets. Samples to be kept on file. Request portfolio review in original query. Will contact for portfolio review if interested. Buys all rights on a work-for-hire basis. **Pays on acceptance**; $1,025 for color front and back covers; $50-500 for color inside. "We are always looking for good hidden pictures. We require a picture that is interesting in itself and has the objects well-hidden. Usually an artist submits pencil sketches. In no case do we pay for any preliminaries to the final hidden pictures." Submit hidden pictures to Jody Taylor.
Tips: "We have a wide variety of needs, so I would prefer to see a representative sample of an illustrator's style."

‡**HOME EDUCATION MAGAZINE**, P.O. Box 1587, Palmer AK 99645. (907)746-1336. Fax: (907)746-1335. E-mail: hem-editor@home-ed-magazine.com. Website: http://www.home-ed-magazine. Managing Editor: Helen Hegener. Estab. 1983. "We publish one of the largest magazines available for home schooling families." Desktop bimonthly published in 2-color; b&w with 4-color cover. Circ. 7,200. Original artwork is returned after publication upon request. Sample copy $4.50. Art guidelines for SASE with first-class postage.
Cartoons: Approached by 20-30 cartoonists/year. Buys 1-2/year. Style preferred is open, but theme must relate to home schooling. Prefers single, double or multiple panel b&w line drawings and washes with or without gagline. Send query letter with samples of style, roughs and finished cartoons, "any format is fine with us." Samples are filed or returned by SASE. Reports back within 3 weeks. Buys reprint rights, one-time rights or negotiates rights purchased. **Pays on acceptance**; $10-20 for b&w.
Illustration: Approached by 100 illustrators/year. Buys illustrations mainly for spots and feature spreads. Considers pen & ink, mixed media, markers, charcoal pencil or any good sharp b&w or color media. Send postcard sample or query letter with brochure, résumé, slides, transparencies, tearsheets, photocopies or photographs. Accepts disk submissions. "We're looking for originality, clarity, warmth. Children, families and parent-child situations are what we need." Samples are filed or are returned by SASE. Will contact for portfolio review if interested. Buys one-time rights, reprint rights or negotiates rights purchased. **Pays on acceptance;** $50 for color cover; $10-50 for color inside; $5-20 for spots. Finds artists primarily through submissions and self-promotions.
Design: Needs freelancers for design. 100% of freelance work demands knowledge of Adobe Photoshop or QuarkXPress. Send query letter with any samples. Pays by project.
Tips: "Most of our artwork is produced by staff artists. We receive very few good cartoons. Study what we've done, suggest how we might improve it."

HOME FURNISHINGS EXECUTIVE, 305 W. High St., Suite 400, High Point NC 27260. (910)883-1650. Fax: (910)883-1195. Editor: Trisha McBride. Estab. 1927. Monthly trade journal "of the National Home Furnishings Association. We provide in-depth coverage of trend, operational, marketing and advertising issues of interest to furniture retailers." Sample copies free for 4 first-class stamps; art guidelines free for SASE with first-class postage.
Cartoons: Approached by 1-5 cartoonists/year. Buys 0-1 cartoon/issue. Prefers single panel, humorous, b&w and color washes, b&w line drawings with or without gagline. Send query letter with finished cartoons, photographs, photocopies, roughs, SASE and tearsheets. Samples are filed unless return requested by SASE. Reports back only if interested. Rights purchased vary according to project. **Pays on acceptance;** $50-500.
Illustration: Approached by 1-5 illustrators/issue. Buys 10-20 illustrations/year. Features humorous and realistic illustration, charts & graphs, informational graphics and computer and spot illustration. Prefers furniture, consumers, human resources and merchandising. Considers all media. Send postcard sample or printed samples, photocopies and SASE. Accepts disk submissions. "We accept submissions compatible with QuarkXPress 7.5/V.3.32. Send EPS files." Samples are filed or are returned by SASE. Reports back only if interested. Art director will contact artist for portfolio review b&w, color, final art and tearsheets if interested. Rights purchased vary according to project. Pays on publication; $500-1,000 for cover; $50-1,000 for inside. Finds illustrators through submissions.
Design: Needs freelancers for design. Prefers local design freelancers only. 90% of freelance work demands knowledge of Adobe Photoshop, Adobe Illustrator, Aldus FreeHand and QuarkXPress. Send query letter with printed samples, photocopies, SASE and tearsheets.
Tips: "We are only interested in work of relevance to home furnishings retailers. Do not call, send queries. Postcards showing work are great reminders of artists work."

‡**HOME OFFICE COMPUTING MAGAZINE**, Curtco Freedom Group, 29160 Heather Cliff Rd., Suite 200, Malibu CA 90265. (310)579-3400. Fax: (310)579-3304. Art Director: Mary Franz. Estab. 1980. Monthly magazine of small business/home office advice; 4-color. Circ. 380,000. Accepts previously published artwork. Originals are returned at job's completion "when possible." Sample copies available.
Cartoons: Interested in *New Yorker* style; buys very few. Pays $200 for b&w inside.
Illustration: Approached by 45 illustrators/year. Buys 12 illustrations/issue. Works on assignment only. Prefers pen & ink, watercolor, collage, acrylic, colored pencil and mixed media. Freelance work demands knowledge of Adobe Photoshop and QuarkXPress. Send query letter with tearsheets. Samples are filed. Reports back only if interested. To show a portfolio, call for appointment. Portfolio should include tearsheets and slides. Buys one-time rights. Pays $250 for b&w and color "spot" art; $500-600 for color cover.

‡**HOMEPC**, 600 Community Dr., Manhasset NY 11030. (516)562-5000. Fax: (516)562-7007. Creative Director: David Loewy. Estab. 1994. Monthly consumer magazine. A magazine for home computer users. Easy to read, non-technical; covering software and hardware, entertainment and personal products. Circ. 650,000. Originals are returned at job's completion. Sample copies available. 50% of freelance work demands knowledge of Adobe Photoshop.
Illustration: Approached by 200 illustrators/year. Buys 15 illustrations/issue. Works on assignment only. Considers airbrush, colored pencil, mixed media, collage, acrylic, oil and computer illustration. Send postcard sample with tearsheets. Accepts Mac compatible disk submissions. Samples are filed and are not returned. Publication will contact artist for portfolio review if interested. Portfolio should include final art and tearsheets. Buys one-time and reprint rights; rights purchased vary according to project. **Pays on acceptance;** $2,000-3,000 for color cover; $500-1,500 for color inside; $200-500 for spots.
Design: Needs freelancers for production. 100% of design work demands knowledge of Aldus FreeHand, Adobe

Photoshop, QuarkXPress and Adobe Illustrator. Send résumé and tearsheets. Pays by the hour, $15-25. Finds 75 percent of illustrators through sourcebooks; 25 percent through mailers and chance discovery.

HONEYMOON MAGAZINE, 4977 SW 74th Court, Miami FL 33155. (305)662-5589. Fax: (305)662-5589. E-mail: adsan@aol.com. Website: http://www.honeymoonmagazine.com. Creative Director: Miranda Newsom. Estab. 1994. Quarterly consumer magazine "focused on romantic travel, honeymoon and destination weddings." Circ. 200,000. Sample copies free for #10 SASE with first-class stamps; art guidelines not available.
Illustration: Approached by 10-15 illustrators/year. Buys 2 illustrations/issue. Features caricatures of celebrities, charts & graphs and spot illustration. Assigns 20% of illustrations to experienced, but not well-known illustrators; 80% to new and emerging illustrators. Prefers tropical and romantic themes. Considers airbrush, collage, colored pencil, mixed media, oil, pastel and watercolor. 50% of freelance illustration demands knowledge of Adobe Photoshop, Adobe Illustrator, Aldus FreeHand and QuarkXPress. Send query letter with printed samples, postcards that show your style of illustration and photocopies. Accepts disk submissions. Must be Quark 3.3.2 comp and on Zip disk only. Samples are filed. Reports back within 2 months. Art director will contact artist for portfolio review of b&w, color, photographs, photostats, roughs, slides, tearsheets and thumbnails if interested. Buys first North American serial, one-time and reprint rights. Pays on publication. Payment for spots negotiable. Finds illustrators through magazines and artist's submissions.
Design: Needs freelancers for design, production and multimedia projects. 100% of freelance work demands knowledge of Adobe Photoshop and QuarkXPress. Send query letter with printed samples, photocopies and tearsheets.
Tips: "We use quite a lot of freelance design and illustration."

HOPSCOTCH, The Magazine for Girls, Box 164, Bluffton OH 45817. (419)358-4610. Contact: Becky Jackman. Estab. 1989. A bimonthly magazine for girls between the ages of 6 and 12; 2-color with 4-color cover; 50 pp.; 7×9 saddle-stapled. Circ. 10,000. Original artwork returned at job's completion. Sample copies available for $3. Art guidelines for SASE with first-class postage. 20% of freelance work demands computer skills.
 ● Also publishes *Boys' Quest*.
Illustration: Approached by 200-300 illustrators/year. Buys 6-7 freelance illustrations/issue. Has featured illustrations by Chris Sabatino, Pamela Harden and Donna Catanese. Features humorous, realistic and spot illustration. Assigns 60% of illustrations to experienced, but not well-known illustrators; 40% to new and emerging illustrators. Artists work mostly on assignment. Needs story illustration. Prefers traditional and humor; pen & ink. Send query letter with photocopies of pen & ink samples. Samples are filed. Reports back within 2 months. Buys first rights and reprint rights. **Pays on acceptance**; $200-250 for color cover; $25-35 for b&w inside; $50-70 for 2-page spreads; $10-25 for spots.

‡HORTICULTURE MAGAZINE, 98 N. Washington St., Boston MA 02114. (617)742-5600. E-mail: hortmag@aol.com. Website: http://www.hortmag.com. Art Director: Pam Conrad. Estab. 1904. Monthly magazine for all levels of gardeners (beginners, intermediate, highly skilled). "*Horticulture* strives to inspire and instruct people who want to garden." Circ. 350,000. Originals are returned at job's completion. Art guidelines are available.
Illustration: Approached by 75 freelance illustrators/year. Buys 10 illustrations/issue. Works on assignment only. Features realistic illustration; informational graphics; spot illustration. Assigns 80% to experienced, but not well-known illustrators; 20% to new and emerging illustrators. Prefers tight botanicals; garden scenes with a natural sense to the clustering of plants; people; hands and "how-to" illustrations. Considers all media. Send query letter with brochure, résumé, SASE, tearsheets, slides. Samples are filed or returned by SASE. Publication will contact artist for portfolio review if interested. Buys one-time rights. Pays 1 month after project completed. Payment depends on complexity of piece; $800-1,200 for 2-page spreads; $150-250 for spots. Finds artists through word of mouth, magazines, artists' submissions/self-promotions, sourcebooks, artists' agents and reps, attending art exhibitions.
Tips: "I always go through sourcebooks and request portfolio materials if a person's work seems appropriate and is impressive."

HOUSE BEAUTIFUL, 1700 Broadway, 29th Floor, New York NY 10019. (212)903-5229. Fax: (212)765-8292. Art Director: Andrzej Janerka. Estab. 1896. Monthly consumer magazine. *House Beautiful* is a magazine about interior decorating—emphasis is on classic and contemporary trends in decorating, architecture and gardening. The magazine is aimed at both the professional and non-professional interior decorator. Circ. 1.3 million. Originals returned at job's completion. Sample copies available.
Illustration: Approached by 75-100 illustrators/year. Buys 2-3 illustrations/issue. Works on assignment only. Prefers contemporary, conceptual, interesting use of media and styles. Considers all media. Send postcard-size sample. Samples are filed only if interested and are not returned. Portfolios may be dropped off every Monday-Friday. Publication will contact artist for portfolio review of final art, photographs, slides, tearsheets and good quality photocopies if interested. Buys one-time rights. Pays on publication; $600-700 for color inside; $600-700 for spots (99% of illustrations are done as spots).
Tips: "We find most of our artists through artist submissions of either portfolios or postcards. Sometimes we will contact an artist whose work we have seen in another publication. Some of our artists are found through artist reps and annuals."

✔HOW, The Bottomline Design Magazine, 1507 Dana Ave., Cincinnati OH 45207. Art Director: Nancy Stetler. Estab. 1985. Bimonthly trade journal covering "how-to and business techniques for graphic design professionals." Circ. 35,000. Original artwork returned at job's completion. Sample copy $8.50.

• Sponsors annual conference for graphic artists. Send SASE for more information.
Illustration: Approached by 100 illustrators/year. Buys 4-6 illustrations/issue. Works on assignment only. Considers all media, including photography and computer illustration. Send non-returnable samples. Accepts disk submissions. Reports back only if interested. Buys first rights or reprint rights. Pays on publication; $150-200 for b&w; $275-800 for color inside.
Tips: "Send good samples that apply to the work I use. Be patient, art directors get a lot of samples."

✔HR MAGAZINE, 1800 Duke St., Alexandria VA 22314. (703)548-3440. Fax: (703)548-9140. E-mail: caroline@shrm.org. Website: http://www.shrm.org. Art Director: Caroline Foster. Estab. 1948. Monthly trade journal dedicated to the field of human resource management. Circ. 100,000.
Illustration: Approached by 70 illustrator/year. Buys 4 illustration/issue. Prefers people, management and stylized art. Considers all media. 50% of illustration demands knowledge of Adobe Photoshop, Adobe Illustrator, Aldus FreeHand and QuarkXPress. Send query letter with printed samples. Accepts disk submissions. Illustrations can be attached to e-mails. *HR Magazine* is PC based. Samples are filed. Art director will contact artist for portfolio review if interested. Rights purchased vary according project. Requires artist to send invoice. Pays within 30 days. Pays $800-3,000 for color cover; $250-2,000 for color inside. Finds illustrators through sourcebooks, magazines, word of mouth and artist's submissions.

HSUS NEWS, 700 Professional Dr., Gaithersburg MD 20814. Art Director: Theodora T. Tilton. Estab. 1954. Quarterly 4-color magazine focusing on Humane Society news and animal protection issues. Circ. 450,000. Accepts previously published artwork. Originals are returned at job's completion. Art guidelines not available.
Illustration: Buys 1-2 illustrations/issue. Works on assignment only. Features natural history, realistic and spot illustration. Assigns 20% of illustrations to well-known or "name" illustrators; 80% to experienced, but not well-known illustrators. Themes vary. Send query letter with samples. Samples are filed or returned. Reports back within 1 month. To show a portfolio, mail appropriate materials. Portfolio should include printed samples, b&w and color tearsheets and slides. Buys one-time rights and reprint rights. **Pays on acceptance**; $250-500 for b&w cover; $250-500 for color cover; $300-500 for b&w inside; $300-500 for color inside; $300-600 for 2-page spreads; $75-150 for spots.

HUMPTY DUMPTY'S MAGAZINE, Children's Better Health Institute, 1100 Waterway Blvd., Box 567, Indianapolis IN 46206. (317)636-8881. Website: http://www.satevepost.org/kidsonline. Art Director: Rebecca Ray. A health-oriented children's magazine for ages 4-7; 4-color; simple and direct design. Published 8 times/year. Circ. 200,000. Originals are not returned at job's completion. Sample copies available for $1.25; art guidelines for SASE with first-class postage.
• Also publishes *Child Life, Children's Digest, Children's Playmate, Jack and Jill, Turtle Magazine* and *U.S. Kids Weekly Reader Magazine*.
Illustration: Approached by 300-400 illustrators/year. Buys 20 illustrations/issue. Has featured illustrations by BB Sams, Alan MacBain, David Helton and Patti Goodnow. Features humorous, realistic, medical, computer and spot illustration. Assigns 90% of illustrations to experienced, but not well-known illustrators; 10% to new and emerging illustrators. Works on assignment only. Preferred styles are mostly cartoon and some realism. Considers any media as long as finish is done on scannable (bendable) surface. Send query letter with slides, brochure, photographs, photocopies, tearsheets and SASE. Samples are filed or returned by SASE if not kept on file. Reports back only if interested. To show a portfolio, mail color tearsheets, photostats, photographs and photocopies. Buys all rights. Pays on publication; $275 for color cover; $35-90 for b&w inside; $70-155 for color inside; $210-310 for 2-page spreads; $35-80 for spots; additional payment for digital pre-separated imagery: $35 full; $15 half; $10 spot.
Tips: "Send us very consistent styles of your abilities, along with a comment card and SASE for return."

HURRICANE ALICE: A FEMINIST QUARTERLY, Rhode Island College, Dept. of English, Providence RI 02908. (401)456-8377. Fax: (401)456-8379. E-mail: mreddy@grog.ric.edu. Submissions Manager: Joan Dagle. Estab. 1983. Quarterly literary magazine featuring nonfiction, fiction, poetry, reviews and artwork reflecting the diversity of women's lives. Sample copies for $2.50. Art guidelines for SASE with first-class postage.
Cartoons: Prefers woman centered/feminist themes. Send query letter with photocopies. Samples are filed and returned by SASE when appropriate. Reports back in 4 months. Pays in copies.
Illustration: Approached by 20 illustrators/year. Accepts 3-5 illustrations/issue. Has featured illustrations by Abigail Test, Kate Duhamel and Shawn Boyle. Prefers woman-centered/feminist themes. Considers all media. Send printed samples or photocopies and SASE when appropriate. Accepts disk submissions compatible with QuarkXPress 7.5/version 3.3, send EPS files, "but prefers photocopies." Samples are filed or returned by SASE if requested. Reports back in 4 months. Pays in copies. Finds illustrators through word of mouth, submissions and previous contributors.

✔HX MAGAZINE, 230 W. 17th St., 8th Floor, New York NY 10011. (212)352-3535. Website: http://www.hx.com. Contact: Art Director. Weekly magazine "covering gay and lesbian general interest, entertainment and nightlife in New York City." Circ. 30,000.
Cartoons: Approached by 5 cartoonists/year. Buys 1 cartoon/issue. Prefers gay and/or lesbian themes. Prefers multiple panel, humorous b&w line drawings with gagline. Send query letter with photocopies. Samples are filed and are not returned. Reports back only if interested. Rights purchased vary according to project. Pays on publication. Payment varies.
Illustration: Approached by 10 illustrators/year. Number of illustrations purchased/issue varies. Prefers gay and/or

"For the beginning humorous illustrator, the children's market is easy to approach and uses a lot of art," says illustrator Richard Weiss. "They're more apt than most markets to respond to direct mail, and frequently they can become regular clients." Weiss created this fun illustration and five others for an article in *Humpty Dumpty's Magazine*, published by the Children's Better Health Institute. Weiss has been doing occasional work for CBHI for the last several years after finding the company in *Artist's & Graphic Designer's Market*.

lesbian themes. Considers all media. Send query letter with photocopies. Samples are filed and are not returned. Reports back only if interested. Art director will contact artist for portfolio review of b&w and color if interested. Rights purchased vary according to project. Pays on publication. Finds illustrators through submissions.
Tips: "Read and be familiar with our magazine. Our style is very specific."

I.E. MAGAZINE, P.O. Box 9873, The Woodlands TX 77387-6873. (409)321-2223. E-mail: yoly@flex.net. Magazine Editor: Yolande Gottlieb. Art Editor: Debra Hensley. Estab. 1990. Annual literary magazine. "We aim to present quality literature and art. Our audience is mostly writers, poets and artists." Circ. 200. Sample copies for $6 postpaid; add $1.50 for foreign postage.
 • Also publishes *Poet's Journey*, same address and art director.
Cartoons: Approached by 10 cartoonists/year. Prefers b&w line drawings. Features informational graphics; computer, humorous and realistic illustration. Considers panel, single page or multiple page strips. "Cartoons should be of interest to artists, writers or poets." Send query letter with postcard-size sample or finished cartoons. Samples are returned by SASE. Reports back in 1-2 months. Buys one-time and first rights. Pays $2-5 for b&w or color cover; $1-2 for b&w or color inside; $1-3 for 2-page spreads; $1-2 for spots.
Illustration: Considers pen & ink, charcoal. Send postcard-size sample, photographs or finished cartoons and SASE.

Samples are filed or returned by SASE. Reports back in 1-3 months. Buys first rights. Pays $2-5 plus copies. Always looking for interesting cover ideas.
Fine Arts: Considers drawings, paintings, sculptures, photographs and mixed media. Prefers b&w, but will try color. Send b&w prints, bio and artist's statement. Often publishes photographs of artist's with their work. Pays $2-5 plus copies.
Tips: "Please do not send us metered mail. We support artists who design postage stamps. Request guidelines with #10 SASE."

✔IDEALS MAGAZINE, 535 Metroplex Dr., Suite 250, Nashville TN 37211. (615)333-0478. Fax: (615)781-1447. Editor: Lisa Ragan. Estab. 1944. 4-color bimonthly seasonal general interest magazine featuring poetry and light prose. Circ. 200,000. Accepts previously published material. Sample copy $4. Art guidelines free for #10 SASE with first-class postage.
Illustration: Approached by 100 freelancers/year. Buys 8 illustrations/issue. Has featured illustrations by Patrick McRae, Gail Roth, Susan Harrison and Stacey Pickett. Features realistic and spot illustration of children, families and pets. Uses freelancers mainly for flowers, plant life, wildlife, realistic people illustrations and botanical (flower) spot art. Prefers seasonal themes rendered in a nostalgic style. Prefers airbrush, colored pencil, oil, watercolor and pastel. Assigns 90% of illustrations to experienced, but not well-known illustrators; 10% to new and emerging illustrators. "We are interested in seeing examples of what illustrators can do with Fractal Design Painter. Must *look* as hand-drawn as possible." Send non-returnable samples or tearsheets. Samples are filed. Reports back only if interested. Do not send originals or slides. Buys artwork outright. Pays on publication; $100 minimum.
Tips: "In submissions, target our needs as far as style is concerned, but show representative subject matter. Artists should be familiar with our magazine before submitting samples of work."

IEEE SPECTRUM, 345 E. 47th St., New York NY 10017. (212)705-7568. Fax: (212)705-7453. Website: http://www.spectrum-ieee.org. Art Director: Mark Montgomery. Estab. 1963. Monthly nonprofit trade magazine serving electrical and electronics engineers worldwide. Circ. 320,000.
Illustration: Buys 3 illustrations/issue. Has featured illustrations by John Hersey, J.D. King, Rob Magieri, Octavio Diaz, Dan Vasconcellos, M.E. Cohen, John Howard. Features natural history; realistic illustration; charts & graphs; informational graphics; medical, computer and spot illustration. Assigns 50% of illustrations to well-known or "name" illustrators; 25% to experienced, but not well-known illustrators; 25% to new and emerging illustrators. Considers all media. 50% of illustration demands knowledge of Adobe Photoshop and Adobe Illustrator. Send postcard sample or query letter with printed samples and tearsheets. Accepts disk submissions: 3.5 Mac disk; file compressed with STUFFIT. Send RGB, TIFF or EPS files. Samples are filed and are not returned. Reports back only if interested. Art director will contact artist for portfolio review if interested. Portfolio should include color, final art and tearsheets. Buys first rights and one year's use on website. **Pays on acceptance**; $1,800 minimum for cover, negotiable if artwork is highly complex; $450 minimum for inside. Finds illustrators through Graphic Artist Guild book, *American Showcase*, *Workbook*.
Design: Needs freelancers for design and multimedia. Local design freelancers only. 100% of freelance work demands knowledge of Adobe Photoshop 4.0, Adobe Illustrator 6.0, QuarkXPress 3.32 and Quark Publishing System. Send query letter with tearsheets.
Tips: "As our subject matter is varied, *Spectrum* uses a variety of illustrators. Artists should have a well-defined style. Read our magazine before sending samples. Prefer realism due to scientific subject matter."

ILLINOIS ENTERTAINER, 124 W. Polk, #103, Chicago IL 60605. (312)922-9333. Fax: (312)922-9369. E-mail: ieeditors@aol.com. Editor: Michael C. Harris. Estab. 1974. Sleek consumer/trade-oriented monthly entertainment magazine focusing on local and national alternative music. Circ. 75,000. Accepts previously published artwork. Originals are not returned. Sample copies for SASE with first-class postage.
Illustration: Approached by 10-20 freelance illustrators/year. Works on assignment only. Send postcard sample or query letter with photocopies and photographs. Will contact for portfolio review if interested. Buys first rights. Pays on publication; $100-140 for color cover; $20-30 for b&w inside; $20-30 for color inside. Finds artists through word of mouth and submissions.
Tips: "Send some clips and be patient."

ILLINOIS MEDICINE, 20 N. Michigan Ave., Suite 700, Chicago IL 60602. (312)782-1654. Fax: (312)782-2023. Production Design Manager: Carla Nolan. Estab. 1989. Biweekly 4-color company tabloid published for the physician members of the Illinois State Medical Society featuring nonclinical socio-economic and legislative news; conservative design. Circ. 20,000. Accepts previously published artwork. Illustrations are returned at job's completion. Sample copies available.
Cartoons: Approached by 20 cartoonists/year. Buys 1 cartoon/issue. Prefers medical themes—geared to physicians; single panel, b&w washes and line drawings with gagline. Send query letter with finished cartoons. Samples are not filed and are returned. Reports back within 2 months. Buys one-time rights. Pays $50 for b&w, $100 for color.
Illustration: Approached by 30 illustrators/year. Buys 1 illustration/issue. Works on assignment only. Send postcard sample or query letter with brochure, tearsheets, photostats or photographs. Accepts disk submissions. Samples are filed. Will contact for portfolio review if interested. Artist should follow up with call or letter. Portfolio should include roughs, printed samples, b&w and color tearsheets, photostats and photographs. Buys one-time rights. **Pays on acceptance**; $500 for b&w, $800-1,200 for color. Finds artists mostly through self-promotions.

"The idea of this piece was to show people interfacing and forming ideas, which are taken up by others and evolve into more complex systems, and eventually into useable technology," says Tim Lewis of his watercolor and ink illustration for *IEEE Spectrum* magazine. *IEEE*'s art director contacted Lewis after seeing his ads in *Graphic Artists Guild Directory of Illustration* and *American Showcase*. Lewis has recently acquired a rep. "In addition to the ads, we send samples or portfolios out upon request. Juried competitions have also been a good marketing tool."

INCOME OPPORTUNITIES, 5300 City Plex Tower, 2448 E. 81st St., Tulsa OK 74137-4207. (918)491-6100. Fax: (918)491-9424. E-mail: sbrown@natcom-publications.com. Website: http://www.incomeops.com. Contact: Steven M. Brown. Estab. 1956. Monthly consumer magazine for home-based and small businesses. Circ. 300,000. Originals returned at job's completion. 5% of freelance work demands knowledge of Illustrator/Photoshop.
Illustration: Approached by 10 illustrators/year. Buys 10 illustrations/issue. Works on assignment only. Considers watercolor and airbrush. Send sample. Accepts disk submissions compatible with Adobe Illustrator 6.0. Samples are filed. Reports back to the artist only if interested. To arrange portfolio review artist should follow up with call and letter after initial query. Portfolio should include tearsheets, final art and photographs. Buys one-time rights. Pays on publication; $400-900 for cover art; $350-500 color inside. Finds artists through sourcebooks like *American Showcase*, also through submissions.
Tips: "Send mailing cards." Looking for "strong design skills with the experience of previous clients."

‡**INDEPENDENT PUBLISHER**, 121 E. Front St., Suite 401, Traverse City MI 49684. (401)789-0074. Fax: (401)789-3793. E-mail: jgdesign@smallpress.com. Website: http://smallpress.com. Managing Editor: Mardi Link. Estab. 1983. Quarterly trade journal for independent publishers. Articles feature areas of interest for anyone in field of publishing; up to 200 reviews of books in each issue. Circ. 9,000. Accepts previously published artwork. Originals returned at job's completion. Sample copies for $5.95; art guidelines available for SASE with first-class postage.
Illustration: Approached by 75 illustrators/year. Uses 10-20 illustrations. Has featured illustrations by Amy Smyth, Beth Jepson and Amy Linton. Features caricatures of celebrities; humorous and realistic illustration; charts & graphs; informational graphics; computer illustrations. Assigns 1% of illustrations to well-known or "name" illustrators; 14% to experienced, but not well-known illustrators; 85% to new and emerging illustrators. Considers pen & ink, airbrush, colored pencil, mixed media, collage, charcoal, watercolor, acrylic, oil and pastel. Send postcard-size sample or query letter with brochure, photographs, photocopies, photostats, slides and transparencies. Samples are not filed and are returned only by SASE if provided by artist. Publication will contact artist for portfolio review of photographs if interested. Rights purchased vary according to project. Pays $100 maximum for b&w and color cover, plus short bio of artist on Portfolio page and 5 copies of magazine.

THE INDEPENDENT WEEKLY, P.O. Box 2690, Durham NC 27715. (919)286-1972. Fax: (919)286-4274. Contact: Sheila Cain. Estab. 1982. Weekly b&w with 2-color cover tabloid; general interest alternative. Circ. 50,000. Original artwork is returned if requested. Sample copies for SASE with first-class postage.
Illustration: Buys 10-15 illustrations/year. Works on assignment only. Prefers political satire, caricatures. Considers pen & ink; b&w and color. Samples are filed or are returned by SASE if requested. Reports back only if interested. Call for appointment to show portfolio or mail b&w tearsheets. Pays on publication; $100-200 for cover; $25-50 for b&w inside and spots.
Tips: "Have a political 'point of view.' Understand the peculiarities of newsprint."

‡**INFORMATION WEEK**, 600 Community Dr., Manhasset NY 11030. (516)562-5512. Fax: (516)562-5036. E-mail: rbundi@cmp.com. Website: http://www.informationweek.com. Art Director: Renee Bundi. Weekly 4-color trade publication for business and technology managers, combining business and technology issues. Circ. 375,000.
Illustration: Approached by 200 illustrators/year. Buys 400 illustrations/year. Has featured illustrations by David Peters, Bill Mayer, Rapheal Lopez, Matsu, D.S. Stevens, Wendy Grossman. Features computer, humorous, realistic and spot illustrations of business subjects. Prefers many different media, styles. Assigns 33% of illustrations to well-known or "name" illustrators; 33% to experienced, but not well-known illustrators; 33% to new and emerging illustrators. 30% of freelance illustration demands knowledge of Adobe Illustrator, Adobe Photoshop. Send postcard sample or query letter with non-returnable printed samples, tearsheets. Send follow-up postcard every 6 months. Accepts Mac-compatible disk submissions. Send EPS files. Samples are filed. Will contact artist for portfolio review if interested. Buys first rights, reprint rights or rights vary according to project. Pays on publication; $700-1,200 for color cover; $500-1,000 for color inside; $800-1,500 for 2-page spreads; $300 for spots. Finds illustrators through mailers, sourcebooks: *Showcase, Work Book, The Alternative Pick, Black Book, New Media Showcase*.
Tips: "We look for a variety of styles and media. To illustrate, sometimes very abstract concepts. Quick turnaround is very important for a weekly magazine."

INGRAMS MAGAZINE, 306 E. 12th, #1014, Kansas City MO 64106. (816)842-9994. Fax: (816)474-1111. E-mail: ingrams@ingramsmag.com. Contact: Art Director. Monthly magazine covering business. Circ. 20,000. Sample copies free for #10 SASE with first-class postage; art guidelines lines not available.
Illustration: Buys 2 illustrations/issue. Features realistic illustration; charts & graphs and computer and spot illustration. Assigns 20% of illustrations to experienced, but not well-known illustrators; 80% to new and emerging illustrators. Considers all media. 50% of freelance illustration demands knowledge of Adobe Photoshop and QuarkXPress. Send query letter with printed samples. "Call us, we will give details!" Samples are filed. Reports back only if interested. Art director will contact artist for portfolio review of b&w and color photographs and tearsheets if interested. Rights purchased vary according to project. Pays $50-75 for b&w inside; $50-150 for color inside; $100-200 for 2-page spreads; $50-150 for spots. Finds illustrators through magazines and artist's submissions.
Tips: "Look through our magazine. If you're interested, send some samples or give me a call."

‡**♣INK MAGAZINE**, P.O. Box 52558, 265 Bloor St., W. Toronto, Ontario M5S 1V0 Canada. Art Director: G. Uhlyarik. Estab. 1993. Quarterly b&w literary magazine. Circ: 500. Art guidelines free for #10 SASE with first-class postage.

Illustration: Has featured illustrations by: Greg Rennick, Jim Walke and Roza Huh. Features all kinds of illustration. Prefers woodcuts, lithos, prints. Send query letter with photocopies and SASE. Accepts disk submissions. Send TIFF files. Samples are returned by SASE. Reports back in 2 months. Will contact artist for portfolio review if interested. Buys first North American serial rights. Pays 1-year subscription. Finds artists through word of mouth.
Tips: "We like high-contrast, bold and expressive work that feels good in your hands and is pleasing to the eye."

INKSLINGER, 8661 Prairie Rd. NW, Washington Court House OH 43160-9490. Publisher/Editor: Nancy E. Martindale. Estab. 1993. Literary magazine published 3 times/year. "We publish only poetry." Sample copy for $4; art guidelines free for #10 SASE with first-class postage.
Illustration: Plans to buy 1 illustration/issue. Has featured illustrations by Jennifer Fennell and Nancy Martindale. Features humorous, realistic, computer and spot illustration. No holiday stuff (e.g., Santa Claus, Easter Bunny, etc.). Considers pen & ink. Send query letter with photocopies and SASE. Samples are not filed and are returned by SASE. Reports back within 3-5 months. Buys one-time rights. Pays 1 copy; extra copies at a discount. Finds illustrators through *Artist's & Graphic Designer's Market* submissions and word of mouth.
Tips: "Obtain guidelines first. There is a submission fee for non-subscribers. We consider artwork for cover only. Subjects and styles wide open. Be persistent; not all editors are moved by the same style, technique, subject, etc., so know your audience; request guidelines when available."

‡INTERRACE, P.O. Box 12048, Atlanta GA 30355-2048. (404)350-7877. Fax: (404)350-0819. Associate Publisher: Gabe Grosz. Estab. 1989. Consumer magazine published 8 times/year. "Magazine of interracial/multiracial/biracial theme for couples and people. Reflects the lives and lifestyles of interracial couples and people." Circ. 25,000. Accepts previously published artwork. Originals are returned at job's completion with SASE if requested. Sample copies available for $2 and 9×12 SASE. Guidelines available for SASE with first-class postage.
 • *Interrace* launched *Biracial Child* magazine ("the only one if its kind in the U.S.") in 1994 for parents of mixed-race children, interracial stepfamilies and transracial adoption. This publication is in need of illustrators. Submit to above address.
Cartoons: Approached by 10 cartoonists/year. Buys 10 cartoons/year. Prefers interracial couple/family, multiracial people themes; any format. Send query letter with roughs or finished cartoons. Samples are filed or are returned by SASE if requested. Reports back if interested within 1 month. Negotiated rights purchased. Pays $10 for b&w, $15 for color.
Illustration: Approached by 20 illustrators/year. Uses 2-3 illustrations/issue. Prefers interracial couple/family, multiracial people themes. Considers pen & ink, airbrush, colored pencil, mixed media, watercolor, acrylic, pastel, collage, marker and charcoal. Send SASE, slides and photocopies. Accepts disk submissions compatible with Adobe Illustrator 5.0. Samples are filed or are returned by SASE if requested. Reports back if interested within 1 month. Request portfolio review in original query. Artist should follow-up with letter after initial query. Portfolio should include photocopies and any samples; "it's up to the artist." Negotiates rights purchased. Pays on publication; $50 for b&w cover; $50-75 for color cover; $10-25 for b&w inside; $20-30 for color inside. Finds artists through submissions.
Tips: "We are looking for artwork for interior or cover that is not only black and white couples/people, but all mixtures of black, white, Asian, Native American, Latino, etc."

JACK AND JILL, Children's Better Health Institute, Dept. AGDM, 1100 Waterway Blvd., Box 567, Indianapolis IN 46206. (317)636-8881. Fax: (317)684-8094. E-mail: danny885@aol.com. Website: http://www.satevepost.org/kidsonline. Art Director: Andrea O'Shea. Emphasizes educational and entertaining articles focusing on health and fitness as well as developing the reading skills of the reader. For ages 7-10. Monthly except bimonthly January/February, April/May, July/August and October/November. Magazine is 32 pages, 27 pages 4-color and 5 pages b&w. The editorial content is 50% artwork. Buys all rights. Original artwork not returned after publication (except in case where artist wishes to exhibit the art; art must be available to us on request). Sample copy $1.25; art guidelines for SASE with first-class postage.
 • Also publishes *Child Life*, *Children's Digest*, *Children's Playmate*, *Humpty Dumpty's Magazine* and *Turtle*.
Illustration: Approached by more than 100 illustrators/year. Buys 25 illustrations/issue. Has featured illustrations by Len Ebert, Cheryl Mendenhall, Gabriella Dellosso and Michael Palan. Feataures humorous, realistic, medical, computer and spot illustration. Assigns 15% of illustrations to well-known or "name" illustrators; 70% to experienced, but not well-known illustrators; 15% to new and emerging illustrators. Uses freelance artists mainly for cover art, story illustrations and activity pages. Interested in "stylized, realistic, humorous illustrations for mystery, adventure, science fiction, historical and also nature and health subjects. Works on assignment only. "Freelancers can work in Aldus FreeHand, Adobe Photoshop or Quark programs." Send postcard sample to be kept on file. Accepts disk submissions. Publication will contact artist for portfolio review if interested. Portfolio should include printed samples, tearsheets, b&w and 2-color pre-separated art. Pays $275-335 for color cover; $90 maximum for b&w inside; $155-190 for color inside; $310-380 for 2-page spreads; $35-80 for spots. Company pays higher rates to artists who can provide color-separated art. Buys all rights on a work-for-hire basis. On publication date, each contributor is sent several copies of the issue containing his or her work. Finds artists through artists' submissions and self-promotion pieces.
Tips: Portfolio should include "illustrations composed in a situation or storytelling way, to enhance the text matter. Send samples of published story for which you did illustration work, samples of puzzles, hidden pictures, mazes and self-promotion art. Research publications to find ones that produce the kind of work you can produce. Send several samples (published as well as self-promotion art). The style can vary if there is a consistent quality in the work."

JACKSONVILLE, 1032 Hendricks Ave., Jacksonville FL 32207. (904)396-8666. E-mail: mail@jacksonvillemag.com. Website: http://www.jacksonvillemag.com. Contact: Art Director. Estab. 1983. City/regional lifestyle magazine covering Florida's First Coast. 10 times/yearly. Circ. 25,000. Accepts previously published artwork. Originals returned at job's completion. Sample copies available for $5 (includes postage); art guidelines for SASE with first-class postage.
Illustration: Approached by 50 illustrators/year. Buys 4 illustrations/issue. Prefers editorial illustration with topical themes and sophisticated style. Send tearsheets. Will accept computer-generated illustrations compatible with Macintosh programs: Adobe Illustrator and Adobe Photoshop. Samples are filed and are returned by SASE if requested. Reports back within 2-4 weeks. Request portfolio review in original query. Publication will contact artist for portfolio review if interested. Portfolio should include b&w and color tearsheets and slides. Buys all rights. Pays on publication; $600 for color cover; $175 for b&w inside; $150 for color inside; $75-100 for spots. Finds artists through illustration annuals.
Tips: "We are very interested in seeing new talent—people who are part of the breaking trends."

‡JAPANOPHILE, P.O. Box 7977, 415 N. Main St., Ann Arbor MI 48104. (734)930-1553. Fax: (734)930-9968. E-mail: susanlapp@aol.com. Website: http://www.Japanophile.com. Editor and Publisher: Susan Lapp. Quarterly emphasizing bonsai, haiku, sports, cultural events, etc. for educated audience interested in Japanese culture. Circ. 800. Accepts previously published material. Original artwork not returned at job's completion. Sample copy $4; art guidelines for SASE.
Cartoons: Approached by 7-8 cartoonists/year. Buys 1 cartoon/issue. Prefers single panel b&w line drawings with gagline. Send finished cartoons. Material returned only if requested. Reports only if interested. Buys all rights. Pays on publication; $20-50 for b&w.
Illustration: Buys 1-5 illustrations/issue. Needs humorous editorial illustration. Prefers sumie or line drawings. Send postcard sample to be kept on file if interested. Samples returned only if requested. Reports only if interested. Buys first-time rights. Pays on publication; $20-50 for b&w cover, b&w inside and spots.
Design: Needs freelancers for design. Send query letter with brochure, photocopies, SASE, résumé. Pays by the project, $20-50.
Tips: Would like cartoon series on American foibles when confronted with Japanese culture. "Read the magazine. Tell us what you think it needs."

✓JEMS, Journal of Emergency Medical Services, 1947 Camino Vida Roble, Suite 200, Carlsbad CA 92008. (619)431-9797. Managing Editor: Lisa Dionne. Estab. 1980. Monthly trade journal aimed at paramedics/paramedic instructors. Circ. 45,000. Accepts previously published artwork. Originals returned at job's completion. Sample copies available. Art guidelines for SASE. 95% of freelance work demands knowledge of QuarkXPress, Adobe Illustrator and Adobe Photoshop.
Illustration: Approached by 240 illustrators/year. Buys 2-6 illustrations/issue. Works on assignment only. Prefers medical as well as general editorial illustration. Considers pen & ink, airbrush, colored pencil, mixed media, collage, watercolor, acrylic, oil and marker. Send postcard sample or query letter with photocopies. Accepts disk submissions compatible with most current versions of Adobe Illustrator or Adobe Photoshop. Samples are filed and are not returned. Portfolio review not required. Publication will contact artist for portfolio review of final art, tearsheets and printed samples if interested. Rights purchased vary according to project. Pays on publication. Pays $200-400 for color, $50-150 for b&w inside; $50-150 for spots. Finds artists through directories, agents, direct mail campaigns.
Tips: "Review magazine samples before submitting. We have had the most mutual success with illustrators who can complete work within one to two weeks and send finals in computer format. We use black & white and four-color medical illustrations on a regular basis."

JOURNAL OF ACCOUNTANCY, AICPA, Harborside 201 Plaza III, Jersey City NJ 07311. (201)938-3450. Art Director: Jeryl Ann Costello. Monthly 4-color magazine emphasizing accounting for certified public accountants; corporate/business format. Circ. 350,000. Accepts previously published artwork. Original artwork returned after publication.
Illustration: Approached by 200 illustrators/year. Buys 2-6 illustrations/issue. Prefers business, finance and law themes. Prefers mixed media, then pen & ink, airbrush, colored pencil, watercolor, acrylic, oil and pastel. Works on assignment only. 35% of freelance work demands knowledge of Adobe Illustrator, QuarkXPress and Aldus FreeHand. Send query letter with brochure showing art style. Samples not filed are returned by SASE. Portfolio should include printed samples, color and b&w tearsheets. Buys first rights. Pays on publication; $1,200 for color cover; $200-600 for color (depending on size) inside. Finds artists through submissions/self-promotions, sourcebooks and magazines.
Tips: "I look for indications that an artist can turn the ordinary into something extraordinary, whether it be through concept or style. In addition to illustrators, I also hire freelancers to do charts and graphs. In portfolios, I like to see tearsheets showing how the art and editorial worked together."

SPECIAL MARKET INDEXES, identifying Licensing, Medical Illustration, Religious Art, Science Fiction/Fantasy Art, Sport Art, T-Shirts, Textiles, Wildlife Art and other categories are located in the back of this book.

JOURNAL OF ASIAN MARTIAL ARTS, 821 W. 24th St., Erie PA 16502-2523. (814)455-9517. Fax: (814)838-7811. E-mail: viamedia@ncinter.net. Website: http://ncinternet/~viamedia. Publisher: Michael A. DeMarco. Estab. 1991. Quarterly journal covering all historical and cultural aspects of Asian martial arts. Interdisciplinary approach. College-level audience. Circ. 12,000. Accepts previously published artwork. Sample copies available for $10. Art guidelines for SASE with first-class postage.

Illustration: Buys 60 illustrations/issue. Has featured illustrations by Oscar Ratti, Tony LaMotta and Michael Lane. Features realistic and medical illustration. Assigns 50% of illustrations to well-known or "name" illustrators; 40% to experienced, but not well-known illustrators; 10% to new and emerging illustrators. Prefers b&w wash; brush-like Oriental style; line. Considers pen & ink, watercolor, collage, airbrush, marker and charcoal. Send query letter with brochure, résumé, SASE and photocopies. Accepts disk submissions compatible with Adobe PageMaker, QuarkXPress and Adobe Illustrator. Samples are filed. Reports back within 4-6 weeks. Publication will contact artist for portfolio review if interested. Portfolio should include b&w roughs, photocopies and final art. Buys first rights and reprint rights. Pays on publication; $100-300 for color cover; $10-100 for b&w inside; $100-150 for 2-page spreads.

Tips: "Usually artists hear about or see our journal. We can be found in bookstores, libraries, or in listings of publications. Areas most open to freelancers are illustrations of historic warriors, weapons, castles, battles—any subject dealing with the martial arts of Asia. If artists appreciate aspects of Asian martial arts and/or Asian culture, we would appreciate seeing their work and discuss the possibilities of collaboration."

‡JOURNAL OF HEALTH EDUCATION, 1900 Association Dr., Reston VA 20191. E-mail: johe@aahperd.org. Website: http://www.aahperd.org/aahe/aahe.html. Editor: Patricia Lyle. Estab. 1970. "Bimonthly trade journal for school and community health professionals, keeping them up-to-date on issues, trends, teaching methods, and curriculum developments in health." Conservative; b&w with 4-color cover. Circ. 10,000. Original artwork is returned after publication if requested. Sample copies available; art guidelines not available.

Illustration: Approached by 50 illustrators/year. Buys 6 illustrations/year. Features realistic illustration; charts & graphs; informational graphics and computer illustrations. Uses artists mainly for covers. Wants health-related topics, any style; also editorial and technical illustrations. Prefers watercolor, pen & ink, airbrush, acrylic, oil and computer illustration. Works on assignment only. 70% of freelance work demands knowledge of Aldus PageMaker, Adobe Illustrator, QuarkXPress and Aldus FreeHand. Send query letter with brochure showing art style or photostats, photocopies, slides or photographs. Samples are filed or are returned by SASE. Publication will contact artist for portfolio review if interested. Portfolio should include color and b&w thumbnails, roughs, printed samples, photostats, photographs and slides. Negotiates rights purchased. **Pays on acceptance**; $600 maximum for color cover.

Tips: "Send samples; follow up."

JOURNAL OF LIGHT CONSTRUCTION, RR 2, Box 146, Richmond VT 05477. (802)434-4747. Fax: (802)434-4467. E-mail: bgiart@aol.com. Art Director: Theresa Emerson. Monthly magazine emphasizing residential and light commercial building and remodeling. Focuses on the practical aspects of building technology and small-business management. Circ. 50,000. Accepts previously published material. Original artwork is returned after publication. Sample copy free.

Cartoons: Buys cartoons relevent to construction industry, especially business topics.

Illustration: Buys 10 illustrations/issue. "Lots of how-to technical illustrations are assigned on various construction topics." Send query letter with SASE, tearsheets or photocopies. Samples are filed or are returned only if requested by artist. Reports back if interested within 2 weeks. Call or write for appointment to show portfolio of printed samples, final reproduction/product and b&w tearsheets. Buys one-time rights. **Pays on acceptance**; $500 for color cover; $100 for b&w inside; $200 for color inside; $150 for spots.

Design: Needs freelancers for design and production. 100% of freelance work demands knowledge of Adobe Photoshop, Adobe Illustrator and QuarkXPress on Macintosh. Send photocopies and résumé. Prefers local freelancers only. Send query letter with résumé, photocopies and SASE. Pays by the hour, $20-30.

Tips: "Write for a sample copy. We are unusual in that we have drawings illustrating construction techniques. We prefer artists with construction and/or architectural experience. We prefer using freelancers in the New England area with home computers."

JUDICATURE, 180 N. Michigan Ave., Suite 600, Chicago IL 60601-7401. E-mail: drichert@ajs.org. Website: http://www.ajs.org. Contact: David Richert. Estab. 1917. Journal of the American Judicature Society. Black & white bimonthly with 4-color cover and conservative design. Circ. 10,000. Accepts previously published material and computer illustration. Original artwork returned after publication. Sample copy for SASE with $1.47 postage; art guidelines not available.

Cartoons: Approached by 10 cartoonists/year. Buys 1-2 cartoons/issue. Interested in "sophisticated humor revealing a familiarity with legal issues, the courts and the administration of justice." Send query letter with samples of style and SASE. Reports in 2 weeks. Buys one-time rights. Pays $35 for unsolicited b&w cartoons.

Illustration: Approached by 20 illustrators/year. Buys 2-3 illustrations/issue. Has featured illustrations by Estelle Carol, Mary Chaney, Jerry Warshaw and Richard Laurent. Features humorous and realistic illustration; charts & graphs; computer and spot illustration. Works on assignment only. Interested in styles from "realism to light humor." Prefers subjects related to court organization, operations and personnel. Freelance work demands knowledge of Aldus PageMaker and Aldus FreeHand. Send query letter, SASE, photocopies, tearsheets or brochure showing art style. Publication will contact artist for portfolio review if interestsed. Portfolio should include roughs and printed samples. Wants to see "black & white and color and the title and synopsis of editorial material the illustration accompanied." Buys one-time

rights. Negotiates payment. Pays $250-375 for 2-, 3- or 4-color cover; $250 for b&w full page, $175 for b&w half page inside; $75-100 for spots.

Design: Needs freelancers for design. 100% of freelance work demands knowledge of Aldus PageMaker and Aldus FreeHand. Pays by the project.

Tips: "Show a variety of samples, including printed pieces and roughs."

✔KALEIDOSCOPE: International Magazine of Literature, Fine Arts, and Disability, 701 S. Main St., Akron OH 44311-1019. (330)762-9755. Editor-in-Chief: Darshan Perusek. Estab. 1979. Black & white with 4-color cover. Semiannual. "Elegant, straightforward design. Unlike medical, rehabilitation, advocacy or independent living journals, explores the experiences of disability through lens of the creative arts. Specifically seeking work by artists with disabilities. Work by artists without disabilities must have a disability focus." Circ. 1,500. Accepts previously published artwork. Sample copy $4; art guidelines for SASE with first-class postage.

Illustration: Freelance art occasionally used with fiction pieces. More interested in publishing art that stands on its own as the focal point of an article. Approached by 15-20 artists/year. Has featured illustrations by Dennis J. Brizendine and Deborah Vidaver Cohen. Features humorous, realistic and spot illustration. Send query letter with résumé, photocopies, photographs, SASE and slides. Do not send originals. Prefers high contrast, b&w glossy photos, but will also review color photos or 35mm slides. Include sufficient postage for return of work. Samples are not filed. Publication will contact artist for portfolio review if interested. Acceptance or rejection may take up to a year. Pays $25-100 for color covers; $10-25 for b&w or color insides. Rights return to artist upon publication. Finds artists through submissions/self-promotions and word of mouth.

Tips: "Inquire about future themes of upcoming issues. Considers all mediums, from pastels to acrylics to sculpture. Must be high-quality art."

KALLIOPE, a journal of women's literature and art, 3939 Roosevelt Blvd., Jacksonville FL 32205. (904)387-8211. Website: http://astro.fccj.cc.fl.us./LearningResources/Kalliope. Editor: Mary Sue Koeppel. Estab. 1978. Literary b&w triannual which publishes an average of 18 pages of art by women in each issue. "Publishes poetry, fiction, reviews, and visual art by women and about women's concerns; high-quality art reproductions; visually interesting design." Circ. 1,600. Accepts previously published "fine" artwork. Original artwork is returned at the job's completion. Sample copy for $7. Art guidelines available for SASE with first-class postage.

Cartoons: Approached by 1 cartoonist/year. Uses 1 cartoon/issue. Topics should relate to women's issues. Send query letter with roughs. Samples are not filed and are returned by SASE. Reports back within 2 months. Rights acquired vary according to project. Pays 1 year subscription or 3 complimentary copies for b&w cartoon.

Illustration: Approached by 35 fine artists/year. Buys 18 photos of fine art/issue. Looking for "excellence in fine visual art by women (nothing pornographic)." Send query letter with résumé, SASE, photographs (b&w glossies) and artist's statement (50-75 words). Samples are not filed and are returned by SASE. Reports back within 2 months. Rights acquired vary according to project. Pays 1 year subscription or 3 complimentary copies for b&w cover or inside.

Tips: Seeking "excellence in theme and execution and submission of materials. Previous artists have included Louise Fishman, Sandra Stanton, Rhonda Roland Shearer and Lorraine Bodger. We accept three to six works from a featured artist. We accept only black & white high quality photos of fine art."

KASHRUS MAGAZINE—The Periodical for the Kosher Consumer, Box 204, Brooklyn NY 11204. (718)336-8544. Fax: (718)336-8550. Website: http://kosherinfo.com. Editor: Rabbi Wikler. Estab. 1980. Bimonthly magazine with 4-color cover which updates consumer and trade on issues involving the kosher food industry, especially mislabeling, new products and food technology. Circ. 10,000. Accepts previously published artwork. Original artwork is returned after publication. Sample copy $2; art guidelines not available.

Cartoons: Buys 2 cartoon/issue. Pays $25-35 for b&w. Seeks "kosher food and Jewish humor."

Illustration: Buys illustrations mainly for covers. Works on assignment only. Has featured illustrations by R. Keith Rugg and Theresa McCracken. Features humorous, realistic and spot illustration. Assigns 50% of illustrations to experienced, but not well-known illustrators; 50% to new and emerging illustrators. Prefers pen & ink. Send query letter with photocopies. Reports back within 7 days. Request portfolio review in original query. Portfolio should include tearsheets and photostats. $100-200 for color cover; $25-75 for b&w inside; $75-150 for color inside; $25-35 for spots. Finds artists through submissions and self-promotions.

Tips: "Send general food or Jewish food- and travel-related material. Do not send off-color material."

KIPLINGER'S PERSONAL FINANCE MAGAZINE, 1729 H St. NW, Washington DC 20006. (202)887-6416. Website: http://www.kiplinger.com. Contact: Melissa Miller. Estab. 1947. A monthly 4-color magazine covering personal finance issues including investing, saving, housing, cars, health, retirement, taxes and insurance. Circ. 1,300,000. Originals are returned at job's completion. Sample copies available; art guidelines not available.

Illustration: Approached by 1,000 illustrators/year. Buys 15 illustrations/issue. Works on assignment only. Has featured illustrations by Steven Guarnaccia, Joe Sorren, Sandra Hendler and Gary Baseman. Features computer and spot illustration. Assigns 90% of illustrations to well-known or "name" illustrators; 5% to experienced, but not well-known illustrators; 5% to new and emerging illustrators. Looking for original conceptual art. Interested in editorial illustration in new styles, including computer illustration. Send tearsheets or postcards. Samples are filed or are returned by SASE if requested by artist. Publication will contact artist for portfolio review if interested. Portfolio should include tearsheets. Buys first rights. **Pays on acceptance**; $400-1,200 for color inside; $250-750 for spots.

Tips: "Send us high-caliber original work that shows creative solutions to common themes. Send postcards regularly. If they're good, they'll get noticed."

KITE LINES, Box 466, Randallstown MD 21133-0466. Fax: (410)922-4262. E-mail: kitelines@compuserve.com. Publisher/Editor: Valerie Govig. Quarterly 4-color magazine emphasizing kites for the adult enthusiast only. Circ. 13,000. Original artwork returned after publication. Sample copy $5.50; art guidelines available.
Illustration: Buys 2-3 illustrations/year. Works on assignment primarily. Needs technical drawings of kites. Send query letter with photocopies showing art style. Samples are filed or returned by SASE. Reports back within 1 month only if interested. Portfolio review not required. Buys first rights. Pay is negotiable, up to $300 for more complicated technical work. Finds artists through word of mouth.
Tips: "Illustrations in *Kite Lines* are so closely related to an article that, if they are not provided by the author, they are assigned to meet a very specific need. Strong familiarity with kites is absolutely necessary. Good technical drawings of kite plans (for kitemaking) are needed as part of articles with instructions for building kites. (In other words, a 'package,' with article, is needed.) We often do computer re-drawing from rough originals but are open to assigning these re-drawings."

KIWANIS, 3636 Woodview Trace, Indianapolis IN 46268. (317)875-8755. Fax: (317)879-0204. E-mail: kiwanismail@kiwanis.org. Managing Editor: Chuck Jonak. Art Director: Jim Patterson. Estab. 1918. 4-color magazine emphasizing civic and social betterment, business, education and domestic affairs for business and professional persons. Published 10 times/year. Original artwork returned after publication. Art guidelines available for SASE with first-class postage.
Cartoons: Buys 30 cartoons/year. Interested in "daily life at home or work. Nothing off-color, no silly wife stuff, no blue-collar situations." Prefers finished cartoons. Send query letter with brochure showing art style or tearsheets, slides, photographs and SASE. Reports in 3-4 weeks. **Pays on acceptance**; $50 for b&w.
Illustration: Works with 20 illustrators/year. Buys 3-6 illustrations/issue. Assigns themes that correspond to themes of articles. Works on assignment only. Keeps material on file after in-person contact with artist. Include SASE. Reports in 2 weeks. To show a portfolio, mail appropriate materials (out of town/state) or call or write for appointment. Portfolio should include roughs, printed samples, final reproduction/product, color and b&w tearsheets, photostats and photographs. Buys first rights. **Pays on acceptance**; $800-1,000 for cover; $400-800 for inside; $50-75 for spots. Finds artists through talent sourcebooks, references/word-of-mouth and portfolio reviews.
Tips: "We deal direct—no reps. Have plenty of samples, particularly those that can be left with us. Too many student or unassigned illustrations in many portfolios."

L.A. WEEKLY, 6715 Sunset Blvd., Los Angeles CA 90028. (213)465-9909. Fax: (213)465-1550. E-mail: weeklyart@aol.com. Website: http://www.laweekly.com. Associate Art Director: Jeff Monzel. Estab. 1978. Weekly alternative arts and news tabloid. Circ. 200,000. Art guidelines available.
Cartoons: Approached by over 100 cartoonists/year. "We contract about 1 new cartoonist per year." Prefers Los Angeles, alternative lifestyle themes. Prefers b&w line drawings without gagline. Send query letter with photocopies. Samples are filed or returned by SASE. Reports back only if interested. Rights purchased vary according to project. Pays on publication; $100-200 for b&w.
Illustration: Approached by over 200 illustrators/year. Buys 4 illustrations/issue. Themes vary according to editorial needs. Considers all media. Send postcard sample or query letter with photocopies. Accepts submissions on disk. "We accept 3.5 high-density disks (Mac or PC), 88mb SyQuest (Mac or PC). Can also e-mail final artwork." Samples are filed or returned by SASE. Reports back only if interested. Portfolio may be dropped off Monday-Friday and should include any samples except original art. Artist should follow-up with call and/or letter after initial query. Buys first rights. Pays on publication; $400-1,000 for cover; $100-400 for inside; $100-200 for spots. Prefers submissions but will also find illustrations through *Black Book*, *American Illustration*, various Los Angeles and New York publications.
Design: Needs freelancers for design and production. 100% of freelance work demands knowledge of Adobe Photoshop 3.x, Adobe Illustrator, QuarkXPress 3.x, Corel Draw 6.x. Prefers local freelancers only. Send query letter with photocopies and résumé. Pays by the hour, $15.
Tips: Wants "less polish and more content. Gritty is good, quick turnaround and ease of contact a must."

LACROSSE MAGAZINE, 113 W. University Pkwy., Baltimore MD 21210-3300. (410)235-6882. Fax: (410)366-6735. E-mail: jparvis@lacrosse.org. Website: http://lacrosse.org. Art Director: Jennifer Parvis Lowe. Estab. 1978. "*Lacrosse Magazine* includes opinions, news, features, student pages, 'how-to's' for fans, players, coaches, etc. of all ages." Published 8 times/year. Circ. 14,000. Accepts previously published work. Sample copies available.
Cartoons: Prefers ideas and issues related to lacrosse. Prefers single panel, b&w washes or b&w line drawings. Send query letter with finished cartoon samples. Samples are filed or returned by SASE if requested. Rights purchased vary according to project. Pays $40 for b&w.
Illustration: Approached by 12 freelance illustrators/year. Buys 3-4 illustrations/year. Works on assignment only. Prefers ideas and issues related to lacrosse. Considers pen & ink, collage, marker and charcoal. Freelancers should be familiar with Adobe Illustrator, Aldus FreeHand or QuarkXPress. Send postcard sample or query letter with tearsheets or photocopies. Accepts disk submissions compatible with Mac. Samples are filed. Call for appointment to show portfolio of final art, b&w and color photocopies. Rights purchased vary according to project. Pays on publication; $100 for b&w cover, $150 for color cover; $75 for b&w inside, $100 for color inside.
Tips: "Learn/know as much as possible about the sport."

Lacrosse Magazine's Art Director Jennifer Lowe likes the fun, lighthearted style of Amy Smyth's artwork, as seen in this cover illustration rendered in charcoal pencil. Smyth found Lacrosse through *Artist's & Graphic Designer's Market*, the source of many of her jobs. "Since I don't advertise in sourcebooks and I don't have a rep, I send about eight to ten mailings a year." Smyth recommends illustrators starting out "find your market, produce a lot of work, send mailings like a maniac, and love what you do!"

LADYBUG, the Magazine for Young Children, Box 300, Peru IL 61354. Art Director: Suzanne Beck. Estab. 1990. Monthly 4-color magazine emphasizing children's literature and activities for children, ages 2-6. Design is "geared toward maximum legibility of text and basically art-driven." Circ. 140,000. Accepts previously published material. Original artwork returned after publication. Sample copy $4; art guidelines for SASE with first class postage.
Illustration: Approached by 600-700 illustrators/year. Works with 40 illustrators/year. Buys 200 illustrations/year. Has featured illustrations by Marc Brown, Cyndy Szekeres, Rosemary Wells, Tomie de Paola and Diane de Groat. Uses artists mainly for cover and interior illustration. Prefers realistic styles (animal, wildlife or human figure); occasionally accepts caricature. Works on assignment only. Send query letter with photocopies, photographs and tearsheets to be kept on file, "if I like it." Prefers photocopies and tearsheets as samples. Samples are returned by SASE if requested. Publication will contact artist for portfolio review if interested. Portfolio should show a strong personal style and include "several pieces that show an ability to tell a continuing story or narrative." Does not want to see "overly slick, cute commercial art (i.e., licensed characters and overly sentimental greeting cards)." Buys reprint rights. **Pays 45 days after acceptance**; $750 for color cover; $250 for color full page; $100 for color, $50 for b&w spots.
Tips: "Has a need for artists who can accurately and attractively illustrate the movements for finger-rhymes and songs and basic informative features on nature and 'the world around you.' Multi-ethnic portrayal is also a *very* important factor in the art for *Ladybug*."

LAW PRACTICE MANAGEMENT, Box 11418, Columbia SC 29211-1418. (803)754-3563. Website: http://www.aba net.org/lpm. Managing Editor/Art Director: Delmar L. Roberts. 4-color trade journal for the practicing lawyer. Estab. 1975. Published 8 times/year. Circ. 20,833. Previously published work rarely used. 15% of freelance work demands computer skills.
Cartoons: Primarily interested in cartoons "depicting situations inherent in the operation and management of a law office, e.g., operating computers and other office equipment, interviewing, office meetings, lawyer/office staff situations and client/lawyer situations. We use 2-4 cartoons/issue. Cartoons depicting courtroom situations are not applicable to an office management magazine." Send cartoons for consideration. Reports in 3 months. Usually buys all rights. **Pays on acceptance**; $50 for all rights.
Illustration: Uses inside illustrations and, rarely, cover designs. Pen & ink, watercolor, acrylic, oil, collage and mixed media used. Currently uses all 4-color artwork. Send postcard sample or query letter with brochure. Reports in 3 months. Usually buys all rights. Pays on publication; $75-125 for b&w inside; $200-300 for 4-color inside.
Tips: "There's an increasing need for artwork to illustrate high-tech articles on technology in the law office. (We have two or more such articles each issue.) We're especially interested in computer graphics for such articles."

‡LAX MAG FOR KIDS, 113 W. University Pkwy., Baltimore MD 21320-3300. (410)235-6882. Fax: (410)366-6735. E-mail: vmorehead@lacrosse.org. Website: http://www.lacrosse.org. Editor: Victoria Morehead. Estab. 1998. Quarterly 4-color children's lacrosse magazine. Circ. 30,000.
Cartoons: Prefers children's comics. Prefers single, double or multiple panel humorous b&w or color washes. Send query letter with color photocopies and SASE. Samples are filed or returned by SASE. Reports back within 2 weeks. Rights purchased vary according to project. Pays on publication.
Illustration: Features caricatures of celebrities, informational graphics, humorous or realistic illustration. Preferred subjects: children, lacrosse. Assigns 20% of illustrations to experienced, but not well-known illustrators; 80% to new and emerging illustrators. Send postcard sample or query letter with printed samples. Accepts Mac-compatible disk submissions. Send EPS, TIFF files or Zip disks. Samples are filed. Reports back within 2 weeks. Will contact artist for portfolio review if interested. Rights purchased vary according to project. Finds illustrators through word of mouth.
Tips: "We're a nonprofit organization, so our budget is limited. If you're a high-end illustrator with high-end fees, I don't recommend soliciting us. However, if you want good exposure and a fun staff to deal with, please call, write or email. We need fun, fresh, imaginative art that'll appeal to kids 6-15 years old."

♣LEISURE WORLD, 1253 Ouellette Ave., Windsor, Ontario N8X 1J3 Canada. (519)971-3209. Fax: (519)977-1197. Website: http://ompc.com. Editor: Douglas O'Neil. Estab. 1988. Bimonthly magazine. Reflects the leisure time activities of members of the Canadian Automobile Association. "Upscale" 4-color with travel spreads; b&w club news is 8-page insert. Circ. 340,000. Accepts previously published artwork. Original artwork returned at the job's completion. Sample copy for SASE with first-class postage. Art guidelines available.
Illustration: Needs people, travel illustration. Needs computer-literate freelancers for design and production in PC-compatible format. Send query letter with photographs, slides, transparencies or disks. Most samples are filed. Those not filed are returned. Reports back in 1 month. Call or write for appointment to show portfolio or mail thumbnails, roughs, original/final art, b&w or color tearsheets, photostats, photographs, slides and photocopies. Pays $200 for b&w and color cover; $75 for b&w inside; $100 for color inside; $75 for spots.

✓LOG HOME LIVING, 4200-T Lafayette Center Dr., Chantilly VA 20151. (800)826-3893 or (703)222-9411. Fax: (703)222-3209. Art Director: Karen Sulmonetti. Estab. 1989. Monthly 4-color magazine "dealing with the aspects of buying, building and living in a log home. We emphasize upscale living (decorating, furniture, etc.)." Circ. 108,000. Accepts previously published artwork. Sample copies not available. Art guidelines for SASE with first-class postage. 20% of freelance work demands knowledge of QuarkXPress, Adobe Illustrator and Adobe Photoshop.
Cartoons: Prefers playful ideas about logs and living and wanting a log home.
Illustration: Buys 2-4 illustrations/issue. Works on assignment only. Prefers editoral illustration with "a strong style—

ability to show creative flair with not-so-creative a subject." Considers watercolor, airbrush, colored pencil and pastel. Send postcard sample. Accepts disk submissions compatible with Adobe Illustrator, Adobe Photoshop and QuarkXPress. Samples are filed. Publication will contact artist for portfolio review if interested. Portfolio should include thumbnails, roughs, printed samples, or color tearsheets. Buys all rights. **Pays on acceptance**; $100-200 for b&w inside; $200-400 for color inside; $100-200 for spots. Finds artists through submissions/self-promotions, sourcebooks.
Design: Needs freelancers for design and production. 80% of freelance work demands knowledge of Adobe Photoshop, Adobe Illustrator and QuarkXPress. Send query letter with brochure, résumé, photographs and slides. Pays by the project.

❧LONDON BUSINESS MAGAZINE, 1147 Gainsborough Rd., London Ontario N5V 4H3 Canada. (519)472-7601. Fax: (519)473-7859. Publisher: Janine Foster. Monthly magazine "covering London and area businesses; entrepreneurs; building better businesses." Circ. 12,000. Sample copies not available; art guidelines not available.
Cartoons: Approached by 2 cartoonists/year. Buys 1 cartoon/issue. Prefers business-related line art. Prefers single panel, humorous b&w washes and line drawings without gagline. Send query letter with roughs. Samples are filed and are not returned. Reports back only if interested. Buys first rights. Pays on publication; $25-50 for b&w, $50-100 for color.
Illustration: Approached by 5 illustrators/year. Buys 2 illustrations/issue. Has featured illustrations by Nigel Lewis and Scott Finch. Features humorous and realistic illustration; informational graphics and spot illustration. Assigns 50% of illustrations to experienced, but not well-known illustrators; 50% to new and emerging illustrators. Prefers business issues. Considers all media. 10% of freelance illustration demands knowledge of Adobe Photoshop 3, Adobe Illustrator 5.5, QuarkXPress 3.2. Send query letter with printed samples. Accepts disk submissions compatible with QuarkXPress 7/version 3.3, Adobe Illustrator 5.5, Adobe Photoshop 3, (TIFFs of EPS files). Samples are filed and are not returned. Art director will contact artist for portfolio review of b&w, color, final art, photographs, slides and thumbnails if interested. Pays on publication; $125 maximum for cover; $25 minimum for b&w inside; $100 maximum for color inside. Finds illustrators through artist's submissions.
Tips: "Arrange personal meetings, provide vibrant, interesting samples, start out cheap! Quick turnaround is a must."

‡LONG ISLAND UPDATE, 990 Motor Pkwy., Central Islip NY 11722. (516)435-8890. Fax: (516)435-8925. Editor: Cheryl A. Meglio. Estab. 1990. Monthly consumer magazine covering events, entertainment and other consumer issues for general audience, ages 21-40, of Long Island area. Circ. 58,000. Originals returned at job's completion.
Illustration: Approached by 25-30 illustrators/year. Buys 1 illustration/issue. Considers watercolor. Send postcard sample or query letter with tearsheets. Samples filed. Reports back within 2 months. Portfolio review not required. Buys first rights. Pays on publication; $25 for color inside.
Tips: Area most open to freelancers is humor page illustrations.

THE LOOKOUT, 8121 Hamilton Ave., Cincinnati OH 45231. (513)931-4050. Fax: (513)931-0950. Weekly 4-color magazine for conservative Christian adults and young adults. Circ. 105,000. Sample copy available for 75¢.
Cartoons: Prefers cartoons on family life and religious/church life; mostly single panel. Pays $50 for b&w.

‡LYNX EYE, 1880 Hill Dr., Los Angeles CA 90041-1244. (213)550-8522. Co-Editor: Pam McCully. Estab. 1994. Quarterly b&w literary magazine. Circ. 500.
Cartoons: Approached by 100 cartoonists/year. Buys 10 cartoons/year. Prefers sophisticated humor. Prefers single panel, political and humorous b&w washes or line drawings. Send b&w photocopies and SASE. Samples are not filed and are returned by SASE. Reports back within 3 months. Buys first North American serial rights. **Pays on acceptance.** Pays $10 for b&w plus 3 copies.
Illustration: Approached by 100 illustrators/year. Buys 20 illustrations/issue. Has featured illustrations by Wayne Hogan, Greg Kidd, Walt Phillips. Features humorous, natural history, realistic or spot illustrations. Prefers b&w work that stands alone as a piece of art—does not illustrate story/poem. Assigns 100% of illustrations to new and emerging illustrators. Send query letter with photocopies and SASE. Samples are not filed and are returned by SASE. Reports back within 3 months. Will contact artist for portfolio review if interested. Buys first North American serial rights. **Pays on acceptance.** Pays $10 for b&w cover or inside plus 3 copies. Finds illustrators through word of mouth, sourcebooks.
Tips: "We are always in need of artwork. Please note that your work is considered an individual piece of art and does not illustrate a story or poem."

‡MAD MAGAZINE, 1700 Broadway, New York NY 10019. (212)506-4850. Fax: (212)506-4848. Art Director: Jonathan Schneider. Monthly irreverent humor, parody and satire magazine. Estab. 1952. Circ. 250,000.
Illustration: Approached by 100 illustrators/year. Works with 30 illustrators/year. Features humor, realism, caricature. Send query letter with photocopies and SASE. Accepts Mac-compatible disk submissions. Samples are filed. Portfolios may be dropped off every Wednesday and can be picked up same day 4:30-5:00 p.m. Buys all rights. Pays $2,500-3,200 for color cover; $400-725 for inside. Finds illustrators through direct mail, sourcebooks (all).
Design: Also needs local freelancers for designs. Works with 2 freelance designers/year. 100% of freelance design demands knowledge of Adobe Illustrator, Adobe Photoshop and QuarkXPress. Send photocopies and résumé.
Tips: "Know what we do! *MAD* is very specific. Everyone wants to work for *MAD*, but few are right for what *MAD* needs!"

‡**MADE TO MEASURE**, 600 Central Ave., Highland Park IL 60035. (312)831-6678. E-mail: toons@halper.com. Website: http://www.halper.com. Publisher: William Halper. Semiannual trade journal emphasizing manufacturing, selling of uniforms, career clothes, men's tailoring and clothing. Magazine distributed to retailers, manufacturers and uniform group purchasers. Circ. 25,000. Art guidelines available.
Cartoons: Buys 15 cartoons/issue. Requires themes relating to subject matter of magazine. Prefers single panel b&w line drawings with or without gagline. Send query letter with finished cartoons. Any cartoons not purchased are returned. Reports back within 3 weeks. Buys first rights. **Pays on acceptance**; $50 for b&w.
Illustration: Features fashion, humorous and spot illustration. Assigns 20% of illustrations to new and emerging illustrators. Pays $50-200 for b&w inside; $100-400 for color inside.

MAIN LINE TODAY, 4 Smedley Lane, Newtown Square PA 19073. (610)325-4630. Fax: (610)325-4636. Art Director: Kelly M. Carter. Estab. 1996. Monthly consumer magazine providing quality information to the main line and western surburbs of Philadelphia. Sample copies for #10 SASE with first-class postage.
Illustration: Approached by 100 illustrators/year. Buys 3-5 illustrations/issue. Prefers comical to realistic. Considers acrylic, charcoal, collage, color washed, mixed media, oil, pastel and watercolor. 10% of freelance illustration demands knowledge of Adobe Photoshop, Adobe Illustrator and QuarkXPress. Send postcard sample or query letter with printed samples and tearsheets. Send follow-up postcard sample every 3-4 months. Samples are filed and are not returned. Reports back only if interested. Buys one-time and reprint rights. Pays on publication; $400 maximum for color cover; $100-150 for b&w inside; $100-200 for color inside. Pays $100 for spots. Finds illustrators by word of mouth and submissions.

MANAGEMENT REVIEW, 1601 Broadway, New York NY 10019-7420. (212)903-8058. Fax: (212)903-8452. E-mail: snewton@amanet.org. Art & Production Director: Seval Newton. Estab. 1921. Monthly company "business magazine for senior managers. A general, internationally-focused audience." 64-page 4-color publication. Circ. 80,000. Original artwork returned after publication. Tearsheets available.
Cartoons: Approached by 10-20 cartoonists/year. Buys 1-2 cartoons/issue. Prefers "business themes and clean drawings of minority women as well as men." Prefers double panel; washes and line drawings. Send query letter with copies of cartoons. Selected samples are filed. Will call for b&w or 4-color original when placed in an issue. (Do not send originals.) Buys first rights. Pays $100 for b&w, $200 for color.
Illustration: Approached by 50-100 illustrators/year. Buys 10-20 illustrations/issue. Electronic chart and graph artists welcome. Works on assignment only. Has featured illustrations by Rob Schuster, Robert Neubecher and Paulette Bogan. Features charts & graphs, informational graphics, computer and spot illustration. Assigns 50% of illustrations to well-known or "name" illustrators; 25% to experienced, but not well-known illustrators; 25% to new and emerging illustrators. Prefers business themes and strong concepts. Considers airbrush, watercolor, collage, acrylic and oil. Electronic art (for Macintosh) can be sent via e-mail. Send query letter with printed samples, tearsheets and SASE. Will accept submissions on disk in Adobe Illustrator using EPS files, Adobe Photoshop, TIFF or JPEG files. Samples are filed. Calls back only if interested. To show a portfolio, mail printed samples and b&w tearsheets, photographs and slides or "drop off portfolio at the above address. Portfolio will be ready to pick up after two days." Rights purchased vary according to project, usually buys multiple usage rights. **Pays on acceptance**; $600-1,100 for color cover; $250-500 for color inside; $600-900 for 2-page spreads; $150-375 for spots.
Tips: "Send tearsheets; periodically send new printed material. The magazine is set on the Macintosh. Any computer illustration helps cut down scanning costs. Do good work. Adhere to deadlines. Be sensitive to revises. Be conceptual. Know the business and definitely read the articles."

MARTIAL ARTS TRAINING, 24715 Avenue Rockefeller, Valencia CA 91380-9018. (805)257-4066. Fax: (805)257-3028. Editor: Doug Jeffrey. Estab. 1980. Bimonthly magazine on martial arts training. Circ. 25,000-35,000. Originals are returned at job's completion. Sample copies available; art guidelines available.
Cartoons: Approached by 1 cartoonist/year. Has featured illustrations by Jerry King. Features caricatures of celebrities. Prefers martial arts training; single panel with gagline. Send query letter with roughs and finished cartoons. Samples are not filed and are returned by SASE. Reports within 1 month. Buys all rights.
Tips: "Contact us! Send samples!"

MASSAGE MAGAZINE, AllWrite Publications, 1315 West Mallon Ave., Spokane WA 99201-2038. (509)536-4461. E-mail: robinf@massagemag.com. Website: http://www.massagemag.com. Art Director: Robin Fontaine. Estab. 1986. Bimonthly trade magazine for practitioners and their clients in the therapeutic massage and allied healing arts and sciences (acupuncture, aromatherapy, chiropractic, etc.) Circ. 45,000. Art guidelines not available.
Illlustration: Not approached by enough illustrators/year. Buys 18-24 illustrations/year. Features medical illustration. Assigns 70% off illustrations to experienced, but not well-known illustrators; 30% to new and emerging illustrators. Themes or style range from full color spiritually-moving to business-like line art. Considers all media. All art must be scanable. Send postcard sample and query letter with printed samples or photocopies. Accepts disk-submitted artwork done in Freehand or Photoshop for use in QuarkXPress version 3.31. Reports back only if interested. Rights purchased vary according to project. Pays on publication; $250 minimum for b&w cover; $450 maximum for color cover; $35 minimum for b&w inside; $90 maximum for color inside. Finds illustrators through word of mouth and artist's submissions.
Tips: "I'm looking for quick, talented artists, with an interest in alternative healing arts and sciences."

MCCALL'S, 375 Lexington Ave., New York NY 10011-5514. (212)499-1777. Art Director: Constance von Collande.
- Art Director Constance von Collande is featured the 1998 edition of *Artist's & Graphic Designer's Market*.
Illustration: Approached by 100-150 illustrators/year. Buys 10-15 illustrations/issue. Send postcard sample or other non-returnable samples. Art Director will contact if interested.

MEDIPHORS, A Literary Journal of the Health Professions, P.O. Box 327, Bloomsburg PA 17815-0327. E-mail: mediphor@ptd.net. Website: http://www.mediphors.org. Editor: Eugene D. Radice, MD. Estab. 1993. Semiannual literary magazine/journal publishing short story, essay and poetry which broadly relate to medicine and health. Circ. 900. Sample copy and art guidelines for SASE with first-class postage; art guidelines also available on website.
Cartoons: Approached by 6 cartoonists/year. Buys 6-12 cartoons/issue. Prefers health/medicine related. Prefers single panel, humorous, b&w line drawings. Samples are returned by SASE. Reports back in 1 month. Buys first North American serial rights. Pays on publication; 2 publication copies.
Illustration: Approached by 6 illustrators/year. Buys 5 illustrations/issue. Features humorous and realistic illustration. Assigns 50% of if illustrations to experienced, but not well-known illustrators; 50% to new and emerging illustrators. Considers charcoal, collage, marker, pen & ink. Send query letter with photocopies and SASE. Samples are filed or returned by SASE. Reports back in 1 month if interested. Buys first North American serial rights. Pays on publication; 2 copies of publication.
Tips: "We enjoy publishing work from beginning artists who would like to see their work published in a nationally-distributed magazine, but do not require cash payment."

‡**MEETINGS IN THE WEST**, 550 Montgomery St., Suite 750, San Francisco CA 94111. (415)788-2005. Fax: (415)788-0301. E-mail: nspell@ix.netcom.com. Website: http://www.meetingsweb.com. Production Manager: Nancy Spellman. Production Assistant: Mike Stahlbrodt. Monthly 4-color and b&w tabloid/trade publication for meeting planners covering the 14 western United States, plus western Canada and Mexico. Circ. 20,000.
Cartoons: Approached by 5 cartoonists/year. Buys 3 cartoons/year. Prefers single panel, humorous color washes, b&w line drawings. Send query letter with samples. Samples are filed and are returned by SASE. Reports back only if interested. Buys one-time rights. Pays on publication.
Illustration: Approached by 5 illustrators/year. Buys 0-1 illustrations/issue. Has featured illustrations by Shari Warren, Beatrice Benjamin. Features computer illustration, humorous and spot illuatration. Prefers subjects portraying business subjects. Prefers watercolor—bright watercolor washes, colorful computer illustration. Assigns 20% of illustration to experienced, but not well-known illustrators; 80% to new and emerging illustrators. 100% of freelance illustration demands knowledge of Adobe Illustrator, Adobe Photoshop. Send postcard sample. Accepts Mac-compatible disk submissions. Samples are filed or returned by SASE. Will contact artist for portfolio review if interested. Buys first rights. Pays on publication; $700-1,000 for color cover; $50-300 for color inside. Finds illustrators through word of mouth, recommendations by colleagues, promo samples.
Tips: "We rely on our in-house production assistant's illustration talent on a regular basis. A few projects may be out-sourced, but the need is not very high."

‡**MICHIGAN LIVING**, 1 Auto Club Dr., Dearborn MI 48126. (313)336-1506. Fax: (313)336-1344. E-mail: michliving @aol.com. Editor: Ron Garbinski. Estab. 1918. Monthly magazine emphasizing travel and lifestyle. Circ. 1.1 million. Sample copies and art guidelines for SASE with first-class postage.
Illustration: Approached by 20 illustrators/year. Features natural history; realistic illustration; charts & graphs; informational graphics; medical, computer and spot illustration. Assigns 50% of illustrations to experienced, but not well-known illustrators; 50% to new and emerging illustrators. Prefers travel related. Considers all media. Knowledge of Aldus FreeHand, Adobe Photoshop, QuarkXPress, Adobe Illustrator helpful, but not required. Send query letter with printed samples, photocopies, SASE, tearsheets. Accepts disk submissions compatible with QuarkXPress 3.32. Samples are not filed and are returned by SASE or not returned. Reports back in 6 weeks. Art director will contact artist for portfolio review of b&w and color final art, photographs, photostats, roughs, slides, tearsheets, thumbnails, transparencies if interested. Buys first North American serial rights or reprint rights. Pays $450 maximum for cover and inside; $400 maximum for spots. Finds illustrators through sourcebooks, such as *Creative Black Book*, word of mouth, submissions.
Tips: "Read our magazine, we need fast workers with quick turnaround."

✍**MICHIGAN NATURAL RESOURCES**, 30600 Telegraph Rd., Suite 1255, Bingham Farms MI 48025. (248)642-9580. Fax: (248)642-5290. E-mail: outdoor3@flash.net. Creative Director: Darlene Smith. Estab. 1930. Bimonthly consumer magazine. "*Michigan Natural Resources Magazine* is the official publication of Michigan's Department of Natural Resources. It's Michigan's oldest outdoor publication." Circ. 50,000. Accepts previously published artwork. Originals returned at job's completion. Art guidelines available. 100% of freelance work demands knowledge of Adobe Illustrator, QuarkXPress and Adobe Photoshop.
Cartoons: Approached by 3 cartoonists/year. Buys 2-6 cartoons/year. Prefers double panel, humorous drawings, b&w and color washes. Send query letter with slides or laser copies of finished work. Samples are filed or returned by SASE if requested by artist. Reports back to the artist only if interested. Buys reprint rights or negotiates rights purchased. Pays $150-250 for b&w, $250-300 for color covers; $50-100 for b&w, $75-200 for color insides; $25-75 for spots.
Illustration: Approached by 8-12 illustrators/year. Prefers bright, crisp and loose style—decorative art, wildlife, flowers, natural outdoor scenery. Considers pen & ink, mixed media, watercolor, acrylic, oil and pastel. Send query letter with résumé, slides, brochure, SASE, tearsheets, transparencies, photographs and photocopies. Accepts disk submissions

compatible with Mac, Adobe Illlustrator and Adobe Photoshop. Send DAT 8mm, SyQuest or 128 3.5 floppy disk. Samples are filed. Publication will contact artist for portfolio review if interested. Portfolio should include b&w and color tearsheets, slides (duplicates for files). Rights purchased vary according to project. Pays on publication. Finds artists through submissions.
Design: Needs freelancers for design. 100% of freelance work demands knowledge of Adobe Photoshop 4.0, Adobe Illustrator 7.0, QuarkXPress 4.0, Streamline Adobe 4.0. Send query letter with brochure, photocopies, SASE, tearsheets, résumé, photographs, slides, transparencies. Pays by the project or hourly rate.

MID-AMERICAN REVIEW, English Dept., Bowling Green State University, Bowling Green OH 43403. (419)372-2725. Editor-in-Chief: George Looney. Estab. 1980. Twice yearly literary magazine publishing "the best contemporary poetry, fiction, essays, and work in translation we can find. Each issue includes poems in their original language and in English." Circ. 700. Originals are returned at job's completion. Sample copies available for $5.
Illustration: Approached by 10-20 illustrators/year. Buys 1 illustration/issue. Considers pen & ink, watercolor, collage, charcoal and mixed media. Send query letter with brochure, SASE, tearsheets, photographs and photocopies. Samples are filed or are returned by SASE if requested by artist. Reports back within 3 months. Buys first rights. Pays on publication. Pays $50 when funding permits. Also pays in copies, up to 20.
Tips: "*MAR* only publishes artwork on its cover. We like to use the same artist for one volume (two issues)."

MILLER FREEMAN, INC., 600 Harrison St., San Francisco CA 94107. (415)905-2200. Fax: (415)905-2236. E-mail: abrokering@mfi.com. Website: http://www.mfi.com. Graphics Operations Manager: Amy R. Brokering. Publishes 80 monthly and quarterly 4-color business and special-interest consumer and trade magazines serving the paper, travel, retail, real estate, sports, design, forest products, computer, music, electronics and healthcare markets. Circ. 20,000-150,000. Returns original artwork after publication.
Illustration: Approached by 1,000 illustrators/year. Uses freelancers occasionally for illustration of feature articles. Needs editorial, technical and medical illustration. No cartoons please. Buys numerous illustrations/year. Works on assignment only. 90% of freelance work demands knowledge of QuarkXPress, Adobe Illustrator or Adobe Photoshop. Send query letter with printed samples to be kept on file. Do not send photocopies or original work. Samples not filed are returned by SASE only. Reports back only if interested. "No phone queries, please." Negotiates rights purchased. **Pays on acceptance.**
Design: Needs freelancers for design, production, multimedia. Prefers local freelancers. Send query letter with brochure, résumé, SASE and tearsheets. Pays for design by the hour.

✔MODE MAGAZINE, 22 E. 49th St., 5th Floor, New York NY 10017. (212)328-0180. Fax: (212)328-0188. E-mail: modemag@aol.com. Art Director: Karmen Lizzul. Estab. 1997. Quarterly beauty and fashion magazine for women sizes 16 and up. Circ. 550,000. Sample copies available.
Cartoons: Buys 1 cartoon/issue. Prefers humorous; single, double or multiple panel; b&w line drawings and b&w or color washes; with or without gagline. Send query letter with finished cartoons or photocopies. Samples are filed. Reports back within 2 weeks. Buys one-time rights. **Pays on acceptance.**
Illustration: Approached by 1-30 illustrators/year. Buys 1-5 illustrations/issue. Has featured illustrations by Eliza Gran, Trisha Krauss and Zohar Lazar. Assigns 20% of illustrations to well-known or "name" illustrators; 70% to experienced, but not well-known illustrators; 10% to new and emerging illustrators. Considers all media. Send postcard sample or send query letter with printed samples and photocopies. Sample are filed. Reports back within 2 weeks. Art director will contact artist for portfolio review if interested. Buys one-time rights. **Pays on acceptance**; $150-800 for color inside; $150-300 for spots. Finds illustrators through agents, sourcebooks, magazines, word of mouth and submissions.
Design: Needs freelancers for design and production. Prefers local freelancers only. 100% of design and production requires knowledge of Adobe Photoshop, Adobe Illustrator and QuarkXPress. Send query letter with printed samples and photocopies.
Tips: "Impress us with your work—it should be exciting, hip and beautiful. Develop an original style and then promote, promote, promote!"

MODEL RAILROADER, P.O. Box 1612, 21027 Crossroads Circle, Waukesha WI 53187. (414)786-8776. Fax: (414)796-1778. E-mail: tlund@kalmbach.com. Website: http://www.modelrailroader.com. Art Director: Thomas Lund. Monthly magazine for hobbiests, rail fans. Circ. 230,000. Sample copies available for 9 × 12 SASE with first-class postage. Art guidelines available.
 ● Published by Kalmbach Publishing. Also publishes *Classic Toy Trains, Astronomy, Finescale Modeler, Model Retailer, Nutshell News* and *Trains*.
Cartoons: Prefers railroading themes. Prefers b&w line drawings with gagline. Send photocopies and tearsheets. Samples are filed and not returned. Reports back only if interested. Buys one-time rights. **Pays on acceptance**; $30 for b&w cartoons.
Illustration: Prefers railroading, construction, how-to. Considers all media. 90% of freelance illustration demands knowledge of Adobe Photoshop 3.0, Adobe Illustrator 6.0, Aldus FreeHand 3.0, QuarkXPress 3.31 and Fractal Painter. Send query letter with printed samples, photocopies, SASE and tearsheets. Accepts disk submissions compatible with QuarkXPress 5.5. (Send EPS files.) Call first. Samples are filed and are not returned. Will contact for portfolio review of final art, photographs and thumbnails if interested. Buys all rights. Pays on publication; negotiable.

MODERN DRUMMER, 12 Old Bridge Rd., Cedar Grove NJ 07009. (201)239-4140. Editor-in-Chief: Ronald Spagnardi. Art Director: Scott Bienstock. Monthly magazine for drummers, "all ages and levels of playing ability with varied interests within the field of drumming." Circ. 95,000. Previously published work OK. Original artwork returned after publication. Sample copy for $4.95.
Cartoons: Buys 3-5 cartoons/year. Interested in drumming themes; single and double panel. Prefers finished cartoons or roughs. Include SASE. Reports in 3 weeks. Buys first North American serial rights. Pays on publication; $5-25.
Tips: "We want strictly drummer-oriented gags."

MODERN MATURITY, Dept. AM, 601 E Street NW, Washington DC 20049. Design Director: Cynthia Friedman. Estab. 1956. Bimonthly 4-color magazine emphasizing health, lifestyles, travel, sports, finance and contemporary activities for members 50 years and over. Circ. 22 million. Originals are returned after publication.
Illustration: Approached by 200 illustrators/year. Buys 40 freelance illustrations/issue. Works on assignment only. Considers digital, watercolor, collage, oil, mixed media and pastel. Samples are filed "if I can use the work." Do not send portfolio unless requested. Portfolio can include original/final art, tearsheets, slides and photocopies and samples to keep. Buys first rights. **Pays on acceptance**; $2,000 for color cover; $1,000 for color inside, full page; $500 for color ¼ page.
Tips: "We generally use people with strong conceptual abilities. I request samples when viewing portfolios."

MOM GUESS WHAT NEWSPAPER, 1725 L St., Sacramento CA 95814. (916)441-6397. E-mail: info@mgwnews.com. Website: http://www.mgwnews.com. Publisher/Editor: Linda Birner. Estab. 1978. Weekly newspaper "for gays/lesbians." Circ. 21,000. Sample copies for 10 × 13 SASE and 4 first-class stamps. Art guidelines for #10 SASE with first-class postage.
Cartoons: Approached by 15 cartoonists/year. Buys 5 cartoons/issue. Prefers gay/lesbian themes. Prefers single and multiple panel political, humorous b&w line drawings with gagline. Send query letter with photocopies and SASE. Samples are filed. Reports back only if interested. Rights purchased vary according to project. Pays on publication; $5-50 for b&w.
Illustration: Approached by 10 illustrators/year. Buys 3 illustrations/issue. Has featured illustrations by Andy Markley and Tim Brown. Features caricatures of celebrities; humorous, realistic and spot illustration. Assigns 50% of illustration to experienced, but not well-known illustrators; 50% to new and emerging illustrators. Prefers gay/lesbian themes. Considers pen & ink. 50% of freelance illustration demands knowledge of Aldus PageMaker. Send query letter with photocopies. Samples are filed. Reports back only if interested. Art director will contact artist for portfolio review of b&w photostats if interested. Rights purchased vary according to project. Pays on publication; $100 for b&w or color cover; $10-100 for b&w or color inside; $300 for 2-page spreads; $25 for spots. Finds illustrators through word or mouth and artist's submissions.
Design: Needs freelancers for design and production. Prefers local design freelancers. 100% of freelance work demands knowledge of Aldus PageMaker 6.5 and Corel Draw. Send query letter with photocopies, phone art director.
Tips: "Send us copies of your ideas that relate to gays/lesbian issues, serious and humorous."

‡**MOMENT**, 4710 41st St. NW, Washington DC 20016. (202)364-3300. Fax: (202)364-2636. Managing Editor: Suzanne Singer. Contact: Judy Oppenheimer, senior editor. Estab. 1973. Bimonthly Jewish magazine, featuring articles on religion, politics, culture and Israel. Circ. 45,000. Accepts previously published artwork. Originals returned at job's completion. Sample copies available for $4.50.
Cartoons: Uses reprints and originals. Prefers political themes relating to Middle East, Israel and contemporary Jewish life. Samples are filed. Reports back only if interested. Rights purchased vary according to project. Pays minimum of $30 for ¼ page, b&w and color.
Illustration: Buys 5-10 illustrations/year. Works on assignment only. Send query letter. Samples are filed. Reports back only if interested. Rights purchased vary according to project. Pays $30 for b&w, $225 for color cover; $30 for color inside (¼ page or less).
Tips: "We look for specific work or style to illustrate themes in our articles. Please know the magazine—read back issues!"

✔**MOTHER JONES**, 731 Market St., San Francisco CA 94103. (415)665-6637. Fax: (415)665-6696. Assistant Art Director: Benjamin Shaykin. Estab. 1976. Bimonthly magazine. Focuses on progressive politics and exposés. Circ. 144,500. Accepts previously published artwork. Originals returned at job's completion. Sample copies available. Freelancers should be familiar with QuarkXPress, Adobe Photoshop and Adobe Illustrator.
Cartoons: Approached by 25 cartoonists/year. Prefers full page, multiple-frame color drawings. Send query letter with postcard-size sample or finished cartoons. Samples are filed or returned by SASE if requested by artist. Reports back to the artist only if interested. Buys first rights. Works on assignment only.
Illustration: Approached by hundreds of illustrators/year. Works on assignment only. Considers pen & ink, colored pencil, mixed media, watercolor, acrylic and oil. Send postcard-size sample or query letter with samples. Samples are filed or returned by SASE if requested by artist. Reports back to the artist only if interested. Portfolio should include photographs, slides and tearsheets. Buys first rights. Pays on publication; payment varies widely. Finds artists through illustration books; other magazines; word of mouth.

MS. MAGAZINE, 135 W. 50th St., 16th Floor, New York NY 10020. (212)445-6100. Contact: Jennifer Walter, art department. Estab. 1972. Bimonthly consumer magazine emphasizing feminist news, essays, arts. Circ. 150,000. Originals returned at job's completion. Art guidelines not available.
Cartoons: Approached by 50 cartoonists/year. Buys 3-4 cartoons/issue. Prefers women's issues. Prefers single panel political, humorous b&w line drawings. Send query letter with photocopied finished cartoons. "Never send originals." Samples sometimes filed or returned by SASE if requested by artist. Does not report back. Buys one-time rights. Pays $100 and up for b&w.
Illustration: Approached by hundreds of illustrators/year. Buys 10 illustrations/issue. Works on assignment only. "Work must reproduce well in 2-color." Considers all media. Send postcard-size sample or color copies. Samples sometimes filed and are not returned. Does not report back. Portfolio review not required, but artists may call to arrange portfolio review of final art. Buys one time rights. Pays on publication. Finds artists through word of mouth, submissions and sourcebooks.

♣MUSCLEMAG INTERNATIONAL, 6465 Airport Rd., Mississauga, Ontario L4V 1E4 Canada. (905)678-7311. Contact: Robert Kennedy. Estab. 1974. Monthly consumer magazine. Magazine emphasizes bodybuilding and fitness for men and women. Circ. 300,000. Originals returned at job's completion. Sample copies available for $5; art guidelines not available.
Cartoons: "We are interested in acquiring a cartoonist to produce one full-page cartoon each month. Send photocopy of your work." Pays $650.
Illustration: Approached by 200 illustrators/year. Buys 70 illustrations/year. Has featured illustrations by Eric Blais and Gino Edwards. Features caricatures of celebrities; charts & graphs; humorous, medical and computer illustrations. Assigns 80% of illustrations to experienced, but not well-known illustrators; 20% to new and emerging illustrators. Prefers bodybuilding themes. Considers all media. Send query letter with photocopies. Samples are filed. Reports back within 1 month. Portfolio review not required. Buys all rights. **Pays on acceptance**; $100-150 for b&w inside; $150-200 for color inside. "Higher pay for high-quality work." Finds artists through "submissions from artists who see our magazine."
Tips: Needs line drawings of bodybuilders exercising. "Study the publication: work to improve by studying others. Don't send out poor quality stuff. It wastes editor's time."

‡MUSHING, P.O. Box 149, Ester AK 99725-0149. (907)479-0454. Fax: (907)479-3137. E-mail: editor@mushing.com. Website: http://www.mushing.com. Publisher: Todd Hoener. Estab. 1988. Bimonthly "year-round, international magazine for all dog-powered sports, from sledding to skijoring to weight pulling to carting to packing. We seek to educate and entertain." Circ. 10,000. Photo/art originals are returned at job's completion. Sample copies available for $5. Art guidelines available for SASE with first-class postage.
Cartoons: Approached by 20 cartoonists/year. Buys 1 cartoon/issue. Prefers humorous cartoons; single panel b&w line drawings with gagline. Send query letter with roughs. Samples are not filed and are returned by SASE if requested by artist. Reports back with 1-6 months. Buys first rights and reprint rights. Pays $25 for b&w and color.
Illustration: Approached by 20 illustrators/year. Buys 0-1 illustrations/issue. Prefers simple; healthy, happy sled dogs; some silhouettes. Considers pen & ink and charcoal. Send query letter with SASE and photocopies. Accepts disk submissions if Mac compatible. Send EPS or TIFF files with hardcopy. Samples are returned by SASE if requested by artist. Prefers to keep copies of possibilities on file and use as needed. Reports back within 1-6 months. Portfolio review not required. Buys first rights. Pays on publication; $150 for color cover; $25 for b&w and color inside; $25 for spots. Finds artists through submissions.
Tips: "Be familiar with sled dogs and sled dog sports. We're most open to using freelance illustrations with articles on dog behavior, adventure stories, health and nutrition. Illustrations should be faithful and/or accurate to the sport. Cartoons should be faithful and tasteful (e.g., not inhumane to dogs)."

MUTUAL FUNDS MAGAZINE, 2200 SW 10th St., Deerfield Beach FL 33442-8799. (954)421-1000. Fax: (954)570-8200. Website: http://www. mfmag.com. Art Director: Mary Branch. Estab. 1994. Monthly consumer magazine covering mutual funds. Circ. 750,000.
Cartoons: Approached by 10 cartoonists/year. Buys 1 cartoon/issue. Prefers mutual fund themes. Prefers single panel, humorous, color washes, with gaglines. Send query with photocopies, tearsheets. Send non-returnable samples only. Samples are filed. Reports back only if interested. Buys first-time rights. Pays on publication; $150-400 for color.
Illustration: Approached by 100 illustrators/year. Buys 10 illustrations/issue. Prefers detailed, colorful, pen & ink, wash. 20% of freelance illustration demands knowledge of any Mac based software. Send postcard sample or query letter with printed samples, photocopies and tearsheets. Reports back only if interested. Art director will contact artist for portfolio review of color final art, photographs, tearsheets, transparencies if interested. Buys one-time rights. Pays on publication; $400-1,500 for color cover; $350-2,000 for color inside; $150-250 for spots. Finds illustrators through sourcebooks, other magazines, direct mail.
Tips: "Look at *Mutual Funds* before you contact me. Know the product and see if you fit in."

‡MY FRIEND, 50 St. Paul's Ave., Boston MA 02130-3491. (617)522-8911. Website: http://www.pauline.org. Contact: Graphic Design Dept. Estab. 1979. Monthly Catholic magazine for kids, b&w with 4-color cover, containing information, entertainment, and Christian information for young people ages 6-12. Circ. 14,000. Originals returned at job's comple-

tion. Sample copies free for 9×12 SASE with first-class postage; art guidelines available for SASE with first-class postage.

Illustration: Approached by 60 illustrators/year. Buys 6 illustrations/issue; 60/year. Works on assignment only. Has featured illustrations by Terry Julien, Jack Hughes, Stephen J. King, Denis Thien and Elaine Garvin. Features realistic illustration; informational graphics; spot illustration. Assigns 10% of illustrations to well-known or "name" illustrators; 80% to experienced, but not well-known illustrators; 10% to new and emerging illustrators. Prefers humorous, realistic portrayals of children. Considers pen & ink, watercolor, airbrush, acrylic, marker, colored pencil, oil, charcoal, mixed media and pastel. Send query letter with résumé, SASE, tearsheets, photocopies. Accepts disk submissions compatible with Windows 3.1, Aldus PageMaker 5.0 or CorelDraw 5.0. Send TIFF files. Samples are filed or are returned by SASE if requested by artist. Reports back to the artist within 1-2 months only if interested. Portfolio review not required. Rights purchased vary according to project. Pays on publication; $200-250 for color cover; $50-100 for b&w inside; $75-125 for color inside; $150-175 for 2-page spreads; $25-50 for spots.

Design: Needs freelancers for design, production and multimedia projects. Design demands knowledge of Aldus Page-Maker, Aldus FreeHand and CorelDraw 5.0. Send query letter with résumé, photocopies and tearsheets. Pays by project.

✓**NAILS**, 21061 S. Western Ave., Torrance CA 90501. (310)533-2400. Fax: (310)533-2501. Art Director: Jennifer Brandes. Estab. 1983. Monthly 4-color trade journal; "seeks to educate readers on new techniques and products, nail anatomy and health, customer relations, chemical safety, salon sanitation and business." Circ. 55,000. Originals can be returned at job's completion. Sample copies available. Art guidelines vary. Needs computer-literate freelancers for design, illustration and production. 100% of freelance work demands knowledge of QuarkXPress, Adobe Illustrator or Photoshop.

Illustration: Buys 3 illustrations/issue. Works on assignment only. Needs editorial and technical illustration; charts and story art. Prefers "bright, upbeat styles." Interested in all media. Send query letter with brochure and tearsheets. Samples are filed. Reports back within 1 month or artist should follow-up with call. Call for an appointment to show a portfolio of tearsheets and transparencies. Buys all rights. **Pays on acceptance**; $200-500 (depending on size of job) for b&w and color inside. Finds artists through self-promotion and word of mouth.

‡**NASHVILLE LIFE**, 2817 West End Ave., Suite 216, Nashville TN 37203. (615)843-8000. Fax: (615)843-4300. E-mail: horton@nashmags.com. Creative Director: Thomas Horton. Art Coordinator: Donna Norfleet. Estab. 1993. Twice monthly consumer/lifestyle city magazine. Circ. 40,000.

• Also owns *Business Nashville*; same creative director for both magazines.

Cartoons: Approached by 2 cartoonists/year. Buys 2-3 cartoons/issue. Prefers whimsical single panel, political, color washes and b&w line drawings. Send query letters with samples. Samples are filed and not returned. Reports back only if interested. Rights purchased vary according to project. **Pays on acceptance.** Pays $50-150 for b&w; $60-200 for color cartoons.

Illustration: Approached by 25 illustrators/year. Buys 2-3 illustrations/issue. Has featured illustrations by Lori Bilter, Pashue House, Mike Harris, Dar Maleki, Kurt Lightner. Features caricatures of celebrities and politicians; charts & graphs; computer and spot illustrations of business subjects and country music celebs. Prefers bright colors and pastels "A styles welcome except 'grunge.' " Assigns 50% of illustrations to experienced, but not well-known illustrators; 50% to new and emerging illustrators. 10% of freelance illustration demands knowledge of Adobe Illustrator, Adobe Photoshop, Aldus FreeHand, QuarkXPress. Send query letter with non-returnable samples. Accepts Mac-compatible disk submissions. Send EPS files. Samples are filed and are not returned. Will contact artist for portfolio review if interested. Rights purchased vary according to project. **Pays on acceptance**; $200-1,000 for color cover; $50-300 for b&w inside; $60-500 for color inside; $150-800 for 2-page spreads; $30 for spots. Finds freelancers through publications.

Tips: I'm looking for folks who can deal with my simple needs and handle all three legs of the "quick—cheap-good" triangle. And leave your attitudes at the door.

Tips: "Professional presentation of artwork is important."

THE NATION, 72 Fifth Ave., New York NY 10011. (212)633-2356. Art Director: Steven Brower. Estab. 1865. A weekly journal of "left/liberal political opinion, covering national and international affairs, literature and culture." Circ. 100,000. Originals are returned after publication upon request. Sample copies available. Art guidelines not available.

Illustration: Approached by 50 illustrators/year. Buys illustrations mainly for spots and feature spreads. Buys 3-4 illustrations/issue. Works with 25 illustrators/year. Works on assignment only. Considers pen & ink, airbrush, mixed media and charcoal pencil; b&w only. Send query letter with tearsheets and photocopies. "On top of a defined style, artist must have a strong and original political sensibility." Samples are filed or are returned by SASE. Reports back only if interested. Buys first rights. Pays $75-125 for b&w inside; $150 for color inside.

‡**NATIONAL BUS TRADER**, 9698 W. Judson Rd., Polo IL 61064. (814) 946-2341. Fax: (815) 946-2347. Editor: Larry Plachno.

• Also publishes books. See listing for Transportation Trails in Book Publishers section. Editor is looking for artists to commission oil paintings for magazine covers. He is also looking for artists who can render historic locomotives. He uses mostly paintings or drawings. He also considers silhouettes of locomotives and other historic transportation. He is open to artists who work on Adobe Illustrator and QuarkXPress.

NATIONAL BUSINESS EMPLOYMENT WEEKLY, P.O. Box 300, Princeton NJ 08543-0300. (609)520-7311. Fax: (609)520-4309. E-mail: lnanton@wsj.com. Art Director: Larry Nanton. Estab. 1981. Weekly newspaper covering

job search and career guidance for middle-senior level executives. Circ. 33,000. Originals returned at job's completion. Art guidelines available.

Cartoons: Buys 1 cartoon/issue. Subject must pertain to some aspect of job hunting; single panel b&w washes and line drawings with or without gagline. Send query letter with finished cartoons. Samples are not filed and are returned by SASE. Reports back to the artist only if interested. Buys first rights. Pays $50 for b&w.

Illustration: Approached by 24 illustrators/year. Buys 4 illustrations/issue. Works on assignment only. Has featured illustrations by Peter Bono, David Klug, Dave Bamundo and Matt Collins. Features humorous, realistic, computer and spot illustration. Assigns 50% of illustrations to experienced, but not well-known illustrators; 50% to new and emerging illustrators. Prefers b&w images and designs of people in all stages of the job search. Considers pen & ink, watercolor, airbrush and pencil. Send postcard sample or query letter with tearsheets. Samples are filed. Reports back to the artist only if interested. Portfolio review not required. Buys one-time rights and reprint rights. Pays on publication; $125 for b&w inside; $500 for 4-color cover, $150 for color inside.

Tips: "Artist should have a good imagination, nice sense of design and be competent in drawing people. Send only samples that you can live up to. Accept the terms of employment in exchange for the exposure."

NATIONAL ENQUIRER, Dept. AGDM, Lantana FL 33464. (561)586-1111, ext. 2274. Assistant Editor: Joan Cannata-Fox. A weekly tabloid. Circ. 3.8 million. Originals are returned at job's completion. Art guidelines available for SASE with first-class postage.

Cartoons: "We get 1,000-1,500 cartoons weekly." Buys 300 cartoons/year. Prefers animal, family, husband/wife and general themes. Nothing political or off-color. Prefers single panel b&w line drawings and washes with or without gagline. Computer-generated cartoons are not accepted. Prefers to do own coloration. Send query letter with finished cartoons and SASE. Samples are not filed and are returned only by SASE. Reports back within 2-3 weeks. Buys first and one-time rights. Pays $300 for b&w plus $40 each additional panel.

Tips: "Study several issues to get a solid grasp of what we buy. Gear your work accordingly."

NATIONAL GEOGRAPHIC, 17th and M Streets NW, Washington DC 20036. (202)857-7000. Art Director: Chris Sloan. Estab. 1888. Monthly. Circ. 9 million. Original artwork returned 1 year after publication, but *National Geographic* owns the copyright.

- *National Geographic* receives up to 30 inquiries a day from freelancers. They report most are not appropriate to their needs. Please make sure you have studied several issues before you submit. They have a roster of artists they work with on a regular basis and it's difficult to break in, but if they like your samples they will file them for consideration for future assignments.

Illustration: Works with 20 illustrators/year. Contracts 50 illustrations/year. Interested in "full-color renderings of historical and scientific subjects. Nothing that can be photographed is illustrated by artwork. No decorative, design material. We want scientific geological cut-aways, maps, historical paintings." Works on assignment only. Send color copies, postcards, tearsheets, proofs or other appropriate samples. Art director will contact for portfolio review if interested. Samples are returned by SASE. **Pays on acceptance**; varies according to project.

Tips: "Do your homework before submitting to any magazine. We only use historical and scientific illustrations, ones that are very informative and very accurate. No decorative, abstract portraits."

NATIONAL LAMPOON, 10850 Wilshire Blvd., Suite 1000, Los Angeles CA 90024. (310)474-5252. Fax: (310)474-1219. Publisher: Duncan Murray. Estab. 1971. Consumer magazine of humor and satire.

Cartoon: Approached by 50 cartoonists/year. Buys 6 cartoons/issue. Prefers satire. Prefers humorous, b&w line drawings. Send photocopies and SASE. Samples are filed. Reports back only if interested. Negotiates rights purchased. Payment negotiable.

Illustration: Approached by 10 illustrators/year. Buys 30 illustrations/issue. Considers all media. Send query letter with photocopies and SASE. Samples are filed. Reports back only if interested. Rights purchased vary according to project. Payment negotiable.

Design: Needs freelancers for design and production. Prefers local designers. 100% of freelance work demands knowledge of Adobe Photoshop and QuarkXPress. Send query letter with photocopies.

‡THE NATIONAL NOTARY, 9350 DeSoto Ave., Box 2402, Chatsworth CA 91313-2402. (818)739-4000. Contact: Production Editor. Emphasizes "notaries public and notarization—goal is to impart knowledge, understanding, and unity among notaries nationwide and internationally." Readers are notaries of varying primary occupations (legal, government, real estate and financial), as well as state and federal officials and foreign notaries. Bimonthly. Circ. 150,000. Original artwork not returned after publication. Sample copy $5.

Cartoons: Approached by 5-8 cartoonists/year. Cartoons "must have a notarial angle"; single or multiple panel with gagline, b&w line drawings. Send samples of style. Samples not returned. Reports in 4-6 weeks. Call to schedule an appointment to show a portfolio. Buys all rights. Pays on publication; pay is negotiable.

Illustration: Approached by 3-4 illustrators/year. Uses about 3 illustrations/issue; buys all from local freelancers. Works on assignment only. Themes vary, depending on subjects of articles. 100% of freelance work demands knowledge of Adobe Illustrator, QuarkXPress or Aldus FreeHand. Send business card, samples and tearsheets to be kept on file. Samples not returned. Reports in 4-6 weeks. Call for appointment. Buys all rights. Negotiates pay; on publication.

Tips: "We are very interested in experimenting with various styles of art in illustrating the magazine. We generally work with Southern California artists, as we prefer face-to-face dealings."

‡**NATIONAL REVIEW**, 150 E. 35th St., New York NY 10016. (212)679-7330. Contact: Art Director. Emphasizes world events from a conservative viewpoint; bimonthly b&w with 4-color cover, design is "straight forward—the creativity comes out in the illustrations used." Originals are returned after publication. Uses freelancers mainly for illustrations of articles and book reviews, also covers.

Cartoons: Buys 17 cartoons/issue. Interested in "light political, social commentary on the conservative side." Send appropriate samples and SASE. Reports in 2 weeks. Buys first North American serial rights. Pays on publication; $50 for b&w.

Illustration: Buys 15 illustrations/issue. Especially needs b&w ink illustration, portraits of political figures and conceptual editorial art (b&w line plus halftone work). "I look for a strong graphic style; well-developed ideas and well-executed drawings." Style of Tim Bower, Jennifer Lawson, Janet Hamlin, Alan Nahigian. Works on assignment only. Send query letter with brochure showing art style or tearsheets and photocopies. No samples returned. Reports back on future assignment possibilities. Call for an appointment to show portfolio of final art, final reproduction/product and b&w tearsheets. Include SASE. Buys first North American serial rights. Pays on publication; $100 for b&w inside; $500 for color cover.

Tips: "Tearsheets and mailers are helpful in remembering an artist's work. Artists ought to make sure their work is professional in quality, idea and execution. Recent printed samples alongside originals help. Changes in art and design in our field include fine art influence and use of more halftone illustration." A common mistake freelancers make in presenting their work is "not having a distinct style, i.e., they have a cross sample of too many different approaches to rendering their work. This leaves me questioning what kind of artwork I am going to get when I assign a piece."

‡*THE NATIONAL TRUST MAGAZINE**, 36 Queen Anne's Gate, London SW1H 9AS England. Phone: (0171)222 9251. Fax: (0171)447 6777. Editor: Gina Guarnieri. Estab. 1969. Thrice yearly 4-color charity membership magazine. Circ. 1.4 million.

Illustration: Approached by 10 illustrators/year. Buys less than 10 illustrations/issue. Features charts & graphs, natural history and realistic illustrations. Send postcard sample. Reports back only if interested. Rights purchased vary according to project. Pays on publication.

Tips: "We have a stable of 10-15 freelancers we work with regularly, but we are open to new talent. Read our magazine and send us something you think we'd like."

‡**NATION'S RESTAURANT NEWS**, 425 Park Ave., 6th Floor, New York NY 10022-3506. (212)756-5208. Fax: (212)756-5215. E-mail: mvila@nrn.com. Website: http://www.nrn.com. Art Director: Manny Vila. Design Associate: Maureen Farrell. Estab. 1967. Weekly 4-color trade publication/tabloid. Circ. 100,000.

Illustration: Approached by 35 illustrators/year. Buys 25 illustrations/issue. Has featured illustrations by Stephen Sweny, Daryl Stevens, Elvira Regince, Garrett Kallenbach. Features computer, humorous and spot illustrations of business subjects in the food service industry. Prefers pastel and bright colors. Assigns 5% of illustrations to well-known or "name" illustrators; 70% to experienced, but not well-known illustrators; 25% to new and emerging illustrators. 20% of freelance illustration demands knowledge of Adobe Illustrator or Adobe Photoshop. Send postcard sample or other non-returnable samples, such as tearsheets. Accepts Windows-compatible disk submissions. Send EPS files. Samples are filed. Will contact artist for portfolio review if interested. Buys one-time rights. Pays on publication; $700-900 for b&w cover; $900-1,200 for color cover; $200-300 for b&w inside; $275-350 for color inside; $350 for spots. Finds illustrators through *Creative Black Book* and *LA Work Book.*

Tips: "Great imagination and inspiration are essential for one's uniqueness in a field of such visual awareness."

NATURAL HISTORY, American Museum of Natural History, Central Park West and 79th St., New York NY 10024. (212)769-5500. Editor: Bruce Stutz. Designer: Tom Page. Emphasizes social and natural sciences. For well-educated professionals interested in the natural sciences. Monthly. Circ. 450,000. Accepts previously published work.

Illustration: Buys 23-25 illustrations/year; 25-35 maps or diagrams/year. Works on assignment only. Query with samples. Samples returned by SASE. Provide "any pertinent information" to be kept on file for future assignments. Buys one-time rights. Pays on publication; $200 and up for color inside.

Tips: "Be familiar with the publication. Always looking for accurate and creative scientific illustrations, good diagrams and maps."

✔**NATURAL WAY**, 1 Bridge St., Suite 125, Irvington NY 10533. (914)591-2011. Fax: (914)591-2017. E-mail: natway@aol.com. Art Director: Amy Crabtree. Estab. 1994. Bimonthly magazine "for the alternative health consumer, 70% women." Circ. 125,000.

Illustration: Buys 2 illustrations/issue. Themes vary. Considers all media. Send query letter with printed samples and photocopies. Send follow-up postcard sample every 6 months. Accepts disk submissions. Samples are filed. Reports back only if interested. Art director will contact artist for portfolio review if interested. Buys one-time rights. Pays on publication; $500 maximum for color cover; $75-600 for color inside. Pays $75-125 for spots. Finds illustrators through magazines, word of mouth and artist's submissions.

NATURALLY MAGAZINE, P.O. Box 317, Newfoundland NJ 07435. (973)697-8313. Fax: (973)697-8313. E-mail: naturally@nac.net. Website: http://www.tiac.net/users/nat. Publisher/Editor: Bernard Loibl. Estab. 1981. Quarterly magazine covering family nudism/naturism and nudist resorts and travel. Circ. 35,000. Sample copies for $6.50 and $2.50 postage; art guidelines for #10 SASE with first-class postage.

Cartoons: Approached by 10 cartoonists/year. Buys 3 cartoons/issue. Prefers nudism/naturism. Send query letter with finished cartoons. Samples are filed. Reports back only if interested. Buys one-time rights. Pays on publication. Pays $20-70.

Illustration: Approached by 10 illustrators/year. Buys 3 illustrations/issue. Prefers nudism/naturism. Considers all media. 20% of freelance illustration demands knowledge of Corel Draw. Contact only through artists' rep. Accepts disk submissions compatible with Corel Draw files or EPS files. Samples are filed. Reports back only if interested. Buys one-time rights. Pays on publication; $140 for cover; $70/page inside.

‡NERVE COWBOY, P.O. Box 4973, Austin TX 78765-4973. Website: http://www.eden.com/. Editors: Joseph Shields and Jerry Hagins. Estab. 1995. Biannual b&w literary journal of poetry, short fiction and b&w artwork. Sample copies for $4 postpaid. Art guidelines free for #10 SASE with first-class postage.

Illustration: Approached by 100 illustrators/year. Buys work from 10 illustrators/issue. Has featured illustrations by Wayne Hogan, Stepan Chapman, Bob Lavin, Andrea Dezso, David Hernandez, Julie McNeil. Features humorous illustration and creative b&w images. Prefers b&w. "Color will be considered if a b&w half-tone can reasonably be created from the piece." Assigns 40% of illustrations to well-known or "name" illustrators; 40% to experienced, but not well-known illustrators; 20% to new and emerging illustrators. Send printed samples, photocopies or SASE. Samples are returned by SASE. Reports back within 1 month. Portfolio review not required. Buys first North American serial rights. Pays on publication; 3 copies of issue in which art appears on cover; or 1 copy if art appears inside.

Tips: "We are always looking for new artists with an unusual view of the world."

‡NEVADA, 1800 Hwy. 50 E., Suite 200, Carson City NV 89710. (702)687-6158. Fax: (702)687-6159. Estab. 1936. Bimonthly magazine "founded to promote tourism in Nevada." Features Nevada artists, history, recreation, photography, gaming. Traditional, 3-column layout with large (coffee table type) 4-color photos. Circ. 130,000. Accepts previously published artwork. Originals are returned to artist at job's completion. Sample copies for $3.50. Art guidelines available.

Cartoons: Prefers 4-color cartoons for humor pieces. Pays $40 for b&w, $60 for color.

Illustration: Approached by 25 illustrators/year. Buys 2 illustrations/issue. Works on assignment only. Send query letter with brochure, résumé and slides. Samples are filed. Reports back within 2 months. To show portfolio, mail 20 slides and bio. Buys one-time rights. Pays $125 for color cover; $20 for b&w inside; $50 for color inside.

NEW HUMOR MAGAZINE, P.O. Box 216, Lafayette Hill PA 19444. (215)482-7673. Fax: (215)487-2640. E-mail: newhumor@aol.com. Editor: Edward Savaria, Jr. Estab. 1994. Quarterly magazine of humor. Circ. 8,500. Sample copy $3.50.

Cartoons: Buys 10 cartoons/issue. Prefers clever humor with edge. Prefers single, double and multiple panel, humorous, b&w washes, b&w line drawings, with gagline. Send photocopies. Samples are not filed and are returned by SASE. Reports back within 1 month. Rights purchased vary according to project. Pays on publication; $10-25 for b&w cartoons.

Illustration: Approached by 25 illustrators/year. Buys 10 illustrations/issue. Prefers simple humorous style. Considers marker and pen & ink. Send photocopies, SASE. Send follow-up postcard sample every 6 months. Samples are filed. Reports back within 1 month. Rights purchased vary according to project. Pays on publication; $25-75 for b&w cover; $10-25 for b&w for inside; $10-25 for spots. Finds illustrators through artist's submissions.

Tips: "I look for work that will fit the style of the magazine and artists who'll work cheap!"

NEW MYSTERY MAGAZINE, 175 Fifth Ave., Room 2001, New York NY 10010. (212)353-1582. E-mail: newmyste @erols.com. Website: http://newmystery.com. Art Director: Dana Irwin. Estab. 1989. Quarterly literary magazine—a collection of mystery, crime and suspense stories with b&w drawings, prints and various graphics. Circ. 100,000. Accepts previously published artwork. Originals are returned at job's completion. Sample copies available for $7 plus $1.24 postage and SASE; art guidelines for SASE with first-class postage.

Cartoons: Approached by 100 cartoonists/year. Buys 1-3 cartoons/issue. Prefers themes relating to murder, heists, guns, knives, assault and various crimes; single or multiple panel, b&w line drawings. Send query letter with finished cartoon samples. Samples are filed and are returned by SASE if requested. Reports back within 1-2 months. Rights purchased vary according to project. Pays $20-50 for b&w, $20-100 for color.

Illustration: Approached by 100 illustrators/year. Buys 12 illustrations/issue. Prefers themes surrounding crime, murder, suspense, noir. Considers pen & ink, watercolor and charcoal. Needs computer-literate freelancers for illustration. Send postcard sample with SASE. Accepts disk submissions compatible with IBM. Send TIFF and GIF files. Samples are filed. Reports back within 1-2 months. To show a portfolio, mail appropriate materials: b&w photocopies and photographs. Rights purchased vary according to project. Pays on publication; $100-200 for covers; $25-50 for insides; $10-25 for spots.

Design: Needs freelancers for multimedia. Freelance work demands knowledge of Adobe Photoshop and QuarkXPress. Send query letter with SASE and tearsheets. Pays by the project, $100-200.

Tips: "Study an issue and send right-on illustrations. Do not send originals. Keep copies of your work. *NMM* is not responsible for unsolicited materials."

THE NEW PHYSICIAN, 1902 Association Dr., Reston VA 20191. (703)620-6600, ext. 246. Art Director: Julie Cherry. For physicians-in-training; concerns primary medical care, political and social issues relating to medicine; 4-color, contemporary design. Published 9 times/year. Circ. 28,000. Original artwork returned after publication. Buys one-time rights. Pays on publication.

Illustration: Approached by 200-300 illustrators/year. Buys 3 illustrations/issue from freelancers, usually commissioned. Samples are filed. Submit résumé and samples of style. Accepts disk submissions compatible with QuarkXPress 3.3, Adobe Illustrator 6, Adobe Photoshop 4. Send EPS files. Reports in 6-8 weeks. Buys one-time rights. Pays $900-1,100 for color cover; $200 minimum for color inside; $75 minimum for spots.

‡**the new renaissance**, 26 Heath Rd., Apt. 11, Arlington MA 02174-3645. E-mail: umichaud@grevi.net. Editor: Louise T. Reynolds. Art Editor: Olivera Sajkovic. Estab. 1968. Biannual (spring and fall) magazine emphasizing literature, arts and opinion for "the general, literate public"; b&w with 2-color cover, 6×9. Circ. 1,600. Originals are only returned after publication if SASE is enclosed. Sample copy available. Recent issue $8.50 US, $9 foreign. (US dollars only.) Art guidelines available.
Cartoons: Approached by 20-32 freelance artists/year. Pays $15-30 for b&w. Very few accepted in any given year.
Illustration: Buys 6-8 illustrations/issue from freelancers and "occasional supplementary artwork (2-4 pages)." Works mainly on assignment. Has featured illustrations by David M. Simon, Jeffrey Hayes, Barry Nolan and Phoebe McKay. Features realistic illustration and symbolism. Assigns 50-60% of illustrations to experienced, but not well-known illustrators; 40-50% to new and emerging illustrators. Send résumé, samples, photos and SASE. Reports within 2-4 months. Publication will contact artist for portfolio review if interested, "but only if artist has enclosed SASE." Portfolio should include roughs, b&w photographs and SASE. Buys one-time rights. Pays after publication; $25-30 for b&w inside; $18-25 for spots.
Tips: "Aside from examining magazine to see if your kind of drawings fit in with our needs, we suggest you provide a realistic or symbolic interpretation without being too literal when illustrating fiction/poetry. Only interested in b&w. We want artists who understand a 'quality' (or 'serious' or 'literary') piece of fiction (or, occasionally, a poem), and we suggest you study our past illustrations. We are receiving work that is appropriate for a newsletter, newsprint or alternative-press magazines. *tnr* takes a classicist position in the arts—we want work that holds up and that adds another dimension to the writing—story or poem—rather than an illustration that simply echoes the storyline. We will only consider work that is submitted with a SASE. No postcards, please. Artists are required buy a back issue ($5.50 or $7.65) so they can see the kind of fiction we publish and the type of illustrations we need."

‡**THE NEW REPUBLIC**, 1220 19th St. NW, Suite 600, Washington DC 20036. (202)331-7494. Design Consultant: Eric Baker. Estab. 1914. Weekly political/literary magazine; political journalism, current events in the front section, book reviews and literary essays in the back; b&w with 4-color cover. Circ. 100,000. Original artwork returned after publication. Sample copy for $3.50. 50% of freelance work demands computer skills.
Illustration: Approached by 400 illustrators/year. Buys up to 5 illustrations/issue. Uses freelancers mainly for cover art. Works on assignment only. Prefers caricatures, portraits, 4-color, "no cartoons." Style of Vint Lawrence. Considers airbrush, collage and mixed media. Send query letter with tearsheets. Samples returned by SASE if requested. Publication will contact artist for portfolio review if interested. Portfolio should include color photocopies. Rights purchased vary according to project. Pays on publication; up to $600 for color cover; $250 for b&w and color inside.

✔**NEW THOUGHT JOURNAL**, 2520 Evelyn Dr., Dayton OH 45409. (937)293-9717. Fax: (937)293-9717. E-mail: ntjmag@aol.com. Editor: Jeffrey M. Ohl. Estab. 1994. Quarerly literary magazine featuring stories (fiction and nonfiction), poetry, art and photography which reflect creative and spiritual experiences. Circ. 5,000. Sample copy for $6; art guidelines for #10 SASE with first-class postage.
Illustration: Has featured illustrations by Josef Gast, Marta Herman, Paul Kane, Craig Carlisle, Dared Levitan and Tom Peyton. Features natural history, realistic and spot illustration. Assigns 50% of illustrations to experienced, but not well-known illustrators; 50% to new and emerging illustrators. Considers all media. Knowledge of Adobe Photoshop, QuarkXPress helpful but not required. Send postcard sample, query letter with printed samples and photocopies. Accepts disk submission compatible with QuarkXPress 3.3 or Photoshop (EPS or PICT File). Reports back only if interested. Buys one-time and reprint rights. Pays on publication; negotiable.

NEW WRITER'S MAGAZINE, Box 5976, Sarasota FL 34277. (941)953-7903. E-mail: newriters@aol.com. Website: http://www.newriters.com. Editor/Publisher: George J. Haborak. Estab. 1986. Bimonthly b&w magazine. Forum "where all writers can exchange thoughts, ideas and their own writing. It is focused on the needs of the aspiring or new writer." Rarely accepts previously published artwork. Original artwork returned after publication if requested. Sample copies for $3; art guidelines for SASE with first-class postage.
Cartoons: Approached by 15 cartoonists/year. Buys 1-3 cartoons/issue. Features spot illustration. Assigns 20% of illustrations to experienced, but not well-known illustrators; 80% to new and emerging illustrators. Prefers cartoons "that reflect the joys or frustrations of being a writer/author"; single panel b&w line drawings with gagline. Send query letter with samples of style. Samples are sometimes filed or returned if requested. Reports back within 1 month. Buys first rights. Pays on publication; $5 for b&w.
Illustration: Buys 1 illustration/issue. Works on assignment only. Prefers line drawings. Considers watercolor, mixed media, colored pencil and pastel. Send postcard sample. Samples are filed or returned if requested by SASE. Reports

within 1 month. To show portfolio, mail tearsheets. Buys first rights or negotiates rights purchased. Pays $10 for spots. Payment negotiated.

THE NEW YORKER, 20 W. 43rd St., 16th Floor, New York NY 10036. (212)840-3800. E-mail (cartoons): bob@cartoo nbank.com. Website: http://www.cartoonbank.com. Emphasizes news analysis and lifestyle features.
Cartoons: Buys b&w cartoons. Receives 3,000 cartoons/week. Cartoon editor is Bob Mankoff, who also runs Cartoon Bank, a stock cartoon agency that features *New Yorker* cartoons. Accepts unsolicited submissions only by mail. Reviews unsolicited submissions every 1-2 weeks. Photocopies only, please. Include SASE. Strict standards regarding style, technique, plausibility of drawing. Especially looks for originality. Pays $575 minimum for cartoons. Contact cartoon editor.
Illustration: All illustrations are commissioned. Portfolios may be dropped off Wednesdays between 10-6 and picked up on Thursdays. Mail samples, no originals. "Because of volume of submissions we are unable to respond to all submissions." No calls please. Emphasis on portraiture. Contact illustration department.
Tips: "Familiarize yourself with *The New Yorker*."

NEWSWEEK, 251 W. 57th St., 15th Floor, New York NY 10019. (212)445-4000. Art Director: Lynn Staley.
Illustration: Send postcard samples or other non-returnable samples. Portfolios may be dropped off at front desk Tuesday or Wednesday from 9 to 5.

NORTH AMERICAN WHITETAIL MAGAZINE, 2250 Newmarket Pkwy., Suite 110, Marietta GA 30067. (770)953-9222. Fax: (770)933-9510. Editorial Director: Ken Dunwoody. Estab. 1982. Consumer magazine "designed for serious hunters who pursue whitetailed deer." 8 issues/year. Circ. 175,000. Accepts previously published artwork. Original artwork is returned at job's completion. Sample copies available for $3; art guidelines not available.
Illustration: Approached by 30 freelance illustrators/year. Buys 1-2 freelance illustrations/issue. Works on assignment only. Considers pen & ink and watercolor. Send postcard sample and/or query letter with brochure and photocopies. Samples are filed or are returned by SASE if requested by artist. Reports back only if interested. To show a portfolio, mail appropriate materials. Rights purchased vary according to project. Pays 10 weeks prior to publication; $25 minimum for b&w inside; $75 minimum for color inside.

✔**NORTH CAROLINA LITERARY REVIEW**, English Dept., East Carolina University, Greenville NC 27858-4353. E-mail: bauerm@mail.ecu.edu. Editor: Margaret Bauer. Estab. 1992. Annual literary magazine of art, literature, clulture having to do with NC. Circ. 2,000. Samples available; art guidelines for SASE with first-class postge.
Illustration: Considers all media. Send postcard sample or send query letter with printed samples, SASE and tearsheets. Send follow-up postcard sample every 2 months. Samples are not filed and are returned by SASE. Reports back within 2 months. Art director will contact artist for portfolio review of b&w, color slides and transparencies if interested. Rights purchased vary according to projects. Pays on publication; $100-250 for cover; $50-250 for inside. Pays $25 for spots. Finds illustrators through magazines and word of mouth.
Tips: "Read our magazine."

‡**THE NORTHERN LOGGER & TIMBER PROCESSOR**, Northeastern Loggers Association Inc., Box 69, Old Forge NY 13420. (315)369-3078. Editor: Eric A. Johnson. Trade publication (8½×11) with an emphasis on education. Focuses on methods, machinery and manufacturing as related to forestry. For loggers, timberland managers and processors of primary forest products. Monthly b&w with 4-color cover. Circ. 13,000. Previously published material OK. Free sample copy and guidelines available.
Cartoons: Buys 1 cartoon/issue. Receives 1 submission/week. Interested in "any cartoons involving forest industry situations." Send finished cartoons with SASE. Reports in 1 week. **Pays on acceptance**; $20 for b&w line drawings.
Illustration: Pays $20 for b&w cover.
Tips: "Keep it simple and pertinent to the subjects we cover. Also, keep in mind that on-the-job safety is an issue we like to promote."

✔**NOTRE DAME MAGAZINE**, 535 Grace Hall, Notre Dame IN 46556. (219)631-4630. Website: http://www.ND. EDU/~NDMAG. Art Director: Don Nelson. Estab. 1971. Quarterly 4-color university magazine that publishes essays on cultural, spiritual and ethical topics, as well as news of the university for Notre Dame alumni and friends. Circ. 130,000. Accepts previously published artwork. Original artwork returned after publication.
 ● Illustrator Octavio Diaz got a great assignment from this magazine that he later used for a promo piece. See article on page 12.
Illustration: Approached by 40 illustrators/year. Buys 5-8 illustrations/issue. Works on assignment only. Has featured illustrations by Carl Prescott, Terry Lacy, Mark Fisher, Joe Ciardiello, Steve Madson. Features editorial art only. Assigns

HUMOR & CARTOON markets are listed in the Humor & Cartoon Index located at the back of this book

20% of illustrations to well-known or "name" illsutrators; 60% to experienced, but not well-known illustrators; 20% to new and emerging illustrators. Tearsheets, photographs, slides, brochures and photocopies OK for samples. Samples are returned by SASE if requested. "Don't send submissions—only tearsheets and samples." To show portfolio, mail published editorial art. Buys first rights. Pays $2,000 maximum for color covers; $150-400 for b&w inside; $200-700 for color inside; $75-150 for spots.

Tips: "Looking for noncommercial style editorial art by accomplished, experienced editorial artists. Conceptual imagery that reflects the artist's awareness of fine art ideas and methods is the kind of thing we use. Sports action illustrations not used. Cartoons not used. Learn to draw well, study art history, develop a style, limit use of color, create images that can communicate ideas."

‡NOVA EXPRESS, P.O. Box 27231, Austin TX 78755. E-mail: lawrence@bga.com. Website: http://www.delphi.com/sflit/novaexpress. Editor: Lawrence Person. Estab. 1987. B&w literary zine featuring cutting-edge science fiction, fantasy, horror and slipstream. Circ. 750.

Illustration: Approached by 6 illustrators/year. Buys 10-15 illustrations/issue. Has featured illustrations by GAK, Cathy Burburuz, Bill D. Fountain, Richard Simental, Kathy Strong, Phil Yeh, Keith Burdak. Features science fiction, fantasy, horror, spot illustrations. Prefers b&w. Assigns 50% of illustrations to experienced, but not well-known illustrators; 50% to new and emerging illustrators. Send non-returnable samples. Accepts Mac-compatible disk submissions. Samples are filed. Reports back within 3 months. Portfolio review not required. Buys one-time rights. Pays on publication in copies and subscription only. Finds illustrators online.

Tips: "We only publish artwork connected to the SF/F/H metagenre (though sometimes we find abstract or futuristic designs useable). However, we do not want clichéd SF/F themes (i.e., Gernsbackian rocket ships, unicorns, elves, or any other generic fantasy). Solid work and originality are always welcome. Though not a paying market, *Nova Express* is widely read and well regarded by genre professionals."

NOW AND THEN, Box 70556 ETSU, Johnson City TN 37614-0556. (423)439-5348. Fax: (423)439-6340. E-mail: fischman@etsu.edu. Website: http://cass.etsu.edu/n&t/art.htm. Editor: Jane Harris Woodside. Estab. 1984. Magazine covering Appalachian issues and arts, published 3 times a year. Circ. 1,000. Accepts previously published artwork. Originals are returned at job's completion. Sample copies available for $5; art guidelines available.

Cartoons: Approached by 5 cartoonists/year. Prefers Appalachia issues, political and humorous cartoons; b&w washes and line drawings. Send query letter with brochure, roughs and finished cartoons. Samples not filed and are returned by SASE if requested by artist. Reports back within 4-6 months. Buys one-time rights. Pays $25 for b&w.

Illustration: Approached by 3 illustrators/year. Buys 1-2 illustrations/issue. Has featured illustrations by Nancy Jane Earnest, David M. Simon and Anthony Feathers. Features natural history; humorous, realistic, computer and spot illustration. Assigns 100% of illustrations to experienced, but not well-known illustrators. Prefers Appalachia, any style. Considers b&w or 2- or 4-color pen & ink, collage, airbrush, marker and charcoal. Freelancers should be familiar with Macromedia FreeHand, PageMaker or Adobe Photoshop. Send query letter with brochure, SASE and photocopies. Samples are not filed and are returned by SASE if requested by artist. Reports back within 4-6 months. Publication will contact artist for portfolio review if interested. Portfolio should include b&w tearsheets, slides, final art and photographs. Buys one-time rights. Pays on publication; $50-100 for color cover; $25 maximum for b&w inside.

Tips: "We have special theme issues. Illustrations have to have something to do with theme. Write for guidelines, enclose SASE."

NUGGET, Firestone Publishing Co., 14411 Commerce Way, Suite 420, Miami Lakes FL 33016-1598. Editor: Christopher James. Illustration Assignments: Nye Willden. 4-color "eclectic, modern" magazine for men and women with fetishes. Published 12 times/year. Art guidelines for SASE with first-class postage.

Cartoons: Buys 5 cartoons/issue. Receives 50 submissions/week. Interested in "funny fetish themes." Black & white only for spots and for page. Prefers to see finished cartoons. Include SASE. Reports in 2 weeks. Buys first North American serial rights. Pays $75 for spot drawings; $125 for full page.

Illustration: Buys 2 illustrations/issue. Interested in "erotica, cartoon style, etc." Works on assignment only. Prefers to see samples of style. Send query letter with photocopies and tearsheets. Samples to be kept on file for future assignments. No samples returned. Publication will contact artist for portfolio review if interested. Buys first North American serial rights. Pays $300 for color inside; $75 for spots. Finds artists through submissions/self-promotions.

Tips: Especially interested in "the artist's anatomy skills, professionalism in rendering (whether he's published or not) and drawings which relate to our needs." Current trends include "a return to the 'classical' realistic form of illustration, which is fine with us because we prefer realistic and well-rendered illustrations."

⊭OFF DUTY MAGAZINE, 3303 Harbor #C2, Costa Mesa CA 92626. Fax: (714)549-4222. E-mail: odutyedit@aol.com. Executive Editor: Tom Graves. Estab. 1970. Consumer magazine published 6 times/year "for U.S. military community worldwide." Sample copy for 8½ × 11 SASE and 6 first-class stamps.

● There are three versions of *Off Duty Magazine*: U.S., Europe and the Pacific.

Illustration: Approached by 10-12 illustrators/year. Buys 0-1 illustration/issue. Considers airbrush, colored pencil, marker, pastel, watercolor and computer art. Knowledge of Adobe Illustrator helpful but not required. Send query letter with printed samples. Samples are filed. Does not report back. Artist should wait for call about an assignment. Buys one-time rights. **Pays on acceptance;** negotiable for cover; $200-300 for color inside. Finds illustrators through previous work and word of mouth.

Tips: "We're looking for computer (Illustrator better than FreeHand, and/or Photoshop) illustrators for an occasional assignment."

OFF OUR BACKS, a woman's journal, 2337B 18th St., Washington DC 20009. (202)234-8072. E-mail: offourbacks @compuserve.com. Office Coordinator: Jennie Ruby. Estab. 1970. Monthly feminist news journal; tabloid format; covers women's issues and the feminist movement. Circ. 10,000. Accepts previously published artwork. Original artwork is returned at the job's completion. Sample copies available; art guidelines free for SASE with first-class postage.
Cartoons: Approached by 6 freelance cartoonists/year. Buys 2 freelance cartoons/issue. Prefers political, feminist themes. Send query letter with roughs. Samples are filed. Reports back to the artist if interested within 2 months.
Illustration: Approached by 20 freelance illustrators/year. Prefers feminist, political themes. Considers pen & ink. Send query letter with photocopies. Samples are filed. Reports back to the artist only if interested. To show a portfolio, mail appropriate materials.
Tips: "Ask for a sample copy. Preference given to feminist, woman-centered, multicultural line drawings."

OFFICEPROⓇ, (formerly The Secretary), 2800 Shirlington Rd., Suite 706, Arlington VA 22206. (703)998-2534. Fax: (703)379-4561. E-mail: officepromag@strattonpub.com. Managing Editor: Angela Hickman Brady. Estab. 1945. Trade journal published 9 times/year. Publication directed to the office support professional. Emphasis is on workplace issues, trends and technology. Readership is 98% female. Circ. 40,000. Accepts previously published artwork. Originals returned at job's completion upon request only. Sample copies available (contact subscription office at (816)891-6600, ext. 235).
Illustration: Approached by 50 illustrators/year. Buys 20 or fewer illustrations/year. Works on assignment and purchases stock art. Prefers communication, travel, meetings and international business themes. Considers pen & ink, airbrush, colored pencil, mixed media, collage, charcoal, watercolor, acrylic, oil, pastel, marker and computer. Send postcard-size sample or send query letter with brochure, tearsheets and photocopies. Samples are filed. Reports back to the artist only if interested. Publication will contact artist for portfolio review if interested. Portfolio should include final art and tearsheets. Buys one-time rights usually, but rights purchased vary according to project. **Pays on acceptance** (net 30 days); $500-600 for color cover; $60-150 for b&w, $200-400 for color inside; $60 for b&w spots. Finds artists through word of mouth and artists' samples.

‡THE OFFICIAL PRO RODEO SOUVENIR PROGRAM, 4565 Hilton Pkwy., Suite 205, Colorado Springs CO 80907. (719)531-0177. Fax: (719)531-0183. Publisher: Steve Rempelos. Estab. 1973. Annual 4-color souvenir program for PRCA rodeo events. "This magazine is purchased by rodeo organizers, imprinted with rodeo name and sold to spectators at rodeo events." Circ. 400,000. Originals are returned at job's completion. Sample copies available. Art guidelines not available.
Illustration: Works on assignment only. "We assign a rodeo event—50%-art, 50%-photos." Considers all media. Send query letter with brochure, résumé, SASE, tearsheets, photographs and photocopies. Samples are filed. Publication will contact artist for portfolio review if interested. Buys one-time rights. Pays on publication; $250 for color cover.
Tips: Finds artists through artists' submissions/self-promotions, sourcebooks, artists' agents and reps, and attending art exhibitions. "Know about rodeos and show accurate (not necessarily photo-realistic) portrayal of event. Artwork is used on the cover about 50 percent of the time. Freelancers get more work now because our office staff is smaller."

OHIO MAGAZINE, 62 E. Broad St., Columbus OH 43215. (614)461-5083. Art Director: Brooke Wenstrup. 10 issues/ year emphasizing feature material of Ohio "for an educated, urban and urbane readership"; 4-color; design is "clean, with white-space." Circ. 90,000. Previously published work OK. Original artwork returned after publication. Sample copy $2.50; art guidelines not available.
Cartoons: Approached by 15 cartoonists/year. Buys 2 cartoons/year. Prefers b&w line drawings. Send brochure. Samples are filed or are returned by SASE. Reports back within 1 month. Buys one-time rights. Pays $50 for b&w and color.
Illustration: Approached by 70 illustrators/year. Buys 2 illustrations/issue. Works on assignment only. Has featured illustrations by David and Amy Butler and Chris O'Leary. Features charts & graphs; informational graphics; spot illustrations. Assigns 10% of illustrations to well-known or "name" illustrators; 80% to experienced, but not well-known illustrators; 10% to new and emerging illustrators. Considers pen & ink, watercolor, collage, acrylic, marker, colored pencil, oil, mixed media and pastel. 20% of freelance work demands knowledge of Adobe Illustrator, QuarkX-Press, Adobe Photoshop or Aldus FreeHand. Send postcard sample or brochure, SASE, tearsheets and slides. Accepts disk submissions. Send Mac EPS files. Samples are filed or are returned by SASE. Reports back within 1 month. Request portfolio review in original query. Portfolio should include b&w and color tearsheets, slides, photostats, photocopies and final art. Buys one-time rights. **Pays on acceptance**; $250-500 for color cover; $50-400 for b&w inside; $50-500 for color inside; $100-800 for 2-page spreads; $50-125 for spots. Finds artists through submissions and gallery shows.
Design: Needs freelancers for design and production. 100% of freelance work demands knowledge of Adobe Photoshop and QuarkXPress. Send query letter with tearsheets and slides.
Tips: "Use more of a fine art-style to illustrate various essays—like folk art-style illustrators. Please take time to look at the magazine if possible before submitting."

⊾OKLAHOMA TODAY MAGAZINE, 15 N. Robinson, Suite 100, Oklahoma City OK 73102. (405)521-2496. Fax: (405)522-4588. Website: http://oklahomatoday.com. Editor: Louisa McCabe. Estab. 1956. Bimonthly regional, upscale consumer magazine focusing on all things that define Oklahoma and interest Oklahomans. Circ. 43,000. Accepts pre-

viously published artwork. Originals are returned at job's completion. Sample copies and art guidelines available.

Cartoons: Buys 1 cartoon/issue. Prefers humorous cartoons focusing on Oklahoma, oil, cowboys or Indians with gagline. Send query letter with roughs. Samples are filed. Reports back within days if interested; months if not. Buys one-time rights. Pays $50 minimum for b&w, $75 minimum for color.

Illustration: Approached by 24 illustrators/year. Buys 2-3 illustrations/issue. Has featured illustrations by Tim Jossel, Steven Walker and Cecil Adams. Features caricatures of celebrities; natural history; realistic and spot illustration. Assigns 10% of illustrations to well-known illustrators; 80% to experienced, but not well-known illustrators; 10% to new and emerging illustrators. Considers pen & ink, watercolor, collage, airbrush, acrylic, marker, colored pencil, oil, charcoal and pastel. 20% of freelance work demands knowledge of Aldus PageMaker, Adobe Illustrator and Adobe Photoshop. Send query letter with brochure, résumé, SASE, tearsheets and slides. Accepts Mac-compatible disk submissions. Samples are filed. Reports back within days if interested; months if not. Portfolio review required if interested in artist's work. Portfolio should include b&w and color thumbnails, tearsheets and slides. Buys one-time rights. Pays $200-500 for b&w cover; $200-750 for color cover; $50-500 for b&w inside; $75-750 for color inside. Finds artists through sourcebooks, other publications, word of mouth, submissions and artist reps.

Tips: Illustrations to accompany short stories and features are most open to freelancers. "Read the magazine; have a sense of the 'New West' spirit and do an illustration or cartoon that exhibits your understanding of *Oklahoma Today*. Be willing to accept low fees at the beginning."

‡OLD BIKE JOURNAL, 1010 Summer St., Stamford CT 06905. (203)425-8777. Fax: (203)425-8775. Art Director: Jonas Land. Estab. 1989. Monthly international classic and collectible motorcycle magazine dedicated to classics of yesterday, today and tomorrow. Includes hundreds of classified ads for buying, selling or trading bikes and parts worldwide. Circ. under 100,000. Originals are returned at job's completion if requested. Sample copy $4 (US only). Art guidelines available. Computer-literate freelancers for illustration should be familiar with Adobe Photoshop, Adobe Illustrator or QuarkXPress.

Cartoons: Approached by 12 cartoonists/year. Buys 1-2 cartoons/issue. Prefers vintage motorcycling and humorous themes; single panel, b&w line drawings. Send query letter with copies of finished work. Samples are filed or are returned by SASE if requested by artist. Reports back within 1 month. Buys one-time rights. Pays $50 for b&w; $100 for color.

Illustration: Approached by 50-100 illustrators/year. Buys 1-5 illustrations/issue. Considers pen & ink, watercolor, airbrush, marker and colored pencil. Send query letter with brochure, SASE, tearsheets, photographs, photocopies, photostats, slides and transparencies. Samples are filed or are returned by SASE if requested. Reports back within 1 month. Call for appointment to show portfolio. Portfolio should include tearsheets, slides, photostats, photocopies and photographs. Buys one-time rights. Pays on publication; $25 for b&w; $100 for color.

Tips: "Send copies or photos of final art pieces. If they seem fit for publication, the individual will be contacted and paid upon publication. If not, work will be returned with letter. Often, artists are contacted for more specifics as to what might be needed."

‡THE OPTIMIST, 4494 Lindell Blvd., St. Louis MO 63108. (314)371-6000. Graphic Designer: Andrea Renner. 4-color magazine with 4-color cover that emphasizes activities relating to Optimist clubs in US and Canada (civic-service clubs). "Magazine is mailed to all members of Optimist clubs. Average age is 42; most are management level with some college education." Circ. 140,000. Sample copy for SASE; art guidelines not available.

Cartoons: Buys 2 or 3 cartoons/issue. Prefers themes of general interest: family-orientation, sports, kids, civic clubs. Prefers color single panel with gagline. No washes. Send query letter with samples. Send art on a disk if possible (Macintosh compatible). Submissions returned by SASE. Reports within 1 week. Buys one-time rights. **Pays on acceptance**; $30 for b&w; $40 for color.

✔OPTIONS, P.O. Box 170, Irvington NY 10533. Contact: Wayne Shuster. E-mail: natway@aol.com. Estab. 1981. Bimonthly consumer magazine featuring erotic stories and letters, and informative items for gay and bisexual males and females. Circ. 60,000. Accepts previously published artwork. Originals are returned at job's completion. Sample copies available for $3.50 and 6×9 SASE with first-class postage; art guidelines available for SASE with first-class postage.

Cartoons: Approached by 10 cartoonists/year. Buys 5 cartoons/issue. Prefers well drawn b&w, ironic, humorous cartoons; single panel b&w line drawings with or without gagline. Send query letter with finished cartoons. Samples are not filed and are returned by SASE if requested by artist. Reports back within 3 weeks. Buys all rights. Pays $20 for b&w.

Illustration: Approached by 2-3 illustrators/year. Buys 2-4 illustrations/issue. Has featured illustrations by Jack Whitlow and Al Pierce. Features realistic and spot illustration. Assigns 100% of illustrations to experienced, but not well-known illustrators. Prefers gay male sexual situations. Considers pen & ink, airbrush b&w only. Also buys color or b&w slides (35mm) of illustrations. Send postcard sample. "OK to submit computer illustration—Adobe Photoshop 3.0 and Adobe Illustrator 5.0 (Mac)." Samples are not filed and are returned by SASE if requested by artist. Reports back to the artist only if interested. Portfolio review not required. Buys all rights. Pays on publication; $50 for b&w inside; $50 for spots. Finds artists through submissions.

‡ORANGE COAST MAGAZINE, 3701 Birch St., Suite 100, Newport Beach CA 92660. (714)862-1133. Fax: (714)862-0133. E-mail: ocmag@aol.com. Website: http://www.orangecoast.com. Art Director: Liza Samala. Estab.

1970. Monthly 4-color local consumer magazine with celebrity covers. Circ. 30,000.

Illustration: Approached by 100 illustrators/year. Has featured illustrations by Cathi Mingus, Gweyn Wong, Scott Lauman, Santiago Veeda, John Westmark, Robert Rose, Nancy Harrison. Features computer, fashion and editorial illustrations featuring children and families. Prefers serious subjects; some humorous subjects. Assigns 10% of illustrations to well-known or "name" illustrators; 40% to experienced, but not well-known illustrators; 50% to new and emerging illustrators. 40% of freelance illustration demands knowledge of Adobe Illustrator or Adobe Photoshop. Send postcard or other non-returnable samples. Accepts Mac-compatible disk submissions. Send EPS files. Samples are filed. Reports back within 1 month. Will contact artist for portfolio review if interested. **Pays on acceptance**; $175 for b&w or color inside; $75 for spots. Finds illustrators through artist promotional samples.

Tips: "Looking for fresh and unique styles. We feature approximately four illustrators per publication. I've developed great relationships with all of them."

‡OREGON CATHOLIC PRESS, 5536 NE Hassalo, Portland OR 97213-3638. (503)281-1191. Fax: (503)282-3486. E-mail: jeang@ocp.org. Website: http://www.ocp.org/. Art Director: Jean Germano. Estab. 1988. Quarterly liturgical music planner in both Spanish and English with articles, photos and illustrations specifically for but not exclusive to the Roman Catholic market.

● See *OCP*'s listing in the Book Publishers section to learn about this publisher's products and needs.

Illustration: Approached by 10 illustrators/year. Buys 20 illustrations/issue. Features spot illustrations. Assigns 100% of illustrations to new and emerging illustrators. Send query letter with printed samples, photocopies, SASE. Samples are filed or returned by SASE. Reports back within 2 weeks. Portfolio review not required. Rights purchased vary according to project. **Pays on acceptance**; $100-250 for color cover; $30-50 for b&w spot art or photo.

THE OTHER SIDE, 300 W. Apsley St., Philadelphia PA 19144. (215)849-2178. Fax: (605)335-0368. Editor: Mark Olson. Art Director: Cathleen Benberg. "We are read by Christians with a radical commitment to social justice and a deep allegiance to biblical faith. We try to help readers put their faith into action." Publication is ½ b&w, ½ color with 4-color cover. Published 6 times/year. Circ. 14,000. Accepts previously published artwork. Sample copy available for $4.50.

Cartoons: Approached by 20-30 cartoonists/year. Buys 12-15 cartoons/year on current events, human interest, social commentary, environment, economics, politics and religion; single and multiple panel. Pays on publication; $25 for b&w line drawings. "Looking for cartoons with a radical political perspective."

Illustration: Approached by 40-50 artists/year. Especially interested in original artwork in color and b&w. Send query letter with tearsheets, photocopies, slides, photographs and SASE. Reports in 6 weeks. Simultaneous submissions OK. Publication will contact artist for portfolio review if interested. Pays within 1 month of publication; $50-100 for 4-color; $30-50 for b&w line drawings and spots.

Tips: "We're looking for artists whose work shares our perspective on social, economic and political issues."

‡☘OUTDOOR CANADA MAGAZINE, 703 Evans Ave., Suite 202, Toronto, Ontario M9C 5E9 Canada. Editor: James Little. 4-color magazine for the Canadian sports enthusiast and their family. Stories on fishing, camping, hunting, canoeing, wildlife and outdoor adventures. Readers are 81% male. Publishes 7 regular issues/year and a fishing special in February. Circ. 95,000. Art guidelines not available.

Illustration: Approached by 12-15 illustrators/year. Buys approximately 10 drawings/issue. Has featured illustrations by Malcolm Cullen, Stephen MacEachren and Jerzy Kolatch. Features humorous, computer and spot illustration. Assigns 90% to experienced, but not well-known illustrators; 10% to new and emerging illustrators. Uses freelancers mainly for illustrating features and columns. Uses pen & ink, airbrush, acrylic, oil and pastel. Send postcard sample, brochure and tearsheets. Accepts disk submissions compatible with Adobe Illustrator 5.0. Send EPS, TIFF and PICT files. Buys first rights. Pays $150-300 for b&w inside; $300-500 for color inside; $500-700 for 2-page spreads; $150-300 for spots. Artists should show a representative sampling of their work, including fishing illustrations. Finds most artists through references/word of mouth.

Design: Needs freelancers for multimedia. 20% of freelance work demands knowledge of Adobe Photoshop, Adobe Illustrator and QuarkXPress. Send brochure, tearsheets and postcards. Pays by the project.

Tips: "Meet our deadlines and our budget. Know our product."

‡OUTDOOR LIFE MAGAZINE, Dept. AGDM, 2 Park Ave., New York NY 10016. (212)779-5246. Fax: (212)686-6877. Contact: Art Director. Estab. 1897. Monthly magazine geared toward hunting, fishing and outdoor activities. Circ. 1,000,000. Original artwork is returned at job's completion. Sample copies not available.

Illustration: Works on assignment only. Considers mixed media. Send query letter with brochure, tearsheets, photographs and slides. Samples are filed. Reports back within a few weeks. Call for appointment to show portfolio of tearsheets, slides, photocopies and photographs. Rights purchased vary according to project. **Pays on acceptance**.

‡OUTER DARKNESS (Where Nightmares Roam Unleashed), 1312 N. Delaware Place, Tulsa OK 74110. (918)832-1246. Editor: Dennis Kirk. Estab. 1994. Quarterly digest/zine of horror and science fiction, poetry and art. Circ. 500. Sample copies free for 6×9 SASE and 2 first-class stamps. Art guidelines free for #10 SASE with first-class postage.

Cartoons: Approached by 12 cartoonists/year. Buys 15 cartoons/year. Prefers horror/science fiction slant, but not necessary. Prefers single panel, humorous, b&w line drawings. Send query letter with b&w photocopies, samples, SASE.

"I wanted to express the solemnity of Advent and Christmas combined with the lights and colors of the season. I like to mix traditional with contemporary," says Michael O'Neill McGrath. His watercolor and colored pencil illustration of Mary, which appeared on the cover of *Today's Liturgy* (published by Oregon Catholic Press), was also reprinted on a notecard. "Many of my published pieces become cards or prints. I have no agent; I don't do much advertising. I sell reproductions of my work via catalog [mailing about 750 a year] and at liturgical shows and presentations."

Samples are returned. Reports back within 2 weeks. Buys one-time rights. Pays on publication in contributor's copies.
Illustration: Approached by 10-12 illustrators/year. Buys 5-7 illustrations/issue. Has featured illustrations by Allen Koszowski, Lee Seed, Chad Savage, Jeff Ward, Russ Miller. Features realistic science fiction and horror illustrations. Prefers b&w, pen & ink drawings. Assigns 10% of illustrations to well-known or "name" illustrators; 80% to experienced, but not well-known illustrators; 10% to new and emerging illustrators. Send query letter with photocopies, SASE. Reports back within 2 weeks. Buys one-time rights. Pays on publication in contributor's copies. Finds illustrators through magazines and submissions.
Tips: "As it enters its fourth year of publication, *Outer Darkness* will feature more art than ever. It is my goal to turn *Outer Darkness* into a full-size, paying publication, similar to *Pirate Writings*, *Cemetery Dance* and *Absolute Magnitude*. In the meantime, contributing artists receive a lot of recognition, since copies are sent to editors of larger magazines and submitted for inclusion in anthologies. I'm eager to work with new artists as well as established professionals."

‡OUTPOSTS, WINGTIPS, COASTINES, 1200 N. Seventh St., Minneapolis MN 55411. (612)522-1200. Fax: (612)522-1182. Art Director: Bruce Krast. Bimonthly magazines. Circ. 500,000. Sample copies and art guidelines available.
• All three are inflight magazines for SkyWest, Comair and Business Express (all Delta Connections).
Cartoons: Approached by 10-15 cartoonists/year. Buys 2-3 cartoons/year. Prefers humor, political cartoons. Prefers single panel, political and humorous, color washes. Send query letter with photocopies and roughs. Samples are filed or returned. Reports back in 2 weeks. Buys all rights. **Pays on acceptance**; $50-250.
Illustration: Approached by 10 illustrators/year. Buys 10-15 illustrations/year. Prefers political, humor, trend issues. Considers all media. 50% of freelance illustration demands knowledge of Adobe Photoshop, Adobe Illustrator, QuarkXPress and Painter. Send postcard sample or query letter with printed samples and photocopies. After initial mailing, send follow-up postcard sample every 2-3 months. Accepts disk submissions. "We are Mac compatible and have the most updated versions of the programs." Samples are filed or returned. Reports back within 2-3 weeks. Request portfolio review in original query. Art director will contact artist for portfolio review of b&w and color thumbnails and transparencies if interested. Buys all rights. Pays on publication. Pays $50-250. Finds illustrators through word of mouth.
Tips: "See the magazines. We will often base an article on good art or ideas."

✔OVER THE BACK FENCE, 5311 Meadow Lane Court, Elyria OH 44035. (440)934-1812. Fax: (440)934-1816. E-mail: backfencepub@centuryinter.net. Website: http://www.backfence.com. Creative Director: Rocky Alten. Estab. 1994. Quarterly consumer magazine emphasizing northern and southern Ohio topics. Circ. 15,000 (each regional version). Sample copies for $4; art guidelines free for #10 SASE with first-class postage.
Illustration: Features humorous and realistic illustration; informational graphics and spot illustration. Assigns 50% of illustration to experienced, but not well-known illustrators; 50% to new and emerging illustrators. Knowledge of Adobe Photoshop and QuarkXPress helpful but not required. Send query letter with photocopies, SASE and tearsheets. Ask for guidelines. Accepts disk submissions compatible with QuarkXPress (for PC) and Photoshop (for PC). Send EPS or TIFF files. Samples are occasionally filed or returned by SASE. Reports back within 1-3 months. Creative director will contact artist for portfolio review if interested. Buys one-time rights. Pays on publication, net 15 days; $100 for b&w and color covers; $25-100 for b&w and color inside; $25-200 for 2-page spreads; $25-100 for spots. Finds illustrators through word of mouth and submissions.
Design: Needs freelancers for design. Prefers designers with experience in Quark and Photoshop for PC. Freelance work demands knowledge of Adobe Photoshop and QuarkXPress for PC. Send query letter with printed samples, photocopies, SASE and tearsheets.
Tips: "Our readership enjoys our warm, friendly approach. The artwork we select will possess the same qualities."

THE OXFORD AMERICAN, P.O. Box 1156, Oxford MS 38655-1156. (601)236-1836. E-mail: oxam@watervalley.net. Art Director: A. Newt Rayburn. Estab. 1992. Bimonthly literary magazine. "The Southern magazine of good writing." Circ. 30,000.
Illustration: Approached by many artists/year. Uses a varying number of illustrations/year. Considers all media. Send postcard sample of work. Samples are filed. Reports back only if interested. Art director will contact artist for portfolio review of final art and roughs if interested. Buys one-time rights. Pays on publication. Finds artists through word of mouth and submissions.
Tips: "See the magazine."

❀OXYGEN, 6465 Airport Rd., Mississauga, Ontario L4V 1E4 Canada. (905)678-7311. Fax: (905)678-9236. Contact: Pam Cottrell. Art Director: Robert Kennedy. Estab. 1997. Bimonthly consumer magazine. "Oxygen is a new magazine devoted entirely to women's fitness, health and physique." Circ. 180,000.
Illustration: Buys 2 illustrations/issue. Has featured illustrations by Erik Blais and Ted Hammond. Features caricatures of celebrities; charts & graphs; computer and realistic illustrations. Assigns 85% of illustrations to experienced, but not well-known illustrators; 15% to new and emerging illustrators. Prefers loose illustration, full color. Considers acrylic, airbrush, charcoal, collage, color washed, colored pencil, mixed media, pastel and watercolor. 50% of freelance illustration demands knowledge of Adobe Photoshop and QuarkXPress. Send query letter with photocopies and tearsheets. Samples are not filed and are returned. Reports back within 21 days. Buys all rights. **Pays on acceptance**; $1,000-2,000 for b&w and color cover; $50-500 for b&w and color inside; $100-1,000 for 2-page spreads. Finds illustrators through word of mouth and submissions.

Tips: "Artists should have a working knowledge of women's fitness. Study the magazine. It is incredible the amount of work that is sent that doesn't begin to relate to the magazine."

P.O.V., 38 The Fenway, Boston MA 02215. (617)247-3200. Fax: (617)247-1110. Contact: Art Director. Estab. 1995. Monthly consumer magazine for men in their 20s. Circ. 285,000
Illustration: Prefers conceptual and cutting-edge style. Considers all media. Send postcard sample of work. Samples are filed. Does not report back. Art director will contact artist for portfolio review if interested. Finds artists through magazines, word of mouth, submissions, *American Illustrator.*

‡✴**PACIFIC YACHTING MAGAZINE**, 300-780 Beatty St., Vancouver, British Columbia V6B 2M1 Canada. (604)606-4644. Fax: (604)687-1925. Editor: Duart Snow. Estab. 1968. Monthly 4-color magazine focused on boating on the West Coast of Canada. Power/sail cruising only. Circ. 25,000. Accepts previously published artwork. Original artwork returned at job's completion. Sample copies available for $3. Art guidelines not available.
Cartoons: Approached by 12-20 cartoonists/year. Buys 1 cartoon/issue. Boating themes only; single panel b&w line drawings with gagline. Send query letter with brochure and roughs. Samples are filed or are returned by SASE if requested by artist. Reports back within 1 month. Buys one-time rights. Pays $25-50 for b&w.
Illustration: Approached by 25 illustrators/year. Buys 6-8 illustrations/year. Boating themes only. Considers pen & ink, watercolor, airbrush, acrylic, colored pencil, oil and charcoal. Send query letter with brochure. Samples are filed or are returned by SASE if requested by artist. Reports back within 2 weeks only if interested. Call for appointment to show portfolio of appropriate samples related to boating on the West Coast. Buys one-time rights. Pays on publication; $300 for color cover; $50-100 for b&w inside; $100-150 for color inside; $25-50 for spots.
Tips: "Know boats and how to draw them correctly. Know and love my magazine."

‡**PALO ALTO WEEKLY**, 703 High St., Palo Alto CA 94301. (415)326-8210. Estab. 1979. Semiweekly newspaper. Circ. 45,000. Accepts previously published artwork. Originals returned at job's completion. Sample copies available..
Illustration: Buys 20-30 illustrations/year. Works on assignment only. Considers all media. Rarely needs computer-literate freelancers for production. Freelancers should be familiar with Adobe Illustrator, QuarkXPress or Aldus Free-Hand. Send query letter with brochure, résumé, SASE, tearsheets, photographs, photocopies, photostats, slides and transparencies. Samples are filed. Publication will contact artist for portfolio review if interested. Pays on publication; $175 for b&w cover, $200 for color cover; $100 for b&w inside, $125 for color inside.
Tips: Most often uses freelance illustration for covers and cover story, especially special section covers such as restaurant guides. "We call for artists' work in our classified ad section when we need some fresh work to look at. We like to work with local artists."

PARADE MAGAZINE, 711 Third Ave., New York NY 10017. (212)450-7000. E-mail: ira_yoffe@parade.com. Director of Design: Ira Yoffe. Photo Editor: Miriam White-Lorentzen. Weekly emphasizing general interest subjects. Circ. 40 million (readership is 86 million). Original artwork returned after publication. Sample copy and art guidelines available. Art guidelines for SASE with first-class postage.
Illustration: Uses varied number of illustrations/issue. Works on assignment only. Send query letter with brochure, résumé, business card and tearsheets to be kept on file. Call or write for appointment to show portfolio. Reports only if interested. Buys first rights, occasionally all rights.
Design: Needs freelancers for design. 100% of freelance work demands knowledge of Adobe Photoshop, Adobe Illustrator, QuarkXPress. Prefers local freelancers. Send query letter with résumé. Pays for design by the project, by the day or by the hour depending on assignment.
Tips: "Provide a good balance of work."

THE PATRIOT, 1816 Brownsville Rd., Pittsburgh PA 15210-3908. (412)885-7600. Fax: (412)885-7617. E-mail: lmona han@bellatlantic.net. Art Director/Production Coordinator: Lori Monahan. Community-oriented biweekly newspaper. Circ. 30,000. Sample copies available.
• Also publishes *American Skating World*, *The Server Food Service News*; and *WeddinGuide.*
Illustration: 2% of freelance illustration demands knowledge of CorelDraw 3 to 7.0; Corel Ventura. Send query letter with printed samples and photocopies. Accepts disk submissions compatible with CorelDraw 3.0 to 7.0; send CDR file. Samples are filed. Reports back only if interested. Art director will contact artist for portfolio review of b&w, color, final art, photographs and photostats if interested. Finds illustrators through magazines, mail, etc.
Tips: "We need fast workers with quick turnaround, people who can handle deadline pressures and know the basics of production when a computer system goes haywire, etc. Get inspired from the artwork that is around you . . . from the classical to science fiction artwork, and then create your own. Be persistent and show off your best work. Present yourself in a professional manner."

‡**PEDIATRIC ANNALS**, 6900 Grove Rd., Thorofare NJ 08086. (609)848-1000. E-mail: kcallan@slackinc.com. Website: http://www.slackinc.com. Managing Editor: Kimberly Callan. Monthly 4-color magazine emphasizing pediatrics for practicing pediatricians. "Conservative/traditional design." Circ. 35,000. Considers previously published artwork. Original artwork returned after publication. Sample copies available; art guidelines available.
Illustration: Has featured illustrations by Peg Gerrity and John Paul Genco. Features realistic and medical illustration. Prefers "technical and conceptual medical illustration which relate to pediatrics." Considers watercolor, acrylic, oil,

pastel and mixed media. Send query letter with brochure, tearsheets, slides and photographs to be kept on file. Publication will contact artist for portfolio review if interested. Buys one-time rights or reprint rights. Pays $250-700 for color cover. Finds artists through submissions/self-promotions and sourcebooks.

Tips: "Illustrators must be able to treat medical subjects with a high degree of accuracy. We need people who are experienced in medical illustration, who can develop ideas from manuscripts on a variety of topics, and who can work independently (with some direction) and meet deadlines. Non-medical illustration is also used occasionally. We deal with medical topics specifically related to children. Include color work, previous medical illustrations and cover designs in a portfolio. Show a representative sampling of work."

PENNSYLVANIA LAWYER, 100 South St., Harrisburg PA 17108-0186. (717)238-6715 ext. 241. Fax: (717)238-7182. Editor: Sherri Kimmel. Bimonthly association magazine "featuring nuts and bolts articles and features of interest to lawyers." Circ. 28,000. Sample copies for #10 SASE with first-class postage.

Cartoons: Approached by 2 cartoonists/year. Buys 1 cartoon/year. "No lawyer jokes." Send query letter with samples. Reports back within 1 month. Negotiates rights purchased. Pays on acceptance; $50 minimum.

Illustration: Approached by 6 illustrators/year. Buys 12 illustrations/year. Considers all media. Send query letter with samples. Samples are filed or returned by SASE. Reports back within 2 weeks. Art director will contact artist for portfolio review if interested. Negotiates rights purchased. **Pays on acceptance**; $185-800 for color cover; $100-200 for b&w inside. Pays $25-50 for spots. Finds illustrators through word of mouth and artists' submissions.

Tips: "Artists must be able to interpret legal subjects, have fresh look."

‡*PEOPLE MANAGEMENT, 17 Britton St., London EC1M 5NQ England. Phone: (044)0171 880 6200. Fax: (044)0171 336 7635. E-mail: mark@ppltd.co.uk. Art Director: Mark Parry. Estab. 1970s. Fortnightly 4-color trade publication for professionals in personnel, training and development. Circ. 80,000.

Illustration: Approached by 50 illustrators/year. Buys 1 illustration/issue. Has featured illustrations by: John-Paul Early and Matthew Richardson. Features computer illustrations of business subjects. Assigns 40% of illustrations to well-known or "name" illustrators; 40% to experienced, but not well-known illustrators; 20% to new and emerging illustrators. Send postcard sample. Accepts Mac-compatible disk submissions. Samples are filed or returned by SASE. Reports back only if interested. Will contact artist for portfolio review if interested. Pays on publication; $450-900 for color cover; $300-450 for color inside. Finds illustrators through agents.

PERSIMMON HILL, 1700 NE 63rd St., Oklahoma City OK 73111. (405)478-6404. Fax: (405)478-4714. Director of Publications: M.J. Van Deventer. Estab. 1970. Quarterly 4-color journal of Western heritage "focusing on both historical and contemporary themes. It features nonfiction articles on notable persons connected with pioneering the American West; art, rodeo, cowboys, flora and animal life; or other phenomena of the West of today or yesterday. Lively articles, well written, for a popular audience. Contemporary design follows style of *Architectural Digest* and *European Travel and Life*." Circ. 15,000. Original artwork returned after publication. Sample copy for $9.

Illustration: Approached by 75-100 illustrators/issue. Buys 1-2 illustrations/issue. Works on assignment only. Prefers Western-related themes and pen & ink sketches. 50% of freelance work demands knowledge of Aldus PageMaker. Send query letter with tearsheets, SASE, slides and transparencies. Samples are filed or returned by SASE if requested. Publication will contact artist for portfolio review if interested. Portfolio should include original/final art, photographs or slides. Buys first rights. Requests work on spec before assigning job. Pay varies. Finds artists through word of mouth and submissions.

Tips: "We are a museum publication. Most illustrations are used to accompany articles. Work with our writers, or suggest illustrations to the editor that can be the basis for a freelance article or a companion story. More interest in the West means we have to provide more contemporary photographs and articles about what people in the West are doing today. Study the magazine first—at least four issues."

‡PET BUSINESS, 7L Dundas Circle, Greensboro NC 27407-1615. Editor: Rita Davis. A monthly 4-color news magazine for the pet industry (retailers, distributors, manufacturers, breeders, groomers). Circ. 19,584. Accepts previously published artwork. Sample copy $3.

Illustration: Occasionally needs illustration for business-oriented cover stories. Portfolio review not required. Pays on publication; $200.

Tips: "Send two or three samples and a brief bio, only."

‡PHI DELTA KAPPAN, Box 789, Bloomington IN 47402. E-mail: kappan@pdkintl.org. Website: http://www.pdkintl.org/kappan/kappan.htm. Design Director: Carol Bucheri. Emphasizes issues, policy, research findings and opinions in the field of education. For members of the educational organization Phi Delta Kappa and subscribers. Black & white with 4-color cover and "conservative, classic design." Published 10 times/year. Circ. 150,000. Include SASE. Reports in 2 months. "We return illustrations and cartoons after publication." Sample copy for $4.50. "The journal is available in most public and college libraries."

Cartoons: Approached by over 100 cartoonists/year. Looks for "finely drawn cartoons, with attention to the fact that we live in a multi-racial, multi-ethnic world."

Illustration: Approached by over 100 illustrators/year. Uses 1 4-color cover and spread and approximately 7 b&w illustrations/issue, all from freelancers who have worked on assignment. Features caricatures of politicans; humorous, realistic, computer and spot illustraion. Prefers style of John Berry, Brenda Grannan, Mario Noche. Most illustrations

depict some aspect of the education process (from pre-kindergarten to university level), often including human figures. Send postcard sample. Samples returned by SASE. To show a portfolio, mail a few slides or photocopies with SASE. "We can accept computer illustrations that are Mac formatted (EPS or TIFF files. Adobe Photoshop 3.0 or Adobe Illustrator 6.0)." Buys one-time rights. Payment varies.

Tips: "We look for artists who can create a finely crafted image that holds up when translated onto the printed page. Our journal is edited for readers with master's or doctoral degrees, so we look for illustrators who can take abstract concepts and make them visual, often through the use of metaphor."

⊮PHYSICIAN'S MANAGEMENT, 7500 Old Oak Blvd., Cleveland OH 44130. (440)243-8100. Fax: (440)891-2683. E-mail: advedhc@en.com. Art Director: Laura Watilo Blake. Monthly 4-color magazine emphasizing business, practice management and legal aspects of medical practice for primary care physicians. Circ. 130,000. Art guidelines not available.

Cartoons: Receives 50-70 cartoons/week. Buys 5 cartoons/issue. Themes typically apply to medical and financial situations "although we do publish general humor cartoons." Prefers camera-ready, single and double panel b&w line drawings with gagline. Uses "only clean-cut line drawings." Send cartoons with SASE. **Pays on acceptance**; $90.

Illustration: Buys 2-4 illustrations/issue. Accepts b&w and color illustrations. All work done on assignment. Send a query letter to editor or art director first or send examples of work. Publication will contact artist for portfolio review if interested. Fees negotiable. Buys all rights.

Tips: "Become familiar with our publication. Cartoons should be geared toward the physician—not the patient. No cartoons about drug companies or medicine men. No sexist cartoons. Illustrations should be appropriate for a serious business publication. We do not use cartoonish or comic book styles to illustrate our articles. We work with artists nationwide." Impressed by freelancers who "do high quality work, have an excellent track record, charge reasonable fees and are able to work under deadline pressure."

PLAYBOY MAGAZINE, 680 Lakeshore Dr., Chicago IL 60611. (312)751-8000. Managing Art Director: Kerig Pope. Estab. 1952. Monthly magazine. Circ. 3.5 million. Originals returned at job's completion. Sample copies available.

Cartoons: Cartoonists should contact Michelle Urry, Playboy Enterprises Inc., Cartoon Dept., 730 Fifth Ave., New York NY 10019. "Please do not send cartoons to Kerig Pope!" Samples are filed or returned. Reports back within 2 weeks. Buys all rights.

Illustration: Approached by 700 illustrators/year. Buys 30 illustrations/issue. Prefers "uncommercial looking" artwork. Considers all media. Send postcard sample or query letter with slides and photocopies or other appropriate sample. Does not accept originals. Samples are filed or returned. Reports back within 2 weeks. Buys all rights. **Pays on acceptance**; $1,200/page; $2,000/spread; $250 for spots.

Tips: "No phone calls, only formal submissions of five pieces."

PN/PARAPLEGIA NEWS, 2111 E. Highland Ave., Suite 180, Phoenix AZ 85016-4702. (602)224-0500. Fax: (602)224-0507. E-mail: pvapub@aol.com. Art Director: Susan Robbins. Estab. 1947. Monthly 4-color magazine emphasizing wheelchair living for wheelchair users, rehabilitation specialists. Circ. 27,000. Accepts previously published artwork. Original artwork not returned after publication. Sample copy free for large-size SASE with $3 postage.

Cartoons: Buys 3 cartoons/issue. Prefers line art with wheelchair theme. Prefers single panel b&w line drawings with or without gagline. Send query letter with finished cartoons to be kept on file. Write for appointment to show portfolio. Material not kept on file is returned by SASE. Reports only if interested. Buys all rights. **Pays on acceptance**; $10 for b&w.

Illustration: Prefers wheelchair living or medical and financial topics as themes. 50% of freelance work demands knowledge of QuarkXPress, Adobe Photoshop or Adobe Illustrator. Send postcard sample. Accepts disk submissions compatible with Adobe Illustrator 7.0 or Photoshop 4.0. Send EPS of TIFF files. Samples not filed are returned by SASE. Publication will contact artist for portfolio review if interested. Portfolio should include final reproduction/product, color and b&w tearsheets, photostats, photographs. Pays on publication; $250 for color cover; $10 for b&w inside, $25 for color inside.

Tips: "When sending samples, include something that shows a wheelchair user. We have not purchased an illustration or used a freelance designer for several years. We do regularly purchase cartoons that depict wheelchair users."

‡THE POCKET GUIDE, 9650 Clayton Rd., St. Louis MO 63124-1569. (314)991-5222. E-mail: pocktguide@primary. net. Website: http://www.pocketguide.com. President: Lawrence D. Jones. Executive Vice President: Andrew K. Jones. Publisher/Managing Editor: Robert Donnelly. Estab. 1983. Publishes bimonthly, quarterly and annual visitor magazines for 47 resorts, cities, areas. Accepts previously published artwork. Originals returned at job's completion. Sample copies free for #10 SASE with first-class postage. Art guidelines for SASE with first-class postage.
 ● Publications include: *The Skier's Pocket Guide, The Golfer's Pocket Guide, The Traveler's Pocket Guide*

Cartoons: Approached by 8-10 freelancers/year. Prefers skiing, golf, families, travel themes. Prefers humorous, single panel color washes and b&w line drawings with or without gagline. Needs computer-literate freelancers. Send postcard-size sample or query letter with finished cartoons. Samples are filed or returned by SASE if requested by artist. Reports back within 10-14 days. Rights purchased vary according to project (usually one-time rights).

Illustration: Approached by 8-10 illustrators/year. Buys 1-2 illustrations/issue. Assigns 70% of illustrations to experienced, but not well-known illustrators; 30% to new and emerging illustrators. Prefers skiing, golf, travel, humorous and families. 100% of freelance work demands knowledge of QuarkXPress and Word. Considers pen & ink, watercolor,

pastel and marker. Send postcard-size sample. Samples are filed or returned by SASE. Reports back within 10-14 days. Publication will contact artist for portfolio review of thumbnails, roughs, tearsheets and photocopies if interested. Rights purchased vary according to project (usually one-time rights). Pays on publication.
Tips "Show up with a portfolio and/or call for an appointment."

POCKETS, Box 189, 1908 Grand Ave., Nashville TN 37202. (615)340-7333. E-mail: pockets@upperroom.org. Website: http://www.upperroom.org. Editor: Janet Knight. Devotional magazine for children 6-12. 4-color with some 2-color. Monthly except January/February. Circ. 100,000. Accepts previously published material. Original artwork returned after publication. Sample copy for SASE with 4 first-class stamps.
Illustration: Approached by 50-60 illustrators/year. Features humorous, realistic, computer and spot illustration. Assigns 5% of illustrations to well-known or "name" illustrators; 80% to experiecned, but not well-known illustrators; 15% to new and emerging illustrators. Uses variety of styles; 4-color, 2-color, flapped art appropriate for children. Realistic, fable and cartoon styles. Send postcard sample, brochure, photocopies, SASE and tearsheets. Also open to more unusual art forms: cut paper, embroidery, etc. Samples not filed are returned by SASE. "No response without SASE." Reports only if interested. Buys one-time or reprint rights. **Pays on acceptance**; $600 flat fee for 4-color covers; $50-250 for b&w inside, $75-350 for color inside.
Tips: "Decisions made in consultation with out-of-house designer. Send samples to our designer: Chris Schechner, 3100 Carlisle Plaza, Suite 207, Dallas, TX 75204."

✔POLICY REVIEW: THE JOURNAL OF AMERICAN CITIZENSHIP, 214 Massachusetts Ave., Washington DC 20002. (202)608-6163. Fax: (202)608-6136. E-mail: polrev@heritage.org. Website: http://www.heritage.org. Managing Editor: David Miller. Estab. 1977. Bimonthly "conservative public-policy magazine focusing on private, non-government solutions to social problems." Circ. 25,000. Sample copies free for #10 SASE with first-class postage.
Illustration: Approached by 40 illustrators/year. Buys 4-5 illustrations/issue. Has featured illustrations by Phil Foster, David Clark and Christopher Bing. Features caricatures of politicians, humorous, realistic, and conceptual spot illustration. Prefers b&w, conceptual work. Considers charcoal, collage and pen & ink. Send postcard sample. Accepts disk submissions compatible with QuarkXPress for PC; prefers TIFF or EPS files. Samples are filed. Reports back only if interested. Art director will contact artist for portfolio review if interested. Rights purchased vary according to project. Pays on publication; negotiable. Pays $100-200 for spots.

POTATO EYES, Box 76, Troy ME 04987. (207)948-3427. E-mail: potatoeyes@uninet.net. Co-Editor: Carolyn Page. Estab. 1988. Biannual literary magazine; b&w with 2-color cover. Design features "strong art showing rural places, people and objects in a new light of respect and regard. Focuses on the Appalachian chain from the Laurentians to Alabama but not limited to same. We publish people from all over the world." Circ. 800. Original artwork returned at job's completion. Sample copies available: $5 for back issues, $6 for current issue; art guidelines available for SASE with first-class postage.
● Also occasionally publishes *The Nightshade Short Story Reader*, same format, and five poetry chapbooks/year.
Illustration: Has featured illustrations by Vasily Kafanov, David Kooharian, Kathryn DiLego and Elena Ivanova. Features realistic illustration. Assigns 60% of illustration to experienced, but not well-known illustrators; 40% to new and emerging illustrators. Prefers detailed pen & ink drawings or block prints, primarily realistic. No cartoons. Send query letter with photocopies. Samples are filed and are not returned. Reports back within 2 months. Acquires one-time rights. Requests work on spec before assigning job. Pays on publication; $50-100 for b&w or color cover; $25-50 for b&w inside. Spots are paid for in contributor's copies. "Our *Artist's & Graphic Designer's Market* listing has sent us hundreds of artists. The rest have come through word of mouth."
Tips: "We hope to utilize more black & white photography to complement the black & white artwork. An artist working with quill pens and a bottle of India ink could do work for us. A woodcarver cutting on basswood using 19th-century tools could work for us. Published artists include Soshanna Cohen, Lynn Foster Hill, David Kooharian and Vasily Kafanov. A Burbank artist, Kathryn DiLego, has done six color covers for us. We look for only the highest-quality illustration. If artists could read a sample issue they would save on time and energy as well as postage. A lot of what we receive in the mail is line drawing verging on cartoon and not particularly well done. We seek a look that is more fine art than flip art or clip art. If you are not a serious artist don't bother us, please."

‡POTPOURRI, A Magazine of the Literary Arts, P.O. Box 8278, Prairie Village KS 66208-0278. (913)642-1503. Fax: (913)642-3128. E-mail: potpourpub@aol.com. Art Director: Sophia Myers. Estab. 1989. Quarterly b&w literary magazine featuring short stories, poetry, essays on arts, illustrations. Circ. 3,000. Art guidelines free for SASE with first-class postage. Sample copy for $4.95.
Illustration: Approached by 20 illustrators/year. Buys 10-12 illustrations/issue. Has featured illustrations by M. Keating, E. Reeve, A. Olsen, T. Devine, D.J. Baker, D. Transue, S. Chapman, W. Philips, M. Larson, D. McMillion. Features caricatures of literary celebrities, computer and realistic illustrations. Prefers pen & ink. Assigns 100% of illustrations to experienced, but not well-known illustrators. Send query letter with printed samples, photocopies and SASE. Samples are filed. Reports back within 3 months. Portfolio review not required. Buys one-time and reprint rights. Pays on publication, in copies. Finds illustrators through sourcebooks, artists' samples, word of mouth.
Tips: "*Potpourri* changed format in the last two years and now seeks original illustrations for its short stories. Also open to submissions for cover illustration of well-known literary persons. Prefer clean, crisp black & white illustrations

and quick turn-around. *Potpourri* is entering its tenth year of publication and offers artists an opportunity for international circulation/exposure."

POWDER MAGAZINE, 33046 Calle Aviador, San Juan Capistrano CA 92675. (714)496-5922. Fax: (714)496-7849. E-mail: rfrank@surferpubs.com. Art Director: Regina Frank. Estab. 1972. Monthly consumer magazine "for core skiers who live, eat and breathe skiing and the lifestyle that goes along with it." Samples are available; art guidelines not available.
Illustration: Approached by 20-30 illustrators/year. Buys 5-10 illustrations/year. Has featured illustrations by Peter Spacek, Dan Ball and Santiago Uceda. Features humorous and spot illustration. Assigns 10% of illustrations to well-known or "name" illustrators; 70% to experienced, but not well-known illustrators; 20% to new and emerging illustrators. "Illustrators have to know a little about skiing." Considers all media. 10% of freelance illustration demands knowledge of Adobe Photoshop 3.0, Adobe Illustrator 5.0 and QuarkXPress 3.3. Send postcard sample or with tearsheets. Accepts Macintosh EPS files compatible with QuarkXPress 3.3. Samples are filed. Reports back only if interested. Buys one-time rights. **Pays on acceptance;** $100-300 for b&w inside; $200-400 for color inside; $400-1000 for 2-page spreads; 100-300 for spots.. Finds illustrators through sourcebooks and submissions.
Design: Needs freelancers for design and multimedia projects. Prefers local design freelancers. 100% of freelance work demands knowledge of Adobe Photoshop 3.0, Adobe Illustrator 5.0 and QuarkXPress 3.3. Send query letter with printed samples and photocopies.
Tips: "We like cutting-edge illustration, photography and design. We need it to be innovative and done quickly. We give illustrators a lot of freedom. Send sample or promo and do a follow-up call."

POWER AND LIGHT, 6401 The Paseo, Kansas City MO 64131. (816)333-7000 ext. 2243. Fax: (816)333-4439. Editor: Beula Postlewait. Associate Editor: Melissa Hammer. Estab. 1992. "*Power and Light* is a weekly 8 page, 2- and 4-color story paper that focuses on the interests and concerns of the preteen (11- to 12-year-old). We try to connect what they learn in Sunday School with their daily lives." Circ. 40,000. Originals are not returned. Sample copies and art guidelines free for SASE with first-class postage.
Cartoons: Buys 1 cartoon/issue. Prefers humor for the preteen; single panel b&w line drawings with gagline. Send query letter with finished cartoon samples and SASE. Samples are filed or are returned by SASE if requested. Reports back within 3 months. Buys multi-use rights. Pays $15 for b&w.
Illustration: Buys 1 illustration/issue. Works on assignment only. Should relate to preteens. Considers acrylic, color washed, colored pencil, pen & ink, watercolor, airbrush, marker and pastel. Send query letter with samples and SASE. Accepts submissions on disk (write for guidelines). Samples are filed. Reports back only if interested. Art Director will contact artist for portfolio review if interested. Portfolio should include roughs, final art samples, black and white, color photographs. Buys all rights. Sometimes requests work on spec before assigning job. Pays on publication; $40 for b&w cover and inside; $75 for color cover and inside. Finds artists through submissions, word of mouth, magazines, WWW.
Tips: "Send a résumé, photographs or photocopies of artwork and a SASE to the office. A follow-up call is appropriate within the month. Adult humor is not appropriate. Keep in touch. Show us age-appropriate, color, quality or black & white materials. Know children."

PRAIRIE DOG, P.O. Box 470757, Aurora CO 80047-0757. (303)753-0956. Fax: (303)753-0956. E-mail: jrhart@isys.net. Editor-in-Chief: John R. Hart. Estab. 1995. Biannual literary magazine. Circ. 600. Sample copy available for $5.95 plus 4 first-class stamps. Art guidelines free for SASE with first-class postage.
Illustration: Approached by 10 illustrators/year. Buys 20 illustrations/issue. Considers all media. Send query letter with printed samples. Accepts disk submission in GIF, JPG, BMP, CDR, PCX or TIF files. Samples are filed. Reports back within 6 months. Buys first-rights. Pays on publication, 1 copy of magazine.
Tips: "Read our magazine."

♣PRAIRIE JOURNAL TRUST, P.O. Box 61203 Brentwood P.O., Calgary, Alberta T2L 2K6 Canada. Estab. 1983. Biannual literary magazine. Circ. 600. Sample copies available for $6; art guidelines for SAE with IRCs only.
Illustration: Approached by 8 illustrators/year. Buys 5 illustrations/issue. Has featured illustrations by C. Weiss, A. Peycha, B. Carlson, H. Spears, H. Love and P. Wheatley. Considers b&w only. Send query letter with photocopies. Samples are not filed and are returned by SASE if requested by artist. Reports back within 6 months. Portfolio review not required. Acquires first rights. Pays honorarium for b&w cover.
Tips: "Send copies only of work available for publication. We are very open to black & white artwork."

‡PRAIRIE SCHOONER, 201 Andrews Hall, University of Nebraska, Lincoln NE 68588-0334. (402)472-3191. Fax: (402)472-9771. Editor: Hilda Raz. Managing Editor: Ladette Randolph. Estab. 1927. Quarterly b&w literary magazine with 2-color cover. "*Prairie Schooner*, now in its 72nd year of continuous publication, is called 'one of the top literary magazines in America' by *Literary Magazine Review*. Each of the four issues contains short stories, poetry, book reviews, personal essays, interviews or some mix of these genres. Contributors are both established and beginning writers. Readers live in all states in the U.S. and in most countries outside the U.S." Circ. 3,200. Original artwork is returned after publication. "We rarely have the space or funds to reproduce artwork in the magazine but hope to do more in the future." Sample copies for $5.
Illustration: Approached by 1-5 illustrators/year. Uses freelancers mainly for cover art. "Before submitting, artist should be familiar with our cover and format, 6×9, black and one color or b&w, vertical images work best; artist should

look at previous issues of *Prairie Schooner*. Portfolio review not required. We are rarely able to pay for artwork; have paid $50 to $100."
Tips: Finds artists through word of mouth. "We're trying for some four-color covers."

THE PREACHER'S MAGAZINE, 10814 E. Broadway, Spokane WA 99206. (509)226-3464. Fax: (509)926-8740. Editor: Randal E. Denny. Estab. 1926. Quarterly trade journal "for pastors and other holiness preachers." Circ. 18,000.
Cartoons: Approached 4-5 cartoonists. Buys 5 cartoons/issue. Prefers single, double and multiple panel, humorous, b&w washes and line drawings with gagline. Send query letter with photocopies. Samples are filed or returned by SASE. Reports back within 1 month with SASE. Buys one-time rights. Pays on publication; $20-25 for b&w.

♣**THE PRESBYTERIAN RECORD**, 50 Wynford Dr., North York, Ontario M3C 1J7 Canada. (416)441-1111. E-mail: pcrecord@presbyterian.ca. Production and Design: Tim Faller. Published 11 times/year. Deals with family-oriented religious themes. Circ. 60,000. Original artwork returned after publication. Simultaneous submissions and previously published work OK. Free sample copy and artists' guidelines for SASE with first-class postage.
Cartoons: Approached by 12 cartoonists/year. Buys 1-2 cartoons/issue. Interested in some theme or connection to religion. Send roughs and SAE (nonresidents include IRC). Reports in 1 month. Pays on publication; $25-50 for b&w.
Illustration: Approached by 6 illustrators/year. Buys 1 illustration/year on religion. Has featured illustrations by Ed Schnurr, Claudio Ghirardo and Chrissie Wysotski. Features humorous, realistic and spot illustration. Assigns 50% of illustrations to experienced, but not well-known illustrators; 50% to new and emerging illustrators. "We are interested in excellent color artwork for cover." Any line style acceptable—should reproduce well on newsprint. Works on assignment only. Send query letter with brochure showing art style or tearsheets, photocopies and photographs. Will accept computer illustrations compatible with QuarkXPress 3.32, Adobe Illustrator 7.0, Adobe Photoshop 4.0. Samples returned by SAE (nonresidents include IRC). Reports in 1 month. To show a portfolio, mail final art and color and b&w tearsheets. Buys all rights on a work-for-hire basis. Pays on publication; $50-100 for b&w cover; $100-300 for color cover; $25-80 for b&w inside; $25-60 for spots.
Tips: "We don't want any 'cute' samples (in cartoons). Prefer some theological insight in cartoons; some comment on religious trends and practices."

PRESBYTERIANS TODAY, 100 Witherspoon St., Louisville KY 40202. (502)569-5636. Fax: (502)569-8632. Art Director: Linda Crittenden. Estab. 1830. 4-color; official church magazine emphasizing religious world news and inspirational features. Publishes 10 issues year. Circ. 85,000. Originals are returned after publication if requested. Sample copies for SASE with first-class postage.
Cartoons: Approached by 20-30 cartoonists/year. Buys 1-2 freelance cartoons/issue. Prefers general religious material; single panel. Send roughs and/or finished cartoons. Samples are filed or are returned. Reports back within 1 month. Rights purchased vary according to project. Pays $25, b&w.
Illustration: Approached by more than 50 illustrators/year. Buys 2-6 illustrations/issue, 50 illustrations/year from freelancers. Works on assignment only. Prefers ethnic, mixed groups and symbolic world unity themes. Media varies according to need. Send query letter with slides. Samples are filed or are returned by SASE. Reports back only if interested. Buys one-time rights. Pays $150-350, cover; $80-250, inside.

PRESS, 125 W., 72nd St., Suite 3-M, New York NY 10023. (212)579-0873. Fax: (212)579-0776. Editor: Daniel Roberts. Estab. 1995. Quarterly literary magazine. "We publish poems, stories and cartoons." Circ. 15,000. Samples copies available.
Cartoons: Approached by 20-50 cartoonists/year. Buys 3-5 cartoons/issue. Prefers humor, satire, oddness. Prefers single, double or multiple panel, humorous, b&w or color washes, b&w line drawings, with or without gagline. Send query letter with photocopies and SASE. Reports back within 6 weeks. Rights purchased vary according to project. **Pays on acceptance;** $50 minimum.
Illustration: Approached by 10-20 illustrators/year. Buys 1-2 illustrations/issue. Considers all media. 25% of freelance illustration demands knowledge of Adobe Photoshop, Adobe Illustrator and QuarkXPress. Send query letter with photocopies and SASE. Reports back within 6 weeks. Artist should follow-up with call and/or letter after initial query. Portfolio should include b&w, color, final art, photographs, photostats and roughs. Rights purchased vary according to project. **Pays on acceptance;** $150 minimum; $100-250 for spots. Finds illustrators through art director's resources.
Design: Needs freelancers for design, production and multimedia projects. Prefers local design freelancers only. 25% of freelance work demands knowledge of Adobe Photoshop, Adobe Illustrator and QuarkXPress. Send query letter with photocopies and SASE.
Tips: "Query often as our freelance needs vary dramatically."

PREVENTION, 33 E. Minor St., Emmaus PA 18098. (610)967-7548. Fax: (610)967-7654. Contact: Art Director. Estab. 1950. Monthly consumer magazine covering health and fitness, women readership. Circ. 3 million. Art guidelines available.
Illustration: Approached by 500-750 illustrators/year. Considers all media. Send query letter with photocopies, tearsheets. Accepts submissions on disk. Samples are filed or are returned. Reports back only if interested. Art director will contact artist for portfolio review of b&w, color, photographs, tearsheets, transparencies if interested. Buys first North American serial rights. Finds illustrators through *Black Book*, *Workbook*, *Showcase*, magazines, submissions.

PRIME TIME SPORTS & FITNESS, P.O. Box 6097, Evanston IL 60201. (847)864-8113. Fax: (847)864-1206. E-mail: dadornea@aol.com. Contact: D. Dorner. Estab. 1977. Magazine published 8 times/year "covering sports and fitness, women's sports and swimwear fashion." Circ. 47,000. Sample copies available; art guidelines for #10 SASE with first-class postage.

Cartoons: Approached by 30 cartoonists/year. Buys 2 cartoons/issue. Prefers sports-fitness theme. Prefers multiple panel, humorous, b&w washes. Send query letter with photocopies, "must see completed work." Samples are filed and are not returned. Buys first North American serial rights, negotiates rights purchased. Pays on publication; $10-100 for b&w, $25-200 for color.

Illustration: Approached by over 100 illustrators/year. Buys 6 illustrations/issue. Has featured illustrations by Nancy Thomas, Phil Greco andLarry Balsamo. Features caricatures of celebrities; fashion, humorous and realistic illustration; charts and graphs; informational graphics; medical, computer andspot illustration. Assigns 5% of illustrations to well-known or "name" illustrators; 25% to experienced, but not well-known illustrators; 60% to new and emerging illustrators. Prefers women in sports. Considers all media. 40% of freelance illustration demands knowledge of Aldus Page-Maker, Draw, Microsoft Publisher. Send query letter with photocopies. Samples are not filed and are returned by SASE. Reports back within 3 months. Buys all rights. Pays on publication; $10-200 for b&w cover; $20-200 for color cover; $10-25 for b&w inside; $10-100 for color inside; $25-100 for 2-page spreads; $5-25 for spots.

Design: Needs freelancers for design, production and multimedia projects. Prefers local design freelancers. 40% of freelance work demands knowledge of Microsoft Publisher. Send query letter with photocopies.

Tips: "Don't waste time giving us credits, work stands alone by itself. In fact we are turned off by experience and credits and turned on by good artwork. Find out what articles and features are planned then work art to fill."

PRINCETON ALUMNI WEEKLY, 194 Nassau St., Princeton NJ 08542. (609)258-4722. Fax: (609)258-2247. Art Director: Stacy Wszola. Estab. 1896. Biweekly alumni magazine, published independent of the university. Circ. 58,000. Sample copies available.

Illustration: Approached by 20-25 illustrators/year. Buys 25-30 illustrations/year. Considers all media. "We prefer hand drawn—use computer graphics only for charts, graphs." 5% of freelance illustration demands knowledge of Aldus PageMaker, Adobe Photoshop, Adobe Illustrator. Send postcard sample. After initial mailing, send follow-up postcard sample every 3 months. Samples are filed and are not returned. Reports back only if interested. Art director will contact artist for portfolio review if interested. Portfolio should include "what artist feels will best show work. In phone call to set up appointment artist will be told what art director is looking for." Buys first or one-time rights; varies according to project. **Pays on acceptance.** Pays $250-1,200 for color cover; $100-400 for b&w, $150-1,000 for color inside; $100-250 for spots. Finds illustrators through agents, submissions and *Graphic Artists Guild Directory of Illustration*.

Tips: "Artist must be able to take art direction."

✿**PRISM INTERNATIONAL**, Department of Creative Writing, U.B.C., Buch E462—1866 Main Mall, Vancouver, British Columbia V6T 1Z1 Canada. (604)822-2514. Fax: (604)822-3616. E-mail: prism@unixg.ubc.ca. Website: http://www.arts.ubc.ca/prism. Editors: Sioux Browning and Melanie Little. Estab. 1959. Quarterly literary magazine. "We use cover art for each issue." Circ. 1,200. Original artwork is returned to the artist at the job's completion. Sample copies for $5, art guidelines for SASE with first-class postage.

Illustration: Approached by 20 illustrators/year. Buys 1 cover illustration/issue. Has featured illustrations by Scott Bakal, Chris Woods, and Angela Grossman. Features representational and non-representational fine art. Assigns 50% of illustrations to experienced, but not well-known illustrators; 50% to new and emerging illustrators. "Most of our covers are full color; however, we try to do at least one black & white cover/year." Send postcard sample. Accepts submissions on disk compatible with CorelDraw 5.0 (or lower) or other standard graphical formats. Most samples are filed. Those not filed are returned by SASE if requested by artist. Reports back within 3 months. Portfolio review not required. Buys first rights. Pays on publication; $150 (Canadian) for b&w and color cover; $10 (Canadian) for b&w and color inside and 3 copies. Finds artists through word of mouth and going to local exhibits.

Tips: "We are looking for fine art suitable for the cover of a literary magazine. Your work should be polished, confident, cohesive and original. Send a postcard sample of your work. As with our literary contest, we will choose work which is exciting and which reflects the contemporary nature of the magazine."

‡**PRIVATE PILOT**, 265 S. Anita Dr., Suite 120, Orange CA 92868. (714)939-9991. Executive Editor: Bill Fedorko. Estab. 1965. Monthly magazine for owners/pilots of private aircraft, student pilots and others aspiring to attain additional ratings and experience. Circ. 105,000. Receives 3 cartoons and 2 illustrations/week from freelance artists.

Cartoons: Buys 1 cartoon/issue on flying. Send finished artwork and SASE. Accepts submissions on disk (call first). Reports in 3 months. Pays on publication; $35 for b&w.

Illustration: Works with 8 illustrators/year. Buys 12-18 illustrations/year. Uses artists mainly for spot art. Send query letter with photocopies, tearsheets and SASE. Accepts submissions on disk (call first). Reports in 3 months. Pays $50-500 for color inside. "We also use spot illustrations as column fillers." Buys 1-2 spot illustrations/issue. Pays $35/spot.

Tips: "Know the field you wish to represent; we specialize in general aviation aircraft, not jets, military or spacecraft."

PROCEEDINGS, U.S. Naval Institute, 118 Maryland Ave., Annapolis MD 21402-5035. (301)268-6110. Website: http://www.usni.org. Art Director: LeAnn Bauer. Monthly b&w magazine with 4-color cover emphasizing naval and maritime subjects. "*Proceedings* is an independent forum for the sea services." Design is clean, uncluttered layout, "sophisticated." Circ. 110,000. Accepts previously published material. Sample copies and art guidelines available.

Cartoons: Buys 23 cartoons/year from freelancers. Prefers cartoons assigned to tie in with editorial topics. Send query letter with samples of style to be kept on file. Material not filed is returned if requested by artist. Reports within 1 month. Negotiates rights purchased. Pays $25-50 for b&w, $50 for color.

Illustration: Buys 1 illustration/issue. Works on assignment only. Has featured illustrations by Tom Freeman, R.G. Smith and Eric Smith. Features humorous and realistic illustration; charts & graphs; informational graphics; computer and spot illustration. Needs editorial and technical illustration. "We like a variety of styles if possible. Do excellent illustrations and meet the requirement for military appeal." Prefers illustrations assigned to tie in with editorial topics. Send query letter with brochure, résumé, tearsheets, photostats, photocopies and photographs. Accepts submissions on disk (call production manager for details). Samples are filed or are returned only if requested by artist. Publication will contact artist for portfolio review if interested. Negotiates rights purchased. Sometimes requests work on spec before assigning job. Pays $50 for b&w inside, $50-75 for color inside; $150-200 for color cover; $25 minimum for spots. "Contact us first to see what our needs are."

Tips: "Magazines such as *Proceedings* that rely on ads from defense contractors will have rough going in the future."

‡❧PROFIT MAGAZINE, 777 Bay St., 5th Floor, Toronto, Ontario M5W 1A7 Canada. (416)596-5457. Fax: (416)596-5111. E-mail: lmacneil@cbmedia.ca. Art Director: Laura Macneil. Estab. 1982. Bimonthly 4-color business magazine.
Illustration: Buys 3-7 illustrations/issue. Has featured illustrations by Jerzy Kolacz, Jason Schneider, Ian Phillips. Features charts & graphs, computer, realistic and humorous illustration, informational graphics and spot illustrations of business subjects. Assigns 50% of illustrations to well-known or "name" illustrations; 50% to experienced, but not well-known illustrators. Send postcard or other non-returnable samples. Accepts Mac-compatible disk submissions. Samples are not returned. Will contact artist for portfolio review if interested. Buys first rights. **Pays on acceptance**; $500-750 for color inside; $750-1,000 for 2-page spreads; $350 for spots. Pays in Canadian funds. Finds illustrators through promo pieces, other magazines.

THE PROGRESSIVE, 409 E. Main St., Madison WI 53703. Website: http://www.progressive.org. Art Director: Patrick JB Flynn. Estab. 1909. Monthly b&w plus 4-color cover. Circ. 40,000. Originals returned at job's completion. Free sample copy and art guidelines.
Illustration: Works with 50 illustrators/year. Buys 10 b&w illustrations/issue. Has featured illustrations by S. Kroninger, S. Coe, B. Holland, M. Fisher, Gale, S. Goldenberg, J. Ciarciello, D. Johnson, H. Drescher, F. Jetter, R. Enos, D. McLimans and M. Duffy. Features caricatures of politicians; humorous and political illustration. Assigns 40% of illustrations to well-known or "name" illustrators; 50% to experienced, but not well-known illustrators; 10% to new and emerging illustrators. Needs editorial illustration that is "smart, bold, expressive." Works on assignment only. Send query letter with tearsheets and/or photocopies. Samples returned by SASE. Reports in 6 weeks. Portfolio review not required. Pays $500 for b&w and color cover; $100-250 for b&w line or tone drawings/paintings/collage inside. Buys first rights.
Tips: Do not send original art. Send samples, postcards or photocopies and appropriate postage for materials to be returned. "The successful art direction of a magazine allows for personal interpretation of an assignment."

PROGRESSIVE RENTALS, 9015 Mountain Ridge, Suite 220, Austin TX 78759-7252. (512)794-0095. Fax: (512)794-0097. E-mail: nferguson@apro-rto.com. Website: http://www.apro-rto.com. Art Director: Neil Ferguson. Estab. 1983. Bimonthly association publication for members of the Association of Progressive Rental Organizations, the national association of the rental-purchase industry. Circ. 5,000. Sample copies free for catalog-size SASE with first-class postage.
Illustration: Buys 3-4 illustrations/issue. Has featured illustrations by Barry Fitzgerald, Aletha Reppel, A.J. Garces, Edd Patton and Jane Marinsky. Features computer and conceptual illustration. Assigns 15% of illustrations to well-known or "name" illustrators; 70% to experienced, but not well-known illustrators; 15% to new and emerging illustrators. Prefers cutting edge; nothing realistic; strong editorial qualities. Considers all media. "Accepts computer-based illustrations (Adobe Photoshop 4.0, Adobe Illustrator 6.0). Send postcard sample, query letter with printed samples, photocopies or tearsheets. Accepts disk submissions. (Must be Photoshop-accessable EPS high-resolution [300 dpi] files or Illustrator 5.0 or greater files.) Samples are filed or returned by SASE. Reports back with 1 month if interested. Rights purchased vary according to project. Pays on publication; $300-400 for color cover; $200-300 for b&w, $250-350 for color inside; $75-125 for spots. Finds illustrators mostly through artist's submissions; some from other magazines.
Tips: "Illustrators who work for us must have a strong conceptual ability—that is, they must be able to illustrate for editorial articles dealing with business/management issues. We are looking for cutting-edge styles and unique approaches to illustration. I am willing to work with new, lesser-known illustrators."

PROTOONER, P.O. Box 2270, Daly City CA 94017-2270. (415)755-4827. Fax: (415)997-0714. Editor: Joyce Miller. Estab. 1995. Monthly trade journal for the professional cartoonist and gagwriter. Circ. 500+. Sample copy $5 U.S., $6 foreign. Art guidelines for #10 SASE with first-class postage.
Cartoons: Approached by tons of cartoonists/year. Buys 5 cartoons/issue. Prefers good visual humorous impact. Prefers single panel, humorous, b&w line drawings, with or without gaglines. Send query letter with roughs, SASE, tearsheets. "SASE a must!" Samples are filed. Reports back in 1 month. Buys reprint rights. **Pays on acceptance**; $10-25 for b&w cartoons.
Illustration: Approached by 6-12 illustrators/year. Buys 3 illustrations/issue. Features humorous illustration; informational graphics; spot illustration. Prefers humorous, original. Avoid vulgarity. Considers pen & ink. 50% of freelance illustration demands computer knowledge. Query for programs. Send query letter with printed samples and SASE.

Illustrator Jane Marinsky has had a professional relationship with Art Director Neil Ferguson for more than ten years, first working together through *Artist's & Graphic Designer's Market*. When Ferguson moved from another magazine to *Progressive Rentals*, he continued to send work her way. "Jane's creative and has an elegant style. I asked her to think of Rene Magritte on this piece; not to rip him off, but just to suggest 'classiness,' " says Ferguson. Marinsky plans to use this illustration in her mailer. In addition to a promotional mailing once a year, she has a website, and advertises in *Stock Illustration Source*.

Samples are filed. Reports back within 1 month. Buys reprint rights. **Pays on acceptance**; $20-30 for b&w cover. Pay for spots varies according to assignment.

Tips: "Pay attention to the magazine slant and SASE a must! Study sample copy before submitting. Request guidelines. Don't mail editors artwork not properly slanted!"

PSYCHOLOGY TODAY, 49 E. 21st St., 11th Floor, New York NY 10010. (212)260-7210. Fax: (212)260-7445. Associate Art Director: Virginia Cahill. Estab. 1991. Bimonthly consumer magazine for professionals and academics, men and women. Circ. 200,000. Accepts previously published artwork. Originals returned at job's completion.
Illustration: Approached by 250 illustrators/year. Buys 5 illustrations/issue. Works on assignment only. Prefers psychological, humorous, interpersonal studies. Considers all media. Needs editorial, technical and medical illustration. 20% of freelance work demands knowledge of QuarkXPress or Adobe Photoshop. Send query letter with brochure, photostats and photocopies. Samples are filed and are not returned. Reports back only if interested. Buys one-time rights. Pays on publication; $200-500 for color inside; $50-350 for spots; cover negotiable.

✓PUBLISH, 501 Second St., San Francisco CA 94107. (415) 978-3200. Fax: (415)975-2613. Website: http://www.publ ish.com. Contact: Art Director. Estab. 1986. Monthly magazine focusing on desktop publishing. Circ. 95,000.
 ● This magazine has been honored with numerous awards for design and was a finalist for five Maggie awards in 1997.
Illustration: Approached by 50-100 illustrators/year. Buys 5-10 illustrations/issue. Considers all media. Send printed samples and photocopies. Accepts submissions on disk. Samples are filed and not returned. Reports back only if interested. Buys first North American serial rights or negotiates rights purchased. **Pays on acceptance**, $100-1,000 for color inside; $100-250 for spots. Finds artists through submissions, sourcebooks, word of mouth and illustration annuals.
Design: Needs freelancers for design and production. Prefers local design freelancers only. 100% of design/production demands knowledge of Adobe Photoshop and QuarkXPress. Send query letter with printed samples to Jean Zambelli, art director.

✓PUBLISHERS WEEKLY, 245 W. 17th St., 6th Floor, New York NY 10011. (212)645-9700. Art Director: Karen E. Jones. Weekly magazine emphasizing book publishing for "people involved in the creative or the technical side of publishing." Circ. 50,000. Original artwork is returned to the artist after publication.
Illustration: Buys 75 illustrations/year. Works on assignment only. "Open to all styles." Send postcard sample or query letter with brochure, tearsheets, photostats, photocopies, slides and/or photographs. Samples are not returned. Reports back only if interested. **Pays on acceptance**; $350-500 for color inside.

‡QECE (QUESTION EVERYTHING CHALLENGE EVERYTHING), 406 Main St., #3C, Collegeville PA 19426. E-mail: qece@aol.com. Creative Director: Larry Nocella. Estab. 1996. Three times yearly b&w zine "encouraging a more questioning mentality." Circ. 450. Art guidelines free for #10 SASE with first-class postage.
Cartoons: Approached by 10 cartoonists/year. Buys 10 cartoons/year. Prefers subversive and bizarre single, double or multiple panel humorous, b&w line drawings. Send query letter with b&w photocopies and SASE. Samples are not filed; returned by SASE. Reports back within 1 month. Buys one-time rights. Pays on publication; $5 maximum or contributor copies.
Illustration: Approached by 12 illustrators/year. Buys 4 illustrations/issue. Has featured illustrations by Randy Moore, Kiel Stuart, GAK, Colin Develin, Steve Barr. Features charts & graphs, humorous and realistic illustrations; "anything that jolts the imagination." Prefers "intelligent rebellion." Prefers b&w line art. Assigns 100% of illustrations to new and emerging illustrators. Send query letter with photocopies, SASE. Samples are not filed; returned by SASE. Reports back within 1 month. Portfolio review not required. Buys one-time rights. Pays on publication; $5 or contributor copies for b&w cover. Finds illustrators through Internet, word of mouth.
Tips: "*QECE* offers you the artistic freedom you've always wanted. Send your most unique black & white creations—our 'gallery' centerfold has no theme other than printing the coolest (in our opinion) art we can get. Throw off your shackles and create what you want. Cartoonists, be subversive, but avoid common subjects, such as latest political scandal, etc. Be pro-activist, pro-action. Be free and question everything. Challenge everything."

‡QUEEN OF ALL HEARTS, 26 S. Saxon Ave., Bay Shore NY 11706. (516)665-0726. Fax: (516)665-4349. Managing Editor: Rev. Roger Charest. Estab. 1950. Bimonthly Roman Catholic magazine on Marian theology and spirituality. Circ. 3,000. Accepts previously published artwork. Sample copy available.
Illustration: Buys 1 or 2 illustrations/issue. Works on assignment only. Prefers religious. Considers pen & ink and charcoal. Send postcard samples. Samples are not filed and are returned by SASE if requested by artist. Buys one-time rights. **Pays on acceptance**; $50 minimum for b&w inside.
Tips: Area most open to freelancers is illustration for short stories. "Be familiar with our publication."

✓ELLERY QUEEN'S MYSTERY MAGAZINE, 1270 Avenue of the Americas, New York NY 10020. Phone/fax: (212)698-1313. Creative Director: Victoria Green. Assistant Art Director: Shirley Chan Levi. All submissions should be sent to Shirley Chan Levi, assistant art director. Emphasizes mystery stories and reviews of mystery books. Art guidelines for SASE with first-class postage.
 ● Also publishes *Alfred Hitchcock Mystery Magazine*, *Analog* and Isaac Asimov's *Science Fiction Magazine*.
Cartoons: "We are looking for cartoons with an emphasis on mystery, crime and suspense."

Illustration: Prefers line drawings. All other artwork is done inhouse. Send SASE and tearsheets or transparencies. Accepts disk submissions. Reports within 3 months. **Pays on acceptance**; $1,200 for color covers; $125 for spots.

✤**QUILL & QUIRE**, 70 The Esplanade, #210, Toronto, Ontario M5E 1R2 Canada. (416)360-0044. Fax: (416)955-0794. E-mail: quill@idirect.com. Editor: Scott Anderson. Estab. 1935. Monthly trade journal "of book news and reviews." Circ. 7,000. Art guidelines not available.
Illustration: Approached by 25 illustrators/year. Buys 3 illustrations/issue. Has featured illustrations by Barbara Spurll, Chum McLeod and Carl Wiens. Assigns 100% of illustrations to experienced, but not well-known illustrators. Considers pen & ink and collage. 10% of freelance illustration requires knowledge of Adobe Photoshop, Adobe Illustrator and QuarkXPress. Send postcard sample. Accepts disk submissions. Samples are filed. Reports back only if interested. Negotiates rights purchased. **Pays on acceptance**; $200-300 for b&w and color cover; $100-200 for b&w and color inside. Finds illustrators through word of mouth, artist's submissions.
Tips: "Read our magazine."

RACQUET, 21 E. 40th St., New York NY 10016. (212)696-2484. Fax: (212)696-1678. Art Director: R. Delgalo. Estab. 1980. Bimonthly magazine "for the avid tennis player, with an emphasis on travel and lifestyle." Circ. 150,000.
• See listing for *The Golfer* for submission requirements.

‡**RACQUETBALL MAGAZINE**, 1685 W. Uintah, Colorado Springs CO 80904-2921. (719)535-9648. Fax: (719)535-0685. E-mail: rbzine@webaccess.net. Website: http://www.racqmag.com. Director of Communications/Editor: Linda Mojer. Bimonthly publication of The American Amateur Racquetball Association. "Distributed to members of AARA and industry leaders in racquetball. Focuses on both amateur and professional athletes." Circ. 50,000. Accepts previously published artwork. Originals returned at job's completion. Sample copies and art guidelines available.
Cartoons: Needs editorial illustration. Prefers racquetball themes. Send query letter with roughs. Samples are filed. Publication will contact artist for portfolio review if interested. Negotiates rights purchased. Pays $50 for b&w, $50 for color (payment negotiable).
Illustration: Approached by 5-10 illustrators/year. Usually works on assignment. Prefers racquetball themes. Freelancers should be familiar with Aldus PageMaker. Send postcard samples. Accepts disk submissions. Samples are filed. Publication will contact artist for portfolio review if interested. Negotiates rights purchased. Pays on publication; $200 for color cover; $50 for b&w, $50 for color inside (all fees negotiable).

✔**R-A-D-A-R**, 8121 Hamilton Ave., Cincinnati OH 45231. Editor: Gary Thacker. Weekly 4-color magazine for children 3rd-4th grade in Christian Sunday schools. Original artwork not returned after publication. Art guidelines available for SASE with first-class postage.
Cartoons: Buys 1 cartoon/month on animals, school and sports. "We want cartoons that appeal to children—but do not put down any group of people; clean humor." Prefers to see finished cartoons. Reports in 1-2 months. **Pays on acceptance**, $17.50.
Illustration: Buys 5 or more illustrations/issue. Features humorous, realistic, computer and spot illustration. Assigns 90% of illustrations to experienced, but not well-known illustrators; 10% to new and emerging illustrators. "Art that accompanies nature or handicraft articles may be purchased, but almost everything is assigned." Send query letter with photocopies, photographs and tearsheets to be kept on file. Samples returned by SASE. Publication will contact artist for portfolio review if interested. Buys all rights on a work-for-hire basis. Sometimes requests work on spec before assigning job. Pays $150 for full-color cover; $100 maximum for color inside; $35 maximum for 2 spots. Finds artists through word of mouth, submissions/self-promotions.
Tips: "Know how to illustrate third and fourth grade children well. Study R-A-D-A-R and understand the types of illustrations we want."

RADIANCE, The Magazine for Large Women, P.O. Box 30246, Oakland CA 94604. Phone/fax: (510)482-0680. E-mail: radmag2@aol.com. Website: http://www.radiancemagazine.com. Publisher/Editor: Alice Ansfield. Estab. 1984. Quarterly consumer magazine "for women *all* sizes of large—encouraging them to live fully *now*." Circ. 14,000 and rising. Accepts previously published artwork. Original artwork returned at job's completion. Sample copy for $3.50 plus postage.
Cartoons: Approached by 200 cartoonists/year. Buys 3 cartoons/year. Wants empowering messages for large women, with humor and perspective on women's issues; single, double or multiple panel b&w or 2-color line drawings with gagline. "We'd like to see any format." Send query letter with brochure, roughs and finished cartoons or postcard-size sample. Samples are filed or are returned by SASE if requested by artist. Buys one-time rights. Pays $15-50 for b&w.
Illustration: Approached by 200 illustrators/year. Buys 3 illustrations/year. Features fashion, humorous and realistic illustration; informational graphics; spot illustration. Assigns 50% of illustrations to experienced, but not well-known illustrators; 50% to new and emerging illustrators. Considers pen & ink, watercolor, airbrush, acrylic, colored pencil, collage and mixed media. 10% of freelance works demands knowledge of Adobe Illustrator, QuarkXPress, Adobe Photoshop, Aldus FreeHand on Macintosh. Send postcard sample or query letter with brochure, photocopies, photographs, SASE and tearsheets. Samples are filed or are returned by SASE if requested by artist. Reports back in 3-4 months. Buys one-time rights. Pays on publication; $30-60 for b&w cover; $100 minimum for color cover.
Design: Needs freelancers for design, production, multimedia. 50% of freelance work demands knowledge of Adobe

Photoshop, Adobe Illustrator, Aldus FreeHand, QuarkXPress. Send query letter with brochure, photocopies, SASE, tearsheets, résumé, photographs. Pays for design by the project; pay is negotiable.

Tips: "Read our magazine. Find a way to help us with our goals and message. We welcome new and previously published freelancers to our magazine. I'd recommend reading *Radiance* to get a feel for our design, work, editorial tone and philosophy. See if you feel your work could contribute to what we're doing and send us a letter with samples of your work or ideas on what you'd like to do!"

RAG MAG, Box 12, Goodhue MN 55027. Contact: Beverly Voldseth. Estab. 1982. Semiannual (fall and spring) b&w magazine emphasizing poetry, graphics, fiction and reviews for small press, writers, poets and editors. Circ. 300. Accepts previously published material. "Send no original art or photos—copies please." Sample copy $6; art guidelines available for SASE with first-class postage.

• Does not accept any work during June, July and August. Work received in those months will be returned.

Cartoons: Approached by 4-5 cartoonists/year. Acquires 2 cartoons/issue. Any theme or style. Prefers single panel or multiple panel b&w line drawings with gagline. Send only finished cartoons. Material returned in 2 months by SASE if unwanted. Reports within 2 months. Acquires first rights. Pays in copies only.

Illustration: Approached by up to 12 illustrators/year. Acquires 6 illustrations/issue. Any style or theme. Send camera-ready copy (3-6 pages of your best work). Samples and responses returned only by SASE. Reports within 1 month. Portfolio review not required. Acquires first rights. Pays in copies.

Tips: "I choose artwork for its own appeal—just as the poems and short stories are. I only take what's ready to be used on receipt. I return what I don't want. I don't hold anything in my files because I think artists should be sending their artwork around. And even if I like someone's artwork very much, I like to use new people. I do not want to see anything portraying violence. Be sure your name and address is somewhere on each submitted page of work."

‡RANGER RICK, 8925 Leesburg Pike, Vienna VA 22184. (703)790-4000. Art Director: Donna D. Miller. Monthly 4-color children's magazine focusing on wildlife and conversation. Circ. 700,000. Art guidelines are free for #10 SASE with first-class postage.

Cartoons: Approached by 100-200 illustrators/year. Buys 4-6 illustrations/issue. Has featured illustrations by Jean Pidgeon, Jack Desrocher, John Dawson and Dave Clegg. Features computer, humorous, natural science and realistic illustrations. Preferred subjects: children, wildlife and natural world. Assigns 4% of illustrations to well-known or "name" illustrators; 95% to experienced, but not well-known illustrators; 1% to new and emerging illustrators. 50% of freelance illustration demands knowledge of Adobe Illustrator, Adobe Photoshop. Send query letter with printed samples, photocopies and SASE. Accepts Mac-compatible disk submissions. Samples are filed or returned by SASE. Reports back within 2 months. Will contact artist for portfolio review if interested. Buys one-time rights. Pays on publication; $50-250 for b&w inside; $150-800 for color inside; $1,000-2,000 for 2-page spreads; $350-450 for spots. Finds illustrators through Graphic Artists Guild, promotional samples, Guild of Natural Science Illustrators.

Tips: "Looking for new artists to draw animals using Illustrator, Photoshop and other computer drawing programs."

‡RAPPORT, 5265 Fountain Ave., Los Angeles CA 90029. (213)660-0433. Art Director: Crane Jackson. Estab. 1974. Bimonthly entertainment magazine featuring book and CD reviews; music focus is on jazz, some popular music. Circ. 60,000. Originals not returned. Samples copies are available.

Illustration: Approached by 12 illustrators/year. Buys 6 illustrations/issue. Works on assignment only. Prefers airbrush and acrylic. Send postcard sample and brochure. Samples are filed. Reports back within 2 months. Pays $50 minimum for b&w cover; $100 for color cover; $50-100 for b&w inside; $100 for color inside.

Tips: "As a small publication, we try to pay the best we can. We do not want artists who have a fixed amount for payment when they see us. We give good exposure for artists who will illustrate our articles. If we find good artists, they'll get a lot of work, payment on receipt and plenty of copies of the magazine to fill their portfolios. Several artists have been recruited by book publishers who have seen their work in our magazine, which reviews more than 100 books from all publishers. One mistake illustrators frequently make is that they don't adapt their artwork to our needs. We often OK a rough then find them deviating from that rough. Many times we will explain or give the article to the illustrator to come up with a concept and find they don't serve the article. Art for art's sake is disappearing from magazines. We'll suggest art to illustrate articles, or will supply article."

REAL PEOPLE MAGAZINE, 450 Seventh Ave., Suite 1701, New York NY 10123. (212)244-2351. Fax: (212)244-2367. E-mail: mrs-z@idt.net. Editor: Alex Polner. Estab. 1988. "Bimonthly 4-color and b&w entertainment magazine featuring celebrities and show business articles, profiles for men and women ages 35 and up." Circ. 100,000. Original artwork returned after publication. Sample copy for $3.50 plus postage; art guidelines not available.

Illustration: Buys 1-2 color illustrations/issue and 4-6 b&w/issue. Works on assignment only. Has featured illustrations by Bob Walker, Chris Sabatino, Matt Baier, Tina Marie and Tom La Baff. Features caricatures of celebrities and politicians, humorous and spot illustration. Assigns 25% of illustrations to experienced, but not well-known illustrators; 75% to new and emerging illustrators. Theme or style depends on the article. Prefers pen & ink, watercolor, acrylic and collage with strong concept and/or sense of humor. Send query letter with tearsheets. Samples are filed. Artist should follow up after initial query. Publication will contact artist for portfolio review if interested. Buys all rights. Pays on publication; $150 for b&w inside; $250-300 for color inside; $75-100 for spots.

Tips: "We prefer illustration with a sense of humor. Show us range—both color and black & white."

REASON, 3415 S. Sepulveda Blvd., Suite 400, Los Angeles CA 90034-6064. (310)391-2245. Fax: (310)391-4395. E-mail: edreason@aol.com. Website: http://www.reason.com. Art Director: Barb Burch. Estab. 1969. Monthly consumer magazine of libertarian public policy—political, social and cultural issues. Circ. 55,000. Art guidelines not available.
Illustration: Buys 1-2 illustrations/issue. Considers all media. Send postcard sample. Samples are filed. Does not report back. Art director will contact artist for portfolio review if interested. Buys one-time rights. Pays on publication; $600-1,200 for color cover; $200 minimum for b&w inside.

REDBOOK MAGAZINE, Dept. AGDM, 224 W. 57th St., New York NY 10019. (212)649-2000. Art Director: Ed Melnitsky. Monthly magazine "geared to baby boomers with busy lives. Interests in fashion, food, beauty, health, etc." Circ. 7 million. Accepts previously published artwork. Original artwork returned after publication with additional tearsheet if requested.
Illustration: Buys 3-4 illustrations/issue. "We prefer photo illustration for fiction and more serious articles, loose or humorous illustrations for lighter articles. Illustrations can be in any medium. Portfolio drop off any day, pick up 2 days later. To show a portfolio, mail work samples that will represent the artist and do not have to be returned. This way the sample can remain on file, and the artist will be called if the appropriate job comes up." Accepts fashion illustrations for fashion page. Send illustrations to the attention of Jennifer Madara, associate art director. Buys reprint rights or negotiates rights.
Tips: "Look at the magazine before you send anything, we might not be right for you. Generally, illustrations should look new, of the moment, intelligent."

REFORM JUDAISM, 838 Fifth Ave., New York NY 10021-7064. (212)650-4210. Managing Editor: Joy Weinberg. Estab. 1972. Quarterly magazine. "The official magazine of the Reform Jewish movement. It covers developments within the movement and interprets world events and Jewish tradition from a Reform perspective." Circ. 295,000. Accepts previously published artwork. Originals returned at job's completion. Sample copies available for $3.50.
Cartoons: Prefers political themes tying into editorial coverage. Send query letter with finished cartoons. Samples are filed. Reports back within 3-4 weeks. Buys first rights, one-time rights and reprint rights.
Illustration: Buys 8-10 illustrations/issue. Works on assignment. 10% of freelance work demands computer skills. Send query letter with brochure, résumé, SASE and tearsheets. Samples are filed. Reports back within 3-4 weeks. Publication will contact artist for portfolio review if interested. Portfolio should include tearsheets, slides and final art. Rights purchased vary according to project. **Pays on acceptance**; varies according to project. Finds artists through sourcebooks and artists' submissions.

REPRO REPORT, 800 Enterprise Dr., #202, Oak Brook IL 60523-1929. (630)571-4685. Fax: (630)571-4731. E-mail: jennifer@irga.com. Website: http://www.irga.com. Editor: Jennifer Karabetsos. Estab. 1928. Trade journal of the International Reprographic Association. Circ. 1,000. Art guidelines not available.
Illustration: Features informational graphics; computer illustration. Assigns 100% of illustrations to new and emerging illustrators. Send postcard sample or query letter with printed samples and tearsheets. Art director will contact artist for portfolio review if interested. Negotiates rights purchased. **Pays on acceptance**. Pays $400-500 for color cover. Finds illustrators through word of mouth, computer users groups, direct mail.
Design: Needs freelancers for design. 80% of freelance design demands knowledge of Aldus PageMaker, Adobe Photoshop, Adobe Illustrator and Aldus FreeHand. Send query letter with brochure, photocopies, photographs and tearsheets. Pays by the project, $400-500. Prefers local freelancers only.
Tips: "We demand a fast turnaround and thus usually only work with artists/designers in the Chicagoland area. We prefer art utilizing the computer."

‡RICHMOND MAGAZINE, 2500 E. Parham Rd., Suite 200, Richmond VA 23228. (804)261-0034. Fax: (804)261-1047. E-mail: editor@richmag.com. Website: http://www.richmag.com. Art Director: Tyler Darden. Assistant Art Director: Fran Osborne. Graphic Artist: Gwen Richlen. Estab. 1980. Monthly 4-color regional consumer magazine focusing on Richmond lifestyles. Circ. 21,000. Art guidelines free for #10 SASE with first-class postage.
Cartoons: Approached by 20 cartoonists/year. Buys 5-10 cartoons/year. Prefers humorous, witty, Richmond-related, single panel, humorous color washes. Send query letter with color photocopies. Samples are filed and not returned. Reports back only if interested. Buys one-time rights. Pays on publication; $75-150 for b&w; $75-200 for color cartoons.
Illustration: Approached by 30 illustrators/year Buys 1-2 illustrations/issue. Has featured illustrations by Kelly Alder, Kerry Talbott, Joel Priddy. Features humorous, realistic, conceptional, medical and spot illustrations. Assigns 75% of illustrations to experienced, but not well-known illustrators; 25% to new and emerging illustrators. Send postcard sample or query letter with photocopies, tearsheets or other non-returnable samples and SASE. Send follow-up postcard every 2 months. Accepts Mac-compatible disk submissions. Send EPS files. Samples are filed or returned by SASE. Will contact artist for portfolio review if interested. Pays $150-200 for b&w cover; $200-500 for color cover; $50-100 for b&w inside; $150-300 for color inside; $200-400 for 2-page spreads; $75 for spots. Finds illustrators through promo samples, word of mouth, regional soucebooks.
Tips: "Be dependable, on time and have strong concepts."

‡ROBB REPORT, One Acton Place, Acton MA 01720. (508)263-7749. Fax: (508)263-0722. Design Director: Russ Rocknak. Monthly 4-color consumer magazine "for the luxury lifestyle, featuring exotic cars, investment, entrepreneur,

boats, etc." Circ. 150,000. Accepts previously published artwork. Original artwork is returned at job's completion. Sample copies not available; art guidelines for SASE with first-class postage.

ROCKFORD REVIEW, P.O. Box 858, Rockford IL 61105. Editor: David Ross. Estab. 1971. Triquarterly literary magazine emphasizing literature and art which contain fresh insights into the human condition. Circ. 750. Sample copy for $5. Art guidelines free for SASE with first-class postage.
Illustration: Approached by 8-10 illustrators/year. Buys 1-2 illustrations/issue. Has featured illustrations by JP Henderson, Christine Schneider. Features humorous, computer and satirical illustration. Prefers satire/human condition. Considers pen & ink and marker. Needs computer-literate freelancers for illustration. Send query letter with photographs, SASE and photocopies. Samples are not filed and are returned by SASE. Reports back within 2 months. Portfolio review not required. Publication will contact artist for portfolio review if interested. Buys first rights. Pays on publication; 1 copy plus eligiblity for $25 Editor's Choice Prize (6 each year)—and guest of honor at summer party. Finds artists through word of mouth and submissions.
Tips: "If something people do makes you smile, go 'hmph' or shake your head, draw it and send it to us. We are starving for satire on the human condition."

ROLLING STONE MAGAZINE, 1290 Avenue of the Americas, New York NY 10104. Website: http://www.rollingsto ne.com. Estab. 1967. Bimonthly magazine. Circ. 1.4 million. Originals returned at job's completion. 100% of freelance design work demands knowledge of Adobe Illustrator, QuarkXPress and Adobe Photoshop. (Computer skills not necessary for illustrators).
Illustration: Approached by "tons" of illustrators/year. Buys approximately 4 illustrations/issue. Works on assignment only. Considers all media. Send postcard sample and/or query letter with tearsheets, photocopies or any appropriate sample. Samples are filed. Does not report back. Portfolios may be dropped off every Tuesday 10 a.m. and should include final art and tearsheets. Publication will contact artist for portfolio review if interested. Buys first and one-time rights. **Pays on acceptance**; payment for cover and inside illustration varies; pays $300-500 for spots. Finds artists through word of mouth, *American Illustration*, *Communication Arts*, mailed samples and drop-offs.

THE ROTARIAN, 1560 Sherman Ave., Evanston IL 60201. Editor-in-Chief: Willmon L. White. Art Director: F. Sanchez. Estab. 1911. Monthly 4-color publication emphasizing general interest, business and management articles. Service organization for business and professional men and women, their families and other subscribers. Accepts previously published artwork. Sample copy and editorial fact sheet available.
Cartoons: Approached by 14 cartoonists/year. Buys 5-8 cartoons/issue. Interested in general themes with emphasis on business, sports and animals. Avoid topics of sex, national origin, politics. Send query letter to Cartoon Editor, Charles Pratt, with brochure showing art style. Reports in 1-2 weeks. Buys all rights. **Pays on acceptance**; $75.
Illustration: Approached by 8 illustrators/year. Buys 10-20 illustrations/year; 7-8 humorous illustrations/year from freelancers. Uses freelance artwork mainly for covers and feature illustrations. Most editorial illustrations are commissioned. Send query letter to art director with photocopies or brochure showing art style. To show portfolio, artist should follow-up with a call or letter after initial query. Portfolio should include original/final art, final reproduction/product, color and photographs. Sometimes requests work on spec before assigning job. Buys all rights. **Pays on acceptance**; payment negotiable, depending on size, medium, etc.; $800-1,000 for color cover; $75-150 for b&w inside; $200-700 for color inside.
Tips: "Preference given to area talent. We're looking for a wide range of styles, although our subject matter might be considered somewhat conservative by those steeped in the avant-garde."

ROUGH NOTES, P.O. Box 1990, 11690 Technology Dr., Carmel IN 46032-5600. Publications Production Manager: Evelyn Egan. Estab. 1878. Monthly 4-color magazine with a contemporary design. Does not accept previously published artwork.
Cartoons: Buys 3-5 cartoons/6 months on property and casualty insurance, automation, office life (manager/subordinate relations) and general humor. No risqué material. Receives 20-30 cartoons/week from freelance artists. Submit art every 6 months. Include SASE. Reports in 1 month. Buys all rights. Prefers 5×8 or 8×10 finished art. Will accept computer-generated work compatible with QuarkXPress 3.3 and Adobe Illustrator 5.0. **Pays on acceptance**; $20, line drawings and halftones.
Tips: "Do not submit sexually discriminating materials. I have a tendency to disregard all of the material if I find any submissions of this type. Send several items for more variety in selection. We would prefer to deal only in finished art, not sketches."

✔RUNNER'S WORLD, 33 E. Minor St., Emmaus PA 18098. (610)967-5171. Fax: (610)967-8883. Website: http:// www.RUNNERSWORLD.com. Art Director: Ken Kleppert. Estab. 1965. Monthly 4-color with a "contemporary, clean" design emphasizing serious, recreational running. Circ. 470,000. Accepts previously published artwork "if appropriate." Returns original artwork after publication. Art guidelines not available.
Illustration: Approached by hundreds of illustrators/year. Works with 50 illustrators/year. Buys average of 10 illustrations/issue. Has featured illustrations by Sam Hundley, Gil Eisner, Randall Enos and Katherine Adams. Features humorous and realistic illustration; charts & graphics; informational graphics; computer and spot illustration. Assigns 40% of illustrations to well-known or "name" illustrators; 40% to experienced, but not well-known illustrators; 20% to new and emerging illustrators. Needs editorial, technical and medical illustrations. "Styles include tightly rendered human

athletes, graphic and cerebral interpretations of running themes. Also, *RW* uses medical illustration for features on biomechanics." Styles range from Sam Hundley to Robert Zimmerman. Prefers pen & ink, airbrush, charcoal/pencil, colored pencil, watercolor, acrylic, oil, pastel, collage and mixed media. "No cartoons or originals larger than 11 × 14." Works on assignment only. 30% of freelance work demands knowledge of Adobe Illustrator, Adobe Photoshop or Aldus FreeHand. Send postcard samples to be kept on file. Accepts submissions on disk compatible with Adobe Illustrator 5.0. Send EPS files. Publication will contact artist for portfolio review if interested. Buys one-time international rights. Pays $1,800 maximum for 2-page spreads; $400 maximum for spots. Finds artists through word of mouth, magazines, submissions/self-promotions, sourcebooks, artists' agents and reps, and attending art exhibitions.

Tips: Portfolio should include "a maximum of 12 images. Show a clean presentation, lots of ideas and few samples. Don't show disorganized thinking. Portfolio samples should be uniform in size. Be patient!"

⟋RUNNING TIMES, 98 N. Washington St., Boston MA 02114. (617)367-2228. Fax: (617)367-2350. E-mail: julertim es@aol.com. Art Director: Julie Betters. Estab. 1977. Monthly consumer magazine covers sports, running. Circ. 70,000. Originals returned at job's completion. Sample copies available; art guidelines available.

Cartoons: Used occasionally.

Illustration: Buys 3-4 illustrations/issue. Works on assignment only. Has featured illustrations by Ben Fishman, Peter Hoex and Paul Cox. Features humorous, medical, computer and spot illustration. Considers pen & ink, colored pencil, mixed media, collage, charcoal, acrylic, oil. 100% of freelance work demands knowledge of QuarkXPress, Adobe Photoshop, Aldus FreeHand and Illustrator. Send postcard sample or query letter with tearsheets. Accepts disk submissions compatible with Adobe Photoshop, Aldus FreeHand or Adobe Illustrator. Samples are filed. Publication will contact artist for portfolio review of roughs, final art and tearsheets if interested. Buys one-time rights. Pays on publication; $400-600 for color inside; $250 maximum for b&w inside; $350 maximum for color inside; $500 maximum for 2-page spreads; $300 maximum for spots. Finds artists through illustration annuals, mailed samples, published work in other magazines.

Design: Needs freelancers for design and production. 100% of design demands knowledge of Aldus FreeHand 4.0, Adobe Photoshop 3.1, QuarkXPress 3.3 and Adobe Illustrator 5.0. Send query letter with résumé and tearsheets. Pays by the hour, $20. Finds artists through illustration annuals, mailed samples, published work in other magazines.

Tips: "Look at previous issues to see that your style is appropriate. Send multiple samples and send samples regularly. I don't usually give an assignment based on one sample. Send out cards to as many publications as you can and make phone calls to set up appointments with the ones you are close enough to get to."

RURAL HERITAGE, 281 Dean Ridge Lane, Gainesboro TN 38562-5039. (931)268-0655. E-mail: editor@ruralheritag e.com. Website: http://www.ruralheritage.com. Editor: Gail Damerow. Estab. 1976. Bimonthly consumer magazine "published in support of modern-day farming and logging with draft animals." Circ. 4,000. Sample copy for $6 postpaid; art guidelines not available.

Cartoons: Approached by "not nearly enough" cartoonists/year. Buys 2 or more cartoons/issue. Prefers bold, clean, minimalistic draft animals and their relationship with the teamster. Prefers single panel, humorous, b&w line drawings with or without gagline. Send query letter with finished cartoons and SASE. Samples are not filed (unless we plan to use them—then we keep them on file until used) and are returned by SASE. Reports back within 2 months. Buys first North American serial rights or all rights very occasionally. Pays on publication; $10 for one-time rights; $20 for all rights.

Tips: "Know draft animals (horses, mules, oxen, etc.) well enough to recognize humorous situations intrinsic to their use or that arise in their relationship to the teamster."

SACRAMENTO MAGAZINE, 4471 D Street, Sacramento CA 95819. (916)452-6200. Fax: (916)452-6061. Website: http://www.sacmag.com. Art Director: Debbie Hurst. Estab. 1975. Monthly consumer lifestyle magazine with emphasis on home and garden, women, health features and stories of local interest. Circ. 20,000. Accepts previously published artwork. Originals returned to artist at job's completion. Sample copies available.

Illustration: Approached by 100 illustrators/year. Buys 5 illustrations/year. Works on assignment only. Considers pen & ink, collage, airbrush, acrylic, colored pencil, oil, marker and pastel. Send postcard sample. Accepts disk submissions. Send EPS files. Samples are filed and are not returned. Publication will contact artist for portfolio review if interested. Portfolio should include b&w and color tearsheets and final art. Buys one-time rights. Pays on publication; $300-400 for color cover; $200-500 for b&w or color inside; $100-200 for spots. Finds artists through submissions.

Tips: Sections most open to freelancers are departments and some feature stories.

SACRAMENTO NEWS & REVIEW, 1015 20th St., Sacramento CA 95814. (916)498-1234. Fax: (916)489-7920. E-mail: donb@newsreview.com. Website: http://www.newsreview.com. Art Director: Don Button. Estab. 1989. "An award-winning black & white with 4-color cover alternative newsweekly for the Sacramento area. We combine a commitment to investigative and interpretive journalism with coverage of our area's growing arts and entertainment scene." Circ. 90,000. Occasionally accepts previously published artwork. Originals returned at job's completion. Art guidelines not available.

● Also publishes issues in Chico, CA and Reno, NV.

Illustration: Approached by 50 illustrators/year. Buys 1 illustration/issue. Works on assignment only. Features caricatures of celebrities and politicans; humorous, realistic, computer and spot illustrations. Assigns 5% of illustrations to well-known or "name" illustrators; 45% to experienced, but not well-known illustrators; 50% to new and emerging

illustrators. For cover art, needs themes that reflect content. Send postcard sample or query letter with photocopies, photographs, SASE, slides and tearsheets. Accepts disk submissions compatible with Photoshop 4.0. Samples are filed. Publication will contact artist for portfolio review if interested. Portfolio should include tearsheets, slides, photocopies, photographs or Mac floppy disk. Buys first rights. **Pays on acceptance**; $75-150 for b&w cover; $150-300 for color cover; $20-75 for b&w inside; $10-40 for spots. Finds artists through submissions.

Tips: "Looking for colorful, progressive styles that jump off the page. Have a dramatic and unique style . . . not traditional or common."

‡SALES & MARKETING MANAGEMENT MAGAZINE, 355 Park Ave. S., New York NY 10010-1789. (212)592-6300. Fax: (212)592-6309. Website: http://www.salesandmarketing.com. Art Director: Victoria Beerman. Estab. 1918. Monthly 4-color trade magazine for sales and marketing executives. Circ. 65,000.

Cartoons: Approached by 10 cartoonists/year. Buys 12 cartoons/year. Prefers single panel, humorous b&w line drawings. Send b&w photocopies and SASE. Samples are filed or returned by SASE. Reports back only if interested. Buys reprint rights or rights purchased vary according to project. Pays on publication; $150.

Illustration: Approached by 250-350 illustrators/year. Buys 1-10 illustrations/issue. Has featured illustrations by Philip Burke, Robert Risko, William Duke, Richard Downs, Amanda Duffy, Harry Campbell, Brian Raszka, Tim Hussey, Katherine Streeter. Features caricatures of celebrities, charts & graphs, computer, humorous, realistic and spot illustrations. Prefers business subjects, men and women. Prefers hip, fresh styles—all media. Avoid standard "business-looking" work in favor of more current approaches. Assigns 25% of illustrations to well-known or "name" illustrators; 50% to experienced, but not well-known illustrators; 25% to new and emerging illustrators. 50% of freelance illustration demands knowledge of Adobe Illustrator or Adobe Photoshop. "Use illustrators that work in all media, so computer skills only necessary if that's how artist works." Send postcard, printed samples, photocopies or tearsheets. Accepts Mac-compatible disk submissions (Prefers printed samples). Samples are filed or returned by SASE. Will contact artist for portfolio review if interested. Buys first North American serial rights. Pays on publication; $800-1,100 for color cover; $650-1,000 full page color inside; $800-1,100 for 2-page spreads; $150-250 for spots. Finds illustrators through all sources, but prefers artist's promo samples.

Tips: "We like to use cutting-edge illustrators who can come up with creative solutions quickly and on time. It's exciting when the illustrators come up with an idea I never would have thought of myself!"

SALT LICK PRESS, 3416-1900 Hwy. 6 W., Waco TX 76712. Editor/Publisher: James Haining. Published irregularly. Circ. 1,000. Previously published material and simultaneous submissions OK. Original artwork returned after publication. Sample copy for $8; art guidelines available for SASE with first-class postage.

Illustration: Buys 2 illustrations/issue. Interested in a variety of themes. Send brochure showing art style or tearsheets, photostats, photocopies, slides and photographs. Publication will contact artist for portfolio review if interested. Samples returned by SASE. Reports in 1 month. Buys first rights. Sometimes requests work on spec before assigning job. Pays in copies.

Design: Needs freelancers for design. Send query letter with transparencies. Pays for design by the project.

‡SALT WATER SPORTSMAN, 77 Franklin St., Boston MA 02210. (617)338-2300. Fax: (617)338-2309. Art Director: Chris Powers. Estab. 1939. Monthly consumer magazine describing the how-to and where-to of salt water sport fishing in the US, Caribbean and Central America. Circ. 140,000. Accepts previously published artwork. Originals returned at job's completion. Sample copies for 8½×11 SASE and 6 first-class stamps. Art guidelines available for SASE with first-class postage.

Illustration: Buys 4-5 illustrations/issue. Works on assignment only. Considers pen & ink, watercolor, acrylic, charcoal and electronic art files. Send query letter with tearsheets, photocopies, SASE and transparencies. Samples are not filed and are returned by SASE if requested by artist. Publication will contact artist for portfolio review if interested. Portfolio should include b&w and color tearsheets and final art. Buys first rights. **Pays on acceptance**; $500-1,000 for color cover; $50 for b&w inside; $100 for color inside. Finds artists mostly through submissions.

Design: Needs freelancers for design. 10% of freelance work demands knowledge of Photoshop, Adobe Illustrator, QuarkXPress. Send query letter with photocopies, SASE, tearsheets, transparencies. Pays by the project.

Tips: Areas most open to freelancers are how-to, semi-technical drawings for instructional features and columns; occasional artwork to represent fishing action or scenes. "Look the magazine over carefully to see the kind of art we run—focus on these styles."

✒SAN FRANCISCO BAY GUARDIAN, 520 Hampshire St., San Francisco CA 94110. (415)255-3100. E-mail: ok@sfbayguardian.com. Website: http://www.sfbg.com. Art Director: Elyse Hochstadt. For "a young, liberal, well-educated audience." Circ. 153,000. Weekly newspaper; tabloid format, b&w with 4-color cover, "progressive design." Art guidelines not available.

Cartoons: Run weekly. "Cartoons need to be anti-establishment, nothing 'run-of-the-mill.' " Cartoons focus on political and social commentary. Prefers local cartoonists. Pays $50-75.

Illustration: Has featured illustrations by Mark Matcho, John Veland, Barbara Pollack, Gabrielle Drinard and Gus D'Angelo. Features caricatures of politicans; humorous, realistic and spot illustration. Assigns 10% of illustrations to well-known or "name" illustrators; 60% to experienced, but not well-known illustrators; 30% to new and emerging illustrators. Weekly assignments given to local artists. Subjects include political and feature subjects. Preferred styles include contemporary, painterly and graphic line—pen and woodcut. "We like intense and we like fun." Artists who

exemplify desired style include Tom Tommorow, George Rieman and Bonnie To. Pays on publication; $300 for b&w and color cover; $34-100 for b&w inside; $75-150 for color inside; $100-250 for 2-page spreads; $34-100 for spots.
Design: 100% of freelance work demands knowledge of Adobe Photoshop, Adobe Illustrator, QuarkXPress. Prefers diversified talent. Send query letter with photocopies, photographs and tearsheets. Pays for design by the project.
Tips: "Please submit samples and letter before calling. Turnaround time is generally short, so long-distance artists generally will not work out." Advises freelancers to "have awesome work—but be modest."

THE SATURDAY EVENING POST, Dept. AM, The Saturday Evening Post Society, 1100 Waterway Blvd., Indianapolis IN 46202. (317)636-8881. Estab. 1897. General interest, family-oriented magazine. Published 6 times/year. Circ. 500,000. Sample copy $4.
Cartoons: Cartoon Editor: Steven Pettinga. Buys about 35 cartoons/issue. Uses freelance artwork mainly for humorous fiction. Prefers single panel with gaglines. Receives 100 batches of cartoons/week. "We look for cartoons with neat line or tone art. The content should be in good taste, suitable for a general-interest, family magazine. It must not be offensive while remaining entertaining. We prefer that artists first send SASE for guidelines and then review recent issues. Political, violent or sexist cartoons are not used. Need all topics, but particularly medical, health, travel and financial." SASE. Reports in 1 month. Buys all rights. Pays on publication; $125 for b&w line drawings and washes, no pre-screened art.
Illustration: Art Director: Chris Wilhoite. Uses average of 3 illustrations/issue. Send query letter with brochure showing art style or résumé and samples. To show a portfolio, mail final art. Buys all rights, "generally. All ideas, sketchwork and illustrative art are handled through commissions only and thereby controlled by art direction. Do not send original material (drawings, paintings, etc.) or 'facsimiles of' that you wish returned." Cannot assume any responsibility for loss or damage. "If you wish to show your artistic capabilities, please send nonreturnable, expendable/sampler material (slides, tearsheets, photocopies, etc.)." Pays $1,000 for color cover; $175 for b&w, $450 for color inside.
Tips: "Send samples of work published in other publications. Do not send racy or too new wave looks. Have a look at the magazine. It's clear that 50 percent of the new artists submitting material have not looked at the magazine."

THE SCHOOL ADMINISTRATOR, %American Association of School Administrators, 1801 N. Moore St., Arlington VA 22209. (703)875-0753. Fax: (703)528-2146. E-mail: lgriffin@aasa.org. Website: http://www@aasa.org. Managing Editor: Liz Griffin. Monthly association magazine focusing on education. Circ. 16,000. Art guidelines available for SASE with first-class postage.
Cartoons: Approached by 8-10 editorial cartoonists/year. Buys 12 cartoons/year. Prefers editorial/humorous, b&w/color washes or b&w line drawings. "Humor should be appropriate to a CEO of a school system, not a classroom teacher." Send photocopies and SASE. Samples are filed. Reports back only if interested. Buys one-time rights. **Pays on acceptance.**
Illustration: Approached by 12 illustrators/year. Buys 6 cover illustrations/year. Has featured illustrations by Michael Gibbs, Tim Haggerty, Ralph Butler and Danuta Jarecka. Features spot illustrations. Assigns 100% of illustrations to experienced, but not well-known illustrators. Considers all media. "Prefers illustrators who can take a concept and translate it into a simple powerful image and who can deliver art in digital form." 50% of freelance illustration demands knowledge of Aldus PageMaker 6.0, Photoshop 4.0, Adobe Illustrator 6.0, Aldus FreeHand 7.0, QuarkXPress 3.32. Send query letter with printed samples or photocopies. Send follow-up postcard every 6-8 months. Samples are filed. Reports back only if interested. Art director will contact artist for portfolio of b&w or color photographs, tearsheets and transparencies if interested. Buys one-time rights. Pays on publication; $400-600 for color cover; $25-50 for b&w inside and spots. Finds illustrators through word of mouth, stock illustration source and Creative Sourcebook.
Tips: "Read our magazine. I like work that takes a concept and translates it into a simple, powerful image."

‡SCHOOL BUSINESS AFFAIRS, 11401 N. Shore Dr., Reston VA 22090-4232. (703)478-0405. Fax: (703)478-0205. Assistant Editor: Katherine Jones. Monthly trade publication for school business managers. Circ. 6,000. Accepts previously published artwork. Originals are returned at job's completion. Sample copies available; art guidelines not available.
Illustration: Buys 2 illustrations/issue. Prefers business-related themes. Send query letter with tearsheets. Accepts disk submissions compatible with IBM format; Adobe Illustrator 4.0. Samples are filed. Reports back to the artist only if interested. Portfolio review not required. Rights purchased vary according to project.
Tips: "Tell me your specialties, your style—do you prefer realistic, surrealistic, etc. Include range of works with samples."

THE SCIENCE TEACHER, 1840 Wilson, Arlington VA 22201-3000. (703)243-7100. Fax: (703)243-7177. Website: http://www.nsta.org/pubs/tst. Design Manager: Kim Alberto. Estab. 1958. Monthly education association magazine; 4-color with straightforward design. "A journal for high school science teachers, science educators and secondary school curriculum specialists." Circ. 27,000. Accepts previously published work. Original artwork returned at job's completion. Sample copies and art guidelines available.
Cartoons: Approached by 6 cartoonists/year. Buys 0-1 cartoon/issue. "Science or education humor is all we publish but cartoons must not be insulting or controversial. Animal testing, dissection, creationism or Darwinism cartoons will not be published." Prefers single panel b&w line drawings or b&w washes with or without gagline. Send query letter with non-returnable samples. Reports back to the artist if interested. Buys one-time rights. Pays $35 for b&w.
Illustration: Approached by 75 illustrators/year. Buys 2 illustrations/issue. Works on assignment only. Has featured

illustrations by Charles Beyl, Leila Cabib and Michael Teel. Features humorous and realistic illustration. Assigns most work to experienced, but not well-known illustrators. Considers pen & ink, airbrush, collage and charcoal. Needs conceptual pieces to fit specific articles. Send query letter with tearsheets and photocopies. Samples are filed. Publication will contact artist for portfolio review if interested. Buys one-time rights. Pays on publication; budget limited.

Tips: Prefers experienced freelancers with knowledge of the publication. "I have found a very talented artist through his own self-promotion, yet I also use a local sourcebook to determine artists' styles before calling them in to see their portfolios. Feel free to send samples, but keep in mind that we're busy, too. Please understand we don't have time to return samples or take calls."

✔SCUBA TIMES MAGAZINE, 14110 Perdido Key Dr., Suite P2, Pensacola FL 32507. (904)492-7805. Fax: (904)492-7807. E-mail: katies@scubatimes.com. Website: http://www.scubatimes.com. Art Director: Scott Bieberich. Bimonthly magazine for scuba enthusiasts. Originals returned at job's completion. Editorial schedule is available.

Illustration: Approached by 10 illustrators/year. Buys 0-1 illustration/issue. Considers all media, particularly interested in Photoshop digital collage techniques that compliment the contemporary design of the magazine. Send postcard sample or query letter with SASE and samples. Accepts disk submissions compatible with Windows. Send EPS or TIFF files. Samples are filed. Publication will contact artist for portfolio review if interested. Buys one-time rights. Pays on publication; $150 for color cover; $25-75 for b&w/color inside; $25-50 for spots. Finds artists through submissions and word of mouth.

Tips: "Be familiar with our magazine. Show us you can draw divers and their gear. Our readers will catch even the smallest mistake. Also a good thing to try would be to get an old issue and pick a story from either the advanced diving journal or the departments where we used a photo and show us how you would have used your art instead. This will show us your ability to conceptualize and your skill as an artist. Samples do not have to be dive-related to win assignments."

SEATTLE MAGAZINE, 701 Dexter Ave. W., Suite 101, Seattle WA 98109. (206)284-1750. Fax: (206)284-2550. Website: http://www.seattlemag.com. Art Director: Skot O'Mahony. Estab. 1992. Monthly magazine covering travel and personalities of the area. Circ. 35,000. Call art director directly for art guidelines.

Illustration: Approached by hundreds of illustrators/year. Buys 2 illustrations/issue. Considers all media. "We can scan any type of illustration." Send postcard sample. Accepts disk submissions. Samples are filed. Reports back only if interested. Art director will contact artist for portfolio review of color, final art and transparencies if interested. Buys one-time rights. Sends payment on 15th of month of publication. Pays on publication; $150-1,100 for color cover; $50-400 for b&w; $50-1,100 for color inside; $50-400 for spots. Finds illustrators through agents, sourcebooks such as *Creative Black Book*, *LA Workbook*, online services, magazines, word of mouth, artist's submissions, etc.

Tips: "Good conceptual skills are the most important quality that I look for in an illustrator as well as unique skills."

‡SEEK, 8121 Hamilton Ave., Cincinnati OH 45231. (513)931-4050, ext. 365. Cartoon editor: Eileen H. Wilmoth. Emphasizes religion/faith. Readers are young adult to middle-aged adults who attend church and Bible classes. Quarterly in weekly issues. Circ. 45,000. Sample copy and art guidelines for SASE with first-class postage.

Cartoons: Approached by 6 cartoonists/year. Buys 8-10 cartoons/year. Buys "church or Bible themes—contemporary situations of applied Christianity." Prefers single panel b&w line drawings with gagline. Send finished cartoons, photocopies and photographs. Include SASE. Reports in 3-4 months. Buys first North American serial rights. **Pays on acceptance**; $30.

Illustration: Send b&w 8×10 glossy photographs.

SENIOR MAGAZINE, 3565 S. Higuera, San Luis Obispo CA 93401. (805)544-8711. Fax: (805)544-4450. Publisher: Gary Suggs. Estab. 1981. Monthly tabloid-sized magazine for people ages 40 and up. Circ. 300,000. Accepts previously published work. Original artwork returned at job's completion. Sample copies for SASE with first-class postage; art guidelines available for SASE.

Cartoons: Buys 1-2 freelance cartoons/issue. Prefers single panel with gagline. Send query letter with finished cartoons. Samples are filed. Reports back within 15 days. Pays $25 for b&w.

Illustration: Works on assignment only. "Would like drawings of famous people." Considers pen & ink. Send query letter with photostats. Samples are filed. Reports back within 15 days. Buys first rights or one-time rights. Pays on publication; $25 for b&w.

‡THE $ENSIBLE SOUND, 403 Darwin Dr., Snyder NY 14226. (716)833-0930. Fax: (716)833-0929 (5p.m.-9a.m.). E-mail: sensisound@aol.com. Publisher: John A. Horan. Editor: Karl Nehring. Bimonthly publication emphasizing audio equipment for hobbyists. Circ. 11,800. Accepts previously published material and simultaneous submissions. Original artwork returned after publication. Sample copy for $2.

Cartoons: Uses 4 cartoons/year. Prefers single panel, with or without gagline; b&w line drawings. Send samples of style and roughs to be kept on file. Material not kept on file is returned by SASE. Will accept material on mal-formatted disk or format via e-mail. Reports within 1 month. Negotiates rights purchased. Pays on publication; rate varies.

Tips: "Audio hobbyist material only please."

‡THE SHAWNEE SILHOUETTE, 940 Second St., Portsmouth OH 45662. (740)354-3205. Estab. 1985. Quarterly color literary magazine. Circ. 2,000. Poetry journal for ages 18-60; audience is mostly college students and professors. Accepts previously published artwork.

Illustration: Publishes 14 illustrations/issue. Restricted to students, faculty, staff of Shawnee State University and Scioto County residents only. For submissions, call (740)355-2689. Buys one-time rights. Pays in copies.

‡**SHEPHERD EXPRESS**, 1123 N. Water St., Milwaukee WI 53202. (414)276-2222. Fax: (414)276-3312. Production Manager: Matthew Karshna. Estab. 1982. "A free weekly newspaper that covers news, entertainment and opinions that don't get covered in our daily paper. We are an alternative paper in the same genre as *LA Weekly* or New York's *Village Voice*." Circ. 58,000. Accepts previously published artwork. Sample copies free for SASE with first-class postage. Art guidelines not available.
Cartoons: Approached by 130 cartoonists/year. Buys 2-3 cartoons/issue. Prefers single panel, b&w line drawings. Send query letter with finished cartoon samples. Samples are filed. Reports back only if interested. Buys one-time rights. Pays $15 for b&w.
Illustration: Approached by 25 illustrators/year. Buys 1-2 illustrations/week. Works on assignment only. Considers pen & ink, watercolor, airbrush, acrylic, marker, colored pencil, oil, charcoal and pastel. Send query letter with tearsheets and photographs. Samples are not filed and are returned by SASE if requested by artist. Reports back within 3-4 weeks. Write for appointment to show portfolio of final art, b&w and color tearsheets and photographs. Buys one-time rights. Pays on publication; $35 for b&w cover; $50 for color cover; $30 for b&w inside.
Tips: "Freelance artists must be good and fast, work on tight deadlines and have a real grasp at illustrating articles that complement the print. I hate it when someone shows up unannounced to show me work. I usually turn them away because I can't take time from my work. It's better to schedule a showing."

SHOFAR, 43 Northcote Dr., Melville NY 11747. (516)643-4598. Managing Editor: Gerald H. Grayson. Estab. 1984. Monthly magazine emphasizing Jewish religious education published October through May—double issues December/January and April/May. Circ. 15,000. Accepts previously published artwork. Originals returned at job's completion. Sample copies free for 9 × 12 SASE and $1.01 in postage; art guidelines available.
Illustration: Buys 3-4 illustrations/issue. Works on assignment only. Send query letter with tearsheets. Reports back to the artist only if interested. Pays on publication; $25-100 for b&w cover; $50-150 for color cover.

‡**SHOW BIZ NEWS AND MODEL NEWS**, 244 Madison Ave., #393, New York NY 10016-2817. (212)969-8715. Publisher: John King. Estab. 1975. "Our newspaper is read by show people—models and the public—coast to coast." Circ. 300,000. Accepts previously published artwork. Originals are returned at job's completion. Sample copies free for SASE with first-class postage.
Cartoons: Approached by 20 cartoonists/year. Buys 10 cartoons/issue. Prefers caricatures of show people and famous models; single or multiple panel b&w line drawings with gagline. Contact through artist rep or send query letter with finished cartoon samples. Samples are returned by SASE. Reports back within 10 days only if interested. Payment negotiable.
Illustration: Approached by 20-30 illustrators/year. Buys 10 illustrations/year. Artists sometimes work on assignment. Considers pen & ink, collage, airbrush, marker, colored pencil, charcoal and mixed media. Contact only through artist rep or send query letter with brochure, résumé, SASE, tearsheets, photographs and photocopies. Samples are filed or returned by SASE. Reports back within 10 days only if interested. Call or write to show a portfolio or mail appropriate materials: thumbnails, final art samples, b&w and color tearsheets and photographs. Buys first rights, one-time rights or reprint rights. Pays on publication.
Tips: "Keep up with the top cebebrities and models. Try to call and send data first. No drop-ins. Face shots are big."

‡**SIERRA MAGAZINE**, 85 Second St., 2nd Floor, San Francisco 94105-3441. (415)977-5572. Fax: (415)977-5794. E-mail: sierra.letters@sierraclub.org. Website: http://www.sierraclub.org. Art Director: Martha Geering. Bimonthly consumer magazine featuring environmental and general interest articles. Circ. 500,000.
Illustration: Buys 8 illustrations/issue. Considers all media. 10% of freelance illustration demands computer skills. Send postcard samples or printed samples, SASE and tearsheets. Samples are filed and are not returned. Reports back only if interested. Call for specific time for drop off. Art director will contact artist for portfolio review If interested. Buys one-time rights. **Pays on acceptance** or publication. Finds illustrators through illustration and design annuals, sourcebooks. submissions, magazines, word of mouth.

✓**SIGNS OF THE TIMES**, 1350 N. King's Rd., Nampa ID 83687. (208)465-2592. Fax: (208)465-2531. E-mail: merste@pacificpress.com. Website: http://www.pacificpress.com. Art Director: Merwin Stewart. A monthly Seventh-day Adventist 4-color publication that examines contemporary issues such as health, finances, diet, family issues, exercise, child development, spiritual growth and end-time events. "We attempt to show that Biblical principles are relevant to everyone." Circ. 225,000. Original artwork returned to artist after publication. Art guidelines available for SASE with first-class postage.
 • They accept illustrations traditionally produced or converted to electronic form on a 3.5″ optical disk, a 5.25″ removable hard disk cartridge, or a Zip disk.
Illustration: Buys 6-10 illustrations/issue. Works on assignment only. Has featured illustrations by Steve Smallwood, Lars Justinen, Consuelo Udave and Kevin Beilfuss. Features realistic illustration. Assigns 10% of illustrations to well-known or "name" illustrators; 80% to experienced, but not well-known illustrators; 10% to new and emerging illustrators. Prefers contemporary "realistic, stylistic, or humorous styles (but not cartoons)." Considers any media. Send postcard sample, brochure, photographs, slides, tearsheets or transparencies. Samples are not returned. "Tearsheets or

color photos (prints) are best, although color slides are acceptable." Samples are filed for future consideration and are not returned. Publication will contact artist for more samples of work if interested. Buys first-time North American publication rights. **Pays on acceptance** (30 days); $600-800 for color cover; $100-600 for b&w inside; $300-700 for color inside. Fees negotiable depending on needs and placement, size, etc. in magazine. Finds artists through submissions, sourcebooks, and sometimes by referral from other art directors.

Tips: "Most of the magazine illustrations feature people. Approximately 20 visual images (photography as well as artwork) are acquired for the production of each issue, half in black & white, half in color, and the customary working time frame is 3 weeks. Quality artwork and timely delivery are mandatory for continued assignments. It is customary for us to work with highly-skilled and dependable illustrators for many years." Advice for artists: "Invest in a good art school education, learn from working professionals within an internship, and draw from your surroundings at every opportunity. Get to know lots of people in the field where you want to market your work, and consistently provide samples of your work so they'll remember you. Then relax and enjoy the adventure of being creative."

THE SILVER WEB, P.O. Box 38190, Tallahassee FL 32315. E-mail: annkl9@mail.idt.net Publisher/Editor: Ann Kennedy. Estab. 1989. Semi-annual literary magazine. Subtitled "A Magazine of the Surreal." Circ. 2,000. Accepts previously published artwork. Originals returned at job's completion. Sample copies available for $7.20; art guidelines for SASE with first-class postage.

Illustration: Approached by 50-100 illustrators/year. Buys 15-20 illustrations/issue. Has featured illustrations by Scott Bagle, David Walters, Carlos Batts, Rodger Gerberding and Micahel Shores. Prefers works of the surreal, horrific or bizarre but not traditional horror/fantasy (dragons or monsters are not desired). Considers pen & ink, collage, charcoal and mixed media. Send query letter with samples and SASE. Samples are filed or are returned by SASE if requested by artist. Reports back within 2 weeks. Publication will contact artist for portfolio review if interested. Rights purchased vary according to project. **Pays on acceptance**; $25-50 for color cover; $10-25 for b&w inside; $5-10 for spots.

Tips: "I am more interested in what an artist creates because it is in his heart—rather than work done to illustrate a certain story. I want to see what you create because you want to create it."

‡SINISTER WISDOM, Box 3252, Berkeley CA 94703. Contact: Art Director. Estab. 1976. Literary magazine. Triannual multicultural lesbian feminist journal of arts and politics, international distribution; b&w with 2-color cover. Design is "tasteful with room to experiment. Easy access to text is first priority." Circ. 3,500. Accepts previously published artwork. Original artwork returned at job's completion. Sample copies available for $6.50. Art guidelines for SASE with first-class postage.

Cartoons: Approached by 15 cartoonists/year. Buys 0-2 cartoons/issue. Prefers lesbian/feminist themes, any style. Prefers single panel, b&w line drawings. Send query letter with roughs. Samples are filed or returned by SASE. Reports back within 9 months. Buys one-time rights. Pays 2 copies upon publication.

Illustration: Approached by 30-75 illustrators/year. Buys 6-15 illustrations/issue. Features caricatures of lesbian celebrities; women's fashion illustration; humorous, realistic and spot illustration. Prefers lesbian themes, images of women, abstraction and fine art. Considers any media for b&w reproduction. 20% of freelance work demands computer skills in PageMaker, Adobe Illustrator or Aldus FreeHand. Send postcard sample, photographs and slides. Accepts disk submissions. Samples are filed or returned by SASE. Reports back within 9 months. Does not review portfolios. Buys one-time rights. Pays on publication; 2 copies; "will pay for production or lab costs."

Tips: "Read it and note the guidelines and themes of upcoming issues. We want work by lesbians only."

‡SKI MAGAZINE, 929 Pearl St., Boulder CO 80302. (303)448-7649. Fax: (303)448-7638. Art Director: Rob Dybec. Estab. 1936. Emphasizes instruction, resorts, equipment and personality profiles. For new, intermediate and expert skiers. Published 8 times/year. Circ. 600,000. Previously published work OK "if we're notified."

Illustration: Approached by 30-40 freelance illustrators/year. Buys 25 illustrations/year. Mail art and SASE. Reports immediately. Buys one-time rights. **Pays on acceptance**; $1,200 for color cover; $150-500 for color inside.

Tips: "The best way to break in is an interview and a consistent style portfolio. Then, keep us on your mailing list."

‡SKIPPING STONES, P.O. Box 3939, Eugene OR 97403-0939. (541)342-4956. E-mail: skipping@efn.org. Editor: Arun Toké. Estab. 1988. Bimonthly b&w (with 4-color cover) consumer magazine. International nonprofit multicultural and nature education magazine for today's youth. Circ. 2,500. Art guidelines are free for SASE with first-class postage. Sample copy available for $5.

Cartoons: Prefers multicultural, social issues, nature/ecology themes. Prefers humorous, b&w washes and line drawings. Send b&w photocopies and SASE. Samples are filed or returned by SASE. Reports back within 3 months only if interested. Buys first rights and reprint rights. Pays on publication in copies.

Illustration: Approached by 100 illustrators/year. Buys 20-30 illustrations/issue. Has featured illustrations by Vidushi Avrati Bhatnagar, India; Inna Svjatova, Russia; Pam Logan, US. Features humorous illustration, informational graphics,

 A CHECKMARK PRECEDING A LISTING indicates a change in either the address or contact information since the 1998 edition.

natural history and realistic illustrations. Preferred subjects: children and teens. Prefers pen & ink. Assigns 20% of illustrations to experienced, but not well-known illustrators; 80% to new and emerging illustrators. Send non-returnable photocopies and SASE. Samples are filed or returned by SASE. Reports back within 3 months if interested. Portfolio review not required. Buys first rights, reprint rights. Pays on publication 1-5 copies. Finds illustrators through word of mouth, artists promo samples.

Tips: "We are a gentle, non-glossy, ad-free magazine not afraid to tackle hard issues. We are looking for work that challenges the mind, charms the spirit, warms the heart; handmade, non-violent, global, for youth 8-15 with multicultural/ nature content. Please, no aliens or unicorns."

SKYDIVING MAGAZINE, 1725 N. Lexington Ave., DeLand FL 32724. (904)736-4793. Fax: (904)736-9786. E-mail: skydiving@interserv.com. Website: http://emporium.turnpike.net/~skydiving.mag/index/.htm. Designer: Sue Clifton. Estab. 1979. "Monthly magazine on the equipment, techniques, people, places and events of sport parachuting." Circ. 14,200. Originals returned at job's completion. Sample copies available; art guidelines not available.

Cartoons: Approached by 10 cartoonists/year. Buys 2 cartoons/issue. Has featured cartoons by Craig Robinson. Prefers skydiving themes; single panel, with gagline. Send query letter with roughs. Samples are filed. Reports back within 2 weeks. Buys one-time rights. Pays $25 for b&w.

‡SLACK PUBLICATIONS, 6900 Grove Rd., Thorofare NJ 08086. (609)848-1000. Fax: (609)853-5991. E-mail: lbaker@slackinc.com. Creative Director: Linda Baker. Estab. 1990. 22 medical publications dealing with clinical and lifestyle issues for people in the medical professions. Circ. 13,000 Accepts previously published artwork. Originals returned at job's completion. Art guidelines not available.

Illustration: Approached by 50 illustrators/year. Buys 2 illustrations/issue. Works on assignment only. Features humorous and realistic illustration; charts & graphs; infomational graphics; medical, computer and spot illustration. Assigns 5% of illustrations to well-known or "name" illustrators; 90% to experienced, but not well-known illustrators; 5% to new and emerging illustrators. Prefers watercolor, airbrush, acrylic, oil and mixed media. Send query letter with tearsheets, photographs, photocopies, slides and transparencies. Samples are filed and are returned by SASE if requested by artist. Reports back to the artist only if interested. To show a portfolio, mail b&w and color tearshcets, slides, photostats, photocopies and photographs. Negotiates rights purchased. Pays on publication; $200-400 for b&w cover; $400-600 for color cover; $100-200 for b&w inside; $100-350 for color inside; $50-150 for spots.

Tips: "Send samples."

‡SMALL BUSINESS TIMES, 1123 N. Water St., Milwaukee WI 53202. (414)277-8181. Fax: (414)277-8191. Website: http://www.biztimes.com. Art Director: Catherine Findley. Estab. 1995. Monthly b&w with 4-color cover and inside spread, regional publication for business owners. Circ. 30,000. Sample copies free for 10×13 SASE and $3 first-class stamps. Art guidelines are free for #10 SASE with first-class postage.

Illustration: Approached by 50 illustrators/year. Buys 1-5 illustrations/issue. Has featured illustrations by Keith Skeen, Mike Waraksa. Features computer, humorous, realistic and b&w spot illustrations. Prefers business subjects in simpler styles that reproduce well on newsprint. Assigns 1% of illustrations to well-known or "name" illustrators; 9% to experienced, but not well-known illustrators; 90% to new and emerging illustrators. Send postcard sample and follow-up postcard every 3 months. Accepts Mac-compatible disk submissions. Send EPS or TIFF files. Samples are returned by SASE. Will contact artist for portfolio review if interested. Buys one-time rights. **Pays on acceptance**; $400-600 for color cover; $50-150 for b&w inside. Finds illustrators through word-of-mouth, *Black Book*, *Workbook*.

Tips: "Conceptual illustrators wanted! We're looking for simpler, black & white illustrations that communicate quickly."

‡THE SMALL POND MAGAZINE OF LITERATURE, Box 664, Stratford CT 06497. Editor: Napoleon St. Cyr. Estab. 1964. Emphasizes poetry and short prose. Readers are people who enjoy literature—primarily college-educated. Usually b&w or 2-color cover with "simple, clean design." Published 3 times/year. Circ. 300. Sample copy for $4; art guidelines for SASE.

Illustration: Receives 50-75 illustrations/year. Acquires 1-3 illustrations/issue. Has featured illustrations by Syd Weedon, Mal Gormley, Matthew Morgaine, Tom Herzberg and Jackie Peterson. Features humorous and spot illustrations. Assigns 20% of illustrations to experienced, but not well known illustrators; 80% to new and emerging illustrators. Uses freelance artwork mainly for covers, centerfolds and spots. Prefers "line drawings (inside and on cover) which generally relate to natural settings, but have used abstract work completely unrelated. Fewer wildlife drawings and more unrelated-to-wildlife material." Send query letter with finished art or production-quality photocopies, 2×3 minimum, 8×11 maximum. Include SASE. Publication will contact artist for portfolio review if interested. Pays 2 copies of issue in which work appears. Buys copyright in copyright convention countries. Finds artists through submissions.

Tips: "Need cover artwork, but inquire first or send for sample copy." Especially looks for "smooth clean lines, original movements, an overall impact. Don't send a heavy portfolio, but rather four to six black & white representative samples with SASE. Don't send your life's history and/or a long sheet of credits. Work samples are worth a thousand words." Advice to artists: "Peruse listings in *Artist's & Graphic Designer's Market* for wants and needs of various publications."

SOCIAL POLICY, 25 W. 43rd St., New York NY 10036. (212)642-2929. E-mail: socpol@igc.apc.org. Website: http://www.socialpolicy.com. Managing Editor: Audrey Gartner. Estab. 1970. Emphasizes the human services—education, health, mental health, self-help, consumer action, voter registration, employment. Quarterly magazine for social action leaders, academics and social welfare practitioners. Black & white with 2-color cover. Circ. 5,000. Accepts simultaneous

submissions. Original artwork returned after publication. Sample copy for $2.50; art guidelines not available.
Illustration: Approached by 10 illustrators/year. Works with 4 illustrators/year. Buys 6-8 illustrations/issue. Accepts b&w only, illustration "with social consciousness." Prefers pen & ink and charcoal/pencil. Send query letter with photocopies and tearsheets to be kept on file. Call for appointment to show portfolio, which should include b&w final art, final reproduction/product and tearsheets. Reports only if interested. Buys one-time rights. Pays on publication; $100 for cover; $25 for b&w inside.
Tips: When reviewing an artist's work, looks for "sensitivity to the subject matter being illustrated."

‡SOLDIERS MAGAZINE, 9325 Gunston Rd., Suite S108, Ft. Belvoir VA 22060-5548. (703)806-4486. Fax: (703)806-4566. Editor-in-Chief: Lt. Col. Ray Whitehead. Lighter Side Compiler: Steve Harding. Monthly 4-color magazine that provides "timely and factual information on topics of interest to members of the Active Army, Army National Guard, Army Reserve and Department of Army civilian employees and Army family members." Circ. 225,000. Previously published material and simultaneous submissions OK. Samples available upon request.
Cartoons: Purchases approximately 60 cartoons/year. Should be single panel with or without gagline. "Those without gaglines need to be self-explanatory. Cartoons should have a military or general interest theme." Buys all rights. **Pays on acceptance**; $25/cartoon.
Tips: "We are actively seeking new ideas and fresh humor, and are looking for new contributors. However, we require professional-quality material, professionally presented. We will not use anti-Army, sexist or racist material. We suggest you review recent back issues before submitting."

✔SOLIDARITY MAGAZINE, Published by United Auto Workers, 8000 E. Jefferson, Detroit MI 48214. (313)926-5291. E-mail: 71112.363@compuserve.com. Website: http://www.uaw.org. Acting Editor: Dick Olson. Four-color magazine for "1.3 million member trade union representing U.S. workers in auto, aerospace, agricultural-implement, public employment and other areas." Contemporary design.
Cartoons: Carries "labor/political" cartoons. Pays $75 for b&w, $125 for color.
Illustration: Works with 10-12 illustrators/year for posters and magazine illustrations. Interested in graphic designs of publications, topical art for magazine covers with liberal-labor political slant. Especially needs illustrations for articles on unemployment and economy. Looks for "ability to grasp our editorial slant." Send postcard sample or tearsheets and SASE. Samples are filed. Pays $500-600 for color cover; $200-300 for b&w inside; $300-450 for color inside.

SONGWRITER'S MONTHLY, 332 Eastwood Ave., Feasterville PA 19053. Phone/fax: (215)953-0952. E-mail: a1foster@aol.com. Editor/Publisher: Allen Foster. Estab. 1992. Monthly trade journal. "We are a cross between a trade journal and a magazine—our focus is songwriting and the music business." Circ. 2,500. Originals returned at job's completion with SASE. Sample copy free; art guidelines free for SASE with first-class postage.
Cartoons: Approached by 24 + cartoonists/year. Buys 1 cartoon/issue. Cartoons must deal with some aspect of songwriting or the music business. Prefers single panel, humorous, b&w line drawings with or without gagline. Send query letter with finished cartoons. Samples are not filed and are returned by SASE if requested by artist. Reports back within 2-4 weeks. Buys one-time rights. Pays $10 for b&w.
Illustration: Has featured illustrations by W.C. Pope and Regina Lafay. Features humorous illustration. Prefers music themes. Considers pen & ink. Send query letter with SASE and photocopies. Samples are filed. Reports back within 2-4 weeks. Portfolio review not required. Buys one-time rights. **Pays on acceptance**; $10 for b&w inside; $10 for spots.
Tips: "Query letters are important to us. Our primary needs are for artists who can find a creative way to illustrate articles dealing with songwriting concepts. We are black & white—please do not send color. A good single-panel cartoon on songwriting is the best way to get in our pages."

‡SOUTH MAGAZINE, P.O. Box 871229, Stone Mountain GA 30087. (770)879-3708. Fax: (770)498-2164. E-mail: cktaylor@mindspring.com. Art Director: Chris Taylor. Estab. 1997. Monthly 4-color regional consumer magazine featuring business and politics of Atlanta, GA. Circ. 30,000. Sample copies are free for #10 SASE with first-class postage. Art guidelines are free for #10 SASE with first-class postage.
Cartoons: Approached by 1-2 cartoonists/year. Prefers business themes in a sophisticated style. Prefers single, double and multiple panel, political, b&w line drawings. Send query letter with b&w photocopies. Samples are filed. Reports back only if interested. Buys one-time rights or rights purchased vary according to project. Pays on publication; $100-300 for b&w.
Illustration: Approached by 5 illustrators/year. Buys 1-2 illustrations/issue. Features caricatures of politicians, charts & graphs, informational graphics and spot illustrations. Prefers b&w line art featuring business subjects. Send query letter with printed samples. Accepts Mac-compatible disk submissions. Send EPS files. Samples are filed. Will contact artist for portfolio review if interested. Rights purchased vary according to project; negotiable. Pays on publication; $250-350 for b&w inside. Finds illustrators through word of mouth.
Tips: "All artwork received must reflect business and politics in the Atlanta, Georgia area. Always looking for fresh talent and new ideas."

SOUTHERN ACCENTS MAGAZINE, 2100 Lakeshore Dr., Birmingham AL 35209. (205)877-6000. Fax: (205)877-6990. Art Director: Ann M. Carothers. Estab. 1977. Bimonthly consumer magazine emphasizing fine Southern interiors and gardens. Circ. 350,000.
Illustration: Buys 25 illustrations/year. Considers color washes, colored pencil and watercolor. Send postcard sample.

Accepts disk submissions. Samples are returned. Reports back only if interested. Art director will contact artist for portfolio of final art, photographs, slides and tearsheets if interested. Rights purchased vary according to project. **Pays on acceptance** or pays on publication; $100-800 for color inside. Finds artists through magazines and sourcebook submissions.

‡SOUTHERN EXPOSURE, Box 531, Durham NC 27702. (919)419-8311. Fax: (919)419-8315. E-mail: editor@i4sou th.org. Editor: Chris Kromm. Estab. 1972. A quarterly magazine of Southern politics and culture emphasizing issues of importance to disenfranchised southern communities. Circ. 5,000. Accepts previously published artwork. Original artwork returned at job's completion. Sample copies available for $5. Guidelines available for SASE with first-class postage.
Illustration: Buys 2 freelance illustrations/issue. Send postcard sample or query letter with brochure, résumé, photographs and photocopies. Samples are nonreturnable. Pays $100 color cover; $25-50, b&w inside.
Tips: This company "prefers artists working in the South with southern themes, but please avoid stereotypes."

✓SOUTHERN LIVING, 2100 Lakeshore Dr., Birmingham AL 35209. (205)877-6000. Fax: (205)877-6700. Art Director: Leonard Loria. Monthly 4-color magazine emphasizing interiors, gardening, food and travel. Circ. 3 million. Original artwork returned after publication.
Illustration: Approached by 30-40 illustrators/year. Buys 3-4 illustrations/issue. Uses freelance artists mainly for illustrating monthly columns. Works on assignment only. Considers all media. Needs editorial and technical illustration. Send query letter with brochure showing art style or résumé and samples. Send follow-up postcard sample every 2-3 months. Samples returned only if requested. Publication will contact artist for portfolio review if interested. Portfolio should include color tearsheets and slides. Rights purchsed vary according to project. **Pays on acceptance**; $500-2,000, b&w or color. Pays $350 for spots.
Tips: In a portfolio include "four to five best pieces to show strengths and/or versatility. Smaller pieces are much easier to handle than large. It's best not to have to return samples but to keep them for reference files." Don't send "too much. It's difficult to take time to plow through mountains of examples." Notices trend toward "lighter, fresher illustration."

SPIDER, P.O. Box 300, Peru IL 61354. Art Director: Ron McCutchan. Estab. 1994. Monthly magazine "for children 6 to 9 years old. Literary emphasis, but also include activities, crafts, recipes and games." Circ. 95,000. Samples copies available; art guidelines for SASE with first-class postage.
Illustration: Approached by 800-1,000 illustrators/year. Buys 20-25 illustrations/issue. Has featured illustrations by Floyd Cooper, Jon Goodell and David Small. Features humorous and realistic illustration. Assigns 25% of illustrations to well-known or "name" illustrations; 50% to experienced, but not well-known illustrators; 25% to new and emerging illustrators. Prefers art featuring children, both realistic and whimsical styles. Considers all media. Send query letter with printed samples, photocopies, SASE and tearsheets. Send follow-up every 4 months. Samples are filed or are returned by SASE. Reports back within 4-6 weeks. Buys first North American serial rights. **Pays on acceptance**; $750 minimum for cover; $150-250 for color inside. Pays $50-150 for spots. Finds illustrators through artists who've published work in the children's field (books/magazines); artist's submissions.
Tips: "Read our magazine, include samples showing children and animals and put your name, address and phone number on every sample. It's helpful to include pieces that take the same character(s) through several actions/emotional states. It's also helpful to remember that most children's publishers need artists who can draw children from many different racial and ethnic backgrounds."

THE SPIRIT OF WOMAN IN THE MOON, 1409 The Alameda, Cupertino CA 95126-2653. (408)279-6626. Fax: (408)279-6636. E-mail: womaninmoon@earthlink. Website: http://wwwwomaninthemoon.com. Publisher: Dr. SD. Adamz-Bogus. Estab. 1993. Quarterly magazine. "We are New Age and we like ghosts, healing, angel, good-feeling stories. We like moon poetry and planet/themes." Circ. 3,000. Sample copies for $5. "Please write for guidelines."
Cartoons: Buys 4 cartoons/issue. Prefers "New Age/wacky!" Prefers single panel, political, humorous, b&w washes with gagline. Send query letter with finished cartoons, photocopies or tearsheets. "We have a cartoon panel series called 'Omen'—we want anonymous contributors to it." Reports back only if interested. "We keep samples but answer written requests." Buys first and reprint rights. Pays on publication; $10-25 for b&w.
Illustration: Approached by 20 illustrators/year. Features women's fashion illustration; humorous illustration. Assigns 10% of illustrations to well-known or "name" illustrators; 80% to experienced, but not well-known illustrators; 10% to new and emerging illustrators. Prefers human drama/life's ironies/Egyptian/animals. Considers acrylic, airbrush, colored pencil, oil, pastel, pen & ink and watercolor. 50% of freelance illustration demands knowledge of Aldus PageMaker, Adobe Photoshop and QuarkXPress. Send postcard sample. Samples are filed and are not returned. Reports back only if interested. Art director will contact artist for portfolio review of b&w, photographs and tearsheets if interested. Buys all rights on completion. Pays $100-600 for b&w cover; $250-600 for color cover; $10-25 for spots. Finds illustrators through *Creative Black Book* and artist's submissions.
Design: Needs freelancers for design and production. This is our biggest need. Prefers local design freelancers only. 50% of freelance work demands knowledge of Aldus PageMaker, Adobe Photoshop and QuarkXPress. Send query letter with printed samples, photocopies and SASE.
Tips: "We look for a fast turnaround and an open personality. We need a part-time regular graphic artist who can work on layout and design of magazine every three months. We want a regular cover designer. Call if able to come in. Simply let us know you've seen the publication or write for one and tell us how your work fits our themes."

‡SPORTS ILLUSTRATED PRESENTS, 1271 Avenue of Americas, Time/Life, New York NY 10020. (212)522-1212. Fax: (212)522-0203. Art Director: Craig Gartner. Designer: Mike Schinnerer. Seasonal magazine focusing on athletics: sport previews and championship commemoratives. Circ. 350,000. Sample copies available.
Illustration: Prefers sports-related caricatures. Considers all media. 15% of freelance illustration demands knowledge of Adobe Photoshop, Adobe Illustrator. Send query letter with printed samples, tearsheets. Samples are filed. Reports back only if interested. Will contact artist for portfolio review if interested. Rights purchased vary according to project. Payment varies on size of reproduction and on issue. Finds illustrators through research, examples of work, word of mouth.

SPORTS 'N SPOKES, 2111 E. Highland Ave., Suite 180, Phoenix AZ 85016-4702. (602)224-0500. Fax: (602)224-0507. E-mail: snsmagaz@aol.com. Art and Production Director: Susan Robbins. Bimonthly consumer magazine with emphasis on sports and recreation for the wheelchair user. Circ. 15,000. Accepts previously published artwork. Sample copies for 11×14 SASE and 6 first-class stamps.
Cartoons: Approached by 10 cartoonists/year. Buys 3-5 cartoons/issue. Prefers humorous cartoons; single panel b&w line drawings with or without gagline. Send query letter with finished cartoons. Samples are filed or returned by SASE if requested by artist. Reports back within 3 months. Buys all rights. **Pays on acceptance**; $10 for b&w.
Illustration: Approached by 5 illustrators/year. Works on assignment only. Considers pen & ink, watercolor and computer-generated art. 50% of freelance work demands knowledge of Adobe Illustrator, QuarkXPress or Adobe Photoshop. Send postcard sample or query letter with résumé and tearsheets. Accepts disk submissions compatible with Adobe Illustrator 7.0 or Photoshop 4.0. Send EPS or TIFF files. Samples are filed or returned by SASE if requested by artist. Reports back to the artist only if interested. Publication will contact artist for portfolio review if interested. Portfolio should include color tearsheets. Buys one-time rights and reprint rights. Pays on publication; $250 for color cover; $10 for b&w inside; $25 for color inside. Finds artists through word of mouth.
Tips: "We have not purchased an illustration or used a freelance designer for four years. We regularly purchase cartoons with wheelchair sports/recreation theme."

STEREOPHILE, 208 Delgado, Sante Fe NM 87501. (505)982-2366. Fax: (505)989-8791. E-mail: mpayne@stereophile.com. Production Director: Martha Payne. Estab. 1962. "We're the oldest and largest subject review high-end audio magazine in the country, approximately 220 pages/monthly." Circ. 80,000. Accepts previously published artwork. Original artwork not returned at job's completion.
Illustration: Approached by 50 illustrators/year. Buys 3-5 illustrations/issue. Works on assignment only. Features realistic illustration; charts & graphs; computer and spot illustration. Assigns 75% of illustrations to experienced, but not well-known illustrators; 25% to new and emerging illustrators. Interested in all media. Send query letter with brochure and tearsheets. Samples are filed. Reports back only if interested. Portfolio should include original/final art, tearsheets or other appropriate samples. Rights purchased vary according to project. Pays on publication; $150-1000 for color inside.
Tips: "Be able to turn a job in three to five days and have it look professional. Letters from previous clients to this effect help."

STONE SOUP, The Magazine by Young Writers and Artists, P.O. Box 83, Santa Cruz CA 95063. (408)426-5557. E-mail: editor@stonesoup.com. Website: http://www.stonesoup.com. Editor: Gerry Mandel. Bimonthly 4-color magazine with "simple and conservative design" emphasizing writing and art by children through age 13. Features adventure, ethnic, experimental, fantasy, humorous and science fiction articles. "We only publish writing and art by children through age 13. We look for artwork that reveals that the artist is closely observing his or her world." Circ. 20,000. Original artwork is returned after publication. Sample copies available for $4. Art guidelines for SASE with first-class postage.
Illustration: Buys 12 illustrations/issue. Prefers complete and detailed scenes from real life. Send query letter with photocopies. Samples are filed or are returned by SASE. Reports back within 1 month. Buys all rights. Pays on publication; $25 for color cover; $8-13 for b&w or color inside; $8-25 for spots.
Tips: "We accept artwork by children only, through age 13."

‡STORYHEAD MAGAZINE, 5701 S. Blackstone, #3N, Chicago IL 60637. (773)324-2194. E-mail: mbgpress-mail.uchicago.edu. Art Director: Michael Brehm. Co-Editor: Joe Peterson. Estab. 1993. Quarterly literary magazine featuring illustrated stories and poems. Circ. 500. Art guidelines are free for #10 SASE with first-class postage.
Illustration: Approached by 4 illustrators/year. Has featured illustrations by Chris Woodward, Kevin Riordan, Joe McDonnell. Features personal fine art and illustration. Prefers b&w. Send query letter with photocopies. Accepts Mac-compatible disk submissions. Send EPS files. Samples are returned by SASE. Reports back within 3 months. Will contact artist for portfolio review if interested. Pays 3 copies of magazine on publication.

STRAIGHT, 8121 Hamilton Ave., Cincinnati OH 45231. (513)931-4050. Fax: (513)931-0950. Editor: Heather E. Wallace. Estab. 1950. Weekly Sunday school take-home paper for Christian teens ages 13-19. Circ. 35,000. Sample copies for #10 SASE with first-class postage; art guidelines not available.
Illustration: Approached by 40-50 illustrators/year. Buys 50-60 illustrations/year. Has featured illustrations by Keith Locke, Patrick Kelley and Randy Glasberger. Features humorous and realistic illustration. Prefers realistic and cartoon. Considers pen & ink, watercolor, collage, airbrush, colored pencil and oil. Send postcard sample or tearsheets. Samples

are filed. Reports back to the artist only if interested. Portfolio review not required. Buys all rights. **Pays on acceptance**; $150 for 1-page inside illustration; $325 for 2-page inside illustration. Finds artists through submissions, other publications and word of mouth.

Tips: Areas most open to freelancers are "realistic and cartoon illustrations for our stories and articles."

THE STRAIN, 1307 Diablo, Houston TX 77532-3004. (713)733-0338. Articles Editor: Alicia Adler. Estab. 1987. Monthly literary magazine and interactive arts publication. "The purpose of our publication is to encourage the interaction between diverse fields in the arts and (in some cases) science." Circ. 1,000. Accepts previously published artwork. Original artwork is returned to the artist at the job's completion. Sample copy for $5 plus 9×12 SAE and 7 first-class stamps.

Cartoons: Send photocopies of finished cartoons with SASE. Samples not filed are returned by SASE. Reports back within 2 years on submissions. Buys one-time rights or negotiates rights purchased.

Illustration: Buys 2-10 illustrations/issue. "We look for works that inspire creation in other arts." Send work that is complete in any format. Samples are filed "if we think there's a chance we'll use them." Those not filed are returned by SASE. Publication will contact artist for portfolio review if interested. Portfolio should include final art or photographs. Negotiates rights purchased. Pays on publication; $10 for b&w, $5 for color cover; $10 for b&w inside; $5 for color inside.

STUDENT LAWYER, 750 N. Lake Shore Dr., Chicago IL 60611. (312)988-6042. E-mail: kulcm@staff.abanet.org. Art Director: Mary Anne Kulchawik. Estab. 1972. Trade journal, 4-color, emphasizing legal education and social/legal issues. "*Student Lawyer* is a legal affairs magazine published by the Law Student Division of the American Bar Association. It is not a legal journal. It is a features magazine, competing for a share of law students' limited spare time—so the articles we publish must be informative, lively, good reads. We have no interest whatsoever in anything that resembles a footnoted, academic article. We are interested in professional and legal education issues, sociolegal phenomena, legal career features, and profiles of lawyers who are making an impact on the profession." Monthly (September-May). Circ. 35,000. Original artwork is returned to the artist after publication. Sample copies for $8.

Illustration: Approached by 20 illustrators/year. Buys 8 illustrations/issue. Has featured illustrations by Sean Kane, Ken Wilson and Charles Stubbs. Features realistic, computer and spot illustration. Assigns 50% of illustrations to experienced, but not well-known illustrators; 50% to new and emerging illustrators. Needs editorial illustration with an "innovative, intelligent style." Works on assignment only. Needs computer-literate freelancers for illustration. Send postcard sample, brochure, tearsheets and printed sheet with a variety of art images (include name and phone number). Samples are filed or returned by SASE. Call for appointment to show portfolio of final art and tearsheets. Buys one-time rights. **Pays on acceptance**; $500-800 for color cover; $300-500 for b&w cover, $450-600 for color inside; $300-450 for b&w inside; $150-200 for spots.

Tips: "In your portfolio, show a variety of color and black & white, plus editorial work."

STUDENT LEADER MAGAZINE, P.O. Box 14081, Gainesville FL 32604-2081. (352)373-6907. Fax: (352)373-8120. E-mail: oxendine@compuserve.com. Website: http://www.studentleader.com. Art Director: Jeff Riemersma. Estab. 1993. National college leadership magazine published once per semester. Circ. 100,000. Sample copies for $8½ \times 11$ SASE and 4 first-class stamps. Art guidelines for #10 SASE with 1 first-class stamp.

● Oxendine Publishing also publishes *Careers & Majors Magazine*, *Florida Leader Magazine* and *Florida Leader Magazine for High School Studends*.

Illustration: Approached by hundreds of illustrators/year. Buys 6 illustrations/issue. Considers all media. 10% of freelance illustration demands computer skills. Disk submissions must be PC-based, TIFF or EPS files. Samples are filed and are not returned. Reports back only if interested. Rights purchased vary according to project. Pays on publication; $125 for color inside. Finds illustrators through sourcebook and artist's submissions.

Tips: "We need responsible artists who complete projects on time and have a great imagination. Also must work within budget."

✔**STYGIAN VORTEX PUBLICATIONS**, E-mail: stygian@mindspring.com. Website: http://www.mindspring.com/~stygian. Art Director: Coyote Osborne. Estab. 1992. Annual anthologies "featuring adult tales with unnerving or unusual twists where all is not as it seems; for a mature audience." Publications include *In Darkness Eternal*, *Shapeshifer!*, *Shadow Sword: The Magazine of Fantasy*, and *Shadow Sword Presents: the Heroines of Fantasy*. Circ. 200+. Originals returned at job's completion. Sample copies available for $5.25. Art guidelines free for 9×12 SAE and 78¢ postage.

Cartoons: Buys 1-4 cartoons/issue. Prefers twisted artwork and illustrations otherwise appropriate to publication. Prefers single, double and multiple panels; humorous, b&w washes and line drawings, with or without gagline. Send query letter with finished cartoons. Samples are filed. Reports back within 2 months. Buys one-time rights. Pays cartoonists in copies and $2-5 token payment. "Please request guidelines!"

Illustration: Buys 40-50 illustrations/issue. Works on assignment only. Considers pen & ink, collage and charcoal. Needs computer-literate freelancers for illustration and presentation. 5-10% of work demands knowledge of Adobe Illustrator, QuarkXPress, Adobe Photoshop and Aldus FreeHand. Send query letter with SASE and photocopies, include phone number. Samples are filed. Reports back within 2 months. Request portfolio review in original query. Portfolio should include thumbnails and final art. Buys one-time rights. Pays on publication; $5-25 for b&w cover; $10-50 for

color cover; $5 maximum for b&w inside; $1 maximum for spots. Finds artists through *Scavenger's Newsletter*, word of mouth, market listings, bulletin boards, notices in papers.
Tips: "Send for our guidelines. We have very specific needs for artwork."

‡♦**SUB-TERRAIN MAGAZINE**, 204-A, 175 E. Broadway, Vancouver, British Columbia V5T 1W2 Canada. (604)876-8710. Fax: (604)879-2667. E-mail: subter@pinc.com. Managing Editor: Brian Kaufman. Estab. 1988. Quarterly b&w literary magazine featuring contemporary literature of all genres.
Cartoons: Prefers single panel cartoons. Samples are filed. Reports back within 2 months. Buys first North American serial rights. Pays $100-300 for b&w.
Illustration: Assigns 100% of illustrations to new and emerging illustratoars. Send query letter with photocopies. Samples are filed. Reports back within 2 months. Portfolio review not required. Buys first rights, first North American serial rights, one-time rights or reprints rights. **Pays on acceptance**; $100-300.
Tips: "Take the time to look at an issue of the magazine to get an idea of what work we use."

THE SUN, 107 N. Roberson, Chapel Hill NC 27516. (919)942-5282. Editor: Sy Safransky. Monthly magazine of ideas. Circ. 30,000. Accepts previously published material. Original artwork returned after publication. Sample copy for $5; art guidelines for SASE with first-class postage.
Cartoons: "We accept very few cartoons." Material not kept on file is returned by SASE. Reports within 3 months. Buys first rights. Pays $50 plus copies and 1 year subscription.
Illustration: Send query letter with samples. Needs illustrations that reproduce well in b&w. Accepts abstract and representational work. Samples not filed are returned by SASE. Reports within 3 months. Buys one-time rights. Pays on publication; $200 for cover; $50 minimum for inside; plus copies and 1 year subscription.

‡**SUNEXPERT**, 320 Washington St., Brookline MA 02146. (617)738-3409. Fax: (617)739-7003. E-mail: jwk@cpg.com. Website: http://www.cpg.com. Art Director: John W. Kelley Jr. Senior Designer: Jerry Cogliano. Designer: Brad Dillman. Estab. 1989. Monthly 4-color trade publication. Circ. 100,000.
Illustration: Approached by 20-30 illustrators/year. Buys 15 illustrations/issue. Has featured illustrations by Paul Anderson, Eric Yang, Ken Call, Will Terry, Paul Zwolak, Tom Barrett. Features computer illustration, informational graphics and spot illustrations. Assigns 33.3% of illustration to well-known or "name" illustrators; 33.3% to experienced, but not well-known illustrators; 33.3% to new and emerging illustrators. Send postcard or other non-returnable samples and follow-up samples every 2 months. Accepts Mac-compatible disk submissions. Send EPS or TIFF files. Samples are filed. Will contact artist for portfolio review if interested. Rights purchased vary according to project. Pays on publication; $325-1,200 for color inside; $125 for spots.
Tips: "We like to give new artists a shot, those who are conceptual are looked at closely. Work should be conceptual because we deal in the high-tech arena. Since we buy at least 15 pieces each issue we alternate the talent every 4-6 months."

SUNSHINE MAGAZINE, 200 E. Las Olas Blvd., Ft. Lauderdale FL 33301. (305)356-4690. E-mail: gcarannante@tribune.com. Art Director: Greg Carannante. Estab. 1983. Consumer magazine; the Sunday magazine for the *Sun Sentinel* newspaper; "featuring anything that would interest an intelligent adult reader living on South Florida's famous 'gold coast.' " Circ. 350,000. Accepts previously published artwork. Original artwork returned to artist at the job's completion. Sample copies and art guidelines available.
Illustration: Approached by 100 illustrators/year. Buys 60-70 freelance illustrations/year. Works on assignment only. Has featured illustrations by Cary Henrie, Hungry Dog Studio and Janet Uram. Features caricatures of celebrities; humorous, realistic, computer and spot illustrations. Assigns 10% of illustrations to well-known or "name" ilustrators; 60% to experienced, but not well-known illustrators; 30% to new and emerging illustrators. Preferred themes and styles vary. Considers all color media. Send postcard sample. Will accept computer art—Quark/Photoshop interface. Samples are filed or are returned by SASE. Reports back to the artist only if interested. To show a portfolio, mail color cards, disks, tearsheets, photostats, slides and photocopies. Buys first rights. **Pays on acceptance**; $600-700 for color cover; $250-500 for color inside; $600-700 for 2-page spreads; $200-300 for spots.
Tips: Looking for stylized, colorful dramatic images "with a difference. Show me something stylistically different—but with fundamental quality."

‡**TAPPI JOURNAL**, 15 Technology Pkwy., Norcross GA 30092. (770)446-1400. Fax: (770)209-7400. Website: http://www.tappi.org. Production Manager: Timothy Whelan. Monthly trade journal covering pulp and paper industry. Circ. 50,000. Sample copies available; art guidelines not available.
Illustration: Approached by 3 illustrators/year. Buys 1 illustration/year. Features realistic illustration; informational graphics; computer illustrations. Prefers pulp and paper/manufacturing and engineering themes. Considers all media. Knowledge of Adobe Photoshop, QuarkXPress, Adobe Illustrator helpful, but not required. Send query letter with printed samples. Send follow-up postcard sample every 3 months. Accepts disk submissions compatible with latest version of Photoshop, QuarkXPress. Send EPS. Reports back within 1 month. Buys all rights. **Pays on acceptance**; $1,000 maximum for color cover. Finds illustrators through word of mouth, magazines.

‡**TECHLINKS**, 2841 Akers Mill Rd., Atlanta GA 30339. (770)984-7577. Fax: (770)612-0780. E-mail: stuartmclelland@apg.com. Website: http://www.jaye.com. Art Director: Stuart McLelland. Estab. 1998. Bimonthly 4-color publication for end users and corporate buyers. Circ. 35,000.

Like many computer magazines, *SunExpert* needs conceptual illustrators, says Art Director John W. Kelley, Jr. "For this illustration, Will Terry conceptually captured the administrative wizard's utility," Kelley explains. *SunExpert* found Terry through the artist's own website. "I send about four mailings a year, have been in the *Workbook* for three years and have a rep," says Terry. "I began five years ago drawing what I thought would sell, and only when I began drawing what I wanted to draw did I start realizing success."

• Also publishes *TechSouth*.

Illustration: Approached by 50 illustrators/year. Has featured illustrations by Basil Berry. Prefers business subjects. Assigns 20% of illustrations to experienced, but not well-known illustrators; 80% to new and emerging illustrators. 100% of freelance illustration demands knowledge of Adobe Photoshop, Aldus PageMaker, QuarkXPress. Send postcard sample and follow-up postcard every 2 months. Accepts Mac-or Windows-compatible disk submissions. Samples are not filed and not returned. Will contact artist for portfolio review if interested. Buys first rights. Pays on publication. Payment negotiable. Finds illustrators through our sister company; America's Performance Group.

TECHNICAL ANALYSIS OF STOCKS & COMMODITIES, 4757 California Ave. SW, Seattle WA 98116-4499. (206)938-0570. E-mail: cmorrison@traders.com. Website: http://www.Traders.com. Art Director: Christine Morrison. Estab. 1982. Monthly traders' magazine for stocks, bonds, futures, commodities, options, mutual funds. Circ. 52,000. Accepts previously published artwork. Sample copies available for $5. Art guidelines for SASE with first-class postage or on website.

Cartoons: Approached by 10 cartoonists/year. Buys 1 cartoon/issue. Prefers humorous cartoons, single panel b&w line drawings with gagline. Send query letter with finished cartoons. Samples are filed or are returned by SASE if

SLOPES OF THE

ILLUSTRATION BY DAVID MILLER

© 1997 David Miller

"I liked his style. It's very original and different from what's on the market now," says New York City-based rep Wanda Nowak of the illustrations of David Miller. Miller contacted Nowak for representation a little over a year ago, and since advertising in sourcebooks such as *The Black Book* and *Alternative Pick*, has landed projects such as this with *Sunshine* magazine. Because Miller's work is highly individual, "you have to do double time to break in," sending out three or four mailings to familiarize potential clients with Miller's style, Nowak says.

requested by artist. Reports back within 3 weeks. Buys one-time rights and reprint rights. Pays $30 for b&w.
Illustration: Approached by 25 illustrators/year. Buys 6 illustrations/issue. Works on assignment only. Has featured illustrations by John English, Carolina Arentsen and Patrick Fitzgerald. Features humorous, realistic, computer (occassionally) and spot illustrations. Assigns 10% of illustrations to well-known or "name" illustrators; 60% to experienced, but not well-known illustrators; 30% to new and emerging illustrators. Send query letter with brochure, tearsheets, photographs, photocopies, photostats, slides. Accepts disks compatible with any Adobe products on TIFF or EPS files. Samples are filed or are returned by SASE if requested by artist. Reports back within 3 weeks. Publication will contact artist for portfolio review if interested. Portfolio should include b&w and color tearsheets, slides, photostats, photocopies, final art and photographs. Buys one-time rights and reprint rights. Pays on publication; $135-350 for color cover; $165-213 for color inside; $105-133 for b&w inside.
Tips: "Looking for creative, imaginative and conceptual types of illustration that relate to the article's concepts. Also caricatures with market charts and computers. Send a few copies of black & white and color work—with cover letter—if I'm interested I will call."

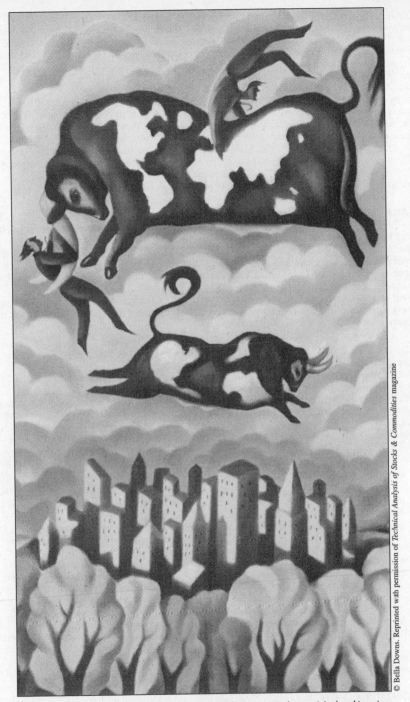

"Our articles are very technical, so it's always a challenge to produce original and imaginative, striking images," says Christine Morrison, art director of *Technical Analysis of Stocks & Commodities*. Illustrator Bella Downs rose to the challenge with this piece for an article on The Investor Preference Index. "I used the Minoan Bulls to express how market traders try to jump from bull market to bull market without being gored by the bull's horns," says Downs. She got the assignment through direct mail self promotion. Downs sends 2 to 4 mailings a year to 500 publications.

TECHNIQUES MAGAZINE, 1410 King St., Alexandria VA 22314. (703)683-3111. Fax: (703)683-7424. E-mail: marlene@avaonline.org. Website: http://www.avaonline.org. Contact: Marlene Lozada. Estab. 1924. Monthly 4-color trade journal. "We publish articles on teaching for educators in the field of vocational education." Circ. 45,000. Accepts previously published artwork. Originals returned at job's completion. Sample copies with 9×11 SASE and first-class postage. Art guidelines not available.
Cartoons: "We rarely use cartoons." Pays $100 for b&w, $200-300 for color.
Illustration: Approached by 50 illustrators/year. Buys 8 illustrations/year. Works on assignment only. Has featured illustrations by John Berry, Valerie Spain, Eric Westbrook, Becky Heavner and Bryan Leister. Features informational graphics; comuter and spot illustrations. Assigns 60% of illustrations to well-known or "name" illustrators; 20% to experienced, but not well-known illustrators; 20% to new and emerging illustrators. Considers pen & ink, watercolor, colored pencil, oil and pastel. Needs computer-literate freelancers for illustration. "We use a lot of CD-ROM art." Send query letter with brochure and photographs. Samples are filed. Reports back within 3 weeks. Portfolio review not required. Rights purchased vary according to project. Sometimes requests work on spec before assigning job. Pays on publication; $600-1,000 for color cover; $275-500 for color inside.
Tips: "Send samples. When we need an illustration we look through our files."

'TEEN MAGAZINE, 6420 Wilshire Blvd., Los Angeles CA 90048-5515. (213)782-2950. Fax: (213)782-2660. Art Director: L. Finnerty. Estab. 1960. Monthly consumer magazine "that focuses on fashion, beauty, entertainment and psychological issues important to the high school and college-age girl." Circ. 1,700,000.
Illustration: Approached by 100 illustrators/year. Buys 1-2 illustrations/issue. Considers all media. Send postcard sample or query letter with printed samples, photocopies, SASE and tearsheets. Samples are filed. Buys one-time rights. Pays on publication; $150-450 for color inside. Finds illustrators through *Creative Black Book, LA Workbook*, word of mouth and artist's submissions.
Design: Needs freelancers for design and production on occasion. Prefers local design freelancers only. 100% of freelance work demands knowledge of Adobe Photoshop, Adobe Illustrator and QuarkXPress. Send query letter with printed samples, photocopies, SASE and tearsheets.

TENNIS, Dept. AGDM, 5520 Park Ave., Trumbull CT 06611. (203)373-7000. Art Director: Lori Wendin. For affluent tennis players. Monthly. Circ. 800,000.
● As AGDM goes to press, we've learned that *Tennis* will move its editorial offices to New York City by June 1, 1998. Please call for new address before sending your samples.
Illustration: Works with 15-20 illustrators/year. Buys 50 illustrations/year. Uses artists mainly for spots and openers. Works on assignment only. Send query letter with tearsheets. Mail printed samples of work. **Pays on acceptance**; $400-800 for color.
Tips: "Prospective contributors should first look through an issue of the magazine to make sure their style is appropriate for us."

✓TEXAS CONNECTION MAGAZINE, 8170 S. Eastern, Suite 4501, Las Vegas, NV 89123. (888)949-1975. E-mail: publish@quantumedia.net. Website: http://www.firstpub.com. Editor: Nanci Drewer. Estab. 1985. Monthly adult magazine. Circ. 25,000. Originals returned at job's completion. Sample copies available for $12; art guidelines available for SASE with first-class postage.
Cartoons: Buys 4-6 cartoons/issue. Prefers adult; single panel b&w washes and line drawings with gagline. Send query letter with finished cartoons. Samples are filed, not filed or returned at artist's request. Reports back to the artist only if interested. Buys first rights. Pays $25 for b&w.
Illustration: Approached by 50 illustrators/year. Buys 12 illustrations/issue. Prefers adult themes. Send query letter with photocopies, tearsheets and SASE. Accepts disk submissions compatible with PageMaker 6 (Windows), CorelDraw. Samples that are not filed are returned. Publication will contact artist for portfolio review if interested. Portfolio should include b&w and color photocopies and final art. Buys one-time rights. Pays on publication; $25-50 for b&w, $100 for color inside; $25 for spots. Finds artists through submissions.
Design: Needs freelancers for production and multimedia. 100% of freelance work demands knowledge of Windows versions of Aldus Pagemaker 6, Adobe Photoshop, CorelDraw. Send query letter with photocopies, tearsheets and SASE.
Tips: Areas most open to freelancers are "adult situations normally—some editorial and feature illustrations. Give us something fresh—some new twist on adult situations—not the same old, tired grind. Artists willing to relocate to Las Vegas to become part of expanding in-house design team are welcome to submit résumés with samples and references."

TEXAS MONTHLY, P.O. Box 1569, Austin TX 78767-1569. (512)320-6900. Fax: (512)476-9007. Art Director: D.J. Stout. Estab. 1973. Monthly general interest magazine about Texas. Circ. 350,000. Accepts previously published artwork. Originals are returned to artist at job's completion.
Illustrations: Approached by hundreds of illustrators/year. Works on assignment only. Considers all media. Send postcard sample of work or send query letter with tearsheets, photographs, photocopies. Samples are filed "if I like them," or returned by SASE if requested by artist. Publication will contact artist for portfolio review if interested. Portfolio should include tearsheets, photographs, photocopies. Buys one-time rights. Pays on publication; $1,000 for color cover; $800-2,000 for color inside; $150-400 for spots.

THEMA, Box 74109, Metairie LA 70033-4109. (504)568-6268. E-mail: bothomos@juno.com. Website: http://www.litline.org. Editor: Virginia Howard. Estab. 1988. Triquarterly. Circ. 300. Sample copies are available for $8. Art guidelines for SASE with first-class postage.

● Each issue of *Thema* is based on a different, unusual theme, such as "Jogging on Ice." Upcoming themes and deadlines include "A Postcard Not Received" (November 1, 1998); "The Road to the Villa" (March 1, 1999).

Cartoons: Approached by 10 cartoonists/year. Buys 1 cartoon/issue. Preferred themes are specified for individual issue (see Tips and Editorial Comment). Prefers humorous cartoons; b&w line drawings without gagline. Send query letter with finished cartoons. Samples are filed or are returned by SASE if requested by artist. Buys one-time rights. Pays $10 for b&w.

Illustration: Approached by 10 illustrators/year. Buys 1 illustration/issue. Has featured illustrations by Thezeus Sarris and Keith Peters. Features theme-related illustrations. Preferred themes are specified for target issue (see Tips and Editorial Comment). Considers pen & ink. Freelancers should be familiar with CorelDraw. Send query letter specifying target theme with photocopies, photographs and SASE. Samples are returned by SASE if requested by artist. Portfolio review not required. Buys one-time rights. **Pays on acceptance**; $25 for b&w cover; $10 for b&w inside; $5 for spots. Finds artists through word of mouth.

Tips: "Please be aware that *Thema* is theme-oriented—each issue based on a different theme. Don't submit anything unless you have one of our themes in mind. No theme—no chance of acceptance."

‡TIKKUN MAGAZINE, 26 Fell St., San Francisco CA 94102. (415)575-1200. Fax: (415)575-1434. Publisher: Michael Lerner. Contact: Eric Goldhagen. Estab. 1986. "A bimonthly Jewish critique of politics, culture and society. Includes articles regarding Jewish and non-Jewish issues, left-of-center politically." Circ. 40,000. Accepts previously published material. Original artwork returned after publication. Sample copies for $6 plus $2 postage or "call our distributor for local availability at (800)846-8575."

Illustration: Approached by 50-100 illustrators/year. Buys 0-8 illustrations/issue. Features realistic illustration. Assigns 90% of illustrations to experienced, but not well-known illustrators; 10% to new and emerging illustrators. Prefers line drawings. Send brochure, résumé, tearsheets, photostats, photocopies. Slides and photographs for color artwork only. Buys one time rights. Slides and photographs returned if not interested. "Often we hold onto line drawings for last-minute use." Pays on publication; $150 for color cover; $40 for b&w inside.

Tips: No "computer graphics, sculpture, heavy religious content. Read the magazine—send us a sample illustration of an article we've printed, showing how you would have illustrated it."

TIME, 1271 Avenue of the Americas, Rockefeller Center, New York NY 10020. (212)522-1212. Fax: (212)522-0536. Website: http://www.time.com. Deputy Art Director: Joe Zeff. Estab. 1923. Weekly magazine covering breaking news, national and world affairs, business news, societal and lifestyle issues, culture and entertainment. Circ. 4,096,000.

Illustration: Considers all media. Send postcard sample, printed samples, photocopies or other appropriate samples. Accepts disk submissions. Samples are filed. Reports back only if interested. Portfolios may be dropped off every Tuesday between 11 and 1. They may be picked up the following day, Wednesday, between 11 and 1. Buys first North American serial rights. Pay is negotiable. Finds artists through sourcebooks and illustration annuals.

TODAY'S FIREMAN, Box 875108, Los Angeles CA 90087. Editor: Jayney Mack. Estab. 1960. Quarterly b&w trade tabloid featuring general interest, humor and technical articles and emphasizing the fire service. "Readers are firefighters—items should be of interest to the fire service." Circ. 10,000. Accepts previously published material. Original artwork is not returned after publication.

Cartoons: Buys 12 cartoons/year from freelancers. Prefers fire-service oriented single panel with gagline; b&w line drawings. Send query letter with samples of style, roughs or finished cartoons. Reports back only if interested. Buys one-time rights. Pays $4.

Illustration: Send postcard sample or query letter with brochure. Pays $4-10 for b&w inside.

Design: Needs freelancers for design, production and multimedia. 50% of freelance work demands knowledge of Aldus FreeHand and QuarkXPress. Send query letter with SASE. Pays by the project.

Tips: "Everything should relate to the fire service."

TOLE WORLD, 1041 Shary Circle, Concord CA 94518. (510)671-9852. Editor: Judy Swager. Estab. 1977. Bimonthly 4-color magazine with creative designs for decorative painters. "*Tole* incorporates all forms of craft painting including folk art. Manuscripts on techniques encouraged." Circ. 90,000. Accepts previously published artwork. Original artwork returned after publication. Sample copies available; art guidelines available for SASE with first-class postage.

Illustrations: Buys illustrations mainly for step-by-step project articles. Buys 8-10 illustrations/issue. Prefers acrylics and oils. Considers alkyds, pen & ink, mixed media, colored pencil, watercolor and pastels. Needs editorial and technical illustration. Send query letter with photographs. Samples are not filed and are returned. Reports back about queries/submissions within 1 month. Pay is negotiable.

Tips: "Submissions should be neat, evocative and well-balanced in color scheme with traditional themes, though style can be modern."

‡TRAINING & DEVELOPMENT MAGAZINE, 1640 King St., Box 1443, Alexandria VA 22313-2043. (703)683-8146. Fax: (703)683-9203. E-mail: ljones@astd.org. Art Director: Elizabeth Z. Jones. Estab. 1945. Monthly trade journal

that covers training and development in all fields of business. Circ. 40,000. Accepts previously published artwork. Original artwork is returned at job's completion. Art guidelines not available.

Illustration: Approached by 20 freelance illustrators/year. Buys 5-7 freelance illustrations/issue. Works on assignment only. Has featured illustrations by Bill Milne, Dave Black, Boris Lyubner and Danuta Jarecka. Features humorous, realistic, computer and spot illustration. Assigns 35% of illustrations to well-known or "name" illustrators; 55% to experienced, but not well-known illustrators; 10% to new and emerging illustrators. Prefers sophisticated business style. Considers collage, pen & ink, airbrush, acrylic, oil, mixed media, pastel. Send postcard sample. Accepts disks compatible with Adobe Illustrator 5.5, Aldus FreeHand 5.0. Send EPS or TIFF files. Use 4-color (process) settings only. Samples are filed. Reports back to the artist only if interested. Write for appointment to show portfolio of tearsheets, slides. Buys one-time rights or reprint rights. Pays on publication; $400-600 for b&w cover, $700-1000 for color cover; $200-300 for b&w inside; $400-600 for color inside; $600-800 for 2-page spreads; $100-300 for spots.

Tips: "Send more than one image if possible. Do not keep sending the same image. Try to tailor your samples to the Art Director's needs if possible."

‡TRAINING MAGAZINE, The Human Side of Business, 50 S. Ninth St., Minneapolis MN 55402. (612)333-0471. Fax: (612)333-6526. Art Director: Nancy Eato. Estab. 1964. Monthly 4-color trade journal covering job-related training and education in business and industry, both theory and practice. Audience: training directors, personnel managers, sales and data processing managers, general managers, etc. "We use a variety of styles, but it is a business-looking magazine." Circ. 51,000. Sample copies for SASE with first-class postage.

Cartoons: Approached by 20-25 cartoonists/year. Buys 1-2 cartoons/issue. "We buy a wide variety of styles. The themes relate directly to our editorial content, which is training in the workplace." Prefers single panel, b&w line drawings or washes with and without gagline. Send query letter with brochure and finished cartoons. Samples are filed or are returned by SASE if requested by artist. Reports back within 1 month. Buys first rights or one-time rights. Pays $50 for b&w.

Illustration: Buys 6-8 illustrations/issue. Works on assignment only. Prefers themes that relate directly to editorial content. Styles are varied. Considers pen & ink, airbrush, mixed media, watercolor, acrylic, oil, pastel and collage. Send postcard sample, tearsheets, photocopies and SASE. Accepts disk submissions. Samples are filed or are returned by SASE if requested by artist. Reports back to the artist only if interested. Call or write for appointment to show portfolio of final art and b&w and color tearsheets, photostats, photographs, slides and photocopies. Buys first rights or one-time rights. **Pays on acceptance**; $1,200-1,500 for color cover; $300-600 for color inside; $100 for spots.

Tips: "Show a wide variety of work in different media and with different subject matter. Good renditions of people are extremely important."

TRAINS, P.O. Box 1612, 21027 Crossroads Circle, Waukesha WI 53187. (414)796-8776. Fax: (414)796-1778. E-mail: lzehner@kalmbach.com. Website: http://www.trains.com. Art Director: Lisa A. Zehner. Estab. 1940. Monthly magazine about trains, train companies, tourist RR, latest railroad news. Circ. 133,000. Art guidelines available.

● Published by Kalmbach Publishing. Also publishes *Classic Toy Trains*, *Astronomy*, *Finescale Modeler*, *Model Railroader* and *Model Retailer*.

Illustration: 100% of freelance illustration demands knowledge of Adobe Photoshop 3.0, Adobe Illustrator 5.5. Send query letter with printed samples, photocopies and tearsheets. Accepts disk submissions (opticals) or CDs, using programs above. Samples are filed. Art director will contact artist for portfolio review of color tearsheets if interested. Buys one-time rights. Pays on publication.

Tips: "Quick turnaround and accurately built files are a must."

✔❀TRAVEL IMPULSE, 9336 117th Street, Delta, British Columbia V4C 6B8 Canada. (604)951-3238. Fax: (604)951-8732. E-mail: travimp@ibm.net. Editor/Publisher: Susan M. Boyce. Estab. 1984 (under name of Travel & Courier News). Quarterly consumer magazine about travel. "Our readers love to travel, in fact, they find it irresistable. We publish unusual, quirky destinations plus tips on how to get there inexpensively." Circ. 1,000. Sample copies available for $5. Art guidelines free for SASE with first-class Canadian postage or IRC.

● The editor told *AGDM* that she is actively searching for new freelance illustrators to help update the look of the magazine.

Cartoons: "We are considering cartoons but have not used them to this point. Query and we might be interested—single panel only."

Illustration: Buys 2-4 illustrations/issue. Features humorous illustration; charts & graphs. Assigns 25% of illustrations to new and emerging illustrators. Prefers "the allure of exotic destinations or the fun, playfulness of travel as themes." Considers all media especially charcoal, mixed media, pen & ink and photos. 50% of freelance illustration demands knowledge of Aldus PageMaker. Send postcard sample, photocopies and tearsheets. Submission/queries with U.S. postage cannot be acknowledged or returned. Accepts disk submissions compatible with Aldus PageMaker 5. Samples are filed. Reports back within 8-10 weeks. Buys first and reprint rights. Pays on publication; $30 minimum for b&w cover; $50 mimimum for color cover; $20 minimum for b&w inside.

Tips: "We are changing the look of *Travel Impulse* so now is a good time to submit. Show us your playful side when submitting work."

‡TRIQUARTERLY, 2020 Ridge Ave., Evanston IL 60208-4302. (847)491-3490. Fax: (847)467-2096. Editor: Susan Hahn. Estab. 1964. Triquarterly literary magazine "dedicated to publishing writing and graphics which are fresh,

adventurous, artistically challenging and never predictable." Circ. 5,000. Originals returned at job's completion. Sample copies for $5.

Illustration: Approached by 10-20 illustrators/year. Considers only work that can be reproduced in b&w as line art or screen for pages; all media; 4-color for cover. Send query letter with SASE, tearsheets, photographs, photocopies and brochure. Samples are filed or are returned by SASE. Reports back within 3 months (if SASE is supplied). Publication will contact artist for portfolio review if interested. Portfolio should include b&w and color thumbnails, tearsheets, slides, photostats, photocopies, final art and photographs. Buys first rights. Pays on publication; $300 for b&w/color cover; $30-50 for b&w inside.

TRUE WEST, 205 W. Seventh, Suite 202, Stillwater OK 74076. (800)749-3369. Fax: (405)743-3374. Editor: Marc Huff. Monthly b&w magazine with 4-color cover emphasizing American Western history from 1830 to 1910. For a primarily rural and suburban audience, middle-age and older, interested in Old West history, horses, cowboys, art, clothing and all things Western. Circ. 65,000. Accepts previously published material and considers some simultaneous submissions. Original artwork returned after publication. Sample copy for $2; art guidelines for SASE.

Cartoons: Approached by 10-20 cartoonists/year. Buys 1 cartoon/issue. Prefers western history theme. Prefers humorous cartoons, single or multiple panel. Send query letter with photocopies. Samples are filed or returned. Reports back within 2 weeks. Buys first rights. Pays $25-75 for b&w cartoons.

Illustration: Approached by 100 illustrators/year. Buys 5-10 illustrations/issue (2 or 3 humorous). "Inside illustrations are usually, but not always, pen & ink line drawings; covers are Western paintings." 10% of freelance illustration demands knowledge of Adobe Photoshop, Adobe Illustrator and QuarkXPress. Send query letter with photocopies to be kept on file; "We return anything on request. For inside illustrations, we want samples of artist's line drawings. For covers, we need to see full-color transparencies." Reports back within 2 weeks. Publication will contact artist for portfolio review if interested. Buys one-time rights. Sometimes requests work on spec before assigning job. "**Pays on acceptance for new artists, on assignment for established contributors.**" Pays $125-200 for color cover; $20-75 for b&w inside; and $20-25 for spots.

Tips: "We think the interest in Western Americana has moved in the direction of fine art, and we're looking for more material along those lines. Our magazine has an old-fashioned Western history design with a few modern touches. We use a wide variety of styles so long as they are historically accurate and have an old-time flavor. We must see samples demonstrating historically accurate details of the Old West. Our readers won't be fooled by bad art."

TURTLE MAGAZINE, For Preschool Kids, Children's Better Health Institute, 1100 Waterway Blvd., Box 567, Indianapolis IN 46206. (317)636-8881. Art Director: Bart Rivers. Estab. 1979. Emphasizes health, nutrition, exercise and safety for children 2-5 years. Published 8 times/year; 4-color. Original artwork not returned after publication. Sample copy for $1.25; art guidelines for SASE with first-class postage. Needs computer-literate freelancers familiar with Macromedia FreeHand and Adobe Photoshop for illustrations.

• Also publishes *Child Life*, *Children's Digest*, *Children's Playmate*, *Humpty Dumpty's Magazine* and *Jack and Jill*.

Illustration: Approached by 100 illustrators/year. Works with 20 illustrators/year. Buys 15-30 illustrations/issue. Interested in "stylized, humorous, realistic and cartooned themes; also nature and health." Works on assignment only. Send query letter with good photocopies and tearsheets. Accepts disk submissions. Samples are filed or are returned by SASE. Reports only if interested. Portfolio review not required. Buys all rights. Pays on publication; $275 for color cover; $35-90 for b&w inside; $70-155 for color inside; $35-70 for spots. Finds most artists through samples received in mail.

Tips: "Familiarize yourself with our magazine and other children's publications before you submit any samples. The samples you send should demonstrate your ability to support a story with illustration."

TV GUIDE, 1211 Sixth Ave., New York NY 10036. (212)852-7500. Fax: (212)852-7470. Art Director: Ken Feisel. Estab. 1953. Weekly consumer magazine for television viewers. Circ. 13,000,000. Sample copies available.

Illustration: Approached by 200 illustrators/year. Buys 100 illustrations/year. Considers all media. Send postcard sample. Accepts disk submissions (300 DPI, CMYK, TIFF). Samples are filed. Art director will contact artist for portfolio review of color tearsheets if interested or, portfolios may be dropped off Monday-Friday. TV Guide will keep to review for 24 hours. Negotiates rights purchased. **Pays on acceptance**; $1,500-4,000 for color cover; $1,000-2,000 for color inside; $200-500 for spots. Finds artists through sourcebooks, magazines, word of mouth, submissions.

Design: Needs freelancers for design. Prefers designers with experience in editorial design. 100% of design work demands knowledge of Aldus FreeHand 5.5, Adobe Photoshop 4.0 and/or QuarkXPress 3.31. Send query letter with printed samples and tearsheets.

✔U. THE NATIONAL COLLEGE MAGAZINE, 1800 Century Park E. #820, Los Angeles CA 90067-1511. (310)551-1381. Fax: (310)551-1659. E-mail: editor@umagazine.com. Website: http://www.umagazine.com. Editor: Frances Huffman. Art Director: Chris Mann. Estab. 1986. Monthly consumer magazine of news, lifestyle and entertainment geared to college students. Magazine is for college students by college students. Circ. 1.5 million. Sample copies and art guidelines available for SASE with first-class postage.

Cartoons: Approached by 25 cartoonists/year. Buys 2 cartoons/issue. Prefers college-related themes. Prefers humorous color washes, single or multiple panel with gagline. Send query letter with photocopies. Samples are filed and not returned. Reports back only if interested. Buys all rights. Pays on publication; $25 for color.

Illustration: Approached by 100 illustrators/year. Buys 10-20 illustrations/issue. Features caricatures of celebrities;

humorous illustration; informational graphics; computer and spot illustration. Assigns 100% of illustrations to new and emerging illustrators. Prefers bright, light, college-related, humorous, color only, no b&w. Considers collage, color washed, colored pencil, marker, mixed media, pastel, pen & ink or watercolor. 20% of freelance illustration demands knowledge of Adobe Photoshop, Adobe Illustrator and QuarkXPress. Send query letter with photocopies and tearsheets. Samples are filed and are not returned. Reports back only if interested. Buys all rights. Pays on publication; $100 for color cover; $25 for color inside; $25 for spots. Finds illustrators through college campus newspapers and magazines.
Tips: "We need light, bright, colorful art. We accept art from college students only."

UNDERGROUND SURREALIST MAGAZINE, P.O. Box 382565, Cambridge MA 02238-2565. (617)789-4107. Website: http://fas-www.harvard.edu~cusimano/chickenlittle.html. Publisher: Mick Cusimano. Estab. 1987. Annual magazine featuring cartoons, social satire, 1-2 page comic stories and strips. Circ. 300. Sample copy for $3. Art guidelines available for SASE with first-class postage.
Cartoons: Approached by 20 cartoonists/year. Buys 10 cartoons/issue. Prefers multiple panel, humorous, b&w line drawings, with gaglines. Send query letter with photocopies. Samples are filed. Reports back in 1 month. Buys one-time rights. Pays 1 contributor's copy to cartoonist.

‡THE UNKNOWN WRITER, 5 Pothat St., Sloatsburg NY 10974. (914)753-8363. Fax: (914)753-6562. E-mail: rsidor@worldnet.att.net. Art Director: Kathryn Houghtaling. Estab. 1995. Quarterly b&w literary zine featuring short fiction, poetry, original artwork and essays. Circ. 500. Sample copies for 6×9 SASE and 3 first-class stamps. Art guidelines free for 4×9½ SASE and 1 first-clss stamp.
Illustration: Approached by 10 illustrators/year. Buys 5 illustrations/issue. Has featured illustrations by Victoria Mesropian, Elizabeth Morse, Greg Leichner. Features computer and humorous illustration, informational graphics, natural history, realistic and spot illustrations. Preferred styles and subjects: abstract, erotic and alternative culture. Assigns 25% of illustrations to experienced, but not well-known illustrators; 75% to new and emerging illustrators. Send query letter with photocopies. Accepts Mac-compatible disk submissions. Send EPS or TIFF files. Samples are not returned. Reports back within 2 months. Buys one-time rights. Pays on publication; 2 copies.
Tips: "We are looking for abnormal and different artwork. Most of our writers submit erotic and twisted stories, we would like our artwork to reflect that theme. Shock us!"

UNMUZZLED OX, 105 Hudson St., New York NY 10013. (212)226-7170. Editor: Michael Andre. Emphasizes poetry, stories, some visual arts (graphics, drawings, photos) for poets, writers, artists, musicians and interested others; b&w with 2-color cover and "classy" design. Circ. 18,000. Return of original artwork after publication "depends on work—artist should send SASE." Sample copy for $4.95 plus $1 postage.
Cartoons: Send query letter with copies. Reports within 10 weeks. No payment for cartoons.
Illustration: Uses "several" illustrations/issue. Themes vary according to issue. Send query letter and "anything you care to send" to be kept on file for possible future assignments. Reports within 10 weeks.
Tips: Magazine readers and contributors are "highly sophisticated and educated"; artwork should be geared to this market. "Really, *Ox* is part of New York art world. We publish art, not 'illustration.'"

US KIDS: A WEEKLY READER MAGAZINE, 1100 Waterway Blvd., Indianapolis IN 46202. (317)636-8881. Fax: (317)684-8094. Art Director: Matthew Brinkman. Estab. 1987. Magazine published 8 times/year focusing on health and fitness for kids 5-12 years old. Circ. 250,000. Sample copy for $2.50. Art guidelines free for SASE with first-class postage.
Illustration: Approached by 120 illustrators/year. Buys 20 illustrations/issue. Prefers health, fitness, fun for kids, simple styles. Considers all media. 25% of freelance illustration demands knowledge of Adobe Photoshop, Adobe Illustrator, Aldus FreeHand and QuarkXPress. Send postcard sample or query letter with printed samples, photocopies, SASE and tearsheets. Send follow-up postcard sample every 3 months. Samples are filed or returned by SASE. Reports back only if interested. Art director will contact artist for portfolio review of color, final art, tearsheets, transparencies. Include a sample with name and address to leave with art director. Buys all rights. Pays on publication; $275 maximum for color cover; $70-190 for color inside. Pays $70 for spots. Finds illustrators through sourcebooks and submissions.
Design: Needs freelancers for design. Prefers designers with experience in Mac applications. 100% of freelance design work demands knowledge of Adobe Photoshop, Adobe Illustrator, Aldus FreeHand and QuarkXPress. Send query letter with printed sampes, photocopies, SASE and tearsheets.
Tips: "I like work that is colorful and little on the traditional side rather than wild and wacky."

‡USA SOFTBALL MAGAZINE, 2801 NE 50th St., Oklahoma City OK 73111. (405)425-3431. Fax: (405)424-4734. Editor-in-Chief: Ronald A. Babb. Estab. 1933. Monthly sports consumer magazine emphasizing amateur and Olympic softball. Circ. 275,000. Originals returned at job's completion. Sample copies and art guidelines available.
Cartoons: Approached by 10 cartoonists/year. Buys 1 cartoon/issue. Only sports-softball single panel cartoons. Send query letter with roughs. Samples are not filed and are returned by SASE if requested by artist. Reports back to the artist only if interested. Buys first rights. Pays $50-100 for b&w.
Illustration: Approached by 10 illustrators/year. Sports-softball only. Considers pen & ink, watercolor, collage, airbrush, acrylic, marker, colored pencil, oil, charcoal, mixed media and pastel. 50% of freelance work demands knowledge of Aldus PageMaker, Adobe Illustrator, QuarkXPress, Adobe Photoshop or Aldus FreeHand. Send query letter with tearsheets and photostats. Samples are not filed and are returned by SASE if requested by artist. Publication will contact

artist for portfolio review if interested. Portfolio should include b&w and color roughs and tearsheets. Buys first rights. Pays on publication; $350 for color cover; $50 for b&w inside; $100 for color inside.

UTNE READER, 1624 Harmon Place, Suite 330, Minneapolis MN 55403. (612)338-5040. Website: http://www.utne.com. Art Director: Lynn Phelps. Estab. 1984. Bimonthly digest of news and opinion with articles and reviews selected from independently published newsletters, magazines and journals. Regularly covers politics, international issues, the arts, science, education, economics and psychology. Circ. 260,644.
• The art director for *Utne Reader* commissions illustrations from renowned illustrators like Brad Holland and Vivienne Flesher to enliven magazine's pages, but he is also open to new illustrators. However, newcomers must show consistency in conceptualizinig ideas, and provide evidence that they can meet deadlines. Read our interview with Lynn Phelps on page 222.
Cartoons: Approached by 20 cartoonists/issue. Buys 4-5 cartoons/issue. Prefers single panel b&w line drawings with gagline. Send query letter with photocopies or other appropriate samples. Samples are filed and are not returned. Reports back only if interested. Buys first North American serial rights. Payment negotiable.
Illustration: Approached by "tons" of illustrators/year. Buys 20-25 illustrations per issue. Considers all media. Send postcard or other appropriate samples. Accepts submissions on disk. Samples are filed and are not returned. Reports back only if interested. Pays $1,500 for color cover; $175-1,000 for original color inside; and $175-200 for spots. Find artists through submissions, illustration annuals and soucebooks.
Tips: "Please send samples that are easy to open. Samples that take a lot of time to open are generally tossed."

‡VANCOUVER MAGAZINE, 555 W. 12th Ave., Suite 300, Vancouver, British Columbia V5Z 4L4 Canada. (604)877-7732. Fax: (604)877-4823. Website: http://www.vanmag.com. Art Director: Anna Belluz. Monthly 4-color city magazine. Circ. 70,000.
Illustration: Approached by 25 illustrators/year. Buys 6 illustrations/issue. Has featured illustrations by Maurice Vellecoup, Seth, Ken Steacy, Amanda Duffy. Features editorial and spot illustrations. Prefers conceptual, alternative, bright and graphic use of color and style. Assigns 70% of illustrations to well-known or "name" illustrators; 20% to experienced, but not well-known illustrators; 10% to new and emerging illustrators. Send postcard or other non-returnable samples and follow-up samples every 3 months. Samples are filed. Reports back only if interested. Portfolio may be dropped off every Tuesday and picked up the following day. Buys one-time and WWW rights. **Pays on acceptance**; negotiable. Finds illustrators through magazines, agents, *Showcase*.
Tips: "We stick to tight deadlines. Aggressive, creative, alternative solutions encouraged. No phone calls please."

‡VANITY FAIR, 350 Madison Ave., New York NY 10017. (212)880-8800. Fax: (212)880-6707. E-mail: vfmail@vf.com. Art Director: David Harris. Estab. 1983. Monthly consumer magazine. Circ. 1.1 million. Does not use previously published artwork. Original artwork returned at job's completion. 100% of freelance design work demands knowledge of QuarkXPress and Adobe Photoshop.
Illustration: Approached by "hundreds" of illustrators/year. Buys 3-4 illustrations/issue. Works on assignment only. "Mostly uses artists under contract."

VARBUSINESS, Dept. AM, One Jericho Plaza, Wing A, Jericho NY 11753. (516)733-8542. E-mail: rgreiner@cmp.com. Website: http://www.varbiz.com. Art Director: Roger Greiner. Estab. 1985. Emphasizes computer business, for and about value added resellers. Biweekly 4-color magazine with an "innovative, contemporary, progressive, very creative" design. Circ. 105,000. Original artwork is returned to the artist after publication. Art guidelines not available.
Illustration: Approached by 100+ illustrators/year. Works with 30-50 illustrators/year. Buys 150 illustrations/year. Needs editorial illustrations. Style of James Yang, Steve Dininno, Joel Nakamura, Robert Pizzo. Uses artists mainly for covers, full and single page spreads and spots. Works on assignment only. Prefers "digitally compiled, technically conceptual oriented art (all sorts of media)." Send postcard sample or query letter with tearsheets. Accepts disk submissions. Samples are filed or are returned only if requested. Reports back only if interested. Call or write for appointment to show portfolio, which should include tearsheets, final reproduction/product and slides. Buys one-time rights. Pays on publication. Pays $1,000-1,500 for b&w cover; $1,500-2,500 for color cover; $500-850 for b&w inside; $750-1,000 for color inside; pays $300-600 for spots. 30-50% of freelance work demands knowledge of Adobe Photoshop and QPS Publishing.
Design: Also needs freelancers for design. 100% of design demands knowledge of Adobe Photoshop 4.0 and QuarkXPress 3.31.
Tips: "Show printed pieces or suitable color reproductions. Concepts should be imaginative, not literal. Sense of humor sometimes important."

VEGETARIAN JOURNAL, P.O. Box 1463, Baltimore MD 21203-1463. (410)366-8343. E-mail: vrg@vrg.org. Website: http://www.vrg.org. Editor: Debra Wasserman. Estab. 1982. Bimonthly nonprofit vegetarian magazine that examines the health, ecological and ethical aspects of vegetarianism. "Highly educated audience including health professionals." Circ. 27,000. Accepts previously published artwork. Originals returned at job's completion upon request. Sample copies available for $3.
Cartoons: Approached by 4 cartoonists/year. Buys 1 cartoon/issue. Prefers humorous cartoons; single panel b&w line drawings. Send query letter with roughs. Samples are not filed and are returned by SASE if requested by artist. Reports back within 2 weeks. Rights purchased vary according to project. Pays $25 for b&w.

INSIDER REPORT

Great follow-up gets you noticed by magazine art directors

Seasoned illustrators will tell newcomers to the trade that *Utne Reader* is a good place to start looking for a possible illustration assignment. The bimonthly features much more original illustration than most magazines, and is always seeking to replenish its supply with fresh new talent.

Art director Lynn Phelps says he commissions about 20 illustrations per issue. Some assignments go to established illustrators he locates in all available visual books, annuals and talent directories. Other projects with tight deadlines go to illustrators he's worked with before who he knows will come through in a pinch. But Phelps always tries to integrate this work with commissions from newcomers. "I need to have a good mix in every issue, and a dynamic range of styles," says Phelps. "I like to bring new work into each issue."

Lynn Phelps

As the art director of a bimonthly publication, Phelps can give work to untried talent because he frequently can allow a longer turnaround time than art directors of monthlies or other tight deadline situations. In fact, in some situations, he can give an illustrator as much as three to four weeks to complete an assignment.

Phelps says savvy newcomers stand a good chance of getting an illustration assignment from *Utne Reader*—if their work is on par with professionals and they know how to promote themselves effectively through mailings of non-returnable printed samples or self-promotion pieces. "I look at everything," says Phelps. He advises illustrators to present only their best work when they send samples, even if it is just a few pieces. "I like to see strong work. If somebody sends me something average, it pulls the other work down."

It doesn't necessarily take a highly designed self promotion to impress Phelps. "The simpler the better," he says, noting that complex packaging schemes often take longer to open and view. Phelps responds just as positively to a collection of printed samples placed in an envelope with a cover letter. "I'm looking for style and work that's credible and that will best illustrate a particular manuscript." Slides or transparencies, he says, inhibit the viewing process as do complicated, overly designed packaging for printed samples.

From the hundreds of illustrators' self-promotional mailings Phelps receives in a 2-month period, about 40 are pulled and saved so illustrators can be contacted for possible assignments. "I have a big board in the design room and I put the samples I really like on it for the next issue," he explains. This allows Phelps better visibility to select the illustrators who best suit the editorial for that particular issue. Because the board changes with each issue, illustrators who aren't picked the first time around have their samples filed alphabetically so they can be contacted for a possible assignment in the near future.

Phelps encourages illustrators to send art directors samples more than once. In fact, regular mailings from an illustrator are more likely to give the impression of an "estab-

INSIDER REPORT, *Phelps*

lished" talent. He cites a situation where he received a promotion from an illustrator who really impressed him with her work. "I've had her in the back of my mind for a project that might come up soon, but I've never seen anything else from her. As time progresses, I start to wonder if this person is still at this address, and if I'm going to be able to reach her if I call."

Phelps says that postcards sent monthly or at other regular intervals can catch his attention just as quickly as a more extensive collection of samples. "If I receive a postcard and it's really great, I'll wonder about the artist's depth and consistency. Then I'll call that person and ask for more samples," he explains.

Because many illustrators are aware that *Utne Reader* gives newcomers a break, Phelps is innundated every week with self promotions. "I have three to four mail bins [of samples] brought in each week, and they're always overflowing," he says.

Out of so many samples, how does anyone's work stand a chance of getting noticed? Phelps says excellent work always stands out from the rest of the pack. "It's work that goes a little further than a lot of the mainstream work I've seen. It has defined credibility and a certain dynamic that gives it an extra edge. That's what I'm looking for."
—*Poppy Evans*

Daniel Craig created the cover for *Utne Reader's* January/February 1998 issue about the high tech renaissance.

Illustration: Approached by 20 illustrators/year. Buys 6 illustrations/issue. Works on assignment only. Prefers strict vegetarian food scenes (no animal products). Considers pen & ink, watercolor, collage, charcoal and mixed media. Send query letter with photostats. Samples are not filed and are returned by SASE if requested by artist. Reports back within 2 weeks. Portfolio review not required. Rights purchased vary according to project. **Pays on acceptance**; $25-50 for b&w/color inside. Finds artists through word of mouth and job listings in art schools.
Tips: Areas most open to freelancers are recipe section and feature articles. "Review magazine first to learn our style. Send query letter with photocopy sample of line drawings of food."

‡**VELONEWS**, 1830 N. 55th St., Boulder CO 80301. (303)440-0601. Fax: (303)444-6788. E-mail: design@7dogs.com. Design Director: Charles Chamberlin. Estab. 1972. Consumer magazine; tabloid format; timely coverage of bicycle racing (no triathlons or fun rides). Occasional features on people and subjects related to racing. Published 8 times/year. Circ. 45,000. Original artwork returned at job's completion. Sample copies available for $6 for back issues. Art guidelines not available.
Cartoons: Approached by 5-10 freelance cartoonists/year. Prefers "pointed commentary on issues relating to bicycle racing"; single or multi-panel with gagline, b&w washes. Send query letter with finished cartoons. Samples are filed or are returned by SASE. Reports back only if interested. Buys one-time rights. Pays $35 for b&w, $75 for color.
Illustrations: Approached by 10-20 freelance illustrators/year. Works on assignment only. Considers any medium as long as it can be digitally recorded, i.e., drum or flatbed scanner. Digital files also accepted (GIF, JPEG or EPS). Send query letter with SASE and photocopies. Samples are filed or are returned by SASE. Reports back only if interested. To show a portfolio, mail roughs and b&w photocopies. Buys one-time rights. Pays on publication; $40 for b&w inside; $150 for color inside.
Tips: "Our stock in trade is timeliness, so an artist must be willing to work quickly. Knowledge of the sport of bicycle racing is essential. We have plenty of interview features, so a good caricaturist could break in without much difficulty."

VERMONT MAGAZINE, P.O. Box 800, 20½ Main St., Middlebury VT 05753. (802)388-8480. Fax: (802)388-8485. E-mail: vtmag@sovern.net. Art Director: Carolyn Brown. Estab. 1989. Bimonthly regional publication "aiming to explore what life in Vermont is like: its politics, social issues and scenic beauty." Circ. 50,000. Accepts previously published artwork. Original artwork returned at job's completion. Sample copies and art guidelines for SASE with first-class postage.
Illustration: Approached by 100-150 illustrators/year. Buys 2-3 illustrations/issue. Works on assignment only. Has featured illustrations by Chris Murphy. Features humorous, realistic, computer and spot illustration. Assigns 50% of illustrations to experienced, but not well-known illustrators; 50% to new and emerging illustrators. "Particularly interested in creativity and uniqueness of approach." Considers pen & ink, watercolor, colored pencil, oil, charcoal, mixed media and pastel. Send query letter with tearsheets, "something I can keep." Materials of interest are filed. Publication will contact artist for portfolio review if interested. Portfolio should include final art and tearsheets. Buys one-time rights. Considers buying second rights (reprint rights) to previously published work. Pays $400 maximum for color cover; $75-150 for b&w inside; $75-350 for color inside; $300-500 for 2-page spreads; $50-75 for spots. Finds artists mostly through submissions/self-promos and from other art directors.
Tips: "Please send me a personalized note that indicates you've seen our magazine and you think your artwork would fit in; give reasons. Handwritten and informal is just fine. We are always working on a shoestring budget. If you can't negotiate price based on our budget your need not apply."

✔**VIBE**, 215 Lexington Ave., 6th Floor, New York NY 10016. (212)448-7300. Fax: (212)448-7400. Art Director: Dwayne Shaw. Estab. 1993. Monthly consumer magazine focused on music, urban culture. Circ. 450,000. Accepts previously published artwork. Originals returned at job's completion. Sample copies available.
Cartoons: Prefers urban culture themes. Send postcard-size sample or query letter with brochure and finished cartoons. Samples are filed. Reports back to the artist only if interested. Buys one-time rights.
Illustration: Works on assignment only. Prefers urban culture themes. Considers all media. Send postcard-size sample or query letter with photocopies. Samples are filed. Portfolios may be dropped off every Wednesday. Publication will contact artist for portfolio review of roughs, final art and photocopies if interested. Buys one-time or all rights. Finds artists through portfolio drop-off.

VICA PROFESSIONAL, 14001 James Monroe Hwy., Box 3000, Leesburg VA 20177. (703)777-8810. Fax: (703)777-8999. E-mail: anyinfo@vica.org. Website: http://www.vica.org. Editor: Tom Hall. Estab. 1965. Four-color quarterly newsletter. "*VICA Professional* helps high school instructors teach about careers, educational opportunities and activities of VICA chapters. VICA is an organization of 230,000 students and teachers in trade, industrial, technical and health occupations education." Circ. 18,000. Accepts previously published artwork. Originals returned at job's completion (if requested). Sample copies available.
Illustration: Approached by 4 illustrators/year. Works on assignment only. Prefers positive, youthful, innovative, action-oriented images. Considers pen & ink, watercolor, collage, airbrush and acrylic. Send postcard sample. Accepts disks compatible with FreeHand 5.0 and PageMaker 6.5. Send FreeHand and EPS files. Samples are filed. Portfolio should include printed samples, b&w and color tearsheets and photographs. Rights purchased vary according to project. **Pays on acceptance**; $100-200 for color; $50-150 for spots.
Design: Needs freelancers for design. 100% freelance work demands knowledge of PageMaker 6.5 and FreeHand 5.0. Send query letter with brochure. Pays by the project.

Tips: "Send samples or a brochure. These will be kept on file until illustrations are needed. Don't call! Fast turnaround helpful. Due to the unique nature of our audience, most illustrations are not re-usable; we prefer to keep art."

✔**VIDEOMAKER MAGAZINE**, Box 4591, Chico CA 95927. (916)891-8410. Fax: (916)891-8443. E-mail: spiper@vi deomaker.com. Art Director: Janet Souza. Monthly 4-color magazine for video camera users with "contemporary, stylish yet technical design." Circ. 150,000. Accepts previously published artwork. Original artwork returned at job's completion. 75% of freelance work demands knowledge of Adobe PageMaker, Adobe Illustrator, FreeHand and Photoshop.
Cartoons: Prefers technical illustrations with a humorous twist. Pays $30-200 for b&w, $200-800 for color.
Illustration: Approached by 30 illustrators/year. Buys 3 illustrations/issue. Works on assignment only. Likes "illustration with a humorous twist." Considers pen & ink, airbrush, colored pencil, mixed media, watercolor, acrylic, oil, pastel, collage, marker and charcoal. Needs editorial and technical illustration. Send postcard sample and/or query letter with photocopies, brochure, SASE and tearsheets. Samples are filed. Publication will contact artist for portfolio review. Portfolio should include thumbnails, tearsheets and photographs. Negotiates rights purchased. Sometimes requests work on spec before assigning job. Pays on publication; $30-800 for b&w inside; $50-1,000 for color inside; $30-50 for spots. Finds artists through submissions/self-promotions.
Design: Needs freelancers for design. Freelance work demands knowledge of Aldus PageMaker and Aldus FreeHand. Send query letter with brochure, photocopies, SASE, tearsheets. Pays by the project, $30-1,000.
Tips: "Read a previous article from the magazine and show how it could have been illustrated. The idea is to take highly technical and esoteric material and translate that into something the layman can understand. Since our magazine is mostly designed on desktop, we are increasingly more inclined to use computer illustrations along with conventional art. We constantly need people who can interpret our information accurately for the satisfaction of our readership."

‡**VIM & VIGOR**, 1010 E. Missouri Ave., Phoenix AZ 85014. (602)395-5850. Fax: (602)395-5853. Senior Art Director: Randi Karabin. Estab. 1985. Quarterly consumer magazine focusing on health. Circ. 1.2 million Originals returned at job's completion. Sample copies available. Art guidelines available.
 • *Salud y Vigor*, a Spanish version of this magazine, is published twice a year. The company publishes 16 magazines focusing on health, business, college and Hispanic issues.
Illustration: Approached by 100 illustrators/year. Buys 50 illustrations/issue. Works on assignment only. Considers mixed media, collage, charcoal, acrylic, oil, pastel and computer. Send postcard sample with tearsheets. Accepts disk submissions. Samples are filed. Publication will contact artist for portfolio review of slides and photocopies if interested. Rights purchased vary according to project. **Pays on acceptance**; $700-1,100 for color inside; $300-400 for spots. Finds artists through agents, sourcebooks, word of mouth and submissions.

‡**VIRTUE MAGAZINE**, 4050 Lee Vance View, Colorado Springs CO 80918. (719)531-7776, ext. 3333. Fax: (719)535-0172. E-mail: adhamilton@aol.com. Art Director: John Hamilton. Creative Assistant: Patty Adams. Estab. 1968. Bimonthly 4-color consumer magazine exploring Christian women's lifestyle. Boomer audience. Circ. 10,000.
Illustration: Approached by 100 illustrators/year. Buys 6 illustrations/issue. Has featured illustrations by Brant Day, Will Terry, Hilber Nelson, Leticia Plate, Susan Gross, Neil Brennan. Features humorous, realistic, medical and spot illustrations of families, women and teens. Prefers oils, pstel, collage and conceptual works. Assigns 75% of illustrations to well-known or "name" illustrators; 25% to experienced, but not well-known illustrators. Send postcard or other nonreturnable samples. Accepts Mac-compatible disk submissions. Send EPS or TIFF files. Samples are filed. Will contact artist for portfolio review if interested. Buys one-time rights. **Pays on acceptance**; $300-750 for color inside; $1,000 for 2-page spreads; $300 for spots. Finds illustrators through national and regional sourcebooks, online services, word of mouth.
Tips: "We are open to a variety of styles. Priority given to article content and tenor match."

VISIONS—INTERNATIONAL, THE WORLD OF ILLUSTRATED POETRY, Black Buzzard Press, 1007 Ficklen Rd., Fredericksburg VA 22405. Editors: Bradley R. Strahan and Shirley Sullivan. Emphasizes literature and the illustrative arts for "well educated, very literate audience, very much into art and poetry." Published 3 times/year. Circ. 750. Original artwork returned after publication *only if requested*. Sample copy for $4 (latest issue $5); art guidelines for SASE with first-class postage.
Illustration: Approached by 40-50 illustrators/year. Acquires approximately 21 illustrations/issue. Needs poetry text illustration. Works on assignment only. Features realistic and spot illustration. Representational to surrealistic and some cubism. Black & white only. Send query letter with SASE and photocopies that clearly show artist's style and capability; no slides or originals. Samples not filed are returned by SASE. Reports within 2 months. Portfolio review not required. Acquires first rights. "For information of releases on artwork, please contact the editors at the above address." Pays in copies or up to $10. Finds new artists through editor or people submitting samples.
Tips: "Don't send slides. We might lose them. We don't use color, anyway. No amateurs."

WASHINGTON CITY PAPER, 2390 Champlain St. N.W., Washington DC 20009. (202)332-2100. E-mail: mail@wa shcp.com. Website: http://www.washingtoncitypaper.com. Art Director: Jandos Rothstein. Estab. 1980. Weekly tabloid "distributed free in D.C. and vicinity. We focus on investigative reportage and general interest stories with a local slant." Circ. 95,000. Art guidelines not available.
Cartoons: Prefers b&w line drawings. Send query letter with photocopies. Samples are not filed and are not returned.

Reports back only if interested. Pays $25 minimum for b&w.

Illustration: Approached by 50-100 illustrators/year. Buys 2-8 illustrations/issue. Has featured illustrations by Michael Kupperman, Peter Kupen, Greg Heuston, Joe Rocco and Robert Meganck. Features caricatures of politicians; humorous illustration; informational graphics; computer and spot illustration. Considers all media, if the results do well in b&w. Send query letter with printed samples, photocopies or tearsheets. We occasionally accept Mac compatible files. Art director will contact artist for portfolio review of b&w, final art, tearsheets if interested. Buys first-rights. Pays on publication which is usually pretty quick; $150 minimum for b&w cover; $150-200 for color cover; $75 minimum for inside. Finds illustrators mostly through submissions.

Tips: "We are a good place for freelance illustrators, we use a wide variety of styles, and we're willing to work with beginning illustrators. We like illustrators who are good on concept and can work fast if needed. We don't use over polished 'clip art' styles. We also avoid cliché DC imagery such as the capitol and monuments."

WASHINGTON PHARMACIST, 1501 Taylor Ave. SW, Renton WA 98055-3139. (206)228-7171. Fax: (206)277-3897. E-mail: wspa@pharmcare.org. Website: http://www.pharmcare.org. Publications Director: Sheri Ray. Estab. 1959. Quarterly association trade magazine, b&w with 2- and 4-color covers, emphasizing pharmaceuticals, professional issues and management for pharmacists. Circ. 2,000. Accepts previously published artwork. Sample copies available.

Cartoons: Approached by 15 cartoonists/year. Buys fewer than 5 cartoons/year. Themes vary. Send query letter with brochure and roughs. Samples are filed. Reports back only if interested. Rights purchased vary according to project. Pays $15 for b&w.

Illustration: Approached by 15 illustrators/year. Buys 2-5 illustrations/year. Send postcard sample or query letter with brochure. Publication will contact artist for portfolio review if interested. Rights purchased vary according to project. **Pays on acceptance**; $25-75 cover; $15-25 inside. Finds artists through submissions and word of mouth.

‡WATERCOLOR MAGIC, 1507 Dana Ave., Cincinnati OH 45207. (513)531-2690. Fax: (513)531-2902. E-mail: wcmedit@aol.com. Art Director: Nancy Stetler. Editor: Ann Abbott. Estab. 1995. Quarterly 4-color consumer magazine to "help artists explore and master watermedia." Circ: 92.000. Art guidelines free for #10 SASE with first-class postage.

Illustration: Pays on publication. Finds illustrators through word of mouth, visiting art exhibitions, unsolicited queries, reading books.

Tips: "We are looking for watermedia artists who are willing to teach special aspects of their work and their techniques to our readers."

WEEKLY READER, (formerly Weekly Reader/Secondary), Weekly Reader Corp., 200 First Stamford Place, Stamford CT 06912. (203)705-3500. Contact: Sandra Forest. Estab. 1928. Educational newspaper, magazine, posters and books. *Weekly Reader* has a newspaper format. The *Weekly Reader* emphasizes news and education for children 4-14. The philosophy is to connect students to the world. Publications are 4-color. Design is "clean, straight-forward." Accepts previously published artwork. Original artwork is returned at job's completion. Sample copies are available.

Illustration: Needs editorial and technical illustration. Style should be "contemporary and age level appropriate for the juvenile audience." Approached by 60-70 illustrators/year. Buys more than 50/week. Works on assignment only. Uses computer and reflective art. Send query letter with brochure, tearsheets, slides, SASE and photocopies. Samples are filed or are returned by SASE if requested by artist. Request portfolio review in original query. Artist should follow up with letter after initial query. Payment is usually made within 3 weeks of receiving the invoice. Finds artists through artists' submissions/self-promotions, sourcebooks, agents and reps.

Tips: "Our primary focus is the children's marketplace; figures must be drawn well if style is realistic. Art should reflect creativity and knowledge of audience's needs. Our budgets are tight and we have very little flexibility in our rates. We need artists who can work with our budgets. Still seeking out artists of all styles—professionals!"

♣WEST COAST LINE, 2027 E. Academic Annex, Simon Fraser University, Burnaby, British Columbia V5A 1S6 Canada. (604)291-4287. Website: http://www.sfu.ca/west-coast-line/wcl.html. Managing Editor: J. Larson. Estab. 1990. Literary magazine published 3 times/year covering contemporary innovative writing and literary criticism/cultural studies by Canadians. Circ. 850. Sample copies available.

Illustration: Send query letter with photocopies. Samples are filed and are returned by SASE (IRC for U.S. submissions). Reports back within 3 weeks. Buys one-time rights. Pays on publication. Pays $100 for color cover; $25 minimum for b&w inside.

Tips: "Each issue features full color cover of visual artist's work—photo, painting, collage, etc."

WESTART, P.O. Box 6868, Auburn CA 95604-6868. (530)885-0969. Editor: Martha Garcia. Estab. 1962. Semimonthly art magazine. *WestArt* serves fine artists and craftspeople on the West Coast. Readership includes art patrons, libraries, galleries and suppliers. It features news about current and upcoming gallery exhibitions, and covers painting, ceramics, sculpture, photography, and related visual arts activities. The "Time to Show" section lists fine art competitions, as well arts and crafts shows and festivals. Circ. 4,000. Originals returned at job's completion. Sample copies and art guidelines available.

• Does not buy cartoons or illustrations, but features the work of fine artists whose work is shown on the West Coast.

Tips: All art published by *WestArt*, including cartoons and illustrations, must be included in current or upcoming West Coast exhibitions. Artists should send for a free sample copy of *WestArt* and art guidelines before submitting any

information or artwork. When submitting information and artwork, a SASE is required for a response.

WILDLIFE ART, P.O. Box 16246, St. Louis Park MN 55416-0246. (612)927-9056. Fax: (612)927-9353. Publisher: Robert Koenke. Estab. 1982. Bimonthly 4-color trade journal with award-winning design. Many two-page color art spreads. "The largest magazine in wildlife art originals, prints, duck stamps, artist interviews and industry information." Circ. 55,000. Accepts previously published artwork. Original artwork returned to artist at job's completion. Sample copy for $6; art guidelines for SASE with first-class postage.
 ● Also publishes *Sculpture Forum* magazine, highlighting the best of three-dimensional artwork in all media.
Illustration: Approached by 100 illustrators/year. Works on assignment only. Prefers nature and animal themes. Considers pen & ink and charcoal. Send postcard sample or query letter. Accepts disk submissions compatible with Mac—QuarkXPress, Adobe Illustrator and Adobe Photoshop. Send EPS files. Samples are not filed and are returned by SASE if requested by artist. Reports back within 1 to 2 months. To show a portfolio, mail color tearsheets, slides and photocopies. Buys first rights. "We do not pay artists for illustration in publication material."
Tips: "Interested wildlife artists should send SASE, three to seven clearly-marked slides or transparencies, short biography and be patient! Also publish annually *1997 Art Collector's Edition*, now the seventh issue, the largest source book of wildlife artists' biographies, color reproductions, print prices and calendar of events for wildlife art shows. Sculptors, photographers, painters, scratchboard, and pastel artists are invited to participate in the volume. Write for packet."

WINDOWS NT MAGAZINE, 221 E. 29th St., Loveland CO 80538. (970)203-2732. Fax: (970)663-3714. E-mail: steve@duke.com. Design Director: Steven Adams. Estab. 1995. Monthly technical publication for users of Windows NT. Circ. 150,000. Art guidelines not available.
Illustration: Buys 10-15 illustrations/issue. Has featured illustrations by A. Shachat, G. Houland, R. Magiera, V. GAD, E. Kelery, S. Liao, E. Yang and A. Baroffi. Features humorous, computer and spot illustration. Assigns 60% of illustrations to well-known or "name" illustrators; 20% to experienced, but not well-known illustrators; 10% to new and emerging illustrators. Considers all media. 80% of freelance illustration demands knowledge of Aldus FreeHand, Adobe Photoshop, Adobe Illustrator. Send postcard sample. Accepts 3.5″ floppy, 44-88-250mb SyQuest disk, optical disk and CD-ROM for Mac. Reports back only if interested. Art director will contact artist for portfolio review of tearsheets if interested. Rights purchased vary according to project. **Pays on acceptance**; $600-2,000 for color cover; $350-1,200 for color inside; $1,000-1,500 for 2-page spread; $125-450 for spots. Finds artists through the *Workbook* and samples.
Tips: "We're looking for illustrators who understand how to bring technical material to life, are professional and 'push the envelope' with their style and technique. Study the styles of artwork in the types of publication you would be interested in illustrating for and create a style similar or new that offers the art director a new choice."

‡✿WINDSOR REVIEW, Department of English, University of Windsor, Windsor, Ontario N9B 3P4 Canada. (519)253-4232, ext. 2332. Fax: (519)973-7050. E-mail: uwrevu@uwindsor.ca. Art Editor: Susan Gold Smith. Estab. 1966. Biannual 4-color literary magazine featuring poetry, short fiction and art. Circ. 400. Art guidelines free for #10 SASE with first-class postage.
Illustration: Has featured illustrations and/or fine art by Eiichi Matsuhashi, Robbert Fortin, John Pufahl, Ellen Katterbach. Features computer, humorous and realistic illustration, fine art. Prefers "anything of quality and taste—intelligent, thought-provoking." Accepts Windows-compatible disk submissions. Reports back within 2-3 months. Buys all rights. Pays on publication.

‡WIRE JOURNAL INTERNATIONAL, 1570 Boston Post Rd., Guilford CT 06437. (203)453-2777. Contact: Art Director. Emphasizes the wire industry worldwide, members of Wire Association International, industry suppliers, manufacturers, research/developers, engineers, etc. Monthly 4-color. Circ. 12,500. Design is "professional, technical and conservative." Original artwork not returned after publication. Free sample copy and art guidelines.
Illustration: Illustrations are "used infrequently." Works on assignment only. Provide samples, business card and tearsheets to be kept on file for possible assignments. To submit a portfolio, call for appointment. Reports "as soon as possible." Buys all rights. Pay is negotiable; on publication. 85% of freelance work demands computer literacy in QuarkXPress and Photoshop.
Tips: "Show practical artwork that relates to industrial needs; and avoid bringing samples of surrealism, for example. Also, show a variety of techniques—and know something about who we are and the industry we serve."

‡WISCONSIN REVIEW, Box 158, Radford Hall, University of Wisconsin-Oshkosh, Oshkosh WI 54901. (414)424-2267. Editor: Jonathan Wittman. Art Editor: Dacey Vander Wal. Triquarterly review emphasizing literature (poetry, short fiction, reviews) and the arts. Black & white with 4-color cover. Circ. 2,000. Accepts previously published artwork. Original artwork returned after publication "if requested." Sample copy for $2; art guidelines available; for SASE with first-class postage.
Illustration: Uses 5-10 illustrations/issue. "Cover submissions can be color, size 5½×8½ or smaller or slides. Submissions for inside must be b&w, size 5½×8½ or smaller unless artist allows reduction of a larger size submission. We are primarily interested in material that in one way or another attempts to elucidate, explain, discover or otherwise untangle the manifestly complex circumstances in which we find ourselves in the 1990s." Send postcard sample, SASE and slides with updated address and phone number to be kept on file for possible future assignments. Send query letter with roughs, finished art or samples of style. Samples returned by SASE. Reports in 5 months. Pays in 2 contributor's copies. Finds artists mainly through sourcebooks, "but hopefully through word of mouth by artists who made it in."

‡**WISCONSIN TRAILS**, Box 5650, Madison WI 53705. (608)231-2444. Production Manager: Nancy Mcad. 4-color publication concerning travel, recreation, history, industry and personalities in Wisconsin. Published 6 times/year. Circ. 35,000. Previously published and photocopied submissions OK. Art guidelines for SASE.
Illustration: Buys 6 illustrations/issue. "Art work is done on assignment, to illustrate specific articles. All articles deal with Wisconsin. We allow artists considerable stylistic latitude." Send postcard samples or query letter with brochure, photocopies, SASE, tearsheets, résumé, photographs, slides and transparencies. Samples kept on file for future assignments. Indicate artist's favorite topics; name, address and phone number. Include SASE. Publication will contact artist for portfolio review if interested. Buys one-time rights on a work-for-hire basis. Pays on publication; $50-150 for b&w inside; $50-400 color inside. Finds artists through magazines, submissions/self-promotions, artists' agents and reps and attending art exhibitions.
Tips: Keep samples coming of new work.

THE WITNESS, 1249 Washington Blvd., #3115, Detroit MI 48226-1868. (313)962-2650. Fax: (313)962-1012. E-mail: editor@thewitness.org. Website: http://www.thewitness.org. Co-Editors: Jeanie Wylie-Kellermann and Julie A. Wortman. Estab. 1917. Christian journal published 10 times/year "focusing on social justice issues. Episcopal roots—quirky, sometimes irreverent." Circ. 3,500. Sample copies free for 9½×12½ SASE and 4 first-class stamps.
Cartoons: Approached by 2 cartoonists/year. Buys 0-4 cartoons/year. Prefers single panel, political, b&w line drawings. Send query letter with finished cartoons, photographs, photocopies, roughs or tearsheets. Samples are filed if suitable and are not returned. Reports back only if interested. Buys one-time rights. Pays on publication; $50 maximum for b&w cartoons.
Illustration: Approached by 20 illustrators/year. Buys 4 illustrations/issue. Has feataured illustrations by Dierdre Luzwick, Betty LaDuke and Robert McGovern. Features humorous, realistic and spot illustration. "Themes: social and economic justice, though we like to use art in unusual and surprising combination with story topics. Style: we appreciate work that is subtle, provocative, never sentimental." Send postcard sample or query letter with printed samples, photocopies and tearsheets. Accepts disk submissions compatible with WordPerfect 5.1. Samples are filed if suitable and are not returned. "We like to keep samples of artists' work on file, with permission to use in the magazine. We rarely commission original work; we prefer to select from existing artwork." Reports back only if interested. Buys one-time rights. Pays on publication; $100 maximum for b&w and color covers; $50 maximum for b&w and color inside.

WOMENWISE, 38 S. Main St., Concord NH 03301-4817. (603)225-2739. Fax: (603)228-6255. E-mail: luitad@aol.com. Editor: Luita D. Spangler. Estab. 1978. Quarterly consumer magazine. "We are a feminist, pro-choice, pro-animal rights, health journal offering articles, book reviews, poetry and feminist analysis and news." Circ. 1,000. Sample copies available. Art guidelines available for SASE with first-class postage.
Illustration: Approached by 8-12 illustrators/year. Buys 40 illustrations/year. Has featured illustrations by Sudie Rakusin, Susan Bliss, Loy McWhirter and Susan Becker. Features natural history; realistic illustration; information graphics; medical illustration. Assigns 10% of illustrations to well-known or "name" illustrators; 70% to experienced, but not well-known illustrators; 20% to new andemerging illustrators. Prefers line drawings of women, marginalia. Considers pen & ink. Send query letter with photocopies. Samples are filed. Reports back in 1 month. Negotiates rights purchased. Pays on publication. Pays $15 and 1 year subscription for b&w cover; subscription and 5 portfolio copies for b&w inside.

∕**WONDER TIME**, 6401 The Paseo, Kansas City MO 64131. (816)333-7000. Fax: (816)333-4439. Editor: Donna Fillmore. Estab. 1969. Weekly 4-color Sunday school "story paper" emphasizing inspiration and character-building material for first and second graders, 6-8 years old, for Sunday School curriculum. Circ. 40,000. Sample copies for SASE with 56¢ postage.
Illustration: Buys 1 illustration/issue. Works on assignment only. Send query letter with tearsheets or photocopies to be kept on file. Buys all rights. **Pays on acceptance**; $40 for b&w; $75 for color.
Tips: "Include illustrations of six- to eight-year-old ethnic children in your portfolio. We use some full-color cartoons to illustrate our Bible-in-Action stories."

WORCESTER MAGAZINE, 172 Shrewsbury St., Worcester MA 01604. (508)755-8004. Fax: (508)755-8860. Production Manager: Paul Leone. Estab. 1976. A weekly alternative newspaper serving the Worcester community with news, investigative reports, arts, music and other cultural events. Circ. 40,000. Sample copies available.
Cartoons: Approached by 12 cartoonists/year. Buys 2 cartoons/issue. Prefers satire, parody, cutting-edge humor. Prefers b&w line drawings. Send query letter with photocopies and tearsheets. Samples are filed. Reports back only if interested. Negotiates rights purchased. Pays on publication; $200-300 for b&w.
Illustration: Approached by 50 illustrators/year. Buys 12 illustrations/year. Prefers seasonal, arts and political themes. Only accepts digital art. 100% of freelance illustration demands knowledge of Adobe Photoshop, Adobe Illustrator and QuarkXPress. Send query letter with photocopies. Accepts disk submissions compatible with Macintosh computer platform—EPS files, QuarkXPress 3.32, Adobe Illustrator 6.0, Adobe Photoshop 3.0, Postscript Type I fonts. Samples are filed. Reports back only if interested. Art director will contact artist for portfolio review of b&w, color, final art, photographs, roughs and tearsheets if interested. Buys all rights. Pays on publication; $75-400 for color cover; $75-100 for spots. Finds illustrators through word of mouth.
Design: Needs freelancers for design and production. Prefers local design freelancers only. 100% of freelance work demands knowledge of Adobe Photoshop, Adobe Illustrator and QuarkXPress. Send query letter with photocopies.

‡**WORKBENCH**, August Home Publishing, Inc., 2200 Grand Ave., Des Moines IA 50312. (515)282-7000. Art Director: Robert Foss. Estab. 1957. Bimonthly 4-color magazine for woodworking and home improvement enthusiasts. Circ. 550,000. 100% of freelance work demands knowledge of Adobe Illustrator or QuarkXPress on PC or Macintosh.
Illustration: Works with 10 illustrators/year. Buys 100 illustrations/year. Artists with experience in the area of technical drawings, especially house plans, exploded views of furniture construction, power tool and appliance cutaways, should send SASE for sample copy and art guidelines. Style of Eugene Thompson, Don Mannes and Mario Ferro. Publication will contact artist for portfolio review if interested. Sometimes requests work on spec before assigning job. Pays $50-1,200 for full color.

WORKING MOTHER MAGAZINE, 135 W. 50th St., 16th Floor, New York NY 10020. (212)445-6100. Fax: (212)445-6174. Creative Director: Alberto Orta. Estab. 1979. "A monthly service magazine for working mothers focusing on work, money, children, food and fashion." Original artwork is returned at job's completion. Sample copies and art guidelines available.
Illustration: Approached by 100 illustrators/year. Buys 3-5 illustrations/issue. Works on assignment only. Prefers light humor and child/parent, work themes. Considers watercolor, collage, airbrush, acrylic, colored pencil, oil, mixed media and pastel. Send query letter with brochure and tearsheets. Samples are filed and are not returned. Does not report back, in which case the artist should call or drop off portfolio. Portfolio should include tearsheets, slides and photographs. Buys first rights. **Pays on acceptance**; $150-2,000 for color inside.

WRITER'S DIGEST, 1507 Dana Ave., Cincinnati OH 45207. Art Director: Daniel T. Pessell. Editor: Tom Clark (for cartoons). Monthly magazine emphasizing freelance writing for freelance writers. Circ. 250,000. Original artwork returned after publication. Sample copy for $3.
 • Cartoons submitted are also considered for inclusion in annual *Writer's Yearbook*.
Cartoons: Buys 3 cartoons/issue. Theme: the writing life. Needs cartoons that deal with writers and the trials of writing and selling their work. Also, writing from a historical standpoint (past works), language use and other literary themes. Prefers single panel with or without gagline. Send finished cartoons. Material returned by SASE. Reports back within 1 month. Buys first rights or one-time rights. **Pays on acceptance**; $50-85 for b&w.
Illustration: Buys 5 illustrations/month. Features: humorous, realistic, computer and spot illustration. Theme: the writing life. Prefers b&w line art primarily. Works on assignment only. Send postcard or any printed/copied samples to be kept on file (limit size to 8½×11). Accepts Mac-formatted disk submissions. "EPS, PICT, TIFF or JPEG OK for viewing—for reproduction we need EPS." Buys one-time rights. **Pays on acceptance**; $400-500 for color cover; $75-350 for inside b&w.
Tips: "We're also looking for black & white spots of writing-related subjects. We buy all rights; $15-25/spot."

WRITER'S YEARBOOK, 1507 Dana Ave., Cincinnati OH 45207. Submissions Editor: Amanda Boyd. Annual publication featuring "the best writing on writing." Topics include writing and marketing techniques, business issues for writers and writing opportunities for freelance writers and people getting started in writing. Original artwork returned with 1 copy of the issue in which it appears. Sample copy $6.25. Affiliated with *Writer's Digest*. Cartoons submitted to either publication are considered for both.
Cartoons: Uses 3-6 cartoons in yearbook. "All cartoons must pertain to writing—its joys, agonies, quirks. All styles accepted, but high-quality art is a must." Prefers single panel, with or without gagline, b&w line drawings or washes. Send finished cartoons. Samples returned by SASE. Reports in 1-2 months. Buys first North American serial rights for one-time use. **Pays on acceptance**; $50 minimum for b&w.
Tips: "A cluttery style does not appeal to us. Send finished, not rough art, with clearly typed gaglines. Cartoons without gaglines must be particularly well-executed."

YACHTING MAGAZINE, 20 E. Elm St., Greenwich CT 06830. (203)625-4480. Fax: (203)625-4481. Website: http://www.yachtingnet.com. Art Director: David Pollard. Estab. 1907. Monthly magazine "with emphasis on high-end power and sail vessels. Gear and how-to also included." Circ. 132,000. Art guidelines not available.
Illustration: Approached by 75 illustrators/year. Buys 5 illustrations/issue. Features humorous illustration; charts & graphs; informational graphics; computer and spot illustration. Assigns 100% of illustrations to experienced, but not well-known illustrators. Prefers tech drawings. Considers all media. 30% of freelance illustration demands knowledge of Adobe Photoshop, Adobe Illustrator and QuarkXPress, all lates versions. Send postcard sample. Send follow-up postcard samle every 3 months. Accepts disk submissions compatible with QuarkXPress 7.5/version 3.3 send EPS files. Files accepted on Syquest 44,00 and ZIP and floppies. Samples are filed and are not returned. Reports back only if interested. Art director will contact artist for portfolio review of b&w, color tearsheets if interested. Buys first rights. Pays on publication; $250-450 for color inside; $450-600 for 2-page spreads; $150-350 for spots.

SPECIAL MARKET INDEXES, identifying Licensing, Medical Illustration, Religious Art, Science Fiction/Fantasy Art, Sport Art, T-Shirts, Textiles, Wildlife Art and other categories are located in the back of this book.

Design: Needs freelancers for design, production and multimedia projects, rarely. Prefers designers with experience in production. 100% of freelance work demands knowledge of Adobe Photoshop, Adobe Illustrator and QuarkXPress. Send query letter with printed samples and tearsheets.
Tips: "Read the magazine. I like clean, professional work done quickly and with little supervision. Have a presentable portfolio. Our subject is pretty slim, but we can see potential."

‡YELLOW SILK: Journal of Erotic Arts, Box 6374, Albany CA 94706. (510)644-4188. Publisher: Lily Pond. Estab. 1981. Annual magazine emphasizing "erotic literature and arts for well educated, highly literate readership, generally personally involved in arts field." Returns original artwork after publication. Sample copy for $7.50.
Illustration: Acquires 10-20 illustrations/issue by 1 artist if possible. Considers "anything in the widest definitions of eroticism except brutality, bondage or S&M. We're looking for work that is beautiful, artistic. We are really fine arts as opposed to illustration. No pornography. All sexual persuasions represented." Prefers acrylic, then pen & ink, watercolor, oil, pastel, collage and mixed media. Send originals, photocopies, slides, photostats, good quality photographs. Color and b&w examples in each submission are preferred. Include name, address and telephone number on all samples. Samples not filed are returned by SASE. Reports back within 3 months. Buys first rights or reprint rights. Negotiates payment plus copies. Pays on publication.
Tips: "Artistic quality is of equal or higher importance than erotic content. There are too many people doing terrible work thinking it will sell if it's sexual. Don't send it to me! Disturbingly, hard-edge S&M images seem more frequent. Don't send us those, either!!"

YM, Dept. AM, 375 Lexington Ave., New York NY 10017-5514. Contact: Art Director. A fashion magazine for teen girls between the ages of 14-21. Ten issues (monthly and 2 joint issues—June-July and December-January.) Original artwork returned at job's completion. Sample copies available.
Illustration: Buys 1-2 illustrations/issue. Buys 12-36 illustrations/year. Prefers funny, whimsical illustrations related to girl/guy problems, horoscopes and dreams. Considers watercolor, collage, acrylic, colored pencil, oil, charcoal, mixed media, pastel. Samples are filed or not filed (depending on quality). Samples are not returned. Reports back to the artist only if interested. Buys one-time rights. **Pays on acceptance** or publication. Offers one half of original fee as kill fee.

‡YOU! MAGAZINE, 31194 La Baya Dr., Suite 200, Westlake Village CA 91362. (818)991-1813. Fax: (818)991-2024. E-mail: youmag@earthlink.net. Website: http://www.youmagazine.com. Art Director: Louanne Tan. Estab. 1986. Magazine for Catholic and Christian high school and college youth, published 10 times/year. Circ. 375,000. Originals are not returned. Sample copies available for $2.98; art guidelines for SASE with first-class postage.
Cartoons: Approached by 30-40 cartoonists/year. Buys 2 cartoons/issue. Prefers Catholic youth, political and humorous cartoons; single or multiple panel b&w line drawings. Send query letter with brochure, roughs and finished cartoons. Samples are filed. Reports back to the artist only if interested. Rights purchased vary according to project. Pays $50 for b&w; $60 for color.
Illustration: Approached by 100 illustrators/year. Buys 20 illustrations/issue. Has featured illustrations by Mark Armstrong and Tony Calvello. Features fashion, humorous, realistic and computer illustrations. Prefers spiritual themes. Considers pen & ink, watercolor, collage, airbrush, acrylic, marker, oil, charcoal, mixed media, pastel and computer art. Needs computer-literate freelancers for design and illustration. 50% of freelance work demands computer knowledge of Adobe Illustrator, QuarkXPress, Adobe Photoshop or Aldus FreeHand. Send query letter with brochure, résumé, SASE, tearsheets, photographs, photocopies, slides and transparencies. Samples are filed. Request portfolio review in original query. Publication will contact artist for portfolio review if interested. Portfolio should include b&w thumbnails, tearsheets, slides, roughs, photocopies, final art and photographs. Rights purchased vary according to project. Pays on publication; $70 for b&w inside; $80 for color inside.
Tips: "Be creative and persistent. Express yourself with confidence by putting all your energy and talent with your creations. Love what you do!"

YOUR HEALTH, 5401 NW Broken Sound Blvd., Boca Raton FL 33487. (561)989-1176. Fax: (561)997-9210. E-mail: yhealth@aol.com. Photo Editor: Judy Browne. Estab. 1960. Monthly health and fitness magazine for the general public. Circ. 50,000. Accepts previously published artwork. Originals returned at job's completion. Sample copies available; art guidelines available for SASE with first-class postage.
Cartoons: Approached by 30 cartoonists/year. Buys 5 cartoons/year. Prefers health and fitness humorous cartoons; b&w line drawings. Send query letter with roughs. Samples are filed. Reports back within 1 month. Buys one-time rights. Pays $50 for b&w/color.
Illustration: Approached by 100 illustrators/year. Buys 2 illustrations/issue. Prefers health and fitness themes. Considers all media. Send query letter with tearsheets, photographs and photocopies. Samples are filed. Reports back within 1 month. Publication will contact artist for portfolio review if interested. Portfolio should include any samples. Buys one-time rights. Pays on publication; $100-125 for b&w inside; $200-250 for color inside; $50-75 for spots. Finds artists through other publications.
Tips: Features and departments are both open to freelancers.

YOUR HEALTH & FITNESS, 900 Skokie Blvd., Suite 200, Northbrook IL 60062. (847)205-3000. Fax:(847)564-8197. Supervisor of Art Direction: Danya Robinson. Art Director: Patricia Gager. Estab. 1978. Quarterly consumer and company magazine. "*Your Health & Fitness* is a magazine that allows clients to customize up to eight pages. Clients

consist of hospitals, HMOs and corporations." Circ. 600,000. Accepts previously published artwork. Originals are returned at job's completion. Sample copies available. 70% of freelance work demands knowledge of Adobe Illustrator, QuarkXPress, Adobe Photoshop and Aldus Freehand.

Cartoons: Approached by 12 cartoonists/year. Buys 1 cartoon/issue. Prefers humorous, health, fitness and food cartoons; single panel, b&w line drawings with gaglines. Send query letter with finished cartoons. Samples are filed or are returned. Reports back to the artist only if interested. Buys one-time or reprint rights. Pays $150 for b&w, $200 for color.

Illustration: Approached by 200 illustrators/year. Buys 6 illustrations/issue. Works on assignment only. Prefers exercise, fitness, psychology, drug data, health cost, first aid, diseases, safety and nutrition themes; any style. Send postcard sample and tearsheets. Accepts disk submissions compatible with Mac, Adobe Illustrator or Adobe Photoshop. Samples are filed or are returned. Reports back to the artist only if interested. Publication will contact artist for portfolio review if interested. Portfolio should include b&w and color tearsheets and slides. Buys one-time or reprint rights. Pays on publication; $400-600 for color cover; $75-150 for b&w, $150-400 for color inside; $100-150 for spots. Finds artists through sourcebooks and submissions.

Design: Needs freelancers for design. 100% of freelance work demands knowledge of Adobe Illustrator or QuarkXPress. Send query letter with tearsheets and résumé. Pays by the project.

Tips: "Fast Facts" section of magazine is most open to freelancers; uses health- or fitness-related cartoons.

✔YOUR MONEY MAGAZINE, 8001 N. Lincoln Ave. 6th Floor, Skokie IL 60077. (847)763-9200. Corporate Art Director: Beth Ceisel. Estab. 1980. Bimonthly 4-color personal finance magazine. "Provides useful advice on saving, investing and spending. Design is accessible and reader-friendly." Circ. 500,000. Original artwork returned after publication. Art guidelines for SASE with first-class postage.

Illustration: Buys 15-20 illustrations/issue. Works on assignment only. "Editorial illustration is based upon specific needs of an article, therefore style, tone and content will vary." Needs computer-literate freelancers for illustration, charts/graphs. 50% of freelance work demands knowledge of Aldus FreeHand, Adobe Illustrator or Photoshop. Send postcard sample or tearsheets. Accepts disk submissions compatible with QuarkXPress, Adobe Illustrator, Adobe Photoshop. Samples not filed are returned by SASE. Publication will contact artist for portfolio review if interested. Buys first rights or one-time rights. Sometimes requests work on spec before assigning job. Pays $300-800 for b&w, $300-1,000 for cover; $300-1,000 for color inside; $200-400 for spots. Finds artists through other magazines, submissions and sourcebooks.

Tips: "Show only your best work. Include tearsheets in portfolio. Computers are taking on a very important role in magazine publishing."

Posters & Prints

Posters and prints of your artwork can boost both your sales and visibility. You can sell your work all over the country at various galleries and commercial outlets. You or your gallery dealer can market more of your work to corporations, hotel chains and hospitals. The exposure you gain from prints will make your original paintings more valuable.

The following pages describe several ways to produce posters or prints. Each method has its advantages. It's a good idea to talk to several artists who have used each method before you make a decision, then choose a method that suits your own temperament and marketing skills.

ART PUBLISHERS & POSTER COMPANIES

The companies listed in this section contract with artists to put a piece of artwork in print form. They pay for and supervise the production and marketing of work. Some run prints of pre-existing images, while others will ask you to create a new piece of art. The resulting work will either be an original print, a poster, a limited edition print or offset reproduction, depending on how it is produced and sold. Prints are published in limited editions, while posters and offset reproductions usually are not.

The benefit of working with a publisher/distributor is that they take on the expense and duties of printing and marketing. (Some companies listed specialize in distribution only and do not publish. Only contact a distributor if you already have a published print.) Research art publishers thoroughly before you sign with them. Examine their catalogs to make sure the colors of prints are true and paper quality is high. Find out how they plan to market your work and what outlets it will be sold to before you sign a contract.

Is your work fine art or decorative?

Some listings in this section are **fine art presses**, others are more commercial. Read the listings carefully to determine if they create editions for the fine art market or for the **decorative market**.

If you don't mind creating commercial images, and following current trends, the decorative market can be quite lucrative. On the other hand, if you should decide to work with a fine art publisher, you will have more control over the final image.

Visit galleries, frame shops, furniture stores and other retail outlets that carry prints to see where your art fits in. You may also want to visit designer showrooms and interior decoration outlets. Read *Decor* magazine to get a sense of what sells in both markets. (See Publications of Interest, page 678 for *Decor*'s address.)

Once you select a list of potential publishers, send for each publisher's catalog. Some publishers will not send their catalogs because they are too expensive, but you can often ask to see one at a local poster shop, print gallery, upscale furniture store or frame shop.

Submitting your work

To approach a publisher, send a brief query letter, a short bio, a list of galleries that represent your work and five to ten slides or whatever samples they specify in their listing. It helps to send printed pieces or tearsheets as samples, as these show publishers that your work reproduces well and that you have some understanding of the publication process.

Negotiating your contract

A few publishers buy work outright for a flat fee, but most pay on a royalty basis. Royalties for handpulled prints are usually based on retail price and range from 5 to 20 percent, while percentages for posters and offset reproductions are lower (from 2½ to 5 percent) and are based on the wholesale price. Be aware that some publishers may hold back royalties to cover promotion and production costs. This is not uncommon.

As in other business transactions, ask for a contract and make sure you understand and agree to all the terms before you sign. Make sure you approve the size, printing method, paper, number of images to be produced and royalties. Other things to watch for include insurance terms, marketing plans, and a guarantee of a credit line or copyright notice.

Always retain ownership of your original work. Work out an arrangement in which you're selling publication rights only. You'll also want to sell rights only for a limited period of time. That way you can sell the image later as a reprint, or license it for other use (for example as a calendar or note card). If you are a perfectionist about color, make sure your contract gives you final approval of your print. Stipulate that you'd like to inspect a press proof prior to the print run. See *Business and Legal Forms for Fine Artists* by Tad Crawford (Allworth Press) for sample contracts.

ADDITIONAL PRINTING OPTIONS

- **Working at a co-op press.** Instead of approaching an art publisher you can learn to make your own hand-pulled original prints—such as lithographs, monoprints, etchings or silk-screens. If there is a co-op press in your city, you can rent time on a printing press and create your own editions. It is rewarding to learn printing skills and have the hands-on experience. You also gain total control of your work. The drawback is you have to market your images yourself, by approaching galleries, distributors and other clients.

- **Self-publishing with a printing company.** Several national printing concerns advertise heavily in artists' magazines, encouraging artists to publish their own work. If you are a savvy marketer, who understands the ins and outs of trade shows and direct marketing, this is a viable option. However it takes a large investment up front. You could end up with a thousand prints taking up space in your basement, or if you are a good marketer you could end up selling them all and making a much larger profit from your work than if you had gone through an art publisher or poster company.

- **Marketing through distributors.** If you choose the self-publishing route, but don't have the resources to market your prints, distributors will market your work to outlets around the country in exchange for a percentage of sales. Distributors have connections with all kinds of outlets like retail stores, print galleries, framers, college bookstores and museum shops.

- **Working with a fine art press.** Fine art presses differ from commercial presses in that press operators (usually artists themselves) work side by side with you to create the edition every step of the way, sharing their experience and knowledge of the printing process. You may be charged a fee for the time your work is on the press and for the expert advice of the printer.

UNDERSTANDING PRINT JARGON

- **Signing and numbering your editions.** Before you enter the print arena, you will need to know the proper method of signing and numbering your editions. You can observe how this is done by visiting galleries and museums and talking to fellow artists. Perhaps you already learned the procedure in art school.

If you are creating a limited edition, with a specific set number of prints, all prints are numbered, such as 35/100. The largest number is the total number of prints in the edition; the smaller number is the number of the print. Some artists hold out 10% as artist's proofs and number them separately with AP after the number (such as 5/100 AP). Many artists sign and number their prints in pencil.

- **Original prints**. Original prints may be woodcuts, engravings, linocuts, mezzotints, etchings, lithographs or serigraphs. What distinguishes them is that they are produced by hand by the artist (and consequently often referred to as hand-pulled prints). In a true original print the work is created specifically to be a print. Each print is considered an original because the artist creates the artwork directly on the plate, woodblock, etching stone or screen. Original prints are sold through specialized print galleries, frame shops and high-end decorating outlets, as well as fine art galleries.
- **Offset reproductions and posters.** Offset reproductions, also known as posters and image prints, are reproduced by photochemical means. Since plates used in offset reproductions do not wear out, there are no physical limits on the number of prints made. Quantities, however, may still be limited by the publisher in order to add value to the edition. Many of the companies listed in this section offer this option.
- **Giclée Prints.** As the new color-copier technology matures, inkjet fine art prints, also called giclée prints, are gaining respectability. Iris prints, images that are scanned into a computer and output on oversized printers, are even showing up in museum collections.
- **Canvas Transfers.** Canvas transfers are becoming increasingly popular. Instead of, and often in addition to, printing an image on paper, the publisher transfers your image onto canvas so the work has the look and feel of a painting. Some publishers market limited editions of 750 prints on paper, along with a smaller edition of 100 of the same work on canvas. The edition on paper might sell for $150 per print, while the canvas transfer would be priced higher, perhaps selling for $395.

PRICING CRITERIA FOR LIMITED EDITIONS AND POSTERS

Because original prints are always sold in limited editions, they command higher prices than posters (which usually are not numbered). Since plates for original prints are made by hand, and as a result can only withstand a certain amount of use, the number of prints pulled is limited by the number of impressions that can be made before the plate wears out. Some publishers impose their own limits on the number of impressions to increase a print's value. These limits may be set as high as 700 to 1,000 impressions, but some prints are limited to just 250 to 500, making them highly prized by collectors.

Prices for reproductions vary widely depending on the quantity available; the artist's reputation; the popularity of the image; the quality of the paper, ink and printing process. Since prices are lower than for original prints, publishers tend to select images with high-volume sales potential.

DON'T OVERLOOK THE COLLECTIBLES MARKET

If your artwork has wide appeal, and you are flexible, another option for you is the lucrative plates and collectibles market. You will be asked to adjust your work to fit into a circular format if it is chosen for a collectible plate, so be prepared to work with the company's creative staff to develop the final image. Consult the Greeting Cards, Gifts & Products section for companies specializing in collectibles.

Find a niche

Many artists do well in small, specialized niches. Limited edition prints with Civil War themes, for example, are avidly collected by Civil War enthusiasts. But to appeal to Civil War buffs, artists must do extensive research. Every detail, from weapons and foliage in battlefields,

MORE INDUSTRY TIPS

- **Work in a series**. It is often easier to market a series of small prints exploring a single theme or idea than to market single images. A series of similar prints works well in long hospital corridors, office meeting rooms or restaurants. Also marketable are "paired" images. Hotels often purchase two similar prints for each of their rooms.
- **Study color trends.** The Color Association of the United States (CAUS) is the association that tracks and discovers color trends for the industry. Each year CAUS publishes a report predicting color trends for the coming season. For more information contact Margaret Walsh, associate director of CAUS at (212)582-6884.
- **Attend trade shows.** Many artists say it's the best way to research the market and make contacts. Increasingly it has become an important venue for self-published artists to market their work. To find out what trade shows are coming up in your area, check the event calendars in industry trade publications, such as *Art Business News* and *Decor* (see Publications of Interest for addresses). Many shows, such as the Art Buyers Caravan, are scheduled to coincide with annual stationery or gift shows, so if you work in both the print and greeting card markets, be sure to take that into consideration. Remember, traveling to trade shows is considered a deductible business expense, so don't forget to save your receipts!

to the buttons on soldiers' uniforms, must be historically accurate. Signed limited editions are usually created in a print run of 950 or so and can average about $175-200; artist's proofs sell from between $195-250, with canvas transfers selling for $400-500. The original paintings from which images are taken often sell for thousands of dollars to avid collectors.

Sport art is another lucrative niche. There's a growing trend toward portraying sports figures from golf, tennis, football, basketball, racing (both sports car and horse racing) in prints which include both the artist's and the athlete's signatures. Movie stars from the 1940s and 50s (such as Humphrey Bogart, James Dean, Marilyn Monroe and Elvis) are also cult favorites.

A NOTE ABOUT SCULPTURE

Some publishers also handle limited editions of sculptural pieces and market them through fine art galleries. Sculptural editions are made by casting several forms from the same mold. Check the listings in this section for more targeted information about this publishing option.

AARON ASHLEY, INC., 230 Fifth Ave., Suite 400, New York NY 10001. (212)532-9227. Fax: (212)481-4214. Contact: Philip D. Ginsburg and Budd Wiesenberg. Produces unlimited edition, offset reproduction fine art prints for distributors, decorators, frame shops, corporate curators, giftshops, museums and galleries. Clients: Freer Museum and Amon Carter.
Needs: Seeking decorative art for the designer and commercial markets. Considers oil, acrylic and watercolor paintings, mixed media and pastel. Prefers realistic or representational works. Artists represented include French-American Impressionists, Bierstadt, Russell Remington, Jacqueline Penney, Ron McKee, Carolyn Blish and Urania Christy Tarbot. Editions created by working from an existing painting or chrome or by collaborating with the artists. Approached by 150 artists/year. Publishes the work of 12 emerging, 12 mid-career and 50 established artists/year.
First Contact & Terms: Query with SASE and slides or photos. "Do not send originals." Samples are returned. Reports within 3 days. Company will contact artist for portfolio review of color photographs and transparencies if interested. Pays royalties or fee. Offers advance. Buys reprint rights. Requires exclusive representation for unlimited editions. Provides advertising and promotion.
Tips: Advises artists to attend Art Expo (industry trade show) held yearly in May in New York City.

ACTION IMAGES INC., 1892 First St., Suite 101, Highland Park, IL 60035. (847)763-9700. President: Tom Green. Estab. 1989. Art publisher of sport prints. Publishes limited edition prints, open edition posters as well as direct printing on canvas. Specializes in sport art prints for events such as the Super Bowl, World Series, Final Four, Indy 500 and NASCAR. Clients include galleries, distributors, sales promotion agencies. Current clients include E&J Gallo Winery, Duracell Battery, Coca Cola, AllSport.

Needs: Seeking sport art for posters and as promotional material for sporting events. Considers all media. Artists represented include Ken Call, Konrad Hack, George Gaadt and Alan Studt. Approached by approximately 25 artists/ year. Publishes the work of 1 emerging, 6 mid-career and 6 established artists/year.

First Contact & Terms: Send query letter with slides or color prints and SASE. Accepts submissions on disk compatible with Mac. Send EPS files. Samples are filed. Reports back only if interested. If interested in samples, will ask to see more of artist's work. Pays flat fee: $1,000-2,000. Buys exclusive reproduction rights. Often acquires original painting. Provides insurance while work is at firm and outbound in-transit insurance. Promotional services vary depending on project. Also needs designers. Prefers designers who own Macs. Designers send query letter and samples. Finds artists through recommendations from other artists, word of mouth and submissions.

Tips: "The trend seems to be moving away from superrealism toward more Impressionistic work. We like to work with artists who are knowledgable about the pre-press process. Sometimes artists don't understand that the colors they create in their studios will not reproduce the exact way they envision them. Greens are tough to reproduce accurately. When you finish an artwork, have a photographer shoot it and get a color print. You'll be surprised how the colors come out. For example, if you use dayglow colors, they will not show up well in the cromalin. When we hire an artist to create a piece, we need to know the cromalin print will come back with accurate colors. This can only occur when the artist understands how colors reproduce and plans his colors so the final version shows the intended color."

‡AEROPRINT, (AKA SPOFFORD HOUSE), South Shore Rd., Box 154, Spofford NH 03462. (603)363-4713. Owner: H. Westervelt. Estab. 1972. Art publisher/distributor handling limited editions (maximum 250 prints) of offset reproductions and unlimited editions for galleries and collectors. Clients: aviation art collectors.

Needs: Seeking creative art. Considers pen & ink, oil, acrylic, pastel, watercolor, tempera or mixed media. Prefers representational, event-oriented subject matter of historical nature. Artists represented include Merv Corning, Jo Kotula, Terry Ryan and Gil Cohen. Publishes the work of 1 emerging and 8 established artists/year. Distributes the work of 5 emerging and 32 established artists/year.

First Contact & Terms: To show a portfolio, mail color or b&w thumbnails, roughs, original/final art, photostats, tearsheets, slides, transparencies or final reproduction/product. Payment method is negotiated. Offers an advance. Negotiates rights purchased. Provides written contract and shipping from firm.

Tips: A common problem is "incomplete or undeveloped talent, prematurely presented for publishing or introduction to a project."

AFFORDABLE BLACK ART, 5146 Fourth Ave., Los Angeles CA 90043-1931. (213)299-8082. Fax: (213)290-0777. Owner: Pamela Miller. Estab. 1992. Publishes/distributes limited edition, fine art prints and posters. Clients: gift shops, bookstores and galleries. Current clients include: Deck The Walls and Picture This Framing.

Needs: Seeking art for the serious collector and lithographs for the wholesale market. Considers prints. Prefers African-American subjects. Artists represented include Brenda Joysmith, George E. Miller II, Jimi Claybrooks, Keith Mallett. Editions created by working from existing painting. Approached by 20 artists/year. Publishes the work of 2 emerging and 1 established artists/year. Distributes the work of 1-2 emerging and 14 established artists/year.

First Contact & Terms: Send résumé and tearsheets. Samples are filed or are returned by SASE. Reports back only if interested. Company will contact artist for portfolio review of final art (if not too large), tearsheets, sample print stock or prints. Pays 50% of 50% of retail. Negotiates rights purchased. Provides shipping from firm. "We refer to our file of submisisons which artists have sent through the year to find new talent."

Tips: "It is helpful if fine artists also have commercial art skills."

ALEXANDRE ENTERPRISES, P.O. Box 34, Upper Marlboro MD 20773. (301)627-5170. Fax: (301)627-5106. Artistic Director: Walter Mussienko. Estab. 1972. Art publisher and distributor. Publishes and distributes handpulled originals, limited editions and originals. Clients: retail art galleries, collectors and corporate accounts.

Needs: Seeking creative and decorative art for the serious collector and designer market. Considers oil, watercolor, acrylic, pastel, ink, mixed media, original etchings and colored pencil. Prefers landscapes, wildlife, abstraction, realism and impressionism. Artists represented include Cantin and Gantner. Editions created by collaborating with the artist. Approached by 30 artists/year. Publishes the work of 2 emerging, 2 mid-career and 3-4 established artists/year. Distributes the work of 2-4 emerging, 2 mid-career and 24 established artists/year.

First Contact & Terms: Send query letter with résumé, tearsheets and photographs. Samples are filed. Reports back within 4-6 weeks only if interested. Call to schedule an appointment to show a portfolio or mail photographs and original pencil sketches. Payment method is negotiated: consignment and/or direct purchase. Offers an advance when appropriate. Negotiates rights purchased. Provides promotion, a written contract and shipping from firm.

Tips: "Artist must be properly trained in the basic and fundamental principles of art and have knowledge of art history. Have work examined by art instructors before attempting to market your work."

AMCAL FINE ART, 2500 Bisso Lane, Bldg. 500, Concord CA 94520. (510)689-9930. Fax: (510)689-0108. Development Manager: Julianna Ross. Licensing: Valerie Weeks. Estab. 1993. Art publisher. Publishes limited and unlimited editions, canvas transfers and offset reproductions. Clients: print galleries.
• Also has listing in Greeting Cards, Gifts & Products section. This company's licensing division licenses images for tabletop, textile, collectibles, gift and stationery products.
Needs: Seeking high quality art for the serious collector. Also needs designers. Considers all media. Prefers representational work. Artist represented include Charles Wysocki. Editions created by collaborating with the artist or by working from an existing painting. Approached by 50 artists/year. Publishes the work of 1 mid-career and 1 established artist/year.
First Contact & Terms: Send postcard size sample of work or query letter with brochure, slides, transparencies, tearsheets and photographs. Samples are not filed and are returned by SASE if requested by artist. Reports back within 2 months. Publisher will contact artist for portfolio review if interested. Portfolio should include color slides, tearsheets, transparencies, final art and photographs. Pays royalties. Offers advance when appropriate. Provides advertising, in-transit insurance, insurance while work is at firm, promotion, shipping from firm and written contract. Finds artists through researching trade, art magazines, attending shows, visiting galleries.
Tips: Suggest artists read *US Art* magazine, *Art Business News*, *GSB*, also home decor magazines.

AMERICAN VISION GALLERY, 625 Broadway, 4th Floor, New York NY 10012. (212)677-2559. Fax: (212)677-2253. President: Bruce Teleky. Estab. 1974. Art publisher and distributor. Publishes and distributes posters, fine art prints, unlimited editions and offset reproductions. Clients: galleries, frame shops, museum shops, decorators, corporate curators, giftshops. Current clients include Museum of Modern Art, The Studio Museum.
Needs: African-American and decorative art for the designer and commercial markets. Considers collage, oil, watercolor, pastel, pen & ink, acrylic. Prefers depictions of African-Americans, Carribean scenes or African themes. Artists represented include Romare Bearden, Jacob Lawrence and several Hatian artists.
First Contact & Terms: Send query letter with slides and brochure. Samples are returned by SASE if requested by artist. Reports back only if interested. Pays flat fee, $400-2,500 maximum, or royalties of 7-15%. Offers advance when appropriate. Rights purchased vary according to project. Interested in buying second rights (reprint rights) to previously published artwork.
Tips: "If you don't think you're excellent, wait until you have something excellent. Posters are a utility, they go somewhere specific, so images I use fit somewhere—over the couch, kitchen, etc."

ANGEL GRAPHICS, A Division of Angel Gifts, Inc., 903 W. Broadway, P.O. Box 530, Fairfield IA 52556. Project Manager: Julie Greeson. Estab. 1981. Publisher of wall decor art (photographic and graphic images) in mini poster (16×20) and smaller sizes and open edition art prints between 2×3 and 24×36. Clients: wholesale gift market, international, picture framers.
Needs: Folk art, especially humorous, country, florals, children, angels, Victorian images; ethnic (Hispanic, African-American including historical figures, African, Spanish, Native American); inspirational/religious, motivational (with and without quotes); fantasy (unicorns, wizards, etc.); western U.S., cowboys. Seeking detailed artwork, realistic subjects with broad appeal. Publishes up to 150 new subjects/year.
First Contact & Terms: Send query letter with photographs or duplicate slides and SASE. Do not send originals. Pays $150-600. Successful artists can make other arrangements. Works with artists to develop proper look.
Tips: "Send $7 for current catalog or $3 for most current supplement to see types of images we publish."

‡ARNOLD ART STORE & GALLERY, 210 Thames St., Newport RI 02890. (401)847-2273. Fax: (401)848-0156. E-mail: arnoldart@aol.com. Owner: Bill Rommer. Estab. 1870. Poster company, art publisher, distributor, gallery specializing in marine art. Publishes/distributes limited and unlimited edition, fine art prints, offset reproduction and posters. Current clients include: Bruce McGaw, Graphique de France.
Needs: Seeking creative, fashionable, decorative art for the serious collector, commercial and designer markets. Considers oil, acrylic, watercolor, mixed media, pastel, pen & ink, sculpture. Prefers sailing images, Americas Cup or other racing images. Artists represented include Willard Bond, Lucia deLieris. Editions created by working from an existing painting. Approached by 100 artists/year. Publishes/distributes the work of 10-15 established artists/year.
First Contact & Terms: Send query letter with 4-5 photographs. Samples are filed or returned by SASE. Call to arrange portfolio review. Pays flat fee, royalties or consignment. Negotiates rights purchased; rights purchased vary according to project. Provides advertising and promotion. Finds artists through word of mouth.

HERBERT ARNOT, INC., 250 W. 57th St., New York NY 10107. (212)245-8287. President: Peter Arnot. Vice President: Vicki Arnot. Art distributor of original oil paintings. Clients: galleries, design firms.
Needs: Seeking creative and decorative art for the serious collector and designer market. Considers oil and acrylic

‡ **MARKETS NEW TO THIS EDITION** are marked with a double dagger.

paintings. Has wide range of themes and styles—"mostly traditional/impressionistic, not modern." Artists represented include An He, Malva, Willi Bauer, Gordon, Yoli and Lucien Delarue. Distributes the work of 250 artists/year.

First Contact & Terms: Send query letter with brochure, résumé, business card, slides or photographs to be kept on file. Samples are filed or are returned by SASE. Reports within 1 month. Portfolios may be dropped off every Monday-Friday or mailed. Pays flat fee, $100-1,000. Provides promotion and shipping to and from distributor.

Tips: "Check colors currently in vogue."

ART A'LA CARTE, 25 Harveston, Mission Viejo CA 92692-5117. (714)455-0957. Director of Marketing: Debra Dalmand. Estab. 1975. Art publisher/distributor. Publishes handpulled originals, limited and unlimited editions, fine art prints, monoprints, photography, offset reproductions, posters, sculpture and copper reliefs. Clients include: galleries, interior designers, framers, architects, gift shops. Current clients include Intercontinental Art, Z Gallerie, Fast Frames.

Needs: Seeking creative, fashionable, decorative, trendsetting art for the serious collector, commercial and designer markets. Considers oil, acrylic, watercolor, mixed media, pastel, pen & ink and sculpture. Considers all themes and styles. Artists represented include Bruce Wood, Endrew Szasz, Guy Begin, Csaba Markus, Marton Varo. Editions created by collaborating with the artist and working from existing painting. Approached by 50 artists/year. Distributes the work of many artists/year.

First Contact & Terms: Send query letter with brochure, photocopies, photographs, résumé. Samples are filed or are returned by SASE. Artists should follow up with call or letter. Company will contact artist for portfolio review if interested. Negotiates payment: royalties from 10-33% or consignment basis: firm receives 50%. Rights vary according to project. Provides promotion. Finds artists through art exhibitions, submissions, art reps.

Tips: Recommends artists be "fast, productive, open minded and flexible."

ART BEATS, INC., P.O. Box 1469, Greenwich CT 06836-1469. (800)338-3315. Fax: (203)661-2480. Estab. 1983. Art publisher. Publishes and distributes open edition posters and gift/fine art cards. Clients: framers, galleries, gift shops. Current clients include Prints Plus, Intercontinental Art. Member of New York Graphic Society Publishing Group.

Needs: Seeking creative, fashionable and decorative art for the commercial and designer markets. Considers oil, watercolor, mixed media, pastel and acrylic. Artists represented include Gary Collins, Nancy Lund, Mark Arian, Robert Duncan and Tracy Taylor. Approached by 1,000 artists/year. Publishes the work of 45 established artists/year.

First Contact & Terms: Send query letter with résumé, color correct photographs, transparencies and tearsheets. Samples are not filed and are returned by SASE if requested by artist. Reports back within 3 months. Publisher will contact artist for portfolio review if interested. Portfolio should include photostats, slides, tearsheets, photographs and transparencies; "no originals please." Pays royalties of 10% gross sales. No advance. Buys first rights, one-time rights or reprint rights. Provides promotion and written contract. Finds artists through art shows, exhibits, word of mouth and submissions.

‡ART BOOM LIMITED EDITIONS, 2421 Sundown Dr., Los Angeles CA 90065. (213)478-7395. Fax: (213)478-7398. Publisher: Steve Rinehart. Art publisher. Publishes and distributes limited editions. Clients: 1,100 galleries.

Needs: Considers oil, mixed media and acrylic. Prefers representational art. Artists represented include Steve Kushner, Alan Murray. Editions created by collaborating with the artist and working from an existing painting. Approached by 100/year. Publishes the work of 2-3 emerging, 1 mid-career and 6-10 established artists/year. Distributes the work of 1-2 emerging and 1-2 established artists/year.

First Contact & Terms: Send query letter with brochure, slides, photocopies, résumé, transparencies, tearsheets and photographs. Samples are not filed and returned by SASE if requested by artist. Portfolio review not required. Publisher will contact artist for portfolio review if interested. Portfolio should include slides and 4×5 or 8×10 transparencies. Pays royalties of 12-15% or negotiates payment. No advance. Buys reprint rights. Requires exclusive representation of artist. Provides in-transit insurance, promotion, shipping from firm and written contract.

Tips: Finds artists through attending art exhibitions.

ART BROKERS OF COLORADO, 2419 W. Colorado Ave., Colorado Springs CO 80904. (719)520-9177. Contact: Nancy Anderson. Estab. 1991. Art publisher. Publishes limited and unlimited editions, posters and offset reproductions. Clients: galleries, decorators, frame shops.

Needs: Seeking decorative art by established artists for the serious collector. Prefers oil, watercolor and acrylic. Prefers western theme. Editions created by collaborating with the artist. Approached by 20-40 artists/year. Publishes the work of 1-2 established artists/year.

First Contact & Terms: Send query letter with photographs. Samples are not filed and are returned by SASE. Reports back within 4-6 weeks. Company will contact artist for portfolio review of final art if interested. Pays royalties. Rights purchased vary according to project. Provides insurance while work is at firm.

Tips: Advises artists to attend all the trade shows and to participate as often as possible.

✔ART EMOTION CORP., 758 S. Edgar, Palatine IL 60067. (847)397-9300. Fax: (847)397-0206. E-mail: gperez@art emo.com. Website: http://www.artemo.com. President: Gerard V. Perez. Estab. 1977. Art publisher and distributor. Publishes and distributes limited editions. Clients: corporate/residential designers, consultants and retail galleries.

Needs: Seeking decorative art. Considers oil, watercolor, acrylic, pastel and mixed media. Prefers representational, traditional and impressionistic styles. Artists represented include Garcia, Johnson and Sullivan. Editions created by

working from an existing painting. Approached by 50-75 artists/year. Publishes and distributes the work of 2-5 artists/year.

First Contact & Terms: Send query letter with slides or photographs. "Supply a SASE if you want materials returned to you." Samples are filed. Does not necessarily report back. Pays royalties of 10%.

Tips: "Send visuals first."

✦ART IN MOTION, 800 Fifth Ave., Suite 150, Seattle WA 98104. Also 2000 Hartley Ave., Coquitlam, British Columbia V3K 6W5 Canada. (604)525-3900. Fax: (604)525-6166. President: Garry Peters. Art publisher and distributor. Publishes and distributes limited editions, original prints, offset reproductions and posters. Clients: galleries, distributors world wide and picture frame manufacturers.

Needs: Seeking creative, fashionable and decorative art for the serious collector, commercial and designer markets. Considers oil, watercolor, acrylic and mixed media. Prefers decorative styles. Artists represented include Marilyn Simandle, Corinne Hartley and Art LaMay. Editions created by collaborating with the artist or by working from an existing painting. Approached by 100 artists/year. Publishes the work of 5-7 emerging, mid-career and established artists/year. Distributes the work of 2-3 emerging and established artists/year.

First Contact & Terms: Send query letter with brochure showing art style or résumé and tearsheets, slides, photostats, photographs and transparencies. Samples are filed or are returned by SASE if requested by artist. Reports back within 2 weeks if interested. If does not report back the artist should call. Call for appointment to show portfolio, or mail photostats, slides, tearsheets, transparencies and photographs. Pays royalties up to 15%. Payment method is negotiated. "It has to work for both parties. We have artists making $200 a month and some that make $10,000 a month or more." Offers an advance when appropriate. Negotiates rights purchased. Requires exclusive representation of artist. Provides in-transit insurance, insurance while work is at firm, promotion, shipping to and from firm and a written contract.

Tips: "We are looking for a few good artists; make sure you know your goals, and hopefully we can help you accomplish them, along with ours."

ARTHURIAN ART GALLERY, 4646 Oakton St., Skokie IL 60076-3145. Website: http://www.arthurart.com. Owner: Art Sahagian. Estab. 1985. Art distributor and gallery. Handles limited editions, handpulled originals, bronze, watercolor, oil and pastel. Current clients include Gerald Ford, Nancy Reagan, John Budnik and Dave Powers.

Needs: Seeking creative, fashionable and decorative art for the serious collector and commercial market. Artists represented include Robert Barnum, Nancy Fortunato, Art Sahagian and Christiana. Editions created by collaborating with the artist. Approached by 25-35 artists/year. Publishes and distributes the work of 5-10 emerging, 1-3 mid-career and 2-5 established artists/year.

First Contact & Terms: Send query letter with brochure showing art style and résumé, slides and prices. Samples not filed are returned by SASE. Reports within 30 days. Write for appointment to show portfolio of original/final art, final reproduction/product and color photographs. Pays flat fee of $25-2,500; royalties of 3-5%; or on a consignment basis (firm receives 25% commission). Rights purchased vary. Provides insurance while work is at firm, promotion and written contract.

Tips: Sees trend toward animal images and bright colors.

‡ARTHUR'S INTERNATIONAL, 2613 High Range Dr., Las Vegas NV 89134. President: Marvin C. Arthur. Estab. 1959. Art distributor handling original oil paintings primarily. Publishes and distributes limited and unlimited edition prints. Clients: galleries, corporate and private collectors, etc.

Needs: Seeking creative art for the serious collector. Considers all types of original work. Artists represented include Wayne Takazono, Wayne Stuart Shilson, Paul J. Lopez, Ray Shry-Ock and Casimir Gradomski. Editions created by collaborating with the artist or by working from an existing painting. Purchases have been made in pen & ink, charcoal, pencil, tempera, watercolor, acrylic, oil, gouache and pastel. "All paintings should be realistic to view, though may be expressed in various manners."

First Contact & Terms: Send brochure, slides or photographs to be kept on file; no originals unless requested. Artist biographies appreciated. Samples not filed are returned by SASE. Reports back normally within 1 week. "We pay a flat fee to purchase the original. Payment made within 5 days. Then we pay 30% of our net profit made on reproductions. The reproduction royalty is paid after we are paid. We automatically raise artist's flat fee as demand increases."

Tips: "Do not send any original paintings unless we have requested them. Having a track record is nice, but it is not a requirement."

‡ARTVISIONS, 12117 SE 26th St., Suite 202A, Bellevue WA 98005-4118. (425)746-2201. Owner: Neil Miller. Estab. 1993. Markets include publishers, manufacturers and others who may require fine art. Fine art licensing of posters and prints. See listing in Artists' Reps.

B.L.D. LIMITED, 118 E. 25th St., New York NY 10010-2915. (212)460-8700. Fax: (212)979-7554. E-mail: finart@worldnet.att.net. President: J.J. Levin. Estab. 1966. Art publisher. Publishes limited editions. Clients: galleries, decorators and frame shops.

Needs: Seeking decorative art for the commercial market. Considers oil, acrylic, watercolor, mixed media and pastel. Editions created by working from an existing painting. Approached by 10-15 artists/year.

First Contact & Terms: Send query letter with brochure, photographs and SASE. Samples are not filed and are returned by SASE. Reports back within 1 week. company will contact artist for portfolio review if interested.

BANKS FINE ART, 3316 Royal Lane, Dallas TX 75229-5061. (214)352-1811. Fax: (214)352-1667. E-mail: artman2@ IX.netcom.com. Website: http://www.banksfineart.com. Owner: Bob Banks. Estab. 1980. Distributor, gallery of original oil paintings. Clients: galleries, decorators.
Needs: Seeking decorative, traditional and impressionistic art for the serious collector and the commercial market. Considers oil, acrylic. Prefers traditional and impressionistic styles. Artists represented include Joe Sambataro, Jan Bain, Marcia Banks, Eleanore Guinther. Approached by 100 artists/year. Publishes/distributes the work of 2 emerging, 7 mid-career, 3 established artists/year.
First Contact & Terms: Send photographs. Samples are returned by SASE. Reports back within 1 week. Offers advance. Rights purchased vary according to project. Provides advertising, in-transit insurance, insurance while work is at firm, promotion, shipping from firm, written contract.
Tips: Needs Paris street scenes. Advises artists entering the poster and print fields to attend Art Expo, the industry's largest trade event, held in New York City every spring. Also recommends reading *Art Business News*.

BENJAMANS ART GALLERY, 419 Elmwood Ave., Buffalo NY 14222. (716)886-0898. Fax: (716)886-0546. Estab. 1970. Art publisher, distributor, gallery, frame shop and appraiser. Publishes and distributes handpulled originals, limited and unlimited editions, posters, offset reproductions and sculpture. Clients include P&B International.
Needs: Seeking decorative art for the serious collector. Considers oil, watercolor, acrylic and sculpture. Prefers art deco and florals. Artists represented include J.C. Litz, Jason Barr and Eric Dates. Editions created by collaborating with the artist. Approached by 20-30 artists/year. Publishes and distributes the work of 4 emerging, 2 mid-career and 1 established artists/year.
First Contact & Terms: Send query letter with SASE slides, photocopies, résumé, transparencies, tearsheets and/or photographs. Samples are filed or returned. Reports back within 2 weeks. Company will contact artist for portfolio review if interested. Pays on consignment basis: firm receives 30-50% commission. Offers advance when appropriate. Rights purchased vary according to project. Does not require exclusive representation of artist. Provides advertising, promotion, shipping to and from firm, written contract and insurance while work is at firm.
Tips: "Keep trying to join a group of artists and try to develop a unique style."

BENTLEY HOUSE FINE ART PUBLISHERS, Box 5551, 1410-J Lesnick Lane, Walnut Creek CA 94596. (510)935-3186. Fax: (510)935-0213. E-mail: alp@bentleyhouse.com. Website: http://www.bentleyhouse.com. Director: Mary Sher. Estab. 1986. Art publisher of open and limited editions of offset reproductions and canvas replicas; also agency (Art Licensing Properties) for licensing of artists' images worldwide. License florals, teddy bear, wildlife and Christmas images to appear on puzzles, tapestry products, doormats, stitchery kits, giftbags, greeting cards, mugs, tiles, wall coverings, resin and porcelain figurines, waterglobes and various other gift items. Clients: framers, galleries, distributors and framed picture manufacturers.
Needs: Seeking decorative fine art for the designer, residential and commercial markets. Considers oil, watercolor, acrylic, gouache, pastel, mixed media and photography. Artists represented include Barbara Mock, Carl Valente, Peggy Abrams, Mary Kay Krell, Richard Judson Zolan, Loren Entz, Charly Palmer and Tom Sierak. Editions created by collaborating with the artist or by working from an existing painting. Approached by 1,000 artists/year.
First Contact & Terms: Send query letter with brochure showing art style or résumé, advertisements, slides and photographs. Samples are filed or are returned by SASE if requested by artist. Reports back within 1 month. Pays royalties of 10% net sales for prints monthly plus 50 artist proofs of each edition. Pays 50% monies received from licensing. Obtains all reproduction rights. Usually requires exclusive representation of artist. Provides national trade magazine promotion, a written contract, worldwide agent representation, 5 annual trade show presentations, insurance while work is at firm and shipping from firm.
Tips: "Bentley House is looking for experienced artists, with images of universal appeal. New imagery added to our line are folk, wildlife and African-Amerian Art so we would particularly like to see that type of work from artists."

BERGQUIST IMPORTS INC., 1412 Hwy. 33 S., Cloquet MN 55720. (218)879-3343. Fax: (218)879-0010. President: Barry Bergquist. Estab. 1946. Distributor. Distributes unlimited editions. Clients: gift shops.
Needs: Seeking creative and decorative art for the commercial market. Considers oil, watercolor, mixed media and acrylic. Prefers Scandinavian or European styles. Artists represented include Jacky Briggs and Cyndi Nelson. Editions created by collaborating with the artist or by working from an existing painting. Approached by 20 artists/year. Publishes the work of 2-3 emerging, 2-3 mid-career and 2 established artists/year. Distributes the work of 2-3 emerging, 2-3 mid-career and 2 established artists/year.
First Contact & Terms: Send brochure, résumé and tearsheets. Samples are not filed and are returned. Reports back within 2 months. Artist should follow-up. Portfolio should include color thumbnails, final art, photostats, tearsheets and photographs. Pays flat fee: $50-300, royalties of 5%. Offers advance when appropriate. Negotiates rights purchased. Provides advertising, promotion, shipping from firm and written contract. Finds artists through art fairs.
Tips: Suggests artists read *Giftware News Magazine*.

BERKSHIRE ORIGINALS, P.O. Box 951, Eden Hill, Stockbridge MA 01263. (413)298-3691. Fax: (413)298-3583. Program Design Assistant: Stephanie Wilcox-Hughes. Estab. 1991. Art publisher and distributor of offset reproductions and greeting cards.
Needs: Seeking creative art for the commercial market. Considers oil, watercolor, acrylic, pastel and pen & ink. Prefers religious themes, but also considers florals, holiday and nature scenes.

First Contact & Terms: Send query letter with brochure showing art style or other art samples. Samples are filed or are returned by SASE if requested by artist. Reports within 1 month. Write for appointment to show portfolio of slides, color tearsheets, transparencies, original/final art and photographs. Pays flat fee; $50-500. Buys all rights.

Tips: "Good draftsmanship is a must, particularly with figures and faces. Colors must be harmonious and clearly executed."

‡BERNARD FINE ART, P.O. Box 1528, Historic Rt. 7A, Manchester Center VT 05255. (802)362-1373. Fax: (802)362-1082. Art Coordinator: Laura Sutherland. Art publisher. Publishes unlimited editions and posters. Clients: picture frame manufacturers, distributors, manufacturers, galleries and frame shops.

Needs: Seeking creative, fashionable and decorative art for commercial and designer markets. Considers oil, watercolor, acrylic, pastel, mixed media and printmaking (all forms). Editions created by collaborating with the artist or by working form an existing painting. Artists represented include Erin Dertner, Sue Dreamer, Rusty Rust, Bill Bell, Shelly Rasche, Steven Klein and Michael Harrison. Approached by hundreds of artists/year. Publishes the work of 8-10 emerging, 10-15 mid-career and 100-200 established artists.

First Contact and Terms: Send query letter with brochure showing art style and/or résumé, tearsheets, photostats, photocopies, slides, photographs or transparencies. Samples are returned by SASE. Reports back within 2-8 weeks. Call or write for appointment to show portfolio of thumbnails, roughs, original/final art, b&w and color photostats, tearsheets, photographs, slides and transparencies. Pays royalty. Offers an advance when appropriate. Buys all rights. Usually requires exclusive representation of artist. Provides in-transit insurance, insurance while work is at firm, promotion, shipping from firm and a written contract. Finds artists through submissions, sourcebooks, agents, art shows, galleries and word of mouth.

Tips: "We look for subjects with a universal appeal. Some subjects that would be appropriate are landscapes, still lifes, wildlife, religious themes and florals. Please send enough examples of your work so we can see a true representation of style and technique"

BIG, (Division of the Press Chapeau), Govans Station, Box 4591, Baltimore City MD 21212-4591. Director: Elspeth Lightfoot. Estab. 1976. Supplier of original tapestries, sculptures, crafts and paintings to architects, interior designers, facility planners and corporate curators. Makes individual presentations to clients.

Needs: Seeking art for the serious and commercial collector and the designer market. "We distribute what corporate America hangs in its board rooms; highest quality traditional, landscapes, contemporary abstracts. But don't hesitate with unique statements, folk art or regional themes. In other words, we'll consider all categories as long as the craftsmanship is there." Prefers individual works of art. Editions created by collaborating with the artist. Approached by 50-150 artists/year. Distributes the work of 10 emerging, 10 mid-career and 10 established artists/year.

First Contact & Terms: Send query letter with slides. Samples are filed or are returned by SASE. Reports back within 5 days. Request portfolio review in original query. Artist should follow up with letter after initial query. Pays $500-30,000. Payment method is negotiated (artist sets net pricing). Usually pays ⅓ at contract, ⅓ at commencement of work and ⅓ at work's completion. Does not require exclusive representation. Provides in-transit insurance, insurance while work is at firm, promotion, shipping to firm, and a written contract.

THE BILLIARD LIBRARY CO., 1570 Seabright Ave., Long Beach CA 90813. (562)437-5413. Fax: (562)436-8817. E-mail: dlar@earthlink.com. Creative Director: Darian Baskin. Estab. 1973. Art publisher. Publishes unlimited and limited editions and offset reproductions. Clients: galleries, frame shops, decorators. Current clients include Deck the Walls, Prints Plus, Adventure Shops.

Needs: Seeking creative, fashionable and decorative art for the commercial and designer markets. Considers oil, watercolor, mixed media, pastel, sculpture and acrylic. Artists represented include George Bloomfield, Dave Harrington and Lance Slaton. Approached by 100 artists/year. Publishes and distributes the work of 1-3 emerging, 1-3 mid-career and 1-2 established artists/year. Also uses freelancers for design. Prefers local designers only.

First Contact & Terms: Send query letter with slides, photocopies, résumé, photostats, transparencies, tearsheets and photographs. Samples are filed and not returned. Reports back only if interested. Publisher/Distributor will contact artists for portfolio review if interested. Pays royalties of 10%. Negotiates rights purchased. Provides promotion, advertising and a written contract. Finds artists through submissions, word of mouth and sourcebooks.

Tips: "The Billiard Library Co. publishes and distributes artwork of all media relating to the sport of pool and billiards. Themes and styles of any type are reviewed with an eye towards how the image will appeal to a general audience of enthusiasts. We are experiencing an increasing interest in nostalgic pieces, especially oils. Will also review any image relating to bowling or darts."

THE BLACKMAR COLLECTION, P.O. Box 537, Chester CT 06412. (860)526-9303. Estab. 1992. Art publisher. Publishes offset reproduction and giclée prints. Clients: individual buyers.

Needs: Seeking creative art. "We are not actively recruiting at this time." Artists represented include DeLos Blackmar, Blair Hammond, Gladys Bates and Keith Murphey. Editions created by working from an existing painting. Approached by 24 artists/year. Publishes the work of 3 established artists/year. Provides advertising, in-transit insurance, insurance while work is at firm. Finds artists through personal contact.

WM. BLACKWELL & ASSOCIATES, 638 S. Governor St., Iowa City IA 52240-5626. (800)366-5208. Fax: (319)338-1247. E-mail: mbrooke@avalon.net. Contact: Margaret Brooke. Estab. 1979. Distributor. Distributes hand-pulled originals. Clients: gallery and design (trade only).

Needs: Seeking decorative art for the designer market. Considers etchings (hand-colored). Prefers traditional and representational. Artists represented include Alice Scott, Charles Leonard, Dan Mitra, Rick Loudermilk. Approached by 10-15 artists/year.

First Contact & Terms: Send query letter with photographs, samples of actual impressions. Samples are not filed and are returned by SASE if requested by artist. Reports back within 1 month. Distributor will contact artists for portfolio review if interested. Portfolio should include final art. Pays on consignment basis: firm receives 50% commission (of 'trade' price); negotiates payment for work purchased out right. No advance. Provides promotion, shipping from firm and distribution (primarily eastern and central US).

Tips: "Artists generally approach us via trade shows."

BOLOGNA FINE ART PUBLISHERS, 445 Terry Pkwy., Suite 8, Terrytown LA 70056. (504)366-9444. Fax: (504)392-6710. Owner: Rick Bologna. Estab. 1993. Art publisher, distributor, gallery. Publishes limited edition, unlimited edition, canvas transfers, offset reproduction, posters. Clients: galleries, frame shops, distributors, gift shops, decorators.

Needs: Seeking decorative art for the commercial market. Considers oil, acrylic, watercolor, mixed media, pastel, pen & ink. Prefers Southern, floral, religious and Christian themes. Artists represented include Pam Shows, Brad Thompson, Doug Kelly, Joan Dupuy and Marilyn Driggers. Editions created by collaborating with the artist, by working from an existing painting. Approached by 20 artists/year. Publishes the work of 3-5 emerging artists, 1 mid-career and 1-2 established artists/year. Distributes the work of 5 emerging, 6 mid-career and 6 established artists/year.

First Contact & Terms: Send query letter with brochure, photographs, SASE, slides, tearsheets, transparencies. Samples are not filed and are returned by SASE. Reports back within 1-2 months. Company will contact artist for portfolio review of b&w, color, final art, photographs, slides, tearsheets, thumbnails. Pays royalties and negotiates payment. Offers advance when appropriate. Rights purchased vary according to project. Provides advertising, insurance while work is at firm, promotion, shipping from firm, written contract. Finds artists through word of mouth.

BRINTON LAKE EDITIONS, Box 888, Brinton Lake Rd., Concordville PA 19331-0888. (610)459-5252. E-mail: lannette@voicenet.com. President: Lannette Badel. Estab. 1991. Art publisher, distributor, gallery. Publishes/distributes limited editions and canvas transfers. Clients: independent galleries and frame shops. Current clients include: over 100 galleries, mostly East Coast.

Needs: Seeking fashioniable art. Considers oil, acrylic, watercolor, mixed media and pastel. Prefers realistic landscape and florals. Artists represented include Gary Armstrong and Lani Badel. Editions created by collaborating with the artist. Approached by 20 artists/year. Publishes/distributes the work of 1 emerging, and 1 established artist/year.

First Contact & Terms: Send query letter with samples. Samples are not filed and are returned. Reports back within 2 months. Company will contact artist for portfolio review of final art, photographs, slides, tearsheets and transparencies if interested. Negotiates payment. Rights purchased vary according to project. Requires exclusive representation of artist.

Tips: "Artists submitting must have good drawing skills no matter what medium used."

BROWN'S FINE ART & FRAMING, 630 Fondren Place, Jackson MS 39216. (601)982-4844 or (800)737-4844. Fax: (601)982-0030. Contact: Joel Brown. Estab. 1965. Gallery/frame shop. Sells originals, limited editions, unlimited editions, fine art prints, monoprints, offset reproductions, posters, sculpture, and "original art by Mississippi artists. We publish Mississippi duck stamp and print." Current clients include: doctors, lawyers, accountants, insurance firms, general public, other frame shops and distributors, decorators and architects, local companies large and small.

Needs: Seeking creative, decorative and investment quality art for the serious collector, commercial and designer markets. Considers oil, acrylic, watercolor, mixed media, pastel, pen & ink and sculpture. Prefers landscapes, florals, unique, traditional and contemporary. Artists represented include Emmitt Thames, Sharon Richardson, Jackie Meena, "plus 25 other Mississippi artists."

First Contact & Terms: Call to make appointment to bring original work. Samples are returned. Request portfolio review of final art and originals in original query. Pays on consignment basis: firm receives 50% commission. Requires exclusive representation of artist. Provides advertising, in-transit insurance, insurance while work is at firm, promotion, shipping from our firm and all framing.

Tips: "*Decor* magazine is the bible of our industry. Also look at what is going on nearby or in the world (i.e., Monet exhibition, Russian influences). Don't be afraid to branch out and try something new and different."

JOE BUCKALEW, 1825 Annwicks Dr., Marietta GA 30062. (800)971-9530. Fax: (770)971-6582. Contact: Joe Buckalew. Estab. 1990. Distributor. Distributes limited editions, canvas transfers, fine art prints and posters. Clients: 600-800 frame shops and galleries.

Needs: Seeking creative, fashionable, decorative art for the serious collector. Considers oil, acrylic and watercolor. Prefers florals, landscapes, Civil War and sports. Artists represented include B. Sumrall, R.C. Davis, F. Buckley, M.

"There's a solid audience following for Glen Green's golf-themed watercolor prints," says B.J. Maloney of the wholesaler Canadian Art Prints, Inc. "There's a popular growing interest in the sport," he says, and in Green's *Art of Golf on the Fairway* "Glen offers excellent representation of form and motion." In his contract for this two-paneled piece, Green receives a royalty based on the number of prints sold.

Ganeck, D. Finley. Approached by 25-30 artists/year. Distributes work of 10 emerging, 10 mid-career and 50 established artists/year.
First Contact & Terms: Send sample prints. Accepts disk submissions. "Please call. Currently using a 460 commercial computer." Samples are filed or are returned. Does not report back. Artist should call. To show portfolio, artist should follow-up with call after initial query. Portfolio should include sample prints. Pays on consignment basis: firm receives 50% commission paid net 30 days. Provides advertising, shipping from firm and company catalog. Finds artists through ABC shows, regional art & craft shows, frame shops, other artists.
Tips: "Paint what the market wants."

❀**BUSCHLEN MOWATT GALLERY**, 1445 W. Georgia St., Vancouver, British Columbia V6G 2T3 Canada. (604)682-1234 or (800)663-8071. Fax: (604)682-6004. Gallery Director: Greg Lejnieks. Assistant Director: Sherri Kajiwara. Estab. 1979 (gallery opened 1987). Art publisher, distributor and gallery. Publishes and distributes handpulled originals and limited editions. Clients are beginning to advanced international collectors and dealers.
Needs: Seeking creative art for the serious collector and the designer market. Considers all media. Artists represented include Cathelin, Brasilier, Moore, Motherwel, Frankenthaler, Olitski, Cassigneu, Bill Reid, Fenwick Lansdowne, Bernard Gantner. Editions created by collaborating with the artist. Approached by 1,000 artists/year. Publishes the work of 2 emerging and 5 established artists/year. Distributes the work of 4 emerging and 5-10 established artists/year.
First Contact & Terms: Send query letter with résumé and photographs. Do not contact through agent. Samples are filed or are returned by SASE if requested by artist. Reports back within 3 months. Publisher/Distributor will contact artist for portfolio review if interested. Portfolio should include color tearsheets and photographs. Negotiates payment. Buys all rights. Requires exclusive representation of artist. Provides advertising, insurance while work is at firm, promotion and written contract. Finds artists through art exhibitions, art fairs, word of mouth, sourcebooks, publications, and submissions.

❦**CANADIAN ART PRINTS INC.**, 160-6551 Westminster Hwy., Richmond, British Columbia V3A 3E4 Canada. (604)276-4551. Fax: (604)276-4552. Art Director: Dennis Tessier. Estab. 1965. Art Publisher/distributor. Publishes or distributes limited and unlimited edition, canvas transfers, fine art prints, offset reproduction, posters. Clients: galleries, decorators, frame shops, distributors, corporate curators, museum shops, giftshops.
Needs: Seeking fashionable and decorative art for the commercial and designer markets. Considers oil, acrylic, watercolor, mixed media, pastel. Prefers florals, landscapes, decorative and still life. Artists represented include Brent Heighton, Kiff Holland, Victor Santos, Dubravko Raos and Don Li-Leger. Editions created by collaborating with the artist and working from an existing painting. Approached by 300-400 artists/year. Publishes/distributes 10-15 emerging, 10 mid-career and 20 established artists/year.
First Contact & Terms: Send query letter with photographs, SASE, slides, tearsheets, transparencies. Samples are not filed and are returned by SASE. Reports back within 1 month. Will contact artist for portfolio review of photographs, slides or transparencies if interested. Pays range of royalties. Buys reprint rights or negotiates rights purchased. Provides advertising, in-transit insurance, insurance while work is at firm, promotion, shipping and contract. Finds artists through art exhibitions, art fairs, word of mouth, art reps, submissions.
Tips: "Keep up with trends by following decorating magazines."

‡**CARMEL FINE ART PRODUCTIONS, LTD.**, 21 Stocker Rd., Verona NJ 07044. (800)951-1950. E-mail: carmelprod@aol. Website: http://carmelprod.com. Vice President Sales: Louise Perrin. Estab. 1995. Art publisher/distributor. Publishes/distributes handpulled originals, limited and unlimited edition fine art prints and offset reproduction. Clients: galleries, corporate curators, distributors, frame shops, decorators.
Needs: Seeking creative art for the serious collector, commercial and designer markets. Considers oil, acrylic, pastel. Prefers family friendly abstract and figurative images. Artists represented include William Carter, G.L. Smothers, William Ward, William Calhoun, Jon Jones. Editions created by collaborating with the artist and working from an existing painging. Approached by 10-20 artists/year. Publishes the work of 2-3 emerging, 1 mid-career and 2-3 established artists/year.
First Contact & Terms: Send query letter with brochure, photographs. Samples are filed. Reports back within 1 month. Will contact artist for portfolio review of final art, roughs if interested. Rights purchased vary according to project. Provides advertising, promotion, shipping from firm and contract. Finds artists through established networks.
Tips: "Be true to your creative callings. Abstracts are being accepted by a wider audience."

✔**CHALK & VERMILION FINE ARTS**, P.O. Box 5119, Greenwich CT 06831. (203)869-9500. Fax: (203)869-9520. Contact: Sheila Emery. Estab. 1980. Art publisher. Publishes original paintings, handpulled serigraphs and lithographs, posters, limited editions and offset reproductions. Clients: 4,000 galleries worldwide.
Needs: Publishes decorative art for the serious collector and the commercial market. Considers oil, mixed media, acrylic and sculpture. Artists represented include Erte, McKnight, Alex Katz, Kondakova, Hallam, Kiraly, Sally Caldwell Fisher, Brennan and Robert Williams. Editions created by collaborating with the artist or working from an existing painting. Approached by 500-1,000 artists/year.
First Contact & Terms: Send query letter with slides, résumé and photographs. Samples are filed or are returned by SASE if requested by artist. Reports back within 3 months. Publisher will contact artist for portfolio review if interested. Pay "varies with artist, generally fees and royalties." Offers advance. Negotiates rights purchased. Requires exclusive representation of artist. Provides advertising, in-transit insurance, promotion, shipping to and from firm, insurance while work is at firm and written contract. Finds artists through exhibitions, trade publications, catalogs, submissions.

CIRRUS EDITIONS, 542 S. Alameda St., Los Angeles CA 90013. (213)680-3473. Fax: (213)680-0903. President: Jean R. Milant. Produces limited edition handpulled originals. Clients: museums, galleries and private collectors.
Needs: Seeking contemporary paintings and sculpture. Prefers abstract, conceptual work. Artists represented include Lari Pittman, Joan Nelson, John Millei, Charles C. Hill and Bruce Nauman. Publishes and distributes the work of 6 emerging, 2 mid-career and 1 established artists/year.
First Contact & Terms: Prefers slides as samples. Samples are returned by SASE.

CLASSIC COLLECTIONS FINE ART, 1 Bridge St., Irvington NY 10533. (914)591-4500. Fax: (914)591-4828. Acquisition Manager: Larry Tolchin. Estab. 1990. Art publisher. Publishes unlimited editions and offset reproductions. Clients: galleries, interior designers, hotels.
Needs: Seeking decorative art for the commercial and designer markets. Considers oil, acrylic, watercolor, mixed media and pastel. Prefers landscapes, still lifes, florals. Artists represented include Harrison Rucker, Henrietta Milan, Sid Willis and Charles Zhan. Editions created by collaborating with the artist and by working with existing painting. Approached by 100 artists/year. Publishes the work of 6 emerging, 6 mid-career and 6 established artists/year.
First Contact & Terms: Send slides and transparencies. Samples are filed. Reports back within 3 months. Company

 A CHECKMARK PRECEDING A LISTING indicates a change in either the address or contact information since the 1998 edition.

will contact artist for portfolio review if interested. Offers advance when appropriate. Buys first and reprint rights. Provides advertising, insurance while work is at firm and written contract. Finds artists through art exhibitions, fairs and competitions.

THE COLONIAL ART CO., 1336 NW First St., Oklahoma City OK 73106. (405)232-5233. Owner: Willard Johnson. Estab. 1919. Publisher and distributor of offset reproductions for galleries. Clients: retail and wholesale. Current clients include Osburns, Grayhorse and Burlington.
Needs: Artists represented include Felix Cole, Dennis Martin, John Walch and Leonard McMurry. Publishes the work of 2-3 emerging, 2-3 mid-career and 3-4 established artists/year. Distributes the work of 10-20 emerging, 30-40 mid-career and hundreds of established artists/year. Prefers realism and expressionism—emotional work.
First Contact & Terms: Send sample prints. Samples not filed are returned only if requested by artist. Publisher/Distributor will contact artist for portfolio review if interested. Pays negotiated flat fee or royalties, or on a consignment basis (firm receives 33% commission). Offers an advance when appropriate. Does not require exclusive representation of the artist. Considers buying second rights (reprint rights) to previously published work.
Tips: "The current trend in art publishing is an emphasis on quality."

COLOR CIRCLE ART PUBLISHING, INC., P.O. Box 190763, Boston MA 02119. (617)437-1260. Fax: (617)437-9217. E-mail: t123@msn.com. Website: http://www.colorcircle.com. Estab. 1991. Art publisher. Publishes limited editions, unlimited editions, fine art prints, offset reproductions, posters. Clients: galleries, art dealers, distributors, museum shops. Current clients include: Deck the Walls, Things Graphis, Essence Art.
Needs: Seeking creative, decorative art for the serious collector, for the commercial market. Considers oil, acrylic, watercolor, mixed media, pastel, pen & ink. Prefers ethnic themes. Artists represented include Paul Goodnight, Essud Fungcap, Charly and Dorothea Palmer. Editions created by collaborating with the artist or by working from an existing painting. Approached by 12-15 artists/year. Publishes the work of 2 emerging, 1 mid-career artists/year. Distributes the work of 4 emerging, 1 mid-career artists/year.
First Contact & Terms: Send query letter with slides. Samples are filed or returned by SASE. Reports back within 2 months. Negotiates payment. Rights purchased vary according to project. Provides advertising, insurance while work is at firm, promotion, shipping from our firm and written contract. Finds artists through submissions, trade shows and word of mouth.
Tips: "We like to present at least two pieces by a new artist that are similar in either theme, treatment or colors."

✔COLVILLE PUBLISHING, 2909 Oregon Ct., #B2, Torrance CA 90503. (310)681-3700. Fax: (310)618-3710. Chairman: Christian Title. Licensing: Bill Dreyer. Estab. 1982. Art publisher. Publishes limited edition serigraphs. Clients: art galleries.
● Since our previous edition, this publisher has added a poster line which is open to a broad range of styles and subjects.
Needs: Seeking creative art for the serious collector. Considers oil on canvas. Considering high end product licensing only. Prefers impressionism and American Realism. Artists represented include John Powell, Henri Plisson and Don Hatfield. Publishes and distributes the work of a varying number of emerging, 2 mid-career and 4 established artists/year.
First Contact & Terms: Send query letter with résumé, slides, photographs, transparencies, biography and SASE. Samples are not filed. Reports back within 1 month. To show a portfolio, mail appropriate materials. Payment method is negotiated. Does not offer an advance. Requires exclusive representation of artist. Provides in-transit insurance, insurance while work is at firm, promotion, shipping to and from firm and a written contract.

COTTAGE EDITIONS, LTD., P.O. Box 335 Carmel CA 93921-0335. Managing Partner: George Goff. Estab. 1992. Art publisher and gallery. Publishes/distributes unlimited edition, canvas transfers, fine art prints, offset reproduction, posters, sculpture, original oils/watercolors. Clients: distributors, galleries, retail, chains, commercial framers, frame shops. Current clients include: Winn Devon Art Group, Image Conscious, International Graphics.
Needs: Creative, fashionable and decorative art for the serious collector, commercial and designer markets. Considers oil, acrylic, watercolor, mixed media, pastel, pen & ink, sculpture. Prefers all styles and themes. Artists represented include John Terelak, Tom Nicholas, Tom Browning, Gordon Wang. Editions created by collaborating with the artist or working from an existing painting.
First Contact & Terms: Send query letter with brochure, photographs, résumé, SASE, slides, transparencies. Samples are not filed and are returned by SASE. Reports back within 1 month. Company will contact artist for portfolio review of color, photographs, slides, tearsheets, transparencies if interested. Pays royalties of 5-10% (percentage paid to artist) or on consignment basis: firm receives 50% commission. Rights purchased vary according to project. Provides advertising, in-transit insurance, insurance while work is at firm, promotion, shipping from firm, written contract. Finds artists through submissions, art shows, exhibitions and fairs, word of mouth.
Tips: "Stress quality, be original."

‡CRAZY HORSE PRINTS, 23026 N. Main St., Prairie View IL 60069. (847)634-0963. Owner: Margaret Becker. Estab. 1976. Art publisher and gallery. Publishes limited editions, offset reproductions and greeting cards. Clients: Native American art collectors.
Needs: "We publish only Indian authored subjects." Considers oil, pen & ink and acrylic. Prefers and nature themes.

Editions created by working from an existing painting. Approached by 10 artists/year. Publishes the work of 2 and distributes the work of 20 established artists/year.

First Contact & Terms: Send résumé and photographs. Samples are filed. Reports back to the artist only if interested. Portfolio review not required. Publisher will contact artist for portfolio review if interested. Portfolio should include photographs and bio. Pays flat fee: $250-1,500 or royalties of 5%. Offers advance when appropriate. Buys all rights. Provides promotion and written contract. Finds artists through art shows and submissions.

CREATIF LICENSING CORP., 31 Old Town Crossing, Mount Kisco NY 10549-4030. (914)241-6211. E-mail: creatiflic@aol.com. Website: http://members.aol.com/creatiflic. Estab. 1975. Art licensing agency. Clients: manufacturers of gifts, stationery, bed and bath accessories, toys and home furnishings.

● Creatif posts submission guidelines on its web page. The company is also listed in the Greeting Cards, Gifts and Products section.

Needs: Seeking art for the commercial market. Considers oil, acrylic, watercolor, mixed media and pastel. Artists represented include Roger La Borde. Approached by hundreds of artists/year.

First Contact & Terms: Send query letter with 8½×11 color copies. Accepts disk submissions if compatible with Macs Adobe Photoshop 2.5. Samples are filed and are returned by SASE. Reports back within 1 month. Company will contact artist for portfolio review of color and photographs if interested. Pays royalties; varies depending on the experience and marketablity of the artist. Also varies advance structure depending on if the artwork is existing vs. new. Offers advance when appropriate. Negotiates licensing rights. "Artist retains all rights, we license rights to clients." Provides advertising, promotion, written contract, sales marketing and negotiating contracts. Finds artists through art fairs, word of mouth, art reps, sourcebooks and referrals.

Tips: "Be aware of current color trends and design with specific products in mind."

✔THE CREATIVE SOCIETY, INC., (formerly The Creative Age), 441 Manitou Ave., Manitou Springs CO 80829. (719)685-3630. Fax: (719)685-3626. Contact: Finley Eversole. Estab. 1969. Art publisher. Publishes unlimited editions, canvas transfers, fine art prints. Clients: distributors, ready-framers, frame stores and decorators. Current clients include Pier I, Carolina Mirror.

Needs: Seeking creative art for the serious collector, commercial, ready-framed and designer markets. Considers oil, watercolor, acrylic, pastel, mixed media. Prefers animals, landscapes, impressionism, Indian and western. Artists represented include Mark Pettit, Monet, Maxfield Parrish. Editions created by working from an existing painting. Publishes the work of 1-2 mid-career artists/year.

First Contact & Terms: Send query letter with résumé, slides, photographs and photocopies. Samples are filed or are returned by SASE if requested by artist. Reports back only if interested. Company will contact artist for portfolio review if interested. Portfolio should include color photographs and transparencies. Pays royalties of 5-10%. Offers advance when appropriate. Provides advertising, promotion, shipping from firm and written contract.

Tips: Advises artists to attend Atlanta ABC show, which is the largest in the industry. "Work must be of very high quality with good sense of color, light and design. Artist should be willing to grow with young company. We only publish top quality art in traditional and 'new age' styles. Both require excellent color."

CREGO EDITIONS, 3960 Dewey Ave., Rochester NY 14616. (716)621-8803. Fax: (716)621-7465. Owner: Paul Crego Jr. Publishes and distributes limited editions and originals.

Needs: Seeking African-American and ethnic artwork with decorative appeal for the serious collector, commercial and designer markets. Considers oil, watercolor, acrylic, pen & ink and mixed media. Artists represented include David Kibuuka. Editions created by collaborating with the artist. Approached by 25 artists/year. Publishes and distributes the work of 1 emerging, 1 mid-career and 2 established artists/year.

First Contact & Terms: Send query letter with brochure showing art style or résumé, photocopies and photographs. Samples are filed or returned by SASE if requested by artist. Reports back only if interested. To show portfolio, mail finished art samples, photographs and slides. Pays royalties of 25%. Also pays on a consignment basis: firm receives 25% commission. Negotiates rights purchased. Requires exclusive representation. Provides in-transit insurance, insurance while work is at firm, promotion, shipping to and from firm and a written contract.

CROSS GALLERY, INC., 180 N. Center, P.O. Box 4181, Jackson Hole WY 83001. (307)733-2200. Fax: (307)733-1414. Director: Mary Schmidt. Estab. 1982. Art publisher and gallery. Publishes handpulled originals, limited and unlimited editions, offset reproductions and canvas reproductions. Also licenses a variety of products. Clients: wholesale and retail.

Needs: Seeking creative art for the serious collector. Considers oil, watercolor, mixed media, pastel, pen & ink, sculpture and acrylic. Prefers realism, contemporary, western and portraits. Artists represented include Penni Anne Cross, Val Lewis, Joe Geshick, Michael Chee, Andreas Goft and Kevin Smith. Editions created by collaborating with the artist or by working from an existing image. Approached by 100 artists/year.

First Contact & Terms: Send query letter with brochure, résumé, tearsheets, slides, photostats, photographs, photocopies and transparencies. Samples are not filed and are returned by SASE if requested by artist. Reports back within 2 days. Publisher will contact artist for portfolio review if interested. Portfolio should include b&w and color thumbnails, roughs, final art, photostats, tearsheets, photographs, slides and transparencies. Pays royalties or on consignment basis (firm receives 33⅓% commission). No advance. Rights purchased vary according to project. Requires exclusive representation of artist. Provides advertising, insurance while work is at firm, promotion, shipping from firm and written contract.

CUPPS OF CHICAGO, INC., 831 Oakton St., Elk Grove IL 60007. (847)593-5655. Fax: (847)593-5550. President: Gregory Cupp. Estab. 1967. Art publisher and distributor of limited and unlimited editions, offset reproductions and posters. Clients: galleries, frame shops, designers and home shows.
 • Pay attention to contemporary/popular colors when creating work for this design-oriented market.
Needs: Seeking creative and decorative art for the commercial and designer markets. Also needs freelance designers. Artists represented include Gloria Rose and Sonia Gil Torres. Editions created by collaborating with the artist or by working from an existing painting. Considers oil and acrylic paintings in "almost any style—only criterion is that it must be well done." Prefers individual works of art. Approached by 150-200 artists/year. Publishes and distributes the work of 25-50 emerging, 100 mid-career and 10 established artists/year.
First Contact & Terms: Send query letter with résumé, photographs, photocopies and tearsheets. Samples are filed or are returned by SASE if requested. Reports back only if interested. Company will contact artist for portfolio review of color photographs if interested. Negotiates payment. Rights purchased vary according to project. Provides advertising, promotion, shipping from firm, insurance while work is at firm.
Tips: This distributor sees a trend toward traditional and Victorian work.

DARE TO MOVE, Dept. AGDM, 1132 S. 274th Place, Des Moines WA 98198. (206)946-7727. Fax: (206)946-7764. E-mail: daretomove@nventere.com. President: Steve W. Sherman. Estab. 1987. Art publisher, distributor. Publishes/distributes limited editions, unlimited editions, canvas transfers, fine art prints, offset reproductions. Clients: art galleries, aviation museums, frame shops and interior decorators.
 • This company has expanded from aviation-related artwork to work encompassing most civil service areas. Steve Sherman likes to work with artists who have been painting for 10-20 years. He usually starts off distributing self-published prints. If prints sell well, he will work with artist to publish new editions.
Needs: Seeking naval, marine, firefighter, civil service and aviation-related art for the serious collector and commercial market. Considers oil and acrylic. Artists represented include John Young, Ross Buckland, Mike Machat, James Dietz, Jack Fellows, John Barber, William Ryan, Patrick Haskett. Editions created by collaborating with the artist or working from an existing painting. Approached by 15-20 artists/year. Publishes the work of 1 emerging, 2-3 mid-career and established artists/year. Distributes the work of 9 emerging and 2-3 established artists/year.
First Contact & Terms: Send query letter with photographs, slides, tearsheets and transparencies. Samples are filed or sometimes returned by SASE. Artist should follow-up with call. Portfolio should include color photographs, transparencies and final art. Pays royalties of 20% commission of wholesale price. Buys one-time or reprint rights. Provides advertising, in-transit insurance, insurance while work is at firm, promotion, shipping from firm and written contract.
Tips: "Present your best work—professionally."

DAUPHIN ISLAND ART CENTER, 1406 Cadillac Ave., Box 699, Dauphin Island AL 36528. Phone/fax: (334)861-5701. Owner: Nick Colquitt. Estab. 1984. Wholesale producer and distributor of marine and nautical decorative art. Clients: West, Gulf and eastern coastline retailers.
Needs: Approached by 12-14 freelance artists/year. Works with 8-10 freelance artists/year. Prefers local artists with experience in marine and nautical themes. Uses freelancers mainly for wholesale items to be retailed. Also for advertising, brochure and catalog illustration, and design. 1% of projects require freelance design.
First Contact & Terms: Send query letter with brochure and samples. Samples not filed are returned only if requested by artist. Reports back within 3 weeks. To show portfolio, mail final reproduction/product. Pays for design and illustration by the finished piece. Considers skill and experience of artist and "retailability" when establishing payment. Negotiates rights purchased.
Tips: Advises artists to attend any of the Art Expo events, especially those held in Atlanta Merchandise Mart. "We're noticing a move away from white as mat or decorative bordering. Use complementary colors instead of white. Final presentation including matting and packaging is critical. Attend workshop to learn how."

DELJOU ART GROUP, INC., (formerly Graphique du Jour, Inc.), 1710 Defoor Ave. NW, Atlanta GA 30318. President: Daniel Deljou. Estab. 1980. Art publisher/distributor of limited editions (maximum 250 prints), handpulled originals and monoprints/monotypes and paintings on paper and canvas. Clients: galleries, designers, corporate buyers and architects. Current clients include Coca Cola, Xerox, Exxon, Marriott Hotels, General Electric, Charter Hospitals, AT&T and more than 3,000 galleries worldwide, "forming a strong network throughout the world."
Needs: Seeking creative, fine and decorative art for the serious and commercial collector and designer market. Considers oil, acrylic, pastel, watercolor and mixed media. Prefers traditional contemporary themes. Prefers individual works of art pairs or unframed series. Artists represented include Lee White, Lyda Claire, Sergey Cherepakhin, Matt Lively, Alexa Kelemen, Ralph Groff, Yasharel, Chemiakin, Bika, Kamy Babak Emanuel and T.L. Lange. Editions created by collaborating with the artist or by working from an existing painting. Approached by 100 artists/year. Publishes and distributes the work of 25 emerging, 15 mid-career artists/year and 50 established artists/year.
First Contact & Terms: Send query leter with photographs, slides, SASE and transparencies. Samples not filed are returned only if requested by artist. Reports back only if interested. Publisher/distributor will contact artist for portfolio review if interested. Pays flat fee or royalties; also sells on consignment basis or commission. Payment method is negotiated. Offers an advance when appropriate. Negotiates rights purchased. Has exclusive and non-exclusive represen-

tation. Provides promotion, a written contract and shipping from firm. Finds artists through visiting galleries.

Tips: "We would like to add a line of traditional art with a contemporary flair. Earth-tone and jewel-tone colors are in. We need landscape artists, monoprint artists, strong figurative artists, strong abstracts and soft-edge abstracts. We are also beginning to publish sculptures and are interested in seeing slides of such. We have had a record year in sales, and have recently relocated into a brand new gallery, framing and studio complex."

DIRECTIONAL PUBLISHING, INC., 2616 Commerce Circle, Birmingham AL 35210. (205)951-1965. Fax: (205)951-3250. President: David Nichols. Estab. 1986. Art publisher. Publishes limited and unlimited editions and offset reproductions. Clients: galleries, frame shops and picture manufacturers.

Needs: Seeking decorative art for the designer market. Considers oil, watercolor, acrylic and pastel. Prefers floral, sporting, landscapes and still life themes. Artists represented include A. Kamelhair, H. Brown, R. Lewis, L. Brewer, A. Nichols, D. Nichols, M.B. Zeitz and N. Raborn. Editions created by working from an existing painting. Approached by 50 artists/year. Publishes and distributes the work of 5-10 emerging, 5-10 mid-career and 3-5 established artists/year.

First Contact & Terms: Send query letter with slides and photographs. Samples are not filed and are returned by SASE. Reports back within 3 months. Pays royalties. Buys all rights. Provides in-transit insurance, insurance while work is at firm, promotion, shipping from firm and written contract.

Tips: "Always include SASE. Do not follow up with phone calls. All work published is first of all *decorative*. The application of artist designed borders to artwork can sometimes greatly improve the decorative presentation. We follow trends in the furniture/accessories market."

DODO GRAPHICS, INC., 145 Cornelia St., P.O. Box 585, Plattsburgh NY 12901. (518)561-7294. Fax: (518)561-6720. Manager: Frank How. Art publisher of offset reproductions, posters and etchings for galleries and frame shops.

Needs: Considers pastel, watercolor, tempera, mixed media, airbrush and photographs. Prefers contemporary themes and styles. Prefers individual works of art, 16×20 maximum. Publishes the work of 5 artists/year.

First Contact & Terms: Send query letter with brochure showing art style or photographs and slides. Samples are filed or are returned by SASE. Reports back within 3 months. Write for appointment to show portfolio of original/final art and slides. Payment method is negotiated. Offers an advance when appropriate. Buys all rights. Requires exclusive representation of the artist. Provides written contract.

Tips: "Do not send any originals unless agreed upon by publisher."

✔DOUBLE J ART & FRAME SHOP, 12645 Fantasia Dr., Herndon VA 20170. Phone/fax: (703)925-9772. Owner: Jesse Johnson. Estab. 1989. Art publisher, distributor and custom framer. Publishes and distributes handpulled originals and limited editions. Clients: retail customers, galleries, frame shops and distributors.

Needs: Needs creative art for the serious collector, commercial and designer markets. Considers oil, watercolor, mixed media, pastel, pen & ink, sculpture and acrylic. Prefers African-American themes. Artists published include Wynston Edun, Poncho Brown. "Only interested in original fine art and graphics. No reproductions." Approached by 5-10 artists/year. Publishes the work of 1-2 emerging, 1-2 mid-career and 1-2 established artists/year. Distributes the work of 10 emerging, 5 mid-career and 3 established artists/year.

First Contact & Terms: Send query letter with brochure, résumé, tearsheets, photostats, photographs and photocopies. Samples are not filed and are returned. Reports back within 2 weeks. Publisher/Distributor will contact artist for portfolio review if interested. Portfolio should include b&w and color thumbnails, roughs, final art, photostats, tearsheets, photographs, slides and transparencies. Negotiates payment. Offers advance when appropriate. Rights purchased vary according to project. Provides advertising, promotion, shipping to and from firm and written contract. Finds artists through word of mouth, referral by other artists.

Tips: Recommends *Decor* and Art Buyers Caravan shows. "Develop your graphic skills as opposed to your canvas skills. Be original, develop your own style, do not copy the styles of others or their work."

DRAGON TALES, P.O. Box 8007, The Woodlands TX 77387-8007. (281)292-7288. Fax: (281)298-5878. Contact: Howard Leap. Estab. 1985. Art publisher. Publishes note cards and children's books. Clients: Gift shops and book stores.

Needs: Seeking creative art for the commercial market. Considers oil, acrylic, watercolor, mixed media and pastel. Prefers fantasy and contemporary styles. Artists represented include James Christensen, Michael Whelan, Don Maite and Alicia Austin. Editions created by collaborating with the artist or by working from an existing painting. Approached by 10-20 artists/year. Publishes the work of 1 emerging, 1 mid-career and 1 established artist/year.

First Contact & Terms: Send query letter with slides. Samples are filed or returned if accompanied by SASE. Reports back only if interested. Pays royalties of 10%. Rights purchased vary according to project. Provides advertising, insurance while work is at firm, promotion, shipping from firm and written contract. Finds artists through art exhibits, art fairs, the internet, other publications and word of mouth.

Tips: "Have 4×5 transparencies made of artwork which you intend to sell but may want published at some later date. Use a professional photographer!"

EDELMAN FINE ARTS, LTD., 386 W. Broadway, Third Floor, New York NY 10012. (212)226-1198. Vice President: H. Heather Edelman. Art distributor of original oil paintings. "We now handle watercolors, lithographs, serigraphs, sculpture and 'works on paper' as well as original oil paintings." Clients: galleries, dealers, consultants, interior designers and furniture stores worldwide.

● The president of Edelman Fine Arts says the mainstream art market is demanding traditional work with great

attention to detail. She feels impressionism is still in vogue but with a coral, peach color tone with a Cortes, Couret or Turner feel. She says Renaissance large nudes, pictured in a typical scene, are being requested.
Needs: Seeking creative and decorative art for the serious collector and designer markets. Considers oil and acrylic paintings, watercolor, sculpture and mixed media. Especially likes Old World themes and impressionist style. Distributes the work of 150 emerging, 70 mid-career and 150 established artists.
First Contact & Terms: Send six 3×5 photos (no slides), résumé, tearsheets. Samples are filed. Portfolios may be dropped off every Monday-Thursday upon request. Portfolio should include original/final art and photographs. Reports as soon as possible. Pays royalties of 40% or works on consignment basis (20% commission). Buys all rights. Provides in-transit insurance, insurance while work is at firm, promotion and shipping from firm.

EDITION D'ART PONT-AVEN, 2746 Feirfield Ave., Bridgeport CT 06605. (203)333-1099. Fax: (203)366-2925. Manager: Danica. Estab. 1984. Art publisher and gallery. Publishes limited and unlimited editions, offset productions. Clients: galleries and framers.
Needs: Needs decorative art for the commercial and designer markets. Considers oil, watercolor and pastel. Artists represented include Glazer, Huchet and Rindom. Editions created by collaborating with the artist. Approached by 5 artists/year. Publishes the work of 2 emerging, 2 mid-career and 2 established artists/year.
First Contact & Terms: Send tearsheets, slides and photographs. Samples are filed. Reports back within 3 months. Portfolios may be dropped off every Thursday. Portfolio should include photostats, photographs and slides. Negotiates payment. Buys first or all rights. Provides advertising, in-transit insurance and promotion. Finds artists through submissions.

✔EDITIONS LIMITED GALLERIES, INC., 625 Second St., Suite 400, San Francisco CA 94107. (415)543-9811. Fax: (415)777-1390. Director: Todd Haile. Art publisher and distributor of limited edition graphics and fine art posters. Clients: galleries, framing stores, art consultants and interior designers.
Needs: Seeking creative art for the designer market. Considers oil, acrylic and watercolor painting, monoprint, monotype, photography and mixed media. Prefers landscape and abstract imagery. Editions created by collaborating with the artist or by working from an existing work.
First Contact & Terms: Send query letter with résumé, slides and photographs. Samples are filed or are returned by SASE. Reports back within 2 months. Publisher/distributor will contact artist for portfolio review if interested. Payment method is negotiated. Offers advance when appropriate. Negotiates rights purchased.
Tips: "We deal both nationally and internationally, so we need work with wide appeal. No figurative or cute animals. When sending slides or photos, send at least six so we can see an overview of the work. We publish artists, not just images." Advises artists to attend Art Expo, New York City and Art Buyers Caravan, Atlanta.

ENCORE GRAPHICS, P.O. Box 812, Madison AL 35758. (800)248-9240. E-mail: jrandjr@hiwaay.net. Website: http://fly.hiwaay.net/~jrandjr/. President: J. Rand, Jr. Estab. 1996. Poster company, art publisher, distributor. Publishes/distributes limited edition, unlimited edition, fine art prints, offset reproduction, posters. Clients: galleries, frame shops, distributors.
Needs: Creative art for the serious collector. Considers all media. Also needs freelance designers with computer experience. Prefers African American and abstract. Artists represented include C. Lewis Perez, Greg Gamble, Buck Brown, Mario Robinson, Lori Goodwin, Wyndall Coleman. Editions created by working from an existing painting. Approached by 15 artists/year. Publishing the work of 3 emerging artists, 1 mid-career artist/year. Distributes the work of 3 emerging, 2 mid-career and 3 established artists/year.
First Contact & Terms: Send photocopies, photographs, résumé, tearsheets. Samples are filed. Reports back only if interested. Company will contact artist for portfolio review of color, photographs, tearsheets if interested. Negotiates payment. Offers advance when appropriate. Requires exclusive representation of artist. Provides advertising, in-transit insurance, insurance while work is at firm, promotion, shipping from firm, written contract. Finds artists through the WWW and art exhibits.
Tips: "Prints of African-Americans with religious themes are popular now."

ESSENCE ART, 1708 Church St., Holbrook NY 11741-5918. (516)589-9420. President: Mr. Jan Persson. Estab. 1989. Art publisher and distributor of posters, limited editions and offset reproductions. "All are African-American images." Clients: galleries and framers. Current clients include Deck the Walls and Fast Frame.
Needs: Seeking artwork with creative expression and decorative appeal for the commercial market. Considers all media. Prefers African-American themes and styles. Artists represented include Dane Tilghman, Cal Massey, Brenda Joysmith, Carl Owens and Synthia Saint-James. Editions created by collaborating with artist or by working from an existing

SPECIAL MARKET INDEXES, identifying Licensing, Medical Illustration, Religious Art, Science Fiction/Fantasy Art, Sport Art, T-Shirts, Textiles, Wildlife Art and other categories are located in the back of this book.

painting. Approached by 20 artists/year. Publishes and distributes the work of 6-20 emerging and up to 5 established artists/year.

First Contact & Terms: Send query letter with slides, photographs and transparencies. Samples are filed or are returned by SASE if requested by artist. Reports back within 2 months. Pays royalties of 10% or payment method negotiated. No advance. Buys reprint rights. Provides insurance while work is at firm, promotion, shipping from firm and a written contract.

Tips: "We are looking for artwork with good messages; family-oriented art is popular."

ELEANOR ETTINGER INCORPORATED, 119 Spring St., New York NY 10012. (212)925-7474. Fax: (212)925-7734. President: Eleanor Ettinger. Estab. 1975. Art publisher of limited edition lithographs, limited edition sculpture and unique works (oil, watercolor, drawings, etc.).

Needs: Seeks classically inspired realistic work involving figurative, landscapes and still lifes for the serious collector, commercial collector and designer markets. Considers oil, watercolor, acrylic, pastel, mixed media, pen & ink and pencil drawings. Prefers American realism.

First Contact & Terms: Send query letter with visuals (slides, photographs, etc.), a brief biography, résumé (including a list of exhibitions and collections) and SASE for return of the materials. Reports back within 2-3 weeks.

S.E. FEINMAN FINE ARTS LTD., 448 Broome St., New York NY 10013. (212)431-6820. Fax: (212)431-6495. President: Stephen E. Feinman. Estab. 1965. Art publisher/distributor, gallery. Publishes/distributes handpulled originals and fine art prints. Clients: galleries, designers.

Needs: Seeking creative art for the serious collector. Considers oil, acrylic, watercolor, pastel, original prints. Artists represented include Mikio Watanabe, Miljenko Bengez, Felix Sherman, J.C. Picard, Karine Boulanger. Approached by hundreds of artists/year. Publishes/distributes the work of 1 emerging and 1 mid-career artist/year.

First Contact & Terms: Send photographs, résumé, SASE, slides. Samples are not filed and are returned by SASE. Reports back within 2 weeks. Company will contact artist for portfolio review of color, final art and photographs if interested. Pays on consignment basis; negotiable. Offers advance when appropriate. Rights purchased vary according to project. Provides insurance while work is at firm, promotion. Finds artists through reps, exhibitions, expos, source-books and word of mouth.

Tips: "When making a presentation to a gallery it must be current work (even if it's sold) with the price that the artist wants fixed as part of the presentation."

FLYING COLORS, INC., 4117 Jefferson, Los Angeles CA 90066. (213)732-9994. Fax: (213)731-0969. E-mail: flyingcolors@artnet.net. President: Jurgen Van Dijk. Estab. 1993. Poster company and art publisher. Publishes/distributes unlimited edition, fine art prints, posters, prints on canvas. Clients: galleries, frame shops, distributors, museum shops, giftshops, mail order, end-users, retailers, chains, direct mail, NASA.

Needs: Seeking decorative art for the commercial market. Considers oil, acrylic, watercolor, mixed media, pastel. Prefers multicultural, religious, inspirational wildlife, Amish, country, scenics, stilllife, american culture. Also needs freelancers for design. Prefers designers who own Mac computers. Artists represented include Cindy Lewis, Greg Gorman, Deidre Madsen. Editions created by collaborating with the artist or by working from an existing painting. Approached by 200 artists/year. Publishes the work of 20 emerging, 5-10 mid-career, 1-2 established artists/year. Distributes the work of 20 emerging, 10 mid-career, 2-4 established artists/year.

First Contact & Terms: Send photocopies, photographs, SASE, slides, transparencies. Accepts disk submissions if compatible with SyQuest, Dat, Jazzy, ZIP, QuarkXPress, Illustrator, Photoshop or FreeHand. Samples are filed or returned by SASE. Reports back only if interested. Artist should follow-up with call to show portfolio. Portfolio should include color, photographs, roughs, slides, transparencies. Negotiates payment. Offers advance when appropriate. Negotiates rights purchased, all rights preferred. Provides advertising, promotion, written contract. Finds artists through attending art exhibitions, art fairs, word of mouth, artists' submissions, clients, local advertisements.

Tips: "Ethnic and inspirational/religious art is very strong. Watch the furniture industry. Come up with themes, sketches and series of at least two pieces. Art has to work on 5×7, 8×10, 10×20, 22×28, 24×36, greeting cards and other possible mediums."

✔FRONT LINE GRAPHICS, INC., 9808 Waples St., San Diego CA 92121. (619)552-0944. Fax: (619)552-0129. Creative Director: Benita Sanserino. Estab. 1981. Publisher of posters, prints, offset reproductions and unlimited editions. Clients: galleries, frame shops, gift shops and corporate curators.

Needs: Seeking creative and decorative art reflecting popular trends for the commercial and designer markets. Also needs freelancers for design. Considers oil, acrylic, pastel, pen & ink, watercolor and mixed media. Prefers contemporary interpretations of landscapes, seascapes, florals, abstracts and African-American subjects. Artists represented include Hannum, Graves, Van Dyke and Cacalono. Editions created by working from an existing painting or by collaborating with the artist. Approached by 300 artists/year. Publishes the work of 40 artists/year.

First Contact & Terms: Send query letter with brochure, photocopies, photographers, tearsheets and slides. Samples not filed are returned by SASE. Reports back within 4 weeks if interested. Company will contact artist for portfolio review of photographs and slides if interested. Payment method is negotiated; royalty based contracts. Requires exclusive representation of the artist. Provides advertising, promotion, written contract and insurance while work is at firm.

Tips: "Front Line Graphics is looking for artists who are flexible and willing to work to develop art that meets the specific needs of the print and poster marketplace. We actively seek out new art and artists on an ongoing basis."

‡**FUNDORA ART GALLERY**, 103400 Overseas Hwy., Key Largo FL 33037. (305)451-2200. Fax: (305)453-1153. E-mail: thomasfund@aol.com. Director: Manny Fundora. Estab. 1987. Art publisher/distributor/gallery. Publishes limited edition fine art prints. Clients: galleries, decorators, frameshops. Current clients include: Ocean Reef Club, Paul S. Ellison.
Needs: Seeking creative and decorative art for the serious collector. Considers oil, watercolor, mixed media. Prefers nautical, maritime, tropical. Artists represented include Tomas Fundora, Gaspel, Juan A. Carballo, Carlos Sierra. Editions created by collaborating with the artist and working from an existing painting. Approached by 15 artists/year. Publishes/distributes the work of 2 emerging, 1 mid-career and 3 established artists/year.
First Contact & Terms: Send query letter with brochure, photographs. Samples are filed. Will contact artist for portfolio review if interested. Pays royalties. Buys all rights. Requires exclusive representation of artist. Provides advertising and promotion. Also works with freelance designers.
Tips: "Trends to watch: Tropical sea and landscapes."

G.C.W.A.P. INC., 12075 Marina Loop, W. Yellowstone MT 59758. (406)646-9551. Executive Vice President: Jack Carter. Estab. 1980. Publishes limited edition art. Clients: galleries and individuals.
Needs: Seeking art for the serious collector and commercial market. Considers oil and pastel. Prefers western, wildlife and train themes. Artists represented include Gary Carter, Arlene Hooker Fry, Jim Norton. Editions created by collaborating with the artist. Approached by 10-20 artists/year. Publishes/distributes the work of 3 established artists/year.
First Contact & Terms: Send query letter with photographs, résumé and transparencies. Samples are returned. Reports back within 1 month. Company will contact artists for portfolio review if interested. Negotiates payment. Buys reprint rights. Requires exclusive representation of artist. Provides advertising.

✓**GALAXY OF GRAPHICS, LTD.**, 460 W. 34th St., New York NY 10001. (212)947-8989. Art Directors: Colleen Buchweitz and Christine Pratti. Estab. 1983. Art publisher and distributor of unlimited editions. Licensing handled by Colleen Buchweitz. Clients: galleries, distributors, and picture frame manufacturers.
 • Since our last edition, this publisher added a new size of 11 × 28 panels to its line.
Needs: Seeking creative, fashionable and decorative art for the commerical market. Artists represented include Glenna Kurz, Christa Keiffer, Ruane Manning and Carol Robinson. Editions created by collaborating with the artist or by working from an existing painting. Considers any media. "Any currently popular and generally accepted themes." Approached by several hundred artists/year. Publishes and distributes the work of 20 emerging and 20 mid-career and established artists/year.
First Contact & Terms: Send query letter with résumé, tearsheets, slides, photographs and transparencies. Samples are not filed and are returned by SASE. Reports back within 2 weeks. Call for appointment to show portfolio. Pays royalties of 10%. Offers advance. Buys rights only for prints and posters. Provides insurance while material is in house and while in transit from publisher to artist/photographer. Provides written contract to each artist.
Tips: "There is a trend of strong jewel-tone colors and spice-tone colors. African-American art very needed."

ROBERT GALITZ FINE ART, 166 Hilltop Court, Sleepy Hollow IL 60118. (847)426-8842. Fax: (847)426-8846. Owner: Robert Galitz. Estab. 1986. Distributor of handpulled originals, limited editions and watercolors. Clients: designers, architects, consultants and galleries—in major cities of seven states.
Needs: Seeking creative, fashionable and decorative art for the serious collector and commercial and designer markets. Considers all media. Prefers contemporary and representational imagery. Editions created by collaborating with the artist. Publishes the work of 1-2 established artists/year. Distributes the work of 100 established artists/year.
First Contact & Terms: Send query letter with slides and photographs. Samples are filed or are returned by SASE. Reports back within 1 month. Call for appointment to show portfolio of original/final art. Pays flat fee of $200 minimum, or pays on consignment basis (25-40% commission). No advance. Buys all rights. Provides a written contract.
Tips: Advises artists to attend an Art Expo event in New York City, Las Vegas, Miami or Chicago. Finds artists through galleries, sourcebooks, word of mouth, art fairs. "Be professional. I've been an art broker or gallery agent for 26 years and very much enjoy bringing artist and client together!"

✓**GALLERIA FINE ARTS & GRAPHICS**, 7305 Edgewater Dr., Unit C, Oakland CA 94621. (510)553-0228. Fax: (510)553-9130. Director: Thomas Leung. Estab. 1985. Art publisher/distributor. Publishes/distributes limited editions, unlimited editions, canvas transfers, fine art prints, offset reproductions, posters.
Needs: Seeking creative, decorative art for the serious collector and the commercial market. Considers oil, acrylic, watercolor. Artists represented include H. Leung and Thomas Leung. Editions created by collaborating with the artist or by working from an existing painting. Approached by 50 artists/year.
First Contact & Terms: Send query letter with photographs. Samples are filed. Reports back only if interested. Company will contact artist for portfolio review of color photographs, slides, transparencies if interested. Negotiates payment. Buy all rights. Requires exclusive representation of artist. Provides advertising, in-transit insurance, insurance while work is at firm, promotion, shipping to and from our firm, written contract.
Tips: "Color/composition/subject are important."

GALLERY GRAPHICS, 227 Main, P.O. Box 502, Noel MO 64854. (417)475-6191. Fax: (417)475-3542. E-mail: gginfo@gallery-graphics.com. Website: http://www.gallery-graphics.com. Contact: Terri Galvin. Estab. 1980. Wholesale

producer and distributor of Victorian and country memorabilia. Clients: frame shops, craft shops, florists, pharmacies and gift shops.

Needs: Seeking art with nostalgic look, children, angels, florals. Considers oil, watercolor, mixed media, pastel and pen & ink. 10% of editions created by collaborating with artist. 90% created by working from an existing painting.

First Contact & Terms: Send query letter with brochure showing art style and tearsheets. Designers send photographs, photocopies and tearsheets. Accepts disk submissions compatible with IBM or Mac. Samples are filed or are returned by SASE. Reports back within 2 months. To show portfolio, mail finished art samples, slides, color tearsheets. Pays flat fee: $300-500. Offers advance when appropriate. Can buy all rights or pay royalties of 5%. Provides insurance while work is at firm, promotion and a written contract.

Tips: "I wish artists would work on different subjects. Some artists do certain subjects particularly well, but you don't know if they can do other subjects. Don't concentrate on just one area—do others as well. Don't limit yourself or you could be missing out on some great opportunities."

GALLERY IN A VINEYARD, P.O. Box 549, Benmarl Vineyards, Marlboro NY 12542. (914)236-4265. E-mail: miller4265@aol.com. Wesbite: http://www.POJONEWS.COM/BENMARL. Owner: Mark Miller. Art publisher, gallery and studio handling limited editions, offset reproductions, unlimited editions, handpulled originals, posters and original paintings and sculpture. Clients: galleries and collectors.

● The owner started out as a self-published artist but has expanded to consider work by other artists.

Needs: Considers any media. Prefers contemporary, original themes in illustrative style and has begun to add digital images. Publishes/distributes the work of 1-2 artists/year.

First Contact & Terms: Send appropriate samples. Samples are not filed and returned only if requested. Reports back within 3 weeks only if interested. Pays on consignment basis (firm receives 50% commission). Negotiates rights purchased. Provides a written contract.

Tips: "Subjects related to the 50s and 60s period of illustrative art are especially interesting. There seems to be a renewed interest in nostalgia."

GAMBOA PUBLISHING, 208 E. Devonshire, Hemet CA 92543. (800)669-1368 or (909)766-6363. Fax: (909)925-5657. Art Publisher/Distributor/Framer. Publishes lithographs, canvas transfers and serigraphs.

Needs: Seeking fine art for serious collectors and decorative art for the commercial market. Considers all media. Artists represented include Gamboa, Joan Sanford.

First Contact & Terms: Send query letter with slides or other appropriate samples and SASE. Will accept submissions on disk or CD-ROM. Publisher will contact artist for portfolio review if interested.

GANGO EDITIONS, 351 NW 12th, Portland OR 97209. (503)223-9694. E-mail: gango@hevanet.com. Contact: Artist Submissions. Estab. 1982. Publishes posters. Clients: poster galleries, art galleries, contract framers and major distributors. Current clients include Bruce McGaw Graphics, Graphique de France, Image Conscious, Editions Limited and In Graphic Detail.

Needs: Seeking creative art for the commercial and designer markets. Considers, oil, watercolor, acrylic, pastel, mixed media and Poloroid transfers. Prefers still life, floral, abstract, landscape, folk art and some photography. Artists represented include Diane Pederson, Amy Melious, Michael Palmer, Randal Painter, Pamela Gladding, Alan Stephenson, Bill Kucha, Gregg Robinson and Av Potzz. Editions created by working from an existing painting or work. Publishes and distributes the work of emerging and established artists.

First Contact & Terms: Send query letter with slides and/or photographs. Samples returned by SASE. Artist is contacted by mail. Reports back within 6 weeks. Write for appointment to show portfolio or mail appropriate materials. Pays royalties of 10%. Requires exclusive representation of artist on posters only. Provides written contract.

Tips: "We are currently looking for contemporary landscapes and are always actively seeking new artists. We are eager to work with fresh ideas, colors and presentations. We like to see pairs. We also like to see classical, traditional works done in a unique style. Be aware of market trends."

✔GEME ART INC., 209 W. Sixth St., Vancouver WA 98660. (360)693-7772. Fax: (360)695-9795. Art Director: Merilee Will. Estab. 1966. Art publisher. Publishes fine art prints and reproductions in unlimited and limited editions. Clients: galleries, frame shops, art museums.

Needs: Considers oil, acrylic, pastel, watercolor and mixed media. "We use a variety of styles from realistic to whimsical catering to "Mid-American art market." Artists represented include Lois Thayer, Crystal Skelley, Rice-Bonin, Campbell, Steve Nelson, Lary McKee, Clancy and Susan Scheewe (plus many other artists).

First Contact & Terms: Send color slides, photocopies or brochure. Include SASE. Publisher will contact artist for portfolio review if interested. Simultaneous submissions OK. Payment is negotiated on a royalty basis. Purchases all rights. Provides promotion, shipping from publisher and contract.

Tips: "We have added new sizes and more artists to our lines since last year."

GENESIS FINE ARTS, 4808 164th St., SE, Bothell WA 98012. (425)481-1581. Fax: (425)487-6766. Art Consultant: Marcia Strickland. Art publisher handling limited editions (maximum 250 prints), offset reproductions and posters for residential and commercial clients.

Needs: Considers watercolor, mixed media and oil—abstract and traditional landscapes. Also interested in artists who specialize in stationery design. Prefers individual works of art. Maximum size 38 × 50. Artists represented include Steve

Vancouver, Washington-based Geme Art seeks fine art prints from realistic to whimsical, and was happy to publish this oil painting of draft horses at rest by Dr. Nona Hengen. "The work is realistic with exacting detail and feeling of movement," says Geme's Merilee Will. Geme Art seeks to build long-term relationships with artists. "We've been publishing prints for over 32 years, and still publish the work of the first artists represented," Will says. Hengen came to Geme Art through a word-of-mouth recommendation.

Strickland, Nancy Rankin and Melinda Cowdery. Publishes and distributes the work of 2-3 emerging and 1 mid-career artist/year.
First Contact & Terms: Send query letter with transparencies. Samples not filed are returned. Reports back within 2 months. Payment method is negotiated. Provides promotion, a written contract and shipping. Buys first rights.

GESTATION PERIOD, Box 2408, Columbus OH 43216-2408. (800)800-1562. President: Robert Richman. Estab. 1971. Importer and distributor of unlimited editions and posters. Clients: art galleries, framers, campus stores, museum shops, bookstores and poster oriented shops.
Needs: Seeking published creative art—especially fantasy, surrealism, innovative art and wildlife.
First Contact & Terms: Send query letter with résumé, tearsheets, pricing list and published samples. Samples are filed or returned by SASE. Reports back within 2 months. Negotiates rights purchased. Provides promotion.
Tips: "We do *not* publish. We are seeking pre-published open edition posters that will retail from $5-30."

✔GRAPHIQUE DE FRANCE, 9 State St., Woburn MA 01801. (781)935-3405. Website: http://www graphiquedefran ce.com. Contact: Katherine Pierce. Estab. 1979. Art publisher and distributor handling offset reproductions, posters, notecards, gift and stationery products, calendars and silkscreens. Clients: galleries, foreign distributors, museum shops, high end retailers.
First Contact & Terms: Artwork may be submitted in the form of slides, transparencies or high-quality photocopies. Please do not send original artwork. Please allow four to six weeks for response. SASE is required for any submitted material to be returned.

‡RAYMOND L. GREENBERG ART PUBLISHING, P.O. Box 239, Circleville NY 10919-0239. (914)469-6699. Fax: (914)409-5955. Owner: Ray Greenberg. Estab. 1995. Art publisher. Publishes unlimited edition fine art prints for major framers and plaque manufacturers. Clients include Crystal Art Galleries, Impulse Designs.
Needs: Seeking decorative artwork in popular styles for the commercial and mass markets. Considers oil, acrylic, watercolor, mixed media, pastel and pen & ink. Prefers inspirational, ethnic, Victorian, nostalgic and religious themes. Artists represented include Leslie Triesch, Diane Viera, Robert Daley, Monicka Aranibar. Editions created by collaborating with the artist and/or working from an existing painting. Approached by 35 artists/year. Publishes 7 emerging, 13 mid-career and 5 established artists/year.
First Contact & Terms: Send query letter with photographs, slides, SASE; "any good, accurate representation of

your work." Samples are filed or returned by SASE. Reports back within 6 weeks. Company will contact artist for portfolio review if interested. Pays flat fee: $50-200; royalties of 5-7%. Offers advance against royalties when appropriate. Buys all rights. Requires exclusive representation. Provides insurance, promotion, shipping from firm and contract. Finds artists through word-of-mouth.
Tips: "Versatile artists who are willing to paint for the market can do very well with me."

GREGORY EDITIONS, 10688 Haddington, Suite 100, Houston TX 77043. (800)288-2724. Fax: (713)932-1427. E-mail: mleace@aol.com. President: Mark Eaker. Estab. 1988. Art publisher and distributor of originals, limited editions, serigraphs and bronze sculptures. Licenses variety art for Texture Touch™ canvas reproduction. Clients: Retail art galleries.
• Since our last edition, this publisher has broadened its scope of artwork to include a wider variety of styles.
Needs: Seeking contemporary, creative artwork. Considers oil and acrylic. Open to all subjects and styles. Artists represented include G. Harvey, J.D. Challenger, Atkinson, L. Gordon, Stan Solomon, James Talmadge, Denis Paul Noyer, Liliana Frasca, Michael Young, James Christensen, Gary Ernest Smith, Robert Heindel and sculptures by Ting Shao Kuang and Jo Challenger. Editions created by working from an existing painting. Publishes and distributes the work of 5 emerging, 2 mid-career and 2 established artists/year.
First Contact & Terms: Send query letter with brochure or slides showing art style. Call for appointment to show portfolio of photographs and transparencies. Purchases paintings outright; pays percentage of sales. Negotiates payment on artist-by-artist basis based on flat negotiated fee per visit. Requires exclusive representation of artist. Provides in-transit insurance, insurance while work is at firm, promotion, shipping from firm and written contract.

HADLEY HOUSE PUBLISHING, 11001 Hampshire Ave. S., Bloomington MN 55438. (612)943-5270. Fax: (612)943-8098. Director of Art Publishing: Lisa Laliberte Belak. Estab. 1974. Art publisher, distributor and 75 retail galleries. Publishes and distributes handpulled originals, limited and unlimited editions and offset reproductions. Clients: wholesale and retail.
Needs: Seeking artwork with creative artistic expression and decorative appeal for the serious collector. Considers oil, watercolor, acrylic, pastel and mixed media. Prefers wildlife, florals, landscapes and nostalgic Americana themes and styles. Artists represented include Olaf Wieghorst, Steve Hanks, Les Didier, Al Agnew, John Banovich, John Seerey-Lester, Darrell Bush, Dave Barnhouse, Michael Capser, Lesley Harrison, Jon Van Zyle, Nancy Howe, Steve Hamrick, Terry Redlin, Bryan Moon, Lynn Kaatz, John Ebner, Cha Ilyong and Linda Daniel. Editions created by collaborating with artist and by working from an existing painting. Approached by 200-300 artists/year. Publishes the work of 3-4 emerging, 15 mid-career and 8 established artists/year. Distributes the work of 1 emerging and 2 mid-career artists/year.
First Contact & Terms: Send query letter with brochure showing art style or résumé and tearsheets, slides, photographs and transparencies. Samples are filed or are returned. Reports back within 4-6 weeks. Call for appointment to show portfolio of slides, original final art and transparencies. Pays royalties. Requires exclusive representation of artist and/or art. Provides insurance while work is at firm, promotion, shipping from firm, a written contract and advertising through dealer showcase.

‡HALLMARK PRESS INC., 5805 State Bridge Rd., Suite G-295, Duluth GA 30097. (770)662-0014 or (800)717-3797. Fax: (770)662-0035. President: Tim Martin. Estab. 1988. Art publisher. Publishes handpulled originals, limited edition, canvas transfers, fine art prints, giclée and offset reproduction. Clients: galleries, frame shops, distributors, corporate curators. Current clients include: Ford, NFL, MLB, NBA.
Needs: Seeking creative, fashionable, decorative and sports art for the serious collector and designer market. Considers oil, acrylic and watercolor. Artists represented include Barbara A. Wood, Danny Day, Ken Wessman, Stephan Holland. Editions created by collaborating with the artist, working from an existing painting. Approached by 75-100 artists/year. Publishes/distributes the work of 4 established artists/year.
First Contact & Terms: Send query letter with photographs, résumé, SASE. Samples are filed. Will contact artist for portfolio review if interested. Negotiates payment. Offers advance when appropriate. Rights purchased vary according to project. Requires exclusive representation of artist. Provides advertising, insurance while work is at firm, promotion, shipping and contract.

‡ICART VENDOR GRAPHICS, 8512 Whitworth Dr., Suite 103, Los Angeles CA 90035. (310)659-1023. Fax: (310)659-1025. Director: John Pace. Estab. 1972. Art publisher and distributor of limited and unlimited editions of offset reproductions and handpulled original prints. Clients: galleries, picture framers, decorators, corporations, collectors.
Needs: Considers oil, acrylic, airbrush, watercolor and mixed media, also serigraphy and lithography. Seeking unusual, appealing subjects in Art Deco period styles as well as wildlife and African-American art. Prefers individual works of art, pairs, series; 30×40 maximum. Artists represented include J.W. Ford, Neely Taugher, Louis Icart and Maxfield Parrish. Publishes the work of 2 emerging, 3 mid-career and 1 established artists/year. Distributes the work of 4 emerging, 20 mid-career and 50 established artists/year.
First Contact & Terms: Send brochure and photographs. Do not send slides. Samples returned by SASE. Reports back within 1 month. Pays flat fee, $500-1,000; royalties (5-10%) or negotiates payment method. Sometimes offers advance. Buys all rights. Usually requires exclusive representation of the artist. Provides insurance while work is at publisher. Negotiates ownership of original art.
Tips: "Be original with your own ideas. Give clean, neat presentations in original or photographic form (no slides)."

No abstracts please. Popular styles include impressionism and landscapes. Posters are becoming less graphic; more of a fine art look is popular."

IMAGE CONSCIOUS, 147 Tenth St., San Francisco CA 94103. (415)626-1555. Website: http://www.imageconscious. com. Creative Director: Cindy Bardy. Estab. 1980. Art publisher and domestic and international distributor of offset and poster reproductions. Clients: poster galleries, frame shops, department stores, design consultants, interior designers and gift stores. Current clients include Z Gallerie, Deck the Walls, Pier 1 and Ballard Designs.
Needs: Seeking creative and decorative art for the designer market. Considers oil, acrylic, pastel, watercolor, tempera, mixed media and photography. Prefers individual works of art, pairs or unframed series. Artists represented include Mary Silverwood, Aleah Koury, Monica Stewart, Dennis Barloga, Andrea Beloff, Sandy Wadlington, David Smith-Harrison, Mark King, Imogen Cunningham, Alan Blaustein and Joseph Holmes. Editions created by collaborating with the artist and by working from an existing painting or photograph. Approached by hundreds of artists/year. Publishes the work of 2-3 emerging, 2-3 mid-career and 4-5 established artists/year. Distributes the work of 50 emerging, 200 mid-career and 700 established artists/year.
First Contact & Terms: Send query letter with brochure, résumé, tearsheets, photographs, slides and/or transparencies. Samples are filed or are returned by SASE. Reports back within 1 month. Publisher/distributor will contact artist for portfolio review if interested. No original art. Payment method is negotiated. Negotiates rights purchased. Provides promotion, shipping from firm and a written contract.
Tips: "Research the type of product currently in poster shops. Note colors, sizes and subject matter trends."

‡**IMAGE SOURCE INTERNATIONAL**, 12 Riverside Dr., Unit 2, Pembroke MA 02359. (781)829-0897. Fax: (781)829-0995. E-mail: pdownes@isiposters.com. Website: http://www.isiposters.com. Contact: Patrick Downes. Art Editor: Mario Testa. Estab. 1992. Poster company, art publisher, distributor, foreign distributor. Publishes/distributes unlimited editions, fine art prints, offset reproductions, posters. Clients: galleries, decorators, frame shops, distributors, architects, corporate curators, museum shops, gift shops, foreign distributors (Germany, Holland, Asia, South America).
● Image Source International is one of America's fastest-growing publishers.
Needs: Seeking fashionable, decorative art for the designer market. Considers oil, acrylic, pastel. Artists represented include Micarelli. Editions created by collaborating with the artist or by working from an existing painting. Approached by hundreds of artists/year. Publishes the work of 6 emerging, 2 mid-career and 2 established artists/year. Distributes the work of 50 emerging, 25 mid-career, 50 established artists/year.
First Contact & Terms: Send query letter with brochure, photocopies, photographs, résumé, slides, tearsheets, transparencies, postcards. Samples are filed and are not returned. Reports back only if interested. Company will contact artist for portfolio review if interested. Pays flat fee "that depends on artist and work and risk." Buys all rights. Requires exclusive representation of artist.
Tips: Notes trends as sports art, neo-classical, nostalgic, oversize editions. "Think marketability."

✒**IMAGES INTERNATIONAL PUBLISHING CORP.**, 2756 N. Green Valley Pkwy. #372, Henderson NV 89014. (702)263-0512. President: Stevenson C. Higa. Estab. 1977. Art publisher and gallery. Publishes limited editions, offset reproductions and originals. Clients: retail galleries, shows and wholesale galleries. Current clients include Hansons Galleries, The Mas Charles Gallery, Shipstore Galleries, C&M Galleries, Images West Galleries and Lahaina Galleries.
Needs: Seeking decorative art for the serious collector and commercial market. Considers oil, watercolor, acrylic and painting on fabric. Prefers oriental themes. Artists represented include Otsuka, Caroline Young and Gary Hostallero. Editions created by collaborating with the artist or by working from an existing painting. Publishes the work of 1 emerging, 1 mid-career and 2 established artists/year.
First Contact & Terms: Send query letter with brochure showing art style or résumé and photographs. Samples are not filed and are returned by SASE if requested by artist. Reports back within 2 months. Payment method is negotiated. Offers an advance when appropriate. Buys one-time rights. Provides in-transit insurance, insurance while work is at firm, promotion, shipping to firm and written contract.

✒**IMAGES OF AMERICA PUBLISHING COMPANY**, P.O. Box 608, Jackson WY 83001. (800)451-2211. Fax: (307)739-1199. Executive Director: Christopher Moran. Estab. 1990. Art publisher. Publishes limited editions, posters. Clients: galleries, frame shops, distributors, gift shops, national parks, natural history associations.
● This company publishes the winning images in the Art for the Parks competition which was created in 1986 by the National Park Academy of the Arts in cooperation with the National Park Foundation. The program's purpose is to celebrate representative artists and to enhance public awareness of the park system. The top 100 paintings tour the country and receive cash awards. Over $86,000 in prizes in all.
Needs: Seeking national park images. Considers oil, acrylic, watercolor, mixed media, pastel, pen & ink. Prefers nature and wildlife images from one of the sites administered by the National Park Service. Artists represented include Jim Wilcox, Linda Tippetts, Howard Hanson, Tom Antonishak, Steve Hanks. Editions created by collaborating with the artist. Approached by over 2,000 artists/year.
First Contact & Terms: Submit by entering the Arts for the Parks contest for a $40 entry fee. Entry form and slides must be postmarked by June 1 each year. Send for prospectus before May 1st. Samples are filed. Reports back within 1 month. Portfolio review not required. Pays flat fee of $50-50,000. Buy one-time rights. Provides advertising.
Tips: "All artwork selected must be representational of a National Park site."

✔**IMCON**, 68 Greene St., Oxford NY 13830. (607)843-5130. Fax: (607)843-2130. President: Fred Dankert. Estab. 1986. Fine art printer of handpulled originals. "We invented the waterless litho plate, and we make our own inks." Clients: galleries, distributors.

Needs: Seeking creative art for the serious collector. Editions created by collaborating with the artist "who must produce image on my plate. Artist given proper instruction."

First Contact & Terms: Call or send query letter with résumé, photographs and transparencies.

Tips: "Artists should be willing to work with me to produce original prints. We do *not* reproduce; we create new images. Artists should have market experience."

IMPACT IMAGES, 4919 Windplay Dr., El Dorado Hills CA 95762. (916)933-4700. Fax: (916)933-4717. Owner: Benny Wilkins. Estab. 1975. Publishes unlimited edition posters. Clients: frame shops, museum and gift shops. Current clients inlcude Impulse Designs, Image Conscious, Prints Plus, Summit Art Inc. and Deck the Walls.

Needs: Seeking traditional and contemporary artwork. Considers oils, acrylics, pastels, watercolors, mixed media. Prefers contemporary, original themes, humor, fantasy, autos, animals, children, western, country, floral, golf, angels, inspirational, aviation, ethnic, wildlife and suitable poster subject matter. Prefers individual works of art. "Interested in licensed subject matter." Artists represented include Jonnie Chardon, Dan McMannis and Beatrix Potter. Publishes the work of 5 emerging, 25 mid-career and 15 established artists/year.

First Contact & Terms: Send query letter with brochure, tearsheets, photographs, slides and transparencies. Samples are not filed and are returned by SASE. Reports back within 1 month. Payment method is negotiated. Offers an advance when appropriate. Negotiates rights purchased. Does not require exclusive representation of the aritst. Provides written contract. Finds artists through art fairs, word of mouth and submissions.

Tips: "In the past we have been 'trendy' in our art; now we are a little more conservative and traditional."

INSPIRATIONART & SCRIPTURE, INC., P.O. Box 5550, Cedar Rapids IA 52406. (319)365-4350. Fax: (319)366-2573. E-mail: lisa@inspirationart.com. Website: http://www.inspirationart.com. President: Lisa Edwards. Estab. 1993 (incorporated 1996). Produces Christian poster prints. "We create and produce jumbo-sized (24×36) posters targeted at pre-teens (10-14), teens (15-18) and young adults (18-30). A Christian message is contained in every poster. Some are fine art and some are very commercial. We prefer very contemporary images."

Needs: Approached by 150-200 freelance artist/year. Works with 10-15 freelancers/year. Buys 10-15 designs, photos, illustrations/year. Christian art only. Uses freelance artists for posters. Considers all media. Looking for "something contemporary or unusual that appeals to teens or young adults and communicates a Christian message." Art guidelines available for SASE with first-class postage. Catalog available for $3.

First Contact & Terms: Send query letter with photographs, slides, SASE or transparencies. Accepts submissions on disk (call first). Samples are filed or are returned by SASE. Reports back within 6 months. Company will contact artist for portfolio review if interested. Portfolio should include color roughs, final art, photographs and transparencies. "We need to see the artist's range. It is acceptable to submit 'secular' work, but we also need to see work that is Christian-inspired." Originals are returned at job's completion. Pays by the project, $50-250. Pays royalties of 5% "only if the artist has a body of work that we are interested in purchasing in the future." Rights purchased vary according to project.

Tips: "The better the quality of the submission, the better we are able to determine if the work is suitable for our use (slides are best). The more complete the submission (e.g., design, art layout, scripture, copy), the more likely we are to see how it may fit into our poster line. We do accept traditional work, but are looking for work that is more commercial and hip (think MTV with values). A poster needs to contain a Christian message that is relevant to teen and young adult issues and beliefs. Understand what we publish before submitting work. Artists can either purchase a catalog for $3 or visit our website to see what it is that we do. We are not simply looking for beautiful art, but rather we are looking for art that communicates a specific scriptural passage."

INTERCONTINENTAL GREETINGS LTD., 176 Madison Ave., New York NY 10016. Art Director: Robin Lipner. Estab. 1967. Sells reproduction rights of design to publisher/manufacturers. Handles offset reproductions, greeting cards, stationery and gift items. Clients: paper product, gift tin, ceramic and textile manufacturers. Current clients include: Franklin Mint, Scandecor, Verkerke, Simon Elvin, others in Europe, Latin America, Japan and Asia.

Needs: Seeking creative, fashionable and decorative art for the commercial and designer markets. Considers oil, watercolor, mixed media, pastel, acrylic, computer and photos. Approached by several hundred artists/year. Publishes the work of 30 emerging, 100 mid-career and 100 established artists/year. Also needs freelance design (not necessarily designers). 100% of freelance design demands knowledge of Adobe Photoshop, Adobe Illustrator and Painter. Prefers designers experienced in greeting card, paper products, giftware.

First Contact & Terms: Send query letter with brochure, tearsheets, slides, photographs, photocopies and transparencies. Samples are filed or returned by SASE if requested by artist. Artist should follow-up with call. Portfolio should include color final art, photographs and slides. Pays flat fee, $30-500, or royalties of 20%. Offers advance when appropriate. Rights purchased vary according to project. Requires exclusive representation of artist, "but only on the artwork we represent." Provides promotion, shipping to firm and written contract. Finds artists through attending art exhibitions, word of mouth, sourcebooks or other publications and submissions.

Tips: Recommends New York Stationery Show held annually. "In addition to having good painting/designing skills, artists should be aware of market needs."

INTERNATIONAL BLACK ART DISTRIBUTORS, 1431 S. LaBrea Ave., Los Angeles CA 90019. (213)939-0843. Owner: D. Cooper. Distributor and gallery. Publishes limited editions and fine art prints. Clients: galleries, distributors.
Needs: Seeking art for the commercial market. Considers mixed media. Prefers black art by black artists. Artists represented include Ernie Barnes, Tom McKinney, Annie Lee, George Porter and Ray Batcheloe.
First Contact & Terms: Send query letter with brochure and photographs. Samples are not filed. Reports back only if interested. Portfolio review not required. Artist should follow up with call after initial query. Portfolio should include color samples. Negotiates payment. Offers advance when appropriate. Rights purchased vary according to project. Also needs freelancers for design.

‡**INTERNATIONAL GRAPHICS GMBH.**, Dieselstr. 7, 76344, Eggenstein Germany. 011(49)721-978-0612. Fax: (49)721-978-0678. E-mail: ig-team@t.online. President: Lawrence Walmsley. Estab. 1983. Poster company/art publisher/distributor. Publishes/distributes limited edition monoprints, monotypes, offset reproduction, posters, original paintings and silkscreens. Clients: galleries, framers, department stores, gift shops, card shops and distributors. Current clients include: Windsor Art and Balangier.
Needs: Seeking creative, fashionable and decorative art for the commercial and designer markets. Also seeking Americana art for our gallery clients. Considers oil, acrylic, watercolor, mixed media, pastel. Prefers landscapes, florals, still lifes. Artists represented include Ida, Janssen, Lilita, Bähr-Clemens, McCulloch, Barth, Mayer, Hecht. Editions created by working from an existing painting. Approached by 20-30 artists/year. Publishes the work of 4-5 emerging, 1-5 mid-career and 1-2 established artists/year. Distributes the work of 40-50 emerging, 10 mid-career, 2-3 established artists/year.
First Contact & Terms: Send query letter with brochure, photocopies, photographs, photostats, résumé, slides, tearsheets. Accepts disk submissions in Mac or Windows. Samples are filed and returned. Reports back within 1-2 months. Will contact artist for portfolio review if interested. Negotiates payment on basis of per piece sold arrangement. Offers advance when appropriate. Buys first rights. Provides advertising, promotion, shipping from our firm and contract. Also work with freelance designers. Prefers local designers only. Finds artists through exhibitions, word of mouth, submissions.
Tips: "Bright landscapes and still life pictures are good at the moment. Blues are popular—especially darker shades."

✦**ISLAND ART**, 6687 Mirah Rd., Saanichton, British Columbia V8M 1Z4 Canada. (250)652-5181. Fax: (250)652-2711. E-mail: islandart@islandart.com. Website: http://www.islandart.com/IslandArt/. President: Myron D. Arndt. Estab. 1985. Art publisher and distributor. Publishes and distributes limited and unlimited editions, offset reproductions, posters and art cards. Clients: galleries, department stores, distributors, gift shops. Current clients include: Disney, Host-Marriott, Ben Franklin.
Needs: Seeking creative and decorative art for the serious collector, commercial and designer markets. Considers oil, watercolor and acrylic. Prefers lifestyle themes/Pacific Northwest. Also needs designers. 10% of products require freelance design and demand knowledge of Adobe Photoshop. Artists represented include Sue Coleman and Lissa Calvert. Editions created by working from an existing painting. Approached by 100 artists/year. Publishes the work of 2 emerging, 2 mid-career and 2 established artists/year. Distributes the work of 4 emerging, 10 mid-career and 5 established artists/year.
First Contact & Terms: Send résumé, tearsheets, slides and photographs. Designers send photographs, slides or transparencies (do not send originals). Accepts submissions on disk compatible with Adobe Photoshop. Send EPS of TIFF files. Samples are not filed and are returned by SASE if requested by artist. Reports back within 3 months. Publisher/distributor will contact artist for portfolio review if interested. Portfolio should include color roughs, final art, slides and 4×5 transparencies. Pays royalties of 5-10%. Offers advance when appropriate. Buys reprint rights. Requires exclusive representation of artist. Provides insurance while work is at firm, promotion, shipping from firm, written contract, trade fair representation and Internet service. Finds artists through art fairs, referrals and submissions.
Tips: "Provide a body of work along a certain theme to show a fully developed style that can be built upon. We are influenced by our market demands. Please ask for our submission guidelines before sending work on spec."

ISLAND INTERNATIONAL ARTISTS, 430 Guemies Island Rd., Anacortes WA 98221. (360)293-9572. Fax: (360)299-9215. Owner: Ria Foster. Estab. 1965. Art publisher and artist's representative. Publishes handpulled originals, etchings only. Clients: galleries, decorators, frame shops, architects. Current clients include: The Nature Company.
Needs: Seeking creative and decorative art for the commercial and designer markets. Considers pen & ink. "Artist must have a well-developed style and must be able to draw well." Publishes/distributes the work of 4-5 emerging and 38 established artists/year.
First Contact & Terms: Send resume, slides and photographs. Samples are not filed and are not returned. Reports back within 1 week. Company will contact artist for portfolio review if interested. Portfolio should include final art, slides and thumbnails. Negotiates payment. Requires exclusive representation of artist. Provides promotion.

‡**J.B. FINE ARTS/CENTRAL GALLERIES**, 420 Central Ave., Cedarhurst NY 11516. (516)569-5686. Fax: (516)569-7114. President: Jeff Beja. Estab. 1983. Art publisher, distributor and gallery. Publishes and distributes limited editions.
Needs: Seeking creative art for the serious collector and commercial market. Considers oil, mixed media and acrylic. Editions created by collaborating with the artist or working from an existing painting. Approached by 100 artists/year.

Publishes the work of 1 emerging artist/year. Distributes the work of 5 emerging, 10 mid-career and 20 established artists/year.

First Contact & Terms: Send query letter with résumé, tearsheets and photographs. Samples are filed or returned by SASE if requested by artist. Reports back within 2 months if interested. Portfolio review not required. Publisher/distributor will contact artist for portfolio review if interested. Negotiates payment. Offers advance when appropriate. Rights purchased vary according to project. Requires exclusive representation of artist. Provides advertising, in-transit insurance, insurance while work is at firm, promotion, shipping from firm and written contract.

JANNES ART PUBLISHING, INC., 3318 N. Lincoln Ave., Chicago IL 60657. (773)404-5090. Fax: (773)404-0150. Owner: Nicholas Jannes. Estab. 1986. Art publisher and distributor. Publishes and distributes limited editions and posters. Clients: galleries, art shops, framing shops and retail. Current clients include: Graphique de France and Modern-art Editions.

Needs: Seeking creative art for the serious collector and the commercial market. Considers oil and watercolor. Prefers automotive, floral and landscape. Artists represented include Scott Mutter, G. Padginton, B. Fuchs, Vargas and Gary Michael. Editions created by working from an existing painting. Approached by 10 artists/year. Publishes the work of 1 emerging, 10 mid-career and 3 established artists/year. Distributes the work of 5 emerging, 23 mid-career and 5 established artists/year.

First Contact & Terms: Send brochure and tearsheets. Samples are filed and are returned. Publisher/Distributor will contact artist for portfolio review if interested. Portfolio should include slides and transparencies. Pays royalties of 10-20%; negotiates payment. No advance. Rights purchased vary according to project. Provides advertising, promotion and shipping from firm.

Tips: Recommends artists attend Art Expo.

MARTIN LAWRENCE LIMITED EDITIONS, 16250 Stagg St., Van Nuys CA 91406. (818)988-0630. Fax: (818)785-4330. President: Barry R. Levine. Estab. 1976. Art publisher, distributor and gallery. Publishes and distributes limited editions, offset reproductions and posters.

Needs: Seeking creative and decorative art for the serious collector and commercial market. Considers oil, watercolor, mixed media, pastel, sculpture and acrylic. Prefers impressionist, naive, Americana, pop art. Artists represented include Mark King, Susan Rios, Linnea Percola, Laurie Zeszut and Mark Kostabi. Editions created by collaborating with the artist or working from an existing painting. Approached by 100 artists/year. Publishes and distributes the work of 2 emerging artists/year.

First Contact & Terms: Send slides, photographs and transparencies. Samples are not filed and are returned by SASE if requested by artist. Publisher/distributor will contact artist for portfolio review if interested. Portfolio should include photographs. Requires exclusive representation of artist. Provides advertising.

Tips: Suggests artist attend Art Expo New York.

LAWRENCE UNLIMITED, 8721 Darby Ave., Northridge CA 91324. (818)349-4120. Fax: (818)349-0450. Owner: Lawrence. Estab. 1966. Art publisher, distributor and manufacturer. Publishes and/or distributes hand-pulled originals and offset reproductions. Clients: furniture stores, designers, commercial markets.

Needs: Seeking artwork with creative expression, fashionableness and decorative appeal for the commercial and designer markets. Considers watercolor, mixed media, pastel, pen & ink and intaglio, monotype. Artists represented include Jeanne Down, Nancy Cowan and M. Duval. Editions created by collaborating with the artist. Approached by 20 artists/year. Distributes the work of 4 emerging and 2 mid-career artists/year. Also needs freelancers for design.

First Contact & Terms: Send query letter with brochure showing art style, photocopies, résumé, transparencies, tearsheets and photographs. Samples are not filed and are returned. Reports back within 2 weeks. Call for appointment to show portfolio. Portfolio should include roughs, final art, tearsheets and photographs. Pays flat fee. Offers advance when appropriate. Negotiates rights purchased. Provides promotion.

Tips: "Have pricing in mind for distributing and quantity."

LESLI ART, INC., Box 6693, Woodland Hills CA 91365. (818)999-9228. President: Stan Shevrin. Estab. 1965. Artist agent handling paintings for art galleries and the trade.

Needs Considers oil paintings and acrylic paintings. Prefers realism and impressionism—figures costumed, narrative content, landscapes, still lifes and florals. Maximum size 36×48, unframed. Works with 20 artists/year.

First Contact & Terms: Send query letter with photographs and slides. Samples not filed are returned by SASE. Reports back within 1 month. To show portfolio, mail slides and color photographs. Payment method is negotiated. Offers an advance. Provides national distribution, promotion and written contract.

Tips: "Considers only those artists who are serious about having their work exhibited in important galleries throughout the United States and Europe. Never stop learning about your craft."

LESLIE LEVY FINE ART PUBLISHING, INC., 1505 N. Hayden, Suite J10, Scottsdale AZ 85257. (602)945-8491. Fax: (602)945-8104. E-mail: leslevy@ix.netcom.com. Director of Marketing: Gary Massey. Licensing: Laura Levy. Estab. 1976. Art publisher of posters and limited editions. "Our publishing customers are mainly frame shops, galleries, designers, framed art manufacturers, distributors and department stores. Currently works with over 10,000 clients."

● Leslie Levy has added a licensing division, Leslie Levy Creative Art Licensing. The division will license calendar notecards and other paper goods, puzzles, book illustrations and covers, cd covers, china, fabric designs,

gifts, menus etc. Laura Levy will direct the program. Look for the interview with Leslie Levy in the introduction to this section.

Needs Seeking creative and decorative art for the residential, hospitality, heath care, commercial and designer markets. Artists represented include: Steve Hanks, Doug Oliver, Robert Staffolino, Kent Wallis, Michael Workman, Raymond Knaub, Terry Isaacs, Doug West, Patricia Hunter, Jean Crane and many others. Considers oil, acrylic, pastel, watercolor, tempera, mixed media and photography. Prefers art depicting florals, landscapes, wildlife, farm scenes, Americana and figurative works. Approached by hundreds of artists/year. Publishes the work of 2 new, 2 mid-career and 2 established artists/year.

First Contact & Terms: Send query letter with résumé, slides or photos. Samples are filed or returned by SASE. Reports back within 6 weeks. "Portfolio will not be seen unless interest is generated by the materials sent in advance." Please do not send limited editions, tansparencies or original works. Posters and prints "are sold quarterly. Pays royalties based on retail and popularity of artist." Insists on acquiring reprint rights for posters. Requires exclusive representation of the artist for the image being published. Provides advertising, promotion, written contract and insurance while work is at firm. "Please, don't call us. After we review your materials, we will contact you or return materials within 6-8 weeks.

Tips: "We are looking for floral, figurative, impressionist, landscapes, wildlife, children's art, smaller images for miniature prints, abstract art and any art of exceptional quality. Please, if you are a beginner do not go through the time and expense of sending materials. Also we publish no copycat art." Advises artists to attend the Ary Buyers Caravan, an annual trade show held in Atlanta, Georgia.

LILY INCORPORATED, 1446 Front St., 4th Floor, San Diego CA 92101. (619)338-0307. Fax: (619)685-3904. President: Diane Roberts. Estab. 1981. Art publisher and distributor. Publishes and distributes handpulled originals, limited editions and offset reproductions. "We're also looking into publishing a line of thematic greeting cards." Clients: museums and those with aviation, military or maritime interests. Current clients include Pearl Harbor Visitors' Museum and the U.S. Navy.

Needs: Seeking art for the serious collector. Considers oil, watercolor, acrylic and mixed media. Prefers realism, maritime and aviation themes. Artists represented include Richard W. DeRosset. Editions created by collaborating with the artist or working from an existing painting. Approached by 3 artists/year. Publishes the work of 1 emerging artist and 1 established artist/year.

First Contact & Terms: Send query letter with brochure showing art style or résumé, slides and photographs. Samples are filed or are returned by SASE if requested by artist. Reports back only if interested within 1 month. To show a portfolio, mail slides and photographs. Pays flat fee, royalties; on a consignment basis. Offers an advance when appropriate. Buys first-rights or reprint rights. Provides in-transit insurance, promotion shipping from firm and a written contract.

Tips: "Know your subject well, as this art is for historians."

✤LIPMAN PUBLISHING, 76 Roxborough St. W., Toronto, Ontario M5R 1T8 Canada. (800)561-4260. Owner: Louise Lipman. Estab. 1976. Art publisher. Publishes unlimited editions, offset reproductions and posters. Clients: wholesale framers, distributors, hospitality. Current clients include: Pier One, Avey and Avey, Spiegel.

Needs: Seeking decorative art for the commercial and designer markets. Considers all 2-dimensional media. Prefers garden, kitchen, landscape, floral themes. Artists represented include William Buffett, Patrick Nagel and Anna Pugh. Editions created by collaborating with the artist or by working from an existing painting.

First Contact & Terms: Send slides, photographs, photocopies or any low-cost facsimile. Samples are filed and not returned. Reports back within a few weeks. Publisher will contact artist for portfolio review if interested. Portfolio should include color thumbnails, photographs and slides. Pays royalties of 10%. Negotiates rights purchased. Requires exclusive representation of artist. Provides advertising, promotion and written contract.

Tips: "There's a trend to small pictures of garden-, kitchen-, and bathroom-related material."

LONDON CONTEMPORARY ART, 6950 Phillips Hwy., Suite 51, Jacksonville FL 32216. (904)296-4982. Fax: (904)296-4943. Website: http://www.artcom.com/lca/. Estab. 1978. Art publisher. Publishes limited editions. Clients: art galleries, dealers, distributors, furniture stores and interior designers.

Needs: Seeking art for the commercial market. Prefers figurative, landscapes, some abstract expressionism. Artists represented include Roy Fairchild, David Dodsworth, Janet Treby, Alexander Ivanov and Csaba Markus. Editions created by working from an existing painting. Approached by hundreds of artists/year. Publishes the work of 1-10 emerging, 1-10 mid-career and 20 established artists/year. Distributes the work of 1-10 emerging, 1-10 mid-career, 20-50 established artists/year.

First Contact & Terms: Send brochure, résumé, tearsheets, photographs and photocopies. Samples are filed or returned by SASE. Publisher/distributor will contact artist for portfolio review if interested. Portfolio should include final art, tearsheets and photographs. Negotiates payment. Rights purchased vary according to project. Provides advertising, in-transit insurance, insurance while work is at firm, promotion, shipping from firm and written contract. Finds artists through attending art exhibitions and art fairs, word of mouth and submissions.

Tips: Recommends artists read *Art Business News* and *U.S. Art*. "Pay attention to color trends and interior design trends. Artists need discipline and business sense and must be productive."

✔LYNESE OCTOBRE, INC., 22121 US 19 N., Clearwater FL 33765. (813)724-8800. Fax: (813)724-8352. President: Jerry Emmons. Estab. 1982. Distributor. Distributes unlimited editions, offset reproductions and posters. Clients: picture framers and gift shops. Current clients include: Deck the Walls, Independent Ben Franklin stores, Crafts & Stuff.
Needs: Seeking fashionable and decorative art for the commercial and designer markets. Considers oil, watercolor, mixed media, pastel, pen & ink and acrylic. Artists represented include James W. Harris, Mark Winter, Roger Isphording, Betsy Monroe, Paul Brendt, Sherry Vintson, Jean Grastorf, AWS. Approached by 50 artists/year. Publishes the work of 2-5 emerging and 1-3 established artists/year. Distributes the work of 2-5 emerging and 1-3 established artists.
First Contact & Terms: Send brochure, tearsheets, photographs and photocopies. Samples are sometimes filed or are returned. Reports back within 1 month. Distributor will contact artist for portfolio review if interested. Portfolio should include final art, photographs and transparencies. Negotiates payment. No advance. Rights purchased vary according to project. Provides written contract.
Tips: Recommends artists attend Art Buyers Caravan by Decor. "The trend is toward quality, color-oriented regional works."

SEYMOUR MANN, INC., 230 Fifth Ave., Suite 1500, New York NY 10001. (212)683-7262. Fax: (212)213-4920. Manufacturer.
Needs: Seeking fashionable and decorative art for the serious collector and the commercial and designer markets. Also needs freelancers for design. 15% of products require freelance design. Considers watercolor, mixed media, pastel, pen & ink and 3-D forms. Editions created by collaborating with the artist. Approached by "many" artists/year. Publishes the work of 2-3 emerging, 2-3 mid-career and 4-5 established artists/year.
Tips: "Focus on commercial end purpose of art."

MANOR ART ENTERPRISES, LTD., 555 E. Boston Post Rd., Mamaroneck NY 10543. (914)738-8569. Fax: (914)738-8581. President: Greg Croston. Estab. 1992. Art publisher of unlimited editions and offset reproductions. Clients: framing, manufacturing, world-wide distributors.
Needs: Seeking artwork with creative expression, fashionableness and decorative appeal for the commercial market. Considers oil, watercolor, acrylic, mixed media. Prefers traditional and realistic. Artists represented include Anton Pieck, Reina, Ruth Morehead, Bill Morehead, Craig Sprovach, Carol Lawson, Jean Barton and Brian Paterson, creator of the Foxwood Tales. Editions created by collaborating with the artist. Approached by 100 artists/year. Publishes the work of 2-4 emerging, 2-4 mid-career and 2-4 established artists/year.
First Contact & Terms: Send query letter with brochure showing art style or résumé and tearsheets, slides and photographs. Samples are not filed and are returned. Reports back within 2 weeks. Write for appointment to show portfolio, which should include slides, tearsheets, transparencies, original/final art and photographs. Pays flat fee or royalties of 7-10%. Offers advance. Negotiates rights purchased. Requires exclusive representation. Provides in-transit insurance and insurance while work is at firm.
Tips: "The focus of our publishing is towards traditional with worldwide appeal—tight and realistic."

MARCO FINE ARTS, 201 Nevada St., El Segundo CA 90245. (310)615-1818. Fax: (310)615-1850. Publishes/distributes limited edition, fine art prints and posters. Clients: galleries, decorators and frame shops.
Needs: Seeking creative and decorative art for the serious collector and design market. Considers oil, acrylic and mixed media. Prefers landscapes, florals, figurative, Southwest, contemporary, impressionist, antique posters. Artists represented include John Nieto, Aldo Luongo, John Axton, Nivia Gonzalez, Sharon B. Kaiser, Nobu Haibara, Ken Auster, Mucha, Cappiello, Cheret. Editions created by collaborating with the artist or working from an existing painting. Approached by 80-100 artists/year. Publishes the work of 0-1 emerging, 0-1 mid-career and 0-1 established artist/year.
First Contact & Terms: Send query letter with brochure, photocopies, photographs, photostats, résumé, SASE, slides, tearsheets and transparencies. Accepts disk submissions. Samples are filed and are returned by SASE. Reports back only if interested. Company will contact artist for portfolio review or original artwork (show range of ability) if interested. Payment to be discussed. Requires exclusive representation of artist.

MARGIEART, 5111 Winewood, Milford MI 48382-1543. (248)684-6538. E-mail: margieart2@aol.com. Vice President, Marketing: Sheryl Inglefield. Estab. 1993. Distributor. Distributes limited editions, unlimited editions, fine art prints, offset reproductions, posters. Clients: galleries, frame shops.
• This publisher is currently seeking abstracts, landscapes and florals.
Needs: Seeking creative, fashionable, decorative art for the commerical and designer markets. Considers oil, acrylic, watercolor, mixed media, pastel, pen & ink. Artists represented include Guy Begin, Pascal, Susanne Lawrence and Richard Zucco. Editions created by working from an existing painting. Approached by 10-20 artists/year. Distributes the work of 6-8 emerging, 12-15 mid-career and 2-3 established artists/year.
First Contact & Terms: Send query letter with brochure, photographs, SASE, tearsheets. Samples are not filed and are returned by SASE. Reports back within 6 weeks. Company will contact artist for portfolio review of color photographs if interested. Pays on consignment basis: firm receives 50% commission. Rights purchased vary according to project. Provides promotion, shipping from our firm, written contract. Finds artists through attending art exhibitions, art fairs, word of mouth, other publications, submissions.
Tips: "Check with several galleries and framing shops regarding image, size and price before printing to be sure your art print is in line with the markets demand. Art prints that require oversized matting and framing are rarely purchased for inventory by galleries or framing shops."

✔**THE MARKS COLLECTION**, 8601 Dunwoody Place, #510, Atlanta GA 30350. 1(800)849-3125. Fax: (770)641-3927. E-mail: jmarks@bellsouth.net. Website: http://www.markscollection.com. President: Jim Marks. Estab. 1981. Art publisher of unlimited and limited editions. Clients: persons interested in the Civil War; Christian and secular.
Needs: Seeking art for the serious collector. Considers oil, acrylic and mixed media. Prefers Christian, nature and Civil War themes. Civil War images are aimed at the romance, human interest and religious themes rather than 'blood and guts' action. Artists represented include John DeMott, Hong Min Zou, William Maugham, Danny Halhbohm, James Tennison, Mark Smothers and Charles Gehm. Editions created by collaborating with the artist. Publishes and distributes the work of 1 emerging and 2 established artists/year.
First Contact & Terms: "Phone first to give an overview of your style, subject matter, etc." Send query letter with brochure showing art style, slides and photographs. Samples are filed. Reports back only if interested. Payment depends upon the use and distribution, pays royalties of 10% or accepts work on consignment. Provides a written contract.
Tips: We are placing more emphasis on Christian subject or inspirational work. We would like to see more Inspirational or Christian artwork from artists.

‡**MARLBORO FINE ART & PUBL., LTD.**, 11 Amagansett Dr., Morganville NJ 07951. (732)972-9044. Fax: (732)845-0577. E-mail: charlin15@aol.com. Estab. 1996. Art publisher/distributor. Publishes/distributes limited and unlimited edition offset reproductions and posters. Clients: galleries, decorators, frame shops, distributors, architects, corporate curators, museum shops, giftshops. Current clients include: Paloma, H&M Gallery, Charray Art.
Needs: Publishes/distributes creative, fashionable and decorative art for the commercial market. Considers acrylic, watercolor, mixed media, pastel, pen & ink. Prefers multicultural themes. Artists represented include Anthony Armstrong, Khalil Bey, Hosa Anderson, Harry Davis, William Buffet. Editions created by collaborating with the artist and working from an existing painting. Approached by 15-20 artists/year. Publishes 1-2 emerging, 2 established artists/year. Distributes the work of 5-10 emerging, 5 mid-career artists/year.
First Contact & Terms: Send query letter with brochure, photocopies, photographs, photostats, slides, transparencies. Samples are not filed and are returned. Reports back within days. Will contact artist for portfolio review if interested. Royalties paid monthly. Offers advance when appropriate. Rights purchased vary according to project. Provides advertising, promotion, shipping from firm and contract. Finds artists through the web, trade publications.
Tips: "Do your own thing—if it feels right—go for it!"

BRUCE MCGAW GRAPHICS, INC., 389 W. Nyack Rd., West Nyack NY 10994. (914)353-8600. Fax: (914)353-3155. E-mail: 75300.2226@compuserve.com. Acquisitions: Martin Lawlor. Clients: poster shops, galleries, I.D., frame shops.
● Bruce McGaw Graphics introduced a new collection of limited edition serigraphs and lithographs in March, 1998 to compliment its fine art poster collection.
Needs: Artists represented include Betsy Cameron, Yuriko Takata, Art Wolfe, Diane Romanello, Jacques Lamy, Peter Sculthorpe, Peter Kitchell, Bob Timberlake, Bernie Horton and P.G. Gravele. Publishes the work of 10 emerging and 20 established artists/year.
First Contact & Terms: Send slides, transparencies or any other visual material that shows the work in the best light. "We review all types of 2-dimensional art with no limitation on media or subject. Review period is 1 month, after which time we will contact you with our decision. If you wish the material to be returned, enclose a SASE. Contractual terms are discussed if work is accepted for publication."
Tips: "Simplicity is very important in today's market (yet there still needs to be 'a story' to the image). Form and palette are critical to our decision process. We have a tremendous need for decorative pieces, especially new abstracts, landscapes, and florals. Environmental images which feature animals and decorative still life images are very popular, and much needed as well. There are a lot of prints and posters being published into the marketplace these days. Market your best material! There are a number of important shows—the largest American shows being Art Expo, New York (March) and the Atlanta A.B.C. Show (September)."

MGLA, 365 W. 131st St., Los Angeles CA 90061. (310)768-3301. Fax: (310)768-1097. E-mail: mglaio@aol.com. President: Marshall Gross. Estab. 1972. Art distributor/gallery handling original acrylic paintings, serigraphs, paper construction, cast paper and sculpture. Licenses ethnic, South American, cast or slumped glass. Clients: designer showrooms, architects, interior designers, galleries, furniture and department stores.
Needs: "We're seeking product designs for decorative mirrors, lamps, tables and chairs, glass cocktail tables, wall placques, large ceramic urns, vases. "We can use contemporary and classic clay sculpture." Special consideration to South American Native designs and themes. After reviewing your work we will advise product groups we wish you to develop for us to purchase."
First Contact & Terms: Send query letter with brochure showing art style or photographs. Samples are not filed and are returned only if requested by artist. Call for instructions to show portfolio of roughs, slides and color photos. Pays flat fee; negotiable.
Tips: "Glass and mirror designs are given special consideration. We represent all types of art from professional gallery quality to street fairs. We're especially looking for ethnic South American designs. Awareness of current color trend in the home furnishings industry is a must." Looking for cast and slumped glass art.

✔**MILL POND PRESS, INC.**, 310 Center Court, Venice FL 34292-3500. (800)535-0331. Fax: (941)497-6026. E-mail: 74774.3332@compuserve.com. Public Relations Director: Ellen Collard. Licensing: Linda Schaner. Estab. 1973.

Publishes limited editions, unlimited edition, offset reproduction and posters. Clients: galleries, frameshops and specialty shops, Christian book stores, licensors. Licenses various genre on a range of products.

Needs: Seeking creative, fashionable, decorative art. Open to all styles. Considers oil, acrylic, watercolor and mixed media. Prefers wildlife, spiritual, figurative and nostalgic. Artists represented include Robert Bateman, Carl Brenders, Dan Smith, Terry Isaac, Peter Ellenshaw, Nita Engle, Greg Olsen, Arleta Pech, Paco Young and Maynard Reece. Editions created by collaborating with the artist or by working from an existing painting. Approached by 400-500 artists/year. publishes the work of 4-5 emerging, 5-10 mid-career and 15-20 established artists/year.

First Contact & Terms: Send query letter with photographs, résumé, SASE, slides, transparencies and description of artwork. Samples are not filed and are returned by SASE. Reports back within 1 year. Company will contact artist for portfolio review if interested. Pays royalties. Rights purchased vary according to project. Requires exclusive representation of artist. Provides advertising, in-transit insurance, insurance while work is at firm, promotion, shipping to and from firm and written contract. Finds artists through art exhibitions, submissions and word of mouth.

Tips: "We continue to expand the genre published. New art by seven artists was added in 1997, and four artists in the first quarter of 1998. Inspirational art has been part of expansion. Realism is our base but we are open to looking at all art."

‡MIXED-MEDIA, LTD., 3355 S. Highland Dr., Suite 109, Las Vegas NV 89109-3490. (702)796-8282. Fax: (702)794-0292. E-mail: mmlasvegas@aol.com. Contact: Brad Whiting. Estab. 1969. Distributor of posters. Clients: galleries, frame shops, decorators, hotels, architects and department stores.

Needs: Considers posters only. Artists represented include Adams, Behrens, Erte, Kimble, McKnight and many others. Distributes the work of hundreds of artists/year.

First Contact & Terms: Send finished poster samples. Samples not returned. Negotiates payment method and rights purchased.

Tips: "We have been in business for over 26 years. The style of artists and their art have changed through the years. Just because we may not accept one thing today, does not mean we will not accept it tomorrow. Don't give up!"

✔MORIAH PUBLISHING, INC., 23500 Mercantile Rd., Unit B, Beechwood OH 44122. (216)595-3131. Fax: (216)595-3140. Contact: Rouven R. Cyncynatus. Estab. 1989. Art publisher and distributor of limited editions. Clients: wildlife art galleries.

Needs: Seeking artwork for the serious collector. Editions created by working from an existing painting. Approached by 100 artists/year. Publishes the work of 6 and distributes the work of 15 emerging artists/year. Publishes and distributes the work of 10 mid-career artists/year. Publishes the work of 30 and distributes the work of 10 established artists/year.

First Contact & Terms: Send query letter with brochure showing art style, slides, photocopies, résumé, photostats, transparencies, tearsheets and photographs. Reports back within 2 months. Write for appointment to show portfolio or mail appropriate materials: rough, b&w, color photostats, slides, tearsheets, transparencies and photographs. Pays royalties. No advance. Buys reprint rights. Requires exclusive representation of artist. Provides in-transit insurance, promotion, shipping to and from firm, insurance while work is at firm, and a written contract.

Tips: "Artists should be honest, patient, courteous, be themselves, and make good art."

MULTIPLE IMPRESSIONS, LTD., 128 Spring St., New York NY 10012. (212)925-1313. Fax: (212)431-7146. President: Elizabeth Feinman. Estab. 1972. Art publisher and gallery. Publishes handpulled originals. Clients: young collectors, established clients, corporate, mature collectors.

Needs: Seeking creative art for the serious collector. Considers oil, watercolor, mixed media and printmaking. Prefers figurative, abstract, landscape. Editions created by collaborating with the artist. Approached by 100 artists/year. Publishes the work of 1 emerging, 1 mid-career and 1 established artist/year.

First Contact & Terms: Send query letter with slides and transparencies. Samples are not filed and are returned by SASE. To show a portfolio, send transparencies. Pays flat fee. Offers advance when appropriate. Buys all rights. Requires exclusive representation of artist.

‡MUSEUM EDITIONS WEST, 4130 Del Rey Ave., Marina Del Rey CA 90292. (310)822-2558. Fax: (310)822-3508. E-mail: jordanarts@aol.com. Director: Grace Yee. Poster company, distributor, gallery. Distributes unlimited editions, canvas transfers, posters. Clients: galleries, decorators, frame shops, distributors, architects, corporate curators, museum shops, giftshops. Current clients include: San Francisco Modern Art Museum and The National Gallery, etc.

Needs: Seeking creative, fashionable art for the commercial and designer markets. Considers oil, acrylic, watercolor, pastel. Prefers landscape, floral, abstract. Artists represented include John Botzy and Carson Gladson. Editions created by working from an existing painting. Approached by 150 artists/year. Publishes/distributes the work of 5 mid-career and 20 established artists/year. Also needs freelancers for design.

First Contact & Terms: Send query letter with brochure, photocopies, photographs, résumé, SASE, slides, tearsheets, transparencies. Samples are not filed and are returned by SASE. Reports back within 3 months. Company will contact artist for portfolio review of photographs, slides, tearsheets and transparencies if interested. Pays royalties of 8-10%. Offers advance when appropriate. Rights purchased vary according to project. Provides advertising, insurance while work is at firm, promotion, shipping from firm, written contract. Finds artists through art exhibitions, art fairs, word of mouth, submissions.

Tips: "Look at our existing catalog for samples."

MUSEUM MASTERS INTERNATIONAL, 26 E. 64th St., New York NY 10021. (212)759-0777. President: Marilyn Goldberg; Director of License: Lauren Rossan; Director of Administration: Lynn Miller. Distributor handling limited editions, posters, tapestry and sculpture for galleries, museums and gift boutiques. Current clients include the Boutique/Galeria Picasso in Barcelona, Spain and The Hakone Museum in Japan.
Needs: Seeking artwork with decorative appeal for the designer market. Considers oil, acrylic, pastel, watercolor and mixed media. Prefers individual works of art in unframed series. Also reproduces art images on boutique product. Artists represented include Pablo Picasso and Ichiro Tsuruta. Editions created by collaborating with the artist. Approached by 100 artists/year. Publishes and distributes the work of 3 emerging, mid-career and established artists/year.
First Contact & Terms: Send query letter with résumé, brochures and samples. Samples are filed or returned. Reports within 2 weeks. Call or write for appointment to show portfolio or mail slides and transparencies. Payment method is negotiated. Offers advance when appropriate. Negotiates rights purchased. Exclusive representation is not required. Provides insurance while work is at firm, shipping to firm and a written contract.
Tips: "We presently have demand for landscapes."

NATIONAL ART PUBLISHING CORP., 11000-32 Metro Pkwy., Ft. Myers FL 33912-1293. Fax: (941)939-7518. (941)936-2788. Website: http://www.artlithos.com. President: David H. Boshart. Estab. 1978. Art distributor, catalog publisher and internet marketer. Distributes limited and unlimited editions, offset reproductions, posters, sculpture, coins and metallic collectibles.
Needs: Seeking quality existing prints or serigraphs for distribution to the serious collector, commercial and designer markets. Considers oil, watercolor, mixed media, pastel, sculpture and acrylic. Considers all styles from realism to impressionism. Artists represented include Vivi Crandall, Richard Luce, Diane Pierce, Brent Townsend and Plasschaert. Editions created by working from an existing painting. Approached by 100 artists/year. Publishes 2-3 emerging, 2-3 mid-career and 2-3 established artists/year. Distributes the work of 10 emerging, 20 mid-career and 30 established artists/year.
First Contact & Terms: Send brochure, résumé, slides, photographs and transparencies. Samples returned by SASE if requested by artist. Reports back within 2 weeks. Publisher will contact artist for portfolio review if interested. Portfolio should include slides. Pays on consignment basis or negotiates payment. No advance. Rights purchased vary according to project. Provides advertising, in-transit insurance, shipping from firm, written contract, color catalog, videotape and access on the internet. Finds artists through sourcebooks, other publications and submissions.

NATIONAL WILDLIFE GALLERIES, 11000-33 Metro Parkway, Fort Myers FL 33912. (941)939-2425, (800)382-5278. Fax (941)936-2788. E-mail: art@artlithos.com. Website: http://www.artlithos.com and www.artfinders.com. Contact: David H. Boshart. Publisher/distributor of wildlife art
• This publisher also owns National Art Publishing Corp. but the two are separate entities. National Wildlife Galleries was established in 1990, when National Art Publishing Corp. acquired Peterson Prints.
Needs: Seeking paintings, graphics, posters for the fine art and commercial markets. Specializes in wildlife art. Artists represented include Larry Barton, Bill Burkett and Guy Coheleach.
First Contact & Terms: Send query letter, slides and SASE. Publisher will contact for portfolio review if interested.

THE NATURE'S WINDOW, P.O. Box 843501, Houston TX 77284. Market Director: Sandee Lichte. Art Publisher. Publishes unlimited edition canvas transfers. Clients: architects, corporations, decorators.
Needs: Seeking decorative art for the commercial and designer markets. Considers oil, acrylic and watercolor. Prefers landscape, floral, wildlife, impressionist and western themes. Editions created by working from an existing painting. Approached by 40 artists/year. Publishes the work of 2 emerging artists/year.
First Contact & Terms: Send query letter with photographs, slides, transparencies, tearsheets, résumé and SASE. Samples are not filed and are returned by SASE. Reports back within 3 months. Company will contact artist for portfolio review if interested. Portfolio should include final art, photographs, slides and tearsheets. Negotiates payment. Buys first rights. Provides advertising, insurance while work is at firm, promotion, shipping from firm and written contract. Finds artists through fairs, magazine ads and WWW.

✓**NEW DECO, INC.**, 23123 Sunfield Dr., Boca Raton FL 33433. (561)488-8041 or (800)543-3326. Fax: (561)488-9743. President: Brad Morris. Estab. 1984. Art publisher and distributor of limited editions using lithography and silkscreen for galleries. Also publishes/distributes unlimited editions and pool and billiard iamges for posters and prints. Clients: art galleries and designers.
• Also has listing in Greeting Cards, Gifts & Products section.
Needs: Interested in contemporary work. Artists represented are Robin Morris, Nico Vrielink and Lee Bomhoff. Needs new designs for reproduction. Publishes and distributes the work of 1-2 emerging, 1-2 mid-career and 1-2 established artists/year.
First Contact & Terms: Send brochure, résumé and tearsheets, photostats or photographs to be kept on file. Samples not filed are returned. Reports only if interested. Portfolio review not required. Publisher/Distributor will contact artist for portfolio review if interested. Pays flat fee or royalties of 7%. Also accepts work on consignment (firm receives 50% commission). Offers advance. Negotiates rights purchased. Provides promotion, shipping and a written contract. Negotiates ownership of original art. "We find most of our artists through *Artist's & Graphic Designer's Market* listing, advertising, trade shows and referrals."
Tips: Advises artists to attend the New York Art Expo.

NEW YORK GRAPHIC SOCIETY, P.O. Box 1469, Greenwich CT 06836-1469. (203)661-2400. President: Richard Fleischmann. Vice President: Owen Hickey. Estab. 1925. Publisher of offset reproductions, posters. Clients: galleries, frame shops and museums shops. Current clients include Deck The Walls, Ben Franklin, Prints Plus.
Needs: Considers oil, acrylic, pastel, watercolor, mixed media and colored pencil drawings. Publishes reproductions, posters. Publishes and distributes the work of numerous emerging artists/year. Art guidelines free with SASE. Response to submissions in 90 days.
First Contact & Terms: Send query letter with transparencies or photographs. All submissions returned to artists by SASE after review. Pays flat fee or royalty. Offers advance. Buys all print reproduction rights. Provides in-transit insurance from firm to artist, insurance while work is at firm, promotion, shipping from firm and a written contract; provides insurance for art if requested. Finds artists through submissions/self promotions, magazines, visiting art galleries, art fairs and shows.
Tips: "We publish a broad variety of styles and themes. We actively seek all sorts of fine decorative art."

NORTHLAND POSTER COLLECTIVE, Dept. AM, 1613 E. Lake St., Minneapolis MN 55407. (612)721-2273. Manager: Ricardo Levins Morales. Estab. 1979. Art publisher and distributor of handpulled originals, unlimited editions, posters and offset reproductions. Clients: mail order customers, teachers, bookstores, galleries, unions.
Needs: "Our posters reflect themes of social justice and cultural affirmation, history, peace." Artists represented include Ralph Fasanella, Karin Jacobson, Betty La Duke, Ricardo Levins Morales and Lee Hoover. Editions created by collaborating with the artist or by working from an existing painting.
First Contact & Terms: Send query letter with tearsheets, slides and photographs. Samples are filed or are returned by SASE. Reports back within months; if does not report back, the artist should write or call to inquire. Write for appointment to show portfolio. Payment method is negotiated. Offers an advance when appropriate. Negotiates rights purchased. Contracts vary but artist always retains ownership of artwork. Provides promotion and a written contract.
Tips: "We distribute work that we publish as well as pieces already printed. We print screen prints inhouse and publish one to four offset posters per year."

NOTTINGHAM FINE ART, 73 Gebig Rd., W. Nottingham NH 03291-0073. Phone/fax: (603)942-7089. President: Robert R. Lemelin. Estab. 1992. Art publisher, distributor. Publishes/distributes handpulled originals, limited editions, fine art prints, monoprints, monotypes, offset reproductions. Clients: galleries, frame shops, architects.
Needs: Seeking creative, fashionable, decorative art for the serious collector. Considers oil, acrylic, watercolor, mixed media, pastel. Prefers sporting, landscape, floral, creative, musical and lifestyle themes. Artists represented include Edward Gordon, Roger Blum, Rick Loudermilk, Barbie Tidwell, Judith Hall, Arthur Miller and Kathleen Cantin. Editions created by collaborating with the artist or by working from an existing painting. Approached by 10 artists/year.
First Contact & Terms: Send query letter with brochure, photographs, slides. Samples are filed or returned by SASE. Reports back within 2 months. Company will contact artist for portfolio review of color photographs, slides and transparencies if interested. Pays in royalties. Rights purchased vary according to project. Requires exclusive representation of artist. Provides advertising, insurance while work is at firm, promotion, shipping from firm, written contract. Finds artists through art fairs, submissions and referrals from existing customers.
Tips: "If you don't have a marketing plan developed or $5,000 you don't need, don't self-publish. We look for artists with consistent quality and a feeling to their work."

NOUVELLES IMAGES INC., 860 Canal St., Stamford CT 06902. (203)969-0509. Fax: (203)969-0889. Director: E. Nicholas Boulard. Estab. 1987. Publishes unlimited edition, fine art prints, offset reproduction and posters. Clients: galleries, decorators, frame shops, etc. Current clients include: all the 12,000 framers in the U.S.
Needs: Seeking creative and decorative art for the commercial and designer markets. Considers oil. Prefers classic to contemporary. Artists represented include Haring, Hopper, Kandinsky, Matisse, Dufy, Klee and Feininger. Edition created by collaborating with the artist or by working from an existing painting. Approached by 50 artists/year. Publishes the work of 12 emerging and a few established artists/year. Also needs freelancers for design. Prefers local designers.
First Contact & Terms: Send query letter with photographs, résumé, slides and transparencies. Samples are returned when requested. Company will contact artist for portfolio review of b&w and color if interested. Pays royalties. Offers advance when appropriate. Rights purchased vary according to project. Provides advertising, promotion and written contract. Finds artists through connections, research and artists' circles.

NOVA MEDIA INC., 1724 N. State, Big Rapids MI 49307. Phone/fax: (616)796-7539. E-mail: trund@nov.com. Website: http://www.nov.com. Editor: Tom Rundquist. Estab. 1981. Poster company, art publisher, distributor. Publishes/distributes limited editions, unlimited editions, fine art prints, posters. Current clients: various galleries.
Needs: Seeking creative art for the serious collector. Considers oil, acrylic. Prefers expressionism, impressionism, abstract. Editions created by collaborating with the artist or by working from an existing painting. Approached by 14 artists/year. Publishes/distributes the work of 2 emerging, 2 mid-career and 1 established artists/year. Also needs freelancers for design. Prefers local designers.
First Contact & Terms: Send query letter with photographs, résumé, SASE, slides, tearsheets. Samples are returned by SASE. Reports back within 2 weeks. Request portfolio review in original query. Company will contact artist for portfolio review of color photographs, slides, tearsheets if interested. Pays royalties of 10% or negotiates payment. No advance. Rights purchased vary according to project. Provides promotion.
Tips: Predicts colors will be brighter in the industry.

OAK TREE ART AGENCY, P.O. Box 1180, Dewey AZ 86327. (520)775-5077. Fax: (520)775-5585. Manager: William F. Cupp. Estab. 1989. Art publisher, distributor. Publishes/distributes limited editions, unlimited editions, canvas transfers, offset reproductions, licensing around the world. Clients: galleries, frame shops, distributors.
Needs: Seeking creative, decorative art for the commercial and designer markets. Considers oil, acrylic, mixed media. Interested in ethnic art. Artists represented include Jorge Tarallo Braun. Editions created by working from an existing painting.
First Contact & Terms: Send brochure, photographs, SASE, slides. Reports back only if interested. Company will contact artist for portfolio review of transparencies if interested. Pays flat fee. No advance. Rights purchased vary according to project. Provides advertising, insurance while work is at firm, shipping from firm.

‡OLD GRANGE GRAPHICS, 1590 Reed Rd., Suite B101, W. Trenton NJ 08628. (800)282-7776. Fax: (609)737-6875. President: Art Ernst. Estab. 1976. Distributor/canvs transfer studio. Publishes/distributes canvas transfers, posters. Clients: galleries, frame shops, museum shops, publishers, artists.
Needs: Seeking decorative art for the commercial and designer markets. Considers lithographs. Prefers prints of artworks that were originally oil paintings. Editions created by working from an existing painting. Approached by 100 artists/year.
First Contact & Terms: Send query letter with brochure. Samples are not filed and are returned. Reports back within 1 month. Will contact artist for portfolio review of tearsheets if interested. Negotiates payment. Rights purchased vary according to project. Provides promotion and shipping from firm. Finds artists through art publications.

‡OLD WORLD PRINTS, LTD., 468 South Lake Blvd., Richmond VA 23236. (804)378-7833. Fax: (804)378-7834. E-mail: owprints@erols.com. President: John Wurdeman. Estab. 1973. Art publisher and distributor of primarily open edition hand printed reproductions of antique engravings. Licenses antique engraving reproductions—all subject matter. Clients: retail galleries, frame shops and manufacturers.
● Old World Prints reports the top-selling art in their 2,500-piece collection includes African animals, urns and parrots.
Needs: Seeking traditional and decorative art for the commercial and designer markets. Specializes in handpainted prints. Considers "b&w (pen & ink or engraved) art which can stand by itself or be hand painted by our artists or originating artist." Prefers traditional, representational, decorative work. Editions created by collaborating with the artist. Distributes the work of more than 500 artists.
First Contact & Terms: Send query letter with brochure showing art style or résumé and tearsheets and slides. Samples are filed. Reports back within 6 weeks. Write for appointment to show portfolio of photographs, slides and transparencies. Pays flat fee of $200-500/piece and royalties of 10% or on a consignment basis: firm receives 50% commission. Offers an advance when appropriate. Negotiates rights purchased. Provides in-transit insurance, insurance while work is at firm, promotion, shipping from firm and a written contract. Finds artists through word of mouth.
Tips: "We are a specialty art publisher, the largest of our kind in the world. We reproduce only black & white engraving, pen & ink and b&w photogravures. All of our pieces are handpainted."

✔OPUS ONE PUBLISHING, (formerly Opus One/Scandecor Development AB), P.O. Box 1469, Greenwich CT 06836-1469. (203)661-2400. Fax: (203)661-2480. Publishing Director: James Munro. Estab. 1970. Art Publisher. Publishes open editions, offset reproductions, posters, cards.
● Opus One was formerly a part of Scandecor. It is now a division of New York Graphic Society.
Needs: Seeking creative, fashionable and decorative art for the commercial and designer markets. Considers all media. Artists represented include Kate Frieman, Jack Roberts, Jean Richardson, Richard Franklin, Lee White. Approached by 100 artists/year. Publishes the work of 20% emerging, 20% mid-career and 60% established artists.
First Contact & Terms: Send brochure, tearsheets, slides, photographs, photocopies, transparencies. Samples are not filed and are returned. Reports back within 1 month. Artist should follow up with call after initial query. Portfolio should include final art, slides, transparencies. Negotiates payment. Offers advance when appropriate. Rights purchased vary according to project.
Tips: "Please attend the Art Expo New York City trade show."

‡PALM DESERT ART PUBLISHERS, 39-725 Garand Lane, Suite J, Palm Desert CA 92211. (888)360-9046. Fax: (760)345-7671. Owner: Hugh Pike. Director: Susan Gibson Brown. Estab. 1996. Art Publisher. Publishes handpulled originals and limited edition fine art prints. Clients: galleries, art dealers, designers, frame shops, art consultants. Current clients include: Ambassador Galleries, Studio of Long Grove Merrill Chase, TC-Frame.
Needs: Seeking creative, fashionable and decorative art for the commercial and designer markets. Considers oil, acrylic, watercolor, mixed media, pastel, pen & ink and collage. Prefers landscapes, florals, figures, interiors, architecture, contemporary abstract, wildlife. Artists represented include Patricia Nix, "Elyse," Zanella, Weilang Zhao. Editions created by collaborating with the artist and working from an existing painting. Approached by 100 artists/year. Publishes/distributes the work of 1 emerging, 2 mid-career and 3 established artists/year.
First Contact & Terms: Send query letter with brochure, photocopies, photographs, résumé, SASE, tearsheets, exhibition list, significant corporate collectors or private collectors. Samples are filed or returned by SASE. Artist should call to set up appointment. Company will arrange for portfolio review if interested. Negotiates payment. Individual compensation packages are developed. Offers advance when appropriate. Negotiates rights purchased. Usually requires exclusive representation of artist unless a previous agreement binds the artist to a limited contrast. Provides advertising,

in-transit insurance, insurance while work is at firm, promotion, contract and sometimes shipping. Finds artists through art exhibitions, art fairs, word of mouth. "We live our jobs and are always keeping an eye out for talented artists."
Tips: "Subscribe to 2-3 trade magazines and read them every month. Stay attuned to color trends that emerge first in fashion and home decor. Watch in business reports for popular trends—these dictate imagery. All of these, plus be prolific, consistant and try to develop a business sense when approaching galleries and publishers. Leave your emotional baggage at home. Have realistic income expectations. It makes no difference if artist has computer skills—we would rather have an artist who can produce 40 originals a year!!"

‡PANACHE EDITIONS LTD, 234 Dennis Lane, Glencoe IL 60022. (847)835-1574. President: Donna MacLeod. Estab. 1981. Art publisher and distributor of offset reproductions and posters. Clients: galleries, frame shops, domestic and international distributors. Current clients are mostly individual collectors.
Needs: Considers acrylic, pastel, watercolor and mixed media. "Looking for contemporary compositions in soft pastel color palettes; also renderings of children on beach, in park, etc." Artists represented include Bart Forbes, Peter Eastwood and Carolyn Anderson. Prefers individual works of art and unframed series. Publishes and distributes work of 1-2 emerging, 2-3 mid-career and 1-2 established artists/year.
First Contact & Terms: Send query letter with brochure showing art style or photographs, photocopies and transparencies. Samples are filed. Reports back only if interested. To show portfolio, mail roughs and final reproduction/product. Pays royalties of 10%. Negotiates rights purchased. Requires exclusive representation of artist. Provides in-transit insurance, insurance while work is at firm, promotion, shipping to and from firm and written contract.
Tips: "We are looking for artists who have not previously been published [in the poster market] with a strong sense of current color palettes. We want to see a range of style and coloration. Looking for a unique and fine art approach to collegiate type events, i.e., Saturday afternoon football games, Founders Day celebrations, homecomings, etc. We do not want illustrative work but rather an impressionistic style that captures the tradition and heritage of one's university. We are very interested in artists who can render figures."

✔PARADISE PRINTS, INC., 223 S. Main St., Livingston MT 59047. Mailing Address: P.O. Box 102, Livingston MT 59047. (406)222-5974 or (800)313-6078. Fax: (406)222-5820. E-mail: paradise@alpinet.net. Website: http://www.p aradise.simplenet.com. President: David C. Lewis. Distributor/gallery dealing in sales of existing limited edition prints. Licensing: Susan Christian. Licenses wildlife, western, angling, scenic, inspirational art for various media/output ("we have used artwork for CD and cassette covers, booklets and J cards also").
 • Also see listing in Galleries. If you self-publish your own prints consider the option of selling them through distributor/galleries, such as this one. Paradise Prints inhabits a 3,200 sq. ft. facility on main street in downtown Livingston. The gallery employs a sales force of six full-time and two part-time sales persons. They also sell prints through their website. According to the company's president, gross sales in 1997 topped one-half million.
Needs: Considers all types of prints to sell in gallery and through www. Prefers framed limited edition prints of Realistic portrayals of scenic sites throughout the US and the world, especially National Parks, waterfalls, wildlife, angling, scenic, Americana, inspirational, religious, angel, New Age, classical, baroque art—preferably oil, acrylic and photography. No modern art, psychedelic art or nudism.
First Contact & Terms: Send clear slides of published prints. Negotiates payment. 25% of consignment in most cases, includes gallery, internet sales, prints and T-shirts.
Tips: "For our market, realism is the key, as well as intense detail work. We also provide internet artist services for $250 setup for web page plus $25 per image and return postage for images."

PENNY LANE PUBLISHING INC., 1791 Dalton Dr., New Carlisle OH 45344. (937)849-1101. Fax: (937)849-9666. Art Coordinator: Theresa Slivinski. Estab. 1993. Art publisher. Publishes limited editions, unlimited editions, offset reproductions. Clients: galleries, frame shops, distributors, decorators.
Needs: Seeking creative, decorative art for the commercial market. Considers oil, acrylic, watercolor, mixed media, pastel. Artists represented include L. Spivey, M. McMenamin, J.O. Yearby and D. Lovitt. Editions created by collaborating with the artist or working from an existing painting. Approached by 40 artists/year. Publishes the work of 3-4 emerging, 18 mid-career and 18 established artists/year.
First Contact & Terms: Send query letter with brochure, résumé, photographs, slides, tearsheets. Samples are filed or returned by SASE. Reports back within 2 weeks. Company will contact artist for portfolio review of color, final art, photographs, slides, tearsheets if interested. Pays royalties. Buys first rights. Requires exclusive representation of artist. Provides advertising, shipping from firm, promotion, written contract. Finds artists through art exhibitions, art fairs, submissions, decorating magazines.
Tips: Advises artists to be aware of current color trends and work in a series.

‡PGM ART WORLD, P.O. Box 110, New Haven VT 05472. (802)453-3733. Fax: (802)453-6680. General Manager: Gary Nihsen. Estab. 1995. (German office established 1969.) International fine art publisher, distributor, gallery. Publishes/distributes limited and unlimited edition, offset reproductions, posters. Clients: world-wide supplier of galleries, framers, distributors, decorators.
 • This publisher's main office is in Germany. PGM publishes more than 300 images and distributes more than 6,000 images in Europe and Asia. The company also operates four galleries in Munich. General manager Gary Nihsen requests that artists living in North America send samples to the New Haven, Vermont office. Artists resideing outside of North America should send samples to PGM's main office: PGM Artworld, Carl-von-Linde-

Str. 33, 85748 Garching, Germany. Phone 011-49-89-3292381. Fax: 011-49-89-3207745. Publishing Manager: Andrea Kuborn.

Needs: Seeking creative, fashionable and decorative art for the commercial and designer markets. Considers oil, acrylic, watercolor, mixed media, pastel, pen & ink. Considers any well accomplished work of any theme or style. Artists represented include Renato Casaro, Diane French-Gaugush Hundertwasser, Fred Hunt, Patricia Nix, Nina Nolte, Roy Schallenberg. Editions created by working from an existing painting. Approached by 100 artists/year. Publishes the work of 25 artists/year.

First Contact & Terms: Send query letter with photographs, résumé, SASE, slides, transparencies. Samples are not filed and are returned by SASE. Reports back within 3 months. Will contact artist for portfolio review if interested. Pays royalties; negotiable. Does not require exclusive representation of artist. Provides advertising, promotion, written contract.

‡PLANET WEST PUBLISHERS, P.O. Box 34033, Las Vegas NV 89133-4033. Phone/fax: (702)242-6752. E-mail: asktoddart@aol.com. Contact: Todd Bingham. Estab. 1995. Art publisher. Publishes graphics and reproductions. Clients: galleries and direct consumer sales.

• Todd Bingham offers marketing advice to artists on his Website (Path: AOL, Keyword *Image Exchange*; Galleries; Member's Showcase; ASKTODDART.)

Needs: Seeking creative art. Artists represented include Bedard, Cassidy, Greer, Morton. Editions created by collaborating with the artist and by working from an existing painting. Publishes the work of 1 emerging, 1 mid-career and 1 established artists/year. Also needs freelancers for design. Prefers designers who own Mac computers and are experienced in Adobe Illustrator and Adobe Photoshop.

First Contact & Terms: Send letter with résumé, SASE and transparencies. Accepts disk submissions compatible with Mac format, Adobe Illustrator, Adobe Photoshop. Samples are not filed and are returned by SASE. Reports back within 10 days. Company will contact artist for portfolio review if interested. Payment negotiable. Offers advance when appropriate. Rights purchased vary according to project. Provides advertising, in-transit insurance, insurance while work is at firm, promotion, shipping from our firm, written contract, career direction.

✐PORTAL PUBLICATIONS, LTD., 201 Alameda del Prado, Suite 200, Novato CA 94949. (415)884-6200. Vice President of Creative: Pamela Prince. Estab. 1954. Poster company and art publisher. Published limited edition prints and posters.

• See listing in Greeting Cards, Gifts & Products section.

✐*PORTER DESIGN—EDITIONS PORTER, The Old Estate Yard, Newton St. Loe, Bath, Somerset BA2 9BR, England. (01144)1225-874250. Fax: (01144)1225-874251. US Address: 38 Anacapa St., Santa Barbara CA 93101. (805)568-5433. (805)568-5435. Partners: Henry Porter, Mary Porter. Estab. 1985. Publishes limited and unlimited editions and offset productions and hand-colored reproductions. Clients: international distributors, interior designers and hotel contract art suppliers. Current clients include Devon Editions, Art Group, Harrods and Bruce McGaw.

Needs: Seeking fashionable and decorative art for the designer market. Considers watercolor. Prefers 17th-19th century traditional styles. Artists represented include Alexandra Churchill, Caroline Anderton, Victor Postolle, Joseph Hooker and Adrien Chancel. Editions created by working from an existing painting. Approached by 10 artists/year. Publishes and distributes the work of 10-20 established artists/year.

First Contact & Terms: Send query letter with brochure showing art style or résumé and photographs. Accepts disk submissions compatible with QuarkXPress on Mac. Samples are filed or are returned. Reports back only if interested. To show portfolio, mail photographs. Pays flat fee or royalties. Offers an advance when appropriate. Negotiates rights purchased.

PORTFOLIO GRAPHICS, INC., 4060 S. 500 W., Salt Lake City UT 84123. (801)266-4844. Fax: (801)263-1076. Website: http://www.sisna.com/graph/home.htm. Creative Director: Kent Barton. Estab. 1986. Publishes and distributes limited editions, unlimited editions and posters. Clients: galleries, designers, poster distributors (worldwide) and framers. Licensing: All artwork is available for license for large variety of products. Portfolio Graphics works with a large licensing firm who represents all of their imagery.

Needs: Seeking creative, fashionable and decorative art for commercial and designer markets. Considers oil, watercolor, acrylic, pastel, mixed media and photography. Publishes 30-50 new works/year. Artists represented include Dawna Barton, Ovanes Berberian, Del Gish, Michael Coleman and Kent Wallis. Editions created by working from an existing painting or transparency.

First Contact & Terms: Send query letter with résumé, biography, slides and photographs. Accepts disk submissions compatible with Adobe Illustrator and QuarkXPress. Send TIFF (preferred) or EPS files. Samples are not filed. Reports back within months. To show portfolio, mail slides, transparencies and photographs with SASE. Pays $100 advance against royalties of 10%. Buys reprint rights. Provides promotion and a written contract.

Tips: "We are currently adding 50 new images to our binder catalog and we'll continue to add new supplemental pages twice yearly. We find artists through galleries, magazines, art exhibits, submissions. We're looking for a variety of artists and styles/subjects." Advises artists to attend Art Expo New York City and Art Buyer Caravan (at various locations throughout the year).

✐POSNER FINE ART, 117 Fourth St., Manhattan Beach CA 90266. (310)260-8858. Fax: (310)260-8860. Director: Judith Posner. Estab. 1994. Art distributor and gallery. Distributes fine art prints, monoprints, sculpture and paintings.

Clients: galleries, frame shops, distributors, architects, corporate curators, museum shops. Current clients include: Arthur Andersen Co.

Needs: Seeking creative art for the serious collector and commercial market. Considers oil, acrylic, watercolor, mixed media, sculpture. Prefers very contemporary style. Artists represented include John Bose, Soja Kim, David Hockney, Robert Indiana. Editions created by collaborating with the artist. Approached by hundreds of artists/year. Distributes the work of 5-10 emerging, 5 mid-career and 200 established artists/year.

First Contact & Terms: Send slides. "Must enclose self-addressed stamped return envelope." Samples are filed or returned. Reports back within a few weeks. Pays on consignment basis: firm receives 50% commission. Buys one-time rights. Provides advertising, promotion, insurance while work is at firm. Finds artists through art fairs, word of mouth, submissions, attending exhibitions, art reps.

Tips: "Know color trends of design market."

‡POSTER PORTERS, P.O. Box 9241, Seattle WA 98109-9241. (206)286-0818. Fax: (206)286-0820. E-mail: marksim ard@posterportus.com. Marketing Director: Mark Simard. Art publisher/distributor/gift wholesaler. Publishes/distributes limited and unlimited edition, posters and art T-shirts. Clients: galleries, decorators, frame shops, distributors, corporate curators, museum shops, giftshops. Current clients include: Prints Plus, W.H. Smith, Smithsonian, Nordstrom.

Needs: Publishes/distributes creative art for regional commercial and designer markets. Considers oil, watercolor, pastel. Prefers regional, whimsical art. Artists represented include Beth Logani, Carolin Oltman, Jean Castaline, M.J. Johnson. Editions created by collaborating with the artist, working from an existing painting. Approached by 144 artists/year. Publishes the work of 2 emerging, 2 mid-career and 1 established artist/year. or Distributes the work of 50 emerging, 25 mid-career, 20 established artists/year.

First Contact & Terms: Send photocopies, SASE, tearsheets. Accepts disk submissions. Samples are filed or returned by SASE. Will contact artist for Friday portfolio drop off. Pays flat fee: $225-500; royalties of 5%. Offers advance when appropriate. Buys all rights. Provides advertising, promotion, contract. Also works with freelance designers. Prefers local designers only. Finds artists through exhibition, art fairs, through art reps, submissions.

Tips: "Be aware of what is going on in the interior design sector. Be able to take criticism."

♣POSTERS INTERNATIONAL, 1200 Castlefield Ave., Toronto, Ontario M6B 1G2. (416)789-7156. Fax: (416)789-7159. President: Esther Cohen. Estab. 1976. Poster company, art publisher. Publishes fine art posters. Clients: galleries, decorators, distributors, hotels, restaurants etc., in U.S., Canada and International. Current clients include: McDonalds, Holiday Inn.

Needs: Seeking creative, fashionable art for the commercial market. Considers oil, acrylic, watercolor, mixed media. Prefers landscapes, florals, collage, architecturals, classical (no figurative). Artists represented include Elizabeth Berry, Catherine Hobart, Fenwick Bonnell, Julie McCarroll. Editions created by collaborating with the artist or by working from an existing painting. Approached by 100 artists/year. Publishes the work of 12 emerging, 10 mid-career artists. Distributes the work of 50 emerging artists/year.

First Contact & Terms: Send query letter with brochure, photographs, slides, transparencies. Samples are filed or returned by SASE. Reports back within 1-2 months. Company will contact artist for portfolio review of photographs, photostats, slides, tearsheets, thumbnails, transparencies if interested. Pays flat fee or royalties of 10%. Offers advance when appropriate. Rights purchased vary according to project. Requires exclusive representation of artist for posters. Provides advertising, promotion, shipping from firm, written contract. Finds artists through art fairs, art reps, submissions.

Tips: "Be aware of current color trends—work in a series (of two)."

THE PRESS CHAPEAU, Govans Station, Box 4591, Baltimore City MD 21212-4591. Director: Elspeth Lightfoot. Estab. 1976. Publishes original prints only, "in our own atelier or from printmaker." Clients: architects, interior designers, corporations, institutions and galleries.

Needs: Considers original handpulled etchings, lithographs, woodcuts and serigraphs. Prefers professional, highest museum-quality work in any style or theme. "Suites of prints are also viewed with enthusiasm." Prefers unframed series.

First Contact & Terms: Send query letter with slides. Samples not filed are returned by SASE. Reports back within 5 days. Write for appointment to show portfolio of slides. Payment method is negotiated. Offers advance. Purchases 51% of edition or right of first refusal. Does not require exclusive representation. Provides insurance, promotion, shipping to and from firm and a written contract. Finds artists through agents.

Tips: "Our clients are interested in investment quality original handpulled prints. Your résumé is not as important as the quality and craftsmanship of your work."

PRESTIGE ART INC., 3909 W. Howard St., Skokie IL 60076. (847)679-2555. E-mail: prestige@prestigeart.com. Website: http://www.prestigeart.com. President: Louis Schutz. Estab. 1960. Publisher/distributor/art gallery. Represents a combination of 18th and 19th century work and contemporary material. Publishes and distributes handpulled originals, limited and unlimited editions, canvas transfers, fine art prints, offset reproductions, posters, sculpture. Licenses artwork for note cards, puzzles, album covers and posters. Clients: galleries, decorators, architects, corporate curators.

● Company president Lonis Shutz now does consultation to new artists on publishing and licensing their art in various mediums.

Needs: Seeking creative and decorative art. Considers oil, acrylic, mixed media, sculpture, glass. Prefers figurative art, impressionism, surrealism/fantasy, photo realism. Artists represented include Jean-Paul Avisse. Editions created by

collaborating with the artist or by working from an existing painting. Approached by 15 artists/year. Publishes the work of 2 emerging and 2 established artists/year. Distributes the work of 5 emerging and 100 established artists/year.

First Contact & Terms: Send query letter with résumé and tearsheets, photostats, slides, photographs and transparencies. Accepts IBM compatible disk submissions. Samples are not filed and are returned by SASE. Reports back only if interested. Company will contact artist for portfolio review of tearsheets if interested. Pays flat fee. Offers an advance when appropriate. Rights purchased vary according to project. Provides insurance in-transit and while work is at firm, advertising, promotion, shipping from firm and written contract.

Tips: "Be professional. People are seeking better quality, lower-sized editions, less numbers per edition—1/100 instead of 1/750."

PRIME ART PRODUCTS, 5772 N. Ocean Shore Blvd., Palm Coast FL 32137. (904)445-3851. Fax: (904)445-6057. Owner: Dee Abraham. Estab. 1990. Art publisher, distributor. Publishes/distributes limited editions, unlimited editions, fine art prints, offset reproductions. Clients include: galleries, specialty giftshops, interior design and home accessory stores.

Needs: Seeking art for the commercial and designer markets. Considers oil, acrylic, watercolor. Prefers realistic wildlife, magnolias and shore birds. Artists represented include Robert Binks, Luke Buck, Art LaMay and Barbara Klein Craig. Editions created by collaborating with the artist or by working from an existing painting. Approached by 30 artists/year. Publishes the work of 1-2 emerging artists/year. Distributes the work of many emerging and 4 established artists/year.

First Contact & Terms: Send photographs, SASE and tearsheets. Samples are filed or returned by SASE. Reports back within 5 days. Company will contact artist for portfolio review if interested. Negotiates payment per signature. Offers advance when appropriate. Rights purchased vary according to project. Finds artists through submissions and small art shows.

Tips: "Color is extremely important."

‡**THE PRINTS AND THE PAPER**, 473 Park St., Upper Montclair NJ 07043. (973)783-6524. Fax: (973)783-6524. Estab. 1996. Distributor of handpulled originals, limited and unlimited edition antiques and reproduced illustration, prints and offset reproduction. Clients: galleries, decorators, frame shops, giftshops.

Needs: Seeking decorative art. Considers watercolor, pen & ink. Prefers illustration geared toward children; also florals. Artists represented include Helga Hislap, Raymond Hughes, Dorothy Wheeler, Arthur Rackham, Richard Doyle. Editions created by working from an existing painting or print. Distributes 2 mid-career and established artists/year.

First Contact & Terms: Send query letter with SASE, slides. Samples are filed or returned by SASE. Will contact artist for portfolio review of slides if interested. Negotiates payment. Offers advance when appropriate. Rights purchased vary according to project. Finds artists through art exhibitions, word of mouth.

Tips: "We are a young company (2 years). We have not established all guidelines. We are attempting to establish a reputation for having quality illustration which covers a broad range."

‡**PROGRESSIVE EDITIONS**, 418 Queen St., Toronto, Ontario M5A 1T4 Canada. (416)860-0983. Fax: (416)367-2724. President: Mike Havers. Estab. 1982. Art publisher. Publishes handpulled originals, limited edition fine art prints and monoprints. Clients: galleries, decorators, frame shops, distributors.

Needs: Seeking creative and decorative art for the serious collector and designer market. Considers oil, acrylic, watercolor, mixed media, pastel. Prefers figurative, abstract, landscape and still lifes. Artists represented include Eric Waugh, Issa Shojaei, Doug Edwards, Marsha Hammel. Editions created by working from an existing painting. Approached by 100 artists/year. Publishes the work of 4 emerging, 10 mid-career, 10 established artists/year. Distributes the work of 10 emerging, 20 mid-career, 20 established artists/year.

First Contact & Terms: Send query letter with photographs, slides. Samples are not filed and are returned. Reports back within 1 month. Will contact artist for portfolio review if interested. Negotiates payment. Offers advance when appropriate. Negotiates rights purchased. Requires exclusive representation of artist. Provides advertising, in-transit insurance, insurance while work is at firm, promotion, shipping and contract. Finds artists through exhibition, art fairs, word of mouth, art reps, sourcebooks, submissions, competitions.

Tips: "Develop organizational skills."

THE RED BALLOON GALLERY, 3701 S. Main St., Elkhart IN 46517. (219)875-5447. Owner: Steven Hite. Estab. 1993. Distributor and gallery. Distributes unlimited edition posters. Clients: galleries, frame shops and giftshops. Current clients include Marriott Co., Sears and Art Avenue.

Needs: Seeking creative art. Considers acrylic, watercolor, pastel and pen & ink. Prefers sports and Christian themes. Artists represented include Ron DiCianni, Don Aceto and Don Stacy. Editions created by collaborating with the artist or by working from an existing painting. Approached by 6-10 artists/year. Distributes the work of 2 emerging, 3 mid-career and 4 established artists/year. "We now distribute limited edition prints."

First Contact & Terms: Send brochure, photocopies, photographs, slides, tearsheets and transparencies. Reports back within 1 month. Company will contact artist for portfolio review of b&w, color, photographs, slides and transparencies. Pays on consignment basis, firm receives 20% commission. No advance. Negotiates rights purchased. Provides advertising, in-transit insurance, insurance while work is at firm, promotion, shipping from firm and written contract. Finds artists through art exhibitions, art fairs, word of mouth and watching art competitions.

RIGHTS INTERNATIONAL GROUP, 463 First St., #3C, Hoboken NJ 07030. (201)963-3123. Fax: (201)420-0679. E-mail: hazaga@aol.com. Contact: Robert Hazaga. Estab. 1996. Agency for cross licensing. Represents artists for

licensing into publishing, stationery, giftware, home furnishing. Clients: galleries, decorators, frame shops, distributors, giftware manufacture, stationery, poster, limited editions publishers, home furnishing manufacturers. Clients include: Scandecor, Nobleworks, Studio Oz, New York Graphic Society, Editions Ltd.
 ● This company is also listed in the Greeting Card, Gifts & Products section.
Needs: Seeking creative, decorative art for the commercial and designer markets. Also looking for textile art. Considers oil, acrylic, watercolor, mixed media, pastel. Prefers commercial style. Artists represented include Gillian Campbell, Camille Pzrewodek, Possi, Planet Art Group, Warabe Aska. Approached by 50 artists/year.
First Contact & Terms: Send brochure, photocopies, photographs, SASE, slides, tearsheets, transparencies. Accepts disk submissions compatible with Adobe Illustrator. Samples are not filed and are returned by SASE. Reports back within 2 months. Company will contact artist for portfolio review if interested. Negotiates payment.

❖RIVER HEIGHTS PUBLISHING INC., 720 Spadina Ave., Suite 501, Toronto, Ontario M5S 2T9 Canada. (416)922-0500. Fax: (416)922-6191. Publisher: Paul Swartz. Art publisher. Publishes limited editions, unlimited editions, fine art prints, offset reproductions, sculpture. Clients: galleries, frame shops, marketing companies, corporations, mail order, chain stores, barter exchanges.
Needs: Seeking decorative art for the commercial market. Considers oil, acrylic, watercolor, sculpture. Prefers wildlife, Southwestern, American Indian, impressionism, nostalgia and Victorian (architecture). Artists represented include A.J. Casson, Paul Rankin, George McLean, Rose Marie Condon. Editions created by collaborating with the artist. Approached by 50 artists/year. Publishes the work of 1 emerging, 2 mid-career, 1 established artists/year. Distributes the work of 3 emerging, 2 mid-career and 3 established artists/year.
First Contact & Terms: Send photographs, résumé, SAE (nonresidents include IRC), slides, tearsheets. Samples are not filed and are returned by SAE. Reports back within 3 weeks. Company will contact artist for portfolio review of final art if interested. Pays flat fee, royalties and/or consignment basis. Rights purchased vary according to project. Requires exclusive representation of artist. Provides advertising, insurance, promotion, shipping from firm, written contract and samples on greeting cards, calendars.

‡IRA ROBERTS LTD., 6321 E. Alondra Blvd., Paramount CA 90723. (562)272-1462. Fax: (562)272-1472. Art Director: Ralph Tepedino. Estab. 1964. Poster company/art publisher/distributor. Publishes/distributes limited and unlimited edition canvas transfers, fine art prints, offset reproduction and posters. Clients: galleries, decorators, frame shops, museum shops, giftshops and mass market clients.
Needs: Seeking creative, fashionable and decorative art for the commercial market. Considers oil, acrylic, watercolor, mixed media, pastel and pen & ink. Open to all styles. Artists represented include Robert Owen, Sergon. Editions created by working from an existing painting. Approached by 100 artists/year. Publishes/distributes the work of 3-5 emerging, 10 mid-career and 10 established artists/year.
First Contact & Terms: Send brochure, photographs, slides, tearsheets, transparencies. Samples are not filed and are returned. Reports back within 1 month. Will contact artist for portfolio review if interested. Pays flat fee, royalties or negotiates payment. Offers advance when appropriate. Rights purchased vary according to project. Requires exclusive representation of artist. Provides advertising, insurance while work is at firm, promotion and contract. Finds artists through art exhibitions, art fairs, word of mouth.

‡ROMM ART CREATIONS, LTD., Maple Lane, P.O. Box 1426, Bridgehampton NY 11932. (516)537-1827. Fax: (516)537-1752. Contact: Steven Romm. Estab. 1987. Art publisher. Publishes unlimited editions, posters and offset reproductions. Clients: distributors, galleries, frame shops.
Needs: Seeking decorative art for the commercial and designer markets. Considers oil, watercolor, mixed media, pastel, acrylic and photography. Prefers traditional and contemporary. Artists represented include Tarkay, Wohlfelder, Switzer. Editions created by collaborating with the artist or by working from an existing painting. Publishes the work of 10 emerging, 10 mid-career and 10 established artists/year.
First Contact & Terms: Send query letter with slides and photographs. Samples are not filed and are returned by SASE if requested by artist. Reports back to the artist only if interested. Publisher will contact artist for portfolio review if interested. Pays royalties of 10%. Offers advance. Rights purchased vary according to project. Requires exclusive representation of artist for posters only. Provides promotion and written contract.
Tips: Advises artists to attend Art Expo and to visit poster galleries to study trends. Finds artists through attending art exhibitions, agents, sourcebooks, publications, submissions.

***FELIX ROSENSTIEL'S WIDOW & SON LTD.,** 33-35 Markham St., London SW3 3NR England. (0171)581-5245. Fax: (0171)581-9008. Contact: Miss Lucy Grieve. Licensing: Miss Justine Egan. Estab. 1880. Publishes handpulled originals, limited edition, canvas transfers, fine art prints and offset reproductions. Licenses all subjects on any quality product.
Needs: Seeking decorative art for the serious collector and the commercial market. Considers oil, acrylic, watercolor, mixed media and pastel. Prefers art suitable for homes or offices. Artists represented include Spencer Hodge, Claire Burton, Adriano Manocchia and Richard Ackerman. Editions created by collaborating with the artist or by working from an existing painting. Approached by 200-500 artists/year.
First Contact & Terms: Send query letter with photographs. Samples are not filed and are returned by SAE. Reports back within 2 weeks. Company will contact artist for portfolio review of final art and transparencies if interested. Negotiates payment. Offers advance when appropriate. Rights purchased vary according to project.

RUSHMORE HOUSE PUBLISHING, 101 E. 38th St., Box 1591, Sioux Falls SD 57101. (605)334-5253. Fax: (605)334-6630. Publisher: Stan Cadwell. Estab. 1989. Art publisher and distributor of limited editions. Clients: art galleries and picture framers.
Needs: Seeking artwork for the serious collector and commercial market. Considers oil, watercolor, acrylic, pastel and mixed media. Prefers realism, all genres. Artists represented include John C. Green, Mary Groth, W.M. Dillard, Patricia Johnson, Sandra Roberts and Tom Phillips. Editions created by collaborating with the artist. Approached by 100 artists/year.
First Contact & Terms: Send query letter with résumé, tearsheets, photographs and transparencies. Samples are filed or are returned by SASE if requested by artist. Reports back within 1 month. Write for appointment to show portfolio of original/final art, tearsheets, photographs and transparencies. Payment method is negotiated. Offers an advance when appropriate. Negotiates rights purchased. Exclusive representation of artist is negotiable. Provides in-transit insurance, insurance while work is at firm, promotion, shipping and written contract. "We market the artist and their work."
Tips: "We are looking for artists who have perfected their skills and have a definite direction in their work. We work with the artist on developing images and themes that will succeed in the print market and aggressively promote our product to the market. Current interests include: wildlife, sports, Native American, Western, landscapes and florals."

SAGEBRUSH FINE ART, 285 West 2855, South, Salt Lake City UT 84115. (801)466-5136. Fax: (801)466-5048. Art Review Coordinator: Rubyn Marshall. Estab. 1991. Art publisher. Publishes fine art prints and offset reproductions. Clients: frame shops, distributors, corporate curators and chain stores.
Needs: Seeking decorative art for the commercial and designer markets. Considers oil, acrylic, watercolor and photography. Prefers traditional themes and styles. Editions created by collaborating with the artist or by working from an existing painting. Approached by 200 artists/year. Publishes the work of 20 emerging artists/year.
First Contact & Terms: Send SASE, slides and transparencies. Samples are not filed and are returned by SASE. Reports back within 3 weeks. Company will contact artist for portfolio review if interested. Pays royalties of 10% or negotiates payment. Offers advance when appropriate. Rights purchased vary according to project. Provides advertising, promotion, shipping from firm and written contract.

‡ST. ARGOS CO., INC., 11040 W. Hondo Pkwy., Temple City CA 91780. (626)448-8886. Fax: (626)579-9133. Manager: Paul Liang. Estab. 1987. Produces Christmas decorations, including ornaments; also giftwrap, boxes, bags, cards and puzzles.
Needs: Approached by 3 artists/year. Works with 2 freelance artists/year. Prefers artists with experience in Victorian or country style. Uses freelance artists mainly for design. Submit seasonal material 6 months in advance.
First Contact & Terms: Send query letter with résumé and slides. Samples are filed. Will contact artist for portfolio review if interested. Portfolio should include color samples. Pays royalties of 7.5%. Negotiates rights purchased.

THE SAWYIER ART COLLECTION, INC., 3445-D Versailles Rd., Frankfort KY 40601. (800)456-1390. Fax: (502)695-1984. President: William H. Coffey. Distributor. Distributes limited and unlimited editions, posters and offset reproductions. Clients: retail art print and framing galleries.
Needs: Seeking fashionable and decorative art. Prefers floral and landscape. Artists represented include Mary Bertrand, Donna Brooks, Robert Conely, Vivian Flasch, Lena Liu, Bobby Sikes, Janice Sumler and John Warr. Distributes prints for 14 art publishers, including Art In Motion, Editions Limited, Rosenstiel's and Winn Devon. Approached by 100 artists/year. Distributes the work of 10 emerging, 50 mid-career and 10 established artists/year.
First Contact & Terms: Send query letter with tearsheets. Samples are not filed and are not returned. Reports back to the artist only if interested. Distributor will contact artist for portfolio review if interested. Portfolio should include color tearsheets. Buys work outright. No advance. Finds artists through publications (*Decor, Art Business News*), retail outlets.

⌐SCAFA-TORNABENE ART PUBLISHING CO. INC., 276 Fifth Ave., Suite 202, New York NY 10001. (212)779-0700, ext. 256. Fax: (212)779-3135. Art Coordinator: Jim Nicoletti. Produces unlimited edition offset reproductions. Clients: framers, commercial art trade and manufacturers worldwide. Licenses florals, still lifes, landscapes, animals, religious, etc. for placemats, puzzles, textiles, furniture, cassette/CD covers.
Needs: Seeking decorative art for the wall decor market. Considers unframed decorative paintings, posters, photos and drawings. Prefers pairs and series. Artists represented include T.C. Chiu, Jack Sorenson, Kay Lamb Shannon and Marianne Caroselli. Editions created by collaborating with the artist and by working from a pre-determined subject. Approached by 100 artists/year. Publishes and distributes the work of dozens of artists/year. "We work constantly with our established artists, but are always on the lookout for something new."
First Contact & Terms: Send query letter first with slides or photos and SASE. Reports in about 3-4 weeks. Pays $200-350 flat fee for some accepted pieces. Royalty arrangements with advance against 5-10% royalty is standard. Buys only reproduction rights. Provides written contract. Artist maintains ownership of original art. Requires exclusive publication rights to all accepted work.
Tips: "Do not limit your submission. We are interested in seeing your full potential. Please be patient. All inquiries will be answered."

***⌐SCANDECOR INC.**, Box 656, S-751, Uppsala Sweden. Contact: Helena Westman. Poster company, art publisher/distributor. Publishes/distributes fine art prints and posters. Clients include gift and stationery stores, craft stores and frame shops.

• See listing for Scandecor in Greeting Cards, Gifts and Products section for editorial comment regarding new address.
Needs: Seeking fashionable, decorative art. Considers acrylic, watercolor and pastel. Themes and styles vary according to current trends. Editions created by working from existing painting. Approached by 150 artists/year. Publishes the work of 5 emerging, 10 mid-career and 10 established artists/year. Also uses freelance designers. 25% of products require freelance design.
First Contact & Terms: Send query letter with brochure, photocopies, photographs, slides, tearsheets, transparencies and SASE. Reports back within 2 months. Company will contact artist for portfolio review if interested. Portfolio should include color photographs, slides, tearsheets and/or transparencies. Pays flat fee, $250-1,000. Rights vary according to project. Provides written contract. Finds artists through art exhibitions, art and craft fairs, art reps, submissions and looking at art already in the marketplace in other forms (e.g., collectibles, greeting cards, puzzles).

SCHLUMBERGER GALLERY, P.O. Box 2864, Santa Rosa CA 95405. (707)544-8356. Fax: (707)538-1953. Owner: Sande Schlumberger. Estab. 1986. Art publisher, distributor and gallery. Publishes and distributes limited editions, posters, original paintings and sculpture. Clients: collectors, designers, distributors, museums, galleries, film and television set designers. Current clients include: Bank of America Collection, Fairmont Hotel, Editions Ltd.
Needs: Seeking decorative art for the serious collector and the designer market. Prefers trompe l'oeil, realist, architectural, figure, portrait. Artists represented include Charles Giulioli, Deborah Deichler, Susan Van Camden. Editions created by collaborating with the artist or by working from an existing painting. Approached by 50 artists/year.
First Contact & Terms: Send query letter with tearsheets and photographs. Samples are not filed and are returned by SASE if requested by artist. Publisher/Distributor will contact artist for portfolio review if interested. Portfolio should include color photographs and transparencies. Negotiates payment. Offers advance when appropriate. Rights purchased vary according to project. Provides advertising, in-transit insurance, insurance while work is at firm, promotion, shipping to and from firm, written contract and shows. Finds artists through exhibits, referrals, submissions and "pure blind luck."
Tips: "Strive for quality, clarity, clean lines and light even if the style is impressionistic. Oddly enough I have requests frequently for vertical images—must be for corporate, hotel and hospital designers who are trying to fit corridor or long decor images."

‡SEGAL FINE ART, 4760 Walnut St., #100, Boulder CO 80301. (800)999-1297. (303)939-8930. Fax: (303)939-8969. E-mail: sfineart@aol.com. Artist Liason: Erica Gardner. Estab. 1986. Art publisher. Publishes limited editions. Clients: galleries.
Needs: Seeking creative and fashionable art for the serious collector and commercial market. Considers oil, watercolor, mixed media and pastel. Artists represented include Lu Hong, Sassone, Scott Jacobs and Ting Shao Kuang. Editions created by working from an existing painting. Publishes limited edition serigraphs, mixed media pieces and posters. Publishes and distributes the work of 1 emerging artist/year. Publishes the work of 7 and distributes the work of 3 established artists/year.
First Contact & Terms: Send query letter with slides, résumé and photographs. Samples are not filed and are returned by SASE. Reports back in 2 months. To show portfolio, mail slides, color photographs, bio and résumé. Offers advance when appropriate. Negotiates payment method and rights purchased. Requires exclusive representation of artist. Provides promotion.
Tips: Advises artists to attend New Trends Expos and Art Expo in New York and California or Art Buyers Caravan.

ROSE SELAVY OF VERMONT, (formerly Rose Selavy USA Inc.), P.O. Box 1528, Historic Rt. 7A, Manchester Center VT 05255. (802)362-0373. Fax: (802)362-1082. Publishes/distributes unlimited edition and fine art prints. Clients: galleries, decorators, frame shops, distributors, architects, corporate curators, museum shops and giftshops.
Needs: Seeking decorative art for the serious collector, commercial and designer markets. Considers oil, acrylic, watercolor, mixed media, pastel and pen & ink. Prefers folk art, antique and traditional. Artists represented include Susan Clickner. Editions created by collaborating with the artist or by working from an existing painting.
First Contact & Terms: Send query letter with brochure, photocopies, photographs, slides and tearsheets. Samples are not filed and are returned by SASE. Reports back only if interested. Company will contact artist for portfolio review if interested. Negotiates payment. Offers advance when appropriate. Rights purchased vary according to project. Usually requires exclusive representation of artist. Provides promotion and written contract. Also needs freelancers for design. Finds artists through art exhibitions and art fairs.

‡SHARDAN INTERNATIONAL FINE ART, INC., 10117 S.E. Sunnyside Rd., Suite F-503, Clackamas OR 97015-7708. (503)654-7979. Fax: (503)654-8600. E-mail: shardan14@aol.com. Website: http://www.shardan.com. President: Daniel Bohlmann. Estab. 1933. Art publisher. Publishes limited and unlimited editions, canvas transfers, fine art prints, offset reproduction posters and giclees. Clients: galleries, cruise ships, frame shops, resorts, gift shops, curators, interior decorators. Current clients include: Deck the Walls, Image Forum, Prints Plus, Fine Art Sales, Inc.
Needs: Seeking creative, fashionable and decorative art for the serious collector, commercial and designer markets. Considers oil, acrylic, watercolor. Prefers landscape, whimsical, cityscape, animals. Artists represented include Shari Hatchett, Shari Bohlmann, Roxy, Shar Dan, De Peaux. Editions created by collaborating with the artist, working from an existing painting and special commission assignments. Approached by 10-15 artists/year. Publishes/distributes the work of 1 mid-career artist and 3 established artists/year. Distributes the work of 5 artists/year.
First Contact & Terms: Send query letter with brochure, photocopies, photographs, photostats, résumé, SASE, slides,

tearsheets. Samples are filed. Will contact artist for portfolio review if interested. Pays on consignment basis: firm receives 50% commission or negotiates payment per agreement. Negotiates rights purchased or rights purchased vary according to project. Provides advertising and promotion. Finds artists through art fairs, internet, publications.
Tips: "Be aware of trends as they change annually."

SIERRA SUN EDITIONS, 5090 Robert J. Mathews Pkwy., Suite 2, El Dorado Hills CA 95762. (916)933-2228. Fax: (916)933-6224. Art Director: Ravel Buckley. Art publisher, distributor. Publishes/distributes handpulled originals, limited editions, unlimited editions, canvas transfers, fine art prints, offset reproductions. Clients: galleries, decorators, frame shops, distributors, architects, corporate curators, museum shops, gift-shops, and sports memorabilia and collectibles stores. Current clients include: Sports Legacy, Field of Dreams, Deck the Walls and Sports Forum.
Needs: Seeking creative, fashionable, decorative art for the serious collector, commercial and designer markets. "We publish/distribute primarily professional team sports art—i.e., celebrity athletes of major leagues—National Football League, Major League Baseball. We accept submissions of all subject matter for our licensing division which deals primarily with placing artworks on giftwares." Considers oil, acrylic, watercolor, mixed media, pastel. Artists represented include Daniel M. Smith, Stephen Holland, Vernon Wells, Eric Franchimon. Rick Rush, Ryan Fritz, Samantha Wendell, Terry Crews. Editions created by collaborating with the artist or by working from an existing painting. Approached by 60 artists/year. Publishes the work of 1-2 emerging, 2-3 mid-career and 7 established artists/year. Distributes the work of 3-8 emerging, 3-8 mid-career and 4-8 established artists/year. Also needs freelancers for design. Prefers local designers who own Mac computers.
First Contact & Terms: Send query letter with brochure, résumé, SASE, slides, tearsheets, photographs. Samples are filed or returned by SASE. Reports back within 1-3 months. Company will contact artist for portfolio review of color, final art, thumbnails, transparencies if interested. Pays royalties of 10-20%; or on a consignment basis: firm receives 20-40% commission for sale of originals. Negotiates payment regarding licensing of works. Offers advance when appropriate. May require exclusive representation of artist. Provides advertising, promotion, shipping from firm, written contract, trade shows, gallery shows. Finds artists through word of mouth, art trade shows, gallery owners.
Tips: "Seek your own creative expression. Don't mimic other artists whom you assume to have successful careers in publishing. Painting likenesses of celebrity athletes and the human body in action must be accurate if your style is photo real or realism. We seek strong concepts that can continue in repetitive series. Freedom of expression, artistic creativity and painterly techniques are acceptable and sought after in sports art."

SIGNATURE SERIES BY ANGEL GRAPHICS, 903 W. Broadway, P.O. Box 530, Fairfield IA 52556. E-mail: angel@franklin.lisco.com. Website: http://www.angelgraphicsinc.com. Project Manager: Julie Greeson. Estab. 1996. Art publisher. Publishes mid to high end open edition art prints in standard sizes between 2×3 and 24×36. Clients include U.S. and international picture framers and galleries.
Needs: Needs all types of currently popular subjects. Art guidelines available for SASE with first-class postage. Best trends include "den art" (golf, sports etc.), Hispanic subjects (churches, slice of life); African-American (especially religious content and leisure); gardens, florals, fruit; whimsical folk art; tropical, nostalgic. Needs high quality, detailed art work, both realistic and stylized. Uses 100-150 new images/year. "We follow trends in the art world."
First Contact & Terms: Send photographs, SASE and duplicate slides. Do not send originals. Pays by the project, $150-600. Competitive pricing and terms.
Tips: "Include expected contract terms in cover letter. Send $3 for current catalog or $10 for catalog and 22×28 print sample."

♣SIMON ART LTD., 5456 Tomken Rd., Unit #10, Mississauga, Ontario L4W 2Z5 Canada. (905)624-8577. Fax: (905)624-6973. Contact: Marketing Coordinator. Estab. 1981. Art publisher and distributor of posters and limited editions. Clients: galleries, framing shops.
Needs: Considers oil, watercolor, pastel and acrylic. Prefers representational, nostalgic, sports, wimsical, spiritual and other. Artists represented include Samantha Wendell, Heather Cooper, Jose Trinidad. Editions created by collaborating with the artist. Approached by 50-75 artists/year. Publishes and distributes the work of 0-1 emerging and 8-10 established artists/year.
First Contact & Terms: Send query letter with slides, résumé and photographs. Accepts disk submissions compatible with CorelDraw III and Aldus PageMaker. Samples are not filed and are returned. Reports back in 2-3 months. To show a portfolio, mail appropriate materials: photostats, slides, tearsheets and photographs. Pays royalties of 10%. Offers advance when appropriate. Requires exclusive representation of artist. Provides promotion and a written contract.

SIPAN LLC, 300 Glenwood Ave., Raleigh NC 27603. Phone/fax: (919)833-2535. Member: Owen Walker III. Estab. 1994. Art publisher. Publishes handpulled originals. Clients: galleries and frame shops.
Needs: Seeking art for the serious collector and the commercial market. Considers oil, acrylic, watercolor. Prefers traditional themes. Artists represented include Altino Villasante. Editions created by collaborating with the artist. Approached by 5 artists/year. Publishes/distributes the work of 1 emerging artist/year.
First Contact & Terms: Send photographs, SASE and transparencies. Samples are not filed and are returned by SASE. Reports back within 2 weeks. Company will contact artist for portfolio review of color final art if interested. Negotiates payment. Offers advance when appropriate. Buy all rights. Requires exclusive representation of artist. Provides advertising, in-transit insurance, insurance while work is at firm, promotion, written contract.

Artist Rian Withaar worked with Monique ven den Hurk, vice president of Netherlands-based Sjatin BV, on the concept of a series of teddy designs for the art publisher. "Monique guided me to create teddy bears which are not too sweet in combination with shells, which are very popular at the moment," says Withaar. "I listen to Monique's advice on what is successful in design, color, style, etc." Withaar made her connection with the company through her father, Reint Withaar, who has worked with them for more than eight years. This design has been selected for a stationery series and is used in the company's advertising.

***SJATIN BV**, P.O. Box 4028, 5950 AA Belfeld/Holland. 3177 475 1998. Fax: 31774 475 1965. Vice President: Monique van den Hurk. Estab. 1977. Art publisher. Publishes handpulled originals, limited editions, unlimited editions, fine art prints, offset reproductions, greeting cards. Licenses romantic art to appear on placemats, notecards, posters, puzzles and gifts. Clients: furniture stores, department stores. Current clients include: Karstadt (Germany), Morres Meubel-Hulst (Holland), Prints Plus (USA).

• Sjatin actively promotes worldwide distribution for artists they sign.

Needs: Seeking decorative art for the commercial market. Considers oil, acrylic, watercolor, mixed media, pastel. Prefers romantic themes, florals, landscapes/garden scenes, women. Artists represented include Willem Haenraets, Peter Motz, Reint Withaar. Editions created by collaborating with the artist or by working from an existing painting. Approached by 50 artists/year. "We work with 20 artists only, but publish a very wide range from cards to oversized prints and we sell copyrights."

First Contact & Terms: Send brochure and photographs. Reports back only if interested. Company will contact artist

for portfolio review of color photographs (slides) if interested. Negotiates payment. Offers advance when appropriate. Buys all rights. Provides advertising, promotion, shipping from firm and written contract (if requested).
Tips: "Follow the trends in interior decoration; look at the furniture and colors. I receive so many artworks that are beautiful and very artistic, but are not commercial enough for reproduction. I need designs which appeal to many many people, worldwide such as flowers, gardens, interiors and kitchen scenes. I do not wish to receive graphic art. Artists entering the poster/print field should attend the I.S.F. Show in Birmingham, Great Britain or the ABC show in Atlanta."

SOHO GRAPHIC ARTS WORKSHOP, 433 W. Broadway, Suite 5, New York NY 10012. (212)966-7292. Director: Xavier H. Rivera. Estab. 1977. Art publisher, distributor and gallery. Publishes and distributes limited editions.
Needs: Seeking art for the serious collector. Considers prints. Editions created by collaborating with the artist or working from an existing painting. Approached by 10-15 artists/year.
First Contact & Terms: Send résumé. Reports back within 2 weeks. Artist should follow-up with letter after initial query. Portfolio should include slides and 35mm transparencies. Negotiates payment. No advance. Buys first rights. Provides written contract.

SOMERSET HOUSE PUBLISHING, 10688 Haddington Dr., Houston TX 77043. (800)444-2540. Fax: (713)932-6847. Marketing Liaison: Shirley Jackson. Estab. 1972. Art publisher of fine art limited and unlimited editions, hand-pulled originals, offset reproductions, posters and canvas transfers. Clients include independent galleries in U.S., Canada, Australia.
Needs: Seeking decorative art for the serious collector and designer market. Considers oil, acrylic, watercolor, mixed media, pastel. Prefers all themes and styles except abstract. Also prefers religious art. Artists represented include G. Harvey, Charles Fracé, Larry Dyke, L. Gordon, Nancy Glazier, Martin Grelle, Tom du Bois, Bart Forbes. Editions created by collaborating with the artist or by working from an existing painting. Approached by 250 artists/year. Publishes the work of 7 emerging, 4 mid-career and 7 established artists/year.
First Contact & Terms: Send query letter with transparencies, tearsheets, résumé, slides or photographs and SASE. Samples are not filed and are returned. Reports back in 3 weeks. Publisher will contact artist for portfolio review if interested. Pays royalties. Rights purchased vary according to project. Provides advertising, insurance in-transit and while work is at firm, promotion, shipping from firm, written contract.
Tips: Artists should be aware of colors which affect the decorator market and subject matter trends. Recommends artists attend the Art Buyers Caravan trade shows in cities near them. Recommends artists read *Decor*, *USART* and *Art Business News*, publications that follow current trends in styles, color, subject matter, etc. "Be open to direction."

***JACQUES SOUSSAN GRAPHICS**, 37 Pierre Koenig St., Jerusalem Israel. (02)678-2678. Fax: (02)678-2426. Estab. 1973. Art publisher. Publishes handpulled originals, limited editions, sculpture. Clients: galleries, decorators, frame shops, distributors, architects. Current clients include: Rozembaum Galleries, Royal Beach Hotel.
Needs: Seeking decorative art for the serious collector and designer market. Considers oil, watercolor and sculpture. Artists represented include Calman Shemi. Editions created by collaborating with the artist. Approached by 20 artists/year. Publishes/distributes the work of 5 emerging, 3 mid-career and 2 established artists/year.
First Contact & Terms: Send query letter with brochure, slides. To show portfolio, artist should follow-up with letter after initial query. Portfolio should include color photographs.

SPORT'EN ART, 1015 W. Jackson St., Sullivan IL 61951-1058. (217)728-2361. E-mail: sportart@moultrie.com. Large publisher/distributor of limited edition prints and posters featuring sports images. Contact: Dan Harshman.
Needs: Artists represented include Harry Antis, Carole Bourdo, Roger Cruwys, Louis Frisino, Rob Leslie, Richard Sloan.
First Contact & Terms: Send query letter with slides and SASE. Publisher will contact for portfolio review if interested.

SPORTMAN SPECIALTIES, Box 217, Youngwood PA 15697. (412)834-2768. Owner: Mr. Burrick. Estab. 1975. Art publisher handling limited editions for galleries.
Needs: Considers oil, acrylic, pastel, watercolor, tempera and mixed media. Prefers contemporary, floral and outdoor themes. Prefers individual works of art. Publishes/distributes the work of 7 artists/year.
First Contact & Terms: Send query letter with résumé and slides—at least 20—of most recent work. Samples not filed are returned by SASE only. Reports back within 2 months. Write to schedule an appointment to show a portfolio that should include original/final art. Payment method is negotiated. Buys reprint rights. Does not require exclusive representation of the artist. Provides promotion and contract while work is at firm.

SPORTS ART INC, Dept. AM, 903 Hwy. 71 NE, P.O. Box 1360, Willmar MN 56201. (800)626-3147. E-mail: saiart@msn.com. President: Dennis LaPoint. Estab. 1989. Art publisher and distributor of limited and unlimited editions, offset reproductions and posters. Clients: over 2,000 active art galleries, frame shops and specialty markets.
Needs: Seeking artwork with creative artistic expression for the serious collector and the designer market. Considers oil, watercolor, acrylic, pastel, pen & ink and mixed media. Prefers sports themes. Artists represented include Ken Call, Anne Peyton, Tom McKinney and Terrence Fogarty. Editions created by collaborating with the artist or working from an existing painting. Approached by 150 artists/year. Publishes the work of 2 emerging and 4 mid-career artists/year. Distributes the work of 30 emerging, 60 mid-career and 30 established artists/year.

First Contact & Terms: Send query letter with brochure showing art style or résumé, tearsheets, SASE, slides and photographs. Accepts submissions on disk. Samples are filed or returned by SASE if requested by artist. To show a portfolio, mail thumbnails, slides and photographs. Pays royalties of 10%. Offers an advance when appropriate. Negotiates rights purchased. Sometimes requires exclusive representation of the artist. Provides promotion and shipping from firm.

Tips: "We are interested in generic sports art that captures the essence of the sport as opposed to specific personalities."

SUMMERFIELD EDITIONS, 2019 E. 3300 S., Salt Lake City UT 84109. (801)484-0700. Fax: (800)485-7172. Contact: Kelly Omana. Publishes limited editions, fine art prints, posters. Clients: galleries, decorators, frame shops and gift shops.

Needs: Seeking decorative art for the designer market. Considers oil, acrylic, watercolor, mixed media and pastel. Prefers traditional themes. Artists represented include Karen Christensen, Ann Cowdell and Pat Enk. Editions created by collaborating with the artist or by working from an existing painting. Approached by 24 artists/year. Samples are not filed and are not returned. Reports back only if interested. Company will contact artists for portfolio review of color sample; "good presentation of work." Negotiates payment. Offers advance when appropriate. Rights purchased vary according to project; prefers all rights. Provides advertising and written contract. Finds artists through art exhibitions, art fairs, word of mouth.

Tips: Sees trend toward "sporting themes without being cute; rich colors. Artwork should come from the heart."

SYMPHONY FINE ART, 4060 Morena Blvd., Suite D, San Diego CA 92117. (619)270-3442. Fax: (619)270-3847. Creative Director: Dan Fletcher. Estab. 1989. Publishes handpulled originals, limited and unlimited edition, fine art prints, offset reproductions, posters and giclée prints. Clients: galleries, designers, frame shops and distributors.

Needs: Seeking creative, fashionable, decorative art for the serious collector and commercial market. Considers oil, acrylic, watercolor, mixed media and pastel. Artists represented include Jin G. Kam, Scott Moore. Editions created by collaborating with the artist or working from an existing painting. Approached by 20-25 artists/year.

First Contact & Terms: Send query letter with brochure, photographs, photostats, résumé and tearsheets. Samples are filed or returned by SASE. Reports back only if interested. "Call, we will give input if artist does a follow-up call, whether interested or not." To show portfolio, artist should follow-up with call and/or letter after initial query or company will contact artist for portfolio review of color, photographs, slides, tearsheets, transparencies and original work. Originals consigned and a split is created, royalty on reproductions negotiated individually. Offers advance when appropriate. Rights purchased vary according to project. Generally requires exclusive representation of artist, "but very flexible, especially concerning existing artist's established business." Provides advertising, promotion, shipping to and from firm, written contract. "Finds some artists through attending exhibitions, fairs and word of mouth, mostly by artist's who contact us."

Tips: "Sometimes painting/creating to the market works, but not often. It is best to recognize the business and trust your creativity. An artist must create what inspires him or her to attain long term success. Being too concerned with 'market' breeds imitation. Take some direction and make it your own."

✔SYRACUSE CULTURAL WORKERS, P.O. Box 6367, Syracuse NY 13217. (315)474-1132. Fax (315)475-1277. Art Director: Karen Kerney. Produces posters, notecards, postcards, greeting cards, T-shirts and calendars.
 • See listing in Greeting Cards, Gifts and Products section. This organization has added a new poster size, 12×36, to its line.

First Contact & Terms: Pays flat fee, $85-400; royalties of 6% of gross sales.

JOHN SZOKE GRAPHICS, INC., 164 Mercer St., New York NY 10012. Director: John Szoke. Produces limited edition handpulled originals for galleries, museums and private collectors.

Considers: Original prints, mostly in middle price range, by up-and-coming artists. Artists represented include James Rizzi, Jean Richardson, Tadashi Asoma, Scott Sandell, Norman Laliberté and others. Publishes the work of 2 emerging, 10 mid-career and 2 established artists/year. Distributes the work of 10 emerging, 10 mid-career and 5 established artists/year.

First Contact & Terms: Send slides with SASE. Request portfolio review in original query. Reports within 1 week. Charges commission, negotiates royalties or pays flat fee. Provides promotion and written contract.

TELE GRAPHICS, 153 E. Lake Brantley Dr., Longwood FL 32779. President: Ron Rybak. Art publisher/distributor handling limited and unlimited editions, offset reproductions and handpulled originals. Clients: galleries, picture framers, interior designers and regional distributors.

Needs: Seeking decorative art for the serious collector. Artists represented include Beverly Crawford, Diane Lacom, Joy Broe and W.E. Coombs. Editions created by collaborating with the artist or by working from an existing painting. Approached by 30-40 artists/year. Publishes the work of 1-4 emerging artists/year.

First Contact & Terms: Send query letter with résumé and samples. Samples are not filed and are returned only if requested. Reports within 30 days. Call or write for appointment to show portfolio of original/final art. Pays by the project. Considers skill and experience of artist and rights purchased when establishing payment. Offers advance. Negotiates rights purchased. Requires exclusive representation. Provide promotions, shipping from firm and written contract.

Tips: "Be prepared to show as many varied examples of work as possible. Forget trends—be yourself. Show transparen-

PAUL ROBESON
VOICE OF THE PEOPLE
"An artist must elect to fight for freedom or for slavery.
I have made my choice. I had no alternative."
from a speech at London rally for Spanish Loyalists, 1937

Karen Kerney, art director of Syracuse Cultural Workers (SCW), created this watercolor poster to commemorate the 100th birthday of Paul Robeson, whose career as an opera singer and actor was punctuated with episodes of political activism. "The vibrancy and color of the portrait and the combination of images and words make it a successful poster," Kerney says. Available also as a postcard and notecard, the design is selling well, adds an a SWC rep.

cies or slides plus photographs in a consistent style. We are not interested in seeing only one or two pieces."

BRUCE TELEKY INC., 625 Broadway, 4th Floor, New York, NY 10012. Publisher/Distributor. President: Bruce Teleky. Clients include galleries, manufacturers and other distributors.
Needs: Works from existing art to create open edition posters or works with artist to create limited editions. Artists represented include Romare Bearden, Faith Ringgold, Joseph Reboli, Barbara Appleyard, Norman Rockwell, Gigi Boldon
First Contact & Terms: Send query letter with slides, transparencies, postcard or other appropriate samples and SASE. Publisher will contact artist for portfolio review if interested. Payment negotiable.

TOP ART, 9863 Pacific Heights Blvd., San Diego CA 92121. (619)554-0102. Fax: (619)554-0309. President: Keith Circosta. Estab. 1991. Publishes offset reproductions and posters. Clients: galleries, decorators, frame shops, distributors, architects, corporate curators, museum shops, giftshops, national retail chains.
Needs: Seeking decorative art for the commercial and designer markets. Considers oil, acrylic, watercolor, mixed media and pastel. Prefers florals, landscapes, coastals, abstracts and classical styles. Editions created by collaborating with the artist or by working from an existing painting. Approached by 100 artists/year. Publishes the work of 5 emerging, 10 mid-career and 15 established artists/year.
First Contact & Terms: Send photographs, slides, tearsheets and transparencies. Samples are filed. Reports back only if interested in 1 month. Company will contact artist for portfolio review of color, final art, photographs, slides and transparencies if interested. Rights purchased vary according to project. Provides advertising, insurance while work is at firm and promotion.

UMOJA FINE ARTS, 16250 Northland Dr., Suite 104, Southfield MI 48075. (800)469-8701. Website: http://www.umoj afinearts.com. Estab. 1995. Art publisher and distributor specializing in African-American posters, graphics, painting and sculpture. President: Ian Grant.
Needs: Seeking fine art and decorative images and sculpture for the serious collector as well as the commercial market. Artists include Lazarus Bain, Jeff Clark, Joe Dobbins, Marcus Glenn, David Haygood, Ivan Stewart. Editions created by collaborating with the artist. Approached by 40-50 artists/year. Publishes the work of 1-2 emerging, 1-2 mid-career and 1 established artists/year. Distributes the work of 2-3 emerging, 2-3 mid-career and 2 established artists/year.
First Contact & Terms: Send query letter with slides and SASE. Samples are filed. Reports back only if interested in 1 month. Publisher will contact for portfolio review if interested. Buys all rights. Requires exclusive representation of artist. Provides advertising, insurance while work is at firm and written contract.

V.F. FINE ARTS, INC., 1737 Siebbins, #240B, Houston TX 77043. (713)461-1944. Fax: (713)461-2557. President: John Kuck. Estab. 1985. Art publisher of limited editions. Clients: collectible shops and galleries. Current clients include Lawrence Galleries, Georgia's Gift Gallery.
Needs: Seeking artwork for the serious collector. Considers oil. Prefers Victorian themes and style. Artists represented include Sandra Kuck. Editions created by collaborating with artist. Approached by 5 artists/year.
First Contact & Terms: Send query letter with brochure showing art style and tearsheets. Samples are filed. Reports back only if interested. To show a portfolio, mail photographs. Pays royalties. Offers advance when appropriate. Buys all rights. Provides promotion, shipping from firm and a written contract.

VARGAS FINE ART PUBLISHING, INC., 4461 Nicole Dr., Lanham MD 20706. (301)731-5175. Fax: (301)731-5712. President: Elba Vargas-Colbert. Estab. 1987. Art publisher and worldwide distributor of serigraphs, limited and open edition offset reproductions, etchings, sculpture, music boxes, ceramic tiles, collector plates, calendars, canvas transfers and figurines. Clients: galleries, frame shops, museums, decorators, movie sets and TV.
Needs: Seeking creative art for the serious collector and commercial market. Considers oil, watercolor, acrylic, pastel pen & ink and mixed media. Prefers ethnic themes. Artists represented include Joseph Holston, Kenneth Gatewood, Tod Haskin Fredericks, Betty Biggs, Charles Bibbs, Sylvia Walker, Ted Ellis, Leroy Campbell, William Tolliver, Sylvia Walker and Paul Goodnight. Approached by 100 artists/year. Publishes/distributes the work of about 80 artists.
First Contact & Terms: Send query letter with résumé, slides and/or photographs. Samples are filed. Reports back only if interested. To show portfolio, mail photographs. Payment method is negotiated. Requires exclusive representation of the artist.
Tips: "Vargas Fine Art Publishing is standing as a major publisher committed to publishing artists of the highest caliber, totally committed to their craft and artistic development."

✓*VERKERKE REPRODUKTIES NV, Wiltonstraat 36, 3905 KW Veenendaal, The Netherlands. (31)318 569200. Fax: (31)318 569209. Art Director: A. Hazenberg. Estab. 1957. Publishes limited edition, unlimited edition, fine art prints, offset reproductions, posters, greeting cards and limited edition handpainted frames. Clients: galleries, decorators, frame shops, distributors, architects, corporate curators, museum shops and giftshops. Current clients include Prints Plus, Image Source.

"Working with a fine art print company is a very valuable venue for sharing my images and ideas with a wider audience," says artist Darryl Daniels. "I get feedback on how the work is being received. It also gets my work into the best galleries in the world—people's homes." Daniels' striking monochromatic piece *Solo* is offered by Vibrant Fine Art. "We like the simplicity and elegance of the subject matter. The work conveys a mood of serenity and captures the universal expression of music," says Phyliss Stevens of Vibrant. "We have received great response to this image from art distributors and clients."

Needs: Seeking creative, fashionable and decorative art for the commercial and designer markets. Considers oil, acrylic, watercolor, mixed media, pastel, pen & ink and photography. Prefers all figurative and abstract art, also photography. Artists represented include Charles Bell, Ralph Goings, H. Leving, Kim Anderson, Xoadoor, Rosina Wachtmeister, Alex. Editions created by collaborating with the artist or by working from an existing painting.
First Contact & Terms: Send brochure, photocopies, photographs, tearsheets and transparencies. "Images can be supplied in EPS or TIFF formats, using Adobe Photoshop, Adobe Illustrator or QuarkXPress. Text can be supplied in QuarkXPress, WordPerfect, MS-Word or ASCII files." Samples are filed or returned. Reports back within 6 weeks. Company will contact artist for portfolio review if interested. Pays royalties of 8-10%. Offers advance. Rights purchased vary according to project. Provides advertising, insurance while work is at firm, promotion, written contract and worldwide distribution of prints. Finds artists through attending art exhibitions, art fairs, word of mouth, World Wide Web, through art reps, sourcebooks, submissions and watching art competitions.

VERNON FINE ART AND EDITIONS, 1738 Treble Dr., 504, Humble TX 77338. (281)446-4340. Fax: (413)446-4657. Owner: Karen Vernon. Estab. 1978. Art publisher and distributor. Publishes and distributes handpulled originals, limited and unlimited editions, offset reproductions and posters. Clients: galleries, frame shops, designers, hotels. Current clients include: Hospitality Galleries (Orlando), Artcorp (Taiwan), Baldwin Art (Highpoint, Ashton-Houston, Atlanta, Dallas, Highpoint).
Needs: Seeking creative art for the serious collector, commercial and designer markets. Considers oil, watercolor, pastel and acrylic. Prefers realism ("color is important"). Artists represented include Vernon, Archer, Muenzemayer, Spann, Eckard, Jackson, Johnson, Stanford. Editions created by working from an existing painting. Approached by 50 artists/year. Publishes the work of 5 mid-career and 2 established artists/year. Distributes the work of 10 established artist/year.
First Contact & Terms: Send query letter with résumé, slides, photographs and photocopies. Samples are not filed and are returned by SASE if requested by artist. Reports back within 2 weeks. Publisher/Distributor will contact artist for portfolio review if interested. Portfolio should include b&w and color photographs and slides. Pays royalties. Offers advance when appropriate. Rights purchased vary according to project. Provides advertising, in-transit insurance, insurance while work is at firm, promotion, shipping from firm and written contract. Finds artists through submissions, art fairs and trade shows.
Tips: Recommends artists attend ABC Show and Art Expo and read *Decor* and *Art Business News*.

VIBRANT FINE ART, 3444 Hillcrest Dr., Los Angeles CA 90016. (213)766-0818. Fax: (213)737-4025. Art Director: Phyliss Stevens. Licensing: Tom Nolen. Estab. 1990. Art publisher and distributor. Publishes and distributes fine art prints, limited and unlimited editions and offset reproductions. Licenses ethnic art to appear on ceramics, gifts, textiles, miniature art, stationery and note cards. Clients: galleries, designers, giftshops, furniture stores and film production companies.
Needs: Seeking decorative and ethnic art for the commercial and designer markets. Considers oil, watercolor, mixed

media and acrylic. Prefers African-American, Native-American, Latino themes. Artists represented include Sonya A. Spears, Van Johnson, Momodou Ceesay, William Crite and Darryl Daniels. Editions created by collaborating with the artist or by working from an existing painting. Approached by 40 artists/year. Publishes the work of 5 emerging; 5 mid-career and 2 established artists/year. Distributes the work of 5 emerging, 5 mid-career and 2 established artists/year. Also needs freelancers for design. 20% of products require design work. Designers should be familiar with Adobe Illustrator and Mac applications. Prefers local designers only.

First Contact & Terms: Send query letter with brochure, tearsheets and slides. Samples are filed or are returned by SASE. Publisher/distributor will contact artist for portfolio review if interested. Portfolio should include color tearsheets, photographs, slides and biographical sketch. Pays royalties of 10%. Rights purchased vary according to project. Provides advertising, insurance while work is at firm, promotion, written contract and shipping from firm. Finds artists through art exhibitions, referrals, sourcebooks, art reps, submissions.

Tips: "Ethnic art is hot. The African-American art market is expanding. I would like to see more submissions from artists that include slides of ethnic imagery, particularly African-American, Latino and Native American. We desire contemporary cutting edge, fresh and innovative art. Artists should familiarize themselves with the technology involved in the printing process. They should posess a commitment to excellence and understand how the business side of the art industry operates."

SHAWN VINSON FINE ART, P.O. Box 746, Decatur GA 30031-0746. (404)370-1720. Fax: (404)370-1845. E-mail: shawnvinson@mindspring.com. Owner: Shawn Vinson. Estab. 1992. Art dealer to the trade distributing handpulled originals and fine art prints. Clients: galleries, designers and collectors. Current clients include: Gallery 71, New York City, Universal Studios Florida, Naomi Judd.

Needs: Seeking fine art originals for the serious collector. Considers oil, acrylic, mixed media and pastel. Prefers contemporary and painterly styles. Artists represented include Ruth Franklin, Cynthia Knapp, Matt Lively and Sergey Cherepaklin. Approached by 6-12 artists/year. Publishes the work of 1-2 emerging, 1-2 mid-career and 1-2 established artists/year. Distributes the work of 8-10 emerging, 8-10 mid-career and 8-10 established artists/year.

First Contact & Terms: Send query letter with photographs, résumé, SASE, slides and tearsheets. Accepts disk submissions compatible with Microsoft applications. Samples are filed. Reports back only if interested. Company will contact artist for portfolio review if interested. Pays on consignment basis or negotiates payment. Rights purchased vary according to project. Provides advertising, in-transit insurance, insurance while work is at firm and promotion.

Tips: "Maintain integrity in your work. Limit number of dealers."

WANDA WALLACE ASSOCIATES, P.O. Box 436, Inglewood CA 90306-0436. (310)419-0376. Website: http://www.sensorium.com. President: Wanda Wallace. Estab. 1980. Art publisher, distributor, gallery and consultant. Publishes handpulled originals, limited and unlimited editions, canvas transfers, fine art prints, monotypes, posters and sculpture. Clients: decorators, galleries, distributors.

Needs: Seeking art by and depicting African-Americans. Considers oil, acrylic, watercolor, mixed media, pastel, pen & ink and sculpture. Prefers traditional, modern and abstract styles. Artists represented include Charles Bibbs, Betty Biggs, Tina Allen, Adrian Won Shue. Editions created by collaborating with the artist or by working from an existing painting. Approached by 100 artists/year. Publishes/distributes the work of 10 emerging, 7 mid-career and 3 established artists/year.

First Contact & Terms: Send query letter with brochure, photocopies, photographs, tearsheets and transparencies. Samples are filed and are not returned. Reports back only if interested. Company will contact artist for portfolio review of color, final art, photographs and transparencies. Pays on consignment basis: firm receives 50% commission or negotiates payment. Offers advance when appropriate. Buys all rights. Requires exclusive representation of artist. Provides advertising, promotion, shipping from firm and written contract.

Tips: "African-American art is very well received. Depictions that sell best are art by black artists. Be creative, it shows in your art. Have no restraints."

WATERMARK FINE ARTS, Lafayette Center, Suite 402, Kennebunk ME 04043. (207)985-6134. Fax: (207)985-7633. E-mail: water@ime.net. Publisher: Alexander Bridge. Estab. 1989. Art publisher/distributor. Publishes and distributes limited and unlimited editions, posters, offset reproductions and stationery. Clients: framers, galleries.

Needs: Seeking creative art for the commercial market. Specializes in rowing, sporting and nature art. Considers oil, watercolor, mixed media, pen & ink, acrylic and b&w photography. Artists and photographers represented include John Gable, David Foster and Amy Wilton. Editions created by collaborating with the artist. Approached by 300 artists/year. Publishes and distributes the work of 4 mid-career artists and photographers and 3 established artists/year. Also uses freelancers for design. 20% of projects require freelance design. Prefers local designers only. Send slides.

Tips: "Persist in your work to succeed!"

✔WEBSTER FINE ART LTD., 1185 Tall Tree Rd., Clemmons NC 27012. (336)712-0900. Fax: (336)712-0974. Design Director: Missy Thronebury. Art publisher/distributor. Estab. 1987. Publishes unlimited editions and fine art prints. Clients: galleries, frame shops, distributors, giftshops. Current clients include: Libermans.

Needs: Seeking decorative art. Considers oil, acrylic, watercolor, pastel, pen & ink, mixed media. Prefers classic, decorative, traditional art. Artists represented include Fiona Butler, Jan Pashley. Editions created by collaborating with the artist.

First Contact & Terms: Send query letter with brochure, photocopies, photographs, slides, tearsheets, transparencies

and SASE. Samples are filed or returned by SASE. Reports back within 1 month. Company will contact artist for portfolio review if interested. Negotiates payment. Offers advance when appropriate. Buys all or reprint rights. Finds artists by word of mouth, attending art exhibitions and fairs, submissions and watching art competitions.

Tips: "Check decorative home magazines—*Southern Accents*, *Architectural Digest*, *House Beautiful*, etc.—for trends. Understand the decorative art market."

THE WHITE DOOR PUBLISHING COMPANY, P.O. Box 427, New London MN 56273. (320)796-2209. Fax: (320)796-2968. President: Mark Quale. Estab. 1988. Art publisher. Publishes limited editions, offset reproductions. Clients: 1,000 galleries (authorized dealer network).

Needs: Seeking creative art for the commercial market. Considers oil, acrylic, watercolor, mixed media, pastel. Prefers "traditional" subject matter. Artists represented include Charles L. Patterson, Morten Solberg, Jan Martin McGuire, Greg Alexander, Dan Mieduch and D. Edward Kucera. Editions created by collaborating with the artist or by working from an existing painting. Approached by 250 artists/year. Publishes the work of 2-3 emerging, 2-3 mid-career and 4-6 established artists/year.

First Contact & Terms: Send photographs, SASE, slides, tearsheets, transparencies. Samples are not filed and are returned by SASE. Reports back within 2 weeks. Company will contact artist for portfolio review of color photographs, slides, transparencies. Pays royalties. Buys one-time and reprint rights. Requires exclusive representation of artist. Provides advertising, in-transit insurance, insurance while work is at firm, shipping to and from firm, written contract. Finds artists through attending art exhibitions, word of mouth, submissions and art publications.

Tips: "Nostalgia and images reflecting traditional values are good subjects. Versatility not important. Submit only the subjects and style you love to paint."

WHITEGATE FEATURES SYNDICATE, 71 Faunce Dr., Providence RI 02906. (401)274-2149. Website: http://www.whitegatefeatures.com. Talent Manager: Eve Green.

• This syndicate is looking for fine artists and illustrators. See listing in Syndicates section for information on their needs.

First Contact & Terms: "Please send (non-returnable) slides or photostats of fine arts works. We will call if a project suits your work." Pays royalties of 50% if used to illustrate for newspaper.

WILD APPLE GRAPHICS, LTD., RR2 Box 25, Route 4 West, Woodstock VT 05091. (802)457-3003. Fax: (802)457-3214. E-mail: wildapple@aol.com. Artist Relations: Maureen Dow. Estab. 1990. Art publisher and distributor of posters and unlimited editions. Clients: frame shops, interior designers and furniture companies. Current clients include 2 galleries and Intercontinental Art.

Needs: Seeking decorative art for the commercial and designer markets. Considers all media. Artists represented include Warren Kimble, Nancy Pallan, Deborah Schenck, David Carter Brown, Isabelle de Borchgrane. Editions created by working from an existing painting or by collaborating with the artist. Approached by 2,000 artists/year. Publishes the work of 5-7 mid-career and 3-5 established artists/year.

First Contact & Terms: Send query letter with résumé and slides, photographs or transparencies. Samples are returned by SASE. Reports back within 1 month. Negotiates payment method and rights purchased. Provides in-transit insurance, insurance while work is at firm, promotion, shipping to and from firm and a written contract. Finds artists through art fairs, museums, galleries and submissions.

Tips: "Don't be trendy. We seek decorative images that will have broad appeal and can stay on walls for a long time. Power Ranger or alien art (which we have, in fact, received) is not saleable for a company like ours. Be aware that techniques have to be tight enough to reproduce well."

WILD WINGS INC., S. Highway 61, Lake City MN 55041. (612)345-5355. Fax: (612)345-2981. Merchandising Manager: Sara Koller. Estab. 1968. Art publisher, distributor and gallery. Publishes and distributes limited editions and offset reproductions. Clients: retail and wholesale.

Needs: Seeking artwork for the commercial market. Considers oil, watercolor, mixed media, pastel and acrylic. Prefers fantasy, military, golf, variety and wildlife. Artists represented include David Maass, Lee Kromschroeder, Ron Van Gilder, Robert Abbett, Michael Sieve and Persis Clayton Weirs. Editions created by working from an existing painting. Approached by 300 artists/year. Publishes the work of 36 artists/year. Distributes the work of numerous emerging artists/year.

First Contact & Terms: Send query letter with slides and résumé. Samples are filed and held for 6 months then returned. Reports back within 3 weeks if uninterested or 6 months if interested. Publisher will contact artist for portfolio review if interested. Pays royalties for prints. Accepts original art on consignment and takes 40% commission. No advance. Buys first-rights or reprint rights. Requires exclusive representation of artist. Provides in-transit insurance, promotion, shipping to and from firm, insurance while work is at firm and a written contract.

SASE MEANS SELF-ADDRESSED, STAMPED ENVELOPE. Send SASEs when requesting return of your samples.

WINDSOR ART & MIRROR CO., INC., 9101 Perkins St., Pico Rivera CA 90660. (562)949-5412. President: Pauline Raschella. Estab. 1970. Manufacturer of decorative framed artwork and mirrors for retail stores.
Needs: Seeking original fine artwork, watercolor, oils, acrylics, limited edition prints, serigraphs, monoprints to produce as prints and sell as original art.
First Contact & Terms: Send query letter and SASE with photographs, slides and brochure showing art style. Samples not filed are returned only if requested. Pays for design and illustration by the project, $300-1,000. Considers complexity of project when establishing payment.

WINN DEVON ART GROUP, 6015 Sixth Ave. S., Seattle WA 98108. (206)763-9544. Fax: (206)762-1389. Vice President Product Develop: Buster Morris. Estab. 1976. Art publisher and wholesaler. Publishes limited editions and posters. Clients: mostly trade, designer, decorators, galleries, poster shops. Current clients include: Pier 1, Z Gallerie, Intercontinental Art, Chamton International, Bombay Co.
Needs: Seeking decorative art for the designer market. Considers oil, watercolor, mixed media, pastel, pen & ink and acrylic. Artists represented include Buffet, de Claviere, Dench, Gunn, Hayslette, Horning, Hall, Wadlington, Singley, Schaar. Editions created by working from an existing painting. Approached by 300-400 artists/year. Publishes and distributes the work of 0-3 emerging, 3-8 mid-career and 8-10 established artists/year.
First Contact & Terms: Send query letter with brochure, slides, photocopies, résumé, photostats, transparencies, tearsheets or photographs. Samples are returned by SASE if requested by artist. Reports back within 4-6 weeks. Publisher will contact artist for portfolio review if interested. Portfolio should include "whatever is appropriate to communicate the artist's talents." Pay varies. Offers advance when appropriate. Rights purchased vary according to project. Provides written contract. Finds artists through attending art exhibitions, agents, sourcebooks, publications, submissions.
Tips: Advises artists to attend Art Expo New York City, ABC Atlanta. "I would advise artists to attend just to see what is selling and being shown, but keep in mind that this is not a good time to approach publishers/exhibitors with your artwork."

Book Publishers

Thousands of books are published every year and each needs an interesting cover to attract buyers. The best way to understand the size of the market and its needs is to visit one of the large "superstores" like Barnes & Noble, Borders or Waldenbooks. Notice how many titles are on the shelves. And as any one of the clerks in the store can tell you, new titles are arriving every day! Each book must compete with all the others for the public's attention.

As an artist working in the book publishing industry, your artwork has two very important jobs to do. First, it must grab readers' attention and make them want to pick up the book. Secondly, it must show at a glance what type of book it is and who it is meant to appeal to. In addition, the cover has to include basic information such as title, the author's name, the publisher's name, blurbs and price.

The interior of a book is important, too. Designers create the page layouts that direct us through the text. This is particularly important in children's books and textbooks. Many publishing companies hire freelance designers with computer skills to design interiors on a contract basis. Look within each listing for the subheading Book Design, to find the number of jobs assigned each year, and how much is paid per project. Look under the Needs heading to find out what computer software the company uses. If you work with compatible software, your chances of winning an assignment increase.

Target your best markets

Within the first paragraph of each listing, we describe the type of books each publisher specializes in. This may seem obvious, but submit only to publishers who specialize in the type of book you want to illustrate or design. There's no use submitting to a publisher of literary fiction if you want to illustrate for children's picture books.

How to submit

Send five to ten nonreturnable samples along with a brief letter and a SASE. Never send originals (see What Should I Submit? on page 4). Most art directors prefer samples that are

LEARNING INDUSTRY TERMS

Mass market books are sold in supermarkets, newsstands, drugstores, etc. They include paperbacks by popular authors like Stephen King.

Trade books are the hardcovers and paperbacks found only in bookstores and libraries. The paperbacks are larger than those on the mass market racks. They are printed on higher quality paper, and feature matte-paper jackets.

Textbooks feature plenty of illustrations, photographs, and charts to explain their subjects. They are also more likely to need freelance designers.

Small press books are books produced by a small, independent publisher. Many are literary or scholarly in theme, and often feature fine art on the cover.

Backlist titles or **reprints** refer to publishers' titles from past seasons that continue to sell year after year. These books are often updated and republished with freshly designed covers to make them more attractive to readers.

8½×11 or smaller that can fit in file drawers. Bulky submissions are considered a nuisance.

Getting paid

Payment for design and illustration varies depending on the size of the publisher, the type of project and the rights bought. Most publishers pay on a per-project basis, although some publishers of highly illustrated books (such as children's books) pay an advance plus royalties. A few very small presses may only pay in copies.

Illustrating for children's books

Working in children's books requires a specific set of skills. You must be able to draw the same characters in a variety of action poses and situations. Like other publishers, many children's publishers are expanding their product lines to include multimedia projects (CD-ROM and software). (Read how Joy Allen broke into children's publishing on page 346.) A number of children's publishers are listed in this book, but *Children's Writer's & Illustrator's Market*, published by Writer's Digest Books (800)289-0963, is a valuable resource if you enter this field.

MORE MARKETING TIPS

The publishers in this section are just the tip of the iceberg. You can find additional publishers by visiting bookstores and libraries and looking at covers and interior art. When you find covers you admire, write down the name of the books' publishers in a notebook. If the publisher is not listed in *Artist's & Graphic Designer's Market*, go to your public library and ask to look at a copy of *Literary Market Place*, also called *LMP*, published annually by Bowker. The cost of this large directory is prohibitive to most freelancers, but you should become familiar with it if you plan to work in the industry. Though it won't tell you how to submit to each publisher, it does give art directors' names. The book also has a section featuring the winners of the year's book awards, including awards for book design.

Must Reading If you decide to focus on book publishing, you'll need to become familiar with *Publishers Weekly*, the trade magazine of the industry. It will keep you abreast of new imprints, publishers that plan to increase their title selection, and the names of new art directors. You should also look for articles on book illustration and design in *HOW* and other graphic design magazines. Book designers like Lorraine Louie, Lucille Tenazas and Chip Kidd (featured in this section on page 326) are regularly featured, as are cover illustrators like Gary Kelley. To find out about one of the innovators of book design, read *Wendell Minor: Art for the Written Word* edited by Wendell Minor and Florence Friedman Minor (Harvest Books). Other great books to browse through are *Jackets Required: An Illustrated History of American Book Jacket Design, 1920-1950*, by Steven Heller and Seymour Chwast (Chronicle Books), which offers nearly 300 examples of book jackets, and *Covers & Jackets! What the Best-Dressed Books & Magazines are Wearing*, by Steven Heller and Anne Fink (PCB Intl. Inc.). While you're at the library, read the Insider Reports in the Book Publishers section of past editions of *Artist's & Graphic Designer's Market*. And don't forget to check Internet Resources on page 680 for helpful websites.

Submission Strategies Research design annuals and awards issues in design magazines, note the names of award-winning art directors and add them to your mailing list. Remember, mailings are cumulative. Be sure to send frequent postcard samples (at least quarterly) to your target art directors.

AACE INTERNATIONAL, 209 Prairie Ave., Suite 100, Morgantown WV 26505. (304)296-8444. Fax: (304)291-5728. E-mail: 74757.2636@compuserve.com. Website: http://aacei.org. Estab. 1958. Publishes trade paperback originals and reprints and textbooks. Specializes in engineering and project management books. Recent titles include: *Cost Engineering* magazine. Catalog available.

Needs: 100% of freelance design demands knowledge of QuarkXPress. 100% of freelance illustration demands knowledge of Adobe Photoshop, Adobe Illustrator and QuarkXPress.

First Contact & Terms: Designers send query letter with résumé and slides.

Book Design: Assigns 1-2 freelance design jobs/year.

Text Illustration: Assigns 1-2 freelance illustration jobs/year.

‡AAIMS PUBLISHERS, 11000 Wilshire Blvd., P.O. Box 241777, Los Angeles CA 90024-9577. (213)934-7685. Fax: (213)931-7217. E-mail: aaimspub@aol.com. Director of Art: Nancy Freeman. Estab. 1969. Publishes hardcover, trade and mass market paperback originals and textbooks. Publishes all types of fiction and nonfiction. Publishes 17 titles/year. Recent titles include *A Message from Elvis*, by Harry McKinzie; and *USMC Force Recon: A Black Hero's Story*, by Amankwa Adeduro. Book catalog for SASE.

Needs: Uses freelancers for jacket/cover design and illustration. Also for text illustration, multimedia projects and direct mail and book catalog design. Works on assignment only. 80% of freelance work requires knowledge of Microsoft Word and WordPerfect. 7% of titles require freelance art direction.

First Contact & Terms: Send query letter with SASE, photographs and photocopies. Samples are filed or are returned by SASE. Portfolio should include thumbnails and roughs. Sometimes requests work on spec before assigning a job. Buys all rights. Originals are not returned. Pays by the project, negotiated.

Book Design: Assigns 5 freelance design jobs/year and 5 freelance art direction projects/year. Pay varies for design.

Jackets/Cover: Assigns 17 freelance design and 7 freelance illustration jobs/year. Pay varies for design.

Tips: "Looking for design and illustration that is appropriate for the general public. Book design is becoming smoother, softer and more down to nature with expression of love of all—humanity, animals and earth."

A&B PUBLISHERS GROUP, 1000 Atlantic Ave., Brooklyn NY 11238. (718)783-7808. Fax: (718)783-7267. Art Director: Maxwell Taylor. Estab. 1992. Publishes trade paperback originals and reprints. Types of books include comic books, history, juvenile, preschool and young adult. Specializes in history. Publishes 15 titles/year. Recent titles include: *Fun with Colors, Come To My Island* and *Fun with Shapes*. 70% require freelance illustration; 25% require freelance design. Catalog available.

Needs: Approached by 36 illustrators and 12 designers/year. Works with 8 illustrators and 2 designers/year. Prefers local illustrators experienced in airbrush and computer graphics. Uses freelancers mainly for "book covers and insides." 85% of freelance design demands knowledge of Adobe Photoshop, Adobe Illustrator and QuarkXPress. 60% of freelance design demands knowledge of Photoshop, Illustrator, QuarkXPress and Fractal Design Painter. 20% of titles require freelance art direction.

First Contact & Terms: Designers send query letter with photocopies. Illustrators send postcard sample, photocopies, photographs, photostats, printed samples, slides and tearsheets. Send follow-up postcard sample every 4 months. Accepts disk submissions from designers compatible with QuarkXPress, Photoshop and Illustrator. Send EPS and TIFF files. Samples are filed. Reports back within 2 months if interested. Portfolio review required. Portfolio should include artwork portraying children, animals, perspective, anatomy and transparencies. Rights purchased vary according to project.

Book Design: Assigns 8 freelance design jobs/year. Pays by the hour, $15-65 and also a flat fee.

Jackets/Covers: Assigns 12 freelance design jobs and 21 illustration jobs/year. Pays by the project, $250-1,200. Prefers "computer generated titles, pen & ink and watercolor or airbrush for finish."

Text Illustration: Assigns 12-25 freelance illustration jobs/year. Pays by the hour, $8-25 or by the project $800-2,400 maximum. Prefers "airbrush or watercolor that is realistic or childlike, appealing to young schoolage children." Finds freelancers through word of mouth, submissions, NYC school of design.

Tips: "I look for artists who are knowledgeable about press and printing systems—from how color reproduces to how best to utilize color for different presses."

HARRY N. ABRAMS, INC., 100 Fifth Ave., New York NY 10011. (212)206-7715. Estab. 1951. Company publishes hardcover originals, trade paperback originals and reprints. Types of books include fine art and illustrated books and textbooks. Publishes 150 titles/year. 8% require freelance design. Book catalog available for $5.

Needs: Uses freelance designers to design complete books including jackets and sales materials. Uses illustrators mainly for textbook diagrams, maps and occasional text illustration. 90% of freelance design and 50% of illustration demands knowledge of Adobe Illustrator, QuarkXPress and Adobe Photoshop. Works on assignment only.

First Contact & Terms: Send query letter with résumé, tearsheets, photocopies. Accepts disk submissions. Samples are filed "if work is appropriate." Samples are returned by SASE if requested by artist. Portfolios may be dropped off every Monday-Thursday. Art Director will contact artist for portfolio review if interested. Portfolio should include printed samples, tearsheets and/or photocopies. Originals are returned at job's completion, with published product. Finds artists through word of mouth, submissions, attending art exhibitions and seeing published work.

Book Design: Assigns a few freelance design jobs/year. Pays by the project.

Text Illustration: Rarely assigns. Pays by the project.

ACROPOLIS BOOKS, INC., 747 Sheridan Blvd., #1A, Lakewood CO 80214-2551. (303)231-9923. Fax: (303)235-0492. E-mail: acropolisbooks@worldnet.att.net. Website: http://www.Acropolisbooks.com. Vice President Operations: Constance Wilson. Estab. 1958. Imprints include I-Level, Flashlight and Awakening. Publishes hardcover originals and reprints, trade paperback originals and reprints. Types of books include mysticism, spiritual, metaphysical, children's, fiction and poetry. Specializes in books of higher consciousness. Publishes 20-25 titles/year. Recent titles include: *The Gift of Love*, by Joel Goldsmith; and *Secret Splendor*, by Ernest Essert. 50% require freelance illustration; 30% require freelance design. Catalog available.

Needs: Approached by 15 illustrators and 10 designers/year. Works with 5-6 illustrators and 2-3 designers/year. Prefers local freelancers experienced in children's books. Uses freelancers mainly for children's books. Knowledge of Aldus PageMaker, Adobe Photoshop and QuarkXPress useful in freelance illustration and design.

First Contact & Terms: Designers send brochure, résumé and SASE. Illustrators send query letter with photocopies, résumé and SASE. Samples are filed. Reports back within 3 weeks. Will contact artist for portfolio review if interested. Buys all rights.

Book Design: Assigns 12 freelance design jobs/year. Pays by the project.

Jackets/Covers: Assigns 5-6 freelance design jobs and 7-8 illustration jobs/year. Pays by the project. Prefers pen & ink.

Text Illustration: Assigns 2-3 freelance illustration jobs/year. Pays by the project. Prefers pen & ink. Finds freelancers through word of mouth.

Tips: "We are looking for people who are familiar with our company and understand our focus."

‡ADAMS MEDIA CORPORATION 260 Center St., Holbrook MA 02343. (617)767-8100. Fax: (617)767-0994. Managing Editor: Christopher Ciaschini. Estab. 1980. Company publishes hardcover originals, trade paperback originals and reprints. Types of books include biography, cookbooks, history, humor, instructional, New Age, nonfiction, reference, self-help and travel. Specializes in business and careers. Publishes 100 titles/year. 10% require freelance illustration; 100% require freelance design. Book catalog free by request.

Needs: Approached by 20 freelancers/year. Works with 3 freelance illustrators and 7-10 designers/year. Buys less than 100 freelance illustrations/year. Uses freelancers mainly for jacket/cover illustration, text illustration and jacket/cover design. 100% of freelance work demands computer skills. Freelancers should be familiar with QuarkXPress 3.3 and Adobe Photoshop, preferably Windows-based.

First Contact & Terms: Send postcard sample of work. Samples are filed. Art Director will contact artist for portfolio review if interested. Portfolio should include tearsheets. Rights purchased vary according to project, but usually buys all rights.

Jackets/Covers: Assigns 70 freelance design jobs/year. Pays by the project, $700-1,500.

Text Illustration: Assigns 10 freelance illustration jobs/year.

ADVANTAGE PUBLISHERS' GROUP, 5880 Oberlin Dr., #400, San Diego CA 92121-9653. (619)457-2500. Fax: (619)812-6476. E-mail: joannp@advmkt.com. Website: http://www.admsweb.com. Managing Editor: JoAnn Padgett. Imprints include Laurel Glen Publishing (adult trade), Silver Dolphin Books (juvenile trade), Thunder Bay Press (adult promotional). Publishes hardcover originals and reprints, trade paperback originals and reprints and books with kits. Types of books include coffee table, cookbooks, history, instructional, juvenile, new age, nonfiction, preschool, reference, self help and travel. Specializes in interactive educational titles (books with components) geared to juveniles and families. Publishes 150 titles/year. Recent titles include *Alternative Healthcare, Art Works* and *Science Nature Guides*. 50% require freelance illustration and design. Book catalog free for 8½×11 SAE with 5 first-class stamps.

Needs: Approached by 40 illustrators/year. Works with 15 illustrators and 6 designers/year. Prefers freelancers experienced in QuarkXPress for Mac. Uses freelancers mainly for book design and page layout and composition. 100% of freelance design work demands knowledge of Adobe Photoshop, Adobe Illustrator and QuarkXPress.

First Contact & Terms: Designers send query letter with brochure, photocopies, tearsheets and résumé. Illustrators send postcard sample. Accepts disk submissions. Send EPS files. Samples are filed or returned by SASE. Reports back only if interested. Art director will contact artist for portfolio review if interested. Rights purchased vary according to project; negotiable.

Book Design: Assigns 6 freelance design jobs/year. Pays by the hour or by the project.

Jackets/Covers: Assigns 6 freelance design and 6 freelance illustration jobs/year. Pays by the project.

Text Illustration: Assigns 6 freelance illustration jobs/year. Pays by the piece.

ALLYN AND BACON INC., College Division, 160 Gould St., Needham MA 02194. (617)455-1200. Fax: (617)455-1294. Art Director: Linda Knowles. Publishes more than 300 hardcover and paperback textbooks/year. 60% require freelance cover designs. Subject areas include education, psychology and sociology, political science, theater, music and public speaking.

Needs: Designers must be strong in book cover design and contemporary type treatment. 50% of freelance work demands knowledge of Adobe Illustrator, Adobe Photoshop and Aldus FreeHand.

Jackets/Covers: Assigns 100 design jobs and 2-3 illustration jobs/year. Pays for design by the project, $300-750. Pays for illustration by the project, $150-500. Prefers sophisticated, abstract style in pen & ink, airbrush, charcoal/pencil, watercolor, acrylic, oil, collage and calligraphy. "Always looking for good calligraphers."

Tips: "Keep stylistically and technically up to date. Learn *not* to over-design: read instructions and ask questions. Introductory letter must state experience and include at least photocopies of your work. If I like what I see, and you

can stay on budget, you'll probably get an assignment. Being pushy closes the door. We primarily use designers based in the Boston area."

THE AMERICAN BIBLE SOCIETY, 1865 Broadway, New York NY 10023. Fax: (212)408-1305. Assistant Director, Product Development: Christina Murphy. Estab. 1868. Company publishes religious products including Bibles/New Testaments, portions, leaflets, calendars, bookmarks. Additional products include religious children's books, posters, seasonal items, teaching aids, audio casettes, videos and CD-ROMs. Specializes in contemporary applications to the Bible. Publishes 80 titles/year. Recent titles include the *Translators to the Reader: The Original Prefaceof the King James Version of 1611 Revisited*. 25% require freelance illustration; 90% require freelance design. Book catalog free by request.

Needs: Approached by 50-100 freelancers/month. Works with 10 freelance illustrators and 20 designers/year. Uses freelancers for jacket/cover illustration and design, text illustration, book design and children's activity books. 90% of freelance work demands knowledge of Adobe Illustrator, QuarkXPress, Adobe Photoshop. Works on assignment only. 5% of titles require freelance art direction.

First Contact & Terms: Send postcard samples of work or send query letter with brochure and tearsheets. Samples are filed and/or returned. **Please do not call.** Reports back within 1-2 months. Product Design will contact artist for portfolio review if additional samples are needed. Portfolio should include final art and tearsheets. Buys all rights. Finds artists through artists' submissions, *The Workbook* (by Scott & Daughters Publishing) and *RSVP Illustrator*.

Book Design: Assigns 3-5 freelance interior book design jobs/year. Pays by the project, $350-1,000 depending on work involved.

Jackets/Covers: Assigns 60-80 freelance design and 20 freelance illustration jobs/year. Pays by the project, $350-2,000.

Text Illustration: Assigns several freelance illustration jobs/year. Pays by the project.

Tips: "Looking for contemporary, multicultural artwork/designs and good graphic designers familiar with commercial publishing standards and procedures. Have a polished and professional-looking portfolio or be prepred to show polished and professional-looking samples."

‡AMERICAN BIOGRAPHICAL INSTITUTE, 5126 Bur Oak Circle, Raleigh NC 27612. (919)781-8710. Fax: (919)781-8712. Executive Vice President: Janet Evans. Estab. 1967. Publishes hardcover reference books and biography. Publishes 5 titles/year. Recent titles include *2,000 Notable American Women; Five Hundred Leaders of Influence*. 75% require freelance illustration and design. Books are "mostly graphic text." Book catalog not available.

Needs: Approached by 4-5 freelance artists/year. Works with 2 illustrators and 2 designers/year. Buys 10 illustrations/year. Prefers artists with experience in graphics and copy design. Uses freelancers mainly for brochures (direct mail pieces). Also uses freelancers for book and direct mail design and jacket/cover illustration. 95% of freelance work demands knowledge of QuarkXPress or Adobe Photoshop. Works on assignment only.

First Contact & Terms: Send query letter with brochure, résumé, SASE and photocopies. Samples are filed. Art Director will contact artists for portfolio review if interested. Portfolio should include art samples, b&w and color dummies and photographs. Sometimes requests work on spec before assigning job. Originals are not returned. Finds artists mostly through word of mouth.

Book Design: Pays by the hour, $35-50; or by the project, $250-500.

✔AMERICAN EAGLE PUBLICATIONS, INC., P.O. Box 1507, Show Low AZ 85902. (520)367-1621. E-mail: ameagle@whitemtns.com. President: Mark Ludwig. Estab. 1988. Publishes hardcover originals and reprints and trade paperback originals and reprints. Types of books include historical fiction, history and computer books. Publishes 10 titles/year. Titles include *Artificial Life & Evolution*; *Computer Viruses*; *The War Nobody Won*; *The Quest for Water Planets*. 100% require freelance illustration and design. Book catalog free for large SAE with 2 first-class stamps.

Needs: Approached by 10 freelance artists/year. Works with 4 illustrators and 4 designers/year. Buys 20 illustrations/year. Uses freelancers mainly for covers. Also for text illustration. 100% of design and 25% of illustration demand knowledge of Ventura Publisher and CorelDraw. Works on assignment only.

First Contact & Terms: Send query letter with résumé, SASE and photocopies. Accepts disk submissions compatible with CorelDraw or Ventura Publisher on PC. Send TIFF files. Samples are filed. Reports back only if interested. Call for appointment to show portfolio, which should include final art, b&w and color photostats, slides, tearsheets, transparencies and dummies. Buys all rights. Originals are returned at job's completion.

Jackets/Covers: Assigns 10 design and 10 illustration jobs/year. Payment negotiable (roughly $20/hr minimum). "We generally do 2-color or 4-color covers composed on a computer."

Text Illustration: Assigns 7 illustration jobs/year. Pays roughly $20/hr minumum. Prefers pen & ink.

Tips: "Show us good work that demonstrates you're in touch with the kind of subject matter in our books. Show us you can do good, exciting work in two colors."

AMERICAN JUDICATURE SOCIETY, 180 N. Michigan, Suite 600, Chicago IL 60601-7401. (312)558-6900, ext. 119. Fax: (312)558-9175. E-mail: drichort@ajs.org. Website: http://www.ajs.org. Editor: David Richert. Estab. 1913. Publishes journals and books. Specializes in courts, judges and administration of justice. Publishes 5 titles/year. 75% require freelance illustration. Catalog available free for SASE.

Needs: Approached by 20 illustrators and 6 designers/year. Works with 3-4 illustrators and 1 designer/year. Prefers local designers. Uses freelancers mainly for illustration. 100% of freelance design demands knowledge of Aldus Page-

Maker, Aldus FreeHand, Adobe Photoshop and Adobe Illustrator. 10% of freelance illustration demands knowledge of Aldus PageMaker, Aldus FreeHand, Adobe Photoshop and Adobe Illustrator.
First Contact & Terms: Designers send query letter with photocopies. Illustrators send query letter with photocopies and tearsheets. Send follow-up postcard every 3 months. Samples are not filed and are returned by SASE. Reports back within 1 month. Will contact artist for portfolio review of photocopies, roughs and tearsheets if interested. Buys one-time rights.
Book Design: Assigns 1-2 freelance design jobs/year. Pays by the project, $500-1,000.
Text Illustration: Assigns 10 freelance illustration jobs/year. Pays by the project, $75-375.

‡AMERICAN PSYCHIATRIC PRESS, INC., 1400 K St. NW, 11th Floor, Washington DC 20005. (202)682-6219. Fax: (202)682-6341. E-mail: eileen@appi.org. Website: http://www.appi.org. Marketing Manager: Eileen Shedrow. Estab. 1981. Imprint of American Psychiatric Association. Company publishes hardcover originals and textbooks. Specializes in psychiatry and its subspecialties. Publishes 60 titles/year. Recent titles include *Posttraumatic Stress Disorder*, *Textbook of Psychiatry* and *Textbook of Psychopharmacology*. 10% require freelance illustration; 10% require freelance design. Book catalog free by request.
Needs: Uses freelancers for jacket/cover design and illustration. Needs computer-literate freelancers for design. 100% of freelance work demands knowledge of QuarkXPress, Adobe Illustrator 3.0, Aldus PageMaker 5.0. Works on assignment only.
First Contact & Terms: Designers send query letter with brochure, photocopies, photographs and/or tearsheets. Illustrators send postcard sample. Samples are filed. Promotions Coordinator will contact artist for portfolio review if interested. Portfolio should include final art, slides and tearsheets. Rights purchased vary according to project.
Book Design: Pays by the project.
Jackets/Covers: Assigns 10 freelance design and 10 illustation jobs/year. Pays by the project.
Tips: Finds artists through sourcebooks. "Book covers are now being done in Corel Draw 5.0 but will work with Mac happily. Book covers are for professional books with clean designs. Type treatment design are done in-house."

AMHERST MEDIA, INC., P.O. Box 586, Amherst NY 14226. (716)874-4450. Fax: (716)874-4508. Publisher: Craig Alesse. Estab. 1974. Company publishes trade paperback originals. Types of books include instructional and reference. Specializes in photography, how-to. Publishes 12 titles/year. Recent titles include *Wedding Photographer's Handbook*, by Robert Hurth. 20% require freelance illustration; 80% require freelance design. Book catalog free for 9×12 SAE with 3 first-class stamps.
Needs: Approached by 12 freelancers/year. Works with 3 freelance illustrators and 3 designers/year. Uses freelance artists mainly for illustration and cover design. Also for jacket/cover illustration and design and book design. 80% of freelance work demands knowledge of QuarkXPress or Adobe Photoshop. Works on assignment only.
First Contact & Terms: Send brochure, résumé and photographs. Samples are filed. Reports back only if interested. Art Director will contact artist for portfolio review if interested. Portfolio should include slides. Rights purchased vary according to project. Originals are returned at job's completion. Finds artists through word of mouth.
Book Design: Assigns 12 freelance design jobs/year. Pays for design by the hour $25 minimum; by the project $1,500.
Jackets/Covers: Assigns 12 freelance design and 4 illustration jobs/year. Pays $200-1200. Prefers computer illustration (QuarkXPress/Adobe Photoshop).
Text Illustration: Assigns 12 freelance illustration job/year. Pays by the project. Prefers computer illustration (QuarkXPress).

‡ANDREWS McMEEL PUBLISHING, 4520 Main, Kansas City MO 64111-7701. (816)932-6600. Fax: (816)932-6781. E-mail: tlynch@amuniversal.com. Website: http://www.andrewsmcmeel.com. Art Director: Tim Lynch. Production Coordinator: Traci Bertz. Estab. 1972. Publishes hardcover originals and reprints; trade paperback originals and reprints. Types of books include biography, children's picture books, cookbooks, history, humor, instructional, juvenile, nonfiction, reference, religious, self help, travel. Specializes in cartoon/humor books. Publishes 200 titles/year. Recent titles include: *Far Side, Dilbert, Jenny Jones My Story, Landing on My Feet*. 10% requires freelance illustration; 80% requires freelance design.
Needs: Approached by 100 illustrators and 10 designers/year. Works with 15 illustrators and 25 designers/year. Prefers freelancers experienced in book jacket design. 100% of freelance design demands knowledge of Adobe Illustrator, Adobe Photoshop, QuarkXPress. 100% of freelance illustration demands knowledge of traditional art skills: printing, watercolor etc.
First Contact & Terms: Designers send query letter with printed samples. Illustrators send query letter with printed samples or contact through artists' rep. Accepts Mac-compatible disk submissions. Samples are filed and not returned. Reports back only if interested. Portfolio review not required. Rights purchased vary according to project. Finds freelancers mostly through sourcebooks and samples sent in by freelancers.
Book Design: Assigns 60 freelance design jobs/year. Pays by the project, $600-3,000.
Jackets/Covers: Assigns 60 freelance design jobs and 20 illustration jobs/year. Pays for design $600-3,000.
Tips: "We want designers who can read a manuscript and design a concept for the best possible cover. Communicate well and be flexible with design."

‡APPALACHIAN MOUNTAIN CLUB BOOKS, 5 Joy St., Boston MA 02108. (617)523-0636. Fax: (617)523-0722. Website: http://www.outdoors.org. Production: Elisabeth L. Brady. Estab. 1876. Publishes trade paperback originals and

reprints. Types of books include adventure, instructional, nonfiction, travel. Specializes in hiking guidebooks. Publishes 7-10 titles/year. Recent titles include: *River Rescue, Classic Northeastern Whitewater Guide, North Carolina Hiking Trails.* 5% requires freelance illustration; 100% requires freelance design. Book catalog free for #10 SAE with 1 first-class stamp.

Needs: Approached by 5 illustrators and 2 designers/year. Works with 1 illustrator and 2 designers/year. Prefers local freelancers experienced in book design. 100% of freelance design demands knowledge of Aldus FreeHand, Adobe Photoshop, QuarkXPress. 100% of freelance illustration demands knowledge of Aldus FreeHand, Adobe Illustrator.

First Contact & Terms: Designers send postcard sample or query letter with photocopies. Illustrators send postcard sample. Accepts Mac-compatible disk submissions. Samples are not filed and are not returned. Will contact artist for portfolio review of book dummy, photocopies, photographs, tearsheets, thumbnails if interested. Negotiates rights purchased. Finds freelancers through professional recommendation (word of mouth).

Book Design: Assigns 10-12 freelance design jobs/year. Pays for design by the project, $1,500-2,500.

Jackets/Covers: Assigns 10-12 freelance design jobs and 1 illustration job/year. Pays for design by the project.

ARDSLEY HOUSE PUBLISHERS, INC., 320 Central Park W., New York NY 10025. (212)496-7040. Assistant Editor: Karyn Bianco. Publishes college textbooks. Specializes in math, music and philosophy. Publishes 8 titles/year. Recent titles include *Twelve Great Philosophers*, by Wayne Pomerleau and *Functional Hearing: A Contextual Method for Ear Training*, by Arthur Gottschalk and Phillip Kloeckner. 100% require freelance illustration and design.

Needs: Works with 3-4 freelance illustrators and 3-4 designers/year. Prefers experienced local freelancers. Uses freelancers mainly for cover illustrations and technical drawing. Also for direct mail and book design. 50% of freelance work demands computer skills. Works on assignment only.

First Contact & Terms: Send query letter with brochure and résumé. Samples are filed and are not returned. Reports back only if interested.

Book Design: Assigns 3-4 freelance design jobs/year. Pays by the project.

Jackets/Covers: Assigns 8 freelance design jobs/year. Pays by the project.

Text Illustration: Assigns 8 freelance jobs/year. Pays by the project.

Tips: "We'd like to see snappy, exciting, but clear designs. We expect freelancers to have a sense of responsibility and show evidence of ability to meet deadlines."

ARJUNA LIBRARY PRESS, 1025 Garner St., D, Space 18, Colorado Springs CO 80905-1774. Director: Count Prof. Joseph A. Uphoff, Jr. Estab. 1979. Company publishes trade paperback originals and monographs. Types of books include experimental fiction, fantasy, horror, nonfiction and science fiction. Specializes in surrealism and metamathematics. Publishes 1 or more titles/year. Recent titles include *Magical Equipment in Daily Use*, by Joseph Uphoff. 100% require freelance illustration. Book catalog available for $1.

Needs: Approached by 1-2 freelancers/year. Works with 1-2 freelance illustrators/year. Buys 1-2 freelance illustrations/year. Uses freelancers for jacket/cover and text illustration.

First Contact & Terms: Send query letter with brochure, résumé, SASE, tearsheets, slides, photographs and photocopies. Samples are filed. Reports back if interested. Portfolio review not required. Originals are not returned.

Book Design: Pays contributor's copy and "royalties by agreement if work becomes profitable."

Jackets/Covers: Pays contributor's copy and "royalties by agreement if work becomes profitable."

Text Illustration: Pays contributor's copy and "royalties by agreement if work becomes profitable."

Tips: "Although color illustrations are needed for dust jackets and paperback covers, because of the printing cost, most interior book illustrations are black and white. It is a valuable skill to be able to make a color image with strong values of contrast that will transcribe positively into black and white. In terms of publishing and computer processing, art has become information. There is yet an Art that presents the manifestation of the object as being a quality. This applies to sculpture, ancient relics, and anything with similar material value. These things should be treated with respect; curatorial values will always be important."

ART DIRECTION BOOK CO. INC., 456 Glenbrook Rd., Glenbrook CT 06906. (203)353-1441. Fax: (203)353-1371. Art Director: Doris Gordon. Publishes hardcover and paperback originals on advertising design and photography. Publishes 12-15 titles/year. Titles include disks of *Scan This Book* and *Most Happy Clip Art*; book and disk of *101 Absolutely Superb Icons* and *American Corporate Identity #11*. Book catalog free on request.

Needs: Works with 2-4 freelance designers/year. Uses freelancers mainly for graphic design.

First Contact & Terms: Send query letter to be filed, and arrange to show portfolio of 4-10 tearsheets. Portfolios may be dropped off Monday-Friday. Samples returned by SASE. Buys first rights. Originals are returned to artist at job's completion. Advertising design must be contemporary. Finds artists through word of mouth.

Book Design: Assigns 8 freelance design jobs/year. Pays $350 maximum.

HOW TO USE THIS BOOK TO SELL YOUR WORK offers suggestions for understanding and using the information in these listings. Read this and other articles in the front of this book for important business tips.

Jackets/Covers: Assigns 8 freelance design jobs/year. Pays $350 maximum.

ARTEMIS CREATIONS, 3395-2J Nostrand Ave., Brooklyn NY 11229. (718)648-8215. President: Shirley Oliveira. Estab. 1992. Publishes trade paperback originals, audio tapes and periodicals. Types of books include erotica, experimental fiction, fantasy, horror, humor, new age, nonfiction and religious. Specializes in powerful women. Publishes 2-4 books, 4 journals and novellas/year. 10% require freelance illustration and design. Catalog available for SAE with 2 first-class stamps.
Needs: Works with 2 illustrators and 1 designer/year. Prefers freelancers experienced in digital, creative and experimental art. Uses freelancers mainly for cover design. 80-90% of freelance design and illustration demands computer skills.
First Contact & Terms: Designers send query letter with photocopies, photographs, résumé and tearsheets. Illustrators send photocopies, résumé, SASE and tearsheets. Accepts disk submissions compatible with PC only. Samples are filed and are returned by SASE. Reports back within 1 day. Rights purchased vary according to project.
Book Design: Pays by the project.
Jackets/Covers: Pays for design by the project $400 maximum. Pays for illustration by the project $100 maximum.
Text Illustration: Finds freelancers through magazines and word of mouth.
Tips: "Artists should follow instructions."

ARTIST'S & GRAPHIC DESIGNER'S MARKET, Writer's Digest Books, 1507 Dana Ave., Cincinnati OH 45207. E-mail: artdesign@fwpubs.com. Editor: Mary Cox. Annual hardcover directory of markets for designers, illustrators and fine artists. Buys one-time rights.
Needs: Buys 35-45 illustrations/year. "I need examples of art that have been sold to the listings in *Artist's & Graphic Designer's Market*. Look through this book for examples. The art must have been freelanced; it cannot have been done as staff work. Include the name of the listing that purchased or exhibited the work, what the art was used for and, if possible, the payment you received. Bear in mind that interior art is reproduced in black and white, so the higher the contrast, the better."
First Contact & Terms: Send printed piece, photographs or tearsheets. "Since *Artist's & Graphic Designer's Market* is published only once a year, submissions are kept on file for the upcoming edition until selections are made. Material is then returned by SASE if requested." Pays $50 to holder of reproduction rights and free copy of *Artist's & Graphic Designer's Market* when published.

ASSOCIATION OF COLLEGE UNIONS INTERNATIONAL, 400 E. Seventh St., Bloomington IN 47405. (812)855-8550. Fax: (812)855-0162. E-mail: avest@indiana.edu. Website: http://www.indiana.edu/~acui. Assistant Director of Publishing and Marketing: Ann Vest. Estab. 1914. Professional education association. Publishes hardcover and trade paperback originals. Specializes in multicultural issues, creating community on campus, union and activities programming, managing staff, union operations, and professional and student development. Recent titles include *Building Community on Campus*, by Susan Young Maul. Book catalog free for SAE with $3 postage.
● This association also publishes a magazine (see Magazines section for listing). Note that most illustration and design are accepted on a volunteer basis. This is a good market if you're just looking to build or expand your portfolio.
Needs: "We are a volunteer-driven association. Most people submit work on that basis." Uses freelancers mainly for illustration. Freelancers should be familiar with CorelDraw. Works on assignment only.
First Contact & Terms: Send query letter with tearsheets. Samples are filed. Reports back to the artist only if interested. Negotiates rights purchased. Originals are returned at job's completion.
Book Design: Assigns 4 freelance design jobs/year.
Tips: Looking for color transparencies of college student union activities.

ATHENEUM BOOKS FOR YOUNG READERS, 1230 Avenue of the Americas, New York NY 10020. (212)698-2781. Art Assistant: Amanda Foley. Imprint of Simon & Schuster. Imprint publishes hardcover originals, picture books for young kids, nonfiction for ages 8-12. Types of books include biography, fantasy, historical fiction, history, instructional, nonfiction, and reference for preschool, juvenile and young adult. Publishes 400 titles/year. Recent titles include *Shiloh Season*; *Summertime Song*; and *Plains Warrior*. 100% require freelance illustration; 15% require freelance design. Book catalog free by request.
Needs: Approached by hundreds of freelance artists/year. Works with 40-60 freelance illustrators and 3-5 designers/year. Buys 40 freelance illustrations/year. "We are interested in artists of varying media and are trying to cultivate those with a fresh look appropriate to each title." 90% of freelance work demands knowledge of Adobe Illustrator 7.0, QuarkXPress 3.31 and Adobe Photoshop 4.0. Works on assignment only.
First Contact & Terms: Send postcard sample of work or send query letter with tearsheets, résumé and photocopies. Samples are filed. Portfolios may be dropped off every Thursday between 9 a.m. and noon. Art Director will contact artist for portfolio review if interested. Portfolio should include final art if appropriate, tearsheets and folded & gathered sheets from any picture books you've had published. Rights purchased vary according to project. Originals are returned at job's completion. Finds artists through submissions, magazines ("I look for interesting editorial illustrators"), word of mouth.
Book Design: Assigns 2-5 freelance design jobs/year. Pays by the project, $750-1,500.
Jackets/Covers: Assigns 1-2 freelance design and 20 freelance illustration jobs/year. Pays by the project, $1,200-1,800. "I am not interested in generic young adult illustrators."

Text Illustration: Pays by the project, $500-2,000.

‡AUGSBURG FORTRESS PUBLISHERS, Box 1209, 100 S. Fifth St., Suite 700, Minneapolis MN 55402. (612)330-3300. Contact: Director of Design, Design Services. Publishes hard cover and paperback Protestant/Lutheran books (90 titles/year), religious education materials, audiovisual resources, periodicals. Recent titles include *Ecotheraphy*, by Howard Clinebell; and *Thistle*, by Walter Wangerin.
Needs: Uses freelancers for advertising layout, design, illustration and circulars and catalog cover design. Freelancers should be familiar with QuarkXPress 3.31, Adobe Photoshop 3.0 and Adobe Illustrator 5.0.
First Contact & Terms: "Majority, but not all, of our freelancers are local." Works on assignment only. Reports back on future assignment possibilities in 5-8 weeks. Call, write or send brochure, flier, tearsheet, good photocopies and 35mm transparencies; if artist is not willing to have samples filed, they are returned by SASE. Buys all rights on a work-for-hire basis. May require designers to supply overlays on color work.
Jackets/Covers: Uses designers primarily for cover design. Pays by the project, $600-900. Prefers covers on disk using QuarkXPress.
Text Illustration: Negotiates pay for 1-, 2- and 4-color. Generally pays by the project, $25-500.
Tips: Be knowledgeable "of company product and the somewhat conservative contemporary Christian market."

‡AVIATION PUBLISHING INC., P.O. Box 5674, Destin FL 32540-5674. (850)654-4696. Fax: (850)654-1542. E-mail: destina@cybertron.com. Art Director: Wallace Kemper. Estab. 1996. Publishes trade paperback originals and reprints. Types of books include history and aviation history. Publishes 20 titles/year. Recent titles include: *Globe/Temco Swift*, *Its a Funk*, *Aeronca: Best of Paul Matt*, and *Worldwide Directory of Racing Aircraft*. 70% requires freelance illustration. Book catalog available for $1.
Needs: Approached by 2-3 illustrators/year. Works with 3 illustrators/year. Prefers local illustrators experienced in book layout or cover design. 100% of freelance design and illustration demands knowledge of Adobe Photoshop, PageMaker.
First Contact & Terms: Send postcard sample. Accepts Windows-compatible disk submissions. Samples are filed. Will contact artist for portfolio review of artwork portraying aircraft if interested. Buys all rights. Finds freelancers through advertisements in newspapers.
Book Design: Assigns 40 art direction projects/year. Pays for design by the hour, $14-50.
Jackets/Covers: Assigns 20 freelance design jobs/year. Pays for design by the hour, $14-50.

AVON BOOKS, 1350 Avenue of the Americas, New York NY 10019. (212)261-6888. Fax: (212)261-6925. Art Director: Tom Egner. Estab. 1941. Publishes hardcover, trade and mass market paperback originals and reprints. Types of books include adventure, biography, cookbooks, fantasy, history, horror, humor, juvenile, mainstream fiction, New Age, nonfiction, romance, science fiction, self-help, travel, young adult. Specializes in romance, mystery, upscale fiction. Publishes 400-450 titles/year. Recent titles include: *Love Me Forever*, by Johanna Lindsey; *Sanctuary*, by Faye Kellerman. 85% requires freelance illustration; 10% requires freelance design.
Needs: Approached by 150 illustrators and 25 designers/year. Works with 125 illustrators and 5-10 designers/year. Prefers freelancers experienced in illustration. Uses freelancers mainly for illustration. 80% of freelance design and 5% of freelance illustration demand knowledge of Adobe Photoshop, Adobe Illustrator and QuarkXPress.
First Contact & Terms: Designers send query letter with slides, tearsheets, transparencies. Illustrators send postcard sample and/or query letter with printed samples, slides, tearsheets and transparencies. Accepts disk submissions from designers, not illustrators, compatible with QuarkXPress 7.5, version 3.3. Send EPS files. Samples are filed or returned. Reports back within days if interested. Portfolios may be dropped off every Thursday. Will contact for portfolio review of slides and transparencies of work in all genres if interested. Rights purchsed vary according to project.
Book Design: Assigns 25 freelance design jobs/year. Pays by the project, $700-1,500.
Jackets/Covers: Assigns 25 freelance design jobs and 325 illustration jobs/year. Pays for design by the project, $700-1,500. Pays for illustration by the project, $1,000-5,000. Prefers all mediums.

BAEN BOOKS, Box 1403, Riverdale NY 10471. (718)548-3100. Website: http://baen.com. Publisher: Jim Baen. Editor: Toni Weisskopf. Estab. 1983. Publishes science fiction and fantasy. Publishes 84-96 titles/year. Titles include *Memory*, by Lois McMaster Bujold; *Glenraven*, by Marion Zimmer Bradley and Holly Lisle ; and *Bug Park*, by James P. Hogan 75% require freelance illustration; 80% require freelance design. Book catalog free on request.
First Contact & Terms: Approached by 500 freelancers/year. Works with 10 freelance illustrators and 3 designers/year. 50% of work demands computer skills. Designers send query letter with résumé, color photocopies, tearsheets (color only) and SASE. Illustrators send query letter with color photocopies, SASE, slides and tearsheets. Samples are filed. Originals are returned to artist at job's completion. Buys exclusive North American book rights.
Jackets/Covers: Assigns 64 freelance design and 64 illustration jobs/year. Pays by the project—$200 minimum, design; $1,000 minimum, illustration.
Tips: Wants to see samples within science fiction, fantasy genre only. "Do not send black & white illustrations or surreal art. Please do not waste our time and your postage with postcards. Serious submissions only."

‡BANDANNA BOOKS, 319-B Anacapa St., Santa Barbara CA 93101. Fax: (805)564-3278. E-mail: art@bandannabooks.com. Publisher: Sasha Newborn. Contact: Joan Blake. Estab. 1981. Publishes nonfiction and fiction trade paperback originals and reprints. Types of books include classics and books for students. Publishes 3 titles/year. Recent titles

include *Benigna Machiavelli*, by Charlotte Perkins Gilman; *Italian for Opera Lovers*; and *Don't Panic: The Procrastinator's Guide to Writing an Effective Term Paper*, by Steven Posusta. 100% of freelance design demands knowledge of QuarkXPress on Mac.

Needs: Approached by 150 freelancers/year. Uses illustrators mainly for woodblock or scratchboard and pen & ink art. Also for cover and text illustration.

First Contact & Terms: Send postcard sample or query letter with samples. Accepts disk submissions compatible with Mac Adobe Photoshop. Send JPEG files. Samples are filed and are returned by SASE only if requested. Reports back within 2 months if interested. Originals are not returned. To show portfolio mail thumbnails and sample work. Considers project's budget when establishing payment.

Jackets/Covers: Prefers b&w. Pays by the project, $50-200.

Text Illustration: Pays by the project, $50-200.

Tips: "Include at least five samples in your submission. Make sure work done for us is equal in quality and style to the samples sent. Make sure samples are generally related to our topics published. We're interested in work that is innovative without being bizarre, quality without looking too 'slick' or commercial. Simplicity is are important. We are not interested in New Age or fantasy work."

‡BANTAM BOOKS, 666 5th Ave., New York NY 10103. Does not need freelance artists at this time.

BARBOUR PUBLISHING, (formerly Barbour & Co., Inc.), 1810 Barbour Dr., P.O. Box 719, Uhrichsville OH 44683. (740)922-6045, ext. 125. Fax: (740)922-5948. E-mail: rmartins@barbourbooks.com. Website: http://www.barbourbooks.com. Creative Director: Robyn Martins. Estab. 1981. Publishes hardcover, trade paperback and mass market paperback originals and reprints. Types of books include contemporary and historical fiction, romance, self help, young adult, reference and juvenile. Specializes in Christian bargain books. Publishes 60 titles/year. Recent titles include *My Utmost for His Highest Journal*, by Oswald Chambers; and *A Treasury of Wisdom Journal*, by various authors. 60% require freelance illustration. Book catalog available for $1.

Needs: Prefers freelancers with experience in people illustration and photorealistic styles. Uses freelancers mainly for fiction romance jacket/cover illustration. Works on assignment only.

First Contact & Terms: Send query letter with photocopies or tearsheets and SASE. Accepts Mac disk submissions compatible with Illustrator 6.0 and Photoshop. Buys all rights. Originals are returned. Finds artists through word of mouth, recommendations, sample submissions and placing ads.

Jackets/Covers: Assigns 10 freelance design and 90 illustration jobs/year. Pays by the project, $300-600.

Text Illustration: Assigns 30 freelance illustration jobs/year. Pays by the project, $15-25/illustration.

Tips: "Submit a great illustration of people suitable for a romance cover or youth cover in a photorealistic style. I am also looking for great background illustrations, such as florals and textures. As a publisher of bargain books, I am looking for top-quality art on a tight budget."

BEAVER POND PUBLISHING, P.O. Box 224, Greenville PA 16125. (724)588-3492. Fax: (724)588-2486. Owner: Rich Faler. Estab. 1988. Subsidy publisher and publisher of trade paperback originals and reprints and how-to booklets. Types of books include instructional and adventure. Specializes in outdoor topics. Publishes 20 titles/year. Recent titles include *The Complete, Authoritative Guide to Self-Publishing*, by Richard E. Faler, Jr. 20% require freelance illustration. Book catalog free by request.

Needs: Approached by 6 freelance artists/year. Works with 3 illustrators/year. Buys 50 illustrations/year. Prefers artists with experience in outdoor activities and animals. Uses freelancers mainly for book covers and text illustration. Works on assignment only.

First Contact & Terms: Send query letter with tearsheets and/or photocopies. Samples are filed. Reports back only if interested. To show portfolio, mail appropriate materials: thumbnails, b&w photocopies. Rights purchased vary according to project. Originals are returned at job's completion (if all rights not purchased).

Jackets/Covers: Assigns 3-4 illustration jobs/year. Pays for covers as package with text art. Prefers pen & ink line art.

Text Illustration: Assigns 3-4 jobs/year. Pays by the project, $100 (booklets)-$1,600 (books). Prefers pen & ink line art.

Tips: "Show an understanding of animal anatomy. We want accurate work."

BEDFORD/ST. MARTIN'S, (formerly Bedford Books of St. Martin's Press), 75 Arlington St., Boston MA 02116. (617)426-7440. Fax: (617)426-8582. Advertising and Promotion Manager: Jeannie Tarkenton; Art Director: Donna Dennison. Estab. 1981. Imprint of St. Martin's Press. Publishes college textbooks. Specializes in English and history. Publishes 40 titles/year. Recent titles include *A Writer's Reference*, *Third Edition*; *The Bedford Handbook*, Third Edition; *The American Promise*; *Literature and Its Writers*. Books have "contemporary, classic design." 5% require freelance illustration; 90% require freelance design.

Needs: Approached by 25 freelance artists/year. Works with 2-4 illustrators and 6-8 designers/year. Buys 2-4 illustrations/year. Prefers artists with experience in book publishing. Uses freelancers mainly for cover and brochure design. Also for jacket/cover and text illustration and book and catalog design. 75% of design work demands knowledge of Adobe PageMaker, QuarkXPress, MacromediaFreeHand, Adobe Photoshop or Adobe Illustrator.

First Contact & Terms: Send query letter with brochure, tearsheets and SASE. Samples are filed or are returned by SASE if requested by artist. Reports back only if interested. Request portfolio review in original query. Art Director

will contact artists for portfolio review if interested. Portfolio should include roughs, original/final art, color photostats and tearsheets. Rights purchased vary according to project. Interested in buying second rights (reprint rights) to previously published work. Originals are returned at job's completion.

Jackets/Covers: Assigns 40 design jobs and 2-4 illustration jobs/year. Pays by the project. Finds artists through magazines, self-promotion and sourcebooks. Contact: Donna Dennison.

Tips: "Regarding book cover illustrations, we're usually interested in buying reprint rights for artistic abstracts or contemporary, multicultural scenes and images of writers and writing-related scenes (i.e. desks with typewriters, paper, open books, people reading, etc.)."

BEHRMAN HOUSE, INC., 235 Watchung Ave., West Orange NJ 07052. (201)669-0447. Fax: (201)669-9769. Projects Editor: Adam Siegel. Estab. 1921. Book publisher. Publishes textbooks. Types of books include preschool, juvenile, young adult, history (all of Jewish subject matter) and Jewish texts. Specializes in Jewish books for children and adults. Publishes 12 titles/year. Recent titles include *Women of Valor*, by Sheila Segal. "Books are contemporary with lots of photographs and artwork; colorful and lively. Design of textbooks is very complicated." 50% require freelance illustration; 100% require freelance design. Book catalog free by request.

Needs: Approached by 50 freelancers/year. Works with 6 freelance illustrators and 6 designers/year. Prefers freelancers with experience in illustrating for children; "Jewish background helpful." Uses freelancers for textbook illustration and book design. 25% of freelance work demands knowledge of QuarkXPress. Works on assignment only.

First Contact & Terms: Send query letter with brochure, résumé and tearsheets. Samples are filed. Reports back only if interested. Buys reprint rights. Sometimes requests work on spec before assigning a job. Originals are returned at job's completion.

Book Design: Assigns 8 freelance design and 3 illustration jobs/year. Pays by project, $4,000-8,000.

Jackets/Covers: Assigns 8 freelance design and 4 illustration jobs/year. Pays by the project, $500-1,000.

Text Illustration: Assigns 6 freelance design and 4 illustration jobs/year. Pays by the project.

‡THE BENEFACTORY, INC., One Post Rd., Fairfield CT 06430. (203)255-7744. Fax: (203)255-6200. E-mail: benfactory@aol.com. Production: Cynthia A. Germain. Estab. 1990. Publishes audio tapes, hardcover and trade paperback originals. Types of books include children's picture books. Specializes in true stories about real animals. Publishes 9 titles/year. Recent titles include: *Chessie, The Travelin' Man*; *Condor Magic*; *Caesar: On Deaf Ears*. 100% requires freelance illustration. Book catalog free for 8½×11 SAE with 3 first-class stamps.

Needs: Approached by 5 illustrators/year. Works with 9 illustrators/year.

First Contact & Terms: Illustrators send query letter with SASE and tearsheets. Samples are filed or returned returned by SASE. Reports back within 3 months. Will contact artist for portfolio review of artwork portraying animals, children, nature if interested. Buys all rights.

Tips: "We look for realistic portrayal of children and animals with great expression. We bring our characters and stories to life for children."

✓ROBERT BENTLEY PUBLISHERS, 1734 Massachusetts Ave., Cambridge MA 02138-1804. (617)547-4170. Website: http://www.rb.com. Publisher: Michael Bentley. Publishes hardcover originals and reprints and trade paperback originals—reference books. Specializes in automotive technology and automotive how-to. Publishes 20 titles/year. Recent titles include *Jeep Owner's Bible*. 50% require freelance illustration; 80% require freelance design and layout. Book catalog for 9×12 SAE.

Needs: Works with 5-10 illustrators and 15-20 designers/year. Buys 1,000 illustrations/year. Prefers artists with "technical illustration background, although a down-to-earth, user-friendly style is welcome." Uses freelancers for jacket/cover illustration and design, text illustration, book design, page layout, direct mail and catalog design. Also for multimedia projects. 50% of design work requires computer skills. Works on assignment only.

First Contact & Terms: Send query letter with résumé, SASE, tearsheets and photocopies. Accepts disk submissions. Samples are filed. Reports in 3-5 weeks. To show portfolio, mail thumbnails, roughs and b&w tearsheets and photographs. Buys all rights. Originals are not returned.

Book Design: Assigns 10-15 freelance design and 20-25 illustration jobs/year. Pays by the project.

Jackets/Covers: Pays by the project.

Text Illustration: Prefers Adobe Illustrator files.

Tips: "Send us photocopies of your line artwork and résumé."

✓BETHLEHEM BOOKS, 15605 Country Road 15, Minto ND 58261. (701)248-3929. Fax: (701)248-3940. E-mail: 102515.1774@compuserve.com. Website: http://www.Catholicity.com/market/bbook/offer.html. Assistant Editor: Peter Sharpe. Estab. 1993. Publishes hardcover originals, trade paperback originals and reprints. Types of books include adventure, biography, history, juvenile and young adult. Specializes in children's books. Publishes 5-10 titles/year. Recent titles include: *Miracle of St. Nicholas*, by Gloria Whelan. Catalog available.

Needs: Approached by 5 illustrators/year. Works with 2 illustrators/year. Prefers freelancers experienced in b&w line drawings. Uses freelancers mainly for covers and book illustrations.

First Contact & Terms: Illustrators send query letter with photocopies. Accepts disk submissions from illustrators compatible with IBM, prefers TIFFs or QuarkXPress 3.32 files. Samples are filed. Reports back within 1 month. Will contact artist for portfolio review if interested. Portfolio should include artwork portraying people in action. Negotiates rights purchased.

Jackets/Covers: Assigns 2 freelance illustration jobs/year. Pays by the project, $300-1,000. Prefers oil or watercolor.
Text Illustration: Assigns 2 freelance illustration jobs/year. Pays by the project, $100-2,000. Prefers pen and ink. Finds freelancers through books and word of mouth.
Tips: "Artists should be able to produce life-like characters that fit the story line."

‡BLUE BIRD PUBLISHING, 2266 Dobson, Suite 275, Mesa AZ 85202. (602)831-6063. Owner/Publisher: Cheryl Gorder. Estab. 1985. Publishes trade paperback originals. Types of books include young adult, reference and general adult nonfiction. Specializes in parenting and home education. Publishes 12 titles/year. Titles include: *Multicultural Education*. 50% require freelance illustration; 25% require freelance design. Book catalog free for #10 SASE.
Needs: Approached by 12 freelancers/year. Works with 3 freelance illustrators and 1 designer/year. Uses freelancers for illustration. Also for jacket/cover and catalog design. Works on assignment only.
First Contact & Terms: Send query letter with brochure and photocopies. Samples are filed. To show portfolio, mail b&w samples and color tearsheets. Rights purchased vary according to project. Originals not returned.
Jackets/Covers: Assigns 1 freelance design and 1 illustration job/year. Pays by the project, $50-200. Style preferences vary per project."
Text Illustration: Assigns 3 freelance illustration jobs/year. Pays by the project, $20-250. Prefers line art.

BLUE DOLPHIN PUBLISHING, INC., P.O. Box 8, Nevada City CA 95959. (916)265-6925. Fax: (916)265-0787. E-mail: bdolphin@netshel.net. Website: http://www.netshel.net/~bdolphin. President: Paul M. Clemens. Estab. 1985. Publishes hardcover and trade paperback originals. Types of books include biography, cookbooks, humor and self-help. Specializes in comparative spiritual traditions, lay psychology and health. Publishes 15 titles/year. Recent titles include *Mary's Message of Hope*; *The Way It Is: One Water, One Air, One Mother Earth*; *You Will Live Again*; and *Dolphin Divination Cards and Text*. Books are "high quality on good paper, with laminated dust jacket and color covers." 10% require freelance illustration; 30% require freelance design. Book catalog free upon request.
Needs: Works with 5-6 freelance illustrators and designers/year. Uses freelancers mainly for book cover design. Also for jacket/cover and text illustration. More hardcovers and mixed media are requiring box design as well. 50% of freelance work demands knowledge of Aldus PageMaker, QuarkXPress, Aldus FreeHand, Adobe Illustrator, Adobe Photoshop, CorelDraw and other IBM compatible programs. Works on assignment only.
First Contact & Terms: Send postcard sample or query letter with brochure and photocopies. Samples are filed or are returned by SASE if requested. Reports back within 1-2 months. Originals are returned to artist at job's completion. Sometimes requests work on spec before assigning job. Considers project's budget when establishing payment. Negotiates rights purchased. Considers buying second rights (reprint rights) to previously published work.
Book Design: Assigns 3-5 jobs/year. Pays by the hour, $10-15; or by the project, $300-900.
Jackets/Covers: Assigns 5-6 design and 5-6 illustration jobs/year. Pays by the hour, $10-15; or by the project, $300-900.
Text Illustration: Assigns 1-2 jobs/year. Pays by the hour, $10-15; or by the project, $300-900.
Tips: "Send query letter with brief sample of style of work. We usually use local people, but always looking for something special. Learning good design is more important than designing on the computer, but we are very computer-oriented."

✔BONUS BOOKS, INC., 160 E. Illinois St., Chicago IL 60611. (312)467-0580. Fax: (312)467-9271. E-mail: leon@bonus-books.com. Website: http://www.bonus-books.com. Associate Publisher: Natalie Leon. Imprints include Precept Press, Teach'em. Company publishes textbooks and hardcover and trade paperback originals. Types of books include instruction, biography, self-help, cookbooks and sports. Specializes in sports, biography, medical, fundraising. Publishes 40 titles/year. Recent titles include *Second to Home*, by Ryne Sandberg; and *Call of the Game*, by Gary Bender. 1% require freelance illustration; 80% require freelance design.
Needs: Approached by 30 freelancers/year. Works with 0-1 freelance illustrator and 10 designers/year. Prefers local freelancers with experience in designing on the computer. Uses freelancers for jacket/cover illustration and design and direct mail design. Also for multimedia projects. 100% of design and 90% of illustration demand knowledge of Aldus PageMaker, Adobe Photoshop, CorelDraw. Works on assignment only.
First Contact & Terms: Designers send brochure, résumé and tearsheets. Illustrators send postcard sample or query letter with brochure, résumé. "We would like to see all rough sketches and all design process, not only final product." Samples are filed. Reports back only if interested. Artist should follow up with call. Portfolio should include color final art, photostats and tearsheets. Rights purchased vary according to project. Finds artists through artists' submissions and authors' contacts.
Book Design: Assigns 4 freelance design jobs/year.
Jackets/Covers: Assigns 10 freelance design and 0-1 illustration job/year. Pays by the project, $250-1,000.

 A CHECKMARK PRECEDING A LISTING indicates a change in either the address or contact information since the 1998 edition.

Tips: First-time assignments are usually regional, paperback book covers; book jackets for national books are given to "proven" freelancers.

THOMAS BOUREGY & CO., INC. (AVALON BOOKS), 401 Lafayette St., New York NY 10003. (212)598-0222. Vice President/Publisher: Marcia Markland. Estab. 1950. Book publisher. Publishes hardcover originals. Types of books include romance, mysteries and Westerns. Publishes 60 titles/year. 100% require freelance illustration and design. Prefers local artists and artists with experience in dust jackets. Works on assignment only.
First Contact & Terms: Send samples. Samples are filed if appropriate. Reports back if interested.

BOWLING GREEN UNIVERSITY POPULAR PRESS, Bowling Green University, Bowling Green OH 43403. (419)372-7867. Fax: (419)372-8095. Director: Pat Browne. Publishes hardcover and paperback originals on popular culture, folklore, women's studies, science fiction criticism, detective fiction criticism, music and drama. Publishes 15-20 titles and 8 journals/year.
First Contact & Terms: Send previously published work and SASE. Reports in 2 weeks. Buys all rights. Free catalog.
Jackets/Covers: Assigns 20 jobs/year. Pays $250 minimum, color washes, opaque watercolors, gray opaques, b&w line drawings and washes.

✓**BROADMAN & HOLDMAN PUBLISHERS** 127 Ninth Ave. N., Nashville TN 37234. (615)251-5730. Art Director: Greg Webster. Estab. 1891. Religious publishing house. Publishes 104 titles/year. 20% of titles require freelance illustration. Recent titles include *Our Sacred Honor*, *Tiptionary* and *Character Is the Issue*. Books have contemporary look. Book catalog free on request.
Needs: Works with 15 freelance illustrators and 20 freelance designers/year. Artist must be experienced, professional. 100% of freelance work demands knowledge of QuarkXPress, Aldus FreeHand, Adobe Illustrator or Adobe Photoshop. Works on assignment only. 100% of titles require freelance art direction.
First Contact & Terms: Send query letter with brochure and samples to be kept on file. Call or write for appointment to show portfolio. Send slides, tearsheets, photostats or photocopies; "samples *cannot* be returned." Reports only if interested. Pays for illustration by the project, $250-1,500. Negotiates rights purchased.
Book Design: Pays by the project, $500-1,000.
Jackets/Covers: "100% of our cover designs are now done on computer." Pays by the project, $1,500-2,000
Text Illustration: Pays by the project, $150-300.
Tips: "We are looking for computer-literate experienced book designers with extensive knowledge of biblical themes." Looks for "the ability to illustrate scenes with multiple figures, to accurately illustrate people of all ages, including young children and babies, and to illustrate detailed scenes described in text."

BROOKS/COLE PUBLISHING COMPANY, 511 Forest Lodge Rd., Pacific Grove CA 93950. (408)373-0728. Website: http://www.brookscole.com. Art Director: Vernon T. Boes. Art Coordinator: Lisa Torri. Estab. 1967. Specializes in hardcover and paperback college textbooks on mathematics, psychology, chemistry and counseling. Publishes 100 titles/year. 85% require freelance illustration. Books are bold, contemporary textbooks for college level.
Needs: Works with 25 freelance illustrators and 25 freelance designers/year. Uses freelance artists mainly for interior illustration. Uses illustrators for technical line art and covers. Uses designers for cover and book design and text illustration. Also uses freelance artists for jacket/cover illustration and design. Works on assignment only.
First Contact & Terms: Send query letter with brochure, résumé, tearsheets, photostats and photographs. Samples are filed or are returned by SASE. Art Director will contact artist for portfolio review if interested. Portfolio should include roughs, photostats, tearsheets, final reproduction/product, photographs, slides and transparencies. Considers complexity of project, skill and experience of artist, project's budget and turnaround time in determining payment. Negotiates rights purchased. Not interested in second rights to previously published work unless first used in totally unrelated market. Finds illustrators and designers through word of mouth, magazines, submissions/self promotion, sourcebooks, and agents.
Book Design: Assigns 70 design and many illustration jobs/year. Pays by the project, $500-1,500.
Jackets/Covers: Assigns 90 design and many illustration jobs/year. Pays by the project, $500-1,200.
Text Illustration: Assigns 85 freelance jobs/year. Prefers ink/Macintosh. Pays by the project, $20-2,000.
Tips: "Provide excellent package in mailing of samples and cost estimates. Follow up with phone call. Don't be pushy. Would like to see more abstract photography/illustration; all age, unique, interactive people photography; single strong, bold images."

‡**CANDLEWICK PRESS**, 2067 Massachusetts Ave., Cambridge MA 02140. (617)661-3330. Art Director: Anne Ghory-Goodman. Estab. 1992. Imprints include Walker Books, London. Publishes hardcover, trade paperback and mass market paperback originals. Publishes biography, history, humor, juvenile, young adult. Specializes in children's books. Publishes 170 titles/year. Recent titles include: *Guess How Much I Love You*; *The Greek News*. 100% requires freelance illustration. Book catalog not available.
Needs: Approached by 400 illustrators and 30 designers/year. Works with 170 illustrators and 1-2 designers/year. 100% of freelance design demands knowledge of Adobe Photoshop, Adobe Illustrator or QuarkXPress.
First Contact & Terms: Designers send query letter with résumé. Illustrators send query letter with photocopies. Accepts non-returnable disk submissions from illustrators. Samples are filed and are not returned. Will contact artist

for portfolio review of artwork of characters in sequence, tearsheets if interested. Buys all rights or rights purchased vary according to project.

Text Illustration: Finds illustrators through agents, sourcebooks, word of mouth, submissions.

Tips: "We generally use illustrators with prior trade book experience."

‡CAROLINA WREN PRESS/LOLLIPOP POWER BOOKS, 120 Morris St., Durham NC 27701. (919)560-2738. Art Director: Martha Scotford. Estab. 1973. Publishes trade paperback originals. Types of books include contemporary fiction, experimental fiction, preschool and juvenile. Specializes in books for children in a multi-racial and non-sexist manner, and women's and black literature. Publishes 3 titles/year. Recent titles include *Journey Proud*, edited by Agnes MacDonald; and *In the Arms of Our Elders*, by W.H. Lewis. 50% require freelance illustration.

Needs: Approached by 20 freelancers/year. Works with 2 freelance illustrators/year. Prefers freelancers with experience in children's literature. Uses freelancers for jacket/cover and text illustration. Works on assignment only.

First Contact & Terms: Send query letter with résumé, tearsheets, photocopies and illustrations of children and adults. No cartoons. Samples are filed or are returned by SASE if requested by artist. To show portfolio, mail b&w and color tearsheets. Rights purchased vary according to project. Originals returned at job's completion.

Jacket/Covers: Assigns 2 freelance jobs/year. Pays by the project, $50-150.

Text Illustration: Assigns 2 freelance illustration jobs/year. Payment is 10% of print run.

Tips: "Understand the world of children in the 1990s. Draw realistically so racial types are accurately represented and the expressions can be interpreted. Our books have a classical, modern and restrained look."

‡CARTWHEEL BOOKS, Imprint of Scholastic, Inc., 555 Broadway, New York NY 10012-3999. Art Director: Edith S. Weinberg. Estab. 1990. Publishes mass market and trade paperback originals. Types of books include children's picture books, instructional, juvenile, preschool, novelty books. Specializes in books for very young children. Publishes 100 titles/year. 100% requires freelance illustration; 25% requires freelance design; 5% requires freelance art direction. Book catalog available for SAE with first-class stamps.

Needs: Approached by 500 illustrators and 50 designers/year. Works with 75 illustrators, 5 designers and 3 art directors/year. Prefers local designers. 100% of freelance design demands knowledge of QuarkXPress.

First Contact & Terms: Designers send query letter with printed samples, photocopies, SASE. Illustrators send postcard sample or query letter with printed samples, photocopies and follow-up postcard every 2 months. Samples are filed. Reports back within 1 month. Will contact artist for portfolio review of artwork portraying children and animals, artwork of characters in sequence, tearsheets if interested. Rights purchased vary according to project. Finds freelancers through submissions on file, reps.

Book Design: Assigns 10 freelance design and 2 art direction projects/year. Pays for design by the hour, $30-50; art direction by the hour, $35-50.

Text Illustration: Assigns 200 freelance illustration jobs/year. Pays by the project, $500-10,000.

Tips: "I need to see cute fuzzy animals, young, lively kids, and/or clear depictions of objects, vehicles and machinery."

‡MARSHALL CAVENDISH, 99 White Plains Rd., Tarrytown NY 10591. (914)332-8888. Fax: (914)332-1888. Art Director: Jean Krulis. Imprints include Benchmark Books and as yet untitled new imprint. Publishes hardcover originals. Types of books include juvenile, preschool and young adult. Publishes 24 titles/year. First trade titles to be published in Fall 1997. 80% requires freelance illustration.

Needs: Uses freelancers mainly for illustration.

First Contact & Terms: Send photocopies and/or printed samples. Samples are filed. Will contact artist for portfolio review of artwork portraying children, adults, animals, artwork of characters in sequence, book dummy, photocopies. Negotiates rights purchased. Finds freelancers mostly through agents.

Jacket/Covers: Assigns 5 illustration jobs/year. Pays by the project; negotiable.

Text Illustration: Assigns 10 freelance jobs/year. Pays by the project; offers royalty.

CCC PUBLICATIONS, 9725 Lurline Ave., Chatsworth Park CA 91311. (818)718-0507. Fax: (818)718-0655. Editorial Director: Cliff Carle. Estab. 1984. Company publishes trade paperback originals and manufactures accessories (T-shirts, mugs, caps). Types of books include self-help and humor. Specializes in humor. Publishes 50 titles/year. Recent titles include *The Better Half*, by Randy Glasbergen; and *Golfaholics*, by Bob Zahn. 90% require freelance illustration; 90% require freelance design. Book catalog free for SAE with $1 postage.

Needs: Approached by 200 freelancers/year. Works with 20-30 freelance illustrators and 10-20 designers/year. Buys 100 freelance illustrations/year. Prefers artists with experience in humorous or cartoon illustration. Uses freelancers mainly for color covers and b&w interior drawings. Also for jacket/cover and book design. 80% of design and 50% of illustration demand computer skills.

First Contact & Terms: Send query letter with samples, résumé, SASE. Samples are filed or are returned by SASE if requested by artist. Reports back only if interested. Art Director will contact artist for portfolio review if interested. Portfolio should include b&w and color samples. Rights purchased vary according to project. Finds artists through agents and unsolicited submissions.

Book Design: Assigns 30 freelance design jobs/year. Pay negotiated based on artist's experience and notoriety.

Jackets/Covers: Assigns 30 freelance design and 30 illustration jobs/year. Pay negotiated on project by project basis.

Text Illustration: Assigns 30 freelance illustration jobs/year. Pay negotiated.

Tips: First-time assignments are usually b&w text illustration; cover illustration is given to "proven" freelancers.

"Sometimes we offer royalty points and partial advance. Also, cartoon characters should have 'hip' today look."

CELO VALLEY BOOKS, 346 Seven Mile Ridge Rd., Burnsville NC 28714. Production Manager: Diana Donovan. Estab. 1987. Publishes hardcover originals and trade paperback originals. Types of books include biography, juvenile, mainstream fiction and nonfiction. Publishes 3-5 titles/year. Recent titles include: *Quaker Profiles*. 5% require freelance illustration.
Needs: Approached by 5 illustrators/year. Works with 1 illustrator every 3 years. Prefers local illustrators. Uses freelancers mainly for working with authors during book design stage.
First Contact & Terms: Illustrators send query letter with photocopies. Send follow-up postcard every year. Samples are filed. Reports back only if interested. Negotiates rights purchased.
Jackets/Covers: Assigns 1 freelance job every 3 years or so. Pay negotiable. Finds freelancers mostly through word of mouth.
Tips: "Artist should be able to work with authors to fit ideas to production."

THE CENTER FOR WESTERN STUDIES, Box 727, Augustana College, Sioux Falls SD 57197. (605)336-4007. Managing Editor: Harry F. Thompson. Estab. 1970. Publishes hardcover originals and trade paperback originals and reprints. Types of books include western history. Specializes in history and cultures of the Northern Plains, especially Plains Indians, such as the Sioux and Cheyenne. Publishes 2-3 titles/year. Recent titles include *Princes, Potentates, and Plain People*, by Reuben Goertz; and *Driftwood in Time of War*, by Marie Christopherson. 75% require freelance design. Books are conservative, scholarly and documentary. Book catalog free by request.
Needs: Approached by 4 freelancers/year. Works with 1-2 freelance designers and 1-2 illustrators/year. Uses freelancers mainly for cover design. Also for book design and text illustration. 25% of freelance work demands knowledge of QuarkXPress. Works on assignment only.
First Contact & Terms: Send query letter with résumé, SASE and photocopies. Samples are filed. Request portfolio review in original query. Reports back only if interested. Portfolio should include roughs and final art. Sometimes requests work on spec before assigning a job. Rights purchased vary according to project. Originals are not returned. Finds illustrators and designers through word of mouth and submissions/self promotion.
Book Design: Assigns 1-2 freelance design jobs/year. Pays by the project, $500-750.
Jackets/Covers: Assigns 1-2 freelance design jobs/year. Pays by the project, $250-500.
Text Illustration: Pays by the project, $100-500.
Tips: "We are a small house, and publishing is only one of our functions, so we usually rely on the work of graphic artists with whom we have contracted previously. Send samples."

‡CENTERSTREAM PUBLISHING, P.O. Box 17878, Anaheim Hills CA 92807. (714)779-9390. E-mail: centerstrm @aol.com. Production: Ron Middlebrook. Estab. 1978. Publishes audio tapes and hardcover originals. Types of books include history, self help, music history and instruction. Publishes 10-20 titles/year. Recent titles include: *History of the Gibson L5 Guitar*, *Drum Yellow Pages*. 100% requires freelance illustration. Book catalog free for 6×9 SAE with 2 first-class stamps.
Needs: Approached by 12 illustrators/year. Works with 3 illustrators/year.
First Contact & Terms: Illustrators send postcard sample or tearsheets. Accepts Mac-compatible disk submissions. Samples are not filed and are returned by SASE. Reports back only if interested. Buys all rights or rights purchased vary according to project.

‡CHARIOT VICTOR PUBLISHING, Cook Communication Ministries, 4050 Lee Vance View, Colorado Springs CO 80918. (719)536-3271. Creative Director: Brenda Franklin. Estab. late 1800s. Imprints include Chariot Publishing, Victor Publishing, Lion Publishing and Rainfall Educational Toys. Imprint publishes hardcover and trade paperback originals and mass market paperback originals. Also toys. Types of books include contemporary and historical fiction, mystery, self-help, religious, juvenile, some teen and preschool. Publishes 100-150 titles/year. Recent titles include *My Lord My God*, *The Heritage* and *The Victors*. 100% require freelance illustration; 20% require freelance design.
Needs: Approached by dozens of freelance artists/year. Works with 50 freelance illustrators and 10 freelance designers/year. Buys 350-400 freelance illustrations/year. Prefers artists with experience in children's publishing and/or packaging. Uses freelance artists mainly for covers, educational products and picture books. Also uses freelance artists for and text illustration, jacket/cover and book design. 50% of design work demands knowledge of Adobe Illustrator, QuarkXPress, Adobe Photoshop or Aldus FreeHand. Works on assignment only.
First Contact & Terms: Send query letter with résumé, tearsheets and photocopies. "Only send samples you want me to keep." Samples are not returned. Reports back only if interested. Artist should follow up with call. Rights purchased vary according to project. Originals are "usually" returned at the job's completion. Finds artists through submissions and word of mouth.
Book Design: Assigns 10 freelance design jobs/year.
Jackets/Covers: Assigns 100 freelance design/illustration jobs/year. Pays by the project, $300-2,000. Prefers computer design for comps, realistic illustration for fiction, cartoon or simplified styles for children's.
Text Illustration: Assigns 75 freelance illustration jobs/year. Pays by the project, $2,000-5,000 buyout for 32-page picture books. "Sometimes we offer royalty agreement." Prefers from simplistic, children's styles to realistic.
Tips: "First-time assignments are frequently available as we are always looking for a fresh look. However, our larger 'A' projects usually are assigned to those who we've worked with in the past."

✔**CHARLESBRIDGE PUBLISHING**, 85 Main St., Watertown MA 02172. E-mail: books@charlesbridge.com. Website: http://www.charlesbridge.com. Senior Editor: Harold Underdown. Estab. 1980. Publishes hardcover and softcover children's trade picture books: a range of nonfiction. Publishes 25 titles/year. Recent titles include *Counting Is for the Birds*, by Fran Mazzola and *COW!* by Jules Older. Books are "realistic art picture books depicting people, outdoor places and animals."
Needs: Works with 5-10 freelance illustrators/year. "Specializes in detailed, color realism, although other styles are gladly reviewed."
First Contact & Terms: Send résumé, tearsheets and photocopies. Samples not filed are returned by SASE. Reports back only if interested. Originals are not returned. Considers complexity of project and project's budget when establishing payment. Buys all rights.
Text Illustration: Assigns 5-10 jobs/year. Pays by the project: flat fee or royalty with advance.

‡**CHELSEA HOUSE PUBLISHERS**, 1974 Sproul Rd., Suite 204, Broomall PA 19008-0914. (610)353-5166, ext. 186. Fax: (610)353-5191. Art Director: Sara Davis. Estab. 1973. Publishes hardcover originals and reprints. Types of books include biography, history, juvenile, reference, young adult. Specializes in young adult literary books. Publishes 150 titles/year. Recent titles include: *Women Writers of English & Their Works*, *Overcoming Adversity* (series includes Tim Allen, Roseanne, Bill Clinton). 85% requires freelance illustration; 30% requires freelance design; 10% requires freelance art direction. Book catalog not available.
Needs: Approached by 200 illustrators and 50 designers/year. Works with 25 illustrators, 10 designers, 5 art directors/year. Prefers local designers and art directors. Prefers freelancers experienced in Macintosh computer for design. 100% of freelance design demands knowledge of Adobe Photoshop, QuarkXPress. 20% of freelance illustration demands knowledge of Adobe Illustrator, Adobe Photoshop, QuarkXPress.
First Contact & Terms: Designers send query letter with non-returnable printed samples, photocopies. Illustrators send postcard sample and follow-up postcard every 3 months. Accepts Mac-compatible disk submissions. Samples are filed and are not returned. Will contact artist for portfolio review if interested. Buys first rights. Finds freelancers through networking, submissions, agents and *American Showcase*.
Book Design: Assigns 25 freelance design and 10 art direction projects/year. Pays for design by the hour, $15-35; for art direction by the hour, $25-45.
Jackets/Covers: Assigns 50 freelance design jobs and 150 illustration jobs/year. Prefers oil, acrylic. Pays for design by the hour, $25-35. Pays for illustration by the project, $650-850. Prefers portraits that capture close likeness of a person.
Tips: "Most of the illustrations we purchase involve capturing an exact likeness of a famous or historical person. Full color only, no black & white line art. Please send non-returnable samples only."

✔**CHERUBIC PRESS**, P.O. Box 5036, Johnstown PA 15904-5036. (814)535-4300. E-mail: juliecht@aol.com. Website: http://www.gicsnet.com/cherubic. Senior Editor: Juliette Gray. Art Coordinator: William Morgan. Estab. 1995. Publishes quality hardcover collections and paperback originals. Publishes specialty cookbooks, instructional, juvenile, New Age, preschool picture books, ethnic and self-help. Specializes in "anything that uplifts, inspires or is self-help." Publishes 3-6 titles/year. Recent titles include *Angel Baby Gifts*, by Vickie L. Higgins; and *Cherubic's Classic Storybook*, by 30 different artists. 90% require freelance illustration; 10% require freelance design. Book catalog free for 4×9½ SASE with 2 first-class stamps.
Needs: Approached by 50 freelancers/year. Works with 30 freelance illustrators and 1-2 designers/year. Commissions 50-90 illustrations/year. Uses freelancers mainly for illustrating children's picture books. Also for jacket/cover design and illustration and text illustration. Works on assignment only.
First Contact & Terms: Send query letter with résumé, SASE and photocopies. Samples are filed or returned by SASE. Reports back within 1-2 months. Will contact for portfolio review if interested. Buys first/all rights.
Jackets/Covers: Assigns 3-4 freelance design and 3-4 illustration jobs/year. Pays by the project, $100 minimum.
Text Illustration: Assigns 50-90 freelance illustration jobs/year. Pays by the project, $100 minimum.
Tips: "Cherubic Press is small so we can't pay big bucks but we can get you published and on your way! Show us your style—send photocopies of your pen & ink, pencil or charcoal portraits capturing the expressions of children and their parents, grandparents. We need to see emotion on the subjects' faces and in their body postures. Also send a few other examples such as animals, a house, 'whatever,' so we get the feeling of your work. Always send pen and ink examples of your work since this is the medium we use the most."

‡**CHICAGO REVIEW PRESS**, Dept. AGDM, 814 N. Franklin, Chicago IL 60610. (312)337-0747. Fax: (312)337-5985. Art Director: Joan Sommers. Editor: Linda Matthews. Publishes hardcover and paperback originals. Specializes in trade nonfiction: how-to, travel, cookery, popular science, Midwest regional. Publishes 12 titles/year. Recent titles include *Westward Ho!*, by Laurie Carlson; and *Creative Nonfiction*, by Lee Gutkind. 30% require freelance illustration; 100% require jacket cover design.
Needs: Approached by 50 freelancers/year. Works with 15 freelance illustrators and 5 designers/year. Uses freelancers for jacket/cover illustration and design, text illustration. 100% of design and 10% of illustration demand knowledge of QuarkXPress, Adobe Photoshop and Adobe Illustrator.
First Contact & Terms: Call or send postcard sample or query letter with résumé and color tearsheets. Samples are filed or are returned by SASE. Art Director will contact artist for portfolio review if interested. Call for appointment to show portfolio of tearsheets, final reproduction/product and slides. Considers project's budget when establishing pay-

ment. Buys one-time rights. Finds artists through magazines, submissions/self promotions, sourcebooks and galleries.
Jackets/Covers: Assigns 10 freelance design and 10 illustration jobs/year. Pays by project, $500-1,000.
Text Illustration: Pays by the project, $500-3,000.
Tips: "Our books are interesting and innovative. Design and illustration we use is sophisticated, above average and unusual. Fine art has become very marketable in the publishing industry."

CHILDREN'S BOOK PRESS, 246 First St., Suite 101, San Francisco CA 94105. (415)995-2200. Fax: (415)995-2222. E-mail: cbookpress@igc.org. Assistant Production Editor: Laura Atkins. Estab. 1975. Publishes hardcover originals and trade paperback reprints. Types of books include juvenile. Specializes in multicultural. Publishes 4-6 titles/year. Recent titles include: *Going Back Home* and *In My Family*. 100% require freelance illustration; 100% require freelance design. Catalog free for 9×6 SASE with 55¢ first-class stamps.
Needs: Approached by 100 illustrators and 20 designers/year. Works with 4-6 illustrators and 3 designers/year. Prefers local designers experienced in QuarkXPress (designers) and previous children's picture book experience (illustrators). Uses freelancers for 32-page picture book design. 100% of freelance design demands knowledge of Adobe Photoshop, Adobe Illustrator and QuarkXPress.
First Contact & Terms: Designers send query letter with brochure, photocopies, photostats, résumé, SASE and tearsheets. Illustrators send postcard sample or query letter with photocopies, photographs, printed samples, résumé, SASE and tearsheets. Samples are not filed and are returned by SASE. Reports back within 4-6 months if interested or if SASE is included. Will contact artist for portfolio review if interested. Buys all rights.
Book Design: Assigns 4-6 freelance design jobs/year. Pays by the project.
Text Illustration: Assigns 4-6 freelance illustration jobs/year. Pays royalty.
Tips: "We look for a multicultural experience. We are especially interested in the use of bright colors and non-traditional instructive approach."

‡CHILDREN'S PRESS, Imprint of Grolier, Publishes nonfiction for the school and library market. Books are closely related to the elementary and middle-school curriculum.
• See listing for Franklin Watts for address and submission on requirements. Art Director is same for both Grolier Imprints.

‡CHRISTIAN SCHOOL INTERNATIONAL, 3350 E. Paris SE, Grand Rapids MI 49512-3054. (616)957-1070. Fax: (616)957-5022. E-mail: csi@gospelcom.net/csi/. Website: http://www.ChristianSchoolsInt.org. Production: Judy Bandstra. Publishes textbooks. Types of books include juvenile, preschool, religious, young adult and teacher guides. Specializes in religious textbooks. Publishes 6-10 titles/year. Recent titles include: *Library Materials Guide*, *Science K-6*, *Literature 3-6*. 50% requires freelance illustration. Book catalog free for 9×12 SAE with 3 first-class stamps.
Needs: Approached by 30-40 illustrators/year. Works with 5-10 illustrators/year. Prefers freelancers experienced in 4-color illustration for textbooks. 90% of freelance design and 10% of freelance illustration demands knowledge of QuarkXPress.
First Contact & Terms: Send query letter with printed samples, photocopies. Send Zip diskettes or floppy. Samples are filed and are not returned. Will contact artist for portfolio review if interested. Buys first rights or rights purchased vary according to project. Finds freelancers through word of mouth, submission packets.
Text Illustration: Assigns 5-10 freelance illustration jobs/year. Pays by the project.

‡CHRONICLE BOOKS, 85 Second St., San Francisco CA 94105. Design Director: Michael Carabetta. Estab. 1979. Company publishes high quality, affordably priced hardcover and trade paperback originals and reprints. Types of books include cookbooks, art, design, architecture, contemporary fiction, travel guides, gardening and humor. Publishes approximately 150 titles/year. Recent best-selling titles include the *Griffin & Sabine* trilogy, by Nick Bantock. Book catalog free on request (call 1-800-722-6657).
• Chronicle has a separate children's book division, and a gift division, which produces blank greeting cards, address books, journals and the like.
Needs: Approached by hundreds of freelancers/year. Works with 15-20 illustrators and 30-40 designers/year. Uses artists for cover and interior design and illustration. 99% of design work demands knowledge of Aldus PageMaker, QuarkXPress, Aldus FreeHand, Adobe Illustrator or Adobe Photoshop; "mostly QuarkXPress—software is up to discretion of designer." Works on assignment only.
First Contact & Terms: Send query letter with tearsheets, color photocopies or printed samples no larger than 8½×11. Samples are filed or are returned by SASE. Reports back only if interested. Art Director will contact artist for portfolio review if interested. Portfolio should include thumbnails, roughs, final art, photostats, tearsheets, slides, tearsheets and transparencies. Buys all rights. Originals are returned at job's completion. Finds artists through submissions, *Communication Arts* and sourcebooks.
Book Design: Assigns 30-50 freelance design jobs/year. Pays by the project; $750-1200 for covers; varying rates for book design depending on page count.
Jackets/Covers: Assigns 30 freelance design and 30 illustration jobs/year. Pays by the project.
Text Illustration: Assigns 25 freelance illustration jobs/year. Pays by the project.
Tips: "Please write instead of calling; don't send original material."

CIRCLET PRESS, INC., 1770 Massachusetts Ave., #278, Cambridge MA 02140. (617)864-0492. Fax: (617)864-0663. E-mail: circlet-info@circlet.com. Website: http://www.circlet.com/circlet/home.html. Publisher: Cecilia Tan. Es-

tab. 1992. Company publishes trade paperback originals. Types of books include science fiction and fantasy. Specializes in erotic science fiction/fantasy. Publishes 8-10 titles/year. Recent titles include: *Sex Magick*, edited by Cecilia Tan; and *The Drag Queen of Elfland*, by Lawrence Schimel. 100% require freelance illustration. Book catalog free for business size SAE with 1 first-class stamp.

● The publisher is currently seeking cover art for anthologies to be published in late 1998 and 1999. Titles include *Wired Hard: Erotica for a Gay Universe*, *Dreams of Dominance*, *Upon a Dungeon* and *Sextopia*.

Needs: Approached by 50-100 freelancers/year. Works with 4-5 freelance illustrators/year. Prefers freelancers with experience in science fiction illustration. Uses freelancers for cover art. Needs computer-literate freelancers for illustration. 100% of freelance work demands knowledge of QuarkXPress or Photoshop. Works on assignment only. 10% of titles require freelance art direction.

First Contact & Terms: Send query letter with color photocopies pitching an idea for specific upcoming books. List of upcoming books available for 32¢ SASE or on website. Ask for "Artists Guidelines." Samples are filed. Reports back only if interested. Portfolio review not required. Buys one-time rights or reprint rights. Originals are returned at job's completion. Finds artists through art shows at science fiction conventions and submission samples. "I need to see human figures well-executed with sensual emotion. No tentacles or gore! Photographs, painting, computer composites all welcomed."

Book Design: Assigns 2-4 freelance design jobs/year. Pays by the project, $100-500.

Jackets/Covers: Assigns 2-4 freelance illustration jobs/year. Pays by the project, $15-100. Now using 4-color and halftones.

Tips: "Follow the instructions in this listing: Don't send me color samples on slides. I have no way to view them. Any jacket and book design experience is also helpful. I prefer to see a pitch idea for a cover aimed at a specific title, a way we can use an image that is already available to fit a theme."

CITY & COMPANY, 22 W. 23rd St., New York NY 10010. (212)366-1988. Fax: (212)242-0415. Publisher: Helene Silver. Estab. 1994. Publishes hardcover originals and trade paperback originals. Types of books include reference. Specializes in New York subjects. Publishes 10-15 titles/year. Recent titles include: *Shop NY: Downtownstyle* and *New York Chocolate Lover's Guide*. 100% require freelance illustration; 100% require freelance design. Catalog available.

Needs: Approached by 25 illustrators and 10 designers/year. Works with 5 illustrators and 2 designers/year. Prefers local freelancers experienced in Quark. Uses freelancers mainly for illustration and design. 100% of freelance design demands knowledge of Adobe Photoshop, Adobe Illustrator and QuarkXPress. 10% of freelance illustration demands computer knowledge.

First Contact & Terms: Illustrators send postcard sample or query letter with photocopies, photographs, photostats, résumé and tearsheets. Samples are filed. Reports back only if interested. Will contact artist for portfolio review of book dummy, photocopies, photographs, photostats and tearsheets. Buys reprint rights.

Book Design: Assigns 10 freelance design jobs/year. Pays by the project, $750-1,500.

Jackets/Covers: Assigns 10 freelance design jobs/year. Pays for design and illustration by the project, $750-1,500.

Text Illustration: Assigns 10 freelance illustration jobs/year. Pays by the project, $250-500. Finds freelancers through agents.

Tips: "Look at our books before sending samples—we have a definite look."

✔**CLARION BOOKS**, 215 Park Ave., 10th Floor, New York NY 10003. (212)420-5889. Fax: (212)420-5855. Website: http://www.hmco.com/trade/. Designer: Eleanor Voorhees. Imprint of Houghton Mifflin Company. Imprint publishes hardcover originals and trade paperback reprints. Specializes in picture books, chapter books, middle grade novels and nonfiction, including historical and animal behavior. Publishes 60 titles/year. Titles include *Piggie Pie!*, by Margie Palatini, illustrated by Howard Fine. 90% of titles require freelance illustration. Book catalog free for SASE.

● Publisher of *The Midwife's Apprentice*, by Karen Cushman, 1996 Newberry Award Winner and *Golem*, by David Wisniewski, 1997 Caldecott Award Winner.

Needs: Approached by "countless" freelancers. Works with 48 freelance illustrators/year. Uses freelancers mainly for picture books and novel jackets. Also for jacket/cover and text illustration.

First Contact & Terms: Send query letter with résumé, tearsheets, photocopies and SASE. Samples are filed "if suitable to our needs." Reports back only if interested. Portfolios may be dropped off every Thursday. Art Director will contact artist for portfolio review if interested. Rights purchased vary according to project. Originals are returned at job's completion.

Text Illustration: Assigns 48 freelance illustration jobs/year. Pays by the project.

Tips: "Be familiar with the type of books we publish before submitting. Send a SASE for a catalog or look at our books in the bookstore. Send us children's book-related samples."

‡**CLEIS PRESS**, P.O. Box 14684, San Francisco CA 94114. (415)575-4700. Fax: (415)575-4703. E-mail: fdcleis@aol. Art Director: Frederique Delacoste. Estab. 1979. Publishes trade paperback originals and reprints. Types of books include comic books, experimental and mainstream fiction, nonfiction and self help. Specializes in lesbian/gay. Publishes 14 titles/year. Recent titles include: *VAMPS: Illustrated History of the Femme Fatale*, by Pam Keesey. 100% requires freelance design. Book catalog free for SAE with 2 first-class stamps.

Needs: Works with 4 designers/year. Prefers local illustrators. Freelance design demands knowledge of Adboe Illustrator, Adobe Photoshop, QuarkXPress.

First Contact & Terms: Designers send postcard sample and follow-up postcard every 6 months or query letter with

photocopies. Illustrators send postcard sample or query letter with printed samples, photocopies. Accepts Mac-compatible disk submissions. Send EPS or TIFF files. Samples are filed and are not returned. Will contact artist for portfolio review if interested.
Book Design: Assigns 17 freelance design jobs/year. Pays for design by the project, $500.
Jackets/Covers: Pays for design by the project, $500.

CLIFFS NOTES INC., Box 80728, Lincoln NE 68501. Contact: Michele Spence. Publishes educational books. Titles include *Cliffs SAT I Preparation Guide* and *Quick Review Microbiology*.
First Contact & Terms: Approached by 30 freelance artists/year. Works on assignment only. Samples returned by SASE. Reports back on future assignment possibilities. Send brochure, flier and/or résumé. Originals are not returned. Buys all rights.
Text Illustration: Uses technical illustrators for mathematics, science, miscellaneous.

‡**COFFEE HOUSE PRESS**, 27 N. Fourth St., Minneapolis MN 55401-1782. (612)338-0125. Fax: (612)338-4004. Production Manager: Kelly Kofron. Publishes hardcover and trade paperback originals. Types of books include experimental and mainstream fiction and poetry. Publishes 14 titles/year. Recent titles include: *The Collected Works of Paul Metcalf*, *High Holiday Sutra* and *Floating Kingdom*. 15% requires freelance illustration. Book catalog free for SASE.
Needs: Approached by 20 illustrators and 10 designers/year. Works with 4 illustrators and 2 designers/year. Prefers freelancers experienced in book covers.
First Contact & Terms: Designers send query letter with photocopies. Illustrators send postcard sample and/or photocopies and printed samples. After introductory mailing send follow-up postcard samples every 6 months. Samples are filed. Will contact artist for portfolio review if interested. Rights purchased vary according to project.
Jackets/Covers: Assigns 1 freelance design and 10 freelance illustration jobs/year. Pays for illustration by the project, $200-400.
Text Illustration: Finds illustrators through sourcebooks, word of mouth, self promos.
Tips: "We are nonprofit and may not be able to provide full market value for artwork and design. However, we can provide national exposure and excellent portfolio pieces, as well as allow for generous creative license."

COMPASS AMERICAN GUIDES, 5332 College Ave., Suite 201, Oakland CA 94618. (510)547-7233. Fax: (510)547-2145. Estab. 1989. Imprint of Fodor's at Random House Inc. Publishes trade paperback originals. Types of books include travel. Specializes in guides to the United States. Publishes 5 titles/year. Recent titles include: *Idaho*, *California Wine Country*, *Alaska*, *Santa Fe*. 100% require freelance illustration. Catalog free for 8×6 SASE with 2 first class stamps.
Needs: Approached by 100 illustrators and 20 designers/year. Works with 20 illustrators/year. Prefers local designers. Knowledge of Adobe Photoshop helpful for freelance illustrators.
First Contact & Terms: Illustrators send query letter with SASE. Samples are filed or returned by SASE. Reports back only if interested. Will contact artist for portfolio review of photographs, slides and transparencies if interested. Buys one-time rights.
Text Illustration: Assigns 15 freelance illustration jobs/year. Pays by the project, $50-200. Finds freelancers through word of mouth and submissions.

‡**CONARI PRESS**, 2550 9th St., Suite 101, Berkeley CA 94710-2551. (510)649-7175. Fax: (510)649-7190. Editor: Mary Jane Ryan. Art Director: Ame Beanland. Estab. 1987. Publishes hardcover and trade paperback originals. Types of books include self help, women's issues and general non-fiction. Publishes 30 titles/year. Titles include *True Love* and *Random Acts of Kindness*. 10% require freelance illustration. Book catalog free.
Needs: Approached by 100 freelancers/year. Uses freelancers for jacket/cover illustration and design. Works on assignment only.
First Contact & Terms: Send query letter with samples. Samples are filed. Reports back to the artist only if interested. Rights purchased vary according to project. Originals returned at job's completion.
Book Design: Assigns 25 freelance design jobs/year. Pays for design: by the hour, $25 minimum; by the project, $1,100 minimum.
Jackets/Covers: Assigns 25 freelance design and 10 illustration jobs/year. Pays for design by the project, $1,100 minimum. Pays for illustration by the project, $300-500.
Text Illustration: Assigns 1-3 freelance jobs/year. Pays by the project, $100-1,000; pays for design $1,100 minimum.
Tips: "To get an assignment with me you need dynamic designs, flexibility and reasonable prices."

‡**COUNCIL FOR EXCEPTIONAL CHILDREN**, 1920 Association Dr., Reston VA 20191-1589. (703)620-3660. Fax: (703)620-3521. Website: http://www.cec.spec.org. Senior Director for Publications: Ms. Jean Boston. Education Specialist: Ms. Susan Bergert. Estab. 1922. Publishes audio tapes, CD-ROMs, hardcover and trade paperback originals. Specializes in professional development/instruction. Publishes 10 titles/year. Book catalog available.
Needs: Prefers local illustrators, designers and art directors. Prefers freelancers experienced in eductaion. Some freelance illustration demands knowledge of PageMaker, QuarkXPress.
First Contact & Terms: Send query letter with printed samples, SASE. Accepts Windows-compatible disk submissions or TIFF files. Samples are not filed and are returned by SASE. Will contact artist for portfolio review showing book dummy and roughs if interested. Buys all rights.

THE COUNTRYMAN PRESS (Division of W.W. Norton & Co., Inc.), Box 748, Woodstock VT 05091. (802)457-4826. E-mail: countrymanpress@wwnorton.com. Prepress Manager: Fred Lee. Production Editor: Christen Brooks. Estab. 1976. Book publisher. Publishes hardcover originals and reprints, and trade paperback originals and reprints. Types of books include contemporary and mainstream fiction, biography, history, travel, humor and recreational guides. Specializes in mysteries, recreational (biking/hiking) guides. Publishes 35 titles/year. Recent titles include *Reading the Forested Landscape* and *Connecticut, An Explorer's Guide*. 10% require freelance illustration; 100% require freelance cover design. Book catalog free by request.
Needs: Works with 4 freelance illustrators and 7 designers/year. Uses freelancers for jacket/cover and book design. Works on assignment only. Prefers working with computer-literate artists/designers within New England/New York with knowledge of Aldus PageMaker, Adobe Photoshop, Adobe Illustrator, QuarkXPress or Aldus FreeHand.
First Contact & Terms: Send query letter with appropriate samples. Samples are filed. Reports back to the artist only if interested. To show portfolio, mail best representations of style and subjects. Negotiates rights purchased.
Book Design: Assigns 10 freelance design jobs/year. Pays for design by the project, $500-1,200.
Jackets/Covers: Assigns 10 freelance design jobs/year. Pays for design $400-1,000.
Text Illustration: Assigns 2 freelance illustration jobs/year.

✔**CRC PRODUCT SERVICES**, 2850 Kalamazoo Ave. SE, Grand Rapids MI 49560. (616)224-0780. Fax: (616)224-0834. Art Director: Dean Heetderks. Estab. 1866. Publishes hardcover and trade paperback originals. Types of books include instructional, religious, young adult, reference, juvenile and preschool. Specializes in religious educational materials. Publishes 8-12 titles/year. 85% require freelance illustration.
Needs: Approached by 30-45 freelancers/year. Works with 12-16 freelance illustrators/year. Prefers freelancers with religious education, cross-cultural sensitivities. Uses freelancers for jacket/cover and text illustration. 95% of freelance work demands knowledge of Adobe Illustrator, QuarkXPress, Adobe Photoshop or Aldus FreeHand. Works on assignment only. 5% of titles require freelance art direction.
First Contact & Terms: Send query letter with brochure, résumé, tearsheets, photographs, photocopies, photostats, slides and transparencies. Samples are filed. Request portfolio review in original query. Portfolio should include thumbnails, roughs, finished samples, color slides, tearsheets, transparencies and photographs. Buys one-time rights. Interested in buying second rights (reprint rights) to previously published artwork. Originals are returned at job's completion.
Jackets/Covers: Assigns 2-3 freelance illustration jobs/year. Pays by the project, $200-1,000.
Text Illustration: Assigns 50-100 freelance illustration jobs/year. Pays by the project, $75-100. "This is high volume work. We publish many pieces by the same artist."
Tips: "Be absolutely professional. Know how people learn and be able to communicate a concept clearly in your art."

‡**CREATIVE WITH WORDS PUBLICATION**, P.O. Box 223226, Carmel CA 93922. Editor-in-Chief: Brigitta Geltrich. Estab. 1975. Publishes mass market paperback originals. Types of books include adventure, children's picture books, history, humor, juvenile, preschool, travel, young adult and folklore. Specializes in anthologies. Publishes 12-14 titles/year. Recent titles include: *Let's have Fun* and *We are Writers, Too!* Book catalog free for 8½×11 SAE with 2 oz firt-class postage.
Needs: Approached by 12-20 illustrators/year. Works with 6 illustrators/year. Prefers freelancers experienced in b&w drawings. Does not want computer art.
First Contact & Terms: Send postcard sample and follow-up postcard every 3 months, or query letter with printed samples, photocopies, SASE. Samples are filed or returned by SASE. Reports back within 2 weeks if SASE was enclosed. Will contact artist for portfolio review if interested. Buys one-time rights and sometimes negotiates rights purchased.
Book Design: Assigns 12-14 freelance design jobs/year. Pays for design by the project, $2-20 a sketch.
Jackets/Covers: Assigns 12-14 illustration jobs/year. Pays for illustration by the project, $2-20 a sketch. Prefers folkloristic themes, general-public appeal.
Text Illustration: Assigns 12-14 freelance illustration jobs/year. Pays by the project, $2-20. Prefers b&w sketches.
Tips: "We aim for a folkloristic slant in all of our publications. Therefore, we always welcome artists who weave this slant into our daily lives for a general (family) public. We also like to have the meanings of a poem or prose expressed in the sketch."

‡**THE CROSSING PRESS**, P.O. Box 1048, Freedom CA 95019. (408)722-0711. Fax: (408)722-2749. E-mail: crossart @aol.com. Website: http://www.crossingpress.com. Art Director: Karen Narita. Estab. 1966. Publishes audio tapes, trade paperback originals and reprints. Types of books include nonfiction and self help. Specialies in natural healing, New Age spirituality, cookbooks. Publishes 50 titles/year. Recent titles include: *Essential Reiki*; *Chakras and Their Archetypes*, *Women's Ventures*, *Women's Visions*. 10% requires freelance illustration; 20% requires freelance cover design; 30% require freelance interior design. Book catalog free for SAE with 4 first-class stamps.
Needs: Approached by 50 illustrators and 20 designers/year. Works with 2-3 illustrators and 2-3 designers/year. Prefers San Francisco Bay Area designers. Illustrators need not be local. Prefers designers experienced in Quark, Photoshop and Book Text design.

First Contact & Terms: Send query letter with printed samples, photocopies, SASE if materials are to be returned. Accepts Mac-compatible disk submissions. Samples are filed or returned by SASE. Will contact artist for portfolio review if interested. Rights purchased vary according to project. Finds freelancers through submissions, promo mailings, *Directory of Illustration*, *California Image*, *Creative Black Book*.

Tips: "We look for artwork that is expressive, imaginative, colorful, textural—abstract or representational—appropriate as cover art for books on natural healing or New Age spirituality. We also are interested in artists/photographers of prepared food for cookbooks."

JONATHAN DAVID PUBLISHERS, 68-22 Eliot Ave., Middle Village NY 11379. (718)456-8611. Fax: (718)894-2818. E-mail: jondavpub@aol.com. Website: http://www.JonathanDavidOnline.com. Production Coordinator: Fiorella de Lima. Estab. 1948. Company publishes hardcover and paperback originals. Types of books include biography, religious, young adult, reference, juvenile and cookbooks. Specializes in Judaica. Publishes 25 titles/year. Recent titles include *Great Jewish Quotations* and *The New Baseball Catalog*. 50% require freelance illustration; 75% require freelance design. Book catalog free by request.

Needs: Approached by numerous freelancers/year. Works with 5 freelance illustrators and 5 designers/year. Prefers freelancers with experience in book jacket design and jacket/cover illustration. 100% of design and 5% of illustration demands computer literacy. Works on assignment only.

First Contact & Terms: Designers send query letter with résumé and photocopies. Illustrators send postcard sample and/or query letter with photocopies, résumé. Samples are filed. Production Coordinator will contact artist for portfolio review if interested. Portfolio should include color final art and photographs. Buys all rights. Originals are not returned. Finds artists through submissions.

Book Design: Assigns 15-20 freelance design jobs/year. Pays by the project.

Jackets/Covers: Assigns 15-20 freelance design and 4-5 illustration jobs/year. Pays by the project.

Tips: First-time assignments are usually book jackets, mechanicals and artwork.

‡DAW BOOKS, INC., 375 Hudson St., 3rd Floor, New York NY 10014-3658. (212)366-2096. Fax: (212)366-2090. Art Director: Betsy Wollheim. Estab. 1971. Publishes hardcover and mass market paperback originals and reprints. Specializes in science fiction and fantasy. Publishes 72 titles/year. Recent titles include: *River of Blue Fire*, by Tad Williams; *Sword-Born*, by Jennifer Roberson. 50% require freelance illustration. Book catalog free by request.

Needs: Works with several illustrators and 1 designer/year. Buys more than 36 illustrations/year. Works with illustrators for covers. Works on assignment only.

First Contact & Terms: Send postcard sample or query letter with brochure, résumé, tearsheets, transparencies, photocopies, photographs and SASE. "Please don't send slides." Samples are filed or are returned by SASE only if requested. Reports back about queries/submissions within 2-3 days. Originals returned at job's completion. Call for appointment to show portfolio of original/final art, final reproduction/product and transparencies. Considers complexity of project, skill and experience of artist and project's budget when establishing payment. Buys first rights and reprint rights.

Jacket/Covers: Pays by the project, $1,500-8,000. "Our covers illustrate the story."

Tips: "We have a drop-off policy for portfolios. We accept them on Tuesdays, Wednesdays and Thursdays and report back within a day or so. Portfolios should contain science fiction and fantasy color illustrations *only*. We do not want to see anything else. Look at several dozen of our covers."

‡DC COMICS, Time Warner Entertainment, 1700 Broadway, 5th Floor, New York NY 10019. (212)636-5990. Fax: (212)636-5977. Design Director: Georg Brewer. Estab. 1948. Publishes hardcover originals and reprints, mass market paperback originals and reprints, trade paperback originals and reprints. Types of books include adventure, comic books, fantasy, horror, humor, juvenile, science fiction. Specializes in comic books. Publishes 1,000 titles/year. 80% requires freelance illustration; 10% requires freelance design; 2% requires freelance art direction. Book catalog not available.

Needs: Approached by 40 illustrators and 50 designers/year. Works with 80 illustrators, 10 designers, 2 art directors/year. Prefers local designers and art directors. Prefers freelancers experienced in desktop pub/publication and advertising design. 100% of freelance design demands knowledge of Adobe Illustrator, Adobe Photoshop, QuarkXPress. 80% of freelance illustration demands knowledge of Adobe Illustrator, Adobe Photoshop.

First Contact & Terms: Designers send postcard sample and follow-up postcard every 6 months, printed samples, photocopies, SASE. Illustrators send printed samples, photocopies, SASE. Accepts Mac-compatible disk submissions. Send EPS or TIFF files. Samples are filed or returned by SASE. Will contact artist for portfolio review if interested. Portfolio should include artwork of character in sequence, photocopies, tearsheets. Negotiates rights purchased or rights purchased vary according to project. Finds freelancers through *Black Book*, NY Graphic Artist Guild, submissions.

Book Design: Assigns 10 freelance design jobs.

Jackets/Covers: Assigns 6 freelance design and 10 illustration jobs/year. Prefers painted, reflective art. Prefers strong

THE MULTIMEDIA INDEX preceding the General Index in the back of this book lists markets seeking freelancers with multimedia, animation and CD-ROM skills.

designs of all sensibilities and genres.

Tips: "DC Comics is in the business of telling stories that are exciting and communicate in a clear fashion. The ability to tell this story in a single image or through a sequential narrative supercedes and individual or preferred style. The diversity of our company has room for many approaches in art and in design. In designers I look for clear solid understanding of materials and typography. As an all Macintosh environment we require compatible skills in all potential design assignments."

DIAL BOOKS FOR YOUNG READERS, 375 Hudson St., New York NY 10014. (212)366-2803. Fax: (212)366-2020. Editor: Toby Sherry. Specializes in juvenile and young adult hardcovers. Publishes 80 titles/year. Recent titles include *John Henry*, by Julius Lester and Jerry Pinkney; *Fanny's Dream*, by Carolyn and Mark Buehner. 100% require freelance illustration. Books are "distinguished children's books."
Needs: Approached by 400 freelancers/year. Works with 40 freelance illustrators/year. Prefers freelancers with some book experience. Works on assignment only.
First Contact & Terms: Send query letter with photocopies, tearsheets and SASE. Samples are filed and returned by SASE. Reports only if interested. Originals returned at job's completion. Send query letter with samples for appointment to show portfolio of original/final art and tearsheets. Considers complexity of project, skill and experience of artist and project's budget when establishing payment. Rights purchased vary.
Book Design: Assigns 2 freelance design jobs/year. Pays by the project.
Jackets/Covers: Assigns 8 illustration jobs/year. Pays by the project.
Text Illustration: Assigns 40 freelance illustration jobs/year. Pays by the project.

‡DOMINIE PRESS, INC., 1949 Kellogg Ave., Carlsbad CA 92008-6582. (760)431-8000. Fax: (760)431-8777. E-mail: info@dominie.com. Website: http://www.dominie.com. C.E.O.: Bob Rowland. Estab. 1975. Publishes textbooks. Types of books include children's picture books, juvenile, nonfiction, preschool, textbooks and young adult. Specializes in educational textbooks. Publishes 180 titles/year. Recent titles include: *The Day Miss Francine Got Skunked* and *Marine Life Series*. 90% requires freelance illustration; 50% requires freelance design; 30% requires freelance art direction. Book catalog free for 9×12 SASE with $2 postage.
Needs: Approached by 50 illustrators and 50 designers/year. Works with 35 illustrators, 10 designers and 2 art directors/year. Prefers local designers and art directors. Prefers freelancers experienced in children's books and elementary textbooks. 100% of freelance design demands knowledge of Adobe Illustrator, Adobe Photoshop, Aldus FreeHand, Aldus PageMaker, PageMaker and Quark XPress.
First Contact & Terms: Designers send printed samples and tearsheets. Illustrators send query letter with printed samples and tearsheets. Samples are not filed and are returned by SASE. Reports back in 6 months only if interested. Will contact artist for portfolio review if interested. Portfolio should include book dummy, photocopies, photographs, roughs, tearsheets, thumbnails, transparencies. Buys all rights.
Book Design: Assigns 25 freelance designs and 5 freelance art direction projects/year. Pays by the project.
Jackets/Covers: Assigns 30 freelance design jobs and 150 illustration jobs/year.
Text Illustration: Assigns 150 freelance illustration jobs/year. Pays by the project.

DOVE BOOKS, 8955 Beverly Blvd., Los Angeles CA 90048. (310)786-1600. Fax: (310)247-2924. Website: http://www.doveaudio.com/dove/. Art Director: Rick Penn-Kraus. Estab. 1985. Imprint of Dove Entertainment. Imprints include Dove Audio, Dove International, Dove Kids, Dove Multimedia. Publishes hardcover, trade paperback and mass market paperback originals, hardcover reprints, audio tapes and CD-ROM. Types of books include biography, cookbooks, experimental fiction, humor, mainstream fiction, New Age, nonfiction, religious, self help. Specializes in biography, business, current events, lifestyle. Publishes 24 titles/year. Recent titles include *An Unseemly Man*, by Larry Flynt; *Chosen By Fate*; *Mile High Club*. 40% require freelance illustration; 25% require freelance design. Book catalog free.
Needs: Approached by 60 illustrators and 20 designers/year. Works with 20 illustrators and 20 designers/year. Prefers local designers. 100% of freelance design demands knowledge of Adobe Photoshop, Adobe Illustrator or QuarkXPress. 15% of freelance illustration demands knowledge of Adobe Photoshop or Adobe Illustrator.
First Contact & Terms: Designers send photocopies, résumé, SASE, tearsheets. Illustrators send postcard sample or query letter with SASE and tearsheets. Samples are filed or returned by SASE. Portfolios may be dropped off every Thursday or art director will contact artist for portfolio review of photocopies, tearsheets, thumbnails or transparencies if interested. Finds freelancers through promo cards, *Workbook*.
Book Design: Assigns 13 jobs/year. Pays by the project.
Jackets/Covers: Assigns 10 design and 7 illustration jobs/year. Pays by project.
Tips: "I look for artists and designers who are flexible and willing to go the extra mile. Good communication is also essential. Be professional. Show a concise, great portfolio. Send me a great postcard to put up on my wall as a reminder."

‡DUTTON CHILDREN'S BOOKS, Penguin Putnam Inc., 375 Hudson St., New York NY 10014. Art Director: Sara Reynolds. Publishes hardcover originals. Types of books include children's picture books, juvenile, preschool, young adult. Publishes 60-80 titles/year. 75% require freelance illustration.
First Contact & Terms: Send postcard sample, printed samples, tearsheets. Samples are filed or returned by SASE. Will contact artist for portfolio review if interested. Portfolios may be dropped off every Tuesday and picked up by end of the day.
Jackets/Covers: Pays for illustration by the project $1,000-1,800.

‡EDITORIAL CARIBE, INC., P.O. Box 14100, Nashville TN 37214. (615)391-3937, ext. 2376. E-mail: production@ editorialcaribe.com. Website: http://editorialcsribe.com. Production Manager: Sam Rodriguez. Publishes hardcover originals, trade paperback originals and reprints and mass market paperback originals and reprints. Types of books include self-help and religious. Specializes in commentary series and Bibles. Publishes 60 titles/year. Recent titles include *Renuevame* and *Cuidado con los extremos!* 90% require freelance illustration; 100% require freelance design. Book catalog free by request.
Needs: Approached by 10 freelance artists/year. Works with 12-18 illustrators and 12 designers/year. Buys 20 freelance illustrations/year. Uses freelancers mainly for cover design. Also uses freelance artists for jacket/cover illustration. 100% of freelance desigin and 40% of illustration demand knowledge of Adobe Photoshop and Adobe Illustrator. Works on assignment only.
First Contact & Terms: Designers send query letter with brochure. Illustrators send postcard sample and/or brochure. Samples are filed. Reports back within 2 weeks. Artist should follow up with call and/or letter after initial query. Requests work on spec before assigning job. Buys all rights. Interested in buying second rights (reprint rights) to previously published work. Originals not returned. Finds artists through word of mouth, submissions and work already done.
Book Design: Assigns 15 design jobs/year. Pays by the project, $300-1,000.
Jackets/Covers: Assigns 40 design and 40 illustration jobs/year. Pays by the project, $400-700.
Tips: "Show creativity at a reasonable price. Keep in touch with industry and know what is out in the marketplace. Visit a large book store. Be flexible and get to know the target market."

EDUCATIONAL IMPRESSIONS, INC., 210 Sixth Ave., Hawthorne NJ 07507. (201)423-4666. Fax: (201)423-5569. E-mail: awpeller@worldnet.att.net. Website: http://www.awpeller.com. Art Director: Karen Sigler. Estab. 1983. Publishes original workbooks with 2-4 color covers and b&w text. Types of books include instructional, juvenile, young adult, reference, history and educational. Specializes in all educational topics. Publishes 4-12 titles/year. Recent titles include *September, October and November*, by Rebecca Stark; *Tuck Everlasting* and *Walk Two Moons Lit Guides*. Books are bright and bold with eye-catching, juvenile designs/illustrations.
Needs: Works with 1-5 freelance illustrators/year. Prefers freelancers who specialize in children's book illustration. Uses freelancers for jacket/cover and text illustration. Also for jacket/cover design. 50% of illustration demands knowledge of QuarkXPress, Aldus FreeHand and Adobe Photoshop. Works on assignment only.
First Contact & Terms: Send query letter with tearsheets, SASE, résumé and photocopies. Samples are filed. Art Director will contact artist for portfolio review if interested. Buys all rights. Interested in buying second rights (reprint rights) to previously published work. Originals are not returned. Prefers line art for the juvenile market. Sometimes requests work on spec before assigning a job.
Book Design: Pays by the project, $20 minimum.
Jackets/Covers: Pays by the project, $20 minimum.
Text Illustration: Pays by the project, $20 minimum.
Tips: "Send juvenile-oriented illustrations as samples."

ELCOMP PUBLISHING, INC., 4650 Arrow Highway #E-6, Montclair CA 91763. (909)626-4070. Fax: (909)624-9574. E-mail: 70414.1170@compuserve.com. Website: http://www.clipshop.com. President: Winfried Hofacker. Estab. 1979. Publishes mass market paperback originals and CD-ROM. Types of books include reference, textbooks, travel and computer. Specializes in computer and software titles. Publishes 2-3 titles/year. Recent titles include: *Bio's*, *CD-ROM* and *Unix*. 90% require freelance illustration; 90% require freelance design. Catalog free for 2 first-class stamps.
Needs: Approached by 2 illustrators and 2 designers/year. Works with 1 illustrator and 1 designer/year. Prefers freelancers experienced in cartoon drawing and clip art drawing. Uses freelancers mainly for clip art drawing. 10% of freelance design demands knowledge of Adobe Photoshop. 10% of freelance illustration demands knowledge of Adobe Photoshop and Adobe Illustrator.
First Contact & Terms: Designers send photocopies. Illustrators send photocopies, printed sample and follow-up postcard samples every 2 months. Accepts disk submissions compatible with EPS files for Windows. Samples are returned. Reports back within 6 weeks. Art director will contact artist for portfolio review if interested.
Book Design: Pays for design by the project, $20-50.
Jackets/Covers: Pays for design by the project, $10-50. Pays for illustration by the project, $10-20.
Text Illustration: Pays by the project, $10-20.

‡EDWARD ELGAR PUBLISHING INC., 6 Market St., Northampton MA 01060. (413)584-5551. Fax: (413)584-9933. E-mail: kwight@e-elgar.com. Website: http://www.e-elgar.co.uk. Promotions Executive: Katy Wight. Publishing Assistant: Michaela Cahillane. Estab. 1986. Publishes hardcover originals and textbooks. Types of books include instructional, nonfiction, reference, textbooks, academic monographs and references in economics. Publishes 200 titles/year. Recent titles include: *Post-Socialist Political Economy*, *The International Yearbook of Environmental and Resource Economics 1997/1998*. Book catalog available.
 ● This publisher uses only freelance designers. Its academic books are produced in the United Kingdom. Direct Marketing material is done in U.S. There is no call for illustration.
Needs: Approached by 2-4 designers/year. Works with 2 designers/year. Prefers local designers. Prefers freelancers experienced in direct mail and academic publishing. 100% of freelance design demands knowledge of Adobe Photoshop, QuarkXPress.

First Contact & Terms: Designers send query letter with printed samples. Accepts Mac-compatible disk submissions. Samples are filed. Will contact artist for portfolio review if interested. Buys one-time rights or rights purchased vary according to project. Finds freelancers through word of mouth, local sources i.e. phone book, newspaper, etc.

‡M. EVANS AND COMPANY, INC., 216 E. 49th St., New York NY 10016. (212)688-2810. Fax: (212)486-4544. Managing Editor: Rik Schell. Estab. 1956. Publishes hardcover and trade paperback originals. Types of books include contemporary fiction, biography, health and fitness, history, self-help and cookbooks. Specializes in general nonfiction. Publishes 30 titles/year. Recent titles include *Robert Crayhon's Nutrition Made Simple*, by Robert Crayhon; and *An Inquiry Into the Existence of Guardian Angels*, by Pierre Jovanovic. 50% require freelance illustration and design.
Needs: Approached by 25 freelancers/year. Works with approximately 3 freelance illustrators and 10 designers/year. Buys 20 illustrations/year. Prefers local artists. Uses freelance artists mainly for jacket/cover illustration. Also for text illustration and jacket/cover design. Works on assignment only.
First Contact & Terms: Send query letter with brochure and résumé. Samples are filed. Art Director will contact artist for portfolio review if interested. Portfolios may be dropped off every Friday. Portfolio should include original/final art and photographs. Rights purchased vary according to project. Originals are returned at job's completion upon request.
Book Design: Assigns 20 freelance jobs/year. Pays by project, $200-500.
Jackets/Covers: Assigns 20 freelance design jobs/year. Pays by the project, $600-1,200.
Text Illustration: Pays by the project, $50-500.

EXCELSIOR CEE PUBLISHING, P.O. Box 5861, Norman OK 73070. (405)329-3909. Fax: (405)329-6886. Estab. 1989. Publishes trade paperback originals. Types of books include how-to, instruction, nonfiction and self help. Specializes in how-to and writing. Publishes 6 titles/year. Recent titles include *Anyone Can Write—Just Let It Come Out* and *How to Record Your Family History.*
Needs: Uses freelancers mainly for jacket and cover design.
First Contact & Terms: Designers send query letter with brochure and SASE. Illustrators send query letter with résumé and SASE. Accepts disk submissions from designers. Samples returned by SASE. Negotiates rights purchased.
Book Design: Assigns 2 freelance design jobs/year. Pays by the project.
Jackets/Covers: Assigns 6 freelance illustration jobs/year. Pays by the project; negotiable.
Text Illustration: Pays by the project. Finds freelancers through word of mouth and submissions.

✓FABER AND FABER, INC., 53 Shore Rd., Winchester MA 01890. (781)721-1427. Fax: (781)729-2783. Managing Editor: Carolyn McGuire. Estab. 1976. Publishes hardcover originals, trade paperback originals and reprints. Types of books include biography, cookbooks, history, mainstream fiction, nonfiction, self help and travel. Publishes 90 titles/year. 30% require freelance design.
Needs: Approached by 60 illustrators and 40 designers/year. Works with 2 illustrators and 14 designers/year. Uses freelancers mainly for book jacket design. 80% of freelance design demands knowledge of Adobe Photoshop and QuarkXPress.
First Contact & Terms: Designers send query letter with photocopies. Illustrators send postcard sample or photocopies. Samples are filed or returned by SASE. Will contact artist for portfolio review if interested. Rights purchased vary according to project.
Jackets/Covers: Assigns 20 freelance design and 4 illustration jobs/year. Pays by project.

✓FALCON PRESS PUBLISHING CO., INC., 48 N. Last Chance Gulch, Helena MT 59601. (406)442-6597. Fax: (406)442-2995. E-mail: falconbk@ix.netcom.com. Website: http://www.falconguide.com. Art/Production Director: Michael Cirone. Estab. 1978. Book publisher. Publishes hardcover originals and reprints, trade paperback originals and reprints, and mass market paperback originals and reprints. Types of books include instruction, juvenile, travel and cookbooks. Specializes in recreational guidebooks and high-quality, four-color coffeetable photo books. Publishes 64 titles/year. Recent titles include *A Field Guide to Cows*, by John Pukite and *Birder's Dictionary*, by Randall Cox. Book catalog free by request.
Needs: Approached by 250 freelance artists/year. Works with 2-5 freelance illustrators/year. Buys 100 freelance illustrations/year. Uses freelance artists mainly for illustrating children's books, map making and technical drawing.
First Contact & Terms: Send postcard sample or query letter with résumé, tearsheets, photographs, photocopies or photostats. Samples are filed if it fits their style. Accepts disk submissions compatible with Aldus PageMaker, QuarkXPress or Adobe Illustrator. Reports back to the artist only if interested. Do not send anything you need returned. Originals are returned at job's completion.
Book Production: Assigns 30-40 freelance production jobs and 1-2 design projects/year. Pays by the project.
Jackets/Covers: Assigns 1-4 freelance design and 1-4 illustration jobs/year.
Text Illustration: Assigns approximately 10 freelance illustration jobs/year. Pays by the project. No preferred media or style.
Tips: "If we use freelancers, it's usually to illustrate nature-oriented titles. These can be for various children's titles or adult titles. We tend to look for a more 'realistic' style of rendering but with some interest."

F&W PUBLICATIONS INC., 1507 Dana Ave., Cincinnati OH 45207. Art Director: Clare Finney. Imprints: Writers Digest Books, North Light Books, Betterway Books, Story Press. Publishes 120 books annually for writers, artists and

photographers, plus selected trade (lifestyle, home improvement) titles. Recent titles include: *Creative Nonfiction*, *The Best of Portrait Painting* and *Perfect Wood Finishing Made Easy*. Books are heavy on type-sensitive design.

Needs: Works with 10-20 freelance illustrators and 5-10 designers/year. Uses freelancers for jacket/cover design and illustration, text illustration, direct mail and book design. Works on assignment only.

First Contact & Terms: Send nonreturnable photocopies of printed work to be kept on file. Art director will contact artist for portfolio review if interested. Interested in buying second rights (reprint rights) to previously published illustrations. "We like to know where art was previously published." Finds illustrators and designers through word of mouth and submissions/self promotions.

Book Design: Pays by the project, $500-1,000.

Jackets/Covers: Pays by the project, $400-850.

Text Illustration: Pays by the project, $100 minimum.

Tips: "Don't call. Send appropriate samples we can keep. Clearly indicate what type of work you are looking for."

‡FANTAGRAPHICS BOOKS, INC., 7563 Lake City Way, Seattle WA 98115. Phone/fax: (206)524-1967. Publisher: Gary Groth. Estab. 1976. Publishes hardcover and trade paperback originals and reprints. Types of books include contemporary, experimental, mainstream, historical, humor and erotic. "All our books are comic books or graphic stories." Publishes 100 titles/year. Recent titles include *Love & Rockets*, *Hate*, *Eightball*, *Acme Novelty Library*, *JIM* and *Naughty Bits*. 10% require freelance illustration. Book catalog free by request.

Needs: Approached by 500 freelancers/year. Works with 25 freelance illustrators/year. Must be interested in and willing to do comics. Uses freelancers for comic book interiors and covers.

First Contact & Terms: Send query letter addressed to submissions editor with résumé, SASE, photocopies and finished comics work. Samples are not filed and are returned by SASE. Reports back to the artist only if interested. Call or write for appointment to show portfolio of original/final art and b&w samples. Buys one-time rights or negotiates rights purchased. Originals are returned at job's completion. Pays royalties.

Tips: "We want to see completed comics stories. We don't make assignments, but instead look for interesting material to publish that is pre-existing. We want cartoonists who have an individual style, who create stories that are personal expressions."

FARRAR, STRAUS & GIROUX, INC., 19 Union Square W., New York NY 10003. (212)741-6900. Art Director: Susan Mitchell. Book publisher. Estab. 1946. Publishes hardcover and trade paperback originals and trade paperback reprints. Publishes nonfiction and fiction. Publishes 200 titles/year. 20% require freelance illustration; 40% freelance design.

Needs: Works with 12 freelance designers and 3-5 illustrators/year. Uses artists for jacket/cover and book design.

First Contact & Terms: Send postcards, samples, tearsheets and photostats. Samples are filed and are not returned. Reports back only if interested. Originals are returned at job's completion. Call or write for appointment to show portfolio of photostats and final reproduction/product. Portfolios may be dropped off every Tuesday before 2 p.m. Considers complexity of project and budget when establishing payment. Buys one-time rights.

Book Design: Assigns 40 freelance design jobs/year. Pays by the project, $300-450.

Jackets/Covers: Assigns 20 freelance design jobs/year and 10-15 freelance illustration jobs/year. Pays by the project, $750-1,500.

Tips: The best way for a freelance illustrator to get an assignment is "to have a great portfolio."

‡FIRST BOOKS, INC., 2040 N. Milwaukee Ave., Chicago IL 60647. (773)276-5911. Website: http://www.firstbooks.com. President: Jeremy Solomon. Estab. 1988. Publishes trade paperback originals. Publishes 4-5 titles/year. Recent titles include: *Gay USA*, by George Hobica. 100% require freelance illustration.

Needs: Uses freelancers mainly for interiors and covers.

First Contact & Terms: Designers send "any samples you want to send and SASE but no original art, please!" Illustrators send query letter with a few photocopies or slides. Samples are filed or returned by SASE. Reports back within 1 month. Rights purchased vary according to project.

Book Design: Payment varies per assignment.

Tips: "We're a small outfit—keep that in mind when sending in samples."

FOCUS ON THE FAMILY, 8605 Explorer Dr., Colorado Springs CO 80920. (719)531-3400. Senior Art Director, Periodicals: Tim Jones. Estab. 1977. Publishes hardcover, trade paperback and mass market paperback originals, audio tapes and periodicals. Types of books include adventure, history, instructional, juvenile, nonfiction, religious, self-help. Specializes in religious-Christian. Publishes 20 titles/year. 30% require freelance illustration; 30% require freelance design. Book catalog free.

Needs: Approached by 60 illustrators and 12 designers/year. Works with 150 illustrators and 1 designer/year. Prefers local designers. Prefers designers experienced in Macintosh. Uses designers mainly for periodicals, publication design/production. 100% of design and 20% illustration demands knowledge of Aldus FreeHand, Adobe Photoshop, Adobe Illustrator, QuarkXPress.

First Contact & Terms: Send query letter with photocopies, printed samples, résumé, SASE and tearsheets. Send follow-up postcard every year. Samples are filed. Reports back within 2 weeks. Will contact artist for portfolio review of photocopies of artwork portraying family themes if interested. Buys first, one-time or reprint rights. Finds freelancers through agents, sourcebooks and submissions.

Book Design: Assigns 6-8 freelance design jobs/year. Pays by the project.
Jackets/Covers: Assigns 6-8 freelance design jobs and 4 illustration jobs/year. Pays by the project. Prefers realistic and stylized work.
Text Illustration: Assigns 150 illustration jobs/year. Pays by project. Prefers realistic, abstract, cartoony styles.

‡**FORT ROSS INC.**, 269 W. 259 St., Riverdale NY 10471-1921. (718)884-1042. Fax: (718)884-3373. Executive Director: Dr. Vladimir P. Kartsev. Represents leading Russian publishing companies in the US and Canada. Estab. 1992. Hardcover originals, mass market paperback originals and reprints, and trade paperback reprints. Works with adventure, children's picture books, fantasy, horror, romance, science fiction and western. Specializes in romance, science fiction, mystery. Publishes 2,000 titles/year. Recent titles include: translations of Steven King, Sandra Braun and Catherine Creel's novels in Eastern Europe. 100% requires freelance illustration. Book catalog not available.
Needs: Approached by 100 illustrators/year. Works with 40 illustrators/year. Prefers freelancers experienced in romance, science fiction, fantasy, mystery cover art.
First Contact & Terms: Illustrators send query letter with printed samples, photocopies, SASE, tearsheets. Accepts Windows or Mac-compatible disk submissions. Send EPS files. Samples are filed. Will contact artist for portfolio review if interested. Buys secondary rights. Finds freelancers through agents, networking events, sourcebooks, *Creative Black Book*, *RSVP*.
Book Design: Assigns 5 freelance design and 5 freelance art direction projects/year. Pays by the project, $300-500.
Jackets/Covers: Buys 2,000 illustrations/year. Pays for illustration by the project, $100-200 for secondary rights (for each country). Prefers experienced romance, mystery, science fiction, fantasy cover illustrators.
Tips: "Fort Ross is a good place for experienced cover artists to sell secondary rights for their images in Russia, countries of the former USSR and Eastern Europe."

‡**FORWARD MOVEMENT PUBLICATIONS**, 412 Sycamore St., Cincinnati OH 45202. (513)721-6659. Fax: (513)421-0315. E-mail: forward.movement@ecunet.org. Website: http://www.dfms.org/fmp. Associate Director: Sally B. Sedgwick. Estab. 1934. Publishes trade paperback originals. Types of books include religious. Publishes 24 titles/year. Recent titles include *Building Up the Church* and *Release*, by Bo Cox. 17% require freelance illustration. Book illustration is usually suggestive, not realistic. Book catalog free for SAE with 3 first-class stamps.
Needs: Works with 2-4 freelance illustrators and 1-2 designers/year. Uses freelancers mainly for illustrations required by designer. "We also keep original clip art-type drawings on file to be paid for as used."
First Contact & Terms: Send query letter with tearsheets, photographs, photocopies and slides. Samples are sometimes filed. Art Director will contact artist for portfolio review if interested. Sometimes requests work on spec before assigning a job. Interested in buying second rights (reprint rights) to previously published work. Rights purchased vary according to project. Originals sometimes returned at job's completion. Finds artists mainly through word of mouth.
Jackets/Covers: Assigns 1-4 freelance design and 6 illustration jobs/year. Pays by the project, $25-175.
Text Illustration: Assigns 1-4 freelance jobs/year. Pays by the project, $10-200; pays $5-25/picture. Prefers pen & ink.
Tips: If you send clip art, include fee you charge for use.

WALTER FOSTER PUBLISHING, 23062 La Cadena, Laguna Hills CA 92653. (714)380-7510. Fax: (714)380-7575. E-mail: sheena@walterfoster.com. Website: http://www.walterfoster.com. Creative Director: Sheena Needham. Estab. 1922. Publishes hardcover, trade paperback and mass market paperback originals and reprints. Types of books include instructional, juvenile, young adult, "all art related." Specializes in art & craft. Publishes 80-100 titles/year. 80% require freelance illustration; 20% require freelance design. Catalog free for 6×9 SASE with 6 first-class stamps.
Needs: Approached by 50-100 illustrators and 50-100 designers/year. Works with 15-20 illustrators and 3-4 designers/year. 100% of freelance design demands knowledge of Adobe Photoshop, Adobe Illustrator and QuarkXPress.
First Contact & Terms: Designers send query letter with brochure. Illustrators send postcard sample or query letter with color photocopies. Accepts disk submissions. "If samples suit us they are filed," or they are returned by SASE. Reports back only if interested. Art director will contact artist for portfolio review of photocopies, photographs, photostats, slides and transparencies if interested. Buys all rights.
Book Design Assigns 5-10 freelance design jobs/year. Pays by the project.
Jackets/Covers: Assigns 5-10 freelance design jobs and 10-20 illustration jobs/year. Pays by the project. Finds freelancers through agents, sourcebooks, magazines, word of mouth and submissions.

✔**FRANKLIN WATTS**, 90 Sherman Turnpike, Danbury CT 06816. (203)797-3500. Fax: (203)797-6986. Estab. 1942. Imprint of Grolier, Inc. Imprints include Children's Press, Orchard Books, Grolier Educational. Imprint publishes hardcover and trade paperback originals. Types of books include biography, young adult, reference, history and juvenile. Specializes in history, science and biography. Publishes 250 titles/year. 5% require freelance illustration; 10% require freelance design.
Needs: Approached by over 500 freelance artists/year. Works with 10 freelance illustrators and 20 freelance designers/year. Buys 30 freelance illustrations/year. Uses freelance artists mainly for jacket/cover design and technical illustrations. Needs computer-literate freelancers for design. 100% of freelance work demands knowledge of Aldus PageMaker, Adobe Illustrator, QuarkXPress, Adobe Photoshop.
First Contact & Terms: Send query letter with brochure, résumé, SASE and photocopies. Samples are not filed and are returned by SASE if requested by artist. Art Director will contact artist for portfolio review if interested. Portfolio

should include b&w and color thumbnails, roughs, final art, photostats, tearsheets, photographs, slides or transparencies. Rights purchased vary according to project. Originals are returned at job's completion. Finds artists through other artists submissions and Graphic Artists Guild."

Book Design: Assigns 30 freelance design jobs/year. Pays by the project.

Jackets/Covers: Assigns 75 freelance design and 10 freelance illustration jobs/year. Pays by the project.

Text Illustration: Assigns 20-30 freelance illustration jobs/year. Pays by the project.

FULCRUM PUBLISHING, 350 Indiana St., Suite 350, Golden CO 80401. (303)277-1623. Fax: (303)279-7111. Production Director: Patty Maher. Estab. 1986. Book and calendar publisher. Publishes hardcover originals and trade paperback originals and reprints. Types of books include biography, Native American, reference, history, self help, teacher resource books, travel, humor, gardening and nature. Specializes in history, nature, teacher resource books, travel, Native American and gardening. Publishes 50 titles/year. Recent titles include *Sex in Your Garden*, by Angela Overy; and *The Colorado Guide, 4th Edition*, by Bruce Caughey and Dean Winstanley. 15% require freelance illustration; 85% require freelance design. Book catalog free by request.

Needs: Approached by 50 freelancers/year. Works with 4 freelance illustrators and 6 designers/year. Uses freelancers mainly for cover and interior illustrations for gardening books and images for calendars. Also for other jacket/covers, text illustration and book design. Works on assignment only.

First Contact & Terms: Send query letter with tearsheets, photographs, photocopies and photostats. Samples are filed. Reports back to artist only if interested. To show portfolio, mail b&w photostats. Buys one-time rights. Originals are returned at job's completion.

Book Design: Assigns 25 freelance design and 6 illustration jobs/year. Pays by the project, $350-2,000.

Jackets/Covers: Assigns 20 freelance design and 4 illustration jobs/year. Pays by the project.

Text Illustration: Assigns 10 freelance design and 1 illustration jobs/year. Pays by the project.

Tips: Previous book design experience a plus.

‡GALISON BOOKS/MUDPUPPY PRESS, 36 W. 44th, New York NY 10036. Editor: Deborah Anderson. Publishes coffee table books. Specializes fine art, botanicals. Publishes 120 titles/year. 50% require design.

• Also has listing in greeting cards, gifts and products section.

Needs: Approached by 10 illustrators/year. Works with 50 illustrators and 20 designers/year. Some freelance design demands knowledge of Adobe Photoshop, Adobe Illustrator, QuarkXPress.

First Contact & Terms: Designers send brochure, photocopies, SASE, slides, tearsheets. Illustrators send photocopies, printed samples, tearsheets. Samples are filed or returned SASE. Will contact artist for portfolio review if interested. Rights purchased vary according to project.

GALLOPADE PUBLISHING GROUP/CAROLE MARSH FAMILY CD-ROM, 200 Northlake Dr., Peachtree City GA 30269. Contact: Art Department. Estab. 1979. Publishes hardcover and trade paperback originals, textbooks and interactive multimedia. Types of books include contemporary fiction, western, instructional, mystery, biography, young adult, reference, history, humor, juvenile and sex-education. Publishes 1,000 titles/year. Titles include *Alabama Jeopardy* and *A Trip to the Beach* (CD-ROM). 20% require freelance illustration; 20% require freelance design.

Needs: Works almost exclusively with paid or unpaid interns. Company selects interns from applicants who send nonreturnable samples, résumé and internship availability. Interns work on an initial unpaid project, anything from packaging and book covers to multimedia and book design. Students can receive credit and add commercial work to their portfolio. Prefers artists with Macintosh experience.

First Contact & Terms: Send non-returnable samples only. Usually buys all rights.

GAYOT PUBLICATIONS, 5900 Wilshire Blvd., Los Angeles CA 90036. (213)965-3529. Fax: (213)936-2883. Website: http://www.gayot.com. Publisher: Alain Gayot. Estab. 1986. Publishes trade paperback originals. Types of books include travel. Publishes 8 titles/year. Recent titles include: *Best of Los Angeles* and *NYC Restaurants*. 100% require freelance illustration and design. Catalog available.

Needs: Approached by 30 illustrators and 2 designers/year. Works with 4 illustrators and 3 designers/year. Prefers local designers. 100% of freelance design demands knowledge of Aldus PageMaker, Adobe Photoshop, Adobe Illustrator and QuarkXPress.

First Contact & Terms: Designers send query letter with brochure, photocopies and résumé. Illustrators send postcard sample or query letter with photocopies, printed samples and tearsheets. Send follow-up postcard every 6 months. Accepts disk submissions compatible with Mac, any program. Samples are filed. Reports back only if interested. Will contact artist for portfolio review if interested. Rights purchased vary according to project.

Book Design: Pays by the hour or by the project.

Jackets/Covers: Assigns 40 freelance design jobs and 8 illustration jobs/year. Pays for design by the hour. Pays for

THE MULTIMEDIA INDEX preceding the General Index in the back of this book lists markets seeking freelancers with multimedia, animation and CD-ROM skills.

illustration by the project, $800-1,200.

Text Illustration: Assigns 20 freelance illustration jobs/year. Pays by the project, $150-500. Finds freelancers through magazines, word of mouth and submissions.

Tips: "We look for rapidity, flexibility, eclecticism and an understanding of the travel guide business."

GEM GUIDES BOOK CO., 315 Cloverleaf Dr., Suite F, Baldwin Park CA 91706. (626)855-1611. Fax: (626)855-1610. Editor: Robin Nordhues. Estab. 1964. Book publisher and wholesaler of trade paperback originals and reprints. Types of books include earth sciences, western, instructional, travel, history and regional (western US). Specializes in travel and local interest (western Americana). Publishes 6 titles/year. Recent titles include *The Rockhound's Handbook*, by James R. Mitchell; and *Recreational Gold Prospecting for Fun and Profit*, by Gail Butler. 75% require freelance illustration and design. Book catalog free for SASE.

Needs: Approached by 24 freelancers/year. Works with 3 freelance illustrators and 3 designers/year. Buys 8 illustrations/year. Uses freelancers mainly for covers. Also for text illustration and book design. 100% of freelance work demands knowledge of Aldus PageMaker 5.0, Aldus FreeHand 4.0, Appleone Scanner and Omnipage Professional. Works on assignment only.

First Contact & Terms: Send query letter with brochure, résumé and SASE. Samples are filed. Editor will contact artist for portfolio review if interested. Requests work on spec before assigning a job. Buys all rights. Originals are not returned. Finds artists through word of mouth and "our files."

Book Design: Assigns 6 freelance design jobs/year. Pays by the project.

Jackets/Covers: Pays by the project.

Text Illustration: Assigns 2 freelance jobs/year. Pays by the project.

GENERAL PUBLISHING GROUP, 2701 Ocean Park Blvd. #140, Santa Monica CA 90405-5200. (310)314-4000. Fax: (310-314-8080). E-mail: genpub@aol.com. Production Director: Trudihope Schlomowitz. Estab. 1993. Publishes hardcover and trade paperback originals and reprints. Publishes biography, coffee table books, cookbooks and retrospectives. Specializes in entertainment. Publishes 50 titles/year. Recent titles include: *Sammy Davis*, *The Young and the Restless*, *The Playmate Book* and *The Monkees*. 25% require freelance design. Catalog available free for 8½×11 SASE with 1 first-class stamp.

Needs: Works with 2 freelance designers/year. Prefers local freelancers. Uses freelancers mainly for design, layout, production. 100% of freelance design demands knowledge of Adobe Photoshop, Adobe Illustrator 6.0 and QuarkXPress 3.32.

First Contact & Terms: Send query letter with brochure, photographs, photocopies, photostats, resume, printed samples, tearsheets and SASE. Accepts disk submissions compatible with QuarkXPress, Adobe Photoshop and Adobe Illustrator (TIFF, EPS files). Samples are filed and are not returned. Will contact artist for portfolio review of artwork portraying entertainment subjects, photocopies, photographs, photostats, roughs and tearsheets. Rights purchased vary according to project. Finds artists through portfolio reviews, recommendations, *LA Times* employment ads.

Book Design: Assigns 2 book design jobs/year. Pays by the hour, $15-25.

Jackets/Covers: Assigns 2 design jobs/year. Pays by the hour $15-25 for design and illustration.

Tips: "We look for unrestrained design approaches that are fresh. You must possess good production skills."

GIBBS SMITH, PUBLISHER, P.O. Box 667, Layton UT 84041. (801)544-2958. Editorial Director: Madge Baird. Estab. 1969. Imprints include Peregrine Smith Books. Company publishes hardcover and trade paperback originals. Types of books include coffee table books, cookbooks, humor, juvenile, textbooks, western. Specializes in home/interior, gardening, humor. Publishes 50-60 titles/year. Recent titles include *The Living Wreath* and *Don't Squat with Yer Spurs On!* 20% require freelance illustration; 100% require freelance design. Book catalog free for 9×12 SASE with first class stamps.

Needs: Approached by 100 freelance illustrators and 25 freelance designers/year. Works with 10 freelance illustrators and 20 designers/year. Prefers freelancers experienced in book illustration. Uses freelancers mainly for cover design and book layout, cartoon illustration, children's book illustration. 100% of freelance design demands knowledge of Aldus PageMaker, Aldus FreeHand, Adobe Photoshop, Adobe Illustrator, QuarkXPress. 10% of freelance illustration demands knowledge of Adobe Photoshop, Adobe Illustrator.

First Contact & Terms: Designers send query with brochure, photocopies, photostats, résumé, SASE, slides (not originals) and tearsheets. Illustrators send postcard sample and/or query letter with photocopies, photographs, photostats, printed samples, résumé, slides and tearsheets. Send follow-up postcard sample every 6-12 months. Samples are filed. Request portfolio review in original query. Reports back only if interested. Artist should follow-up with call and/or letter after initial query. Portfolio should include artwork portraying nature, cartoon characters and children, book dummy, photocopies, photographs, photostats, tearsheets, transparencies. Rights purchased vary according to project. Finds freelancers through word of mouth, submissions.

Book Design: Assigns 50-60 freelance design jobs/year. Pays by the project, $1,000-3,000; $700 cover design plus per page fee.

Jackets/Covers: Assigns 50-60 freelance design jobs and 5-10 illustration jobs/year. Pays for design by the project, $500-800. Pays for illustration by the project, $250-400. Prefers watercolor or oil, or pastels.

Text Illustration: Assigns 10-15 freelance illustration jobs/year. Pays by the project, $400-3,000. Prefers line art, watercolor, pastel.

GLENCOE/McGRAW-HILL PUBLISHING COMPANY, 3008 W. Willow Knolls Rd., Peoria IL 61615. (309)689-3200. Fax: (309)689-3211. Contact: Ardis Parker, Design and Production Manager, and Art and Photo Editors. Specializes in secondary educational materials (hardcover, paperback, filmstrips, software), in industrial and computer technology, home economics and family living, social studies, career education, etc. Publishes more than 100 titles/year.
Needs: Works with over 30 freelancers/year. 60% of freelance work demands knowledge of Adobe Illustrator, QuarkXPress or Adobe Photoshop. Works on assignment only.
First Contact & Terms: Send query letter with brochure, résumé and "any type of samples." Samples not filed are returned if requested. Reports back in weeks. Originals are not returned; works on work-for-hire basis with rights to publisher. Considers complexity of the project, skill and experience of the artist, project's budget, turnaround time and rights purchased when establishing payment. Buys all rights.
Book Design: Assigns 30 freelance design jobs/year. Pays by the project.
Jackets/Covers: Assigns 50 freelance design jobs/year. Pays by the project.
Text Illustration: Assigns 50 freelance jobs/year. Pays by the hour or by the project.
Tips: "Try not to cold call and never drop in without an appointment."

THE GRADUATE GROUP, P.O. Box 370351, W. Hartford CT 06137-0351. (860)233-2330. President: Mara Whitman. Estab. 1967. Publishes trade paperback originals. Types of books include instructional and reference. Specializes in internships and career planning. Publishes 35 titles/year. Recent titles include *New Internships for 1998*, by Robert Whitman and *Careers in Law Enforcement*, by Lt. Jim Nelson. 10% require freelance illustration and design. Book catalog free by request.
Needs: Approached by 20 freelancers/year. Works with 1 freelance illustrator and 1 designer/year. Prefers local freelancers only. Uses freelancers for jacket/cover illustration and design; direct mail, book and catalog design. 5% of freelance work demands computer skills. Works on assignment only.
First Contact & Terms: Send query letter with brochure and résumé. Samples are not filed. Reports back only if interested. Write for appointment to show portfolio.

GRAYWOLF PRESS, 2402 University Ave., St. Paul MN 55114. (612)641-0077. Fax: (612)641-0036. E-mail: czarniec@graywolfpress.org. Website: http://www.graywolfpres.org. Executive Editor: Anne Czarniecki. Estab. 1974. Publishes hardcover originals, trade paperback originals and reprints of literary classics. Specializes in novels, nonfiction, memoir, poetry, essays and short stories. Publishes 16 titles/year. Recent titles include: *Tolstoy's Dictaphone*, Editor: Sven Birkerts; and *Burning Down the House*, by Charles Baxter. 100% require freelance design. Books use solid typography, strikingly beautiful and well-integrated artwork. Book catalog free by request.
● Graywolf is recognized as one of the finest small presses in the nation.
Needs: Approached by 50 freelance artists/year. Works with 5 designers/year. Buys 20 illustrations/year (existing art only). Prefers artists with experience in literary titles. Uses freelancers mainly for cover design. Also for direct mail and catalog design. Works on assignment only.
First Contact & Terms: Send query letter with résumé and photocopies. Samples are returned by SASE if requested by artist. Executive Editor will contact artist for portfolio review if interested. Portfolio should include b&w, color photostats and tearsheets. Negotiates rights purchased. Interested in buying second rights (reprint rights) to previously published work. Originals are returned at job's completion. Pays by the project. Finds artists through submissions and word of mouth.
Jackets/Covers: Assigns 16 design jobs/year. Pays by the project, $800-1,200. "We use existing art—both contemporary and classical—and emphasize fine typography."
Tips: "Have a strong portfolio of literary (fine press) design."

GREAT QUOTATIONS PUBLISHING, 1967 Quincy Court, Glendale Heights IL 60139. (630)582-2800. Fax: (630)582-2813. Editor: Ringo Suek. Estab. 1985. Imprint of Greatime Offset Printing. Company publishes hardcover, trade paperback and mass market paperback originals. Types of books include coffee table books, humor and self-help. Specializes in humor and inspiration. Publishes 50 titles/year. Recent titles include *Let's Talk Decorative*, *Kid Bit*. 90% require freelance illustration and design. Book catalog available for $1.50 with SASE.
Needs: Approached by 100 freelancers/year. Works with 10 freelance illustrators/year and 10 designers/year. Prefers local artists. Uses freelancers for jacket/cover illustration and design; book and catalog design. 50% of freelance work demands knowledge of QuarkXPress and Adobe Photoshop. Works on assignment only. 50% of titles require freelance art direction.
First Contact & Terms: Send query letter with brochure, résumé, SASE, photographs and photocopies. Accepts disk submissions compatible with Adobe Illustrator 5.0. Send EPS files. Samples are filed or returned by SASE if requested by artist. Reports back within 1 month. Art Director will contact artist for portfolio review if interested. Portfolio should include book dummy and final art. Rights purchased vary according to project. Originals are returned at job's completion. Finds artists through word of mouth and *Creative Black Book*.
Book Design: Assigns 35 freelance design jobs/year. Pays by the project, $300-3,000.
Jackets/Covers: Assigns 15 freelance design jobs/year and 15 illustration jobs/year. Pays by the project, $300-3,000.
Text Illustration: Assigns 20 freelance illustration jobs/year. Pays by the project, $100-1,000.
Tips: "We're looking for bright, colorful cover design on a small size book cover (around 6×6). Outstanding humor or inspirational titles will be most in demand."

‡GROLIER PUBLISHING, Parent company of imprints Children's Press, Grolier Educational Publishing, Franklin Watts and Orchard Books.
- Grolier specializes in reference, educational and children's books. See individual imprints for address and contact person.

✓GROUP PUBLISHING BOOK PRODUCT, (formerly Group Publishing—Book & Curriculum Division), 1515 Cascade Ave., Loveland CO 80539. (970)669-3836. Fax: (970)669-1994. Art Directors: Jean Bruns, Karl Monson and Ray Tollison (interior illustration). Company publishes books, Bible curriculum products (including puzzles and posters), clip art resources and audiovisual materials for use in Christian education for children, youth and adults. Publishes 35-40 titles/year.
- This company also produces magazines. See listing in Magazines section for more information.

Needs: Uses freelancers for cover illustration and design. 100% of design and 50% of illustration demand knowledge of QuarkXPress 3.32-4.0, Aldus Freehand 5.0, Adobe Photoshop 4.0, Adobe Illustrator 5.0. Occasionally uses cartoons in books and teacher's guides. Uses b&w and color illustration on covers and in product interiors.

First Contact & Terms: Contact Jeff Storm, Marketing Art Director, if interested in cover design or illustration. Send query letter with non-returnable b&w or color photocopies, slides, tearsheets or other samples. Accepts disk submissions compatible with above programs. Send EPS files. Samples are filed, additional samples may be requested priot to assignment. Reports back only if interested. Rights purchased vary according to project.

Jackets/Covers: Assigns 15 freelance design and 10 freelance illustration jobs/year. Pays for design, $250-1,200; pays for illustration, $250-1,200.

Text Illustration: Assigns 30 freelance illustration jobs/year. **Pays on acceptance**: $35-150 for b&w (from small spot illustrations to full page). Fees for color illustration and design work vary and are negotiable. Prefers b&w line or line and wash illustrations to accompany lesson activities.

Tips: "We prefer contemporary, nontraditional styles appropriate for our innovative and upbeat products and the creative Christian teachers and students who use them. We seek artists who can help us achieve our goal of presenting biblical material in fresh, new and engaging ways. Submit design/illustration on disk. Self promotion booklets help get you noticed. Have book covers/jackets, brochure design, newsletter or catalog design in your portfolio."

‡*GRUPO EDITORIAL BAIO LATINO AMERICANO S.A. de C.V., Imprint of Baio Childrens Titles, Calderon De la Barca #358, Apartimento #401, Colonia Polanco Mexico D.F. 11550 Mexico. Phone/fax: 001(52)(5)531-0948. US address: P.O. Box 998, Edison NJ 08818-0998. (732)287-4411. Fax: (732)287-4211. E-mail: baio@aol.com. Chairman of the Board and President: Louis J. Baio, Sr. Estab. 1992. Publishes mass market paperback originals. Types of books include children's picture books, comic books, fantasy, juvenile, young adult. Specializes in children's activity books. Publishes 10 titles/year. Recent titles include: *Warner Bros. Space Jam, All Dogs Go to Heaven II, Mortal Kombat, Dragon Doll.* 100% requires freelance illustration; 50% requires freelance design, 25% requires freelance art direction. Book catalog not available.

Needs: Approached by 20 illustrators and 15 designers/year. Works with 5 illustrators, 4 designers and 10 art directors/year. Prefers freelancers experienced in children's books. 50% of freelance design and illustration demands knowledge of Adobe Illustrator, Adobe Photoshop, Aldus FreeHand, Aldus PageMaker, PageMaker, QuarkXPress.

First Contact & Terms: Send query letter with printed samples, photocopies, SASE, tearsheets, and follow-up postcard every 2 months. Samples are filed. Reports back within 1 month if interested. Will contact artist for portfolio review of portraying children, photocopies, photographs, roughs, tearsheets, thumbnails, transparencies. Buys all rights or rights purchased vary according to project. Finds freelancers through literary guide..

Book Design: Assigns 10 freelance design and 10 art direction projects/year. Pays for design by the project; negotiable.

Jackets/Covers: Assigns 10 freelance design jobs/year. Payment negotiable.

Text Illustration: Assigns 10 freelance illustration jobs/year. Payment negotiable.

GRYPHON PUBLICATIONS, P.O. Box 209, Brooklyn NY 11228. Publisher: Gary Lovisi. Estab. 1983. Book and magazine publisher of hardcover originals, trade paperback originals and reprints, reference and magazines. Types of books include science fiction, mystery and reference. Specializes in crime fiction and bibliography. Publishes 10 titles/year. Titles include *Difficult Lives*, by James Salli; and *Vampire Junkies*, by Norman Spinrad. 40% require freelance illustration; 10% require freelance design. Book catalog free for #10 SASE.
- Also publishes *Hardboiled*, a quarterly magazine of noir fiction, and *Paperback Parade* on collectible paper-backs.

Needs: Approached by 50-100 freelancers/year. Works with 5 freelance illustrators and 1 designer/year. Prefers freelancers with "professional attitude." Uses freelancers mainly for book and magazine cover and interior illustrations. Also for jacket/cover, book and catalog design. Works on assignment only.

First Contact & Terms: Send query letter with résumé, SASE, tearsheets or photocopies. Samples are filed. Reports back within 2 weeks only if interested. Buys one-time rights. "I will look at reprints if they are of high quality and cost effective." Originals are returned at job's completion if requested.

Jackets/Covers: Assigns 2 freelance design and 5-6 illustration jobs/year. Pays by the project, $25-150.

Text Illustration: Assigns 2 freelance jobs/year. Pays by the project, $10-100. Prefers b&w line drawings.

♣GUERNICA EDITIONS, P.O. Box 117, Station P, Toronto, Ontario M5S 2S6 Canada. (416)657-8885. Fax: (416)657-8885. Publisher/Editor: Antonio D'Alfonso. Estab. 1978. Book publisher and literary press specializing in

translation. Publishes trade paperback originals and reprints. Types of books include contemporary and experimental fiction, biography and history. Specializes in ethnic/multicultural writing and translation of European and Quebecois writers into English and Italian-Canadian and Italian-American writers. Publishes 16-20 titles/year. Recent titles include *Devils in Paradise*, by Pasquale Verdicchio (artist: Hono Lulu); *The Power of Allepiances*, by Marino Tuzi (artist: Nick Palazzo); and *Looking through My Mother's Eyes*, by Giovanna Del Negro (artist: Vince Manuoso). 40-50% require freelance illustration. Book catalog available for SAE; nonresidents send IRC.

Needs: Approached by 6 freelancers/year. Works with 6 freelance illustrators/year. Uses freelancers mainly for jacket/ cover illustration.

First Contact & Terms: Send query letter with résumé, SASE (or SAE with IRC), tearsheets, photographs and photocopies. Samples are filed or are returned by SASE if requested by artist. Reports back only if interested. To show portfolio, mail photostats, tearsheets and dummies. Buys one-time rights. Originals are not returned at job completion.

Jackets/Covers: Assigns 10 freelance illustration jobs/year. Pays by the project, $150-200.

‡HARCOURT BRACE & CO., 525 B St., Suite 1900, San Diego CA 92101. (619)699-6568. Fax: (619)699-6290. Art Director, Children's Books: Michael Farmer. Trade Books: Vaughn Andrews. Specializes in hardcover and paperback originals and reprints. Publishes "general books of all subjects (not including text, school or institutional books)." Publishes 250 titles/year. Books contain "high quality art and text." 100% require freelance illustration. Recent titles include *Stellaluna* and *On the Day You Were Born*.

First Contact & Terms: Approached by 1,500 freelance artists/year. Works with 200 freelance illustrators and 25 freelance designers/year, "experienced artists from all over the world." Works on assignment only. Send query letter with brochure, tearsheets and photostats. Samples are filed or are returned by SASE. Reports back within 8 weeks. Originals returned to artist at job's completion. To show a portfolio, mail photostats, tearsheets, final reproduction/ product, photographs and photocopy of book dummy, if a children's book. Buys all rights.

Book Design: Assigns 50 freelance design and 50 freelance illustration jobs/year. Pays by project, $300-600.

Jackets/Covers: Assigns 250 freelance design and 200 freelance illustration jobs/year. Pays by the project, $750-$1,500.

Text Illustration: Assigns 50 freelance jobs/year. Prefers that all work be rendered on flexible paper. Pays a royalty with advance.

Tips: "Send samples with strong concepts along with a cover letter and background experience. Look at our books to see if your artwork is appropriate to our style. The recession has not affected our needs at all."

HARMONY HOUSE PUBLISHERS—LOUISVILLE, P.O. Box 90, Prospect KY 40059. (502)228-4446. Fax: (502)228-2010. Art Director: William Strode. Estab. 1980. Publishes hardcover books. Specializes in general books, cookbooks and education. Publishes 20 titles/year. Titles include *The Saddlebred—America's Horse of Distinction* and *Sandhurst—The Royal Military Academy*. 10% require freelance illustration.

Needs: Approached by 10 freelancers/year. Works with 2-3 freelance illustrators/year. Prefers freelancers with experience in each specific book's topic. Uses freelancers mainly for text illustration. Also for jacket/cover illustration. Usually works on assignment basis.

First Contact & Terms: Send query letter with brochure, résumé, SASE and appropriate samples. Samples are filed or are returned. Reports back only if interested. "We don't usually review portfolios, but we will contact the artist if the query interests us." Buys one-time rights. Sometimes returns originals at job's completion. Assigns 2 freelance design and 2 illustration jobs/year. Pays by the project.

HARVEST HOUSE PUBLISHERS, 1075 Arrowsmith, Eugene OR 97402. (541)343-0123. Fax: (541)342-6410. Cover Director: Barbara Sherrill. Specializes in hardcover and paperback editions of adult fiction and nonfiction, children's books, gift books and youth material. Publishes 100-125 titles/year. Recent titles include *Beyond the Picket Fence*; *Let's Have a Tea Party!*; *A Father for All Seasons*; and *I'll Be Home for Christmas*. Books are of contemporary designs which compete with the current book market.

Needs: Works with 4-5 freelance illustrators and 7-8 freelance designers/year. Uses freelance artists mainly for cover art. Also uses freelance artists for text illustration. Works on assignment only.

First Contact & Terms: Send query letter with brochure, résumé, tearsheets and photographs. Art Director will contact artist for portfolio review if interested. Requests work on spec before assigning a job. Originals may be returned at job's completion. Buys all rights. Finds artists through word of mouth and submissions/self-promotions.

Book Design: Pays by the project.

Jackets/Covers: Assigns 100-125 design and less than 10 illustration jobs/year. Pays by the project.

Text Illustration: Assigns 5 jobs/year. Pays by the project.

THE HAWORTH PRESS, INC., 10 Alice St., Binghamton NY 13904-1580. (607)722-5857. Fax: (607)722-6362. E-mail: getinfo@haworth.com. Website: http://www.haworth.com. Cover Design Director: Marylouise E. Doyle. Estab. 1979. Imprints include Harrington Park Press, Haworth Pastoral Press, International Business Press, Food Products Press, Haworth Medical Press, Haworth Maltreatment, The Haworth Hospitality/Tourism Press and Trauma Press. Publishes hardcover originals, trade paperback originals and reprints and textbooks. Types of books include biography, new age, nonfiction, reference, religious and textbooks. Specializes in social work, library science, gerontology, gay and lesbian studies, addictions, etc. Catalog available.

Needs: Approached by 2 illustrators and 5 designers/year. 100% of freelance design and illustration demands knowledge

of Aldus PageMaker, Adobe Photoshop and Adobe Illustrator.

First Contact & Terms: Designers send photocopies, SASE and slides. Illustrators send postcard sample or query letter with photocopies. Accepts disk submissions compatible with Adobe Illustrator and Photoshop 3.0. Samples are filed. Reports back only if interested. Will contact artist for portfolio review of slides if interested. Buys reprint rights. Rights purchased vary according to project. Finds freelancers through word of mouth.

Book Design: Pay varies.

Jackets/Covers: Pay varies. Prefers a variety as long as camera ready art can be supplied.

HAY HOUSE, INC., P.O. Box 5100, Carlsbad CA 92018-5100. (800)654-5126. Art Director: Christy Allison. Publishes hardcover originals and reprints, trade paperback originals and reprints, audio tapes, CD-ROM. Types of book include New Age, astrology, metaphysics, psychology. Specializes in self-help. Publishes 100 titles/year. Recent titles include *You Can Heal Your Life*, *The Western Guide to Feng Shu* and *Heal Your Body A-Z*. 20% require freelance illustration; 50% require freelance design. Book catalog free on request.

● Hay House is also looking for people who design for the gift market.

Needs: Approached by 10 freelance illustrators and 5 freelance designers/year. Works with 2-3 freelance illustrators and 2-5 freelance designers/year. Uses freelancers mainly for cover design. 80% of freelance design demands knowledge of Adobe Photoshop, Adobe Illustrator, QuarkXPress. 30% of titles require freelance art direction.

First Contact & Terms: Designers send photocopies (color), résumé, SASE "if you want your samples back." Illustrators send photocopies. "We accept TIFF and EPS images compatible with the latest versions of QuarkXPress, Adobe Photoshop and Adobe Illustrator. Samples are filed or are returned by SASE. Art director will contact artist for portfolio review of printed samples or original artwork if interested. Buys all rights. Finds freelancers through word of mouth, submissions.

Book Design: Assigns 10 freelance design jobs/year; 10 freelance art direction projects/year.

Jacket/Covers: Assigns 20 freelance design jobs and 20 illustration jobs/year. Pays for design by the project, $800-1,200. Payment for illustration varies for covers.

Text Illustration: Assigns 10 freelance illustration jobs/year.

Tips: "We look for freelancers with experience in graphic design, desktop publishing, printing processes, production."

‡HEARTLAND SAMPLERS, INC., 3255 Spring St. NE, Minneapolis MN 55413. (612)379-8029. Fax: (612)378-4835. Art Director: Marty Nimerfroh. Estab. 1987. Book publisher. Types of products include perpetual calendars, books and inspirational gifts. Publishes 50 titles/year. Titles include *Share the Hope* and *Tea Time Thoughts*. 100% require freelance illustration and design. Book catalog for SAE with first-class postage.

Needs: Approached by 4 freelancers/year. Works with 10-12 freelance illustrators and 2-4 designers/year. Prefers freelancers with experience in the gift and card market. Uses freelancers for illustrations; jacket/cover illustration and design; direct mail, book and catalog design.

First Contact & Terms: Send query letter with brochure, résumé, SASE, tearsheets, photographs and photocopies. Samples are filed or are returned by SASE if requested by artist. Art Director will contact artist for portfolio review if interested. Portfolio should include thumbnails, roughs, 4-color photographs and dummies. Sometimes requests work on spec before assigning a job. Rights purchased vary according to project.

Book Design: Assigns 12 freelance design jobs/year. Pays by the project, $35-300.

Jackets/Covers: Assigns 15-40 freelance design jobs/year. Prefers watercolor, gouache and acrylic. Pays by the project, $50-350.

Text Illustration: Assigns 2 freelance design jobs/year. Prefers watercolor, gouache and acrylic. Pays by the project, $50-200.

‡HEAVEN BONE PRESS, Box 486, Chester NY 10918. (914)469-9018. E-mail: poetsteve@compuserve.com. President/Editor: Steve Hirsch. Estab. 1987. Book and magazine publisher of trade paperback originals. Types of books include poetry and contemporary and experimental fiction. Publishes 4-6 titles/year. Recent titles include *Fountains of Gold*, by Wendy Vig and Jon Anderson. Design of books is "off-beat, eclectic and stimulating." 80% require freelance illustration. Book catalog available for SASE.

● This publisher often pays in copies. Approach this market if you're seeking to build your portfolio and are not concerned with payment. The press also publishes *Heaven Bone* magazine for which illustrations are needed.

Needs: Approached by 10-12 freelancers/year. Works with 3-4 freelance illustrators. Uses freelancers mainly for illustrations. Needs computer-literate freelancers for illustration. 5% of work demands knowledge of QuarkXPress, Aldus FreeHand, Adobe Illustrator or Photoshop.

First Contact & Terms: Send query letter with brochure, tearsheets, photostats, photographs and slides. Samples are filed or returned by SASE. Reports back within 3 months. To show portfolio, mail finished art, photostats, tearsheets, photographs and slides. Rights purchased vary according to project. Originals are returned at job's completion.

Book Design: Assigns 1-2 freelance design jobs/year. Prefers to pay in copies, but has made exceptions.

 INTERNATIONAL MARKETS, those located outside the United States and Canada, are marked with an asterisk.

Jackets/Covers: Prefers to pay in copies, but has made exceptions. Prefers pen & ink, woodcuts and b&w drawings.
Text Illustration: Assigns 1-2 freelance design jobs/year.
Tips: "Know our specific needs, know our magazine and be patient."

‡*HEMKUNT PUBLISHERS LTD.**, A-78 Naraina Indl. Area Ph.I, New Delhi 110028 India. Phone: 011-91-11 579-2083, 579-0032. Fax: 611-3705. Website: http://www.gen.com/knowindu/indianbooks/hemkunt.htm. Chief Executive: Mr. G.P. Singh. Specializes in educational text books, illustrated general books for children and also books for adults. Subjects include religion and history. Publishes 30-50 new titles/year. Recent titles include *Tales of Birbal and Akbar*, by Vernon Thomas.
Needs: Works with 30-40 freelance illustrators and 3-5 designers/year. Uses freelancers mainly for illustration and cover design. Also for jacket/cover illustration. Works on assignment only. Freelancers should be familiar with Ventura.
First Contact & Terms: Send query letter with résumé and samples to be kept on file. Prefers photographs and tearsheets as samples. Samples not filed are not returned. Art Director will contact artist for portfolio review if interested. Requests work on spec before assigning a job. Originals are not returned. Considers complexity of project, skill and experience of artist and project's budget when establishing payment. Buys all rights. Interested in buying second rights (reprint rights) to previously published artwork.
Book Design: Assigns 40-50 freelance design jobs/year. Payment varies.
Jackets/Covers: Assigns 30-40 freelance design jobs/year. Pays $20-50.
Text Illustration: Assigns 30-40 freelance jobs/year. Pays by the project.

‡**HILL AND WANG**, 19 Union Square W., New York NY 10003. (212)741-6900. Fax: (212)633-9385. Art Director: Susan Mitchell. Imprint of Farrar, Straus & Giroux. Imprint publishes hardcover, trade and mass market paperback originals and hardcover reprints. Types of books include biography, coffee table books, cookbooks, experimental fiction, historical fiction, history, humor, mainstream fiction, New Age, nonfiction and self-help. Specializes in literary fiction and nonfiction. Publishes 120 titles/year. Recent titles include *Bird Artist, Grace Paley Collected Stories.* 20% require freelance illustration; 10% require freelance design.
Needs: Approached by hundreds of freelancers/year. Works with 10-20 freelance illustrators and 10-20 designers/year. Prefer artist without rep with a strong portfolio. Uses freelancers for jacket/cover illustration and design. Works on assignment only.
First Contact & Terms: Send postcard sample of work or query letter with portfolio samples. Samples are filed and are not returned. Reports back only if interested. Artist should continue to send new samples. Portfolios may be dropped off every Tuesday and should include printed jackets. Rights purchased vary according to project. Originals are returned at job's completion. Finds artists through word of mouth and submissions.
Book Design: Pays by the project.
Jackets/Covers: Assign 10-20 freelance design and 10-20 illustration jobs/year. Pays by the project, $500-1,500.
Text Illustration: Assigns 10-20 freelance illustration jobs/year. Pays by the project, $500-1,500.

‡**HIPPOCRENE BOOKS INC.**, 171 Madison Ave., Suite 1602, New York NY 10016. (212)685-4371. Fax: (212)779-9338. E-mail: hippocre@ix.netcom.com. Website: http://www.netcom.com/~hippocre. Managing Editor: Carol Chitnis. Estab. 1971. Publishes hardcover originals and trade paperback reprints. Types of books include biography, cookbooks, history, nonfiction, reference, travel, dictionaries, foreign language, bilingual. Specializes in dictionaries, cookbooks, love poetry. Publishes 60 titles/year. Recent titles include: *Polish Folk Dances & Songs, Art of South Indian Cooking, Treasury of Love Quotations from Mary Lands.* 10% requires freelance illustration. Book catalog free for 9×12 SAE with 4 first-class stamps.
Needs: Approached by 10 illustrators and 5 designers/year. Works with 3 illustrators and 1 designer/year. Prefers local freelancers experienced in line drawings.
First Contact & Terms: Designers send query letter with photocopies, SASE, tearsheets. Illustrators send postcard sample and follow-up postcard every 4-6 months. No disk submissions. Samples are filed. Will contact artist for portfolio review if interested. Portfolio should include photocopies of artwork portraying "love" poetry subjects. Buys one-time rights. Finds freelancers through promotional postcards and suggestion of authors.
Jackets/Covers: Assigns 2 freelance design and 4 freelance illustration jobs/year. Pays by the project, $200-500.
Text Illustration: Assigns 4 freelance illustration jobs/year. Pays by the project, $250-1,700. Prefers freelancers who create drawings/sketches for love or poetry books.
Tips: "We prefer traditional illustrations appropriate for gift books."

‡**HOLCOMB HATHAWAY, PUBLISHERS**, 6207 N. Cattle Track Rd., Scottsdale AZ 85250. (602)991-7881. Fax: (602)991-4770. E-mail: sales@hh-pub.com. Production Director: Gay Pauley. Estab. 1997. Publishes textbooks. Specializes in education, communication. Publishes 10 titles/year. Recent titles include: *The Agricultural Marketing System.* 50% requires freelance cover illustration; 10% requires freelance design. Book catalog not available.
Needs: Approached by 15 illustrators and 15 designers/year. Works with 3 illustrators and 10 designers/year. Prefers freelancers experienced in cover design, typography, graphics. 100% of freelance design and 50% of freelance illustration demands knowledge of Adobe Photoshop, Adobe Illustrator, QuarkXPress.
First Contact & Terms: Send query letter with brochure. Illustrators send postcard sample. Will contact artist for portfolio review of photocopies and tearsheets if interested. Rights purchased vary according to project.
Book Design: Assigns 3 freelance design jobs/year. Pays for design by the project, $500-1,500.

Jackets/Covers: Assigns 10 design jobs/year. Pays by the project, $250-1,000. Pays for cover illustration by the project.
Text Illustration: Assigns 2 freelance illustration jobs/year. Pays by the piece. Prefers computer illustration. Finds freelancers through word of mouth, submissions.
Tips: "It is helpful if designer has experience with college textbook design and good typography skills."

HOLLOW EARTH PUBLISHING, P.O. Box 1355, Boston MA 02205-1355. (603)433-8735. Fax: (603)433-8735. E-mail: hep2@aol.com. Publisher: Helian Yvette Grimes. Estab. 1983. Company publishes hardcover, trade paperback and mass market paperback originals and reprints, textbooks, electronic books and CD-ROMs. Types of books include contemporary, experimental, mainstream, historical and science fiction, instruction, fantasy, travel and reference. Specializes in mythology, photography, computers (Macintosh). Publishes 5 titles/year. Titles include *Norse Mythology, Legend of the Niebelungenlied.* 50% require freelance illustration; 50% require freelance design. Book catalog free for #10 SAE with 1 first-class stamp.
Needs: Approached by 250 freelancers/year. Prefers freelancers with experience in computer graphics. Uses freelancers mainly for graphics. Also for jacket/cover design and illustration, text illustration, book design and multimedia projects. 100% of freelance work demands knowledge of Adobe Illustrator, QuarkXPress, Adobe Photoshop, Aldus FreeHand, Director or rendering programs. Works on assignment only.
First Contact & Terms: Send e-mail queries only. Reports back within 1 month. Art Director will contact artist for portfolio review if interested. Portfolio should include color thumbnails, roughs, tearsheets and photographs. Buys all rights. Originals are returned at job's completion. Finds artists through submissions and word of mouth.
Book Design: Assigns 12 book and magazine covers/year. Pays by the project, $100 minimum.
Jackets/Covers: Assigns 12 freelance design and 12 illustration jobs/year. Pays by the project, $100 minimum.
Text Illustration: Assigns 12 freelance illustration jobs/year. Pays by the project, $100 minimum.
Tips: Recommends being able to draw well. First-time assignments are usually article illustrations; covers are given to "proven" freelancers.

HENRY HOLT BOOKS FOR YOUNG READERS, 115 W. 18th St., 6th Floor, New York NY 10011. (212)886-9200. Fax: (212)645-5832. Art Director: Martha Rago. Estab. 1866. Imprint of Henry Holt and Company, Inc. Imprint publishes hardcover and trade paperback originals and reprints. Types of books include juvenile, preschool and young adult. Specializes in picture books and young adult nonfiction and fiction. Publishes 75-100 titles/year. 100% require freelance illustration. Book catalog free by request.
Needs: Approached by 1,300 freelancers/year. Works with 30-50 freelance illustrators and designers/year. Uses freelancers for jacket/cover and text illustration. Works on assignment only.
First Contact & Terms: Send postcard sample of work or query letter with tearsheets, photostats and SASE. Samples are filed or returned by SASE if requested by artist. Reports back within 1-3 months if interested. Portfolios may be dropped off every Monday. Art Director will contact artist for portfolio review if interested. Portfolio should include photostats, final art, roughs and tearsheets. "Anything artist feels represents style, ability and interests." Rights purchased vary according to project. Originals are returned at job's completion. Finds artists through word of mouth, artists' submissions and attending art exhibitions.
Jackets/Covers: Assigns 20-30 freelance illustration jobs/year. Pays $800-1,000.
Text Illustration: Assigns 30-50 freelance illustration jobs/year. Pays $5,000 minimum.

HONOR BOOKS, 2448 E. 81st St., Suite 4800, Tulsa OK 74137. (918)496-9007. E-mail: dianew@honorbooks.com. Creative Director: Diane Whisner. Estab. 1991. Publishes hardcover originals, trade paperback originals, mass market paperback originals and gift books. Types of books include biography, coffee table books, humor, juvenile, motivational, religious and self help. Specializes in inspirational and motivational. Publishes 60-70 titles/year. Recent titles include: *God's Little Instruction Book* and *Treasury of Virtues.* 40% require freelance illustration; 90% require freelance design.
Needs: Works with 4 illustrators and 10 designers/year. Prefers illustrators experienced in line art; designers experienced in book design. Uses freelancers mainly for design and illustration. 100% of freelance design demands knowledge of Aldus FreeHand, Adobe Photoshop, Adobe Illustrator and QuarkXPress. 20% of freelance illustration demands knowledge of Aldus FreeHand, Adobe Photoshop and Adobe Illustrator. 15% of titles rquire freelance art direction.
First Contact & Terms: Designers send query with with brochure, photocopies and tearsheets. Illustrators send query letter with printed samples and tearsheets. Send follow-up postcard every 3 months. Accepts disk submissions compatible with QuarkXPress or EPS files. Samples are filed. Reports back within 3 weeks. Request portfolio review in original query. Will contact artist for portfolio review of book dummy, photographs, roughs and tearsheets if interested. Rights purchased vary according to project.
Book Design: Assigns 60 freelance design jobs/year. Pays by the project, $300-1,800.
Jackets/Covers: Assigns 60 freelance design jobs and 30 illustration jobs/year. Pays for design by the project, $700-2,400. Pays for illustration by the project, $400-1,500.
Text Illustration: Pays by the project. Finds freelancers through *Creative Black Book*, word of mouth, conventions and submissions.
Tips: "Artist should be knowledgeable of CBA/general interest market and digital prepress."

HOUGHTON MIFFLIN COMPANY, Children's Book Department, 222 Berkeley St., Boston MA 02116. (617)351-5000. Website: http://www.hmco.com. Art Director: Bob Kosturko. Estab. 1880. Company publishes hardcover originals. Types of books include juvenile, preschool and young adult. Publishes 60-70 titles/year. Recent titles include *Burnt*

Toast on Davenport Street, by Tim Egan and *Rome Antics*, by David Macaulay. 100% require freelance illustration; 10% require freelance design.

Needs: Approached by 400 freelancers/year. Works with 50 freelance illustrators and 10 designers/year. Prefer artists with interest in or experience with children's books. Uses freelance illustrators mainly for jackets, picture books. Uses freelance designers primarily for photo essay books. 100% of freelance work demands knowledge of QuarkXPress, Adobe Photoshop and Adobe Illustrator.

First Contact & Terms: Send postcard sample of work or send query letter with tearsheets, photographs, slides, photocopies, transparencies and SASE. Do not send originals! Samples are filed or returned by SASE. Reports back within 1-2 months. Art director will contact artist for portfolio review if interested. Portfolio should include printed books, book dummy, slides, transparencies, roughs and tearsheets. Rights purchased vary according to project. Works on assignment only. Finds artists through sourcebooks, word of mouth, submissions.

Book Design: Assigns 10 freelance design jobs/year. Pays by the project.

Jackets/Covers: Assigns 12 freelance illustration jobs/year. Pays by the project.

Text Illustration: Assigns 50 freelance illustration jobs/year. Pays by the project.

HOWELL PRESS, INC., 1117 River Rd., Suite 2, Charlottesville VA 22901. (804)977-4006. Fax: (804)971-7204. E-mail: howellpres@aol.com. Website: http://www.howellpress.com. President: Ross Howell. Estab. 1985. Company publishes hardcover and trade paperback originals. Types of books include history, coffeetable books, cookbooks, gardening and transportation. Publishes 9-10 titles/year. Recent titles include *Davey Allison*, by Liz Allison; and *Stuck on Cactus*, by David E. Wright. 100% require freelance illustration and design. Book catalog free by request.

Needs: Approached by 6-8 freelancers/year. Works with 1-2 freelance illustrators and 1-2 designers/year. "It's most convenient for us to work with local freelance designers." Uses freelancers mainly for graphic design. Also for jacket/cover, direct mail, book and catalog design. 100% of freelance work demands knowledge of Aldus PageMaker, Adobe Illustrator, Adobe Photoshop or QuarkXPress.

First Contact & Terms: Designers send query letter with résumé, SASE, slides and tearsheets. Illustrators send query letter with résumé, photocopies, SASE and tearsheets. Samples are not filed and are returned by SASE if requested by artist. Reports back within 1 month. Art Director will contact artist for portfolio review if interested. Portfolio should include color tearsheets and slides. Negotiates rights purchased. Originals are returned at job's completion. Finds artists through submissions.

Book Design: Assigns 9-10 freelance design jobs/year. Pays for design by the hour, $15-25; by the project, $500-5,000.

‡HUMANICS LIMITED, 1482 Mecaslin St. NW, Atlanta GA 30309. (404)874-2176. Fax: (404)874-1976. Acquisitions Editor: W. Arthur Bligh. Estab. 1976. Publishes soft and hardcover children's books, trade paperback originals and educational activity books. Publishes 12 titles/year. Recent titles include *Creatures of an Exceptional Kind*, by Dorothy B. Whitney; and *The Tao of Learning*, by Pamela Metz and Jacqueline Tobin. Learning books are workbooks with 4-color covers and line art within; Children's House books are high-quality books with full color; trade paperbacks are 6×9 with 4-color covers. Book catalog for 9×12 SASE. Specify which imprint when requesting catalog: Learning, Children's House or trade paperbacks.

Needs: Works with 3-5 freelance illustrators and designers/year. Needs computer-literate freelancers for design, production and presentation. "Artists must provide physical mechanicals or work on PC compatible disk." Works on assignment only.

First Contact & Terms: Send query letter with résumé, SASE and photocopies. Samples are filed or are returned by SASE if requested by artist. Rights purchased vary according to project. Originals are not returned.

Book Design: Pays by the project, $250 minimum.

Jackets/Covers: Pays by the project, $150 minimum.

Text Illustration: Pays by the project, $150 minimum.

‡HUNTINGTON HOUSE PUBLISHERS, P.O. Box 53788, Lafayette LA 70505. (318)237-7049. Fax: (318)237-7060. Publisher: Mark Anthony; Marketing Director: Theresa Trosclair. Estab. 1979. Book publisher. Publishes hardcover, trade paperback and mass market paperback originals. Types of books include contemporary fiction, juvenile, religious and political issues. Specializes in politics, exposés and religion. Publishes 30 titles/year. Recent titles include: *The First Lady*, by Peter and Timothy Flaherty; *Legacy Builders*, by Jim Burton; and *The Gender Agenda*, by Dale O'Leary. 5% require freelance illustration. Book catalog free upon request.

Needs: Approached by 15 freelancers/year. Works with 2 freelance illustrators/year. Uses freelancers for jacket/cover illustration and design and text illustration. Works on assignment only.

First Contact & Terms: Send query letter with brochure, résumé and photocopies. Samples are filed. Reports back to artist only if interested. To show a portfolio, mail thumbnails, roughs and dummies. Buys all rights. Originals are returned at job's completion.

Text Illustration: Assigns 1 freelance design and 1 illustration job/year. Payment "is arranged through author."

IDEAL, 1300 Villa St., Mountain View CA 94041. (415) 988-8904. Fax: (415)988-1111. Creative Director: Nancy Tseng. Estab. 1898. Imprint of Tribune Company. Other imprints include Instructional Fair. Publishes text supplementals for children from "pre-K to 8th grade." Specializes in math and science, early learning. Publishes 15 titles/year. Recent

titles include *Math Discovery* series and *Read-N-Do* series. 40% require freelance design and illustration. Book catalog free by mail or by calling 1-800-845-8149.

Needs: Approached by 60 freelance illustrators and 2 designers/year. Works with 5 illustrators/year. Prefers local designers only. Illustrators "can be from anywhere." Uses freelancers mainly for book illustration. 90% of freelance design demands knowledge of Adobe Photoshop 4.0, Adobe Illustrator 6.0 and QuarkXPress 3.32. 25% of illustration demands knowledge of Adobe Photoshop, Adobe Illustrator and Painter.

First Contact & Terms: Designers send query letter with brochure, photocopies, tearsheets or transparancies, résumé and SASE. Illustrators send postcard sample of work and/or query letter with photocopies, printed samples, tearsheets and SASE. Accepts disk submissions compatible with QuarkXPress 7.5/version 3.3. Send EPS files. Samples are filed. Art director will contact artist for portfolio review if interested. Negotiates right purchased.

Book Design: Pays by the project.

Jackets/Covers: Pays for illustration by the project, $300-800.

Tips: "We are looking for illustrators who create bright color work and have a whimsical style—mainly illustrations of animals and children."

✔IDEALS CHILDREN'S BOOKS, 1501 County Hospital Rd., Nashville TN 37218. (615)254-2480. Fax: (615)254-2405. Editor: Laura Rader. Estab. 1940. Imprint of Hambleton-Hill Publishing, Inc. Publishes hardcover originals, trade paperback originals and reprints, mass market paperback originals and reprints. Types of books include children's picture books, juvenile and preschool. Specializes in fiction and nonfiction for children aged 3-10. Publishes 40 titles/year. Recent titles include: *The Sea Maidens of Japan*; *Let's Care About Sharing*, by P.K. Halliman; *Sing Henrietta! Sing!*; and *The Home*. 100% require freelance illustration; 5% require freelance design.

Needs: Approached by 400 illustrators/year. Works with 30 illustrators and 2 designers/year. Prefers freelancers experienced in picture book illustration. Uses freelancers mainly for picture book illustration. 100% of freelance design demands knowledge of Adobe Photoshop, Adobe Illustrator and QuarkXPress.

First Contact & Terms: Designers send query letter with photocopies and résumé. Illustrators send postcard sample or query letter with photocopies, photographs, printed samples, résumé and tearsheets. Send follow-up postcard every 3-6 months. Samples are filed. Reports back only if interested. Portfolio review not required. Buys all rights.

Book Design: Assigns 2-4 freelance design jobs/year. Pays by the project.

Jackets/Covers: Assigns 2-4 freelance design jobs and 40 illustration jobs/year. Pays for design and illustration by the project.

Text Illustration: Assigns 40 freelance illustration jobs/year. Pays by the project. Finds freelancers through agents, submissions and sourcebooks.

Tips: "Primarily, we look for quality and consistency of character development. It is helpful if artist has some knowledge of the printing and scanning processes."

IDEALS PUBLICATIONS INC., P.O. Box 305300, Nashville TN 37230. (615)333-0478. Editor: Lisa C. Ragan. Estab. 1944. Company publishes hardcover originals and *Ideals* magazine. Specializes in nostalgia and holiday themes. Publishes 5-7 titles/year. Recent titles include *Easter Ideals* and *First Ladies of the White House*. 100% require freelance illustration; 30% require freelance design. Guidelines free for #10 SASE with 1 first-class stamp.

Needs: Approached by 100 freelancers/year. Works with 10-12 freelance illustrators and 1-3 designers/year. Prefers freelancers with experience in illustrating people, nostalgia, botanical flowers. Uses freelancers mainly for flower borders (color), people and spot art. Also for text illustration, jacket/cover and book design. Works on assignment only.

First Contact & Terms: Send query letter with tearsheets and SASE. Samples are filed or returned by SASE. Reports back only if interested. Buys all rights. Finds artists through submissions.

Book Design: Assigns 3 freelance design jobs/year.

Jackets/Covers: Assigns 3 freelance design jobs/year.

Text Illustration: Assigns 75 freelance illustration jobs/year. Pays by the project, $125-400. Prefers oil, watercolor, gouache, colored pencil or pastels.

IGNATIUS PRESS, Catholic Publisher, 2515 McAllister St., San Francisco CA 94118. Production Editor: Carolyn Lemon. Art Editor: Roxanne Lum. Estab. 1978. Company publishes Catholic theology and devotional books for lay people, priests and religious readers. Recent titles include *Father Elijah: An Apocalypse* and *Angels (and Demons): What Do We Really Know About Them?*

Needs: Works with 2-3 freelance illustrators/year. Works on assignment only.

First Contact & Terms: Will send art guidelines "if we are interested in the artist's work." Accepts previously published material. Send brochure showing art style or résumé and photocopies. Samples not filed and not returned. Reports back only if interested. To show a portfolio, mail appropriate materials; "we will contact you if interested." **Pays on acceptance.**

Jackets/Covers: Buys cover art from freelance artists. Prefers Christian symbols/calligraphy and religious illustrations of Jesus, saints, etc. (used on cover or in text). "Simplicity, clarity, and elegance are the rule. We like calligraphy, occasionally incorporated with Christian symbols. We also do covers with type and photography." Pays by the project.

Text Illustration: Pays by the project.

Tips: "I do not want to see any schmaltzy religious art. Since we are a nonprofit Catholic press, we cannot always afford to pay the going rate for freelance art, so we are always appreciative when artists can give us a break on prices and work *ad maiorem Dei gloriam*."

INCENTIVE PUBLICATIONS INC., 3835 Cleghorn Ave., Nashville TN 37215. (615)385-2934. Art Director: Marta Johnson Drayton. Specializes in supplemental teacher resource material, workbooks and arts and crafts books for children K-8. Publishes 15-30 titles/year. Recent titles include *All-New Science Mind Stretchers*, by Imogene Forte and Sandra Schurr; and *Real-Life Drama For Real Live Students*, by Judy Truesdale Mecca. 40% require freelance illustration. Books are "cheerful, warm, colorful, uncomplicated and spontaneous."
Needs: Works with 3-6 freelance illustrators and 1-2 designers/year. Uses freelancers mainly for covers and text illustraion. Also for promo items (occasionally). Works on assignment only, primarily with local artists. 10% of design work demands knowledge of Adobe Illustrator, QuarkXPress, Adobe Photoshop or Aldus FreeHand.
First Contact & Terms: Designers send query letter with photocopies and SASE. Illustrators send query letter with photocopies, SASE and tearsheets. Samples are filed. Samples not filed are returned by SASE. Art Director will contact artist for portfolio review if interested. Portfolio should include original/final art, photostats, tearsheets and final reproduction/product. Sometimes requests work on spec before assigning a job. Considers complexity of project, project's budget and rights purchased when establishing payment. Buys all rights. Originals are not returned.
Jackets/Covers: Assigns 4-6 freelance illustration jobs/year. Prefers 4-color covers in any medium. Pays by the project, $200-350.
Text Illustration: Assigns 4-6 freelance jobs/year. Black & white line art only. Pays by the project, $175-1,250.
Tips: "We look for a warm and whimsical style of art that respects the integrity of the child. We sell to parents and teachers. Art needs to reflect specific age children/topics for immediate association of parents and teachers to appropriate books."

‡INNER TRADITIONS INTERNATIONAL, 1 Park St., Rochester VT 05767. (802)767-3174. Fax: (802)767-3726. Website: http://www.gotoit.com. Art Director: Peri Champine. Estab. 1975. Publishes hardcover originals and trade paperback originals and reprints. Types of books include self-help, psychology, esoteric philosophy, alternative medicine, and art books. Publishes 60 titles/year. Recent titles include: *The Great Book of Hemp, The Lakota Sweat Lodge Cards* and *Nicholas Rorich: a Russian Master*. 60% require freelance illustration; 60% require freelance design. Book catalog free by request.
Needs: Works with 8-9 freelance illustrators and 10-15 freelance designers/year. 100% of freelance design demands knowledge of QuarkXPress, Adobe Illustrator, Aldus FreeHand and Adobe Photoshop. Buys 30 illustrations/year. Uses freelancers for jacket/cover illustration and design. Works on assignment only.
First Contact & Terms: Send query letter with résumé, SASE, tearsheets, photocopies, photographs and slides. Accepts disk submissions. Samples filed if interested or are returned by SASE if requested by artist. Reports back to the artist only if interested. To show portfolio, mail tearsheets, photographs, slides and transparencies. Rights purchased vary according to project. Originals returned at job's completion. Pays by the project.
Jackets/Covers: Assigns approximately 32 design and 26 illustration jobs/year. Pays by the project.

INSTRUCTIONAL FAIR ● TS DENISON, Box 1650, Grand Rapids MI 49501. Website: http//.www.instructionalfair.com. Creative Director: Annette Hollister-Papp. Also, 9601 Newton Ave. S., Minneapolis MN 55431, attn: Art Director: Darcy Bell-Myers. Also, P.O. Box 128, Rt. 1, Hwy. 94 S., Carthage IL 62321, Attn: Jeff VanKanegan, Art Director (middle school division). Publishes supplemental educational print materials—secular and Christian print, software, and toys—and software for teachers, parents, and home school educators at preschool through high school levels.
 ● Because this company has three divisions be sure to submit materials to all directors.
Needs: Works with 50 freelancers/year. Full-color and blackline art. Prefers traditionally illustrated art in oils, acrylics, watercolors, and markers, as well as computer-generated art in Adobe Illustrator and Adobe Photoshop. Works on assignment only.
First Contact & Terms: Designers, illustrators and animators send query letter with photocopies and SASE. Samples are filed or are returned by SASE. Reports back within 1-2 months if interested. Pays by the project (amount negotiated), but generally pays $300-400/full-color cover and $20-45/page of text art. Buys all rights. Originals are not returned.

✔INTERCULTURAL PRESS, INC., 374 U.S. Route 1, Yarmouth ME 04096. (207)846-5168. Fax: (207)846-5181. E-mail: interculturalpress@internetmci.com. Website: http://www.bookmasters.com/interclt.htm. Production Manager: Patty Topel. Estab. 1982. Company publishes paperback originals. Types of books include text and reference. Specializes in intercultural and multicultural. Publishes 12 titles/year. Recent titles include *The Color of Words*, by Philip Herbit; and *Host Family Survival Kit*, by Nancy King and Ken Huff. 100% require freelance illustration. Book catalog free by request.
Needs: Approached by 20 freelancers/year. Works with 3-4 freelance illustrators/year. Prefers freelancers with experience in trade books, multicultural field. Uses freelancers mainly for jacket/cover design and illustration. 50% of freelance work demands knowledge of Aldus PageMaker or Adobe Illustrator. "If a freelancer is conventional (i.e., not computer driven) they should understand production and pre-press."
First Contact & Terms: Send query letter with brochure, tearsheets, résumé and photocopies. Samples are filed or are returned by SASE if requested by artist. Does not report back. Will contact artist for portfolio review if interested. Portfolio should include b&w final art. Buys all rights. Originals are not returned. Finds artists through submissions and word of mouth.
Jackets/Covers: Assigns 10 freelance illustration jobs/year. Pays by the project, $300-500.
Text Illustration: Assigns 1 freelance illustration job/year. Pays "by the piece depending on complexity." Prefers b&w line art.

Tips: First-time assignments are usually book jackets only; book jackets with interiors (complete projects) are given to "proven" freelancers. "We look for artists who have flexibility with schedule and changes to artwork. We appreciate an artist that will provide artwork that doesn't need special attention by pre-press in order for it to print properly. For black & white illustrations keep your lines crisp and bold. For color illustrations keep your colors pure and saturated to keep them from reproducing 'muddy.' "

‡INTERNATIONAL MARINE/RAGGED MOUNTAIN PRESS, Box 220, Camden ME 04843. (207)236-4837. Director of Editing, Design and Production: Molly Mulhern. Estab. 1969. Imprint of McGraw-Hill. Specializes in hardcovers and paperbacks on marine (nautical) and outdoor recreation topics. Publishes 50 titles/year. Recent titles include *Get Rolling, The Beginner's Guide to In-Line Skating*, by Liz Miller and *Cruising Cnisihe*, by Kay Pastorins. 50% require freelance illustration. Book catalog free by request.

Needs: Works with 20 freelance illustrators and 20 designers/year. Uses freelancers mainly for interior illustration. Prefers local freelancers. Works on assignment only.

First Contact & Terms: Send résumé and tearsheets. Samples are filed. Reports back within 1 month. Considers project's budget when establishing payment. Buys one-time rights. Originals are not returned.

Book Design: Assigns 20 freelance design jobs/year. Pays by the project, $150-550; or by the hour, $12-30.

Jackets/Covers: Assigns 20 freelance design and 3 illustration jobs/year. Pays by the project, $100-500; or by the hour, $12-30.

Text Illustration: Assigns 20 jobs/year. Prefers technical drawings. Pays by the hour, $12-30; or by the project, $30-80/piece.

Tips: "Do your research. See if your work fits with what we publish. Write with a résumé and sample; then follow with a call; then come by to visit."

IRON CROWN ENTERPRISES, P.O. Box 1605, Charlottesville VA 22902. (804)295-3918. Fax: (804)977-6987. E-mail: askice@aol.com. Art Director: Jessica Ney-Grimm. Assistant Art Director: Jason O. Hawkins. Estab. 1980. Company publishes fantasy role playing games, supplements, collectible card games and mass market board games and card games. Specializes in fantasy in a variety of genres. Publishes 25-50 titles/year. Recent titles include *Southern Gondor: The People*, *Middle-earth: The White Hand*, *Fluxx* and *Pyramidis*. 100% require freelance illustration; 50% require freelance design. Book catalog free by request.

• Iron Crown commissions 200-500 freelance paintings per year for collectible trading cards. They pay $100 flat fee plus a pro rata royalty per painting.

Needs: Approached by 120 freelancers/year. Works with 75 freelance illustrators and 4 designers/year. Buys 1,500 freelance illustrations/year. Prefers freelancers with experience in fantasy illustration and sci-fi illustration; prefers local freelancers for book design. Uses freelancers mainly for full color cover art, full color art for collectible trading cards, b&w interior illustration. Also for jacket/cover and text illustration and page design for interior. 5% of freelance work demands knowledge of QuarkXPress and Adobe Photoshop.

First Contact & Terms: Send query letter with photographs and photocopies. Samples are filed or returned by SASE if requested by artist. Reports back within 4 months. Assistant Art Director will contact artist for portfolio review if interested. Portfolio should include photographs, slides and tearsheets. Buys all rights. Originals are returned at job's completion. Finds artists through submissions.

Book Design: Assigns 20-30 freelance design jobs/year. Pays by the hour, $8.

Jackets/Covers: Assigns 25-50 freelance illustration jobs/year. Pays by the hour, $15. Prefers paintings for cover illustrations, QuarkXPress for cover design.

Text Illustration: Assigns 25-50 freelance jobs/year. Pays per published page. Prefers pen & ink.

Tips: "Send me 6-12 samples of your current work and present it neatly. I choose artists who thrive on team brainstorming in the creative endeavor and who reliably make deadlines."

♥ITP NELSON, 1120 Birchmount Rd., Scarborough, Ontario M1K 5G4 Canada. (416)752-9100 ext. 343. Fax: (416)752-7144. E-mail: acluer@nelson.com. Creative Director: Angela Cluer. Estab. 1931. Company publishes hardcover originals and reprints and textbooks. Types of books include instructional, juvenile, preschool, reference, high school math and science, primary spelling, textbooks and young adult. Specializes in a wide variety of education publishing. Publishes 150 titles/year. Recent titles include *Marketing Our Environment: A Canadian Perspective*; *Language Arts K-6*; *The Learning Equation: Mathematics 9*. 70% require freelance illustration; 25% require freelance design. Book catalog free by request.

Needs: Approached by 50 freelancers/year. Works with 30 freelance illustrators and 10-15 designers/year. Prefers Canadian artists, but not a necessity. Uses freelancers for jacket/cover design and illustration, text illustration and book design. Also for multimedia projects. 100% of design and 40% of illustration demand knowledge of Adobe Illustrator, QuarkXPress and Adobe Photoshop. Works on assignment only.

First Contact & Terms: Designers send query letter with tearsheets and résumé. Illustrators send postcard sample, brochure and tearsheets. Accepts disk submissions. Samples are filed. Art Director will contact artist for portfolio review if interested. Portfolio should include book dummy, transparencies, final art, tearsheets and photographs. Rights purchased vary according to project. Originals usually returned at the job's completion. Finds artists through *American Showcase, Creative Source*, submissions, designers' suggestions (word of mouth).

Book Design: Assigns 15 freelance design jobs/year. Pays by the project, $800-1,200 for interior design, $800-1,200 for cover design.

Jackets/Covers: Assigns 15 freelance design and 40 illustration jobs/year. Pays by the project, $800-1,300.
Text Illustration: Pays by the project, $30-450.

JAIN PUBLISHING CO., Box 3523, Fremont CA 94539. (510)659-8272. Fax: (510)659-0501. E-mail: mail@jainpub. com Website: http://www.jainpub.com. Publisher: M.K. Jain. Estab. 1989. Publishes hardcover originals, trade paperback originals and reprints and textbooks. Types of books include business, health, self help, religious and philosopohies (Eastern). Publishes 10 titles/year. Recent titles include *Menopause*, by Alan Silverstein, M.D.; and *Windows Into the Infinite: A Guide to Hindu Scripture*, by Barbara Powell. Books are "uncluttered, elegant, using simple yet refined art." 100% require freelance jacket/cover design.
Needs: Approached by 50 freelancers/year. Works with 4 freelance illustrators and designers/year. Prefers freelancers with experience in book cover design. Uses freelancers mainly for jacket/cover design. Also for jacket/cover illustration. 100% of freelance work demands knowledge of Adobe Illustrator, Adobe Photoshop and QuarkXPress.
First Contact & Terms: Send postcard sample or query letter with brochure. Accepts disk submissions. Samples are filed. Reports back to the artist only if interested. Rights purchased vary according to project. Originals are not returned.
Jackets/Covers: Assigns 10 freelance design and 10 illustration jobs/year. Prefers "color separated disk submissions." Pays by the project, $300-500.
Tips: Expects "a demonstrable knowledge of art suitable to use with health and religious (Eastern) books."

JALMAR PRESS, 24426 S. Main St., Suite 702, Carson CA 90745. (310)816-3085. Fax: (310)816-3092. E-mail: blwjalmar@worldnet.att.net. Website: http://www.ierc.com/blwinch/. President: Bradley L. Winch. Project and Production Director: Jeanne Iler. Estab. 1971. Publishes books emphasizing positive self-esteem. Publishes 6-10 titles/year. Recent titles include *Infinity Walk*, by Dr. Deborah Sunbeck and *Creating Positive Support Groups*, by Susan Dennison. Books are contemporary, yet simple.
Needs: Works with 3-5 freelance illustrators and 5 designers/year. Uses freelancers mainly for cover design and illustration. Also for direct mail and book design. Works on assignment only.
First Contact & Terms: Send query letter with brochure showing art style. Samples not filed are returned by SASE. Artist should follow up after initial query. 80% of freelance work demands knowledge of Adobe Photoshop, Adobe Illustrator and QuarkXPress. Buys all rights. Considers reprints but prefers original works. Considers complexity of project, budget and turnaround time when establishing payment.
Book Design: Pays by the project, $200 minimum.
Jackets/Covers: Pay by the project, $400 minimum.
Text Illustration: Pays by the project, $25 minimum.
Tips: "Portfolio should include samples that show experience. Don't include 27 pages of 'stuff.' Stay away from the 'cartoonish' look. If you don't have any computer design and/or illustration knowledge—get some! If you can't work on computers, at least understand the process of using traditional artwork with computer generated film. For us to economically get more of our product out (with fast turnaround and a minimum of rough drafts), we've gone exclusively to computers for total book design; when working with traditional artists, we'll scan their artwork and place it within the computer-generated document."

JAMSA PRESS, 2975 S. Rainbow, Suite I, Las Vegas NV 89102. (702)248-6111. Fax: (702)248-6116. Website: http://www.jamsa.com. Director of Publishing Operations: Janet Lawric. Estab. 1993. Publishes trade paperback originals and CD-ROMs. Types of books include computers. Specializes in computers, internet and programming. Publishes 20 titles/year. Recent titles include: *Jamsa's c/ctt Programmer's Bible*, *1001 Visual Basic Programmer's Tips* and *ActiveX Programmer's Library*. 20% require freelance illustration. Catalog available.
Needs: Approached by 5 illustrators and 5 designers/year. Works with 3 illustrators and 3 designers/year. Prefers local freelancers experienced in Adobe Illustrator and Adobe Photoshop. Uses freelancers mainly for cover design. 100% of freelance design demands knowledge of Aldus PageMaker, Adobe Photoshop and Adobe Illustrator. 100% of freelance illustration demands knowledge of Aldus PageMaker, Adobe Photoshop and Adobe Illustrator.
First Contact & Terms: Designers send query letter with brochure. Illustrators send query letter with printed samples. Send follow-up postcard every 3 months. Samples are filed and are not returned. Reports back within 1 month. Will contact artist for portfolio review if interested. Buys all rights.
Jackets/Covers: Assigns 20 freelance design jobs and 5 illustration jobs/year. Pays $800-1,000/project.
Text Illustration: Assigns 5 freelance illustration jobs/year.
Tips: "We look for professionalism and references."

‡JEWISH LIGHTS PUBLISHING, Sunset Farm Offices, Rt. 4, P.O. Box 237, Woodstock VT 05091. (802)457-4000. Fax: (802)457-4004. E-mail: editorial@jewishlights.com. Website: http://www.jewishlights.com. Editorial Assistant: Jennifer P. Goneau. Production Manager: Maria O'Donnell. Estab. 1990. Publishes hardcover originals, trade paperback originals and reprints. Types of books include children's picture books, cookbooks, fantasy, history, juvenile, nonfiction, reference, religious, science fiction, self help, travel, spirituality, life cycle, theology and philosophy, wellness. Specializes in adult nonfiction and children's picture books. Publishes 12 titles/year. Recent titles include: *The Book of Miracles: A Young Person's Guide to Jewish Spiritual Awareness*, *A Heart of Wisdom: Making the Jewish Journey from Midlife through the Elder Years*. 30% requires freelance illustration; 100 requires freelance design. Book catalog free on request.
Needs: Approached by 200 illustrators and 8 designers/year. Works with 3 illustrators and 12 designers/year. Prefers

local illustrators. Prefers freelancers experienced in fine arts, children's book illustration, typesetting and design. 100% of freelance design demands knowledge of PageMaker, QuarkXPress.

First Contact & Terms: Designers send postcard sample, query letter with printed samples, tearsheets. Illustrators send postcard sample or other printed samples. Samples are filed and are not returned. Portfolio review not required. Buys all rights. Finds freelancers through submission packets, searching local galleries and shows, Graphic Artists' Guild's *Directory of Illustrators*.

Book Design: Assigns 12 freelance design jobs/year. Pays for design by the project.

Jackets/Covers: Assigns 12 freelance design jobs and 2 illustration jobs/year. Pays for design by the project.

Tips: "We prefer a painterly, fine-art approach to our children's book illustration to achieve a quality that would intrigue both kids and adults. We do not consider cartoonish, cariacature-ish art for our children's book illustration."

‡**JUDSON PRESS**, Imprint of American Baptist Board of Education & Publication, P.O. Box 851, Valley Forge PA 19482-0851. Fax: (610)768-2441. Website: http://www.judsonpress.com. Estab. 1824. Publishes hardcover originals and reprints, trade paperback originals and reprints. Types of books: religious. Specializes in pastoral aid, church school curriculum. Publishes 15 titles/year. Book catalog available. Call 800-4-JUDSON for catalog.

First Contact & Terms: Send postcard sample or other printed samples. Accepts Windows-compatible disk submissions. Samples are filed and not returned. Reports back only if interested. Portfolio review not required. Buys all rights or negotiates rights purchased. Finds freelancers through watching for samples in mail. "We use most designers and illustrators for years."

Jackets/Covers: Assigns 15 freelance design jobs and 5 illustration jobs/year.

Text Illustration: Assigns 10 freelance illustration jobs/year.

KAEDEN BOOKS, P.O. Box 16190, Rocky River OH 44116. (216)356-0030. Fax: (216)356-5081. Vice President Creative/Production: Dennis Graves. Estab. 1989. Publishes textbooks. Types of books include juvenile and preschool. Specializes in learning-to-read books. Publishes 50-100 titles/year. 90% require freelance illustration; 10% require freelance design. Book catalog available upon request.

Needs: Approached by 40-50 illustrators/year. Works with 10-20 illustrators/year. Prefers freelancers experienced in juvenile/humorous illustration and children's books. Uses freelancers mainly for story illustration. 10% of freelance illustrations demands knowledge of Adobe Illustrator, QuarkXPress and CorelDraw 7.

First Contact & Terms: Designers send query letter with brochure and résumé. Illustrators send postcard sample or query letter with photocopies, photographs, printed samples, tearsheets and résumé. Send follow-up postcard every 6 months. Samples are filed or returned only by request. Reports back only if interested. Art director will contact artist for portfolio review if interested. Buys all rights.

Jackets/Covers: Assigns 50-100 illustration jobs/year. Pays by the project, $75-150 per page. Looks for a variety of styles.

Text Illustration: Assigns 50-100 jobs/year. Pays by the project, $50-150 per page. "We accept all media, though most of our books are watermedia."

Tips: "We look for professional level drawing and rendering skills, plus the ability to interpret a juvenile story. There is a tight correlation between text and visual in our books, plus a need for attention to detail."

KALMBACH PUBLISHING CO., 21027 Crossroads Circle, P.O. Box 1612, Waukesha WI 53187. (414)796-8776. Fax: (414)796-1142. E-mail: kludwig@kalmbach.com. Website: http://www.kalmbach.com. Books Art Director: Kristi L. Ludwig. Estab. 1934. Imprints include Greenberg Books. Company publishes hardcover and trade paperback originals. Types of books include instruction, reference and history. Specializes in hobby books. Publishes 35 titles/year. Recent titles include *Manhattan Gateway, New York's Pennsylvania Station*, by William D. Middleton; *Easy Electronics Projects for Toy Trains*, by David E. Greenwald. 10-20% require freelance illustration; 10-20% require freelance design. Book catalog free by request.

Needs: Approached by 10 freelancers/year. Works with 2 freelance illustrators and 2 designers/year. Prefers freelancers with experience in the hobby field. Uses freelance artists mainly for book layout, line art illustrations. Also for book design. 90% of freelance work demands knowledge of Adobe Illustrator, QuarkXPress or Adobe Photoshop. "Freelancers should have most updated versions." Works on assignment only.

First Contact & Terms: Send query letter with résumé, tearsheets and photocopies. Samples are filed. Art Director will contact artist for portfolio review if interested. Portfolio should include slides and final art. Rights purchased vary according to project. Originals are returned at job's completion. Finds artists through word of mouth, submissions.

Book Design: Assigns 10-12 freelance design jobs/year. Pays by the project, $1,000-3,000.

Text Illustration: Assigns 5 freelance illustration jobs/year. Pays by the project, $250-2,000.

Tips: First-time assignments are usually text illustration, simple book layout; complex track plans, etc., are given to "proven" freelancers. Admires freelancers who "present an organized and visually strong portfolio; meet deadlines (especially when first working with them) and listen to instructions."

KAMEHAMEHA SCHOOLS PRESS, 1887 Makuakane St., Honolulu HI 96817-1887. Fax: (808)842-8875. E-mail: kspress@ksbe.edu. Website: http://www.ksbe.edu/pubs/KSPress/catalog.html. Contact: Henry Bennett. Publishes hardcover originals and reprints, trade paperback originals and reprints and textbooks. Types of books include biography, Hawaiian culture and history, instruction, juvenile, nonfiction, preschool, reference, textbooks and young adult. Publishes

3-5 titles/year. Recent titles include: *From the Mountains to the Sea* and *Kamehameha IV: Alexander Liholiho*. 25% require freelance illustration; 5% require freelance design. Catalog available.

Needs: Approached by 3-5 illustrators and 5-10 designers/year. Works with 2-3 illustrators and 1-2 designers/year. Prefers local freelancers knowledgeable in Hawaiian culture. Uses freelancers mainly for b&w line illustration. 100% of freelance design demands knowledge of QuarkXPress.

First Contact & Terms: Designers send query letter with photocopies of book design. Illustrators send query letter with photocopies. Samples are filed. Reports back only if interested. Will contact artist for portfolio review of roughs and tearsheets if interested. Portfolio should include artwork portraying Hawaiian cultural material. Buys all rights.

Book Design: Assigns 1-3 freelance design jobs/year. Pays by the project.

Jackets/Covers: Assigns 1-3 freelance design jobs and 1-3 illustration jobs/year. Pays for design and illustration by the project.

Text Illustration: Assigns 1-3 freelance illustration jobs/year. Pays by the project. Finds freelancers through word of mouth and submissions.

Tips: "We require our freelancers to be extremely knowledgeable in accurate and authentic presentation of Hawaiian-culture images."

KAR-BEN COPIES, INC., 6800 Tildenwood Lane, Rockville MD 20852. Fax: (301)881-9195. E-mail: karben@aol.com. Website: http://www.karben.com. Editor: Madeline Wikler. Estab. 1975. Company publishes hardcovers and paperbacks on juvenile Judaica. Publishes 6-8 titles/year. Recent titles include *Brainteasers from Jewish Folklore*, written and illustrated by Rosalyn Charney Kaye; and *Sammy Spider's First Shabbat*, by Sylvia Rouss, illustrated by Katherine Kahn. Books contain "colorful illustrations to appeal to young readers." 100% require freelance illustration. Book catalog free on request.

Needs: Uses 10-12 freelance illustrators/year. Uses freelancers mainly for book illustration. Also for jacket/cover design and illustration, book design and text illustration.

First Contact & Terms: Send query letter with photostats, brochure or tearsheets to be kept on file or returned. Samples not filed are returned by SASE. Reports within 2 weeks only if SASE included. Originals are returned at job's completion. Sometimes requests work on spec before assigning a job. Considers skill and experience of artist and turnaround time when establishing payment. Pays by the project, $500-3,000 average, or advance plus royalty. Buys all rights. Considers buying second rights (reprint rights) to previously published artwork.

Tips: Send samples showing active children, not animals or still life. Don't send original art. "Look at our books and see what we do. We are using more full-color as color separation costs have gone down."

KENDALL/HUNT PUBLISHING CO., 4050 Westmark Dr., Dubuque IA 52004-1840. (319)589-1040. Fax: (319)589-1038. Website: http://www.kendallhunt.com. Vendor Coordinator: Sara Eisbach. Estab. 1940. Publishes hardcover and trade paperback originals and reprints, textbooks, audio tapes and CD-ROM. Types of books include adventure, biography, coffee table books, history, instructional, nonfiction, self help and textbooks. Publishes 1,800 titles/year. 5% require freelance illustration.

Needs: Approached by 8-10 illustrators and 8-10 designers/year. Works with 4 illustrators and 3 designers/year. 100% of freelance design demands knowledge of Aldus PageMaker, Aldus FreeHand, Adobe Photoshop and Adobe Illustrator. 95% of freelance illustration demands knowledge of Aldus FreeHand, Adobe Photoshop, Adobe Illustrator and Corel Draw.

First Contact & Terms: Designers send query letter with brochure. Illustrators send query letter with printed samples and résumé. Samples are filed. Reports back only if interested. Buys all rights.

Book Design: Assigns 25-50 freelance design jobs/year. Pays by the project.

Jackets/Covers: Pays by the project, $125-250. Media and style varies.

Text Illustration: Assigns 10-15 freelance illustration jobs/year. Payment negotiable. Finds freelancers through artist's submissions.

KIRKBRIDE BIBLE CO. INC., 335 W. 9th St., Indianapolis IN 46202 0606. (317)633-1900. Fax: (317)633-1444. E-mail: gage@kirkbride.com. Website: http://www.kirkbride.com. Art Director: Michael B. Gage. Estab. 1920. Imprint of Kirkbride Bible & Technology. Publishes hardcover originals, CD-ROM and many styles and translations of the Bible. Types of books include reference and religious. Specializes in reference and study material. Publishes 3 main titles/year. Recent titles include *Thompson Exhaustive Topical Bible*. 5% require freelance illustration; 20% require freelance design. Catalog available.

Needs: Approached by 1-2 designers/year. Works with 1-2 designers/year. Prefers freelancers experienced in layout and cover design. Uses freelancers mainly for artwork and design. 100% of freelance design and most illustration demands knowledge of Aldus PageMaker, Aldus FreeHand, Adobe Photoshop, Adobe Illustrator and QuarkXPress. 5-10% of titles require freelance art direction.

First Contact & Terms: Designers send query letter with photostats, printed samples and résumé. Illustrators send query letter with photostats, printed samples and résumé. Accepts disk submissions compatible with QuarkXPress or Adobe Photoshop files—4.0 or 3.1. Samples are filed. Reports back only if interested. Rights purchased vary according to project.

Book Design: Assigns 1 freelance design job/year. Pays by the hour $100 minimum.

Jackets/Covers: Assigns 1-2 freelance design jobs and 1-2 illustration jobs/year. Pays for design by the project, $100-1,000. Pays for illustration by the project, $100-1,000. Prefers modern with traditional text.

Text Illustration: Assigns 1 freelance illustration/year. Pays by the project, $100-1,000. Prefers traditional. Finds freelancers through sourcebooks and references.

✔KITCHEN SINK PRESS, 76 Pleasant St., Northampton MA 01060. (413)586-9525. Fax: (413)586-7040. E-mail: art@kitchensink.com. Website: http://www.kitchensink.com. Editors: Chris Couch, Katherine Garnier and Robert Boyd. Art Director: Evan Metcalf. Estab. 1969. Book and comic book publisher of hardcover and trade paperback originals and reprints. Types of books include science fiction, adventure, humor, graphic novels and comic books. Publishes 24 books and 48 comic books/year. Recent titles include James O'Barr's *The Crow*™; Will Eisner's *The Spirit*®; and Mark Schultz's *Xenozoic Tales*. 10% require freelance illustration; 10% require freelance design.
Needs: Approached by more than 100 freelancers/year. Works with 10-20 illustrators and 4-5 designers/year. Buys 300 illustrations/year. Prefers artists with experience in comics. Uses freelancers mainly for covers, contributions to anthologies and new series. Also for comic book covers and text illustration. Works on assignment only, although "sometimes a submission is accepted as is."
First Contact & Terms: Send query letter with tearsheets, SASE and photocopies. Samples are filed or are returned by SASE. Reports back within 6-8 weeks. Rights purchased vary according to project. Originals are returned at job's completion.
Book Design: Assigns 2-3 freelance design jobs/year. Pays by the project, $600-1,000.
Jackets/Covers: Assigns 6-8 freelance design jobs/year. Pays by the project, $200-600. Prefers line art with color overlays.
Tips: "We are looking for artist-writers."

‡B. KLEIN PUBLICATIONS INC., P.O. Box 6578, Delray Beach FL 33482. (561)496-3316. Fax: (561)496-5546. Editor: Bernard Klein. Estab. 1955. Publishes reference books, such as the *Guide to American Directories*. Publishes approximately 15-20 titles/year. 25% require freelance illustration. Book catalog free on request.
Needs: Works with 1-3 freelance illustrators and 1-3 designers/year. Uses freelancers for jacket design and direct mail brochures. 25% of titles require freelance art direction.
First Contact & Terms: Submit résumé and samples. Pays $50-300.

‡ALFRED A. KNOPF, INC., 201 E. 50th St., New York NY 10022. (212)751-2600. Art Director: Carol Carson. Imprint is Random House. Publishes hardcover originals for adult trade. Specializes in history, art and cookbooks. Publishes 150 titles/year. Recent titles include *Cooking With Master Chefs*, *Disclosure* and *The Victory Garden Fish and Vegetable Cookbook*.
● Jackets and covers are done in another department. Read about Chip Kidd, one of Knopf's award-winning jacket designers, on page 326.
Needs: Works with 3-5 freelance illustrators and 3-5 freelance designers/year. Prefers artists with experience in b&w. Uses freelancers mainly for cookbooks and biographies. Also for text illustration and book design.
First Contact & Terms: Send query letter with SASE. Request portfolio review in original query. Artist should follow up. Sometimes requests work on spec before assigning a job. Originals are returned at job's completion.
Book Design: Pays by the hour, $15-30; by the project, $450 minimum.
Text Illustration: Pays by the project, $100-5,000; $50-150/illustration; $300-800/maps.
Tips: Finds artists through submissions, agents and sourcebooks. "Freelancers should be aware that Macintosh/Quark is a must for design and becoming a must for maps and illustration."

LAREDO PUBLISHING CO., 8907 Wilshire Blvd. 102, Beverly Hills CA 90211. (310)358-5288. Fax: (310)358-5282. E-mail: larpub@aol.com. Art Director: Silvana Cervera. Estab. 1991. Publishes juvenile, preschool textbooks. Specializes in Spanish texts educational/readers. Publishes 16 titles/year Recent titles include *Barriletes*, *Kites*. 30% require freelance illustration; 30% require freelance design. Book catalog free on request.
Needs: Approached by 10 freelance illustrators and 2 freelance designers/year. Works with 2 freelance designers/year. Uses freelancers mainly for book development. 100% of freelance design demands knowledge of Adobe Photoshop, Adobe Illustrator, QuarkXPress. 20% of titles require freelance art direction.
First Contact & Terms: Designers send query letter with brochure, photocopies. Illustrators send photocopies, photographs, résumé, slides, tearsheets. Samples are not filed and are returned by SASE. Reports back only if interested. Portfolio review required for illustrators. Art director will contact artist for portfolio review if interested. Portfolio should include artwork portraying children, book dummy, photocopies, photographs, tearsheets. Buys all rights or negotiates rights purchased.
Book Design: Assigns 5 freelance design jobs/year. Pays for design by the project.
Jacket/Covers: Pays for illustration by the project, page.
Text Illustration: Pays by the project, page.

LEE & LOW BOOKS, 95 Madison Ave., New York NY 10016-7801. (212)779-4400. Website: http://www.leeandlow.com. Editor-in-Chief: Elizabeth Szabla. Publisher: Philip Lee. Estab. 1991. Book publisher. Publishes hardcover originals and reprints for the juvenile market. Specializes in multicultural children's books. Publishes 8-10 titles/year. First list published in spring 1993. Recent titles include *Confetti: Poems for Children*, by Pat Mora; and *In Daddy's Arms I Am Tall*, by Javaka Steptoe. 100% require freelance illustration and design. Book catalog available.
Needs: Approached by 100 freelancers/year. Works with 6-10 freelance illustrators and 1-3 designers/year. Uses free-

lancers mainly for illustration of children's picture books. 100% of design work demands computer skills. Works on assignment only.

First Contact & Terms: Contact through artist rep or send query letter with brochure, résumé, SASE, tearsheets, photocopies and slides. Samples are filed. Art Director will contact artist for portfolio review if interested. Portfolio should include b&w and color tearsheets, slides and dummies. Rights purchased vary according to project. Originals are returned at job's completion.

Book Design: Pays by the project.

Text Illustration: Pays by the project.

Tips: "We want an artist who can tell a story through pictures and is familiar with the children's book genre. Lee & Low Books makes a special effort to work with writers and artists of color and encourages new voices. We prefer filing samples that feature children."

LIBRARIES UNLIMITED/TEACHER IDEAS PRESS, Box 6633 Englewood CO 80155-6633. (303)770-1220. Fax: (303)220-8843. E-mail: lu-marketing@lu.com. Website: http://www.lu.com. Contact: Publicity Department. Estab. 1964. Specializes in hardcover and paperback original reference books concerning library science and school media for librarians, educators and researchers. Also specializes in resource and activity books for teachers. Publishes more than 60 titles/year. Book catalog free by request.

Needs: Works with 4-5 freelance artists/year.

First Contact & Terms: Designers send query letter with brochure, résumé and photocopies. Illustrators send query letter with photocopies. Samples not filed are returned only if requested. Reports within 2 weeks. Considers complexity of project, skill and experience of artist, and project's budget when establishing payment. Buys all rights. Originals not returned.

Text Illustration: Assigns 2-4 illustration jobs/year. Pays by the project, $100 minimum.

Jackets/Covers: Assigns 4-6 design jobs/year. Pays by the project, $350 minimum.

Tips: "We look for the ability to draw or illustrate without overly-loud cartoon techniques. Freelancers should have the ability to use two-color effectively, with screens and screen builds. We ignore anything sent to us that is in four-color. We also need freelancers with a good feel for typefaces."

LIFETIME BOOKS, 2131 Hollywood Blvd., Hollywood FL 33020. (305)925-5242. E-mail: lifetime@shadow.net. Website: http://lifetimebooks.com. President: Donald L. Lessne. Specializes in hardcovers, paperbacks and magazines—mostly trade books. Publishes 20 titles/year. Recent titles include *All the Secrets of Magic Revealed*, *Og Mandino's Great Trilogy* and *How to Be the Complete Professional Salesperson*. Books have a striking look.

Needs: Works with 3 freelance illustrators and 3 freelance designers/year. Uses freelance artists mainly for cover, jacket and book design. Also for jacket/cover and text illustration, catalog design, tip sheets and direct mail. Prefers local artists only. Needs computer-literate freelancers for design, illustration and production. 50% of freelance work demands knowledge of Aldus PageMaker. Works on assignment only.

First Contact & Terms: Send brochure showing art style or photocopies and résumé. Samples not filed are returned only if requested. Editor will contact artists for portfolio review if interested. Originals are returned at job's completion. Considers rights purchased when establishing payment. Rights purchased vary according to project. Interested in buying second rights (reprint rights) to previously published work.

Book Design: Assigns 20 freelance design and 20 illustration jobs/year. Pays by the project, $400-1,000.

Jackets/Covers: Assigns 20 freelance design and a variable amount of illustration jobs/year. Pays by the project, $400-1,000.

Tips: "As the trade market becomes more competitive, the need for striking, attention-grabbing covers increases. Be ready to generate multiple ideas on a subject and to create something professional and unique."

THE LITURGICAL PRESS, St. John's Abbey, Collegeville MN 56321. (320)363-2213. Fax: (320)363-3278. Art Director: Ann Blattner. Estab. 1926. Publishes hardcover and trade paperback originals and textbooks. Specializes in liturgy and scripture. Publishes 150 titles/year. 50% require freelance illustration and design. Book catalog available for SASE.

Needs: Approached by 100 freelancers/year. Works with 10 freelance illustrators and 15 designers/year. Uses freelancers for book cover design, jacket/cover illustration and design and text illustration. Also for multimedia projects. 50% of freelance work demands computer skills.

First Contact & Terms: Send query letter with brochure, photographs, photocopies and slides. Samples are filed. Reports back to the artist only if interested. To show portfolio, mail b&w photostats and photographs. Rights purchased vary according to project. Originals are returned at job's completion.

Jackets/Covers: Assigns 100 freelance design and 50 illustration jobs/year. Pays by the project, $150-450.

Text Illustration: Assigns 25 freelance illustration jobs/year. Pays by the project, $45-500.

‡LOWELL HOUSE, a division of the RGA Publishing Group, Inc., Juvenile Division, 202 Avenue of the Stars, Suite 300, Los Angeles CA 90067. (310)552-7555. Fax: (310)552-7573. Senior Designer: Shellie Pomeroy. Production Director: Bret Perry. Estab. 1987. Types of books include adventure, fantasy, history, horror, instructional, juvenile, nonfiction, preschool, reference, young adult, educational/workbooks. Specializes in workbooks, activity books, craft. Publishes 65 titles/year. Recent titles include: *Super Friendship Crafts*, *Draw Fantasy*, *Creepy Crafts*, *Tutor Books*, My First Science Fair Projects, *Gifted & Talented Series®*, and *Gradebooster Series*. 90% requires freelance illustration;

INSIDER REPORT

Succeeding in publishing from cover to cover

Chip Kidd

Alfred A. Knopf designer Chip Kidd has been responsible for many remarkable book covers over the years, including *Naked* by David Sedaris and *Geek Love* by Katherine Dunn, as well as the ubiquitous dinosaur from Michael Crichton's *Jurassic Park*. Not bad for a guy who wanted to grow up to be Bozo the Clown.

Like many trained graphic designers, Kidd began looking for a job in a "good studio" after graduating from Penn State in 1986. In the beginning, he didn't set out to take the publishing world by storm; he just wanted to find a job in design. After a month of job hunting in New York City, Kidd began doing freelance assignments for Vintage Books. His first cover, for the 1987 book *How to Work for a Jerk,* was loathed by the editors. The author, Robert M. Hochheiser, loved it. Before long, he was getting more and more freelance book jacket assignments: "New York is a small town. The publishing and design world is even smaller . . . you get referrals from people."

Coming from what he describes as a "stable, middle-class background," the idea of continuing to work on his own scared him. Though many designers enjoy freelancing because it allows them to set their own hours, Kidd realized he needed the structure of a nine-to-five job. Straight freelance work requires a kind of discipline Kidd doesn't himself embrace. "I like the part of the process of getting up and out of the house, and not falling out of bed at 4 p.m."

Through the friends and contacts he made while freelancing, Kidd learned that Alfred A. Knopf needed an assistant in the art department. Thus Kidd's illustrious career in publishing began from a freelance gig.

Once at Knopf, Kidd began making a name for himself with his sophisticated, eye-catching and often elegantly quirky covers. As his reputation grew, other publishers sought him out when they needed a "Chip Kidd" treatment for a book jacket or magazine layout. "Now I have the best of both worlds," says Kidd, who designed the smiling/crying "baby heads" for *Time's* 1997 best and worst edition with Geoff Spear, and has worked on projects for *Esquire* and *Vanity Fair.*

Kidd has recently been selected to design the new trade paperback editions of Elmore Leonard's novels, broadening the circle of authors he has worked with, including Anne Rice, Martin Amis and John Updike. Knopf has an art director who hands out assignments while books are still in manuscript form, so Kidd is able to read each manuscript before he considers the cover.

Aside from his own work, Kidd also hires freelance designers, photographers and illustrators for his department. What qualities does he seek in the freelancers he chooses?

INSIDER REPORT, *Kidd*

"Just because you didn't study design doesn't mean you can't do it," Kidd points out. "No one cares where a designer went to school, or if he or she studied fine art rather than graphic design. I want an intern or freelancer to be able to work." This means familiarity, if not complete expertise, in the usual design programs: QuarkExpress, Photoshop and Illustrator. This doesn't mean Kidd prefers the look of computer illustrations or hi-tech digital-looking work, however. He's been known to use a copy machine, and even his own hand, to create some of the typefaces used in his designs.

Kidd also advises would-be designers and illustrators to become acquainted with the market. He strongly suggests that, before sending out promotional mailings, you browse bookstores and libraries to find out which publishers intrigue you. After a while, you'll be able to identify publishers whose design sense agrees with yours. Those publishers should be at the top of your list to contact for freelance work.

When targeting your market, pay attention to the type of books as well as the subject matter each publisher specializes in. For example, if you'd love to design or illustrate science fiction titles, only submit your work to publishers who deal in that subject. If you hope to design covers for literary fiction, don't send your samples to a children's picture book publisher. "It really bothers me when an artist shows me work that is just wildly inappropriate," says Kidd. So be sure to do your homework.

Though Kidd is hesitant to encourage others into the field ("I don't need more competition"), he concedes that good freelancers are self-motivated, talented, reliable individuals, whose chances of getting hired increase with their physical attractiveness and insatiable will to please. The latter two attributes Kidd mentions are just a taste of the candor and sly wit that has made him a sought-after speaker on the design conference circuit, where he speaks with abandon on his life as a book cover designer. In a hilarious slide show, with the timing of a stand-up comic, Kidd regales audiences with tales of the often serendipitous evolutionary process of his cover designs. (You can eavesdrop on one

Whether he is immortalizing the dynamic duo, or capturing the essence of a literary work, Chip Kidd's designs are always elegant, often witty. The outer jacket for *Naked*—a sedate pair of boxers—slips off to reveal an equally sedate x-ray.

INSIDER REPORT, *continued*

of Kidd's lectures by ordering a tape through *HOW* magazine's website at www.howdesign.com.)

As Kidd reveals in his slide show, designing the cover of a book puts particular demands on a designer. This could be anything from the need to afix the words "a novel" on the cover, using only two colors, or in Kidd's case, placing various versions of the Knopf greyhound logo on the spine of each jacket. While Kidd vehemently denies that book jackets sell books, he does admit they can act as posters that grab attention. As such, the design of the cover also plays into the publisher's marketing strategy, creating the first impression of a book. Somehow, between the preferences of the author, the needs of marketing, the concerns of the editor and the designer's concept, a cover is agreed upon. The final version, reveals Kidd, is often a compromise of sorts. He and his colleagues routinely feel the pain of abandoning a brilliant idea in favor of a more "marketable" cover. One of the challenges Kidd enjoys is somehow pleasing everyone while coming up with another fantastic design. "In general, I view limitations as possibilities.

"If you want to make art, go be Picasso—this is not what this is," says Kidd, speaking of book cover design. "This is a tremendously obscure trade, not something you get rich in. Unless you loved books, this [occupation] wouldn't occur to you." Yet it's an occupation that suits him well. He feels he is part of the publishing world, as opposed to strictly in the realm of design. "The people are smart, interesting. I'm comfortable there."

Somehow between his Knopf duties and freelance projects, Kidd, a passionate Batman memorabilia collector since age four, also managed to design and write his own pet book project, *Batman Collected* (Bulfinch Press). Of all the work he has done in publishing, Kidd is most proud of this lavish book filled with every kind of Batman-related toy, game, book and lunchbox imaginable, all beautifully photographed by Geoff Spear.

The Batman book, and a companion 1998 *Batman Collected* wall calendar, added to Kidd's reputation in the design and publishing world. That he has achieved celebrity status within the industry still surprises Kidd, who at the start of his career never imagined himself concentrating on a career in books. In that way, Kidd's path to a rewarding career is similar to the circuitous creative process he employs when designing his famous covers. "What ends up," he says "is the opposite of what I intend."

—*Tricia Suit*

10% requires freelance design. Book catalog free for 9×12 SAE with $1.24 first-class stamps.
Needs: Approached by 80 illustrators and 20 designers/year. Works with 40 illustrators and 10 designers/year. Prefers freelancers experienced in children's illustration. 100% of freelance design demands knowledge of Adobe Illustrator, Adobe Photoshop, QuarkXPress. 10% of freelance illustration demands knowledge of Adobe Illustrator, Adobe Photoshop.
First Contact & Terms: Designers send query letter with printed samples. Illustrators send postcard sample, printed samples, tearsheets. Accepts Mac-compatible disk submissions. Samples are filed or returned. Will contact artist for portfolio review if interested. Buys all rights. Finds freelancers through sourcebooks, illustrator annuals, mailings, word of mouth.
Book Design: Assigns 6-10 freelance design/year. Pays for design by the project, $500-2,000.
Jackets/Covers: Assigns 40-50 freelance illustration jobs/year. Pays for illustration by the project, $100-1,500. Prefers vibrant colors and compositions that engage the viewer.
Text Illustration: Assigns 40-50 freelance illustration jobs/year. Pays by the project, $100-4,000. Prefers clean lines and consistency, both of which are necessary when working on juvenile educational workbooks.

‡LUMEN EDITIONS/BROOKLINE BOOKS, P.O. Box 1047, Cambridge MA 02238. (617)868-0360. Fax: (617)868-1772. E-mail: brooklinebks@delphi.com. Editor: Sadi Ranson. Estab. 1970. Publishes hardcover originals,

textbooks, trade paperback originals and reprints. Types of books include biography, children's picture books, experimental and mainstream fiction, instructional, nonfiction, reference, self help, textbooks, travel. Specializes in translations of literaray works/education books. Publishes 30 titles/year. Recent titles include: *Writing*, by Marguerite Duras; *Pursuit of a Woman*, by Hans Koning; *Study Power*, *The Well Adjusted Dog*. 100% requires freelance illustration; 70% requires freelance design. Book catalog free for 6×9 SAE with 2 first-class stamps.

Needs: Approached by 20 illustrators and 50 designers/year. Works with 5 illustrators and 20 designers/year. Prefers freelancers experienced in book jacket design. 100% of freelance design demands knowledge of Adobe Photoshop, PageMaker, QuarkXPress.

First Contact & Terms: Send query letter with printed samples, SASE. Samples are filed. Will contact artist for portfolio review of book dummy, photocopies, tearsheets if interested. Negotiates rights purchased. Finds freelancers through agents, networking, other publishers, Book Builders.

Book Design: Assigns 30-40 freelance design/year. Pays for design by the project, varies.

Jackets/Covers: Pays for design by the project, varies. Pays for illustration by the project, $200-2,500. Prefers innovative trade cover designs. Classic type focus.

Text Illustration: Assigns 5 freelance illustration jobs/year. Pays by the project, $200-2,500.

Tips: "We have a house style, and we recommend that designers look at some of our books before approaching us. We like subdued colors—that still pop. Our covers tend to be very provocative, and we want to keep them that way. No 'mass market' looking books or display typefaces. All designers should be knowledgeable about the printing process and be able to see their work through production."

‡THE LYONS PRESS, 31 W. 21 St., New York NY 10010. (212)620-9580. Fax: (212)929-1836. Art Director: Catherine L. Hunt. Designer: John Gray. Estab. 1980. Publishes hardcover and trade paperback originals and reprints. Types of books include adventure, cookbooks, instructional, nonfiction, gardening, sports, outdoors. Publishes 90 titles/year. Recent titles include: *The Good Cigar*. 50% requires freelance illustration; 40% requires freelance design. Book catalog available.

Needs: Approached by 20 illustrators and 10 designers/year. Works with 15-20 illustrators and 10-15 designers/year. Prefers freelancers experienced in designing books and covers. 100% of freelance design and 20% of freelance illustration demands knowledge of Adobe Illustrator, Adobe Photoshop, QuarkXPress.

First Contact & Terms: Designers send query letter with printed samples, photocopies, tearsheets. Illustrators send postcard sample or query letter with tearsheets. Accepts Mac-compatible disk submissions. Samples are filed and are not returned. Will contact artist for portfolio review if interested. Portfolio showing book dummy and tearsheets may be dropped off every Wednesday and can be picked up the following day. Rights purchased vary according to project. Finds freelancers through *Workbook*, *RSVP*.

Book Design: Assigns 25 freelance design jobs/year. Pays by the project.

Jackets/Covers: Assigns 25 freelance design and 30 illustration jobs/year. Pays for design by the project, $400 maximum. Pays for illustration by the project, $300-450.

Text Illustration: Assigns 35 freelance illustration jobs/year. Pays by the project, $200-700 depending on job.

MACMILLAN COMPUTER PUBLISHING, 201 W. 103rd St., Indianapolis IN 46290. (317)581-3500. Website: http://www.mcp.com. Operations Specialist: Angela Boley. Imprints include Que, New Riders, Sams, Hayden, Adobe Press, Que Education, Training, Macmillan Technical Publishing and Brady Games. Company publishes instructional computer books. Publishes 800 titles/year. 5-10% require freelance illustration; 3-5% require freelance design. Book catalog free by request with SASE.

Needs: Approached by 100 freelancers/year. Works with 20+ freelance illustrators and 10 designers/year. Buys 100 freelance illustrations/year. Uses freelancers for jacket/cover illustration and design, text illustration, direct mail and book design. 50% of freelance work demands knowledge of Aldus PageMaker, QuarkXPress, Aldus FreeHand, Adobe Illustrator and Adobe Photoshop. Finds artists through agents, sourcebooks, word of mouth, submissions and attending art exhibitions.

First Contact & Terms: Send query letter with brochure, tearsheets, photostats, résumé, photographs, slides, photocopies or transparencies. Samples are filed or returned by SASE if requested by artist. Art Director will contact artist for portfolio review if interested. Portfolio should include final art, photographs, photostats, roughs, slides, tearsheets and transparencies. Rights purchased vary according to project.

Book Design: Assigns 10 freelance design jobs/year. Pays by the project, $1,000-4,000.

Jackets/Covers: Assigns 15 freelance design and 25+ illustration jobs/year. Pays by the project, $1,000-3,000.

Text Illustration: Pays by the project.

‡MADISON BOOKS, Dept. AGDM, 4720 Boston Way, Lanham MD 20706. (301)731-9534. Fax: (301)459-3464. Vice President, Design: Gisele Byrd Henry. Estab. 1984. Publishes hardcover and trade paperback originals. Specializes in biography, history and popular culture. Publishes 16 titles/year. Titles include *Keys to the White House*, *Written Out of Television* and *The Art of Drawing*. 40% require freelance illustration; 100% require freelance jacket design. Book catalog free by request.

Needs: Approached by 20 freelancers/year. Works with 4 freelance illustrators and 12 designers/year. Prefers freelancers with experience in book jacket design. Uses freelancers mainly for book jackets. Also for catalog design. 80% of freelance work demands knowledge of Adobe Illustrator, QuarkXPress, Adobe Photoshop or Aldus FreeHand. Works on assignment only.

First Contact & Terms: Send query letter with tearsheets, photocopies and photostats. Samples are filed or are returned by SASE if requested by artist. Reports back to the artist only if interested. Call for appointment to show portfolio of roughs, original/final art, tearsheets, photographs, slides and dummies. Buys all rights. Interested in buying second rights (reprint rights) to previously published work.

Jackets/Covers: Assigns 16 freelance design and 2 illustration jobs/year. Pays by the project, $400-1,000. Prefers typographic design, photography and line art.

Text Illustration: Pays by project, $100 minimum.

Tips: "We are looking to produce trade-quality designs within a limited budget. Covers have large type, clean lines; they 'breathe.' If you have not designed jackets for a publishing house but want to break into that area, have at least five 'fake' titles designed to show ability. I would like to see more Eastern European style incorporated into American design. It seems that typography on jackets is becoming more assertive, as it competes for attention on bookstore shelf. Also, trends are richer colors, use of metallics."

‡McCLANAHAN BOOK CO., 23 W. 26th St., New York NY 10010. (212)725-1515. Creative Director: David Werner. Estab. 1990. Publishes educational mass retail books. Types of books include board books, novelty books, wookbooks, activity books, sticker books, flash cards, paperback picture books. Audience is infant to 12 yr. olds. Publishes approximately 60 titles/year. Recent titles include: *Alpha Zoo, 50 Great Americans, Letters of the Alphabet* and *Pre-School Science.*

Needs: Approached by 1,000 illustrators and 75 designers/year. Works with 35 illustrators and 10 designers/year. Works with 35 illustrators and 10 designers/year. All design is electronic using Quark, Illustrator, Photoshop.

First Contact & Terms: Send photocopies, printed samples and tearsheets. Accepts disk submissions. Samples are filed if appropriate or returned by SASE. Will contact for portfolio review of artwork portraying anthropomorphic animals, cute children and tearsheets only if interested in artist's work. Buys all rights. Finds freelancers through word of mouth and submissions.

Book Design: Pays for design by the hour, $25.

Jackets/Covers: Pays for design/illustration by the project, $500-1,000. "Trend is toward computer 3-D."

Text Illustration: Assigns 60 freelance illustration jobs/year. Pays $3,000-20,000 for books (24-96 pages). "Prefer Photoshop illustration."

Tips: "Illustrators must know children's book mass and educational market."

✓McFARLAND & COMPANY, INC., PUBLISHERS, Box 611, Jefferson NC 28640. (336)246-4460. Fax: (336)246-5018. E-mail: mcfarland@skybest.com. Website: http://www.mcfarlandpub.com. Sales Manager: Rhonda Herman. Estab. 1979. Company publishes hardcover and trade paperback originals. Specializes in nonfiction reference and scholarly monographs, including film and sports. Publishes 150 titles/year. Recent titles include *The Cultural Encyclopedia of Baseball* and *The Chinese Filmography.* Book catalog free by request.

Needs: Approached by 50 freelancers/year. Works with 5-8 freelance illustrators/year. Prefers freelancers with experience in catalog and brochure work in performing arts and school market. Uses freelancers mainly for promotional material. Also for direct mail and catalog design. Works on assignment only. 20% of illustration demands knowledge of QuarkXPress, version 3.3.

First Contact & Terms: Send query letter with résumé, SASE, tearsheets and photocopies. "Send relevant samples. We aren't interested in children's book illustrators, for example, so we do not need such samples." Samples are filed. Reports back within 2 weeks. Portfolio review not required. Buys all rights. Originals are not returned.

Tips: First-time assignments are usually school promotional materials; performing arts promotional materials are given to "proven" freelancers. "Send materials relevant to our subject areas, otherwise we can't fully judge the appropriateness of your work."

‡R.S. MEANS CO., INC., Parent company: CMDG, 100 Construction Plaza, Kingston MA 02364-0800. (781)585-7880. Fax: (781)585-7466. E-mail: hmarcella@rsmeans.com. Website: http://www.rsmeans.com. Sr. Marketing Specialist: Helen Marcella. Estab. 1942. Publishes CD-ROMs, hardcover originals and reprints; textbooks; trade paperback originals and reprints. Types of books include instructional, reference, construction. Specializes in construction cost books. Publishes 25-30 titles/year. Recent titles include: *Cyberplaces, Value Engineering.* 50% requires freelance illustration; 100% requires freelance design.

Needs: Prefers local freelancers.

First Contact & Terms: Send query letter with printed samples, photocopies. Samples are filed. Will contact artist for portfolio review if interested. Buys all rights. Finds freelancers through word of mouth.

Tips: "We are looking for an updated look, but still professional. It is helpful if you have some background or familiarity with construction."

MEDIA ASSOCIATES-ARKIVES PRESS, P.O. Box 46, Wilton CA 95693. (800)373-1897. Fax: (916)682-7090. E-mail: ed@arkives.com. Website: http://www.arkives.com. Editor-in-Chief: Phil Wycliff. Estab. 1968. Imprint of Media Associates. Imprints include Arkives Press and Epona Books. Publishes hardcover originals and reprints, trade paperback originals and reprints, audio tapes and CD-ROMs. Types of books include biography, coffee table books, cookbooks, history, new age, nonfiction and self help. Specializes in archaeology, Irish history and rock and roll. Publishes 12 titles/year. Recent titles include: *Kurt Coban-Beyond Nirvana* and *Grateful Dead: Garcia.* 50% require freelance illustration; 50% require freelance design. Catalog free for 5 first class stamps or 1 priority mail stamp.

Needs: Approached by 100 illustrators and 100 designers/year. Works with 10 illustrators and 3 designers/year. Prefers freelancers experienced in book design. Uses freelancers mainly for book design, children's illustrations and special contributions depending upon style. 100% of freelance design and illustration demands knowledge of most Adobe products.

First Contact & Terms: Designers send query letter with brochure, photocopies, photographs, photostats, résumé, SASE, slides, tearsheets and transparencies. Illustrators send query letter with photocopies, photographs, photostats, printed samples, résumé, SASE, slides, tearsheets and transparencies. "Be creative." Send follow-up postcard every 6 months. Accepts disk submissions compatible with MAC/OS files only. "One sample is filed—the one we think is the best example." The rest are returned by SASE. Reports back in 6 weeks if interested. Will contact artist for portfolio review of book dummy if interested. Rights purchased vary according to project.

Book Design: Assigns 3-6 freelance design jobs/year. Pays by arrangement.

Jackets/Covers: Assigns 10 freelance design jobs and 10 illustration jobs/year. Pay for design and illustration open to negotiations.

Text Illustration: Assigns 3-6 freelance illustration jobs/year. Pay open to negotiation. Celtic themes preferred. "We do not work with agents—we have had good luck with university references and art schools."

Tips: "We prefer someone who is an enthusiastic book collector and antiquarian as well as an avid book reader."

MENNONITE PUBLISHING HOUSE/HERALD PRESS, 616 Walnut Ave., Scottdale PA 15683. (412)887-8500, ext. 244. Fax: (412)887-3111. E-mail: jim@mph.org. Website: http://www.mph.org. Art Director: James M. Butti. Estab. 1918. Publishes hardcover and paperback originals and reprints; textbooks and church curriculum. Specializes in religious, inspirational, historical, juvenile, theological, biographical, fiction and nonfiction books. Publishes 24 titles/year. Recent titles include *Ellie* series, *A Winding Path* and *A Joyous Heart*. Books are "fresh and well illustrated." 30% require freelance illustration. Catalog available free by request.

Needs: Approached by 150 freelancers each year. Works with 8-10 illustrators/year. Prefers oil, pen & ink, colored pencil, watercolor, and acrylic in realistic style. "Prefer artists with experience in publishing guidelines who are able to draw faces and people well." Uses freelancers mainly for book covers. 10% of freelance work demands knowledge of Adobe Illustrator, QuarkXPress or CorelDraw. Works on assignment only.

First Contact & Terms: Send query letter with résumé, tearsheets, photostats, slides, photocopies, photographs and SASE. Samples are filed ("if we feel freelancer is qualified") and are returned by SASE if requested by artist. Reports back only if interested. Art Director will contact artist for portfolio review of final art, photographs, roughs and tearsheets. Buys one-time or reprint rights. Originals are not returned at job's completion "except in special arrangements." To show portfolio, mail photostats, tearsheets, final reproduction/product, photographs and slides and also approximate time required for each project. Considers complexity of project, skill and experience of artist and project's budget when establishing payment. Buys all rights.

Jackets/Covers: Assigns 8-10 illustration jobs/year. Pays by the project, $200 minimum. "Any medium except layered paper illustration will be considered."

Text Illustration: Assigns 6 jobs/year. Pays by the project. Prefers b&w, pen & ink or pencil.

Tips: "Design we use is colorful, realistic and religious. When sending samples, show a wide range of styles and subject matter—otherwise you limit yourself."

MERLYN'S PEN, P.O. Box 1058, East Greenwich RI 02818. (401)885-5175. Fax: (401)885-5222. E-mail: merlynspen @aol.com. Website: http://www.merlynspen.com. President: R.J. Stahl. Estab. 1985. Imprints include The American Teen Writer Series. Publishes hardcover originals, trade paperback originals, textbooks, audio tapes and magazines. Types of books include young adult—most are by teen authors. Publishes 10 titles/year. Recent titles include: *Taking Off*, *Eighth Grade*, *Sophomores*. 100% requires freelance illustration and design. Catalog free.

Needs: Approached by 5 illustrators and 5 designers/year. Works with 10 illustrators/year. Prefers freelancers experienced in design and typography and illustration and typography. Uses freelancers mainly for book jackes and magazine articles. 100% of freelance design demands knowledge of Adobe Photoshop, Adobe Illustrator and QuarkXPress. 50% of free illustration demands knowledge of Adobe Photoshop, Adobe Illustrator and QuarkXPress.

First Contact & Terms: Designers send query letter with brochure, photocopies, SASE and tearsheets. Illustrators send postcard sample, photocopies and printed samples. Send follow-up postcard every 3 months. Accepts disk submissions compatible with QuarkXPress 7.5. Samples are filed and are not returned. Reports back only if interested. Will contact artist for portfolio review if interested. Portfolio should include artwork portraying teens, sci-fi, real life and story illustrations. Rights purchased vary according to project.

Book Design: Assigns 2 freelance design jobs/year. Pays by the project, $250-1,000.

Jackets/Covers: Assigns 10 freelance design and 10 illustration jobs/year. Pays for design by the hour, $20-50 or by the project, $250-1,000. Pays for illustration by the project, $200-500. Prefers oils and watercolors.

Text Illustration: Assigns 50 freelance illustration jobs/year. Pays by the project, $100-250. Prefers pen and ink, scratchboard, watercolor, tempera and oil. Finds freelancers through Rhode Island School of Design.

Tips: "We look for professionalism and the ability to work with a low pay scale."

MILKWEED EDITIONS, 430 First Ave. N., Suite 400, Minneapolis MN 55401. (612)332-3192. Fax: (612)332-6248. Managing Editor: Beth Olson. Estab. 1979. Publishes hardcover and trade paperback originals and trade paperback reprints of contemporary fiction, poetry, essays and children's novels (ages 14-16). Publishes 12-14 titles/year. Recent titles include *Behind the Bedroom Wall*, by Laura Williams; *All American Dream Dolls*, by David Haynes; *Shedding*

Life, by Miroslav Holub; and *Eating Bread and Honey*, Pattiann Rogers. Books have "colorful quality" look. Book catalog available for SASE with $1.50.

Needs: Approached by 150 illustrators/year. Works with 10 illustrators and designers/year. Buys 100 illustrations/year. Prefers artists with experience in book illustration. Prefers freelancers experienced in color and b&w. Uses freelancers mainly for jacket/cover illustration and text illustration. 100% of freelance design demands knowledge of Adobe Illustrator, Adobe Photoshop and QuarkXPress. Needs computer-literate freelancers for design. Works on assignment only. 80% requires freelance illustration; 100% requires freelance design; 10% requires freelance art direction.

First Contact & Terms: Send query letter with résumé, SASE and tearsheets. Samples are filed. Editor will contact artists for portfolio review if interested. Portfolio should include best possible samples. Rights purchased vary according to project. Interested in buying second rights (reprint rights) to previously published work. Originals are returned at job's completion. Finds artists through word of mouth, submissions and "seeing their work in already published books."

Book Design: Assigns 14-16 freelance design jobs/year. Pays for design and art direction by the project.

Jackets/Covers: Assigns 14-16 illustration jobs and 5 design jobs/year. Pays by the project, $250-800 for design. "Prefer a range of different media—according to the needs of each book."

Text Illustration: Assigns 3 jobs/year. Pays by the project. Prefers various media and styles.

Tips: "Show quality drawing ability, narrative imaging and interest—call back. Design and production are completely computer-based. Budgets have been cut so any jobs tend to neccesitate experience."

‡MITCHELL LANE PUBLISHERS, INC., 17 Matthew Bathon Court, Elkton MD 21921-3669. (410)392-5036. Fax: (410)392-4781. E-mail: mitchelllane@dpnet.net. Website: http://www.angelfire.com/biz/mitchelllane. Publisher: Barbara Mitchell. Estab. 1993. Publishes hardcover and trade paperback originals. Types of books include biography. Specializes in multicultural biography for young adults. Publishes 15-17 titles/year. Recent titles include: *Rafael Palmeiro: At Home With the Baltimore Orioles*; *Famous People of Hispanic Heritage*. 50% requires freelance illustration; 10% requires freelance design.

Needs: Approached by 20 illustrators and 5 designers/year. Works with 2 illustrators/year. Prefers freelancers experienced in illustrations of people.

First Contact & Terms: Send query letter with printed samples, photocopies. Samples are not filed and are not returned. Will contact artist for portfolio review if interested. Buys all rights.

Jackets/Covers: Prefers realistic portrayal of people.

MODERN PUBLISHING, Dept. AGDM, 155 E. 55th St., New York NY 10022. (212)826-0850. Editorial Director: Kathy O'Hehir. Specializes in children's hardcovers, paperbacks, coloring books and novelty books. Publishes approximately 200 titles/year. Recent titles include *Popular Mechanics for Kids*, Fisher Price books and Disney books.

Needs: Approached by 10-30 freelancers/year. Works with 25-30 freelancers/year. Works on assignment and royalty.

First Contact & Terms: Send query letter with résumé and samples. Samples are not filed and are returned by SASE only if requested. Reports only if interested. Originals are not returned. Considers turnaround time and rights purchased when establishing payment.

Jackets/Covers: Pays by the project, $150-250/cover, "usually four books/series."

Text Illustration: Pays by the project, $15-25/page; line art, "24-382 pages per book, always four books in series." Pays $50-125/page; full color art.

Tips: "Do not show samples that don't reflect the techniques and styles we use. Research our books and bookstores to know our product line better."

MONDO PUBLISHING, One Plaza Rd., Greenvale NY 11548. (516)484-7812. Fax: (516)484-7813. Website: http://www.mondopub.com. Senior Editor: Louise May. Estab. 1992. Publishes hardcover and trade paperback originals and reprints and audio tapes. Types of books include juvenile. Specializes in fiction, nonfiction. Publishes 75 titles/year. Recent titles include *Thinking About Ants*, by Barbara Brenner; *Could We Be Friends? Poems for Pals*, by Bobbi Katz; and *Look at the Moon*, by May Garelick. Book catalog free for 9×12 SASE with 78¢ postage.

Needs: Approached by 12 illustrators and 5 designers/year. Works with 40 illustrators and 10 designers/year. Prefers freelancers experienced in children's hardcovers and paperbacks, plus import reprints. Uses freelancers mainly for illustration, art direction, design. 90% of freelance design demands knowledge of Aldus PageMaker, Adobe Photoshop, Adobe Illustrator, QuarkXPress. 67% of titles require freelance art direction.

First Contact & Terms: Send query letter with photocopies, printed samples and tearsheets. Samples are filed. Will contact for portfolio review if interested. Portfolio should include artist's areas of expertise, photocopies, tearsheets. Rights purchased vary according to project. Finds freelancers through agents, sourcebooks, illustrator shows, submissions, recommendations of designers and authors.

Book Design: Assigns 40 jobs/year. Pays by project.

Text Illustration: Assigns 45-50 freelance illustration jobs/year. Pays by project.

MOREHOUSE PUBLISHING GROUP, P.O. Box 1321, Harrisburg PA 17105. (717)541-8130. Fax: (717)541-8128. Website: http://www.morehousegroup.com. Art Director: Corey Kent. Estab. 1884. Company publishes trade paperback and hardcover originals and reprints. Books are religious. Specializes in spirituality, religious history, Christianity/contemporary issues. Publishes 60 titles/year. Recent titles include *Elizabeth's Beauty*, by Nancy Alberts, illustrated by Pat Skiles; *Glendalough: A Celtic Pilgrimage*, by Michael Rodgers and Marcus Losack. Book catalog free by request.

Needs: Works with 7-8 illustrators and 7-8 designers/year. Prefers freelancers with experience in religious (particularly

Christian) topics. Uses freelancers for book design and formatting. Freelancers should be familiar with Adobe Illustrator, QuarkXPress and Adobe Photoshop. Also uses original art—all media. Works on assignment only.

First Contact & Terms: Send query letter with résumé and photocopies. "Show samples particularly geared for our 'religious' market." Samples are filed or are returned. Reports back only if interested but returns slides/transparencies that are submitted. Portfolio review not required. Usually buys one-time rights. Originals are returned at job's completion. Finds artists through freelance submissions, *Literary Market Place* and mostly word of mouth.

Book Design: Assigns 15 freelance design jobs/year. Pays hourly or by the page.

Text Illustration: Assigns 5 freelance illustration jobs/year for children's books.

Tips: "Prefer using freelancers who are located in central Pennsylvania and are available for meetings when necessary. We also have a special need for freelancers to format text pages."

WILLIAM MORROW & CO. INC., (Lothrop, Lee, Shepard Books), 1350 Avenue of the Americas, New York NY 10019. (212)261-6695. Art Director: Barbara Fitzsimmons. Specializes in hardcover originals and reprint children's books. Publishes 70 titles/year. 100% require freelance illustration. Book catalog free for 8½ × 11″ SASE with 3 first-class stamps.

First Contact & Terms: Works with 30 freelance artists/year. Uses artists mainly for picture books and jackets. Works on assignment only. Send query letter with résumé and samples, "followed by call." Samples are filed. Reports back within 3-4 weeks. Originals returned to artist at job's completion. Portfolio should include original/final art and dummies. Considers complexity of project and project's budget when establishing payment. Negotiates rights purchased.

Book Design: "Most design is done on staff." Assigns 1 or 2 freelance design jobs/year. Pays by the project.

Jackets/Covers: Assigns 1 or 2 freelance design jobs/year. Pays by the project.

Text illustration: Assigns 70 freelance jobs/year. Pays by the project.

Tips: "Be familiar with our publications."

MOUNTAIN PRESS PUBLISHING CO., P.O. Box 2399, Missoula MT 59806. (406)728-1900. Fax: (406)728-1635. E-mail: mtnpress@montana.com. Website: http://www.mnpress.com. Editor: Kathleen Ort. Estab. 1960s. Company publishes trade paperback originals and reprints; some hardcover originals and reprints. Types of books include western history, geology, natural history/nature. Specializes in geology, natural history, history, horses, western topics. Publishes 15 titles/year. Recent titles include Roadside Geology series, Roadside History series, regional photographic field guides. Book catalog free by request.

Needs: Approached by 100 freelance artists/year. Works with 5-10 freelance illustrators/year. Buys 10-50 freelance illustrations/year. Prefers artists with experience in book illustration and design, book cover illustration. Uses freelance artists for jacket/cover illustration, text illustration and maps. 100% of design work demands knowledge of Aldus PageMaker, Aldus FreeHand or Adobe Illustrator. Works on assignment only.

First Contact & Terms: Send query letter with brochure, résumé, SASE and any samples. Samples are filed or are returned by SASE. Reports back only if interested. Project editor will contact artist for portfolio review if interested. Buys one-time rights or reprint rights depending on project. Originals are returned at job's completion. Finds artists through submissions, word of mouth, sourcebooks and other publications.

Book Design: Pays by the project.

Jackets/Covers: Assigns 0-1 freelance design and 3-6 freelance illustration jobs/year. Pays by the project.

Text Illustration: Assigns 0-1 freelance illustration jobs/year. Pays by the project. Prefers b&w: pen & ink, scratchboard, ink wash, pencil.

Tips: First-time assignments are usually book cover/jacket illustration or map drafting; text illustration projects are given to "proven" freelancers.

MOYER BELL, Kymbolde Way, Wakefield RI 02879. (401)789-0074. Fax: (401)789-3793. E-mail: britt@moyerbell.com. Contact: Britt Bell. Estab. 1984. Imprints include Asphodel Press. Publishes hardcover originals, trade paperback originals and reprints. Types of books include biography, coffee table books, history, instructional, mainstream fiction, nonfiction, reference, religious, self-help. Publishes 20 titles/year. 25% require freelance illustration, 25% require freelance design. Book catalog free.

Needs: Works with 5 illustrators and 5 designers/year. Prefers electronic media. Uses freelancers mainly for illustrated books and book jackets. 100% of design and illustration demand knowledge of Adobe Photoshop, Adobe Illustrator, QuarkXPress and Postscript.

First Contact & Terms: Designers send query letter with photocopies. Illustrators send postcard sample and/or photocopies. Accepts disk submissions. Samples are filed or returned by SASE. Rights purchased vary according to project.

Book Design: Assigns 5 freelance design jobs/year. Pays by project; rates vary.

Jackets/Covers: Assigns 5 design jobs and 5 illustration jobs/year. Pays by project; rates vary. Prefers Postscript.

Text Illustration: Assigns 5 freelance illustration jobs/year. Payment varies. Prefers Postscript.

JOHN MUIR PUBLICATIONS, Box 613, Santa Fe NM 87504. (505)982-4078. Production Manager: Nikki Rooker. Publishes trade paperback nonfiction. "We specialize in travel books and children's books and are always actively looking for new illustrations." Publishes 70 titles/year. Recent titles include *The 100 Best Small Art Towns*, by John Villani; and *Europe Through the Back Door*, by Rick Steves.

Needs: Works with 10-15 freelancers/year and 8-10 designers/year. Prefers local layout artists. Must be computer-

literate. 100% of freelance layout and design demand knowledge of QuarkXPress. Illustrations can be camera-ready or digital in EPS or TIFF format.

First Contact & Terms: Send query letter with résumé and samples to be kept on file. Accepts any type of sample "as long as it's professionally presented." Samples and originals are not returned. No phone calls please.

Book Design: Pays by the project. Fees vary between $250-750 per series or project. Considers complexity of project, project's budget, number of books in series and rights purchased when establishing payment. Buys all rights.

Jackets/Covers: Assigns 10-20 freelance design and illustration jobs/year. Pays by the project. Fees vary, most between $250 and $750.

Text Illustration: Assigns approximately 20 freelance jobs/year. Many are maps. Fees vary.

Tips: Looks for "professionalism, experience and attention to detail. History of meeting deadlines is a must."

‡**NATURE PUBLISHING HOUSE**, 6399 Wilshire Blvd. #412, Los Angeles CA 90048. (213)651-2540. Fax: (213)651-2546. E-mail: naturehouse@sprynet.com. Editor: Jon Thibault. Estab. 1997. Publishes trade paperback originals. Types of books include adventure, children's picture books, comic books and fantasy. Specializes in science/nature children's books. Publishes 8-16 titles/year. Recent titles include: *Wildlife Adventure*, *Car Adventure*, *Rain Forest Adventure* and *Volcano Adventure*. 100% requires freelance illustration, freelance design and freelance art direction. Book catalog available for SASE with 1 first-class stamp.

Needs: Approached by 50 illustrators and 30 designers/year. Works with 16 illustrators and 3 designers/year. Prefers freelancers experienced in comic and children's books. 50% of freelance design and 50% of freelance illustration demands knowledge of Adobe Illustrator, Adobe Photoshop, Aldus FreeHand, Aldus PageMaker, PageMaker and Quark XPress.

First Contact & Terms: Designers and illustrators send query letter with printed samples, photocopies and SASE. Samples are filed or are returned by SASE. Reports back in 2 months only if interested. Portfolio review not required. Will contact artist for portfolio review if interested. Rights purchased vary according to project.

Book Design: Assigns 8-16 freelance design jobs and 2-3 freelance art direction projects/year. Fees are negotiated according to project.

Jackets/Covers: Assigns 8-16 freelance design jobs/year. Payment is negotiated. Prefers science, nature, cartoon and comic book experience.

Text Illustration: Assigns 8-16 freelance illustration jobs/year. Payment is negotiated. Prefers illustrators who can combine cartoon/comic characters with serious science/nature information.

Tips: "Looking for 64-page, full-color illustrated children's books that combine fantasy and adventure with science and nature."

NBM PUBLISHING CO., 185 Madison Ave., Suite 1504, New York NY 10016. (212)545-1223. Website: http://www.nbmpub.com. Publisher: Terry Nantier. Publishes graphic novels for an audience of 18-34 year olds. Types of books include adventure, fantasy, mystery, science fiction, horror and social parodies. Recent titles include *Jack the Ripper*, by Rick Geary; and *Kafka Stories*, by Peter Kuper. Circ. 5,000-10,000.

Needs: Approached by 60-70 freelancers/year. Works with 2 freelance designers/year. Uses freelancers for lettering, paste-up, layout design and coloring. Prefers pen & ink, watercolor and oil for graphic novels submissions.

First Contact & Terms: Send query letter with résumé and samples. Samples are filed or are returned by SASE. Reports back within 2 weeks. To show portfolio, mail photocopies of original pencil or ink art. Originals are returned at job's completion.

Tips: "We are interested in submissions for graphic novels. We do not need illustrations or covers only!"

‡**THE NEW ENGLAND PRESS**, Box 575, Shelburne VT 05482. (802) 863-2520. E-mail: nep@together.net. Website: http://www.nepress.com. Managing Editor: Mark Wanner. Specializes in paperback originals on regional New England subjects and nature. Publishes 6-8 titles/year. Recent titles include *The Black Bonnet* and *Spanning Time: Vermont's Covered Bridges*. 50% require freelance illustration. Books have "traditional, New England flavor."

First Contact & Terms: Approached by 50 freelance artists/year. Works with 3-6 illustrators and 1-2 designers/year. Northern New England artists only. Send query letter with brochure, photocopies and tearsheets. Samples are filed. Reports back only if interested. Considers complexity of project, skill and experience of artist, project's budget and turnaround time when establishing payment. Negotiates rights purchased. Originals not usually returned to artist at job's completion, but negotiable.

Book Design: Assigns 6-8 jobs/year. Payment varies.

Jackets/Covers: Assigns 2-4 illustration jobs/year. Payment varies.

Text Illustration: Assigns 2-4 jobs/year. Payment varies.

Tips: Send a query letter with your work, which should be "more folksy than impressionistic."

NORTHWOODS PRESS, P.O. Box 298, Thomaston ME 04561. Division of the Conservatory of American Letters. Editor: Robert Olmsted. Estab. 1972. Specializes in hardcover and paperback originals of poetry. Publishes approximately

6 titles/year. Titles include *Dan River Anthology, 1991*, *Broken Dreams* and *Bound*. 10% require freelance illustration. Book catalog for SASE.
- The Conservatory of American Letters now publishes the *Northwoods Journal*, a quarterly literary magazine. They're seeking cartoons and line art and pay cash on acceptance. Send SASE for complete submission guidelines.

Needs: Approached by 40-50 freelance artists/year. Works with 1-2 illustrators/year. Uses freelance artists mainly for cover illustration. Also uses freelance artists for text illustration.

First Contact & Terms: Send query letter to be kept on file. Art Director will contact artist for portfolio review if interested. Sometimes requests work on spec before assigning a job. Considers complexity of project, skill and experience of artist, project's budget, turnaround time and rights purchased when establishing payment. Buys one-time rights and occasionally all rights. Originals are returned at job's completion.

Book Design: Pays by the project, $10-100.

Jackets/Covers: Assigns 2-3 design jobs and 4-5 illustration jobs/year. Pays by the project, $10-100.

Text Illustration: Pays by the project, $5-20.

Tips: Portfolio should include "art suitable for book covers—contemporary, usually realistic."

‡**NORTHWORD PRESS, INC.**, 5900 Green Oak Dr., Minnetonka MN 55343. (612)936-4700. Fax: (612)933-1456. Editorial Director: Barbara Harold. Estab. 1984. Book publisher; imprint of Cowles Creative Publishing. Publishes hardcover originals and reprints and trade paperback originals and reprints. Types of books include juvenile, history, coffee table books, children's, travel, natural histories and nature guides. Specializes in nature, wildlife and environmental. Publishes about 40 titles/year. Recent titles include *Brother Wolf*, *Trout Country* and *Dear Children of the Earth*. 20% require freelance illustration; 80% require freelance design. Book catalog free by request.

Needs: Approached by 10-15 freelance artists/year. Works with 1-2 illustrators and 3-4 designers/year. "We commission packages of 30-40 illustrations for 1-2 titles/year, possibly a cover. Most books are illustrated with photos." Prefers artists with experience in wildlife art. Uses freelancers mainly for illustration. Works on assignment only.

First Contact & Terms: Send query letter with brochure, SASE, tearsheets, photographs, photocopies, photostats, slides and transparencies. "No originals, and make sure they fit in standard-size folders." Samples are filed or are returned by SASE. Reports back only if interested. "I prefer samples mailed and will call to contact the artist if I want to see a portfolio." Negotiates rights purchased. Originals returned at job's completion "unless we purchase all rights."

Text Illustration: Assigns 4-6 illustration jobs/year. Pays by the project, $50-2,000. Any medium accepted.

Tips: "Sales materials are assigned throughout the year."

‡❀**NOVALIS PUBLISHING, INC.**, 49 Front St. E., 2nd Floor, Toronto, Ontario M53 1B3 Canada. (416)363-3303. Fax: (416)363-9409. E-mail: novalis@interlog.com. Director of Sales & Marketing: Lauretta Santarossa. Publicity Coordinator: Kathy Shaidle. Estab. 1936. Publishes hardcover, mass market and trade paperback originals and textbooks. Primarily religious. Publishes 30 titles/year. Recent titles include: *Fergie the Frog* series, *On Our Way With Jesus* (sacramental preparation textbook). 100% requires freelance illustration; 25% requires freelance design; and 25% require freelance art direction. Free book catalog available.

Needs: Approached by 4 illustrators and 4 designers/year. Works with 3-5 illustrators and 2-4 designers/year. Prefers local freelancers experienced in graphic design and production. 100% of freelance work demands knowledge of Adobe Illustrator, Adobe Photoshop, Aldus PageMaker, PageMaker, QuarkXPress.

First Contact & Terms: Send postcard sample or query letter with printed samples, photocopies, tearsheets. Samples are filed or returned on request. Will contact artist for portfolio review if interested. Rights purchased vary according to project; negotiable.

Book Design: Assigns 10-20 freelance design and 2-5 art direction projects/year. Pays for design by the hour, $25-40.

Jackets/Covers: Assigns 5-10 freelance design and 2-5 illustration jobs/year. Prefers b&w, ink, woodcuts, linocuts, varied styles. Pays for design by the project, $100-800, depending on project. Pays for illustration by the project, $100-800, depending on project. Pays for illustration by the project, $100-600.

Text Illustration: Assigns 2-10 freelance illustration jobs/year. Pays by the project, $100 minimum, depending on project.

Tips: "We look for dynamic design incorporating art and traditional, non-traditional, folk etc. with spiritual, religious, Gospel, biblical themes—mostly Judaeo Christian."

‡**NTC/CONTEMPORARY PUBLISHING**, 4255 W. Touhy Ave., Lincolnwood IL 60646. (847)679-5500. Art Director: Kim Bartko. Book publisher. Publishes hardcover originals and trade paperback originals. Publishes nonfiction. Types of books include arts and crafts, biography, cookbooks, foreign language, humor, instructional, mainstream/contemporary, parenting business, pets, quilting, reference and self-help. Publishes 225 titles/year. 15% require freelance

 SPECIAL COMMENTS within listings by the editor of *Artist's & Graphic Designer's Market* are set off by a bullet.

illustration. Recent titles include *The Game That Was*, by Richard Cahan and Mark Jacob; *Feng Shui: The Book of Cures*, by Nancilee Wydra; *What to Eat If You Have Cancer*, by Daniela Chase and *Dog Smart*, by Myrna Milani. Book catalog not available.

Needs: Approached by 150 freelancers/year. Works with 20 freelance illustrators/year. Works with freelance illustrators for covers and interiors. Book interiors require spot illustrations in 1 and 2-color, also icon-type illustration for interiors. Works on assignment only. 100% design and 40% illustration demand knowledge of QuarkXPress 3.31, Adobe Photoshop 3.0 and Adobe Illustrator 5.5.

First Contact & Terms: Designer send query letter with tearsheets and résumé. Illustrators should send postcard sample, query letter with tearsheets. Accepts disk submissions compatible with above programs. Samples are filed or are not returned. Does not report back. To show portfolio, mail tearsheets and final reproduction/product. Considers complexity of project, skill and experience of artist and project's budget when establishing payment. Buys reprint rights.

Jackets/Covers: Assigns 20 freelance illustration jobs/year. Pays by the project, $500-1,000.

Text Illustration: Assigns 10 freelance jobs/year.

OCTAMERON PRESS, 1900 Mount Vernon Ave., Alexandria VA 22301. Website: http://www.octameron.com. Editorial Director: Karen Stokstod. Estab. 1976. Specializes in paperbacks—college financial and college admission guides. Publishes 10-15 titles/year. Titles include *College Match* and *The Winning Edge*.

Needs: Approached by 25 freelancers/year. Works with 1-2 freelancers/year. Works on assignment only.

First Contact & Terms: Send query letter with brochure showing art style or résumé and photocopies. Samples not filed are returned if SASE included. Considers complexity of project and project's budget when establishing payment. Rights purchased vary according to project.

Jackets/Covers: Works with 1-2 designers and illustators/year on 15 different projects. Pays by the project, $300-700.

Text Illustration: Works with variable number of artists/year. Pays by the project, $35-75. Prefers line drawings to photographs.

Tips: "The look of the books we publish is friendly! We prefer humorous illustrations."

ORCHARD BOOKS, 95 Madison Ave., Room 701, New York NY 10016. E-mail: jwilson@grolier.com. Website: http://grolierpublishing.com. Book publisher. Division of Grolier Inc. Art Director: Mina Greenstein. Estab. 1987. Publishes hardcover and paperback children's books. Specializes in picture books and novels for children and young adults. Publishes 60 titles/year. Recent titles include *Graphic Alphabet*, by David Pelletier and *A Girl Named Disaster*, by Nancy Farmer. 100% require freelance illustration; 25% require freelance design. Book catalog free for SAE with 2 first-class stamps.

Needs: Works with 50 illustrators/year. Works on assignment only. 5% of titles require freelance art direction.

First Contact & Terms: Designers send brochure and/or photocopies. Illustrators send brochure, photocopies and/or tearsheets. Samples are filed or are returned by SASE only if requested. Reports back about queries/submissions only if interested. Originals returned to artist at job's completion. Call or write for appointment to show portfolio or mail appropriate materials. Portfolio should include thumbnails, tearsheets, final reproduction/product, slides and dummies or whatever artist prefers. Considers complexity of project, skill and experience of artist and project's budget when establishing payment. Buys all rights.

Book Design: Assigns 15 freelance design jobs/year. Pays by the project, $650 minimum.

Jackets/Covers: Assigns 20 freelance design jobs/year. Pays by the project, $650 minimum.

Text Illustration: Assigns 5 freelance jobs/year. Pays by the project, minimum $2,000 advance against royalties.

Tips: "Send a great portfolio."

‡OREGON CATHOLIC PRESS, 5536 NE Hassalo, Portland OR 97213-3638. (503)281-1191. Fax: (503)282-3486. E-mail: jeang@ocp.org. Website: http://ocp.org/. Art Director: Jean Germano. Estab. 1997. Types of books include religious and liturgical books specifically for, but not exclusively to, the Roman Catholic market. Publishes 2-5 titles/year. Recent titles include: *Trouble Shooters Voice Manual*, *Good Guitar Stuff* and *Children's Prayers*. 50% requires freelance illustration; 100% requires freelance art direction. Book catalog available for 9×12 SAE with first-class stamps.

● Oregon Catholic Press (OCP Publications) is a nonprofit publishing company, producing music and liturgical publications used in parishes throughout the United States, Canada, England and Australia. A piece written by one of their composers was sung at Princess Diana's funeral. This publisher also has listings in the Magazine and Record Labels sections.

Tips: "I am always looking for appropriate art for our projects. We tend to use work already created, on a one-time use basis, as opposed to commissioned pieces. I look for tasteful, not overtly religious art. Our book division is a new division. We anticipate 2-3 new books per year."

‡OREGON HISTORICAL SOCIETY PRESS, 1200 SW Park Ave., Portland OR 97205. (503)222-1741. Fax: (503)221-2035. Managing Editor: Adair Law. Estab. 1898. Imprints include Eager Beaver Books. Company publishes hardcover originals, trade paperback originals and reprints, mars, posters, plans, postcards. Types of books include biography, travel, reference, history, reprint juvenile and fiction. Specializes in Pacific Northwest history, geography, natural history. Publishes 10-12 biography titles/year. Recent titles include *So Far From Home: An Army Bride on the Western Frontier*; *Hail, Columbia*; *Journal of Travels*; and *Oregon Geographic Names*, Sixth Edition. 25% require freelance illustration; 50% require freelance design. Book catalog free by request.

Needs: Approached by 10-50 freelance artists/yaer. Works with 8-10 freelance illustrators and 2-5 freelance designers/year. Buys 0-50 freelance illustrations/year. Prefers local artists only. Uses freelance artists mainly for illustrations and maps. Also uses freelance artists for jacket/cover and text illustration, book design. 20% of freelance work demands knowledge of Aldus PageMaker. Works on assignment only.
First Contact & Terms: Send query letter with brochure, résumé, tearsheets and photocopies. Samples are filed or are returned by SASE. Reports back within 10 days. Art Director will contact artist for portfolio review if interested. Portfolio should include b&w thumbnails, roughs, final art, slides and photographs. Buys one-time rights or rights purchased vary according to project. Originals are returned at job's completion.
Book Design: Assigns 2-5 freelance design jobs/year. Pays by the project.
Jackets/Covers: Assigns 2-5 freelance design and 2-5 freelance illustration jobs/year. Pays by the project.
Text Illustration: Assigns 8-10 freelance illustration jobs/year. Pays by the hour or by the project.

✓OTTENHEIMER PUBLISHERS, INC., 5 Park Center Court #300, Owings Mills MD 21117. (410)902-9100. Fax: (410)902-7210. Contact: Art Director. Estab. 1890. Book producer. Specializes in mass market and trade, hardcover, pop and paperback originals—cookbooks, children's, encyclopedias, dictionaries, novelty and self-help. Publishes 200 titles/year. Titles include *Ancient Healing Secrets* and *Santa's Favorite Sugar Cookies*. 80% require freelance illustration.
Needs: Works with 100 illustrators and 3 freelance designers/year. Prefers professional graphic designers and illustrators. 100% of design demands knowledge of the latest versions of Adobe Illustrator, QuarkXPress and Adobe Photoshop.
First Contact & Terms: Designers send résumé, client list, photocopies or tearsheets to be kept on file. Illustrators send postcard sample and/or photocopies, tearsheets and client list. Accepts disk submissions from designers, not illustrators. Samples not filed are returned by SASE. Reports back only if interested. Call or write for appointment to show portfolio. No unfinished work or sketches. Considers complexity of project, project's budget and turnaround time when establishing payment. Buys all rights. Originals are returned at job's completion. No phone calls.
Book Design: Assigns 20-40 design jobs/year. Pays by the project, $500-4,000.
Jackets/Covers: Assigns 25 design and 25 illustration jobs/year. Pays by the project, $500-1,500, depending upon project, time spent and any changes.
Text Illustration: Assigns 30 jobs/year, both full color media and b&w line work. Prefers graphic approaches as well as very illustrative. "We cater more to juvenile market." Pays by the project, $500-10,000.
Tips: Prefers "art geared towards children—clean work that will reproduce well. I also look for the artist's ability to render children/people well. We use art that is realistic, stylized and whimsical but not cartoony. The more samples, the better. Take schedules seriously. Maintain a sense of humor."

‡THE OVERLOOK PRESS, 386 W. Broadway, New York NY 10012. (212)965-8400. Fax: (212)965-9834. Art Director: Bridgid McCarthy. Estab. 1970. Book publisher. Publishes hardcover originals. Types of books include contemporary and experimental fiction. Publishes 40 titles/year. 60% require freelance illustration; 40% require freelance design. Book catalog for SASE.
Needs: Approached by 10 freelance artists/year. Works with 4 freelance illustrators and 4 freelance designers/year. Buys 5 freelance illustrations/year. Prefers local artists only. Uses freelance artists mainly for jackets. Works on assignment only.
First Contact & Terms: Send query letter with SASE. Samples are filed or are returned by SASE. Reports back within 1 week. To show a portfolio, mail tearsheets and slides. Buys one-time rights. Originals returned to artist at job's completion.
Jackets/Covers: Assigns 10 freelance design jobs/year. Pays by the project, $250-350.

RICHARD C. OWEN PUBLICATIONS INC., P.O. Box 585, Katonah NY 10536. (914)232-3903. Fax: (914)232-3977. Art Director: Janice Boland. Estab. 1986. Company publishes children's books. Types of books include juvenile fiction and nonfiction. Specializes in books for 5-, 6- and 7-year-olds. Publishes 20-23 titles/year. Recent titles include: *Jump The Brook*, by Candy Grant Helmso; *There Was A Mouse*, by Blanchard/Suhr. 100% require freelance illustration.
Needs: Approached by 200 freelancers/year. Works with 20-40 freelance illustrators/year. Prefers freelancers with experience in children's books. Uses freelancers for jacket/cover and text illustration. Works on assignment only.
First Contact & Terms: First request guidelines. Send samples of work (color brochure, tearsheets and photocopies). Samples are filed. Art director will contact artist if interested. Buys all rights. Original illustrations are returned at job's completion.
Text Illustration: Assigns 20-40 freelance illustration jobs/year. Pays by the project, $1,000-3,000 for a full book; $25-100 for spot illustrations.
Tips: "Show adequate and only best samples of work. Send varied work—but target the needs of the individual publisher. Send color work—no slides. Be persistent—keep file updated. Be willing to work with the art director."

OXFORD UNIVERSITY PRESS, English as a Second Language (ESL), 198 Madison Ave., 9th Floor, New York NY 10016. Website: http://www.oup-usa.org. Art Buyers: Tracy Hammond, Donna Goldberg, Alexandra F. Rockafeller. Chartered by Oxford University. Estab. 1478. Specializes in fully illustrated, not-for-profit, contemporary textbooks emphasizing English as a second language for children and adults. Also produces wall charts, picture cards, CDs and cassettes. Recent titles include *Hotline*, *Let's Go* and various Oxford Picture Dictionaries.
Needs: Approached by 1,000 freelance artists/year. Works with 100 illustrators and 8 designers/year. Uses freelancers mainly for interior illustrations of exercises. Also uses freelance artists for jacket/cover illustration and design. Some

need for computer-literate freelancers for illustration. 20% of freelance work demands knowledge of QuarkXPress or Adobe Illustrator. Works on assignment only. 10% of titles require freelance art direction.

First Contact & Terms: Send query letter with brochure, tearsheets, photostats, slides or photographs. Samples are filed. Art Buyer will contact artist for portfolio review if interested. Artists work from detailed specs. Considers complexity of project, skill and experience of artist and project's budget when establishing payment. Artist retains copyright. Originals are returned at job's completion. Finds artists through submissions, artist catalogs such as *Showcase*, *Guild Book*, etc. occasionally from work seen in magazines and newspapers, other illustrators.

Jackets/Covers: Pays by the project, $750 minimum.

Text Illustration: Assigns 500 jobs/year. Uses "black line, half-tone and 4-color work in styles ranging from cartoon to realistic. Greatest need is for natural, contemporary figures from all ethnic groups, in action and interaction." Pays for text illustration by the project, $45/spot, $2,500 maximum/full page.

Tips: "Please wait for us to call you. You may send new samples to update your file at any time. We would like to see more natural, contemporary, nonwhite people from freelance artists. Most art is fairly realistic and cheerful. We do appreciate verve and style—we don't do stodgy texts."

PAGES PUBLISHING GROUP, 801 94th Ave. N., St. Petersburg FL 33702-2426. (813)578-7600. Fax: (813)578-3105. E-mail: mpetty@pagesinc.com. Art Director: Michael Petty. Estab. 1982. Imprints include Riverbank Press, Hamburger Press, Willowisp Press, Worthington Press. Publishes trade paperback originals and reprints, mass market paperback originals and reprints, audio tapes. Types of book include adventure, biography, comic books, fantasy, history, horror, humor, juvenile, mainstream, nonfiction, preschool, romance, science fiction, young adult, calendars, activity kits, bookmarks, posters, diary books, etc. Specializes in juvenile and young adult fiction and nonfiction. Publishes 60-70 titles/year. Recent titles include *The Gingerbread Man*, *Big Bad Bugs!*, *Scary Kids*, *Bobby and the Great Great Booger*, *The Haunted Underwear*, *Wonderful Wolves of the Wild*. 90% require freelance illustration. Book catalog free for 9×11 SASE with 6 first-class stamps.

Needs: Approached by 100-150 freelance illustrators and 20 freelance designers/year. Works with 30-35 freelance illustrators/year. Prefers freelancers experienced in children's book publishing. Uses freelancers mainly for illustration work for picture books and covers.

First Contact & Terms: Illustrators send query letter with photocopies, photographs, photostats, printed samples, résumé, SASE and/or tearsheets. Send postcard sample and follow-up postcards every year. Accepts disk submissions compatible with QuarkXPress 7.5/version 3.3 or Adobe Photoshop. Send EPS files. Samples are filed and are returned by SASE. Art director will contact artist for portfolio review if interested. Rights vary according to project. Finds freelancers through agents, submissions.

Jacket/Covers: Assigns 60-70 freelance illustration jobs/year. Pays for illustration by the project $500-2,600.

Text Illustration: Assigns 60-70 freelance illustration jobs/year. Pays by the project, $50-6,000.

Tips: It is helpful if artist is knowledgeable about the way color reproduces in the printing process. "Have a clear, clean and well done submission."

PARADIGM PUBLISHING INC., 875 Montreal Way, St. Paul MN 55102. (612)771-1555. E-mail: jsilver@emcp.com. Production Director: Joan D'Onofrio. Estab. 1989. Book publisher. Publishes textbooks. Types of books include business and office, communications, software-specific manuals. Specializes in basic computer skills. Publishes 50 titles/year. Recent titles include *Key to Success*, JoAnn Sheeron; and *Word Perfect 6.0*, by Nita Rutkosky. 100% require freelance illustration and design. Books have very modern high-tech design, mostly computer-generated. Book catalog free by request.

Needs: Approached by 50-75 freelancers/year. Works with 14 freelance illustrators and 20 designers/year. Uses freelance artists mainly for covers. Works on assignment only.

First Contact & Terms: Send brochure and slides. Samples are filed. Slides are returned. Art director will contact artist for portfolio review if interested. Portfolio should include b&w and color transparencies. Rights purchased vary according to project. Interested in buying second rights (reprint rights) to previously published work. Finds artists through submissions, agents and recommendations.

Book Design: Assigns 10 freelance design jobs and 30 illustration jobs/year. Pays by the project, $500-1,500.

Jackets/Covers: Assigns 20 freelance design jobs and 20 illustration jobs/year. Pays by the project, $400-1,500.

Text Illustration: Pays $25-100/illustration.

Tips: "All work is being generated by the computer. I don't use any art that is done by hand, however, I am not interested in computer techies who think they are now designers. I'm looking for excellent designers who are highly competent on the computer."

‡PAULINE BOOKS & MEDIA, 50 St. Pauls Ave., Boston MA 02130-3491. (617)522-8911. Fax: (617)541-9805. Website: http://www.pauline.org. Contact: Graphic Design Dept. Estab. 1932. Book publisher. "We also publish a children's magazine and produce audio and video cassettes." Publishes hardcover and trade paperback originals and reprints and textbooks. Also electronic books and software. Types of books include instructional, biography, preschool, juvenile, young adult, reference, history, self-help, prayer and religious. Specializes in religious topics. Publishes 20 titles/year. Art guidelines available. Sample copies for SASE with first-class postage.

Needs: Approached by 50 freelancers/year. Works with 10-20 freelance illustrators/year. Also needs freelancers for multimedia projects. 65% of freelance work demands knowledge of Aldus PageMaker, Illustrator, Photoshop, etc.

First Contact & Terms: Send query letter with résumé, SASE, tearsheets and photocopies. Accepts disk submissions

Joe Veno brought a gecko to life in acrylics with airbrush on the pages of *Gecko's Story*, by Kathleen Hardcastle (published by Richard C. Owen Publications). Art Director Janice Boland says her company's criteria is demanding, but Veno's "child-appealing, colorful, rich, detailed, energetic, authentic, painterly style" more than meets it. Veno got the assignment through his rep, and feels doing this book has opened him up to working with more publishers.

compatible with Windows 95, Mac. Send EPS, TIFF, GIF or TARGA files. Samples are filed or are returned by SASE. Reports back within 1-3 months only if interested. Rights purchased vary according to project. Originals are returned at job's completion.

Jackets/Covers: Assigns 1-2 freelance illustration jobs/year. Pays by the project.

Text Illustration: Assigns 3-10 freelance illustration jobs/year. Pays by the project.

PAULIST PRESS, 997 Macarthur Blvd., Mahwah NJ 07430. (201)825-7300. Fax: (201)825-8345. Managing Editor: Don Brophy. Juvenile Book Editor: Karen Scialabba. Estab. 1869. Company publishes hardcover and trade paperback originals and textbooks. Types of books include biography, juvenile and religious. Specializes in academic and pastoral theology. Publishes 95 titles/year. 5% require freelance illustration; 5% require freelance design.

Needs: Works with 10-12 freelance illustrators and 15-20 designers/year. Prefers local freelancers. Uses freelancers for juvenile titles, jacket/cover and text illustration. 10% of freelance work demands knowledge of QuarkXPress. Works on assignment only.

First Contact & Terms: Send query letter with brochure, résumé and tearsheets. Samples are filed. Reports back only if interested. Portfolio review not required. Negotiates rights purchased. Originals are returned at job's completion if requested.

Book Design: Assigns 10-12 freelance design jobs/year.

Jackets/Covers: Assigns 90 freelance design jobs/year. Pays by the project, $400-800.

Text Illustration: Assigns 3-4 freelance illustration jobs/year. Pays by the project.

‡THE PAY DAY NEWS, P.O. Box 792, Woodbine NJ 08270-0792. (609)628-2653. Fax: (609)628-4711. E-mail: payday2@bellatlantic.net. Website: http://youonline.net/payday. President: John Mason. Estab. 1982. Publishes trade

paperback originals. Types of books include humor, instructional, reference, religious, self help, homebased business. Specializes in instructional books. Publishes 12 titles/year. Recent titles include: *How To Sell Your Products on the Internet*, *How To Avoid Informercial Scams*. 10% requires freelance illustration; 90% requires freelance design. Free book catalog available.
Needs: Works with 25 designers/year. 100% of freelance work demands knowledge of Adobe Photoshop, Aldus PageMaker.
First Contact & Terms: Send query letter with photocopies. Accepts Window-compatible disk submissions, TIFF files or html. Samples are not filed and are returned by SASE. Will contact artist for portfolio review if interested. Buys one-time rights. Finds freelancers through Internet and newsletters.
Text Illustration: Assigns 50 freelance illustration jobs/year. Pays by the project, $25-200.
Tips: "We also place freelancers in our Internet directory in an attempt to help network their talents. Visit our website and get listed."

‡PEACHPIT PRESS, INC., 1249 Eighth St., Berkeley CA 94710. (510)524-2178. Fax: (510)524-2221. Estab. 1986. Book publisher. Types of books include instruction and computer. Specializes in desktop publishing and Macintosh topics. Publishes 50-60 titles/year. Recent titles include: *The Macintosh Bible*, *HTML for the World Wide Web: Visual Quickstart Guide* and *The Little PC Book*. 50% require freelance design. Book catalog free by request.
Needs: Approached by 50-75 artists/year. Works with 4 freelance designers/year. Prefers artists with experience in computer book cover design. Uses freelance artists mainly for covers, fliers and brochures. Also uses freelance artists for direct mail and catalog design. Works on assignment only.
First Contact & Terms: Send query letter with résumé, photographs and photostats. Samples are filed. Reports back to the artist only if interested. Call for appointment to show a portfolio of original/final art and color samples. Buys all rights. Originals are not returned at job's completion.
Book Design: Pays by the project, $500-2,000.
Jackets/Covers: Assigns 40-50 freelance design jobs/year. Pays by the project, $1,000-7,000.

✔PEANUT BUTTER PUBLISHING, Pier 55, Seattle WA 98101. (206)281-5965. E-mail: pnutpub@aol.com. Website: http://www.pbpublishing.com. Editor: Elliott Wolf. Estab. 1972. Book publisher. Publishes 100 titles/year. 100% require freelance illustration. Titles include *A Wok with Mary Pang*, *Lentil and Split Pea Cookbook* and *Miss Ruby's Southern Creole and Cajun Cuisine*.
Needs: Approached by 70 freelance artists/year. Needs freelancers for multimedia projects. 95% of design demands computer skills.
First Contact & Terms: Works on assignment only. Send résumé and brochure showing art style or tearsheets, photostats and photocopies. Accepts disk submissions. Samples not filed are returned only if requested. Reports only if interested. To show portfolio, mail appropriate materials. Payment negotiable.
Tips: Books contain pen & ink and 4-color photos."Don't act as if you know more about the work than we do. Do exactly what is assigned to you."

PELICAN PUBLISHING CO., Box 3110, Gretna LA 70054. (504)368-1175. Fax: (504)368-1195. Contact: Production Manager. Publishes hardcover and paperback originals and reprints. Publishes 60-70 titles/year. Types of books include travel guides, cookbooks, business/motivational, architecture, golfing, history and children's books. Books have a "high-quality, conservative and detail-oriented" look.
Needs: Approached by 200 freelancers/year. Works with 20 freelance illustrators/year. Uses freelancers for illustration and multimedia projects. Works on assignment only. 100% of design and 50% of illustration demand knowledge of QuarkXPress, Adobe Photoshop 4.0, Adobe Illustrator 4.0.
First Contact & Terms: Designers send photocopies, photographs, SASE, slides and tearsheets. Illustrators send postcard sample or query letter with photocopies, SASE, slides and tearsheets. Samples are not returned. Reports back on future assignment possibilities. Buys all rights. Originals are not returned.
Book Design: Pays by the project, $500 minimum.
Jackets/Covers: Pays by the project, $150-500.
Text Illustration: Pays by the project, $50-250.
Tips: "Show your versatility. We want to see realistic detail and color samples."

PEN NOTES, INC., 61 Bennington Ave., Freeport NY 11520-3919. (516)868-5753. Fax: (516)868-8441. E-mail: pennotes@worldnet.att.net. Website: http://www.PenNotes.com. President: Lorette Konezny. Produces learning books and calligraphy kits for children ages 3 and up, teenagers and adults. Clients: Bookstores, toy stores and parents.
Needs: Prefers New York artists with book or advertising experience. Works on assignment only. Each year assigns 1-2 books (with 24 pages of art) to freelancers. Uses freelancers for children's illustration, P-O-P display and design and mechanicals for catalog sheets for children's books. 100% of freelance design and up to 50% of illustration demand computer skills. Prefers knowledge of press proofs on first printing. Prefers imaginative, realistic style with true perspective and color. 100% of the titles require freelance art direction.
First Contact & Terms: Designers send brochure, résumé, SASE, tearsheets and photocopies. Illustrators send sample with brochure, résumé and tearsheets. Samples are filed. Call or write for appointment to show portfolio or mail final reproduction/product, color and b&w tearsheets and photostats. Pays for design by the hour, $15-36; by the project, $60-125. Pays for illustration by the project, $60-500/page. Buys all rights.

Tips: "Work must be clean, neat and registered for reproduction. The style must be geared for children's toys. Looking for realistic/cartoon outline with flat color. You must work on deadline schedule set by printing needs. Must have full range of professional and technical experience for press proof. All work is property of Pen Notes, copyright property of Pen Notes."

PENGUIN BOOKS, 375 Hudson St., New York NY 10014. (212)366-2000. Website: http://www.penguin.com. Art Director: Paul Buckley. Publishes hardcover and trade paperback originals.
Needs: Works with 10-20 freelance illustrators and 10-20 freelance designers/year. Uses freelancers mainly for jackets, catalogs, etc.
First Contact & Terms: Send query letter with tearsheets, photocopies and SASE. Rights purchased vary according to project.
Book Design: Pays by the project; amount varies.
Jackets/Covers: Pays by the project; amount varies.

‡PERFECTION LEARNING CORPORATION, COVER-TO-COVER, 10520 New York Ave., Des Moines IA 50322-3775. (515)278-0133. Fax: (515)278-2980. E-mail: rmesser@plconline.com. Website: http://www.plconline.com. Art Director: Randy Messer. Senior Designer: Deb Bell. Estab. 1927. Publishes audio tapes, hardcover originals and reprints, mass market paperback originals and reprints, educational resources, trade paperback originals and reprints, careers, health, high general interest/low reading level, multicultural, nature, science, social issues, sports. Specializes in high general interest/low reading level and Lit-based teacher resources. Publishes 50-75 titles/year. Recent titles include: *Kooties Club Mysteries*, *The Iditarod*, *Gorillas*, *Child Care*. 50% requires freelance illustration.
Needs: Approached by 100 illustrators and 10-20 designers/year. Works with 20-30 illustrators/year. Prefers local designers and art directors. Prefers freelancers experienced in cover illustration and interior spot—4-color and b&w. 100% of freelance design demands knowledge of QuarkXPress.
First Contact & Terms: Illustrators send postcard or query letter with printed samples, photocopies, SASE, tearsheets. Accepts Mac-compatible disk submissions. Send EPS. Samples are filed or returned by SASE. Reports back only if interested. Portfolio review not required. Rights purchased vary according to project. Finds freelancers through tearsheet submissions, illustration annuals, phone calls, artists' reps.
Jackets/Covers: Assigns 20-30 freelance illustration jobs/year. Pays for illustration by the project, $250-750, depending on project. Prefers illustrators with conceptual ability.
Text Illustration: Assigns 5-10 freelance illustration jobs/year. Pays by the project. Prefers freelancers who are able to draw multicultural children and good human anatomy.
Tips: "We look for good conceptual skills, good anatomy, good use of color. Our materials are sold through schools for classroom use—they need to meet educational standards."

PETER PAUPER PRESS, INC., 202 Mamaroneck Ave., White Plains NY 10601. (914)681-0144. Fax: (914)681-0389. E-mail: pauperp@aol.com. Contact: Creative Director. Estab. 1928. Company publishes hardcover small format illustrated gift books and photo albums. Specializes in friendship, love, celebrations, holidays, topics of interest to women. Publishes 72 titles/year. Recent titles include *A Woman's Book of Zen*, photographed and designed by Lesley Ehlers; *The Key to Friendship*, illustrated by Jo Gershman; and *Truehearts® Beat As One*; illustrated by Wendy Wallin-Malinow. 100% require freelance illustration; 100% require freelance design.
 ● Peter Pauper has significantly increased its pay for illustration and now relies 100% on freelance illustration and design.
Needs: Approached by 75-100 freelancers/year. Works with 15-20 freelance illustrators and 3-5 designers/year. Uses freelancers for jacket/cover and text illustration. 100% of freelance design demands knowledge of QuarkXPress. Works on assignment only.
First Contact & Terms: Send query letter with brochure, résumé, SASE, photographs, tearsheets or photocopies. Samples are filed or are returned by SASE. Reports back within 1 month with SASE. Art Director will contact artist for portfolio review if interested. Portfolio should include book dummy, final art, photographs and photostats. Rights purchased vary according to project. Originals are returned at job's completion. Finds artists through submissions, gift and card shows.
Book Design: Assigns 65 freelance design jobs/year. Pays by the project, $500-2,500.
Jackets/Covers: Assigns 65 freelance design and 40 illustration jobs/year. Pays by the project, $800-1,200.
Text Illustration: Assigns 65 freelance illustration jobs/year. Pays by the project, $1,000-2,800.
Tips: "Knowledge of the type of product we publish is extremely helpful in sorting out artists whose work will click for us."

‡THE PILGRIM PRESS/UNITED CHURCH PRESS, 700 Prospect Ave. E., Cleveland OH 44115-1100. (216)736-3726. Art Director: Martha Clark. Production: Madrid Tramble. Estab. 1957. Company publishes hardcover originals and trade paperback originals and reprints. Types of books environmental ethics, human sexuality, devotion, women's studies, justice, African-American studies, world religions, Christian education, curriculum, reference and social and ethical philosophical issues. Specializes in religion. Publishes 45-50 titles/year. Recent titles include *In Good Company: A Woman's Journal for Spiritual Reflection*. 75% require freelance illustration; 50% require freelance design. Books are progressive, classic, exciting, sophisticated—conceptually looking for "high design." Book catalog free by request.
Needs: Approached by 50 freelancers/year. Works with 20 freelance illustrators and 10 designers/year. Buys 50 illustra-

tions/year. Prefers freelancers with experience in book publishing. Uses freelancers mainly for covers, catalogs and illustration. Also for book design. Works on assignment only.

First Contact & Terms: Send query letter with résumé, tearsheets and photocopies. Samples are filed and are not returned. Art Director will contact artist for portfolio review if interested. Negotiates rights purchased. Interested in buying second rights (reprint rights) to previously published work based on need, style and concept/subject of art and cost. "I like to see samples." Originals are returned at job's completion. Finds artists through agents and stock houses.

Book Design: Assigns 50 freelance design jobs/year. Pays by the project, $500.

Jackets/Covers: Assigns 125 freelance design jobs/year. Prefers contemporary styles. Pays by the project, $500-700.

Text Illustration: Assigns 15-20 design and 15-20 illustration jobs/year. Pays by the project, $200-500; negotiable, based on artist estimate of job, number of pieces and style.

Tips: "I also network with other art directors/designers for their qualified suppliers/freelancers. If interested in curriculum illustration, show familiarity with illustrating biblical art and diverse races and ages."

PINCUSHION PRESS, 6001 Johns Rd., Suite 148, Tampa FL 33634-4448. (813)855-3071. Fax: (813)855-4213. Art Director: Jeffrey Lawrence. Estab. 1990. Publishes hardcover and trade paperback originals. Types of books include coffee table books and nonfiction. Specializes in antiques and collectibles. Publishes 8 titles/year. Recent titles include: *Collecting Tin Toys.* 10% require freelance illustration; 90% require freelance design. Book catalog free for $1.01 postage.

Needs: Approached by 10 illustrators and 10 designers/year. Works with 1 freelance illustrator and 5 designers/year. Uses freelancers mainly for book jacket and book interior design. 75% of freelance design and 50% of illustration demands knowledge of Aldus PageMaker, Aldus FreeHand, Adobe Photoshop, Adobe Illustrator, QuarkXPress.

First Contact & Terms: Designers send query letter with photocopies and photographs. Illustrators send printed samples. Samples are not filed and are returned by SASE. Portfolio review required from designers. Request portfolio review in original query. Portfolio should include book dummy, photocopies, photographs. Negotiates rights purchased, rights purchased vary according to project. Finds freelancers through word of mouth and artists' submissions.

Book Design: Assigns 8 freelance design jobs/year. Pays by project.

Jackets/Covers: Pays by project. Prefers fully rendered art.

Text Illustration: Pays by project.

‡PIPPIN PRESS, 229 E. 85th St., Gracie Station Box 1347, New York NY 10028. (212)288-4920. Fax: (908)225-1562. Publisher: Barbara Francis. Estab. 1987. Company publishes hardcover juvenile originals. Publishes 4-6 titles/year. Recent titles include *Abigail's Drums*, *The Spinner's Daughter*, *The Sounds of Summer* and *Windmill Hill*. 100% require freelance illustration; 50% require freelance design. Book catalog free for SAE with 2 first-class stamps.

Needs: Approached by 50-75 freelance artists/year. Works with 6 freelance illustrators and 2 designers/year. Prefers artists with experience in juvenile books for ages 4-10. Uses freelance artists mainly for book illustration. Also uses freelance artists for jacket/cover illustration and design and book design.

First Contact & Terms: Send query letter with résumé, tearsheets, photocopies. Samples are filed "if they are good" and are not returned. Reports back within 2 weeks. Portfolio should include selective copies of samples and thumbnails. Buys all rights. Originals are returned at job's completion.

Book Design: Assigns 3-4 freelance design jobs/year.

Text Illustration: All text illustration assigned to freelance aritsts.

Tips: Finds artists "through exhibits of illustration and looking at recently published books in libraries and bookstores."

PLAYERS PRESS, Box 1132, Studio City CA 91614. Associate Editor: Jean Sommers. Specializes in plays and performing arts books. Recent titles include *Period Costume for Stage & Screen—Medieval*, by Jean Hunnisett; and *Assignments in Musical Theatre*, by Jacque Wheeler and Haller Laughlin.

Needs: Works with 3-15 freelance illustrators and 1-3 designers/year. Uses freelancers mainly for play covers. Also for text illustration. Works on assignment only.

First Contact & Terms: Send query letter with brochure showing art style or résumé and samples. Samples are filed or are returned by SASE. Request portfolio review in original query. Art Director will contact artist for portfolio review if interested. Portfolio should include thumbnails, final reproduction/product, tearsheets, photographs and "as much information as possible." Sometimes requests work on spec before assigning a job. Buys all rights. Considers buying second rights (reprint rights) to previously published work, depending on usage. "For costume books this is possible."

Book Design: Pays by the project, rate varies.

Jackets/Covers: Pays by the project, rate varies.

Text Illustration: Pays by the project, rate varies.

Tips: "Supply what is asked for in the listing and don't waste our time with calls and unnecessary cards. We usually select from those who submit samples of their work which we keep on file. Keep a permanent address so you can be reached."

‡CLARKSON N. POTTER, INC., Imprint of Crown Publishers. Parent company: Random House, 201 E. 50th St., 5th Floor, New York NY 10022. (212)572-6165. Fax: (212)572-6181. Art Director: Marysarah Quinn. Publishes hardcover originals and reprints. Types of books include biography, coffee table books, cookbooks, history, gardening, crafts, decorating. Specializes in lifestyle (cookbooks, gardening, decorating). Publishes 60 titles/year. Recent titles include:

Martha Stewart's Healthy Quick Cook, *Moosewood Restaurants Low-fat Favorites*, *Spirit of African Design*. 20% requires freelance illustration; 65% requires freelance design.

Needs: Works with 10-15 illustrators and 30 designers/year. Prefers freelancers experienced in illustrating food in traditional styles and mediums and designers with previous book design experience. 100% of freelance design demands knowledge of Adobe Illustrator, Adobe Photoshop, QuarkXPress.

First Contact & Terms: Send postcard sample or query letter with printed samples, photocopies, tearsheets. Prefers not to receive disk submissions. Samples are filed and are not returned. Will contact artist for portfolio review if interested or portfolios may be dropped off any day. Leave for 2-3 days. Negotiates rights purchased. Finds freelancers through submission packets, promotional postcards, sourcebooks and illustration annuals, previous books.

Book Design: Assigns 30 freelance design jobs/year.

Jackets/Covers: Assigns 30 freelance design and 15 illustration jobs/year. Pays for design by the project.

Text Illustration: Assigns 15 freelance illustration jobs/year.

Tips: "We no longer have a juvenile books department. We do not publish books of cartoons or humor. We look at a wide variety of design styles. We look at mainly traditional illustration styles and mediums and are always looking for unique food illustrations."

‡❤**THE PRAIRIE PUBLISHING COMPANY**, Box 2997, Winnipeg, Manitoba R3C 4B5 Canada. (204)885-6496. Publisher: Ralph E. Watkins. Specializes in paperback juvenile fiction and local history. Publishes 3 titles/year. Recent titles include *The Tale of Jonathan Thimblemouse* and *The Small Straw Goat*.

First Contact & Terms: Approached by 5 freelance artists/year. Works with 4 freelance illustrators and 1 freelance designer/year. Works on assignment only. Send query letter with résumé and tearsheets. Samples are filed or are returned. Reports back within weeks. Originals not returned at job's completion. To show a portfolio, mail roughs. Considers skill and experience of artist and project's budget when establishing payment. Negotiates rights purchased.

Jackets/Covers: Pays by the project, $200-300.

Text Illustration: Prefers line drawings. Pays by the project, $150-200.

Tips: "The work should not appear too complete. What I look for is open-ended art. Artists have to aim at being less dramatic and more focused on the subject."

‡**PRAKKEN PUBLICATIONS, INC.**, 3970 Varsity Dr., Box 8623, Suite 1, Ann Arbor MI 48107. (734)975-2800. Fax: (734)975-2787. Production and Design Manager: Sharon Miller. Estab. 1934. Imprints include The Education Digest, Tech Directions. Company publishes textbooks, educator magazines and reference books. Specializes in vocational, technical education. Publishes 2 magazines and 2 new book titles/year. Titles include *High School-to-Employment Transition*, *Exploring Solar Energy, II: Projects in Solar Electricity*, and *Technology's Past*. Book catalog free by request.

Needs: Rarely uses freelancers. 50% of freelance work demands knowledge of Adobe PageMaker. Works on assignment only.

First Contact & Terms: Send samples. Samples are filed or are returned by SASE if requested by artist. Reports back only if interested. Art Director will contact artist for portfolio review if interested. Portfolio should include b&w and color final art, photostats and tearsheets.

PRENTICE HALL COLLEGE DIVISION, 445 Hutchinson Ave., Columbus OH 43235. (614)841-3700. Fax: (614)841-3645. Production Services Manager: Connie Geldis. Imprint of Simon & Schuster. Specializes in college textbooks in education, career and technology. Publishes 300 titles/year. Recent titles include: *Exceptional Children*, by Heward and *Electronics Fundamentals*, by Floyd.

Needs: Approached by 25-40 freelancers/year. Works with 30 freelance illustrators/year. Uses freelancers mainly for book cover illustrations in all types of media. Also for jacket/cover design. 100% of freelance design and 70% of illustration demand knowledge of QuarkXPress 3.32, Aldus FreeHand 5.02, Adobe Illustrator 6.0 or Adobe Photoshop 3.05.

First Contact & Terms: Send query letter with résumé and tearsheets; sample cover designs on disk in Mac format. Accepts submissions on disk in Mac files only (not PC) in software versions stated above. Samples are filed and portfolios are returned. Reports back within 30 days. Rights purchased vary according to project. Originals are returned at job's completion.

Book Design: Pays by the project, $200-1,500.

Jackets/Covers: Assigns 300 cover designs/year.

Tips: "Send a style that works well with our particular disciplines. All covers are produced with a computer, but the images from freelancers can come in whatever technique they prefer. We are looking for new art produced on the computer."

PRICE STERN SLOAN, 200 Madison Ave., New York NY 10016. Attn: The Penguin Putnam Group. Estab. 1971. Book publisher. Publishes juvenile only—hardcover, trade paperback and mass market originals and reprints. Types of books include picture books, middle-grade and young adult fiction, games, crafts, and occasional novelty titles. Also publishes adult calendars. Publishes 100 titles/year. Recent titles include *Bang on the Door: Bat, Slug, Spider, Braincell*; *I Love To Smell My Daddy's Socks*; and *Marco! Polo!*. 75% require freelance illustration; 10% require freelance design. Books vary from edgy to quirky to illustrative, "but always unique!"

 ● Price Stern Sloan is a division of the Penguin Putnam Group. It does quite a few license tie-in books with the film and TV industries.

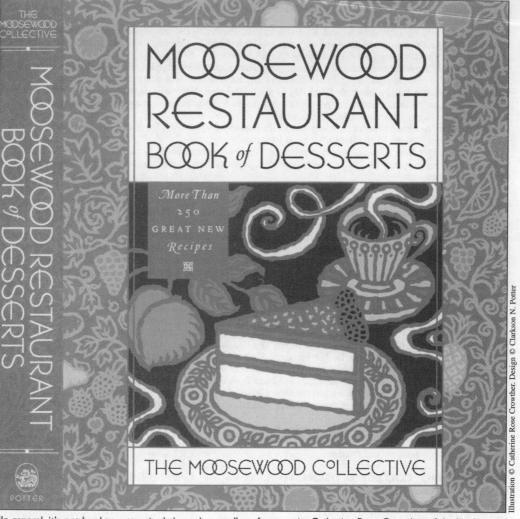

"In general, it's not hard to get excited about desserts," confesses artist Catherine Rose Crowther of the book cover she illustrated for Random House. "We were aiming for a woodcut look in the classic craftsman style, with an awareness of pattern." Crowther created the illustration and designer Sheri Lee of joyfunstudio created the overall design for the book cover, and served as art director for the book. Crowther, who received a flat fee for the cover and numerous interior illustrations, says she finds most projects through mailings and an annual sourcebook promotion piece. Exposure following her work on this book also led her to other work.

Needs: Approached by 300 freelancers/year. Works with 20-30 freelance illustrators and 10-20 designers/year. Prefers freelancers with experience in book or advertising art. Uses freelancers mainly for illustration. Also for jacket/cover and book design. Needs computer-literate freelancers for production.

First Contact & Terms: Send query letter with brochure, résumé and photocopies. Samples are filed or are returned by SASE if requested by artist. Art Director will contact artist for portfolio review if interested. "Please don't call." Portfolios may be dropped off every Thursday. Portfolio should include b&w and color tearsheets. Rights purchased vary according to project. Finds artists through word of mouth, magazines, submissions/self-promotion, sourcebooks and agents.

Book Design: Assigns 5-10 freelance design jobs and 20-30 illustration jobs/year. Pays by the project.

Jackets/Covers: Assigns 5-10 freelance design jobs and 10-20 illustration jobs/year. Pays by the project, rate varies.

Text Illustration: Pays by the project and occasionally by participation.

Tips: "Do not send original art. Become familiar with the types of books we publish. We are always looking for excellent book submissions. We are extremely selective when it comes to children's books, so please send only your

best work. Any book submission that does not include art samples should be sent to our editorial department."

‡**PRIDE & IMPRINTS**, 7419 Ebbert Dr. SE, Port Orchard WA 98367. (360)769-7174. E-mail: pridepblsh@aol.com. Website: http://members.aol.com/pridepblsh/pride.html. Senior Editor: Ms. Cris Newport. Estab. 1989. Publishes audio tapes, CD-ROMs, trade paperback originals. Types of books include children's picture books, experimental and main-stream fiction, fantasy, history, juvenile, nonfiction, science fiction, young adult. Specializes in genre fiction. Publishes 8-10 titles/year. Recent titles include: *Queen's Champion: The Legend of Lancelot Retold*, *The Best Thing*, *Caruso the Mouse*. 80% requires freelance illustration. Book catalog available for $1 and 2 first-class stamps.
Needs: Approached by 50 illustrators/year. Works with 20 illustrators/year. Prefers freelancers experienced in all media, pen & ink, watercolor.
First Contact & Terms: Illustrators send query letter with printed samples, photocopies, SASE, tearsheets. Samples are filed or returned by SASE. Reports back within 2 months. Will contact artist for portfolio review of photocopies of artwork portraying characters, landscapes if interested. Buys first rights. Finds freelancers through *Creative Black Book*, submissions.
Book Design: Assigns 10-15 illustration jobs/year. Pays for illustration by the project, $500-2,000.
Tips: "Artists must be able to work on a deadline. Be flexible in working with a variety of authors. Be willing to revise. We offer 10-15% royalty and our books never go out of print. Push the envelope."

‡**PROLINGUA ASSOCIATES**, 15 Elm St., Brattleboro VT 05301. (802)257-7779. Fax: (802)257-5117. E-mail: prolingu@sover.net. President: Arthur A. Burrows. Estab. 1980. Company publishes textbooks. Specializes in language textbooks. Publishes 3-8 titles/year. Recent titles include: *Living in Mexico* and *Conversation Strategies*. 100% require freelance illustration. Book catalog free by request.
Needs: Approached by 5 freelance artists/year. Works with 2-3 freelance illustrators/year. Uses freelance artists mainly for pedagogical illustrations of various kinds. Also uses freelance artists for jacket/cover and text illustration. Works on assignment only.
First Contact & Terms: Send postcard sample and/or query letter with brochure, photocopies and photographs. Samples are filed. Reports back within 1 month. Portfolio review not required. Buys all rights. Originals are returned at job's completion if requested. Finds artists through word of mouth and submissions.
Text Illustration: Assigns 5 freelance illustration jobs/year. Pays by the project, $100-1,000.

‡**PULSE-FINGER PRESS**, Box 488, Yellow Springs OH 45387. Contact: Orion Roche or Raphaello Farnese. Publishes hardbound and paperback fiction, poetry and drama. Publishes 5-10 titles/year.
Needs: Prefers local freelancers. Works on assignment only. Uses freelancers for advertising design and illustration. Pays $25 minimum for direct mail promos.
First Contact & Terms: Send query letter. "We can't use unsolicited material. Inquiries without SASE will not be acknowledged." Reports back in 6 weeks; reports on future assignment possibilities. Samples returned by SASE. Send résumé to be kept on file. Artist supplies overlays for all color artwork. Buys first serial and reprint rights. Originals are returned at job's completion.
Jackets/Covers: "Must be suitable to the book involved; artist must familiarize himself with text. We tend to use modernist/abstract designs. Try to keep it simple, emphasizing the thematic material of the book." **Pays on acceptance**; $25-100 for b&w jackets.
Tips: "We do most of our work in-house; otherwise, we recruit from the rich array of talent in the colleges and universities in our area. We've used the same people—as necessary—for years; so it's very difficult to break into our line-ups. We're receptive, but our needs are so limited as to preclude much of a market."

G.P. PUTNAM'S SONS, PHILOMEL BOOKS, PAPERSTAR BOOKS, 200 Madison Ave., New York NY 10016. (212)951-8733. Art Director, Children's Books: Cecilia Yung. Assistant to Art Director: Tony Sahara. Publishes hardcover and paperback juvenile books. Publishes 100 titles/year. Free catalog available.
Needs: Works on assignment only.
First Contact & Terms: Provide flier, tearsheet, brochure and photocopy or stat to be kept on file for possible future assignments. Samples are returned by SASE. "We take drop-offs on Tuesday mornings. Please call in advance with the date you want to drop of your portfolio."
Jackets/Covers: "Uses full-color paintings, realistic painterly style."
Text Illustration: "Uses a wide cross section of styles for story and picture books."

QUITE SPECIFIC MEDIA GROUP LTD., (formerly Drama Book Publishers), 260 Fifth Ave., New York NY 10001. (212)725-5377. Estab. 1967. Publishes hardcover originals and reprints, trade paperback reprints and textbooks. Specializes in costume, fashion, theater and performing arts books. Publishes 12 titles/year. 10% require freelance illustration; 60% require freelance design.
 • Imprints of Quite Specific Media Groupo Ltd. include Drama Publishers, Costume & Fashion Press, By Design Press, Entertainment Pro and Jade Rabbit.
Needs: Works with 2-3 freelance designers/year. Uses freelancers mainly for jackets/covers. Also for book, direct mail and catalog design and text illustration. Works on assignment only.
First Contact & Terms: Send query letter with brochure and tearsheets. Samples are filed. Reports back to the artist only if interested. Rights purchased vary according to project. Originals not returned. Pays by the project.

INSIDER REPORT

Illustrating for children and loving it

Those among us who can honestly say, "I love my job" are indeed lucky. And while good fortune does play a part in the careers we end up with, hard work, education and research are involved, too. Illustrator Joy Allen learned this as she mustered up the courage to dive into a midlife career change. After working 15 years as an art director and graphic designer, Allen decided to switch paths and do what she always wanted—illustrate books for children.

Joy Allen

Working in graphic design, Allen says, gave her special knowledge which helps her in illustrating for children's books and magazines. "Customers would come in and bring me a screw and say, 'We make these screws. We need a beautiful, exciting brochure about our screws.' We'd have to make something for these clients that didn't have any text, only their product. Soon you learn how to get into the psyche of each customer, understand each person's needs." When she started illustrating books, this empathy was valuable. "I can relate to a book and understand what the author is (hopefully) trying to convey and expand on it."

As her career shifted from graphic design to children's publishing, promoting her artwork to prospective publishers became a big part of Allen's job. But before she contacted publishers, Allen decided to learn as much as she could about how things worked, something she can't recommend highly enough to those shifting careers or just delving into children's publishing.

"The first thing I did was take a class with illustrator Marla Frazee [*Seven Silly Eaters*], who taught children's illustration at one of the best colleges in my area. She really filled me in on what I needed. She helped me to link up with SCBWI [Society of Children's Book Writers and Illustrators] and put together an appropriate portfolio."

Attending conferences sponsored by SCBWI was also a great help to Allen, and something she encourages other illustrators entering the field to do. "When SCBWI had an 'Illustrator's Day' and allowed you to show your work, I was there and made sure I had photocopies of my work and my business cards to hand out."

An important step for newcomers, says Allen, is researching the publishing market—going to libraries and bookstores to browse and get an idea of which publishers might appreciate your style. "You need to study and learn the market. You have to see what else is out there, what you're competing against."

The next important step is networking. Through classes, memberships and conference contacts, Allen was able to amass a small network of illustrators throughout the country via the Internet. "I feel we all help each other. I love the kinship. People in the children's industry are so different than in the commercial end where everybody is biting at each other. If there's something I can do for someone, I want to help. There's not a feeling of competition."

INSIDER REPORT, *Allen*

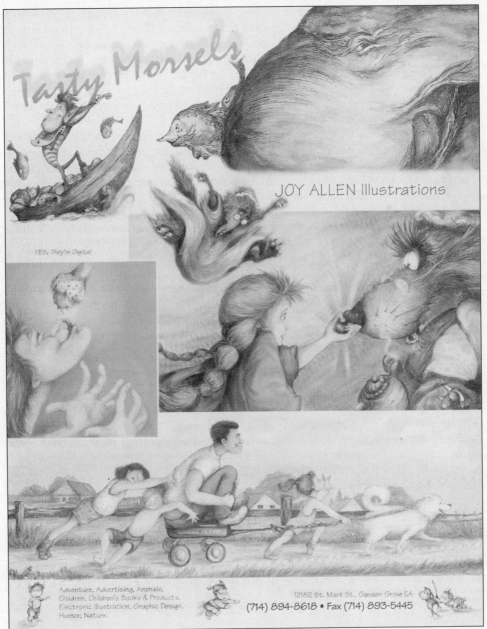

After learning as much as she could about children's publishing and illustrating children's books, Joy Allen created this self-promotion piece, "Tender Morsels," with unpublished illustrations from her portfolio. The sample helped her land her first assignments illustrating for children's magazines and book publishers. Later, when Allen had a few publishing credits, she created a jacket for the piece featuring some of her published work.

INSIDER REPORT, *continued*

After learning all she could and developing a support base, Allen began putting together promotional material. She started by sending photocopies of 10 or 12 pieces to publishers. Eventually she bought an ad in *California Images* (a sourcebook), creating a piece called "Tender Morsels" made up of unpublished art she created as samples. Later, after she began landing assignments, Allen created a jacket for the promo piece featuring samples of her published images. "Sourcebooks are definitely worth the expense if you've already studied what's out there. It's important to know what you're competing against first." Allen has also advertised in *Directory of Illustration*.

Allen got her first assignment from *Guideposts for Kids* magazine, and her illustrations appeared in all but one edition of *Guideposts* in 1997. In just her first year, in addition to *Guideposts*, she had illustrations published in *Highlights for Children*, *Your Big Backyard*, *Clubhouse* and *U*S*Kids*. She illustrated *A Dollar for Penny*, an early reader for Random House, and seven picture books for Harcourt Brace, Stech-Vaughn and Creative Teaching Press (all educational publishers). She has a contract with Price, Stern, Sloan, and has done several covers for Meadowbrook Press for books in their successful Girls to the Rescue and Newfangled Fairy Tales series. Allen landed a rep at an SCBWI conference and she's had Giclee prints of her work (digital prints on watercolor stock) displayed in several galleries in the U.S.

Though her research paid off with much success, there's still one area of children's publishing Allen has yet to penetrate. "I haven't gotten that trade book [a picture book you'd find a bookstore] yet," she says. "I feel really fortunate with what I've accomplished, but I'd like to illustrate a trade book." Rejection, however, does not phase Allen. "That's part of the game. Not every art director can love your work—you only need to find one who does."
—*Alice P. Buening*

Editor's note: *The Society of Children's Book Writers and Illustrators is a national organization with more than 11,000 members. A bimonthly newsletter, a number of informational publications, a roster of members, and national and regional conferences are some of the services they provide. Contact them for more information: SCBWI, 345 N. Maple Dr., Suite 296, Beverly Hills CA 90210. (310)859-9887. E-mail: info@scbwi.org. Website: http://www.scbwi.org.*

RAGNAROK PRESS, Box 140333, Austin TX 78714. Fax: (512)472-6220. E-mail: ragnarokgc@aol.com. Editor: David F. Nall.

● Ragnarok Press is primarily a book and game publisher, but also publishes *Abyss Magazine*. See listing for *Abyss* in Magazines section for more information. According to Editor David Nall, Ragnarok Press is buying more art than *Abyss* and has different needs. *Abyss* is more open to new artists; Ragnarok is higher paying. Ragnorak Games is looking for good color artists to do card illustration. See Greeting Cards, Gifts & Products section for additional needs and websites.

RAINBOW BOOKS, INC., P.O. Box 430, Highland City FL 33846-0430. (941)648-4420. Fax: (941)648-4420. E-mail: naip@aol.com. Media Buyer: Betsy A. Lampe. Estab. 1979. Company publishes hardcover and trade paperback originals. Types of books include instruction, adventure, biography, travel, self help, religious, reference, history and cookbooks. Specializes in nonfiction, self help and how-to. Publishes 20 titles/year. Recent titles include *The Insect Book: A Basic Guide to The Collection and Care of Common Insects for Young Children*, by Connie Zakowski.
Needs: Approached by hundreds of freelance artists/year. Works with 5 illustrators/year. Prefers freelancers with experience in book cover design and line illustration. Uses freelancers for jacket/cover illustration and design and text illustration. Needs computer-literate freelancers for design, illustration and production. 90% of freelance work demands knowledge of Aldus PageMaker, Aldus FreeHand or CorelDraw. Works on assignment only.

First Contact & Terms: Send brief query, tearsheets, photographs and book covers or jackets. Samples are not returned. Reports back within 2 weeks. Art Director will contact artist for portfolio review if interested. Portfolio should include b&w and color tearsheets, photographs and book covers or jackets. Rights purchased vary according to project. Originals are returned at job's completion.

Jackets/Covers: Assigns 10 freelance illustration jobs/year. Pays by the project, $250-1,000.

Text Illustration: Pays by the project. Prefers pen & ink or electronic illustration.

Tips: "Nothing Betsy Lampe receives goes to waste. After consideration for Rainbow Books, Inc., artists/designers are listed free in her newsletter (Publisher's Report), which goes out to over 500 independent presses (quarterly). Then, samples are taken to the art department of a local school to show students how professional artists/designers market their work. Send samples (never originals), be truthful about the amount of time needed to complete a project, learn to use the computer. Study the competition (when doing book covers), don't try to write cover copy, learn the publishing business (attend small press seminars, read books, go online, make friends with the lcoal sales reps of major book manufacturers). Pass along what you learn."

RANDOM HOUSE, INC., (Juvenile), 201 E. 50th St., New York NY 10022. (212)940-7664. Associate Art Director: Susan Banta Zooto. Specializes in hardcover and paperback originals and reprints. Publishes 200 titles/year. 100% require freelance illustration.

Needs: Works with 100-150 freelancers/year. Works on assignment only.

First Contact & Terms: Send query letter with résumé, tearsheets and photostats; no originals. Samples are filed or are returned. "No appointment necessary for portfolio drop-offs. Come in on Wednesdays only, before noon." Considers drop-offs, complexity of project, skill and experience of artist, budget, turnaround time and rights purchased when establishing payment. Negotiates rights purchased.

Book Design: Assigns 5 freelance design jobs/year. Pays by the project.

Text Illustration: Assigns 150 illustration jobs/year. Pays by the project.

RANDOM HOUSE VALUE PUBLISHING, 201 E. 50th St., New York NY 10022. E-mail: gpapadopoulos@random house.com. Art Director: Gus Papadopoulos. Imprint of Random House, Inc. Other imprints include Wings, Gramercy, Crescent, Jellybean. Imprint publishes hardcover, trade paperback and reprints, and trade paperback originals. Types of books include adventure, coffee table books, cookbooks, fantasy, historical fiction, history, horror, humor, instructional, mainstream fiction, New Age, nonfiction, reference, religious, romance, science fiction, self-help, travel and western. Specializes in contemporary authors' work. Recently published titles by John Saul, Mary Higgins Clark, Tom Wolfe, Dave Barry and Michael Chrichton (all omnibuses). 80% require freelance illustration; 50% require freelance design.

Needs: Approached by 50 freelancers/year. Works with 30-40 freelance illustrators and 15-20 designers/year. Uses freelancers mainly for jacket/cover illustration and design for fiction and romance titles. 100% of design and 50% of illustration demand knowledge of Adobe Illustrator, QuarkXPress, Adobe Photoshop and Aldus FreeHand. Works on assignment only.

First Contact & Terms: Designers send résumé and tearsheets. Illustrators send postcard sample, brochure, résumé and tearsheets. Accepts disk submissions compatible with Adobe Illustrator and Adobe Photoshop. Samples are filed. Request portfolio review in original query. Art Director will contact artist for portfolio review if interested. Portfolio should include tearsheets. Buys first rights. Originals are returned at job's completion. Finds artists through *American Showcase*, *Workbook*, *The Creative Illustration Book*, artist's reps.

Book Design: Pays by the project.

Jackets/Covers: Assigns 20-30 freelance design and 40 illustration jobs/year. Pays by the project, $500-1,500.

Tips: "Study the product to make sure styles are similar to what we have done: new, fresh, etc."

READ'N RUN BOOKS, Box 294, Rhododendron OR 97049. (503)622-4798. Publisher: Michael P. Jones. Estab. 1985. Specializes in fiction, history, environment and wildlife books for children through adults. "Books for people who do not have time to read lengthy books." Publishes 60 titles/year. Recent titles include *Nikki, Rooster & Chick-a-Biddy*, by Naomi Russell and *Sir Dominick's Bargain*, by J. Sheridan LeFanu. "Our books, printed in b&w or sepia, are both hardbound and softbound, and are not slick looking, They are home-grown-looking books that people love." Accepts previously published material. Art guidelines for #10 SASE.

• Read 'N Run is an imprint of Crumb Elbow publishing. See listing for other imprints.

Needs: Works with 55 freelance illustrators and 10 designers/year. Prefers pen & ink, airbrush, charcoal/pencil, markers, calligraphy and computer illustration. Uses freelancers mainly for illustrating books. Also for jacket/cover, direct mail, book and catalog design. 50% of freelance work demands computer skills.

First Contact & Terms: Send query letter with brochure, tearsheets, photocopies and SASE. Samples not filed are returned by SASE. Request portfolio review in original query. Art Director will contact artist for portfolio review if interested. Artist should follow up after initial query. Portfolio should include thumbnails, roughs, final reproduction/product, color and b&w tearsheets, photostats and photographs. Will not respond to postcards. Buys one-time rights. Interested in buying second rights (reprint rights) to previously published work. Originals are returned at job's completion. Pays in copies, on publication.

Book Design: Assigns 20 freelance design jobs/year.

Jackets/Covers: Assigns 20 freelance design and 30 illustration jobs/year. Pays $75-250 or in published copies.

Text Illustration: Assigns 70 freelance illustration jobs/year. Pays by the project, $75-250.

Tips: "Generally, the artists find us by submitting samples—lots of them, I hope. Artists may call us, but we will not

return calls. We will be publishing short-length cookbooks. I want to see a lot of illustrations showing a variety of styles. There is little that I actually don't want to see. We have a tremendous need for illustrations on the Oregon Trail (i.e., oxen-drawn covered wagons, pioneers, mountain men, fur trappers, etc.) and illustrations depicting the traditional way of life of Plains Indians and those of the North Pacific Coast and Columbia River with emphasis on mythology and legends. Pen & ink is coming back stronger than ever! Don't overlook this. Be versatile with your work. We will also evaluate your style and may utilize your work through another imprint that is under us, or even through our 'Wy-East Historical Journal.' "

❦RED DEER COLLEGE PRESS, 56 Ave. & 32nd St., Box 5005, Red Deer Alberta T4N 5H5 Canada. (403)342-3321. Fax: (403)340-8940. E-mail: vmix@admin.rdc.ab.ca. Managing Editor: Dennis Johnson. Estab. 1975. Book publisher. Publishes hardcover and trade paperback originals. Types of books include contemporary and mainstream fiction, fantasy, biography, preschool, juvenile, young adult, humor and cookbooks. Specializes in contemporary adult and juvenile fiction, picture books and natural history for children. Recent titles include *How Smudge Came* and *Tiger's New Cowboy Boots*. 100% require freelance illustration; 30% require freelance design. Book catalog available for SASE with first-class postage.
Needs: Approached by 50-75 freelance artists/year. Works with 10-12 freelance illustrators and 2-3 freelance designers/year. Buys 100+ freelance illustrations/year. Prefers artists with experience in book and cover illustration. Also uses freelance artists for jacket/cover and book design and text illustration. Works on assignment only.
First Contact & Terms: Send query letter with résumé, tearsheets, photographs and slides. Samples are filed. Reports back within 3 months. To show a portfolio, mail b&w slides and dummies. Rights purchased vary according to project. Originals returned at job's completion.
Book Design: Assigns 3-4 design and 6-8 illustration jobs/year. Pays by the project.
Jackets/Covers: Assigns 6-8 design and 10-12 illustration jobs/year. Pays by the project, $300-1,000 CDN.
Text Illustration: Assigns 3-4 design and 4-6 illustration jobs/year. Pays by the project. May pay advance on royalties.
Tips: Looks for freelancers with a proven track record and knowledge of Red Deer College Press. "Send a quality portfolio, preferably with samples of book projects completed."

‡REGNERY PUBLISHING INC., Parent company: Eagle Publishing Inc., 1 Massachusetts Ave. NW, Washington DC 20001. (202)216-0601. Fax: (202)216-0612. E-mail: mwalker@eaglepub.com. Art Director: Marja Walker. Estab. 1947. Publishes hardcover originals and reprints; trade paperback originals and reprints. Types of books include biography, coffee table books, cookbooks, history, humor, instructional, nonfiction and self help. Specializes in nonfiction. Publishes 24 titles/year. Recent titles include: *Murder In Brentwood, The Arthritis Cure Cookbook*. 20-50% requires freelance design. Book catalog available for SASE.
Needs: Approached by 20 illustrators and 20 designers/year. Works with 6 designers/year. Prefers local illustrators and designers. Prefers freelancers experienced in Mac, QuarkXPress and Photoshop. 100% of freelance design demands knowledge of QuarkXPress. 50% of freelance illustration demands knowledge of Adobe Photoshop, QuarkXPress.
First Contact & Terms: Send postcard sample and follow-up postcard every 6 months. Accepts Mac-compatible disk submissions. Send TIFF files. Samples are filed. Will contact artist for portfolio review if interested. Finds freelancers through *Workbook*, networking and submissions.
Book Design: Assigns 5-10 freelance design jobs/year. Pays for design by the project; negotiable.
Jackets/Covers: Assigns 5-10 freelance design and 1-5 illustration jobs/year. Pays by the project; negotiable.
Tips: "We welcome designers with knowledge of Mac platforms . . . and the ability to design 'Bestsellers' under extremely tight guidelines and deadlines!"

RIO GRANDE PRESS, P.O. Box 71745, Las Vegas NV 89170-1745. Editor/Publisher: Rosalie Avara. Estab. 1989. Small press. Publishes trade paperback originals. Types of books include poetry journal and anthologies. Publishes 7 titles/year. Recent titles include *Winter's Gems VI*, Anthology, by R. Avara; and *The Story Shop V*, Anthology, by R. Avara. 95% require freelance illustration; 90% require freelance design. Book catalog for SASE with first-class postage. Artist guidelines available.
Needs: Approached by 30 freelancers. Works with 5-6 freelance illustrators and 1 designer/year. Prefers freelancers with experience in spot illustrations for poetry and b&w cartoons about poets, writers, etc. Uses freelancers for jacket/cover illustration and design and text illustration.
First Contact & Terms: Designers send query letter and cover designs with résumé. Illustrators send tearsheets, photocopies and/or examples of small b&w drawings and SASE. Samples are filed. Reports back within 1 month. To show portfolio, mail roughs, finished art samples and b&w tearsheets. Buys first rights or one-time rights. Originals are not returned.
Book Design: Assigns 3 freelance illustration jobs/year. Pays by the project; $4 or copy.
Jackets/Covers: Assigns 3 freelance designs and 4 illustration jobs/year. Pays by the project, $4; or copy.
Text Illustration: Assigns 4 freelance illustration jobs/year. Prefers small b&w line drawings to illustrate poems. Pays by the project; $4 or copy.
Tips: "We are currently seeking cover designs for *The Story Shop VII* (short stories) and *Summer's Treasures, Winter's Gems* (poetry anthologies). Send copies of very small b&w drawings of everyday objects, nature, animals, seasonal drawings, small figures and/or faces with emotions expressed. Pen & ink preferred."

‡**ROWMAN & LITTLEFIELD PUBLISHERS, INC.,** Parent company: University Press of America, 4720 Boston Way, Suite A, Lanham MD 20706. (301)731-9534. Fax: (301)459-3464. E-mail: ghenry@univpress.com. Art Director: Giséle Byrd Henry. Estab. 1980. Publishes hardcover originals and reprints, textbooks, trade paperback originals and reprints. Types of books include biography, history, nonfiction, reference, self help, textbooks. 60% of titles require freelance design. Book catalog not available.

Needs: Approached by 50 illustrators and 10 designers/year. Works with 15 designers/year. Prefers freelancers experienced in typographic design, Photoshop special effects. 100% of freelance design demands knowledge of Adobe Illustrator, Adobe Photoshop, QuarkXPress.

First Contact & Terms: Designers send query letter with printed samples, SASE. Accepts Mac-compatible disk submissions. Samples are filed or returned by SASE. Will contact artist for portfolio review if interested. Buys all rights.

Jackets/Covers: Assigns 150 freelance design jobs/year. Pays for design by the project $500-1,000. Prefers interesting "on the edge" typography. Must be experienced book jacket designer.

‡**SAUNDERS COLLEGE PUBLISHING,** Public Ledger Bldg., Suite 1250, 150 S. Independence Mall West, Philadelphia PA 19106. (215)238-5500. E-mail: cbleistine@saunderscollege.com. Manager of Art & Design: Carol Bleistine. Imprint of Harcourt Brace College Publishers. Company publishes textbooks. Specializes in sciences. Publishes 30 titles/year. 100% require freelance illustration; 20% require freelance design. Book catalog not available.

Needs: Approached by 10-20 freelancers/year. Works with 10-20 freelance illustrators and 10-20 designers/year. Prefers local freelancers with experience in hard sciences (biology, chemistry, physics, math, etc.). Uses freelancers mainly for design of text interiors, covers, page layout. Also for jacket/cover and text illustration. Needs computer-literate freelancers for design and illustration. 95% of freelance work demands knowledge of Adobe Illustrator, QuarkXPress, Adobe Photoshop and Aldus FreeHand. Works on assignment only.

First Contact & Terms: Send query letter with brochure, résumé, tearsheets, photographs, photocopies or color copies. Samples are filed or returned by SASE if requested by artist. Request portfolio review in original query. Art Director will contact artist for portfolio review if interested. Portfolio should include book dummy, final art, photographs, roughs, slides, tearsheets and transparencies. Buys all rights. Finds artists through sourcebooks, word of mouth and submissions.

Books Design: Assigns 5-10 freelance design jobs/year. Pays by the project.

Jackets/Covers: Assigns 5-10 freelance design and 1-2 illustration jobs/year. Pays by the project.

Text Illustration: Assigns 30 freelance illustration jobs/year. Pays by the project or per figure. Prefers airbrush reflective; electronic art, styled per book requirements—varies.

‡**SCHOLARLY RESOURCES INC.,** 104 Greenhill Ave., Wilmington DE 19805-1897. (302)654-7713. Fax: (302)654-3871. E-mail: sr@scholarly.com. Marketing Manager: Toni Moyer. Managing Editor: Carolyn J. Travers. Estab. 1972. Publishes textbooks and trade paperback originals. Types of books include history, reference and textbooks. Publishes 40 titles/year. 60% requires freelance illustration; 80% requires freelance design. Book catalog free.

Needs: Works with 3 illustrators and 6 designers/year. Prefers local designers. Prefers freelancers experienced in book design. 100% of freelance design demands knowledge of Aldus PageMaker, PageMaker and Quark XPress.

First Contact & Terms: Designers and illustrators send query letter with printed samples, photocopies, tearsheets and SASE. Accepts Mac-compatible disk submissions. Samples are filed. Reports back only if interested. Will contact artist for portfolio review if interested. Buys all rights. Finds freelancers through submission packets and networking events.

Book Design: Assigns 6 freelance design jobs/year. Pays by the project, $200-800.

Jackets/Covers: Assigns 30 freelance design jobs/year. Pays by the project, $350-1,250.

SCHOLASTIC INC., 555 Broadway, New York NY 10012. Executive Art Director: David Tommasino. Specializes in paperback originals of young adult, biography, classics, historical romance and contemporary teen romance. Publishes 250 titles/year. Titles include *Goosebumps, Animorphs* and *Baby-sitters Club*. 80% require freelance illustration. Books have "a mass-market look for kids."

Needs: Approached by 100 freelancers/year. Works with 75 freelance illustrators and 2 designers/year. Prefers local freelancers with experience. Uses freelancers mainly for mechanicals. Also for jacket/cover illustration and design and book design. 20% of illustration demand knowledge of QuarkXPress, Adobe Illustrator, Adobe Photoshop.

First Contact & Terms: Designers send query letter with résumé and tearsheets. Illustrators send postcard sample and tearsheets. Accepts disk submissions compatible with Adobe Illustrator 5.0. Samples are filed or are returned only if requested. Art Director will contact artist for portfolio review if interested. Considers complexity of project and skill and experience of artist when establishing payment. Originals are returned at job's completion. Finds artists through word of mouth, *American Showcase, RSVP* and Society of Illustrators.

Book Design: Pays by the project, $2,500-4,000.

Jackets/Covers: Assigns 200 freelance illustration jobs/year. Pays by the project, $1,800-3,500.

Text Illustration: Pays by the project, $1,000-2,500.

Tips: "In your portfolio, show tearsheets or proofs only of printed covers. I want to see oil, acrylic tightly rendered; illustrators should research the publisher. Go into a bookstore and look at the books. Gear what you send according to what you see is being used."

✔**SILVER BURDETT GINN**, (formerly Silver Burdett & Ginn and Modern Curriculum), 299 Jefferson Rd., Parsippany NJ 07054-0480. (201)739-8000. Fax: (201)739-8057. Creative Director: Cynthia Mackowicz. Book publisher. Estab. 1890. Publishes textbooks. Specializes in math, science, social studies, reading, music and religion. Publishes approx. 75 titles/year. Books look lively and inviting with fresh use of art and photos. 100% require freelance illustration; 20% require freelance design. Recent titles include *Science: Discoveryworks*; and *Silver Burdett Ginn Mathematics*.
Needs: Approached by 200-500 artists/year. Works with 50-200 illustrators and 1-5 designers/year. Buys 1,000 illustrations/year. Uses artists mainly for text illustration and page layout. Also works with artists for jacket/cover illustration and design and book, catalog, packaging and ad design. 100% of freelance design and 20% of illustration demand knowledge of QuarkXPress or Adobe Illustrator. Works on assignment only.
First Contact & Terms: Send query letter with résumé, photocopies, SASE and tearsheets. Accepts disk submissions compatible with Adobe Illustrator 7.0 or Photoshop 4.0. Samples are filed or are returned by SASE only if requested. Reports back only if interested. Originals are returned to artist at job's completion. Art Director will contact artist for portfolio review if interested. Portfolio should include thumbnails, roughs, final art, tearsheets and final reproduction/product. Sometimes requests work on spec before assigning a job. Considers complexity of project and skill and experience of artist when establishing payment. Considers buying second rights (reprint rights) to previously published artwork. Negotiates rights purchased.
Book Design: Assignments for design jobs are ongoing. Pays by the hour, $20-30.
Jackets/Covers: Pays by the project, $500-1,000.
Text Illustration: Assigns 1,000 illustrations jobs/year. Pays by the project, $350-1,000.
Tips: "Educational print materials need to compete with design intensive non-educational media. Submit samples periodically as new work is done. Timing can be everything."

‡**SIMON & SCHUSTER**, 1230 Avenue of the Americas, New York NY 10020. (212)698-7556. Fax: (212)698-7455. Art Director: Gina Bonanno. Imprints include Pocket Books, Minstrel and Archway. Company publishes hardcover, trade paperback and mass market paperback originals, reprints and textbooks. Types of books include juvenile, preschool, romance, self-help, young adult and many others. Specializes in young adult, romance and self help. 95% require freelance illustration; 80% require freelance design.
Needs: Works with 50 freelance illustrators and 5 designers/year. Prefers freelancers with experience working with models and taking direction well. Uses freelancers for hand lettering, jacket/cover illustration and design and book design. 100% of design and 75% of illustration demand knowledge of Adobe Illustrator and Adobe Photoshop. Works on assignment only.
First Contact & Terms: Send query letter with tearsheets. Accepts disk submissions. Samples are filed and are not returned. Reports back only if interested. Portfolios may be dropped off every Monday and Wednesday and should include tearsheets. Buys all rights. Originals are returned at job's completion.
Text Illustration: Assigns 50 freelance illustration jobs/year.

SIMON & SCHUSTER BOOKS FOR YOUNG READERS, 1230 Avenue of the Americas, 4th Floor, New York NY 10020. (212)698-7000. Art Director: Lucille Chomowicz. Imprint of Simon & Schuster. Other imprints include Atheneum, Macmillan and McElderry. Imprint publishes hardcover originals and reprints. Types of books include picture books, nonfiction and young adult. Publishes 80 titles/year. 100% require freelance illustration; 1% require freelance design.
Needs: Approached by 200 freelancers/year. Works with 40 freelance illustrators and 2-3 designers/year. Uses freelancers mainly for jackets and picture books ("all illustration work is freelance"). 100% of design work demands knowledge of Adobe Illustrator, QuarkXPress and Adobe Photoshop. Works on assignment only.
First Contact & Terms: Designers send query letter with résumé and photocopies. Illustrators send postcard sample or other non-returnable samples. Accepts disk submissions. Art Director will contact artist for portfolio review if interested. Portfolio should include original art, photographs and transparencies. Originals are returned at job's completion. Finds artists through submissions, agents, scouting in nontraditional juvenile areas such as painters, editorial artists.
Jackets/Covers: Assigns 20 freelance illustration jobs/year. Pays by the project, $800-2,000. "We use full range of media: collage, photo, oil, watercolor, etc."
Text Illustration: Assigns 30 freelance illustration jobs/year. Pays by the project.

‡✤**SOMERVILLE HOUSE BOOKS LIMITED**, 3080 Yonge St., Suite 5000, Toronto, Ontario M4N 3N1 Canada. (416)488-5938. Fax: (416)488-5506. E-mail: sombooks@goodmedia.com. Website: http://www.combooks.com. Editor, Acquisitions & Development, Juvenile Publishing Division: Jill Bryant. President and Publisher: Jane Somerville. Publishes hardcover and trade paperback originals. Types of books include children's picture books, juvenile, fiction and nonfiction, literary fiction, metaphysics, science and technology. Specializes in nonfiction children's books. Publishes 20 titles/year. Recent titles include: *The Ultimate Science Kit*, *Eye to Eye*™ books: *Insects and Spiders*, *Snakes and Lizards*, *Sew Your Own Bean Bag Friends*. 100% requires freelance illustration and 100% requires freelance design. Book catalog free for SASE.
Needs: Approached by 100 illustrators and designers/year. Works with 15 illustrators and 7 designers/year. Prefers local freelancers. 100% of freelance design demands knowledge of Adobe Illustrator, Adobe Photoshop, QuarkXPress.
First Contact & Terms: Send query letter with photocopies and follow-up postcard every 3 months. Samples are filed. Will contact artist for portfolio review of artwork portraying science, nature and children if interested. Finds freelancers through word of mouth.

Book Design: Assigns 20 freelance design jobs/year. Pays by the project.
Text Illustration: Assigns 20 freelance illustration jobs/year. Pays by the project.

THE SPEECH BIN, INC., 1965 25th Ave., Vero Beach FL 32960. (561)770-0007. Fax: (561)770-0006. Senior Editor: Jan Binney. Estab. 1984. Publishes textbooks and educational games and workbooks for children and adults. Specializes in tests and materials for treatment of individuals with all communication disorders. Publishes 20-25 titles/year. Recent titles include *Funology Fables*, by R. Sunderbruch; and *Techniques for Aphasia Rehabilitation*, by M.J. Santo Pietro and R. Goldfarb. 5% require freelance illustration; 50% require freelance design. Book catalog available for 8½×11 SAE with $1.48 postage.
Needs: Works with 8-10 freelance illustrators and 2-4 designers/year. Buys 1,000 illustrations/year. Work must be suitable for handicapped children and adults. Uses freelancers mainly for instructional materials, cover designs, gameboards, stickers. Also for jacket/cover and text illustration. Occasionally uses freelancers for catalog design projects. Works on assignment only.
First Contact & Terms: Send query letter with brochure, SASE, tearsheets and photocopies. Samples are filed or are returned by SASE if requested by artist. Reports back to the artist only if interested. Do not send portfolio; query only. Usually buys all rights. Considers buying second rights (reprint rights) to previously published work. Finds artists through "word of mouth, our authors and submissions by artists."
Book Design: Pays by the project.
Jackets/Covers: Assigns 10-12 freelance design jobs and 10-12 illustration jobs/year. Pays by the project.
Text Illustration: Assigns 6-10 freelance illustration jobs/year. Prefers b&w line drawings. Pays by the project.

SPINSTERS INK, 3201 Columbus Ave. S., Minneapolis MN 55407-2030. (612)827-6177. Fax: (612)827-4417. E-mail: liz@spinsters-ink.com. Website: http://www.spinsters-ink.com. Production Manager: Liz Tufte. Estab. 1978. Company publishes trade paperback originals and reprints. Types of books include contemporary fiction, mystery, biography, young women, reference, history of women, humor and feminist. Specializes in "fiction and nonfiction that deals with significant issues in women's lives from a feminist perspective." Publishes 6 titles/year. Recent titles include *A Gift of the Emperor*, by Therese Park (novel); *Living at Night*, by Mariana Romo-Carmona (mystery). 50% require freelance illustration; 100% require freelance design. Book catalog free by request.
Needs: Approached by 24 freelancers/year. Works with 2-3 freelance illustrators and 2-3 freelance designers/year. Buys 2-6 freelance illustrations/year. Prefers artists with experience in "portraying positive images of women's diversity." Uses freelance artists for jacket/cover illustration and design, book and catalog design. 100% of freelance work demands knowledge of Adobe Illustrator, Adobe Photoshop, QuarkXPress or Adobe PageMaker. Works on assignment only.
First Contact & Terms: Designers send query letter with résumé. Illustrators send postcard sample with photocopies and SASE. Accepts submissions on disk compatible with PageMaker 5.0 or QuarkXPress. Samples are filed or are returned by SASE if requested by artist. Reports back within 1 month. Art Director will contact artist for portfolio review if interested. Portfolio should include b&w and color thumbnails, final art and photographs. Buys first rights. Originals are returned at job's completion. Finds artists through word of mouth and submissions.
Jackets/Covers: Assigns 6 freelance design and 2-6 freelance illustration jobs/year. Pays by the project, $200-1,000. Prefers "original art with appropriate type treatment, b&w to 4-color. Often the entire cover is computer-generated, with scanned image. Our production department produces the entire book, including cover, electronically."
Text Illustration: Assigns 0-6 freelance illustrations/year. Pays by the project, $75-150. Prefers "b&w line drawings or type treatment that can be converted electronically. We create the interior of books completely using desktop publishing technology on the Macintosh."
Tips: "We're always looking for freelancers who have experience portraying images of diverse women, with current technological experience on the computer."

‡STOREY BOOKS, Schoolhouse Rd., Pownal VT 05261. Art Director: Meredith Maker. Estab. 1982. Publishes hardcover and trade paperback originals. Publishes: cookbooks, instructional, self help, animal, gardening, crafts, building, herbs, natural healthcare. Publishes 60 titles/year. Recent titles include *The Big Book of Gardening Secrets*, *Herbed-Wine Cuisine*, *Keeping Life Simple*, *The Soap Maker's Companion*. 50% requires freelance illustration; 25% requires freelance design; 75% require freelance cover/jacket design.
Needs: Approached by 100 illustrators and 30 designers/year. Works with 10 designers/year. Prefers local freelancers (but not necessary). Prefers freelancers experienced in book design and building. 100% of freelance design demands knowledge of QuarkXPress. Knowledge of Adobe Illustration or Adobe Photoshop a plus.
First Contact & Terms: Send query letter with printed samples, photocopies, SASE (if wish returned), tearsheets. Samples are filed or returned by SASE. Will contact artist for portfolio review if interested. Buys one-time rights or all rights. Finds freelancers through submission packets, ABA (BookExpo).
Book Design: Assigns 15 freelance design and 2 art direction projects/year. Pays for design by the project, $500-3,000.
Jackets/Covers: Assigns 45 freelance design jobs/year. Pays for design by the project, $250-1,000. Prefers strong type treatment, fresh looking, graphic appeal.
Tips: "Storey Books are filled with how-to illustrations, tips, sidebars and charts. Storey covers are fresh, readable and clean."

‡JEREMY P. TARCHER, INC., 200 Madison Ave., New York NY 10016. (212)951-8400. Fax: (212)951-8543. Art Director: Ann Spinelli. Estab. 1970s. Imprint of G.P. Putnam Co. Imprint publishes hardcover and trade paperback originals and trade paperback reprints. Types of books include instructional, New Age, adult contemporary and self-help. Publishes 25-30 titles/year. Recent titles include *The End of Work*; *The Artist's Way*; *Executive Orders* by Tom Clancy; and *The Temple in the House*. 30% require freelance illustration; 30% require freelance design.
Needs: Approached by 10 freelancers/year. Works with 10-12 freelance illustrators and 4-5 designers/year. Works only with artist reps. Uses jacket/cover illustration. 50% of freelance work demands knowledge of QuarkXPress. Works on assignment only.
First Contact & Terms: Send postcard sample of work or send query letter with brochure, tearsheets and photocopies. Samples are filed. Art Director will contact artist for portfolio review if interested. Portfolio should include book dummy, final art, photographs, roughs, tearsheets and transparencies. Buys first rights or one-time rights. Originals are returned at job's completion. Finds artists through sourcebooks, *Communication Arts*, word of mouth, submissions.
Book Design: Assigns 4-5 freelance design jobs/year. Pays by the project, $800-1,000.
Jackets/Covers: Assigns 4-5 freelance design and 10-12 freelance illustration jobs/year. Pays by the project, $950-1,100.
Text Illustration: Assigns 1 freelance illustration job/year. Pays by the project, $100-500.

TEHABI BOOKS, INC., 1201 Camino del Mar, Suite 100, Del Mar CA 92014. (619)481-7600. Fax: (619)481-3247. E-mail: nancy@tehabi.com. Website: http://www.tehabi.com. Managing Editor: Nancy Cash. Estab. 1992. Publishes softcover, hardcover, trade. Specializes in design and production of large-format, visual books. Works hand-in-hand with publishers, corporations, institutions and nonprofit organizations to identify, develop, produce and market high-quality visual books for the international market place. Produces lifestyle/gift books; institutional books; children's books; corporate-sponsored books and CD-ROMs. Publishes 10 titles/year. Recent titles include *Still Wild/Always Wild*, by Susan Zwinger; and *Boston Celtics—Fifty Years*, by George Sullivan.
Needs: Approached by 50 freelancers/year. Works with 75-100 freelance illustrators and 3 designers/year. Freelancers should be familiar with Aldus PageMaker, Adobe Illustrator, QuarkXPress, Adobe Photoshop, Aldus FreeHand and 3-D programs. Works on assignment only. 3% of titles require freelance art direction.
First Contact & Terms: Send query letter with résumé, samples. "Give a followup call." Rights purchased vary according to project. Finds artists through sourcebooks, publications and submissions.
Text Illustration: Pays by the project, $100-10,000.

♣THISTLEDOWN PRESS LTD., 633 Main St., Saskatoon, Saskatchewan S7H 0J8 Canada. (306)244-1722. Fax: (306)244-1762. E-mail: thistle@sk.sympatico.ca. Website: http://www.thistledown.sk.ca. Director, Production: Allan Forrie. Estab. 1975. Publishes trade and mass market paperback originals. Types of books include contemporary and experimental fiction, juvenile, young adult and poetry. Specializes in poetry creative and young adult fiction. Publishes 10-12 titles/year. Titles include *The Blue Jean Collection*; *The Big Burn*, by Lesley Choyce; and *The Blue Camaro*, by R.P. MacIntyre. 50% require freelance illustration. Book catalog for SASE.
Needs: Approached by 25 freelancers/year. Works with 8-10 freelance illustrators/year. Prefers local Canadian freelancers. Uses freelancers for jacket/cover illustration. Uses only Canadian artists and illustrators for its title covers. Works on assignment only.
First Contact & Terms: Designers send query letter with résumé and photocopies. Illustrators send postcard samples. Samples are filed or are returned by SASE. Reports back to the artist only if interested. Call for appointment to show portfolio of original/final art, tearsheets, photographs, slides and transparencies. Buys one-time rights.
Jackets/Covers: Assigns 10-12 illustration jobs/year. Prefers painting or drawing, "but we have used tapestry—abstract or expressionist to representational." Also uses 10% computer illustration. Pays by the project, $250-600.
Tips: "Look at our books and send appropriate material. More young adult and adolescent titles are being published, requiring original cover illustration and cover design. New technology (Adobe Illustrator, Photoshop) has slightly altered our cover design concepts."

THOMPSON WORKS, INC., 4600 Longfellow Ave., Minneapolis MN 55407-3638. E-mail: blt@skypoint.com. President: Brad Thompson. Book publisher and independent book producer/packager. Estab. 1980. Publishes trade paperback originals and textbooks. Publishes nonfiction. Types of books include instructional self-help, software, technical and business. Specializes in business and computer. Publishes 10 titles/year. 100% require freelance illustration.
Needs: Works with 20 freelance illustrators and 7 designers/year. Uses illustrators mainly for textbook graphics and cartoons. Also for book design and jacket/cover design. 50% of freelance work demands knowledge of Aldus PageMaker, QuarkXPress and Ventura. Works on assignment only.
First Contact & Terms: Send query letter with résumé and photostats. Samples are filed. Reports back about queries/submissions only if interested. To show portfolio mail photostats. "We will request what we need based on photostats." Considers complexity of project and budget when establishing payment. Negotiates rights purchased. Originals not returned.
Book Design: Assigns 15 freelance design and 20 freelance illustration jobs/year. Pays by the hour, $25 minimum.
Jackets/Covers: Assigns 10 freelance design and 10 freelance illustration jobs/year. Pays by the project, $400-1,200.
Text Illustration: Assigns several large freelance jobs/year. Prefers technical illustration (maps, complex tints, obviously beyond computer graphic capabilities). Pays by the hour, $25 minimum.
Tips: "Make sure we have a good representation of the kind of work you want to get. Then be patient. We do not begin

shopping for art until the project is underway to avoid wasting time and false starts. We are not shy about using people across the country as long as they take deadline commitments seriously."

‡TORAH AURA PRODUCTIONS/ALEF DESIGN GROUP, 4423 Fruitland Ave., Los Angeles CA 90058. (213)585-7312. Fas: (213)585-0327. E-mail: misrad@torahaura.com. Website: http://www.torahaura.com. Art Director: Jane Golub. Estab. 1981. Publishes hardcover and trade paperback originals, textbooks. Types of books include children's picture books, cookbooks, juvenile, nonfiction and young adult. Specializes in Judaica titles. Publishes 15 titles/year. Recent titles include: *The Bonding of Isaac, Two Cents and a Milk Bottle, Mark Stark's Amazing Jewish Cookbook*. 85% requires freelance illustration. Book catalog free for 9×12 SAE with 10 first-class stamps.
Needs: Approached by 50 illustrators and 20 designers/year. Works with 25 illustrators/year.
First Contact & Terms: Illustrators send postcard sample and follow-up postcard every 6 months, printed samples, photocopies. Accepts Windows-compatible disk submissions. Samples are filed. Will contact artist for portfolio review if interested. Rights purchased vary according to project. Finds freelancers through submission packets.
Jackets/Covers: Assigns 6-24 illustration jobs/year. Pays by the project.

‡TRANSPORTATION TRAILS, National Bus Trader, Inc., 9698 W. Judson Rd., Polo IL 61064. (815)946-2341. Fax: (815)946-2347. Editor: Larry Plachno. Production Manager: Joseph Plachno. Estab. 1977. Imprints include National Bus Trader, Transportation Trails Books; also publishes *Bus Tours Magazine*. Company publishes hardcover and mass market paperback originals and magazines. Types of books include "primarily transportation history but some instruction and reference." Publishes 5-7 titles/year. Titles include *Breezers—A Lighthearted History of The Open Trolley Car in America* and *The Steam Locomotive Directory of North America*. Book catalog free by request.
Needs: Approached by 1 freelancer/year. Works with 3 freelance illustrators/year. Prefers local freelancers if possible with experience in transportation and rail subjects. Uses freelancers mainly for covers and chapter logo lines. Also for text illustration, maps, occasional magazine illustrations, and oil paintings for Christmas magazine covers. Works on assignment only. 20% of freelance work requires knowledge of Adobe Illustrator.
First Contact & Terms: Send query letter with "any reasonable sample." Accepts disk submissions compatible with Adobe Illustrator and QuarkXPress. Samples are returned by SASE if requested by artist. Artist should follow up with letter after initial query. Buys all rights. Originals are not returned.
Jackets/Covers: Assigns 3-6 freelance illustration jobs/year. Pays by the project, $150-700. Prefers b&w pen & ink line drawing of subject with rubylith/amberlith overlays for color.
Text Illustration: Assigns 3-6 freelance illustration jobs/year. Pays by the project, $50-200. Prefers silhouette b&w line drawing approximately 42×6 picas.
Tips: First-time assignments are usually silhouette text illustrations; book jackets and magazine covers are given to "proven" freelancers. "Send samples and ask for our letter, which explains what we want."

‡TREEHAUS COMMUNICATIONS, INC., 906 W. Loveland Ave., P.O. Box 249, Loveland OH 45140. (513)683-5716. Fax: (513)683-2882. President: Gerard Pottebaum. Estab. 1973. Publisher. Specializes in books, periodicals, texts, TV productions. Product specialties are social studies and religious education.
Needs: Approached by 12-24 freelancers/year. Works with 10 freelance illustrators/year. Prefers freelancers with experience in illustrations for children. Works on assignment only. Uses freelancers for all work. Also for illustrations and designs for books and periodicals. 5% of work is with print ads. Needs computer-literate freelancers for illustration.
First Contact & Terms: Send query letter with résumé, transparencies, photocopies and SASE. Samples sometimes filed or are returned by SASE if requested by artist. Reports back within 1 month. Art Director will contact artist for portfolio review if interested. Portfolio should include final art, tearsheets, slides, photostats and transparencies. Pays for design and illustration by the project. Rights purchased vary according to project. Finds artists through word of mouth, submissions and other publisher's materials.

‡TRIUMPH BOOKS, 644 S. Clark St., Suite 2000, Chicago IL 60605. (312)939-3330. Fax: (312)663-3557. E-mail: triumphbk@aol.com. Production: Sarah Burgundy. Estab. 1990. Publishes hardcover originals and reprints, trade paperback originals and reprints. Types of books include biography, coffee table books, humor, instructional, reference, sports. Specializes in sports titles. Publishes 50 titles/year. 5% requires freelance illustration; 60% requires freelance design. Book catalog free for SAE with 2 first-class stamps.
Needs: Approached by 5 illustrators and 5 designers/year. Works with 2 illustrators and 8 designers/year. Prefers freelancers experienced in book design. 100% of freelance design demands knowledge of Adobe Photoshop, PageMaker, QuarkXPress.
First Contact & Terms: Send query letter with printed samples, SASE. Accepts Mac-compatible disk submissions. Send TIFF files. Samples are filed or returned by SASE. Will contact artist for portfolio review if interested. Buys all right. Finds freelancers through word or mouth, organizations (Chicago Women in Publishing), submission packets.
Book Design: Assigns 20 freelance design jobs/year. Pays for design by the project.
Jackets/Covers: Assigns 30 freelance design and 2 illustration jobs/year. Pays for design by the project. Prefers simple, easy-to-read, in-your-face cover treatment.
Tips: "Most of our interior design requires a fast turnaround. We do mostly 1-color work with occasional 2-color and 4-color jobs. We like a simple, professional design."

‡TROLL ASSOCIATES, Book Division, 100 Corporate Dr., Mahwah NJ 07430. (201)529-4000. Publisher: Roy Wandelmaier. Specializes in hardcovers and paperbacks for juveniles (3- to 15-year-olds). Publishes more than 100 titles/year. 30% require freelance design and illustrations.
Needs: Works with 30 freelancers/year. Prefers freelancers with 2-3 years of experience. Works on assignment only.
First Contact & Terms: Send query letter with brochure/flier, résumé and tearsheets or photostats. Samples returned by SASE only if requested. Reports in 1 month. Write for appointment to show portfolio. Considers complexity of project, skill and experience of artist, budget and rights purchased when establishing payment. Buys all rights or negotiates rights purchased. Originals usually not returned at job's completion.

‡TSR, INC., a subsidiary of Wizards of the Coast, Art Submissions, P.O. Box 707, Renton WA 98057.
 ● Due to the large number of submissions this company receives, they ask that you send non-returnable samples only.

UAHC PRESS, 838 Fifth Ave., New York NY 10021. (212)249-0100. Director of Publications: Stuart L. Benick. Produces books and magazines for Jewish school children and adult education. Recent titles include *TOT Shabbat*, by Camille Kress; and *Seven Blessings*, by Susan Marks and Bruce Black.
Needs: Approached by 20 freelancers/year.
First Contact & Terms: Send samples or write for interview. Include SASE. Reports within 3 weeks.
Jackets/Covers: Pays by the project, $250-600.
Text Illustration: Pays by the project, $150-200.
Tips: Seeking "clean and catchy" design and illustration.

UNIVELT INC., Box 28130, San Diego CA 92198. (760)746-4005. Fax: (760)746-3139. Manager: R.H. Jacobs. Publishes hardcover and paperback originals on astronautics and related fields; occasionally publishes veterinary first-aid manuals. Specializes in space. Publishes 10 titles/year; all have illustrations. Titles include *Spaceflight Mechanics 1994*, *Guidance and Control 1994*, *Space Programs and Fiscal Reality*. Books have "glossy covers with illustrations." Book catalog free by request.
Needs: Prefers local freelancers. Sometimes uses freelancers for covers, title sheets, dividers, occasionally a few illustrations.
First Contact & Terms: Please call before making any submissions. "We have been only using local sources." Reports in 1 month on unsolicited submissions. Buys one-time rights. Originals are returned at job's completion.
Jackets/Covers: Assigns 10 freelance design and 10 illustration jobs/year. Pays $50-100 for front cover illustration or frontispiece.
Text Illustration: Pays by the project, $50-100.
Tips: "Books usually include a front cover illustration and frontispiece. Illustrations have to be space-related. We obtain most of our illustrations from authors and from NASA. We usually do not use freelance sources."

THE UNIVERSITY OF NEBRASKA PRESS, 312 N. 14th, Lincoln NE 68588-0484. (402)472-3581. Fax: (402)472-0308. Website: http://www.unl.edu/UP/home.htm. Production Manager: Debra K. Turner. Estab. 1941. Publishes hardcover originals and trade paperback originals and reprints. Types of books include history, musicology, translations. Specializes in Western history, American Indian ethnohistory, Judaica, nature, Civil War, sports history, women's studies. Publishes 150 titles/year. Recent titles include *Seven Faces*, by Max Brand; and *Cherokee Women*, by Perdue. 5-10% require freelance illustration; 20% require freelance design. Book catalog free by request and available online.
Needs: Approached by 10 freelancers/year. Works with 2-3 freelance illustrators/year. Prefers freelancers experienced in 4-color, action in Civil War, basketball or Western topics. "We must use Native American artists for books on that subject." Uses freelancers for jacket/cover illustration. Works on assignment only.
First Contact & Terms: Send query letter with photocopies. Samples are filed. Reports back to the artist only if interested. Buys one-time rights. Originals are returned at job's completion.
Jackets/Covers: Assigns 2-3 illustration jobs/year. Usually prefers realistic, western, action styles. Pays by the project, $200-500.

‡UNIVERSITY OF OKLAHOMA PRESS, 1005 Asp Ave. Norman OK 73019. (405)325-5111. Fax: (405)325-4000. E-mail: pwillcox@ou.edu. Website: http://www.ou.edu/oupress. Production Manager: Patsy Willcox. Estab. 1927. Company publishes hardcover and trade paperback originals and reprints and textbooks. Types of books include biography, coffee table books, history, nonfiction, reference, textbooks, western. Specializes in Western/Indian nonfiction. Publishes 100 titles/year. 75% require freelance illustration (for jacket/cover). 5% require freelance design. Book catalog free by request.
Needs: Approached by 15-20 freelancers/year. Works with 40-50 freelance illustrators and 4-5 designers/year. "We cannot commission work, must find existing art." Uses freelancers mainly for jacket/cover illustrations. Also for jacket/cover and book design. 25% of freelance work demands knowledge of Aldus PageMaker, Adobe Illustrator, QuarkXPress, Adobe Photoshop, Aldus FreeHand, CorelDraw and Ventura.
First Contact & Terms: Send query letter with brochure, résumé and photocopies. Samples are filed. Does not report back. Artist should contact us 1 month after submission. Art Director will contact artist for portfolio review if interested. Portfolio should include book dummy and photostats. Buys reprint rights. Originals are returned at job's completion. Finds artists through submissions, attending exhibits, art shows and word of mouth.

Book Design: Assigns 4-5 freelance design jobs/year. Pays by the project.
Jackets/Covers: Assigns 4-5 freelance design jobs/year. Pays by the project.

‡**UNIVERSITY OF PENNSYLVANIA PRESS**, 9200 Pine St., Philadelphia PA 19104-4011. (215)898-1675. Fax: (215)898-0404. E-mail: cgross@upenn.edu. Art Director: Carl Gross. Estab. 1920. Publishes hardcover originals and reprints, textbooks, trade paperback originals and reprints. Types of books include biography, history, nonfiction. Publishes 60 titles/year. Recent titles include: *ABC's of Architecture*, *Empire of Free Trade*. 10% requires freelance illustration; 100% requires freelance design. Book catalog free for SAE with 4 first-class stamps.
Needs: Approached by 15 illustrators and 3 designers/year. Works with 2 illustrators and 5 designers/year. Prefers freelancers experienced in book jacket design. 100% of freelance work demands knowledge of Adobe Illustrator, Adobe Photoshop, QuarkXPress.
First Contact & Terms: Send query letter with photocopies. Accepts Mac-compatible disk submissions. Send EPS files. Samples are filed or returned. Will contact artist for portfolio review if interested. Finds freelancers through submission packets.
Book Design: Assigns 10 freelance design jobs/year. Pays by the project, $600-3,000.
Jackets/Covers: Assigns 60 freelance design jobs and 10 illustration jobs/year. Prefers colorful, elegant design. Pays for design by the project, $600-800. Pays for illustration by the project $200-800.
Text Illustration: Assigns 5 freelance illustration jobs/year. Pays by the project, $200-800. Prefers freelancers who can create colorful, elegant, jackets/covers.
Tips: "Artists should have excellent knowledge of the use of good typography in creating and communicating a concept clearly."

‡**VISUAL EDUCATION CORPORATION**, 14 Washington Rd., Princeton NJ 08543. (609)799-9200. Production Manager: Barbara Kopel. Estab. 1969. Independent book producer/packager of textbooks and reference books. Specializes in social studies, history, geography, vocational, math, science, etc. 10% require freelance illustration; 80% require freelance design.
Needs: Approached by 30 freelance artists/year. Works with 4-5 illustrators and 5-15 designers/year. Buys 5-10 illustrations/year. Prefers artists with experience in textbooks, especially health, medical, social studies. Uses freelancers mainly for interior illustration. Also for jacket/cover illustration. Works on assignment only.
First Contact & Terms: Send query letter with tearsheets and résumé. Samples are filed. Reports back to the artist only if interested. To show portfolio, mail roughs and tearsheets. Rights purchased vary according to project. Originals returned at job's completion.
Book Design: Assigns 5-15 jobs/year. Pays by the project.
Jackets/Covers: Assigns 1-2 design jobs/year. Pays by the project.
Text Illustration: Assigns 2-3 illustration jobs/year. Pays by the project.
Tips: "Designers, if you contact us with samples we will invite you to do a presentation and make assignments as suitable work arises. Graphic artists, when working assignments we review our files. Enclose typical rate structure with your samples."

‡**VOYAGEUR PRESS**, 123 N. Second St., Stillwater MN 55082. (612)430-2210. Fax: (612)430-2211. E-mail: books@ voyageurpress.com. Editorial Director: Michael Dregni. Pre-Press Director: Andrea Rud. Estab. 1973. Book publisher. Publishes hardcover and trade paperback originals. Types of books include Americana, collectibles, travel, cookbooks, natural history and regional. Specializes in natural history, travel and regional subjects. Publishes 25 titles/year. Recent titles include *Loons: Song of the Wild* and *Backroads of Colorado*. 10% require freelance illustration; 10% require freelance design. Book catalog free by request.
Needs: Approached by 100 freelance artists/year. Works with 2-5 freelance illustrators and 2-5 freelance designers/year. Prefers artists with experience in maps and book and cover design. Uses freelance artists mainly for cover and book design. Also uses freelance artists for jacket/cover illustration and direct mail and catalog design. 100% of design requires computer skills. Works on assignment only.
First Contact & Terms: Send postcard sample and/or query letter with brochure, photocopies, SASE and tearsheets, list of credits and nonreturnable samples of work that need not be returned. Samples are filed. Reports back to the artist only if interested. "We do not review portfolios unless we have a specific project in mind. In that case, we'll contact artists for a portfolio review." Usually buys first rights. Originals returned at job's completion.
Book Design: Assigns 2-5 freelance design jobs and 2-5 freelance illustration jobs/year.
Jackets/Covers: Assigns 2-5 freelance design and 2-5 freelance illustration jobs/year.
Text Illustration: Assigns 2-5 freelance design and 2-5 design illustration jobs/year.
Tips: "We use more book designers than artists or illustrators, since most of our books are illustrated with photographs."

‡**J. WESTON WALCH PUBLISHING**, 321 Valley St., Portland ME 04102. (207)772-2846. Fax: (207)774-7167. Art Director: Linwood N. Houghton. Estab. 1927. Company publishes supplementary educational books and other material (video, software, audio, posters, cards, games, etc.). Types of books include instructional and young adult. Specializes in all middle and high school subject areas. Publishes 100 titles/year. 15-25% require freelance illustration. Book catalog free by request.
Needs: Approached by 70-100 freelancers/year. Works with 10-20 freelance illustrators and 5-10 designers/year. Prefers local freelancers only. Uses freelancers mainly for text and/or cover illustrations. Also for jacket/cover design.

First Contact & Terms: Send tearsheets, SASE and photocopies. Samples are filed or returned by SASE. Accepts disk submissions compatible with Adobe Photoshop, QuarkXPress, Aldus FreeHand or Framemaker. Art Director will contact artist for portfolio review if interested. Portfolio should include final art, roughs and tearsheets. Buys one-time rights. Originals are returned at job's completion. Finds artists through submissions, reviewing with other art directors in the local area.

Jackets/Covers: Assigns 10-15 freelance design and 10-20 illustration jobs/year. Pays by the project, $300-600.

Text & Poster Illustration: Pays by the project, $500-4,000.

Tips: "Show a facility with taking subject matter appropriate for middle and high school curriculums and presenting it in a new way."

WARNER BOOKS INC., 1271 Sixth Ave., New York NY 10020. (212)522-7200. Vice President and Creative Director of Warner Books: Jackie Meyer. Publishes mass market paperbacks and adult trade hardcovers and paperbacks. Publishes 350 titles/year. Recent titles include *WASP Cookbook* and *The Winner*. 20% require freelance design; 80% require freelance illustration.

 • Others in the department are Diane Luger, Flamur Tonuzi, Don Puckey and Rachel McClain. Send them mailers for their files as well.

Needs: Approached by 500 freelancers/year. Works with 150 freelance illustrators and 30 designers/year. Uses freelancers mainly for illustration and handlettering. Works on assignment only.

First Contact & Terms: Do not call for appointment or portfolio review. Mail samples only. Send brochure or tearsheets and photocopies. Samples are filed or are returned by SASE. Art Director will contact artist for portfolio review if interested. Negotiates rights purchased. Considers buying second rights (reprint rights) to previously published work. Originals are returned at job's completion (artist must pick up). "Check for most recent titles in bookstores." Finds artists through books, mailers, parties, lectures, judging and colleagues.

Jackets/Covers: Pays for design and illustration by the project; $1,000 minimum. Uses all styles of jacket illustrations.

Tips: Industry trends include "more graphics and stylized art." Looks for "photorealistic style with imaginative and original design and use of eye-catching color variations. Artists shouldn't talk too much. Good design and art should speak for themselves."

‡✽WEIGL EDUCATIONAL PUBLISHERS LTD., 1902 11th St. SE, Calgary, Alberta T2G 3G2 Canada. (403)233-7747. Fax: (403)233-7769. E-mail: weigl@mail.telusplane.net. Contact: Senior Editor. Estab. 1979. Textbook publisher catering to juvenile and young adult audience. Specializes in social studies, science-environmental, life skills, multicultural and Canadian focus. Publishes 15 titles/year. Titles include *The Untamed World* series; *Twentieth Century Canada*; and *Women In Profile* series. 20-40% require freelance illustration. Book catalog free by request.

Needs: Approached by 50-60 freelancers/year. Works with 2-3 illustrators/year. Prefers freelancers with experience in children's text illustration in line art/watercolor. Uses freelancers mainly for text illustration. Also for direct mail design. Freelancers should be familiar with PageMaker 5.0, Illustrator and Photoshop 3.0.

First Contact & Terms: Send query letter with brochure, résumé, SASE, tearsheets, photographs, photocopies ("representative samples of quality work"). Samples are returned by SASE if requested by artist. Reports back to the artist only if interested. Write for appointment to show portfolio of original/final art (small), b&w photostats, tearsheets and photographs. Rights purchased vary according to project.

Text Illustration: Assigns 5-10 freelance illustration jobs/year. Pays by the hour, $20-60. Prefers line art and watercolor appropriate for elementary and secondary school students.

SAMUEL WEISER INC., Box 612, York Beach ME 03910. (207)363-4393. Fax: (207)363-5799. E-mail: weiserbooks @worldnet.att.net. Vice President: B. Lundsted. Specializes in hardcover and paperback originals, reprints and trade publications on metaphysics/oriental philosophy/esoterica. Publishes 24 titles/year. Recent titles include *Tarot as a Way of Life: A Jungian Approach to the Tarot*, by Karen Hamaker-Zondag and *The River of Life*, by Ruth White. "We use visionary art or nature scenes." Publishes 20 titles/year. Catalog available for SASE.

Needs: Approached by approximately 25 artists/year. Works with 10-15 illustrators and 2-3 designers/year. Uses freelancers for jacket/cover design and illustration. 80% of design and 40% of illustration demand knowledge of Adobe Illustrator, Adobe Photoshop and QuarkXPress.

First Contact & Terms: Designers send query letter with résumé, photocopies and tearsheets. Illustrators send query letter with photocopies, photographs, SASE and tearsheets. "We can use art or photos. I want to see samples I can keep." Samples are filed or are returned by SASE only if requested by artist. Reports back within 1 month only if interested. Originals are returned to artist at job's completion. To show portfolio, mail tearsheets, color photocopies or slides. Considers complexity of project, skill and experience of artist, project's budget, turnaround time and rights purchased when establishing payment. Buys one-time nonexclusive rights. Finds most artists through references/word-of-mouth, portfolio reviews and samples received through the mail.

Jackets/Covers: Assigns 20 design jobs/year. Prefers airbrush, watercolor, acrylic and oil. Pays by the project, $100-500.

Tips: "Send me color copies of work—something we can keep in our files. Stay in touch with phone numbers. Sometimes we get material and suddenly can use it and can't because we can't find the photographer or artist! We're interested in buying art that we use to create a cover, or in artists with professional experience with cover film—who can work from inception of design to researching/creating image to type design; we work with old-fashioned mechanicals,

Mary Beckman's piece "The Reading" was first published on a notecard. The author of *Tarot Celebrations: Honoring the Inner Voice* recommended the illustration be used on her book published by Samuel Weiser. "It was a thrill to see my first book cover published," says Beckman. "It adds credibility to my work as an artist." Weiser does not look for exclusive rights to cover art. "We want to be the only publisher who is using that art on a book cover in the genre in which we publish," explains Betty Lundsted, the publisher's vice president. "We try to help artists find their way into the world, and are happy to help in the process of them becoming 'known.' "

film and disk. Don't send us drawings of witches, goblins and demons, for that is not what our field is about. You should know something about us before you send materials."

WHALESBACK BOOKS, Box 9546, Washington DC 20016. (202)333-2182. Fax: (202)333-2184. Publisher: W.D. Howells. Estab. 1988. Imprint of Howells House. Company publishes hardcover and trade paperback originals and reprints. Types of books include biography, history, art, architecture, social and human sciences. Publishes 2-4 titles/year. 80% require freelance illustration; 80% require freelance design.
Needs: Approached by 6-8 freelance artists/year. Works with 1-2 freelance illustrators and 1-3 freelance designers/year. Buys 10-20 freelance illustrations/job. Prefers local artists with experience in color and desktop. Uses freelance artists mainly for illustration and book/jacket designs. Also uses freelance artists for jacket/cover illustration and design; text, direct mail, book and catalog design. 20-40% of freelance work demands knowledge of Aldus PageMaker, Adobe Illustrator or QuarkXPress. Works on assignment only.
First Contact & Terms: Send query letter with brochure, SASE and photocopies. Samples are not filed and are returned by SASE if requested by artist. Reports back only if interested. Art Director will contact artist for portfolio review if interested. Portfolio should include b&w roughs and photostats. Rights purchased vary according to project.
Book Design: Assigns 2-4 freelance design jobs/year. Pays by the project.
Jackets/Covers: Assigns 2-4 freelance design jobs/year. Pays by the project.
Text Illustration: Assigns 6-8 freelance illustration jobs/year. Pays by the project.

ALBERT WHITMAN & COMPANY, 6340 Oakton, Morton Grove IL 60053-2723. Editor: Kathleen Tucker. Art Director: Scott Piehl. Specializes in hardcover original juvenile fiction and nonfiction—many picture books for young children. Publishes 25 titles/year. Recent titles include *Two of Everything*, by Lily Toy Hong; and *Do Pirates Take Baths*, by Kathy Tucker. 100% require freelance illustration. Books need "a young look—we market to preschoolers mostly."
Needs: Prefers working with artists who have experience illustrating juvenile trade books. Works on assignment only.
First Contact & Terms: Illustrators send postcard sample and tearsheets. "One sample is not enough. We need at least three. Do *not* send original art through the mail." Accepts disk submissions. Samples are not returned. Reports back "if we have a project that seems right for the artist. We like to see evidence that an artist can show the same children and adults in a variety of moods, poses and environments." Rights purchased vary. Original work returned at job's completion.
Cover/Text Illustration: Cover assignment is usually part of text illustration assignment. Assigns 25-30 freelance jobs/year. Prefers realistic and semi-realistic art. Pays by flat fee or royalties.
Tips: Especially looks for "an artist's ability to draw people, especially children and the ability to set an appropriate mood for the story."

‡WILLIAMS & WILKINS BOOK DIVISION, Imprint of Williams & Wilkins. Parent company: Waverly, Inc. 351 W. Camden St., Baltimore MD 21201-2436. (410)528-4267. Fax: (410)361-8015. E-mail: mfernandez@wwilkins.com. Website: http://www.wwilkins.com. Design Coordinator: Mario Fernandez. Estab. 1890. Publishes audio tapes, CD-ROMs, hardcover originals and reprints, textbooks, trade paperbook originals. Types of books include medical. Specializes in medical publishing. Publishes 170 titles/year. Recent titles include: *Principles of Medical Genetics-2nd Edition*, *Communication Development: Foundations Processes and Clinical Applications*. 100% requires freelance illustration; 100% requires freelance design. Book catalog available online; see website address above.
Needs: Works with 10 illustrators and 20 designers/year. Prefers freelancers experienced in clinical and textbook medical books. 100% of freelance design demands knowledge of Adobe Illustrator, Adobe Photoshop, QuarkXPress.
First Contact & Terms: Send query letter with printed samples. Accepts Mac-compatible disk submissions. Send EPS files. Samples are filed. If not filed samples are returned. Reports back only if interested. Will contact artist for portfolio review of artwork portraying medical subjects if interested. Rights purchased vary according to project. Finds freelancers through submission packets, networking events.
Book Design: Assigns 170 freelance design jobs/year. Pays by the project, $200-5,000.
Jackets/Covers: Assigns 170 freelance design jobs/year. Prefers multidiscipline experience, bold colors. Pays for design by the project, $200-5,000. Prefers multidiscipline (clinical and textbook) experience.
Tips: "Artists must be proficient in Windows and Macintosh platform using Quark, Illustrator and Photoshop. In addition, they must have a strong background in print production (4-color process, overprinting, etc.) Designs must be discipline-driven (clinical or textbook), clean, fresh and contemporary."

WILLIAMSON PUBLISHING, P.O. Box 185, Charlotte VT 05445. (802)425-2102. E-mail: susan@williamsonbooks.com. Website: http://www.williamsonbooks.com. Editorial Director: Susan Williamson. Estab. 1983. Publishes trade paperback originals. Types of books include juvenile, children's nonfiction, preschool, folktales. Specializes in children's active hands-on learning. Publishes 15 titles/year. Recent titles include: *Bird Tales*; *Pyramids!*. Book catalog free for 8½×11 SASE with 5 first-class stamps.
Needs: Approached by 100 illustrators and 10 designers/year. Works with 10 illustrators and 5 designers/year. 100% of freelance design demands computer skills.
First Contact & Terms: Designers send query letter with brochure, photocopies, résumé, SASE. Illustrators send postcard sample and/or query letter with photocopies, résumé and SASE. Samples are filed. Reports back only if interested.

Book Design: Pays for design and illustration by the project.

Tips: "We are actively seeking freelance illustrators and book designers to support our growing team. We are looking for both black & white and 4-color illustration—everything from step-by-step how-to (always done with personality as opposed to technical drawings) to full-page pictorial interpretation with folk tales. Go to the library and look up several of our books in our four series. Then do a few sample spreads for us. If we're excited about your work, you'll definitely hear from us."

WILSHIRE BOOK CO., 12015 Sherman Rd., North Hollywood CA 91605. (818)765-8579. President: Melvin Powers. Company publishes trade paperback originals and reprints. Types of books include biography, humor, instructional, New Age, psychology, self help, inspirational and other types of nonfiction. Publishes 25 titles/year. Recent titles include *Think Like a Winner!*, *The Princess Who Believed in Fairy Tales*, and *The Knight in Rusty Armor*. 100% require freelance design. Catalog for SASE with first-class stamps.

Needs: Uses freelancers mainly for book covers, to design cover plus type. Also for direct mail design. "We need graphic design ready to give to printer. Computer cover designs are fine."

First Contact & Terms: Send query letter with fee schedule, tearsheets, photostats, photocopies (copies of previous book covers). Portfolio may be dropped off every Monday-Friday. Portfolio should include book dummy, slides, tearsheets, transparencies. Buys first, reprint or one-time rights. Interested in buying second rights (reprint rights) to previously published work. Negotiates payment.

Book Design: Assigns 25 freelance design jobs/year.

Jackets/Covers: Assigns 25 cover jobs/year.

‡WISDOM PUBLICATIONS INC., 199 Elm St., Somerville MA 02144. (617)776-7416. Fax: (617)776-7841. E-mail: info@wisdompubs.org. Website: http://www.wisdompubs.org. Contact: Production Manager. Publisher: Timothy McNeill. Estab. 1989. Publishes hardcover and trade paperback originals. Types of books include biography, religious, self help. Specializes in Buddhism. Publishes 14 titles/year. Recent titles include: *The Good IIeurt: A Buddhist Perspective on the Teachings of Jesus*. 10% requires freelance illustration; 70% requires freelance design; 50% requires freelance art direction. Book catalog free for SAE with 3 first-class stamps.

Needs: Approached by 20 illustrators/year and 10 designers/year. Works with 4 illustrators/year; 6 designers/year; 2 art directors/year. Prefers local freelancers experienced in computer-based design (Macs). 100% of freelance design demands knowledge of Adobe Illustrator, Adobe Photoshop, QuarkXPress.

First Contact & Terms: Send query letter with printed samples. Will contact artist for portfolio review of examples of book covers if interested. Rights purchased vary according to project. Finds freelancers through networking.

Book Design: Assigns 8 freelance design and art direction projects/year.

Jackets/Covers: Assigns 8 freelance design jobs and 6 illustration jobs/year. Prefers sophisticated or traditionsl styles.

Text Illustration: Assigns 4 freelance illustration jobs/year.

Tips: "Specialize in Buddhist books. Most utilize Buddhist art. Some East-West titles are narrated by Western art."

✔WORD PUBLISHING, 545 Marriott Dr., Suite 750, Nashville TN 37214. Fax: (615)902-3206. Executive Art Director: Tom Williams. Estab. 1951. Imprints include Word Bibles. Company publishes hardcover, trade paperback and mass market paperback originals and reprints; audio; and video. Types of books include biography, fiction, nonfiction, religious, self-help and sports biography. "All books have a strong Christian content—including fiction." Publishes 85 titles/year. Recent titles include *Storm Warning*, by Billy Graham; *The Great House of God*, by Max Lucado and *Miracle Man*, by Nolan Ryan. 30-35% require freelance illustration; 100% require freelance design.

Needs: Approached by 1,500 freelancers/year. Works with 20 freelance illustrators and 30 designers/year. Buys 20-30 freelance illustrations/year. Uses freelancers mainly for book cover and packaging design. Also for jacket/cover illustration and design and text illustration. 100% of design and 5% of illustration demand knowledge of Adobe Illustrator, QuarkXPress and Adobe Photoshop. Works on assignment only. 10% of titles require freelance art direction.

First Contact & Terms: Send query letter with SASE, tearsheets, photographs, photocopies, photstats, "whatever shows artist's work best." Accepts disk submissions, but not preferred. Samples are returned by SASE. Art Director will contact artist for portfolio review if interested. Portfolio should include tearsheets and transparencies. Purchases first rights. Originals are returned at job's completion. Finds artists through agents, *Creative Illustration Book, American Showcuse, Workbook, Directory of Illustration.*

Jacket/Covers: Assigns 85 freelance design and 20-30 freelance illustration jobs/year. Pays by the project $1,200-5,000. Considers all media—oil, acrylic, pastel, watercolor, mixed.

Text Illustration: Assigns 10 freelance illustration jobs/year. Pays by the project $75-250. Prefers line art.

Tips: "Please do not phone. I'll choose artists who work with me easily and accept direction and changes gracefully. Meeting deadlines is also extremely important. I regret to say that we are not a good place for newcomers to start. Experience and success in jacket design is a must for our needs and expectations. I hate that. How does a newcomer start? Probably with smaller companies."

‡WRIGHT GROUP PUBLISHING INC., Parent company: The Chicago Tribune, 19201 120th Ave. NE, Bothell WA 98011. (425)486-8011. Website: http://www.wrightgroup.com. Art Directors: Debra Lee and Patty Andrews. Publishes educational children's books. Types of books include children's picture books, history, nonfiction, preschool, educational reading materials. Specializes in education pre K-8. Publishes 50 titles/year. 100% requires freelance illustration; 5% requires freelance design.

"The artist makes it easy to empathize with the characters' emotions, affection and sensibility," says Art Director Debra Lee of Wright Publishing Group. Taylor Bruce's illustration of a son comforting his grieving mother is from a picture book entitled *The Day Martin Luther King, Jr. Died*. This assignment was Bruce's first job in the children's book market. "This particular piece is included in my portfolio and has helped to secure other book jobs." The artist sends out a new promo or tearsheet twice a year, and advertises in *The Black Book* yearly.

Needs: Approached by 100 illustrators and 10 designers/year. Works with 50 illustrators and 2 designers/year. Prefers local designers and art directors. Prefers freelancers experienced in children's book production. 100% of freelance design demands knowledge of Adobe Photoshop, Aldus FreeHand, PageMaker, QuarkXPress.

First Contact & Terms: Send query letter with printed samples, color photocopies and follow-up postcard every 6 months. Samples are filed or returned. Will contact artist for portfolio review if interested. Buys all rights. Finds freelancers through submission packets, agents, sourcebooks, word of mouth..

Book Design: Assigns 2 freelance design and 2 freelance art direction projects/year. Pays for design by the hour, $20-25.
Text Illustration: Assigns 50 freelance illustration jobs/year. Pays by the project, $3,000-3,800.
Tips: "Illustrators will have fun and enjoy working on our books, knowing the end result will help children learn to love to read."

✢**WUERZ PUBLISHING LTD.**, 895 McMillan, Winnipeg, Manitoba R3M 0T2. (204)453-7429. Fax: (204)453-6598. E-mail: swuerz@wuerzpubl.mb.ca. Website: http://www.mbnet.mb.ca/~swuerz. Director: Steve Wuerz. Estab. 1989. Publishes trade paperback originals, textbooks and CD-ROMs. Types of books include native, science and textbooks. Publishes 12 titles/year.
First Contact & Terms: Designers send query letter with brochure. Illustrators send postcard sample or query letter with photocopies. Samples are not filed and are returned only if requested. Will contact artist for portfolio review if interested. Rights purchased vary according to project.
Jackets/Covers: Pays by the project; payment negotiable on quote or bid basis.
Text Illustration: Pays by the project; negotiable on quote or bid basis, $25-1,000.

YE GALLEON PRESS, Box 25, Fairfield WA 99012. (509)283-2422. Editorial Director: Glen Adams. Estab. 1937. Publishes hardcover and paperback originals and reprints. Types of books include rare Western history, Indian material, antiquarian shipwreck and old whaling accounts and town and area histories. Publishes 20 titles/year. 10% require freelance illustration. Book catalog for SASE.
First Contact & Terms: Works with 2 freelance illustrators/year. Query with samples and SASE. No advance. Pays promised fee for unused assigned work. Buys book rights.
Text Illustration: Buys b&w line drawings (pen & ink) of a historical nature; prefers drawings of groups with facial expressions and some drawings of sailing and whaling vessels. Pays for illustration by the project, $7.50-35.
Tips: " 'Wild' artwork is hardly suited to book illustration for my purposes. Many correspondents wish to sell oil paintings. At this time we do not buy them. It costs too much to print them for short edition work."

✢**ZAPP STUDIO INC.**, 338 St. Antoine St. E., 3rd Floor, Montreal, Quebec H2Y 1A3 Canada. (514)871-4707. Fax: (514)871-4803. Art Director: Hélène Cousineau. Estab. 1986. Company publishes hardcover originals and reprints. Types of books include cookbooks, instructional, juvenile, preschool and textbooks. Specializes in children's books. Publishes 40 titles/year. Recent titles include *Atlas Puzzle Book* boxed set with 16 blocks, passport, stickers and trivia cards) and *Instant Creatures* (plastic aquarium, book, creature eggs and food, stickers). 50% require freelance illustration; 30% require freelance design.
Needs: Approached by 30 freelancers/year. Works with 15 freelance illustrators and 7 designers/year. Prefers freelancers with experience in children's illustration. Uses freelancers for jacket/cover illustration and design and book design. 50% of freelance work demands knowledge of Adobe Illustrator, QuarkXPress and Adobe Photoshop. Works on assignment only.
First Contact & Terms: Send postcard sample or query letter with brochure, résumé, photographs, SASE, tearsheets and photocopies. Accepts disk submissions compatible with Adobe Illustrator 5.0 and Adobe Photoshop. Send EPS files. Samples are filed and are not returned. Reports back within 1 month. Art Director will contact artist for portfolio review if interested. Portfolio should include book dummy, final art and transparencies. Buys first rights. Does not pay royalties. Originals are not returned. Finds artists through sourcebooks, word of mouth, submissions and attending art exhibitions.
Book Design: Assigns 15 freelance design jobs/year. Pays by the project, $500-2,000.
Jackets/Covers: Assigns 15 freelance design and 30 illustration jobs/year. Pays by the project.
Text Illustration: Assigns 30 freelance illustration jobs/year. Pays by the project.
Tips: "Our studio's major publications are children's books and cookbooks."

ZOLAND BOOKS, INC., 384 Huron Ave., Cambridge MA 02138. (617)864-6252. Design Director: Lori Pease. Estab. 1987. Publishes hardcover and trade paperback originals and reprints. Types of books include literary fiction, biography, travel, poetry, fine art and photography. Publishes 10-12 titles/year. Recent titles include *Glorie*, by Caryn James; and *Reinventing a Continent*, by André Brink (essays). Books are of "quality manufacturing with full attention to design and production." 10% require freelance illustration; 80% require freelance design. Book catalog with an oversized SASE.
Needs: Works with 2 freelance illustrators and 6 freelance designers/year. Buys 3 illustrations/year. Uses freelancers mainly for book and jacket design. Also for jacket/cover illustration and catalog design. 100% of design work demands knowledge of Aldus PageMaker or QuarkXPress. Works on assignment only.
First Contact & Terms: Send query letter with brochure, résumé, tearsheets, photocopies or photostats. Samples are filed or are returned by SASE if requested by artist. Design Director will contact artist for portfolio review if interested. Rights purchased vary according to project. Originals are returned at job's completion.
Book Design: Assigns 10-12 jobs/year. Pays by the project, $500 minimum.
Jacket/Covers: Assigns 10-12 design and 1-3 freelance illustration jobs/year. Pays by the project, $500 minimum.

Galleries

You don't have to move to New York City to find a gallery. Whether you live in a small town or a big city, the easiest galleries to try first are the ones closest to you. It's much easier to begin developing a reputation within a defined region. New artists rarely burst onto the scene on a national level.

The majority of galleries will be happy to take a look at your slides. If they feel your artwork doesn't fit their gallery, most will gently let you know, often steering you toward a more appropriate one. Whenever you meet rejection (and you will), tell yourself it's all part of being an artist.

Three Very Important Rules

1. **Make sure you are truly ready for gallery representation.** Do you have a full body of work to show (at least 30 artworks)? Is the work consistent in style? Do you have a track record of exhibiting in group shows?
2. **Narrow your search to galleries that show the type of work you create.** Since you'll probably be approaching galleries in your region first, visit galleries before you send. Browse for a while and see what type of work they sell. Do you like the work? Is it similar to yours in quality and style? What about the staff? Are they friendly and professional? Do they seem to know about the artists the gallery handles? Do they have convenient hours? When submitting to galleries outside your city, if you can't manage a personal visit before you submit, read the listing carefully to make sure you understand what type of work is shown in that gallery and get a feel for what the space is like. Ask a friend or relative who lives in that city to check out the gallery for you. Ask to be placed on galleries' mailing lists. That's also one good way to make sure the gallery sends out professional mailings to prospective collectors.
3. **Do not walk into a gallery without an appointment**. When we ask gallery directors for pet peeves they always discuss the talented newcomer walking into the gallery with paintings in hand. Send a polished package of about 8 to 12 neatly labeled, mounted slides of your work submitted in plastic slide sheet format (refer to the listings for more specific information on each gallery's preferred submission method).

Showing in multiple galleries

Most successful artists show in several galleries. Once you have achieved representation on a local level, you are ready to broaden your scope by querying galleries in other cities. You may decide to concentrate on galleries in surrounding states, becoming a "regional" artist. Some artists like to have an East Coast and a West Coast gallery.

To develop a sense of various galleries, look to the myriad of art publications that contain reviews and advertising. A few such publications are *ARTnews*, *Art in America*, *The Artist's Magazine*, *The New Art Examiner* and regional publications such as *ARTweek* (West Coast), *Southwest Art*, *Dialogue* and *Art New England*. Lists of galleries can be found in *Art in America's Guide to Galleries, Museums and Artists* and *Art Now, U.S.A.'s National Art Museum and Gallery Guide*.

What should I charge?

A common question of beginning artists is "What do I charge for my paintings?" There are no hard and fast rules. The better known you become, the more people will pay for your work.

ALL GALLERIES ARE NOT ALIKE

As you search for the perfect gallery, it's important to understand the different types of spaces and how they operate. The route you choose depends on your needs, the type of work you do, your long term goals, and the audience you're trying to reach.

• **Retail or commercial galleries.** The goal of the retail gallery is to sell and promote artists while turning a profit. Retail galleries take a commission of 40 to 50 percent of all sales.

• **Co-op galleries.** Co-ops exist to sell and promote artists' work, but they are run by artists. Members exhibit their own work in exchange for a fee, which covers the gallery's overhead. Some co-ops also take a small commission of 20 to 30 percent to cover expenses. Members share the responsibilities of gallery-sitting, sales, housekeeping and maintenance.

• **Rental galleries.** The gallery makes its profit primarily through renting space to artists and consequently may not take a commission on sales (or will take only a very small commission). Some rental spaces provide publicity for artists, while others do not. Showing in this type of gallery is risky. Rental galleries are sometimes thought of as "vanity galleries" and, consequently they do not have the credibility other galleries enjoy.

• **Nonprofit galleries.** Nonprofit spaces will provide you with an opportunity to sell work and gain publicity, but will not market your work aggressively, because their goals are not necessarily sales-oriented. Nonprofits normally take a small commission of 20 to 30 percent.

• **Museums.** Don't approach museums unless you have already exhibited in galleries. The work in museums is by established artists and is usually donated by collectors or purchased through art dealers.

• **Art consultancies.** Generally, art consultants act as liasions between fine artists and buyers. Most take a commission on sales (as would a gallery). Some maintain small gallery spaces and show work to clients by appointment.

Though you should never underprice your work, you must take into consideration what people are willing to pay. Also keep in mind that you must charge the same amount for a painting sold in a gallery as you would for work sold from your studio. If you plan to sell work from your studio, or from a website or other galleries, be upfront with your gallery. Work out a commission arrangement that feels fair to both of you and everybody wins. For "rules of thumb" about pricing and gallery commissions, see pages 41-42.

While you're waiting to be discovered . . .

As you submit your work and get feedback you might find out your style hasn't developed enough to grab a gallery's interest. It may take months, maybe years, before you find a gallery to represent you. But don't worry, there are plenty of other venues to show in until you are accepted in a commercial gallery. If you get involved with your local art community, attend openings, read the arts section of your local paper, you'll see there are hundreds of opportunities right in your city.

Enter group shows every chance you get. Go to the art department of your local library and check out the bulletin board, then ask the librarian to steer you to regional arts magazines like *Art Calendar*, that list "calls to artists" and other opportunities to exhibit your work. Join a co-op gallery and show your work in a space run by artists for artists. Is there a restaurant in your town that shows the work of local artists? Ask the manager how you can show your work. Become an active member in an arts group. It's important to get to know your fellow artists. And since art groups often mount exhibitions of their members' work you'll have a way to show your work until you find a gallery to represent you.

KNOW WHO'S WHO IN THE GALLERY

It's important to understand the different roles of gallery personnel. Galleries are comprised of many people, each with their own distinct personality. It's these people who will be your partners in developing your art career. Treat them with respect and consideration, and expect that they will treat you the same.

Here is a list of titles and duties in a typical gallery.

OWNER OR ART DEALER
The person with ultimate control of a gallery is the owner (or owners). This person is also called an art dealer.

GALLERY DIRECTOR
The owner might or might not be the same person as the gallery director. The gallery director decides which artists to exhibit, when to have shows and so on. The gallery director is also responsible for the sales staff. You might find the gallery director on the floor of the gallery or in a separate office.

SALES STAFF
The sales staff works directly with collectors and other visitors to the gallery. You will find them on the floor of the gallery. Their responsibility is, obviously, to sell art. Get to know the sales staff, because they can tell you about the art and artists represented, as well as giving background information on the gallery. When I am showing with a gallery, I make a point of becoming friends with the salespeople because they are the ones who will be selling my art.

SERVICE STAFF
Larger galleries have various assistants, a receptionist, assistant to the director, maintenance crew and so on. Be friendly with everyone. In one way or another they all help sell your art.

STABLE OF ARTISTS
The last members of the gallery personnel are the stable of artists, the artists whose work is represented by the gallery. When I choose a new gallery, I always talk with one of the artists who is already represented by them. I ask how these people are to work with—Are they honest? Are they aggressive about promoting and selling their artists' work? Do they work hard for all their artists?

Excerpted from How To Get Started Selling Your Art, *copyright © 1996 by Carole Ketchen. Used with permission of North Light Books ($17.99).*

Alabama

ART GALORE!, 3322 S. Memorial Pkwy. 109, Huntsville AL 35801. (205)882-9040. E-mail: artgalor@traveller.com. Website: http://www.b17.com. Owner: Charles Hayes. Retail gallery. Estab. 1994. Represents 41 emerging, mid-career and established artists/year. Exhibited artists include Chuck Long and Anita Hoodless. Sponsors 9 shows/year. Average display time 3 months. Open all year; Tuesday-Friday, 11-5; Saturday, 1-5. 600 sq. ft. 100% of space for gallery artists. Clientele: local. 90% private collectors, 10% corporate collectors. Overall price range: $50-5,000; most work sold at $100-500.
Media: Considers all media and all types of prints. Most frequently exhibits watercolor, oil and acrylic.
Style: Exhibits all styles and genres. Prefers landscapes, florals and portraits.
Terms: Accepts work on consignment (25% commission). Retail price set by the artist. Gallery provides promotion. Artist pays shipping costs. Prefers artwork framed.
Submissions: Send query letter with slides and photographs. Call for appointment to show portfolio of photographs and slides. Replies in 2 weeks. Finds artist's through submissions.
Tips: "Include painting dimensions."

CORPORATE ART SOURCE, 2960-F Zelda Rd., Montgomery AL 36106. (334)271-3772. Owner: Jean Belt. Retail gallery and art consultancy. Estab. 1985. Interested in mid-career and established artists. "I don't represent artists, but

keep a slide bank to draw from as resources." Exhibited artists include: Beau Redmond and Dale Kenington. Open Monday-Friday, 10-5. Located in exclusive shopping center; 1,000 sq. ft. Clientele: corporate upscale, local. 20% private collectors, 80% corporate collectors. Overall price range: $100-250,000. Most work sold at $500-5,000.

Media: Considers all media and all types of prints. Most frequently exhibits oil/acrylic paintings on canvas, pastel and watercolor. Also interested in sculpture.

Style: Exhibits expressionism, painterly abstraction, impressionism and realism. Genres include landscapes, abstract and architectural work.

Terms: Artwork is accepted on consignment (50% commission). Retail price set by artist. Gallery provides contract, shipping costs from gallery. Prefers artwork unframed.

Submissions: Send query letter with résumé, slides or photographs and SASE. Call for appointment to show portfolio of slides and photographs. Replies in 6 weeks.

FAYETTE ART MUSEUM, 530 N. Temple Ave., Fayette AL 35555. (205)932-8727. Director: Jack Black. Museum. Estab. 1969. Exhibits the work of emerging, mid-career and established artists. Open all year, Sundays from 1-4 p.m. and weekdays by appointment. Located downtown Fayette Civic Center; 16,500 sq. ft. Six galleries devoted to folk art.

Media: Considers all media and all types of prints. Most frequently exhibits oil, watercolor and mixed media.

Style: Exhibits expressionism, primitivism, painterly abstraction, minimalism, postmodern works, impressionism, realism and hard-edge geometric abstraction. Genres include landscapes, florals, Americana, wildlife, portraits and figurative work.

Terms: Shipping costs negotiable. Prefers artwork framed.

Submissions: Send query letter with résumé, brochure and photographs. Write for appointment to show portfolio of photographs. Files possible exhibit material.

Tips: "Do not send expensive mailings (slides, etc.) before calling to find out if we are interested. We want to expand collection. Top priority is folk art from established artists."

LEON LOARD GALLERY OF FINE ARTS, 2781 Zelda Rd., Montgomery AL 36106. (800)270-9017. Fax: (334)270-0150. Gallery Director: Barbara Smith. Retail gallery. Estab. 1989. Represents about 70 emerging, mid-career and established artists/year. Exhibited artists include Paige Harvey and Pete Beckman. Sponsors 4 shows/year. Average display time 3 months. Open all year; Monday-Friday, 9-4:30; weekends by appointment. Located in upscale suburb; cloth walls. 45% of space for special exhibitions; 45% of space for gallery artists. Clientele: local community—many return clients. 80% private collectors, 20% corporate collectors. Overall price range: $100-75,000; most work sold at $500-3,000.

Media: Considers oil, acrylic, watercolor, pastel, pen & ink, drawing, mixed media, collage, paper, sculpture, ceramics, fiber and glass. Most frequently exhibits oil on canvas, acrylic on canvas and watercolor on paper.

Style: Exhibits all styles and all genres. Prefers impressionism, realism and abstract.

Terms: Accepts work on consignment. Retail price set by the gallery and the artist. Gallery provides insurance, promotion and contract. Shipping costs are shared. Prefers artwork unframed.

Submissions: Send query letter with résumé, slides, bio and photographs. Portfolio should include photographs and slides. Replies in 2 weeks. Files bios and slides.

MAYOR'S OFFICE FOLK ART GALLERY, 5735 Hwy. 431, P.O. Box 128, Pittsview AL 36871. (334)855-3568. Owner: Frank Turner. Wholesale gallery. Estab. 1994. Represents 5-6 emerging, mid-career and established artists/year. Exhibited artists include: Buddy Snipes and Butch Anthony. Average display time 6 months. Open all year; by chance or appointment. Located in rural community on main highway; 800-1,000 sq. ft.; folk/outsider art only. 75% of space for gallery artists. Clientele: tourists, upscale collectors, dealers. 50% private collectors (wholesale). Overall price range: $60-1,000; most work sold at $60-150.

Media: Considers oil, acrylic, watercolor, pastel, pen & ink, drawing, mixed media, collage, paper, sculpture, fiber and glass; considers all types of prints. Most frequently exhibits oil, house paint and wood.

Style: Exhibits: expressionism and primitivism. (It's folk art—you name it and they do it.)

Terms: Buys outright. Retail price set by the gallery and the artist. Gallery provides promotion; shipping costs are shared.

Submissions: Accepts only artists from east Alabama and west Georgia. Prefers folk/outsider only—must be "unique and true." Call to show portfolio of photographs and original art. Finds artists through word of mouth, referrals by other artists and submissions.

Tips: "No craft items. Art must be true—straight from the heart and mind of the artist."

‡MOBILE MUSEUM OF ART, 4850 Museum Dr., Mobile AL 36689. (334)343-2667. E-mail: mmoa01@ci.mobile.al. us. Director: Joe Schenk. Clientele: tourists and general public. Sponsors 6 solo and 12 group shows/year. Average display time 6-8 weeks. Interested in emerging, mid-career and established artists. Overall price range: $100-5,000; most artwork sold at $100-500.

Media: Considers all media and all types of visual art.

Style: Exhibits all styles and genres. "We are a general fine arts museum seeking a variety of style, media and time periods." Looking for "historical significance."

Terms: Accepts work on consignment (20% commission). Retail price set by artist. Exclusive area representation not required. Gallery provides insurance, promotion, contract; shipping costs are shared. Prefers framed artwork.

Submissions: Send query letter with résumé, brochure, business card, slides, photographs, bio and SASE. Write to schedule an appointment to show a portfolio, which should include slides, transparencies and photographs. Replies only if interested within 3 months. Files résumés and slides. All material is returned with SASE if not accepted or under consideration.

Tips: "Be persistent—but friendly!"

⊭RENAISSANCE GALLERY, INC., 431 Main Ave., Northport AL 35476. (205)752-4422. Owners: Judy Buckley and Kathy Groshong. Retail gallery. Estab. 1994. Represents 25 emerging, mid-career and established artists/year. Exhibited artists include: Karen Jacobs, John Wagner and Sharon Tavis. Sponsors 8 shows/year. Average display time 6 months. Open all year; Monday-Saturday, 11-4:30. Located in downtown historical district; 1,000 sq. ft.; historic southern building. 25% of space for special exhibitions; 75% of space for gallery artists. Clientele: tourists and local community. 95% private collectors; 5% corporate collectors. Overall price range: $65-3,000; most work sold at $100-900.

Media: Considers oil, acrylic, watercolor, pastel, pen & ink, mixed media, sculpture, ceramics and leaded glass; types of prints include woodcuts, etchings and monoprints. Most frequently exhibits oil, acrylic and watercolor.

Style: Exhibits: painterly abstraction, impressionism, photorealism, realism, imagism and folk-whimsical. Genres include florals, portraits, landscapes, Americana and figurative work. Prefers: realism, imagism and abstract.

Terms: Accepts work on consignment (50% commission). Retail price set by the artist. Gallery provides promotion; shipping costs are shared. Prefers artwork framed.

Submissions: Prefers only painting, pottery and sculpture. Send query letter with slides or photographs. Write for appointment to show portfolio of photographs and sample work. Replies only if interested within 1 month. Files artists slides/photographs, returned if postage included. Finds artists through referrals by gallery artists.

Tips: "Do your homework. See the gallery before approaching. Make an appointment to discuss your work. Be open to suggestions, not defensive. Send or bring decent photos. Have work that is actually available, not already given away or sold. Don't bring in your first three works. You should be comfortable with what you are doing, past the experimental stage. You should have already produced many works of art (zillions!) before approaching galleria."

MARCIA WEBER/ART OBJECTS, INC., 1050 Woodley Rd., Montgomery AL 36106. (334)262-5349. Fax: (334)567-0060. E-mail: weberart@mindspring.com. Owner: Marcia Weber. Retail, wholesale gallery. Estab. 1991. Represents 21 emerging, mid-career and established artists/year. Exhibited artists include: Woodie Long, Jimmie Lee Sudduth. Sponsors 6 shows/year. Open all year except July by appointment only. Located in Old Cloverdale near downtown in older building with hardwood floors in section of town with big trees and gardens. 90% of space for special exhibitions; 10% of space for gallery artists. Clientele: tourists, upscale. 90% private collectors, 10% corporate collectors. Overall price range: $300-3,000; most work sold at $300-2,000.

• This gallery owner displays the work of self-taught folk artists or outsider artists. The artists she shows generally "live down dirt roads without phones," so a support person first contacts the gallery for them. Marcia Weber moves the gallery to New York's Soho district 3 weeks each winter.

Media: Considers all media except prints. Must be original one-of-a-kind works of art. Most frequently exhibits acrylic, oil, found metals, found objects, mud and paint.

Style: Exhibits genuine contemporary folk/outsider art.

Terms: Accepts work on consignment (variable commission) or buys outright. Gallery provides insurance, promotion and contract if consignment is involved. Prefers artwork unframed.

Submissions: Folk/outsider artists usually do not contact dealers. If they have a support person or helper, they might write or call. Send query letter with photographs, artist's statement. Call or write for appointment to show portfolio of photographs, original material. Finds artists through word of mouth, other artists and "serious collectors of folk art who want to help an artist get in touch with me."

Tips: "One is not a folk artist or outsider artist just because their work resembles folk art. They have to *be* folks or live outside mainstream America to create folk art or outsider art. To be represented by a gallery, all artists must be committed to full-time creating. That leap already has to be made. Also, they must not be out at every art fair that comes along. If they want to market their own work, then they should, but don't look at a gallery and expect to compete with them through self-marketing."

Alaska

DECKER/MORRIS GALLERY, (formerly Stonington Gallery), 621 W. Sixth Ave., Anchorage AK 99501-2127. (907)272-1489. Fax: (907)272-5395. Manager: Don Decker. Retail gallery. Estab. 1983. Interested in emerging, mid-career and established artists. Represents 50 artists. Sponsors 15 solo and group shows/year. Average display time 3 weeks. Clientele: 90% private collectors, 10% corporate clients. Overall price range: $100-5,000; most work sold at $500-1,000.

Media: Considers oil, acrylic, watercolor, pastel, mixed media, collage, works on paper, sculpture, ceramic, craft, fiber, glass and all original handpulled prints. Most frequently exhibits oil, mixed media and all types of craft.

Style: Exhibits all styles. "We have no pre-conceived notions as to what an artist should produce." Specializes in original works by artists from Alaska and the Pacific Northwest. "We are the only source of high-quality crafts in the

state of Alaska. We continue to generate a high percentage of our sales from jewelry and ceramics, small wood boxes and bowls and paper/fiber pieces. We push the edge to avante garde."

Terms: Accepts work on consignment (50% commission). Retail price set by artist. Exclusive area representation required. Gallery provides insurance, promotion.

Submissions: Send letter of introduction with résumé, slides, bio and SASE.

Tips: Impressed by "high quality ideas/craftsmanship—good slides."

Arizona

SUZANNE BROWN GALLERIES, 7160 Main St., Scottsdale AZ 85251. (602)945-8475. Director: Ms. Linda Corderman. Retail gallery and art consultancy. Estab. 1962. Interested in established artists. Represents 60 artists. Exhibited artists include Veloy Vigil, Ed Mell and Nelson Boren. Sponsors 6 solo and 2 group shows/year. Average display time 2 weeks. Located in downtown Scottsdale. Clientele: valley collectors, tourists, international visitors. 80% private collectors; 20% corporate clients. Overall price range: $500-30,000; most work sold at $1,000-10,000.

● Though focus is mainly on contemporary interpretations of Southwestern themes, gallery shows work of artists from all over the country. Director is very open to 3-dimensional work.

Media: Considers oil, acrylic, watercolor, pastel, drawings, mixed media, collage, sculpture, ceramic, craft, glass, lithographs, monoprints and serigraphs. Most frequently exhibits oil, acrylic and watercolor.

Style: Exhibits realism, painterly abstraction and postmodern works; will consider all styles. Genres include landscapes, florals and Southwestern and Western themes. Prefers contemporary Western, Southwestern and realism. Likes "contemporary American art, specializing in art of the 'New West.' Our galleries exhibit realistic and abstract paintings, drawings and sculpture by American artists.

Terms: Accepts work on consignment. Retail price set by the gallery and the artist. Exclusive area representation required. Gallery provides insurance, promotion and contract; gallery pays for shipping costs from gallery. Prefers framed artwork.

Submissions: Send query letter with résumé, brochure, slides, photographs, bio and SASE. Replies in 2 weeks. All material is returned with SASE. No appointments are made.

Tips: "Include a complete slide identification list, including availability of works and prices. The most common mistakes are presenting poor reproductions."

JOAN CAWLEY GALLERY, LTD., 7135 E. Main St., Scottsdale AZ 85251. (602)947-3548. Fax: (602)947-7255. E-mail: joanc@jcgltd.com. Website: http://www/jcgltd/com. President: Joan M. Cawley. Retail gallery and print publisher. Estab. 1974. Represents 20 emerging, mid-career and established artists/year. Exhibited artists include: Carol Grigg, Adin Shade. Sponsors 5-10 shows/year. Average display time 2-3 weeks. Open all year; Monday-Saturday, 10-5; Thursday, 7-9. Located in art district, center of Scottsdale; 2,730 sq. ft. (about 2,000 for exhibiting); high ceilings, glass frontage and interesting areas divided by walls. 50% of space for special exhibitions; 75% of space for gallery artists. Clientele: tourists, locals. 90% private collectors. Overall price range: $100-12,000; most work sold at $3,500-5,000.

Media: Considers all media except fabric or cast paper; all graphics. Most frequently exhibits acrylic on canvas, watercolor, pastels and chine colle.

Style: Exhibits expressionism, painterly abstraction, impressionism. Exhibits all genres. Prefers Southwestern and contemporary landscapes, figurative, wildlife.

Terms: Accepts work on consignment (50% commission.) Gallery provides insurance, promotion and contract; shipping costs are shared. Prefers artwork framed.

Submissions: Prefers artists from west of Mississippi. Send query letter with bio and at least 12 slides or photos. Call or write for appointment to show portfolio of photographs, slides or transparencies. Replies as soon as possible.

Tips: "We are a contemporary gallery in the midst of traditional Western galleries. We are interested in seeing new work always." Advises artists approaching galleries to "check out the direction the gallery is going regarding subject matter and media. Also always make an appointment to meet with the gallery personnel. We always ask for a minimum of five to six paintings on hand. If the artist sells for the gallery we want more but a beginning is about six paintings."

‡EL PRADO GALLERIES, INC., Tlaquepaque Village, Box 1849, Sedona AZ 86336. (520)282-7390. President: Don H. Pierson. Two retail galleries. Estab. 1976. Represents 110 emerging, mid-career and established artists. Exhibited artists include Guy Manning and Jerome Grimmer. Sponsors 3-4 shows/year. Average display time 1 week. Open all year. One gallery located in Santa Fe, NM; 1 gallery in Sedona's Tlaquepaque Village: 5,000 sq. ft. "Each gallery is different in lighting, grouping of art and variety." 95% private collectors, 5% corporate collectors. Accepts artists from all regions. Overall price range: $75-125,000.

Media: Considers oil, acrylic, watercolor, pastel, mixed media, collage, works on paper, sculpture, ceramic, craft, fiber and glass. Considers woodcuts, engravings, lithographs, wood engravings, mezzotints, serigraphs, linocuts and etchings. Most frequently exhibits oil, acrylic, watercolor and sculpture.

Style: Exhibits all styles and genres. Prefers landscapes, Southwestern and Western styles. Does not want to see avantgarde.

Terms: Accepts work on consignment (50% commission). Retail price set by the gallery and the artist. Gallery provides

insurance and promotion; shipping costs are shared. Prefers unframed work.

Submissions: Send query letter with photographs. Call or write to schedule an appointment to show a portfolio which should include photographs. "A common mistake artists make is presenting work not up to our standards of quality." Replies in 3 weeks. Files material only if interested.

Tips: "The artist's work must be original, not from copyrighted photos, and must include SASE. Our clients today are better art educated than before."

EL PRESIDIO GALLERY, 7000 E. Tanque Verde Rd., Tucson AZ 85715. (520)733-0388. E-mail: presidio@dakotaco m.net. Director: Henry Rentschler. Retail gallery. Estab. 1981. Represents 30 artists; emerging, mid-career and established. Sponsors 5-6 group shows/year. Average display time 2 months. Located at upscale Santa Fe Square Shopping Plaza; 7,000 sq. ft. of exhibition space. Accepts mostly artists from the West and Southwest. Clientele: locals and tourists. 80% private collectors, 20% corporate clients. Overall price range: $500-20,000; most artwork sold at $1,000-5,000.

Media: Considers oil, acrylic, watercolor, mixed media, works on paper, sculpture, ceramic, glass, egg tempera, pastel and original handpulled prints. Most frequently exhibits oil, watercolor and acrylic.

Style: Exhibits impressionism, expressionism, realism, photorealism and painterly abstraction. Genres include landscapes, Southwestern, Western, wildlife and figurative work. Prefers realism, representational works and representational abstraction.

Terms: Accepts work on consignment (50% commission). Retail price set by the gallery and the artist. Exclusive area representation required. Gallery provides insurance, promotion and contract; artist pays for shipping. Prefers framed artwork.

Submissions: Send query letter with résumé, brochure, slides, photographs with sizes and retail prices, bio and SASE. Call or write to schedule an appointment to show a portfolio, which should include originals, slides, transparencies and photographs. A common mistake is artists overpricing their work. Replies in 2 weeks.

Tips: "Work hard. Have a professional attitude. Be willing to spend money on good frames."

ELEVEN EAST ASHLAND INDEPENDENT ART SPACE, 11 E. Ashland, Phoenix AZ 85004. (602)257-8543. Director: David Cook. Estab. 1986. Represents emerging, mid-career and established artists. Exhibited artists include Erastes Cinaedi, Frank Mell, David Cook, Vernita N. Cognita, Ron Crawford and Mark Dolce. Sponsors 1 juried, 1 invitational and 13 solo and mixed group shows/year. Average display time 3 weeks. Located in "two-story old farm house in central Phoenix, off Central Ave." Overall price range: $100-5,000; most artwork sold at $100-800.

• An anniversary exhibition is held every year in April and is open to national artists. Work must be submitted by March. Work will be for sale, and considered for permanent collection and traveling exhibition.

Media: Considers all media. Most frequently exhibits photography, painting, mixed media and sculpture.

Style: Exhibits all styles, preferably contemporary. "This is a non-traditional proposal exhibition space open to all artists excluding Western and Southwest styles (unless contemporary style)."

Terms: Accepts work on consignment (25% commission); rental fee for space covers 1 month. Retail price set by artist. Artist pays for shipping.

Submissions: Accepts proposal in person or by mail to schedule shows 6 months in advance. Send query letter with résumé, brochure, business card, 3-5 slides, photographs, bio and SASE. Call or write for appointment to show portfolio of slides and photographs. Be sure to follow through with proposal format. Replies only if interested within 1 month. Samples are filed or returned if not accepted or under consideration.

Tips: "Be yourself, avoid hype and commercial glitz. Be ready to show, sincere and have a positive attitude. Our space is somewhat unique as I deal with mostly new and emerging artists. The main thing I look for is confidence, workmanship and presentation."

‡ETHERTON GALLERY, 135 S. Sixth Ave., Tucson AZ 85701. (520)624-7370. Fax: (520)792-4569. Contact: Terry Etherton. Retail gallery and art consultancy. Estab. 1981. Represents 50+ emerging, mid-career and established artists. Exhibited artists include Holly Roberts, Fritz Scholder, James G. Davis and Mark Klett. Sponsors 7 shows/year. Average display time 5 weeks. Open from September to June. Located "downtown; 3,000 sq. ft.; in historic building—wood floors, 16' ceilings." 75% of space for special exhibitions; 10% of space for gallery artists. Clientele: 50% private collectors, 25% corporate collectors, 25% museums. Overall price range: $100-50,000; most work sold at $500-2,000.

Media: Considers oil, acrylic, drawing, mixed media, collage, sculpture, ceramic, all types of photography, original handpulled prints, woodcuts, wood engravings, linocuts, engravings, mezzotints, etchings and lithographs. Most frequently exhibits photography, painting and sculpture.

Style: Exhibits expressionism, neo-expressionism, primitivism, postmodern works. Genres include landscapes, portraits and figurative work. Prefers expressionism, primitive/folk and post-modern. Interested in seeing work that is "cutting-edge, contemporary, issue-oriented, political."

Terms: Accepts work on consignment (50% commission). Buys outright for 50% of retail price (net 30 days). Retail price set by gallery and artist. Gallery provides insurance and promotion; shipping costs are shared. Prefers framed artwork.

Submissions: Only "cutting-edge contemporary—no decorator art." No "unprepared, incomplete works or too wide a range—not specific enough." Send résumé, brochure, slides, photographs, reviews, bio and SASE. Call or write to schedule an appointment to show a portfolio, which should include slides. Replies in 6 weeks only if interested. Files slides, résumés and reviews.

Tips: "Become familiar with the style of our gallery and with contemporary art scene in general."

GALERIA MESA, 155 N. Center, Box 1466, Mesa AZ 85211-1466. (602)644-2056. Fax: (602)644-2901. E-mail: robert_schultz@ci.mesa.az.us. Website: http://artresources.com. Owned and operated by the City of Mesa. Estab. 1981. Exhibits the work of emerging, mid-career and established artists. "We only do national juried shows and curated invitationals. We are an exhibition gallery, NOT a commercial sales gallery." Sponsors 8 shows/year. Average display time 4-6 weeks. Closed August. Located downtown; 3,600 sq. ft., "wood floors, 14' ceilings and monitored security." 100% of space for special exhibitions. Clientele: "cross section of Phoenix metropolitan area." 95% private collectors, 5% gallery owners. "Artists selected only through national juried exhibitions." Overall price range: $100-10,000; most artwork sold at $200-400.
Media: Considers all media and original handpulled prints, woodcuts, engravings, lithographs, wood engravings, mezzotints, monotypes, serigraphs, linocuts and etchings.
Style: Exhibits all styles and genres. Interested in seeing contemporary work.
Terms: Charges 25% commission. Retail price set by artist. Gallery provides insurance, promotion and contract; pays for shipping costs from gallery. Requires framed artwork.
Submissions: Send a query letter or postcard with a request for a prospectus. After you have reviewed prospectus, send up to 8 slides. "We do not offer portfolio review. Artwork is selected through national juried exhibitions." Files slides and résumés. Finds artists through gallery's placement of classified ads in various art publications, mailing news releases and word of mouth.
Tips: "Scout galleries to determine their preferences before you approach them. Have professional quality slides. Present only your very best work in a professional manner."

SCHERER GALLERY, Hillside, 671 Hwy. 179, Sedona AZ 86336. (520)203-9000. Fax: (520)203-0643. Owners: Tess Scherer and Marty Scherer. Retail gallery. Estab. 1968. Represents over 30 mid-career and established artists. May be interested in seeing the work of emerging artists in the future. Exhibited artists include Tamayo, Hundertwasser, Friedlaender, Delaunay, Calder and Barnet. Sponsors 4 solo and 3 group shows/year. Average display time 2 months. Open daily 10-6. 1,200 sq. ft.; 25% of space for special exhibitions; 75% for gallery artists. Clientele: upscale, local community and international collectors. 90% private collectors, 10% corporate clients. Overall price range: $1,000-20,000; most artwork sold at $5,000-10,000.
 • This gallery moved from New Jersey to Arizona last year. Owners says "after 30 years in New Jersey we headed for a warmer climate. So far, we love it here."
Media: Considers non-functional glass sculpture; paintings and other works on paper including hand-pulled prints in all mediums; and kaleidoscopes.
Style: Exhibits color field, minimalism, surrealism, expressionism, modern and post modern works. Looking for artists "with a vision. Work that shows creative handling of the medium(s) and uniqueness to the style—'innovation,' 'enthusiasm.' " Specializes in handpulled graphics, art-glass and kaleidoscopes.
Terms: Accepts work on consignment (50% commission). Retail price set by artist. Exclusive area representation required. Gallery provides insurance, promotion and contract; shipping costs are shared.
Submissions: Send query letter, résumé, bio, at least 12 slides (no more than 30), photographs and SASE. Follow up with a call for appointment to show portfolio. Replies in 2-4 weeks.
Tips: "Persevere! Don't give up!" Considers "originality and quality of handling the medium."

TEMPE ARTS CENTER, P.O. Box 549, Tempe AZ 85280. (602)968-0888. Curator: Claudia Anderson. Nonprofit gallery. Estab. 1982. 200 members: emerging artists. Exhibiting local, regional, national and international artists. Sponsors 4-5 shows/year. Average display time 6-7 weeks. Closed month of August. Located in downtown Tempe, near Arizona State University. "Beautiful, historic park grounds also feature an outdoor sculpture garden." 100% of space for special exhibitions. Clientele: college students, retirees, families and visitors. 75% private collectors, 25% corporate collectors. Overall price range: $500-10,000; most work sold at $750-2,000.
Media: Considers mixed media, sculpture, ceramic, craft, fiber, glass and installation. Prefers only 3D media: crafts and sculpture. Most frequently exhibits sculpture, clay and fiber.
Style: Exhibits all contemporary styles and all genres.
Terms: Accepts work on consignment (25% commission). Retail price is set by artist. Gallery provides insurance, promotion and shipping costs from gallery. Prefers artwork framed and/or ready for display.
Submissions: Send query letter with résumé, slides, bio, photographs and SASE.

VANIER FINE ART, LTD., (formerly Vanier & Roberts, Ltd. Fine Art), 7106 E. Main St., Scottsdale AZ 85251. (602)946-7507. Fax: (602)945-2448. Website: http://www.vanier.roberts.com. President: John Rothschild. Retail gallery.

● **SPECIAL COMMENTS** within listings by the editor of *Artist's & Graphic Designer's Market* are set off by a bullet.

Estab. 1994. Represents 50 emerging, mid-career and established artists/year. Sponsors 7 shows/year. Average display time 1 month. Open all year; Monday-Saturday, 10-5; Thursday, 7-9 pm. Located in Old Town (downtown) Scottsdale; 6,500 sq. ft.; multi-levels, multiple rooms, 25 foot ceilings. Clientele: tourists, upscale, local. 90% private collectors, 10% corporate collectors. Overall price range: $500-295,000; most work sold at $2,000-10,000.
Media: Considers oil, pen & ink, drawing, sculpture, watercolor, mixed media, pastel and photography. Most frequently exhibits oil and sculpture.
Style: Exhibits: photorealism and realism. Exhibits all genres. Prefers landscape, florals and portrait.
Terms: Accepts work on consignment (50% commission). Retail price set by the artist in conjunction with gallery. Gallery provides insurance, promotion and contract; shipping costs are shared. Prefers artwork framed.
Submissions: Send query letter with résumé, brochure, business card, slides, photographs, reviews, artist's statement, bio, SASE and price list. Write for appointment to show portfolio of photographs and slides. Replies in 3 weeks. Finds artists through out of town (state) shows, referrals by other artists, national publications.

WILDE-MEYER GALLERY, 4142 North Marshall Way, Scottsdale AZ 85251. (602)945-2323. Fax: (602)941-0362. Owner: Betty Wilde. Retail/wholesale gallery and art consultancy. Estab. 1983. Represents/exhibits 40 emerging, mid-career and established artists/year. Exhibited artists include Linda Carter-Holman and Jacqueline Rochester. Sponsors 5-6 shows/year. Average display time 1-12 months rotating. Open all year; Monday-Saturday, 9-6; Sunday, 12-4. Located in downtown Scottsdale in the heart of Art Walk; 3,000 sq. ft.; 20% of space for special exhibitions; 80% of space for gallery artists. Clientele: upscale tourists: local community. 50% private collectors, 50% corporate collectors. Overall price range: $1,000-20,000; most work sold at $1,500-5,000.
Media: Considers all media and all types of prints. Most frequently exhibits original oil/canvas, mixed media and originals on paper.
Style: Exhibits primitivism, painterly abstraction, figurative, landscapes, all styles. All genres. Prefers contemporary artwork.
Terms: Accepts work on consignment (50% commission). Retail price set by gallery and artist. Insurance and promotion shared 50/50 by artist and gallery. Artist pays for shipping costs.
Submissions: Send query letter with résumé, slides, bio, photographs, SASE, business card, reviews and prices. Write for appointment to show portfolio of photographs, slides, bio and prices. Replies only if interested within 4-6 weeks. Files all material if interested. Finds artists through word of mouth, referrals by artists and artists' submissions.
Tips: "Just do it."

‡RIVA YARES GALLERY, 3625 Bishop Lane, Scottsdale AZ 85251. (602)947-3251. Fax: (602)947-4251. Second gallery at 123 Grant Ave., Santa Fe NM 87501. (505)984-0330. Retail gallery. Estab. 1963. Represents 30-40 emerging, mid-career and established artists/year. Exhibited artists include: Rodolfo Morales and Esteban Vicente. Sponsors 12-16 shows/year. Average display time 3-6 weeks. Open all year; Tuesday-Saturday, 10-5; Sunday by appointment. Located in downtown area; 8,000 sq. ft.; national design award architecture; international artists. 50% of space for special exhibitions; 50% of space for gallery artists. Clientele: collectors. 90% private collectors; 10% corporate collectors. Overall price range: $1,000-1,000,000; most work sold at $20,000-50,000.
Media: Considers all media except craft and fiber and all types of prints. Most frequently exhibits paintings (all media), sculpture and drawings.
Style: Exhibits expressionism, photorealism, neo-expressionism, minimalism, pattern painting, color field, hard-edge geometric abstraction, painterly abstraction, realism, surrealism and imagism. Prefers abstract expressionistic painting and sculpture, surrealistic sculpture and modern schools painting and sculpture.
Terms: Accepts work on consignment (50% commission). Retail price set by the artist. Gallery provides insurance, promotion and contract; gallery pays for shipping from gallery; artist pays for shipping to gallery. Prefers artwork framed.
Submissions: Not accepting new artists at this time.
Tips: "Few artists take the time to understand the nature of a gallery and if their work even applies."

Arkansas

AMERICAN ART GALLERY, 724 Central Ave., Hot Springs National Park AR 71901. (501)624-0550. Retail gallery. Estab. 1990. Represents 22 emerging, mid-career and established artists. Exhibited artists include Jimmie Tucek and Jimmie Leach. Sponsors 12 shows/year. Average display time 1 month. Open all year. Located downtown; 4,000 sq. ft.; 40% of space for special exhibitions. Clientele: private, corporate and the general public. 85% private collectors, 15% corporate collectors. Overall price range: $50-12,000; most work sold at $350-800.
Media: Considers oil, acrylic, watercolor, pastel, pen & ink, sculpture, ceramic, photography, original handpulled prints, woodcuts, wood engravings, lithographs and offset reproductions. Most frequently exhibits oil, wood sculpture and watercolor.
Style: Exhibits all styles and genres. Prefers realistic, abstract and impressionistic styles; wildlife, landscapes and floral subjects.
Terms: Accepts work on consignment (40% commission). Retail price set by gallery and the artist. Gallery provides

promotion and contract; artist pays for shipping. Offers customer discounts and payment by installments. Prefers artwork framed.

Submissions: Prefers Arkansas artists, but shows 5-6 others yearly. Send query letter with résumé, 8-12 slides, bio and SASE. Call or write for appointment to show portfolio of originals and slides. Reports in 6 weeks. Files copy of résumé and bio. Finds artists through agents, by visiting exhibitions, word of mouth, various art publications and sourcebooks, submissions/self promotions and art collectors' referrals.

Tips: "We have doubled our floor space and have two floors which allows us to separate the feature artist from the regular artist. We have also upscaled the quality of artwork exhibited. Our new gallery is located between two other galleries. It's a growing art scene in Hot Springs."

✔THE ARKANSAS ARTS CENTER, P.O. Box 2137, Little Rock AR 72203. (501)372-4000. Fax: (501)375-8053. Curator of Art: Brian Young. Curator of Decorative Arts: Alan DuBois. Museum art school, children's theater and traveling exhibition service. Estab. 1930s. Exhibits the work of emerging, mid-career and established artists. Sponsors 25 shows/year. Average display time 6 weeks. Open all year. Located downtown; 10,000 sq. ft.; 60% of space for special exhibitions.

Media: Most frequently exhibits drawings and crafts.

Style: Exhibits all styles and all genres.

Terms: Retail price set by the artist. "Work in the competitive exhibitions (open to artists in Arkansas and six surrounding states) is for sale; we usually charge 10% commission."

Submissions: Send query letter with samples, such as photos or slides.

Tips: Write for information about exhibitions for emerging and regional artists, and various themed exhibitions.

‡ARKANSAS STATE UNIVERSITY FINE ARTS CENTER GALLERY, P.O. Drawer 1920, State University AR 72467. (870)972-3050. E-mail: csteele@aztec.astate.edu. Website: http://www.astate.edu/docs/acad/cf2/art. Chair, Department of Art: Curtis Steele. University—Art Department Gallery. Estab. 1968. Represents/exhibits 3-4 emerging, mid-career and established artists/year. Sponsors 3-4 shows/year. Average display time 1 month. Open fall, winter and spring; Monday-Friday, 10-4. Located on university campus; 1,600 sq. ft.; 60% of time devoted to special exhibitions; 40% to faculty and student work. Clientele: students/community.

Media: Considers all media. Considers all types of prints. Most frequently exhibits painting, sculpture and photography.

Style: Exhibits conceptualism, photorealism, neo-expressionism, minimalism, hard-edge geometric abstraction, painterly abstraction, postmodern works, realism, impressionism and pop. "No preference except quality and creativity."

Terms: Exhibition space only; artist responsible for sales. Retail price set by the artist. Gallery provides insurance, promotion and contract; shipping costs are shared. Prefers artwork framed.

Submissions: Send query letter with résumé, slides and SASE. Portfolio should include photographs, transparencies and slides. Replies only if interested within 2 months. Files résumé. Finds artists through call for artists published in regional and national art journals.

Tips: "Show us 20 slides of your best work. Don't overload us with lots of collateral materials (reprints of reviews, articles, etc.). Make your vita as clear as possible."

CANTRELL GALLERY, 8206 Cantrell Rd., Little Rock AR 72207. (501)224-1335. E-mail: cgallery@aristotle.net. Website: http://www.befound.com/bargainart/. President: Helen Scott; Director: Cindy Huisman. Wholesale/retail gallery. Estab. 1970. Represents/exhibits 75 emerging, mid-career and established artists/year. Exhibited artists include Boulanger, Dali, G. Harvey, Warren Criswell, N. Scolt and Robin Morris. Sponsors 8-10 shows/year. Average display time 1 month. Open all year; Monday-Saturday, 10-5. Located in the strip center; 3,500 sq. ft.; "we have several rooms and different exhibits going at one time." Clientele: collectors, retail, decorators. Overall price range: $100-10,000; most work sold at $250-3,000.

Media: Considers oil, acrylic, watercolor, pastel, pen & ink, drawing, mixed media, collage, paper, sculpture, woodcut, engraving, lithograph, wood engraving, mezzotint, serigraphs, linocut, etching. Most frequently exhibits etchings, watercolor, mixed media, oils and acrylics.

Style: Exhibits eclectic work, all genres.

Terms: Gallery provides insurance and promotion; shipping costs are shared. Prefers artwork unframed.

Submissions: Send query letter with résumé, 5 photos and bio. Write for appointment to show portfolio of originals. Replies in 2 months. Files all material. Finds artists through agents, by visiting exhibitions, word of mouth, art publications and sourcebooks, artists' submissions.

Tips: "Be professional. Be honest. Place a retail price on each piece, rather than only knowing what 'you need to get' for the piece. Don't spread yourself too thin—in any particular area—only show in one gallery."

DUCK CLUB GALLERY, 2333 N. College, Fayetteville AR 72703. (501)443-7262. Vice President-Secretary: Frances Sego. Retail gallery. Estab. 1980. Represents mid-career and established artists. May be interested in seeing the work of emerging artists in the future. Exhibited artists include Terry Redlin, Jane Garrison and Linda Cullers. Displays work "until it sells." Open all year; Monday-Friday, 10-5:30; Saturday, 10-4. Located midtown; 1,200 sq. ft. 100% of space for gallery artists. Clientele: tourists, local community, students "we are a university community." 80% private collectors, 20% corporate collectors. Overall price range: $50-400; most work sold at $50-200.

Media: Considers all media including wood carved decoys. Considers engravings, lithographs, serigraphs, etchings, posters. Most frequently exhibits limited edition and open edition prints and poster art.

Style: Exhibits and styles and genres. Prefers: wildlife, local art and landscapes.
Terms: Buys outright for 50% of retail price (net 30 days). Retail price set by the artist. Gallery provides insurance and promotion; artist pays for shipping. Prefers artwork unframed.
Submissions: Send query letter with brochure, photographs and business card. Write for appointment to show portfolio. Finds artists through word of mouth, referrals by other artists, visiting art fairs and exhibitions, submissions, referrals from customers.

EILEEN'S GALLERY OF FINE ARTS, 10720 N. Rodney Parham, Little Rock AR 72212. (501)223-0667. Owner: Eileen Lindemann. Retail gallery. Estab. 1987. Represents 30 emerging and mid-career artists/year. Exhibited artists include: Robert Moore and Dale Terbush. Sponsors 2 shows/year. Average display time 6 months. Open all year; Tuesday-Saturday, 10-5. Located west Little Rock; 1,800 sq. ft. 100% of space for gallery artists. Clientele: local (statewide) and upscale. 95% private collectors; 5% corporate collectors. Overall price range: $300-15,000; most work sold at $1,500-3,500.
Media: Considers oil, acrylic and sculpture. Most frequently exhibits oils, well executed acrylics and wood and marble sculpture.
Style: Exhibits: impressionism, photorealism and realism. Genres include florals, landscapes Americana and figurative work. Prefers: florals, figuratives and landscapes.
Terms: Accepts work on consignment (40% commission). Retail price set by the artist. Gallery provides promotion and contract for out of state artists; shipping costs are shared. "If the artist is out of state, the gallery will provide frames."
Submissions: Prefers only canvas. Send query letter with bio and photographs. Call or write for appointment to show portfolio of photographs and information on shows, other galleries and years in profession. Reports ASAP. Artist should send stamped return envelope. Finds artists through word of mouth, my excellent reputation, visiting galleries in travel, requests by my clients for interest in special artists.
Tips: "Artists should not send unrequested work or walk in uninvited and take up my time before they know I'm interested."

GALLERY FOUR INC., 11330 Arcade Dr., Little Rock AR 72212-4084. (501)224-4090. E-mail: mmargo7421@aol.com. Owner: Michael Margolis. Retail gallery. Estab. 1985. Represents 5 emerging artists/year. Exhibited artists include Judy Honey and Mary Ann Stafford. Average display time 3 months. Open all year; Tuesday-Friday, 10-5:30; Saturday, 10-5; also by appointment. Located in West Little Rock; 650 sq. ft. Clientele: upscale-local. 100% private collectors. Overall price range: $50-750; most work sold at $100-350.
Media: Considers all media and all types of prints. Most frequently exhibits watercolor, pastel and oil-acrylic.
Style: Exhibits all styles and all genres. Prefers impressionism, wildlife and portrait.
Terms: Accepts work on consignment (40% commission). Retail price set by the gallery and the artist. Gallery provides insurance, promotion and contract. Artist pays shipping costs. Prefers artwork unframed.
Submissions: Send query letter with brochure, business card and 2-3 slides. Call for appointment to show portfolio of slides. Replies in 1 week. Files name, address, phone and type of artwork and sizes. Finds artists through word of mouth and artist's submissions.
Tips: "Ask! Don't be afraid to ask for gallery representation. We're all human. 'No' is just a word. It's a numbers game. Don't stop until you find a gallery that will give you a chance. We all started somewhere—didn't we?"

‡HERR-CHAMBLISS FINE ARTS, P.O. Box 2840, Hot Springs AR 71914. (501)624-7188. Director: Malinda Herr-Chambliss. Corporate art consultant. Estab. 1988. Represents emerging, mid-career and established artists. Overall price range: $50-24,000.
 ● This art consultant formerly ran a retail gallery for 12 years. She now works exclusively with corporate and private clients as an art consultant.
Media: Considers oil, acrylic, watercolor, pastel, pen & ink, drawings, mixed media, sculpture, fiber, glass, etchings, charcoal and large scale work.
Style: Exhibits all styles, specializing in Italian contemporary art.
Terms: "Negotiation is part of acceptance of work; generally commission is 40%." Gallery provides insurance, promotion and contract (depends on negotiations); artist pays for shipping to and from gallery. Prefers artwork framed.
Submissions: Prefers painting and sculpture of regional, national and international artists. Send query letter with résumé, slides, bio, brochure, photographs, SASE, business card and reviews. Do not send any materials that are irreplaceable. Write for appointment to show portfolio of originals, slides, photographs and transparencies. Replies in 4-6 weeks.
Tips: "When mailing your submission to galleries, make your presentation succinct, neat and limited. Consider how you would review the information if you received it. Respect the art gallery owner's position—realizing the burdens that face them each day—help the gallery help you and your career by providing support in their requests to you. Slides should include the date, title, medium, size, and directional information. Also, résumé should show the number of one-person shows, educational background, group shows, list of articles (as well as enclosure of articles). The neater the presentation, the greater chance the dealer can glean important information quickly. Put yourself behind the dealer's desk, and include what you would like to have for review."

MORRISON-WOODWARD GALLERY, 78 Spring St., Eureka Springs AR 72632. (501)253-8788. Fax: (501)253-7713. Owner: Susan Morrison. Retail gallery. Estab. 1979. Represents over 30 emerging, mid-career and established artists/year. Exhibited artists include Susan Morrison and Charlts Peer. Sponsors 5 shows/year. Average display time 1 year. Open all year; Monday-Friday, 10-6; Saturday, 10-9. Located on the main street of the Historic District; 6,000 sq. ft.; Victorian building restored to pristine condition. Clientele: tourists, upscale. 60% private collectors, 40% corporate collectors. Overall price range: $150-25,000; most work sold at $500-10,000.
Media: Considers all media and all types of prints.
Style: Exhibits all styles and genres. Prefers: landscape, wildlife and figurative.
Terms: Accepts work on consignment (50% commission). Retail price set by the artist. Gallery provides promotion and contract; artist pays for shipping. Prefers artwork framed.
Submissions: Send query letter with résumé, slides, brochure, photographs and SASE. Write for appointment to show portfolio of photographs, slides and transparencies. Replies in 2 months. Artist should check to see if we received art. Files brochures, slides and résumé. Finds artists through word of mouth, referrals by other artists, visiting art fairs and exhibitions, submissions and master thesis exhibitions.

SOUTH ARKANSAS ARTS CENTER, 110 E. Fifth, El Dorado AR 71730. (870)862-5474. Executive Director: Linda Boydsten. Nonprofit gallery. Estab. 1963. Exhibits the work of 50 emerging, mid-career and established artists. Exhibited artists include George Price and Dee Ludwig. Sponsors 15 shows/year. Average display time 1 month. Open all year. Located "in the middle of town; 3,200 sq. ft." 60% of space for special exhibitions. 100% private collectors. Overall price range: $50-1,500; most work sold at $200-300.
Media: Considers all media and prints. Most frequently exhibits watercolor, oil and mixed media.
Style: Exhibits all styles.
Terms: Accepts work on consignment (25% commission). Retail price set by the artist. Gallery provides insurance and promotion; contract and shipping may be negotiated. Prefers artwork framed.
Submissions: Send query with slides, photographs, SASE and "any pertinent materials." Only after a query, call to schedule an appointment to show a portfolio. Portfolio should include originals and artist's choice of work. Replies in 2 weeks. Files materials unless artist requests return. "Keeping something on file helps us remember your style."
Tips: "We exhibit a wide variety of works by local, regional and national artists. We have facilities for 3-D works."

THEARTFOUNDATION, 520 Central Ave., Hot Springs AR 71901. (501)623-9847. Fax: (501)623-9847. E-mail: benini@benini.com. Website: http://www.benini.com. Retail gallery. Estab. 1988. Represents/exhibits 15 established artists/year. May be interested in seeing the work of emerging artists in the future. Exhibited artists include Benini, Galardini and Cunningham. Sponsors 12 shows/year. Average display time 1 month. Open during monthly Hot Springs Gallery Walks, weekends and by appointment. Located on historic Central Avenue; 5,000 sq. ft.; housed in 1886 brick structure restored in 1988 according to National Historic Preservation Guidelines. Clientele: tourists, upscale, community and students. 90% private collectors, 10% corporate collectors.
Media: Considers all media except prints. Most frequently exhibits painting, sculpture, drawing/photography.
Style: Exhibits contemporary Italian masters.
Tips: Considers "individual style and quality" when choosing artists.

California

BARLETT FINE ARTS GALLERY, 77 West Angela St., Pleasanton CA 94566. (510)846-4322. E-mail: dshoen940@aol.com. Website: http://www.barlettgallery.com. Owner: Dorothea Barlett Schoenstein. Retail gallery. Estab. 1981. Represents/exhibits 10-20 mid-career and established artists/year. Sponsors 4-6 shows/year. Average display time 3 weeks. Open all year. Located in downtown Pleasanton; 1,800 sq. ft.; excellent lighting from natural source. 70% of space for special exhibitions; 70% of space for gallery artists. Clientele: "wonderful, return customers." 99% private collectors, 1% corporate collectors. Overall price range: $500-3,500; most work sold at under $2,000.
Media: Considers oil, acrylic, watercolor, pastel, drawing, mixed media, collage, paper, sculpture, ceramics, fine craft, glass, woodcuts, engravings, lithographs, mezzotints, serigraphs and etchings. Most frequently exhibits oil, acrylic, etching, watercolor and handblown glass.
Style: Exhibits painterly abstraction and impressionism. Genres include landscapes and figurative work. Prefers landscapes, figurative and abstract.
Terms: Accepts work on consignment. Retail price set by the gallery. Gallery provides promotion and contract; artist pays shipping costs to and from gallery.
Submissions: Prefers artists from the Bay Area. Send query letter with résumé, 20-30 slides representing current style and SASE. Write for appointment to show portfolio of originals, slides and transparencies. Replies only if interested within 1 month. Files only accepted artists' slides and résumés (others returned). Finds artists through word of mouth and "my own canvassing."
Tips: "I accept artists with large portfolios/works or a body of work (at least 20-30 works) to represent the style or objective the artist is currently producing. Slides must include work currently for sale! Have recent sales of work and know prices they sold for."

© 1997 Liz Maxwell

Whether working in papier mache and acrylic, as for this piece called *Solo*, or oils on canvas, jazz is a favorite subject matter for artist Liz Maxwell. *Solo* was featured in an exhibit of the artist's mixed media scultpure at gallery Bartlett Fine Arts, "Figures Inspired by Music and Life." The gallery's Dorothea Bartlett found Maxwell through and "open studio" program. "I hold open studios twice a year [in conjunction with arts organizations], send comprehensive mailings and smaller mailings for gallery exhibitions." Maxwell is currently represented by three galleries including California gallery Bartlett.

CATHY BAUM & ASSOCIATES, 384 Stevick Dr., Atherton CA 94027. (415)854-5668. Fax: (415)854-8522. Principal: Cathy Baum. Art advisor. Estab. 1976. Keeps files on several hundred artists. Open all year. Clientele: developers, architects, corporations, small businesses and private collectors. 10% private collectors, 90% corporate collectors. Prices are determined by clients' budget requirements.
Media: Considers all media and all types of prints.
Style: Considers all styles and genres.
Terms: Accepts appropriate projects on consignment (50% commission on per project basis only). Retail price set by artist. Shipping costs are shared. Prefers artwork unframed.
Submissions: Send query letter with résumé, slides, reviews, bio, SASE, retail and wholesale prices. Write for appointment to show portfolio, which should include slides. Replies in 2-3 weeks. Files all accepted material.

CENTRAL CALIFORNIA ART CENTER, (formerly Central California Art League Art Center & Gallery), 1402 I St., Modesto CA 95354. (209)529-3369. Fax: (209)529-9002. Website: http://www.ainet.com/cca/. Gallery Director: Mary Gallagher. Cooperative, nonprofit sales, rental and exhibition gallery. Estab. 1951. Represents emerging, mid-career and established artists. Exhibited artists include Buster Dyer, Dwight Smith, Ike Laitenen and Suzanne Staud. Sponsors 2 shows/year and hosts the American Watercolor Society Traveling Exhibition. Average display time 3 months. Open all year. Located downtown; 2,500 sq. ft.; in historic building consisting of 2 large gallery rooms, two classrooms and auditorium. 50% of space for special exhibitions, 50% for gallery artists. Clientele: 75% private collectors, 25% corporate clients. Overall price range: $50-3,000; most artwork sold at $300-800.
Media: Considers oil, pen & ink, works on paper, fiber, acrylic, drawing, sculpture, watercolor, mixed media, ceramic, pastel, collage, photography and original handpulled prints. Most frequently exhibits watercolor, oil and acrylic.
Style: Exhibits mostly impressionism, realism and abstract. Will consider all styles and genres.
Terms: Artwork is accepted on consignment (30% commission), a gallery fee and/or a donation of time for a minimum of 3 months. Price set by artist. Customer discounts and installment payment available. Gallery provides insurance. Prefers framed artwork.
Submissions: Call for information. All works subject to jury process. Portfolio review not accepted. Finds artists primarily through referrals from other artists.

CUESTA COLLEGE ART GALLERY, P.O. Box 8106, San Luis Obispo CA 93403-8106. (805)546-3202. Fax: (805)546-3904. E-mail: efournie@bass.cuesta.cc.ca.us. Director: Marta Peluso. Nonprofit gallery. Estab. 1965. Exhibits the work of emerging, mid-career and established artists. Exhibited artists include William T. Wiley and Catherine Wagner. Sponsors 5 shows/year. Average display time 4½ weeks. Open all year. Space is 750 sq. ft.; 100% of space for special exhibitions. Overall price range: $250-5,000; most work sold at $400-1,200.

Media: Considers all media and all types of prints. Most frequently exhibits painting, sculpture and photography.
Style: Exhibits all styles, mostly contemporary.
Terms: Accepts work on consignment (20% commission). Retail price set by artist. Customer discounts and payment by installment are available. Gallery provides insurance, promotion and contract; shipping costs are shared. Prefers artwork framed.
Submissions: Send query letter with résumé, slides, bio, brochure, SASE and reviews. Call for appointment to show portfolio. Replies in 6 months. Finds artists mostly by reputation and referrals, sometimes through slides.
Tips: "Only submit quality fine art. We have a medium budget, thus cannot pay for extensive installations or shipping. Present your work legibly and simply. Include reviews and/or a coherent statement about the work. Don't be too slick or too sloppy."

DELPHINE GALLERY, 1324 State St., Santa Barbara CA 93101. Director: Michael Lepere. Retail gallery and custom frame shop. Estab. 1979. Represents/exhibits 10 mid-career artists/year. Exhibited artists include Jim Leonard, Edwin Brewer and Steve Vessels. Sponsors 8 shows/year. Average display time 4-6 weeks. Open all year; Tuesday-Friday, 10-5; Saturday, 10-3. Located downtown Santa Barbara; 300 sq. ft.; natural light (4th wall is glass). 33% of space for special exhibitions. Clientele: upscale, local community. 40% private collectors, 20% corporate collectors. Overall price range: $1,000-4,500; most work sold at $1,000-3,000.
Media: Considers all media except photography, installation and craft. Considers serigraphs. Most frequently exhibits oil on canvas, acrylic on paper and pastel.
Style: Exhibits conceptualism and painterly abstraction. Includes all genres and landscapes.
Terms: Artwork is accepted on consignment (50% commission). Retail price set by the gallery. Gallery provides insurance and promotion; shipping costs are shared. Prefers artwork unframed.
Submissions: Prefers artists from Santa Barbara/Northern California. Send query letter with résumé, slides and SASE. Write for appointment to show portfolio of slides. Replies in 1 month.

SOLOMON DUBNICK GALLERY, 2131 Northrop Ave., Sacramento CA 95825. (916)920-4547. Fax: (916)923-6356. Director: Shirley Dubnick. Retail gallery and art consultancy. Estab. 1981. Represents/exhibits 20 emerging, mid-career and established artists/year. "Must have strong emerging record of exhibits." Exhibited artists include Jerald Silva and Gary Pruner. Sponsors 11-12 shows/year. Average display time 1 month. Open all year; Tuesday-Saturday, 11-6 or by appointment. Located in suburban area on north side of Sacramento; 7,000 sq. ft.; large space with outside sculpture space for large scale, continued exhibition space for our stable of artists, besides exhibition space on 1st floor. Movable walls for unique artist presentations. 75% of space for special exhibitions; 25% of space for gallery artists. Clientele: upscale, local, students, national and international clients due to wide advertising of gallery. 80% private collectors, 20% corporate collectors. Overall price range: $500-50,000; most work sold at $2,000-10,000.
Media: Considers oil, pen & ink, paper, acrylic, drawing, sculpture, watercolor, mixed media, ceramics, pastel and photography. Considers original prints produced only by artists already represented by gallery. Most frequently exhibits painting, sculpture and functional sculpture.
Style: Exhibits all styles (exhibits very little abtract paintings unless used in landscape). Genres include landscapes, figurative and contemporary still life. Prefers figurative, realism and color field.
Terms: Accepts work on consignment (50% commission). Retail price set by the gallery with artist concerns. Gallery provides insurance, promotion and contract; shipping costs are shared (large scale delivery to and from gallery is paid for by artist). Prefers artwork framed.
Submissions: Accepts only artists from Northern California with invited artists outside state. Send query letter with résumé, slides, photographs, reviews, bio and SASE. Call for appointment to show portfolio of photographs, transparencies and slides. Replies only if interested within 3-4 weeks. Files all pertinent materials. Finds artists through word of mouth, referrals by other artists, art fairs, advertising in major art magazines and artists' submissions.
Tips: "Be professional. Do not bring work into gallery without appointment with Director or Assistant Director. Do not approach staff with photographs of work. Be patient."

‡GALLERY WEST, P.O. Box 16197, Beverly Hills CA 90209-2197. (213)271-1145. Director: Roberta Feuerstein. Private dealer/art consultant. Estab. 1971. Represents 25 emerging, mid-career and established artists. Located near showrooms catering to interior design trade and several restaurants. Overall price range: $500-25,000; most artwork sold at $3,500-6,500.
Media: Considers oil, acrylic, watercolor, pastel, mixed media, collage, works on paper, sculpture, ceramic, craft, fiber and limited edition original handpulled prints. Prefers paintings.
Style: Exhibits color field, painterly abstraction, photorealistic and realistic works. Prefers abstract expressionism, trompe l'oeil and realism.
Terms: Accepts work on consignment (50% commission). Retail price set by gallery and artist. Exclusive area representation required. Gallery provides insurance, promotion and contract; shipping costs are shared.
Submissions: Send query letter, résumé, 6-12 slides and SASE. Slides and biography are filed.
Tips: "Continue submitting your work until you hook up with the right dealer."

GREENLEAF GALLERY, 20315 Orchard Rd., Saratoga CA 95070. (408)867-3277. Owner: Janet Greenleaf. Director: Chris Douglas. Collection and art consultancy and advisory. Estab. 1979. Represents 45 to 60 emerging, mid-career and established artists. By appointment only. "Features a great variety of work in diverse styles and media. We have become

a resource center for designers and architects, as we will search to find specific work for all clients." Clientele: professionals, collectors and new collectors. 50% private collectors, 50% corporate clients. Prefers "very talented emerging or professional full-time artists—already established." Overall price range: $400-15,000; most artwork sold at $500-8,000.

Media: Considers oil, acrylic, watercolor, pastel, mixed media, collage, works on paper, sculpture, glass, original handpulled prints, lithographs, serigraphs, etchings and monoprints.

Style: Deals in expressionism, neo-expressionism; painterly abstraction, minimalism, impressionism, realism or "whatever I think my clients want—it keeps changing." Traditional, landscapes, florals, wildlife and figurative work. Prefers all styles of abstract.

Terms: Artwork is accepted on consignment. "The commission varies." Artist pays for shipping or shipping costs are shared.

Submissions: Send query letter, résumé, 6-12 photographs (but slides OK), bio, SASE, reviews and "any other information you wish." Call or write to schedule an appointment for a portfolio review, which should include originals. If does not reply, the artist should call. Files "everything that is not returned. Usually throw out anything over two years old." Finds artists through visiting exhibits, referrals from clients, or artists, submissions and self promotions.

Tips: "Send good photographs with résumé and ask for an appointment. Send to many galleries in different areas. It's not that important to have a large volume of work. I would prefer to know if you are full time working artist and have representation in other galleries."

✔**JUDITH HALE GALLERY**, (formerly Judy's Fine Art Connection), 2890 Grand Ave., P.O. Box 884, Los Olivos CA 93441-0884. (805)688-1222. Fax: (805)688-2342. Owner: Judy Hale. Retail gallery. Estab. 1987. Represents 70 mid-career and established artists. Exhibited artists include Neil Boyle, Susan Kliewer, Karl Dempwolt, Alice Nathan, Larry Bees and Joyce Birkenstock. Sponsors 4 shows/year. Average display time 6 months. Open all year. Located downtown; 2,100 sq. ft.; "the gallery is eclectic and inviting, an old building with six rooms." 20% of space for special exhibitions which are regularly rotated and rehung. Clientele: homeowners, tourists, decorators, collectors. Overall price range: $100-5,000; most work sold at $500-2,000.

• This gallery specializes in western artwork, with focus on original work instead of prints. They are moving toward established-known artists.

Media: Considers oil, acrylic, watercolor, pastel, sculpture, ceramic, original handpulled prints, offset reproductions, lithographs and etchings. Most frequently exhibits watercolor, oil, acrylic and sculpture.

Style: Exhibits impressionism and realism. Genres include landscapes, florals, southwestern, western, portraits and figurative work. Prefers figurative work, western, florals, landscapes, structure. No abstract or expressionistic.

Terms: Accepts work on consignment (40% commission). Retail price set by artist. Offers payment by installments. Gallery arranges reception and promotion; artist pays for shipping. Prefers artwork framed.

Submissions: Send query letter with 10-12 slides, bio, brochure, photographs, business card and reviews. Call for appointment to show portfolio of photographs. Replies in 2 weeks. Files bio, brochure and business card.

Tips: "Create a nice portfolio. See if your work is comparable to what the gallery exhibits. Do not plan your visit when a show is on; make an appointment for future time. I like 'genuine' people who present quality with fair pricing. Rotate artwork in a reasonable time, if unsold. Bring in your best work, not the 'seconds' after the show circuit."

L. RON HUBBARD GALLERY, 7051 Hollywood Blvd., Suite 400, Hollywood CA 90028. (213)466-3310. Fax: (213)466-6474. Website: http://www.authorservicesinc.com. Contact: Joni Labaqui. Retail gallery. Estab. 1987. Exhibited artists include Frank Frazetta and Jim Warren. Open all year. Located downtown; 6,000 sq. ft. Clientele: "business-oriented people." 90% private collectors, 10% corporate collectors. Overall price range: $200-15,000; most work sold at $4,000-6,000.

Media: Considers oil and acrylic. Most frequently exhibits "continuous tone offset lithography."

Style: Exhibits surrealism and realism. Prefers science fiction, fantasy and western.

Terms: Artwork is bought outright. Retail price set by the gallery.

Submissions: Send query letter with résumé, slides and photographs. Write or call to schedule an appointment to show a portfolio. Replies in 1 week. Files all material, unless return requested.

INTERNATIONAL GALLERY, 643 G St., San Diego CA 92101. (619)235-8255. Director: Stephen Ross. Retail gallery. Estab. 1980. Represents over 50 emerging, mid-career and established artists. Sponsors 6 solo and 6 group shows/year. Average display time is 2 months. Clientele: 99% private collectors. Overall price range: $15-10,000; most artwork sold at $25-500.

Media: Considers sculpture, ceramic, craft, fiber, glass and jewelry.

Style: "Gallery specializes in contemporary crafts (traditional and current), folk and primitive art, as well as naif art."

Terms: Accepts work on consignment. Retail price set by gallery and artist. Exclusive area representation not required. Gallery provides insurance, promotion and contract; shipping costs are shared.

Submissions: Send query letter, résumé, slides and SASE. Call or write for appointment to show portfolio of slides and transparencies. Files résumés, work description and sometimes slides. Common mistakes artists make are using poor quality, unlabeled slides or photography and not making an appointment.

‡**JESSEL MILLER GALLERY**, 1019 Atlas Peak Rd., Napa CA 94558. (707)257-2350. Owner: Jessel. Retail gallery. Represents 300 emerging, mid-career and established artists. Exhibited artists include Clark Mitchell and Jessel. Sponsors

6 shows/year. Average display time 1 month. Open all year; 7 days/week 9:30-5:30. Located 1 mile out of town; 9,000 sq. ft. 20% of space for special exhibitions; 50% of space for gallery artists. Clientele: upper income collectors. 95% private collectors, 5% corporate collectors. Overall price range: $100-10,000; most work sold at $2,000-3,500.
Media: Oil, acrylic, watercolor, pastel, collage, sculpture, ceramic and craft. Most frequently exhibits acrylic, watercolor and pastel.
Style: Exhibits painterly abstraction, photorealism, realism and traditional. Genres include landscapes, florals and figurative work. Prefers figurative, landscape and abstract.
Terms: Accepts work on consignment (50% commission). Retail price set by gallery. Gallery provides promotion; artist pays for shipping costs. Prefers artwork framed.
Submissions: Send query letter with résumé, slides, bio, SASE and reviews. Call (after sending slides and background info) for appointment to show portfolio of photographs or slides. Replies in 1 month.

LINCOLN ARTS, 540 F St., P.O. Box 1166, Lincoln CA 95648. (916)645-9713. Fax: (916)645-3945. E-mail: lincarts@ psyber.com. Website: http://www.psyber.com/lincoln/arts. Executive Director: Jeanne-Marie Fritts. Nonprofit gallery and alternative space area coordinator. Estab. 1986. Represents 100 emerging, mid-career and established artists/year. 400 members. Exhibited artists include Bob Arneson, Tommie Moller. Sponsors 19 shows/year (9 gallery, 9 alternative and 1 major month-long ceramics exhibition). Average display time 5 weeks. Open all year; Tuesday-Friday, 10-3, or by appointment. Located in the heart of downtown Lincoln; 900 sq. ft.; housed in a 1926 bungalow overlooking beautiful Beermann Plaza. "Our annual 'Feats of Clay®' exhibition is held inside the 122-year-old Gladding McBean terra cotta factory." 70% of space for gallery artists. 90% private collectors, 10% corporate collectors. Overall price range: $90-7,000; most work sold at $150-2,000.
Media: Considers all media including linocut prints. Most frequently exhibits ceramics and mixed media.
Style: Exhibits all styles, all genres.
Terms: Accepts work on consignment (30% commission). "Membership donation (min. $25) is encouraged but not required." Retail price set by the artist. Gallery provides promotion; artist pays shipping costs to and from gallery. Prefers artwork framed.
Submissions: Send query letter with résumé, slides or photographs, bio and SASE. Call or write for appointment to show portfolio of originals (if possible) or photographs or slides. Replies in 1 month. Artist should include SASE for return of slides/photos. Files bio, résumé, review notes. "Scheduling is done minimum one year ahead in August for following calendar year. Request prospectus for entry information for Feats of Clay© exhibition." Finds artists through visiting exhibitions, word of mouth, art publications and sourcebooks and submissions.

LIZARDI/HARP GALLERY, P.O. Box 91895, Pasadena CA 91109. (626)791-8123. Fax: (626)791-8887. Director: Grady Harp. Retail gallery and art consultancy. Estab. 1981. Represents 15 emerging, mid-career and established artists/ year. Exhibited artists include Christopher James, John Nava, Stephen Freedman, Harrison Storms, Don Bachardy, Stephen De Staebler, Stephen Douglas, Curtis Wright, Jan Saether, Ruprecht von Kaufmann and Erik Olson. Sponsors 9 shows/year. Average display time 1 month. Open all year; Tuesday-Saturday. 80% private collectors, 20% corporate collectors. Overall price range: $900-80,000; most work sold at $2,000-15,000.
 • Director reports gallery has "more emphasis on representation art now as I am curating shows and writing more about this area."
Media: Considers oil, acrylic, watercolor, pastel, pen & ink, drawing, mixed media, sculpture, installation, photography, woodcuts, lithographs, serigraphs and etchings. Most frequently exhibits works on paper and canvas, sculpture, photography.
Style: Exhibits representational art. Genres include landscapes, figurative work, all genres. Prefers figurative, landscapes and experimental.
Terms: Accepts work on consignment (50% commission). Retail price set by the gallery and the artist. Gallery provides insurance, promotion, contract; artist pays shipping costs.
Submissions: Send query letter with artist's statement, résumé, 20 slides, bio, photographs, SASE and reviews. Write for appointment to show portfolio of photographs, slides and transparencies. Replies in 3-4 weeks. Files "all interesting applications." Finds artists through studio visits, group shows, submissions.
Tips: "Timelessness of message is a plus (rather than trendy). Our emphasis is on quality or craftsmanship, evidence of originality . . . and maturity of business relationship concept."

✔MONTEREY MUSEUM OF ART AT LA MIRADA, 720 Via Mirada, Monterey CA 93940. (408) 372-5477. Fax: (408)372-5680. Nonprofit museum. Estab. 1959. Exhibits the work of emerging, mid-career and established artists. Average display time is 3-4 months.
Media: Considers all media.
Style: Exhibits contemporary, abstract, impressionistic, figurative, landscape, primitive, non-representational, photorealistic, western, realist, neo-expressionistic and post-pop works.
Terms: No sales. Museum provides insurance, promotion and contract; shipping costs are shared.
Submissions: Send query letter, résumé, 20 slides and SASE. Portfolio review not required. Résumé and cover letters are filed. Finds artists through agents, visiting exhibitions, word of mouth, various art publications and sourcebooks, artists' submissions/self promotions, art collectors' referrals.

OFF THE WALL GALLERY, 18561 Main St., Huntington Beach CA 92648. (714)847-2204. Estab. 1981. Represents 50 emerging, mid-career and established artists. Exhibited artists include Thomas Kinkade, Vadik Suluakov and Bob Byerley. Sponsors 2 shows/year. Average display time 3 weeks. Open all year. Located in outdoor mall; 1,000 sq. ft.; "creative matting and framing with original art hand-cut into mats." 30% of space for special exhibitions. Clientele: 95% private collectors, 5% corporate clients. Overall price range: $10-5,000; most artwork sold at $200-1,000.
Media: Considers mixed media, collage, sculpture, ceramic, craft, original handpulled prints, engravings, etchings, lithographs, pochoir, serigraphs and posters. Most frequently exhibits serigraphs, lithographs and posters.
Style: Exhibits expressionism, primitivism, conceptualism, impressionism, realism and photorealism. Genres include landscapes, florals, Americana, southwestern and figurative work. Prefers impressionism and realism.
Terms: Accepts work on consignment (50% commission) or buys outright for 50% of retail price (net 30 days). Retail price set by artist. Gallery provides promotion; artist pays for shipping. Prefers framed artwork but will accept unframed art.
Submissions: Send query letter with brochure and photographs. Call for appointment to show portfolio of originals and photographs. "We prefer to see actual art, as we can't use slides." Replies only if interested within 1 week. Files photographs, brochures and tearsheets.

‡OLIVER ART CENTER—CALIFORNIA COLLEGE OF ARTS & CRAFTS, 5212 Broadway, Oakland CA 94618. (510)594-3650. Fax: (510)428-1346. Contact: Kristin Burt. Nonprofit gallery. Estab. 1989. Exhibits the work of emerging, mid-career and established artists. Sponsors 5-8 shows/year. Average display time 6-8 weeks. Located on the campus of the California College of Arts & Crafts; 3,500 sq. ft. of space for special exhibitions.
Media: Considers all media.
Style: Exhibits contemporary works of various genres and styles. Interested in seeing "works that relate to a cross-cultural audience."
Terms: Gallery provides insurance and promotion, pays for incoming shipping costs to gallery. Prefers artwork framed.
Submissions: Send query letter with résumé, professional quality slides, statement of intent related to slides sent, brochure, photographs, SASE, business card and reviews. Replies in 3 weeks.
Tips: "Proposals for collaborative works or special installations/projects should be accompanied by a complete write-up, including descriptions, costs, rationale, and drawings/slides as available." A frequent mistake artists make is continuing to call even after material has been reviewed and turned down.

ORLANDO GALLERY, 14553 Ventura Blvd., Sherman Oaks CA 91403. Website: http://artscencal.com. Co-Directors: Robert Gino and Don Grant. Retail gallery. Estab. 1958. Represents 30 emerging, mid-career and established artists. Sponsors 22 solo shows/year. Average display time is 1 month. Accepts only California artists. Overall price range: up to $35,000; most artwork sold at $2,500.
Media: Considers oil, acrylic, watercolor, pastel, pen & ink, drawings, mixed media, collage, works on paper, sculpture, ceramic and photography. Most frequently exhibits oil, watercolor and acrylic.
Style: Exhibits painterly abstraction, conceptualism, primitivism, impressionism, photorealism, expressionism, neo-expressionism, realism and surrealism. Genres include landscapes, florals, Americana, figurative work and fantasy illustration. Prefers impressionism, surrealism and realism. Interested in seeing work that is contemporary. Does not want to see decorative art.
Terms: Accepts work on consignment. Retail price set by artist. Offers customer discounts and payment by installments. Exclusive area representation required. Gallery provides insurance and promotion; artist pays for shipping.
Submissions: Send query letter, résumé and 12 or more slides. Portfolio should include slides and transparencies. Finds artists through submissions.
Tips: "Be inventive, creative and be yourself."

‡PALO ALTO CULTURAL CENTER, 1313 Newell Rd., Palo Alto CA 94303. (650)329-2366. Director: Linda Craighead. Municipal visual arts center. Estab. 1971. Exhibits the work of regional and nationally known artists in group and solo exhibitions. Interested in established artists or emerging/mid-career artists who have worked for at least 3 years in their medium. Overall price range: $150-20,000; most artwork sold at $200-3,000.
Media: Considers oil, acrylic, watercolor, pastel, pen & ink, drawings, sculpture, ceramic, fiber, photography, mixed media, collage, glass, installation, decorative art (i.e., furniture, hand-crafted textiles, etc.) and original handpulled prints. "All works on paper must be suitably framed and behind plexiglass." Most frequently exhibits ceramics, painting, photography and fine arts and crafts.
Style: "Our gallery specializes in contemporary and historic art."
Terms: Accepts work on consignment (10-30% commission). Retail price is set by the gallery and the artist. Exclusive area representation not required. Gallery provides insurance, promotion and contract; artist pays for shipping.

HOW TO USE THIS BOOK TO SELL YOUR WORK offers suggestions for understanding and using the information in these listings. Read this and other articles in the front of this book for important business tips.

Submissions: Send query letter, résumé, slides, business card and SASE.

SAMIMI ART GALLERY, P.O. Box 200, Orinda CA 94563. or 6 Sunrise Hill Rd., Orinda CA 94563. Phone/fax: (510)254-3994. E-mail: esamim@aol.com. Director: Ellie Samimi. Retail gallery and art consultancy. Estab. 1991. Represents 10 mid-career and established artists/year. May be interested in seeing the work of emerging artists in the future. Exhibited artists include Mehrdad Samimi, Pam Glover. Sponsors 4-5 shows/year. Average display time 1 month. Open all year; by appointment. Located in Orinda Village across from golf course; 400 sq. ft.; interior decor. warm and cozy. 90% of space for special exhibitions; 90% of space for gallery artists. Clientele: collectors/private collectors. 70% private collectors, 30% corporate collectors. Overall price range: $1,000-15,000; most work sold at $3,000.
 • This gallery also accepts commissioned artwork and portraits.
Media: Considers oil, acrylic, watercolor, sculpture and engraving. Most frequently exhibits oil, acrylic and sculpture (bronze).
Style: Exhibits impressionism and realism. Genres include landscapes, florals, portraits and figurative work. Prefers impressionism, realism, representational (also sculptures). Accepts work on consignment (40-50% commission). Retail price set by the gallery and the artist. Gallery provides insurance, promotion, contract and shipping costs from gallery; artist pays shipping costs to gallery. Prefers artwork framed.
Submissions: Prefers only oil. Send query letter with résumé, brochure, slides and photographs. Call for appointment to show portfolio of originals, photographs and slides. Replies only if interested within 2 weeks. Files photos, résumé. Finds artists through visiting exhibitions, word of mouth.

‡SUSAN STREET FINE ART GALLERY, 444 S. Cedros Ave., Studio 100, Solana Beach CA 92075. (619)793-4442. Fax: (619)793-4491. Gallery Director: Susan Street. Retail and wholesale gallery, art consultancy. Estab. 1984. Represents emerging, mid-career and established artists. Exhibited artists include Joseph Maruska, Marcia Burtt. Sponsors 8 shows/year. Average display time 6 weeks. Open all year; Monday-Friday, 9:30-5; Saturday, 12-4 and by appointment. Located in North San Diego County coastal; 2,000 sq. ft.; 16 foot ceiling lobby, unique artist-designed counter, custom framing design area. 50% of space for special exhibitions; 50% of space for gallery artists. Clientele: corporate, residential, designers. 30% private collectors, 70% corporate collectors. Overall price range: $125-15,000; most work sold at $400-2,000.
Media: Considers oil, acrylic, watercolor, pastel, pen & ink, mixed media, collage, sculpture, ceramics, glass and photography. Considers all types of prints. Most frequently exhibits painting (oil/acrylic/mixed media), sculpture.
Style: Exhibits all styles, all genres. Prefers impressionism, abstract expressionism and minimalism.
Terms: Accepts work on consignment (50% commission). Retail price set by the artist. Gallery provides insurance, promotion; shipping costs are shared. Prefers artwork unframed.
Submissions: Send query letter with résumé, slides, bio, business card, reviews, price list and SASE. Call for appointment to show portfolio of slides. Replies in 1 month. Finds artists through referrals, scouting fairs and exhibitions, slide submissions.

ATELIER RICHARD TULLIS, (formerly A.R. Tullis/Atelier Richard Tullis), P.O. Box 2370, Santa Barbara CA 93103. (805)965-1091. Fax: (805)965-1093. Director: Richard Tullis II. Specializes in collaborations with artists. Exploration of material and image making on various media. Estab. 1992. Exhibited artists Kirkeby, Millei, Carroll, Haynes, Kaneda, Humphries, Arnoldi, Tanner, Oulton. Hours by appointment. Located in industrial area; 6,500 sq. ft.; sky lights in saw tooth roof; 27′ ceiling.
Submissions: By invitation.

LEE YOUNGMAN GALLERIES, 1316 Lincoln Ave., Calistoga CA 94515. (707)942-0585. Fax: (707)942-6657. E-mail: leeyg@earthlink.net. Website: http://home.earthlink.net/~leeyg. Owner: Ms. Lee Love Youngman. Retail gallery. Estab. 1985. Represents 40 established artists. Exhibited artists include Ralph Love and Paul Youngman. Sponsors 3 shows/year. Average display time 2 months. Open all year. Located downtown; 3,000 sq. ft.; "warm Southwest decor, somewhat rustic." Clientele: 100% private collectors. Overall price range: $500-24,000; most artwork sold at $1,000-3,500.
Media: Considers oil, acrylic, watercolor and sculpture. Most frequently exhibits oils, bronzes and alabaster.
Style: Exhibits impressionism and realism. Genres include landscapes, Southwestern, Western and wildlife. Interested in seeing American realism. No abstract art.
Terms: Accepts work on consignment (50% commission). Retail price set by gallery. Customer discounts and payment by installment are available. Gallery provides insurance and promotion. Artist pays for shipping to and from gallery. Prefers framed artwork.
Submissions: Accepts only artists from Western states. "No unsolicited portfolios." Portfolio review requested if interested in artist's work. "The most common mistake artists make is coming on weekends, the busiest time, and expecting full attention." Finds artists through publication, submissions and owner's knowledge.
Tips: "Don't just drop in—make an appointment. No agents."

Los Angeles

VICTOR SALMONES SCULPTURE GARDEN, 433 N. Camden Dr., Suite 1200, Beverly Hills CA 90210. (310)271-1297. Fax: (310)205-2088. Vice President: Travis Hansson. Retail and wholesale gallery. Estab. 1962. Repre-

sents 4 established artists/year. Interested in seeing the work of emerging artists. Exhibited artists include Victor Salmones, Robert Toll, George Lundeen, Dennis Smith, Axel Cassel, Xavier Medina-Compeny and Rosie Sandifer. Sponsors 3 shows/year. Average display time 3 months. Open all year; Monday-Friday, 10-5. Space is 20,000 sq. ft.; very architectural—showing mainly large sculpture. 100% of space for gallery artists. Clientele: corporate and private. 90% private collectors, 10% corporate collectors. Overall price range: $15,000-250,000; most work sold at $15,000-50,000.
Media: Considers sculpture only. Most frequently exhibits bronze, stones, steel.
Style: Exhibits all styles, all genres; prefers figurative work and cubism.
Terms: Retail price set by the gallery. Gallery provides insurance, promotion and contract. Shipping costs are shared.
Submissions: Send query letter with bio and photographs. Write for appointment to show portfolio of photographs. Replies only if interested within 1 week. Files only photos. Finds artists through agents, by visiting exhibitions, word of mouth, various art publications and sourcebooks, submissions.

SYLVIA WHITE CONTEMPORARY ARTISTS' SERVICES, 2022 B Broadway, Santa Monica CA 90404. (310)828-6200. E-mail: artadvice@aol.com. Website: http://www.sylviawhite.com. Owner: Sylvia White. Retail gallery, art consultancy and artist's career development services. Estab. 1979. Represents 20 emerging, mid-career and established artists. Interested in seeing work of emerging artists. Exhibited artists include Martin Mull, John White. Sponsors 12 shows/year. Average display time 1 month. Open all year; Tuesday-Saturday, 11-6. Located in downtown Santa Monica; 2,000 sq. ft.; 100% of space for special exhibitions. Clientele: upscale. 50% private collectors, 50% corporate collectors. Overall price range: $1,000-10,000; most work sold at $3,000.
 • Sylvia White also has a location in Soho in New York City.
Media: Considers all media, including photography. Most frequently exhibits painting and sculpture.
Style: Exhibits all styles, including painterly abstraction and conceptualism.
Terms: Retail price set by gallery and artist. Gallery provides insurance, promotion and contract. Artist pays for shipping costs.
Submissions: Send query letter with résumé, slides, bio and SASE. Portfolio should include slides.

San Francisco

‡A.R.T.S. RESOURCE, 545 Sutter St., #305, San Francisco CA 94102. (415)775-0709. Director: Will Stone. Art consultancy and artist's management agency. Estab. 1972. Represents 6-10 emerging, mid-career and established artists/year. Exhibited artists include Arthur Bell and Lee Madison. Sponsors 4-6 shows/year. Average display time 4-6 weeks. Open September-June by appointment. Located downtown—Union Square; 600 sq. ft.; 80% private collectors, 20% corporate collectors. Overall price range: $500-10,000; most work sold at $1,200-3,000.
Media: Considers all media and all types of prints. Most frequently exhibits painting, sculpture and photography.
Style: Exhibits all styles and all genres. Prefers surrealism, expressionism and photorealism.
Terms: Artwork is accepted on consignment and there is a 50% commission. Retail price set by gallery and artist. Gallery provides contract. Artist pays for shipping costs. Prefers artwork unframed.
Submissions: Send query letter with résumé slides, bio, SASE and evaluation fee. Portfolio should include slides and artist's statement. Replies in 3-6 weeks. Files all material.
Tips: "Persevere. Form good business practices—get an agent."

‡AUROBORA PRESS, 147 Natoma St., San Francisco CA. (415)546-7880. Fax: (415)546-7881. E-mail: monotype@aurobora.com. Website: http://www.aurobora.com. Directors: Michael Dunev and Michael Liener. Retail gallery and fine arts press. Invitational Press dedicated to the monoprint and monotype medium. Estab. 1991. Represents/exhibits emerging, mid-career and established artists. Exhibited artists include William T. Wiley and Charles Arnoldi. Sponsors 10 shows/year. Average display time 4-6 weeks. Open all year; Monday-Saturday, 11-5. Located south of Market—Yerba Buena; 1,000 sq. ft.; turn of the century firehouse—converted into gallery and press area. Clientele: collectors, tourists and consultants. Overall price range: $1,200-6,000; most work sold at $1,500-4,000.
 • Aurobora Press invites artists each year to spend a period of time in residency working with Master Printers.
Media: Considers and prefers monotypes.
Terms: Retail price set by gallery and artist. Gallery provides promotion.
Submissions: By invitation only.

J.J. BROOKINGS GALLERY, 669 Mission St., San Francisco CA 94025. (415)546-1000. Website: http://www.jjbrookings.com. Director: Timothy Duran. Retail gallery. Estab. 1970. Of artists represented 15% are emerging, 25% are mid-career and 60% are established. Exhibited artists include Ansel Adams, Robert Motherwell, Richard Diebenkorn, Bill Barrett, Katherine Chang Liu, Lisa Gray, Misha Grodin, Nancy Genn, Sandy Skoglund and James Crable. Sponsors 10-12 shows/year. Average display time 40 days in rotation. Open all year; Monday-Saturday, 10-6; Sunday, 12-6. Located next to San Francisco MOMA and Moscone Center; 7,500 sq. ft.; 60% of space for special exhibitions. Clientele: collectors and private art consultants. 60% private collectors, 10% corporate collectors, 30% private art consultants. Overall price range: $1,000-125,000; most work sold at $2,000-8,000. Works with architects and designers for site-specific commissions—often in the $4,000-$60,000 range.
 • Timothy Duran also owns Museum West Fine Art & Framing, which is more open to emerging artists. See listing in this section.

Media: Considers oil, acrylic, sculpture, watercolor, mixed media, pastel, collage, photography, original handpulled prints, woodcuts, wood engravings, linocuts, engravings, mezzotints, etchings, lithographs and serigraphs. Most frequently exhibits high-quality paintings, prints, sculpture and photography.
Style: Exhibits expressionism, conceptualism, photorealism, minimalism, painterly abstraction, realism and surrealism. Genres include landscapes, florals, figurative work and city scapes.
Terms: Retail price set by gallery and artist. Gallery provides insurance, promotion, contract and shipping costs from gallery; artist pays for shipping costs to gallery.
Submissions: Prefers "intellectually mature artists who know quality and who are professional in their creative and business dealings. Artists can no longer be temperamental." Send query letter with résumé, 20 current slides, bio, brochure, photographs, SASE, business card and reviews. Replies if interested within 2-3 months; if not interested, replies in a few days.
Tips: "First, determine just how unique or well crafted or conceived your work really is. Secondly, determine your market—who would want this type of art and especially your type of art; then decide what is the fair price for this work and how does this price fit with the price for similar work by artists of similar stature. Lastly, have a well thought-out presentation that shows consistent work and/or consistent development over a period of time. We want artists with an established track record and proven maturity in artistic vision. Bill Vouksonovich only creates 7-10 pieces a year, but at prices from $13,000-20,000 and he has a waiting list. Katherine Chang Liu creates 300-400 works a year, has an established international network of dealers and sells at $700-4,000. You need a sufficient number of works for a dealer to see the growth of your vision and technique, but, depending on the artist, this could be ten pieces over five years or twenty pieces over two years because the artist has yet to ground himself."

‡**EBERT GALLERY**, 49 Geart St., San Francisco CA 94108. (415)296-8405. Website: http://www.ebertgallery.com. Owner: Dick Ebert. Retail gallery. Estab. 1989. Represents 24 established artists "from this area." Interested in seeing the work of emerging artists. Sponsors 11-12 shows/year. Average display time 1 month. Open all year; Tuesday-Friday, 10:30-5:30; Saturday, 11-5. Located downtown near bay area; 1,200 sq. ft.; one large room which can be divided for group shows. 85% of space for special exhibitions; 15% of space for gallery artists. Clientele: collectors, tourists, art students. 80% private collectors. Overall price range: $500-20,000; most work sold at $500-8,000.
Media: Considers oil, acrylic, watercolor, pastel, pen & ink, drawing, mixed media, collage, paper, sculpture, glass, photography, woodcuts, engravings, mezzotints, etchings and encostic. Most frequently exhibits acrylic, oils and pastels.
Style: Exhibits expressionism, painterly abstraction, impressionism and realism. Genres include landscapes, figurative work, all genres. Prefers landscapes, abstract, realism.
Terms: Accepts work on consignment (50% commission). Retail price set by the artist. Gallery provides promotion. Shipping costs are shared. Prefers artwork framed.
Submissions: San Francisco Bay Area artists only. Send query letter with résumé and slides. Finds artists through referral by professors or stable artists.
Tips: "You should have several years of practice as an artist before approaching galleries. Enter as many juried shows as possible."

‡**MUSEUM WEST FINE ARTS & FRAMING, INC.**, 170 Minna, San Francisco CA 94105. (415)546-1113. Director: Karen Imperial. Assistant Manager: Susan Pitcher. Retail gallery. Represents/exhibits 14 emerging artists/year. Sponsors 8-11 shows/year. Average display time 6 weeks. Open all year; Monday-Saturday. Located downtown next to San Francisco Museum of Modern Art; 3,500 sq. ft.; 30% of space for special exhibitions. Clientele: upscale tourists, art consultants, sophisticated corporate buyers, collectors. Overall price range: $200-5,000; most work sold at $500-2,500.
 • This gallery is affiliated with J.J. Brookings Gallery. J.J. Brookings exhibits mainly established artists, while this gallery is more open to emerging and mid-career artists.
Media: Considers all media except fabric. No installation work.
Style: Exhibits expressionism, painterly abstraction, impressionism, photorealism, pattern painting and realism. Genres include florals, landscapes, figurative work and cityscapes. Prefers colorful still lifes, San Francisco Bay imagery and landscapes.
Terms: Artwork is accepted on consignment (50% commission). Retail price set by the gallery and artist. Gallery provides insurance, promotion and contract; shipping costs are shared or negotiated.
Submissions: No sexually explicit or politically-oriented art. Send query letter with résumé, slidesheet of 10-20 current slides, bio, brochure, photographs, SASE, business card and and reviews. Write for appointment to show portfolio of photographs, slides and transparencies. Replies in 3-5 weeks. Files all material if interested. Finds artists through open studios, mailings, referrals by other artists and collectors.
Tips: "Since we work with a lot of younger or non-established artists from all over the country we do not expect extensive museum representation. We look for artists who are serious enough about their work to stay with it, yet we understand that their main source of income may not be from art. We do not expect or demand consistency of images since we know the artist is still experimenting. We do expect a professional presentation package. We reserve the right to pick and choose or simply say 'no' to a new, but unresolved body of work. We want images of current work, not work sold three years ago and no longer available."

SAN FRANCISCO ART COMMISSION GALLERY & SLIDE REGISTRY, 401 Van Ness, Civic Center, San Francisco CA 94102. (415)554-6080. Fax: (415)252-2595. E-mail: sfacgallery@mail.telis.org. Website: www.postfun.

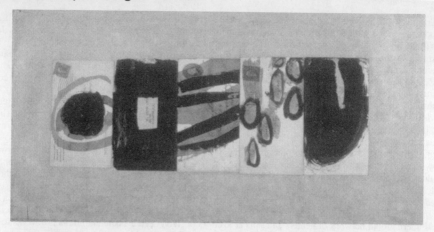

Dennis Parlante united expressive, spontaneous brush strokes with old and antique used envelopes to create this striking triptych. "Dennis has a wide audience. His work is in collection all over the U.S., as well as England, Japan, Singapore, Autralia, Switzerland and Germany," reports Susan Pitcher of Museum West Fine Arts in San Francisco. The piece was part of an exhibition of the artist's work at Museum West, and was sold to a collector. Parlante formed his relationship with the gallery through a studio visit by the owner. He holds "open studio" events twice a year.

com/sfac/. Director: Rupert Jenkins. Nonprofit municipal gallery; alternative space. Estab. 1983. Exhibits work of approximately 150 emerging and mid-career artists/year; 400-500 in Slide Registry. Sponsors 7 indoor group shows/year; 3 outdoor site installations/year. Average display time 5 weeks (indoor); 3 months (outdoor installations). Open all year. Located at the Civic Center; 1,000 sq. ft. (indoor), 4,500 sq. ft. (outdoor); City Site lot across the street from City Hall and in the heart of the city's performing arts complex. 100% of space for special exhibitions. Clientele: cross section of San Francisco/Bay Area including tourists, upscale, local and students. Sales are minimal.

● A newly renovated exhibition space opened in January, '96. The program continues with window installations, site specific projects, the Artists' Slide Registry, artists' talks and special projects.

Media: Considers all media. Most frequently exhibits installation, mixed media, sculpture/3-D, painting, photography.
Style: Exhibits all styles. Prefers cutting-edge, contemporary works.
Terms: Accepts artwork on consignment (20% commission). Retail price set by artist. Gallery provides insurance, promotion and contract; artist pays for shipping.
Submissions: Accepts only artists residing in one of nine Bay Area counties. Write for guidelines to join the slide registry to automatically receive calls for proposals and other exhibition information. Do not send unsolicited slides.
Tips: "The Art Commission Gallery serves as a forum for exhibitions which reflect the aesthetic and cultural diversity of contemporary art in the Bay Area. Temporary installations in the outdoor lot adjacent to the gallery explore alternatives to traditional modes of public art. Gallery does not promote sale of art, as such, but will handle sale of available work if a visitor wishes to purchase it. Exhibit themes, artists, and selected works are recommended by the Gallery Director to the San Francisco Art Commission for approval. Gallery operates for the benefit of the public as well as the artists. It is not a commercial venue for art."

Colorado

‡COGSWELL GALLERY, 223 Gore Creek Dr., Vail CO 81657. (970)476-1769. President/Director: John Cogswell. Retail gallery. Estab. 1980. Represents 40 emerging, mid-career and established artists. Exhibited artists include Steve Devenyns, Frances Donald and Jean Richardson. Sponsors 8-10 shows/year. Average display time 3 weeks. Open all year. Located in Creekside Building in Vail; 3,000 sq. ft. 50% of space for special exhibitions. Clientele: American and international, young and active. 80% private collectors, 20% corporate collectors. Overall price range: $100-50,000; most work sold at $1,000-5,000.
Media: Considers oil, acrylic, sculpture, watercolor, ceramic, photography and bronze; lithographs and serigraphs. Most frequently exhibits bronze, oil and watercolor.
Style: Exhibits painterly abstraction, impressionism and realism. Genres include landscapes, Southwestern and Western.
Terms: Accepts work on consignment (50% commission). Retail price set by the artist. Offers customer discounts and payment by installments. Gallery provides insurance and promotion; shipping costs from gallery. Prefers artwork framed.
Submissions: Send query letter with résumé, slides and bio. Call for appointment to show portfolio of slides. Replies only if interested within 1 month.

FOOTHILLS ART CENTER, 809 15th St., Golden CO 80401. (303)279-3922. Fax: (303)279-9470. Executive Director: Carol Dickinson. Nonprofit gallery. Estab. 1968. Exhibits approximately 600 established artists/year in invitational and competitive juried shows. Sponsors 9 shows/year. Average display time 6 weeks. Open all year; daily (except major holidays); Monday-Saturday, 9-4; Sunday, 1-4. Located downtown; 5 self-contained spaces (under one roof) 2,232 sq. ft. "We are housed in a National Historic Register building of classic Gothic/Victorian design—a church linked to a parsonage and remodeled into modern gallery interior spaces." 100% of space for special exhibitions. 90% private collectors, 10% corporate collectors. Overall price range: $100-30,000; most work sold at $1,500-2,000. Foothill's director urges artists to call or write for prospecti on how to enter their two national shows.
Media: Considers all media and all types of prints (size limitations on sculpture). Most frequently exhibits watermedia and mixed media, sculpture and clay.
Style: Exhibits all genres. Prefers figurative, realism, impressionism and contemporary-experimental.
Terms: Accepts work on consignment (35% commission). Retail price set by the artist. Gallery provides insurance, promotion and contract; shipping costs are shared. Prefers artwork framed.
Submissions: "The exhibition schedule offers opportunities to nationwide artists primarily through the biennial North American Sculpture Exhibition (May/June—competitive, juried, catalog, $10,000 in awards) and the annual Rocky Mountain National Watermedia Exhibition (August/September; juried, slide entries and small fee required, $10,000 in awards, catalog published)."
Tips: "Artists often include too much variety when multiple slides are submitted, with the result that jurors are unable to discern a recognizable style or approach, or artists submit poor photography or slides."

E.S. LAWRENCE GALLERY, 516 E. Hyman Ave., Aspen CO 81611. (970)920-2922. Fax: (970)920-4072. Director: Kert Koski. Retail gallery. Estab. 1988. Represents emerging, mid-career and established artists. Exhibited artists include Zvonimir Mihanovic, Graciela Rodo Boulanger, Steve Hanks. Sponsors 2 shows/year. Open all year; daily 10-10. Located downtown. 100% of space for gallery artists. 95% private collectors, 5% corporate collectors.
Media: Considers oil, acrylic, watercolor, pastel, mixed media, sculpture, glass, lithograph and serigraphs. Most frequently exhibits oil, acrylic, watercolor.

Style: Exhibits expressionism, impressionism, photorealism and realism. Genres include landscapes, florals, Americana, western, wildlife, figurative work. Prefers photorealism, impressionism, expressionism.
Terms: Accepts artwork on consignment (50% commission). Retail price set by the gallery and the artist. Gallery provides insurance, promotion and contract; artist pays shipping costs to and from gallery "if not sold." Prefers artwork framed.
Submissions: Send query letter with résumé, slides and photographs. Write for appointment to show portfolio of photographs, slides and reviews. Replies in 1 month. Finds artists through agents, visiting exhibitions, word of mouth, art publications and artists' submissions.
Tips: "We are always willing to look at submissions."

MAGIDSON FINE ART, 525 E. Cooper Ave., Dept. AM, Aspen CO 81617. (970)920-1001. Fax: (970)925-6181. E-mail: art@magidson.com. Website: http://www.magidson.com. Owner: Jay Magidson. Retail gallery. Estab. 1990. Represents 50 emerging, mid-career and established artists. Exhibited artists include Annie Leibovitz, Andy Warhol. Sponsors 5 shows/year. Average display time 3 months. Open all year; December 15-April 15, 10-9 daily; June 15-September 15, 10-9; rest of the year, Tuesday-Sunday, 10-6. Located in central Aspen; 800 sq. ft.; exceptional window exposure; free hanging walls; 12 ft. ceilings. 50% of space for special exhibitions; 50% of space for gallery artists. Clientele: emerging and established collectors. 95% private collectors, 5% corporate collectors. Overall price range: $1,200-75,000; most work sold at $2,500-7,500.
Media: Considers oil, acrylic, watercolor, pastel, pen & ink, drawing, mixed media, collage, paper, sculpture, ceramics, fiber, photography, woodcut, engraving, lithograph, wood engraving, serigraphs, linocut and etching. Most frequently exhibits oil/acrylic on canvas, photography and sculpture.
Style: Exhibits painterly abstraction, surrealism, color field, photorealism, hard-edge geometric abstraction and realism; all genres. Prefers pop, realism and unique figurative (colorful and imaginative).
Terms: Accepts work on consignment (40-60% commission). Retail price set by the gallery. Gallery provides insurance, promotion and shipping costs from gallery; artist pays shipping costs to gallery. Prefers artwork framed.
Submissions: Send query letter with slides, bio, photographs and SASE. Call for appointment to show portfolio of photographs, slides, "never originals!" Replies only if interested in 1 month. Files slides, "bios on artists we represent." Finds artists through recommendations from other artists, reviews in art magazines, museum shows, gallery shows.
Tips: "I prefer photographs over slides. No elaborate artist statements or massive résumés necessary."

‡ONE WEST ART CENTER, 201 S. College Ave., Ft. Collins CO 80524. (970)482-2787. Executive Director: Jill Dalager. Nonprofit retail gallery. Estab. 1983. Represents emerging and mid-career artists. 700 members. Exhibited artists include Louis Recchia, Pam Furumo. Sponsors 8 shows/year. Average display time 2 months. Open all year; Wednesday-Saturday, 10-5. Located downtown; 2,500 sq. ft.; 1911 renovated Italian renaissance federal building. 15% of space for special exhibitions; 20% of space for gallery artists. Clientele: community citizens and patrons. 5% private collectors, 5% corporate collectors. Overall price range: $12-6,000; most work sold at $12-500.
Media: Considers all media and all types of prints. Most frequently exhibits oil, acrylic and bronze.
Style: Exhibits all styles, all genres. Prefers impressionism, abstraction and surrealism.
Terms: Accepts work on consignment (40% commission). Retail price set by the artist. Gallery provides insurance and promotion; shipping costs are shared. Prefers artwork framed.
Submissions: Send query letter with résumé, slides, bio and SASE. Write for appointment to show portfolio of originals and slides. Replies in three months. Files slides, résumés.

PINE CREEK ART GALLERY, 2419 W. Colorado Ave., Colorado Springs CO 80904. (719)633-6767. Website: http://www.pcagallery.com. Owner: Nancy Anderson. Retail gallery. Estab. 1991. Represents 10+ established artists. Exhibited artists include Lorene Lovell, Karen Noles, Kirby Sattler, Chuck Mardosz and Don Grzybowski. Sponsors 2-4 shows/year. Average display time 1 month. Open all year Monday-Saturday, 10-6; Sunday, 11-5. 2,200 sq. ft.; in a National Historic District. 30% of space for special exhibitions. Clientele: middle to upper income. Overall price range: $30-5,000; most work sold at $100-500.
Media: Considers most media, including bronze, pottery and all types of prints.
Style: Exhibits all styles and genres.
Terms: Accepts artwork on consignment (40% commission). Retail price set by gallery and artist. Gallery provides insurance, promotion and shipping costs from gallery. Prefers artwork "with quality frame only."
Submissions: No fantasy or abstract art. Prefer experienced artists only—no beginners. Send query letter with 6-12 slides and photographs. Call or write for appointment to show portfolio or originals, photographs, slides and tearsheets. Replies in 2 weeks.
Tips: "Make sure your presentation is professional. We like to include a good variety of work, so show us more than one or two pieces."

‡REISS GALLERY, Dept. AM, 429 Acoma St., Denver CO 80204. (303)778-6924. Director: Rhoda Reiss. Retail gallery. Estab. 1978. Represents 160 emerging and mid-career artists. Exhibited artists include Sica, Nancy Hannum and Jim Foster. Sponsors 3-4 shows/year. Average display time 6-8 weeks. Open all year. Located 6 blocks south of downtown; 2,100 sq. ft.; "in an old Victorian house." 40% of space for special exhibitions. Clientele: "corporate and interior designers." 30% private collectors, 70% corporate collectors. Overall price range: $100-12,000; most artwork sold at $600-1,000.

Media: Considers oil, acrylic, watercolor, pastel, mixed media, collage, works on paper, sculpture, ceramic, fiber, glass, original handpulled prints, offset reproductions, woodcuts, engravings, lithographs, posters, wood engravings, mezzotints, serigraphs, linocuts and etchings. Most frequently exhibits oil, prints and handmade paper.

Style: Exhibits painterly abstraction, color field and impressionism. Genres include landscapes, Southwestern and Western. Does not want to see "unsalable imagery, figurative work or traditional oil paintings." Interested in seeing large abstract work on canvas or landscapes on canvas.

Terms: Accepts work on consignment (50% commission). Retail price set by the artist. Gallery provides insurance and promotion; artist pays for shipping. Prefers unframed artwork.

Submissions: Send query letter with résumé, slides, bio, brochure, photographs, SASE and reviews. Call to schedule appointment to show portfolio, which should include originals, photographs and slides. Replies in 2-4 weeks. Files bios, slides and photos.

Tips: Suggests "that artist send large scale work. Small pieces do not work in corporate spaces. Contemporary work shows best in our gallery. I look at craftsmanship, composition and salability of subject matter. Don't send poor slides or poorly framed work."

SANGRE DE CRISTO ARTS CENTER AND BUELL CHILDREN'S MUSEUM, 210 N. Santa Fe Ave., Pueblo CO 81003. (719)543-0130. Fax: (719)543-0134. Curator of Visual Arts: Jennifer Cook. Nonprofit gallery and museum. Estab. 1972. Exhibits emerging, mid-career and established artists. Sponsors 25-30 shows/year. Average display time 10 weeks. Open all year. Free to the public. Located "downtown, right off Interstate I-25"; 7,500 sq. ft.; six galleries, one showing a permanent collection of western art; changing exhibits in the other five. Also a new 7,500 sq. ft. children's museum with changing, interactive exhibits. Clientele: "We serve a 19-county region and attract 200,000 visitors yearly." Overall price range for artwork: $50-100,000; most work sold at $50-10,000.

Media: Considers all media.

Style: Exhibits all styles. Genres include southwestern, regional and contemporary.

Terms: Accepts work on consignment (30% commission). Retail price set by artist. Gallery provides insurance, promotion, contract and shipping costs. Prefers artwork framed.

Submissions: "There are no restrictions, but our exhibits are booked into 2000 right now." Send query letter with slides. Write or call for appointment to show portfolio of slides. Replies in 2 months.

TREASURE ALLEY, 514 San Juan, Alanosa CO 81101-2326. Partners: Carol Demlo and Melody Johnson. Retail gallery and specialty gift shop. Estab. 1995. Represents regional artwork. Open all year. Located in the southern Rocky Mountains in the hub of the San Luis Valley; gallery includes a historic walk-in vault. Overall price range: $40-400.

Media: Considers oil, acrylic, watercolor, pastel, pen & ink, drawings, mixed media, works on paper, sculpture, ceramic, glass posters, linocuts and etchings. Most frequently exhibits watercolor, oil, ceramics and pastels.

Style: Genres include landscapes, florals, southwestern and still lifes. Prefers realism, impressionism and color field.

Terms: Accepts work on consignment (35% commission). Retail price set by gallery. Customer discounts and payment by installment available. Gallery provides insurance and promotion; artist pays for shipping. Prefers artwork framed.

Submissions: Send query letter with résumé, 3 slides of each work, brochure, photographs and SASE for return. Finds artists through visiting exhibitions and referrals.

Tips: Have at least 20-25 good pieces before approaching galleries. You should have a complete portfolio including current and past work.

Connecticut

MONA BERMAN FINE ARTS, 78 Lyon St., New Haven CT 06511. (203)562-4720. Fax: (203)787-6855. E-mail: mbfineart@snet.net. Director: Mona Berman. Art consultancy. Estab. 1979. Represents 100 emerging and mid-career artists. Exhibited artists include Tom Itricko, David Dunlop, Will McCarthy and S. Wind-Greenbain. Sponsors 1 show/ year. Open all year by appointment. Located near downtown; 1,400 sq. ft. Clientele: 5% private collectors, 95% coporate collectors. Overall price range: $200-20,000; most artwork sold at $500-5,000.

Media: Considers all media except installation. Shows very little sculpture. Considers all limited edition prints except posters and photolithography. Most frequently exhibits works on paper, painting, relief and ethnographic arts.

Style: Exhibits most styles. Prefers abstract, landscape and transitional. No figurative, little still life.

Terms: Accepts work on consignment (50% commission; net 30 days). Retail price is set by gallery and artist. Customer discounts and payment by installment are available. Gallery provides insurance; artist pays for shipping. Prefers artwork unframed.

Submissions: Send query letter, résumé, "about 20 slides," bio, SASE, reviews and "price list—retail only at stated commission." Portfolios are reviewed only after slide submission. Replies in 1 month. Slides and reply returned only if SASE is included. Finds artists through word of mouth, art publications and sourcebooks, submissions and self-promotions and other professionals' recommendations.

Tips: "Please understand that we are not a gallery, although we do a few exhibits. We are primarily art consultants. We continue to be busy selling high-quality art and related services to the corporate, architectural and design sectors."

CONTRACT ART, INC., P.O. Box 520, Essex CT 06426. (203)767-0113. Fax: (203)767-7247. President: K. Mac Thames. In business approximately 30 years. "We contract artwork for blue-chip businesses." Represents emerging,

mid-career and established artists. Approached by hundreds of artists/year. Assigns site-specific commissions to artists based on client needs and preferences. Showroom is open all year to corporate art directors, architects and designers. 1,600 sq. ft.. Clientele: 98% commercial. Overall price range: $500-500,000.

Media: Considers all art media and all types of prints.

Terms: Pays for design by the project, negotiable; 50% up front. Prefers artwork unframed. Rights purchased vary according to project.

Submissions: Send query letter with résumé, slides, bio, brochure, photographs and SASE. If local, write for appointment to show portfolio; otherwise, mail appropriate materials, which should include slides and photographs. "Show us a good range of what you can do. Also, keep us updated if you've changed styles or media." Replies in 1 week. Files all samples and information in registry library.

Tips: "We exist mainly to solicit commissioned artwork for specific projects."

‡FARMINGTON VALLEY ARTS CENTER'S FISHER GALLERY, 25 Arts Center Lane, Avon CT 06001. (860)678-1867. Manager: Brecca Loh. Nonprofit gallery. Estab. 1972. Exhibits the work of 300 emerging, mid-career and established artists. Exhibited artists include Kerr Grabowski and Randall Darwall. Sponsors 5 shows/year. Average display time 2-3 months. Open all year; Wednesday-Saturday, 11-5; Sunday, 12-4; extended hours November-December. Located in Avon Park North just off Route 44; 600 sq. ft.; "in 19th-century brownstone factory building once used for manufacturing." 25% of space for special exhibitions. Clientele: upscale contemporary craft buyers. Overall price range: $100-1,000; most work sold at $100-300.

Media: Considers "primarily crafts," also considers some mixed media, works on paper, ceramic, fiber, glass and small size prints. Most frequently exhibits jewelry, ceramics and fiber.

Style: Exhibits all styles, including craft.

Terms: Accepts artwork on consignment (40% commission). Retail price set by the artist. Gallery provides promotion and contract; shipping costs are shared. Prefers artwork framed.

Submissions: Send query letter with résumé, slides, brochure, photographs, SASE and reviews. Write for appointment to show portfolio of slides and transparencies. Replies only if interested within 2 months. Files a slide or photo, résumé and brochure.

SILVERMINE GUILD GALLERY, 1037 Silvermine Rd., New Canaan CT 06840. (203)966-5617. Fax: (203)972-7236. Director: Vincent Baldassano. Nonprofit gallery. Estab. 1922. Represents 268 emerging, mid-career and established artists/year. Sponsors 20 shows/year. Average display time 1 month. Open all year; Tuesday-Saturday, 11-5; Sunday, 1-5. 5,000 sq. ft. 95% of space for gallery artists. Clientele: tourist, upscale. 40% private collectors, 10% corporate collectors. Overall price range: $250-10,000; most work sold at $1,000-2,000.

Media: Considers all media and all types of prints. Most frequently exhibits paintings, sculpture and ceramics.

Style: Exhibits all styles.

Terms: Accepts work on consignment (50% commission). Co-op membership fee plus donation of time (50% commission.) Retail price set by the gallery and the artist. Gallery provides insurance, promotion and contract; shipping costs are shared. Prefers artwork framed.

Submissions: Send query letter.

‡SMALL SPACE GALLERY, Arts Council of Greater New Haven, 70 Audubon St., New Haven CT 06511. (203)772-2788. Fax: (203)772-2262. E-mail: arts.council@snet.net. Director: Helen Herzig. Alternative space. Estab. 1985. Interested in emerging artists. Sponsors 10 solo and group shows/year. Average display time: 1 month. Open to Arts Council artists only (Greater New Haven). Overall price range: $35-3,000.

Media: Considers all media.

Style: Exhibits all styles and genres. "The Small Space Gallery was established to provide our artist members with an opportunity to show their work. Particularly those who were just starting their careers. We're not a traditional gallery, but an alternative art space.

Terms: AAS Council requests 10% donation on sale of each piece. Retail price set by artist. Exclusive area representation not required. Gallery provides insurance (up to $10,000) and promotion.

Submissions: Send query letter with résumé, brochure, slides, photographs and bio. Call or write for appointment to show portfolio of originals, slides, transparencies and photographs. Replies only if interested. Files publicity, price lists and bio.

‡WILDLIFE GALLERY, 172 Bedford St., Stamford CT 06901. (203)324-6483. Fax: (203)324-6483. Director: Patrick R. Dugan. Retail gallery. Represents 72 emerging, mid-career and established artists. Exhibited artists include R. Bateman and R.T. Peterson. Sponsors 4 shows/year. Average display time 6 months. Open all year. Located downtown; 1,200 sq. ft. 30% of space for special exhibitions. Clientele: 20% private collectors, 10% corporate collectors. Overall price range: $300-10,000; most artwork sold at $500-3,000.

Media: Considers oil, acrylic, watercolor, pastel, woodcuts, wood engravings, engravings, lithographs and serigraphs. Most frequently exhibits acrylic, oil and watercolor.

Style: Prefers realism. Genres include landscapes, florals, Americana, Western, wildlife and sporting art. No "impressionism, over-priced for the quality of the art."

Terms: Accepts work on consignment (50% commission). Retail price set by gallery. Sometimes offers customer

discounts and payment by installment. Gallery provides promotion and contract; shipping costs are shared. Prefers unframed artwork.

Submissions: Send query letter with photographs, bio and SASE. Write for appointment to show portfolio of originals and photographs. Replies by SASE only if interested within 2 weeks. Files all material, if interested.

Tips: "Must be work done within last six months. Don't send art that is old that you have not been able to sell." Quote prices on first mailing.

Delaware

BEYOND DIMENSIONS, 59 S. Governors Ave., Dover DE 19904. (302)674-9070. Fax: (302)674-9070. Owner: Jean Francis. Retail gallery. Estab. 1990. Represents 15-20 emerging and mid-career artists; 25-30 emerging and mid-career craftspersons. Average display time 4-6 weeks. Open all year; Monday-Friday, 10-6; Saturday, 10-4. Located downtown; Victorian house with contemporary interior. Clientele: tourists, upscale. Overall price range: $10-1,000; most work sold at $30-95.

Media: Considers all media; types of prints include limited artist pulled.

Style: Exhibits expressionism, painterly abstraction, conceptualism, photorealism and realism.

Terms: Accepts work on consignment (35% commission) or buys outright for 50% of retail price (net 30 days) fine craft only. Retail price set by the artist. Gallery provides insurance and promotion. Shipping costs are shared. Prefers artwork framed (acid free, clean, well presented).

Submissions: Send query letter with résumé or brochure, photographs, artist's statement and telephone number. Call or write for appointment to show portfolio of photographs. Replies only if interested within 2-3 weeks. Files all relative to specific works and of artist/craftsperson. Finds artists through referrals, juried art fairs and exhibitions, artist submissions.

DELAWARE CENTER FOR THE CONTEMPORARY ARTS, 103 E. 16th St., Wilmington DE 19801. (302)656-6466. Fax: (302)656-6944. Director: Steve Lanier. Nonprofit gallery. Estab. 1979. Exhibits the work of emerging, mid-career and established artists. Sponsors 30 solo/group shows/year of both national and regional artists. Average display time is 1 month. 2,000 sq. ft.; 19 ft. ceilings. Overall price range: $50-10,000; most artwork sold at $500-1,000.

Media: Considers all media, including contemporary crafts.

Style: Exhibits contemporary, abstract, figurative, conceptual, non-representational and contemporary crafts.

Terms: Accepts work on consignment (35% commission). Retail price is set by the gallery and the artist. Exclusive area representation not required. Gallery provides insurance and promotion; shipping costs are shared.

Submissions: Send query letter, résumé, slides and/or photographs and SASE. Write for appointment to show portfolio. Seeking consistency within work as well as in presentation. Slides are filed. Submit up to 20 slides with a corresponding slide sheet describing the work (i.e. media, height by width by depth), artist's name and address on top of sheet and title of each piece in the order in which you would like them reviewed.

MICHELLE'S OF DELAWARE, 831 North Market St., Wilmington DE 19801. (302)655-3650. Fax: (302)655-3650. Art Director: Raymond Bullock. Retail gallery. Estab. 1991. Represents 18 mid-career and established artists/year. May be interested in seeing the work of emerging artists in the future. Exhibited artists include: William Tolliver and Joseph Holston. Sponsors 8 shows/year. Average display time 1-2 weeks. Open all year; Saturday-Sunday, 11-5 and 1-5 respectively. Located in Market Street Mall (downtown); 2,500 sq. ft. 50% of space for special exhibitions. Clientele: local community. 97% private collectors; 3% corporate collectors. Overall price range: $300-20,000; most work sold at $1,300-1,500.

Media: Considers oil, acrylic, watercolor, pastel, pen & ink, mixed media, collage and sculpture; types of prints include woodcuts, lithographs, mezzotints, serigraphs, linocuts and etchings. Most frequently exhibits acrylic, watercolor, pastel and oil.

Style: Exhibits: Cubism. Exhibits all genres. Prefers: jazz, landscapes and portraits.

Terms: Retail price set by the artist. Gallery provides insurance and contract; shipping costs are shared. Prefers artwork framed.

Submissions: Send slides. Write for appointment to show portfolio of artwork samples. Replies only if interested within 1 month. Files bio. Finds artists through art fairs and exhibitions.

Tips: "Use conservation materials to frame work."

‡REHOBOTH ART LEAGUE, INC., 12 Dodds Lane, Henlopen Acres DE 19971. (302)227-8408. Nonprofit gallery; offers education in visual arts. Estab. 1938. Exhibits the work of 1,000 emerging, mid-career and established artists. Sponsors 8-10 shows/year. Average display time 3½ weeks. Open January through November. Located in a residential area just north of town; "3½ acres, rustic gardens, built in 1743; listed in the National Register of Historic Places; excellent exhibition and studio space. Regional setting attracts artists and arts advocates." 100% of space for special exhibitions. Clientele: members, artists (all media), arts advocates.

Media: Considers all media (except installation and photography) and all types of prints.

Style: Exhibits all styles and all genres.

Terms: Accepts artwork on consignment (30% commission). Retail price set by the artist. Gallery provides insurance and promotion. Artist pays for shipping. Prefers artwork framed for exhibition, unframed for browser sales.

Submissions: Send query letter with résumé, slides and bio. Write to schedule an appointment to show a portfolio, which should include appropriate samples. Replies in 6 weeks. Files bios and slides in Member's Artist Registry.

District of Columbia

ATLANTIC GALLERY OF GEORGETOWN, 1055 Thomas Jefferson St. NW, Washington DC 20007. (202)337-2299. Fax: (202)333-4467. E-mail: vsmith2299@aol.com. Director: Virginia Smith. Retail gallery. Estab. 1976. Represents 10 mid-career and established artists. Exhibited artists include John Stobart, Tim Thompson, John Gable, Frits Goosen and Robert Johnson. Sponsors 5 solo shows/year. Average display time is 2 weeks. Open all year. Located downtown; 700 sq. ft. Clientele: 70% private collectors, 30% corporate clients. Overall price range: $100-20,000; most artwork sold at $300-5,000.
Media: Considers oil, watercolor and limited edition prints.
Style: Exhibits realism and impressionism. Prefers realistic marine art, florals, landscapes and historic narrative leads.
Terms: Accepts work on consignment (40% commission). Retail price set by gallery and artist. Exclusive area representation required. Gallery provides insurance, promotion and contract; artist pays for shipping.
Submissions: Send query letter, résumé and slides. Portfolio should include originals and slides.

BIRD-IN-HAND BOOKSTORE & GALLERY, 323 7th St. SE, Box 15258, Washington DC 20003. (202)543-0744. Fax: (202)547-6424. E-mail: chrisbih@aol.com. Director: Christopher Ackerman. Retail gallery. Estab. 1987. Represents 36 emerging artists. Exhibited artists include Susan Nees, Lise Drost and Richard Pardee. Sponsors 6 shows/year. Average display time 6-8 weeks. Located on Capitol Hill at Eastern Market Metro; 300 sq. ft.; space includes small bookstore, art and architecture. "Most of our customers live in the neighborhood." Clientele: 100% private collectors. Overall price range: $75-1,650; most work sold at $75-350.
Media: Considers original handpulled prints, woodcuts, wood engravings, artists' books, linocuts, engravings, etchings. Also considers small paintings. Prefers small prints.
Terms: Accepts work on consignment (50% commission). Retail price set by gallery. Gallery provides insurance, promotion and contract; shipping costs are shared.
Submissions: Send query letter with résumé, 10-12 slides and SASE. Write for appointment to show portfolio of originals and slides. Interested in seeing tasteful work. Replies in 1 month. Files résumé; slides of accepted artists.
Tips: "The most common mistake artists make in presenting their work is dropping off slides/samples without SASE and without querying first. We suggest a visit to the gallery before submitting slides. We show framed and unframed work of our artists throughout the year as well as at time of individual exhibition. Also, portfolio/slides of work should have a professional presentation, including media, size, mounting, suggested price."

‡DE ANDINO FINE ARTS, 2450 Virginia Ave. NW, Washington DC 20037. (202)861-0638. Fax: (202)659-1899. Director: Jean-Pierre de Andino. Retail gallery and art consultancy. Estab. 1988. Represents/exhibits 4 mid-career and established artists/year. May be interested in seeing the work of emerging artists in the future. Exhibited artists include Sam Gilliam and Rainer Fetting. Sponsors 2 shows/year. Open all year by appointment only. Located downtown; 1,800 sq. ft.; discreet, private gallery in established upscale downtown neighborhood. Clientele: upscale. 60% private collectors, 20% corporate collectors. Overall price range: $1,000-100,000; most work sold at $15,000-50,000.
Media: Considers all media and types of prints. Most frequently exhibits painting, sculpture and conceptual work.
Style: Exhibits conceptualism, neo-expressionism, minimalism, color field, hard-edge geometric abstraction and surrealism. All genres. Prefers minimal, conceptual and color field.
Terms: Artwork is accepted on consignment and there is a 50% commission or is bought outright for a percentage of the retail price; net 60 days. Retail price set by the gallery. Gallery provides promotion. Artist pays for shipping costs. Prefers artwork framed.
Submissions: Send query letter with résumé, slides, bio and SASE. Write for appointment to show portfolio of slides and transparencies. Replies in 1-2 months.
Tips: Finds artists through referrals. "Work is a constant, do not stop."

DISTRICT OF COLUMBIA ARTS CENTER (DCAC), 2438 18th St. NW, Washington DC 20009. (202)462-7833. Fax: (202)328-7099. Executive Director: B. Stanley. Nonprofit gallery 'and performance space. Estab. 1989. Exhibits emerging and mid-career artists. Sponsors 7-8 shows/year. Average display time 4-6 weeks. Open Wednesday-Thursday, 2-6; Friday-Sunday, 2-10; and by appointment. Closed August. Located "in Adams Morgan, a downtown neighborhood; 132 running exhibition feet in exhibition space and a 52-seat theater." Clientele: all types. Overall price range: $200-10,000; most work sold at $600-1,400.
Media: Considers all media including fine and plastic art. "No crafts." Most frequently exhibits painting, sculpture and photography.
Style: Exhibits all styles. Prefers "innovative, mature and challenging styles."
Terms: Accepts artwork on consignment (30% commission). Artwork only represented while on exhibit. Retail price set by the gallery and artist. Offers payment by installments. Gallery provides promotion and contract; artist pays for shipping. Prefers artwork framed.
Submissions: Send query letter with résumé, slides, bio and SASE. Portfolio review not required. Replies in 2 months.

Tips: "We strongly suggest the artist be familiar with the gallery's exhibitions, and the kind of work we show: strong, challenging pieces that demonstrate technical expertise and exceptional vision. Include SASE if requesting reply and return of slides!"

FOUNDRY GALLERY, Dept. AM, 9 Hillyer Court, Washington DC 20008. (202)387-0203. E-mail: info@foundry_gallery. Website: http://www.foundry_gallery.org. Membership Director: Marcia Mayne. Cooperative gallery and alternative space. Estab. 1971. Sponsors 10-20 solo and 2-3 group shows/year. Average display time 1 month. Interested in emerging artists. Clientele: 80% private collectors; 20% corporate clients. Overall price range: $100-2,000; most work sold at $100-1,000.
Media: Considers oil, acrylic, watercolor, pastel, pen & ink, drawings, mixed media, collage, paper, sculpture, ceramic, fiber, glass, installation, photography, woodcuts, engravings, mezzotints, etchings, pochoir and serigraphs. Most frequently exhibits painting, sculpture, paper and photography.
Style: Exhibits "expressionism, painterly abstraction, conceptualism and hard-edge geometric abstraction, as well as representational." Prefers non-objective, expressionism and neo-geometric. "Founded to encourage and promote Washington area artists and to foster friendship with artists and arts groups outside the Washington area. The Foundry Gallery is known in the Washington area for its promotion of contemporary works of art."
Terms: Co-op membership fee plus donation of time required; 30% commission. Retail price set by artist. Offers customer discounts and payment by installments. Exclusive area representation not required. Gallery provides insurance and a promotion contract. Prefers framed artwork.
Submissions: Send query letter with résumé, 20 slides, and SASE. "Local artists drop off actual work." Call or write for appointment to drop off portfolio. Replies within 1 week. Finds artists through submissions.
Tips: "Build up résumé by entering/showing at juried shows. Visit gallery to ascertain where work fits in. Have coherent body of work. Show your very best, strongest work. Present yourself well—slides clearly labeled with slide list, résumé typed, enclose in a clean folder. Before approaching us, you should have a minimum of 10 actual, finished works."

FOXHALL GALLERY, 3301 New Mexico Ave. NW, Washington DC 20016. (202)966-7144. Director: Jerry Eisley. Retail gallery. Represents emerging and established artists. Sponsors 6 solo and 6 group shows/year. Average display time 3 months. Overall price range: $500-20,000; most artwork sold at $1,500-6,000.
Media: Considers oil, acrylic, watercolor, pastel, sculpture, mixed media, collage and original handpulled prints (small editions).
Style: Exhibits contemporary, abstract, impressionistic, figurative, photorealistic and realistic works and landscapes.
Terms: Accepts work on consignment (50% commission). Retail price set by gallery and artist. Customer discounts and payment by installment are available. Exclusive area representation required. Gallery provides insurance.
Submissions: Send résumé, brochure, slides, photographs and SASE. Call or write for appointment to show portfolio. Finds artists through agents, by visiting exhibitions, word of mouth, various art publications and sourcebooks, artists' submissions, self promotions and art collectors' referrals.
Tips: To show in a gallery artists must have "a complete body of work—at least 30 pieces, participation in a juried show and commitment to their art as a profession."

‡GALLERY K, 2010 R St. NW, Washington DC 20009. (202)234-0339. Fax: (202)334-0605. E-mail: galleryk@ix.netcom.com. Website: http://www.artline.com/washingtonartdealer/galleryk. Director: Komei Wachi. Retail gallery. Estab. 1976. Represents 47 emerging, mid-career and established artists. Interested in seeing the work of emerging artists. Exhibited artists include Jody Mussoff and Y. David Chung. Sponsors 10 shows/year. Average display time 1 month. Closed mid July through mid-September; Tuesday-Saturday 11-6. Located in DuPont Circle area; 2,500 sq. ft. Clientele: local. 80% private collectors, 10% corporate collectors; 10% other galleries. Overall price range: $100-250,000; most work sold at $200-2,000.
Media: Considers oil, pen & ink, paper, acrylic, drawing, sculpture, watercolor, mixed media, ceramic, pastel, collage, photography, woodcuts, wood engravings, linocuts, engravings, mezzotints, etchings, lithographs and serigraphs. Most frequently exhibits oil, acrylic, drawing.
Style: Exhibits realism and surrealism. Genres include landscapes and figurative work. Prefers surrealism, realism and postmodernism.
Terms: Accepts work on consignment (20-50% commission). Retail price set by gallery and artist. Gallery provides insurance, promotion and contract; artist pays for shipping costs. Prefers artwork framed.
Submissions: Accepts artists mainly from DC area. Send query letter with résumé, 1 sheet of 25 slides and SASE. Replies in 4-6 weeks only if SASE enclosed.
Tips: You should have completed about 30-50 works of art before approaching galleries.

‡THE GLASS GALLERY, ongoing display at Art on the 7th Floor, Washington Design Center, 300 D St., Washington DC 20034. (202)686-9290. Owner: Sally Hansen. Retail gallery. Estab. 1981. Sponsors 5 shows/year. Open all year; Monday-Saturday 11-5. Clientele: collectors.
Media: Considers sculpture in glass and monoprints (only if they are by glass sculptors who are represented by The Glass Gallery). Also interested in sculpture in glass incorporated with additional materials (bronze, steel etc.). "Focus is on creativity as well as on ability to handle the material well. The individuality of the artist must be evident."
Terms: Accepts work on consignment. Retail price set by artist. Sometimes offers customer discounts and payment by installment. Gallery provides insurance (while work is in gallery), promotion, contract and shipping costs from gallery.

Submissions: Send query letter with résumé, slides, photographs, reviews, bio and SASE. Portfolio review requested if interested in artist's work.

Tips: Finds artists through visits to exhibitions and professional glass conferences, plus artists' submissions and keeping up-to-date with promotion of other galleries (show announcements and advertising). "Send good slides with SASE and clear, concise cover letter and/or description of process. Familiarize yourself with the work of gallery displays to evaluate whether the quality of your work meets the standard."

‡**STUDIO GALLERY**, 2108 R Street NW, Washington DC 20008. (202)232-8734. Fax: (202)239-9222. Cooperative and nonprofit gallery. Estab. 1964. Exhibits the work of 30 emerging, mid-career and established artists. Sponsors 11 shows/year. Average display time 1 month. Guest artists in August. Located downtown in the Dupont Circle area; 550 sq. ft.; "gallery backs onto a courtyard, which is a good display space for exterior sculpture and gives the gallery an open feeling." 5% of space for special exhibitions. Clientele: private collectors, art consultants and corporations. 85% private collectors; 8% corporate collectors. Overall price range: $300-10,000; most work sold at $500-3,000.

Media: Considers oil, acrylic, watercolor, pastel, pen & ink, drawings, mixed media, collage, works on paper, sculpture, ceramic, fiber, installation, photography, original handpulled prints, woodcuts, engravings, lithographs, wood engravings, mezzotints, monoprints and monotypes, serigraphs, linocuts and etchings. Most frequently exhibits painting, sculpture and prints.

Style: All genres. "Work is exhibited if it is high quality—the particular style varies."

Terms: Co-op membership fee plus a donation of time (70% commission).

Submissions: Send query letter with SASE. "Artists must be local—or willing to drive to Washington for monthly meetings and receptions. Artist is informed as to when there is a membership opening and a selection review." Files artist's name, address, telephone.

Tips: "This is a cooperative gallery. Membership is decided by the gallery membership. This is peer review. The director does not determine membership. Ask when the next review for membership is scheduled. Do not send slides. Feel free to ask the director questions about gallery operations. Dupont Circle is an exciting gallery row and is drawing more public interest. We are making more of an effort to reach local corporations. We have an outreach program to see to the local businesses and high-tech industries."

‡**WASHINGTON PRINTMAKERS GALLERY**, 2106-b R St. NW, Washington DC 20008. (202)332-7757. Director: Pam Hoyle. Cooperative gallery. "We trade shows internationally." Estab. 1985. Exhibits 3 emerging and mid-career artists/year. Exhibited artists include George Chung and Beth MacDonald. Sponsors 12 exhibitions/year. Average display time 1 month. Open all year; Wednesday-Saturday, 11-5 and Sunday, 12-5. Located downtown in Dupont Circle area. 100% of space for gallery artists. Clientele: varied. 90% private collectors, 10% corporate collectors. Overall price range: $50-900; most work sold at $200-400.

Media: Considers only all types of original prints, hand pulled by artist. Most frequently exhibits etchings, lithographs, serigraphs.

Style: Considers all styles and genres. Prefers expressionism, abstract, realism.

Terms: Co-op membership fee plus donation of time (35% commission). Retail price set by artist. Gallery provides promotion; artist pays shipping costs.

Submissions: Prefers only regional printmakers. Send query letter. Call for appointment to show portfolio of original prints and slides. Replies in 1 month.

Tips: "There is a yearly jury in April for prospective new members. We are especially interested in artists who exhibit a strong propensity for not only the traditional conservative approaches to printmaking, but also the looser, more daring and innovative experimentation in technique."

Florida

ALBERTSON-PETERSON GALLERY, 329 S. Park Ave., Winter Park FL 32789. (407)628-1258. Fax: (407)647-6928. Owner: Judy Albertson. Retail gallery. Estab. 1984. Represents 10-25 emerging, mid-career and established artists/year. Exhibited artists include Carol Bechtel and Frank Faulkner. Sponsors 6 shows/year. Average display time 3 weeks. Open all year; Tuesday-Friday, 10-5:30; Saturday, 11:00-5:30. Located downtown; 3,000 sq. ft.; great visability, lots of glass. 45% of space for special exhibitions (during exhibitions); 95% of space for gallery artists (generally). Clientele: 50% local, 50% tourist. 15-20% private collectors, 40-50% corporate collectors. Overall price range: $200-15,000; most work sold at $500-3,000.

Media: Considers oil, acrylic, watercolor, pastel, mixed media, collage, paper, sculpture, ceramics, craft, fiber, glass, installation, photography, woodcut, engraving, lithograph, wood engraving, mezzotint, serigraphs, linocut and etching. Most frequently exhibits paintings, ceramic, sculpture.

SASE MEANS SELF-ADDRESSED, STAMPED ENVELOPE. Send SASEs when requesting return of your samples.

Style: Exhibits all styles. Prefers abstract, contemporary landscape and nonfunctional ceramics.

Terms: Accepts work on consignment (varying commission). Retail price set by the gallery and the artist. Gallery provides insurance, promotion, contract and shipping costs from gallery; artist pays shipping costs to gallery. Prefers artwork unframed.

Submissions: Accepts only artists "exclusive to our area." Send query letter with résumé, slides, bio, photographs, SASE and reviews. Call or write for appointment to show portfolio of photographs, slides and transparencies. Replies within a month. Finds artists through exhibitions, art publications and artists' submissions.

APROPOS ART GALLERY, INC., 1016 E. Las Olas Blvd., Ft. Lauderdale FL 33301. (954)524-2100. Fax: (954)524-1817. Director: Laurie Lee Clark. Retail and wholesale gallery. Estab. 1988. Represents/exhibits 25 mid-career and established artists/year. Interested in seeing the work of emerging artists. Sponsors 4 shows/year. Average display time 3 months. Open all year; Monday-Sunday, 10-7. Located downtown, Main Blvd.; 4,000 sq. ft.; newly remodeled, wood floors, high ceiling. 90% of space for gallery artists. Clientele: tourists, upscale, local community. 100% private collectors. Overall price range: $1,000-30,000.

Media: Considers all media except pastel and wood. Considers woodcut, engraving, lithograph, wood engraving, mezzotint, serigraphs, linocut and etching. Most frequently exhibits oil and acrylic painting.

Style: Exhibits expressionism, conceptualism, photorealism, neo-expressionism, painterly abstract, realism, surrealism and imagism. Genres include figurative work. Prefers figurative, surrealism and expressionism.

Terms: Artwork is accepted on consignment and there is a 50% commission. Retail price set by the gallery and the artist. Gallery provides insurance, promotion and contract; shipping costs are shared. Prefers artwork framed.

Submissions: Send query letter with résumé, slides, reviews, bio, SASE and detail/wholesale price list. Gallery will contact artist if interested. Portfolio should include photographs and slides. Replies in 1-2 months. Finds artists through word of mouth, referrals by other artists, visiting art fairs and exhibitions and artists' submissions.

Tips: "Keep your portfolio updated and complete."

✍AUTHORS/OPUS 71 GUESTHOUSE, (formerly Opus 71 Galleries), 725 White St., Key West FL 33040. (800)898-6909. E-mail: lionxsx@aol.com. Co-Directors: Charles Z. Candler III and Gary R. Johnson. Retail and wholesale gallery, alternative space, art consultancy and salon style organization. Estab. 1969. Represents 50 (25-30 on regular basis) emerging, mid-career and established artists/year. Open all year; appointment only on weekdays, most weekend afternoons without appointment. Clientele: upscale, local, international and regional. 75% private collectors; 25% corporate collectors. Overall price range: $200-85,000; most work sold at $500-5,000.

Media: Considers oil, acrylic, pastel, pen & ink, drawing, mixed media, collage, sculpture and ceramics; types of prints include woodcuts and wood engravings. Most frequently exhibits oils or acrylic, bronze and marble sculpture and pen & ink or pastel drawings.

Style: Exhibits: expressionism, neo-expressionism, primitivism, painterly abstraction, surrealism, conceptualism, minimalism, color field, postmodern works, impressionism, photorealism, hard-edge geometric abstraction, realism and imagism. Exhibits all genres. Prefers: figural, objective and nonobjective abstraction and realistic bronzes.

Terms: Accepts work on consignment or buys outright. Retail price set by "consulting with the artist initially." Gallery provides insurance (with limitations), promotion and contract; artist pays for shipping. Prefers artwork framed.

Submissions: Telephone call is important. Call for appointment to show portfolio of photographs and actual samples. "We will not look at slides." Replies in 2 weeks. Files résumés, press clippings and some photographs. "Artists approach us from a far flung area. We currently have artists from about ten states and three foreign countries. Most come to us. We approach only a handful of artists annually."

Tips: "Know yourself . . . be yourself . . . ditch the jargon. Quantity of work available not as important as quality, and the fact that the presenter is a working artist. We don't want hobbyists."

BAKEHOUSE ART COMPLEX, 561 N.W. 32 St., Miami FL 33127. (305)576-2828. Alternative space and nonprofit gallery. Estab. 1986. Represents 150 emerging and mid-career artists. 150 members. Sponsors 11 shows/year. Average display time 3 weeks. Open all year; Tuesday-Friday, 10-4. Also second Sunday Open House 1-5. Located in Design District; 3,200 sq. ft.; retro fitted bakery preparation area, 17′ ceilings, tile floors. Clientele: 80% private collectors, 20% corporate collectors. Overall price range: $500-5,000.

 • Bakehouse Art Complex is new home to the group "Emerging Caribbean Artists"—Caribbean-born artists of all media living in the U.S. Call or write for info.

Media: Considers all media; looking particularly to bring work in stone, of all scales, to the region.

Style: Exhibits all styles, all genres.

Terms: Co-op membership fee plus donation of time (30% commission). Rental fee for space; covers 1 month. Retail price set by the artist.

Submissions: Accepts artists to juried membership. Send query letter for application.

Tips: Don't stop painting, sculpture, etc. while you are seeking representation. Daily work (works-in-progress, studies) evidences a commitment to the profession. Speaking to someone about your work while you are working brings an energy and an urgency—an energy that move the art and the gallery representation relationship forward.

BOCA RATON MUSEUM OF ART, 801 W. Palmetto Park Rd., Boca Raton FL 33486. (561)392-2500. Fax: (561)391-6410. Executive Director: George S. Bolge. Museum. Estab. 1950. Represents established artists. 2,500 members. Exhibits change every 2 months. Open all year; Tuesday, Thursday-Friday, 10-4; Wednesday, 10-9. Located one

mile east of I-95 on Palmetto Park Road in Boca Raton; 3,000 sq. ft.; three galleries—one shows permanent collection, two are for changing exhibitions. 66% of space for special exhibitions.

Media: Considers all media.

Submissions: "Contact executive director, in writing."

Tips: "Photographs of work of art should be professionally done if possible. Before approaching museums, an artist should be well-represented in solo exhibitions and museum collections. Their acceptance into a particular museum collection, however, still depends on how well their work fits into that collection and how well it fits with the goals and collecting policies of that museum."

CAPITOL COMPLEX EXHIBITION PROGRAM, Division of Cultural Affairs, The Capitol, Tallahassee FL 32399-0250. (904)487-2980. Fax: (904)922-5259. E-mail: kdempsey@mail.dos.state.fl.us. Website: http://www.dos.stat e.fl.us. Arts Consultant: Katie Dempsey. Exhibition spaces (5 galleries). Represents 20 emerging, mid-career and established artists/year. Sponsors 20 shows/year. Average display time 3 months. Open all year; Monday-Friday, 8-5; Saturday-Sunday, 8:30-4:30. "Exhibition spaces include 22nd Floor Gallery, Cabinet Meeting Room, Secretary of State's Reception Area, Old Capitol-Gallery and the Florida Supreme Court."

Media: Considers all media and all types of prints. Most frequently exhibits oil, watercolor and acrylic.

Style: Exhibits all genres.

Terms: Free exhibit space—artist sells works. Retail price set by the artist. Gallery provides insurance; artist pays for shipping to and from gallery.

Submissions: Accepts only artists from Florida. Send query letter with résumé, 20 slides, artist's statement and bio.

✔THE CENTER FOR EMERGING ART, INC., 17070 Collins Ave., RK Center, Suite 267, Sunny Isles Beach FL 33160. Executive Director: Ava L. Rado. Retail/nonprofit, professionally administered exhibition studio space for contemporary art. Estab. 1995. Represents/exhibits emerging artists. Exhibited artists include Alan J. Smith, Jackie Gorissen, Gene Tinnie and Frederick Soler. Sponsors 6 shows/year. Average display time 1 month. 1,700 sq. ft. 90% of space for special exhibitions.

 • The center is administered by Ava Rado. It is funded in part by the Florida Department of State, Division of Cultural Affairs and the Florida Arts Council, Miami-Dade County Cultural Affairs Council and by donation.

Media: Considers all media and all types of prints. Most frequently exhibits acrylic on canvas, oil on canvas, abstract expressionism and ceramics.

Style: Exhibits all styles. Prefers abstract, landscape and minimalism.

Terms: Gallery provides promotion and contract. Artist pays for insurance and shipping costs. Prefers artwork framed.

Submissions: Send query letter with résumé, brochure, slides, photographs, reviews, bio, SASE and video. Write for appointment to show portfolio of pertinent material. Replies only if interested within 1 month. Finds artists through "Call to Artist" for juried exhibitions, word of mouth, submissions and referrals.

Tips: "Have persistence."

‡CREATIONS INTERNATIONAL GALLERY, P.O. Box 492, New Smyrna Beach FL 32170. (904)673-8778. E-mail: creationsintl@prodigy.net. Director: Michell Starry. Retail gallery, art consultancy. Estab. 1984. Represents emerging, mid-career and established artists. Exhibited artists include Benton Ledbetter. Sponsors 12 shows/year. Average display time 1 month. Open all year; Tuesday-Friday, 12-5. Located between 2 museums; 850 sq. ft.; historical building in cultural area of town. 100% of space for special exhibitions ("Every month is a different theme.") 90% private collectors, 10% corporate collectors. Overall price range: $500-10,000; most work sold at $50-2,500.

 • This gallery maintains several pages on the Internet featuring art shown in the gallery. They have a slide and disk registry to show clients and will assist artists in creating résumés, bios and portfolios. Gallery is active in bringing environmental issues and issues involving children to public attention.

Media: Considers all media and all types of prints. Most frequently exhibits sculpture, pen & ink, oil.

Style: Exhibits surrealism, photorealism, hard-edge geometric abstraction, realism, imagism. Exhibits all genres. Prefers realism, surrealism, imagism.

Terms: Accepts work on consignment (25% commission). "We are selective and require the artist to pay for insurance and a portion of expenses for the exhibition of his/her work." Retail price set by the artist. Gallery provides promotion and contract; artist pays for shipping. Prefers artwork framed.

Submissions: Send query for appointment to show portfolio of photographs, slides. Replies in 2-4 weeks. Files all material. Finds artists through submissions, requests by clients, visiting exhibitions.

Tips: "The most common mistakes artists make is appearing unannounced with work. We have a protocol that must be followed. Send SASE for information about philosophy and services. All artists are important. Call us if you need real art world information. If you are dedicated to the arts we will be dedicated to you."

‡CULTURAL RESOURCE CENTER METRO-DADE, 111 NW First St., Miami FL 33128. (305)375-4635. Director: Patricia Risso. Alternative space/nonprofit gallery. Estab. 1989. Exhibits 800 emerging and mid-career artists. Sponsors 10 shows/year. Average display time 3½ weeks. Open all year; Monday-Friday 10-3. Located in Government Center in downtown Miami.

Media: Most frequently exhibits oil, mixed media and sculpture.

Terms: Retail price set by artist. Gallery provides insurance and promotion; artist pays shipping costs. Prefers artwork framed.

Submissions: Accepts only artists from South Florida. Send query letter with résumé, slides, brochure, SASE and reviews. Call for appointment to show portfolio of slides. Replies only if interested within 2 weeks. Files slides, résumés, brochures, photographs.

DUNCAN GALLERY OF ART, Campus Box 8252, Stetson University, DeLand FL 32720-3756. (904)822-7266. Fax: (904)822-7268. E-mail: cnelson@stetson.edu. Website: www.stetson.edu/departments/art. Gallery Director: Dan Gunderson. Nonprofit university gallery. Represents emerging, mid-career and established artists. Sponsors 6-8 shows/ year. Average display time 6 weeks. Open all year except during university holidays and breaks; Monday-Friday, 10-4; Saturday and Sunday, 1-4. Located in the heart of the Stetson University campus, which is adjacent to downtown; 2,400 sq. ft. in main gallery; 144 cu. ft. in glass display cases in foyer; in 100+-year-old, recently renovated building with Neo-Classical trappings and 16-foot ceilings. 95% of space for special exhibitions. Clientele: students, faculty, community members. 99% private collectors, 1% corporate collectors. Overall price range: $100-35,000.
Media: Considers all media and all types of prints. Most frequently exhibits paintings, ceramics and sculpture.
Style: Exhibits all styles, all genres.
Terms: Accepts work on consignment (20% commission). Retail price set by the artist. Gallery provides insurance and promotion; shipping costs are shared. Prefers artwork framed.
Submissions: "Exhibiting artists tend to be from the Southeast, but there are no restrictions." Send query letter with résumé, 20 slides, SASE and proposal. Write for appointment to show portfolio of originals, photographs, slides or transparencies. Replies in 3-4 months. Files slides, postcards, résumés. Finds artists through proposals, visiting exhibitions and word of mouth.
Tips: "Contact us; we'll be happy to provide our requirements."

‡GALLERY CONTEMPORANEA, 11 Aviles St., St. Augustine FL 32084. Director: Sally Ann Freeman. Retail gallery and art consultancy. Estab. 1974. Represents/exhibits 120 mid-career and established artists. Exhibited artists include Allison Watson and Gretchen Ebersol. Sponsors 3-4 shows/year. Average display time 2 months. Open all year; by appointment. Located near downtown—historic neighborhood; 1,100 sq. ft.; "corporate consulting is 50-60% of sales." Clientele: Southeasterners. 40-50% private collectors, 50-60% corporate collectors. Overall price range: open; most work sold at $600-12,000.
Media: Considers all media and all types of prints. Most frequently exhibits paintings, original prints, sculpture, clay, fiber and photos.
Style: Exhibits expressionism, painterly abstraction, realism and impressionism. Genres include landscapes and florals. Prefers realism, impressionism and abstraction.
Terms: Artwork is accepted on consignment (50% commission). Retail price set by artist. Gallery provides insurance, promotion and contract; artist pays shipping costs.
Submissions: Send query letter with résumé, 20-30 slides, reviews, bio and SASE. Write for appointment to show portfolio of slides. Replies in 2-3 weeks. Files reviews, bio and slides. Finds artists through word of mouth, referrals by other artists and submissions.
Tips: "Be professional and flexible. Check out the dealer with other known artists of the area. You should have completed a body of work of 100-250 pieces before approaching galleries."

GLASS CANVAS GALLERY, INC., 233 4th Ave. NE, St. Petersburg FL 33701. (813)821-6767. Fax: (813)821-1775. Website: www.glasscanvasgallery.com. President: Judy Katzin. Retail gallery. Estab. 1992. Represents 300 emerging and mid-career artists/year. Exhibited artists from US, Canada, Australia, England. Sponsors 6 shows/year. Average display time 6-8 weeks. Open all year; Monday-Friday, 10-6; Saturday, 10-5; Sunday, 12-5 (closed Sunday June-September). Located by the waterfront downtown; 1,800 sq. ft. 25% of space for special exhibition; 75% of space for gallery artists. 5% private collectors, 5% corporate collectors. Overall price range: $20-5,000; most work sold at $200-700.
Media: Considers mixed media, sculpture, glass and some 2-dimensional work. Most frequently exhibits glass, ceramic and mixed.
Style: Exhibits color field. Prefers unique, imaginative, contemporary, colorful and unusual.
Terms: Accepts work on consignment (50% commission) or buys outright for 50% of retail price (net 30 days). Retail price set by the artist. Gallery provides insurance, promotion, contract and shipping costs from gallery; artist pays shipping costs to gallery. Prefers artwork framed.
Submissions: Prefers only glass. Send query letter with résumé, brochure, photographs and business card. Call for appointment to show portfolio of photographs. Replies in 2 weeks. Files all material.
Tips: "We look at the pieces themselves (and not the slides) to evaluate the technical expertise prior to making the decision to represent an artist."

THE HANG-UP, INC., 45 S. Palm Ave., Sarasota FL 34236. (813)953-5757. President: F. Troncale. Manager: Lynlee Troncale. Retail gallery. Estab. 1971. Represents 25 emerging and mid-career artists. Sponsors 6 shows/year. Average display time 1 month. Open all year. Located in arts and theater district downtown; 1,700 sq. ft.; "high tech, 10 ft. ceilings with street exposure in restored hotel." 50% of space for special exhibitions. Clientele: 75% private collectors, 25% corporate collectors. Overall price range: $500-5,000; most artwork sold at $500-1,000.
Media: Considers oil, acrylic, watercolor, mixed media, collage, works on paper, sculpture, original handpulled prints, lithographs, etchings, serigraphs and posters. Most frequently exhibits painting, graphics and sculpture.
Style: Exhibits expressionism, painterly abstraction, surrealism, impressionism, realism and hard-edge geometric ab-

straction. All genres. Prefers abstraction, impressionism, surrealism.

Terms: Accepts artwork on consignment (50% commission). Retail price set by artist. Sometimes offers customer discounts and payment by installment. Gallery provides insurance, promotion and contract; shipping costs are shared. Prefers unframed work. Exhibition costs shared 50/50.

Submissions: Send résumé, brochure, slides, bio and SASE. Write for appointment to show portfolio of originals and photographs. "Be organized and professional. Come in with more than slides; bring P.R. materials, too!" Replies in 1 week.

KOUCKY GALLERY, 1300 Third St. S., Naples FL 34102. (813)261-8988. Fax: (813)261-8576. E-mail: ckoucky178 @aol.com. Owners: Chuck and Nancy. Retail gallery. Focus is on contemporary American artists and craftsmen. Estab. 1986. Represents/exhibits 175 emerging, mid-career and established artists/year. Exhibited artists include Todd Warner and Jack Dowd. Sponsors 6 shows/year. Open all year; Monday-Saturday. Located downtown; 2,300 sq. ft. Clientele: upscale international, resort. 98% private collectors, 2% corporate collectors. Overall price range: $14-35,000; most work sold at $85-900.

• Koucky Gallery also has a location in Charlevoix, Michigan.

Media: Considers all media. Most frequently exhibits sculpture, painting, jewelry and designer crafts.

Style: Exhibits expressionism, painterly abstraction, impressionism, contemporary works and imagism.

Terms: Artwork is accepted on consignment. Retail price set by the artist. Gallery provides insurance. Artist pays shipping costs. Prefers artwork framed.

Submissions: Accepts only US artists. Send query letter with at least 6 slides, photographs, bio and SASE. Call for appointment to show portfolio of photographs. "Replies slowly." Finds artists through word of mouth.

Tips: "Send portfolio and résumé with retail prices and SASE. Then call for appointment. Follow up is required, we're so busy we might not have time to follow up. Don't show up in the middle of our busy season and expect to be represented or even seen."

A LAUREL ART GALLERY, 2112 Crystal Dr., Ft. Myers FL 33907. (941)278-0489. Fax: (941)482-6879. E-mail: alaurelart@cyberstreet.com. Website: www.alaurelart.com. Retail gallery. Estab. 1990. Represents 6 emerging artists/year. Exhibited artists include Ch Vaurina and G. Valtier. Sponsors 2 shows/year. Average display time 6 weeks. Open all year; 11-4. 6,000 sq. ft.. 75% of space for special exhibitions. Clientele: tourists and upscale. 10% private collectors. Overall price range: $1,000-10,000; most work sold at $3,000.

Media: Considers oil and acrylic.

Style: Exhibits: impressionism. Genres include landscapes and still lifes.

Terms: Accepts work on consignment (50% commission). Retail price set by the gallery. Gallery provides promotion; artist pays for shipping.

Submissions: Send résumé, brochure and 12 slides. Call for appointment to show portfolio of photographs.

Tips: You should have completed a body of work of approximately 200 works before approaching galleries.

LIPWORTH HARTMAN INTERNATIONAL ARTS, INC., 608 Banyan Trail, Boca Raton FL 33431. (561)241-6688. Fax: (561)241-6685. E-mail: liphart@aol.com. Directors: Erica Hartman and Margaret Lipworth. Retail gallery, private dealer. Estab. 1990. Represents 10-15 established artists/year. Exhibited artists include: Alex Katy, Roy Lichtenstein. Sponsors 6 shows/year. Average display time 1 month. Open all year accept August; Monday-Saturday, 10:30-5, December-March; closed Monday April-November. Located in Gallery Center; 2,000 sq. ft. Clientele: upscale, collectors. 100% private collectors. Overall price range: $5,000-100,000.

Media: Considers oil, pen & ink, paper, acrylic, drawing, sculpture, watercolor, mixed media, ceramics, pastel, collage and all types of prints. Prefers sculpture, oil, prints.

Style: Exhibits minimalism, color field, hard-edge geometric abstraction, painterly abstraction, postmodern works.

Submissions: Send query letter with 3 slides or photographs.

Tips: "Contact galleries you believe are consistent with your aesthetics."

‡MIAMI ART MUSEUM, 101 W. Flagler St., Miami FL 33130. (305)375-3000. Fax: (305)375-1725. Director: Suzanne Delehant. Museum. Estab. 1984. Exhibitions include emerging, mid-career and established artists. Average display time 2 months. Open all year; Tuesday, 10-5; Thursday, 10-9; Saturday and Sunday, noon-5 pm. Located downtown; cultural complex designed by Philip Johnson. 16,000 sq. ft. for exhibitions.

Media: Considers all media.

Style: Has exhibited art of the Western Hemisphere since 1945; large scale traveling exhibitions, retrospective of internationally known artists.

Submissions: Accepts only artists nationally and internationally recognized. Send query letter with résumé, slides, bio, brochure, photographs, SASE and reviews. Write for appointment to show portfolio of slides. Replies in 2-3 months.

Tips: Finds artists through visiting exhibitions, word of mouth, art publications and artists' submissions.

‡NUANCE GALLERIES, 720 S. Dale Mabry, Tampa FL 33609. (813)875-0511. Owner: Robert A. Rowen. Retail gallery. Estab. 1981. Represents 70 emerging, mid-career and established artists. Sponsors 3 shows/year. Open all year. 3,000 sq. ft. "We've reduced the size of our gallery to give the client a more personal touch. We have a large extensive front window area."

Media: Specializing in watercolor, original mediums including sculpture.

Style: "Majority of the work we like to see are realistic landscapes, escapism pieces, bold images, bright colors and semitropical subject matter. Our gallery handles quite a selection and it's hard to put us into any one class."
Terms: Accepts work on consignment (50% commission). Retail price set by gallery and artist. Offers customer discounts and payment by installments. Gallery provides insurance and contract; shipping costs are shared.
Submissions: Send query letter with slides and bio. SASE if want slides/photos returned. Portfolio review requested if interested in artist's work.
Tips: "Be professional; set prices (retail) and stick with them. There are still some artists out there that are not using conservation methods of framing. As far as submissions we would like local artists to come by to see our gallery and get the idea what we represent. Tampa has a healthy growing art scene and the work has been getting better and better. But as this town gets more educated it is going to be much harder for up-and-coming artists to emerge."

PARADISE ART GALLERY, 1359 Main St., Sarasota FL 34236. (941)366-7155. Fax: (941)366-8729. Website: http://www.paradisegallery.com. President: Gudrún Newman. Retail gallery, art consultancy. Represents hundreds of emerging, mid-career and established artists/year. May be interested in seeing the work of emerging artists in the future. Exhibited artists include: John Lennon, Hessam, Sabzi, Britto. Open all year; Monday-Saturday, 10-10; Sunday by appointment. Located in downtown Sarasota; 2,500 sq. ft. 50% of space for special exhibitions. Clientele: tourists, upscale. 90% private collectors, 10% corporate collectors. Overall price range: $500-30,000; most work sold at $1,000.
Media: Considers all media. Most frequently exhibits serigraphs, acrylics, 3-D art.
Style: Exhibits all styles. Prefers contemporary, pop.
Terms: Accepts work on consignment (50% commission). Buys outright for 50-70% of retail price (net 30-60 days). Retail price set by the gallery. Gallery provides promotion and contract; shipping costs are shared. Prefers artwork framed.
Submissions: Send query letter with résumé, brochure, photographs, artist's statement and bio. Call for appointment to show portfolio of photographs. Replies in 2-3 weeks.

PASTA FINE ART (PROFESSIONAL ARTISTS OF ST. AUGUSTINE) GALLERY INC., 214 Charlotte St., St. Augustine FL 32084. (904)824-0251. Director/Vice President: Jean W. Troemel. Cooperative nonprofit gallery. Estab. 1984. Represents 17 emerging, mid-career and established artists/year. 17 artist members. Exhibited artists include Jean W. Troemel. Continuous exhibition of members' work plus a featured artist each month. Average display time 2 months. Open all year; Monday-Friday, 10:30-4; Saturday and Sunday, 10-5. Located downtown—"South of The Plaza"; 1,250 sq. ft.; a 100-year-old building adjoining a picturesque antique shop and located on a 400-year-old street in our nation's oldest city. 100% of space for gallery artists. Clientele: tourists and visitors. 100% private collectors. "We invite two guest artists for two month exhibitions. Same conditions as full membership."
Overall price range: $10-3,000; most work sold at $10-800.
 • This gallery reports that their clients are looking for larger paintings.
Media: Considers oil, acrylic, watercolor, pastel, pen & ink, drawing, mixed media, collage, sculpture, ceramics, photography, alkyd, serigraphs and mono prints. Most frequently exhibits watercolor, oil and alkyd.
Style: Exhibits expressionism, primitivism, painterly abstraction, impressionism and realism. Genres include landscapes, florals, portraits and figurative work. Prefers impressionism and realism.
Terms: Co-op membership fee (30% commission). Retail price set by the artist. Gallery provides insurance, promotion and contract; artist pays shipping costs to and from gallery.
Submissions: Accepts only artists from Northeast Florida. Work must be no larger than 60 inches. Send query letter with résumé, 5 slides or photographs, bio, brochure, and SASE. Call or write for appointment to show portfolio of originals, photographs and brochures. "New members must meet approval of a committee and sign a 4-month contract with the 1st and 4th month paid in advance." Replies only if interested within 2 weeks. Finds artists through visiting exhibitions, word of mouth, artists' submissions.
Tips: "We can tell when artists are ready for gallery representation by their determination to keep producing and improving regardless of negative sales plus individual expression and consistent good workmanship. They should have up to ten works—large pieces, medium sizes and small pieces—in whatever medium they choose."

PENSACOLA MUSEUM OF ART, 407 S. Jefferson, Pensacola FL 32501. (904)432-6247. Website: http://www.artsnwfl.org/pma. Director: Linda Nolan Ph.D. Nonprofit museum. Estab. 1954. Interested in emerging, mid-career and established artists. Sponsors 18 exhibitions/year. Average display time: 6-8 weeks. Open all year. Located in the historic district; renovated 1906 city jail. Clientele: 90% private collectors; 10% corporate clients. Overall price range: $200-20,000; most work sold at $500-3,000.
 • This museum has guidelines for submitting work. Write to Curator of Exhibitions for "Unsolicited Exhibition Policy" guidelines.
Media: Considers all media. Most frequently exhibits painting, sculpture, photography, glass and new-tech (i.e. holography, video art, computer art etc.).
Style: Exhibits neo-expressionism, realism, photorealism, surrealism, minimalism, primitivism, color field, postmodern works, imagism; all styles and genres.
Terms: Retail price set by museum and artist. Exclusive area representation not required. Museum provides insurance and promotion costs.
Submissions: Send query letter with résumé, at least 3 slides, SASE and/or videotape. "A common mistake of artists is making impromptu drop-ins." Files guides and résumé.

Tips: Looks for "skill and expertise and a broad selection of definitive works."

THE SUWANNEE TRIANGLE G, #5 On The Dock, P.O. Box 127, Cedar Key FL 32625. (904)543-5744. Retail gallery. Estab. 1983. Represents 100 emerging and mid-career artists. Full-time exhibited artists include Connie Nelson and Kevin Hipe. Open all year. Located in the historic district; 1,000 sq. ft.; "directly on the Gulf of Mexico." Overall price range: $50-3,500; most artwork sold at $150-1,200.
Media: Considers oil, watercolor, pastel, ceramic, contemporary craft and jewelry, glass, offset reproductions, T-shirts, posters, serigraphs and etchings. Most frequently exhibits watercolor, oil and craft.
Style: Exhibits painterly abstraction and surrealism.
Terms: Artwork is bought outright (net 30 days). Some consignment. Retail price set by the gallery. Gallery provides promotion.
Submissions: Send query letter with résumé, slides, bio, SASE and reviews. Call for appointment to show a portfolio. Files material of future interest.
Tips: "Send me slides or photos of some incredibly original, incredibly good work at an affordable price."

Georgia

ANTHONY ARDAVIN GALLERY, 309 E. Paces Ferry Rd., Atlanta GA 30305. (404)233-9686. Fax: (404)233-9686. President: Anthony Ardavin. Retail gallery. Estab. 1988. Represents 18 emerging artists/year. Exhibited artists include Robert Sentz and Maxey Andress. Sponsors 10 shows/year. Average display time 3 weeks. Located in Buckhead; 1,400 sq. ft. 50% of space for special exhibitions; 50% of space for gallery artists. Clientele: upscale. 95% private collectors, 5% corporate collectors. Overall price range: $500-6,000; most work sold at $2,000-3,000.
Media: Considers oil, acrylic, drawing, sculpture, watercolor, mixed media, ceramics, pastel. Most frequently exhibits pastel, paintings, mixed media.
Style: Exhibits all styles and genres.
Terms: Accepts work on consignment. Prefers artwork framed.
Submissions: Send query letter with résumé and slides. Write for appointment to show portfolio of slides. Replies in 2 weeks. Files résumés.

BRENAU UNIVERSITY GALLERIES, One Centennial Circle, Gainesville GA 30501. (770)534-6263. Fax: (770)534-6114. Gallery Director: Jean Westmacott. Nonprofit gallery. Estab. 1980s. Represents/exhibits emerging, mid-career and established artists. Sponsors 9 shows/year. Average display time 6 weeks. Open all year; Monday-Friday, 10-4; Sunday, 2-5 during exhibit dates. Summer hours are Monday-Thursday, 1-4 only. Located near downtown; 3,958 sq. ft., two galleries—the main one in a renovated 1914 neoclassic building, the other in an adjacent renovated Victorian building dating from the 1890s. 100% of space for special exhibitions. Clientele: tourists, upscale, local community, students. "Although sales do occur as a result of our exhibits, we do not currently take any percentage except in our National Invitational Exhibitions. Our purpose is primarily educational."
Media: Considers all media.
Style: Exhibits wide range of styles. "We intentionally try to plan a balanced variety of media and styles."
Terms: Retail price set by the artist. Gallery provides insurance and promotion; shipping costs are shared, depending on funding for exhibits. Prefers artwork framed. "Artwork must be framed or otherwise ready to exhibit."
Submissions: Send query letter with résumé, 10-20 slides, photographs and bio. Write for appointment to show portfolio of slides and transparencies. Replies within months if possible. Artist should call to follow up. Files one or two slides or photos with a short résumé or bio if interested. Remaining material returned. Finds artists through referrals, direct viewing of work and inquiries.
Tips: "Be persistent, keep working, be organized and patient. Take good slides and develop a body of work. Galleries are limited by a variety of constraints—time, budgets, location, taste and rejection does not mean your work may not be good; it may not 'fit' for other reasons at the time of your inquiry."

COASTAL CENTER FOR THE ARTS, INC., 2012 Demere Rd., St. Simons Island GA 31522. Phone/fax: (912)634-0404. Director: Mittie B. Hendrix. Nonprofit regional art center. Estab. 1947. Represents over 150 emerging, mid-career and established artists/year. Sponsors 15 shows/year. Average display time 3 weeks. Open all year; Monday-Saturday, 9-5. Located on main thoroughfare; 9,000 sq. ft.; 6 large galleries, 1 small built for display. "We do not hang multiple paintings on wall, but display as in a museum. 90% for special exhibitions. Clientele: tourists, upscale, local community, students. Overall price range: $ 25-7,000; most work sold at $300 minimum.
 • Coastal Center for the Arts celebrated its 50th anniversary in 1997.
Media: Considers all media and all types of prints. Most frequently exhibits paintings, sculpture, pottery.
Style: Exhibits all styles and genres. Prefers neo-Impressionism, realism, superrealism.
Terms: Accepts work on consignment (30-40% commission.) Gallery consults the artist about retail price. Gallery provides promotion and contract; artist pays for shipping. Prefers artwork framed or shrink-wrapped for bins.
Submissions: Send query letter with at least 12 slides, bio, SASE. Write for appointment to show portfolio of photographs. "We have limited clerical staff but reply ASAP." Finds artists through word of mouth, other artists' recommendations.

Tips: "Don't overframe. Be honest and realistic. Don't be too sensitive. We want to see you succeed so we try to give helpful constructive critique if needed. Most of our artists are not prolific, but we would like to have a minimum of three for selection by patrons. For a show, you need 20-25, according to size."

‡**KIANG GALLERY**, 1923 Peachtree Rd., Atlanta GA 30309. (404)351-5477. Fax: (404)951-8707. Owner: Marilyn Kiang. Retail gallery. Exhibits the work of non-traditional contemporary artists—with a special emphasis on biculturally influenced artists. Estab. 1992. Represents/exhibits 15 emerging and mid-career artists/year. Exhibited artists include Junco Safo Pollack, Hoang Van Biet and Amy Landesberg. Sponsors 10 shows/year. Average display time 1 month. Open all year; Tuesday-Friday, 11-5; Saturday, 12-5. Located in Buckhead; 2,500 sq. ft.; clean, minimal, authoritative, "white walls-grey floor." 70% of space for special exhibitions; 30% of space for gallery artists. Clientele: upscale. 60% private collectors, 40% corporate collectors. Overall price range: $2,000-10,000; most work sold at $3,000-6,000.
Media: Considers all media, lithography, photography, sculpture, painting.
Style: Exhibits conceptualism, minimalism.
Terms: Artwork is accepted on consignment (50% commission). Retail price set by the gallery and the artist. Gallery provides insurance, promotion and contract; shipping costs are shared. Prefers artwork framed.
Submissions: Prefers serious works. Send query letter with résumé, slides and reviews. Call for appointment to show portfolio of slides. Finds artists through referrals by other artists.

THE LOWE GALLERY, 75 Bennett St., Space A-2, Atlanta GA 30309. (404)352-8114. Fax: (404)352-0564. E-mail: loweart@bellsouth.net. Director: Courtney Maier. Retail gallery. Estab. 1989. Represents emerging to mid-career artists. Exhibited artists include Margarita Checa, Gail Foster, Maggie Hasbrouck, Kathleen Morris, Andrew Saftel and Steve Seinberg. Hosts 10-12 exhibits/year. Average display time 4-6 weeks. Open all year; Tuesday-Friday, 10:30-5:30; Monday and Saturday, 12-5 and Sunday by appointment. Located uptown (Buckhead); 12,000 sq. ft.; 4 exhibition rooms with a dramatic split level Grand Salon with 30 ft. ceilings and 18 ft. walls. 100% of space for gallery artists. 75% private collectors, 25% corporate collectors. Overall price range: $2,000-70,000; most work sold at $2,000-10,000.
Media: Considers any 2- or 3-dimensional medium. Most frequently exhibits painting, drawing and sculpture.
Style: Exhibits a wide range of aesthetics from figurative realism to painterly abstraction. Prefers postmodern works with a humanistic/spiritual content.
Terms: Artwork is accepted on consignment (50% commission). Retail price set by the gallery. Gallery provides promotion and contract; shipping costs are shared. Prefers artwork framed.
Submissions: Send query letter with résumé, 10-20 slides and SASE. Write for appointment to show portfolio of slides. Replies only if interested within 6 weeks. Finds artists through submissions.
Tips: "Put together an organized, logical submission. Do not bring actual pieces into the gallery. Be sure to include a SASE. Show galleries at least one cohesive body of work, could be anywhere between 10-40 pieces."

‡**NŌVUS, INC.**, 495 Woodward Way NW, Atlanta GA 30305. (404)355-4974. Fax: (404)355-2250. Vice President: Pamela Marshall. Art dealer. Estab. 1987. Represents 200 emerging, mid-career and established artists. Open by appointment; Monday-Friday, 9-5. Located in Buckhead, GA. 50% of space for gallery artists. Clientele: corporate, hospitality, healthcare. 5% private collectors, 95% corporate collectors. Overall price range: $500-20,000; most work sold at $800-5,000.
Media: Considers oil, acrylic, watercolor, pastel, mixed media, collage, paper, sculpture, ceramics, craft, fiber, glass, photography, and all types of prints. Most frequently exhibits mixed/paper and oil/acrylic.
Style: Exhibits all styles. Genres include landscapes, abstracts, florals and figurative work. Prefers landscapes, abstract and figurative.
Terms: Accepts work on consignment (50% commission). Retail price set by the artist. Gallery provides promotion and contract; shipping costs are shared. Prefers artwork unframed.
Submissions: Artists must have no other representation in our area. Send query letter with résumé, slides, brochure and reviews. Write for appointment to show portfolio of originals, photographs and slides. Replies only if interested within 1 month. Files slides and bio. Finds artists through agents, visiting exhibitions, word of mouth, art publications and sourcebooks, submissions.
Tips: "Send complete information and pricing. Do not expect slides and information back. Keep the dealer updated with current work and materials."

‡**TRINITY GALLERY**, 315 E. Paces Ferry Rd., Atlanta GA 30305. (404)237-0370. Fax: (404)240-0092. President: Alan Avery. Retail gallery and corporate sales consultants. Estab. 1987. Represents/exhibits 67 mid-career and established artists and old masters/year. Exhibited artists include Frederick Hart, Adrian Arleo and David Fraley. Sponsors 6 shows/year. Average display time 1 month. Open all year; Tuesday-Friday, 10-6; Saturday, 11-5 and by appointment. Located mid-city; 6,700 sq. ft.; 25-year-old converted restaurant. 50-60% of space for special exhibitions; 40-50% of space for gallery artists. Clientele: upscale, local, regional, national and international. 70% private collectors, 30% corporate collectors. Overall price range: $300-100,000; most work sold at $1,500-5,000.
 • Gallery has a second location at 47 Forsyth, The Healey Building, Atlanta GA 30303. (404)659-0084.
Media: Considers all media and all types of prints. Most frequently exhibits painting, sculpture and work on paper.
Style: Exhibits expressionism, conceptualism, color field, painterly abstraction, postmodern works, realism, impressionism and imagism. Genres include landscapes, Americana and figurative work. Prefers realism, abstract and figurative.
Terms: Artwork is accepted on consignment (negotiable commission), or it is bought outright for a negotiable price.

SUNDAY, January 12, 2-5PM

"Make It Up Outta Your Head" ceramic, wood, wire, found objects 25" x 32" x 10"

ANDREW SAFTEL

© Andrew Saftel

This whimsical sculpture of fired ceramics, carved wood and found objects titled *Make It Up Outta Your Head* is about "how the power of imagination is strengthened the more it is used," says artist Andrew Saftel. The philosphy of the piece is in sync with the artist's feelings on maintaining a successful career as an artist. "Do what feels honest. Work long enough to find your own voice, style and content. Trust your instincts and don't expect anything in return—do it because you love it." The piece was shown at the Lowe Gallery in Atlanta.

Retail price set by gallery. Gallery pays promotion and contract. Shipping costs are shared. Prefers artwork framed.
Submissions: Send query letter with résumé, at least 20 slides, bio, prices, medium, sizes and SASE. Reviews every 6 weeks.
Tips: Finds artists through word of mouth, referrals by other artists and artists' submissions. "Be as complete and professional as possible in presentation."

‡**VESPERMANN GLASS GALLERY**, 2140 Peachtree Rd., Atlanta GA 30309. (404)350-9698. Fax: (404)350-0046. Manager: Tracey Lofton. Retail gallery. Estab. 1984. Represents 200 emerging, mid-career and established artists/year. Sponsors 4-5 shows/year. Average display time 1 month. Open all year; Monday-Saturday, 10-6 and holiday hours. Located between Mid-town and Buckhead; 2,500 sq. ft.; features contemporary art glass. Overall price range: $100-10,000; most work sold at $200-2,000.
Media: Considers glass and craft.
Style: Exhibits contemporary.
Terms: Accepts work on consignment (50% commission). Buys outright for 50% of retail price (net 30 days). Retail price set by the gallery and the artist. Gallery provides insurance, promotion and contract; shipping costs are shared.
Submissions: Send query letter with résumé, slides, bio. Write for appointment to show portfolio of photographs, transparencies and slides. Replies only if interested within 2 weeks. Files slides, résumé, bio.

Hawaii

HANA COAST GALLERY, Hotel Hana-Maui, P.O. Box 565, Hana Maui HI 96713. (808)248-8636. Fax: (808)248-7332. E-mail: 72162.261@compuserve.com. Website: http://www.maui.net/~coast. Managing Director: Patrick Robinson. Retail gallery and art consultancy. Estab. 1990. Represents 56 mid-career and established artists. May consider emerging artists in the future. Sponsors 12 group shows/year. Average display time 1 month. Open all year. Located in the Hotel Hana-Maui at Hana Ranch; 3,000 sq. ft.; "an elegant ocean-view setting in one of the top small luxury resorts in the world." 20% of space for special exhibitions. Clientele: ranges from very upscale to highway traffic walk-ins. 85% private collectors, 15% corporate collectors. Overall price range: $150-50,000; most work sold at $1,500-25,000.
Media: Considers oil, acrylic, watercolor, pastel, mixed media, collage, works on paper, sculpture, ceramic, craft, fiber, glass, photography, original handpulled prints, engravings, lithographs, pochoir, wood engravings, mezzotints, serigraphs and etchings. Most frequently exhibits oil, watercolor and Japanese woodblock/old master etchings.
Style: Exhibits expressionism, primitivism, painterly abstraction, postmodern works, impressionism and realism. Genres include landscapes, florals, portraits, figurative work and Hawaiiana. Prefers landscapes, florals and figurative work. "We display very painterly Hawaiian landscapes. Master-level craftwork, particularly turned-wood bowls and smaller jewelry chests. We are *the* major gallery featuring Hawaiian crafts/furniture."
Terms: Accepts artwork on consignment (50% commission). Retail price set by gallery and artist. Gallery provides insurance, promotion and shipping costs from gallery. Framed artwork only.
Submissions: Accepts only full-time Hawaii resident artists. Send query letter with résumé, slides, bio, brochure, photographs, SASE and reviews. Write for appointment to show portfolio after query and samples submitted. Portfolio should include originals, photographs, slides and reviews. Replies only if interested within 1 week. If not accepted at time of submission, all materials returned.
Tips: "Know the quality level of art in our gallery and know that your own art would be companionable with what's being currently shown. We represent artists instead of just being 'picture sellers.' "

HONOLULU ACADEMY OF ARTS, 900 S. Beretania St., Honolulu HI 96814. (808)532-8700. Fax: (808)532-8787. E-mail: academy808@aol.com. Director: George R. Ellis. Nonprofit museum. Estab. 1927. Exhibits emerging, mid-career and established Hawaiian artists. Interested in seeing the work of emerging artists. Sponsors 40-50 shows/year. Average display time 6-8 weeks. Open all year; Tuesday-Saturday 10-4:30, Sunday 1-5. Located just outside of downtown area; 40,489 sq. ft. 30% of space for special exhibition. Clientele: general public and art community.
Media: Considers all media. Most frequently exhibits painting, works on paper, sculpture.
Style: Exhibits all styles and genres. Prefers traditional, contemporary and ethnic.
Terms: "On occasion, artwork is for sale." Retail price set by artist. Museum provides insurance and promotion; museum pays for shipping costs. Prefers artwork framed.
Submissions: Exhibits artists of Hawaii. Send query letter with résumé, slides and bio directly to curator(s) of Western and/or Asian art. Curators are: Jennifer Saville, Western art; Julia White, Asian art. Write for appointment to show portfolio of slides, photographs and transparencies. Replies in 3-4 weeks. Files résumés, bio.
Tips: "Be persistent but not obnoxious." Artists should have completed a body of work of 50-100 works before approaching galleries.

‡MAYOR'S OFFICE OF CULTURE AND THE ARTS, 530 S. King, #404, Honolulu HI 96813. (808)523-4674. Fax: (808)527-5445. Acting Director: J.P. Orias. Local government/city hall exhibition areas. Estab. 1965. Exhibits group shows coordinated by local residents. Sponsors 50 shows/year. Average display time 3 weeks. Open all year; Monday-Friday, 7:45-4:30. Located at the civic center in downtown Honolulu; 3 galleries—courtyard (3,850 sq. ft.), lane gallery (873 sq. ft.), 3rd floor (536 sq. ft.); Mediterranean-style building, open interior courtyard. "City does not participate in sales. Artists make arrangements directly with purchaser."
Media: Considers all media and all types of prints. Most frequently exhibits oil/acrylic, photo/print and clay.
Terms: Gallery provides promotion; local artists deliver work to site. Prefers artwork framed.
Submissions: "Local artists are given preference." Send query letter with résumé, slides and bio. Write for appointment to show portfolio of slides. "We maintain an artists registry for acquisition review for the art in City Buildings Program."
Tips: "Selections of exhibitions are made through an annual application process. Have a theme or vision for exhibit. Plan show at least one year in advance."

QUEEN EMMA GALLERY, 1301 Punchbowl St., Honolulu HI 96813. (808)547-4397. Fax: (808)547-4646. E-mail: efukuda@queens.org. Website: http://www.queens.org. Director: Masa Morioka Taira. Nonprofit gallery. Estab. 1977. Exhibits the work of emerging, mid-career and established artists. Average display time is 5½ weeks. Weekend and holiday hours: 8 a.m.-2:30 p.m. Located in the main lobby of The Queen's Medical Center; "intimate ambiance allows close inspection." Clientele: M.D.s, staff personnel, hospital visitors, community-at-large. 90% private collectors. Overall price range: $50-5,000.
● The display wall space in this gallery has been expanded with the addition of a 32' × 8' panel along corridor outside gallery.
Media: Considers all media. "Open to innovation and experimental work appropriate to healing environment."
Style: Exhibits contemporary, abstract, impressionism, figurative, primitive, non-representational, photorealism, realism and neo-expressionism. Specializes in humanities-oriented interpretive, literary, cross-cultural and cross-disciplinary works. Interested in folk art, miniature works and ethnic works. "Our goal is to offer a variety of visual expressions by

regional artists. Subject matter and aesthetics appropriate for audience in a healthcare facility is acceptable." Interested in seeing "progressive, honest, experimental works with artist's personal interpretation."

Terms: Accepts work on consignment (30% commission). Retail price set by artist. Accepts payment by installments. Exclusive area representation not required. Gallery provides promotion and contract.

Submissions: Send query letter with résumé, brochure, business card, 24 slides (including at least 12 slides or current work intended to show), photographs and SASE. Wishes to see a portfolio of slides, blown-up full color reproduction is also acceptable. "Prefer brief proposal or statement or proposed body of works." Preference given to artists with local connections. "Include prices, title and medium information." Finds artists through direct inquiries, referral by art professionals, news media publicity.

Tips: "Pound the pavement. Get exposure. Enter as many juried shows as you can. Build your portfolio. Show professionalism, integrity, preparation, new direction and readiness to show. Be honest. Adhere to basics. We look for professional appearance of materials submitted, i.e., curriculum vita, proposal, artworks, photographic materials, slides, etc. Slides should be representative of your style and preferably current and/or works-in-progress. We regret the gallery is not equipped to handle and show oversized paintings, 2-D items, or large, heavy sculptures, ceramic wares, etc."

RAMSAY MUSEUM, 1128 Smith St., Honolulu HI 96817. (808)537-ARTS. Fax: (808)531-MUSE. E-mail: ramsay@lava.net. Website: http://www.ramsaymuseum.org. CEO: Ramsay. Retail gallery, museum shop, permanent exhibit and reference library. Estab. 1981. Represents 50 emerging, mid-career and established artists/year. Exhibited artists include Ron Kent, Aki Sogabe, Laura Ruby, Macario Pascual, John Young, Esther Shimazu. Sponsors 12 solo shows/year. Average display time 1 month. Open all year; Monday-Friday, 10-5; Saturday, 10-4. Located in downtown historic district; 5,000 sq. ft.; historic building with courtyard. 25% of space for special exhibitions; 25% of space for gallery artists. 50% of space for permanent collection of Ramsay Quill and Ink originals spanning 50 years. Clientele: 50% tourist, 50% local. 60% private collectors, 40% corporate collectors. Overall price range: $100-100,000; most work sold at $500-25,000.

Media: Considers all media and all types of prints. Most frequently exhibits paintings and drawings.

Style: Exhibits all styles and genres. Prefers landscapes, still lifes, painterly abstraction.

Terms: Accepts work on consignment. Retail price set by the artist. Gallery provides promotion; artist pays for shipping. Prefers artwork framed.

Submissions: Prefers artists of Hawaii. Send query letter with résumé, 20 slides, bio, SASE. Write for appointment to show portfolio of original art. Replies only if interested within 1 month. Files all material that may be of future interest. Finds artists through submissions and art judging.

Tips: "Keep a record of all artistic endeavors (working shots) and products on film for future book use, and to show your range to prospective commissioners and galleries. Prepare your gallery presentation packet with the same care that you give to your art creations. For us, quality counts more than quantity. We would like to see samples of current work with a show concept in writing. Because shows are booked well in advance, the slide sheet of 20 can be of a prior exhibition."

VOLCANO ART CENTER GALLERY, P.O. Box 104, Hawaii National Park HI 96718. (808)967-7511. Fax: (808)967-8512. Gallery Manager: Natalie Pfeifer. Nonprofit gallery to benefit arts education; nonprofit organization. Estab. 1974. Represents 200 emerging, mid-career and established artists/year. 1,400 member organization. Exhibited artists include Dietrich Varez and Brad Lewis. Sponsors 25 shows/year. Average display time 1 month. Open all year; daily 9-5. Located Hawaii Volcanoes National Park; 3,000 sq. ft.; in the historic 1877 Volcano House Hotel. 15% of space for special exhibitions; 90% of space for gallery artists. Clientele: affluent travelers from all over the world. 95% private collectors, 5% corporate collectors. Overall price range: $20-4,500; most work sold at $50-400.

Media: Considers all media, all types of prints. Most frequently exhibits wood, mixed media, ceramics and glass.

Style: Exhibits expressionism, neo-expressionism, primitivism and painterly abstraction. Prefers traditional Hawaiian, contemporary Hawaiian and contemporary fine crafts.

Terms: "Artists must become Volcano Art Center members." Accepts work on consignment (50% commission). Retail price set by the gallery. Gallery provides promotion and contract; artist pays shipping costs to gallery.

Submissions: Prefers only work relating to the area or by Hawaiian artists. Call for appointment to show portfolio. Replies only if interested within 1 month. Files "information on artists we represent."

Idaho

BROWN'S GALLERIES, 1022 Main St., Boise ID 83702. (208)342-6661. Fax: (208)342-6677. E-mail: buyart@micron.net. Director: Randall Brown. Retail gallery featuring appraisal and restoration services. Estab. 1968. Represents 35 emerging, mid-career and established artists. Exhibited artists include Gerald Merfield and John Horéjs. Sponsors 12 shows/year. Average display time 1 month. Open all year. Located downtown; 2,500 sq. ft. Up to 50% of space for special exhibitions. Clientele: mid-to above average income, some tourists. 50% private collectors, 50% corporate collectors. Overall price range: $10-65,000; most work sold at $1,000-5,000.

Media: Considers oil, acrylic, watercolor, pastel, pen & ink, drawings, mixed media, collage, works on paper, sculpture, ceramic, fiber, glass, original handpulled prints, woodcuts, engravings, lithographs, pochoir, wood engravings, mezzotints, serigraphs, linocuts and etchings. Most frequently exhibits painting, sculpture and glass.

Style: Exhibits all styles, including expressionism, neo-expressionism, painterly abstraction, imagism, conceptualism, color field, postmodern works, impressionism, realism, photorealism, pattern painting and hard-edge geometric abstraction. All genres. Prefers impressionism, realism and abstraction.

Terms: Accepts artwork on consignment (50% commission). Retail price set by artist. "We also do some 'wholesale' purchasing." Sometimes offers customer discounts and payment by installment. Gallery provides insurance, promotion and contract; artist pays for shipping. Prefers artwork framed.

Submissions: Send query letter with all available information. Portfolio review requested if interested in artist's work. Files all materials.

Tips: "We deal only with professionals. Amateurs frequently don't focus enough on the finish, framing, display, presentation or marketability of their work. We have a second gallery, Brown's Gallery McCall, located in the heart of a popular summer and winter resort town. We carry an eclectic group of work focusing slightly more on tourists than our first location."

KNEELAND GALLERY, P.O. Box 2070, Sun Valley ID 83353. (208)726-5512. Fax: (208)726-7495. (800)338-0480. Director: Jennifer Jaros. Retail gallery, art consultancy. Estab. 1981. Represents 40 emerging, mid-career and established artists/year. Exhibited artists include: Ovanes Berberian, Steven Lee Adams. Sponsors 9 shows/year. Average display time 3 weeks. Open all year; Monday-Saturday, 10-5. Located downtown; 2,500 sq. ft.; features a range of artists in several exhibition rooms. 50% of space for special exhibitions; 50% of space for gallery artists. Clientele: tourist, seasonal, local, upscale. 95% private collectors, 5% corporate collectors. Overall price range: $200-25,000; most work sold at $1,000-2,000.

Media: Considers all media and all types of prints. Most frequently exhibits oil, acrylic, watercolor.

Style: Exhibits expressionism, realism. Genres include landscapes, florals, figurative work. Prefers landscapes-realism, expressionism, abstraction.

Terms: Accepts work on consignment (50% commission). Retail price set by the artist. Gallery provides insurance, promotion and contract; shipping costs are shared. Prefers artwork framed.

Submissions: Send query letter with résumé, slides, photographs, artists' statement, bio, SASE. Write for appointment to show portfolio of photographs and slides. Replies in 1-2 months. Files photo samples/business cards. Finds artists through submissions and referrals.

ANNE REED GALLERY, P.O. Box 597, Ketchum ID 83340. (208)726-3036. Fax: (208)726-9630. E-mail: annereed@micron.net. Director: Jennifer Gately. Retail Gallery. Estab. 1980. Represents mid-career and established artists. Exhibited artists include Jun Kaneko, James Renner, Howard Bentre and Carolyn Olblim. Sponsors 8 exhibitions/year. Average display time 1 month. Open all year. Located in the Walnut Avenue Mall. 10% of space for special exhibitions; 90% of space for gallery artists. Clientele: 80% private collectors, 20% corporate collectors.

Media: Most frequently exhibits sculpture, wall art and photography.

Style: Exhibits expressionism, abstraction, conceptualism, impressionism, photorealism, realism. Prefers contemporary and landscapes.

Terms: Accepts work on consignment (50% commission). Retail price set by gallery and artist. Sometimes offers customer discounts and payment by installment. Gallery provides insurance, promotion, contract and shipping costs from gallery. Prefers artwork framed.

Submissions: Send query letter with résumé, 40 slides, bio and SASE. Call or write for appointment to show portfolio of originals (if possible), slides and transparencies. Replies in 2 months. Finds artists through word of mouth, exhibitions, publications, submissions and collector's referrals.

‡THE ROLAND GALLERY, 601 Sun Valley Rd., P.O. Box 221, Ketchum ID 83340. (208)726-2333. Fax: (208)726-6266. Owner: Roger Roland. Retail gallery. Estab. 1990. Represents 100 emerging, mid-career and established artists. Sponsors 8 shows/year. Average display time 1 month. Open all year; daily 11-5. 800 sq. ft. 50% of space for special exhibitions; 50% of space for gallery artists. Clientele: 75% private collectors, 25% corporate collectors. Overall price range: $10-10,000; most work sold at $500-1,500.

Media: Considers oil, pen & ink, paper, fiber, acrylic, sculpture, glass, watercolor, mixed media, ceramic, installation, pastel, collage, craft and photography, engravings, mezzotints, etchings, lithographs. Most frequently exhibits glass, paintings and jewelry.

Style: Considers all styles and genres.

Terms: Accepts work on consignment (50% commission) or buys outright for 50% of the retail price (net 30 days). Retail price set by artist. Gallery provides insurance, promotion, shipping costs from gallery. Prefers artwork framed.

Submissions: Send query letter with résumé, slides, bio, brochure, photographs, SASE, business card and reviews. Write for appointment to show portfolio of photographs, slides and transparencies. Replies only if interested within 2 weeks.

WILLOWTREE GALLERY, 210 Cliff St., Idaho Falls ID 83402. (208)524-4464. E-mail: willow@sru.net. Website: http://www.sru.net/~willow/willow.html. Owner: Lisa Kelly. Retail gallery. Estab. 1987. Represents 12 emerging artists. Exhibited artists include Miller-Allen and Hansen. Average display time 2 months. Open all year. Located on the fringe of downtown; 3,000 sq. ft.; "used to be a wrought-iron foundry; triangular building." 40% of space for special exhibitions. Clientele: 100% private collectors. Overall price range: $500-10,000; most work sold at $600-1,500.

Media: Considers oil, acrylic, watercolor, pastel, collage, works on paper, sculpture, ceramic, fiber, glass, original

© 1996 Gary Nisbet

Seattle artist Gary Nisbet connected with the Anne Reed Gallery in one of those "man bites dog stories every artist hopes for," he says. Nisbet met a gallery representative by coincidence at a Seattle arts fair where Nisbet's work was being exhibited. The gallery is exhibiting this mixed media collage *Story*, which is one of a series of pieces inspired by Nisbet's quest for the simple, quiet life. Before he began showing in galleries, Nisbet sought out alternative exhibit spaces to gain exposure for his work—restaurants, bars, playhouses, nonprofit galleries, "anyplace I could get my work shown." The exposure helps fill out an artist's biography when sending submission packages to galleries, he says.

handpulled prints, relief prints, engravings, mezzotints and serigraphs. Most frequently exhibits watercolor, limited edition reproductions and oil.
Style: Exhibits expressionism, impressionism and photorealism. Genres include landscapes, florals, Western and wildlife. Prefers landscapes, florals and expressionism.
Terms: Accepts artwork on consignment (40% commission). Retail price set by artist. Gallery provides insurance and promotion; shipping costs are shared.
Submissions: Send query letter with photographs and SASE. Call for appointment to show portfolio of originals. Replies in 1 week. Files material of interest.
Tips: Looks for "quality of the art itself and presentation, such as framing."

Illinois

‡**GALESBURG CIVIC ART CENTER**, 114 E. Main St., Galesburg IL 61401. (309)342-7415. E-mail: artcenter@mis slink.net. Contact: Julie Layer. Nonprofit gallery. Estab. 1965. Exhibits emerging, mid-career and established artists. 375 members. Exhibited artists include Mark Barone and Harold Gregor. Sponsors 10 shows/year. Average display time 1 month. Closed August. Located downtown; 1,400 sq. ft. "We have 3 gallery spaces: 1 exhibition gallery, 1 consignment gallery and 1 permanent collection." Overall price range: $100-10,000; most artwork sold at $100-300.
Media: Considers oil, acrylic, watercolor, pastel, mixed media, works on paper, sculpture, ceramic, fiber, glass, photography, original handpulled prints. Most frequently exhibits painting, prints and ceramic.
Style: Exhibits expressionism, painterly abstraction, color field, postmodern works, realism, all styles. Genres include landscapes, florals and figurative work. Prefers realism and painterly abstraction. Interested in seeing "fine crafts and quality 2- and 3-D work."
Terms: Accepts work on consignment (40% commission). Retail price set by artist. Gallery provides insurance and promotion; artist pays for shipping. Framed artwork only.
Submissions: Accepts primarily artists from Midwest. Send query letter with résumé, slides and bio. Call for appointment to show portfolio, which should include slides. "No unsolicited samples, please." Replies in 3 months.

‡**GROVE ST. GALLERY**, 919 Grove St., Evanston IL 60201. (847)866-7340. Gallery Director: Chris or George. Retail gallery. Estab. 1889. Represents 15 emerging and established artists. Sponsors 6 solo and 5 group shows/year. Average display time 1 month. Clientele: 60% private collectors, 40% corporate clients. Overall price range: $500-25,000; most work sold at $2,500-10,000.
● Gallery has two new locations: State Street Gallery in Sarasota FL and Lerner Gallery in Encinitas, CA.
Media: Considers oil, acrylic, watercolor, pastel, glass and serigraphs. Most frequently exhibits oil.
Style: Exhibits impressionism. Genres include landscapes, florals, Southwestern and Western themes and figurative work. Prefers Mediterranean landscapes, florals and Southwestern/Western works.
Terms: Accepts work on consignment. Retail price set by artist. Exclusive area representation required. Gallery provides

partial insurance and promotion; shipping costs are shared. Prefers artwork framed.

Submissions: Send query letter with résumé, slides, brochure, photographs and bio. Call or write for appointment to show portfolio of originals, slides, transparencies and photographs. Replies in 3 weeks. Files photographs or slides. All material is returned if not accepted or under consideration.

HOWE MODERN ART, P.O. Box 358, Bloomingdale IL 60108. (630)529-0787. E-mail: howeart@aol.com. Website: http://www.howeart.com. Owner/Director: Ron Howe. Retail/wholesale gallery. Estab. 1978. Represents 20 emerging, mid-career and established artists/year. Exhibited artists include Harold Altman and Jon Neuse. Sponsors 4 shows/year. Average display time 2 months. Open all year; Tuesday-Saturday, 10-6. Located in a residential area; 1,000 sq. ft.; art nouveau decor. 25% of space for special exhibitions; 75% of space for gallery artists. 90% private collectors, 10% corporate collectors. Overall price range: $100-10,000; most work sold at $1,000-5,000.

Media: Considers oil, acrylic, watercolor, pastel, drawing, ceramics, glass, oil pastel, woodcut, lithograph, wood engraving, mezzotint, linocut and etching. Most frequently exhibits color wood block prints, pastels and watercolors.

Style: Exhibits all styles. Genres include landscapes, neighborhood scenes, cityscapes and abstracts.

Terms: Accepts work on consignment (50% commission). Retail price set by the artist. Gallery provides insurance and promotion; artist pays shipping costs to and from gallery. Prefers oil paintings framed; works on paper unframed but matted.

Submissions: Send query letter with résumé, bio, brochure, SASE, business card and reviews. Call for appointment to show portfolio of originals, photographs, slides and transparencies. Replies only if interested within 1 month. Files all submissions. Finds artists by visiting exhibitions, art fairs.

‡THE PEORIA ART GUILD, 1831 N. Knoxville Ave., Peoria IL 61603. (309)685-7522. Fax: (309)685-7446. E-mail: peoria_art@aol.com. Director: Tyson Joye. Retail gallery for a nonprofit organization. Also has rental program. Estab. 1888. Represents 450 emerging, mid-career and established artists. Sponsors 7 solo and 3 group shows/year. Average display time 6 weeks. Open Tuesday-Saturday, 10-5. Clientele: 50% private collectors, 50% corporate clients. Overall price range: $25-3,000; most work sold at $125-500.

• This gallery will be moving to a new space in the Fall of 1998, with four times the exhibit and consignment space.

Media: Considers oil, acrylic, watercolor, pastel, mixed media, collage, works on paper, sculpture, ceramic, jewelry, fiber, glass, photography, woodcuts, wood engravings, linocuts, engravings, mezzotints, etchings, lithographs and serigraphs and all other traditional and non-traditional media.

Style: Exhibits all styles. Genres include landscapes, florals and figurative work. Prefers contemporary work, landscapes, realism and painterly abstraction. "Our main gallery supplies all the two-dimensional work to our extensive art rental program. Realistic watercolors, acrylics and oils work into this program easily with painterly abstractions and color field work always a possibility. The main gallery primarily exhibits newly emerging and established Midwestern artists with no restriction to style."

Terms: Accepts work on consignment (40% commission). Retail price set by artist. Offers customer discounts and payment by installments. Gallery provides insurance, promotion and contract. Prefers artwork framed. Bin work accepted.

Submissions: Send query letter with résumé, 1 sheet of slides and SASE. "It's important to include a résumé or an artist's statement." Call for appointment to show portfolio of originals. Replies in 2 months. Files résumé, slides and statement. All material is returned if not accepted or under consideration. Finds artists by visiting exhibitions, word of mouth, artists' submissions/self-promotions and referrals.

Tips: "Present your work in a professional manner with excellent slides and well-done supporting materials. Quality slides are the key. If your work is great and your slides are terrible nobody will ever know what a genius you are. A consistent body of work numbering no less than 20 is encouraged. The work should indicate a maturity in a style and content that is evident overall."

‡PRESTIGE ART GALLERIES, 3909 W. Howard, Skokie IL 60076. (847)679-2555. E-mail: 76751-1327@compuserve.com. Website: http://www.prestigeart.com. President: Louis Schutz. Retail gallery. Estab. 1960. Exhibits 100 mid-career and established artists/year. Interested in seeing the work of emerging artists. Exhibited artists include Jean Paul Avisse. Sponsors 4 shows/year. Average display time 4 months. Open all year; Saturday and Sunday, 11-5; Monday-Wednesday, 10-5. Located in a suburb of Chicago; 3,000 sq. ft. 20% of space for special exhibitions; 50% of space for gallery artists. Clientele: professionals. 20% private collectors, 10% corporate collectors. Overall price range: $100-100,000; most work sold at $1,500-2,000.

Media: Considers oil, acrylic, mixed media, paper, sculpture, ceramics, craft, fiber, glass, lithographs and serigraphs. Most frequently exhibits paintings, glass and fiber.

Style: Exhibits surrealism, New Age visionary, impressionism, photorealism and realism. Genres include landscapes, florals, portraits and figurative work. Prefers landscapes, figurative-romantic and floral.

Terms: Accepts work on consignment (50% commission). Retail price set by the gallery and the artist. Gallery provides insurance, promotion and contract; shipping costs are shared. Prefers artwork framed.

Submissions: Send query letter with résumé, slides, bio, SASE and prices/sizes. Call for appointment to show portfolio of photographs. Replies in 2 weeks. "Returns all material if SASE is included."

© 1994 Nicholas Sist

Nicholas Sist's gouache work *Still Life with Green Dodecaheron*—shown actual size—has been included in exhibits of the artist's work four times since 1994, including a show at Sprague Art Gallery in Illinois. "In tiny, brightly colored still life images I create an imaginary 'inner reality.' Traveling from this world to another, as through a keyhole, the viewer is invited to leave behind external limitations," says Sist. The artist sends three to five mailings a year in addition to being represented by three galleries. "Trust your intuition both with your creative process and in business dealings," he advises.

‡**LAURA A. SPRAGUE ART GALLERY**, Joliet Junior College, 1215 Houbolt Rd., Joliet IL 60431-8938. (815)729-9020. Gallery Director: Joe B. Milosevich. Nonprofit gallery. Estab. 1978. Interested in emerging and established artists. Sponsors 6-8 solo and group shows/year. Average display time is 3-4 weeks.
Media: Considers all media except performance. Most frequently exhibits painting, drawing and sculpture (all media).
Style: Considers all styles.
Terms: Gallery provides insurance and promotion.
Submissions: Send query letter with résumé, brochure, slides, photographs and SASE. Call or write for appointment to show portfolio of originals and slides. Query letters and résumés are filed.

Chicago

A.R.C. GALLERY/EDUCATIONAL FOUNDATION, 1040 W. Huron, 2nd Floor, Chicago, IL 60622. (312)733-2787. E-mail: jmorris@chicom.com. Website: http://www.chicom.com/arc. President: Pamela Staker-Matson. Nonprofit gallery. Estab. 1973. Exhibits emerging, mid-career and established artists. Interested in seeing the work of emerging artists. 21 members. Exhibited artists include Miriam Schapiro. Average display time 1 month. Closed August. Located in the River West area; 3,500 sq. ft. Clientele: 80% private collectors, 20% corporate collectors. Overall price range $50-40,000; most work sold at $200-4,000.
Media: Considers oil, acrylic, drawings, mixed media, paper, sculpture, ceramics, installation, photography and original handpulled prints. Most frequently exhibits painting, sculpture (installation) and photography.
Style: Exhibits all styles and genres. Prefers postmodern and contemporary work.
Terms: Rental fee for space. Rental fee covers 1 month. Gallery provides promotion; artist pays shipping costs. Prefers work framed.
Submissions: Send query letter with résumé, slides, bio and SASE. Call for deadlines for review. Portfolio should include slides.

ALTER ASSOCIATES INC., 1040 Lake Shore Dr., Chicago IL 60611. (312)944-4304. Fax: (312)944-8480. President: Chickie Alter. Art consultancy. Estab. 1972. Represents 200 emerging, mid-career and established artists through slides. Open all year; Monday-Sunday. Clientele: upscale, residential and corporate. 60% private collectors, 40% corporate collectors. Overall price range: $500-10,000; most work sold at $1,000-4,000.

Media: Considers all media except conceptual. Most frequently sells acrylic, oil, mixed media and 3-D work.
Style: Exhibits expressionism, photorealism, neo-expressionism, pattern painting, color field, illustrative, painterly abstraction, realism and imagism.
Terms: Artwork is accepted on consignment (40% commission). Retail price set by the artist. Shipping costs are usually shared. Prefers artwork unframed.
•**Submissions:** Accepts only artists from US. Send query letter with résumé, slides, bio and SASE. Portfolio should include slides and SASE. Reports in 2 weeks.
Tips: Submit clear, well-marked slides and SASE.

‡**ARTEMISIA GALLERY**, 700 N. Carpenter, Chicago IL 60622. (312)226-7323. E-mail: artemisi@enteract.com. Website: http://www.enteract.com/~artemisi. Gallery Coordinator: Clodagh Kenny. Presidents: Ellie Wallace and Susan Senserman. Cooperative and nonprofit gallery/alternative space run by women artists. Estab. 1973. 14 active members, 15 associate members. Sponsors 60 solo shows/year. Average display time 4 weeks. Interested in emerging and established artists. Overall price range: $150-10,000; most work sold at $600-2,500.
Media: Considers all traditional media including craft, installation, performance and new technologies.
Terms: Rental fee for space; rental fee covers 1 month. Retail price set by artist. Exclusive area representation not required. Artist pays for shipping and announcement cards.
Submissions: Send query letter with résumé, statement, 10 slides, slide sheet and SASE. Portfolios reviewed each month. Replies in 6 weeks. All material is returned if not accepted or under consideration if SASE is included.
Tips: "Send clear, readable slides, labeled and marked 'top' or with red dot in lower left corner."

‡**MARY BELL GALLERIES**, 740 N. Franklin, Chicago IL 60610. (312)642-0202. Fax: (312)642-6672. President: Mary Bell. Retail gallery. Estab. 1975. Represents mid-career artists. Interested in seeing the work of emerging artists. Exhibited artists include Mark Dickson. Sponsors 4 shows/year. Average display time 6 weeks. Open all year. Located downtown in gallery district; 5,000 sq. ft. 25% of space for special exhibitions. Clientele: corporations, designers and individuals. 20% private collectors, 80% corporate collectors. Overall price range: $500-8,000; most work sold at $1,000-3,000.
Media: Considers oil, acrylic, watercolor, pastel, mixed media, collage, paper, sculpture, ceramic, fiber, glass, original handpulled prints, offset reproductions, woodcuts, engravings, lithographs, pochoir, posters, wood engravings, mezzotints, serigraphs, linocuts and etchings. Most frequently exhibits canvas, unique paper and sculpture.
Style: Exhibits expressionism, painterly abstraction, impressionism, realism and photorealism. Genres include landscapes and florals. Prefers abstract, realistic and impressionistic styles. Does not want "figurative or bizarre work."
Terms: Accepts artwork on consignment (50% commission). Retail price set by gallery and artist. Offers customer discounts and payment by installments. Gallery provides insurance and contract; shipping costs are shared. Prefers artwork unframed.
Submissions: Send query letter with slides and SASE. Portfolio review requested if interested in artist's work. Portfolio should include slides.
Tips: "Today less expensive works are selling, pieces between $2,000-3,000."

✔**BERET INTERNATIONAL GALLERY**, 1550 N. Milwaukee St., Chicago IL 60622. (773)489-6518. Fax: (773)342-5012. Director: Ned Schwartz. Alternative space. Estab. 1991. Represents 20 emerging, mid-career and established artists/year. Exhibited artists include Jno Cook and Dennis Kowalski. Sponsors 8 shows/year. Average display time 5 weeks. Open all year; Thursday, 1-5; Friday and Saturday, 1-5; or by appointment. Located near north west Chicago, Bucktown; 2,500 sq. ft.; shows conceptual art, mechanical sculpture. 100% of space for special exhibitions; backrooms for gallery artists. Clientele: "serious art intellectuals." 90% private collectors, 10% corporate collectors. Overall price range: $25-5,000.
Style: Exhibits conceptualism.
Terms: Accepts work on consignment (40% commission). Retail price set by the gallery and the artist. Gallery provides insurance, promotion and contract; artist pays shipping costs to and from gallery.
Submissions: "All art has strong social relevance. No decorative craft." Send query letter with slides, photographs and SASE. Call or write for appointment. Files résumé, 10-20 slides and photos. Finds artists through visiting exhibitions, submissions.
Tips: "Be familiar with the art that the gallery exhibits. Basically artists should not send any submissions unless they are familiar with the gallery."

‡**CAIN GALLERY**, 111 N. Marion St., Oak Park IL 60301. (708)383-9393. Owners: Priscilla and John Cain. Retail gallery. Estab. 1973. Represents 75 emerging, mid-career and established artists. "Although we occasionally introduce unknown artists, because of high overhead and space limitations, we usually accept only artists who are somewhat established, professional and consistently productive." Sponsors 6 solo shows/year. Average display time 6 months. Open all year. Recent move triples space, features an on-site interior design consultant. Clientele: 80% private collectors, 20% corporate clients. Overall price range: $100-6,000; most artwork sold at $500-1,000.
Media: Considers oil, acrylic, watercolor, mixed media, collage, sculpture, crafts, ceramic, woodcuts, engravings, mezzotints, etchings, lithographs and serigraphs. Most frequently exhibits acrylic, watercolor and serigraphs.
Style: Exhibits impressionism, realism, surrealism, painterly abstraction, imagism and all styles. Genres include landscapes, florals, figurative work. Prefers impressionism, abstraction and realism. "Our gallery is a showcase for living

American artists—mostly from the Midwest, but we do not rule out artists from other parts of the country who attract our interest. We have a second gallery in Saugatuck, Michigan, which is open during the summer season. The Saugatuck gallery attracts buyers from all over the country."

Terms: Accepts artwork on consignment. Retail price set by artist. Sometimes offers customer payment by installment. Exclusive area representation required. Gallery provides insurance, promotion, contract and shipping costs from gallery. Prefers artwork framed.

Submissions: Send query letter with résumé and slides. Portfolio review requested if interested in artist's work. Portfolio should include originals and slides. Finds artists through visiting exhibitions, word of mouth, submissions/self-promotions and art collectors' referrals.

Tips: "We are now showing more fine crafts, especially art glass and sculptural ceramics. The most common mistake artists make is amateurish matting and framing."

‡CHIAROSCURO, 700 N. Michigan Ave., Chicago IL 60611. (312)988-9253. Proprietors: Ronna Isaacs and Peggy Wolf. Contemporary retail gallery. Estab. 1987. Represents over 200 emerging artists. Average display time 6 months. Located on Chicago's "Magnificent Mile"; 2,500 sq. ft. on Chicago's main shopping boulevard, Michigan Ave. "Space was designed by award winning architects Himmel & Bonner to show art and contemporary crafts in an innovative way." Overall price range: $30-2,000; most work sold at $50-1,000.

Media: All 2-dimensional work—mixed media, oil, acrylic; ceramics (both functional and decorative works); sculpture, art furniture, jewelry. "We moved out of Chicago's gallery district to a more 'retail' environment 3 years ago because many galleries were closing. Paintings seemed to stop selling, even at the $500-1,000 range, where functional pieces (i.e. furniture) would sell at that price."

Style: "Generally we exhibit bright contemporary works. Paintings are usually figurative works either traditional oil on canvas or to the very non-traditional layers of mixed-media built on wood frames. Other works are representative of works being done by today's leading contemporary craft artists. We specialize in affordable art for the beginning collector, and are focusing on 'functional works'. We are currently carrying fewer of the 'funky' brightly painted objects—though we still feature them—and have added more metals and objects with 'cleaner' lines."

Terms: Accepts work on consignment (50% commission). Retail price set by gallery and artist. Customer discounts and payment by installment are available. Gallery provides insurance.

Submissions: Send query letter (Attn: Peggy Wolf) with résumé, slides, photographs, price list, bio and SASE. Portfolio review requested if interested in artist's work. All material is returned if not accepted or under consideration. Finds artists through agents, by visiting exhibitions and national craft and gift shows, word of mouth, various art publications and sourcebooks, submissions/self-promotions and art collectors' referrals.

Tips: "Don't be afraid to send photos of anything you're working on. I'm happy to work with the artist, suggest what's selling (at what prices). If it's not right for this gallery, I'll let them know why."

CHICAGO CENTER FOR THE PRINT & POSTER, 1509 W. Fullerton, Chicago IL 60614. (312)477-1585. Fax: (312)477-1851. Website: http://www.prints-posters.com. Owner/Director: Richard H. Kasvin. Retail gallery. Estab. 1979. Represents 100 mid-career and established artists/year. Interested in seeing the work of emerging artists. Exhibited artists include Hiratsuka, J. Buck, Armin Hoffmann, Herbert Leupin. Sponsors 5-6 shows/year. Average display time 4-6 weeks. Open all year; Tuesday-Saturday, 11-7; Sunday, 12-5. Located in Lincoln Park, Chicago; 2,500 sq. ft. "We represent works on paper, Swiss graphics and European Vintage Posters." 40% of space for special exhibitions; 60% of space for gallery artists. 90% private collectors, 10% corporate collectors. Overall price range: $300-3,000; most work sold at $500-1,300.

Media: Considers mixed media, paper, woodcuts, engravings, lithographs, wood engravings, mezzotints, serigraphs, linocuts, etchings and vintage posters. Most frequently exhibits prints and vintage posters.

Style: Exhibits all styles. Genres include landscapes and figurative work. Prefers abstract, figurative and landscape.

Terms: Accepts work on consignment (50% commission) or buys outright for 40-60% of the retail price (30-60 days). Retail price set by the gallery and the artist. Gallery provides promotion; shipping costs are shared. Prefers artwork unframed.

Submissions: Send query letter with résumé, slides and photographs. Write for appointment to show portfolio of originals, photographs and slides. Files everything. Finds new artists through agents, by visiting exhibitions, word of mouth, art publications and sourcebooks, submissions.

CIRCA GALLERY, 1800 W. Cornelia Ave., Chicago IL 60657. (773)935-1854. E-mail: richardelange@hotmail.com. Website: http://www.fota.com. Director: Richard E. Lange. Alternative space, art consultancy, rental gallery. Estab. 1992. Represents 12 emerging artists/year. Exhibited artists include Terry Gaskins. Sponsors 10 shows/year. Average display time 1 month. Open all year; Friday evenings; Saturday afternoon; or by appointment. Located 7 miles northwest of downtown Chicago; 700 sq. ft.; placed in 1910 Ice House factory, 14 ft. ceilings, brick walls. 50% of space for special exhibitions; 50% of space for gallery artists. Clientele: local community, students. 90% private collectors, 10% corporate collectors. Overall price range: $100-1,500; most work sold at $100-500.

Media: Considers all media except installation and all types of prints. Most frequently exhibits photography, paintings and sculpture.

Style: Exhibits expressionism, conceptualism, photorealism, minimalism, pattern painting, color field, hard-edge geometric abstraction, painterly abstraction, postmodern works, realism and surrealism. Exhibits all genres. Prefers cutting edge, figurative and abstract.

Terms: Accepts work on consignment (20% commission). There is a rental fee for space. Retail price set by the artist. Gallery provides promotion and contract; artist pays for shipping. Prefers artwork framed.
Submissions: Send query letter with résumé, business card, 12 slides, photographs, artist's statement, bio and SASE. Call or write for appointment to show portfolio of photographs and slides. Replies in 2 weeks. Files slides. Finds artists through visiting art fairs, word of mouth, friends, local listings.
Tips: Looks for "the artist's professional attitude towards working with us in a collaborative effort!"

CONTEMPORARY ART WORKSHOP, 542 W. Grant Place, Chicago IL 60614. (773)472-4004. Director: Lynn Kearney. Nonprofit gallery. Estab. 1949. Interested in emerging and mid-career artists. Average display time is 4½ weeks "if it's a show, otherwise we can show the work for an indefinite period of time." Open Tuesday-Friday, 12:30-5:30. Clientele: art-conscious public. 75% private collectors, 25% corporate clients. Overall price range: $300-5,000; most artwork sold at $1,000 "or less."
 ● This gallery also offers studios for sculptors, painters and fine art crafts on month to month arrangement, and open space for sculptors.
Media: Considers oil, acrylic, mixed media, works on paper, sculpture, installations and original handpulled prints. Most frequently exhibits paintings, sculpture and works on paper and fine art furniture.
Style: "Any high-quality work" is considered.
Terms: Accepts work on consignment (33% commission). Retail price set by gallery or artist. "Discounts and payment by installments are seldom and only if approved by the artist in advance." Exclusive area representation not required. Gallery provides insurance and promotion.
Submissions: Send query letter with résumé, slides and SASE. Slides and résumé are filed. "First we review slides and then send invitations to bring in a portfolio based on the slides." Finds artists through call for entries in arts papers; visiting local BFA, MFA exhibits; referrals from other artists, collectors.
Tips: "Looks for a professional approach and a fine art school degree (or higher). Artists a long distance from Chicago will probably not be considered."

CORTLAND-LEYTEN GALLERY, 815 N. Milwaukee Ave., Chicago IL 60622. (312)733-2781. Director: S. Gallas. Retail gallery. Estab. 1984. Represents 6 emerging artists/year. Exhibited artists include Martin Geese, Wayne Bertola. Sponsors 4 shows/year. Average display time 1 month. Open all year; Saturday, 12:30-5; Sunday, 12:30-3; and by appointment. Located in River West area near downtown; 2,000 sq. ft. 50% of space for special exhibitions; 50% of space for gallery artists. Clientele: upscale. 75% private collectors, 25% corporate collectors.
Media: Considers oil, pen & ink, acrylic, drawing, sculpture, mixed media, ceramics, collage, craft, engravings and lithographs. Most frequently exhibits sculpture, oil, mixed media.
Style: Exhibits all styles and all genres. Prefers figurative, oil.
Terms: Accepts work on consignment (50% commission). Retail price set by the gallery. Gallery provides insurance, promotion and contract; artist pays for shipping. Prefers artwork framed.
Submissions: Accepts local artists only. Send query letter with résumé, slides, bio. Write for appointment to show portfolio of slides. Replies only if interested within 2 weeks. Files slides, résumés. Finds artists through word of mouth, submissions.

‡OSKAR FRIEDL GALLERY, 1463 W. Chicago Ave., Chicago IL 60622. (312)421-3141. Fax: (312)421-0771. E-mail: o@pg.net. Website: http://www.pg.net/o. Retail gallery. Estab. 1988. Represents 10 emerging, mid-career and established artists. Exhibited artists include (Art)ⁿ Laboratory, Miroslaw Regala, Florian Depenthal and Zhou Brothers. Sponsors 6 shows/year. Average display time 7 weeks. Open all year; Thursday, Friday, Saturday, 12-7. Located downtown in River West gallery district; 800 sq. ft. Clientele: emerging private collectors. 80% private collectors, 20% corporate collectors. Overall price range: $500-30,000; most work sold at $3,000-8,000.
 ● This gallery has an emphasis on interactive material and CD-ROM.
Media: Considers oil, acrylic, pastel, pen & ink, drawings, mixed media, collage, sculpture, interactive multimedia, CD-ROM and installation. Most frequently exhibits oil, acrylic and sculpture.
Style: Exhibits expressionism, neo-expressionism, conceptualism and painterly abstraction. Prefers contemporay, abstract expressionist and conceptualist styles.
Terms: Accepts artwork on consignment (50% commission). Retail price set by gallery and artist. Gallery provides insurance, promotion, contract and some shipping costs from gallery.
Submissions: Send query letter with résumé, sheet of slides, bio, brochure, photographs, SASE and reviews. Portfolio review requested if interested in artist's work. Portolio should include photographs, slides and transparencies. Replies in 4-6 weeks.
Tips: "Apply only to galleries that you know are right for you. Have a body of work of 100 pieces before approaching galleries before approaching galleries."

ROBERT GALITZ FINE ART, 166 Hilltop Court, Sleepy Hollow IL 60118. (847)426-8842. Fax: (847)426-8846. Owner: Robert Galitz. Wholesale representation to the trade. Makes portfolio presentations to corporations. Estab. 1986. Represents 40 emerging, mid-career and established artists. Exhibited artists include Marko Spalatin and Jack Willis. Open by appointment. Located in far west suburban Chicago.
Media: Considers oil, acrylic, watercolor, mixed media, collage, ceramic, fiber, original handpulled prints, engravings, lithographs, pochoir, wood engravings, mezzotints, serigraphs and etchings. "Interested in original works on paper."

Style: Exhibits expressionism, painterly abstraction, surrealism, minimalism, impressionism and hard-edge geometric abstraction. Interested in all genres. Prefers landscapes and abstracts.

Terms: Accepts artwork on consignment (variable commission) or artwork is bought outright (25% of retail price; net 30 days). Retail price set by artist. Customer discounts and payment by installment are available. Gallery provides promotion and shipping costs from gallery. Prefers artwork unframed only.

Submissions: Send query letter with SASE and submission of art. Portfolio review requested if interested in artist's work. Files bio, address and phone.

Tips: "Do your thing and seek representation—don't drop the ball!—Keep going—don't give up!"

✓GALLERY E.G.G. (EARTH GODDESS GROUP), 1474 W. Hubbard St., 2nd Floor, Chicago IL 60622. (312)666-0553. Fax: (312)666-0553. Directors: Analisa Leppanen and Marianne Taylor-Leppanen. Nonprofit gallery, alternative space and museum. Estab. 1993. Represents 10 emerging, mid-career and established artists/year. Exhibited artists include James Mesplé, Maureen Warren. Sponsors 8 shows/year. Average display time 6 weeks. Open all year; Tuesday-Saturday, 12-5. Located in River West, 3,000 sq. ft.; large loft space in industrial building. 50% for rotating exhibit, 50% for permanent collection/museum. Clientele: varied. 100% private collectors. Overall price range: $300-10,000; most work sold at $300-2,000.

Media: Considers all media except glass and craft, and all types of prints. Most frequently exhibits sculpture, assemblage, oil and acrylic.

Style: Exhibits abstract, naturalism, primitivism, surrealism. Genres include environmental and spiritual.

Terms: Accepts work on consignment (30% commission). Buys outright for permanent collection for 70% of retail price. For group shows, there is a participation fee of $35. Retail price set by the gallery and the artist. Gallery provides insurance, promotion and contract; artists pays for shipping. Prefers paintings unframed; drawings, watercolors, etc. framed. For 1-4 person shows, artists/gallery split cost of promotion.

Submissions: Send query letter with résumé, brochure, 10-20 slides, artists's statement, SASE. Call for appointment to show portfolio of photographs and slides. Replies in 2 months. Files "anything the artist wants me to keep, otherwise slides and photos are returned in a SASE. I advertise thematic shows, but I find many artists through word of mouth and referrals by other artists."

Tips: "Develop a focused and consistent body of work of about 20-30 works, then research those galleries that seem to show that type of work. We are interested in environmental and spiritual artwork, work that expresses a reverence for the earth, as well as artwork that uses found or recycled objects. Call for themes of upcoming shows."

GALLERY 312, 312 N. May St., Suite 110, Chicago IL 60607. (312)942-2500. Fax: (312)942-0574. Nonprofit gallery which benefits the Peach Club—working with children at risk. Estab. 1994. Exhibits established artists. Interested in seeing the work of emerging artists only for special shows. Exhibited artists include Harry Callahan, Michiko Itatani, Leon Golub, Ray K. Metzker, Jed Fielding, Joseph Jachna, Joseph Sterling, Charles Swedlund, John Heward, Sylvia Safdie and Yasuhiro Ishimoto. Sponsors 6 shows/year. Average display time 6 weeks. Open all year; Tuesday-Saturday, 11-5. Located in Fulton/Randolph Market District; 7,200 sq. ft.; 28 ft. ceiling. Gallery is in restored boiler room of large warehouse. 100% of space for special exhibitions. Clientele: "museum-goers," educators, artists, collectors, students. 50% private collectors, 50% corporate collectors. Overall price range: $2,000-75,000; most work sold at $5,000-15,000.

Media: Considers oil, acrylic, drawing, mixed media, sculpture, installation, photography, video. Considers woodcuts and linocuts. Most frequently exhibits oil on canvas, photography, sculpture and museum exhibits on loan.

Style: Exhibits conceptualism, minimalism, color field, postmodern. Prefers contemporary, abstract, book paper art.

Terms: Accepts work on consignment (50% commission). Retail price set by gallery. Gallery provides insurance, promotion and contract; artist pays for shipping. Prefers paper and photographs framed; canvas etc. unframed.

Submissions: Send query letter with résumé, brochure, business card, slides, photographs, reviews, artists' statement, bio and SASE. Write for appointment to show portfolio of transparencies. Replies in 6-8 weeks. Files catalogs. Finds artists through referrals by other galleries, museums, guest curators and submissions.

GRUEN GALLERIES, 226 W. Superior St., Chicago IL 60610. (312)337-6262. Co-Directors: Bradley Lincoln and Renée Sax. Estab. 1959. Represents 20 emerging, mid-career and established artists. Sponsors 9 solo and 3 group shows/year. Average display time is 1 month. Large space with high ceiling. Overall price range: $500-25,000; most artwork sold at $2,500-5,000.

Media: Considers oil, acrylic, paper and contemporary sculpture. Most frequently exhibits acrylic and oil.

Style: Exhibits painterly abstraction. Genres include landscapes and figurative work.

Terms: Accepts work on consignment (50% commission). Retail price set by gallery or artist. Sometimes offers customer discounts and payment by installment. Exclusive area representation required. Gallery provides promotion; shipping costs are shared.

Submissions: Send query letter, artist's statement, résumé, at least 10-12 slides of current work (properly labeled) and SASE. Portfolio review requested if interested in artist's work.

Tips: "Label slides well, with dimensions, medium and dates. Artist should have created at least six pieces (that would constitute a series) before approaching galleries. Although this varies a great deal."

‡HYDE PARK ART CENTER, 5307 S. Hyde Park Blvd., Chicago IL 60615. (773)324-5520. Executive Director: Eva Olson. Nonprofit gallery. Estab. 1939. Exhibits emerging artists. Sponsors 9 group shows/year. Average display time is 4-6 weeks. Located in the historic Del Prado building, in a former ballroom. "Primary focus on Chicago area

artists not currently affiliated with a retail gallery." Clientele: general public. Overall price range: $100-10,000.
Media: Considers all media. Interested in seeing "innovative, 'cutting edge' work by young artists; also interested in proposals from curators, groups of artists."
Terms: Accepts work "for exhibition only." Retail price set by artist. Sometimes offers payment by installment. Exclusive area representation not required. Gallery provides insurance and contract.
Submissions: Send query letter with résumé, no more than 6 slides and SASE. Will not consider poor slides. "A coherent artist's statement is helpful." Portfolio review not required. Replies in 3-6 weeks.
Tips: Finds artists through open calls for slides, curators, visiting exhibitions (especially MFA programs) and artists' submissions. Prefers not to receive phone calls. "Do not bring work in person."

ILLINOIS ART GALLERY, Suite 2-100, 100 W. Randolph, Chicago IL 60601. (312)814-5322. Fax: (312)814-3471. Assistant Administrator: Jane Stevens. Museum. Estab. 1985. Exhibits emerging, mid-career and established artists. Sponsors 6-7 shows/year. Average display time 7-8 weeks. Open all year. Located "in the Chicago loop, in the James R. Thompson Center designed by Helmut Jahn." 100% of space for special exhibitions.
Media: All media considered, including installations.
Style: Exhibits all styles and genres, including contemporary and historical work.
Terms: "We exhibit work, do not handle sales." Gallery provides insurance and promotion; artist pays for shipping. Prefers artwork framed.
Submissions: Accepts only artists from Illinois. Send résumé, 10 high quality slides, bio and SASE.

‡ILLINOIS ARTISANS PROGRAM, James R. Thompson Center, 100 W. Randolph St., Chicago IL 60601. (312)814-5321. Fax: (312)814-3891. Director: Ellen Gantner. Three retail shops operated by the nonprofit Illinois State Museum Society. Estab. 1985. Represents over 1,000 artists; emerging, mid-career and established. Average display time 6 months. "Accepts only juried artists living in Illinois." Clientele: tourists, conventioneers, business people, Chicagoans. Overall price range: $10-5,000; most artwork sold at $25-100.
Media: Considers all media. "The finest examples in all media by Illinois artists."
Style: Exhibits all styles. "Seeks contemporary, traditional, folk and ethnic arts from all regions of Illinois."
Terms: Accepts work on consignment (50% commission). Retail price set by gallery and artist. Sometimes offers customer discounts. Exclusive area representation not required. Gallery provides promotion and contract.
Submissions: Send résumé and slides. Accepted work is selected by a jury. Résumé and slides are filed. "The finest work can be rejected if slides are not good enough to assess." Portfolio review not required. Finds artists through word of mouth, requests by artists to be represented and by twice-yearly mailings to network of Illinois crafters announcing upcoming jury dates.

KLEIN ART WORKS, 400 N. Morgan, Chicago IL 60622. (312)243-0400. Fax: (312)243-6782. E-mail: info@kleinart. com. Website: http://www.kleinart.com. Director: Paul Klein and Judith Simon. Retail gallery. Estab. 1981. Represents 20 emerging, mid-career and established artists. Interested in seeing the work of emerging artists. Exhibited artists include Sam Gilliam and Stephanie Weber. Sponsors 10 shows/year. Average display time 5 weeks. Open all year. Located in industrial section of downtown; 4,000 sq. ft.; spacious, with steel floors, no columns and outdoor sculpture garden. 80% of space for special exhibitions; 20% of space for gallery artists. Clientele: 75% private collectors, 25% corporate collectors. Overall price range: $1,000-50,000; most artwork sold at $2,000-10,000.
Media: Considers oil, acrylic, mixed media, sculpture, ceramic, installation and photography. Most frequently exhibits painting and sculpture.
Style: Exhibits abstraction.
Terms: Accepts work on consignment (50% commission). Retail price set by gallery and artist. Gallery provides insurance, promotion and contract; shipping costs are shared.
Submissions: Send query letter with résumé, slides, bio, reviews and SASE. Replies in 2-6 weeks.

KUNSTWERK GALERIE, 1800 W. Cornelia Ave., #106A, Chicago IL 60657. (773)935-1854. Fax: (773)478-2395. Website: http://www.fota.com. Director: Thomas E. Frerk. Retail gallery, alternative space, art consultancy. Estab. 1993. Represents 12 emerging artists/year. Exhibited artists include Colin Lambides and Doug Birkenheuer. Sponsors 6 shows/year. Average display time 1 month. Open all year; Friday evenings, Saturday afternoons by appointment. Located 7 miles northwest of downtown Chicago; 500 sq. ft.; well-lighted, 14 ft. ceilings, located in old factory, lots of brick wall and dry wall to show. Clientele: local community—many diverse groups. 90% private collectors, 10% corporate collectors. Overall price range: $100-2,000; most work sold at $200-500.
Media: Considers all media and all types of prints. Most frequently exhibits paintings, photography, mixed media, sculpture and installation art.
Style: Exhibits neoexpressionism, conceptualism, street art, environmental/cultural, painterly abstraction and surrealism. Prefers conceptualism, mixed media, pop art and avant garde.
Terms: Accepts work on consignment (25% commission) and/or rental fee for space. The rental fee covers 1 month; there is a per event price. Price set per artist. Gallery provides promotion and contract; artist pays for shipping. Prefers artwork framed.
Submissions: Send query letter with résumé, business card, 3 or more slides, photographs, artist's statement, bio, SASE. Call for appointment to show portfolio of photographs and slides. Replies in 1 week. Files color photocopies. Finds artists through visiting shows/openings, referrals and word of mouth.

Tips: "Let gallery dealer know why you are approaching his or her gallery as opposed to another. You should have a body of work of at least six pieces."

NORTHERN ILLINOIS UNIVERSITY ART GALLERY IN CHICAGO, 215 W. Superior, 3rd Floor, Chicago IL 60610. (312)642-6010. Fax: (312)642-9635. Website: http://www.vpa.niu.edu/museum. Executive Director: Peggy Doherty. Nonprofit university gallery. Estab. 1984. Exhibits emerging, mid-career and established artists. Sponsors 6 shows/year. Average display time 6-7 weeks. Closed August. Located in Chicago gallery area (near downtown); 1,656 sq. ft. 100% of space for special exhibitions. Overall price range: $100-50,000.
Media: Considers all media.
Style: Exhibits all styles and genres. Interested in seeing contemporary styles.
Terms: "No charge to artist and no commission." Retail price set by artist. Gallery provides insurance and promotion; shipping costs are shared, depending on costs. Prefers artwork framed.
Submissions: Send query letter with résumé, slides, SASE, reviews and statement. Replies "ASAP." Files résumés, bios, statements and paperwork.
Tips: "Always include SASE. Work for exhibition is rarely selected at the first viewing."

‡**SOUTHPORT GALLERY**, 3755 N. Southport, Chicago IL 60613. (312)327-0372. Owner: Donna Wolfe. Retail gallery. Estab. 1988. Represents 3 artists. Interested in emerging artists. Sponsors 5 solo shows/year. Average display time 2 months. Accepts only artists from Chicago. Located near Wrigley Field and Music Box Theatre. Clientele: neighborhood people as well as the theatre crowd. Overall price range: $100-1,000; "we do exhibit and sell work for over $1,000."
Media: Considers oil, acrylic, watercolor, pen & ink, drawings, mixed media, collage, sculpture and photography. Most frequently exhibits watercolor, oil, pen & ink and etchings.
Style: Exhibits impressionism, realism, photorealism, surrealism, primitivism, color field, painterly abstraction and figurative work. Prefers realism, surrealism and photorealism. "Ideally, we seek emerging artists, offering them the opportunity to exhibit their work under standards that require it to be presented in a very professional manner. More established artists have found Southport gallery to be the perfect place to have an exhibit of their etchings, drawings or smaller works that fit within our price range."
Terms: Accepts work on consignment (40% commission). Retail price set by gallery and artist. Exclusive area representation not required. Gallery provides promotion and contract, opening reception and announcements. Prefers artwork framed.
Submissions: Send query letter with résumé, at least 5 slides, brochure, photographs, business card and bio. Call for appointment to show portfolio of originals, slides and photographs. Replies only if interested within 3 weeks. Files résumé, bio and photos.
Tips: "Keep in mind our general price range and the fact that our gallery is small and therefore not suitable for exhibits of entirely large pieces (60×64). Qualities we look for include enthusiasm, professionalism and pride, plus a body of work of at least 20-25 pieces. Present a fair representation of strong work and be secure about the way you present it. Presentation is extremely important."

‡**SUBURBAN FINE ARTS CENTER**, 1913 Sheridan Rd., Highland Park IL 60035-2607. (708)432-1888. Executive Director: Ann Rosen. Nonprofit gallery. Estab. 1960. Represents "hundreds" of emerging, mid-career and established artists/year. 2,200 members. Sponsors 12 shows/year. Average display time 1 month. Open all year, Monday-Saturday, 9-5. Located downtown, in Highland Park, a suburb of Chicago; 7,000 sq. ft.; spacious, light and airy. 20% of space for special exhibitions; 20% of space for gallery artists. Clientele: vast array. 100% private collectors. Overall price range: $20-30,000; most work sold at $100.
Media: Considers all media and all types of prints. Most frequently exhibits painting and photography.
Style: Exhibits all styles, all genres. Prefers expressionism, conceptualism and contemporary.
Terms: Accepts work on consignment (20% commission). Retail price set by the artist. Gallery provides insurance, promotion and contract; artist pays shipping costs to and from gallery. Prefers artwork framed.
Submissions: Send query letter with résumé, slides and bio. Call or write for appointment to show portfolio of slides. Replies in 1 week. Files résumé, bio, artist statement.
Tips: "Prepare slides well, along with well written proposal. Talent counts more than quantity."

‡**VALE CRAFT GALLERY**, 230 W. Superior St., Chicago IL 60610. (312)337-3525. Fax: (312)337-3530. Owner: Peter Vale. Retail gallery. Estab. 1992. Represents 50 emerging, mid-career artists/year. Exhibited artists include Liz Mamorsky and Maria Simon. Sponsors 7 shows/year. Average display time 2 months. Open all year; Tuesday-Friday, 10:30-5:30; Saturday, 11-5; Sunday, 12-4 (April-December); first Fridays are openings with hours expanded to 8 p.m. Located in River North gallery district near downtown; 2,100 sq. ft.; lower level of prominent gallery building; corner location with street-level windows provides great visibility. 40% of space for special exhibitions; 60% of space for gallery artists. Clientele: private collectors, tourists, people looking for gifts, people furnishing and decorating their homes. 50% private collectors, 5% corporate collectors. Overall price range; $50-5,000; most work sold at $100-500.
Media: Considers paper, sculpture, ceramics, craft, fiber, glass, metal, wood and jewelry. Most frequently exhibits fiber wall pieces, jewelry, glass, ceramic sculpture and mixed media.
Style: Exhibits contemporary craft. Prefers decorative, colorful and natural or organic.
Terms: Accepts work on consignment (50% commission). Retail price set by the artist. Gallery provides insurance,

promotion, contract and shipping costs from gallery; artist pays shipping costs to gallery.
Submissions: Accepts only artists from US. Only craft media. Send query letter with résumé, 10-20 slides (including slides of details), bio or artist's statement, photographs, record of previous sales, SASE and reviews if available. Call for appointment to show portfolio of originals and photographs. Replies in 1 month. Files résumé (if interested). Finds artists through submissions, art and craft fairs, publishing a call for entries, artists' slide registry and word of mouth.
Tips: "Call ahead to find out if the gallery is interested in showing the particular type of work you do; send professional slides and statement about the work or call for an appointment to show original work. Try to visit the gallery ahead of time to find out if your work fits into the gallery's focus. I would suggest you have completed at least ten pieces in a body of work before approaching galleries."

SONIA ZAKS GALLERY, 311 W. Superior St., Suite 207, Chicago IL 60610. (312)943-8440. Fax: (312)943-8489. Director: Sonia Zaks. Retail gallery. Represents 25 emerging, mid-career and established artists/year. Sponsors 10 solo shows/year. Average display time is 1 month. Overall price range: $500-15,000.
Media: Considers oil, acrylic, watercolor, drawings, sculpture.
Style: Specializes in contemporary paintings, works on paper and sculpture. Interested in narrative work.
Terms: Accepts work on consignment. Retail price is set by gallery and artist. Exclusive area representation required. Gallery provides insurance and contract.
Submissions: Send query letter with 20 slides.
Tips: "A common mistake some artists make is presenting badly-taken and unmarked slides. Artists should write to the gallery and enclose a résumé, about one dozen well-marked slides and a SASE."

Indiana

‡ARTLINK, 437 E. Berry St., Suite 202, Fort Wayne IN 46802-2801. (219)424-7195. Executive Director: Betty Fishman. Nonprofit gallery. Estab. 1979. Exhibits emerging and mid-career artists. 50 members. Sponsors 9 shows/year. Average display time 5-6 weeks. Open all year. Located 4 blocks from central downtown, 2 blocks from Art Museum and Theater for Performing Arts; in same building as a cinema theater, dance group and historical preservation group; 1,600 sq. ft. 100% of space for special exhibitions. Clientele: "upper middle class." Overall price range: $100-500; most artwork sold at $200.
 • Publishes a newsletter, *Genre*, which is distributed to members. Includes features about upcoming shows, profiles of members and other news. Some artwork shown at gallery is reproduced in b&w in newsletter. Send SASE for sample and membership information.
Media: Considers all media, including prints. Prefers work for annual print show and annual photo show, sculpture and painting.
Style: Exhibits expressionism, neo-expressionism, painterly abstraction, conceptualism, color field, postmodern works, photorealism, hard-edge geometric abstraction; all styles and genres. Prefers imagism, abstraction and realism. "Interested in a merging of craft/fine arts resulting in art as fantasy in the form of bas relief, photo/books, all experimental media in nontraditional form."
Terms: Accepts work on consignment only for exhibitions (35% commission). Retail price set by artist. Gallery provides insurance, promotion and contract; shipping costs are shared. Prefers framed artwork.
Submissions: Send query letter with résumé, no more than 6 slides and SASE. Reviewed by 14-member panel. Replies in 2-4 weeks. "Jurying takes place three times per year unless it is for a specific call for entry. A telephone call will give the artist the next jurying date."
Tips: "Call ahead to ask for possibilities for the future and an exhibition schedule for the next two years will be forwarded." Common mistakes artists make in presenting work are "bad slides and sending more than requested—large packages of printed material. Printed catalogues of artist's work without slides are useless." Sees trend of community-wide cooperation by organizations to present art to the community.

CENTRE ART GALLERY, 301B E. Carmel Dr., Carmel IN 46032. (317)844-6421. Fax: (317)844-7875. President: Mark Weintraut. Retail gallery and art consultancy. Estab. 1955. Represents 30 emerging, mid-career and established artists. Exhibited artists include Rosemary Thomas and Ron Parker. Sponsors 5 shows/year. Average display time 1 month. Open all year. Located "on most traveled street in town;" 4,000 sq. ft.; "freestanding building, professionally designed and built as gallery." 50% of space for special exhibitions. Clientele: 80% private collectors, 20% corporate collectors. Overall price range: $300-60,000; most work sold at $1,500-15,000.
Media: Considers oil, acrylic, watercolor, pastel, collage, paper, sculpture, ceramic, craft, fiber, glass, original handpulled prints, offset reproductions, engravings, lithographs, mezzotints, serigraphs and etchings.
Style: Exhibits expressionism, painterly abstraction, conceptualism, impressionism and realism. Genres include landscapes, florals, Southwestern and wildlife. Prefers realism, impressionism and abstract.
Terms: Accepts artwork on consignment (50% commission). Retail price set by artist. Gallery provides insurance, promotion, contract and shipping costs from gallery. Prefers artwork unframed.
Submissions: Send query letter with résumé, slides, photographs and SASE. Call for appointment to show portfolio of originals and photographs. Replies in 1 month. Files all accepted work.
Tips: "Be professional in your approach."

‡EDITIONS LIMITED GALLERY OF FINE ART, 4040 E. 82nd St., Indianapolis IN 46250-1620. (317)842-1414. Owner: John Mallon. Director: Marta Blades. Retail gallery. Represents emerging, mid-career and established artists. Sponsors 4 shows/year. Average display time 1 month. Open all year. Located "north side of Indianapolis; track lighting, exposed ceiling, white walls." Clientele: 60% private collectors, 40% corporate collectors. Overall price range: $100-8,500; most artwork sold at $200-1,200.
Media: Considers oil, acrylic, watercolor, pastel, pen & ink, drawings, mixed media, collage, works on paper, sculpture, ceramics, craft, fiber, glass, photography, original handpulled prints, woodcuts, engravings, mezzotints, etchings, lithographs, pochoir and serigraphs. Most frequently exhibits mixed media, acrylic and pastel.
Style: Exhibits all styles and genres. Prefers abstract, landscapes and still lifes.
Terms: Accepts work on consignment (50% commission). Retail price set by artist. "I do discuss the prices with artist before I set a retail price." Sometimes offers customer discounts and payment by installment. Gallery provides insurance, promotion and contract; shipping costs are shared. Prefers artwork unframed.
Submissions: Send query letter with slides, SASE and bio. Portfolio review requested if interested in artist's work. Portfolio should include originals, slides, résumé and bio. Files bios, reviews, slides and photos.
Tips: Does not want to see "hobby art."

‡WILLIAM ENGLE GALLERY, 1724 E. 86th St., Indianapolis IN 46240-2360. (317)255-5700. President: William E. Engle. Retail gallery. Estab. 1981. Represents 50 mid-career and established artists; interested in seeing the work of emerging artists. Exhibited artists include Lilian Fendig and Hirokazu Yamaguchi. Sponsors 2-3 shows/year. Open all year. Located in the gallery area. 50% of space for special exhibitions. Clientele: 50% private collectors, 50% corporate clients. Overall price range: $100-10,000; most artwork sold at $600.
Media: Considers oil, acrylic, watercolor, pastel, pen & ink, drawings, mixed media, collage, works on paper, sculpture, ceramic, craft, fiber, glass, photography, original handpulled prints, woodcuts, lithographs, serigraphs, linocuts and etchings. Most frequently exhibits painting, ceramics, photography and watercolor.
Style: Exhibits expressionism, painterly abstraction, conceptualism, postmodern works, impressionism, realism and hard-edge geometric abstraction. All genres. Prefers figurative work, landscapes, traditional and Western painting.
Terms: Artwork is accepted on consignment (50% commission). Retail price set by the artist. Gallery provides promotion, contract and shipping costs from gallery. Prefers framed artwork.
Submissions: Send query letter with résumé, slides, bio, brochure, photographs, SASE, business card and reviews. Write to schedule an appointment to show a portfolio, which should include slides and photographs. Replies in 2 weeks.
Tips: "Be imaginative. Have a good presentation available accurately showing work—true size and color. Ask and research area to determine the most appropriate gallery to contact. Should have had at least five years of exhibitions, solo or group to qualify as a sincere practicing artist."

‡THE FORT WAYNE MUSEUM OF ART SALES AND RENTAL GALLERY, 311 E. Main St., Ft. Wayne IN 46802. (219)422-6467. E-mail: fwma@art-museum-ftwayne.org. Website: http://www.art-museum-ftwayne.org. Gallery Coordinator: Vanessa Freygang. Retail and rental gallery. Estab. 1983. Represents emerging, mid-career and established artists who reside within a 150 mile radius of Fort Wayne. Clientele: 25% private collectors, 75% corporate clients. Overall price range: $15-4,500; most artwork sold at $250-650.
Media: Considers oil, acrylic, watercolor, pastel, pen & ink, sculpture, photography, mixed media, collage, ceramics, glass, original handpulled prints and computer-generated art.
Style: "We try to show the best regional artists available. We jury by quality, not salability." Exhibits impressionism, expressionism, realism, photorealism and painterly abstraction. Genres include landscapes, florals, Americana, Southwestern, Western and wildlife. Prefers landscapes, abstractions and florals. "We do not do well with works that are predominantly figures."
Terms: Accepts work on consignment (40% commission). Retail price set by artist. Exclusive area representation not required. Gallery provides insurance, promotion and contract; artist pays for shipping.
Submissions: Send query letter with résumé, brochure, 3-8 slides, photographs, bio and SASE. Slides and résumés are filed.
Tips: "Our Club Art seems to be selling quite a bit of merchandise. 'Clever' art at moderate prices sells well in our gift shop."

‡INDIAN IMAGE GALLERY, 100 NW Second St., Dept. AGDM, Suite 108, Evansville IN 47708. (812)464-5703. President: Stephen Falls. Retail gallery. Estab. 1972. Represents 40 emerging, mid-career and established artists. Exhibited artists include Donald Vann and Paladine Roye. Sponsors 3 shows/year. Average display time 3 weeks. Open all year. Located downtown; 1,200 sq. ft.; historic building. 20% of space for special exhibitions. Clientele: business/professional. 95% private collectors, 5% corporate collectors. Overall price range: $30-10,000; most work sold at $100-600.
Media: Considers all media, including original handpulled prints, engravings, lithographs, etchings, serigraphs, offset reproductions and posters. Most frequently exhibits painting, sculpture and jewelry.
Style: Exhibits realism. Genres include Southwestern and Western.
Terms: Accepts artwork on consignment (40% commission) or artwork is bought outright for 50% of the retail price. Retail price set by the gallery and the artist. Gallery provides promotion and contract; shipping costs are shared. Prefers artwork unframed.
Submissions: Accepts mainly Native American artists. Send query letter with slides and bio. Call for appointment to

show portfolio, which should include slides and photographs. Replies in 2 weeks.

INDIANAPOLIS ART CENTER, 820 E. 67th St., Indianapolis IN 46220. (317)255-2464. Fax: (317)254-0486. E-mail: inartctr@inetdirect.net. Website: http://www.inetdirect.net/inartctr. Director of Exhibitions and Artist Services: Julia Moore. Nonprofit art center. Estab. 1934. Prefers emerging artists. Exhibits approximately 100 artists/year. 1,800 members. Sponsors 15-20 shows/year. Average display time 5 weeks. Open Monday-Friday, 9-10; Saturday, 9-3; Sunday, 12-3. Located in urban residential area; 2,560 sq. ft. in 3 galleries; "Progressive and challenging work is the norm!" 100% of space for special exhibitions. Clientele: mostly private. 90% private collectors, 10% corporate collectors. Overall price range: $50-15,000; most work sold at $100-5,000. Also sponsors annual Broad Ripple Art Fair in May.
Media: Considers all media and all types of original prints. Most frequently exhibits painting, sculpture installations and fine crafts.
Style: All styles. Interested in figurative work. "In general, we do not exhibit genre works. We do maintain a referral list, though." Prefers postmodern works, installation works, conceptualism.
Terms: Accepts work on consignment (35% commission). Commission is in effect for 3 months after close of exhibition. Retail price set by artist. Gallery provides insurance, promotion, contract; artist pays for shipping. Prefers artwork framed.
Submissions: "Special consideration for IN, OH, MI, IL, KY artists." Send query letter with résumé, minimum of 20 slides, SASE, reviews and artist's statement. Replies in 5-6 weeks. Season assembled in January.
Tips: "Research galleries thoroughly—get on their mailing lists, and visit them in person at least twice before sending materials. Always phone to get the gallery's preferred timing and method of viewing new work, and adhere to these preferences. Find out the 'power structure' of the targeted galleries and use it to your advantage. Most artists need to gain experience exhibiting in smaller or non-profit spaces before approaching a gallery—work needs to be of consistent, dependable quality. Have slides done by a professional if possible. Stick with one style—no scattershot approaches. Have a concrete proposal with installation sketches (if it's never been built). We book two years in advance—plan accordingly. Do not call. Put me on your mailing list one year before sending application so I can be familiar with your work and record—ask to be put on my mailing list so you know the gallery's general approach. It works!"

‡RUSCHMAN GALLERY, 948 N. Alabama St., Indianapolis IN 46202. (317)634-3114. Director: Mark Ruschman. Retail gallery. Estab. 1985. Represents 40 emerging and mid-career artists/year. Sponsors 10 shows/year. Average display time 1 month. Open all year; Tuesday-Saturday, 11-5. Located downtown—near Northeast side; 1,800 sq. ft.; two gallery showrooms which allow solo and group exhibitions to run concurrently. 100% of space for gallery artists. Clientele: local individual and corporate collectors. 60% private collectors, 40% corporate collectors. Overall price range: $500-30,000; most work sold at $1,000-4,000.
Media: Considers all media (including all types of prints small editions) except large run prints and posters. Most frequently exhibits painting, sculpture, textile.
Style: Exhibits all styles. Prefers abstract, landscape, figurative.
Terms: Accepts work on consignment (40-50% commission). Retail price set by the gallery and the artist. Gallery provides promotion and contract; gallery pays shipping costs to gallery; artist pays for shipping from gallery. Prefers artwork framed.
Submissions: Send query letter with résumé, slides, bio, SASE. Call for appointment to show portfolio of slides, bio. Replies in 3 weeks. Files referrals by other artists and submissions.

Iowa

‡ARTS FOR LIVING CENTER, P.O. Box 5, Burlington IA 52601-0005. Located at Seventh & Washington. (319)754-8069. Fax: (319)754-4731. Executive Director: Lois Rigdon. Nonprofit gallery. Estab. 1974. Exhibits the work of mid-career and established artists. May consider emerging artists. 425 members. Sponsors 10 shows/year. Average display time 3 weeks. Open all year; Tuesday-Friday, 12-5; weekends, 1-4. Located in Heritage Hill Historic District, near downtown; 2,500 sq. ft.; "former sanctuary of 1868 German Methodist church with barrel ceiling, track lights." 35% of space for special exhibitions. Clientele: 80% private collectors, 20% corporate collectors. Overall price range: $25-1,000; most work sold at $75-500.
Media: Considers all media and all types of prints. Most frequently exhibits watercolor, intaglio and sculpture.
Style: Exhibits all styles.
Terms: Accepts work on consignment (25% commission). Retail price set by artist. Gallery provides insurance, promotion and contract; artist pays for shipping. Prefers artwork framed.
Submissions: Send query letter with résumé, slides, bio, brochure, photographs, SASE and reviews. Call or write for appointment to show portfolio of slides and gallery experience verification. Replies in 1 month. Files résumé and photo for reference if interested.

BARB'S FINE ART, 788 Sixth St., Marion IA 52302. (319)373-1090. Fax: (319)373-8401. Owner: Barb. Retail Gallery. Estab. 1970. Represents 10-15 emerging, mid-career and established artists. Exhibited artists include Barb Prall and Lena Lew. Sponsors 6 exhibtions/year. Average display time 2 months. Open all year; Tuesday and Thursday, 10-9; Wednesday and Friday, 10-5; Saturday, 10-4. Located near downtown; 3,000 sq. ft. Clientele: upscale, local commu-

nity, students. 90% private collectors, 10% corporate collectors. Overall price range: $50-1,800.

Media: Considers all media and prints. Most frequently exhibits oil paintings, photographs and hand-made paper.

Style: Exhibits painterly abstraction, impressionism, photorealism and realism. Exhibits all genres. Most frequently exhibits figurative impressionism, portraits and wildlife.

Terms: Artwork accepted on consignment. Retail price set by artist. Gallery provides promotion. Artist pays for shipping.

Submissions: Send query letter with slides. Write for appointment to show portfolio of photographs or slides. Replies in 3 weeks.

CORNERHOUSE GALLERY AND FRAME, 2753 First Ave. SE, Cedar Rapids IA 52402. (319)365-4348. Fax: (319)365-1707. Director: Janelle McClain. Retail gallery. Estab. 1976. Represents 150 emerging, mid-career and established artists. Exhibited artists include John Preston, Grant Wood and Stephen Metcalf. Sponsors 3 shows/year. Average display time 1 month. Open all year; Monday-Friday, 9:30-5:30; Saturday, 9:30-4. 3,000 sq. ft.; "converted 1907 house with 3,000 sq. ft. matching addition devoted to framing, gold leafing and gallery." 25% of space for special exhibitions. Clientele: "residential/commercial, growing collectors." 80% private collectors. Overall price range: $50-20,000; most artwork sold at $200-2,000.

Media: Considers oil, acrylic, watercolor, pastel, drawings, mixed media, collage, works on paper, sculpture, ceramic, fiber, glass, original handpulled prints, woodcuts, wood engravings, linocuts, engravings, mezzotints, jewelry, etchings, lithographs and serigraphs. Most frequently exhibits oil, acrylic, original prints and ceramic works.

Style: Exhibits all styles. Genres include florals, landscapes, figurative work. Prefers regionalist/midwestern subject matter. Exhibits only original work—no reproductions.

Terms: Accepts work on consignment (45% commission) or artwork is bought outright for 50% of retail price (net 30 days). Retail price set by artist and gallery. Gallery provides insurance, promotion and shipping costs from gallery. Prefers artwork unframed.

Submissions: Prefers only Midwestern artists. Send résumé, 20 slides, photographs and SASE. Portfolio review requested if interested in artist's work. Replies in 1 month. Files résumé and photographs. Finds artists through word of mouth, submissions/self promotions and art collectors' referrals. Do not stop in unannounced.

Tips: "Send a written letter of introduction along with five representative images and retail prices. Ask for a return call and appointment. Once appointment is established, send a minimum of 20 images and résumé so it can be reviewed before appointment. Do not approach a gallery with only a handful of works to your name. I want to see a history of good-quality works. I tell artists they should have completed at least 50-100 high-quality works with which they are satisfied. An artist also needs to know which works to throw away!"

KAVANAUGH ART GALLERY, 131 Fifth St., W. Des Moines IA 50265. (515)279-8682. Fax: (515)279-7609. E-mail: kagallery@aol.com. Director: Carole Kavanaugh. Retail gallery. Estab. 1990. Represents 25 mid-career and established artists/year. May be interested in seeing the work of emerging artists in the future. Exhibited artists include Kati Roberts, Don Hatfield, Dana Brown, Gregory Steele, August Holland, Ming Feng and Larry Guterson. Sponsors 3-4 shows/year. Averge display time 3 months. Open all year; Monday-Saturday, 10-5. Located in Old Town shopping area; 2,800 sq. ft. 70% private collectors, 30% corporate collectors. Overall price range: $300-20,000; most work sold at $800-3,000.

Media: Considers all media and all types of prints. Most frequently exhibits oil, acrylic and pastel.

Style: Exhibits color field, impressionism, realism, florals, portraits, western, wildlife, southwestern, landscapes, Americana and figurative work. Prefers landscapes, florals and western.

Terms: Accepts work on consignment (50% commission). Retail price set by the artist. Gallery provides insurance, promotion and contract. Shipping costs are shared. Prefers artwork unframed.

Submissions: Send query letter with résumé, bio and photographs. Portfolio should include photographs. Replies in 2-3 weeks. Files bio and photos. Finds artists through word of mouth, referrals by other artists, visiting art fairs and exhibitions, artist's submissions.

Tips: "Get a realistic understanding of the gallery/artist relationship by visiting with directors. Be professional and persistent."

‡PERCIVAL GALLERIES, INC., 528 Walnut, Firstar Bank Building, Des Moines IA 50309-4106. (515)243-4893. Fax: (515)243-9716. Director: LaDonna Matthes. Retail gallery. Estab. 1969. Represents 100 emerging, mid-career and established artists. Exhibited artists include Byron Burford, Mauricio Lasansky and Karen Strohbeen. Sponsors 10 shows/year. Average display time is 3 weeks. Open all year. Located in downtown Des Moines; 3,000 sq. ft. 50-75% of space for special exhibitions.

Terms: Accepts work on consignment (50% commission). Retail price set by gallery. Gallery provides insurance and promotion.

Submissions: Send query letter with résumé, slides, photographs, bio and SASE. Call or write for appointment to show portfolio of originals, photographs and slides. Replies in 1 month. Files only items of future interest.

Kansas

‡ARTFRAMES ... Bungalo Gallery, 912 Illinois St., Lawrence KS 66044. (913)842-1991. Owner: Fred Dack. Retail gallery, cooperative gallery (private), alternative space and art consultancy of community-based fine arts and

crafts. Estab. 1989. Represents 25 emerging, mid-career and established artists. Exhibited artists include Gary Hinman, Christine Musgrave, Stan Herd and Kim Webster. Sponsors 4-8 shows/year. Average display time 5-8 weeks. Open all year. Located "near the historic downtown shopping center and the Kansas University campus; 18,000 sq. ft.; (6,000 sq. ft. outdoor sculpture garden center), 3 floors in 65-year-old bungalow with wood floors, woodwork and multi-level spaces." 15% of space for special exhibitions. Clientele: "community leaders, academic, business leaders." 65% private collectors, 20% corporate collectors. Overall price range: $65-21,000; most artwork sold at $65-950.

Media: Considers oil, acrylic, watercolor, pastel, pen & ink, drawings, mixed media, collage, sculpture, ceramic, craft (fine), fiber, glass, photography, original handpulled prints, etchings, lithographs and serigraphs. Most frequently exhibits watercolor, oil, acrylic and mixed media.

Style: Exhibits all styles and genres. Prefers landscapes, literal and abstract.

Terms: Accepts work on consignment (40% commission). Retail price set by gallery and artist. Gallery provides insurance (limited), promotion and contract; shares shipping costs from gallery. Requires framed artwork.

Submissions: Send résumé, bio, brochure, photographs, SASE, business card and reviews. No slides. Call to schedule an appointment to show a portfolio, which should include originals and photographs. Replies in 1 month. Files "full package." Common artists' mistake is providing poorly framed work.

Tips: "Come in person. It is necessary for proper consignment. Coffee is free. We are constantly in need of new 'marketable' art."

‡**GALLERY XII**, 412 E. Douglas, Suite A, Wichita KS 67202. (316)267-5915. Consignment Committee: Diane Curtis. Cooperative nonprofit gallery. Estab. 1977. Represents 50 mid-career and established artists/year and 20 members. Average display time 1 month. Open all year; Monday-Saturday, 10-4. Located in historic Old Town which is in the downtown area; 1,300 sq. ft.; historic building. 20% of space for special exhibitions; 80% of space for gallery artists. Clientele: private collectors, corporate collectors, people looking for gifts, tourists. Overall price range: $10-2,000.

Media: Considers all painting and drawing media, artists' prints (no mechanical reproductions), weaving, sculpture, ceramics, jewelry.

Style: Exhibits abstract, impressionism, realism, etc.

Terms: Only accepts 3-D work on consignment (35% commission). Co-op membership screened and limited. Annual exhibition fee, 15% commission and time involved. Artist pays shipping costs to and from gallery.

Submissions: Limited to local artists or those with ties to area. Work juroried from slides.

PHOENIX GALLERY TOPEKA, 2900-F Oakley Dr., Topeka KS 66614. (913)272-3999. Owner: Kyle Garcia. Retail gallery. Estab. 1990. Represents 60 emerging, mid-career and established artists/year. Exhibited artists include Dave Archer, Louis Copt, Nagel, Phil Starke, Ernst Ulmer and Raymond Eastwood. Sponsors 6 shows/year. Average display time 6 weeks-3 months. Open all year, 7 days/week. Located downtown; 2,000 sq. ft. 100% of space for special exhibitions; 100% of space for gallery artists. Clientele: upscale. 75% private collectors, 25% corporate collectors. Overall price range: $500-20,000.

Media: Considers all media and engravings, lithographs, woodcuts, mezzotints, serigraphs, linocuts, etchings and collage. Most frequently exhibits oil, watercolor, ceramic and artglass.

Style: Exhibits expressionism and impressionism, all genres. Prefers regional, abstract and 3-D type ceramic; national glass artists. "We find there is increased interest in original work and regional themes."

Terms: Terms negotiable. Retail price set by the gallery and the artist. Prefers artwork framed.

Submissions: Call for appointment to show portfolio of originals, photographs and slides.

Tips: "We are scouting [for artists] constantly."

THE SAGEBRUSH GALLERY OF WESTERN ART, 115 E. Kansas, P.O. Box 128, Medicine Lodge KS 67104. (316)886-5163. Fax: (316)886-5104. Co-Owners: Earl and Kaye Kuhn. Retail gallery. Estab. 1979. Represents up to 20 emerging, mid-career and established artists. Exhibited artists include Garnet Buster, Lee Cable, H.T. Holden, Earl Kuhn, Gary Morton and David Vollbracht. Sponsors 4 shows/year. Average display time 3-6 months. Open all year. Located ½ block off Main St.; 1,000 sq. ft. 100% of space for special exhibitions. Clientele: 80% private collectors, 20% corporate collectors. Overall price range: $100-7,000; most work sold at $500-4,000.

Media: Considers oil, acrylic, watercolor, pastel, pen & ink, drawings, mixed media, sculpture, original handpulled prints, lithographs and posters. Most frequently exhibits watercolors, acrylics and bronze sculpture.

Style: Exhibits realism. Genres include landscapes, southwestern, western and wildlife. Prefers representational works of contemporary and historical western.

Terms: Accepts artwork on consignment (25% commission). Retail price set by artist. Offers payment by installments. Gallery provides promotion; artist pays for shipping.

Submissions: Send query letter with résumé, slides, brochure, photographs and SASE. Portfolio review requested if interested in artist's work. Files résumés, bio info and photos. Finds artists by any source but the artist's work must speak for itself in quality.

Tips: "Looks for professional presentation of portfolios. Neatness counts a great deal! and of course—quality! We are careful to screen wildlife and western livestock to be anatomically correct. Ask about the annual Indian Summer Days Western and Wildlife Art Show Sale."

STRECKER GALLERY, 332 Poyntz, Manhattan KS 66502. (913)539-2139. President: Julie Strecker. Retail gallery. Estab. 1979. Represents 20 emerging and mid-career artists. Exhibited artists include Dean Mitchell and Judy Love.

Sponsors 4 shows/year. Average display time 6 weeks. Open all year; Tuesday-Saturday, 10-5. Located downtown; 3,000 sq. ft.; upstairs in historic building. 50% of space for special exhibitions; 50% of space for gallery artists. Clientele: university and business. 95% private collectors, 5% corporate collectors. Overall price range: $300-5,000; most work sold at $300-500.

Media: Considers all media and all types of prints (no offset reproductions). Most frequently exhibits watercolor, intaglio, lithograph.

Style: All styles. Genres include landscapes, florals, portraits, Southwestern, figurative work. Prefers landscapes, figurative and floral.

Terms: Accepts work on consignment (50% commission). Retail price set by artist. Sometimes offers payment by installment. Gallery provides promotion; artist pays for shipping costs. Prefers artwork framed.

Submissions: Send query letter with résumé, slides, reviews, bio and SASE. Write for appointment to show portfolio of slides. Replies in 1-2 weeks.

Tips: "I look for uniqueness of vision, quality of craftsmanship and realistic pricing."

TOPEKA & SHAWNEE COUNTY PUBLIC LIBRARY GALLERY, 1515 W. Tenth, Topeka KS 66604-1374. (913)231-0527. Fax: (913)233-2055. E-mail: lpeters@tscpl.lib.ks.us. Website: http://www.tscpl.org. Gallery Director: Larry Peters. Nonprofit gallery. Estab. 1976. Exhibits emerging, mid-career and established artists. Sponsors 8-9 shows/year. Average display time 1 month. Open all year; Monday-Saturday, 9-6; Sunday, 2-6. Closed summer Sundays. Located 1 mile west of downtown; 1,200 sq. ft.; security, track lighting, plex top cases; recently added two moveable walls. 100% of space for special exhibitions. Overall price range: $150-5,000.

 • As AGDM went to press, this gallery was temporarily closed for construction to be completed in 2000/2001. They are not accepting submissions until 2001.

Media: Considers oil, fiber, acrylic, sculpture, glass, watercolor, mixed media, ceramic, pastel, collage, metal work, woodcuts, wood engravings, linocuts, engravings, mezzotints, etchings, lithographs. Most frequently exhibits ceramic, oil and watercolor.

Style: Exhibits neo-expressionism, painterly abstraction, postmodern works and realism. Prefers painterly abstraction, realism and neo-expressionism.

Terms: Artwork accepted or not accepted after presentation of portfolio/résumé. Retail price set by artist. Gallery provides insurance; artist pays for shipping costs. Prefers artwork framed.

Submissions: Usually accepts only artists from KS, MO, NE, IA, CO, OK. Send query letter with résumé and 12-24 slides. Call or write for appointment to show portfolio of slides. Replies in 1-2 months. Files résumé. Finds artists through visiting exhibitions, word of mouth and submissions.

Tips: "Find out what each gallery requires from you and what their schedule for reviewing artists' work is. Do not go in unannounced. Have good quality slides—if slides are bad they probably will not be looked at. Have a dozen or more to show continuity within a body of work. Your entire body of work should be at least 50-100 pieces. Competition gets heavier each year. Looks for originality."

‡WICHITA ART MUSEUM STORE SALES GALLERY, 619 Stackman Dr., Wichita KS 67203. (316)268-4975. Fax: (316)268-4980. Manager/Buyer: Mark Fisher. Nonprofit retail and consignment gallery. Estab. 1963. Exhibits 150 emerging and established artists. Sponsors 4 group shows/year. Average display time is 6 months. 1,228 sq. ft. Accepts only artists from expanded regional areas. Clientele: tourists, residents of city, students. 75% private collectors, 25% corporate clients. Overall price range: $25-2,500; most work sold at $25-800.

Media: Considers oil, acrylic, watercolor, pastel, mixed media, collage, works on paper, sculpture, ceramic, fiber, glass and original handpulled prints.

Style: Exhibits organic/abstraction, impressionism, expressionism and realism. Genres include landscapes, florals, portraits and figurative work. Most frequently exhibits realism and impressionism.

Terms: Accepts work on consignment (40% commission). Retail price set by artist. Exclusive area representation not required. Gallery provides insurance and contract.

Submissions: Send query letter with résumé. Resumes and brochures are filed.

Tips: "Framing and proper matting very important. Realism and impressionism are best sellers. Landscapes and florals most popular. We are constantly looking for and exhibiting new artists. We have a few artists who have been with us for many years but our goal is to exhibit the emerging artist."

Kentucky

BANK ONE GALLERY, 416 W. Jefferson, Louisville KY 40207. (502)566-2081. Fax: (502)566-1800. E-mail: jpcollage@aol.com. Director: Jacque Parsley. Nonprofit gallery. Estab. 1976. Represent/exhibits 50 emerging, mid-career and established artists/year. Exhibited artists include Dudley Zopp and Chery Correll. Sponsors 6 shows/year. Average display time 2 months. Open all year; Monday-Thursday, 9-4; Friday, 9-5. Located downtown in Bank One Kentucky. 100% of space for special exhibitions. Clientele: tourists, local community and students. 20% private collectors, 15% corporate collectors. Overall price range: $200-2,000; most work sold at $300.

Media: Considers all media. Most frequently exhibits crafts—ceramics, oil paintings, watercolors and folk art.

Style: Exhibits expressionism, painterly abstraction and pattern painting. Genres include florals, portraits and landscapes.

Prefers abstract, landscapes and fine crafts.

Terms: Artwork is accepted on consignment and there is no commission. Retail price set by the artist. Gallery provides insurance, promotion and contract. Artist pays for shipping costs. Artwork must be framed.

Submissions: Accepts only regional artists. Send query letter with résumé, slides, bio and SASE. Write for appointment to show portfolio of slides. Replies in 2 months. Files announcements. Finds artists through referrals by other artists and submissions.

Tips: "Submit professional slides."

BROWNSBORO GALLERY, 4802 Brownsboro Center, Louisville KY 40207. (502)893-5209. Owner: Leslie Spetz. Retail gallery. Estab. 1990. Represents 20-25 emerging, mid-career and established artists. Exhibited artists include Tarleton Blackwell and Michaele Ann Harper. Sponsors 9-10 shows/year. Average display time 5 weeks. Open all year; Tuesday-Friday, 10-5; Saturday, 10-3; closed Sunday and Monday. Located on the east end (right off I-71 at I-264); 1,300 sq. ft.; 2 separate galleries for artist to display in give totally different feelings to the art; one is a skylight room. 85% of space for gallery artists. Clientele: upper income. 90% private collectors, 10% corporate collectors. Overall price range; $100-2,500; most work sold at $800-1,000.

Media: Considers oil, acrylic, watercolor, pastel, pen & ink, drawing, mixed media, collage, paper, sculpture, ceramics, fiber, glass, installation, photography, woodcuts, engravings and etchings. Most frequently exhibits oil, mixed (oil or watercolor pastel) and watercolor.

Style: Exhibits painterly abstraction, all styles, color field, postmodern works, impressionism, photorealism and realism. Genres include landscapes, Americana and figurative work. Prefers landscape, abstract and collage/contemporary.

Term: Accepts work on consignment (40% commission). Retail price set by the gallery and the artist. Gallery provides insurance, promotion, contract and shipping costs from gallery; artist pays shipping costs to gallery. Prefers artwork framed.

Submissions: Send query letter with résumé, at least 10 slides, bio, price list and SASE. Call for appointment to show portfolio of photographs and slides. Replies only if interested within 3-4 weeks. Finds artists through word of mouth and submissions, "sometimes by visiting exhibitions."

Tips: "Check the spaces out before approaching galleries to see how comfortable they are. Check out and agree to whatever contract the gallery may have and honor it. Have a body of work of at least 25-30, so if a show would be available they would know that there was enough work."

‡CAPITAL GALLERY OF CONTEMPORARY ART, 314 Lewis, Frankfort KY 40601. (502)223-2649. Owner: Ellen Glasgow. Retail gallery, art consultancy. Estab. 1981. Represents 20-25 emerging, mid-career and established artists/year. Exhibited artists include Kathleen Kelly, Robert Kipniss. Sponsors 8 shows/year. Average display time 1-2 months. Open all year; Tuesday-Saturday, 10-5. Located downtown, historic district; 1,200 sq. ft.; historic building, original skylights, vaults, turn-of-century. 50% of space for special exhibitions; 50% of space for gallery artists. 60% private collectors; 40% corporate collectors. Overall price range: $30-10,000; most work sold at $300-3,000.

Media: Considers all media except photography; all prints except posters. Most frequently exhibits oil paintings, watercolor, fine printmaking.

Style: Exhibits all styles and genres. Prefers landscapes, floral/figurative, works on paper.

Terms: Accepts work on consignment (40% commission). Retail price set by the artist. Gallery provides insurance and promotion; shipping costs are shared. Prefers artwork framed.

Submissions: Send query letter with résumé, slides, photographs, bio, SASE. Write for appointment to show portfolio of photographs and slides. Replies in 2-4 weeks. Files bios, cards.

Tips: "Visit the gallery first."

CENTRAL BANK GALLERY, 300 W. Vine St., Lexington KY 40507. (606)253-6135. Fax: (606)253-6069. Curator: John Irvin. Nonprofit gallery. Estab. 1985. Interested in seeing the work of emerging artists. Represented more than 1,000 artists in the past 10 years. Exhibited artists include Arturo Sandoval and John Tuska. Sponsors 12 shows/year. Average display time 3 weeks. Open all year; Monday-Friday, 9-4.30. Located downtown. 100% of space for special exhibitions. Clientele: local community. 100% private collectors. Overall price range: $100-5,000; most work sold at $350-500.

● Central Bank Gallery considers Kentucky artists only.

Media: Considers all media. Most frequently exhibits oils, watercolor, sculpture.

Style: Exhibits all styles. "Please, no nudes."

Terms: Retail price set by the artist "100% of proceeds go to artist." Gallery provides insurance and promotion; artist pays for shipping.

Submissions: Call or write for appointment.

Tips: "Don't be shy, call me. We pay 100% of the costs involved once the art is delivered."

KENTUCKY ART & CRAFT GALLERY, 609 W. Main St., Louisville KY 40202. (502)589-0102. Fax: (502)589-0154. Retail Marketing Director: Marcie Warner. Retail gallery operated by the private nonprofit Kentucky Art & Craft Foundation, Inc. Estab. 1984. Represents more than 400 emerging, mid-career and established artists. Exhibiting artists include Arturo Sandoval, Stephen Powell and Rude Osolnik. Sponsors 10-12 shows/year. Open all year. Located downtown in the historic Main Street district; 5,000 sq. ft.; a Kentucky tourist attraction located in a 120-year-old cast iron building. 33% of space for special exhibitions. Clientele: tourists, the art-viewing public and schoolchildren. 10% private

collectors, 5% corporate clients. Overall price range: $3-20,000; most work sold at $25-500.

Media: Considers mixed media, metal, glass, clay, fiber, wood and stone.

Terms: Accepts work on consignment (50% commission). Retail price set by artist. Gallery provides insurance, promotion, contract and shipping costs from gallery.

Submissions: Contact gallery for jury application and guidelines first; then send completed application, résumé and 5 samples. Replies in 2-3 weeks. "If accepted, we file résumé, slides, signed contract, promotional materials and PR about the artist."

Tips: "The artist must live or work in a studio within the state of Kentucky."

LOUISVILLE VISUAL ART ASSOCIATION, Suite 275, Louisville Galleria, Louisville KY 40202. (502)581-1445. E-mail: paint@aol.com. Gallery Manager: Janice Emery. Nonprofit sales and rental gallery. Estab. 1990. Represents 80+ emerging, mid-career and established regional artists. Average display time 3 months. Open all year; Monday-Friday, 11:30-3:30 and by appointment. Located downtown; 1,500 sq. ft. 10% of space for special exhibitions; 90% of space for gallery artists. Clientele: all ages and backgrounds. 50% private collectors, 50% corporate collectors. Overall price range: $300-4,000; most work sold at $300-1,000.

• Headquarters for LVAA are at 3005 Upper River Rd.; LVAA Sales and Rental Gallery is at #275 Louisville Galleria (Fourth and Liberty).

Media: Considers oil, acrylic, watercolor, pastel, pen & ink, drawing, mixed media, collage, paper, sculpture, ceramics, craft (on a limited basis), fiber, glass, photography, woodcuts, engravings, lithographs, wood engravings, mezzotints, serigraphs, linocuts, etchings and some posters. Most frequently exhibits oil, acrylic, watercolor, sculpture and glass.

Style: Exhibits contemporary, local and regional visual art, all genres.

Terms: Accepts work on consignment (40% commission). Membership is suggested. Retail price set by the artist. Gallery provides insurance, promotion and contract (nonexclusive gallery relationship). Artist pays shipping costs to and from gallery. Accepts framed or unframed artwork. Artists should provide necessary special displays. (Ready-to-hang is advised with or without frames.)

Submissions: Accepts only artists from within a 400-mile radius, or former residents or those trained in Kentucky (university credentials). Send query letter with résumé, slides, bio and reviews. Write for appointment to show portfolio of slides. Replies only if interested within 4-6 weeks. Files up to 20 slides (in slide registry), bio, résumé, brief artist's statement, reviews, show announcement. Finds artists through visiting exhibitions, word of mouth, art publications and submissions.

Tips: "If the artist has a reasonable number of works and has prepared slides/résumé/artist statement, we take a serious look at their potential. The quality must be a factor, however early development is not considered a drawback when viewing work. Strength of ideas and artistic ability are first and foremost in our selection criteria. Sophisticated use of materials is considered."

MAIN AND THIRD FLOOR GALLERIES, Northern Kentucky University, Nunn Dr., Highland Heights KY 41099. (606)572-5148. Fax: (606)572-5566. Gallery Director: David Knight. University galleries. Program established 1975; new main gallery in fall of 1992; renovated third floor gallery fall of 1993. Represents emerging, mid-career and established artists. Sponsors 10 shows/year. Average display time 1 month. Open Monday-Friday, 9-9; Saturday, Sunday, 1-5; closed major holidays and between Christmas and New Years. Located in Highland Heights, KY, 8 miles from downtown Cincinnati; 3,000 sq. ft.; two galleries—one small and one large space with movable walls. 100% of space for special exhibitions. 90% private collectors, 10% corporate collectors. Overall price range; $25-50,000; most work sold at $25-2,000.

Media: Considers all media and all types of prints. Most frequently exhibits painting, printmaking and photography.

Style: Exhibits all styles, all genres.

Terms: Proposals are accepted for exhibition. Retail price set by the artist. Gallery provides insurance, promotion and contract; shipping costs are shared. Prefers artwork framed "but we are flexible."

Submissions: Send query letter with résumé, slides, bio, photographs, SASE and reviews. Write for appointment to show portfolio of originals, photographs and slides. Submissions are accepted in December for following academic school year. Files résumés and bios. Finds artists through agents, visiting exhibitions, word of mouth, art publications, sourcebooks and submissions.

UNIVERSITY ART GALLERIES, Murray State University, P.O. Box 9, Murray KY 42071-0009. (502)762-6734. Fax: (502)762-3920. Director: Albert Sperath. University gallery. Estab. 1971. Represents emerging, mid-career and established artists. Sponsors 8 shows/year. Average display time 6 weeks. Open Monday, Wednesday, Friday, 8-6; Tuesday, Thursday 8-7:30; Saturday, 10-4; Sunday, 1-4; closed during university holidays. Located on campus, small town; 4,000 sq. ft.; modern multi-level dramatic space. 100% of space for special exhibitions. Clientele: "10,000 visitors per year."

 A CHECKMARK PRECEDING A LISTING indicates a change in either the address or contact information since the 1998 edition.

Media: Considers all media and all types of prints.

Style: Exhibits all styles.

Terms: "We supply the patron's name to the artist for direct sales. We take no commission." Retail price set by the artist. Gallery provides insurance, promotion and shipping costs from gallery. Prefers artwork framed.

Submissions: Send query letter with résumé and 10-20 slides. Replies in 1 month.

Tips: "Do good work that *expresses* something."

YEISER ART CENTER INC., 200 Broadway, Paducah KY 42001-0732. (502)442-2453. Executive Director: Dan Carver. Nonprofit gallery. Estab. 1957. Exhibits emerging, mid-career and established artists. 450 members. Sponsors 8-10 shows/year. Average display time 6-8 weeks. Open all year. Located downtown; 1,800 sq. ft.; "in historic building that was farmer's market." 90% of space for special exhibitions. Clientele: professionals and collectors. 90% private collectors. Overall price range: $200-8,000; most artwork sold at $200-1,000.

Media: Considers all media except installation. Prints considered include original handpulled prints, woodcuts, wood engravings, linocuts, mezzotints, etchings, lithographs and serigraphs. Most frequently exhibits oil, acrylic and mixed media.

Style: Exhibits all styles. Genres include landscapes, florals, Americana and figurative work. Prefers realism, impressionism and abstraction.

Terms: Accepts work on consignment (35% commission). Retail price set by artist. Gallery provides insurance and promotion; shipping costs are shared. Prefers artwork framed.

Submissions: Send résumé, slides, bio, SASE and reviews. Replies in 1 month.

Tips: "Do not call. Give complete information about the work: media, size, date, title, price. Have good-quality slides of work, indicate availability and include artist statement. Presentation of material is important."

ZEPHYR GALLERY, 610 E. Market St., Louisville KY 40202. (502)585-5646. Directors: Patrick Donley, Peggy Sue Howard. Cooperative gallery and art consultancy with regional expertise. Estab. 1987. Exhibits 18 emerging and mid-career artists. Exhibited artists include Chris Radtke, Kerry Malloy, Kocka, Robert Stagg, Guinever Smith, Jenni Deamer. Sponsors 11 shows/year. Average display time 1 month. Open all year. Located downtown; approximately 1,800 sq. ft. Clientele: 25% private collectors, 75% corporate collectors. Most work sold at $200-2,000.

Media: Considers all media. Considers only small edition handpulled print work by the artist. Most frequently exhibits painting, photography and sculpture.

Style: Exhibits individual styles.

Terms: Co-op membership fee plus donation of time (25% commission). Must live within 50 mile radius of Louisville. Prefers artwork framed. No glass.

Submissions: No functional art (jewelry, etc.). Send query letter with résumé and slides. Call for appointment to show portfolio of slides; may request original after slide viewing. Replies in 6 weeks. Files slides, résumés and reviews (if accepted). Submissions accepted for January 15 and June 15 review.

Tips: "Submit well-organized slides with slide list. Include professional résumé with notable exhibitions."

Louisiana

BATON ROUGE GALLERY, INC., 1442 City Park Ave., Baton Rouge LA 70808-1037. (504)383-1470. Director: Kathleen Pheney. Cooperative gallery. Estab. 1966. Exhibits the work of 50 emerging, mid-career and established artists. 300 members. Sponsors 12 shows/year. Average display time 1 month. Open all year. Located in the city park pavilion; 1,300 sq. ft. Overall price range: $100-10,000; most work sold at $50-100.

- Every Sunday at 4 p.m. the gallery has a multicultural performance. Programs include literary readings, ethnic dance and music by performance artists.

Media: Considers oil, acrylic, watercolor, pastel, video, drawing, mixed media, collage, paper, sculpture, ceramic, fiber, glass, installation, photography, woodcuts, engravings, lithographs, pochoir, wood engravings, mezzotints, serigraphs, linocuts and etchings. Most frequently exhibits painting, sculpture and glass.

Style: Exhibits all styles and genres.

Terms: Co-op membership fee plus donation of time. Gallery takes 33% commission. Retail price set by artist. Artist pays for shipping. Artwork must be framed.

Submissions: Membership and guest exhibitions are selected by screening committee. Send query letter for application. Call for appointment to show portfolio of slides.

Tips: "The screening committee screens applicants in March and October each year. Call for application to be submitted with portfolio and résumé."

CASELL GALLERY, 818 Royal St., New Orleans LA 70116. (800)548-5473. Title/Owner-Directors: Joachim Casell. Retail gallery. Estab. 1970. Represents 20 mid-career artists/year. Exhibited artists include J. Casell and Don Picou. Sponsors 2 shows/year. Average display time 10 weeks. Open all year; 10-6. Located in French Quarter; 800 sq. ft. 25% of space for special exhibitions. Clientele: tourists and local community. 20-40% private collectors, 10% corporate collectors. Overall price range: $100-1,200; most work sold at $300-600.

Media: Considers all media, wood engravings, etchings, lithographs, serigraphs and posters. Most frequently exhibits

pastel and pen & ink drawings.

Style: Exhibits impressionism. All genres including landscapes. Prefers pastels.

Terms: Artwork is accepted on consignment (50% commission). Retail price set by the artist. Gallery provides promotion and pays for shipping costs. Prefers artwork unframed.

Submissions: Accepts only local area and southern artists. Replies only if interested within 1 week.

‡EARTHWORKS FINE ART GALLERY, 1424 Ryan, Lake Charles LA 70601. (318)439-1430. Fax: (318)439-1441. Owner: Ray Fugatt. Retail gallery. Estab. 1989. Represents 25-30 emerging, mid-career and established artists. Exhibited artists include Elton Louviere. Sponsors 7 shows/year. Average display time 1 month. Open all year. Located downtown; 4,000 sq. ft.; "a remodeled 50-year-old, art-deco designed grocery building." 40% of space for special exhibitions. Overall price range: $100-15,000; most work sold at $500-8,000.

Media: Considers oil, acrylic, watercolor, pen & ink, drawings, mixed media, sculpture, ceramic, glass, original handpulled prints, woodcuts, etchings and "any repros by artist; no photo lithos." Most frequently exhibits oil, acrylic and watercolor.

Style: Exhibits expressionism, impressionism, realism and photorealism. Genres include landscapes, florals, Americana, Southwestern, Western, wildlife and figurative works.

Terms: 90% of work accepted on consignment (40% commission); 10% bought outright for 50% of the retail price (net 30 days). Exclusive area representation required. Retail price set by artist. Gallery provides insurance, promotion, contract and shipping costs from gallery. Prefers artwork framed.

Submissions: Send query letter with résumé and slides. Call or write for appointment to show portfolio of originals and slides. Replies in 2-4 weeks. Files résumés.

Tips: "Have a body of work available that shows the range of uniqueness of your talent."

GALLERY OF THE MESAS, 2010-12 Rapides Ave., Alexandria LA 71301. (318)442-6372. E-mail: wayne@popalex 1.linknet.net. Website: http://www.gallerymesas.com. Artist/Owner: C.H. Jeffress. Retail and wholesale gallery and artist studio. Focus is on southwest and Native American art. Estab. 1975. Represents 6 established artists. Exhibited artists include John White, Charles H. Jeffress, Peña, Gorman, Atkinson and Mark Snowden. Open all year; Tuesday-Friday, 11-5. Located on the north edge of town; 2,500 sq. ft. Features new canvas awnings, large gold letters on brick side of buildings and new mini-gallery in home setting next door. Clientele: 95% private collectors, 5% corporate collectors. Overall price range: $165-3,800.

Media: Considers original handpulled prints, watercolor, intaglio, lithographs, serigraphs, Indian jewelry, sculpture, ceramics and drums. Also exhibits Hopi-carved Katchina dolls. Most frequently exhibits serigraphs, inkless intaglio, collage and lithographs.

Style: Exhibits realism. Genres include landscapes, southwestern and figurative work. Most frequently exhibits landscapes.

Submissions: Handles only work of well-known artists in southwest field. Owner contacts artists he wants to represent.

Tips: "Visit galleries to see if your work 'fits in' with others in the gallery. Present strictly professional work. You should create at least 3-4 works per year, with a body of at least 30 works."

‡ANTON HAARDT GALLERY, 2714 Coliseum St., New Orleans LA 70130. (504)897-1172. Website: http://www.au tonart.com. Owner: Anton Haardt. Retail gallery. Estab. 1987. Represents 25 established, self-taught artists. Exhibited artists include Mose Tollirer, Sybil Gibson. Open all year by appointment only. Located in New Orleans—Garden District, Montgomery—downtown; 1,000 sq. ft. 100% of space for gallery artists. Clientele: collectors, upscale. 50% private collectors, 50% corporate collectors. Overall price range: $200-10,000; most work sold at $300-1,000.

Media: Considers oil, pen & ink, paper, acrylic, drawing, sculpture, watercolor, mixed media, pastel and collage. Most frequently exhibits paint, pen & ink, mixed media.

Style: Exhibits primitivism, folk art. Prefers folk art.

Terms: Price set by the gallery. Gallery provides promotion; shipping costs to gallery. Prefers artwork unframed.

Submissions: Accepts only artists from the South (mainly). Must be self-taught—untrained. Send query letter with slides, bio. Call for appointment to show portfolio of photographs and slides. Replies in 2 months. Finds artists through word of mouth, newspaper and magazine articles.

Tips: "I have very strict requirements for absolute purist form of self-taught artists."

‡LE MIEUX GALLERIES, 332 Julia St., New Orleans LA 70130. (504)522-5988. Fax: (504)522-5682. President: Denise Berthiaume. Retail gallery and art consultancy. Estab. 1983. Represents 30 mid-career artists. Exhibited artists include Shirley Rabe Masinter and Kathleen Sidwell. Sponsors 7 shows/year. Average display time 6 months. Open all year. Located in the warehouse district/downtown; 1,400 sq. ft. 20-75% of space for special exhibitions. Clientele: 75% private collectors; 25% corporate clients.

Media: Considers oil, acrylic, watercolor, pastel, drawings, mixed media, works on paper, sculpture, ceramic, glass and egg tempera. Most frequently exhibits oil, watercolor and drawing.

Style: Exhibits impressionism, neo-expressionism, realism and hard-edge geometric abstraction. Genres include landscapes, florals, wildlife and figurative work. Prefers landscapes, florals and paintings of birds.

Terms: Accepts work on consignment (50% commission). Retail price set by artist. Exclusive area representation required. Gallery provides promotion and contract; artist pays for shipping.

Submissions: Accepts only artists from the Southeast. Send query letter with SASE, bio, brochure, résumé, slides and

photographs. Write for appointment to show portfolio of originals. Replies in 3 weeks. All material is returned if not accepted or under consideration.

Tips: "Send information before calling. Give me the time and space I need to view your work and make a decision; you cannot sell me on liking or accepting it; that I decide on my own."

‡**RICHARD RUSSELL GALLERY**, 639 Royal St., New Orleans LA 70130. (504)523-0533. Owner: Richard Russell. Retail gallery. Estab. 1989. Represents/exhibits 10 emerging, mid-career and established artists/year. Exhibited artists include Barrett DeBusk and Jim Tweedy. Open all year. Located in the French Quarter; 800 sq. ft. 100% of space for gallery artists. Clientele: tourists, upscale. 95% private collectors. Overall price range: $200-2,000; most work sold at $800-1,200.

Media: Considers fiber, sculpture, ceramics, and serigraphs. Most frequently exhibits sculpture of metal, mixed media and clay.

Style: Whimsical and representational work.

Terms: Artwork is accepted on consignment and there is a 50% commission, or artwork is bought outright for 50% of the retail price. Retail price set by the gallery and the artist. Gallery provides insurance and promotion. Artist pays for shipping costs. Prefers artwork framed.

Submissions: Send query letter with résumé, brochure, business card, photographs, bio and SASE. Call for appointment to show portfolio of photographs, slides and transparencies. Replies in 2-4 weeks. Does not reply. Artist should send SASE. Files material. Finds artists through word of mouth, referrals by by other artists, visiting art fairs and exhibitions and artists' submissions.

‡**ST. TAMMANY ART ASSOCIATION**, P.O. Box 704, Covington LA 70434-0704. (504)892-8650. Director: Jan Pine. Nonprofit gallery. Estab. 1958. Represents 120 emerging, mid-career and established artists/year. 80 members. Exhibited artists include John Prebble and Jayne Adams. Sponsors 7 shows/year. Average display time 7 weeks. Open all year; Tuesday-Saturday 10-4, Sunday 1-4. Located downtown; 500 sq. ft.; historic home. 100% of space for special exhibitions. Clientele: upper middle class. 100% private collectors. Overall price range: $100-15,000; most work sold at $100-500.

Media: Considers all media, all types of prints. Most frequently exhibits painting (oil or acrylic), watercolor and sculpture.

Style: Exhibits all styles, all genres. Prefers figurative, landscape and abstract.

Terms: Accepts work on consignment (30% commission). Retail price set by the artist. Gallery provides insurance, promotion and contract; shipping costs are shared. Prefers artwork framed.

Submissions: Send query letter with résumé, slides and photographs. Call for appointment to show portfolio of originals, photographs and slides. Replies in 2 months. Files résumé.

Tips: Finds artists through visiting exhibitions.

‡**STILL-ZINSEL**, 328 Julia, New Orleans LA 70130. (504)588-9999. Fax: (504)588-1111. E-mail: ufax@aol.com. Contact: Suzanne Zinsel. Retail gallery. Estab. 1982. Represents 25 emerging, mid-career and established artists. Sponsors 12 shows/year. Average display time 3 weeks. Open all year. Located in the warehouse district; 4,200 sq. ft.; unique architecture. 40% of space for special exhibitions. Clientele: collectors, museums and businesses.

Media: Considers oil, acrylic, watercolor, pastel, pen & ink, drawings, mixed media, paper, sculpture, glass, installation, photography, original handpulled prints, woodcuts, engravings, wood engravings, mezzotints, linocuts and etchings.

Style: Exhibits neo-expressionism, painterly abstraction, conceptualism, minimalism, color field, postmodern works, impressionism, realism, photorealism and hard-edge geometric abstraction. All genres.

Terms: Accepts work on consignment (50% commission). Retail price set by gallery and artist. Offers customer discounts and payment by installments. Gallery provides promotion and contract; artist pays for shipping.

Submissions: Send query letter with résumé, slides, SASE and reviews. Portfolio review requested if interested in artist's work.

Tips: "Please send clearly labeled slides."

‡**STONE AND PRESS GALLERIES**, 238 Chartres St., New Orleans LA 70130. (504)561-8555. Fax: (504)561-5814. Owner: Earl Retif. Retail gallery. Estab. 1988. Represents/exhibits 20 mid-career and established artists/year. Interested in seeing the work of emerging artists. Exhibited artists include Carol Wax and Benton Spruance. Sponsors 9 shows/year. Average display time 1 month. Open all year; Monday-Saturday, 10:30-5:30. Located in historic French Quarter; 1,200 sq. ft.; in historic buildings. 50% of space for special exhibitions; 50% of space for gallery artists. Clientele: collectors nationwide also tourists. 90% private collectors, 10% corporate collectors. Overall price range: $50-10,000; most work sold at $400-900.

● This gallery has a second location at 608 Julia St., also in New Orleans.

Media: Considers all drawing, pastel and all types of prints. Most frequently exhibits mezzotint, etchings and lithograph.

Style: Exhibits realism. Genres include Americana, portraits and figurative work. Prefers American scene of '30s and '40s and contemporary mezzotint.

Terms: Artwork is accepted on consignment (40% commission) or bought outright for 50% of the retail price; net 30 days. Retail price set by the gallery and the artist. Gallery provides insurance, promotion and contract; shipping costs are shared. Prefers artwork unframed.

Submissions: Send query letter with résumé, slides and SASE. Write for appointment to show portfolio of photographs.

Replies in 2 weeks.

Tips: Finds artists through word of mouth and referrals of other artists.

Maine

‡**BAYVIEW GALLERY**, 33 Bayview St., Camden ME 04843. (207)236-4534. E-mail: art@bayviewgallery.com. Website: http://www.bayviewgallery.com. Owners: John and Susan Starr. Retail gallery. Estab. 1971. Represents 50 emerging, mid-career and established artists. Exhibited artists include Donald Mosher, Stapleton Kearns, Scott Moore and Don Stone, N.A. Sponsors 4 shows/year. Average display time 1 month. Open all year. Located in downtown; 1,500 sq. ft. 50% of space for special exhibitions. Clientele: 60% private collectors, 40% corporate collectors. Overall price range: $100-10,000; most work sold at $100-2,500.

Media: Considers oil, acrylic, watercolor, pastel, sculpture, original handpulled prints and offset reproductions. Most frequently exhibits oil and sculpture.

Style: Exhibits primitivism, impressionism and realism. Genres include landscapes and marine art. Prefers realism, impressionism and primitivism.

Terms: Accepts work on consignment (45% commission). Retail price set by gallery in consultation with artist. Gallery provides insurance, promotion and contract; artist pays for shipping. Requires artwork framed.

Submissions: Send query letter with résumé, at least 10 slides (preferably more), bio, SASE and reviews.

Tips: Call to make an appointment or to let the gallery know slides are forthcoming.

BIRDSNEST GALLERY, 12 Mt. Desert St., Bar Harbor ME 04609. (207)288-4054. Owner: Barbara Entzminger. Retail gallery. Estab. 1972. Represents 40 mid-career and established artists/year. Interested in seeing the work of emerging artists. Exhibited artists include Rudolph Colao and Tony Van Hasselt. Sponsors 6-9 shows/year. Average display time 1-6 months. Open May 15-October 30; daily 10-9; Sundays, 12-9. Located downtown, opposite Village Green; 4,800 sq. ft.; good track lighting, 5 rooms. 10% of space for special exhibitions; 90% of space for gallery artists. Clientele: tourists, summer residents, in-state collectors. 80% private collectors, 20% corporate collectors. Overall price range: $100-30,000; most work sold at $250-1,600.

Media: Considers all media except functional items and installations; types of prints include woodcuts, engravings, lithographs, wood engravings, mezzotints, serigraphs, linocuts and etchings. Original prints only, no reproductions. Most frequently exhibits oils, watercolors and serigraphs/etchings.

Style: Exhibits: expressionism, neo-expressionism, painterly abstraction, impressionism, photorealism, realism and imagism from traditional to semi-abstract. Genres include florals, wildlife, landscapes, figurative work and seascapes. Prefers: impressionism and traditional, contemporary realism and semi-abstract work.

Terms: Accepts work on consignment (50% commission). Retail price set by the artist. Gallery provides limited insurance and promotion; artist pays shipping. Gallery prefers artwork to be delivered and picked up; does not ship from gallery. Prefers artwork framed, matted and shrinkwrapped.

Submissions: Accepts only artists who paint in the Northeast. Prefers only oils and watercolor. Send query letter with résumé, 12 slides or photographs, bio, brochure, SASE and reviews. Call or write for appointment to show portfolio of photographs, slides. Final decision for acceptance of artwork is from the original. Replies only if interested with 1 month. Files photographs and bio. Finds artists through word of mouth, referrals by other artists and submissions.

Tips: "Test yourself by exhibiting in outdoor art shows. Are you winning awards? Are you winning awards and sell well? You should have 6 to 12 paintings before approaching galleries."

DUCKTRAP BAY TRADING COMPANY, 28 Bayview St., Camden ME 04843. (207)236-9568. Fax: (207)236-6203. Owners: Suzanne Keefer and James Keefer. Retail gallery. Estab. 1983. Represents 200 emerging, mid-career and established artists/year. Exhibited artists include: Ward Huber, Rudy Miller, Grace Ellis, Maris Shepherd and Peter Sculthorpe. Open all year; Monday-Saturday, 9-5. Located downtown waterfront; small, 20×30. "We display everything we take until it sells. No storage." 100% of space for gallery artists. Clientele: tourists, upscale. 70% private collectors, 30% corporate collectors. Overall price range: $250-18,000; most work sold at $500-1,500.

Media: Considers oil, acrylic, pastel, pen & ink, drawing, paper, sculpture and bronze; types of prints include lithographs. Most frequently exhibits woodcarvings, watercolor, acrylic and bronze.

Style: Exhibits: realism. Genres include Western, wildlife and landscapes. Prefers: marine, wildlife and western.

Terms: Accepts work on consignment (40% commission) or buys outright for 50% of the retail price (net 30 days). Retail price set by the artist. Gallery provides insurance and minimal promotion; artist pays for shipping. Prefers artwork framed or shrinkwrapped.

Submissions: Send query letter with 10-20 slides or photographs. Call or write for appointment to show portfolio of photographs. Files all material. Finds artists through word of mouth, referrals by other artists and submissions.

Tips: "Find the right gallery and location for your subject matter. Have at least eight to ten pieces or carvings or three to four bronzes."

‡**GREENHUT GALLERIES**, 146 Middle St., Portland ME 04101. (207)772-2693. Fax: (207)772-2758. President: Peggy Greenhut Golden. Retail gallery. Estab. 1990. Represents/exhibits 20 emerging and mid-career artists/year. Sponsors 6-9 shows/year. Exhibited artists include: Alison Goodwin and Connie Hayes. Average display time 3 weeks. Open

all year; Monday-Friday, 10-5:30; Saturday, 10-5. Located in downtown-Old Port; 3,000 sq. ft. with neon accents in interior space. 60% of space for special exhibitions. Clientele: tourists and upscale. 55% private collectors, 10% corporate collectors. Overall price range: $400-6,000; most work sold at $600-2,000.
Media: Most frequently exhibits oil paintings, acrylic paintings and mixed media.
Style: Exhibits contemporary realism. Prefers landscape, seascape and abstract.
Terms: Artwork is accepted on consignment (50% commission). Retail price set by the gallery and artist. Gallery provides insurance and promotion. Artists pays for shipping costs. Prefers artwork framed.
Submissions: Accepts only artists from Maine or New England area with Maine connection. Send query letter with slides, reviews, bios and SASE. Call for appointment to show portfolio of slides. Replies in 1 month. Finds artists through word of mouth, referrals by other artists, visiting art fairs and exhibitions and submissions.
Tips: "Visit the gallery and see if you feel your work fits in."

ROUND TOP CENTER FOR THE ARTS GALLERY, Business Rt. 1, P.O. Box 1316, Damariscotta ME 04543. (207)563-1507. Artistic Director: Nancy Freeman. Nonprofit gallery. Estab. 1988. Represents emerging, mid-career and established artists. 1,200 members (not all artists). Exhibited artists include Lois Dodd and Marlene Gerberick. Sponsors 12-14 shows/year. Average display time 1 month. Open all year; Monday-Saturday, 11-4; Sunday, 1-4. Located on a former dairy farm with beautiful buildings and views of salt water tidal river. Exhibition space is on 2 floors 30×60, several smaller gallery areas, and a huge barn. 50% of space for special exhibitions; 25% of space for gallery artists. "Sophisticated year-round community and larger summer population." 25% private collectors. Overall price range: $75-10,000; most work sold at $300-1,000.
Media: Considers all media and all types of prints. Most frequently exhibits watercolor, fiber arts (quilts) and mixed media.
Style: Exhibits all styles. Genres include landscapes, florals, Americana and figurative work. Prefers landscape and historic.
Terms: Accepts work on consignment (30% commission). Retail price set by the artist. Gallery provides insurance, promotion and contract; shipping costs are shared. Prefers artwork simply framed.
Submissions: Send query letter with résumé, slides or photographs, bio and reviews. Write for appointment to show portfolio. Replies only if interested within 2 months. Files everything but slides, which are returned. Finds artists through visiting exhibitions, word of mouth and artists' submissions.

STEIN GALLERY CONTEMPORARY GLASS, 20 Milk St., Portland ME 04101. (207)772-9072. Contact: Anne Stein. Retail gallery. Represents 75 emerging, mid-career and established artists/year. Open all year. Located in "old port" area. 100% of space for gallery artists.
Media: Considers glass only.
Terms: Retail price set by the artist. Gallery provides insurance and promotion.
Submissions: Send query letter with résumé and slides.

UNION RIVER GALLERY, 92 Main St., Ellsworth ME 04605. (207)667-7700. E-mail: easternbay@midmaine.com. Owner: Sarah Morton. Manager: Cathy Bram. Retail gallery. Estab. 1995. Represents 30 emerging, mid-career and established artists. Exhibited artists include Helen Rundell, Terrell Lester and Consuelo Hanks. Sponsors approximately 3 shows/year. Average display time 1 month. Open all year; Monday-Friday, 10-5; Saturday, 10-4. Located downtown; 1,000 sq. ft.; high ceilings, attractive old building. Clientele: tourists, upscale, summer residents and locals.
Terms: Prefers artwork unframed.
Submissions: Send query letter with résumé, slides or photographs. Write for appointment to show portfolio of photographs or slides. Replies in 2 weeks. Files résumé, slides and articles. Finds artists through artist's submissions and word of mouth.

‡UNIVERSITY OF MAINE MUSEUM OF ART, 109 Carnegie Hall, Orono ME 04469. (207)581 3255. Fax: (207)581-1604. Contact: Director. Museum. Estab. 1946. Exhibits emerging, mid-career and established artists. Sponsors 18 shows/year. Average display time 4-6 weeks. Open all year. Located on a rural university campus; 2,750 sq. ft. (500 linear feet of display space); museum is located in 1904 original granite library building. 100% of space for special exhibitions.
Media: Considers all media and all types of prints.
Style: Exhibits all styles and genres.
Terms: Accepts donated artwork for exhibition. Gallery provides insurance and promotion; shipping costs are shared. Prefers artwork framed.
Submissions: Send query letter with résumé, slides, bio and reviews. Write for appointment to show portfolio of originals and slides. Replies in 1 month. Files bio, slides, if requested, and résumé.

Maryland

ARTEMIS, INC., 4715 Crescent St., Bethesda MD 20816. (301)229-2058. Fax: (301)229-2186. E-mail: sjtropper@aol. com. Owner: Sandra Tropper. Retail and wholesale dealership and art consultancy. Represents more than 100 emerging

and mid-career artists. Does not sponsor specific shows. Clientele: 40% private collectors, 60% corporate clients. Overall price range: $100-10,000; most artwork sold at $1,000-3,000.

Media: Considers oil, acrylic, watercolor, mixed media, collage, works on paper, sculpture, ceramic, craft, fiber, glass, installations, woodcuts, engravings, mezzotints, etchings, lithographs, pochoir, serigraphs and offset reproductions. Most frequently exhibits prints, contemporary canvases and paper/collage.

Style: Exhibits impressionism, expressionism, realism, minimalism, color field, painterly abstraction, conceptualism and imagism. Genres include landscapes, florals and figurative work. "My goal is to bring together clients (buyers) with artwork they appreciate and can afford. For this reason I am interested in working with many, many artists." Interested in seeing works with a "finished" quality.

Terms: Accepts work on consignment (50% commission). Retail price set by dealer and artist. Exclusive area representation not required. Gallery provides insurance and contract; shipping costs are shared. Prefers unframed artwork.

Submissions: Send query letter with résumé, slides, photographs and SASE. Write to schedule an appointment to show a portfolio, which should include originals, slides, transparencies and photographs. Indicate net and retail prices. Replies only if interested within 1 month. Files slides, photos, résumés and promo material. All material is returned if not accepted or under consideration.

Tips: "Many artists have overestimated the value of their work. Look at your competition's prices."

✔GOMEZ GALLERY, 836 Leadenhall St., Baltimore MD 21230. (410)752-2080. E-mail: walter@gomez.com. Website: http://www.gomez.com. Director: Walter Gomez. Contemporary art and photography gallery. Estab. 1988. Represents 60 emerging and mid-career artists. Sponsors 10 shows/year. Average display time 4-5 weeks. Open all year. Located downtown; 1,350 sq. ft.; "clean, open warehouse space." 70% private collectors, 30% corporate collectors. Overall price range: $100-10,000; most work sold at $1,000-2,500.

Media: Considers painting, sculpture and photography in all media.

Style: Interested in all genres. Prefers figurative, abstract and landscapes with an experimental edge.

Terms: Accepts artwork on consignment. Retail price set by the gallery and the artist. Gallery provides insurance and promotion. Artist pays for shipping. Prefers artwork framed.

Submissions: Send query letter with résumé, slides, bio, brochure, SASE and reviews.

Tips: "Find out a little bit about this gallery first; if work seems comparable, send a slide package."

LOBBY FOR THE ARTS GALLERY, Cumberland Theatre, 101 Johnson St., Cumberland MD 21502. Exhibitions Director: Shirley Giarritta. Alternative space. Estab. 1989. Sponsors 6 shows/year. Average display time 3 weeks. Open June-October; Tuesday-Sunday, 1-7 during performances in artists Equity Theatre. Located in downtown area; 600 sq. ft.; museum-standard lighting. 100% of space for special exhibitions. 95% private collectors, 5% corporate collectors. Overall $100-2,000; most work sold at $1,000.

Media: Considers all media, 2 and 3 dimensional. All genres.

Terms: Artwork is accepted on consignment (25% commission). Retail price set by the artist. Gallery provides promotion and contract. Artwork must be ready to hang.

Submissions: Accepts only artists who are able to have work hand-picked up. Send résumé, at least 10 slides and bio. Include SASE; all materials returned by June 1st of each year. "All replies made once a year in April, submission deadline is March 1." Finds artists solely through submissions.

Tips: "Slides must be of the highest quality. Organization of packet is important. Use clips, staples, folders, etc. Slides should be of recent work. Use professional quality matts, frames, bases to show work off at its best! Follow entry directions. Call if you need assistance. Have a fairly large body of work (depending on media that could mean 50 paintings or 6 sculptures of marble, etc.)"

MARLBORO GALLERY, 301 Largo Rd., Largo MD 20772. (301)322-0965. Coordinator: John Krumrein. Nonprofit gallery. Estab. 1976. Interested in emerging, mid-career and established artists. Sponsors 4 solo and 4 group shows/year. Average display time 3 weeks. Seasons for exhibition: September-May. 2,100 sq. ft. with 10 ft. ceilings and 25 ft. clear story over 50% of space—track lighting (incandescent) and daylight. Clientele: 100% private collectors. Overall price range: $200-10,000; most work sold at $500-700.

Media: Considers all media. Most frequently exhibits acrylics, oils, photographs, watercolors and sculpture.

Style: Exhibits expressionism, neo-expressionism, realism, photorealism, minimalism, primitivism, painterly abstraction, conceptualism and imagism. Exhibits all genres. "We are open to all serious artists and all media. We will consider all proposals without prejudice."

Terms: Accepts artwork on consignment. Retail price set by artist. Exclusive area representation not required. Gallery provides insurance. Artist pays for shipping. Prefers artwork ready for display.

Submissions: Send query letter with résumé, slides, SASE, photographs, artist's statement and bio. Portfolio review requested if interested in artist's work. Portfolio should include slides and photographs. Replies every 6 months. Files résumé, bio and slides. Finds artists through word of mouth, visiting exhibitions and submissions.

Tips: Impressed by originality. "Indicate if you prefer solo shows or will accept inclusion in group show chosen by gallery."

‡PYRAMID ATLANTIC, 6001 66th Ave., Suite 103, Riverdale MD 20737. (301)459-7154, (301)577-3424. Artistic Director: Helen Frederick. Nonprofit gallery/library. Estab. 1981. Represents emerging, mid-career and established artists. Sponsors 6 shows/year. Average display time 2 months. Open all year; 10-6. 15% of space for special exhibitions;

10% of space for gallery artists. Also features research library. Clientele: print and book collectors, general audiences. Overall price range: $1,000-10,000; most work sold at $800-2,500.

Media: Considers watercolor, pastel, pen & ink, drawing, mixed media, collage, paper, sculpture, craft, installation, photography, artists' books and all types of prints. Most frequently exhibits works in and on paper, prints and artists' books and mixed media by faculty who teach at the facility and members of related programs.

Style: Exhibits all styles and genres.

Terms: Accepts work on consignment (50-60% commission). Print subscription series produced by Pyramid; offers 50% to artists. Retail prices set by gallery and artist. Gallery provides insurance, promotion and contract; shipping costs are shared.

Submissions: Send query letter with résumé, slides, bio, brochure, SASE and reviews. Call or write for an appointment to show portfolio, which should include originals and slides. Replies in 1 month. Files résumés.

‡ROMBRO'S ART GALLERY, 1805 St. Paul St., Baltimore MD 21202. (410)962-0451. Retail gallery, rental gallery. Estab. 1984. Represents 3 emerging, mid-career and established artists/year. May be interested in seeing the work of emerging artists in the future. Exhibited artists include Dwight Whitley and Judy Wolpert. Sponsors 4 shows/year. Average display time 3 months. Open all year; Tuesday-Saturday, 9-5; closed August. Located in downtown Baltimore; 3,500 sq. ft. Clientele: upscale, local community. Overall price range: $350-15,000.

Media: Considers oil, acrylic, watercolor, pastel, pen & ink, drawing, mixed media, collage, paper, sculpture and ceramics. Considers all types of prints. Most frequently exhibits oil, pen & ink, lithographs.

Style: Exhibits expressionism, painterly abstraction, color field, postmodern works, hard-edge geometric abstraction. Genres include florals and figurative work. Prefers florals and figurative.

Terms: Accepts work on consignment (50% commission) or buys outright for 35% of the retail price; net 45 days. Rental fee for space ($650). Retail price set by the gallery and the artist. Gallery provides promotion and contract; artist pays for shipping costs to gallery. Prefers artwork framed.

Submissions: Send query letter with résumé, brochure, slides and artist's statement. Write for appointment to show portfolio of slides. Files slides. Finds artists through visiting exhibitions.

STEVEN SCOTT GALLERY, 515 N. Charles St., Baltimore MD 21201. (410)752-6218. Director: Steven Scott. Retail gallery. Estab. 1988. Represents 15 mid-career and established artists/year. May be interested in seeing the work of emerging artists in the future. Exhibited artists include Hollis Sigler, Gary Bukovnik. Sponsors 6 shows/year. Average display time 2 months. Open all year; Tuesday-Saturday, 12-6. Located downtown; 1,200 sq. ft.; white walls, grey carpet—minimal decor. 80% of space for special exhibitions; 20% of space for gallery artists. 80% private collectors, 20% corporate collectors. Overall price range: $300-15,000; most work sold at $1,000-7,500.

Media: Considers oil, acrylic, watercolor, pastel, pen & ink, drawing, mixed media, collage, paper and photography. Considers all types of prints. Most frequently exhibits oil, prints and photography.

Style: Exhibits expressionism, neo-expressionism, surrealism, postmodern works, photorealism, realism and imagism. Genres include florals, landscapes and figurative work. Prefers florals, landscapes and figurative.

Terms: Retail price set by the gallery and the artist. Gallery provides insurance, promotion and contract; shipping costs are shared. Prefers artwork unframed.

Submissions: Accepts only artists from US. Send query letter with résumé, brochure, slides, photographs, reviews, bio and SASE. Call for appointment to show portfolio of photographs and slides. Replies in 2 weeks.

Tips: "Don't send slides which are unlike the work we show in the gallery, i.e. abstract or minimal."

Massachusetts

‡BRUSH ART GALLERY, 256 Market St., Lowell MA 01852. (978)459-7819. Contact: E. Linda Poras. Estab. 1984. Represents 35 mid-career and established artists/year. May be interested in seeing the work of emerging artists in the future. Exhibited artists include Vassilios Giavis, Ann Sullivan, Deirdre Grunwald. Sponsors 6 shows/year. Average display time 2 months. Open all year; Tuesday-Sunday, 11-5. Located in National Park Complex; 2,000 sq. ft.; old, restored mill building. 85% of space for special exhibitions; 15% of space for gallery artists. Clientele: tourists, local community. Overall price range: $25-2,500; most work sold at $50-200.

Media: Considers oil, acrylic, watercolor, pastel, pen & ink, mixed media, collage, paper, ceramics, fiber, glass, photography, woodcuts and serigraphs. Most frequently exhibits watercolor, glass and fiber.

Style: Exhibits all styles. Genres include florals, portraits, landscapes, figurative work. Prefers landscapes, florals, figures.

Terms: Accepts work on consignment (40% commission). Rental fee for space; covers 1 year. Retail price set by the artist. Gallery provides insurance, promotion and contract. Gallery pays for shipping from gallery. Artist pays shipping to gallery.

Submissions: Send query letter with résumé, slides and SASE. Call for appointment to show portfolio of photographs. Replies in 1 month. Files résumé and slides.

CAPE MUSEUM OF FINE ARTS, Box 2034, 60 Hope Lane, Dennis MA 02638. (508)385-4477. Executive Director: Gregory F. Harper. Museum. Estab. 1981, opened to public in 1985. Represents emerging and established artists, from

region or associated with Cape Cod. Located "on the grounds of the historic Cape Playhouse." Sponsors 9 exhibitions/year. Average display time 6 weeks.

Media: "We accept all media." No offset reproductions or posters. Most frequently exhibits oil, sculpture, watercolor and prints.

Style: Exhibits all styles and all genres. "The CMFA provides a year-round schedule of art-related activities and programs for the Cape community: exhibitions, Reel Art Cinema, lectures, bus trips and specially planned events for all ages. The permanent collection of over 850 works focuses on art created by Cape artists from the 1800s to the present."

Submissions: Send query letter with résumé and slides. Write for appointment to show portfolio, which should include originals. The most common mistakes artists make in presenting their work are "dropping off work unannounced and not including bio, reference materials or phone number." All material is returned if not accepted or under consideration with SASE.

Tips: "We encourage artist to leave with the Museum their résumé and slides so that we can file it in our archives." Wants to see works by "innovators, creators . . . leaders. Museum-quality works. Artist should be organized. Present samples that best represent your abilities and accomplishments."

DE HAVILLAND FINE ART, 39 Newbury St., Boston MA 02116. (617)859-3880. Fax: (617)859-3973. Website: http://www.artexplorer.com. Contact: Gallery Manager. Retail gallery. Estab. 1989. Represents 20 emerging New England artists. Sponsors 10-12 shows/year. Average display time 1 month. Open all year. Located downtown ½ block from the Ritz Hotel; 1,200 sq. ft. 75% of space for special exhibitions. Clientele: 80% private collectors, 20% corporate collectors. Overall price range: $200-7,000.

Media: Considers oil, acrylic, watercolor, pastel, mixed media and sculpture. Most frequently exhibits oil/acrylic, watercolor/pastel and mixed media.

Style: Exhibits painterly abstraction, impressionism and realism. Genres include landscapes, florals and abstracts. Prefers realism and painterly abstraction.

Terms: Accepts artwork on consignment (50% commission). Retail price set by the gallery and artist. Sometimes offers customer discounts. Gallery provides promotion and contract; artist pays for shipping. Prefers artwork framed.

Submissions: Send query letter with résumé, slides, and SASE. "We support emerging artists who reside in New England." Replies in 1 month. Files résumé.

Tips: Looks for "maturity of visual expression and professionalism."

THE FREYDA GALLERY, 28 Main St., Rockport MA 01966. (978)546-9828. Owner: Freyda M. Craw. Retail gallery. Represents/exhibits 8 mid-career and established artists/year. Exhibited artists include David L. Millard and Rudy Colao. Sponsors ongoing group show and 2-3 special shows/year. Average display time 9 months. Open March through December; Monday-Saturday, 9-5; Sunday, 1-5 (summer); Saturday-Sunday 1-5 (spring and fall). Located downtown. Clientele: tourist, beginning and experienced collectors. 50% private collectors. Overall price range: $200-8,000; most work sold at $200-4,000.

Media: Considers oil, acrylic and watercolor. Most frequently exhibits oil, watercolor and acrylic.

Style: Exhibits expressionism and impressionism. Genres include landscapes, florals, Americana, figurative work and seascapes. Prefers impressionism, realism and expressionism.

Terms: Artwork is accepted on consignment and there is a 40% commission. Retail price set by the gallery and the artist. Gallery provides promotion and contract. Shipping costs are shared. Prefers artwork framed.

Submissions: Interested in established artists only as evidenced by membership in national juried art associations and exhibitions in major juried art shows. Regional gallery exclusivity required. Send query letter with résumé, slides, reviews, bio and SASE. Write for appointment to show portfolio of slides. Replies only if interested within 1 month. Files artist's résumé and bio if future interest. Finds artists through referrals by other artists, exhibitions and artists' submissions.

Tips: "Consistency in quality and style of work but evidence of continued maturity and refinement without loss of creativity."

GALLERY NAGA, 67 Newbury St., Boston MA 02116. (617)267-9060. Directors: Arthur Dion and Virginia Anderson. Retail gallery. Estab. 1977. Represents 30 emerging, mid-career and established artists. Exhibited artists include Robert Ferrandini and George Nick. Sponsors 10 shows/year. Average display time 1 month. Open Tuesday-Saturday 10-5:30. Gallery Naga is open the first Thursday each of month until 7 p.m. Closed August. Located on "the primary street for Boston galleries; 1,500 sq. ft.; housed in an historic neo-gothic church." Clientele: 90% private collectors, 10% corporate collectors. Overall price range: $500-40,000; most work sold at $2,000-10,000.

Media: Considers oil, acrylic, mixed media, sculpture, photography, studio furniture and monotypes. Most frequently exhibits painting and furniture.

Style: Exhibits expressionism, painterly abstraction, postmodern works and realism. Genres include landscapes, portraits and figurative work. Prefers expressionism, painterly abstraction and realism.

Terms: Accepts work on consignment (50% commission). Retail price set by gallery and artist. Gallery provides insurance and promotion; artist pays for shipping. Prefers artwork framed.

Submissions: "Not seeking submissions of new work at this time."

Tips: "We focus on Boston and New England artists. We exhibit the most significant studio furnituremakers in the country. Become familiar with a gallery to see if your work is appropriate before you make contact."

LE PETIT MUSÉE OF WORDPLAY, P.O. Box 556, Housatonic MA 01236. (413)274-1200. E-mail: indearts@aol.c om. Owner: Sherry Steiner. Retail gallery. Estab. 1991. "Specializes in vintage and contemporary small works of art of extraordinary merit." Interested in the work of emerging artists. Exhibited artists include Roy Interstate and Felicia Zumakoo. Average display time 1-3 months. Open all year; weekends 12-5; weekdays by appointment or chance, opens at noon or by appointment. Located in village of Housatonic "Soho of the Berkshires"; 144 sq. ft.; storefront in an arts community. Clientele: tourists, upscale local. 70% private, 30% corporate collectors. Overall price range: $100-10,000; most work sold at $100-10,000.
Media: Considers all media except craft. Considers wood engravings, engravings, mezzotints, lithographs and serigraphs. Most frequently exhibits paintings, drawings, photographs, mixed media.
Style: Exhibits all styles. Prefers postmodern works, realism and imagism.
Terms: Artwork is accepted on consignment (50% commission). Retail price set by the gallery. Gallery provides promotion. Artist pays for shipping costs. Framed art only.
Submissions: Send 10 slides, photographs, reviews, bio and SASE. Call for appointment. Replies in 1 week. Finds artists through word of mouth, referrals and submissions.
Tips: Advises artists to "submit adequate information on work. Send clear photos or slides and label each."

‡LICHTENSTEIN CENTER FOR THE ARTS/BERKSHIRE ARTISANS GALLERY, 28 Renne Ave., Pittsfield MA 01201. (413)499-9348. Artistic Director: Daniel M. O'Connell. Nonprofit gallery, alternative space exhibiting juried shows. Estab. 1976. Represents/exhibits emerging, mid-career and established artists. Exhibited artists include: Thomas Patti and Rapheal Soyer. Sponsors 8 shows/year. Average display time 6 weeks. Open Monday-Friday, 11-5. Located in downtown Pittsfield, 2,400 sq. ft.; historic brownstone, high oak ceilings, north light, wood floors. 100% of space for special exhibitions of gallery artists. 35% private collectors, 10% corporate collectors. Overall price range: $150-20,000; most work sold at $150-20,000.
Media: Considers all media. Most frequently exhibits painting, drawing/prints, sculpture/glass.
Style: Exhibits all styles and genres.
Terms: "We exhibit juried works at 20% commission." Retail price set by the artist. Gallery provides insurance, promotion and contract. Artist pays for shipping costs.
Submissions: Send query letter with résumé, slides, photographs, reviews, bio and SASE. Does not reply. Artist should send 20 slides with résumé and SASE only. No entry fee.
Tips: "We are usually booked solid for exhibitions 3-5 years ahead of schedule." Advises artists to "develop professional, leather bound portfolio in duplicate with up to 20 slides, résumé, exhibit listings and SASE."

ANDREA MARQUIT FINE ARTS, 38 Newbury St., Floor 4, Boston MA 02116. (617)859-0190. Director: Andrea Marquit Clagett. Retail gallery and art consultancy. Estab. 1982 in NY, 1989 in Boston. Represents 25 emerging and mid-career artists. Exhibited artists include Barbara Farrell and Adrianne Wortzel. Sponsors 7 shows/year. Average display time 5 weeks. Open Wednesday-Saturday, 11-5. Located in the Back Bay; 600 sq. ft.; "small space in excellent location, in gallery building." Clientele: collectors, architects, designers, corporations. 40% private collectors, 60% corporate collectors. Overall price range: $800-50,000; most work sold at $1,000-5,000.
Media: Oil, acrylic, watercolor, pastel, drawings, mixed media, collage, works on paper, sculpture, ceramic, photography, original handpulled multiples. Most frequently exhibits paintings and unique works on paper.
Style: Exhibits painterly abstraction, minimalism, color field and hard-edge geometric abstraction.
Terms: Accepts artwork on consignment. Retail price set by the gallery and the artist. Gallery provides promotion and contract. Artist pays for shipping to and from gallery.
Submissions: Send query letter with résumé, slides, bio, brochure, SASE and reviews. Replies only if interested within 1 month; if not interested, 2-3 months. If interested, files slides, bio and reviews.
Tips: "If you are on a serious career path, have a gallery exhibition history and you stylistically fall into our range, you can consider sending slides."

MERCURY GALLERY, 8 Newbury St., Boston MA 02116. (617)859-0054. Fax: (617)859-5968. Retail gallery. Represents 12 emerging and mid-career artists/year. Exhibited artists include Karl Zerbe and Joseph Solman. Sponsors 4 shows/year. Average display time 1 month. Open all year; Monday-Saturday, 10-6. Located on Back Bay. 50% of space for special exhibitions; 50% of space for gallery artists. Overall price range: $200-80,000.
Media: Considers oil, acrylic, watercolor, pen & ink, drawing, mixed media, collage, paper; no prints.
Style: Exhibits expressionism, painterly abstraction, surrealism, conceptualism, minimalism, postmodern works, impressionism. All genres.
Terms: Accepts work on consignment (50% commission.) Retail price set by the gallery and the artist. Gallery provides promotion. Shipping costs are shared. Prefers artwork framed.
Submissions: Send query letter with slides, photographs, reviews, bio and SASE. Write for appointment to show portfolio of photographs, transparencies and slides. Replies in 2 weeks. Files bio. Finds artists through referrals by other artists, submissions.

R. MICHELSON GALLERIES, 132 Main St., Northampton MA 01060. (413)586-3964. Also 25 S. Pleasant St., Amherst MA 01002. (413)253-2500. Owner: R. Michelson. Retail gallery. Estab. 1976. Represents 30 emerging, mid-career and established artists/year. Exhibited artists include Barry Moser and Leonard Baskin. Sponsors 6 shows/year. Average display time 1 month. Open all year; Monday-Saturday, 10-6; Sunday, 12-5. Located downtown; Northampton

gallery has 1,500 sq. ft.; Amherst gallery has 1,800 sq. ft. 50% of space for special exhibitions. Clientele: 80% private collectors, 20% corporate collectors. Overall price range: $10-75,000; most artwork sold at $1,000-25,000.
Media: Considers all media and all types of prints. Most frequently exhibits oil, egg tempera, watercolor and lithography.
Style: Exhibits impressionism, realism and photorealism. Genres include florals, portraits, wildlife, landscapes, Americana and figurative work.
Terms: Accepts work on consignment (50% commission). Retail price set by gallery and artist. Customer discounts and payment by installment are available. Gallery provides promotion; shipping costs are shared.
Submissions: Prefer local, Pioneer Valley artists. Send query letter with résumé, slides, bio, brochure and SASE. Write for appointment to show portfolio. Replies in 3 weeks. Files slides.

‡**PIERCE GALLERIES, INC.**, 721 Main St., Rt. 228, Hingham MA 02043. (617)749-6023. Fax: (617)749-6685. President: Patricia Jobe Pierce. Retail and wholesale gallery, art historians, appraisers and consultancy. Estab. 1968. Represents 8 established artists. May consider emerging artists in the future. Exhibited artists include Eric Midttun, Joseph Fontaine, Geetesh De Cünto and Kahlil Gibran. Sponsors 8 shows/year. Average display time 1 month. Open all year. Hours by appointment only. Located "in historic district on major road; 3,800 sq. ft.; historic building with high ceilings and an elegant ambiance." 100% of space for special exhibits. Overall price range: $1,500-400,000; most work sold at $1,500-100,000.
Media: Considers oil, acrylic, watercolor, pastel, pen & ink, drawings and sculpture. Does not consider prints. Most frequently exhibits oil, acrylic and watercolor.
Style: Exhibits expressionism, neo-expressionism, surrealism, impressionism, realism, photorealism and social realism. All genres and subjects, including landscapes, florals, Americana, western, wildlife and figurative work. Prefers impressionism, expressionism and super realism.
Terms: Often buys artwork outright for 50% of retail price; sometimes accepts on consignment (20-33% commission). Retail price set by artist, generally. Sometimes offers customer discounts and payment by installment. Gallery provides insurance and promotion; contract and shipping costs may be negotiated.
Submissions: Send query letter with résumé, slide sheets of 10 slides and SASE. Gallery will contact if interested for portfolio review. Portfolio should include photos or slides of originals. Replies in 48 hours. Files material of future interest.
Tips: Finds artists through referrals, portfolios/slides "sent to me or I see the work in a show or magazine. I want to see consistent, top quality work and techniques—not a little of this, a little of that. Please supply three prices per work: price to dealer buying outright, price to dealer for consigned work and a retail price. The biggest mistake artists make is that they sell their own work (secretly under the table) and then expect dealers to promote them! If a client can buy art directly from an artist, dealers don't want to handle the work. Artists should have a body of work of around 300 pieces before approaching galleries."

PUCKER GALLERY, INC., 171 Newbury St., Boston MA 02116. (617)267-9473. Fax: (617)424-9759. Director: Bernard Pucker. Retail gallery. Estab. 1967. Represents 30 emerging, mid-career and established artists. Exhibited artists include modern masters such as Picasso, Chagall, Braque, and Samuel Bak and Brother Thomas. Sponsors 8 shows/year. Average display time 4-5 weeks. Open all year. Located in the downtown retail district. 5% of space for special exhibitions. Clientele: private clients from Boston, all over the US and Canada. 90% private collectors, 10% corporate clients. Overall price range: $20-200,000; most artwork sold at $5,000-20,000.
Media: Considers all media. Most frequently exhibits paintings, prints and sculpture.
Style: Exhibits all styles. Genres include landscapes and figurative work.
Terms: Terms of representation vary by artist, "usually it is consignment." Retail price set by gallery. Gallery provides promotion; artist pays shipping. Prefers artwork unframed.
Submissions: Send query letter with résumé, slides, bio and SASE. Write for appointment to show portfolio of originals and slides. Replies in 3 weeks. Files résumés.

‡**JUDI ROTENBERG GALLERY**, 130 Newbury St., Boston MA 02116. (617)437-1518. Retail gallery. Estab. 1964. Represents 14 emerging, mid-career and established artists. Average display time 3 weeks. Open all year. Located in the Back Bay; 1,400 sq. ft. 100% of space for special exhibitions. Overall price range: $800-19,000; most work sold at $1,200-7,000.
Media: Considers all media. Most frequently exhibits oil, watercolor and acrylic.
Style: Exhibits expressionism, painterly abstraction and postmodern works. Genres include landscapes, florals, portraits and figurative work. Prefers expressionism and post-modernism.
Terms: Accepts artwork on consignment (50% commission). Retail price set by the artist. Gallery provides insurance, promotion and contract; artist pays shipping costs. Prefers artwork framed.
Submissions: Send query letter with résumé, slides, bio and photographs, reviews and SASE. Write for appointment to show portfolio of photographs. Replies only if interested.

THE SOCIETY OF ARTS AND CRAFTS, 175 Newbury St., Boston MA 02116. (617)266-1810. E-mail: societycraft@earthlink.net. Website: http://www.societyofcrafts.org. Also, second location at 101 Arch St., Boston MA 02110. (617)345-0033. Executive Director: Beth Ann Gerstein. Retail gallery with for-sale exhibit space. Estab. 1897. Represents 350 emerging, mid-career and established artists. 900 members. Sponsors 6-10 exhibitions/year (in the 2 gallery spaces). Average display time 6-8 weeks. Open all year; main: Monday-Saturday, 10-6; Sunday 12-5; second: Monday-

Friday, 11-7. Located in the Copley Square Area; 2nd floor of a brownstone. "The Society is the oldest nonprofit craft organization in America." 50% of space for special exhibitions; 50% of space for gallery artists. Clientele: corporate, collectors, students, interior designers. 85% private collectors, 15% corporate collectors. Overall price range: $2.50-6,000; most work sold at $100-300.

Media: Considers mixed media, metals, paper, sculpture, ceramics, wood, fiber and glass. Most frequently exhibits wood, clay and metal.

Style: Exhibits contemporary American crafts in all mediums, all genres.

Terms: Accepts work on consignment (50% commission). "Exhibiting/gallery artists can become members of the Society for $25 membership fee, annual." Retail price set by the artist; "if assistance is needed, the gallery will suggest." Gallery provides insurance, promotion and contract. Prefers artwork framed.

Submissions: Accepts only artists residing in the US. Send query letter with résumé, no more than 10 slides, bio, brochure, SASE, business card and reviews. Portfolio should include slides or photos (if slides not available). Replies in 6 weeks. Files résumés (given out to purchaser), reviews, visuals. Finds artists through networking with artists and other craft organizations, trade shows (ACC Philadelphia, Springfield, Rosen Baltimore), publications (*Niche, American Craft*) and various specialty publications (*Metalsmith, Sculpture, American Woodworking*, etc.), collectors, other galleries, general submissions.

‡**TOWNE GALLERY**, 88 Main St., Lenox MA 01240. (413)637-0053. Owner: James Terry. Retail gallery. Estab. 1977. Represents 25 mid-career artists. Sponsors 1 solo and 2 group shows/year. Average display time 1 month. "Located in center of village with 800 sq. ft. of space." Clientele: 95% private collectors, 5% corporate clients. Overall price range: $100-3,500; most artwork sold at $350-650.

Media: Considers oil, acrylic, watercolor, pastel, mixed media, collage, paper, sculpture, ceramic, craft, fiber, glass, mezzotints, etchings, lithographs and serigraphs. Most frequently exhibits serigraphs, collagraphs and ceramics.

Style: Exhibits color field, painterly abstraction and landscapes. "The gallery specializes in contemporary abstracts for the most part. We also show large ceramics as an addition to the fine arts." No political statements.

Terms: Accepts work on consignment (60% commission). Retail price set by gallery and artist. Exclusive area representation required. Gallery provides insurance, promotion and contract; artist pays for shipping. Prefers artwork framed.

Submissions: Send query letter with résumé, brochure, slides, photographs, bio and SASE. Write for appointment to show portfolio of originals, "after query letter is responded to." Replies only if interested within 6 months. Files bios and slides. All material returned if not accepted or under consideration.

Tips: "Use professional slides and show current work that fits our gallery image."

WENNIGER GALLERY, 19 Mount Pleasant St., Rockport MA 01966. (508)546-8116. Directors/Owners: Mary Ann and Mace Wenniger. Retail gallery and art consultancy. Estab. 1971. Represents 250 emerging, mid-career and established artists. Exhibited artists include Yuji Hiratsuka, Wil Barnet, Helen Frank and Stowe Wengenroth. Sponsors 10 shows/year. Average display time 3 weeks. Open all year; Monday-Saturday, 11-5. Located on waterfront; 1,000 sq. ft.; downtown, attractive, cheery building. 50% of space for special exhibitions, 50% of space for gallery artists and crafts. Clientele: young professionals, young families. Overall price range: $50-1,000.

Media: Considers watercolor, woodcuts, engravings, lithographs, wood engravings, mezzotints, serigraphs, etchings, collagraphs, monoprints. Most frequently exhibits collagraphs, mezzotints, wood engravings, etchings and watercolors.

Style: Exhibits expressionism, color field and realism. Genres include figurative work.

Terms: Accepts work on consignment (50% commission). Retail prices set by the artist. Gallery provides insurance and shipping costs from gallery; artist pays shipping costs to gallery. Prefers artwork unframed, matted and shrinkwrapped.

Submissions: Send query letter with résumé, 6 slides or 6 color photographs. Write for appointment to show portfolio. Replies only if interested within 2 months. Finds artists through visiting exhibitions and through gallery contacts.

Michigan

‡**THE ART CENTER**, 125 Macomb Place, Mount Clemens MI 48043. (810)469-8666. Fax: (810)469-4529. Executive Director: Jo-Anne Wilkie. Nonprofit gallery. Estab. 1969. Represents emerging, mid-career and established artists. 500 members. Sponsors 10 shows/year. Average display time 1 month. Open all year except July and August; Tuesday-Friday, 11-5; Saturday, 9-2. Located in downtown Mount Clemens; 1,300 sq. ft. The Art Center is housed in the historic Carnegie Library Building, listed in the State of Michigan Historical Register. 100% of space for special exhibitions. Clientele: private and corporate collectors. Overall price range: $5-1,000; most work sold at $50-500.

Media: Considers oil, acrylic, watercolor, pastel, pen & ink, drawing, mixed media, collage, paper, sculpture, ceramics, photography, jewelry, metals, craft, fiber, glass, all types of printmaking. Most frequently exhibits oils/acrylics, watercolor, ceramics and mixed media.

Style: Exhibits all styles, all genres.

Terms: The Art Center receives a 30% commission on sales of original works; 50% commission on prints.

Submissions: Send query letter with good reviews, 12 or more professional slides and a professional artist biography. Send photographs or slides and résumé with SASE for return. Finds artists through submissions, queries, exhibit announcements, word of mouth and membership.

Tips: "Join The Art Center as a member, call for placement on our mailing list, enter the Michigan Annual Exhibition."

‡**ART TREE GIFT SHOP/GALLERY II**, 461 E. Mitchell, Petoskey MI 49770. (616)347-4337. Manager: Mary Wiklanski. Retail shop and gallery of a nonprofit arts council. Estab. 1982. Represents emerging, mid-career and established artists. Prefers Michigan artists. Clientele: heavy summer tourism. 99% private collectors, 1% corporate clients. Overall price range: $6-2,000; most work sold at $20-1,000.
- Gallery II is an exhibit gallery. Monthly thematic exhibits will feature work from the area. Some work exhibited will be for sale.

Media: Considers collage, works on paper, sculpture, ceramic, wood, fiber, glass, original handpulled prints, posters, watercolor, oil, acrylics and mixed media.
Style: Seeks "moderately sized work that expresses creativity and fine art qualities."
Terms: "A handler's fee is charged on all gallery sales." Retail price is set by gallery and artist. All work is accepted by jury. Gallery provides insurance and promotion; artist pays for shipping.
Submissions: Call or write for information.
Tips: "Our audience tends to be conservative, but we enjoy stretching that tendency from time to time. A common mistake artists make in presenting their work is not having it ready for presentation." Great need for new work to attract the potential purchaser. "We work from an artist list which is constantly being updated by request, participation or reference."

‡**BELIAN ART CENTER**, 5980 Rochester Rd., Troy MI 48098. (313)828-7001. Directors: Garabedor Zabel Belian. Retail gallery and art consultancy. Estab. 1985. Represents 20 emerging, mid-career and established artists/year. Exhibited artists include Reuben Nakian and Edward Avesdisian. Sponsors 8-10 shows/year. Average display time 1 month. Open all year; Monday-Saturday, 12-6. Located in a suburb of Detroit; 2,000 sq. ft.; has outdoor area for pool side receptions; different levels of exhibits. 50% of space for special exhibitions; 50% of space for gallery artists. Clientele: 50-60% local, 30% Metropolitan area 10-20% national. 70-80% private collectors, 10-20% corporate collectors. Overall price range: $1,000-20,000.
Media: Considers oil, acrylic, watercolor, pastel, pen & ink, drawing, mixed media, collage, paper, sculpture, ceramics, installation, photography, woodcuts, engravings, lithographs, wood engravings, mezzotints and serigraphs. Most frequently exhibits oils, sculptures (bronze) and engraving.
Style: Exhibits expressionism, neo-expressionism, primitivism, painterly abstraction, surrealism, conceptualism, minimalism, color field, postmodern works, impressionism, photorealism, hard-edge geometric abstraction, realism and imagism. Includes all genres. Prefers abstraction, realism, mixed.
Terms: Accepts work on consignment (commission varies) or buys outright for varying retail price. Retail price set by the gallery and the artist. Gallery provides insurance and promotion; shipping costs are shared. prefers artwork framed.
Submissions: Send query letter with résumé, 6-12 slides, bio, brochure, photographs and reviews. Call or write for appointment to show portfolio of photographs, slides and transparencies. Replies only if interested within 2-3 weeks. Finds artists through catalogs, sourcebooks, exhibitions and magazines.
Tips: "Produce good art at an affordable price. Have a complete biography and representative examples of your characteristic style. Have enough art pieces for a viable exhibition, which will also show your artistic merit and ability."

‡**JESSE BESSER MUSEUM**, 491 Johnson St., Alpena MI 49707. (517)356-2202. Director: Dennis R. Bodem. Chief of Resources: Robert E. Haltiner. Nonprofit gallery. Estab. 1962. Interested in emerging and established artists. Sponsors 5 solo and 16 group shows/year. Average display time 1 month. Prefers but not limited to northern Michigan artists. Clientele: 80% private collectors, 20% corporate clients. Overall price range: $10-2,000; most artwork sold at $50-250.
Media: Considers oil, acrylic, watercolor, pastel, pen & ink, drawings, mixed media, collage, works on paper, sculpture, ceramic, craft, fiber, glass, installation, photography, original handpulled prints and posters. Most frequently exhibits prints, watercolor and acrylic.
Style: Exhibits hard-edge geometric abstraction, color field, painterly abstraction, pattern painting, primitivism, impressionism, photorealism, expressionism, neo-expressionism, realism and surrealism. Genres include landscapes, florals, Americana, portraits, figurative work and fantasy illustration.
Terms: A 20% commission on sales is charged by the museum..
Submissions: Send query letter, résumé, brochure, slides and photographs to Robert E. Haltiner. Write for appointment to show portfolio of slides. Letter of inquiry and brochure are filed. Finds artists through word of mouth, art publications and sourcebooks, artists' submissions, self-promotions, art collectors' referrals and through visits to art fairs and festivals.
Tips: "Make sure you submit good quality slides with necessary information on them—title, media, artist, size."

‡**DETROIT ARTISTS MARKET**, 300 River Place, Suite 1650, Detroit MI 48207. (313)393-1770. Fax: (313)393-1772. Executive Director: MariaLuisa Belmonte. Nonprofit gallery. Estab. 1932. Exhibits the work of 600 emerging, mid-career and established artists/year; 1,100 members. Sponsors 12-14 shows/year. Average display time 1 month. Open Tuesday-Saturday, 11-5; Friday until 8. Closed August. Located in downtown Detroit; 3,500 sq. ft. 95% of space for special exhibitions. Clientele: "extremely diverse client base—varies from individuals to the Detroit Institute of Arts." 95% private collectors; 5% corporate collectors. Overall price range: $200-15,000; most work sold at $100-500.
Media: Considers all media. No posters. Most frequently exhibits painting, sculpture and craft.
Style: All contemporary styles and genres.
Terms: Accepts artwork on consignment (40% commission). Retail price set by the artist. Gallery provides insurance; artist pays for shipping. Prefers artwork framed.
Submissions: Accepts only artists from Michigan. Send query letter with résumé, slides and SASE. "No portfolio

reviews." Replies only if interested.

Tips: "The Detroit Artists Market is a nonprofit contemporary art gallery that exhibits the work of Michigan artists and educates the public of southeastern Michigan about contemporary art and artists. It is the oldest continuously operating gallery in Detroit."

FIELD ART STUDIO, 24242 Woodward Ave., Pleasant Ridge MI 48069. (810)399-1320. Director: Jerome Feig. Retail gallery and art consultancy. Estab. 1950. Represents 6 mid-career and established artists. Average display time 1 month. Overall price range: $25-3,000; most work sold at $100-800.

Media: Considers watercolor, pastel, pen & ink, mixed media, collage, paper, fiber and original handpulled prints. Specializes in etchings and lithographs.

Style: Exhibits landscapes, florals and figurative work. Genres include aquatints, watercolor and acrylic paintings.

Terms: Accepts work on consignment (40% commission). Retail price set by gallery and artist. Exclusive area representation not required. Gallery provides insurance, promotion and contract; shipping costs are shared.

Submissions: Send query letter, résumé, slides or photographs. Write for appointment to show portfolio of originals and slides. Bio and résumé are filed.

Tips: "We are looking for creativeness in the artists we consider. Do not want to see commercial art. Approach gallery in a businesslike manner."

GALLERY SHOP: BIRMINGHAM BLOOMFIELD ART ASSOCIATION, 1516 S. Cranbrook Rd., Birmingham MI 48009. (248)644-0866. Fax: (248)644-7904. Gallery Shop Manager: Sarah Zimmermann. Nonprofit gallery shop. Estab. 1962. Represents emerging, mid-career and established artists. Sponsors ongoing exhibition. Open all year; Monday-Saturday, 9-5. Suburban location. 50% of space for special exhibitions; 50% of space for gallery artists. Clientele: upscale, local. 100% private collectors. Overall price range: $50-2,000.

Media: Considers all media. Most frequently exhibits glass, jewelry and ceramics.

Style: Exhibits all styles.

Terms: Accepts work on consignment (30% commission). Retail price set by the artist. Gallery provides promotion and contract; artist pays for shipping costs to gallery.

Submissions: "We do not represent individual artists except in gallery shop. We review proposals for group or concept shows twice yearly." Send query letter with résumé, brochure, slides, photographs, reviews, artist's statement, bio, SASE; "as much information as possible." Files résumé, bio, brochure, photos.

Tips: "We consider the presentation of the work (framing, matting, condition) and the professionalism of the artist, meaning the level of commitment they have to marketing their work—not how they dress or present themselves."

‡THE GALLERY SHOP/ANN ARBOR ART CENTER, 117 W. Liberty, Ann Arbor MI 48104. (313)994-8004. E-mail: a2artcen@aol.com. Gallery Shop Director: Julie Brannon. Estab. 1978. Represents over 200 artists, primarily regional. Clientele: private collectors and corporations. Overall price range: $2,000; most 2-dimensional work sold at $400-800; 3-dimensional work from $25-100. "Proceeds help support the Art Center's exhibits and education programs for all ages."

● The Ann Arbor Art Center also has exhibition opportunities for Michigan artists in off-site exhibits; and a 2-month holiday gifts show, which features 25 new artists every November and December.

Media: Considers original work in virtually all 2- and 3-dimensional media, including jewelry, original handpulled prints and etchings, ceramics, glass, fiber and painting.

Style: "The gallery specializes in well-crafted and accessible artwork. Many different styles are represented, including innovative contemporary."

Terms: Accepts work on consignment (40% commission on members' work; 50% on nonmembers). Retail price set by artist. Offers customer discounts and payment by installments. Exclusive area representation not required. Gallery provides contract; artist pays for shipping.

Submissions: Send query letter, résumé, brochure, 5 slides and SASE. Materials are considered on a rolling basis. Great Lakes area artists may be called in for one-on-one review. "We look for artists through visiting exhibitions, wholesale and retail craft shows, networking with graduate and undergraduate schools, word of mouth, artist referral and submissions."

Tips: "We are particularly interested in contemporary, glass, ceramics, wood and metal at this time."

‡ROBERT L. KIDD GALLERY, 107 Townsend St., Birmingham MI 48009. (248)642-3909. Fax: (248)647-1000. Director: Ray Frost Fleming. Retail gallery. Estab. 1976. Represents approximately 125 emerging, mid-career and established artists. Sponsors 8 solo and 3 group shows/year. Average display time is 1 month. Open: Tuesday-Saturday, 10:30-5:30; or by appointment. Clientele: 50% private collectors, 50% corporate clients. Overall price range: $1,000-100,000; most artwork sold at $4,000-20,000.

Media: Considers oil, acrylic, watercolor, pastel, mixed media, works on paper, sculpture, ceramic, fiber and glass. Most frequently exhibits acrylic, oil and sculpture.

Style: Exhibits color field, painterly abstraction, photorealism and realism. "We specialize in original contemporary paintings, sculpture, glass and clay by contemporary American artists."

Terms: Accepts work on consignment. Retail price set by gallery and artist. Exclusive area representation required. Gallery provides insurance and promotion; shipping costs are shared.

Submissions: Send query letter, résumé, slides and SASE.

Tips: Looks for "high-quality technical expertise and a unique and personal conceptual concept. Understand the direction we pursue and contact us with appropriate work."

RUSSELL KLATT GALLERY, 1467 S. Woodward, Birmingham MI 48009. (810)647-6655. Fax: (810)644-5541. Director: Sharon Crane. Retail gallery. Estab. 1987. Represents 100 established artists/year. Interested in seeing the work of emerging artists. Exhibited artists include Henri Plisson, Roy Fairchild, Don Hatfield, Mary Mark, Eng Tay. Open all year; Monday-Friday, 10-6; Saturday, 10-5. Located on Woodward, 4 blocks north of 14 mile on the east side; 800 sq. ft. 100% private collectors. Overall price range: $800-1,500; most work sold at $1,000.
Media: Considers oil, acrylic, watercolor, pastel, ceramics, lithograph, mezzotint, serigraphs, etching and posters. Most frequently exhibits serigraphs, acrylics and oil pastels.
Style: Exhibits painterly abstraction, impressionism and realism. Genres include landscapes, florals and figurative work. Prefers traditional European style oil paintings on canvas.
Terms: Accepts work on consignment (60% commission) or buys outright for 50% of retail price (net 30-60 days). Retail price set by the gallery and the artist. Gallery provides insurance and shipping to gallery; artist pays shipping costs from gallery. Prefers artwork unframed.
Submissions: Send query letter with brochure and photographs. Write for appointment to show portfolio of photographs. Finds artists through visiting exhibitions.

KRASL ART CENTER, 707 Lake Blvd., St. Joseph MI 49085. (616)983-0271. Fax: (616)983-0275. Director: Dar Davis. Retail gallery of a nonprofit arts center. Estab. 1980. Clientele: community residents and summer tourists. Sponsors 30 solo and group shows/year. Average display time is 1 month. Interested in emerging and established artists. Most artwork sold at $100-500.
Media: Considers oils, acrylics, watercolor, pastels, pen & ink, drawings, mixed media, collage, paper, sculpture, ceramics, crafts, fibers, glass, installations, photography and performance.
Style: Exhibits all styles. "The works we select for exhibitions reflect what's happening in the art world. We display works of local artists as well as major traveling shows from SITES. We sponsor all annual Michigan competitions and construct significant holiday shows each December."
Terms: Accepts work on consignment (35% commission). Retail price is set by artist. Sometimes offers customer discounts. Exclusive area representation required. Gallery provides insurance, promotion, shipping and contract.
Submissions: Send query letter, résumé, slides, and SASE. Call for appointment to show portfolio of originals.

SAPER GALLERIES, 433 Albert Ave., East Lansing MI 48823. Phone/fax: (517)351-0815. E-mail: rsaper812@aol.com. Website: http://home.aol.com/RSaper812. Director: Roy C. Saper. Retail gallery. Estab. in 1978 as 20th Century Fine Arts; in 1986 designed and built new location and name. Displays the work of 100 artists; mostly mid-career, and artists of significant national prominence. Exhibited artists include Picaasso and Peter Max. Sponsors 2-3 shows/year. Average display time 6 weeks. Open all year. Located downtown; 3,700 sq. ft.; "We were awarded *Decor* magazine's Award of Excellence for gallery design." 30% of space for special exhibitions. Clientele: students, professionals, experienced and new collectors. 80% private collectors, 20% corporate collectors. Overall price range: $30-140,000; most work sold at $500-15,000.
Media: Considers oil, acrylic, watercolor, pastel, drawings, mixed media, collage, paper, sculpture, ceramic, craft, glass and original handpulled prints. Considers all types of prints except offset reproductions. Most frequently exhibits intaglio, serigraphy and sculpture. "Must be of highest quality."
Style: Exhibits expressionism, painterly abstraction, surrealism, postmodern works, impressionism, realism, photorealism and hard-edge geometric abstraction. Genres include landscapes, florals, southwestern and figurative work. Prefers abstract, landscapes and figurative. Seeking artists who will continue to produce exceptional work.
Terms: Accepts work on consignment (negotiable commission); or buys outright for negotiated percentage of retail price. Retail price set by gallery and artist. Offers payment by installments. Gallery provides insurance, promotion and contract; shipping costs are shared. Prefers artwork unframed (gallery frames).
Submissions: Send query letter with bio or résumé, brochure and 6-12 slides or photographs and SASE. Call for appointment to show portfolio of originals or photos of any type. Replies in 1 week. Files any material the artist does not need returned. Finds artists mostly through NY Art Expo.
Tips: "Present your very best work to galleries which display works of similar style, quality and media. Must be outstanding, professional quality. Student quality doesn't cut it. Must be great. Be sure to include prices and SASE."

PERRY SHERWOOD GALLERY, 200 Howard St., Petoskey MI 49770. (616)348-5079. Fax: (616)348-5057. Director: Zalmon Sherwood. Retail gallery. Estab. 1993. Represents 25 emerging, mid-career and established artists/year. Sponsors 4 shows/year. Average display time 6 weeks. Open all year; Monday-Saturday, 10-6; Sunday, 12-4. Located in downtown historic district; 3,000 sq. ft. 25% of space for special exhibitions; 75% of space for gallery artists. Clientele: tourists and upscale. 80% private collectors, 20% corporate collectors. Overall price range: $800-25,000; most work sold at $2,000-5,000.
 ● Perry Sherwood Gallery has a second location at 24-A N. Blvd. of the Presidents, Sarasota FL 34236. (941)388-
 5334. Fax: (941)388-5253. Estab. 1996. Located in southwest Florida Gulf resort; 2,000 sq. ft.
Media: Considers oil, glass, watercolor, ceramics, pastel and photography. Most frequently exhibits oil painting, sculptural glass and ceramics.
Style: Exhibits realism and impressionism. Genres include florals, landscapes and figurative work.

Terms: Accepts work on consignment (50% commission). Retail price set by the artist. Gallery provides insurance, promotion and contract; artist pays for shipping. Prefers artwork framed.
Submissions: Send query letter with résumé, slides, photographs, reviews, artist's statement and SASE. Call for appointment to show portfolio of photographs and slides. Replies in 3 weeks. Finds artists through word of mouth, referrals by other artists, visiting art fairs and exhibitions, submissions.

Minnesota

‡**ART DOCK INC.**, 394 Lake Ave. S., Duluth MN 55802. (218)722-1451. Owner: Bev L. Johnson. Retail consignment gallery. Estab. 1985. Represents 185 emerging and mid-career artists/year. Exhibited artists include: Cheng Khee Chee and Jay Steinke. Sponsors 4 exhibitions/year. Average display time 6 months. Open all year; January 1-Memorial Day; Monday-Wednesday and Saturday, 10-6; Thursday-Friday, 10-9; Sunday, 11-5; Memorial Day-December, Monday-Friday, 10-9; Saturday, 10-8; Sunday, 11-5. Located downtown-Canal Park, 1,200 sq. ft. historical building. #1 tourist attraction in the state on the shores of Lake Superior. We feature local artist within a 100 mile radius of Duluth. Clientele: 50% local, 50% tourists. 95% private collectors, 5% corporate collectors. Over price range: $1-5,000; most work sold at $30-75.
Media: Considers all painting, sculpture and fine craft media, including all types of prints. Also includes books, tapes, cards, jewelry, stained glass and batik. Most frequently exhibits watercolor, pottery and photographs.
Style: Exhibits: painterly abstraction, photorealism and realism. Genres include florals, landscapes and still life.
Terms: Accepts work on consignment (40% commission). Retail price set by the artist. Gallery provides insurance, promotion and contract; artists pays for shipping.
Submissions: Accepts only artists from 100 mile radius of Duluth. Send query letter with photographs, or call for appointment to show portfolio of photographs and slides. Replies in 2 months. Files current artist information. Finds artists through submissions.
Tips: "Submit your work if you live within the 100 radius of Duluth. Be sure to present your work in a professional manner. The most common mistake new artists make is poor presentation."

✔**ART OPTIONS GALLERY**, 132 E. Superior St., Duluth MN 55802. (218)727-8723. President: Sue Pavlatos. Retail gallery. Estab. 1988. Represents 35 mid-career artists/year. Sponsors 4 shows/year. Average display time 1 month. Open all year; Tuesday-Friday, 10:30-5; Monday and Saturday, 10:30-2. Located downtown. Clientele: tourists and local community. 70% private collectors, 30% corporate collectors. Overall price range: $50-1,000; most work sold at $300.
Media: Considers all media and all types of prints. Most frequently exhibits watercolor, mixed media and oil.
Style: Exhibits all styles and genres. Prefers: landscape, florals and Americana.
Terms: Accepts work on consignment (40% commission). Retail price set by the artist. Gallery provides insurance and promotion; artist pays for shipping. Prefers artwork framed.
Submissions: Send query letter with résumé, slides and bio. Write for appointment to show portfolio of slides. Replies in 2 weeks. Files bio and résumé. Finds artists through word of mouth.
Tips: "Paint or sculpt as much as you can. Work, work, work. You should have at least 50-100 pieces in your body of work before approaching galleries."

CALLAWAY GALLERIES, INC., 101 SW First Ave., Rochester MN 55902. (507)287-6525. Owner: Barbara Callaway. Retail gallery. Estab. 1971. Represents 50+ emerging, mid-career and established artists/year. Average display time 1 month. Open all year; Monday-Friday, 9:30-5:30; Saturday, 10-4. Located downtown; 700 sq. ft. Clientele: tourists and upscale corporate. 30% corporate collectors. Overall price range: $100-4,000; most work sold at $200-1,000.
Media: Considers oil, acrylic, watercolor, collage, paper, sculpture, fiber and glass. Considers all types of prints except numbered photo repros. Most frequently exhibits pastel, mixed media and glass.
Style: Exhibits: expressionism, primitivism, painterly abstraction and realism. Genres include florals, southwestern, landscapes and figurative work.
Terms: Accepts work on consignment (50% commission) or buys outright for 50% of retail price (net 30 days). Retail price set by the artist. Shipping costs are shared. Prefers artwork unframed.
Submissions: Send query letter with bio, photographs, SASE, reviews and artist's statement. Write for appointment to show portfolio of photographs or slides. Replies in 1 month (if SASE provided). Finds artists through word of mouth, referrals by other artists, visiting art fairs and exhibitions and submissions.
Tips: "Dropping in does not work."

‡**FLANDERS CONTEMPORARY ART**, 400 N. First Ave., Minneapolis MN 55401. (612)344-1700. Fax: (612)344-1643. Director: Douglas Flanders. Retail gallery. Estab. 1972. Represents emerging, mid-career and established artists. Exhibited artists include Jim Dine and David Hockney. Sponsors 8 shows/year. Average display time 6 weeks. Open all year; Tuesday-Saturday 10-5. Located in downtown warehouse district: 2,600 sq. ft.: 17' ceilings. Clientele: private, public institutions, corporations, museums. Price range starts as low as $85. Most work sold at $9,500-55,000.
Media: Considers all media and original handpulled prints. Most frequently exhibits sculpture, paintings and various prints; some photography.

Style: Exhibits all styles and genres. Prefers abstract expressionism, impressionism and post-impressionism.
Terms: Accepts work on consignment (50% commission). Gallery provides insurance, promotion and contract; shipping costs are shared. Prefers artwork framed.
Submissions: Send query letter with résumé, 20 slides, bio and SASE. Write for appointment to show portfolio of slides. Replies in 1 week.
Tips: "Include a statement about your ideas and artwork."

ICEBOX QUALITY FRAMING & GALLERY, 2401 Central Ave. NE, Minneapolis MN 55418. (612)788-1790. Fine Art Representative: Howard Christopherson. Retail gallery and alternative space. Estab. 1988. Represents emerging and mid-career artists. Sponsors 4-7 shows/year. Average display time 1-2 months. Open all year. Intimate, black-walled space.
Media: Considers photography and all fine art.
Style: Exhibits: any thought-provoking artwork.
Terms: "Exhibit expenses and promotional material paid by the artist along with a sliding scale commission." Gallery provides promotion.
Submissions: Accepts predominantly Minnesota artists but not exclusively. Send 20 slides, materials for review, letter of interest and reasons you would like to exhibit at Icebox.
Tips: "Be more interested in the quality and meaning in your artwork than in a way of making money. Do not give up, but do not start too early."

M.C. GALLERY, 400 First Ave., #332, Minneapolis MN 55401. (612)339-1480. Fax: (612)339-1480-04. Gallery Director: M.C. Anderson. Retail gallery. Estab. 1984. Represents 25 emerging, mid-career and established artists/year. Exhibited artists include Terri Hallman and Michael Gustavson. Sponsors 8 shows/year. Average display time 5 weeks. Open all year; Wednesday-Saturday, 1-5. Located downtown; 1,600 sq. ft.; in a warehouse with 8 other galleries. 80% of space for special exhibitions, 50% private collectors; 50% corporate collectors. Overall price range: $1,000-12,000; most work sold at $1,500-3,000.
Media: Considers oil, acrylic, pastel, mixed media, paper, sculpture, ceramics, fiber, glass, photography and monotype prints. Most frequently exhibits ceramics and works on paper/canvas.
Style: Exhibits painterly abstraction, neo-expressionism, color field and photorealism. Genres include landscapes and figurative work.
Terms: Accepts work on consignment (50% commission). Retail price set by the artist. Gallery provides promotion; insurance and shipping costs from gallery; artist pays shipping costs to gallery.
Submissions: Send query letter with résumé, 1 sheet of 20 slides and bio. Call or write for appointment to show portfolio of photographs or slides. Replies if interested within 6 months. Finds artists through agents, visiting exhibitions, word of mouth, art publications and sourcebooks and artists' submissions.
Tips: "Develop your art first. When you have a mature style that is consistent, network to find a gallery that has kindred spirits to your expression. Be organized, submit good slides and updated résumé." Looks for art "from the higher self, from the heart and soul of the person."

✔**MHIRIPIRI GALLERY**, 530 Nicollet Mall, Minneapolis MN 55402. (612)332-7406. Owner: Rex. Retail and whole-sale gallery. Estab. 1986. Represents 10+ emerging, mid-career and established artists/year. Exhibits artists include: Henry Munyaradzi and Damien Manuhwa. Open all year; Monday-Saturday, 10-6. Located downtown; 3,100 sq. ft.; massive wood pedestals. Clientele: tourists, upscale, local community and students. Overall price range: $60-20,000.
● Gallery owner reports Mhiripiri Gallery has a roster of artists and is not looking for new artists at this time.
Media: Oil, acrylic, watercolor, mixed media and sculpture; some types of prints. Most frequently exhibits stone, oil, acrylics, watercolors and some batik on silk.
Style: Genres include landscapes and figurative work.
Terms: Accepts work on consignment or buys outright. Retail price set by the gallery. Gallery provides insurance, promotion and contract.
Tips: "Be direct, honest, not too modest."

‡**THE CATHERINE G. MURPHY GALLERY**, The College of St. Catherine, 2004 Randolph Ave., St. Paul MN 55105. (612)690-6637. Fax: (612)690-6024. Curator: Kathleen M. Daniels. Nonprofit gallery. Estab. 1973. Represents emerging, mid-career and nationally and regionally established artists. "We have a mailing list of 1,000." Sponsors 6 shows/year. Average display time 5-6 weeks. Open September-June; Monday-Friday, 8-8; Saturday, 12-5; Sunday, 12-8. Located on the college campus of the College of St. Catherines; 1,480 sq. ft.
● This gallery also exhibits art historical and didactic shows of visual significance. Gallery shows 75% women's art since it is an all women's undergraduate program.
Media: Considers all media and all types of prints.
Style: Exhibits all styles.
Terms: Artwork is loaned for the period of the exhibition. Gallery provides insurance. Shipping costs are shared. Prefers artwork framed.
Submissions: Send query letter with résumé, slides, bio and SASE. Write for appointment to show portfolio. Replies in 4-6 weeks. Files résumé and cover letters.

✓**NATURE'S PALETTE ART GALLERY**, 204 E. Second St., Hastings MN 55033. (612)438-9944. Fax: (612)438-6651. Owner: Karen Latham. Retail gallery. Estab. 1994. Represents 20 emerging and mid-career artists. Exhibited artists include: Rollie Brandt and Randall Raduenz. Sponsors 4 shows/year. Average display time 1 month. Open all year; Tuesday-Saturday, 10-5; Sunday 1-4. Located downtown; 2,500 sq. ft.; along Mississippi River in historic downtown. 10% of space for special exhibitions. Clientele: tourists and local community. 90% private collectors, 10% corporate collectors. Overall price range: $35-3,000; most work sold at $35-1,000.
Media: Considers all media and all types of prints. Most frequently exhibits acrylic, oil, pastel and watercolor.
Style: Exhibits impressionism, photorealism and realism. Exhibits all genres. Prefers realism, photo realism and impressionism.
Terms: Artwork is accepted on consignment (30% commission). Retail price set by the artist. Gallery provides promotion. Shipping costs are shared. Prefers artwork framed.
Submissions: Send query letter with résumé, slides and photographs. Call or write for appointment to show portfolio of photographs, slides and transparencies. Replies in 2 weeks. Finds artists through visiting art fairs and exhibitions and artist's submissions.
Tips: "Present yourself well. The way you present yourself and your work is critical. A well-framed piece reflects the quality of your work and enhances it. Poorly presented pieces may never be recognized as quality work because the viewer can't get past the framing."

‡**NORMANDALE COLLEGE CENTER GALLERY**, 9700 France Ave., So., Bloomington MN 55431. (612)832-6340. Fax: (612)896-4571. Director of Student Life: Gail Anderson Cywinski. College gallery. Estab. 1975. Exhibits 6 emerging, mid-career and established artists/year. Sponsors 6 shows/year. Average display time 2 months. Open all year. Suburban location; 30 running feet of exhibition space. 100% of space for special exhibitions. Clientele: students, staff and community. Overall price range: $25-750; most artwork sold at $100-200.
Media: Considers oil, acrylic, watercolor, pastel, pen & ink, drawings, mixed media, collage, works on paper, sculpture, ceramic, craft, fiber, glass, photography, original handpulled prints, offset reproductions, woodcuts, wood engravings, linocuts, engravings, mezzotints, etchings, lithographs, pochoir, serigraphs and posters. Most frequently exhibits watercolor, photography and prints.
Style: Exhibits all styles and genres.
Terms: "We collect 10% as donation to our foundation." Retail price set by artist. Gallery provides insurance, promotion and contract; artist pays for shipping. Prefers framed artwork.
Submissions: "Send query letter; we will send application and info." Portfolio should include slides. Replies in 2 months. Files "our application/résumé."

NORTH COUNTRY MUSEUM OF ARTS, Third and Court Streets, P.O. Box 328, Park Rapids MN 56470. (218)732-5237. Curator/Administrator: Johanna M. Verbrugghen. Museum. Estab. 1977. Interested in seeing the work of emerging and established artists. 100 members. Sponsors 8 shows/year. Average display time 3 weeks. Open May-October; Tuesday-Sunday, 11-5. Located next to courthouse; 4 rooms in a Victorian building built in 1900 (on Register of Historic Monuments). 50% of space for special exhibitions; 50% of space for gallery artists.
Media: Considers all media and all types of prints. Most frequently exhibits acrylic, watercolor and sculpture.
Style: Exhibits all genres; prefers realism.
Terms: Accepts work on consignment (20% commission). Retail price set by the artist. Artist pays shipping costs to and from gallery. Prefers artwork framed.
Submissions: "Work should be of interest to general public." Send query letter with résumé and 4-6 slides. Portfolio should include photographs and slides. Replies only if interested within 1-2 months. Finds artists through word of mouth.

PINE CONE GALLERY INC., 130 W. Front St., Pequot Lakes MN 56472. (218)568-8239. President: Robert Kargel. Retail gallery. Estab. 1983. Represents 400 at any time and currently representing 30 emerging, mid-career and established artists/year. Exhibited artists include: Russell Norberg, Rose Edin, Thomas Philabaum, Peter Vanderlaan and David Ahrendt. Sponsors 3 shows/year. Average display time 1 month. Open all year; 10-5:30. Located downtown; 4,000 sq. ft. 20% of space for special exhibitions; 50% of space for gallery artists. Clientele: tourists. 90% private collectors, 10% corporate collectors. Overall price range: $295-10,000; most work sold at $1,000-2,500.
Media: Considers oil, acrylic, watercolor, pastel, collage, paper, sculpture, ceramics, fiber, glass and wood; types of prints include woodcuts, engravings, lithographs and serigraphs. Most frequently exhibits watercolor, wood sculpture and glass sculpture.
Style: Exhibits: surrealism, impressionism and realism. Genres include florals, wildlife and landscapes. Prefers: landscape, florals and wildlife.
Terms: Accepts work on consignment (45% commission) or buys outright for 50% of retail price (net 30 days). Retail price set by the gallery. Gallery provides promotion; shipping costs are shared. Prefers artwork framed.
Submissions: Send query letter with résumé and 9 slides. Write for appointment to show portfolio of photographs and slides. Replies in 1-2 weeks. Files any that are of present or future interest. Finds artists through word of mouth and other artists.
Tips: "Submit a range of talent; do not overprice."

‡**C. G. REIN GALLERIES**, In the Galleria, 3205 Galleria, Edina MN 55435. (612)927-4331. Fax: (612)927-5276. Director: Heather Anderson. Retail gallery. Estab. 1974. Represents 25-30 emerging, mid-career and established artists. Exhibited artists include Jerome Tapa and John Richen. Sponsors 6 shows/year. Average display time 2½ weeks. Open all year. Located southwest of downtown; 4,500 sq. ft.; "broad, open space, high ceilings." 40% of space for special exhibitions. Clientele: mid-to upper-income, business executives. 50% private collectors; 50% corporate collectors. Overall price range: $800-5,000+; most work sold at $2,000-3,000.
Media: Considers oil, acrylic, watercolor, pastel, mixed media, collage, sculpture, and original handpulled prints. Most frequently exhibits painting, sculpture and mixed-media "No photography or ceramics at this time."
Style: Exhibits expressionism, neo-expressionism, painterly abstraction, color field, postmodern works and impressionism. Genres include landscapes and figurative work. Prefers neo-expressionism, painterly abstraction and semi-abstract figurative sculpture.
Terms: Accepts artwork on consignment (50% commission, sculpture: 60%). Retail price set by the artist with director. Gallery provides insurance, promotion and contract; artist pays for shipping. Prefers artwork framed.
Submissions: Send query letter with résumé, slides, brochure, photographs and bio. Write to schedule an appointment to show a portfolio, which should include slides and transparencies. Replies in 2-4 weeks.

✔**JEAN STEPHEN GALLERIES**, 917 Nicollet Mall, Minneapolis MN 55402. (612)338-4333. Directors: Steve or Jean Danko. Retail gallery. Estab. 1987. Represents 12 established artists. Interested in seeing the work of emerging artists. Exhibited artists include Jiang, Hart and Max. Sponsors 2 shows/year. Average display time 4 months. Open all year; Monday-Saturday, 10-6. Located downtown; 2,300 sq. ft. 15% of space for special exhibitions; 85% of space for gallery artists. Clientele: upper income. 90% private collectors, 10% corporate collectors. Overall price range: $600-12,000; most work sold at $1,200-2,000.
Media: Considers oil, acrylic, pastel, pen & ink, drawing, mixed media, collage, paper, sculpture, ceramics, woodcuts, engravings, lithographs, wood engravings, mezzotints, serigraphs, linocuts and etchings. Most frequently exhibits serigraphs, stone lithographs and sculpture.
Style: Exhibits expressionism, neo-expressionism, surrealism, minimalism, color field, postmodern works and impressionism. Genres include landscapes, southwestern, portraits and figurative work. Prefers Chinese contemporary, abstract and impressionism.
Terms: Accepts work on consignment (50% commission). Retail price set by the gallery. Gallery provides insurance and contract; artist pays shipping costs to and from gallery.
Submissions: Send query letter with résumé, slides and bio. Call for appointment to show portfolio of originals, photographs and slides. Replies in 1-2 months. Finds artists through art shows and visits.

STUDIO 10, 1021 Bandana Blvd. E, St. Paul MN 55108. (612)646-3346. Manager: Kathi. Retail gallery owned and operated by artists. Estab. 1989. Represents 100 artists/year. Interested in seeing the work of emerging artists and fine craftspeople. Exhibited artists include Michael Bond, Michael Shoop, Joan Gray and Linda Sumner. Average display time 1 year. Open all year; daily, 10-9; Saturday, 10-6; Sunday, 12-5. Located in energy park; 1,400 sq. ft.; located in 100-year-old historic railroad building. 100% of space for gallery artists. 95% private collectors, 5% corporate collectors. Overall price range: $5-800; most work sold at $20-100.
Media: Considers all 2D and 3D media.
Style: Exhibits all styles and genres. Prefers florals, wildlife and southwestern.
Terms: Accepts work on consignment (36% commission and 3% on all charge sales). Retail price set by the artist. Gallery provides promotion and contract. Artist pays for shipping.
Submissions: Accepts only artists from Midwest. Send query letter with 10-12 slides, brochure, SASE, business card and artist's statement. Call or write for appointment to show portfolio of original art. Replies in 2 weeks. Finds artists through word of mouth, referrals by other artists, visiting art fairs and exhibitions and artist's submissions.
Tips: "Learn to frame and mat professionally, use top quality frames, mats, glass and wiring apparatus. Keep your work clean and unscratched. Strive to be an expert in one medium."

WINGS 'N WILLOWS ART GALLERY & FRAME SHOP, 42 NW Fourth St., Grand Rapids MN 55744. (218)327-1649. Owner: Linda Budrow. Retail gallery, custom frame shop. Estab. 1976. Represents 30 established artists/year. Exhibited artists include Redlin and Bateman. Sponsors 1 show/year. Average display time 3 months. Open all year; Monday-Saturday, 10-5. Located downtown; 1,000 sq. ft. 5% of space for special exhibitions; 95% of space for gallery artists. Clientele: tourists, local community. 95% private collectors, 5% corporate collectors. Overall price range: $30-1,000; most work sold at $150-600.
Media: Considers paper, ceramics, glass, photography, wood carvings, lithographs and posters. Most frequently exhibits limited edition prints, posters and wood carvings.
Style: Genres include wildlife and landscapes. Prefers wildlife, landscape and nostalgic.
Terms: Buys outright for 50% of retail price (net 30 days). Retail price set by the artist. Gallery provides promotion. Gallery pays shipping costs. Prefers artwork unframed.
Submissions: Send query letter with bio, brochure and photographs. Write for appointment to show portfolio of photographs. Replies only if interested within 2 weeks. Finds artists through visiting art fairs and exhibitions, artist's submissions and publishers.

Mississippi

ART-FX STUDIO GALLERY, 824 E. Pass Rd., Gulfport MS 39507. Phone/fax: (601)896-6287. Owner: Jacqueline Wilson. Retail, cooperative gallery, frames-conservation-custom. Estab. 1993. Interested in seeing the work of 30 emerging and mid-career artists, 30 members. Exhibited artists include: Marty Wilson and Catharine Satchfield. Sponsors 3 shows/year. Average display time 3 months. Open all year; Monday-Saturday, 10-5. Located in commercial area; 3,000 sq. ft.; 100-year-old Victorian building. 100% of space for gallery artists. Clientele: tourists, upscale, local community and students. 90% private collectors, 10% corporate collectors.
Media: Considers oil, acrylic, watercolor, pastel, pen & ink, drawing, mixed media, collage, sculpture, ceramics and photography; types of prints include lithographs, serigraphs and posters. Most frequently exhibits limited edition prints, originals and pottery.
Style: Exhibits impressionism, photorealism and realism. Genres include florals, portraits, wildlife, landscapes and historical. Prefers: wildlife/local (flora, sealife, fowl), historical land sights and architecture.
Terms: Accepts work on consignment (30% commission) or buys outright for 50% of the retail price. Retail price set by the artist. Gallery provides promotion; artists pays shipping costs. Prefers artwork unframed.
Submissions: Accepts only local artists. Send query letter with brochure, business card and 3 slides or photographs. Call or write for appointment to show portfolio of photographs, slides and transparencies. Replies in 2 weeks. Finds artists through word of mouth, referrals by other artists, visiting art fairs and exhibitions and submissions.
Tips: "Make personal contact."

BROWN'S FINE ART & FRAMING, INC., 630 Fondren Place, Jackson MS 39216. (800)737-4844. Fax: (601)982-0030. E-mail: bffa@misnet.com. Website: http://www.brownsfineart.com. Manager of Operations: Joel Brown. Retail gallery. Estab. 1965. Represents 30 emerging, mid-career and established artists/year. Exhibited artists include: Emmitt Thames and Sharon Richardson. Sponsors 6-8 shows/year. Average display time 1 month. Open all year; Monday-Friday, 9-5:30; Saturday, 10-4. Located in the Woodland Hills/Fondren business district; 6,000 sq. ft.; one of the first specifically designed art gallery/picture framing in the country. 60% of space for special exhibitions. Clientele: locals, tourists, etc. 50% private collectors, 50% corporate collectors. Overall price range: $200-30,000; most work sold at $1,000-2,000.
Media: Considers oil, acrylic, watercolor, pastel, pen & ink, drawing, mixed media, collage, sculpture and ceramics. Most frequently exhibits oil, watercolor and pastel.
Style: Exhibits: expressionism, painterly abstraction, impressionism and realism. Genres include florals and landscapes. Prefers: landscapes, floral and contemporary abstracts.
Terms: Accepts work on consignment (50% commission). Retail price set by the gallery and artist. Gallery provides promotion. Prefers artwork unframed. "We do all of our own framing at no expense to artist."
Submissions: Prefers only Mississippi artists. Send query letter with résumé, slides, bio and artist's statement. Call for appointment to show portfolio of actual work. Replies immediately. Files résumé, samples, slides and bio. Finds artists through artists who come to us who wish to be represented by us. We do not solicit.
Tips: "Be original. Take what you have learned from school and others who may have taught you, and come up with your own innovations and style. Paint everyday. Don't make the mistakes of dressing slovenly, not showing up on time, not looking around our gallery before initial contact, not having a bio or résumé and having a bad attitude."

‡BRYANT GALLERIES, 2845 Lakeland Dr., Jackson MS 39208. (601)932-1993. Fax: (601)932-8031. Vice-President: David Lambert. Retail gallery. Estab. 1965. Represents 20 emerging, mid-career and established artists/year. Exhibited artists include Leonardo Nierman, Ed Dwight. Sponsors 12 shows/year. Average display time 1 month. Open all year; Monday-Friday, 10-5:30; Sataurday, 10-5. 3,500 sq. ft. 20% of space for special exhibitions; 80% of space for gallery artists. Clientele: tourist, upscale, local community, students. 95% private collectors, 5% corporate collectors. Overall price range: $200-30,000; most work sold at $3,000-7,000.
Media: Considers oil, acrylic, watercolor, pastel, mixed media, collage, paper, sculpture, ceramics, glass. Considers all types of prints except posters. Most frequently exhibits oil, watercolor and acrylic.
Style: Exhibits expressionism. Genres include landscapes. Prefers impressionism, realism, expressionism.
Terms: Artwork is accepted on consignment and there is a 50% commission. Retail price set by the artist. Gallery provides insurance and promotion; artist pays shipping costs. Prefers artwork framed.
Submissions: Send query letter with résumé, brochure, slides, bio and SASE. Call for appointment to show portfolio. Replies in 3 weeks. Files brochures, sometimes slides. Finds artists through word of mouth, traveling to other cities, submissions, referrals by other artists.

‡CARTMELL GALLERY, 204 22nd St., Meridian MS 39301. (601)485-1122. Fax: (601)485-1122. Manager: Deborah Martin. Retail gallery. Estab. 1993. Represents 8 emerging, mid-career and established artists/year. Exhibited artists include: Greg Cartmell and Patricia Kent. Sponsors 6 shows/year. Average display time 2-3 weeks. Open all year; Monday-Friday, 10-5. Located downtown; 1,200 sq. ft.; located next door to Weidman's Restaurant which has numerous people from out of town visiting. Clientele: tourists, upscale. 75% private collectors, 25% corporate collectors. Overall price range: $50-10,000; most work sold at $50-1,000.
Media: Considers all media and all types of prints. Most frequently exhibits oils, watercolor, pastel.
Style: Exhibits: expressionism, painterly abstraction, impressionism, realism. Prefers: impressionism, expressionism and painterly abstraction.

Terms: Accepts work on consignment (33% commission) or buys outright for 50% of retail price (net 30 days). Retail price set by the artist. Gallery provides insurance, promotion and contract; artists pays for shipping costs to gallery. Prefers artwork framed.
Submissions: Send query letter with résumé, bio, brochure, photographs, SASE and artist's statement. Call for appointment to show portfolio of photographs. Replies in 2-3 weeks. Files résumé and photographs. Finds artists through word of mouth, referrals by other artists, art fairs and exhibitions, submissions and national magazine advertising.
Tips: "Have good quality photographs or slides taken of your work before submitting to galleries."

‡HILLYER HOUSE INC., 207 E. Scenic Dr., Pass Christian MS 39571. (601)452-4810. Owners: Katherine and Paige Reed. Retail gallery. Estab. 1970. Represents emerging, mid-career and established artists: 19 artists, 34 potters, 46 jewelers, 10 glass-blowers. Interested in seeing the work of emerging artists. Exhibited artists include Barbara Quigley and Patt Odom. Sponsors 24 shows/year. Average display time 2 months. Open Monday-Saturday 10-5; Sunday 12-5. Open all year. Located beachfront-middle of CBD historic district; 1,700 sq. ft. 50% of space for special exhibitions; 50% of space for gallery artists. Clientele: 80% of clientele are visitors to the Mississippi Gulf Coast, 20% private collectors. Overall price range: $25-700; most work sold at $30-150; paintings $250-700.
● Hillyer House has special exhibitions in all areas.
Media: Considers oil, watercolor, pastel, mixed media, sculpture (metal fountains), ceramic, craft and jewelry. Most frequently exhibits watercolor, pottery and jewelry.
Style: Exhibits expressionism, imagism, realism and contemporary. Genres include aquatic/nautical. Prefers: realism, impressionism and expressionism.
Terms: Accepts work on consignment (35% commission); or artwork is bought outright for 50% of the retail price (net 30 days). Retail price set by gallery or artist. Gallery provides promotion and contract; artist pays for shipping. Prefers artwork framed.
Submissions: Send query letter with résumé, slides, bio, brochure, photographs, SASE and reviews. Call or write for appointment to show portfolio of originals and photographs. Replies only if interested within 3 weeks. Files photograph and bio. (Displays photo and bio with each person's art.)
Tips: "Work must be done in last nine months. Watercolors sell best. Make an appointment. Looking for artists with a professional attitude and approach to work. Be sure the work submitted is in keeping with the nature of our gallery."

MERIDIAN MUSEUM OF ART, 628 25th Ave., P.O. Box 5773, Meridian MS 39302. (601)693-1501. Acting Director: Terence Heder. Museum. Estab. 1970. Represents emerging, mid-career and established artists. Interested in seeing the work of emerging artists. Exhibited artists include Terry Cherry, Bruce Brady, Jere Allen, Susan Ford and Hugh Williams. Sponsors 15 shows/year. Average display time 5 weeks. Open all year; Tuesday-Sunday, 1-5. Located downtown; 1,750 sq. ft.; housed in renovated Carnegie Library building, originally constructed 1912-13. 50% of space for special exhibitions. Clientele: general public. Overall price range: $75-1,000; most work sold at $300-500.
● Sponsors annual Bi-State Art Competition for Mississippi and Alabama artists.
Media: Considers all media, woodcut, engraving, lithograph, wood engraving, mezzotint, serigraphs, linocut and etching. Most frequently exhibits oils, watercolors and sculpture.
Style: Exhibits all styles, all genres.
Terms: Work available for sale during exhibitions (25% commission). Retail price set by the artist. Gallery provides insurance and promotion; shipping costs are shared. Prefers artwork framed.
Submissions: Prefers artists from Mississippi, Alabama and the Southeast. Send query letter with résumé, slides, bio and SASE. Replies in 3 months. Finds artists through submissions, referrals, work included in competitions and visiting exhibitions.

MISSISSIPPI CRAFTS CENTER, Box 69, Ridgeland MS 39158. (601)856-7546. Director: Martha Garrott. Retail and nonprofit gallery. Estab. 1975. Represents 70 emerging, mid-career and established guild members. 250 members. Exhibited artists include Odie May Anderson, Choctaw basket-maker and Craig McMillin, Mudflap Pottery. Open all year. Located in a national park near the state capitol of Jackson; 1200 sq. ft.; a traditional dogtrot log cabin. Clientele: travelers and local patrons. 99% private collectors. Overall price range: $2-900; most work sold at $10-60.
Media: Considers paper, sculpture, ceramic, craft, fiber and glass. Most frequently exhibits clay, basketry and metals.
Style: Exhibits all styles. Crafts media only. Interested in seeing a "full range of craftwork—Native American, folk art, naive art, production crafts, crafts as art, traditional and contemporary. Work must be small enough to fit our limited space."
Terms: Accepts work on consignment (40% commission), first order; buys outright for 50% of retail price (net 30 days), subsequent orders. Retail price set by the gallery and the artist. Gallery provides promotion and shipping costs to gallery.
Submissions: Accepts only artists from the Southeast. Artists must be juried members of the Craftsmen's Guild of Mississippi. Ask for standards review application form. Call or write for appointment to show portfolio of 5 slides. Replies in 1 week.
Tips: "All emerging craftsmen should read *Crafts Report* regularly and know basic business procedures. Read books on the business of art like *Crafting as a Business* by Wendy Rosen, distributed by Chilton—available by mail order through our crafts center or the *Crafts Report*. An artist should have mastered the full range of his medium—numbers don't matter, except that you have to do a lot of practice pieces before you get good or fully professional."

Missouri

‡**THE ASHBY-HODGE GALLERY OF AMERICAN ART**, Central Methodist College, Fayette MO 65248. (816)248-3391 ext. 563. Fax: (816)248-2622. Curator: Thomas L. Yancey. Nonprofit gallery, "Not primarily a sales gallery—only with special exhibits." Estab. 1993. Exhibits the work of 47 artists in permanent collection. Exhibited artists include Robert MacDonald Graham, Jr. and Birger Sandzén. Sponsors 4 shows/year. Average display time 2 months. Open Tuesday-Thursday, 1:30-4:30. Located on campus of Central Methodist college. 1,400 sq. ft.; on lower level of campus library. 100% of gallery artists for special exhibitions. Clientele: local community and surrounding areas of Mid-America.
Media: Considers all media. Considers lithographs. Most frequently exhibits acrylic, lithographs and oil.
Style: Exhibits midwestern regionalists. Genres include portraits and landscapes. Prefers: realism.
Terms: Accepts work on consignment (30% commission.) Retail price set by the gallery. Gallery provides insurance and promotion; shipping costs are shared. Prefers artwork framed.
Submissions: Accepts primarily midwestern artists. Send query letter with résumé, slides, photographs and bio. Call for appointment to show portfolio of photographs, transparencies and slides. Finds artists through word of mouth and submissions.

‡**BARUCCI'S ORIGINAL GALLERIES**, 8101 Maryland Ave., St Louis MO 63105. (314)727-2020. President: Shirley Taxman Schwartz. Retail gallery and art consultancy. Estab. 1977. Represents 40 artists. Interested in emerging and established artists. Sponsors 3-4 solo and 4 group shows/year. Average display time is 2 months. Located in "affluent county, a charming area. Clientele: affluent young area. 70% private collectors, 30% corporate clients. Overall price range: $500-5,000.
• This gallery has moved into a corner location featuring three large display windows.
Media: Considers oil, acrylic, watercolor, pastel, collage and works on paper. Most frequently exhibits watercolor, oil, acrylic and hand blown glass.
Style: Exhibits painterly abstraction, primitivism and impressionism. Genres include landscapes and florals. Currently seeking contemporary works: abstracts in acrylic and fiber, watercolors and some limited edition serigraphs.
Terms: Accepts work on consignment (50% commission). Retail price set by gallery or artist. Sometimes offers payment by installment. Gallery provides contract.
Submissions: Send query letter with résumé, slides and SASE. Portfolio review requested if interested in artist's work. Slides, bios and brochures are filed.
Tips: "More clients are requesting discounts or longer pay periods."

‡**BYRON COHEN LENNIE BERKOWITZ**, 2000 Baltimore, Kansas City MO 64108. (816)421-5665. Fax: (816)421-5775. Owner: Byron Cohen. Retail gallery. Estab. 1994. Represents emerging and established artists. Exhibited artists include Squeak Carnwath. Sponsors 6-7 shows/year. Average display time 7 weeks. Open all year; Thursday-Saturday, 11-5. Located downtown; 1,500 sq. ft.; 100% of space for gallery artists. 90% private collectors, 10% corporate collectors. Overall price range: $300-42,000; most work sold at $2,000-7,000.
Media: Considers all media. Most frequently exhibits painting, works on paper and sculpture.
Style: Exhibits all styles. Prefers contemporary painting and sculpture, contemporary prints, contemporary ceramics.
Terms: Accepts work on consignment (50% commission.) Retail price set by the gallery and the artist. Gallery provides insurance, promotion and contract; shipping costs are shared. Prefers artwork framed.
Submissions: Send query letter with résumé, slides, artist's statement and bio. Write for appointment to show portfolio of photographs, transparencies and slides. Call. Files slides, bio and artist's statement. Finds artists through word of mouth, referrals by other artists, visiting art fairs and exhibitions.

FINE ARTS RESOURCES, 11469 Olive St., #266, St. Louis MO 63141. Phone/fax: (314)432-5824. E-mail: mikeb@m octy.com. President: R. Michael Bush. Art consultancy, broker. Estab. 1986. Represents over 50 emerging, mid-career and established artists. Interested in seeing the work of emerging artists. Open all year; by appointment only. Located in suburb. Clientele: commercial/residential. 25% private collectors, 75% corporate collectors. Overall price range: $150-10,000; most work sold at $1,000-3,000.
Media: Considers oil, pen & ink, paper, acrylic, drawing, sculpture, glass, watercolor, pastel and all types of prints. Most frequently exhibits oil, acrylic and sculpture.
Terms: Artwork is accepted on consignment (40% commission). Retail price set by the gallery and the artist. Shipping costs are shared. Prefers artwork framed.
Submissions: Send query letter with résumé, 7-10 slides and bio. Write for appointment to show portfolio of slides. Replies only if interested within 2 weeks.

‡**GOMES GALLERY OF SOUTHWESTERN ART**, 7513 Forsyth, Clayton MO 63105. (314)725-1808. Fax: (314)725-2870. E-mail: artgal1@aol.com. Website: http://www.icon-stl.net/gomes/. Director: Jim Belknap. Retail gallery. Estab. 1985. Represents 80 emerging, mid-career and established artists. Exhibited artists include R.C. Gorman and Frank Howell. Sponsors 5 shows/year. Average display time 4 months. Open all year; Monday-Thursday, 10-6; Friday and Saturday, 10-8; Sunday, 11-4. Located "downtown, across from the Ritz Carlton; 3,600 sq. ft.; total Southwestern theme, free covered parking." 35% of space for special exhibition during shows. Free standing display wall on

wheels. Clientele: tourists, local community. 96% private collectors, 4% corporate collection. Overall price range: $100-15,000; most work sold at $1,200-2,000.
 ● This gallery reports that business is up 10%.
Media: Considers all media and all types of prints. Most frequently exhibits stone lithos, originals and serigraphs.
Style: Exhibits all styles. Genres include landscapes, western, wildlife and southwestern. Prefers western/southwestern themes and landscapes.
Terms: Accepts artwork on consignment (50% commission); or buys outright for 40-50% of retail price (net 10-30 days). Retail price set by gallery and artist. Customer payment by installment is available. Gallery provides insurance, promotion and contract; shipping costs are shared.
Submissions: Prefer, but not limited to Native American artists. Send query letter with slides, bio, medium, price list, brochure and photographs. Portfolio review requested if interested in artist's work. Portfolio should include originals, slides, photographs, transparencies and brochure. Replies in 2-3 weeks; or does not reply, in which case the artist should "call and remind." Files bio.
Tips: "Send complete package the first time you submit. Include medium, size and cost or retail. Submit until you get 8-10 galleries, then do serigraphs and stone lithos. Promote co-op advertising with your galleries."

THE JAYNE GALLERY, 108 W. 47th St., Kansas City MO 64112. (816)561-5333. Fax: (816)561-8402. E-mail: cjnkc@jaynegallery.net. Owners: Ann Marie Jayne and Clint Jayne. Retail gallery. Represents/exhibits 30 emerging, mid-career and established artists/year. Exhibited artists include Jim Rabby and Robert Striffolino. Sponsors 4-6 shows/year. Average display time 3 weeks. Open all year; Monday-Saturday, 10-7; Thursday, 10-6; Sunday, 12-5. 2,000 sq. ft. in outdoor gallery located on The Plaza, a historic shopping district featuring Spanish architecture such as stucco buildings with red tile roofs, ornate towers and beautiful courtyards. 100% of space is devoted to the work of gallery artists. 40% out-of-town clients; 60% Kansas City metro and surrounding communities. Overall price range: $500-5,000; most work sold at $1,500-3,700.
Media: Considers all media and all types of prints by artists whose original work is handled by gallery. Most frequently exhibits paintings—all media, ceramics, glass and other fine crafts.
Style: Exhibits all styles. Genres include landscapes and figurative work. Prefers: impressionism, expressionism and abstraction.
Terms: Artwork is accepted on consignment (50% commission). Retail price set by the artist. Gallery provides insurance, promotion and contract; shipping costs are shared. Requires artwork framed.
Submissions: Accepts only artists from US. Send query letter with résumé, brochure, business card, slides, photographs, reviews, bio, SASE and price list. Write for appointment to show portfolio of photographs, transparencies, slides of available work. Replies in 6-8 weeks; if interested within 2 weeks. Files résumé, any visuals that need not be returned. Finds artists through referrals, travel, art fairs and exhibitions.
Tips: "Visit galleries to see if your work 'fits' with gallery's look, vision, philosophy."

MORTON J. MAY FOUNDATION GALLERY, Maryville University, 13550 Conway, St. Louis MO 63141. (314)576-9300. E-mail: nrice@maryville.edu. Director: Nancy N. Rice. Nonprofit gallery. Exhibits the work of 6 emerging, mid-career and established artists/year. Sponsors 10 shows/year. Average display time 1 month. Open all year. Located on college campus. 10% of space for special exhibitions. Clientele: college community. Overall price range: $100-4,000.
 ● The gallery is long and somewhat narrow, therefore it is inappropriate for very large 2-D work. There is space in the lobby for large 2-D work but it is not as secure.
Media: Considers oil, acrylic, watercolor, pastel, pen & ink, drawings, mixed media, collage, works on paper, sculpture, ceramic, fiber, installation, photography, original handpulled prints, woodcuts, engravings, lithographs, wood engravings, mezzotints, linocuts and etchings. Exhibits all genres.
Terms: Artist receives all proceeds from sales. Retail price set by artist. Gallery provides insurance and promotion; artist pays for shipping. Prefers framed artwork.
Submissions: Prefers St. Louis area artists. Send query letter with résumé, slides, bio, brochure and SASE. Portfolio review requested if interested in artist's work. Portfolio should include slides, photographs and transparencies. Replies only if interested within 3 months. Finds artists through referrals by colleagues, dealers, collectors, etc. "I also visit group exhibits especially if the juror is someone I know and or respect."
Tips: Does not want "hobbyists/crafts fair art." Looks for "a body of work with thematic/aesthetic consistency."

‡NEW STRUCTURES/NEW CIRCLE PUBLICATIONS, 4923 Walnut St., Kansas City MO 64112. (816)531-7799 or (316)429-1529. Fax: (816)474-1307. E-mail: weldon@sky.net. Coordinator: T. Michael Stephens. Retail, nonprofit gallery/art consultancy. Estab. 1978. Represents 40 emerging, mid-career and established artists include: Manfred Mohr and Elizabeth Willmott. Open all year by appointment. Located midtown; 1,000 sq. ft. Specializes in structural, systematic and "constructive" art, architecture design, art related to science and technology. Clientele: tourists, upscale, local community, students. 60% private collectors, 40% corporate collectors. Overall price range: $10-100,000; most work sold at $600-1,200.
Media: Considers all media except crafts. Most frequently exhibits graphics and painting/constructions.
Style: Exhibits: conceptualism, minimalism, pattern painting, hard-edge geometric abstraction, "constructive" and structural abstract. Prefers: systematic work.
Terms: Accepts work on consignment (40% commission). Retail price set by the gallery and the artist. Gallery provides

insurance, promotion and contract; shipping costs are shared.

Submissions: Accepts international artists of constructive intent/commitment. Send query letter with résumé, slides, bio, brochure, photographs, SASE, business card, reviews, artist's statement. Write for appointment to show portfolio of slides and statement of context. Replies only if interested within 6-8 weeks. Files vitae, slides, catalogs, brochures if relevant. Finds artists through referrals by other artists, exhibitions, submissions, catalogs, books, other groups and galleries/museums.

WILLIAM SHEARBURN FINE ART, 4740-A McPherson, St. Louis MO 63108. (314)367-8020. Owner/Director: William Shearburn. Sponsors 5 shows/year. Average display time 6 weeks. Open all year; Tuesday-Saturday, 1-5. Located midtown; 1,200 sq. ft. "Has feel of a second floor New York space." 60% of space for special exhibitions; 40% of space for gallery artists. Overall price range: $500-50,000; most work sold at $2,500-5,000.

Media: Considers all media including drawings, paintings, prints and photography.

Style: Specializes in 20th Century American art.

Terms: Artwork is accepted on consignment (50% commission). Retail price set by the gallery. Gallery provides promotion and contract; shipping costs are shared. Prefers artwork framed.

Submissions: Prefers established artists only. Send query letter with résumé, slides, reviews and SASE. Call for appointment to show portfolio of photographs or transparencies.

Tips: "Please stop by the gallery first to see the kind of work we show and the artists we represent before you send us your slides."

‡THE SOURCE FINE ARTS, 4137 Pennsylvania, Kansas City MO 64111. (816)931-8282. Fax: (816)913-8283. Owner: Denyse Ryan Johnson. Retail gallery. Estab. 1985. Represents/exhibits 50 mid-career artists/year. Exhibited artists include Jack Roberts and John Gary Brown. Sponsors 3-4 openings, monthly shows/year. Open all year; Monday-Friday, 9-5; Saturday, 11-4. Located in midtown Westport Shopping District; 2,000 sq. ft. 50% of space for special exhibitions. Clientele: tourists, upscale. 40% private collectors, 60% corporate collectors. Overall price range: $200-5,000; most work sold at $1,000-4,500.

Media: Considers all media except photography and all types of prints. Most frequently exhibits oil, acrylic, mixed media, ceramics and glass.

Style: Exhibits expressionism, minimalism, color field, hard-edge geometric abstraction, painterly abstraction and impressionism. Genres include landscapes. Prefers: non-objective, abstraction and impressionism.

Terms: Artwork is accepted on consignment (50% commission). Retail price set by the gallery. Gallery provides insurance, promotion and contract; shipping costs are shared.

Submissions: Prefers Midwest artists with exhibit, sales/gallery record. Send query letter with résumé, brochure, business card, 8-12 slides, photographs, reviews and SASE. Call for appointment to show portfolio of photographs, slides and transparencies. Replies in 1 month. Files slides and résumé. Finds artists through word of mouth, referrals by other artists, visiting art fairs and exhibitions and artists' submissions.

Tips: Advises artists who hope to gain gallery representation to "visit the gallery to see what media and level of expertise is represented. If unable to travel to a gallery outside your region, review gallery guides for area to find out what styles the gallery shows. You need to develop a recognizable style and exhibit in non-profits or free exhibition spaces prior to approaching a gallery. When you are ready to approach galleries, present professional materials and make follow-up calls."

Montana

AMERICAN WEST GALLERIES, 2814 Second Ave. N., Billings MT 59101. (406)248-5014. Or 111 S. 24th St. W., Billings MT 59102. (406)652-7032. Owner: Donna Lehm. Retail gallery. Estab. 1980. Represents 100 emerging, mid-career and established artists/year. Exhibited artists include: Bev Doolittle, Stephen Lyman, Mike Capser and Robert Salo. Sponsors 6-10 shows/year. Average display time 4-6 weeks. Open all year; Monday-Friday, 9:30-5:30; Saturday, 9:30-3:30. Located downtown (1st) and in suburban strip mall (2nd); 8,000 sq. ft. (1st) and 2,000 sq. ft. (2nd); located at the main corner of downtown, in an historic building. We have the 1st 2 floors; high ceilings, chandeliers (1st). 25% of space for special exhibitions; 75% of space for gallery artists. Clientele: upscale, local and some tourists. 80% private collectors; 20% corporate collectors. Overall price range: $200-7,000; most work sold at $200-500.

Media: Considers oil, acrylic, watercolor, pastel, pen & ink, drawing, mixed media, sculpture and ceramics; types of prints include woodcuts, engravings, lithographs, wood engravings, mezzotints, serigraphs and etchings. Most frequently exhibits limited edition prints from national artists, oils, acrylics and watercolors.

Style: Exhibits: expressionism, primitivism, impressionism, photorealism and realism. Genres include florals, western, wildlife, landscapes and Americana. Prefers: realism, photorealism and impressionism.

Terms: Accepts work on consignment (33% commission). Retail price set by the artist. Gallery provides insurance, promotion and contract; artists pay for shipping.

Submissions: Send query letter with résumé, slides, bio, brochure and photographs. Write for appointment to show portfolio of photographs and slides. Replies in 2 weeks. Files brochures. Photos will be returned. "I review all work sent and respond with information on whether it will work in our galleries."

Tips: "Send work at least two months in advance. It takes time to review work, receive work, plan show, ads, etc."

ARTISTS' GALLERY, 111 S. Grand, #106, Bozeman MT 59715. (406)587-2127. Chairperson: Justine Heisel. Retail and cooperative gallery. Estab. 1992. Represents the work of 20 emerging and mid-career artists, 20 members. Sponsors 12 shows/year. Average display time 3 months. Open all year; Tuesday-Saturday, 10-5. Located near downtown; 900 sq. ft.; located in Emerson Cultural Center with other galleries, studios, etc. Clientele: tourists, upscale, local community and students. 100% private collectors. Overall price range: $35-600; most work sold at $100-300.
Media: Considers oil, acrylic, watercolor, pastel, pen & ink, drawing, mixed media, collage, paper, sculpture, ceramics and glass, woodcuts, engravings, linocuts and etchings. Most frequently exhibits oil, watercolor and ceramics.
Style: Exhibits painterly abstraction, impressionism, photorealism and realism. Exhibits all genres. Prefers realism, impressionism and Western.
Terms: Co-op membership fee plus donation of time (20% commission). Rental fee for space; covers 1 month. Retail price set by the artist. Gallery provides promotion; artist pays for shipping costs to gallery. Prefers artwork framed.
Submissions: Artists must be able to fulfill "sitting" time or pay someone to sit. Send query letter with résumé, slides, photographs, artist's statement and actual work. Write for appointment to show portfolio of photographs and slides. Replies in 2 weeks.

THE BET ART & ANTIQUES, 416 Central Ave., Great Falls MT 59401. Phone/fax: (406)453-1151. Partners: D. Carter and E. Bowden. Retail gallery-antiques, old prints and art. Estab. 1955. Represents 12 mid-career and established artists/year. Interested in seeing the work of emerging artists. Exhibited artists include: Lisa Lorimer and King Kuka. Open all year; Monday-Saturday, 10-5:30. Located downtown; 140 sq. ft. 50% of space for gallery artists. Clientele: tourists and locals. 50% private collectors. Overall price range: $150-5,000; most work sold at $150-500.
Media: Considers oil, acrylic, watercolor, pastel, pen & ink, drawing, sculpture and photography; all types of prints. Most frequently exhibits oil paintings, watercolors and woodblock prints.
Style: Exhibits: expressionism and neo-expressionism. Exhibits all genres. Prefers: western, expressionism and landscapes.
Terms: Accepts work on consignment (30% commission) or buys outright for 50% of retail price. Retail price set by the gallery and artist. Gallery provides promotion; shipping costs are shared. Prefers artwork framed.
Submissions: Call or write for appointment to show portfolio of photographs. Replies in 1 month. Finds artists through word of mouth, local art shows and ads in phone book.
Tips: "Don't bring in work in bad condition or unframed. Don't set exaggerated and unrealistic prices."

CORBETT GALLERY, Box 339, 459 Electric Ave. B, Bigfork MT 59911. (406)837-2400. Director: Jean Moore. Retail gallery. Estab. 1993. Represents 20 mid-career and established artists. Exhibited artists include Greg Beecham. Sponsors 2 shows/year. Average display time 3 weeks. Open all year; Sunday-Friday, 10-8 summer, 10-5 winter. Located downtown; 2,800 sq. ft. Clientele: tourists and upscale. 90% private collectors. Overall price range: $250-10,000; most work sold at $2,400.
Media: Considers all media; types of prints include engravings, lithographs, serigraphs and etchings. Most frequently exhibits oil, watercolor and acrylic.
Style: Exhibits photorealism. Genres include western, wildlife, southwestern and landscapes. Prefers: wildlife, landscape and western.
Terms: Accepts work on consignment (40% commission). Retail price set by the artist. Gallery provides insurance, promotion and contract. Shipping costs are shared. Prefers artwork framed.
Submissions: Send query letter with slides, brochure and SASE. Call for appointment to show portfolio of photographs or slides. Replies in 1 week. Files brochures and bios. Finds artists through art exhibitions and referrals.
Tips: "Don't show us only the best work, then send mediocre paintings that do not equal the same standard."

FAR WEST GALLERY, 2817 Montana Ave., Billings MT 59101. (406)245-2334. Fax: (406)245-0935. E-mail: info@f arwestgal.com. Website: http://farwestgal.com. Manager: Sondra Daly. Retail gallery. Estab. 1994. Represents emerging, mid-career and established artists. Exhibited artists include Joe Beeler and Dave Powell. Sponsors 4 shows/year. Average display time 6-12 months. Open all year; 9-6. Located in downtown historic district in a building built in 1910. Clientele: tourists. Overall price range: $1-9,500; most work sold at $300-700.
Media: Considers all media and all types of prints. Most frequently exhibits native American beadwork, oil and craft/handbuilt furniture.
Style: Exhibits all styles. Genres include western and Americana. Prefers: Native American beadwork, western bits, spurs, memorabilia, oil, watercolor and pen & ink.
Terms: Buys outright for 50% of retail price. Retail price set by the gallery and the artist. Gallery provides insurance and promotion.

GRIZZLY GALLERY, 111 S. Canyon, W. Yellowstone MT 59758. (406)646-4030. Fax: (406)646-7111. Owner: Michael Letson. Retail gallery. Estab. 1994. Represents 45 emerging, mid-career and established artists/year. Exhibited artists include Mimi Grant and Frank Hagel. Sponsors 2 shows/year. Average display time 4 months. Open all year; daily, 9-5; summer, 9-8. Located downtown; 1,287 sq. ft. Clientele: tourists, upscale. 80% private collectors, 20% corporate collectors. Overall price range: $300-15,000; most work sold at $1,500-3,000.
Media: Considers oil, acrylic, watercolor, pastel, pen & ink, drawing, mixed media, sculpture, engravings, lithographs, serigraphs and etchings. Most frequently exhibits oil, watercolor and pastel.
Style: Exhibits conceptualism, impressionism and realism. Genres include western, wildlife, southwestern and land-

scapes. Prefers: western, wildlife and landscapes.

Terms: Accepts work on consignment (40% commission). Retail price set by the artist. Gallery provides promotion. Shipping costs are shared. Prefers artwork framed.

Submissions: Finds artists through referrals by other artists, "artists seek me out."

HARRIETTE'S GALLERY OF ART, 510 First Ave. N., Great Falls MT 59405. (406)761-0881. Owner: Harriette Stewart. Retail gallery. Estab. 1970. Represents 20 artists. Exhibited artists include Don Begg, Larry Zabel, Frank Miller, Arthur Kober, Richard Luce, Susan Guy, J. Schoonover, Johnye Cruse and Lee Cable. Sponsors 1 show/year. Average display time 6 months. Open all year. Located downtown; 1,000 sq. ft. 100% of space for special exhibitions. Clientele: 90% private collectors, 10% corporate collectors. Overall price range: $100-10,000; most artwork sold at $200-750.

Media: Considers oil, acrylic, watercolor, pastel, pencils, pen & ink, mixed media, sculpture, original handpulled prints, lithographs and etchings. Most frequently exhibits watercolor, oil and pastel.

Style: Exhibits expressionism. Genres include wildlife, landscape, floral and western.

Terms: Accepts work on consignment (33⅓% commission); or outright for 50% of retail price. Retail price set by gallery and artist. Sometimes offers customer discounts and payment by installment. Gallery provides promotion; "buyer pays for shipping costs." Prefers artwork framed.

Submissions: Send query letter with résumé, slides, brochure and photographs. Portfolio review requested if interested in artist's work. "Have Montana Room in the largest Western Auction in U.S.—The Charles Russell Auction, in March every year—looking for new artists to display."

Tips: "Proper framing is important."

HOCKADAY CENTER FOR THE ARTS, P.O. Box 83, Kalispell MT 59903. (406)755-5268. E-mail: eubank@cyber port.net. Website: http://www.vtown.com/hockaday. Director: Joan Baucus. Museum. Estab. 1968. Exhibits emerging, mid-career and established artists. Interested in seeing the work of emerging artists. 500 members. Exhibited artists include Theodore Waddell, Dale Chihuly and David Shaner. Sponsors approximately 15 shows/year. Average display time 2 months. Open year round. Located 2 blocks from downtown retail area; 2,650 sq. ft.; historic 1906 Carnegie Library Building with new (1989) addition; wheelchair access to all of building. 50% of space for special exhibitions. Overall price range $500-35,000.

Media: Considers all media, plus woodcuts, wood engravings, linocuts, engravings, mezzotings, etchings, lithographs and serigraphs. Most frequently exhibits painting (all media), sculpture/installations (all media), photography and original prints.

Style: Exhibits all styles and genres. Prefers: contemporary art (all media and styles), historical art and photographs and traveling exhibits. "We are not interested in wildlife art and photography, mass-produced prints or art from kits."

Terms: Accepts work on consignment (40% commission). Also houses permanent collection: Montana and regional artists acquired through donations. Sometimes offers customer discounts and payment by installment to museum members. Gallery provides insurance, promotion and contract; shipping costs are shared. Prefers artwork framed.

Submissions: Send query letter with résumé, slides, bio, reviews and SASE. Portfolio should include b&w photographs and slides (20 maximum). "We review *all* submitted portfolios once a year, in spring." Finds artists through submissions and self-promotions.

Tips: "Present yourself and your work in the best possible professional manner. Art is a business. Make personal contact with the director, by phone or in person. You have to have enough work of a style or theme to carry the space. This will vary from place to place. You must plan for the space. A good rule to follow is to present 20 completed works that are relative to the size of space you are submitting to. As a museum whose mission is education we choose artists whose work brings a learning experience to the community."

INDIAN UPRISING GALLERY, 111 S. Grand Ave. #104, Bozeman MT 59715. (406)586-5831. Fax: (406)587-5998. E-mail: indianuprising@mcn.net. Retail gallery. Estab. 1991. Represents 75 emerging, mid-career and established artists/year. Exhibited artists include: Sam English, Bruce Contway, Rance Hood, Frank Shortey and Gale Running Wolf. Sponsors 4 shows/year. Average display time 1 month. Open all year; 10-5. Located in Emerson Cultural Center; 500 sq. ft. 100% of space for gallery artists. 25% private collectors.

Media: Considers all media. Most frequently exhibits fine, contemporary and traditional tribal.

Style: Exhibits all styles and genres.

Terms: Accepts work on consignment (20% commission) or buys outright for 50% of retail price (net 30 days). Retail price set by the gallery. Gallery provides insurance, promotion and contract; shipping costs are shared. Prefers artwork framed.

Submissions: Accepts only Native artists from northern U.S. Send résumé, slides, bio and artist's statement. Write for appointment to show portfolio of photographs. Replies in 2 weeks. Finds artists through visiting museums art shows for Indian art.

JAILHOUSE GALLERY, 218 Center Ave., Hardin MT 59034. (406)665-3239. Director: Terry Jeffers. Nonprofit gallery. Estab. 1978. Represents 25 emerging, mid-career and established artists/year. Exhibited artists inlcude Gale Reenning Wolf, Sr. and Mary Blair. Sponsors 9 shows/year. Average display time 6 weeks. Open all year; January-April; Tuesday-Friday, 10-5 (winter); May-December; Monday-Saturday, 9:30-5:30. Located downtown; 1,440 sq. ft. 75% space for special exhibitions; 25% of space for gallery artists. Clientele: all types. 95% private collectors, 5% corporate collectors. Overall price range: $20-2,000; most work sold at $20-500.

Media: Considers all media and all types of prints. Most frequently exhibits mixed media, watercolor and pen & ink.
Style: Exhibits all styles and all genres. Prefers: western, Native American and landscapes.
Terms: Accepts work on consignment (30% commission). Retail price set by the gallery. Gallery provides insurance, promotion and contract. Artist pays shipping costs.
Submissions: Send query letter with résumé, business card, bio, artist's statement and bio. Call for appointment to show portfolio of photographs. Replies in 2-3 weeks. Finds artists through word of mouth, referrals by other artists, visiting art fairs and exhibitions and artist's submissions.

LIBERTY VILLAGE ARTS CENTER, 400 S. Main, Chester MT 59522. (406)759-5652. Contact: Director. Nonprofit gallery. Estab. 1976. Represents 12-20 emerging, mid-career and established artists/year. Sponsors 6-12 shows/year. Average display time 6-8 weeks. Open all year; Tuesday-Friday, 12-4; Sunday, 12-4. Located near a school; 1,000 sq. ft.; former Catholic Church. Clientele: tourists and local community. 100% private collectors. Overall price range: $100-2,500; most work sold at $250-500
Media: Considers all media; types of prints include woodcuts, lithographs, mezzotints, serigraphs, linocuts and pottery. Most frequently exhibits paintings in oil, water, acrylic, b&w photos and sculpture assemblages.
Style: Exhibits all styles. Prefers: contemporary and historic
Terms: Accepts work on consignment (30% commission) or buys outright for 40% of retail price. Retail price set by the gallery. Gallery provides insurance and promotion; shipping costs are shared. Prefers artwork framed or unframed.
Submissions: Send query letter with slides, bio and brochure. Artists portfolio should include slides. Replies only if interested within 3-12 months. Artist should cross us off their list. Files everything. Finds artists through word of mouth and seeing work at shows.
Tips: "Artists make the mistake of not giving us enough information and permission to pass information on to other galleries."

MISSOURI RIVER GALLERY, 201 N. Main St., Three Forks MT 59752. (406)285-4462. Owner: Amber. Retail gallery and frame shop. Estab. 1995. Represents 10 emerging, mid-career and established artists/year. Exhibited artists include: Zabel and Dooley. Open all year; Monday-Saturday, 10-5. Located north end of town on Main; 1,000 sq. ft.; homestyle. 50% of space for special exhibitions; 50% of space for gallery artists. Overall price range: $10-2,000; most work sold at $75-300.
Media: Considers all media and all types of prints. Most frequently exhibits limited edition prints, oil colors and sculpture.
Style: Exhibits all styles. Genres include florals, western, wildlife, southwestern and landscapes. Prefers: western, Victorian and wildlife.
Terms: Accepts work on consignment (30% commission). Retail price set by the artist. Prefers artwork unframed.
Submissions: Send brochure, photographs and business card. Call for appointment. Does not reply. Artist should call. Finds artists through magazines and art fairs.

OLD MAIN GALLERY & FRAMING, 129 E. Main St., Bozeman MT 59715. (406)587-8860. Fax: (406)587-9828. Owner: Jim Brown. Retail gallery. Estab. 1964. Represents 20 emerging, mid-career and established artists/year. Exhibited artists include: Bruce Park, Russell Chatham and Mike Stidham. Sponsors 2 shows/year. Average display time 1 month. Open all year; 7 days a week 9-9. Located downtown; 1,500 sq. ft.; restored 19th century building. 25% of space for special exhibitions; 25% of space for gallery artists. Clientele: complete spectrum. 95% private collectors, 5% corporate collectors. Overall price range: $25-7,000; most work sold at $300-400
Media: Considers oil, acrylic, watercolor, pastel, mixed media, sculpture, ceramics and fiber; types of prints include engravings, lithographs, wood engravings, serigraphs, etchings, posters and monoprints. Most frequently exhibits pastel, oil and etchings.
Style: Exhibits all styles. Genres include florals, western, wildlife and landscapes. Prefers: landscape, wildlife and western.
Terms: Accepts work on consignment (40% commission) or buys outright for 50% of retail price (net 30 days). Retail price set by the artist. Gallery provides insurance, promotion, contract and framing; shipping costs are shared. Prefers artwork unframed.
Submissions: Send query letter with bio, brochure and photographs. Call or write for appointment to show portfolio of photographs. Replies ASAP, if interested within 1 month. Files photos and bios. Finds artists through word of mouth, research and exhibitions.
Tips: "Know retail price structure; don't make cold calls without advance notice."

✔**PARADISE PRINTS, INC.**, 223 S. Main St., Livingston MT 59047. (406)222-5974. Fax: (406)222-5820. E-mail: paradise@alpinet.net. Website: http://www.paradise.simplenet.com. President: David C. Lewis. Retail gallery. Estab. 1994. Represents 30 emerging, mid-career and established artists/year. Exhibited artists include Tim Cox and Manuel Manzanarez. Sponsors 12 shows/year in gallery and 40 shows/year throughout the West. Average display time 2-3 weeks. Open all year; Monday-Saturday, 8:30-5:30; Sunday by appointment. Located downtown Livingston; 3,200 sq. ft. 25% of space for special exhibitions; 75% of space for gallery artists. Clientele: local community, tourists, in-state interest. 85% private collectors, 15% corporate collectors. Overall price range: $50-10,500; most work sold at $130-275. "We have 13 artists currently on the Internet and are adding more monthly. We provide low-cost web pages for artists throughout the West. (We currently get about 30 hits a day on our site.)"

Media: Considers all media and all types of prints. Most frequently exhibits limited-edition, framed, wildlife art prints; limited-edition, framed western art prints; open-edition, framed, wildlife art prints.

Style: Exhibits photorealism and realism. Genres include florals, portraits, western, wildlife, landscapes, limited edition framed angling art prints, open edition angel Renaissance art prints, Americana and New Age.

Terms: Accepts work on consignment (25% commission). Retail price set by the gallery. Gallery provides insurance, promotion and contract. Artist pays shipping costs. Prefers artwork framed.

Submissions: Prefers limited-edition prints. Send query letter with résumé, brochure, business card, reviews, artist's statement and bio. Call for appointment to show portfolio of photographs. Files artist's brochures. Finds artists through word of mouth, visiting art fairs and exhibitions and through publications.

THE WADE GALLERY, 116 N. Main St., Livingston MT 59047. Phone/fax: (406)222-0404. E-mail: simonsez@sunris e.alpinet.net. Owner: Kelly Wade. Retail gallery and custom frame shop. Estab. 1986. Represents 15-20 emerging, mid-career and established artists/year. Exhibited artists include Russell Chatham and Bruce Park. Sponsors 4 exhibitions/ year. Average display time 1 month. Open all year; Tuesday-Saturday, 10-5. Located downtown; 1,200 sq. ft.; newly remodeled, individual alcoves to showcase artists. Clientele: tourists, upscale and local. 90% private collectors, 10% corporate collectors. Overall price range: $50-20,000; most work sold at $100-1,500.

Media: Considers all media including jewelry. Considers all types of original prints. Most frequently exhibits pastel, watercolor and oil.

Style: Exhibits realism, impressionism and historic photos. Genres include portraits, wildlife and landscapes. Prefers: impressionism, realism and historic photos.

Terms: Accepts work on consignment (40% commission). Retail price set by the artist. Gallery provides insurance, promotion and contract. Shipping costs are shared. Prefers artwork framed.

Submissions: Accepts only artists from Yellowstone area. Prefers original art. No limited edition reproductions. Send query letter with résumé, brochure, 20 slides, photographs, artist's statement, bio, SASE in January and February only. Write for appointment to show portfolio of photographs, slides and transparencies. Replies in 1 month. Finds artists through word of mouth, referrals and artist submissions.

Tips: "Don't drop in unannounced and want to show me your work!"

✓YELLOWSTONE GALLERY, 216 W. Park St., P.O. Box 472, Gardiner MT 59030. (406)848-7306. Owner: Jerry Kahrs. Retail gallery. Estab. 1985. Represents 20 emerging and mid-career artists/year. Exhibited artists include: Mary Blain and Nancy Glazier. Sponsors 2 shows/year. Average display time 2 months. Open all year; seasonal 7 days; winter, Tuesday-Saturday, 10-6. Located downtown; 3,000 sq. ft. new building. 25% of space for special exhibitions; 50% of space for gallery artists. Clientele: tourist and regional. 90% private collectors, 10% corporate collectors. Overall price range: $25-8,000; most work sold at $75-600.

Media: Considers oil, acrylic, watercolor, ceramics, craft and photography; types of prints include wood engravings, serigraphs, etchings and posters. Most frequently exhibits watercolors, oils and limited edition, signed and numbered reproductions.

Style: Exhibits: impressionism, photorealism and realism. Genres include western, wildlife and landscapes. Prefers: wildlife realism, western and watercolor impressionism.

Terms: Accepts work on consignment (45% commission). Retail price set by the artist. Gallery provides contract; artist pays for shipping. Prefers artwork framed.

Submissions: Send query letter with brochure or 10 slides. Write for appointment to show portfolio of photographs. Replies in 1 month. Files brochure and biography. Finds artists through word of mouth, regional fairs and exhibits, mail and periodicals.

Tips: "Don't show up unannounced without an appointment."

Nebraska

ANDERSON O'BRIEN, 8724 Pacific St., Omaha NE 68114. (402)390-0717. Fax: (402)390-0479. Owner: Jo Anderson. Retail gallery. Estab. 1970. Represents 30 established artists/year. Exhibited artists include Hal Holoun. Sponsors 14 shows/year. Average display time 3 weeks. Open all year; Monday-Friday, 9:30-5:30; Saturday, 10-5. Located in suburbs; 2,000 sq. ft. 40% of space for special exhibitions; 60% of space for gallery artists. Clientele: upscale. 50% private collectors; 50% corporate collectors. Overall price range: $500-150,000; most work sold at $3,500-7,500.

Media: Considers all media except photography and craft; types of prints include woodcuts. Most frequently exhibits oil/canvas, acrylic/canvas and pastel

Style: Exhibits primitivism, painterly abstraction, conceptualism and minimalism. Genres include landscapes and figurative work. Prefers abstraction and landscapes.

Terms: Accepts work on consignment (50% commission). Retail price set by the artist. Gallery provides insurance and promotion; shipping costs are shared. Prefers artwork unframed.

Submissions: Accepts only artists with MFA degrees. Send résumé, slides and bio. Write for appointment to show portfolio of transparencies. Finds artists through university exhibitions.

Tips: "Make an appointment."

‡**ARTISTS' COOPERATIVE GALLERY**, 405 S. 11th St., Omaha NE 68102. (402)342-9617. President: Robert Schipper. Cooperative and nonprofit gallery. Estab. 1974. Exhibits the work of 30-35 emerging, mid-career and established artists. 35 members. Exhibited artists include Carol Pettit and Jerry Jacoby. Sponsors 14 shows/year. Average display time 1 month. Open all year. Located in historic old market area; 5,000 sq. ft.; "large open area for display with 25' high ceiling." 20% of space for special exhibitions. Clientele: 85% private collectors, 15% corporate collectors. Overall price range: $20-2,000; most work sold at $20-1,000.
Media: Considers oil, acrylic, watercolor, pastel, drawings, mixed media, collage, paper, sculpture, ceramic, fiber, glass, photography, woodcuts, serigraphs. Most frequently exhibits pastel, acrylic, oil and ceramic.
Style: Exhibits all styles and genres.
Terms: Co-op membership fee plus donation of time. Retail price set by artist. Sometimes offers payment by installment. Artist provides insurance; artist pays for shipping. Prefers artwork framed. No commission charged by gallery.
Submissions: Accepts only artists from the immediate area. "We each work one day a month." Send query letter with résumé, slides and bio. Write for appointment to show portfolio of originals and slides. "Applications are reviewed and new members accepted and notified in August if any openings are available." Files applications.
Tips: "Fill out application and touch base with gallery in July."

CARNEGIE ARTS CENTER, P.O. Box 375, 204 W. Fourth St., Alliance NE 69301. (308)762-4571. Gallery Director: Gretchen Garwood. Nonprofit gallery. Estab. 1993. Represents 300 emerging, mid-career and established artists/year. 90 members. Exhibited artists include Rose Edin. Sponsors 12 shows/year. Average display time 1 month. Open all year; Tuesday-Saturday, 10-4; Sunday, 1-4. Located downtown; 2,346 sq. ft.; renovated Carnegie library built in 1911. Clientele: tourists, upscale, local community and students. 90% private collectors, 10% corporate collectors. Overall price range: $10-500; most work sold at $10-75.
Media: Considers all media and all types of prints. Most frequently exhibits watercolor, oil and silver jewelry.
Style: Exhibits all styles and all genres. Prefers western, florals and Americana.
Terms: Accepts work on consignment (35% commission). Retail price set by the artist. Gallery provides promotion. Shipping costs are shared. Prefers artwork framed.
Submissions: Accepts only quality work. Send query. Write for appointment to show portfolio review of photographs, slides or transparencies. Replies only if interested within 1 month. Files résumé and contracts. Finds artists through word of mouth, referrals by other artists, visiting art fairs and exhibitions and artist's submissions.

HAYDON GALLERY, 335 N. Eighth St., Suite A, Lincoln NE 68508. (402)475-5421. Fax: (402)472-9185. E-mail: ap63142@mail.itec.net. Director: Anne Pagel. Nonprofit project of the Nebraska Art Association in support of Sheldon Memorial Art Gallery and Sculpture Garden, UNL. Estab. 1984. Exhibits 100 mid-career and established artists. Exhibited artists include Karen Kunc, Stephen Dinsmore, Kirk Pedersen, Tom Rierden and Susan Puelz. Sponsors 12 shows/year. Average display time 1 month. Open all year; Monday-Saturday, 10-5. Located in Historic Haymarket District (downtown); 1,100 sq. ft. 85% of space for special exhibitions; 10% of space for gallery artists. Clientele: collectors, corporate, residential, architects and interior designers. 75% private collectors, 25% corporate collectors. Overall price range: $75-20,000; most work sold at $500-3,000.
Media: Considers all media and all types of original prints. Most frequently exhibits paintings, mixed media and prints.
Style: Exhibits all styles. Genres include landscapes, abstracts, still lifes and figurative work. Prefers: contemporary realism, nonrepresentational work in all styles.
Terms: Accepts work on consignment (45% commission). Retail price set by gallery and artist. Offers customer discounts and payment by installments. Gallery provides insurance, promotion, contract; artist pays for shipping.
Submission: Accepts primarily Midwest artists. Send query letter with résumé, slides, reviews and SASE. Portfolio review requested if interested in artist's work. Portfolio should include originals, photographs or slides. Replies only if interested within 1 month (will return slides if SASE enclosed). Files slides and other support information. Finds artists through submissions, regional educational programs, visiting openings and exhibitions and news media.
Tips: When choosing work considers "marketability of work, probability of a long-term working relationship with artist and professionalism and seriousness of the artist."

WAREHOUSE GALLERY, 381 N. Walnut St., Grand Island NE 68801. (308)382-8589. Owner: Virginia Rinder. Retail gallery and custom framing. Estab. 1971. Represents 25-30 emerging artists/year. Exhibited artists include: Doug Johnson and Cindy Duff. Sponsors 3 shows/year. Average display time 1 month. Open all year; Monday-Friday, 10-5; Saturday, 10-3. Located in old downtown; 900 sq. ft.; old tin ceilings and skylights. 50% of space for special exhibitions. Clientele: upscale and local community. Overall price range: $150-2,000; most work sold at $200-300.
Media: Considers oil, acrylic, watercolor, pastel, pen & ink, mixed media, collage, sculpture, ceramics, fiber, glass and photography; types of prints include woodcuts, wood engravings, serigraphs and linocuts. Most frequently exhibits watercolor, oil, acrylic and pastel.

‡ **MARKETS NEW TO THIS EDITION** are marked with a double dagger.

Style: Exhibits: realism. Genres include florals and landscapes. Prefers: landscapes, florals and experimental.
Terms: Accepts work on consignment (33% commission). Retail price set by the artist. Gallery provides insurance, promotion and contract; artist pays for shipping. Prefers artwork framed.
Submissions: Accepts only artists from the Midwest. Send query letter with résumé, slides, photographs and SASE. Write for appointment to show portfolio of photographs or slides. Replies only if interested within 3 weeks. Finds artists through referrals by other artists, art fairs and exhibitions.

‡**ADAM WHITNEY GALLERY**, 8725 Shamrock Rd., Omaha NE 68114. (402)393-1051. Manager: Linda Campbell. Retail gallery. Estab. 1986. Represents 350 emerging, mid-career and established artists. Exhibited artists include Valerie Berlin and Christopher Darling. Average display time 3 months. Open all year; Monday-Saturday, 10-5. Located in countryside village; 2,500 sq. ft. 40% of space for special exhibitions. Overall price range: $150-7,000.
Media: Considers oil, paper, fiber, acrylic, sculpture, glass, watercolor, mixed media, ceramic, installation, pastel, collage, craft, jewelry, mezzotints, lithographs and serigraphs. Most frequently exhibits glass, jewelry, 2-dimensional works.
Style: Exhibits all styles and genres.
Terms: Accepts work on consignment (50% commission). Retail price set by gallery and artist. Gallery provides insurance, promotion and contract; shipping costs are shared. Prefers artwork framed.
Submissions: Send query letter with résumé, slides, photographs and reviews. Call or write for appointment to show portfolio of originals, photographs and slides. Files résumé, slides, reviews.

Nevada

ART ENCOUNTER, 3979 Spring Mountain Rd., Las Vegas NV 89102. (702)227-0220. Fax: (702)227-3353. E-mail: rod@artencounter.com. Director: Rod Maly. Retail gallery. Estab. 1992. Represents 100 emerging, mid-career and established artists/year. Exhibited artists include: Hermon Adams. Sponsors 4 shows/year. Average display time 3 months. Open all year; Tuesday-Friday, 10-6; Saturday and Monday, 12-5. Located near the famous Las Vegas strip; 6,000 sq. ft. 20% of space for special exhibitions; 80% of space for gallery artists. Clientele: upscale tourists and locals. 95% private collectors, 5% corporate collectors. Overall price range: $200-20,000; most work sold at $400-600.
Media: Considers all media and all types of prints. Most frequently exhibits watercolor, oil and acrylic.
Style: Exhibits all styles and genres. Prefers: Southwestern, landscapes and wildlife.
Terms: Accepts work on consignment (50% commission). Rental fee for space; covers 6 months. Retail price set by the gallery and artist. Gallery provides promotion and contract; artist pays for shipping, shipping costs are shared. Prefers artwork framed.
Submissions: Send 5-10 slides, photographs and SASE. Write for appointment to show portfolio of photographs or slides. Replies only if interested within 1 week. Files artist bio and résumé. Finds artists by advertising in the *Artist's Magazine, American Artist*, art shows and word of mouth.
Tips: "Poor visuals and no SASE are common mistakes."

✔**GARRETT'S FRAMES**, (formerly Artworks), 4796 Caughlin Pkwy., Suite 104, Reno NV 89509. (702)826-6008. Fax: (702)826-9733. Manager: Robert Garrett. Retail gallery and frame shop. Estab. 1996. Represents 1-5 emerging artists/year. Open all year; Monday-Saturday, 10-6. Located in residential area; 1,200 sq. ft. 50% of space for special exhibitions; 95% of space for gallery artists. Clientele: mid-upscale professionals. 90% private collectors, 10% corporate collectors. Overall price range: $50-5,500; most work sold at $150-250.
Media: Considers all media and all types of prints. Most frequently exhibits oil on canvas, pastel and watercolor.
Style: Exhibits: expressionism, neo-expressionism, painterly abstraction, conceptualism, postmodern works, impressionism, hard-edge geometric abstraction, realism and imagism. Genres include florals, western, wildlife and landscapes. Prefers: realism, painterly abstracts and impressionism.
Terms: Accepts work on consignment (35% commission). Retail price set by the artist. Gallery provides insurance, promotion and contract; shipping costs are shared. Prefers artwork unframed.
Submissions: Only accepts artists from Northern Nevada and Northern California. Send query letter with bio and 20 slides or photographs. Write for appointment to show portfolio of photographs. Replies only if interested within 2 weeks. Files all material. Finds artists through submissions and other exhibitions.
Tips: "Be patient and inexpensive. Don't expect to get sales immediately. Presentation is key; it should catch the eye but not be gaudy. The more work you create the better. It shows you are focused and active. But only present around 20 of your best examples."

‡**NEVADA MUSEUM OF ART**, E.L. Wiegand Gallery, 160 W. Liberty St., Reno NV 89501. (702)329-3333. Fax: (702)329-1541. E-mail: art@nma.reno.nv.us. Website: http://nevadaart.org. Curator: Diane Deming. Museum. Estab. 1931. Shows the work of mid-career and established artists. Hosts 12 solo shows/year. Average display time: 6-8 weeks. Open all year. Located downtown in business district. 80% of space for special exhibitions. "NMA is a nonprofit private art museum. Museum curates individual and group exhibitions and has active acquisition policy for West/Great Basin artists."
Media: Considers all media and all types of original prints. Most frequently exhibits painting, sculpture, prints and

photography.
Style: Exhibits all styles and all genres.
Terms: Acquires art through donation or occasional special purchase.
Submissions: Send query letter with nonreturnable samples. Include SASE for return of work. Write to schedule an appointment to show a portfolio.

GENE SPECK'S SILVER STATE GALLERY, 719 Plumas St., Reno NV 89509. (702)324-2323. Fax: (702)324-5425. Owner: Carolyn Barnes. Retail gallery. Estab. 1989. Represents 10-15 emerging, mid-career and established artists/year. Exhibited artists include Gene Speck and Mary Lee Fulkerson. Sponsors 15-20 shows/year. Average display time 2-4 weeks. Closed for the month of January. Open Monday-Saturday, 11-6; Sunday, 12-5. Located within walking distance of downtown; 700 sq. ft.; refurbished brick house from 1911, charming garden patio. 50% of space for special exhibitions; 50% of space for gallery artists. Clientele: tourists, upscale, local community and students. 80% private collectors, 20% corporate collectors. Overall price range $20-5,500; most work sold at $100-2,000.
Media: Considers oil, acrylic, watercolor, pastel, pen & ink, paper, ceramics, fiber, jewelry and glass. Most frequently exhibits oils, fiber and watercolor.
Style: Exhibits realism. Genres include western, wildlife, southwestern, landscapes and Americana.
Terms: Accepts work on consignment (30% commission). Retail price set by the artist. Gallery provides insurance, promotion and contract. Shipping costs are shared. Prefers artwork framed.
Submissions: Accepts only local artists. Send query letter with résumé, brochure, slides, photographs, artist's statement and bio. Call or write for appointment to show portfolio of photographs. Replies only if interested within 3 weeks. Finds artists through word of mouth and referrals by other artists.

✔**STUDIO WEST**, 8447 W. Lake Mead, Las Vegas NV 89128. (702)228-1901. Fax: (702)228-1622. Manager: Sharon Darcy. Retail gallery, framing. Estab. 1994. Represents 20 mid-career and established artists/year. May be interested in seeing the work of emerging artists in the future. Exhibited artists include Thomas Kinkade and Robert Bateman. Sponsors 2 shows/year. Average display time 1 month. Open all year; Monday-Friday, 10-6; Saturday, 10-5. 1,200 sq. ft.; pueblo style architecture. 50% of space for special exhibitions; 50% of space for gallery artists. Clientele: local. 90% private collectors, 10% corporate collectors. Overall price range: $100-1,200; most work sold at $700.
Media: Considers all media and all types of prints. Most frequently exhibits watercolor, paper and oil.
Style: Exhibits all styles and all genres. Prefers landscape, wildlife and florals.
Terms: Accepts work on consignment (40% commission). Buys outright for 50% of the retail price. Retail price set by the artist. Gallery provides insurance, promotion and contract. Artists pays shipping costs.
Submissions: Send query letter with photographs. Call or write for appointment to show portfolio of photographs. Replies only if interested with 1 month. Files bio photos. Finds artists through word of mouth, referrals by other aritsts, visiting art fairs and exhibitions and artist's submissions.
Tips: "I will view without an appointment if I am not busy. They need to ask if I have time."

New Hampshire

DOWNTOWN ARTWORKS, P.O. Box 506, Plymouth NH 03264. (603)536-8946. Fax: (603)536-1876. Manager: Ruth Preston. Retail and nonprofit gallery. Estab. 1991. Represents 30 emerging artists/year. 30 members. Exhibited artists include: Cam Sinclair. Sponsors 10 shows/year. Average display time 3 weeks. Open all year; Monday-Friday, 10-5; Saturday, 10-2. Located downtown Plymouth; 600 sq. ft. 25% of space for special exhibitions; 25% of space for gallery artists. Clientele: tourists and locals. Overall price range: $50-2,000; most work sold at $150-250
Media: Considers all media and all types of prints (limited edition). Most frequently exhibits oil, watercolor and mixed.
Style: Exhibits: photorealism. Genres include florals, wildlife and landscapes. Prefers: landscapes, florals and wildlife.
Terms: Accepts work on consignment (30% commission). Rental fee for space $30 for 1 month. Retail price set by the artist. Gallery provides insurance, promotion, contract, patron's list and tax information; artist pays for shipping. Prefers artwork framed.
Submissions: Accepts only artists from New Hampshire. Send business card and artist's statement. Call for appointment to show portfolio of photographs. Replies in 1 month. Finds artists by going to exhibitions and shows.
Tips: "Work should not be poorly framed and artists should not be unsure of price range."

MCGOWAN FINE ART, INC., 10 Hills Ave., Concord NH 03301. (603)225-2515. E-mail: mcgowanfa@aol.com. Owner/Art Consultant: Mary McGowan. Retail gallery and art consultancy. Estab. 1980. Represents emerging, mid-career and established artists. Sponsors 4 shows/year. Average display time 1 month. Located just off Main Street. 75-100% of space for special exhibitions. Clientele: residential and corporate. Most work sold at $125-9,000.
Media: Considers oil, acrylic, watercolor, pastel, mixed media, collage, works on paper, sculpture, woodcuts, wood engravings, linocuts, engravings, mezzotints, etchings, lithographs and serigraphs. Most frequently exhibits limited edition prints, monoprints and oil/acrylic.
Style: Exhibits painterly abstraction, landscapes, etc.
Terms: Accepts work on consignment (50% commission). Retail price set by artist. Gallery provides insurance and promotion; negotiates payment of shipping costs. Prefers artwork unframed.

Submissions: Send query letter with résumé, 5-10 slides and bio. Replies in 1 month. Files materials.
Tips: "Be professional. I am interested in the number of years you have been devoted to art. Are you committed? Do you show growth in your work?"

THE OLD PRINT BARN—ART GALLERY, RR2, Box 1008, Winona Rd., Meredith NH 03253-9599. (603)279-6479. Fax: (603)279-1337. Director: Sophia Lane. Retail gallery. Estab. 1976. Represents 90-100 mid-career and established artists/year. May be interested in seeing the work of emerging artists in the future. Exhibited artists include: Michael McCurdy, Ryland Loos and Joop Vegter. Sponsors 3-4 shows/year. Average display time 3-4 months. Open daily 10-5 (except Columbus Day to Thanksgiving Day, Christmas and New Years). Located in the country; over 4,000 sq. ft. May to October; remodeled antique 19th century barn; winters smaller quarters in 1790 home. 30% of space for special exhibitions; 70% of space for gallery artists. Clientele: tourists and local. 99% private collectors. Overall price range: $10-18,000; most work sold at $200-900
Media: Considers oil, watercolor, pastel, pen & ink, drawing, paper and photography; types of prints include woodcuts, engravings, lithographs, wood engravings, mezzotints, serigraphs, linocuts and etchings. Most frequently exhibits all works of art on paper.
Style: Exhibits: realism. Genres include florals, wildlife, landscapes and Americana. Prefers: landscapes, wildlife and antique engravings.
Terms: Accepts work on consignment. Retail price set by the gallery and artist. Gallery provides promotion; shipping costs are shared. Prefers artwork unframed but shrink-wrapped with 1 inch on top for clips so work can hang without damage to image or mat.
Submissions: Prefers only works of art on paper. No abstract or abstract work. Send query letter with résumé, brochure, 10-12 slides and artist's statement. Title, medium and size of artwork must be indicated, clearly on slide label. Call or write for appointment to show portfolio of photographs. Replies in a few weeks. Files query letter, statements, etc. Finds artists through word of mouth, referrals of other artists, visiting art fairs and exhibitions and submissions.
Tips: "Show your work to gallery owners in as many different regions as possible. Most gallery owners have a feeling of what will sell in their area. I certainly let artists know if I feel their images are not what will move in this area."

SHARON ARTS CENTER/KILLIAN GALLERY, RR2, Box 361, Route 123, Peterborough NH 03458. (603)924-7256. Fax: (603)924-6074. E-mail: sharonarts@sharonarts.org. Website: http://www.sharonarts.org. Curator of Exhibits: Randall Hoel. Nonprofit gallery. Estab. 1947. Represents 5-7 invitationals, 140 juried, 180 members emerging, mid-career and established artists/year. 970 members. Sponsors 8 shows/year. Average display time 6 weeks. Open all year; Monday-Saturday, 10-5; Sunday, 12-5. Located in a woodland setting; 1,000 sq. ft. Part of an arts center with a school of art and crafts and a crafts gallery shop. 87% of space for special exhibitions; 13% of space for gallery artists. Clientele: tourist, local and regional. 85% private collectors, 15% corporate collectors. Overall price range: $200-10,000; most work sold at $200-700.
Media: Considers all media and all types of prints including computer generated. Most frequently exhibits fine arts, crafts and historical.
Style: Exhibits: expressionism, primitivism, painterly abstraction, surrealism, postmodern works, impressionism, photorealism, realism and imagism. Exhibits all genres. Prefers: representation, impressionism and abstractions.
Terms: Accepts work on consignment (40% commission). Retail price set by the artist. Gallery provides insurance, promotion and contract; artist pays for shipping. Prefers artwork framed.
Submissions: Send query letter with résumé, slides, bio, photographs and reviews. Call for appointment to show portfolio of photographs or slides. Replies in 1-2 months. Files résumé, sample slides or photos. Send copies. Finds artists through visiting exhibitions, submissions and word of mouth.
Tips: "Artists shouldn't expect to exhibit right away. We plan exhibits 18 months in advance."

✔THORNE-SAGENDORPH ART GALLERY, Keene State College, Wyman Way, Keene NH 03435-3501. (603)358-2720. Director: Maureen Ahern. Nonprofit gallery. Estab. 1965. Represents emerging, mid-career and established artists. 600 members. Exhibited artists include Jules Olitski and Fritz Scholder. Sponsors 5 shows/year. Average display time 4-6 weeks. Open Monday-Saturday, 12-4; Thursday and Friday evenings till 7. Follows college schedule. Located on campus; 4,000 sq. ft.; climate control, security. 50% of space for special exhibitions. Clientele: local community and students.
Media: Considers all media and all types of prints.
Style: Exhibits all styles.
Terms: Accepts work on consignment (30% commission). Retail price set by the artist. Gallery provides insurance, promotion and contract; shipping costs are shared. Prefers artwork framed.
Submissions: Artists portfolio should include photographs and transparencies. Replies only if interested within 2 months. Files all material.

New Jersey

ARC-EN-CIEL, 64 Naughright Rd., Long Valley NJ 07853. (908)832-6605. Fax: (908)832-6509. E-mail: arreed@aol.com or areed@escape.cnct.com. Owner: Ruth Reed. Retail gallery and art consultancy. Estab. 1980. Represents 35 mid-

career and established artists/year. Exhibited artists include Andre Pierre, Petian Savain, Alexander Gregoire, Gerard Valcin and Seymore Bottex. Clientele: 50% private collectors, 50% corporate clients. Average display time is 6 weeks-3 months. Open by appointment only. Represents emerging, mid-career and established artists. Overall price range: $150-158,000; most artwork sold at $250-2,000.

Media: Considers oil, acrylic, wood carvings, sculpture. Most frequently exhibits acrylic, painted iron, oil.

Style: Exhibits minimalism and primitivism. "I exhibit country-style paintings, naive art from around the world. The art can be on wood, iron or canvas."

Terms: Accepts work on consignment (50% commission). Retail price is set by gallery and artist. Customer discounts and payment by installment are available. Exclusive area representation required. Gallery provides promotion; shipping costs are shared.

Submissions: Send query letter, photographs and SASE. Portfolio review requested if interested in artist's work. Photographs are filed. Finds artists through word of mouth and art collectors' referrals.

‡**MABEL SMITH DOUGLASS LIBRARY**, Douglass College, New Brunswick NJ 08901. (732)932-9407. Fax: (732)932-6667. E-mail: olin@rci.rutgers.edu. Website: http://www.libraries.rutgers.edu/rulib/abtlib/dglsslib/gen/events/was.htm. Curator: Ferris Olin. Alternative exhibition space for exhibitions of works by women artists. Estab. 1971. Represents/exhibits 5-7 emerging, mid-career and established artists/year. Interested in seeing the work of emerging artists. Sponsors 5-7 shows/year. Average display time 5-6 weeks. Open September-June; Monday-Sunday approximately 12 hours a day. Located on college campus in urban area; lobby-area of library. Clientele: students, faculty and community. Overall price range: $3,000-10,000.

Media: Considers all media. Most frequently exhibits painting, prints, photographs and sculpture.

Style: Exhibits all styles and all genres.

Terms: Retail price by the artist. Gallery provides insurance, promotion and arranges transportation. Prefers artwork framed.

Submissions: Exhibitions are curated by invitation. Portfolio should include 5 slides. Finds artists through referrals.

‡**EXTENSION GALLERY**, 60 Ward Ave. Extension, Mercerville NJ 08619. (609)890-7777. Fax: (609) 890-1816. Gallery Director: Jim Ulry. Nonprofit gallery/alternative space. Estab. 1984. Represents 60 emerging, mid-career, established artists/year. Sponsors 11 exhibitions/year. Average display time: 1 month. Open all year; Monday-Thursday 10-4 p.m. 1400 sq. ft.; attached to the Johnson Atelier Technical Institute of Sculpture. 90% of space devoted to showing the work of gallery artists.

● Extension Gallery is a service-oriented space for Johnson Atelier members; all work is done inhouse by Atelier members, apprentices and staff.

Media: Considers oils, acrylics, watercolor, pastels, drawings, mixed media, sculpture and all types of prints. Most frequently exhibits sculpture and drawing.

Style: Considers all styles. Prefers contemporary sculpture. Most frequently exhibits realism, expressionism, conceptualism.

GALMAN LEPOW ASSOCIATES, INC., #12, 1879 Old Cuthbert Rd., Cherry Hill NJ 08034. (609)354-0771. Contact: Judith Lepow. Art consultancy. Estab. 1979. Represents emerging, mid-career and established artists. Open all year. Clientele: 1% private collectors, 99% corporate collectors. Overall price range: $300-20,000; most work sold at $500-5,000.

Media: Considers oil, acrylic, watercolor, pastel, mixed media, collage, paper, sculpture, ceramic, craft, fiber, glass, photography, original handpulled prints, woodcuts, engravings, lithographs, pochoir, wood engravings, mezzotints, linocuts, etchings, and serigraphs.

Style: Exhibit painterly abstraction, impressionism, realism, photorealism, pattern painting and hard-edge geometric abstraction. Genres include landscapes, florals and figurative work.

Terms: Accepts artwork on consignment (40-50% commission). Retail price set by artist. Gallery provides insurance; shipping costs are shared. Prefers artwork unframed.

Submissions: Send query letter with résumé, slides and SASE. Call for appointment to show portfolio of originals, slides and transparencies. Replies in 3 weeks. Files "anything we feel we might ultimately show to a client."

‡**MARKEIM ART CENTER**, Lincoln Ave. and Walnut St., Haddonfield NJ 08033. Phone/fax: (609)429-8585. Executive Director: Danielle Reich. Nonprofit gallery. Estab. 1956. Represents emerging, mid-career and established artists. 150 members. Sponsors 8-10 shows/year, both on and off site. Average display time 6-8 weeks. Open all year; Monday-Friday 8-3. Located downtown; 600 sq. ft. 75% of space for special exhibitions; 20% of space for gallery artists. Overall price range: $85-5,000.

Media: Considers all media. Must be original. Most frequently exhibits paintings, photography and sculpture.

Style: Exhibits all styles and genres.

Terms: Work not required to be for sale (20% commission taken if sold.) Retail price set by the artist. Gallery provides promotion and contract. Artwork must be ready to hang.

Submissions: Send query letter with résumé, slides, bio/brochure, photographs, SASE, business card, reviews and artist's statement. Write for appointment to show portfolio of photographs and slides. Files slide registry.

THE NOYES MUSEUM OF ART, Lily Lake Rd., Oceanville NJ 08231. (609)652-8848. Fax: (609)652-6166. Curator of Collections and Exhibitions: Stacy Smith. Museum. Estab. 1982. Exhibits emerging, mid-career and established

artists. Sponsors 15 shows/year. Average display time 6 weeks to 3 months. Open all year; Wednesday-Sunday, 11-4. 9,000 sq. ft.; "modern, window-filled building successfully integrating art and nature; terraced interior central space with glass wall at bottom overlooking Lily Lake." 75% of space for special exhibitions. Clientele: rural, suburban, urban mix; high percentage of out-of-state vacationers during summer months. 100% private collectors. "Price is not a factor in selecting works to exhibit."

Media: All types of fine art, craft and folk art.

Style: Exhibits all styles and genres.

Terms: Accepts work on consignment (10% commission). "Artwork not accepted solely for the purpose of selling; we are a nonprofit art museum." Retail price set by artist. Gallery provides insurance. Prefers artwork framed.

Submissions: Send query letter with résumé, slides, photographs and SASE. "Letter of inquiry must be sent; then museum will set up portfolio review if interested." Portfolio should include originals, photographs and slides. Replies in 1 month. "Materials only kept on premises if artist is from New Jersey and wishes to be included in New Jersey Artists Resource File or if artist is selected for inclusion in future exhibitions."

‡SHEILA NUSSBAUM GALLERY, 325 Ravine Dr., South Orange NJ 07834. (201)467-1720. Fax: (201)467-2114. Director: Sheila Nussbaum Drill. Retail gallery. Estab. 1982. Represents 300 emerging and mid-career artists/year. Exhibited artists include Hal Larsen (painter), MaryLou Higgins (ceramics). Sponsors 5 shows/year. Average display time 1 month. Open all year; Monday-Saturday, 9-5; Thursday, 9-8. Located downtown; 3,500 sq. ft. 70% of space for special exhibitions. Clientele: upscale. 90% private collectors, 10% corporate collectors. Overall price range: $30-15,000; most work sold at $250-2,000.

Media: Considers all media except installation. Most frequently exhibits oil/acrylic paintings, ceramics, fine art jewelry.

Style: Exhibits primitivism, painterly abstraction, color field, postmodern works. Prefers: contemporary abstract, postmodern and folk art.

Terms: Accepts work on consignment (50% commission). Retail price set by the artist. Gallery provides insurance and promotion; shipping costs are shared. Prefers artwork framed.

Submissions: Send query letter with résumé, slides and artist's statement. Portfolio should include slides. Replies ASAP. Finds artists through submissions, art shows and referrals.

‡POLO GALLERY, 276 River Rd., Edgewater NJ 07020. (201)945-8200. Fax: (201)224-0150. Director: Robert Zimmerman. Retail gallery, art consultancy. Estab. 1993. Represents 250 emerging, mid-career and established artists/year. Exhibited artists include Christian Hal. Sponsors 6 shows/year. Average display time 6-8 weeks. Open all year; Tuesday-Sunday, 1:30-6; Friday, 1:30-7. Located downtown, Shadyside section; 1,100 sq. ft.; Soho atmosphere in burgeoning art center. 70% of space for special exhibitions; 30% of space for gallery artists. Clientele: tourists-passersby, private clientele, all economic strata. 90% private collectors, 10% corporate collectors. Overall price range: $80-18,000; most work sold at $350-4,000.

Media: Considers all media and all types of prints. Most frequently exhibits oil, sculpture, works on paper.

Style: Exhibits all styles and genres. Prefers realism, painterly abstraction, conceptual.

Terms: Accepts work on consignment (50% commission). Retail price set by the gallery and the artist. Gallery provides promotion and contract; artist pays for shipping or costs are shared.

Submissions: Send query letter with résumé slides, bio, artist's statement, assumed price list. Call or write for appointment to show portfolio of slides and b&w prints for newspapers. Replies in 2 months. Artist should call if no contact. Files future show possibilities.

Tips: Common mistakes artists make are not labeling slides, not including price list, and not indicating which slides are available.

QUIETUDE GARDEN GALLERY, 24 Fern Rd., East Brunswick NJ 08816. (732)257-4340. Fax: (732)257-1378. Owner: Sheila Thau. Retail/wholesale gallery and art consultancy. Estab. 1988. Represents 80 emerging, mid-career and established artists/year. Exhibited artists include Tom Blatt and Nora Chavooshian. Open April 27-November 1; Friday and Saturday and by appointment. Located in a suburb; 4 acres; unique work exhibited in natural and landscaped, wooded property—each work in its own environment. 25% of space for special exhibitions; 75% of space for gallery artists. Clientele: upper middle class, private home owners and collectors, small corporations. 75% private collectors, 25% corporate collectors. Overall price range: $2,000-50,000; most work sold at $10,000-20,000.

Media: Considers "only sculpture suitable for outdoor (year-round) display and sale." Most frequently exhibits metal (bronze, steel), ceramic and wood.

Style: Exhibits all styles.

Terms: Accepts work on consignment. Retail price set by the artist. Gallery provides insurance, promotion and contract; artist pays shipping costs to and from gallery.

Submissions: Send query letter with résumé, slides, bio, photographs, SASE and reviews. Write for appointment to show portfolio of photographs, slides and bio. Replies in 2 weeks. Files "slides, bios of artists who we would like to represent or who we do represent." Finds artists through word of mouth, publicity on current shows and ads in art magazines.

Tips: "Always looking for different 'voices' to enhance range in the gallery."

✔BEN SHAHN GALLERIES, William Paterson University, 300 Pompton Rd, Wayne NJ 07470. (973)720-2654. Director: Nancy Einreinhofer. Nonprofit gallery. Estab. 1968. Interested in emerging and established artists. Sponsors

5 solo and 10 group shows/year. Average display time is 6 weeks. Clientele: college, local and New Jersey metropolitan-area community.

- The gallery specializes in contemporary art and encourages site-specific installations. They also have a significant public sculpture collection and welcome proposals.

Media: Considers all media.

Style: Specializes in contemporary and historic styles, but will consider all styles.

Terms: Accepts work for exhibition only. Gallery provides insurance, promotion and contract; shipping costs are shared.

Submissions: Send query letter with résumé, brochure, slides, photographs and SASE. Write for appointment to show portfolio. Finds artists through submissions, referrals and exhibits.

‡WALKER-KORNBLUTH ART GALLERY, 7-21 Fair Lawn Ave., Fair Lawn NJ 07410. (201)791-3374. Director: Sally Walker. Retail gallery. Estab. 1965. Represents 20 mid-career and established artists/year. Exhibited artists include Wolf Kahn and Richard Segaliran. Sponsors 10 shows/year. Open Tuesday-Saturday, 10-5:30; Sunday, 1-5; closed August. 2,000 sq. ft., 1920's building (brick), 2 very large display windows. 75% of space for special exhibitions; 25% of space for gallery artists. Clientele: mostly professional and business people. 85% private collectors, 15% corporate collectors. Overall price range: $400-45,000; most work sold at $1,000-4,000.

Media: Considers all media except installation. Considers all types of prints. Most frequently exhibits oil, watercolor, pastel and monoprints.

Style: Exhibits painterly abstraction, impressionism, realism. Exhibits florals, southwestern, landscapes, figurative work. Prefers painterly realism, painterly abstraction, impressionism.

Terms: Accepts work on consignment (40-50% commission). Retail price set by the gallery and the artist. Gallery provides insurance and promotion; shipping costs are shared. Prefers artwork framed.

Submissions: "We don't usually show local artists." Send query letter with résumé, slides, reviews and SASE. Write for appointment to show portfolio of transparencies and slides. Files slides. Finds artists through word of mouth, referrals by other artists, visiting art fairs and exhibitions and submissions.

Tips: "Don't ask to show work before submitting slides."

WYCKOFF GALLERY, 648 Wyckoff Ave., Wyckoff NJ 07481. (201)891-7436. Director: Sherry Cosloy. Retail gallery. Estab. 1980. Interested in emerging, mid-career and established artists. Sponsors 1-2 solo and 4-6 group shows/year. Average display time 1 month. Clientele: collectors, art lovers, interior decorators and businesses. 75% private collectors, 25% corporate clients. Overall price range: $250-10,000; most artwork sold at $500-3,000.

Media: Considers oil, acrylic, watercolor, pastel, pen & ink, pencil, mixed media, sculpture, ceramic, collage and limited edition prints. Most frequently exhibits oil, watercolor and pastel.

Style: Exhibits contemporary, abstract, traditional, impressionistic, figurative, landscape, floral, realistic and neo-expressionistic works.

Terms: Accepts work on consignment. Retail price set by gallery or artist. Gallery provides insurance and promotion.

Submissions: Send query letter with résumé, slides and SASE. Résumé and biography are filed.

Tips: Sees trend toward "renewed interest in traditionalism and realism."

New Mexico

THE ALBUQUERQUE MUSEUM, 2000 Mountain Rd. NW, Albuquerque NM 87104. (505)243-7255. Curator of Art: Ellen Landis. Nonprofit museum. Estab. 1967. Interested in emerging, mid-career and established artists. Sponsors mostly group shows. Average display time is 3-6 months. Located in Old Town (near downtown).

Media: Considers all media.

Style: Exhibits all styles. Genres include landscapes, florals, Americana, western, portraits, figurative and nonobjective work. "Our shows are from our permanent collection or are special traveling exhibitions originated by our staff. We also host special traveling exhibitions originated by other museums or exhibition services."

Submissions: Send query letter, résumé, slides, photographs and SASE. Call or write for appointment to show portfolio.

Tips: "Artists should leave slides and biographical information in order to give us a reference point for future work or to allow future consideration."

‡ART CENTER AT FULLER LODGE, Box 790, 2132 Central Ave., Los Alamos NM 87544. (505)662-9331. Director: Gloria Gilmore-House. Retail gallery/nonprofit gallery and rental shop for members. Estab. 1977. Represents over 50 emerging, mid-career and established artists. 388 members. Sponsors 11 shows/year. Average display time 1 month. Open all year. Located downtown; 1,300 sq. ft. 98% of space for special exhibitions. Clientele: local, regional and international visitors. 99% private collectors, 1% corporate collectors. Overall price range: $50-1,200; most artwork sold at $30-300.

Media: Considers all media, including original handpulled prints, woodcuts, engravings, lithographs, wood engravings, mezzotints, serigraphs, linocuts and etchings.

Style: Exhibits all styles and genres.

Terms: Accepts work on consignment (30% commission). Retail price set by the artist. Gallery provides insurance and promotion; artist pays for shipping. "Work should be in exhibition form (ready to hang)."

Submissions: "Prefer the unique." Send query letter with résumé, slides, bio, brochure, photographs, SASE and reviews. Files "résumés, etc.; slides returned only by SASE."
Tips: "No one-person shows—artists will be used as they fit in to scheduled shows." Should show "impeccable craftsmanship."

‡**BAREISS GALLERY**, 15 Taos Ski Valley, Box 2739, Taos NM 87571. (505)776-2284. E-mail: pbareiss@newmex.c om. Associate Director: Susan Strong. Retail gallery and 3-acre sculpture park. Estab. 1989 at current location "but in business over ten years in Taos." Represents 21 mid-career and established artists. Exhibited artists include Jim Wagner and Patricia Sanford. Sponsors 8 shows/year. Average display time 2 months. Open all year. "Located in the countryside, close to town next to Taos Pueblo reservation under stunning aspect of Taos Mountain.; 4,000 sq. ft.; gallery is unique metal building with sculptural qualities, walls 10-20 ft. high." Clientele: 99% private collectors, 1% corporate collectors. Overall price range: $250-65,000.
Media: Most frequently exhibits outdoor sculpture, paintings and monotypes.
Styles: Exhibits all styles and genres, including abstract. Interested in seeing original contemporary art, especially outdoor sculpture by artists who are committed to being represented in Taos.
Terms: Accepts work on consignment (varying commission). Gallery provides contract; artist pays for shipping.
Submissions: Currently interested in outdoor sculpture. Send query letter with photographs. Do not send slides. Write for appointment to show portfolio of photographs. Replies only if interested. Files résumés and photos only if interested.
Tips: "Gallery representation should be seen as only one part of an artist's promotional effort. An artist would do well to have an active market before looking to a gallery."

‡**BENT GALLERY AND MUSEUM**, 117 Bent St., Box 153, Taos NM 87571. (505)758-2376. Owner: Otto Noeding. Retail gallery and museum. Estab. 1961. Represents 15 emerging, mid-career and established artists. Exhibited artists include E. Martin Hennings, Joseph Sharp, Herbert Dunton and Leal Mack. Open all year. Located 1 block off of the Plaza; "in the home of Charles Bent, the first territorial governor of New Mexico." Clientele: 95% private collectors, 5% corporate collectors. Overall price range: $100-10,000; most work sold at $500-1,000.
Media: Considers oil, acrylic, watercolor, pastel, pen & ink, drawings, sculpture, original handpulled prints, woodcuts, engravings and lithographs.
Style: Exhibits impressionism and realism. Genres include traditional, landscapes, florals, southwestern and western. Prefers: impressionism, landscapes and western works. "We continue to be interested in collectors' art: deceased Taos artists and founders works."
Terms: Accepts work on consignment (33⅓-50% commission). Retail price set by gallery and artist. Artist pays for shipping. Prefers artwork framed.
Submissions: Send query letter with brochure and photographs. Write for appointment to show portfolio of originals and photographs. Replies if applicable.
Tips: "It is best if the artist comes in person with examples of his or her work."

‡**CLAY & FIBER**, 147 Candelario St., #B, Sante Fe NM 82501. (505)758-8093. Owner: Sue Westbrook. Retail gallery. Estab. 1974. Represents/exhibits 50 emerging, mid-career and established artists/year. Interested in emerging artists. Exhibited artists include Hilary Walker and Bob Smith. Sponsors 4 shows/year. Average display time 1 month. Open all year; Monday-Saturday, 10-5; Sunday, 11-4. Located ½ block off Plaza; 2,000 sq. ft.; historical adobe with handcarved corbels. 75% of space for gallery artists. Clientele: tourist, local- long-time clients. Overall price range: $50-2,500; most work sold at $75-500.
Media: Considers paper, fiber, sculpture, glass, ceramics and craft. Most frequently exhibits clay-decorative and functional; fiber-wearable and wall; jewelry.
Style: Exhibits minimalism, pattern painting, painterly abstraction and realism.
Terms: Artwork is accepted on consignment (50% commission). Retail price set by the artist. Gallery provides insurance, promotion and contract; shipping costs are shared.
Submissions: Send query letter with slides and bio. Call or write for appointment to show portfolio of photographs and slides. Replies in 1 month.
Tips: Finds artists through word of mouth, referrals by other artists, visiting art fairs and exhibitions, artists' submissions.

FENIX GALLERY, 228-B N. Pueblo Rd., Taos NM 87571. Phone/Fax: (505)758-9120. E-mail: fenix@taos.webb.com. Website: http://taoswebb.com/nmusa/FENIX. Director/Owner: Judith B. Kendall. Retail gallery. Estab. 1989. Represents 18 emerging, mid-career and established artists/year. Exhibited artists include Alyce Frank and Earl Stroh. Sponsors 4 shows/year. Average display time 4-6 weeks. Open all year; daily, 10-5; Sunday, 12-5; closed Tuesday during winter months. Located on the main road through Taos; 2,000 sq. ft.; minimal hangings; clean, open space. 100% of space for special exhibitions during one-person shows; 50% of space for gallery artists during group exhibitions. Clientele: experienced and new collectors. 90% private collectors, 10% corporate collectors. Overall price range: $400-10,000; most work sold at $1,000-2,500.
 • The Fenix Gallery has doubled its exhibition space.
Media: Considers all media; primarily non-representational, all types of prints except posters. Most frequently exhibits oil, sculpture and paper work/ceramics.
Style: Exhibits expressionism, painterly abstraction, conceptualism, minimalism and postmodern works. Prefers: conceptualism, expressionism and abstraction.

Terms: Accepts work on consignment (50% commission). Retail price set by the artist or a collaboration. Gallery provides insurance, promotion and contract; artist pays shipping costs to and from gallery. Prefers artwork framed.

Submissions: Prefers artists from area; "we do very little shipping of artist works." Send query letter with résumé, slides, bio, brochure, photographs, SASE, business card and reviews. Call for appointment to show portfolio of photographs. Replies in 3 weeks. Files "material I may wish to consider later—otherwise it is returned." Finds artists through personal contacts, exhibitions, studio visits, reputation regionally or nationally.

Tips: "I rely on my experience and whether I feel conviction for the art and whether sincerity is present."

‡**MEGAN FOX**, 311 Aztec St., Santa Fe NM 87501. (505)989-9141. Fax: (505)820-6885. Owner: Megan Fox. Retail gallery. Estab. 1995. Represents 20 emerging, mid-career and established artists/year. Exhibited artists include Charles Thomas ONeil, Tom Baril. Sponsors 9 shows/year. Average display time 1 month. Open all year; Tuesday-Saturday, 11-5. Located downtown; 1,200 sq. ft.; 1920s bungalow. 80% of space for special exhibitions; 20% of space for gallery artists. Clientele: tourists, international collectors and local community. 95% private collectors, 5% corporate collectors. Overall price range: $500-50,000; most work sold at $1,000-5,000.

Media: Considers oil, acrylic, watercolor, pastel, drawing, collage, paper, photography. Most frequently exhibits photography, oil painting on steel and canvas, works on paper—various media.

Style: Exhibits painterly abstraction, conceptualism, conceptual photography. Prefers conceptual photography, painterly abstraction, conceptual painting.

Terms: Accepts work on consignment (60% commission). Retail price set by the gallery. Gallery provides insurance, promotion and contract; shipping costs are shared. Prefers artwork framed.

Submissions: Send query letter with slides, bio, photographs, SASE, reviews and artist's statement. Portfolio should include slides. Replies only if interested within 1 week. Files résumés. Finds artists through word of mouth, referrals by other artists, visiting art fairs and exhibitions and submissions.

Tips: "Visit the gallery; know scale of the gallery; send work that has relevance to my programme."

GALLERY A, 105 Kit Carson, Taos NM 87571. (505)758-2343. E-mail: galataos@aol.com. Website: http://www.collectorsguide.com/ts/g069.html. Owner: Mary L. Sanchez. Director: Gene Sanchez. Retail gallery. Estab. 1960. Represents 40 emerging, mid-career and established artists. Exhibited artists include Gene Kloss and Fran Larsen. Sponsors 3 shows/year. Average display time 2 weeks. Open all year. Located one block from the plaza; 4,000 sq. ft; "southwestern interior decor." 50% of space for special exhibitions. Clientele: "from all walks of life." 98% private collectors. Overall price range: $100-12,000; most artwork sold at $500-5,000.

Media: Considers oil, acrylic, watercolor, pastel, original handpulled prints, etchings and sculpture—bronze, stone or wood. Most frequently exhibits oil, watercolor and acrylic.

Style: Exhibits expressionism, impressionism and realism. Genres include landscapes, florals, southwestern and western works. Prefers: impressionism, realism and expressionism.

Terms: Accepts work on consignment (50% commission). Retail price set by artist. Sometimes offers customer discount and payment by installment. Gallery and artist provide promotion; artist pays for shipping. Prefers artwork framed.

Submissions: Send query letter with bio and photographs. Replies only if interested. Portfolio review not required. Files bios. Finds artists through word of mouth, visiting exhibitions and artists' submissions.

IAC CONTEMPORARY ART/FISHER GALLERY, P.O. Box 11222, Albuquerque NM 87192-0222. (505)248-0612. E-mail: iac2@iac2.com. Website: http://www.iac2.com/iac2. Broker/Gallery Owner: Michael F. Herrmann. Gallery, art consultancy. Estab. 1992. Represents/exhibits emerging, mid-career and established artists. Exhibited artists include Russ Ball, Michelle Cook, Richard Garriott-Stejskal, Katrina Lasko, Mary Sweet and Francine Tint. Sponsors 6 shows/year. Average display time 3 weeks. Open all year; Wednesday-Saturday, 12:30-6; winter hours Thursday-Saturday, 12:30-5. Gallery located at 1620 Central SE, one block west of University of New Mexico. 100% of space for gallery artists. 80% private collectors, 10% corporate collectors, 10% museums. Overall price range: $250-40,000; most work sold at $800-7,000.

Media: Considers all media. Most frequently exhibits acrylics on canvas.

Style: Exhibits painterly abstraction, postmodern works and surrealism. Genres include figurative work.

Terms: Artwork is accepted on consignment (50% commission). "Fees vary depending on event, market, duration." Retail price set by collaborative agreement with artist. Artist pays shipping costs. Prefers artwork framed.

Submissions: Send query letter with résumé, brochure, business card, slides, photographs, reviews, bio and SASE. Call or write for appointment to show portfolio. Replies in 1 month.

Tips: "I characterize the work we show as Fine Art for the *Non*-McMainstream. We are always interested in seeing new work. We look for a strong body of work and when considering emerging artists we inquire about the artist's willingness to financially commit to their promotion. A website is essential today and it's much easier, at least initially, than slides. When sending slides, don't send a query letter, but always include a SASE (assuming you've checked and think your work will fit the gallery)."

‡**EDITH LAMBERT GALLERY**, 300 Galisteo St., 2nd Floor, Santa Fe NM 87501. (505)984-2783. Fax: (505)983-4494. E-mail: elbuyart@nets.com. Website: http://www.elg.com. Contact: Director. Retail gallery. Estab. 1986. Represents 30 emerging and mid-career artists. Exhibited artists include Karen Yank, Deborah Edwards and Margaret Nes. Sponsors 4 shows/year. Average display time 3 weeks. Open Monday-Saturday, hours vary. Located in "downtown Santa Fe, south of the river. Parking available behind building." 20% of space for special exhibitions. Clientele: 95%

© 1997 Richard Garriott-Stejskal

Following a trip to the National Museum in Washington, D.C., sculptor Richard Garriott-Stejskal created this coil-built piece, *To a Man's Heart I*, which is one of a series. A personal connection brought Garriot-Stejskal to exhibit his work at the IAC Contemporary Art/Fischer Gallery in Albuquerque—both the artist and gallery director are involved with the Albuquerque Art Business Association. To nuture interest in his work, Garriott-Stejskal advertises his work in regional magazines and sends out promotional mailings for exhibits.

private collectors. Overall price range: $100-4,500; most artwork sold at $500-2,600.

Media: Considers oil, acrylic, watercolor, pastel, mixed media, collage, works on paper, ceramic, mixed metal sculpture. Most frequently exhibits pastel, oil and mixed metal sculpture.

Style: Exhibits expressionism, neo-expressionism and painterly abstraction. Genres include landscapes, southwestern and figurative work. No portraits or "animal" paintings.

Terms: Accepts work on consignment (50% commission). Exclusive area representation required. Retail price set by gallery. Sometimes offers customer discounts and payment by installments. Provides insurance, promotion and contract; shipping costs are shared. Prefers framed artwork.

Submissions: Send query letter with résumé, 1 full sheet of slides, bio, SASE and reviews. Call for an appointment to show portfolio, which should include originals and slides. Replies only if interested within 1 month. Finds artists through visiting exhibitions, word of mouth, various art publications and sourcebooks, artists' submissions and art collectors' referrals.

Tips: Looks for "consistency, continuity in the work; artists with ability to interact well with collectors and have a commitment to their career."

‡THE LEWALLEN CONTEMPORARY GALLERY, 129 W. Palace Ave., Santa Fe NM 87501. (505)988-8997. Fax: (505)989-8702. Assistant Director: Craig Leibelt. Retail gallery. Represents 75 emerging, mid-career and established artists/year. Exhibited artists include Tom Palmore, John Fincher. Sponsors 7 shows/year. Average display time 3-4 weeks. Open all year; Monday-Saturday, 9:30-5:30; Sunday 12-5:30 (summer); Tuesday-Saturday, 9:30-5; (winter). Located downtown; 10,000 sq. ft.; varied gallery spaces; upstairs barrel-vaulted ceiling with hardwood floors. 25-30% of space for special exhibitions; 75-70% of space for gallery artists. Clientele: "broad range—from established well-known collectors to those who are just starting." 95% private collectors, 5% corporate collectors. Overall price range: $650-350,000; most work sold at $1,500-15,000.

Media: Considers oil, acrylic, mixed media, sculpture and installation, lithograph and serigraphs. Most frequently exhibits oil, mixed media and acrylic/sculpture.

Style: Exhibits surrealism, minimalism, postmodern works, photorealism, hard-edge geometric abstraction and realism. Genres include landscapes, southwestern and western. Prefers realism/photorealism, postmodern works and minimalism.

Terms: Accepts work on consignment (50% commission). Retail price set by the gallery and the artist. Gallery provides insurance, promotion, contract and shipping costs from gallery; artist pays shipping costs to gallery. Prefers artwork framed.

Submissions: Prefers only "artists from the western United States but we consider all artists." Send query letter with résumé, slides or photographs, reviews and bio. "Artist must include self-addressed, stamped envelope if they want materials returned." Call for appointment to show portfolio of originals, photographs, slides or transparencies. Replies in 2 months. Finds artists through visiting exhibitions, various art magazines and art books, word of mouth, other artists and submissions.

MAYANS GALLERIES, LTD., 601 Canyon Rd., Santa Fe NM 87501; also at Box 1884, Santa Fe NM 87504. (505)983-8068. Fax: (505)982-1999. E-mail: arte2@aol.com. Website: http://www.artnet.com/mayans.html. Contact: Ava Hu. Retail gallery and art consultancy. Estab. 1977. Represents 10 emerging, mid-career and established artists. Sponsors 2 solo and 2 group shows/year. Average display time 1 month. Clientele: 70% private collectors, 30% corporate clients. Overall price range: $350 and up; most work sold at $500-7,500.

Media: Considers oil, acrylic, watercolor, pastel, pen & ink, drawings, mixed media, sculpture, photography and original handpulled prints. Most frequently exhibits oil, photography, and lithographs.

Style: Exhibits 20th century American and Latin American art. Genres include landscapes and figurative work. Interested in work "that takes risks and is from the soul."

Terms: Accepts work on consignment. Retail price set by gallery and artist. Exclusive area representation required. Shipping costs are shared.

Submissions: Send query letter (or e-mail first), résumé, business card and SASE. Discourages the use of slides. Prefers 2 or 3 snapshots or color photocopies which are representative of body of work. Files résumé and business card.

Tips: "Currently seeking contemporary figurative work and still life with strong color and technique. Gallery space can accomodate small-scale work comfortably."

‡THE MUNSON GALLERY, 225 Canyon Rd., Santa Fe NM 87501. (505)983-1657. Fax: (505)988-9867. E-mail: art@munsongallery.com. Website: http://www.munsongallery.com. Retail gallery. Estab. 1860. Represents 30 emerging, mid-career and established artists/year. Exhibited artists include Elmer Schooley. Sponsors 10 shows/year. Average display time 2 weeks. Open all year; everyday, 10-5. Features several rooms that vary in size, wall height; all adobe construction, brick floors, etc. 100% of space for gallery artists. Clientele: upscale locals and tourists. 95% private collectors, 5% corporate collectors. Overall price range: $200-45,000, most work sold at $3,000-5,000.

Media: Considers oil, acrylic, watercolor, pastel, mixed media, sculpture, ceramics. Considers all types of prints. Most frequently exhibits paintings, works on paper, mixed media.

Style: Exhibits expressionism, minimalism, color field, impressionism, photorealism, realism. Genres include florals, wildlife, southwestern, landscapes, figurative work. Prefers: painterly realism, expressionism, realism.

Terms: Accepts work on consignment (50% commission). Retail price set by the gallery and the artist. Gallery provides insurance and promotion; shipping costs are shared.

Submissions: Send query letter with bio, 6-8 current slides, photographs, SASE. Call or write for appointment to show

portfolio of photographs. Replies in 2 weeks. Files bios occasionally, announcements.

Tips: "Familiarize yourself with the gallery. Do not send materials blindly as they may be inappropriate, thus tying up slides and wasting the gallery's time. Do not say that another gallery said we should show your work. Send current, relevant slides or photographs of work. You should create at least 12 closely related pieces (though the size and even medium can vary) before approaching galleries."

‡**NEW DIRECTIONS GALLERY**, 107-B N. Plaza, Taos NM 87571. Phone/fax: (505)758-2771. Director: Cecelia Torres. Assistant Director: Ann Emory. Retail gallery. Estab. 1988. Represents/exhibits 12 emerging, mid-career and established artists. Interested in seeing work of emerging artists. Exhibited artists include Maye Torres and Larry Bell. Sponsors 1-3 shows/year. Average display time 1 month. Open all year; Monday-Sunday, 10-5. Located in North Plaza; 1,100 sq. ft.. 25-33⅓% of space for special exhibitions; 66-75% of space for gallery artists. 100% private collectors. Overall price range: $150-32,000; most work sold at $900-12,000.

Media: Considers all media except craft. Considers woodcut, etching, lithograph, serigraphs and posters. Most frequently exhibits mixed media/collage, acrylic or oil on canvas, sculpture-bronze.

Style: Exhibits expressionism, conceptualism, minimalism, hard-edge geometric abstraction, painterly abstraction and postmodern works. Prefers: non-objective, highly stylized and expressive.

Terms: Artwork is accepted on consignment (40% commission). Retail price set by the artist. Gallery and artist split promotion. Prefers artwork framed.

Submissions: Accepts only artists from Taos. Call or come in to gallery for appointment to show portfolio of photographs. Replies in weeks. Files only "material I'm seriously considering."

Tips: "I'm always looking."

‡**NEW MILLENIUM ART/THE FOX GALLERY**, 217 W. Water, Santa Fe NM 87501. (505)983-2002. Owner: S.W. Fox. Retail gallery. Estab. 1980. Represents 12 mid-career artists. Exhibited artists include R.C. Gorman and T.C. Cannon. Sponsors 4 shows/year. Average display time 1 month. Open all year. Located 3 blocks from plaza; 3,000 sq. ft.; "one large room with 19′ ceilings." 20% of space for special exhibitions. Clientele: "urban collectors interested in Indian art." 90% private collectors; 10% corporate collectors.

Media: Considers oil, acrylic, watercolor, pastel, mixed media, sculpture, original handpulled prints, offset reproductions, woodcuts, lithographs, serigraphs and posters. Most frequently exhibits acrylic, woodblock prints and posters.

Style: Exhibits expressionism and impressionism. Genres include Southwestern.

Terms: Accepts artwork on consignment (40% commission). Retail price set by the gallery. Gallery provides insurance and promotion. Shipping costs are shared. Prefers artwork framed.

Submissions: Accepts only Native American artists from the Southwest. Send query letter with résumé, brochure, photographs and reviews. Write for appointment to show a portfolio of photographs. Replies in 2 weeks.

Tips: "We are only interested in art by American Indians; occasionally we take on a new landscapist."

✔**ROSWELL MUSEUM AND ART CENTER**, 100 W. 11th St., Roswell NM 88201. (505)624-6744. Fax: (505)624-6765. Director: Laurie J. Rufe. Museum. Estab. 1937. Represents emerging, mid-career and established southwestern artists. Sponsors 12-14 shows/year. Average display time 2 months. Open all year; Monday-Saturday, 9-5; Sunday and holidays, 1-5. Closed Thanksgiving, Christmas and New Year's Day. Located downtown; 40,000 sq. ft.; specializes in Southwest. 50% of space for special exhibitions; 50% of space for gallery artists.

Media: Considers all media and all types of prints but posters. Most frequently exhibits painting, prints and sculpture.

Style: Exhibits all styles. Prefers: southwestern but some non-SW for context.

Terms: Accepts work on consignment (20% commission). Retail price set by the artist. Gallery provides insurance, promotion and shipping costs to and from gallery. Prefers artwork framed.

Submissions: Accepts only artists from southwest or SW genre. Send query letter with résumé, slides, bio, brochure, photographs, SASE and reviews. Write for appointment to show portfolio of photographs, slides and transparencies. Replies in 1 week. Files "all material not required to return."

Tips: Looks for "southwest artists or artists consistently working in southwest genre." Advises artists to "make an appointment well in advance. Be on time. Be prepared. Don't bring a truckload of paintings or sculpture. Have copies of résumé and transparencies for filing. Be patient. We're presently scheduling shows two years in advance."

‡**SHIDONI GALLERIES**, P.O. Box 250, Tesuque NM 87574. (505)988-8001. Fax: (505)984-8115. Owner: T.C. Hicks. Retail galleries, art consultancy and sculpture garden. Estab. 1971. Clientele: 80% private collectors, 20% corporate clients. Represents 100 emerging, mid-career and established artists. Exhibited artists include Bill Weaver and Frank Morbillo. "Located 5 miles north of Santa Fe; 5,000 sq. ft.; sculpture gardens are 8½ acres."Open all year; Monday-Saturday, 9-5 (winter); Monday-Sunday (summer). Overall price range: $400-150,000; most artwork sold at $1,800-15,000.

Media: Considers all media primarily indoor and outdoor sculpture. Most frequently exhibits cast bronze, fabricated sculpture.

Style: Exhibits all styles. Genres include wildlife and figurative work. "The ideal artwork is new, exciting, original, unpretentious and honest. We seek artists who are totally devoted to art, who display a deep passion for the process of making art and who are driven by a personal and spiritual need to satisfy an inventive mind." Interested in seeing a full range of artworks. Sculpture: varies from classical-traditional to figurative and contemporary.

Terms: Accepts work on consignment (45% on 3-dimensional work). Retail price is set by artist. Exclusive area

representation required. Gallery provides insurance, promotion and contract; artist pays for shipping.
Submissions: Send query letter, résumé, slides, bio, photographs and SASE. Call to schedule an appointment to show a portfolio, which should include slides and transparencies, résumé, catalogs, clippings, dimensions and prices. Slides and résumés are filed in registry. "Please indicate your interest in leaving your slides and résumé in the registry." The most common mistakes artists make in presenting their work is failing to show up for an appointment, having inadequate or poor slides and apologizing for their work. Replies only if interested in 6 weeks.
Tips: Looks for "continuity, focus for subject matter."

UNIVERSITY ART GALLERY, NEW MEXICO STATE UNIVERSITY, Williams Hall, Box 30001, MSG 3572, University Ave. E. of Solano, Las Cruces NM 88003-8001. (505)646-2545. E-mail: artglry@nmsu.edu. Director: Charles Lovell. Estab. 1972. Represents emerging, mid-career and established artists. Exhibited artists include Liliana Porter, Celia Muñoz, Gregory Amenoff and Eric Avery. Sponsors 8 shows/year. Average display time 6-8 weeks. Open all year. Located at university; 4,600 sq. ft. 100% of space for special exhibitions.
Media: Considers all media and all types of prints.
Style: Exhibits all styles and genres.
Terms: Shipping costs are paid by the gallery. Prefers artwork framed, or ready to hang.
Submissions: Send query letter with résumé, 20 slides, bio, SASE, brochure, photographs, business card and reviews. Write for appointment to show portfolio of originals, photographs, transparencies and slides. Replies in 2 months. Files résumés.
Tips: "Tenacity is a must."

New York

⭰**ADIRONDACK LAKES CENTER FOR THE ARTS**, Route 28, Blue Mountain Lake NY 12812. (518)352-7715. E-mail: alca@netheaven.com. Director: Ellen C. Bütz. Nonprofit gallery in multi-arts center. Estab. 1967. Represents 107 emerging, mid-career and established artists/year. Sponsors 6-8 summer shows/year. Average display time 1 month. Exhibits Memorial Day-Columbus Day, 10-4. Located on Main Street next to Post Office; 176 sq. ft.; "pedestals and walls are white, some wood and very versatile." Clientele: tourists, summer owners and year-round residents. 90% private collectors, 10% corporate collectors. Overall price range: $100-10,000; most work sold at $100-1,000.
Media: Considers all media and all types of prints. Most frequently exhibits paintings, sculpture, wood and fiber arts.
Style: Exhibits all styles. Genres include landscapes, Americana, wildlife and portraits. Prefers landscapes, wildlife and folk art/crafts (quilts).
Terms: Accepts work on consignment (30% commission). Retail price set by the artist. Gallery provides insurance, contract; shares promotion. Prefers artwork framed.
Submissions: Send query letter with slides or photos and bio. Annual reviews of submissions each February; selections complete by April 1. Files "slides, photos and bios on artists we're interested in." Reviews submissions once/year. Finds artists through word of mouth, art publications and artists' submissions.

ALBANY CENTER GALLERIES, 23 Monroe St., Albany NY 12210. (518)462-4775. Nonprofit gallery. Estab. 1977. Represents/exhibits emerging, mid-career and established artists. May be interested in seeing work of emerging artists in the future. Presents 12 exhibitions of 6 weeks each year. Exhibited artists include Leigh Wen, David Coughtry, Regis Brodie, Harry Orlyk, Martin Benjamin, Sue Rees, David Miller, Robert Cartmell and Benigna Chilla. Selects 12 shows/year. Average display time 6 weeks. Located downtown; 9,000 sq. ft.; "excellent well-lit space." 100% of space for gallery artists. Clientele: tourists, upscale, local community and students. 2% private collectors. Overall price range: $250-5,000; most work sold at $800-1,200.
Media: Considers all media and prints except posters. Most frequently exhibits oil, sculpture and photography.
Style: Exhibits all styles and all genres. Prefers: painterly abstraction, representational, sculpture and ceramics.
Terms: Artwork is accepted on consignment (30% commission). Retail price set by the artist. Gallery provides insurance, promotion, contract, reception and sales. Artist pays for shipping costs. Prefers artwork framed.
Submissions: Accepts only artists from within a 75 mile radius of Albany (the Mohawk-Hudson area). Send query letter with résumé, slides, reviews, bio and SASE. Call for appointment to show portfolio of photographs, slides and transparencies. Replies only if interested within 1 week. Files slides, résumés, etc. Finds artists through visiting exhibitions, submissions.

‡**ANDERSON GALLERY**, Martha Jackson Place, Buffalo NY 14214. (716)834-2579. Fax: (716)834-7789. Retail gallery. Estab. 1953. Exhibits emerging, mid-career and established artists. Exhibited artists include Antoni Tapies, Karel Appel. Presents 8-10 shows/year. Average display time 6 weeks. Open September-July; Thursday-Sunday, 10:30-5:30. Located University Heights; 25,000 sq. ft.; 2 floors, sculpture atrium; award-winning building. 100% of space for special exhibitions. 75% private collectors, 10% corporate collectors, 5% museums. Overall price range: $100-2,000,000.
Media: Considers oil, acrylic, watercolor, pastel, pen & ink, drawing, mixed media, collage, paper, sculpture, ceramics, installation, all types of prints but posters.
Style: Exhibits neo-expressionism, painterly abstraction, surrealism, conceptualism, minimalism, color field, postmodern works, photorealism, pattern painting, hard-edge geometric abstraction, realism and imagism.

Terms: Accepts work on consignment (commission varies). Retail price set by the gallery. Gallery provides insurance, some promotion and simple contract.

Submissions: Send September-February query letter with résumé, slides and SASE. Include 20 slides (1 page) of most current work; 20 slides (1 page) of selected retrospective images. Replies in 3 months.

Tips: "Research gallery and be selective. Visit gallery and meet staff. If these suit, submit slides. Re-submit when new work appears. Have 300 works in a major media and mature style completed over 3-5 years; current production 75 works in minor media (oil), 100 works in major media (on paper), half these numbers of sculpture."

ART DIALOGUE GALLERY, One Linwood Ave., Buffalo NY 14209-2203. (716)885-2251. Director: Donald James Siuta. Retail gallery, art consultancy. Estab. 1985. Represents 550 emerging, mid-career and established artists/year. Exhibited artists include Catherine Burchfield Parker, Alberto Rey, Raymond A Massey. Sponsors 14 shows/year. Average display time 4-6 weeks. Open all year; Tuesday-Friday, 11-5; Saturday, 11-3. Located in downtown Buffalo/Allentown District; 1,200 sq. ft. 80% of space for special exhibitions; 20% of space for gallery artists. Clientele: young professionals and collectors. 60% private collectors, 20% corporate collectors. Overall price range: $100-25,000; most work sold at $300-500.

• The gallery recently added an additional 800 sq. ft. of exhibition space.

Media: Considers oil, acrylic, watercolor, pastel, pen & ink, drawing, mixed media, collage, paper, sculpture, ceramics, glass, photography and all types of prints. Most frequently exhibits oil painting, watercolor and mixed media.

Style: Prefers: realism, abstract and cutting edge.

Terms: Accepts work on consignment (40% commission). Retail price set by the gallery. "Artwork is insured from time of delivery to set pick-up date. Artists pay for promotion-invitations, etc." Artist pays shipping costs. Prefers artwork framed for shows, unframed for stacks.

Submissions: Accepts only artists from western New York, southern Ontario. Send query letter with résumé, full sheet of slides (work that is available only), bio, photographs, SASE, reviews, artist's statement. Call or write for appointment to show portfolio of slides. Files slides and résumés. Finds artists through word of mouth, referrals by artists, visiting art fairs and exhibitions and submissions.

Tips: "Enter as many juried exhibits as you can. Even if an artist can only supply us with one or two works a year, we will show his work as long as it is good. We hope this attitude will encourage more work more often if it sells."

‡ARTFORMS, 5 New Karner Rd., Guilderland NY 12084. (518)464-3355. Fax: (518)464-3358. President: Gary Weitzman and Jan Reiss-Weitzman. Retail gallery and art consultancy featuring fine art and art glass. Estab. 1997. Represents 10-20 emerging, mid-career and established artists. Exhibited artists include Jane Bloodgood-Abrams, Thom O'Connor, John Stockwell and John Burchetta. Open all year. Located 2.5 miles west of the Adirondack Northway. Clientele: in banking, industry and health care. Overall price range: $50-5,000; most work sold at $500-2,000.

Media: Considers oil, acrylic, watercolor, pastel, mixed media, glass, sculpture, ceramic, fiber, original handpulled prints.

Style: Exhibits expressionism, painterly abstraction, minimalism, color field, postmodern works, impressionism, realism. Prefers low edition sizes in multiples.

Terms: Accepts artwork on consignment (40% commission); or buys outright for 50% of retail price (net 30 days). Retail price set by gallery, sometimes with artist's input. Gallery provides insurance and promotion; shipping costs are shared. Prefers artwork unframed.

Submissions: Send query letter with résumé, slides, photographs and bio. Call or write for appointment to show portfolio of originals. Replies in 1-3 months. Files materials of artists represented or previously sold.

Tips: "Try to visit the gallery first to see if we are compatible with you and your work."

✓BURCHFIELD-PENNEY ART CENTER, Buffalo State College Museum, 1300 Elmwood Ave., Buffalo NY 14222. (716)878-6012. Director: Ted Pietrzak. Nonprofit. Estab. 1966. Interested in emerging, mid-career and established artists who have lived in western New York state. Sponsors solo and group shows. Average display time 6-8 weeks. Clientele: urban and suburban adults, college students, corporate clients, all ages in touring groups.

Media: Considers all media, folk, craft and performance art, architecture and design.

Style: Exhibits contemporary, abstract, impressionism, primitivism, non-representational, photorealism, realism, neo-expressionism and post-pop works. Genres include figurative and landscape. "We show both contemporary and historical work by western New York artists, Charles Burchfield and his contemporaries. The museum is not oriented toward sales."

Terms: Accepts work on craft consignment for gallery shop (50% commission). Retail price set by gallery and artist. Exclusive area representation not required. Gallery provides insurance, promotion and contract; shipping costs are shared.

Submissions: Send query letter, résumé, slides and photographs. Files biographical materials about artist, work, slides and photos, etc.

Tips: "Keep us on your mailing list. Send invitations to shows elsewhere. Send new slides periodically. We have annual exhibitions for emerging artists, annual Buffalo State College site specific installations and include newer artists regularly in group shows."

✓CEPA (CENTER FOR EXPLORATORY AND PERCEPTUAL ART), 617 Main St. #201, Buffalo NY 14203. Fax: (716)856-2720. E-mail: cepa@aol.com. Website: http://cepa.buffnet.net. Director/Curator: Robert Hirsch. Alterna-

tive space and nonprofit gallery. Interested in emerging, mid-career and established artists. Sponsors 5 solo and 1 group show/year. Average display time 4-6 weeks. Open fall, winter and spring. Office and underground hours are Monday-Friday, 10-5. Passageway Gallery is open Monday-Sunday 9-9. Clientele: artists, students, photographers and filmmakers. Prefers photographically related work.

Media: Installation, photography, film, mixed media, computer imaging and digital photography.

Style: Contemporary photography. "CEPA provides a context for understanding the aesthetic, cultural and political intersections of photo-related art as it is produced in our diverse society." Interested in seeing "conceptual, installation, documentary and abstract work."

Terms: Accepts work on consignment (25% commission).

Submissions: Call first regarding suitability for this gallery. Send query letter with résumé, 20 numbered slides, SASE, brochure, slides, bio and artist's statement. Call or write for appointment to show portfolio of slides and photographs. Replies in 6 weeks.

Tips: "It is a policy to keep slides and information in our file for indefinite periods. Grant writing procedures require us to project one and two years into the future. Provide a concise and clear statement to give staff an overview of your work."

CHAPMAN ART CENTER GALLERY, Cazenovia College, Cazenovia NY 13035. (315)655-9446. Fax: (315)655-2190. Website: http://www.cazcollege.edu. Director: John Aistars. Nonprofit gallery. Estab. 1978. Interested in emerging, mid-career and established artists. Sponsors 8-9 shows/year. Average display time is 3 weeks. Clientele: the greater Syracuse community. Overall price range: $50-3,000; most artwork sold at $100-200.

Media: Considers oil, acrylic, watercolor, pastel, pen & ink, drawings, sculpture, ceramic, fiber, photography, craft, mixed media, collage, glass and prints.

Style: Exhibits all styles. "Exhibitions are scheduled for a whole academic year at once. The selection of artists is made by a committee of the art faculty in early spring. The criteria in the selection process is to schedule a variety of exhibitions every year to represent different media and different stylistic approaches; other than that, our primary concern is quality. Artists are to submit to the committee by March 1 a set of slides or photographs and a résumé listing exhibitions and other professional activity."

Terms: Retail price set by artist. Exclusive area representation not required. Gallery provides insurance and promotion; works are usually not shipped.

Submissions: Send query letter, résumé, 10-12 slides or photographs.

Tips: A common mistake artists make in presenting their work is that the "overall quality is diluted by showing too many pieces. Call or write and we will mail you a statement of our gallery profiles."

‡JAMES COX GALLERY AT WOODSTOCK, 4666 Rt. 212, Willow NY 12495. (914)679-7608. Fax: (914)679-7627. Retail gallery. Estab. 1990. Represents 30 mid-career and established artists. Exhibited artists include Richard Segalman and Mary Anna Goetz. Represents estates of 7 artists including James Chapin, Margery Ryerson and Winold Reiss. Sponsors 5 shows/year. Average display time 1 month. Open all year; Monday-Friday, 10-5. Elegantly restored Dutch barn. 50% of space for special exhibitions. Clientele: New York City and tourists, residents of 50 mile radius. 95% private collectors. Overall price range: $500-50,000; most work sold at $3,000-10,000.

Media: Considers oil, watercolor, pastel, drawing and sculpture. Considers "historic Woodstock, fine prints." Most frequently exhibits oil paintings, watercolors, sculpture.

Style: Exhibits impressionism, realism. Genres include landscapes and figurative work. Prefers: expressive or evocative realism, painterly landscapes and stylized figurative sculpture.

Terms: Accepts work on consignment (40% commission). Retail price set by the artist. Gallery provides promotion; artist pays shipping costs to and from gallery. Prefers artwork framed.

Submissions: Prefers only artists from New York region. Send query letter with résumé, slides, bio, brochure, photographs, SASE and business card. Replies in 3 months. Files material on artists for special, theme or group shows.

Tips: "Be sure to enclose SASE—be patient for response. Include information on present pricing structure."

GIL'S BOOK LOFT AND GALLERY, 82 Court St., 2nd Floor, Binghamton NY 13901. (607)771-6800. E-mail: bookloft@spectra.net. Owner: Gil Williams. Retail gallery. Estab. 1991. Represents 50 emerging, mid-career and established artists/year. Exhibited artists include James Skvarch and Mel Fowler. Sponsors 6 shows/year. Average display time 2 months. Open all year; Monday-Friday, 10:30-5:30; Saturday, 10:30-4. 1,800 sq. ft. "We create a living room atmosphere with new and old pottery, art and books." 10% of space for special exhibitions; 10% of space for gallery artists. Clientele: upscale, tourists. 100% private collectors. Overall price range: $25-2,500; most work sold at $50-200.

Media: Considers oil, watercolor, pastel, pen & ink, drawing, ceramics, photography, woodcuts, engravings, lithographs, wood engravings, mezzotints, serigraphs, linocuts, etchings; "Must be artist-made prints—no photo prints, offset or photocopy." Most frequently exhibits etchings, oils, drawings (pencil or pastel).

Style: Exhibits impressionism, photorealism, realism. Genres include florals, portraits, landscapes, Americana, figurative work. Prefers: American realism, American impressionists.

Terms: Buys outright for 50% of retail price (net 90 days). Retail price set by the gallery with the artist's help. Gallery provides promotion; artist pays for shipping costs to gallery. Prefers artwork unframed.

Submissions: Accepts only artists from PA, NY and New England. Send query letter with résumé, 6 slides, bio, SASE, business card, reviews. Call or write for appointment to show portfolio. Replies in 2 weeks. Files almost all material. Finds artists through exhibitions, print clubs, *American Artist* profiles.

Tips: "Be honest and upfront! Direct communication. Having been an artist and holding degrees in art history, I can spot talent quickly. I trust my eye, whether the artist is still in school or has been doing his trade for 20 or 30 years!"

THE GRAPHIC EYE GALLERY OF LONG ISLAND, 301 Main St., Port Washington NY 11050. (516)883-9668. President: Hannah Ritter. Cooperative gallery. Estab. 1974. Represents 25 artists. Sponsors solo, 2-3 person and 4 group shows/year. Average display time: 1 month. Interested in emerging and established artists. Overall price range: $35-7,500; most artwork sold at $500-800.
Media: Considers mixed media, collage, works on paper, pastels, photography, paint on paper, woodcuts, wood engravings, linocuts, engravings, mezzotints, etchings, lithographs, serigraphs, and monoprints.
Style: Exhibits impressionism, expressionism, realism, primitivism and painterly abstraction. Considers all genres.
Terms: Co-op membership fee plus donation of time. Retail price set by artist. Offers payment by installments. Exclusive area representation not required. Prefers framed artwork.
Submissions: Send query letter with résumé, SASE, slides and bio. Portfolio should include originals and slides. "When submitting a portfolio, the artist should have a body of work, not a 'little of this, little of that.'" Files historical material. Finds artists through visiting exhibitions, word of mouth, artist's submissions and self-promotions.
Tips: "Artists must produce their *own* work and be actively involved. We have a competitive juried art exhibit annually. Open to all artists who work on paper."

‡GUILD HALL MUSEUM, 158 Main St., East Hampton NY 11937. (516)324-0806. Fax: (516)324-2722. Curator: Lisa Panzera. Assistant Curator: Heather Dimon. Museum. Estab. 1931. Represents emerging, mid-career and established artists. Sponsors 6-10 shows/year. Average display time 6-8 weeks. Open all year; Wednesday-Sunday, 11-5. 500 running feet; features artists who live and work on eastern Long Island. 85% of space for special exhibitions.
Media: Considers all media and all types of prints. Most frequently exhibits painting, prints and sculpture.
Style: Exhibits all styles, all genres.
Terms: Artwork is donated or purchased. Gallery provides insurance and promotion. Prefers artwork framed.
Submissions: Accepts only artists from eastern Long Island. Send query letter with résumé, slides, bio, brochure, SASE and reviews. Write for appointment to show portfolio of originals and slides. Replies in 2 months.

KIRKLAND ART CENTER, East Park Row, P.O. Box 213 Clinton NY 13323-0213. (315)853-8871. E-mail: kac@borg.com. Contact: Director. Nonprofit gallery. Estab. 1960. Interested in emerging, mid-career and established artists. Sponsors 4 solo and 6 group shows/year. Average display time is 1 month. Clientele: general public and art lovers; 99% private collectors, 1% corporate clients. Overall price range: $60-4,000; most artwork sold at $200-1,200.
Media: Considers oil, acrylic, watercolor, pastel, pen & ink, drawings, mixed media, collage, works on paper, sculpture, ceramic, craft, fiber, glass, installation, photography, performance art and original handpulled prints. Most frequently exhibits watercolor, oil/acrylic, prints, sculpture, drawings, photography and fine crafts.
Style: Exhibits painterly abstraction, conceptualism, impressionism, photorealism, expressionism, realism and surrealism. Genres include landscapes, florals and figurative work.
Terms: Accepts work on consignment (25% commission). Retail price set by artist. Exclusive area representation not required. Gallery provides insurance, promotion and contract; artist pays for shipping.
Submissions: Send query letter, résumé, slides, slide list and SASE.
Tips: "Shows are getting very competitive—artists should send us slides of their most challenging work, not just what is most saleable. We are looking for artists who take risks in their work and display a high degree of both skill and imagination. It is best to call or write for instructions and more information."

⊭LEATHERSTOCKING GALLERY, 52 Pioneer St., P.O. Box 446, Cooperstown NY 13326. (607)547-5942. (Gallery) (607)547-8044 (Publicity). Publicity: Dorothy V. Smith. Retail nonprofit cooperative gallery. Estab. 1968. Represents emerging, mid-career and established artists. 45 members. Sponsors 1 show/year. Average display time 3 months. Open in the summer (mid-June to Labor Day); daily 11-5. Located downtown Cooperstown; 300-400 sq. ft. 100% of space for gallery artists. Clientele: varied locals and tourists. 100% private collectors. Overall price range: $25-500; most work sold at $25-100.
Media: Considers oil, acrylic, watercolor, pastel, pen & ink, drawing, mixed media, collage, paper, sculpture, ceramics, craft, photography, handmade jewelry, woodcuts, engravings, lithographs, wood engravings, mezzotints, serigraphs, linocuts and etchings. Most frequently exhibits watercolor, oil and crafts.
Style: Exhibits impressionism and realism, all genres. Prefers landscapes, florals and American decorative.
Terms: Co-op membership fee, a donation of time plus 10% commission. Retail price set by the artist. Gallery provides insurance, promotion and contract; artist pays shipping costs from gallery if sent to buyer. Prefers artwork framed.
Submissions: Accepts only artists from Otsego County; over 18 years of age; member of Leatherstocking Brush & Palette Club. Replies in 2 weeks. Finds artists through word of mouth locally; articles in local newspaper.
Tips: "We are basically non-judgmental (unjuried). You just have to live in the area!"

⊭OXFORD GALLERY, 267 Oxford St., Rochester NY 14607. (716)271-5885. Fax: (716)271-2570. Director: Lisa Pietrangeli. Retail gallery. Estab. 1961. Represents 80 emerging, mid-career and established artists. Sponsors 10 shows/year. Average display time 1 month. Open all year; Tuesday-Friday, 12-5; Saturday, 10-5; and by appointment. Located "on the edge of downtown; 1,000 sq. ft.; large gallery in a beautiful 1910 building." Overall price range: $100-30,000; most work sold at $1,000-2,000.

Media: Considers oil, acrylic, watercolor, pastel, pen & ink, drawings, mixed media, collage, paper, sculpture, ceramic, fiber, original handpulled prints, woodcuts, engravings, lithographs, wood engravings, mezzotints, serigraphs, linocuts and etchings.

Styles: All styles.

Terms: Accepts artwork on consignment (50% commission). Retail price set by gallery and artist. Gallery provides promotion and contract.

Submissions: Send query letter with résumé, slides, bio and SASE. Replics in 2-3 months. Files résumés, bios and brochures.

Tips: "Have professional slides done of your artwork. Have a professional résumé and portfolio. Do not show up unannounced and expect to show your slides. Either send in your information or call to make an appointment. An artist should have enough work to have a one-man show (20-30 pieces). This allows an artist to be able to supply more than one gallery at a time, if necessary. It is important to maintain a strong body of available work."

PRAKAPAS GALLERY, 1 Northgate 6B, Bronxville NY 10708. (914)961-5091 or (914)961-5192. Private dealers. Estab. 1976. Represents 50-100 established artists/year. Exhibited artists include Leger and El Lissitsky. Located in suburbs. Clientele: institutions and private collectors. Overall price range: $500-500,000.

Media: Considers all media with special emphasis on photography.

Style: Exhibits all styles. "Emphasis is on classical modernism."

Submissions: Finds artists through word of mouth, referrals by other artists, visiting art fairs and exhibitions.

PRINT CLUB OF ALBANY, 140 N. Pearl St., P.O. Box 6578, Albany NY 12206. (518)432-9514. President: Dr. Charles Semowich. Nonprofit gallery and museum. Estab. 1933. Exhibits the work of 70 emerging, mid-career and established artists. Sponsors 1 show/year. Average display time 6 weeks. Located in downtown arts district. "We currently have a small space and hold exhibitions in other locations." Clientele: varies. 90% private collectors, 10% corporate collectors.

Media: Considers original handpulled prints.

Style: Exhibits all styles and genres. "No reproductions."

Terms: Accepts work on consignment from members. Membership is open internationally. "We welcome donations (of artists' works) to the permanent collection." Retail price set by artist. Customer discounts and payment by installment are available. Gallery provides promotion. Artist pays for shipping. Prefers artwork framed.

Submissions: Prefers prints. Send query. Write for appointment to show portfolio of slides. Replies in 1 week.

Tips: "We are a nonprofit organization of artists, collectors and others. Artist members exhibit without jury. We hold member shows and the Triannual National Open Competitive Exhibitions. We commission an artist for an annual print each year. Our shows are held in various locations. We are planning a museum (The Museum of Prints and Printmaking) and building. We also collect artists' papers, etc. for our library."

PYRAMID ARTS CENTER, 302 N. Goodman St., Rochester NY 14607. (716)461-2222. Fax: (716)461-2223. Director: Elizabeth McDade. Nonprofit gallery. Estab. 1977. Exhibits 200 emerging, mid-career and established artists/year. 400 members. Sponsors 20 shows/year. Average display time 2-6 weeks. Open 11 months. Business hours Wednesday-Friday, 10-5; gallery hours, Thursday-Sunday 12-5. Located in museum district of Rochester; 1,500 sq. ft.; features 3 gallery spaces. 80% of space for special exhibitions. Clientele: artists, curators, collectors, dealers. 90% private collectors, 10% corporate collectors. Overall price range: $25-15,000; most work sold at $40-500.

● Gallery strives to create a forum for challenging, innovative ideas and works.

Media: Considers all media, video, film, dance, music, performance art, computer media; all types of prints including computer, photo lithography.

Style: Exhibits all styles, all genres.

Terms: During exhibition a 25% commission is taken on sold works. Retail price set by the artist. Gallery provides insurance, promotion and contract; shipping costs are shared, "depending upon exhibition, funding and contract." Prefers artwork framed.

Submissions: Includes regional national artists and alike in thematic solo/duo exhibitions. Send query letter with résumé and slides. Call for appointment to show portfolio of originals and slides. "We have a permanent artist archive for slides, bios, résumés and will keep slides in file if artist requests." Finds artists through national and local calls for work, portfolio reviews and studio visits.

Tips: "Present slides that clearly and accurately reflect your work. Label slides with name, title, medium and dimensions. Be sure to clarify intent and artistic endeavor. Proposals should simply state the artist's work. Documentation should be accompanied by clear, concise script."

ROCKLAND CENTER FOR THE ARTS, 27 S. Greenbush Rd., West Nyack NY 10994. (914)358-0877. Fax: (914)358-0971. Website: http://www.rocklandartcenter.org. Executive Director: Julianne Ramos. Nonprofit gallery. Estab. 1972. Exhibits emerging, mid-career and established artists. 1,500 members. Sponsors 6 shows/year. Average display time 5 weeks. Open September-May. Located in suburban area; 2,000 sq. ft.; "contemporary space." 100% of space for special exhibitions. Clientele: 100% private collectors. Overall price range: $500-50,000; most artwork sold at $1,000-5,000.

Media: Considers oil, acrylic, watercolor, pastel, pen & ink, mixed media, sculpture, ceramic, fiber, glass and installation. Most frequently exhibits painting, sculpture and craft.

Style: Exhibits all styles and genres.
Terms: Accepts work on consignment (33% commission). Retail price set by artist. Gallery provides insurance, promotion and shipping costs to and from gallery. Prefers artwork framed.
Submissions: "Proposals accepted from curators only. No one-person shows. Artists should not apply directly." Replies in 2 months.
Tips: "Artist may propose a curated show of three or more artists: curator may not exhibit. Request curatorial guidelines. Unfortunately for artists, the trend is toward very high commissions in commercial galleries. Nonprofits like us will continue to hold the line."

‡THE SCHOOLHOUSE GALLERIES, Owens Rd., Croton Falls NY 10519. (914)277-3461. Fax: (914)277-2269. Director: Lee Pope. Retail gallery. Estab. 1979. Represents 30 emerging and mid-career artists/year. Exhibited artists include Joseph Keiffer and Allen Whiting. Average display time 1 month. Open all year; Wednesday-Sunday, 1-5. Located in a suburban community of New York City; 1,200 sq. ft.; 70% of space for special exhibitions; 30% of space for gallery artists. Clientele: residential, corporate, consultants. 50% private collectors, 50% corporate collectors. Overall price range: $75-6,000; most work sold at $350-2,000.
Media: Considers oil, acrylic, watercolor, pastel, pen & ink, drawing, mixed media, collage, paper, sculpture, ceramics, fiber and photography, all types of prints. Most frequently exhibits paintings, prints and sculpture.
Style: Exhibits expressionism, painterly abstraction, impressionism and realism. Genres include landscapes. Prefers: impressionism and painterly abstraction.
Terms: Accepts work on consignment (40% commission). Retail price set by the artist. Gallery provides insurance and promotion; shipping costs are shared. Prefers artwork on paper, unframed.
Submissions: Send query letter with slides, photographs and SASE. We will call for appointment to view portfolio of originals. Replies in 2 months. Files slides, bios if interested. Finds artists through visiting exhibitions and referrals.

‡SCHWEINFURTH MEMORIAL ART CENTER, 205 Genesee St., Auburn NY 13021. (315)255-1553. Director: David Kwasigroh. Museum. Estab. 1981. Represents emerging, mid-career and established artists. Sponsors 15 shows/year. Average display time 2 months. Closed in January. Located on the outskirts of downtown; 7,000 sq. ft.; large open space with natural and artificial light.
 ● Schweinfurth has an AA Gift Shop featuring handmade arts and crafts, all media, for which they're looking for work.
Media: Considers all media, all types of prints.
Style: Exhibits all styles and all genres.
Terms: Retail price set by the artist. Gallery provides insurance and promotion; artist pays for shipping costs. Artwork must be framed and ready to hang.
Submissions: Accepts artists from central New York. Send query letter with résumé, slides and SASE.

‡SOUNDVIEW ART GALLERY LTD., 35 Chandler Square, Port Jefferson NY 11777. (516)473-9544. Fax: (516)254-3895. Gallery Director: Maria Cassady. Retail/rental gallery. Estab. 1975. Represents 10-20 emerging, mid-career and established artists. Exhibited artists include Diane Romanello and Ken Keeley. Sponsors 9 shows/year. Average display time 6 weeks. Open all year. Located in resort area on water; 2,000 sq. ft. 50% of space for special exhibitions; 50 of space for gallery artists. Clientele: 80% private collectors, 20% corporate collectors. Overall price range: $250-30,000; most work sold at $800-2,500.
Media: Considers oil, acrylic, watercolor, mixed media, sculpture, fiber, mezzotints and serigraphs. Most frequently exhibits oil, watercolor and acrylic.
Style: Exhibits impressionism, photorealism and realism. All genres.
Terms: Accepts work on consignment (50% commission). Rental fee for space. Rental fee covers 1 year. Gallery provides promotion; artist pays for shipping.
Submissions: Prefers exclusive representation. Send query letter with résumé, bio, brochures, photographs and SASE. Write for appointment to show portfolio of originals and photographs. Replies only if interested within 1 month.
Tips: "We would like to see a consistent professional level of work. No amateurish efforts or mixture of styles. The public is more aware of quality and is looking for very good value."

‡BJ SPOKE GALLERY, 299 Main St., Huntington NY 11743. (516)549-5106. President: Constance Wain-Schwartz. Cooperative and nonprofit gallery. Estab. 1978. Exhibits the work of 24 emerging, mid-career and established artists. Sponsors 2-3 invitationals and juried shows/year. Average display time 1 month. Open all year. "Located in center of town; 1,400 sq. ft.; flexible use of space—3 separate gallery spaces." Generally, 66% of space for special exhibitions. Overall price range: $300-2,500; most work sold at $900-1,600. Artist is eligible for a 2-person show every 18 months. Entire membership has ability to exhibit work 11 months of the year.
 ● Sponsors annual national juried show. Deadline December. Send SASE for prospectives.
Media: Considers all media except crafts, all types of printmaking. Most frequently exhibits paintings, prints and

sculpture.

Style: Exhibits all styles and genres. Prefers painterly abstraction, realism and expressionism.

Terms: Co-op membership fee plus donation of time (25% commission). Monthly fee covers rent, other gallery expenses. Retail price set by artist. Payment by installment is available. Gallery provides promotion and publicity; artists pay for shipping. Prefers artwork framed; large format artwork can be tacked.

Submissions: For membership, send query letter with résumé, high-quality slides, bio, SASE and reviews. For national juried show send SASE for prospectus and deadline. Call or write for appointment to show portfolio of originals and slides. Files résumés; may retain slides for awhile if needed for upcoming exhibition.

Tips: "Send slides that represent depth and breadth in the exploration of a theme, subject or concept. They should represent a cohesive body of work."

New York City

A.I.R. GALLERY, 40 Wooster St., Floor 2, New York NY 10013-2229. (212)966-0799. Website: http://www.airnyc.org. Director: Alissa Schoenfeld. Cooperative nonprofit gallery, alternative space to advance the status of women artists and provide a sense of community. Estab. 1972. Represents/exhibits emerging, mid-career and established women artists. 20 New York City members; 15 National Affiliates. Sponsors 15 shows/year. Average display time 3 weeks. Open all year except late summer; Tuesday-Saturday, 11-6. Located in Soho; 1,600 sq. ft., 11'8" ceiling; the end of the gallery which faces the street is entirely windows. 20% of space for special exhibitions; 80% of space for gallery artists. Clientele: art world professionals, students, artists, local community, tourists. Overall price: $500-15,000; most work sold at $1,000-5,000.

- A.I.R. has both New York City members and members across the United States. They show emerging artists in their Gallery II program which is open to all artists interested in a one-time exhibition. Please specify whether you are applying for membership, Gallery II or both.

Media: Considers all media and all types of prints.

Style: Exhibits all styles and all genres.

Terms: 15% commission. Retail price set by the artist. Gallery provides limited promotion (i.e., Gallery Guide listing). Artist pays for shipping costs. Prefers artwork framed.

Submissions: Membership and exhibitions are open to women artists. Send query letter with résumé, 10-20 slides and SASE. Replies in 2 months. Files no material unless an artist is put on the waiting list for membership. Finds artists through word of mouth, referrals by other artists, suggestions by past and current members.

Tips: "Look at a lot of art. Develop a relationship with a potential gallery by engaging in the work they show. Know what they like."

ARTISTS SPACE, 38 Greene St., 3rd Floor, New York NY 10013. (212)226-3970. Fax: (212)966-1434. Website: http://www.avsi.com\artistsspace. Curator: Pip Day. Nonprofit gallery, alternative space. Estab. 1973. Exhibits emerging artists. Sponsors 4-5 shows/year. Average display time 6-8 weeks. Open Tuesday-Saturday, 10-6. Located in Soho; 5,000 sq. ft. 100% of space for special exhibitions.

Media: Considers all media.

Terms: "All curated shows selected by invitation." Gallery provides insurance and promotion.

Submissions: Send query letter with 10 slides and SASE and application. Portfolio should include slides.

Tips: "Choose galleries carefully, i.e., look at work represented and decide whether or not it is an appropriate 'stable.' "

‡ASIAN AMERICAN ARTS CENTRE, 26 Bowery, New York NY 10013. (212)233-2154. Fax: (212)766-1287. Executive Director: Robert Lee. Nonprofit gallery. Estab. 1974. Exhibits the work of emerging and mid-career artists; 600 artists in archives file. Sponsors 4 shows/year. Average display time 4-6 weeks. Open September through June. Located in Chinatown; 1,800 sq. ft.; "a gallery and a research facility." 100% of space for special exhibitions. Overall price range: $500-10,000; most work sold at $500-3,000.

Media: Considers all media and all types of prints. Prefers paintings, installation and mixed media.

Style: Exhibits all styles and genres.

Terms: Suggests a donation of 20% of the selling price. Retail price set by the artist. Gallery provides insurance and promotion. Shipping costs are shared. Prefers artwork framed.

Submissions: Send query letter with résumé and slides. Will call artists if interested. Portfolio should include slides. Replies only if interested within 6-8 weeks. Files slides.

BLUE MOUNTAIN GALLERY, 121 Wooster St., New York NY 10012. (212)941-9753. Director: Morgan Taylor. Artist-run cooperative gallery. Estab. 1980. Exhibits 27 mid-career artists. Sponsors 13 solo and 1 group shows/year. Display time is 3 weeks. "We are located on the second floor of a loft building in Soho. We share our floor with two other well-established cooperative galleries. Each space has white partitioning walls and an individual floor-plan." Clientele: art lovers, collectors and artists. 90% private collectors, 10% corporate clients. Overall price range: $100-8,000; most work sold at $100-4,000.

Media: Considers painting, drawing and sculpture.

Style: "The base of the gallery is figurative but we show work that shows individuality, commitment and involvement

with the medium."

Terms: Co-op membership fee plus donation of time. Retail price set by artist. Exclusive area representation not required. Gallery provides insurance, some promotion and contract; artist pays for shipping.

Submissions: Send name and address with intent of interest and sheet of 15-20 good slides. "We cannot be responsible for material return without SASE." Finds artists through artists' submissions and referrals.

Tips: "This is a cooperative gallery: it is important to represent artists who can contribute actively to the gallery. We look at artists who can be termed local or in-town more than out-of-town artists and would choose the former over the latter. The work should present a consistent point of view that shows individuality. Expressive use of the medium used is important also."

‡BRIDGEWATER/LUSTBERG GALLERY, 560 Broadway, New York NY 10012-3945. (212)941-6355. Fax: (212)674-7712. Directors: Jamie Lustberg and Paul Bridgewater. Retail gallery. Estab. 1985. Represents 18 emerging and mid-career artists. Exhibited artists include Michelle Harvey and Steven Skollar. Sponsors 10 shows/year. Average display time 5 weeks. Closed August. Located in Soho; 1,700 sq. ft. 33% of space for special exhibitions. Clientele: international. 90% private collectors, 10% corporate collectors. Overall price range: $250-15,000; most work sold at $1,500-5,000.

Media: Considers oil, acrylic, watercolor, pen & ink, sculpture, photography, original handpulled prints, engravings, lithographs and etchings. Most frequently exhibits oil on canvas, sculpture and photography.

Style: Prefers figurative and narrative styles and landscapes.

Terms: Accepts artwork on consignment (50% commission). Retail price set by gallery and artist. Sometimes offers customer discounts and payment by installment. Gallery provides insurance and promotion; artist pays for shipping. Prefers artwork framed.

Submissions: Send slides with SASE. Reports back in 2-8 weeks. Call for dates. Files information applicable to future shows.

Tips: The most common mistake artists make in presenting their work is showing work "too diverse in style, often looking as if it is the work of two or three people."

BROADWAY WINDOWS, New York University, 80 Washington Square E., New York NY 10003. Viewing address: Broadway at E. 10th St. (212)998-5751. Fax: (212)998-5752. Website: http://www.nyu.edu/pages/galleries. Directors: Marilynn Karp and Ruth D. Newman. Nonprofit gallery. Estab. 1984. Interested in emerging and established artists. On view to vehicular and pedestrian traffic 24 hours a day. "We do not formally represent any artists. We are operated by New York University as a nonprofit exhibition space whose sole purpose is to showcase artwork and present it to a new ever-growing art-interested public." Sponsors 9 solo shows/year. Average display time is 5 weeks. Clientele: the metropolitan public.

Media: Considers all media. "We are particularly interested in site-specific installations."

Style: "No thematic restrictions or aesthetic restrictions are applied. We are interested in a tremendous range of style, approach and media."

Terms: Accepts work on consignment (20% commission). Retail price set by artist. Exclusive area representation not required. Gallery provides insurance, promotion and contract; artist pays for shipping.

Submissions: Send query letter, résumé, slides, photographs and SASE. "Proposals are evaluated once annually in response to an ad calling for proposals. Jurors look for proposals that make the best use of the 24-hour space."

Tips: "Often artists do not provide the visual evidence that they could produce the large scale artwork the Windows' physical structure dictates. And, in general, their installation proposals lack details of scale and substance."

‡BRUSHSTROKES FINE ART GALLERY, 4612 13th Ave., Brooklyn NY 11219. (718)972-0682. Fax: (718)972-3642. Director: Sam Pultman. Retail gallery. Estab. 1993. Represents 15 emerging, mid-career and established artists/year. Exhibited artists include Elena Flerova, Itshak Holtz, Anton Rosenberg and Zvi Malnovitzer. Sponsors 2 shows/year. Average display time 1 month. Open all year; Sunday and Monday, 11-6:30; Tuesday by appointment; Wednesday-Thursday, 11-6:30; Friday, 11-1:30; Closed Saturday. 1,100 sq. ft. "We're one of the only sources for fine art Judaica." 100% of space for gallery artists. Clientele: upscale. 100% private collectors. Overall price range: $1,000-75,000; most work sold at $15,000-30,000.

Media: Considers oil, acrylic, watercolor, pastel, pen & ink, drawing. Considers all types of prints. Most frequently exhibits oil, acrylic, pastel.

Style: Exhibits surrealism, impressionism, realism. Genres include florals, portraits, landscapes, Judaic themes. Prefers: realism, impressionism, surrealism.

Terms: Accepts work on consignment. Retail price set by the gallery. Gallery provides promotion; artist pays for shipping costs to gallery. Prefers artwork unframed.

Submissions: "No abstract art please." Send query letter with 10 slides, bio, brochure, photographs. Call for appointment to show portfolio of photographs. Replies only if interested within 1 week. Finds artists through word of mouth, referrals by other artists, submissions.

CITYARTS, INC., 525 Broadway, Suite 700, New York NY 10012. (212)966-0377. Fax: (212)966-0551. Executive Director: Tsipi Ben-Haim. Art consultancy, nonprofit public art organization. Estab. 1968. Represents 500 emerging, mid-career and established artists. Sponsors 4-8 projects/year. Average display time varies. "A mural or public sculpture will last up to 15 years." Open all year; Monday-Friday, 10-5. Located in Soho; "the city is our gallery. CityArts's 200

murals are located in all 5 boroughs on NYC. We are funded by foundations, corporations, government and membership ('Friends of CityArts')."

Media: Considers oil, acrylic, drawing, sculpture, mosaic and installation. Most frequently exhibits murals (acrylic), mosaics and sculpture.

Style: Exhibits all styles and all genres.

Terms: Artist receives a flat commission for producing the mural or public art work. Retail price set by the gallery. Gallery provides insurance, promotion, contract, shipping costs.

Submissions: "We prefer New York artists due to constant needs of a public art work created in the city." Send query letter with SASE. Call for appointment to show portfolio of originals, photographs and slides. Replies in 1 month. "We reply to original query with an artist application. Then it depends on commissions." Files application form, résumé, slides, photos, reviews. Finds artists through recommendations from other art professionals.

Tips: "We look for artists who are dedicated to making a difference in people's lives through art."

‡AMOS ENO GALLERY, 594 Broadway, Suite 404, New York NY 10012. (212)226-5342. Director: Jane Harris. Nonprofit and cooperative gallery. Estab. 1973. Exhibits the work of 34 mid-career artists. Sponsors 16 shows/year. Average display time 3 weeks. Open all year. Located in Soho; about 1,000 sq. ft.; "excellent location."

Media: Considers oil, acrylic, watercolor, pastel, pen & ink, drawings, mixed media, collage, works on paper, sculpture, fiber, glass, installation and photography.

Style: Exhibits a range of styles. Not interested in genre art.

Terms: Co-op membership fee (20% commission). Retail price set by the gallery and the artist. Artist pays for shipping.

Submissions: Send query letter with SASE for membership information.

STEPHEN E. FEINMAN FINE ARTS LTD., 448 Broome St., New York NY 10012. (212)925-1313. Contact: S.E. Feinman. Retail/wholesale gallery. Estab. 1972. Represents 20 emerging, mid-career and established artists/year. Exhibited artists include Mikio Watanabe, Johnny Friedlaender, Andre Masson, Felix Sherman, John Axton, Miljenko and Bengez. Sponsors 4 shows/year. Average display time 10 days. Open all year; Monday-Sunday, 12-6. Located in Soho; 1,000 sq. ft. 100% of space for gallery artists. Clientele: prosperous middle-aged professionals. 90% private collectors, 10% corporate collectors. Overall price range, $300-20,000; most work sold at $1,000-2,500.

Media: Considers oil, acrylic, watercolor, pastel, pen & ink, drawing, mixed media, sculpture, woodcuts, engravings, lithographs, mezzotints, serigraphs, linocuts and etchings. Most frequently exhibits mezzotints, aquatints and oils. Looking for artists that tend toward abstract-expressionists (watercolor/oil or acrylic) in varying sizes.

Style: Exhibits painterly abstraction and surrealism, all genres. Prefers abstract, figurative and surrealist.

Terms: Mostly consignment but also buys outright for % of retail price (net 90-120 days). Retail price set by the gallery. Gallery provides insurance, promotion, contract and shipping costs from gallery; artist pays shipping costs to gallery. Prefers artwork unframed.

Submissions: Send query letter with résumé, slides and photographs. Replies in 2-3 weeks.

Tips: Currently seeking artists of quality who (1) see a humorous bent in their works (sardonic, ironic), (2) are not pretentious. "Artists who show a confusing presentation drive me wild. Artists should remember that dealers and galleries are not critics. They are merchants who try to seduce their clients with aesthetics. Artists who have a chip on their shoulder or an 'attitude' are self-defeating. A sense of humor helps!"

FIRST STREET GALLERY, 560 Broadway, #402, New York NY 10012. (212)226-9127. Contact: Members Meeting. Cooperative gallery. Estab. 1964. Represents emerging and mid-career artists. 30 members. Sponsors 10-13 shows/year. Average display time 3 weeks. Open Tuesday-Saturday, 11-6. Closed in August. Located in the heart of Soho Art District; 2,100 sq. ft.; good combination natural/artificial light, distinguished gallery building. 100% of space for gallery artists. Clientele: collectors, consultants, retail. 50% private collectors, 50% corporate collectors. Overall price range: $500-40,000; most work sold at $1,000-3,000.

• First Street sponsors an open juried show each spring with a well-recognized figurative artist as judge. Contact them for details.

Media: Considers oil, acrylic, watercolor, pastel, drawing. Considers prints "only in connection with paintings." Most frequently exhibits oil on canvas and works on paper.

Style: Exhibits realism. Genres include landscapes and figurative work. "First Street's reputation is based on showing figurative/realism almost exclusively."

Terms: Co-op membership fee plus a donation of time (no commission). "We occasionally rent the space in August for $4,500/month." Retail price set by the artist. Artist pays shipping costs to and from gallery.

Submissions: "We accept figurative/representational work." Send query letter with résumé, slides, bio and SASE. "Artists' slides reviewed by membership at meetings once a month—call gallery for date in any month. We need to see original work to accept a new member." Replies in 1-2 months.

Tips: "Before approaching a gallery make sure they show your type of work. Physically examine the gallery if possible. Try to find out as much about the gallery's reputation in relation to its artists (many well-known galleries do not treat artists well). Show a cohesive body of work with as little paperwork as you can, no flowery statements, the work should speak for itself. You should have enough work completed in a professional manner to put on a cohesive-looking show."

‡FISCHBACH GALLERY, 24 W. 57th St., New York NY 10019. (212)759-2345. Director: Lawrence DiCarlo. Retail gallery. Estab. 1960. Represents 30 emerging, mid-career and established artists. Exhibited artists include Jane Freilicher

and Nell Blaine. Sponsors 12 shows/year. Average display time 1 month. Open all year. Located in midtown; 3,500 sq. ft. 80% of space for special exhibitions. Clientele: private, corporate and museums. 70% private collectors, 30% corporate collectors. Overall price range: $3,000-300,000; most work sold at $10,000-20,000.

Media: Considers oil, acrylic, watercolor, pastel, pen & ink, drawings, mixed media, collage and paper. Interested in American contemporary representational art; oil on canvas, watercolor and pastel.

Style: Exhibits realism. Genres include landscapes, florals, figurative work and still lifes. Prefers landscapes, still lifes and florals.

Terms: Accepts artwork on consignment (50% commission). Retail price set by gallery. Gallery provides promotion and shipping costs from gallery.

Submissions: Send query letter with résumé, slides, bio and SASE. Portfolio should include slides. Replies in 1 week.

Tips: "No videotapes—slides only with SASE. All work is reviewed."

FOCAL POINT GALLERY, 321 City Island, Bronx NY 10464. (718)885-1403. Artist/Director: Ron Terner. Retail gallery and alternative space. Estab. 1974. Interested in emerging and mid-career artists. Sponsors 2 solo and 6 group shows/year. Average display time 3-4 weeks. Clientele: locals and tourists. Overall price range: $175-750; most work sold at $300-500.

Media: Most frequently exhibits photography. Will exhibit painting and etching and other material by local artists only.

Style: Exhibits all styles and genres. Prefers figurative work, landscapes, portraits and abstracts. Open to any use of photography.

Terms: Accepts work on consignment (30% commission). Exclusive area representation required. Customer discounts and payment by installment are available. Gallery provides promotion. Prefers artwork framed.

Submissions: "Please call for submission information. Do not include résumés. The work should stand by itself. Slides should be of high quality."

Tips: "Be nice. (Personality helps.)"

GALLERY HENOCH, 80 Wooster, New York NY 10012. (212)966-6360. Director: George Henoch Shechtman. Retail gallery. Estab. 1983. Represents 40 emerging and mid-career artists. Exhibited artists include Daniel Greene and Max Ferguson. Sponsors 10 shows/year. Average display time 3 weeks. Closed August. Located in Soho; 4,000 sq. ft. 50% of space for special exhibitions. Clientele: 95% private collectors, 5% corporate clients. Overall price range: $3,000-40,000; most work sold at $10,000-20,000.

Media: Considers oil, acrylic, watercolor, pastel, pen & ink, drawings, and sculpture. Most frequently exhibits painting, sculpture, drawings and watercolor.

Style: Exhibits photorealism and realism. Genres include still life, cityscapes and figurative work. Prefers landscapes, cityscapes and still lifes.

Terms: Accepts work on consignment (50% commission). Retail price set by gallery. Gallery provides insurance and promotion; shipping costs are shared. Prefers artwork framed.

Submissions: Send query letter with 12-15 slides, bio and SASE. Portfolio should include slides and transparencies. Replies in 3 weeks.

Tips: "We suggest artists be familiar with the kind of work we show and be sure their work fits in with our styles."

GALLERY JUNO, 568 Broadway, Suite 604B, New York NY 10012. (212)431-1515. Fax: (212)431-1583. Gallery Director: June Ishihara. Retail gallery, art consultancy. Estab. 1992. Represents 18 emerging artists/year. Exhibited artists include Pierre Jacquemon, Kenneth McIndoe and Otto Mjaanes. Sponsors 8 shows/year. Average display time 6 weeks. Open all year; Monday-Friday, 10-6; Saturday, 11-6. Located in Soho; 1,000 sq. ft.; small, intimate space. 50% of space for special exhibitions; 50% of space for gallery artists. Clientele: corporations, private, design. 20% private collectors, 80% corporate collectors. Overall price range: $600-10,000; most work sold at $2,000-5,000.

Media: Considers oil, acrylic, watercolor, pastel, pen & ink, drawing, mixed media. Most frequently exhibits painting and works on paper.

Style: Exhibits expressionism, neo-expressionism, painterly abstraction, pattern painting and abstraction. Genres include landscapes. Prefers: contemporary modernism and abstraction.

Terms: Accepts work on consignment (50% commission). Retail price set by the gallery and the artist. Gallery provides insurance and promotion; artist pays shipping costs. Prefers artwork framed.

Submissions: Send query letter with résumé, slides, bio, photographs, SASE, business card and reviews. Write for appointment to show portfolio of originals, photographs and slides. Replies in 3 weeks. Files slides, bio, photos, résumé. Finds artists through visiting exhibitions, word of mouth and submissions.

GALLERY 10, 7 Greenwich Ave., New York NY 10014. (212)206-1058. Website: http://www.gallery10.com. Director: Marcia Lee Smith. Retail gallery. Estab. 1972. Open all year. Represents approximately 150 emerging and established artists. Clientele: 100% private collectors. Overall price range: $24-1,000; most work sold at $50-300.

Media: Considers ceramic, craft, glass, wood, metal and jewelry.

Style: "The gallery specializes in contemporary American crafts."

Terms: Accepts work on consignment (50% commission); or buys outright for 50% of retail price (net 30 days). Retail price set by gallery and artist.

Submissions: Call or write for appointment to show portfolio of originals, slides, transparencies or photographs.

‡**GOLDSTROM GALLERY**, Suite 303, 560 Broadway, New York NY 10012 (212)941-9175. Owner: Foster Golds-trom. Retail gallery. Estab. 1970. Clientele: 90% private collectors, 10% corporate clients. Represents 14 artists; emerging and established. Sponsors 15 solo and 4 group shows/year. Average display time 2-3 weeks. Located in SoHo, "in a clean, medium space in a good location." Overall price range: $650-300,000.
Media: Considers oil, acrylic, drawings, mixed media, collage, works on paper, sculpture, ceramic and photography.
Style: Exhibits all styles and genres, both emerging artists and secondary market. Prefers abstracts. Interested in seeing "expressionistic work or aggressive use of content or materials."
Terms: Accepts work on consignment (50% commission) or buys outright (50% retail price). Retail price set by gallery and artist. Exclusive area representation required.
Submissions: Send query letter with well-marked, clear slides and SASE. Replies in 1 month. All material is returned if not accepted or under consideration.
Tips: "Please come into gallery, look at our stable of work, and see first if your work fits our aesthetic."

‡**O.K. HARRIS WORKS OF ART**, 383 W. Broadway, New York NY 10012. Director: Ivan C. Karp. Commercial exhibition gallery. Estab. 1969. Represents 55 emerging, mid-career and established artists. Sponsors 50 solo shows/year. Average display time 3 weeks. Open fall, winter, spring and early summer. "Four separate galleries for four separate one-person exhibitions. The back room features selected gallery artists which also change each month." Clientele: 90% private collectors, 10% corporate clients. Overall price range: $50-250,000; most work sold at $12,500-100,000.
Media: Considers all media. Most frequently exhibits painting, sculpture and photography.
Style: Exhibits realism, photorealism, minimalism, abstraction, conceptualism, photography and collectibles. Genres include landscapes, Americana but little figurative work. "The gallery's main concern is to show the most significant artwork of our time. In its choice of works to exhibit, it demonstrates no prejudice as to style or materials employed. Its criteria demands originality of concept and maturity of technique. It believes that its exhibitions have proven the soundness of its judgment in identifying important artists and its pertinent contribution to the visual arts culture."
Terms: Accepts work on consignment (50% commission). Retail price set by gallery. Customer discounts and payment by installment are available. Exclusive area representation required. Gallery provides insurance and limited promotion. Prefers artwork ready to exhibit.
Submissions: Send query letter with slides "labeled with size, medium, etc." and SASE. Replies in 1 week.
Tips: "We suggest the artist be familiar with the gallery's exhibitions, and the kind of work we prefer to show. Always include SASE." Common mistakes artists make in presenting their work are "poor, unmarked photos (size, material, etc.), submissions without return envelope, inappropriate work. We affiliate about one out of 10,000 applicants."

JEANETTE HENDLER, 55 E. 87th St., Suite 15E, New York NY 10128. (212)860-2555. Fax: (212)360-6492. Art consultancy. Represents/exhibits mid-career and established artists. Exhibited artists include Warhol, Johns and Haring. Open all year by appointment. Located uptown. 50% private collectors, 50% corporate collectors.
Media: Considers oil and acrylic. Most frequently exhibits oils, acrylics and mixed media.
Style: Exhibits all styles. Genres include landscapes, florals, figurative and Latin. Prefers: realism, classical, neo classical, pre-Raphaelite, still lifes and florals.
Terms: Artwork is accepted on consignment and there is a commission. Retail price set by the gallery and the artist. Gallery provides insurance, promotion and contract.
Submissions: Finds artists through word of mouth, referrals by other artists, visiting art fairs and exhibitions.

IMAGES, 580 Broadway, New York NY 10012. (212)219-8484. Fax: (212)219-9144. Contact: Gallery Director. Retail gallery, art consultancy. Estab. 1980. Represents 12 mid-career and established artists/year. Exhibited artists include Connie Cohen, Ruth Epstein, Charlotte Hinzman, Ron Mehlman, Mason Nye, Carl Scorza, Teril Stray, Yale Epstein and Sylvie Yarza. Open all year; Tuesday-Friday, 12-5. Located in Soho, gallery district; 1,200 sq. ft.; in historic landmark building. 70% of space for special exhibitions; 30% of space for gallery artists. Clientele: corporate, institutional, retail. 25% private collectors, 75% corporate collectors. Overall price range: $2,000-20,000.
Media: Considers all media except installation and photography, all types of prints. Most frequently exhibits oil painting, lithograph/serigraph, sculpture/tapestry.
Style: Exhibits painterly abstraction, impressionism, photorealism and realism. Genres include landscapes, florals, Americana and figurative work. Prefers: color realism, expressionist landscape and figurative sculpture.
Terms: Accepts work on consignment (50% commission). Retail price set by the artist. Gallery provides insurance, promotion and contract; artist pays shipping costs to and from gallery. Prefers artwork framed.
Submissions: Send query letter with résumé, slides ("2-3 slides for our permanent file, not to be returned"), brochure and business card. Replies only if interested within 2 months. Files slides, résumés.

MICHAEL INGBAR GALLERY OF ARCHITECTURAL ART, 568 Broadway, New York NY 10012. (212)334-1100. Curator: Millicent Hathaway. Retail gallery. Estab. 1977. Represents 145 emerging, mid-career and established artists. Exhibited artists include Richard Haas and Judith Turner. Sponsors 6 shows/year. Average display time 2 months. Open all year; Tuesday-Saturday, 12-6. Located in Soho; 1,000 sq. ft. 60% private collectors, 40% corporate clients. Overall price range: $500-10,000; most work sold at $3,000.
Media: Considers all media and all types of prints. Most frequently exhibits paintings, works on paper and sculpture.
Style: Exhibits photorealism, realism and impressionism. Prefers: New York City buildings, New York City structures (bridges, etc.) and New York City cityscapes.

In *Underground Serenade*, Richard Pantell sought to visually link the song of a saxophone with the sounds produced by moving trains. Shown in an exhibit to benefit the New York Transit Museum, the print was also featured on 3 1/2 × 5" cards mailed to promote the exhibit. The 6-color print was created from hand-carved linoleum blocks, and each print of the 150-print edition sells for $200. "If you want a life in the fine arts, always do the work that represents who you are. Be honest," says Pantell. "Don't be untrue to yourself—the insincerity will show."

Terms: Artwork accepted on consignment (50% commission). Artists pays shipping costs.
Submissions: Accepts artists preferably from New York City metro area. Send query letter with SASE. Call for appointment to show portfolio of 20 slides. Replies in 1-2 weeks.
Tips: "Study what the gallery sells before you go through lots of trouble and waste their time. Be professional in your presentation." The most common mistakes artists make in presenting their work are "coming in person, constantly calling, poor slide quality (or unmarked slides)."

‡**JADITE GALLERIES**, 413 and 415 W. 50th St., New York NY 10019. (212)315-2740. Fax: (212)315-2793. Director: Roland Sainz. Retail gallery. Estab. 1985. Represents 25 emerging and established, national and international artists. Sponsors 20 solo and 2 group shows/year. Average display time 3 weeks. Clientele: 80% private collectors, 20% corporate clients. Overall price range: $500-8,000; most artwork sold at $1,000-3,000.
Media: Considers oil, acrylic, watercolor, pastel, pen & ink, drawings, mixed media, collage, sculpture and original handpulled prints. Most frequently exhibits oils, acrylics, pastels and sculpture.
Style: Exhibits minimalism, postmodern works, impressionism, neo-expressionism, realism and surrealism. Genres include landscapes, florals, portraits, Western collages and figurative work. Features mid-career and emerging international artists dealing with contemporary works."
Terms: Accepts work on consignment (40% commission). Retail price set by gallery and artist. Exclusive area representation not required. Gallery provides insurance, promotion and contract; exhibition costs are shared.
Submissions: Send query letter, résumé, brochure, slides, photographs and SASE. Call or write for appointment to show portfolio of originals, slides or photos. Resume, photographs or slides are filed.

‡**THE JEWISH MUSEUM**, 1109 Fifth Ave., New York NY 10128. (212)423-3200. Fax: (212)423-3232. Curator of Fine Arts: Norman Kleeblatt. Museum. Estab. 1904. Represents/exhibits emerging, mid-career and established artists. Sponsors 5-8 exhibitions/year. Average display time 4 months. Open all year; Sunday-Thursday, 11-5:45; Tuesday, 11-8; closed Friday and Saturday. Located in Manhattan; 20,000 sq. ft. 50% of space for special exhibitions.
Media: Considers all media and all types of prints.
Submissions: Send query letter with résumé, slides, photographs, reviews and bio. Write for appointment.

‡LA MAMA LA GALLERIA, 6 E. First St., New York NY 10003. (212)505-2476. Director: Merry Geng. Nonprofit gallery. Estab. 1981. Exhibits the work of emerging, mid-career and established artists. Sponsors 14 shows/year. Average display time 3 weeks. Open September-June; Thursday-Sunday 1-6. Located in East Village; 2,500 sq. ft.; "very large and versatile space." 100% of space for special exhibitions. Clientele: 20% private collectors, 20% corporate clients. Overall price range: $1,000-5,000; most work sold at $1,000.
Media: Considers oil, acrylic, watercolor, pastel, pen & ink, drawings, mixed media, collage, sculpture, ceramic, craft, installation, photography, original handpulled prints, woodcuts, engravings and lithographs. Most frequently exhibits oil, installation and collage. "No performance art."
Style: Exhibits expressionism, neo-expressionism, primitivism, painterly abstraction, imagism, conceptualism, minimalism, postmodern works, impressionism, photorealism and hard-edge geometric abstraction.
Terms: Accepts work on consignment (20% commission). Retail price set by gallery. Gallery provides promotion; artist pays for shipping or shipping costs are shared. Prefers artwork framed.
Submissions: Send query letter with résumé, slides and bio. Write for appointment to show portfolio of originals, slides, photographs or transparencies. Replies in 6 weeks. Files slides and résumés.
Tips: Make sure to "include résumé and artist's statement and label slides (size, medium, etc)."

BRUCE R. LEWIN GALLERY, 136 Prince St., New York NY 10012. (212)431-4750. Fax: (212)431-5012. Director: Bruce R. Lewin. Retail gallery. Estab. 1992. Represents/exhibits 30 emerging, mid-career and established artists/year. Sponsors 20 shows/year. Average display time 3-4 weeks. Open all year; Tuesday-Saturday, 10-6. Located in Soho; 7,500 sq. ft.; high ceilings; 40 ft. walls; dramatic architecture. 100% of space for gallery artists. Clientele: upscale. 80% private collectors, 20% corporate collectors. Overall price range: $500-500,000; most work sold at $5,000-100,000.
Media: Considers all media. Most frequently exhibits paintings, watercolors and sculpture.
Style: Exhibits photorealism, color field and realism. Genres include figurative work and also pop (Andy Warhol).
Terms: Artwork is accepted on consignment (50% commission). Retail price set by the gallery. Gallery provides insurance and promotion; shipping costs are shared. Prefers artwork framed.
Submissions: Send query letter with slides. Portfolio should include slides or transparencies. Replies only if interested within 1 week. Finds artists through word of mouth and submission of slides.

‡THE JOE & EMILY LOWE ART GALLERY AT HUDSON GUILD, 441 W. 26th St., New York NY 10001. (212)760-9812. Director: Jim Furlong. Nonprofit gallery. Estab. 1948. Represents emerging, mid-career community-based and established artists. Sponsors 7 shows/year. Average display time 2 months. Open all year. Located in West Chelsea; 1,200 sq. ft.; a community center gallery in a New York City neighborhood. 100% of space for special exhibitions. Clientele: 100% private collectors.
Media: Considers oil, acrylic, watercolor, pastel, pen & ink, drawings, mixed media, collage, paper, sculpture, original handpulled prints, woodcuts, wood engravings, linocuts, engravings, mezzotints, etchings, lithographs, pochoir and serigraphs. Most frequently exhibits paintings, sculpture and graphics. Looking for artist to do an environmental "installation."
Style: Exhibits all styles and genres.
Terms: Accepts work on consignment (20% commission). Retail price set by artist. Sometimes offers payment by installments. Gallery provides insurance; artist pays for shipping. Prefers artwork framed.
Submissions: Send query letter, résumé, slides, bio and SASE. Portfolio should include photographs and slides. Replies in 1 month.
Tips: Finds artists through visiting exhibitions, word of mouth, various art publications and sourcebooks, artists' submissions/self-promotions, art collectors' referrals.

‡MALLET FINE ART LTD., 141 Prince St., New York NY 10012. (212)477-8291. Fax: (212)673-1051. President: Jacques Mallet. Retail gallery, art consultancy. Estab. 1982. Represents 3 emerging and established artists/year. Exhibited artists include Sonntag and Ouattara. Sponsors 1 show/year. Average display time 3 months. Open fall and spring; Tuesday-Saturday, 11-6. Located in Soho; 2,000 sq. ft. 50% of space for special exhibitions; 50% of space for gallery artists. Clientele: private and art dealers, museums. 80% private collectors. Overall price range: $2,000-5,000,000; most work sold at $40,000-400,000.
Media: Considers oil, acrylic, watercolor, pastel, pen & ink, drawing, mixed media, collage, paper, sculpture, engraving, lithograph and etching. Most frequently exhibits oil, works on paper and sculpture.
Style: Exhibits expressionism, surrealism, all styles and impressionism.
Terms: Accepts work on consignment (20% commission) or buys outright for 50% of retail price (net 30 days). Retail price set by the gallery. Gallery provides insurance and contract; shipping costs are shared. Prefers artwork framed.
Submissions: Accepts only artists from America and Europe. Send query letter with résumé, slides, bio, photographs and SASE. Write for appointment to show portfolio of transparencies. Replies in 3 weeks. Finds artists through word of mouth.

THE MARBELLA GALLERY INC., 28 E. 72nd St., New York NY 10021. (212)288-7809. President: Mildred Thaler Cohen. Retail gallery. Estab. 1971. Represents/exhibits established artists. Exhibited artists include Pre Ten and The Eight. Sponsors 1 show/year. Average display time 6 weeks. Open all year; Tuesday-Saturday, 11-5:30. Located uptown; 750 sq. ft. 100% of space for special exhibitions. Clientele: tourists, upscale. 50% private collectors, 10% corporate collectors, 40% dealers. Overall price range: $1,000-60,000; most work sold at $2,000-4,000.

Style: Exhibits expressionism, realism and impressionism. Genres include landscapes, florals, Americana and figurative work. Prefers Hudson River, "The Eight" and genre.
Terms: Artwork is bought outright for a percentage of the retail price. Retail price set by the gallery. Gallery provides insurance.

‡**MARLBOROUGH GALLERY**, 40 W. 57th St., New York NY 10019. (212)541-4900. Fax: (212)541-4948. Director: Pierre Levai. Retail gallery. Estab. 1962; renovated space opened Fall 1992. Represents 30 mid-career and established artists. Interested in seeing the work of emerging artists. Exhibited artists include Fernando Botero and Larry Rivers. Sponsors 8 shows/year. Average display time 1 month. Open all year. Located midtown; 19,000 sq. ft. Clientele: domestic and international.
Media: Open.
Style: Open.
Terms: Accepts work on consignment or buys artwork outright. Retail price set by gallery and artist. Prefers artwork framed.
Submissions: Send query letter with résumé, slides and bio. Portfolio should include slides. Replies only if interested within 1 month. Files material of interest.

✔**JAIN MARUNOUCHI GALLERY**, 24 W. 57th St., New York NY 10019. (212)969-9660. Fax: (212)969-9715. E-mail: jainmar@aol.com. Website: http://www.jainmargallery.com. President: Ashok Jain. Retail gallery. Estab. 1991. Represents 30 emerging artists. Exhibited artists include Fernando Pamalaza and Pauline Gagnon. Open all year; Monday-Friday, 11-6. Located in Design & Decoration Bldg., 800 sq. ft. 80% of space for special exhibitions; 20% of space for gallery artists. Clientele: corporate and designer. 50% private collectors, 50% corporate collectors. Overall price range: $1,000-20,000; most work sold at $5,000-10,000.
Media: Considers oil, acrylic and mixed media. Most frequently exhibits oil, acrylic and collage.
Style: Exhibits painterly abstraction. Prefers: abstract and landscapes.
Terms: Accepts work on consignment (50% commission). Retail price set by artist. Offers customer discount. Gallery provides contract; artist pays for shipping costs. Prefers artwork framed.
Submissions: Send query letter with résumé, brochure, slides, reviews and SASE. Portfolio review requested if interested in artist's work. Portfolio should include originals, photographs, slides, transparencies and reviews. Replies in 1 week. Finds artists through referrals and promotions.

‡**FRIEDRICH PETZEL GALLERY**, 26 Wooster St., New York NY 10013. (212)334-9466. Fax: (212)431-6638. Contact: Petzel. Retail gallery and office for organization of art events. Estab. 1993. Represents 7 emerging artists/year. Exhibited artists include Paul Myoda, Keith Edmier, Jorge Pardo. Sponsors 9-10 shows/year. Average display time 1 month. Open September-July; Tuesday-Saturday, 11-6. Located in Soho; 800 sq. ft. 100% of space for gallery artists. 80% private collectors, 20% corporate collectors. Overall price range: $1,000-8,000; most work sold at $4,000.
Media: Considers all media. Most frequently exhibits mixed media.
Terms: Accepts work on consignment (50% commission). Retail price set by the gallery and the artist. Gallery provides promotion, contract and shipping costs to and from gallery. Prefers artwork framed.
Submissions: Send query letter with résumé, slides, bio and reviews. Call for appointment to show portfolio of photographs, slides and transparencies. Replies in 2-3 weeks. Files "only material we are interested in." Finds artists through various art publications, word of mouth and studio visits.

THE PHOENIX GALLERY, 568 Broadway, Suite 607, New York NY 10012. (212)226-8711. Website: http://www.gallery-guide.com/gallery/phoenix. Director: Linda Handler. Nonprofit gallery. Estab. 1958. Exhibits the work of emerging, mid-career and established artists. 32 members. Exhibited artists include Pamela Bennet Ader and Beth Cartland. Sponsors 10-12 shows/year. Average display time 1 month. Open fall, winter and spring. Located in Soho; 180 linear ft.; "We are in a landmark building in Soho, the oldest co-op in New York. We have a movable wall which can divide the gallery into two large spaces." 100% of space for special exhibitions. Clientele: 75% private collectors, 25% corporate clients, also art consultants. Overall price range: $50-20,000; most work sold at $300-10,000.
● In addition to providing a venue for artists to exhibit their work, the Phoenix Gallery also actively reaches out to the members of the local community, scheduling juried competitions, dance programs, poetry readings, book signings, plays and lectures. A special exhibition space, The Project Room, has been established for guest-artist exhibits.
Media: Considers oil, acrylic, watercolor, pastel, pen & ink, drawings, mixed media, collage, works on paper, sculpture, ceramic, photography, original handpulled prints, woodcuts, engravings, wood engravings, linocuts, etchings and photographs. Most frequently exhibits oil, acrylic and watercolor.
Style: Exhibits painterly abstraction, minimalism, realism, photorealism, hard-edge geometric abstraction and all styles.
Terms: Co-op membership fee plus donation of time (25% commission). Retail price set by gallery. Offers customer discounts and payment by installment. Gallery provides promotion and contract; artist pays for shipping. Prefers artwork framed.
Submissions: Send query letter with résumé, slides and SASE. Call for appointment to show portfolio of slides. Replies in 1 month. Only files material of accepted artists. The most common mistakes artists make in presenting their work are "incomplete résumés, unlabeled slides and an application that is not filled out properly. We find new artists by

advertising in art magazines and art newspapers, word of mouth, and inviting artists from our juried competition to be reviewed for membership."

Tips: "Come and see the gallery—meet the director."

‡THE ERNEST RUBENSTEIN GALLERY, 197 E. Broadway, New York NY 10024. (212)780-2300 ext. 378. Fax: (212)533-2654. Website: http://www.edalliance.org. Alternative space. Estab. 1964. Exhibits 50 emerging, mid-career artists. Exhibited artists include Paul Lucchesi and Franco Ciarlo. Sponsors 9 shows/year. Average display time 3-4 weeks. Open all year; Monday-Friday, 9:30 a.m.-10:00 p.m.; Sunday, 12-6. Located on Lower East Side; 600 sq. ft. 100% of space for gallery artists. 100% private collectors. Overall price range: $100-10,000; most work sold at $2,500.
Media: Considers oil, pen & ink, paper, acrylic, drawings, sculpture, watercolor, mixed media, ceramic, pastel, collage and photography. Most frequently exhibits painting, photography, sculpture.
Style: Exhibits all styles and genres. Prefers: realism, painterly abstraction, stone sculpture, photography.
Terms: Retail price set by artist. Gallery provides insurance; artist pays for shipping costs. Prefers artwork framed.
Submissions: Send query letter with résumé, slides and SASE. "We only look at new work in the spring. All inquiries get replies." Send 4-5 slides of each artist in group exhibit proposals. Artists should not send slides for proposing a solo exhibit.
Tips: "Be aggressive, friendly, outgoing and call back."

ST. LIFER FINE ART, (formerly St. Lifer Art Exchange, Inc.), 11 Hanover Square #703, New York NY 10005. (212)825-2059. Fax: (212)422-0711. E-mail: stliterart@aol.com. Director: Jane St. Lifer. Fine art appraisers, brokers and lectures. Estab. 1988. Represents established artists. May be interested in seeing the work of emerging artists in the future. Exhibited artists include Miro and Picasso. Open all year by appointment. Located in the Wall Street area. Clientele: national and international contacts. 50% private collectors, 50% corporate collectors. Overall price range: $300-8,000.
Media: Considers woodcuts, engravings, lithographs, wood engravings, mezzotints, serigraphs, linocuts, etchings, posters (original).
Style: Exhibits postmodern works, impressionism and realism. Considers all genres.
Terms: Accepts work on consignment or buys outright. Retail price set by the gallery. Gallery pays shipping costs from gallery; artist pays shipping costs to gallery. Prefers artwork framed.
Submissions: Send query letter with résumé, bio, photographs, SASE and business card. Portfolio should include photographs. Replies in 3-4 weeks. Files résumé, bio.

‡SCULPTURECENTER GALLERY, 167 E. 69th St., New York NY 10021. (212)879-3500. Fax: (212)879-7155. E-mail: sculptur@interport.net. Website: http://www.interport.net/~sculptur. Gallery Director: Marian Griffiths. Alternative space, nonprofit gallery. Estab. 1928. Exhibits emerging and mid-career artists. Sponsors 8-10 shows/year. Average display time 3-4 weeks. Open September-June; Tuesday-Saturday, 11-5. Located Upper East Side, Manhattan; main gallery, 1,100 sq. ft.; gallery 2, 104 sq. ft.; old carriage house with 14 ft. ceilings. 85% of space for gallery artists. 90% private collectors, 10% corporate collectors. Overall price range: $100-100,000; most work sold at $200-3,000.
Media: Considers drawing, mixed media, sculpture and installation. Most frequently exhibits sculpture, installations and video installations.
Terms: Accepts work on consignment (25% commission). Retail price set by the gallery and the artist. Gallery provides promotion; artist pays shipping costs.
Submissions: Send query letter with résumé, 10-20 slides, bio and SASE. Call for appointment to show portfolio of photographs, slides and transparencies. Replies in 2 months. Files bios and slides. Finds artists through artists' and curators' submissions (mostly) and word of mouth.

‡NATHAN SILBERBERG FINE ARTS, 301 E. 63rd St., Suite 7-G, New York NY 10021. (212)752-6160. Owner: N. Silberberg. Retail and wholesale gallery. Estab. 1973. Represents 10 emerging and established artists. Exhibited artists include Joan Miro, Henry Moore and Nadezda Vitorovic. Sponsors 4 shows/year. Average display time 1 month. Open March-July. 2,000 sq. ft. 75% of space for special exhibitions. Overall price range: up to $50,000; most work sold at $4,000.
Media: Considers oil, acrylic, watercolor, original handpulled prints, lithographs, pochoir, serigraphs and etchings.
Style: Exhibits surrealism and conceptualism. Interested in seeing abstract work.
Terms: Accepts work on consignment (40-60% commission). Retail price set by gallery. Sometimes offers customer discounts. Gallery provides insurance and promotion; shipping costs are shared. Prefers framed artwork.
Submissions: Send query letter with résumé, slides and SASE. Write for appointment to show portfolio of originals, slides and transparencies. Replies in 1 month. Finds artists through visiting art schools and studios.
Tips: "First see my gallery and the artwork we show."

SLOWINSKI GALLERY, 215 Mulberry St., New York NY 10012. Phone/fax: (212)431-1190. E-mail: slowart@aol.com. Website: http://www.slowart.com/slow. Director: Tim Slowinski. Slowinski Gallery is an artist-owned alternative retail (consignment) gallery. Estab. 1987. Represents emerging and mid-career artists. Hosts biannual exhibitions of emerging artists selected by competition, cash awards up to $1,000. Entry available for SASE or from website. Sponsors 6-8 shows/year. Average display time 3 weeks. Open Wednesday-Saturday, 12-6, July 15-August 30, by appointment. Located in Soho, 700 sq. ft. storefront. 60-80% of space for special exhibitions; 20-40% of space for gallery artists.

Clientele: lawyers, real estate developers, doctors, architects. 95% private collectors, 5% corporate collectors. Overall price range: $300-10,000.

Media: Considers all media, all types of prints except posters. Most frequently exhibits painting, sculpture and works on paper.

Style: Exhibits primitivism, surrealism, all styles, postmodern works, all genres. "Gallery exhibits all styles but emphasis is on non-traditional figurative work."

Terms: Accepts work on consignment (50% commission). Retail price set by the gallery and the artist. Gallery provides promotion and contract; artist pays shipping costs to and from gallery. Prefers artwork framed.

Submissions: Send query letter with résumé, slides, bio and SASE. Call for appointment to show portfolio of originals, photographs, slides and transparencies. Replies in 2-3 weeks. Files slides, résumé. Finds artists through word of mouth, art publications and sourcebooks, submissions.

Tips: "Keep at least ten sets on slides out on review at all times."

‡SOHO 20 GALLERY, 469 Broome St., New York NY 10013. (212)226-4167. Contact: Tom Slaughter. Nonprofit cooperative gallery and alternative space. Estab. 1973. Represents/exhibits 55 emerging, mid-career and established artists/year. Sponsors approximately 50 shows/year. Average display time 3½-4 weeks. Open all year; Tuesday-Saturday, 12-6. Located in Soho; 1,700 sq. ft.; ground floor space in historical building; 12 ft. ceilings; "Greene St. Window." 25-35% of space for special exhibitions; 75% of space for gallery artists. Clientele: wide range: private, corporate. 75% private collectors, 25% corporate collectors. Overall price range: $100-20,000; most work sold at $500-7,500.

Media: Considers all media and all types of prints except posters. Most frequently exhibits painting, sculpture, mixed media and installations.

Style: Exhibits all styles and genres.

Terms: There is a co-op membership fee plus a donation of time, a 20% commission and a rental fee for space. The rental fee covers exhibition dates. Retail price set by the artist. Gallery provides promotion. Artists usually pays for shipping costs. Prefers artwork framed "ready to exhibit. Artists generally install their own exhibits."

Submissions: "Soho 20 is a feminist cooperative gallery. The gallery exhibits work by women artists." Send résumé, brochures, slides, reviews SASE and letter stating which exhibit opportunities they are interested in (call gallery first). Call for appointment to show portfolio of slides and résumé. Replies in 1 month. Finds artists through word of mouth, referrals by other artists, visiting art fairs and exhibitions, artist's submissions and advertising.

Tips: "We have several categories of exhibition opportunities. Call first in order to decide which category best meets the artist's and gallery's needs/intent. Clearly state exhibition category that you are applying for. Send all materials SASE."

HOLLIS TAGGART GALLERIES, INC., 48 E. 73rd St., New York NY 10021. (212)628-4000. Gallery Contact: Hollis Taggart. Retail gallery. Estab. 1978. Interested in seeing the work of mid-career and established artists. Sponsors 2 shows/year in New York gallery. Average display time 4 weeks. "Interested only in artists working in contemporary realism." Clientele: 80% private collectors, 10% corporate clients. Overall price range: $1,000-1,000,000; most historical artwork sold at $20,000-500,000; most contemporary artwork sold at $7,000-30,000.

Media: Considers oil, watercolor, pastel, pen & ink and drawings.

Style: Prefers figurative work, landscapes and still lifes. "We specialize in 19th and early 20th century American paintings and contemporary realism. We are interested only in contemporary artists who paint in a realist style. As we handle a limited number of contemporary artists, the quality must be superb."

Terms: Retail price set by gallery and artist. Exclusive area representation required. Insurance, promotion, contract and shipping costs negotiable.

Submissions: "Please call first; unsolicited query letters are not preferred. Looks for technical excellence."

Tips: "Collectors are more and more interested in seeing traditional subjects handled in classical ways. Works should demonstrate excellent draftsmanship and quality."

‡SYLVIA WHITE CONTEMPORARY ARTISTS' SERVICES, 560 Broadway, #206, New York NY 10012. (212)966-3564. E-mail: artadvice@aol.com. Website: http://www.sylviawhite.com. Contact: Sylvia White. Retail gallery, art consultancy, artist's career development services.

● This gallery has two locations (New York and Santa Monica, California). See their California listing for information about the galleries' submission policies as well as media and style needs.

‡WIESNER GALLERY, Suite 4D, 730 57th St., Brooklyn NY 11220. (718)492-6123. Director: Nikola Vizner. Retail gallery and art consultancy. Estab. 1985. Represents 30 emerging and established artists. Sponsors 5 solo and 5 group shows/year. Average display time 1 month. Clientele: 50% private collectors, 50% corporate clients. Overall price range: $200-15,000; most artwork sold at $1,200.

Media: Considers oil, acrylic, watercolor, pastel, pen & ink, drawings, mixed media, collage, works on paper, sculpture, installations, photography and limited edition prints. Most frequently exhibits oil, acrylic and photography.

Style: Exhibits color field, painterly abstraction, minimalism, conceptualism, post-modernism, feminist/political, neo-expressionism, realism and surrealism. Genres include landscapes, Americana and figurative work. Seeks "strong contemporary works regardless of medium, with artist's statement about his viewpoint, philosophy, personal or universal message."

Terms: Accepts work on consignment (50% commission). Retail price set by gallery and artist. Exclusive area represen-

tation not required. Gallery provides insurance and promotion; artist pays for shipping.
Submissions: Send résumé, slides and SASE. Write for appointment to show portfolio of slides and transparencies. Files résumés, slides, photogrpahs, brochures and transparencies.
Tips: "Looks for high artistic knowledge and intelligence."

PHILIP WILLIAMS POSTERS, 60 Grand St., New York NY 10013. (212)226-7830. Fax: (212)226-0712. Contact: Philip Williams. Retail and wholesale gallery. Represents/exhibits 40 emerging, mid-career and established artists. Open all year; Monday-Sunday, 11-7. Located in downtown Soho; 2,500 sq. ft.
Terms: Shipping costs are shared. Prefers artwork unframed.
Submissions: Prefers only vintage posters and outsider artist. Send query letter with photographs. Call for appointment to show portfolio of photographs.

North Carolina

ASSOCIATED ARTISTS OF WINSTON-SALEM, 226 N. Marshall St., Winston-Salem NC 27101. (910)722-0340. Executive Director: Sue Kneppelt. Nonprofit gallery. Gallery estab. 1982; organization estab. 1956. Represents 500 emerging, mid-career and established artists/year. 375 members. Sponsors 12 shows/year. Average display time 1 month. Open all year; office hours: Monday-Friday, 9-5; gallery hours: Monday-Friday, 9-9; Saturday, 9-6. Located in the historic Sawtooth Building downtown. "Our gallery is 1,000 sq. ft., but we often have the use of 2 other galleries with a total of 3,500 sq. ft. The gallery is housed in a renovated textile mill (circa 1911) with a unique 'sawtooth' roof. 30% of space for special exhibitions; 70% of space for gallery artists. Clientele: "generally walk-in traffic—this is a multi-purpose public space, used for meetings, receptions, classes, etc." 85% private collectors, 15% corporate collectors. Overall price range: $50-3,000; most work sold at $100-500.
Media: Considers oil, acrylic, watercolor, pastel, pen & ink, drawing, mixed media, collage, paper, sculpture, photography, woodcuts, engravings, lithographs, wood engravings, mezzotints, serigraphs, linocuts and etchings (no photo-reproduction prints). Most frequently exhibits watercolor, oil and photography.
Style: Exhibits all styles, all genres.
Terms: "Artist pays entry fee for each show; if work is sold, we charge 30% commission. If work is unsold at close of show, it is returned to the artist." Retail price set by the artist; artist pays shipping costs to and from gallery. Artwork must be framed.
Submissions: Request membership information and/or prospectus for a particular show. Replies in 1 week to membership/prospectus requests. Files "slides and résumés of our exhibiting members only."
Tips: "We don't seek out artists per se—membership and competitions are generally open to all. We advertise call for entries for our major shows in national art magazines and newsletters. Artists can impress us by following instructions in our show prospecti and by submitting professional-looking slides where appropriate. Because of our non-elitist attitude, we strive to be open to all artists—from novice to professional, so first-time artists can exhibit with us."

‡BARTON MUSEUM, Barton College, College Station Wilson NC 27893. (919)399-6477. E-mail: cwilson@e-mail.barton.edu. Director of Exhibitions: J. Chris Wilson. Nonprofit gallery. Estab. 1965. Represents mid-career and established artists, especially artists from North Carolina. Sponsors both solo and group shows during academic year. Artwork up to $3,500 has sold.
Media: Considers all media and original handpulled prints. Most frequently exhibits pottery, painting, historic decorative arts, prints and photographs. Interested in seeing "all types of visual arts—glass, sculpture, drawings, etc."
Style: Considers all styles.
Terms: Retail price set by artist. Gallery provides standard insurance coverage and promotion locally through the media and mailings; shipping expenses are negotiated.
Submissions: Contact the Director of Exhibitions for additional information.
Tips: "Make sure that the gallery you are approaching is a good match in terms of quality and profile."

BROADHURST GALLERY, 800 Midland Rd., Pinehurst NC 28374. (910)295-4817. Owner: Judy Broadhurst. Retail gallery. Estab. 1990. Represents/exhibits 50 emerging, mid-career and established artists/year. Sponsors about 4 large shows and many smaller shows/year. Average display time 1-3 months. Open all year; Tuesday-Friday, 11-5; Saturday, 1-4; and by appointment. Located on the main road between Pinehurst and Southern Pines; 3,000 sq. ft.; lots of space, lots of light, lots of parking spaces. 50% of space for special exhibitions; 50% of space for gallery artists. Clientele: people building homes and remodeling, also collectors. 80% private collectors, 20% corporate collectors. Overall price range: $500-10,000; most work sold at $1,000-2,400.
Media: Considers oil, acrylic, watercolor, pastel, mixed media, collage, sculpture, craft and glass. Most frequently exhibits oil, acrylic, sculpture (stone and bronze), watercolor, glass.
Style: Exhibits all styles, all genres.
Terms: Retail price set by the artist. Gallery provides insurance, promotion and contract; shipping costs are shared. Prefers artwork framed.
Submissions: Send query letter with résumé, slides and/or photographs, and bio. Write for appointment to show portfolio of originals and slides. Replies only if interested within 2-3 weeks. Files résumé, bio, slides and/or photographs.

Finds artists through agents, by visiting exhibitions, word of mouth, various art publications and sourcebooks and artists' submissions.
Tips: "Talent is always the most important factor but professionalism is very helpful."

‡**COMPTON ART GALLERY**, 409 W. Fisher Ave., Greensboro NC 27401. (336)370-9147. Owner: Anne Compton. Retail gallery and art consultancy. Estab. 1985. Represents 60 emerging, mid-career and established artists. Exhibited artists include Marcos Belhove and Betty Mitchell. Sponsors 6 shows/year. Average display time 1 month. Open all year. Located near downtown. 75% of space for special exhibitions. 50% private collectors, 50% corporate collectors. Overall price range: $100-4,000; most work sold at $1,500.
Media: Considers oil, acrylic, watercolor and pastel.
Style: Considers contemporary expressionism, impressionism and realism. Genres include landscapes, florals and figurative work.
Terms: Accepts artwork on consignment (45% commission). Retail price set by the artist. Gallery provides some insurance, promotion and contract; artist pays for shipping. Prefers artwork framed if oil, or a finished canvas. Prefers matted watercolors.
Submissions: Send query letter with slides, résumé, brochure, photographs and SASE. Write to schedule an appointment to show a portfolio, which should include originals, slides and transparencies. Replies in 1 month. Files brochures, résumé and some slides.
Tips: "We only handle original work."

‡**THE DAVIDSON COUNTY MUSEUM OF ART**, 224 S. Main St., Lexington NC 27292. (336)249-2742. Curator: Mark Alley. Nonprofit gallery. Estab. 1968. Exhibits 30 emerging, mid-career and established artists. Interested in seeing the work of emerging artists. 400 members. Exhibited artists include Bob Timberlake and Zoltan Szabo. Disney Animation Archives (1993), Ansel Adams (1994), P. Bukeley Moss (1996). Sponsors 11 shows/year. Average display time 1 month. Open all year. 6,000 sq. ft; historic building, good location, marble foyer. 80% of space for special exhibitions; 10% of space for gallery artists. Clientele: 98% private collectors, 2% corporate collectors. Overall price range: $50-20,000; most work sold at $50-4,000.
Media: Considers all media and all types of prints. "Originals only for exhibition. Most frequently exhibits painting, photography and mixed media. "We try to provide diversity."
Style: Exhibits expressionism, painterly abstraction, postmodern works, expressionism, photorealism and realism. Genres include landscapes and Southern artists.
Terms: Accepts work on consignment (30% commission). Members can exhibit art for 2 months maximum per piece in our members gallery. 30% commission goes to Guild. Retail price set by gallery and artist. Gallery provides insurance, promotion and contract; artist pays for shipping. Prefers artwork framed for exhibition and unframed for sales of reproductions.
Submissions: Send query letter with résumé, slides, bio, brochure, photographs, business card, reviews and SASE. Write for appointment to show portfolio of originals, photographs and slides. Entries reviewed every May for following exhibition year.

‡**WELLINGTON B. GRAY GALLERY, EAST CAROLINA UNIVERSITY**, Jenkins Fine Art Center, Greenville NC 27858. (919)757-6336. Fax: (919)757-6441. Website: http://ecuuax.cis.@cu.edu/academics/schdept/art/art.htm. Director: Gilbert W. Leebrick. Nonprofit university gallery. Estab. 1977. Represents emerging, mid-career and established artists. Sponsors 12 shows/year. Average display time 5-6 weeks. Open year round. Located downtown, in the university; 5,500 sq. ft.; "auditorium for lectures, sculpture garden." 100% of space for special exhibitions. Clientele: 25% private collectors, 10% corporate clients, 50% students, 15% general public. Overall price range: $1,000-10,000.
Media: Considers all media plus environmental design, architecture, crafts and commercial art, original prints, relief, intaglio, planography, stencil and offset reproductions. Most frequently exhibits paintings, printmaking and sculpture.
Style: Exhibits all styles and genres. Interested in seeing contemporary art in a variety of media.
Terms: 30% suggested donation on sales. Retail price set by artist. Gallery provides insurance and promotion; shipping costs are shared. Prefers artwork framed.
Submissions: Send query letter with résumé, slides, brochure and SASE. Write for appointment to show portfolio of originals, slides, photographs and transparencies. Replies in 2-6 months. Files "all mailed information for interesting artists. The rest is returned."

‡**LEE HANSLEY GALLERY**, 16 W. Martin St., Suite 201, Raleigh NC 27601. (919)828-7557. Proprietor: Lee Hansley. Retail gallery, art consultancy. Estab. 1993. Represents 40 mid-career and established artists/year. Exhibited artists include Mary Anne K. Jenkins, Paul Hartley. Sponsors 10 shows/year. Average display time 5-7 weeks. Open all year; Tuesday-Friday, 10:30-6; Saturday, 11-4. Located downtown; 1,200 sq. ft.; 3 small, intimate exhibition galleries, one small hallway interior. 75% of space for special exhibitions; 25% of space for gallery artists. Clientele: local, state collectors. Overall price range: $250-18,000; most work sold at $500-2,500.
Media: Considers all media except large-scale sculpture. Considers all types of prints except poster. Most frequently exhibits painting/canvas, mixed media on paper.
Style: Exhibits expressionism, neo-expressionism, painterly abstraction, minimalism, color field, photorealism, pattern painting, hard-edge geometric abstraction. Genres include landscapes, figurative work. Prefers geometric abstraction, expressionism, minimalism.

Terms: Accepts work on consignment (50% commission). Retail price set by the gallery and the artist. Gallery provides insurance, promotion and verbal contract; shipping costs are shared. Prefers artwork framed.
Submissions: "Work must be strong, not political please." Send query letter with slides, bio and artist's statement. Write for appointment to show portfolio of photographs or slides. Replies in 2 months. Files slides, résumés.

JERALD MELBERG GALLERY INC., 3900 Colony Rd., Suite C, Charlotte NC 28211. (704)365-3000. Fax: (704)365-3016. President: Jerald Melberg. Retail gallery. Estab. 1983. Represents 26 emerging, mid-career and established artists/year. Exhibited artists include Arless Day and Wolf Kahn. Sponsors 15-16 shows/year. Average display time 5 weeks. Open all year; Monday-Saturday, 10-6. Located in suburbs; 2,500 sq. ft. 100% of space for gallery artists. Clientele: national. 70-75% private collectors, 25-30% corporate collectors. Overall price range: $1,000-80,000; most work sold at $2,000-6,000.
Media: Considers all media except photography. Considers all types of prints. Most frequently exhibits pastel, oil/acrylic and monotypes.
Style: Genres include painterly abstraction, color field, impressionism and realism. Genres include florals and landscapes. Prefers landscapes, abstraction and still life.
Terms: Artwork is accepted on consignment (50% commission). Retail price set by the gallery and the artist. Gallery provides insurance, promotion. Gallery pays for shipping costs from gallery. Artists pays for shipping costs to gallery. Prefers artwork unframed.
Submissions: Send query letter with résumé, slides, reviews, bio, SASE and price structure. Replies in 2-3 weeks. Finds artists through art fairs, other artists, travel.
Tips: "The common mistake artists make is not finding out what I handle and not sending professional materials."

‡RALEIGH CONTEMPORARY GALLERY, 323 Blake St., Raleigh NC 27601. (919)828-6500. Director: Rory Parnell. Retail gallery. Estab. 1984. Represents 20-25 emerging and mid-career artists/year. Sponsors 6 shows/year. Average display time 1 month. Open all year; Monday-Saturday, 11-4. Located downtown; 1,300 sq. ft.; architect-designed; located in historic property in a revitalized downtown area. 30% of space for special exhibitions; 70% of space for gallery artists. Clientele: corporate and private. 35% private collectors, 65% corporate collectors. Overall price range: $500-5,000; most work sold at $1,200-2,500.
Media: Considers oil, acrylic, watercolor, pastel, pen & ink, drawing, woodcut, engraving and lithograph. Most frequently exhibits oil/acrylic paintings, drawings and lithograph.
Style: Exhibits all styles. Genres include landscapes and florals. Prefers landscapes, realistic and impressionistic; abstracts.
Terms: Accepts work on consignment (50% commission). Retail price set by the gallery and the artist. Gallery provides insurance, promotion and contract; shipping costs are shared.
Submissions: Send query letter with résumé, slides, bio, SASE and reviews. Call or write for appointment to show portfolio of slides. Replies in 1 month. Finds artists through exhibitions, word of mouth, referrals.

North Dakota

‡THE ARTS CENTER, Dept. AGDM, 115 Second St. SW, Box 363, Jamestown ND 58402. (701)251-2496. Director: Taylor Barnes. Nonprofit gallery. Estab. 1981. Sponsors 8 solo and 4 group shows/year. Average display time 6 weeks. Interested in emerging artists. Overall price range: $50-600; most work sold at $50-350.
Style: Exhibits contemporary, abstraction, impressionism, primitivism, photorealism and realism. Genres include Americana, figurative and 3-dimensional work.
Terms: 40% commission on sales from regularly scheduled exhibitions. Retail price set by artist. Gallery provides insurance, promotion and contract; shipping costs are shared.
Submissions: Send query letter, résumé, brochure, slides, photograph and SASE. Write for appointment to show portfolio. Invitation to have an exhibition is extended by Arts Center curator.
Tips: Interested in variety.

HUGHES FINE ART CENTER ART GALLERY, Department of Visual Arts, University of North Dakota, Grand Forks ND 58202-7099. (701)777-2257. E-mail: mcelroye@badland.nodak.edu. Website: http://www.nodak.edu/dept/fac/visual_home.html. Director: Brian Paulsen. Nonprofit gallery. Estab. 1979. Exhibits emerging, mid-career and established artists. Sponsors 5 shows/year. Average display time 3 weeks. Open all year. Located on campus; 96 running ft. 100% of space for special exhibitions.
● Director states gallery is interested in "well-crafted, clever, sincere, fresh, inventive, meaningful, unique, well-designed compositions—surprising, a bit shocking, etc."
Media: Considers all media. Most frequently exhibits painting, photographs and jewelry/metal work.
Style: Exhibits all styles and genres.
Terms: Retail price set by artist. Gallery provides "space to exhibit work and some limited contact with the public and the local newspaper." Gallery pays for shipping costs. Prefers artwork framed.
Submissions: Send query letter with 10-20 slides and résumé. Portfolio review not required. Replies in 1 week. Files "duplicate slides, résumés." Finds artists from submissions through *Artist's & Graphic Designer's Market* listing, *Art*

in America listing in their yearly museum compilation; as an art department listed in various sources as a school to inquire about; the gallery's own poster/ads.

Tips: "We are not a sales gallery. Send slides and approximate shipping costs."

NORTHWEST ART CENTER, Minot State University, 500 University Ave. W., Minot ND 58707. (701)858-3264 or 3836. Fax: (701)839-6933. E-mail: olsonl@warp6.cs.misu.nodak.edu. Director: Linda Olson. Nonprofit gallery. Estab. 1970. Represents emerging, mid-career and established artists. Sponsors 15-25 shows/year. Average display time 4-6 weeks. Open all year. Two galleries: Hartnett Hall Gallery; Monday-Friday, 8-5; The Library Gallery; Monday-Friday, 8-10. Located on University campus; 1,000 sq. ft. 100% of space for special exhibitions. 100% private collectors. Overall price range: $100-40,000; most work sold at $100-4,000.

Media: Considers all media and all types of prints except posters.

Style: Exhibits all styles, all genres.

Terms: Retail price set by the artist. Gallery provides insurance, promotion and contract; shipping costs are shared. Prefers artwork framed.

Submissions: Send query letter with résumé, slides, bio, SASE and artist's statement. Call for appointment to show portfolio of originals, photographs, slides and transparencies. Replies in 1-2 months. Files all material. Finds artists through submissions, visiting exhibitions, word of mouth.

Tips: "Develop a professional presentation. Use excellent visuals—slides, etc."

‡LILLIAN AND COLEMAN TAUBE MUSEUM OF ART, Box 325, Minot ND 58702. (701)838-4445. Executive Director: Jeanne M. Rodgers. Nonprofit gallery. Estab. 1970. Represents emerging, mid-career and established artists. Sponsors 9-12 shows/year. Average display time 1-2 months. Open all year. Located at North Dakota state fairgrounds; 1,600 sq. ft.; "2-story turn-of-the-century house." 100% of space for special exhibitions. Clientele: 100% private collectors. Overall price range: $50-2,000; most work sold at $100-400.

Media: Considers oil, acrylic, watercolor, pastel, pen & ink, drawings, mixed media, collage, works on paper, sculpture, ceramic, fiber, glass, photograph, woodcuts, engravings, lithographs, serigraphs, linocuts and etchings. Most frequently exhibits watercolor, acrylic and mixed media.

Style: Exhibits all styles and genres. Prefers figurative, Americana and landscapes. No "commercial-style work (unless a graphic art display)." Interested in all media.

Terms: Accepts work on consignment (30% commission). Retail price set by artist. Offers discounts to gallery members and sometimes payment by installments. Gallery provides insurance, promotion and contract; pays shipping costs from gallery or shipping costs are shared. Requires artwork framed.

Submissions: Send query letter with résumé and slides. Write for appointment to show portfolio of good quality photographs and slides. "Show variety in your work." Files material interested in. Finds artists through visiting exhibitions, word of mouth, submissions of slides and members' referrals.

Tips: "Do not call for appointment. We are seeing many more photographers wanting to exhibit. Will take in a small show to fill in an exhibit."

Ohio

‡ACME ART COMPANY, 129 N. High St., Columbus OH 43201. (614)299-4003. Art Director: Lori McCargish. Nonprofit gallery. Estab. 1986. Represents 300 emerging and mid-career artists/year. 250 members. Exhibited artists include Rick Borg, Eric Lubkeman. Sponsors 12 shows/year. Average display time 1 month. Open all year; Wednesday-Saturday, 1:00-7:00. Located in Short North District; 1,200 sq. ft.; 3 gallery areas. 70% of space for special exhibitions; 70% of space for gallery artists. Clientele: avant-garde collectors, private and professional. 85% private collectors, 15% corporate collectors. Overall price range: $30-5,000; most work sold at $50-1,000.

Media: Considers all media and all types of prints except posters. Most frequently exhibits painting, installations and sculpture.

Style: Exhibits all styles, prefers avante-garde and cutting edge. Genres include all types of experimental and emerging art forms. Prefers experimental, socio/political and avante-garde.

Terms: Accepts work on consignment (30% commission). Retail price set by the gallery and the artist. Gallery provides promotion and contract; shipping costs are shared. Prefers artwork framed.

Submissions: Prefers only "artists who push the envelope, who explore new vision and materials of presentation." Send query letter with résumé, slides, bio, SASE and reviews. Write for appointment to show portfolio of originals if possible, slides or transparencies. Call for following fiscal year line-up ("we work 1 year in advance"). Files bio, slides, résumé and other support materials sent by artists.

Tips: Finds artists through art publications, slides from call-for-entries, minority organizations, universities and word of mouth.

ALAN GALLERY, 36 Park St., Berea OH 44017. (216)243-7794. Fax: (216)243-7772. President: Alan Boesger. Retail gallery and arts consultancy. Estab. 1983. Represents 25-30 emerging, mid-career and established artists. Sponsors 4 solo shows/year. Average display time 6-8 weeks. Clientele: 20% private collectors, 80% corporate clients. Overall price range: $700-6,000; most work sold at $1,500-2,000.

Media: Considers all media and limited edition prints. Most frequently exhibits watercolor, works on paper and mixed media.

Style: Exhibits color field, painterly abstraction and surrealism. Genres include landscapes, florals, western and figurative work.

Terms: Accepts work on consignment (40% commission). Retail price set by gallery and artist. Exclusive area representation not required. Gallery provides insurance, promotion and contract; shipping costs are shared.

Submissions: Send résumé, slides and SASE. Call or write for appointment to show portfolio of originals and slides. All material is filed.

‡THE ART EXCHANGE, 539 E. Town St., Columbus OH 43215. (614)464-4611. Fax: (614)464-4619. Art consultancy. Estab. 1978. Represents 40 emerging, mid-career and established artists/year. Exhibited artists include Mary Beam, Carl Krabill. Open all year; Monday-Friday, 9-5. Located near downtown; historic neighborhood; 2,000 sq. ft.; showroom located in Victorian home. 100% of space for gallery artists. Clientele: corporate leaders. 20% private collectors; 80% corporate collectors. Overall price range: $150-6,000; most work sold at $1,000-1,500.

Media: Considers oil, acrylic, watercolor, pastel, mixed media, collage, sculpture, ceramics, fiber, glass, photogrpahy and all types of prints. Most frequently exhibits oil, acrylic, watercolor.

Style: Exhibits painterly abstraction, impressionism, realism. Genres include florals and landscapes. Prefers impressionism, painterly abstraction, realism.

Terms: Accepts work on consignment. Retail price set by the gallery and the artist.

Submissions: Send query letter with résumé and slides or photographs. Write for appointment to show portfolio. Replies in 2 weeks. Files slides or photos and artist information. Finds artists through word of mouth, referrals by other artists, visiting art fairs and exhibitions, submissions.

Tips: "Our focus is to provide high-quality artwork and consulting services to the corporate, design and architectural communities. Our works are represented in corporate offices, health care facilities, hotels, restaurants and private collections throughout the country."

‡ARTSPACE/LIMA, P.O. Box 1948, Lima OH 45802. (419)222-1721. Fax: (419)222-6587. Gallery Director: Tracey Ladd. Nonprofit gallery. Exhibits 50-70 emerging and mid-career artists/year. Interested in seeing the work of emerging artists. Sponsors 10-13 shows/year. Average display time 5 weeks. Open all year; Monday-Friday, 10-4; Saturday, 10-2; Sunday, 2-4. Located downtown; 1,104 sq. ft. 100% of space for special exhibitions. Clientele: local community. 80% private collectors, 5% corporate collectors. Overall price range: $300-6,000; most work sold at $500-1,000.

● Most shows are thematic and geared toward education. A ceramic teapot exhibition was featured in *Ceramics Monthly* (March 1996). An April 1996 show featured contemporary abstract sculpture.

Media: Considers all media and all types of prints. Most frequently exhibits painting, sculpture, drawing.

Style: Exhibits all styles of contemporary and traditional work.

Terms: Accepts work on consignment (30% commission). Retail price set by the artist. Gallery provides insurance, promotion and contract; shipping costs are shared. Prefers artwork framed.

Submissions: Send query letter with résumé, slides, artist's statement and SASE. Portfolio should include slides. Replies only if interested within 3-6 weeks. Files résumé. Also represents about 30 regional artists working in fine craft (glass, ceramics, etc.) and painting in gallery shop. Contact Megan Runk, Artspace Gallery Shop if interested.

‡THE CANTON MUSEUM OF ART, 1001 Market Ave. N., Canton OH 44702. (330)453-7666. Executive Director: M. Joseph Albacete. Nonprofit gallery. Estab. 1935. Represents emerging, mid-career and established artists. Sponsors 25 solo and 5 group shows/year. Average display time is 6 weeks. Price range: $50-3,000; few above $300-500.

Media: Considers all media. Most frequently exhibits oil, watercolor and photography.

Style: Considers all styles. Most frequently exhibits painterly abstraction, post-modernism and realism.

Terms: "While every effort is made to publicize and promote works, we cannot guarantee sales, although from time to time sales are made, at which time a 25% charge is applied." One of the most common mistakes in presenting portfolios is "sending too many materials. Send only a few slides or photos, a brief bio and an SASE."

Tips: There seems to be "a move back to realism, conservatism and support of regional artists."

‡CHELSEA GALLERIES, 23225 Mercantile Rd., Beachwood OH 44122. (216)591-1066. Fax: (216)591-1068. Director: Jill T. Wieder. Retail gallery. Estab. 1975. Represents/exhibits 400 emerging and mid-career artists/year. Exhibited artists include Leonard Urso and Tom Seghi. Sponsors 5 shows/year. Average display time 6 months. Open all year; Monday-Friday, 9-5; Saturday, 12-4. Located in suburban design and architectural resource area; 3,500 sq. ft.; open, adjustable showroom; easy access, free parking, halogen lighting. 40% of space for special exhibitions; 100% of space for gallery artists. Clientele: upscale. 85% private collectors, 15% corporate collectors. Overall price range: $50-10,000; most work sold at $500-2,000.

Media: Considers all media and all types of prints. Most frequently exhibits painting, glass and ceramics.

Style: Exhibits all styles and all genres. Prefers: impressionism, realism and abstraction.

Terms: Artwork is accepted on consignment (50% commission). Retail price set by the gallery and the artist. Gallery provides insurance, promotion and contract; shipping costs are shared. Prefers artwork framed.

Submissions: Send query letter with résumé and slides. Call for appointment to show portfolio of photographs and slides. Replies in 6 weeks. Files résumé and slides.

Tips: "Be realistic in pricing—know your market."

CLEVELAND STATE UNIVERSITY ART GALLERY, 2307 Chester Ave., Cleveland OH 44114. (216)687-2103. Fax: (216)687-2275. E-mail: rthurmer@csu-e.csuohio.edu. Website: http://www.math3.csuohio.edu/~anderson/gall.ht ml. Director: Robert Thurmer. Assistant Director: Tim Knapp. University gallery. Exhibits 50 emerging, mid-career and established artists. Exhibited artists include Ellen Phelan and Kay Walkingstick. Sponsors 9 shows/year. Average display time 1 month. Open Monday-Saturday, 10-4. Closed Sunday and holidays. Located downtown: 4,500 sq. ft. (250 running ft. of wall space). 100% of space for special exhibitions. Clientele: students, faculty, general public. 85% private collectors, 15% corporate collectors. Overall price range: $250-50,000; most work sold at $300-1,000.
Media: Considers all media and all types of prints. Prefers painting, sculpture and new genres of work.
Style: Exhibits all styles and genres. Prefers: contemporary, modern and postmodern. Looks for challenging work.
Terms: 25% commission. Sales are a service to artists and buyers. Gallery provides insurance, promotion, shipping costs to and from gallery; artists handle crating. Prefers artwork framed.
Submissions: Send query letter with résumé and slides. Portfolio review requested if interested in artist's work. Files résumé and slides. Finds artists through visiting exhibitions, artists' submissions, publications and word of mouth. Submission guidelines available for SASE.
Tips: "No oversized or bulky materials please! 'Just the facts ma'am.' "

THE A.B. CLOSSON JR. CO., 401 Race St., Cincinnati OH 45202. (513)762-5510. Fax: (513)762-5515. Director: Phyllis Weston. Retail gallery. Estab. 1866. Represents emerging, mid-career and established artists. Average display time 3 weeks. Clientele: general. Overall price range: $600-75,000.
Media: Considers oil, watercolor, pastel, mixed media, sculpture, original handpulled prints, limited offset reproductions.
Style: Exhibits all styles and genres.
Terms: Accepts work on consignment or buys outright. Retail price set by gallery and artist. Customer discounts and payment by installment are available. Exclusive area representation required. Gallery provides insurance and promotion; shipping costs are shared.
Submissions: Send photos, slides and résumé. Call or write for appointment. Portfolio review requested if interested in artist's work. Portfolio should include originals. Finds artists through agents, visiting exhibitions, word of mouth, various art publications, sourcebooks, submissions/self-promotions and art collectors' referrals.

‡**EMILY DAVIS GALLERY**, School of Art, University of Akron, Akron OH 44325-7801. (216)972-5950. E-mail: bengsto@uakron.edu. Director: Rod Bengston. Nonprofit gallery. Estab. 1974. Clientele: persons interested in contemporary/avant-garde art. 12 shows/year. Average display time is 3½ weeks. Interested in emerging and established artists. Overall price range: $100-65,000; "no substantial sales."
Media: Considers all media.
Style: Exhibits contemporary, abstract, figurative, non-representational, photorealistic, realistic, avant-garde and neo-expressionistic works.
Terms: Retail price is set by artist. Exclusive area representation not required. Gallery provides insurance, shipping costs, promotion and contract.
Submissions: Send query letter with 1-page résumé, brochure, 20 slides, photographs and SASE. Write for an appointment to show a portfolio. Résumés are filed. Finds artists through visiting exhibitions, word of mouth, various art publications, sourcebooks and artists' submissions/self-promotions.
Tips: "The gallery is a learning laboratory for our students. To that end, we exhibit contemporary, and avant-garde artists drawn from national level." Advice for artists looking for gallery representation: "Match the work to the gallery before approaching the gallery director or curator. Present the work in person, if possible."

‡**EAST/WEST ALTERNATIVE GALLERY**, 2025 Murray Hill Rd., Cleveland OH 44106. (216)231-6141. Contact: Director. Cooperative/consignment gallery. Estab. 1990. Interested in seeing the work of all artists. Sponsors 8 shows/year. Average display time 6 weeks. Open all year. Located in historic Little Italy. 40% of space for special exhibitions. Clientele: 90% private collectors, 10% corporate collectors. Overall price range: $30-3,000; most work sold at $30-750.
Media: Considers all media and all types of prints except posters and offset reproductions. Most frequently exhibits paintings, sculpture and ceramics.
Style: Exhibits all styles and genres.
Terms: Co-op membership fee plus donation of time (80% commission). Retail price set by artist. Sometimes offers customer discounts and payment by installment. Gallery provides promotion. Prefers artwork framed.
Submissions: Send query letter with résumé and bio. Write for appointment to show portfolio of slides. Replies in 1 month. Files résumé and letter of acceptance or rejection.
Tips: Looking for "financial ability to split rent, time to gallery sit, and quality artwork and commitment."

‡**FAVA**, New Union Center for the Arts, 39 S. Main St., Oberlin OH 44074. (440)774-7158. Fax: (440)774-1107. Nonprofit gallery. Estab. 1979. Exhibits emerging, mid-career and established artists. Approached by 100 artists/year. Represents/exhibits 8 artists. Sponsors 7 exhibits/year. Average display time 1 month. Open all year; Tuesday-Saturday, 12-5; Sunday, 2-4. Located on ground floor of historic 1874 building; 2 galleries, total 1,525 sq. ft.; 14 ft. ceilings. Clientele: local community, tourists, upscale. 5% corporate collectors. Overall price range: $75-3,000; most work sold at $250.

Media: Considers all media. Most frequently exhibits sculpture, photography, art quilts. Considers all types of prints except posters.
Style: Considers all styles.
Terms: Gallery retains 30% commission on artwork sold by exhibitors. Retail price set by the artist. Gallery provides insurance, promotion and contract. Accepted work should be framed and matted. Does not require exclusive representation locally.
Submissions: Send query letter with artist's statement, bio or résumé, brochure, business card, slides and SASE. Returns material with SASE. Finds artists through submissions and referrals by other artists.

FIRELANDS ASSOCIATION FOR VISUAL ARTS at New Union Center for the Arts, 39 S. Main St., Oberlin OH 44074. (216)774-7158. Fax: (216)775-1107. Gallery Director: Susan Jones. Nonprofit gallery. Estab. 1979. Represents/exhibits 15 emerging, mid-career and established artists/year. Presents 7 shows/year. Average display time 1 month. Open all year; Tuesday-Saturday, 12-5; Sunday, 2-4. Located downtown Oberlin; ground floor galleries, 1,525 sq. ft.; 14′ ceilings, elegant white walls. 100% of space for special exhibitions. Clientele: national audience. 85% private collectors, 15% corporate collectors. Overall price range: $100-4,000; most work sold at $100-1,000.
Media: Considers all media and all types of prints except posters.
Style: Exhibits all styles. Not interested in genre work.
Terms: "We select artists once a year in the fall based on slide application. Artists are not represented after show ends." 30% commission on sales during show. Retail price set by the artist. Gallery provides insurance, promotion and contract. Artist pays for shipping cost. Prefers artwork framed.
Submissions: Send query letter with résumé, 15-20 slides, slide list, artist statement and SASE by October 15 each year to be considered for the following year's season.

‡**CHARLES FOLEY GALLERY**, 973 E. Broad St., Columbus OH 43205. (614)253-7921. Director: Charles Foley. Retail gallery. Estab. 1982. Represents established artists. Interested in seeing the work of emerging artists. Exhibited artists include Tom Wesselmann and Richard Anuszkiewicz. Sponsors 2 shows/year. Average display time 8 weeks. Open all year. Located east of the Columbus Museum of Art; 5,000 sq. ft.; "housed in a turn-of-the-century house, specializing in 20th-century masters." 50% of space for special exhibitions, 50% for gallery artists. Clientele: 90% private collectors, 10% corporate clients. Overall price range: $30-150,000; most artwork sold at $2,500-20,000.
Media: Considers oil, acrylic, watercolor, pen & ink, drawings, mixed media, collage, works on paper, sculpture, ceramic, original handpulled prints, woodcuts, linocuts, engravings, etchings, lithographs, serigraphs and posters. Most frequently exhibits paintings, etchings and drawings.
Style: Exhibits expressionism, color field and hard-edge geometric abstraction. Prefers pop art, op art and expressionism.
Terms: Accepts work on consignment (30% commission). Retail price set by the gallery and the artist. Gallery provides promotion. Gallery pays for shipping costs. Prefers framed artwork.
Submissions: Send query letter with SASE. Call to schedule an appointment to show portfolio, which should include originals and transparencies.

HILLEL JEWISH STUDENT CENTER GALLERY, 2615 Clifton Ave., Cincinnati OH 45220. (513)221-6728. Fax: (513)221-7134. Gallery Curator: Claire Lee. Nonprofit gallery, museum. Estab. 1982. Represents 5 emerging artists/academic year. Exhibited artists include Gordon Baer, Irving Amen and Lois Cohen. Sponsors 5 shows/year. Average display time 5-6 weeks. Open all year fall, winter, spring; Monday-Thursday, 9-5; Friday, 9-3; other hours in conjunction with scheduled programming. Located uptown (next to University of Cincinnati); 1,056 sq. ft.; features the work of Jewish artists in all media; listed in AAA Tourbook; has permanent collection of architectural and historic Judaica from synagogues. 20% of space for special exhibitions; 80% of space for gallery artists. Clientele: upscale, community, students. 90% private collectors, 10% corporate collectors. Overall price range: $150-3,000; most work sold at $150-800.
Media: Considers all media except installations. Considers all types of prints. Most frequently exhibits prints/mixed media, watercolor, photographs.
Style: Exhibits all styles. Genres include landscapes, figurative work and Jewish themes. Avoids minimalism and hard-edge geometric abstraction.
Terms: Artwork accepted for exhibit and there is a 30% commission. Retail price set by the artist. Gallery provides insurance, promotion, contract, opening reception; shipping costs are shared. Prefers artwork framed.
Submissions: "With rare exceptions, we feature Jewish artists." Send query letter with slides, bio or photographs, SASE. Call or write for appointment to show portfolio. Replies in 1 week. Files bios/résumés, description of work.

‡**IBEL SIMENOV**, 1055 N. High St., Columbus OH 43201. (614)291-2555. Fax: (614)291-2715. Contact: Rebecca Ibel or Iana Simeonov. Retail gallery and art consultancy. Estab. 1993. Represents/exhibits 20-25 emerging, mid-career and established artists/year. Sponsors 9 shows/year. Average display time 6 weeks. Open all year; Tuesday-Saturday, 10-6. Located in Short North (gallery district) near downtown; 2,100 sq. ft. renovated garage; double storefront, white walls, 18 ft. ceilings. 85% of space for special exhibitions. 100% private collectors. Overall price range: $100-50,000; most work sold at $6,000-10,000.
Media: Considers all media except crafts and all types of prints. Most frequently exhibits painting, works on paper and sculpture.
Terms: Artwork is accepted on consignment (50% commission). Retail price set by the gallery and artist. Gallery

provides insurance, promotion, contract; shipping costs are shared. Prefers artwork unframed.
Submissions: Send query letter with slides, reviews, bio and SASE. Call for appointment to show portfolio of slides. Replies in 3 weeks. Finds artists through referrals, art fairs and artists' submissions.
Tips: "Clearly label all slides including name, title, year, full description, size and price. Do not include an artist statement."

‡KUSSMAUL GALLERY, 140 E. Broadway, P.O. Box 338, Granville OH 43023. (740)587-4640. Owner: James Young. Retail gallery, custom framing. Estab. 1989. Represents 6-12 emerging and mid-career artists/year. Exhibited artists include James Young and Greg Murr. Sponsors 3-4 shows/year. Average display time 30 days. Open all year; Tuesday-Saturday, 10-5; Sunday, 11-3. Located downtown; 3,200 sq. ft.; restored building erected 1830—emphasis on interior brick walls and restored tin ceilings. New gallery space upstairs set to open spring of '98 with cathedral ceilings, exposed brick walls, skylights, approximately 1,600 sq. ft. devoted only to framed art and sculpture. 25% of space for art displays. Clientele: upper-middle. 75% private collectors, 25% corporate collectors. Overall price range: $75-2,500; most work sold at $150-350.
Media: Considers oil, acrylic, watercolor, mixed media, sculpture, glass, all types of prints. Most frequently exhibits watercolor.
Style: Exhibits expressionism, neo-expressionism, primitivism, abstraction, impressionism, realism. Prefers: impressionism and realism.
Terms: Accepts work on consignment (40% commission) or buys outright. Retail price set by the gallery. Gallery provides insurance on work purchased outright and promotion; artist pays shipping costs to and from gallery. Prefers artwork unframed.
Submissions: Send query letter with résumé, slides, bio and SASE. Replies only if interested within 1 month. Files slides, bio or returns them. Finds artists through networking, talking to emerging artists.
Tips: "Don't overprice your work, be original. Have large body of work representing your overall talent and style."

LICKING COUNTY ART GALLERY, P.O. Box 4277, Newark OH 43058-4277. (740)349-8031. Nonprofit gallery. Estab. 1959. Represents 30 artists; emerging, mid-career and established. Sponsors 12 shows/year. Average display time 1 month. Located 6 blocks north of downtown; 784 sq. ft.; in a Victorian brick building. 70% of space for special exhibitions. Clientele: 90% private collectors, 10% corporate clients. Overall price range: $30-6,000; most work sold at $100-500.
Media: Considers oil, acrylic, watercolor, pastel, pen & ink, drawings, mixed media, collage, works on paper, sculpture, ceramic, fiber, glass, installation, photography, original handpulled prints, woodcuts, engravings, lithographs, wood engravings, serigraphs and etchings. Most frequently exhibits watercolor, oil/acrylic and photography.
Style: Exhibits conceptualism, color field, impressionism, realism, photorealism and pattern painting. Genres include landscapes, florals, wildlife, portraits and all genres.
Terms: Artwork is accepted on consignment (30% commission.) Retail price set by artist. Gallery provides insurance, promotion and contract; artist pays for shipping. Prefers framed artwork.
Submissions: Send query letter with résumé, brochure and photographs. Write to schedule an appointment to show a portfolio, which should include originals and slides. Replies only if interested within 6 weeks.

MALTON GALLERY, 2709 Observatory, Cincinnati OH 45208. (513)321-8614. Director: Donald Malton. Retail gallery. Estab. 1974. Represents about 75 emerging, mid-career and established artists. Exhibits 12 artists/year. Exhibited artists include Carol Henry, Mark Chatterley, Patrick Trauth and Philippe Lejeune. Sponsors 6 shows/year. Average display time 1 month. Open all year; Monday-Saturday, 10-5. Located in high-income neighborhood shopping district. 1,700 sq. ft. "Friendly, non-intimidating environment." 2-person shows alternate with display of gallery artists. Clientele: private and corporate. Overall price range: $250-10,000; most work sold at $400-2,500.
Media: Considers oil, acrylic, drawing, sculpture, watercolor, mixed media, pastel, collage and original handpulled prints.
Style: Exhibits all styles. Genres include contemporary landscapes, figurative and narrative and abstractions work.
Terms: Accepts work on consignment (50% commission). Retail price set by artist (sometimes in consultation with gallery). Gallery provides insurance, promotion, contract and shipping costs from gallery; artist pays shipping costs to gallery. Prefers framed works for canvas; unframed works for paper.
Submissions: Send query letter with résumé, slides or photographs, reviews, bio and SASE. Replies in 2-4 weeks. Files résumé, review or any printed material. Slides and photographs are returned.
Tips: "Never drop in without an appointment. Be prepared and professional in presentation. This is a business. Artists themselves should be aware of what is going on, not just in the 'art world,' but with everything."

THE MIDDLETOWN FINE ARTS CENTER, 130 N. Verity Pkwy., P.O. Box 441, Middletown OH 45042. (513)424-2416. Contact: Peggy Davish. Nonprofit gallery. Estab. 1957. Represents emerging, mid-career and established artists. Sponsors 5 solo and/or group shows/year. Average display time 3 weeks. Clientele: tourists, students, community. 95% private collectors, 5% corporate clients. Overall price range: $100-1,000; most work sold at $150-500.
Media: Considers all media except prints. Most frequently exhibits watercolor, oil, acrylic and drawings.
Style: Exhibits all styles and genres. Prefers: realism, impressionism and photorealism. "Our gallery does not specialize in any one style or genre. We offer an opportunity for artists to exhibit and hopefully sell their work. This also is an important educational experience for the community. Selections are chosen two years in advance by a committee."

Terms: Accepts work on consignment (30% commission). Retail price set by artist. Sometimes offers customer discounts and payment by installment. Exclusive area representation not required. Gallery provides promotion; artist pays for shipping. Artwork must be framed and wired.

Submissions: Send query letter with résumé, brochure, slides, photographs and bio. Write for an appointment to show portfolio, which should include originals, slides or photographs. Replies in 3 weeks-3 months (depends when exhibit committee meets.). Files résumé or other printed material. All material is returned if not accepted or under consideration. Finds artists through word of mouth, submissions and self-promotions.

Tips: "Decisions are made by a committee of volunteers, and time may not permit an on-the-spot interview with the director."

‡**MILLER GALLERY**, 2715 Erie Ave., Cincinnati OH 45208. (513)871-4420. Fax: (513)871-4429. E-mail: gallery123 @aol.com. Co-Directors: Barbara and Norman Miller. Retail gallery. Estab. 1960. Interested in emerging, mid-career and established artists. Represents about 50 artists. Sponsors 5 solo and 4 group shows/year. Average display time 1 month. Located in affluent suburb. Clientele: private collectors. Overall price range: $100-35,000; most artwork sold at $300-12,000.

Media: Considers, oil, acrylic, mixed media, collage, works on paper, ceramic, fiber, bronze, stone, glass and original handpulled prints. Most frequently exhibits oil or acrylic, glass, sculpture and ceramics.

Style: Exhibits impressionism, realism and painterly abstraction. Genres include landscapes, interior scenes and still lifes. "Everything from fine realism (painterly, impressionist, pointilist, etc.) to beautiful and colorful abstractions (no hard-edge) and everything in between. Also handmade paper, collage, fiber and mixed mediums."

Terms: Accepts artwork on consignment (50% commission). Retail price set by artist and gallery. Sometimes offers payment by installment. Exclusive area representation is required. Gallery provides insurance, promotion and contract; shipping and show costs are shared.

Submissions: Send query letter with résumé, brochure, 10-12 slides or photographs with sizes, wholesale (artist) and selling price and SASE. All submissions receive phone or written reply. Finds artists through agents, visiting exhibitions, word of mouth, various art publications and sourcebooks, submissions/self-promotions, art collectors' referrals, and *Artist's and Graphic Designer's Market.*

Tips: "Artists often either completely omit pricing info or mention a price without identifying as artist's or selling price. Submissions without SASE will receive reply, but no return of materials submitted. Make appointment—don't walk in without one. Quality, beauty, originality are primary. Minimal, conceptual, political works not exhibited."

‡**REINBERGER GALLERIES, CLEVELAND INSTITUTE OF ART**, 11141 E. Blvd., Cleveland OH 44106. (216)421-7407. Fax: (216)421-7438. Director: Bruce Checefsky. Nonprofit gallery, college. Estab. 1882. Represents established artists. 8 gallery committee members. Sponsors 9 shows/year. Average display time 4-6 weeks. Open all year; Sunday 1-4, Monday 9-4, Tuesday-Saturday, 9:30-9. Located University Circle; 5,120 sq. ft.; largest independant exhibit facility in Cleveland (for college or university). 100% of space for special exhibitions. Clientele: students, faculty and community at large. 80% private collectors, 30% corporate collectors. Overall price range: $50-75,000; most work sold under $1,000.

Media: Considers all media. Most frequently exhibits prints, drawings, paintings, sculpture, installation, fiber and experimental.

Style: Exhibits all styles, all genres.

Terms: Accepts work on consignment (15% commission). Retail price set by the artist. Gallery provides insurance, promotion, contract and shipping costs.

Submissions: Send query letter with résumé, slides, bio, photographs, SASE and reviews. No phone inquires. Replies in 6 months. Files bio and slides when applicable.

RUTLEDGE GALLERY, 1964 N. Main St., Dayton OH 45405. (513)278-4900. Director: Jeff Rutledge. Retail gallery, art consultancy. Focus is on artists from the Midwest. Estab. 1991. Represents 80 emerging and mid-career artists/year. Exhibited artists include Pat Antonic, Chris Shatzby and M. Todd Muskopf. Sponsors 12 shows/year. Average display time 2 months. Open all year; Tuesday-Saturday, 11-6. Located 1 mile north of downtown in Dayton's business district; 2800 sq. ft. "We specialize in sculpture and regional artists. We also offer commissioned work and custom framing." 70% of space for special exhibitions; 70% of space for gallery artists. Clientele: residential, corporate, private collectors, institutions. 65% private collectors, 35% corporate collectors.

Media: Considers oil, acrylic, watercolor, pastel, pen & ink, drawing, mixed media, paper, sculpture, ceramic, craft, glass, jewelry, woodcuts, engravings, lithographs, linocuts, etchings and posters. Most frequently exhibits paintings, drawings, prints and sculpture.

Style: Exhibits expressionism, painterly abstraction, surrealism, color field, impressionism and realism. Considers all genres. Prefers: contemporary (modern), geometric and abstract.

Terms: Accepts work on consignment (40% commission). Retail price set by gallery. Gallery provides insurance, promotion and contract; artists pays shipping costs. Prefers artwork framed.

Submissions: Accepts mainly Midwest artists. Send query letter with résumé, brochure, 20 slides and 10 photographs. Call for appointment to show portfolio of originals, photographs, slides and transparencies. Replies only if interested within 1 month. Files "only material on artists we represent; others returned if SASE is sent or thrown away."

Tips: "Be well prepared, be professional, be flexible on price and listen."

SPACES, 2220 Superior Viaduct, Cleveland OH 44113. (216)621-2314. Alternative space. Estab. 1978. Represents emerging artists. Has 300 members. Sponsors 10 shows/year. Average display time 6 weeks. Open all year; Tuesday-Sunday. Located downtown Cleveland; 6,000 sq. ft.; "loft space with row of columns." 100% private collectors.
Media: Considers all media. Most frequently exhibits installation, painting and sculpture.
Style: Exhibits all styles. Prefers challenging new ideas.
Terms: Accepts work on consignment. 20% commission. Retail price set by the artist. Sometimes offers payment by installment. Gallery provides insurance, promotion and contract.
Submissions: Send query letter with résumé, 15 slides and SASE. Annual deadline in spring for submissions.
Tips: "Present yourself professionally and don't give up."

‡THE ZANESVILLE ART CENTER, 620 Military Rd., Zanesville OH 43701. (614)452-0741. Fax: (614)452-0797. Director: Philip Alan LaDouceur. Nonprofit gallery, museum. Estab. 1936. Represents emerging, mid-career and established artists. "We usually hold three exhibitions per month." Sponsors 25-30 shows/year. Average display time 6-8 weeks. Open all year; closed Mondays and major holidays. 1,152 sq. ft. 50% of space for special exhibitions; 50% of space for gallery artists. Clientele: artists of distinguished talent. 25% private collectors, 25% corporate collectors. Most work sold at $300-1,500.
Media: Considers all media. Most frequently exhibits watermedia, oil, collage, ceramics, sculpture and children's art, as well as all photography media.
Style: Exhibits all styles and genres.
Terms: Accepts work on consignment (30% commission on sales). Retail price set by the artist. Gallery provides insurance and promotion; artist responsible for shipping costs to and from gallery. Prefers artwork framed.
Submissions: Send query letter with résumé, slides, bio, photographs and reviews. Replies in 1 month. Artist should follow up after query letter or appointment. Files bio or résumé. Finds artists through exhibitions, word of mouth, art publications and submissions.

Oklahoma

‡CITY ARTS CENTER, 3000 Pershing Blvd., Oklahoma City OK 73107. (405)951-0000. Fax: (405)951-0003. Nonprofit gallery. Estab. 1988. Exhibits feature emerging, mid-career and established artists. 200 patron members. Exhibited artists include Michi Susan and Gloria Duncan. Sponsors 11 shows/year. Open all year; Monday-Thursday, 9-10; Friday and Saturday, 9-5; Sunday, 1-5. Located on the State Fairgrounds. 5,000 sq. ft. "Main Gallery is large and spacious and newly renovated; Circle Gallery is old Planetarium space." 60% of space for special exhibitions; 40% of space for gallery artists. Clientele: art patrons from Oklahoma City metro area. 70% private collectors, 30% corporate collectors. Overall price range: $12-3,000; most work sold at $500-3,000.
Media: Considers oil, pen & ink, paper, fiber, acrylic, oil, drawings, sculpture, glass, watercolor, mixed media, ceramic, installation, pastel, collage, craft, photography, relief, intaglio, lithographs and serigraphs. Prefers mixed media, photography and ceramic.
Style: Exhibits expressionism, neo-expressionism, primitivism, painterly abstraction and realism. All genres. Prefers abstraction, conceptualism and postmodern works.
Terms: Accepts work on consignment (60% commission). Retail price set by artist. Gallery provides promotion and contract (when required); artist pays for shipping costs. Prefers artwork framed.
Submissions: Cannot exhibit works of a graphic sexual nature. Send query letter with résumé, brochure, business card, 15-20 slides, bio and SASE. Call or write for appointment to show portfolio of slides and transparencies. Replies in 2 months. Files résumé, bio, slides (unless artist wants returned).
Tips: "Professional quality slides are a must. Select work to be presented carefully—work should have related elements."

‡FIREHOUSE ART CENTER, 444 S. Flood, Norman OK 73069. (405)329-4523. Contact: Gallery Committee. Nonprofit gallery. Estab. 1971. Exhibits emerging, mid-career and established artists. 400 members. Sponsors 10-12 group and solo shows/year. Average display time 3-4 weeks. Open all year. Located in former fire station; 629.2 sq. ft. in gallery; consignment sales gallery has additional 620 sq. ft. display area; handicapped-accessible community art center offering fully equipped ceramics, painting, sculpture, jewelry and fiber studios plus b&w photography lab. Classes and workshops for children and adults are offered quarterly. Clientele: 99% private collectors, 1% corporate collectors.
Media: Most frequently exhibits functional and decorative ceramics and sculpture, jewelry, paintings and wood.
Style: All styles and fine crafts. All genres. Prefers: realism and impressionism.
Terms: Accepts work on consignment (35% commission). Offers discounts to gallery members. Gallery provides insurance and promotion for gallery exhibits and consignment sales; artist pays for shipping. Prefers artwork framed.
Submissions: Accepts only artists from south central US. Send query letter with résumé, bio, artist's statement, 20 slides of current work and SASE. Portfolio review required. Replies in 4 months. Finds artists through word of mouth, art publications, and art collectors' referrals.
Tips: "Develop a well-written statement and résumé. Send professional slides!"

‡GUSTAFSON GALLERY, 7000 N. Country Club Place, Oklahoma City OK 73116. (405)840-9818. President: Diane. Retail gallery. Estab. 1973. Represents 15 mid-career artists. Exhibited artists include D. Norris Moses and

Downey Burns. Sponsors 1 show/year. Average display time 2 months. Open all year. Located in a suburban mall; 1,800 sq. ft. 100% of space for special exhibitions. Clientele: upper and middle income. 60% private collectors, 40% corporate collectors. Overall price range: $4,000 maximum.

Media: Considers oil, acrylic, pastel, mixed media, collage, works on paper, sculpture, ceramic, fiber, offset reproductions, lithographs, posters and serigraphs. Most frequently exhibits acrylic, pastel and serigraphs.

Style: Exhibits primitivism and painterly abstraction. Genres include landscapes, southwestern and western. Prefers contemporary southwestern art.

Terms: Artwork is accepted on consignment (40% commission); or buys outright for 50% of the retail price; net 30 days. Retail price set by the artist. Gallery provides promotion; Shipping costs are shared.

Submissions: Send query letter with résumé, brochure, photographs, business card and reviews. Call to schedule an appointment to show a portfolio, which should include originals and photographs. Replies in 1 month.

HOUSE GALLERY, 5536 N. Western, Oklahoma City OK 73118. (405)848-3690. Fax: (405)848-0514. President: Kay Hubbard. Retail and corporate art gallery and art consultancy. Estab. 1977. Represents 30 emerging and collectable artists and mid-career artists/year. Exhibited artists include Margaret Martin and Cletus Smith. Sponsors 12 shows/year. Average display time 1 month. Open all year; Monday-Friday, 9-5; Saturday by appointment. Located close to upper residential areas; 3,000 sq. ft.; contemporary building, space design, unique framing. 50% of space for special exhibitions; 50% of space for gallery artists. Clientele: upscale. 20% private collectors; 40% corporate collectors. Overall price range: $250-10,000; most work sold at $500-3,000.

Media: Considers all media and all types of prints. Most frequently exhibits abstract oils, impressionist oils and traditional oils.

Style: Exhibits expressionism, painterly abstraction, conceptualism, impressionism and realism. Exhibits all genres. Prefers landscapes, abstracts and impressionism.

Terms: Accepts work on consignment (45% commission). Retail price set by the gallery. Gallery provides promotion and contract; shipping costs are shared. Prefers artwork framed.

Submissions: "Only artists working full time in the field who are dedicated to growth and have consistency in style." Send résumé, slides, bio, photographs and SASE. Write for appointment to show portfolio of photographs or slides. Replies in 2-4 weeks. Files only that of potentially good work. Finds artists through publications, major shows, submissions and word of mouth.

Tips: "Artist's three biggest mistakes are walking in, insisting on bringing work instead of following gallery rules of submittal and sending slides or photos of work inconsistent in style."

LACHENMEYER ARTS CENTER, 700 S. Little, P.O. Box 586, Cushing OK 74023. (918)225-7525. Director: Rob Smith. Nonprofit. Estab. 1984. Exhibited artists include Darrell Maynard, Steve Childers and Dale Martin. Sponsors 4 shows/year. Average display time 2 weeks. Open in August, September, December; Monday, Wednesday, Friday, 9-5; Tuesday, Thursday, 5-9. Located inside the Cushing Youth and Community Center; 550 sq. ft. 80% of space for special exhibitions; 80% of space for gallery artists. 100% private collectors.

Media: Considers oil, acrylic, watercolor, pastel, pen & ink, drawing, mixed media, collage, paper, sculpture, ceramics, fiber, photography, woodcuts, engravings, lithographs, wood engravings, mezzotints, serigraphs, linocuts and etchings. Most frequently exhibits oil, acrylic and works on paper.

Style: Exhibits all styles. Prefers: landscapes, portraits and Americana.

Terms: Retail price set by the artist. Gallery provides promotion; shipping costs are shared. Prefers artwork framed.

Submissions: Send query letter with résumé, professional quality slides, SASE and reviews. Call or write for appointment to show portfolio of originals. Replies in 1 month. Files résumés. Finds artists through visiting exhibits, word of mouth, other art organizations.

Tips: "We are booked one to two years in advance. I prefer local and regional artists."

MERCANTILE GALLERY, (formerly Bricktown Gallery), 4417 N. Western, Oklahoma City OK 73318. (405)235-0505. Director: Will Gumerson. Retail gallery. Estab. 1993. Represents 50 emerging, mid-career and established artists/year. Exhibited artists include Dennis Parker, O. Gail Poole, Donna Berryhill, Caroll Houser and Marge Donley. Sponsors 6 shows/year. Average display time 3 months. Open all year; Monday, 10-6; Tuesday-Thursday, 10-8; Friday, 10-9; Saturday, 12-9; closed Sunday. Located historic bricktown just east of downtown; 3,000 sq. ft.; wonderful high ceilings, historic building, lots of light and windows, art reference library. 50% of space for special exhibitions; 50% of space for gallery artists. Clientele: tourists, local community and upscale. 90% private collectors, 10% corporate collectors. Overall price range: $10-10,000; most work sold at $200-500.

Media: Considers oil, acrylic, watercolor, pastel, paper, sculpture, ceramics, craft, fiber, glass and photography; all types of prints. Most frequently exhibits oil, acrylic and sculpture of all kinds, especially glass.

Style: Exhibits expressionism, painterly abstraction, impressionism, photorealism and realism. Genres include florals, portraits, wildlife, landscapes and figurative work. Prefers impressionism, realism and painterly abscraction.

Terms: Accepts work on consignment (40% commission). Retail price set by the artist. Gallery provides promotion and contract; artist pays for shipping except in the case of shipping art to collectors. Prefers artwork framed (must be exceptional quality).

Submissions: Must have professional attitude and spirit of excellence. Send query letter with résumé, slides, bio, photographs, SASE and artist's statement. Write for appointment to show portfolio of slides. Replies in 2 weeks. Files bios and slides. Finds artists through word of mouth, referrals by other artists, visiting exhibitions and submissions.

In this piece, titled *Our Lodges Were Many and the Prairie Was Full*, artist Darran Cooper tried to capture the "nobility of the Osage people, their strength and connection with the earth." Drawn with graphite pencil, this portrait was the 1994 first place winner, graphics division, at the Red Earth/Native American Art Show in Oklahoma City. Cooper exhibits and sells prints of his work at Scissortail Fine Arts gallery in Poteau, Oklahoma, where he also keeps studio space. Advises the artist: "Find two or three good galleries and show to market your work, and concentrate on those."

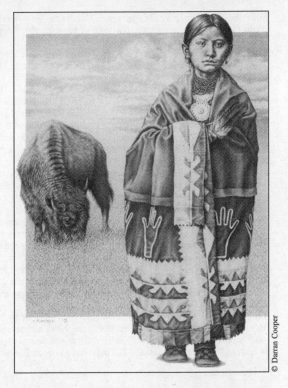

© Darran Cooper

Tips: "We will not accept artwork that is obviously done in attempt to copy another artist's popular style or subject."

NATIVE AMERICAN ART, 317 S. Main, Tulsa OK 74103. (918)584-5792. Owner: Wes Gan. Retail gallery. Estab. 1985. Represents 25 emerging, mid-career and established artists/year. Exhibited artists include Ruthe Blalock Jones and Will Wilson. Sponsors 1 show/year. Open all year; Monday-Friday, 10-5. Located downtown; 1,000 sq. ft. 100% of space for gallery artists. Clientele: tourists, upscale, local community and students. 90% private collectors; 10% corporate collectors. Overall price range: $100-5,000; most work sold at $250-500.
Media: Considers oil, acrylic, watercolor, pastel, pen & ink, drawing, mixed media, collage, paper, sculpture, ceramics and fiber; and all types of prints. Most frequently exhibits watercolor, monotype and acrylic.
Style: Exhibits primitivism, surrealism, minimalism, impressionism, photorealism, realism and imagism. Genres include Indian. Prefers: traditional, contemporary as in monotypes and impressionism.
Terms: Accepts work on consignment (40% commission) or buys outright for 50% of retail price. Retail price set by the gallery and artist. Gallery provides insurance, promotion and framing; shipping costs are shared. Prefers artwork unframed.
Submissions: Membership in a Native American tribe. Send query letter with résumé, bio, brochure, photographs, reviews and artist's statement. Call or write for appointment to show portfolio of photographs. Finds artists through referrals from other artists and submissions.
Tips: "Artists should let their work speak for itself and keep working—quality takes talent and much time and effort."

SCISSORTAIL FINE ARTS, 103 N. Broadway, Poteau OK 74953. (918)647-4060. E-mail: handprints@clnk.com. Owner: Carol W. Smith. Retail and wholesale gallery. Estab. 1991. Represents 6 mid-career and established artists/year. Exhibited artists include Darran Cooper and Carol Keeny. Sponsors shows on an ongoing basis. Average display time 4 months. Open all year; Monday-Friday, 9:30-5:30; Saturday, 9:30-2:30. Located near Town Center; 1,000 sq. ft.. Clientele: local and tourists. 85% private collectors, 15% corporate collectors. Overall price range: $100-1,200; most work sold at $150-500 (originals), $40-100 (prints).
 ● Now included with Scissortail Fine Arts is a new company, Handprints, which does graphic arts and in-house silk screening.
Media: Considers oil, acrylic, watercolor, pastel, pen & ink, drawing, sculpture, ceramics, photography, lithographs, serigraphs and posters. Most frequently exhibits acrylics, graphite pencil and watercolor.
Style: Exhibits: impressionism and realism. Genres include florals, western, wildlife, landscapes and Native American. Prefers: Native American realism, impressionist watercolors, realistic acrylics/oils.
Terms: Accepts work on consignment (30% commission). Retail price set by the artist. Gallery provides promotion; artist pays shipping costs. Prefers artwork framed.

Submissions: Accepts only artists from Oklahoma. Send query letter with brochure, 3-5 slides, photographs and SASE. Write for appointment to show portfolio of photographs, sample prints or brochure. Replies in 1 month. Finds artists through word of mouth, artists referral.

Tips: "We are not particularly looking for new artists because our space is committed to our area artists. However, we will always consider a new artist."

THE WINDMILL GALLERY, 3750 W. Robinson, Suite 103, Norman OK 73072. (405)321-7900. Director: Andy Denton. Retail gallery. Estab. 1987. Focus is on Oklahoma American Indian art. Represents 20 emerging, mid-career and established artists. Exhibited artists include Rance Hood and Doc Tate Neuaquaya. Sponsors 4 shows/year. Average display time 1 month. Open all year. Located in northwest Norman (Brookhaven area); 900 sq. ft.; interior decorated Santa Fe style: striped aspen, adobe brick, etc. 30% of space for special exhibitions. Clientele: "middle-class to upper middle-class professionals/housewives." 100% private collectors. Overall price range $50-15,000; most artwork sold at $100-2,000.

Media: Considers oil, acrylic, watercolor, pastel, pen & ink, drawings, mixed media, works on paper, sculpture, craft, original handpulled prints, offset reproductions, lithographs, posters, cast-paper and serigraphs. Most frequently exhibits watercolor, tempera and acrylic.

Style: Exhibits primitivism and realism. Genres include landscapes, southwestern, western, wildlife and portraits. Prefers Native American scenes (done by Native Americans), portraits and western-southwestern and desert subjects.

Terms: Artwork is accepted on consignment (40% commission). Retail price set by the artist. Customer discounts and payment by installments available. Gallery provides insurance and promotion. Shipping costs are shared. Prefers framed artwork.

Submissions: Send query letter with slides, bio, brochure, photographs, SASE, business card and reviews. Replies only if interested within 1 month. Portfolio review not required. Files brochures, slides, photos, etc. Finds artists through agents, visiting exhibitions, word of mouth, art publications and sourcebooks, artists' submissions/self-promotions and art collectors' referrals.

Tips: Accepts artists from Oklahoma area; Indian art done by Indians only. Director is impressed by artists who conduct business in a very professional manner, have written biographies, certificates of limited editions for prints, and who have honesty and integrity. "Call, tell me about yourself, try to set up appointment to view works or to hang your works as featured artist. Fairly casual—but must have bios and photos of works or works themselves! Please, no drop-ins!"

Oregon

BUSH BARN ART CENTER, 600 Mission St. SE, Salem OR 97302. Phone/fax: (503)581-2228. Gallery Director: Saralyn Hilde. Nonprofit gallery. Represents 125 emerging, mid-career and established artists/year. Sponsors 18 shows/year. Average display time 5 weeks. Open all year; Tuesday-Friday, 10-5; Saturday-Sunday, 1-5. Located near downtown in an historic park near Mission and High Streets in a renovated historic barn—the interior is very modern. 50% of space for special exhibitions; 50% of space for gallery artists. Overall price range: $10-2,500.

Media: Considers oil, acrylic, watercolor, pastel, pen & ink, drawing, mixed media, collage, paper, sculpture, ceramics, fiber, glass, installation, photography, all types of prints.

Style: Exhibits all styles.

Terms: Accepts work on consignment (40% commission). Gallery provides contract. Prefers artwork framed.

Submissions: Send query letter with résumé, 1 sheet of slides and bio. Write for appointment.

Tips: "Visit prospective galleries to insure your work would be compatible and appropriate to the space."

‡**FRAME DESIGN & SUNBIRD GALLERY**, 916 Wall St., Bend OR 97701. (541)389-9196. Fax: (541)389-8831. Gallery Director: Sandra Miller. Retail gallery. Estab. 1980. Represents/exhibits 25-50 emerging, mid-career and established artists/year. Exhibited artists include Dittebrandt and Rie Muñoz. Sponsors 3 shows/year. Average display time 1 month. Open all year; Monday-Saturday, 11-5:30; by appointment Tuesday-Saturday; open till 9 p.m. first Friday of every month. Located downtown; 4,000 sq. ft. "We feature large outdoor sculpture in an indoor setting." 60% of space for special exhibitions; 40% of space for gallery artists. Clientele: tourists, upscale, local community. 90% private collectors, 2% corporate collectors. Overall price range: $100-15,000; most work sold at $200-2,500.

Media: Considers all media and all types of prints. Most frequently exhibits acrylic, sculpture and mixed media.

Style: Exhibits all styles. All genres. Prefers: contemporary Native American and landscape (all media).

Terms: Artwork is accepted on consignment (50% commission). Artwork is bought outright for 50% of the retail price. Retail price set by the gallery and the artist. Gallery provides promotion and contract; shipping costs are shared.

Submissions: Send query letter with résumé, brochure, business card, 10 slides, photographs, reviews, bio and SASE. Call or write for appointment to show portfolio of photographs, slides and transparencies. Replies in 2-4 weeks. Files material on possible future shows. Finds artists through word of mouth, referrals by other artists, visiting art fairs and exhibitions and artists' submissions.

Tips: "Know the kind of artwork we display before approaching us. Be sure you have something to offer the gallery. Make an appointment and ask for help. Invite the gallery person to your studio—find out the criteria for that gallery."

‡**THE MAUDE KERNS ART CENTER**, 1910 E. 15th Ave., Eugene OR 97403. (503)345-1571. Executive Director: Doris Rager. Nonprofit gallery. Estab. 1963. Exhibits hundreds of emerging, mid-career and established artists. Interested

in seeing the work of emerging artists. 650 members. Sponsors 8-10 shows/year. Average display time 2 months. Open all year. Located in church bulding on Historic Register. 4 renovated galleries with over 2,500 sq. ft. of modern exhibit space. 100% of space for special exhibitions. Clientele: 50% private collectors, 50% corporate collectors. Overall price range: $200-20,000; most work sold at $200-500.

Media: Considers all media and original handpulled prints. Most frequently exhibits oil/acrylic, mixed media and sculpture.

Style: Contemporary artwork.

Terms: Accepts work on consignment (40% commission). Retail price set by artist. Offers customer discounts and payment by installments. Gallery provides insurance and contract; artist pays for shipping. Prefers artwork framed.

Submissions: Send query letter with résumé, slides, bio and SASE. Call for appointment to show portfolio of photographs, slides and transparencies. Files slide bank, résumé and statement. Finds artists through calls to artists, word of mouth, and local arts council publications.

Tips: "Call first! Come visit to see exhibits and think about whether the gallery suits you."

‡LANE COMMUNITY COLLEGE ART GALLERY, 4000 E. 30th Ave., Eugene OR 97405. (503)747-4501. Gallery Director: Harold Hoy. Nonprofit gallery. Estab. 1970. Exhibits the work of emerging, mid-career and established artists. Sponsors 7 solo and 2 group shows/year. Average display time 3 weeks. Most work sold at $100-2,000.

Media: Considers all media.

Style: Exhibits contemporary works. Interested in seeing "contemporary, explorative work of quality. Open in terms of subject matter."

Terms: Retail price set by artist. Sometimes offers customer discounts. Exclusive area representation not required. Gallery provides insurance, promotion and contract; shipping costs are shared. "We retain 25% of the retail price on works sold."

Submissions: Send query letter, résumé and slides with SASE. Portfolio review required. Résumés are filed.

LAWRENCE GALLERY, Box 187, Sheridan OR 97378. (503)843-3633. Owners: Gary and Carole Lawrence. Retail gallery and art consultancy. Estab. 1977. Represents 150 mid-career and established artists. Sponsors 15 shows/year. Open daily 10-5:30. "The gallery is surrounded by several acres of landscaping in which we feature sculpture, fountains and other outdoor art." Clientele: tourists, Portland and Salem residents. 80% private collectors, 20% corporate clients. Overall price range: $10-50,000; most work sold at $1,000-5,000.

Media: Considers oil, acrylic, watercolor, pastel, mixed media, collage, sculpture, clay, glass, jewelry and original handpulled prints. Always exhibits paintings, bronze sculpture, clay, glass and jewelry.

Style: Exhibits painterly abstraction, impressionism, photorealism and realism. Genres include landscapes and florals. "Our gallery features beautiful artworks that celebrate life."

Terms: Accepts work on consignment (50% commission). Retail price set by artist. Offers payment by installments. Exclusive area representation required. Gallery provides insurance, promotion and contract; artist pays for shipping.

Submissions: Send query letter, résumé, brochure, slides and photographs. Portfolio review required if interested in artists' work. Files résumés, photos of work, newspaper articles, other informative pieces and artist's statement. Finds artists through agents, visiting exhibitions, word of mouth, art publications and sourcebooks, submissions/self-promotions, art collectors' referrals.

Tips: "Artists seen by appointment only."

‡RICKERT ART CENTER AND GALLERY, 620 N. Hwy. 101, Lincoln City OR 97367. (503)994-0430. Fax: (503)1-800-732-8842. Manager/Director: Lee Lindberg. Retail gallery. Represents more than 20 emerging, mid-career and established artists/year. Exhibited artists include Sharon Rickert, Don Driggars, Ron Nicolaides, Ann Bridge, Jesse Roadbruck and Mike Hall. Sponsors 3 shows/year. Open all year; daily, weekdays and Saturdays, 10-5; Sundays, 10-4. Located south end of town on main street; 2,300 sq. ft.; 50-year-old building. 20% of space for special exhibitions; 60% of space for gallery artists. Overall price range: $200-6,000; most work sold at $800-3,000.

Media: Considers oil, acrylic, watercolor, pastel, mixed media, sculpture, lithographs, serigraphs and posters. Most frequently exhibits oil, acrylic, watercolor and pastel.

Style: Exhibits all styles. Genres include landscapes, florals, southwestern, western, wildlife, portraits, figurative work, seascapes. Prefers: seascapes, florals, landscapes.

Terms: Accepts work on consignment (50% commission). Retail price set by the gallery and the artist. Gallery provides promotion; artist pays shipping costs to and from gallery. Prefers artwork framed.

Submissions: Send query letter with résumé, 10 or less slides and photographs. Call or write for appointment to show portfolio of originals. Artist should follow up with call.

Tips: Looking for landscapes and seascapes in oil.

‡ROGUE GALLERY & ART CENTER, 40 S. Bartlett, Medford OR 97501. (503)772-8118. Executive Director: Nancy Jo Mullen. Nonprofit rental gallery. Estab. 1961. Represents emerging, mid-career and established artists. Sponsors 8 shows/year. Average display time 6 weeks. Open all year; Tuesday-Friday, 10-5; Saturday, 10-4. Located downtown; main gallery 240 running ft. (2,000 sq. ft.); rental/sales and gallery shop, 1,800 sq. ft.; classroom facility, 1,700 sq. ft. "This is the only gallery/art center/exhibit space of its kind in the region, excellent facility, good lighting." 33% of space for special exhibitions; 33% of space for gallery artists. 95% private collectors. Overall price range: $100-5,000; most work sold at $400-1,000.

Media: Considers all media and all types of prints. Most frequently exhibits mixed media, drawing, painting, sculpture, watercolor.

Style: Exhibits all styles, all genres. Prefers: figurative work, collage, landscape, florals, handpulled prints.

Terms: Accepts work on consignment (35% commission to members; 40% non-members). Retail price set by the artist. Gallery provides insurance, promotion and contract; in the case of main gallery exhibit, gallery assumes cost for shipping 1 direction, artist 1 direction.

Submissions: Send query letter with résumé, 10 slides, bio and SASE. Call or write for appointment. Replies in 1 month.

Tips: "The most important thing an artist needs to demonstrate to a prospective gallery is a cohesive, concise view of himself as a visual artist and as a person working with direction and passion."

Pennsylvania

‡**THE ART BANK**, 3028 N. Whitehall Rd., Norristown PA 19403-4403. Phone/fax: (610)539-2265. Director: Phyllis Sunberg. Retail gallery, art consultancy, corporate art planning. Estab. 1985. Represents 40-50 emerging, mid-career and established artists/year. Exhibited artists include Lisa Fedon, and Bette Ridgeway. Average display time 3-6 months. Open all year; by appointment only. Located in a Philadelphia suburb; 1,000 sq. ft.; Clientele: corporate executives and their corporations. 20% private collectors, 80% corporate collectors. Overall price range: $300-35,000; most $500-1,000.

Media: Considers oil, acrylic, watercolor, pastel, mixed media, collage, sculpture, glass, installation, holography, exotic material, lithography, serigraphs. Most frequently exhibits acrylics, serigraphs and sculpture.

Style: Exhibits expressionism, painterly abstraction, color field and hard-edge geometric abstraction. Genres include landscapes. Prefers color field, hard edge abstract and impressionism.

Terms: Accepts work on consignment (40% commission). Shipping costs are shared. Prefers artwork unframed.

Submissions: Prefers artists from the region (PA, NJ, NY, DE). Send query letter with résumé, slides, brochure, SASE and prices. Write for appointment to show portfolio of originals (if appropriate), photographs and corporate installation photos. Replies only if interested within 2 weeks. Files "what I think I'll use—after talking to artist and seeing visuals." Finds artists through agents, by visiting exhibitions, word of mouth, art publications and sourcebooks, submissions.

CAT'S PAW GALLERY, 31 Race St., Jim Thorpe PA 18229. (717)325-4041. Director/Owner: John and Louise Herbster. Retail gallery. Represents 100 emerging, mid-career and established artists/year. Exhibited artists include Shelley Buonaiuto and Nancy Giusti. Sponsors 1 or 2 shows/year. Average display time 1 month. Open seasonally; May-December, Wednesday-Sunday, 11-5, or by appointment. Located in historic downtown district; 400 sq. ft.; in one of 16 "Stone Row" 1848 houses built into mountainside. 40% of space for special exhibitions; 60% of space for gallery artists. Clientele: collectors, tourists, corporate. 50% private collectors, 5% corporate. Overall price range: $2-2,000; most work sold at $20-200.

Media: Considers oil, acrylic, watercolor, pastel, pen & ink, drawing, mixed media, collage, paper, sculpture, ceramics, craft, fiber, glass, original hand-pulled prints. Most frequently exhibits ceramics, sculpture and jewelry.

Style: Exhibits all styles. Only domestic feline subjects.

Terms: Accepts work on consignment (40% commission) or buys outright for 50% of retail price (net 30 days). "We usually purchase, except for major exhibits." Retail price set by the artist. Gallery provides insurance, promotion and contract; shipping costs are shared. Prefers artwork framed.

Submissions: Accepts artists from all regions of the US. Send query letter with résumé, slides or photographs, bio, brochure and reviews. Call or write for appointment to show portfolio of photographs. Replies only if interested within 1 week. Files all material of interest. Finds artists through visiting exhibitions and trade shows, word of mouth, submissions, collectors, art publications.

Tips: "We accept only artists who use the cat subject in their work. Some artists have sent us expensive sales sheets showing work that has no relationship to our interests. Artists should visit us, or read about us, to learn about our gallery subject matter and our views on cat art. We prefer artists whose work expresses some spiritual affinity for the cat subject. Preferred work has that extra spark beyond technical command of the medium. Many can draw cats; fewer can capture the cat essence."

✔**CENTER GALLERY OF BUCKNELL UNIVERSITY**, Elaine Langone Center, Lewisburg PA 17837. (717)524-3792. Fax: (717)524-3480. E-mail: peltier@bucknell.edu. Website: http://www.bucknell.edu/departments/center_gallery/. Director: Stuart Horodner. Assistant Director: Cynthia Peltier. Nonprofit gallery. Estab. 1983. Represents emerging, mid-career and established artists. Sponsors 6 shows/year. Average display time 6 weeks. Open all year; Monday-Friday, 11-5; Saturday-Sunday, 1-4. Located on campus; 3,000 sq. ft. plus 40 movable walls.

Media: Considers all media, all types of prints. Most frequently exhibits painting, prints and photographs.

Style: Exhibits all styles, all genres.

Terms: Retail price set by the artist. Gallery provides insurance, promotion (local) and contract; artist pays shipping costs to and from gallery. Prefers artwork framed.

Submissions: Send query letter with résumé, slides and bio. Write for appointment to show portfolio of originals. Replies in 2 weeks. Files bio, résumé, slides. Finds artists through occasional artist invitationals/competitions.

Tips: "We usually work with themes and then look for work to fit that theme."

✓**DOSHI GALLERY FOR CONTEMPORARY ART/THE SUSQUEHANNA ART MUSEUM**, 511 Strawberry Square, Harrisburg PA 17101. (717)233-8668. Contact: Executive Director. Estab. 1972. Nonprofit gallery. Exhibits hundreds of emerging, mid-career and established artists. 150 members. Sponsors 10 shows/year. Average display time 1 month. Open all year; Monday-Saturday, 11-3. Located in Strawberry Square, Walnut and Fourth Streets. 100% of space for gallery artists. Clientele: 100% private collectors. Overall price range: $250-9,000.
Media: Considers all media and types of prints. Most frequently exhibits oil/acrylic, photography and mixed media.
Style: Exhibits all styles and genres. Prefers: figurative work, expressionism/painterly abstraction and geometric abstraction/realism.
Terms: Accepts work on consignment for annual art auction and holiday sale (40% commission); or is bought outright for 100% of retail price (gallery then receives 30% donation). Retail price is set by artist. Gallery provides insurance and promotion; artist pays for shipping. Prefers artwork framed.
Submissions: Send query letter with résumé, 5-10 slides and bio. "No portfolio reviews. Slides are accepted for possible show in June of each year. Files bios and résumés.
Tips: Jurors tend to select more cutting edge work.

FLEISHER/OLLMAN GALLERY, 211 S. 17th St., Philadelphia PA 19103. (215)545-7562. Fax: (215)545-6140. Director: John Ollman. Retail gallery. Estab. 1952. Represents 12 emerging and established artists. Exhibited artists include Tony Fitzpatrick and Bill Traylor. Sponsors 10 shows/year. Average display time 5 weeks. Closed August. Located downtown; 3,000 sq. ft. 75% of space for special exhibitions. Clientele: primarily art collectors. 90% private collectors, 10% corporate collectors. Overall price range: $2,500-100,000; most work sold at $2,500-30,000.
Media: Considers oil, acrylic, watercolor, pastel, pen & ink, drawing, mixed media and collage. Most frequently exhibits drawing, painting and sculpture.
Style: Exhibits self-taught and contemporary works.
Terms: Accepts artwork on consignment (commission) or buys outright. Retail price set by the gallery. Gallery provides insurance and promotion; shipping costs are shared. Prefers artwork framed.
Submissions: Send query letter with résumé, slides, bio and SASE; gallery will call if interested within 1 month.
Tips: "Be familiar with our exhibitions and the artists we exhibit."

GALLERY ENTERPRISES, 310 Bethlehem Plaza Mall, Bethlehem PA 18018. (610)868-1139. Fax: (610)868-9482. Website: http://moravian.edu/people/students/stdmdo2/aboutme.html. Owner: David Michael Donnangelo. Wholesale gallery. Estab. 1981. Represents/exhibits 10 established artists/year. May be interested in seeing the work of emerging artists in the future. Exhibited artists include K. Haring and Andy Warhol. Sponsors 1 show/year. Average display time 3 weeks. Open all year; 12:30-5:30. Located in mall, 700 sq. ft.; good light and space. 100% of space for special exhibitions. Clientele: upscale. 50% private collectors, 10% corporate collectors. Overall price range: $350-5,000; most work sold at $1,200-2,500.
Media: Considers all media, etchings, lithographs, serigraphs and posters. Most frequently exhibits serigraphs, lithography and posters.
Style: Exhibits neo-expressionism, realism, surrealism and environmental. Genres include landscapes and wildlife. Prefers: pop art, kenetic art, environmental and surrealism.
Terms: Artwork is accepted on consignment. Retail price set by the gallery. Prefers artwork unframed.
Submissions: Well-established artists only. Send query letter with 10 slides and photographs. Call for appointment to show portfolio of photographs and slides. "If slides or photos are sent they will be kept on file but not returned. We reply only if we are interested."
Tips: "Pay attention to what sells."

GALLERY 500, Church & Old York Rds., Elkins Park PA 19027. (215)572-1203. Fax: (215)572-7609. Owners: Harriet Friedberg and Rita Greenfield. Retail gallery. Estab. 1969. Represents emerging, mid-career and established artists/year. Sponsors 6-8 shows/year. Average display time 1 month. Open all year; Monday-Saturday, 10-5:30. Located in Yorktown Inn Courtyard of Shops; 3,000 sq. ft.; 40% of space for special exhibitions; 60% of space for gallery artists. 20% private collectors, 30% corporate collectors. Overall price range: $50-6,000; most work sold at $200-3,000.
Media: Considers oil, acrylic, watercolor, pastel, drawing, mixed media, collage, handmade paper, sculpture, ceramics, metal, wood, furniture, jewelry, fiber and glass. Most frequently exhibits jewelry, ceramics, glass, furniture and painting.
Style: Exhibits painterly abstraction, color field, pattern painting and geometric abstraction. Genres include landscape, still life and figurative work.
Terms: Accepts work on consignment (50% commission) or buys outright for 50% of retail price (net 30 days). Retail price set by the gallery and the artist. Gallery provides insurance, promotion, contract and shipping costs from gallery; artist pays shipping costs to gallery. Prefers artwork framed.
Submissions: Accepts only artists from US and Canada. Send query letter with résumé, at least 6 slides, bio, brochure, price list and SASE. Replies in 1 month. Files all materials pertaining to artists who are represented. Finds artists through craft shows, travel to galleries.
Tips: "Have at least three years of post-college experience in the field before approaching galleries."

GALLERY JOE, 304 Arch St., Philadelphia PA 19106. (215)592-7752. Fax: (215)238-6923. Director: Becky Kerlin. Retail and commercial exhibition gallery. Estab. 1993. Represents/exhibits 15-20 emerging, mid-career and established

artists. Exhibited artists include Donna Dennis and Harry Roseman. Sponsors 6 shows/year. Average display time 6 weeks. Open all year; Wednesday-Saturday, 12-5:30. Located in Old City; 350 sq. ft. 100% of space for gallery artists. 80% private collectors, 20% corporate collectors. Overall price range: $500-20,000; most work sold at $1,000-5,000.
Media: Only exhibits sculpture, drawing and architectural drawings/models.
Style: Exhibits representational/realism.
Terms: Artwork is accepted on consignment (50% commission). Retail price set by the gallery and the artist. Gallery provides insurance and promotion. Artist pays for shipping costs. Prefers artwork framed.
Submissions: Send query letter with résumé, slides, reviews and SASE. Replies in 6 weeks. Finds artists mostly by visiting galleries and through artist referrals.

‡INTERNATIONAL IMAGES, LTD., The Flatiron Building, 514 Beaver St., Sewickley PA 15143. (412)741-3036. Fax: (412)741-8606. E-mail: intimage@concentric.net. Director of Exhibitions: Charles M. Wiebe. Retail gallery. Estab. 1978. Represents 100 emerging, mid-career and established artists; primarily Russian, Estonian, Latvian, Lithuanian, Georgian, Bulgarian, African and Cuban. Sponsors 8 solo shows/year. Average display time: 4-6 weeks. Clientele: 90% private collectors, 10% corporate clients. Overall price range: $150-150,000; most work sold at $10,000-65,000.
Media: Considers oils, watercolors, pastels, pen & ink, drawings and original handpulled prints, small to medium sculptures, leather work from Africa and contemporary jewelry. Most frequently exhibits oils, watercolors and works on paper.
Style: Exhibits all styles. Genres include landscapes, florals and portraits. Prefers: abstraction, realism and figurative works.
Terms: Accepts work on consignment. Retail price set by gallery. Exclusive area representation required. Shipping costs are shared.
Submissions: Send query letter with résumé and slides. Portfolio should include slides. "Include titles, medium, size and price with slide submissions." Replies in 1 month. All material is returned if not accepted or under consideration.
Tips: "Founded by Elena Kornetchuk, it was the first gallery to import Soviet Art, with an exclusive contract with the USSR. In 1986, we began to import Bulgarian art as well and have expanded to handle several countries in Europe and South America as well as the basic emphasis on Eastern bloc countries. We sponsor numerous shows each year throughout the country in galleries, museums, universities and conferences, as well as featuring our own shows every four to six weeks. Looks for Eastern European, Bulgarian and International art styles." The most common mistakes artists make in presenting their work are "neglecting to include pertinent information with slides/photographs, such as size, medium, date, and cost and failing to send biographical information with presentations."

‡NEWMAN GALLERIES, 1625 Walnut St., Philadelphia PA 19103. (215)563-1779. Fax: (215)563-1614. E-mail: newgall@ix.netcom.com. Website: http://www.webness.net/newman. Manager: Terrence C. Newman. Retail gallery. Estab. 1865. Represents 40-50 emerging, mid-career and established artists/year. Exhibited artists include Tim Barr and Philip Jamison. Sponsors 2-4 shows/year. Average display time 1 month. Open September through June, Monday-Friday, 9-5:30; Saturday, 10-4:30; July through August, Monday-Friday, 9-5. Located in Center City Philadelphia. 4,000 sq. ft. "We are the largest and oldest gallery in Philadelphia." 50% of space for special exhibitions; 100% of space for gallery artists. Clientele: traditional. 50% private collectors, 50% corporate collectors. Overall price range: $1,000-100,000; most work sold at $2,000-20,000.
Media: Considers oil, acrylic, watercolor, pastel, mixed media, sculpture, woodcut, wood engraving, linocut, engraving, mezzotint, etching, lithograph, serigraphs and posters. Most frequently exhibits watercolor, oil/acrylic, and pastel.
Style: Exhibits expressionism, impressionism, photorealism and realism. Genres include landscapes, florals, Americana, wildlife, portraits and figurative work. Prefers: landscapes, Americana and figurative work.
Terms: Accepts work on consignment (45% commission). Retail price set by gallery and artist. Gallery provides insurance and promotion; shipping costs are shared. Prefers oils framed; prints, pastels and watercolors unframed but matted.
Submissions: Send query letter with résumé, 12-24 slides, bio and SASE. Call for appointment to show portfolio of originals, photographs and transparencies. Replies in 2-4 weeks. Files "things we may be able to handle but not at the present time." Finds artists through agents, visiting exhibitions, word of mouth, art publications, sourcebooks and artists' submissions.

THE STATE MUSEUM OF PENNSYLVANIA, Third and North St., Box 1026, Harrisburg PA 17108-1026. (717)787-4980. Contact: Senior Curator, Art Collections. The State Museum of Pennsylvania is the official museum of the Commonwealth, which collects, preserves and exhibits Pennsylvania history, culture and natural heritage. The Museum maintains a collection of fine arts, dating from 1645 to present. Current collecting and exhibitions focus on works of art by contemporary Pennsylvania artists. The Archives of Pennsylvania Art includes records on Pennsylvania artists and continues to document artistic activity in the state by maintaining records for each exhibit space/gallery in the state. Estab. 1905. Sponsors 9 shows/year. Accepts only artists who are Pennsylvania natives or past or current residents. Interested in emerging and mid-career artists.
Media: Considers all media including oil, works on paper, photography, sculpture, installation and crafts.
Style: Exhibits all styles and genres.
Submissions: Send query letter with résumé, slides, SASE and bio. Replies in 1-3 months. Retains résumé and bio for archives of Pennsylvania Art. Photos returned if requested. Finds artists through professional literature, word of mouth, Gallery Guide, exhibits, all media and unsolicited material.

Tips: "Have the best visuals possible. Make appointments. Remember most curators are also overworked, underpaid and on tight schedules."

‡**SANDE WEBSTER GALLERY**, 2018 Locust St., Philadelphia PA 19102. (215)732-8850. Fax: (215)732-7850. E-mail: swgart@erols.com. Director: Megan Walborn. Retail gallery. Estab. 1969. Represents emerging, mid-career and established artists. "We exhibit from a pool of 40 and consign work from 200 artists." Exhibited artists include Charles Searles and Moe-Brooker. Sponsors 12-14 shows/year. Average display time 1 month. Open all year; Monday-Friday, 10-6; Saturday, 11-4. Located downtown; 2,000 sq. ft.; "We have been in business in the same location for 25 years." 50% of space for special exhibitions; 50% of space for gallery artists. Clientele: art consultants, commercial and residential clients. 30% private collectors, 70% corporate collectors. Overall price range: $25-25,000; most work sold at $1,000-2,000.
Media: Considers oil, acrylic, watercolor, drawing, mixed media, collage, sculpture, fiber, photography, woodcut, engraving, lithograph, wood engraving, mezzotint, serigraphs, linocut and etching.
Style: Exhibits all styles, all genres. Prefers: non-objective painting and sculpture and abstract painting.
Terms: Accepts work on consignment (50% commission). Retail price set by agreement. Gallery provides insurance, promotion, contract and shipping costs from gallery; artist pays shipping costs to gallery. "We also own and operate a custom frame gallery."
Submissions: Send query letter with résumé, 10 slides with list of size, media and price, bio, SASE and retail PR. Call for appointment to show portfolio of slides. "All submissions reviewed from slides with no exceptions." Replies within 2 months. Files "slides, résumés of persons in whom we are interested." Finds artists through referrals from artists, seeing work in outside shows, and unsolicited submissions.

‡**THE WORKS GALLERY**, Dept. AGDM, 303 Cherry St., Philadelphia PA 19106. (215)922-7775. Owner: Ruth Snyderman. Retail gallery. Estab. 1965. Represents 200 emerging, mid-career and established artists. Exhibited artists include William Scholl and Catherine Butler. Sponsors 5 shows/year. Average display time 6 weeks. Open all year; Tuesday-Saturday, 10-6. First Friday of each month hours extend to 9 p.m. as all galleries in this district have their openings together. Exhibitions usually change on a monthly basis except through the summer. Located downtown; 2,000 sq. ft. 65% of space for special exhibitions. Clientele: designers, lawyers, businessmen and women, students. 90% private collectors, 10% corporate collectors. Overall price range: $25-10,000; most work sold at $200-600.
Media: Considers ceramic, fiber, glass, photography and metal jewelry. Most frequently exhibits jewelry, ceramic and fiber.
Style: Exhibits all styles.
Terms: Accepts artwork on consignment (50% commission); some work is bought outright. Gallery provides insurance, promotion and contract; shipping costs are shared.
Submissions: Send query letter with résumé, 5-10 slides and SASE. Files résumé and slides, if interested.
Tips: "Most work shown is one-of-a-kind. We change the gallery totally for our exhibitions. In our gallery, someone has to have a track record so that we can see the consistency of the work. We would not be pleased to see work of one quality once and have the quality differ in subsequent orders, unless it improved."

Rhode Island

ARTIST'S COOPERATIVE GALLERY OF WESTERLY, 12 High St., Westerly RI 02891. (401)596-2020. Cooperative gallery and nonprofit corporation. Estab. 1992. Represents 35 emerging, mid-career and established artists/year. Sponsors 12 shows/year. Average display time 1 month. Open all year; Tuesday-Saturday, 11-4. Located downtown on a main street; 30′ × 80′; ground level, store front, arcade entrance, easy parking. 80% private collectors, 20% corporate collectors. Overall price range: $20-2,500; most work sold at $50-200.
Media: Considers all media and all types of prints. Most frequently exhibits oils, watercolors, ceramics, sculpture and jewelry.
Style: Exhibits expressionism, primitivism, painterly abstraction, postmodern works, impressionism and realism.
Terms: Co-op membership fee of $120/year, plus donation of time and hanging/jurying fee of $10. Gallery takes no percentage. Regional juried shows each year. Retail price set by the artist. Gallery provides promotion; artist pays for shipping. Prefers artwork framed.
Submissions: Send query letter with 3-6 slides or photos and artist's statement. Call or write for appointment. Replies in 2-3 weeks. Membership flyer and application available on request.
Tips: "Take some good quality pictures of your work in person, if possible, to galleries showing the kind of work you want to be associated with. If rejected, reassess your work, presentation and the galleries you have selected. Adjust what you are doing appropriately. Try again. Be upbeat and positive."

CADEAUX DU MONDE, 140 Bellevue Ave., Newport RI 02840. (401)848-0550. Fax: (401)624-8224. Website: http://www.cadeauxdumonde.com. Owners: Jane Perkins, Katie Dyer and Bill Perkins. Retail gallery. Estab. 1987. Represents emerging, mid-career and established artists. Exhibited artists include John Lyimo and A.K. Paulin. Sponsors 3 changing shows and 1 ongoing show/year. Average display time 3-4 weeks. Open all year; daily, 10-6 and by appointment. Located in commercial district; 1,300 sq. ft. Located in historic district in an original building with original high

tin ceilings, wainscoating and an exterior rear Mediterranean-style courtyard garden that has rotating exhibitions during the summer months. 15% of space for special exhibitions; 85% of space for gallery artists. Clientele: tourists, upscale, local community and students. 95% private collectors, 5% corporate collectors. Overall price range: $20-5,000; most work sold at $100-300.

Media: Considers all media suitable for display in a garden atmosphere for special exhibitions. No prints.

Style: Exhibits folk art. Style is unimportant, quality of work is deciding factor—look for unusual, offbeat and eclectic.

Terms: Accepts work on consignment (30% commission). Retail price set by the artist. Gallery provides insurance. Artist pays shipping costs and promotional costs of opening. Prefers artwork framed.

Submissions: Send query letter with résumé, 10 slides, bio, photographs and business card. Call for appointment to show portfolio of photographs or slides. Replies only if interested within 2 weeks. Finds artists through word of mouth, referrals by other artists, visiting art fairs and exhibitions, artist's submissions.

Tips: Artists who want gallery representation should "present themselves professionally; treat their art and the showing of it like a small business; arrive on time and be prepared; and meet deadlines promptly."

COMPLEMENTS ART GALLERY, Fine Art Investments, Ltd., 50 Lambert Lind Hwy., Warwick RI 02886. (401)739-9300. Fax: (401)739-7905. E-mail: fineartinv@aol.com. President: Domenic B. Rignanese. Retail gallery. Estab. 1986. Represents 100s of international and New England emerging, mid-career and established artists. Exhibited artists include Fairchild and Hatfield. Sponsors 6 shows/year. Average display time 2-3 weeks. Open all year; Monday-Friday, 8:30-6; Saturday-Sunday, 9-5. 2,250 sq. ft.; "we have a piano and beautiful hardwood floors also a great fireplace." 20% of space for special exhibitions; 60% of space for gallery artists. Clientele: upscale. 40% private collectors, 15% corporate collectors. Overall price range: $25-5,000; most work sold at $600-1,200.

Media: Considers all media except offset prints. Types of prints include engravings, lithographs, wood engravings, mezzotints, serigraphs and etchings. Most frequently exhibits serigraphs, oils and etchings.

Style: Exhibits expressionism, painterly abstraction, impressionism, photorealism, realism and imagism. Genres include florals, portraits and landscapes. Prefers realism, impressionism and abstract.

Terms: Accepts work on consignment (30% commission) or bought outright for 50% of retail price (90 days). Retail price set by the gallery. Gallery provides insurance, promotion and contract. Shipping costs are shared. Prefers artwork unframed.

Submissions: Size limitation due to wall space. Drawing no larger than 40×60 sculpture not heavier than 150 pounds. Send query letter with résumé, bio, 6 slides or photographs. Call for appointment to show portfolio of photographs and slides. Replies in 3-4 weeks. Files all materials from artists. Finds artists through word of mouth, referrals by other artists, visiting art fairs and all exhibitions and artist's submissions.

Tips: "Artists need to have an idea of the price range of their work and better written résumés."

THE DONOVAN GALLERY, 3879 Main Rd., Tiverton Four Corners RI 02878. (401)624-4000. Fax: (401)624-4100. E-mail: kdono427@aol.com. Owner: Kris Donovan. Retail gallery. Estab. 1993. Represents 50 emerging, mid-career and established artists/year. Sponsors 8 shows/year. Average display time 1 month. Open all year; Tuesday-Saturday, 10-5; Sunday, 12-5; shorter winter hours. Located in a rural shopping area; 1,600 sq. ft.; located in 1820s historical home. 100% of space for gallery artists. Clientele: tourists, upscale, local community and students. 90% private collectors, 10% corporate collectors. Overall price range: $80-6,500; most work sold at $250-800.

Media: Considers oil, acrylic, watercolor, pastel, mixed media, collage, paper, sculpture, ceramics, some craft, fiber and glass; and all types of prints. Most frequently exhibits watercolors, oils and pastels.

Style: Exhibits conceptualism, impressionism, photorealism and realism. Exhibits all genres. Prefers: realism, impressionism and representational.

Terms: Accepts work on consignment (45% commission). Retail price set by the artist. Gallery provides limited insurance, promotion and contract; artist pays for shipping. Prefers artwork framed.

Submissions: Accepts only artists from New England. Send query letter with résumé, 6 slides, bio, brochure, photographs, SASE, business card, reviews and artist's statement. Call or write for appointment to show portfolio of photographs or slides or transparencies. Replies in 1 week. Files material for possible future exhibition. Finds artists through networking and submissions.

Tips: "Do not appear without an appointment, especially on a weekend. Be professional, make appointments by telephone, be preapred with résumé, slides and (in my case) some originals to show. Don't give up. Join local art associations and take advantage of show opportunities there."

GALLERY AT UPDIKE SQUARE, 16 W. Main St., 2nd Floor, Wickford RI 02852. (401)294-7773. E-mail: galleryups@aol.com. Owner: Marisa Tomlins. Retail gallery. Estab. 1994. Represents 20 emerging, mid-career and established artists/year. Exhibited artists include Denise Patchell Olson, Maxwell Mays, Thomas Kinkade and Dena Hibel. Sponsors 2 shows/year. Open all year; Monday-Saturday, 10-5; Sunday, 12-5 or by appointment. Located downtown in historic Wickford; 470 sq. ft. 75% of space for gallery artists. Clientele: tourists, upscale, local community. 90% private collectors. Overall price range: $40-1,800; most work sold at $70-350.

Media: Considers oil, acrylic, watercolor, pastel, pen & ink, drawing, paper, sculpture, ceramics, craft, glass, photography, woodcuts, engravings, lithographs, wood engravings, mezzotints, serigraphs, etchings. Most frequently exhibits signed and numbered prints, original watercolors and photograhy.

Style: Genres include florals, landscapes, Americana and figurative work.

Terms: Accepts work on consignment (50% commission) or buys outright for 50% of the retail price; net 30 days.

Retail price set by the gallery and the artist. Prefers artwork unframed.

Submissions: Send query letter with brochure and business card. Write for appointment to show portfolio of photographs. Replies only if interested within 1 month. Finds artists through word of mouth, referrals, fairs and exhibitions.

‡HERA EDUCATIONAL FOUNDATION, HERA GALLERY, 327 Main St., P.O. Box 336, Wakefield RI 02880. (401)789-1488. Nonprofit professional artist cooperative gallery. Estab. 1974. Located in downtown Wakefield, a Northeast area resort community (near Newport beaches). Exhibits the work of emerging and established artists. 30 members. Sponsors 16 shows/year. Average display time 3 weeks. Open all year; Wednesday, Thursday and Friday, 1-5; Saturday, 10-4. Located downtown; 1,200 sq. ft. 40% of space for special exhibitions.

Media: Considers all media and original handpulled prints.

Style: Exhibits expressionism, neo-expressionism, painterly abstraction, surrealism, conceptualism, postmodern works, realism and photorealism. "We are interested in innovative, conceptually strong, contemporary works that employ a wide range of styles, materials and techniques." Prefers "a culturally diverse range of subject matter which explores contemporary social and artistic issues important to us all."

Terms: Co-op membership. Retail price set by artist. Sometimes offers customer discount and payment by installments. Gallery provides promotion; artist pays for shipping, and shares expenses like printing and postage for announcements.

Submissions: Send query letter with SASE. "After sending query letter and SASE artists interested in membership receive membership guidelines with an application. Twenty slides are required for application review along with résumé, artist statement and slide list." Portfolio required for membership; slides for invitational/juried exhibits. Finds artists through word of mouth, advertising in art publications, and referrals from members.

Tips: "Please write for membership guidelines, and send SASE. We are perfect for emerging artists and others needing venue."

South Carolina

AUDUBON WILDLIFE GALLERY, 233 King St., Charleston SC 29401. (803)853-1100. Fax: (800)453-BIRD. Website: http://audubongallery.com. Managers: Burton Moore or Maria Sopranzi. Retail gallery. Estab. 1987. Represents 4-6 emerging and established artists. Exhibited artists include John James Audubon and Vernon Washington. Sponsors 2 shows/year. Average display time 6 months. Open all year; every day 10-6. Located in the heart of downtown Charleston; 2,800 sq. ft.; interior atrium with small pond; running fountain with stone sculptures. 30% of space for gallery artists. Clientele: tourists, upscale, local community, students. 15% private collectors, 10% corporate collectors. Overall price range: $30-12,000; most work sold at $50-3,500.

Media: Considers oil, acrylic, watercolor, pen & ink, drawing, mixed media, sculpture, ceramics and photography; considers all types of prints. Most frequently exhibits watercolor, mixed media and sculpture.

Style: Genres include florals/botanicals, wildlife and Americana. Prefers: North American wildlife, African wildlife and botanicals, rare antiques to contemporary.

Terms: Accepts work on consignment (40% commission) or buys outright for 50% of retail price (net 30 days). Retail price set by the gallery. Gallery provides insurance, promotion and contract; shipping costs are shared. Prefers artwork unframed.

Submissions: Must be wildlife art—birds, animals—North American or African. Send query letter with 3-5 slides, photographs, reviews, artist's statement, bio and SASE. Call for appointment to show portfolio of photographs and slides. Replies in 1 month. Files price quotes, inventory lists, facsimilies of prints by the artist. Finds artists through word of mouth, referrals by other artists, visiting art fairs and exhibitions and artist's submissions.

CECELIA COKER BELL GALLERY, Coker College, 300 E. College Ave., Hartsville, SC 29550. (803)383-8152. E-mail: merriman@coker.edu. Website: http://www.coker.edu/art.dept Director: Larry Merriman. "A campus located teaching gallery which exhibits a great diversity of media and style to expose students and the community to the breadth of possibility for expression in art. Exhibits include regional, national and international artists with an emphasis on quality. Features international shows of emerging artists and sponsors competitions." Estab. 1984. Interested in emerging and mid-career artitsts. Sponsors 5 solo shows/year. Average display time 1 month. "Gallery is 30×40, located in art department; grey carpeted walls, track lighting."

Media: Considers oil, acrylic, drawings, mixed media, collage, works on paper, sculpture, installation, photography, performance art, graphic design and printmaking. Most frequently exhibits painting, sculpture/installation and mixed media.

Style: Considers all styles. Not interested in conservative/commercial art.

Terms: Retail price set by artist (sales are not common). Exclusive area representation not required. Gallery provides insurance, promotion and contract; shipping costs are shared.

Submissions: Send résumé, 10-15 good-quality slides and SASE by November 1. Write for appointment to show portfolio of slides.

COLEMAN FINE ART, 45 Hasell St., Charleston SC 29401. (803)853-7000. Fax: (803)722-2552. Gallery Director: Normandie Updyke. Retail gallery, art consultancy and frame restoration. Estab. 1974. Represents 14 emerging, mid-career and established artists/year. Exhibited artists include Mary Whyte, Jan Pawlowski and Howard Watson. Sponsors

3 shows/year. Average display time 1 month. Open all year; Tuesday-Saturday, 10-6. Located in downtown historic Charleston; 900 sq. ft.; in 1840s building that once housed a grocery. Clientele: tourists, upscale and locals. 95-98% private collectors, 2-5% corporate collectors. Overall price range: $14-12,000; most work sold at $2,000-7,000.

Media: Considers oil, watercolor, pastel, pen & ink, drawing, mixed media, sculpture, ceramics, glass, woodcuts, engravings, lithographs, serigraphs and etchings. Most frequently exhibits watercolor, oil and stained glass.

Style: Exhibits expressionism, impressionism, photorealism and realism. Genres include portraits, landscapes, still lifes and figurative work. Prefers: figurative work/expressionism, realism and impressionism.

Terms: Accepts work on consignment (40% commission) or buys outright for 50% of retail price; net 90 days. Retail price set by the gallery and the artist. Gallery provides promotion and contract. Shipping costs are shared. Prefers artwork framed.

Submissions: Send query letter with brochure, 20 slides, reviews, bio and SASE. Write for appointment to show portfolio of photographs, slides and transparencies. Replies only if interested within 1 month. Files slides. Finds artists through submissions.

Tips: "Approach galleries with 20 slides, information on where artist has exhibited, sales, prices of work."

IMPERIAL FRAMING & SPECIALTIES, 960 Bacons Bridge Rd., Summerville SC 29485. (803)891-9712. Owner: Clyde A. Hess. Retail gallery/framing shop. Estab. 1992. Represents 30 and up emerging, mid-career and established artists/year. Exhibited artists include Jim Booth, Redlin and Art Lemay. Sponsors 3 shows/year. Average display time 2 weeks. Open all year; Monday-Saturday, 10-6. Located in town, Palmetto Plaza; 1,000 sq. ft. 10% of space for special exhibitions; 90% of space for gallery artists. Clientele: local, upscale and students. Overall price range: $25-2,000; most work sold at $50-600.

Media: Considers oil, pen & ink, acrylic, drawing, watercolor, mixed media and photography; all types of prints. Most frequently exhibits signed limited edition prints, originals—oil, watercolor and posters.

Style: Exhibits all styles and genres. Prefers: wildlife, Charleston SC printers and eastern coastal scenes.

Terms: Buys outright for 50% of retail price (net 30 days). Will consider rental and co-op and acquire more space. Retail price set by the gallery. Gallery provides insurance, promotion and contract; gallery pays shipping costs to gallery. Prefers artwork unframed.

Submissions: Send query letter with résumé, brochure, business card, photographs and artist's statement. Call for appointment to show portfolio of photographs, slides or samples. Replies in 2 weeks. Finds artists through word of mouth, personal contact and artist submissions.

McCALLS, 111 W. Main, Union SC 29379. (864)427-8781. Owner: William H. McCall. Retail gallery. Estab. 1972. Represents 5-7 established artists/year. Exhibited artists include Mary Ellen Smith and William McCall. Sponsors 3 shows and 1 competition/year. Average display time 9-12 weeks. Open all year; Tuesday-Friday, 11-4 (10 months); Monday-Sunday, 10-6 (2 months). Located downtown; 900 sq. ft. 10% of space for special exhibitions; 90% of space for gallery artists. Clientele: upscale. 60% private collectors, 40% corporate collectors. Overall price range: $150-2,500; most work sold at $150-850.

Media: Considers oil, pen & ink, acrylic, drawing, watercolor, mixed media, pastel, collage; considers all types of prints. Most frequently exhibits acrylics, collage and watercolor.

Style: Exhibits painterly, realism and impressionism. Genres include florals, western, southwestern, landscapes and Americana. Prefers: southwestern, florals and landscapes.

Terms: Accepts work on consignment (40% commission). Retail price set by the gallery and the artist. Gallery provides insurance, promotion and contract.

Submissions: "I prefer to see actual work by appointment only."

Tips: "Contact the gallery and request an appointment. Request that you would like to show some of your new work. Be persistent in your requests for an appointment."

PICKENS COUNTY MUSEUM, 307 Johnson St., Pickens SC 29671. (803)898-7818. Director: C. Allen Coleman. Nonprofit museum located in old county jail. Estab. 1976. Interested in emerging, mid-career and established artists. Sponsors 8 art exhibits/year. Average display time is 2 months. Open all year: Tuesdays, 8:30 a.m.-8:30 p.m.; Wednesday-Friday, 8:30 a.m.-5 p.m.; Saturday, 12-4 p.m.; closed Monday and Sunday. Clientele: artists and public. Overall price range: $200-2,000; most artwork sold at $400.

Media: Considers oil, acrylic, watercolor, pastel, pen & ink, drawings, sculpture, ceramics, fiber, photography, crafts, mixed media, collage and glass.

Style: Exhibits contemporary, abstract, landscape, floral, folk, primitive, non-representational, photo-realistic and realism.

Terms: Accepts work on consignment (30% commission). Retail price is set by artist. Sometimes offers customer discounts. Exclusive area representation not required. Gallery provides insurance, promotion and contract.

Submissions: Send query letter with résumé, 10-12 slides or photographs and SASE. Portfolio review required. Call or write, "no drop-ins." Find artists by visiting exhibitions, reviewing submissions, slide registries and word of mouth.

Tips: "We are interested in work produced by artists who have worked seriously enough to develop a signature style." Advises artists to "keep appointments, answer correspondence, honor deadlines."

PORTFOLIO ART GALLERY, 2007 Devine St., Columbia SC 29205. (803)256-2434. E-mail: portfolio@mindspring. com. Owner: Judith Roberts. Retail gallery and art consultancy. Estab. 1980. Represents 40-50 emerging, mid-career

and established artists. Exhibited artists include Donald Holden, Sigmund Abeles and Joan Ward Elliott. Sponsors 4-6 shows/year. Average display time 3 months. Open all year. Located in a 1930s shopping village, 1 mile from downtown; 2,000 sq. ft.; features 12 foot ceilings. 100% of space for work of gallery artists. "A unique feature is glass shelves where matted and medium to small pieces can be displayed without hanging on the wall." Clientele: professionals, corporations and collectors. 40% private collectors, 40% corporate collectors. Overall price range: $150-12,500; most work sold at $300-3,000.

● Portfolio Art Gallery was selected by readers of the local entertainment weekly paper and by *Columbia Metropolitan* magazine as the best gallery in the area.

Media: Considers oil, acrylic, watercolor, pastel, mixed media, collage, works on paper, sculpture, ceramic, glass, original handpulled prints, woodcuts, wood engravings, linocuts, engravings, mezzotints, etchings, lithographs and serigraphs. Most frequently exhibits watercolor, oil and original prints.

Style: Exhibits neo-expressionism, painterly abstraction, imagism, minimalism, color field, impressionism, realism, photorealism and pattern painting. Genres include landscapes and figurative work. Prefers: landscapes/seascapes, painterly abstraction and figurative work. "I especially like mixed media pieces, original prints and oil paintings. Pastel medium and watercolors are also favorites. Kinetic sculpture and whimsical clay pieces."

Terms: Accepts work on consignment (40% commission). Retail price set by gallery and artist. Offers payment by installments. Gallery provides insurance, promotion and contract; artist pays for shipping. Artwork may be framed or unframed.

Submissions: Send query letter with slides, bio, brochure, photographs, SASE and reviews. Write for appointment to show portfolio of originals, slides, photographs and transparencies. Replies only if interested within 1 month. Files tearsheets, brochures and slides. Finds artists through visiting exhibitions and referrals.

Tips: "The most common mistake beginning artists make is showing all the work they have ever done. I want to see only examples of recent best work—unframed, originals (no copies)—at portfolio reviews."

SMITH GALLERIES, The Village at Wexford, Suite J-11, Hilton Head Island SC 29928. Phone/fax: (803)842-2280. E-mail: smithgal@hargray.com. Website: http://smithgalleries.com. Owner: Wally Smith. Retail gallery. Estab. 1988. Represents 300 emerging, mid-career and established artists. Exhibited artists include Mike Smith and Hessam. Sponsors 10 shows/year. Average display time 6 weeks. Open all year; Monday-Friday, 10-6; Saturday, 10-5. Located in upscale shopping center near town center; 3,600 sq. ft.; designed by Taliesan Architect Bennett Strahan and accompanied by custom fixtures. 30% of space for special exhibitions; 70% of space for gallery artists. Clientele: 95% private collectors, 5% corporate collectors. Overall price range: $200-4,000; most work sold at $400-1,200.

Media: Considers oil, acrylic, watercolor, pastel, paper, sculpture, ceramics, craft, fiber, glass, photography, woodcuts, engravings, lithographs, mezzotints, serigraphs, linocuts, etchings and posters. Most frequently exhibits serigraphs, oil and acrylic.

Style: Exhibits all styles. Genres include florals, wildlife, landscapes, Americana and figurative work. Prefers: realism, expressionism and primitivism.

Terms: Buys outright for 50% of retail price (net 30 days). Retail price set by the gallery. Gallery provides insurance and promotion; shipping costs are shared. Prefers consigned artwork framed; purchase artwork unframed.

Submissions: No restrictions. Send query letter with résumé, 6-10 slides, bio, brochure, photographs, SASE, business card, reviews, artist's statement, "no phone or walk in queries." Write for appointment to show portfolio or photographs. "No slides or transparencies." Replies only if interested within 6 weeks. Files résumé, photos, reviews and bio. Finds artists through art expo, ABC shows and word of mouth.

Tips: "Know the retail value of your work. Don't skimp on framing. Learn to frame yourself if necessary. In short, make your work desirable and easy for the gallery to present. Don't wait until you are out of school to start developing a market. Give marketing a higher priority than your senior show or masters exhibition."

THE SPARTANBURG COUNTY MUSEUM OF ART, 385 S. Spring St., Spartanburg SC 29306. (803)583-2776. Fax: (803)948-5353. Exhibits Coordinator: Theresa H. Mann. Nonprofit art museum. Estab. 1968. Represents emerging, mid-career and established artists. Sponsors 25 shows/year. Average display time 6-8 weeks. Open all year; Monday-Friday, 9-5; Saturday, 10-2; Sunday, 2-5. Located downtown, in historic neighborhood; 2,500 sq. ft.; Overall price range: $150-20,000; most work sold at $150-800.

Media: Considers oil, acrylic, watercolor, pastel, pen & ink, drawings, mixed media, collage, works on paper, sculpture, ceramic, craft, fiber, glass, installation and photography.

Style: Exhibits all styles and genres.

Terms: Accepts artwork on consignment (33⅓% commission). Retail price set by artist. The museum provides insurance and promotion; shipping costs are negotiable. Artwork must be framed.

Submissions: Send query letter with résumé, 10 slides, bio, brochure, SASE and reviews. Write for appointment to show portfolio of slides. Replies in 4-6 weeks. Files bio, résumé and brochure.

South Dakota

✔DAKOTA ART GALLERY, 713 Seventh St., Rapid City SD 57701. (605)394-4108. Director: Jean Fricke. Retail gallery. Estab. 1971. Represents approximately 300 emerging, mid-career and established artists, approximately 150

"By submitting slides I have found galleries willing to represent my work, which sometimes leads to a 15- to 20-piece show," says Karen Brinson, creator of this fiber and mixed media sculpture titled *Cross*. "I also enter art contest exhibitions trying to build my résumé." The structure of this piece was created to enhance the central appliqué, which was composed of scrap fabrics from the artist's life and embellished with other found objects.

© 1997 Karen Brinson

members. Exhibited artists include Howard Olsen and Russell Norberg. Sponsors 12 shows/year. Average display time 1 month. Open all year; Monday-Saturday, 9:30-5; Sunday, 1-5. Memorial Day through Labor Day: Monday-Saturday 9:30-7; Sunday, 1-7. Located in downtown Rapid City; 1,800 sq. ft. 40% of space for special exhibitions; 60% of space for gallery artists. 80% private collectors, 20% corporate collectors. Overall price range: $25-7,500; most work sold at $25-400.

Media: Considers all media and all types of prints. Most frequently exhibits oil, fiber and ceramics.

Style: Exhibits expressionism, painterly abstraction and impressionism and all genres. Prefers: landscapes, western and florals.

Terms: Accepts work on assignment (35% commission). Retail price set by the artist. Gallery provides insurance, promotion and contract. Artist pays shipping costs.

Submissions: "Our main focus is on artists from SD, ND, MN, WY, CO, MT and IA. We also show artwork from any state that has been juried in." Must be juried in by committee. Send query letter with résumé, 15-20 slides, bio and photographs. Call for appointment to show portfolio of photographs, slides, bio and résumé. Replies in 1 month. Files résumés and photographs. Finds artists through word of mouth, referrals by other artists, visiting art fairs and exhibitions, artist's submissions.

Tips: "Make a good presentation with professional résumé, biographical material, slides, etc."

THE HERITAGE CENTER, INC., Red Cloud Indian School, Pine Ridge SD 57770. (605)867-5491. Fax: (605)867-1291. Director: Brother Simon. Nonprofit gallery. Estab. 1984. Represents emerging, mid-career and established artists. Sponsors 6 group shows/year. Accepts only Native Americans. Average display time 10 weeks. Clientele: 80% private collectors. Overall price range: $50-1,500; most work sold at $100-400.

Media: Considers oil, acrylic, watercolor, pastel, pen & ink, drawings, sculpture and original handpulled prints.

Style: Exhibits contemporary, impressionism, primitivism, western and realism. Genres include western. Specializes in contemporary Native American art (works by Native Americans). Interested in seeing pictographic art in contemporary style. Likes clean, uncluttered work.

Terms: Accepts work on consignment (20% commission). Retail price set by artist. Customer discounts and payment by installments are available. Exclusive area representation not required. Gallery provides insurance and promotion; artist pays for shipping.

Submissions: Send query letter, résumé, brochure and photographs Wants to see "fresh work and new concepts, quality

work done in a professional manner." Portfolio review requested if interested in artist's work. Finds artists through word of mouth, publicity in Native American newspapers.

Tips: "Show art properly matted or framed. Good work priced right always sells. We still need new Native American artists if their prices are not above $300. Write for information about annual Red Cloud Indian Art Show."

Tennessee

✔**BENNETT GALLERIES**, 5308 Kingston Pike, Knoxville TN 37919. (423)584-6791. Director: Mary Morris. Owner: Rick Bennett. Retail gallery. Represents established artists. Exhibited artists include Richard Jolley, Carl Sublett, Scott Duce, Charles Movalli and James Tormey. Sponsors 10 shows/year. Average display time 1 month. Open all year; Monday-Thursday, 10-6; Friday-Saturday, 10-5:30. Located in West Knoxville. Clientele: 70% private collectors, 30% corporate collectors. Overall price range: $200-20,000; most work sold at $2,000-4,000.

Media: Considers oil, acrylic, watercolor, pastel, drawing, mixed media, works on paper, sculpture, ceramic, craft, glass, original handpulled prints. Most frequently exhibits painting, ceramic/clay, wood, glass and sculpture.

Style: Exhibits abstraction, figurative, non-objective, impressionism and realism. Genres include landscapes, still life and interiors.

Terms: Accepts artwork on consignment (50% commission). Retail price set by the gallery and the artist. Sometimes offers customer discounts and payment by installments. Gallery provides insurance on works at the gallery, promotion, contract from gallery. Prefers artwork framed. Shipping to gallery to be paid by the artist.

Submissions: Send query letter with résumé, no more than 20 slides, bio, photographs, SASE and reviews. Portfolio review requested if interested in artist's work. Portfolio should include originals, slides, photographs and transparencies. Replies in 6 weeks. Files samples and résumé. Finds artists through agents, visiting exhibitions, word of mouth, various art publications, sourcebooks, submissions/self-promotions and art collectors' referrals.

Tips: "Make a professional presentation, label everything, call before dropping in, do not overkill with non-relevant information, do your research on the galleries to see if you belong."

COOPER ST. GALLERY, 964 S. Cooper St., Memphis TN 38104. (901)272-7053. Owner: Jay S. Etkin. Retail gallery. Estab. 1989. Represents/exhibits 20 emerging, mid-career and established artists/year. Exhibited artists include: Rob vander Schoor and Pamela Cobb. Sponsors 10 shows/year. Average display time 1 month. Open all year; Tuesday-Saturday, 11-5. Located in midtown Memphis; 1,200 sq. ft.; gallery features public viewing of works in progress. 33⅓ of space for special exhibitions; 75% of space for gallery artists. Clientele: young upscale, corporate. 80% private collectors, 20% corporate collectors. Overall price range $200-12,000; most work sold at $500-2,000.

Media: Considers all media except craft, papermaking. Also considers kinetic sculpture and conceptual work. "We do very little with print work." Most frequently exhibits oil on paper canvas, mixed media and sculpture.

Style: Exhibits expressionism, conceptualism, neo-expressionism, painterly abstraction, postmodern works, realism, surrealism. Genres include landscapes and figurative work. Prefers: figurative expressionism, abstraction, landscape.

Terms: Artwork is accepted on consignment (60% commission). Retail price set by the gallery and the artist. Gallery provides promotion. Artist pays for shipping or costs are shared at times.

Submissions: Accepts artists generally from mid-south. Prefers only original works. Looking for long-term committed artists. Send query letter with 6-10 sildes or photographs, bio and SASE. Write for appointment to show portfolio of photographs, slides and cibachromes. Replies only if interested within 1 month. Files bio/slides if interesting work. Finds artists through referrals, visiting area art schools and studios, occasional drop-ins.

Tips: "Be patient. The market in Memphis for quality contemporary art is only starting to develop. We choose artists whose work shows technical know-how and who have ideas about future development in their work. Make sure work shows good craftsmanship and good ideas before approaching gallery. Learn how to talk about your work."

‡**PAUL EDELSTEIN GALLERY/EDELSTEIN ART INVESTMENTS**, 519 N. Highland St., Memphis TN 38122-4521. (901)454-7105. E-mail: pedelst414@aol.com. or pedelst@bellsouth.net. Owner/Director: Paul Edelstein. Assistant: Todd Perkins. Retail gallery and art consultancy. Estab. 1985. Represents 30 emerging, mid-career and established artists. Exhibited artists include Nancy Cheairs, Marjorie Liebman and Carroll Cloar. Sponsors 1-2 shows/year. Average display time 12 weeks. Open all year; by appointment only. Located in East Memphis; 2,500 sq. ft.; 80% of space for special exhibitions. Clientele: upscale. 80% private collectors, 20% corporate collectors. Overall price range: $100-25,000; most work sold at $200-400.

● The gallery is in a 1930s house with many different rooms for exhibiting.

Media: Considers all media and all types of prints. Most frequently exhibits oil, watercolor and prints.

Style: Exhibits hard-edge geometric abstraction, color field, painterly abstraction, minimalism, postmodern works,

SPECIAL MARKET INDEXES, identifying Licensing, Medical Illustration, Religious Art, Science Fiction/Fantasy Art, Sport Art, T-Shirts, Textiles, Wildlife Art and other categories are located in the back of this book.

feminist/political works, primitivism, photorealism, expressionism and neo-expressionism. Genres include florals, land-scapes, Americana and figurative. Most frequently exhibits primitivism, painterly abstraction and expressionism. "Especially seeks new folk artists and N.Y. Soho undiscovered artists." Specializes in contemporary and black folk art, southern regionalism, modern contemporary abstract and WPA 1930s modernism. Interested in seeing modern, contemporary art and contemporary photography.

Terms: Accepts work on consignment (40% commission). Retail price set by gallery. Offers customer discounts and payment by installments. Gallery provides insurance and contract; artist pays for shipping. Prefers artwork framed.

Submissions: Send query letter with résumé, 20 slides, bio, brochure, photographs, SASE and business card. Portfolio review not required. Replies in 2 months. Files all material. Finds artists mostly through word of mouth, *Art in America*, and also through publications like *Artist's & Graphic Designer's Market*.

Tips: "Most artists do not present enough slides or their biographies are incomplete. Professional artists need to be more organized when presenting their work."

THE PARTHENON, Centennial Park, Nashville TN 37201. (615)862-8431. Fax: (615)880-2265. E-mail: info@parthe non.org. Website: http://www.parthenon.org. Museum Director: Ms. Wesley Paine. Nonprofit gallery in a full-size replica of the Greek Parthenon. Estab. 1931. Exhibits the work of emerging to mid-career artists. Clientele: general public, tourists. Sponsors 8 solo and 3 group shows/year. Average display time 6 weeks. Overall price range: $300-2,000; most work sold at $750. We also house a permanent collection of American paintings (1765-1923).

Media: Considers "nearly all" media.

Style: "Interested in both objective and non-objective work. Professional presentation is important."

Terms: "Sale require a 20% commission." Retail price set by artist. Gallery provides a contract and limited promotion. The Parthenon does not represent artists on a continuing basis.

Submissions: Send 10-20 slides with résumé and supporting materials, addressed to Artist Submissions.

Tips: "We plan our gallery calendar at least one year in advance."

Texas

ARCHWAY GALLERY, 2013 W. Gray St., #C, Houston TX 77014-3601. (713)522-2409. Director: Gary Kosmas. Cooperative gallery. Estab. 1976. Represents 15 emerging artists. Interested in emerging and established artists. Sponsors 9 solo and 3 group shows/year. Average display time 1 month. Accepts only artists from the Houston area. Clientele: 70% private collectors, 30% corporate clients. Overall price range: $150-4,000; most work sold at $150-1,000.

Media: Considers all 2- and 3- dimensional media.

Style: Considers all styles and genres.

Terms: Co-op membership "buy-in" fee, plus monthly rental fee, donation of time and 10% commission. Retail price set by artist. Exclusive area representation not required. Gallery provides promotion and contract.

Submissions: Send query letter with résumé, brochure and SASE. Write for appointment to show portfolio of originals, slides and photographs. Replies in 1 month. Files résumé, brochure and slides. All material returned if not accepted or under consideration.

Tips: "Please query before sending materials and know that we don't accept out-of-Houston-area artists. Make sure materials include telephone number."

Tips: "Since our gallery is artist owned and run, our decisions are strongly influenced by how well we feel the person will work within the group. When they are interacting with the artists, and when they are representing everyone when they work with the public in the gallery."

ART LEAGUE OF HOUSTON, 1953 Montrose Blvd., Houston TX 77006. (713)523-9530. Executive Director: Linda Haag Carter. Nonprofit gallery. Estab. 1948. Represents emerging and mid-career artists. Sponsors 12 individual/group shows/year. Average display time 3-4 weeks. Located in a contemporary metal building; 1,300 sq. ft., specially lighted; smaller inner gallery/video room. Clientele: general, artists and collectors. Overall price range: $100-5,000; most artwork sold at $100-2,500.

Media: Considers all media.

Style: Exhibits contemporary avant-garde, socially aware work. Features "high-quality artwork reflecting serious aesthetic investigation and innovation. Additionally the work should have a sense of personal vision."

Terms: 30% commission. Retail price set by artist. Exclusive area representation not required. Gallery provides insurance, promotion and contract; artist pays for shipping.

Submissions: Must be a Houston-area-resident. Send query letter, résumé and slides that accurately portray the work. Portfolio review not required. Submissions reviewed once a year in mid-June and exhibition agenda determined for upcoming year.

ARTHAUS GALERIE, 4319 Oak Lawn Ave., Suite F, Dallas TX 75219. (214)522-2721. Director: Michael Cross. Retail gallery, art consultancy. Estab. 1991. Exhibits 5 emerging, mid-career and established artists/year. Exhibited artists include Michael Cross. Sponsors 9 shows/year. Average display time 3 weeks. Open all year; Tuesday-Saturday, 11-5; Sunday, 1-5. Located in Highland Park/Oak Lawn area of Dallas; 500 sq. ft. of exhibition space. Clientele: international collectors of contemporary art. 80% private collectors, 20% corporate collectors. Overall price range: $500-8,000; most work sold at $500-3,000.

• Arthaus Galerie shows artists on an individual-exhibit basis.
Media: Considers oil, acrylic and mixed media. Most frequently exhibits mixed media, acrylic and oil.
Style: Exhibits painterly abstraction, minimalism and postmodern works. Genres include landscapes and abstract figurative work. Prefers: painterly abstraction and landscape.
Submissions: Send query letter with résumé, slides, bio and photographs of works from the past 2-3 years.

✔JULIA C. BUTRIDGE GALLERY AT THE DOUGHERTY ARTS CENTER, (formerly Dougherty Arts Center Gallery) 1110 Barton Springs Rd., Austin TX 78704. (512)397-1455. E-mail: pardarts@bga.com. Website: http://www.ci. austin.tx.us/parks/. Preparator: Megan Hill. Nonprofit gallery. Represents emerging, mid-career and established artists. Exhibited artists include John Christensen and T. Paul Hernandez. Sponsors 12 shows/year. Average display time 1 month. Open all year; Monday-Thursday, 9-9:30; Friday 9-5:30; Saturday 10-2. Located in downtown Austin; 1,800 sq. ft.; open to all artists. 100% of space for special exhibitions. Clientele: citizens of Austin and central Texas. Overall price range: $100-5,000.
Media: Considers all media, all types of prints.
Style: Exhibits all styles, all genres. Prefers: contemporary.
Terms: "Gallery does not handle sales or take commissions. Sales are encouraged but must be conducted by the artist or his/her affiliate." Rental fee for space; covers 1 month. Retail price set by the artist. Gallery provides insurance and promotion; artist pays shipping costs to and from gallery. Artwork must be framed.
Submissions: Accepts only regional artists, central Texas. Send query letter with résumé and 10-20 slides. Write for appointment to show portfolio of photographs and slides. Replies in 1 month. Files résumé, slides. Finds artists through visiting exhibitions, publications, submissions.
Tips: "Since most galleries will not initially see an artist via an interview, have fun and be creative in your paper presentations. Intrigue them!"

‡EL TALLER GALLERY-AUSTIN, 8015 Shoal Creek Blvd., #109, Austin TX 78757. (512)302-0100. Fax: (512)302-4895. Website: http://www.instar.com. Owner/Director: Olga or Diana. Retail gallery, art consultancy. Estab. 1980. Represents 20 emerging, mid-career and established artists/year. Exhibited artists include R.C. Gorman and Amado Peña. Sponsors 6 shows/year. Average display time 2-4 weeks. Open all year; Tuesday-Saturday, 10-6. 1,850 sq. ft. 50% of space for special exhibitions; 100% of space for gallery artists. Clientele: tourists, upscale. 90% private collectors, 10% corporate collectors. Overall price range: $500-15,000; most work sold at $2,500-4,000.
Media: Considers all media and all types of prints. Most frequently exhibits mixed media, pastels and watercolors.
Style: Exhibits expressionism, primitivism, conceptualism, impressionism. Genres include florals, western, southwestern, landscapes. Prefers: southwestern, landscape, florals.
Terms: Accepts work on consignment (50% commission). Retail price set by the artist. Gallery provides insurance, promotion and contract; artist pays shipping costs. Prefers artwork framed.
Submissions: Send query letter with bio, photographs and reviews. Write for appointment to show portfolio of photographs and actual artwork. Replies only if interested within 2 months.

IRVING ARTS CENTER—MAIN AND NEW TALENT GALLERIES, 3333 N. MacArthur Blvd., Irving TX 75062. (972)252-7558. Fax: (972)570-4962. E-mail: iac@airmail.net. Gallery Director: Marcie J. Inman. Nonprofit municipal arts center. Estab. 1990. Represents emerging, mid-career and established artists. Sponsors 25-30 shows/year. Average display time 3-6 weeks. Open all year; Monday-Friday, 9-5; Saturday, 10-5; Sunday, 1-5. Located in the middle of residential, commercial area; 4,600 sq. ft.; utilizes two theater lobbies for rotating exhibitions in addition to the galleries—Main Gallery has 30′ ceiling, skylights and 45′ high barrel vault. 100% of space for special exhibitions. Clientele: local community. Overall price range: $200-80,000; most work sold at $200-4,000.
Media: Considers all media except craft. Considers all types of prints except posters. Most frequently exhibits painting, sculpture, photography.
Style: Exhibits all styles.
Terms: Artists may sell their work and are responsible for the sales. Retail price set by the artist. Gallery provides insurance, promotion, contract and some shipping costs. Prefers artwork framed ready to install.
Submissions: Send query letter with résumé, brochure, business card, 10-20 slides, photographs, reviews, artist's statement, bio and SASE. Call for appointment to show portfolio of photographs, transparencies or slides. Replies in 6-18 months. Files slides, résumé, artist's statement. Finds artists through word of mouth, referrals by other artists, visiting galleries and exhibitions, submissions, visiting universities' galleries and graduate students' studios.
Tips: "Have high-quality slides or photographs made. It's worth the investment. Be prepared—i.e. know something about the Arts Center. Present yourself professionally—whatever your level of experience. We are not a commercial gallery—artists are chosen for exhibitions based on their work—not necessarily on name recognition and definitely not based on commercial viability (sales)."

‡IVÁNFFY & UHLER GALLERY, 4623 W. Lovers Lane, Dallas TX 75209. (214)350-3500. Fax: (214)353-8709. Director: Paul Uhler. Retail/wholesale gallery. Estab. 1990. Represents 20 mid-career and established artists/year. May be interested in seeing the work of emerging artists in the future. Exhibited artists include Maria Bozoky and Rudolf Lang. Sponsors 3-4 shows/year. Average display time 1 month. Open all year; Tuesday-Sunday, 10-6. Located near Love Field Airport. 4,000 sq. ft. 100% of space for gallery artists. Clientele: upscale, local community. 85% private collectors, 15% corporate collectors. Overall price range: $1,000-20,000; most work sold at $1,500-4,000.

Media: Considers oil, acrylic, watercolor, pastel, pen & ink, drawing, mixed media, collage, paper, sculpture, woodcuts, engravings, lithographs, wood engravings, mezzotints, serigraphs, linocuts and etchings. Most frequently exhibits oils, mixed media, sculpture.
Style: Exhibits neo-expressionism, painterly abstraction, surrealism, postmodern works, impressionism, hard-edge geometric abstraction, postmodern European school. Genres include florals, landscapes, figurative work.
Terms: Gallery provides promotion; shipping costs are shared.
Submissions: Accepts only artists from Europe. Send query letter with résumé, photographs, bio and SASE. Write for appointment to show portfolio of photographs. Replies only if interested within 1 month.

JOJUMA CYBERGALLERY, P.O. Box 221953, El Paso TX 79913. (505)589-3502. E-mail: jbower@whc.net. Retail gallery and alternative space. Estab. 1998. Represents emerging and mid-career artists. "We anticipate 10 for the year. Our space is electronic and mobile. Sales are made in cyberspace or by appointments in homes and offices in W. Texas and New Mexico." Overall price range: $100-2,000, anticipated.
• Cybergallery will open in mid-1998.
Media: Considers all media and all types of print. Oil and acrylic are the most frequently exhibited media.
Style: Exhibits all styles and all genres. "We look for diversity in style and type."
Terms: Accepts work on consignment. Retail price set by the gallery in consultation with the artist. Gallery provides promotions. Insurance provided by buyer. Buyer pays shipping costs. Prefers artwork unframed.
Submissions: Send 8×10 glossies of 6-8 representative works with SASE, also send slides of same work. Write or e-mail for appointment to show portfolio of photographs and slides. Replies only if interested within 2 months. All SASEs returned with ineligible slides and glossies. Finds artists through referrals by other artists, exhibitions and artist's submissions.
Tips: "Because of the cyber nature of our gallery, we are not too orthodox. We may even be categorized as art-reps, yet we deal with fine arts."

✔LONGVIEW MUSEUM OF FINE ARTS, (formerly Longview Art Museum) 215 E. Tyler St, P.O. Box 3484, Longview TX 75606. (903)753-8103. E-mail: foxhearne@kilgore.net. Director: Carolyn Fox Hearne. Museum. Estab. 1967. Represents 80 emerging, mid-career and established artists/year. 600 members. Sponsors 6-9 shows/year. Average display time 6 weeks. Open all year; Tuesday-Saturday, 10-4. Located downtown. 75% of space for special exhibitions. Clientele: members, visitors (local and out-of-town) and private collectors. Overall price range: $200-2,000; most work sold at $200-800.
Media: Considers all media, all types of prints. Most frequently exhibits oil, acrylic and photography.
Style: Exhibits all styles and genres. Prefers contemporary American art and photography.
Terms: Accepts work on consignment (30% commission). Retail price set by the artist. Offers customer discounts to museum members. Gallery provides insurance and promotion. Prefers artwork framed.
Submissions: Send query letter with résumé and slides. Portfolio review not required. Replies in 1 month. Files slides and résumés. Finds artists through art publications and shows in other areas.

‡SELECT ART, 10315 Gooding Dr., Dallas TX 75229. (214)353-0011. Fax: (214)350-0027. Owner: Paul Adelson. Private art gallery. Estab. 1986. Represents 25 emerging, mid-career and established artists. Exhibited artists include Barbara Elam and Larry Oliverson. Open all year; Monday-Saturday, 9-5 by appointment only. Located in North Dallas; 2,500 sq. ft. "Mostly I do corporate art placement." Clientele: 15% private collectors, 85% corporate collectors. Overall price range: $200-7,500; most work sold at $500-1,500.
Media: Considers oil, fiber, acrylic, sculpture, glass, watercolor, mixed media, ceramic, pastel, collage, photography, woodcuts, linocuts, engravings, etchings and lithographs. Prefers monoprints, paintings on paper and photography.
Style: Exhibits photorealism, minimalism, painterly abstraction, realism and impressionism. Genres include landscapes. Prefers: abstraction, minimalism and impressionism.
Terms: Accepts work on consignment (50% commission). Retail price set by consultant and artist. Sometimes offers customer discounts. Provides contract (if the artist requests one). Consultant pays shipping costs from gallery; artist pays shipping to gallery. Prefers artwork unframed.
Submissions: "No florals or wildlife." Send query letter with résumé, slides, bio and SASE. Call for appointment to show portfolio of slides. Replies only if interested within 1 month. Files slides, bio, price list. Finds artists through word of mouth and referrals from other artists.
Tips: "Be timely when you say you are going to send slides, artwork, etc., and neatly label slides."

‡EVELYN SIEGEL GALLERY, 3700 W. Seventh, Fort Worth TX 76107. (817)731-6412. Fax: (817)731-6413. Owner: E. Siegel. Retail gallery and art consultancy. Estab. 1983. Represents about 30 artists; emerging, mid-career and established. Interested in seeing the work of emerging artists. Exhibited artists include Judy Pelt and John Bryant. Sponsors 9 shows/year. Average display time 3 weeks. Open all year; Monday-Friday, 11-5; Saturday, 11-4. Located in museum area; 2500 sq. ft.; diversity of the material and artist mix. "The gallery is warm and inviting; a reading area is provided with many art books and publications." 66% of space for special exhibitions. Clientele: upscale, community, tourists. 90% private collectors. Overall price range: $30-10,000; most work sold at $1,500.
Media: Considers oil, acrylic, watercolor, pastel, mixed media, collage, sculpture, ceramic; original handpulled prints; woodcuts, wood engravings, linocuts, engravings, mezzotints, etchings, lithographs and serigraphs. Most frequently exhibits painting and sculpture.

Style: Exhibits expressionism, neo-expressionism, painterly abstraction, color field, impressionism and realism. Genres include landscapes, florals and figurative work. Prefers: landscape, florals, interiors and still life.
Terms: Accepts work on consignment (50% commission), or is sometimes bought outright. Retail price set by gallery and artist. Gallery provides insurance, promotion and contract. Artist pays for shipping. Prefers artwork framed.
Submissions: Send query letter with résumé, slides and bio. Call or write for appointment to show portfolio of two of the following: originals, photographs, slides and transparencies.
Tips: Artists must have an appointment.

Utah

‡**APPLE YARD ART**, 3096 S. Highland Dr., Salt Lake City UT 84106. (801)467-3621. Manager: Sue Valentine. Retail gallery. Estab. 1981. Represents 15 established artists. Interested in seeing the work of emerging, mid-career and established artists. Average display time 3 months. "We have added European pine antiques and home accessories to compliment our art." Clientele: 70% private collectors, 30% corporate clients. Overall price range: $150-2,000; most artwork sold at $450.
Media: Most frequently exhibits watercolor, oil, mixed media, serigraphs and limited edition lithographs.
Style: Exhibits impressionisim. Genres include landscapes and florals. Prefers impressionistic watercolors.
Terms: Accepts work on consignment (40% commission). Retail price set by artist. Gallery provides insurance, promotion and contract; artist pays for shipping.
Submissions: Send query letter, résumé and 6-10 slides. Write for appointment to show portfolio of well-matted and framed originals.
Tips: Looks for "fresh, spontaneous subjects, no plagiarism." The most common mistakes artists make in presenting their work are "poor framing, no established prices, wanting us to tell them what to sell it for. The artists should establish a retail price that is affordable and competitive. Decide whether you want your work to sell or 'sit.' "

BARKER'S WHITEPINE GALLERY, 855 S. Main St., Logan UT 84321. (435)752-3657 or 752-6469. Fax: (435)753-9677. E-mail: art@atmystudio.com or dreena@atmystudio.com. Website: http://wwwatmystudio.com. Gallery Director: Dreena Barker. Retail Gallery. Estab. 1978. Represents 8-15 emerging and mid-career artists. Exhibited artists include Glen Edwards and Barbara Edwards. Sponsors 1 exhibition/year. Average display time is 4 months. Open daily, 7-10. Located south of downtown; 1,200 sq. ft. Clientele: tourists, local. 90% private collectors, 10% corporate collectors. Overall price range, $50-3,000; most work sold at $100-500.
Media: Considers all media and all types of prints. Most frequently exhibits oils, prints and watercolors.
Style: Exhibits primitivism and realism. Genres include western, wildlife, southwestern and landscapes.
Terms: Artwork is accepted on consignment (30% commission). Retail price set by the artist. Gallery provides promotion. Artist pays for shipping costs to the gallery. Prefers artwork framed.
Submissions: Send query letter with résumé, brochure, 8 photographs, reviews, business card, "best non-returnable promotion information." Replies only if interested in 1 month. Files promotion sheets. Finds artists through referrals, exhibits and interviews.

BRAITHWAITE FINE ARTS GALLERY, 351 West Center, Cedar City UT 84720. (801)586-5432. E-mail: museums @suu.edu. Website: http://www.suu.edu/webpages/MuseumGaller. Director: Lydia Johnson. Nonprofit gallery. Estab. 1976. Represents emerging, mid-career and established artists. Has "100 friends (donors)." Sponsors 17 shows/year. Average display time 1 month. Open all year. Located on "college campus; 2,000 sq. ft. (300 ft. running wall); historic building." 100% of space for special exhibitions. Clientele: local citizens, visitors for Shakespeare festival during summer. Clientele: 100% private collectors. Overall price range: $100-8,000; most work sold at $100-500.
Media: Considers oil, acrylic, watercolor, pastel, pen & ink, drawings, mixed media, collage, works on paper, sculpture, ceramic, fiber, glass, installation, photography, original handpulled prints, woodcuts, wood engravings, linocuts, engravings, mezzotints, etchings, lithographs, serigraphs. Most frequently exhibits oil, watercolor and ceramic.
Style: Exhibits all styles and genres.
Terms: Accepts work on consignment (25% commission). Retail price set by the artist. Customer discounts and payment by installment are available. Gallery provides insurance, promotion and contract (duration of exhibit only); shipping costs are shared. Ready-to-hang artwork only.
Submissions: Send query letter with résumé, slides, bio and SASE. Write for appointment to show portfolio of slides and transparencies. Replies in 3-4 weeks. Files bios, slides, résumé (only for 2 years).
Tips: "Know our audience! Generally conservative; during summer (Shakespeare festival) usually loosens up. We look for broad stylistic vision and content. Artists often send no slides, no bio, no artist's statement. We book exhibits two years in advance."

C GALLERY, 466 S. Fifth E., Salt Lake City UT 84102-2705. Phone/fax: (801)359-8995. E-mail: theodore@xmission.c om. Director: Constance Theodore. Retail gallery. Estab. 1992. Represents 8 emerging, mid-career and established artists/year Exhibited artists include Joan Nelson and Michael Peglau. Sponsors 2 shows/year. Average display time 3 months. Open all year; Monday-Friday, 8-5. Located in downtown outskirts; 100 sq. ft.; attic loft of 1910 home converted to offices. 60% of space for special exhibitions; 40% of space for gallery artists. Clientele: upscale. 100% private collectors. Overall price range: $10-6,500; most work sold at $200.

Media: Considers bronze sculpture, landscape originals in oil, portraiture. Most frequently exhibits oil paintings on linen, acrylic on canvas and charcoal on paper portraits.

Style: Exhibits all styles. Genres include portraits, western contemporary, landscapes and Americana. Prefers: landscape, soulscapes, portraits and Americana.

Terms: Accepts work on consignment (50% commission). Retail price set by the gallery. Gallery provides promotion. Shipping costs are shared. Prefers artwork framed.

Submissions: Accepts only artists with Utah heritage. Send query letter with résumé, 6 slides, bio, SASE, reviews and artist's statement. Call or write for appointment to show portfolio review of photographs and slides. Replies in 1 week. Finds artists through word of mouth, referrals by other artists, visiting art fairs and exhibitions, artist's submissions.

Tips: "I like to see the originals. Call personally for an appointment with the director. At your meeting, present at least one original work and slides or photos. Have a résumé and artists' statement ready to leave as your calling card."

THE GALLERY ETC., 2340 Washington, Ogden UT 84401. (801)621-8282. Fax: (801)621-3461. Owner: Evaline Petersen. Retail gallery. Estab. 1994. Represents 25 established artists/year. May be interested in seeing the work of emerging artists in the future. Exhibited artists include Scott Wallis and Steve Songer. Sponsors 4 shows/year. Average display time 2 months. Open all year; Tuesday-Friday, 11-6; Saturday, 11-4. Located downtown; 3,000 sq. ft.; the building is 100 years old, restored and improved. 100% of space for gallery artists. Overall price range: $250-10,000; most work sold at $1,500-2,500.

Media: Considers all media and all types of prints. Most frequently exhibits oil, watercolor, sculpture.

Style: Exhibits expressionism, impressionism and realism. Exhibits all genres. Prefers: landscapes, florals and Americana.

Term; Accepts work on consignment (40-50% commission). Retail price set by the gallery and the artist. Gallery provides insurance, promotion and contract. Shipping costs are shared.

Submissions: "We basically show northwest regional but not exclusively." Write for appointment to show portfolio of photographs, slides and transparencies. Replies only if interested within 1 month. Finds artists through word of mouth, referrals by other artists, visiting art fairs and exhibitions, artist's submissions.

✔**SERENIDAD GALLERY**, 360 W. Main, Escalante UT 84726. Phone/fax: (435)826-4720. E-mail: sunshine@color-country.net. Website: http://www.escalante-cc.com/serenidad/html. Co-owners: Philip and Harriet Priska. Retail gallery. Estab. 1993. Represents 7 mid-career and established artists/year. May be interested in seeing the work of emerging artists in the future. Exhibited artists include Lynn Griffin and Rachel Bentley. All work is on continuous display. Open all year; Monday-Saturday, 8-8; Sunday, 1-8. Located on Highway 12 in Escalante; 1,700 sq. ft.; "rustic western decor with log walls." 50% of space for gallery artists. Clientele: tourists. 100% private collectors. Overall price range: $100-3,000; most work sold at $300-1,100.

Media: Considers oil, acrylic, watercolor, sculpture, fiber (Navajo and Zapotec rugs), photography and china painting. Most frequently exhibits acrylics, watercolors and oils.

Style: Exhibits realism. Genres include western, southwestern and landscapes. Prefers: Utah landscapes—prefer local area here, northern Arizona-Navajo reservation and California-Nevada landscapes.

Terms: Accepts work on consignment (commission set by artist) or buys outright (prices set by artist). Retail price set by the gallery. Gallery provides promotion.

Submissions: Accepts only artists from Southwest. Prefers only oil, acrylic and watercolor. Realism only. Contact in person. Call for appointment to show portfolio of photographs. Replies in 3 weeks. Finds artists "generally by artists coming into the gallery."

Tips: "Work must show professionalism and have quality. This is difficult to explain; you know it when you see it."

Vermont

HAYLOFT GALLERY, P.O. Box 416, Rt. 100, West Dover VT 05356. (802)464-5525. Director: Gloria Levine. Retail gallery. Estab. 1989. Represents 16 emerging, mid-career and established artists/year. Exhibited artists include Edward Gordon and Ted Jeremenko. Sponsors 3 shows/year. Average display time 6 months. Open all year; Sunday-Saturday, 10-5. Located in center of small village; 1,500 sq. ft.; in a 150-year-old house which is part of a historic district. 30% of space for special exhibitions; 70% of space for gallery artists. Clientele: upscale tourists and second home owners. 98% private collectors, 2% corporate collectors. Overall price range: $300-9,000; most work sold at $300-1,000.

Media: Considers all media except installation and signed limited-edition graphics.

Style: Exhibits all styles. Genres include florals, wildlife, landscapes and Americana.

Terms: Accepts work on consignment (60% commission) or buys outright for 50% of retail price. Retail price set by the artist. Gallery provides insurance and promotion. Shipping costs are shared. Prefers artwork framed.

Submissions: Send query letter with résumé, 15 slides, bio, photographs, reviews and artist's statement. Call or write for appointment to show portfolio of photographs and slides. Replies in 2 weeks. Files bio, reviews and statement. Finds artists through word of mouth, referrals by other artists, visiting art fairs and exhibitions, artist's submissions.

Tips: "Frame professionally! If you can't frame well yourself then have some one else do it. Presentation usually makes or breaks a sale."

PARADE GALLERY, Box 245, Warren VT 05674. (802)496-5445. Fax: (802)496-4994. E-mail: parade@madriver.com. Website: http://www.discover-vermont.com. Owner: Jeffrey S. Burnett. Retail gallery. Estab. 1982. Represents 15-20 emerging, mid-career and established artists. Clientele: tourist and upper middle class second-home owners. 98% private collectors. Overall price range: $20-2,500; most work sold at $50-300.
Media: Considers oil, acrylic, watercolor, pastel, mixed media, collage, works on paper, sculpture and original hand-pulled prints. Most frequently exhibits etchings, silkscreen and watercolor. Currently looking for oil/acrylic and watercolor.
Style: Exhibits primitivism, impressionistic and realism. "Parade Gallery deals primarily with representational works with country subject matter. The gallery is interested in unique contemporary pieces to a limited degree." Does not want to see "cutesy or very abstract art."
Terms: Accepts work on consignment (33⅓% commission) or occasionally buys outright (net 30 days). Retail price set by gallery or artist. Sometimes offers customer discounts and payment by installment. Exclusive area representation required. Gallery provides insurance and promotion.
Submissions: Send query letter with résumé, slides and photographs. Portfolio review requested if interested in artist's work. A common mistake artists make in presenting their work is having "unprofessional presentation or poor framing." Biographies and background are filed. Finds artists through customer recommendations, shows, magazines or newspaper stories and photos.
Tips: "We need to broaden offerings in price ranges which seem to offer a good deal for the money."

Virginia

EMERSON GALLERY McLEAN PROJECT FOR THE ARTS, 1234 Ingleside Ave., McLean VA 22101. (703)790-0123. Fax: (703)556-0547. Alternative space. Estab. 1962. "Over 400 artists have exhibited at the space." Exhibited artists include Yuriko Yamaguchi and Christopher French. Sponsors 6 shows/year. Average display time 5-6 weeks. Open Tuesday-Friday, 11-4; Saturday, 1-5. 3,000 sq. ft.; large luminous "white cube" type of gallery; moveable walls. 85% of space for special exhibitions. Clientele: local community, students, artists' families. 100% private collectors. Overall price range: $200-15,000; most work sold at $800-1,800.
Media: Considers all media except graphic design and traditional crafts; all types of prints except posters. Most frequently exhibits painting, sculpture and installation.
Style: Exhibits all styles, all genres.
Terms: Artwork is accepted on consignment (25% commission). Retail price set by the artist. Gallery provides insurance and promotion. Artist pays for shipping costs. Prefers artwork framed (if works on paper).
Submissions: Accepts only artists from Maryland, DC, Virginia and some regional Mid-Atlantic. Send query letter with résumé, slides, reviews and SASE. Replies within 1-2 months. Artists' slides, bios and written material kept on file for 2 years. Finds artists through referrals by other artists and curators; by visiting exhibitions and studios.

‡HAMPTON UNIVERSITY MUSEUM, Huntington Building on Ogden Circle, Hampton VA 23668. (757)727-5308. Fax: (757)727-5170. Website: http://www.hamptonu.edu. Director: Jeanne Zeidler. Curator of Exhibitions: Jeffrey Bruce. Museum. Estab. 1868. Represents/exhibits established artists. Exhibited artists include Elizabeth Catlett and Jacob Lawrence. Sponsors 4-5 shows/year. Average display time 4-5 weeks. Open all year; Monday-Friday, 8-5; Saturday-Sunday, 12-4; closed on major and campus holidays. Located on the campus of Hampton University.
Media: Considers all media and all types of prints. Most frequently exhibits oil or acrylic paintings, ceramics and mixed media.
Style: Exhibits African-American, African and/or Native American art.
Submissions: Send query letter with résumé and a dozen or more slides. Portfolio should include photographs and slides.

MARSH ART GALLERY, University of Richmond, Richmond VA 23173. (804)289-8276. Fax: (804)287-6006. E-mail: rwaller@richmond.edu. Website: http://www.urich.edu/. Director: Richard Waller. Museum. Estab. 1968. Represents emerging, mid-career and established artists. Sponsors 10 shows/year. Average display time 6 weeks. Open all year; with limited summer hours May-August. Located on University campus; 5,000 sq. ft. 100% of space for special exhibitions.
Media: Considers all media and all types of prints. Most frequently exhibits painting, sculpture, photography and drawing.
Style: Exhibits all styles and genres.
Terms: Work accepted on loan for duration of special exhibition. Retail price set by the artist. Gallery provides insurance, promotion, contract and shipping costs. Prefers artwork framed.
Submissions: Send query letter with résumé, 8-12 slides, brochure, SASE, reviews and printed material if available. Write for appointment to show portfolio of photographs, slides, transparencies or "whatever is appropriate to understanding the artist's work." Replies in 1 month. Files résumé and other materials the artist does not want returned (printed material, slides, reviews, etc.).

‡PREMIER GALLERY, 814 Caroline St., Fredericksburg VA 22401. (703)899-3100. E-mail: rtgar@aol. Owner: Jack Garver. Retail gallery. Estab. 1986. Represents/exhibits 35 mid-career and established artists/year. Interested in seeing

the work of emerging artists. Exhibited artists include Richard Millerand Hessam. Sponsors 4 shows/year. Average display time 1 month. Open all year; Monday-Saturday, 11-5; Sunday, 1-5; closed Wednesday. Located in Old Town in historic district; 2,800 sq. ft.; intimate, elegant setting in historic building. 50% of space for special exhibitions; 50% of space for gallery artists. Clientele: tourists, upscale, local community Washington DC and metropolitan area. 90% private collectors. Overall price range: $100-15,000; most work sold at $600-3,500.

Media: Considers all media except photography. Most frequently exhibits oil, watercolor and sculpture.

Style: Exhibits realism and impressionism, some contemporary. Genres include landscapes, florals, wildlife and figurative work. Prefers realism and impressionism.

Terms: Artwork is accepted on consignment (40% commission) or bought outright for 50% of retail price; net 30 days. Retail price set by the gallery and the artist. Gallery provides insurance, promotion and contract; shipping costs are shared. Prefers artwork framed.

Submission: Prefers only established artists with credentials. Send query letter with résumé, slides and reviews. Call or write for appointment to show portfolio of slides. Replies only if interested within 3 weeks. Finds artists mostly through artist referrals and national shows.

Tips: "Some surprises have come by unsolicited presentations. Always looking during my travels. Try to determine what area of country might be best suited and send out letters and sampling of slides. Enter as many quality shows as possible for feedback."

THE PRINCE ROYAL GALLERY, 204 S. Royal St., Alexandria VA 22314. (703)548-5151. E-mail: princeroyal@look .net. Website: http://look.net/PrinceRoyal. Director: John Byers. Retail gallery. Estab. 1977. Interested in emerging, mid-career and established artists. Sponsors 6 shows/year. Average display time 3-4 weeks. Located in middle of Old Town Alexandria. "Gallery is the ballroom and adjacent rooms of historic hotel." Clientele: primarily Virginia, Maryland and Washington DC residents. 95% private collectors, 5% corporate clients. Overall price range: $75-8,000; most artwork sold at $700-1,200.

Media: Considers oil, acrylic, watercolor, pastel, mixed media, sculpture, egg tempera, engravings, etchings and lithographs. Most frequently exhibits oil, watercolor and bronze.

Style: Exhibits impressionism, expressionism, realism, primitivism and painterly abstraction. Genres include landscapes, florals, portraits and figurative work. "The gallery deals primarily in original, representational art. Abstracts are occasionally accepted but are hard to sell in northern Virginia. Limited edition prints are accepted only if the gallery carries the artist's original work."

Terms: Accepts work on consignment (40% commission). Retail price set by artist. Customer discounts and payment by installment are available, but only after checking with the artist involved and getting permission. Exclusive area representation required. Gallery provides insurance, promotion and contract. Requires framed artwork.

Submissions: Send query letter with résumé, brochure, slides and SASE. Call or write to schedule an appointment to show a portfolio, which should include originals, slides and transparencies. Replies in 1 week. Files résumés and brochures. All other material is returned.

Tips: "Write or call for an appointment before coming. Have at least six pieces ready to consign if accepted. Can't speak for the world, but in northern Virginia collectors are slowing down. Lower-priced items continue okay, but sales over $3,000 are becoming rare. More people are buying representational rather than abstract art. Impressionist art is increasing. Get familiar with the type of art carried by the gallery and select a gallery that sells your style work. Study and practice until your work is as good as that in the gallery. Then call or write the gallery director to show photos or slides."

Washington

‡THE AMERICAN ART COMPANY, 1126 Broadway Plaza, Tacoma WA 98402. (206)272-4377. Director: Rick Gottas. Retail gallery. Estab. 1978. Represents/exhibits 50 emerging, mid-career and established artists/year. Exhibited artists include Toko Shinoda. Sponsors 10 shows/year. Open all year; Monday-Friday, 10-5:30; Saturday, 10-5. Located downtown; 3,500 sq. ft. 60% of space for special exhibitions; 40% of space for gallery artists. Clientele: local community. 95% private collectors, 5% corporate collectors. Overall price range: $500-15,000; most work sold at $1,800.

Media: Considers oil, fiber, acrylic, sculpture, glass, watercolor, mixed media, pastel, collage, woodcuts, wood engravings, linocuts, engravings, mezzotints, etchings, lithographs and serigraphs. Most frequently exhibits works on paper, sculpture and oils.

Style: Exhibits all styles. Genres include landscapes, Chinese and Japanese.

Terms: Artwork is accepted on consignment (50% commission) or bought outright for 50% of retail price; net 30 days. Retail price set by the gallery and the artist. Gallery provides insurance and promotion; shipping costs are shared. Prefers artwork unframed.

Submissions: Send query letter with résumé, slides, bio and SASE. Write for appointment to show portfolio of slides. Replies in 2-3 weeks. Finds artists through word of mouth, referrals by other artists, visiting art fairs and exhibitions, submissions.

‡BRUSKIN GALLERY, 820 Water, Port Townsend WA 98368. (206)385-6227. Contact: Kathleen Bruskin. Retail gallery. Estab. 1985. Repersents 200 established artists/year. Sponsors 12 shows/year. Average display time 1 month.

Open all year; daily, 10-4:30. Located downtown. 100% of space for special exhibitions. Clientele: upper middle class. 100% private collectors. Overall price range: $200-900; most work sold at $350-500.
Media: Considers oil, acrylic, watercolor, pastel, mixed media, collage. Most frequently exhibits oil, watercolor and mixed media.
Style: Exhibits all styles, all genres. Prefers landscapes, figures, abstractions.
Terms: Retail price set by the gallery and the artist. Gallery provides promotion and contract; artist pays shipping costs to and from gallery. Prefers artwork framed.
Submissions: Send query letter with slides and photographs. Write for appointment to show portfolio of originals, photographs, slides and transparencies. Replies in 2 weeks. Finds artists through visiting exhibitions and submissions.

✓**DAVIDSON GALLERIES**, 313 Occidental Ave. S., Seattle WA 98104. (206)624-7684. Website: http://www.halcyo n.com/davidson/. Director: Sam Davidson. Retail gallery. Estab. 1973. Represents 150 emerging, mid-career and established artists. Sponsors 36 shows/year. Average display time 3½ weeks. Open all year; Monday-Saturday, 11-5:30. Located in old, restored part of downtown: 3,200 sq. ft.; "beautiful antique space with columns and high ceilings in 1890 style." 20% of space for special exhibitions; 80% of space for gallery artists. Clientele: 90% private collectors, 10% corporate collectors. Overall price range: $10-350,000; most work sold at $150-5,000.
Media: Considers oil, acrylic, drawing (all types), sculpture, watercolor, mixed media, pastel, woodcuts, wood engravings, linocuts, engravings, mezzotints, etchings, lithographs, limited interest in digital manipulation.
Style: Exhibits expressionism, neo-expressionism, primitivism, painterly abstraction, postmodern works, realism, surrealism, impressionism.
Terms: Accepts work on consignment (50% commission). Retail price set by gallery and artist. Gallery provides insurance, promotion and contract; shipping costs are one way.
Submissions: Send query letter with résumé, 20 slides, bio and SASE. Replies in 4-6 weeks.
Tips: Impressed by "simple straight-forward presentation of slides, résumé with SASE included. No videos."

KIRSTEN GALLERY, INC., 5320 Roosevelt Way NE, Seattle WA 98105. (206)522-2011. Director: R.J. Kirsten. Retail gallery. Estab. 1975. Represents 60 emerging, mid-career and established artists. Exhibited artists include Birdsall and Daiensai. Sponsors 10 shows/year. Average display time 1 month. Open all year. 3,500 sq. ft.; outdoor sculpture garden. 40% of space for special exhibitions; 60% of space for gallery artists. 90% private collectors, 10% corporate collectors. Overall price range: $75-15,000; most work sold at $75-2,000.
Media: Considers oil, acrylic, watercolor, mixed media, sculpture, glass and offset reproductions. Most frequently exhibits oil, watercolor and glass.
Style: Exhibits surrealism, photorealism and realism. Genres include landscapes, florals, Americana. Prefers: realism.
Terms: Accepts work on consignment (50% commission). Retail price set by artist. Offers payment by installments. Gallery provides promotion; artist pays shipping costs. "No insurance; artist responsible for own work."
Submissions: Send query letter with résumé, slides and bio. Write for appointment to show portfolio of photographs and/or slides. Replies in 2 weeks. Files bio and résumé. Finds artists through visiting exhibitions and word of mouth.
Tips: "Keep prices down. Be prepared to pay shipping costs both ways. Work is not insured (send at your own risk). Send the best work—not just what you did not sell in your hometown."

‡**MING'S ASIAN GALLERY**, 10217 Main St., Old Bellevue WA 98004-6121. (206)462-4008. Fax: (206)453-8067. Director: Nelleen Klein Hendricks. Retail gallery. Estab. 1964. Represents/exhibits 3-8 mid-career and established artists/year. Exhibited artists include Kim Man Hee, Kai Wang and Kaneko Jonkoh. Sponsors 8 shows/year. Average display time 1 month. Open all year; Monday-Saturday, 10-6. Located downtown; 6,000 sq. ft.; exterior is Shanghai architecture circa 1930. 20% of space for special exhibitions. 35% private collectors, 20% corporate collectors. Overall price range: $350-10,000; most work sold at $1,500-3,500.
Media: Considers oil, acrylic, watercolor, sumi paintings, Japanese woodblock. Most frequently exhibits sumi paintings with woodblock and oil.
Style: Exhibits expressionism, primitivism, realism and imagism. Genres include Asian. Prefers: antique, sumi, watercolors, temple paintings and folk paintings.
Terms: Artwork is accepted on consignment (50% commission). Retail price set by the gallery and the artist. Gallery provides insurance, promotion and contract; shipping costs are shared. Prefers artwork framed.
Submissions: Send query letter with résumé, brochure, slides, photographs, reviews, bio and SASE. Write for appointment to show portfolio of photographs, slides and transparencies. Replies in 2 weeks. Finds artists by traveling to Asia, visiting art fairs, and through submissions.

PAINTERS ART GALLERY, 30517 S.R. 706 E., P.O. Box 106, Ashford WA 98304-9739. (360)569-2644. E-mail: mtwoman@mashell.com. Owner: Joan Painter. Retail gallery. Estab. 1972. Represents 60 emerging, mid-career and established artists. Exhibited artists include Cameron Blagg, Kirk Stirnweis and David Bartholet. Open all year. Located 5 miles from the entrance to Mt. Rainier National Park; 1,200 sq. ft. 50% of space for work of gallery artists. Clientele: collectors and tourists. Overall price range $10-7,500; most work sold at $300-2,500.
 ● The gallery has over 100 people on consignment. It is a very informal, outdoors atmosphere.
Media: Considers oil, acrylic, watercolor, pastel, pen & ink, drawings, mixed media, stained glass, reliefs, offset reproductions, lithographs and serigraphs. "I am seriously looking for totem poles and outdoor carvings." Most frequently exhibits oil, pastel and acrylic.

Style: Exhibits primitivism, surrealism, imagism, impressionism, realism and photorealism. All genres. Prefers: Mt. Rainier themes and wildlife. "Indians and mountain men are a strong sell."

Terms: Accepts artwork on consignment (30% commission on prints and sculpture; 40% on paintings). Retail price set by gallery and artist. Gallery provides promotion; artist pays for shipping. Prefers artwork framed.

Submissions: Send query letter or call. "I can usually tell over the phone if artwork will fit in here." Portfolio review requested if interested in artist's work. Does not file materials.

Tips: "Sell paintings and retail price items for the same price at mall and outdoor shows that you price them in galleries. I have seen artists underprice the same paintings/items, etc. when they sell at shows."

PHINNEY CENTER GALLERY, 6532 Phinney Ave. N., Seattle WA 98103. (206)783-2244. Fax: (206)783-2246. E-mail: pnacenter@aol.com. Website: http://www.poppyware.com/PNA/. Arts Coordinator: Ed Medeiros. Nonprofit gallery. Estab. 1982. Represents 10-12 emerging artists/year. Sponsors 10-12 shows/year. Average display time 1 month. Open all year; Monday-Friday, 10-9; Saturday, 10-1. Located in a residential area; 92 sq. ft.; in 1904 building—hardwood floors, high ceilings. 20% of space for special exhibitions; 80% of space for gallery artists. Overall price range: $50-4,000; most work sold at $300-1,000.
• Phinney Center Gallery is open to Puget Sound artists only.

Media: Considers oil, acrylic, watercolor, pastel, pen & ink, drawing, mixed media, collage, paper, sculpture, ceramics, installation, photography, all types of prints. Most frequently exhibits painting, sculpture and photography.

Style: Exhibits painterly abstraction, all genres.

Terms: Accepts work on consignment (25% commission). Retail price set by the artist. Gallery provides promotion and contract; artist pays shipping costs to and from gallery. Prefers artwork framed.

Submissions: Send query letter with résumé, bio, up to 20 slides and SASE. Finds artists through calls for work in local publications.

PRO ART SOURCE, 5311 Pt. Fosdick Dr. NW, Gig Harbor WA 98335-7939. (253)851-3440. Fax: (253)858-6514. E-mail: proart@ptinet.net. Retail gallery. Estab. 1983. Represents 22 emerging, mid-career and established artists. Exhibited artists include Tom Lynch and Russell Chatham. Sponsors 6 shows/year. Average display time 2 months. Open all year; Monday-Friday, 10-6; Saturday, 11-5. Located near Gig Harbor City Center; 2,500 sq. ft. 25% of space for gallery artists. Clientele: upscale, affluent. 80% private collectors, 20% corporate collectors. Overall price range: $50-100,000; most work sold at $500-30,000.

Media: Considers oil, acrylic, watercolor, pastel, pen & ink, drawings, mixed media, collage, sculpture, fiber, glass, original handpulled prints, lithograph, mezzotint and serigraph. Most frequently exhibits watercolor, original lithograph and sculpture.

Style: Exhibits expressionism and photorealism. All genres. Prefers: landscapes, florals and NW art.

Terms: Accepts work on consignment (50% commission); or buys outright for 65% of retail price (net 30 days). Retail price set by artist. Gallery provides insurance, 50% promotion and shipping costs from gallery. Requires artwork framed.

Submissions: Send query letter with résumé, slides, bio, brochure, SASE and reviews. Portfolio review requested if interested in artist's work. Files artist information and media. Finds artists through word of mouth, various art publications, submissions/self-promotions and art collectors' referrals.

Tips: "Be prepared and professional."

‡WALSDORF GALLERY, P.O. Box 245, Spokane WA 99210-0245. (509)922-4545. President: Don Walsdorf. Major art show producer. Estab. 1988. Sponsors 8 1-or 2-artist shows and 2 large group shows/year. Clientele: collectors, hotel guests and tourists. 70% private collectors, 30% corporate collectors. Overall price range $200-250,000; most work sold at $500-3,000.

Media: Considers all media except craft.

Style: Interested in all genres.

Submissions: Send query letter with bio, brochure and photographs. Portfolio review requested if interested in artist's work. Files biography and brochures.

West Virginia

THE ART STORE, 1013 Bridge Rd., Charleston WV 25314. (304)345-1038. Fax: (304)345-1858. Director: E. Schaul. Retail gallery. Estab. 1980. Represents 16 mid-career and established artists. Sponsors 4 shows/year. Average display time 1 month. Open all year. Located in a suburban shopping center; 2,000 sq. ft. 50% of space for special exhibitions. Clientele: professionals, executives, decorators. 60% private collectors, 40% corporate collectors. Overall price range: $200-8,000; most work sold at $1,800.

Media: Considers oil, acrylic, watercolor, pastel, mixed media, works on paper, ceramic, woodcuts, engravings, linocuts, etchings, and monoprints. Most frequently exhibits oil, pastel, mixed media and watercolor.

Style: Exhibits expressionism, painterly abstraction, color field and impressionism.

Terms: Accepts artwork on consignment (40% commission). Retail price set by gallery and artist. Gallery provides insurance, promotion and shipping costs from gallery. Prefers artwork unframed.

Submissions: Send query letter with résumé, slides, SASE and announcements from other galleries if available. Gallery

makes the contact after review of these items; replies in 4-6 weeks.
Tips: "Do not send slides of old work."

Wisconsin

‡ART INDEPENDENT GALLERY, 623 Main St., Lake Geneva WI 53147. (414)248-3612. Fax: (414)248-2227. Owner: Betty C.S. Sterling. Retail gallery. Estab. 1968. Represents 180 emerging, mid-career and established artists/ year. Exhibited artists include Peg Sindelar, Martha Hayden, Gail Jones, Eric Jensen, John Yapelli and Lou Taylor. Sponsors 2-3 shows/year. Average display time 6-8 weeks. Open January-March: Thursday/Friday/Saturday, 10-5; Sunday, 12-5. April-May: daily, 10-5; Sunday, 12-5; closed Tuesday. June-August: daily, 10-5; Sunday, 12-5. September-December: daily 10-5; Sunday, 12-5; closed Tuesday. 3,000 sq. ft.; loft-like 1st floor, location in historic building. 25% of space for special exhibitions; 100% of space for gallery artists. Clientele: collectors, tourists, designers. 90% private collectors, 10% corporate collectors. Overall price range: $2-4,000; most work sold at $200-800.
Media: Considers oil, acrylic, watercolor, pastel, pen & ink, mixed media, collage, paper, sculpture, ceramics, fiber, glass, photography, jewelry, woodcuts, engravings, serigraphs, linocuts and etchings. Most frequently exhibits paintings, ceramics and jewelry.
Style: Exhibits expressionism and painterly abstraction. Genres include landscapes, florals, portraits and figurative work. Prefers: abstracts, impressionism and imagism.
Terms: Accepts work on consignment (50% commission). Retail prices set by the artist. Gallery provides insurance, promotion, contract and shipping costs from gallery; artist pays shipping costs to gallery. Prefers artwork framed.
Submissions: Send query letter with résumé, slides, bio and SASE. Call or write for application. Portfolio should include slides and transparencies. Replies in 2-4 weeks. Files bios and résumés. Finds artists through visiting exhibitions, word of mouth, shows/art fairs.

TORY FOLLIARD GALLERY, 233 N. Milwaukee St., Milwaukee WI 53202. (414)273-7311. Fax: (414)273-7313. Contact: Barbara Morris. Retail gallery. Estab. 1988. Represents mid-career and established artists. Exhibited artists include Tom Uttech and John Wilde. Sponsors 8-9 shows/year. Average display time 4-5 weeks. Open all year; Tuesday-Friday, 11-5; Saturday, 11-4. Located downtown in historic Third Ward; 3,000 sq. ft. 60% of space for special exhibitions; 40% of space for gallery artists. Clientele: tourists, upscale, local community and artists. 90% private collectors, 10% corporate collectors. Overall price range: $300-25,000; most work sold at $1,000-2,500.
Media: Considers all media except installation and craft. Most frequently exhibits painting, sculpture.
Style: Exhibits expressionism, abstraction, realism, surrealism and imagism. Prefers: realism.
Terms: Accepts work on consignment. Retail price set by the gallery and the artist. Gallery provides insurance and promotion; artist pays shipping costs. Prefers artwork framed.
Submissions: Prefers artists working in midwest regional art. Send query letter with résumé, slides, photographs, reviews, artist's statement and SASE. Portfolio should include photographs or slides. Replies in 2 weeks. Finds artists through referrals by other artists.

THE FANNY GARVER GALLERY, 230 State St., Madison WI 53703. (608)256-6755. Vice President: Jack Garver. Retail Gallery. Estab. 1972. Represents 100 emerging, mid-career and established artists/year. Exhibited artists include Harold Altman and Josh Simpson. Sponsors 11 shows/year. Average display time 1 month. Open all year; Monday-Saturday, 10-5. Located downtown; 3,000 sq. ft.; older refurbished building in unique downtown setting. 33% of space for special exhibitions; 95% of space for gallery artists. Clientele: private collectors, gift-givers, tourists. 40% private collectors, 10% corporate collectors. Overall price range: $10-10,000; most work sold at $30-200.
Media: Considers oil, pen & ink, paper, acrylic, drawing, sculpture, glass, watercolor, mixed media, ceramics, pastel, collage, craft, woodcuts, wood engravings, linocuts, engravings, mezzotints, etchings, lithographs and serigraphs. Most frequently exhibits watercolor, oil and glass.
Style: Exhibits all styles. Prefers: landscapes, still lifes and abstraction.
Terms: Accepts work on consignment (50% commission) or buys outright for 50% of retail price (net 30 days). Retail price set by gallery. Gallery provides promotion and contract, artist pays shipping costs both ways. Prefers artwork framed.
Submissions: Send query letter with résumé, 8 slides, bio, brochure, photographs and SASE. Write for appointment to show portfolio, which should include originals, photographs and slides. Replies only if interested within 1 month. Files announcements and brochures.

Wyoming

CROSS GALLERY, 180 N. Center, Box 4181, Jackson Hole WY 83001. (307)733-2200. Fax: (307)733-1414. Director: Mary Schmidt. Retail gallery. Estab. 1982. Exhibited artists include Penni Anne Cross, Kennard Real Bird, Joe Geshick, Val Lewis and Kevin Smith. Sponsors 2 shows/year. Average display time 1 month. Open all year. Located at the corner of Center and Gill; 1,000 sq. ft. 50% of space for special exhibitions. Clientele: retail customers and corporate businesses. Overall price range: $20-35,000.

Media: Considers oil, acrylic, watercolor, pastel, pen & ink, drawings, mixed media, sculpture, original handpulled prints, engravings, lithographs, pochoir, serigraphs and etchings. Most frequently exhibits oil, original graphics, alabaster, bronze, metal and clay.

Style: Exhibits realism and contemporary styles. Genres include southwestern, western and portraits. Prefers contemporary western and realist work.

Terms: Accepts artwork on consignment (33⅓% commission) or buys outright for 50% of retail price. Retail price set by gallery and artist. Offers payment by installments. Gallery provides insurance, promotion and contract; shipping costs are shared. Prefers artwork unframed.

Submissions: Send query letter with résumé, slides and photographs. Portfolio review requested if interested in artist's work. Portfolio should include originals, slides and photographs. Samples not filed are returned by SASE. Reports back within "a reasonable amount of time."

Tips: "We are seeking artwork with creative artistic expression for the serious collector. We look for originality. Presentation is very important."

HALSETH GALLERY—COMMUNITY FINE ARTS CENTER, 400 C, Rock Springs WY 82901. (307)362-6212. Fax: (307)382-6657. E-mail: cfac@rock.sw1k1l2.wy.us. Director: Gregory Gaylor. Nonprofit gallery. Estab. 1966. Represents 12 emerging, mid-career and established artists/year. Sponsors 8-10 shows/year. Average display time 1 month. Open all year; Monday-Friday, 9-12; Wednesday, 6-9; Saturday, 10-12 and 1-5; closed Sunday. Located downtown on the Rock Springs Historic Walking Tour route; 2,000 ground sq. ft. and 120 running sq. ft. of rotating exhibition space remodeled to accommodate painting and sculpture. 50% of space for special exhibitions; 50% of space for gallery artists. Clientele: community at large. 100% private collectors. Overall price range: $100-1,000; most work sold at $200-600.

Media: Considers all media, all types of prints. Most frequently exhibits oil/watercolor/acrylics, sculpture/ceramics, and installation.

Style: Exhibits all styles, all genres.

Terms: "We require a donation of a work." Retail price set by the artist. Gallery provides promotion; artist pays shipping costs to or from gallery. Prefers artwork framed.

Submissions: Send query letter with résumé, 15-30 slides, bio, brochure, photographs, SASE, business card, reviews, "whatever available." Call or write for appointment to show portfolio of slides. Replies only if interested within 1 month. Files all material sent. Finds artists through submissions.

Tips: "Prepare a professional portfolio."

Puerto Rico

‡GALERIA BOTELLO INC., 208 Cristo St., Old San Juan Puerto Rico 00901. (787)723-9987. Fax: (787)724-6776. E-mail: jbotcllo@galeriabotello.com. Website: http://www.galeriabotello.com. Owner: Juan Botello. Retail gallery. Estab. 1952. Represents 10 emerging and established artists. Sponsors 3 solo and 2 group shows/year. Average display time 3 months. Accepts only artists from Latin America. Clientele: 60% tourist and 40% local. 75% private collectors, 30% corporate clients. Overall price range: $500-30,000; most work sold at $1,000-5,000.

Media: Considers oil, acrylic, watercolor, pastel, drawings, mixed media, collage, sculpture, ceramic, woodcuts, wood engravings, linocuts, engravings, mezzotints, etchings, lithographs and serigraphs. Most frequently exhibits oil on canvas, mixed media and bronze sculpture. "The Botello Gallery exhibits major contemporary Puerto Rican and Latin American artists. We prefer working with original paintings, sculpture and works on paper."

Style: Exhibits expressionism, neo-expressionism and primitivism. Genres include Americana and figurative work. Prefers: expressionism and figurative work.

Terms: Accepts work on consignment or buys outright. Retail price set by artist. Exclusive area representation required. Gallery provides insurance and contract; artist pays for shipping. Prefers artwork framed.

Submissions: Send query letter with résumé, brochure, slides and photographs. Call for appointment to show portfolio of originals. Replies in 2 weeks. Files résumés.

Tips: "Artists have to be Latin American or major European artists."

Canada

‡✤A & A GALLERY & CUSTOM FRAMING, 104-561 Johnson, Victoria, British Columbia V8W 1M2 Canada. Phone/fax: (250)380-9461. President: Andy Lou. Art consultancy, wholesale gallery. Estab. 1994. Approached by 10 artists/year. Represents 6 emerging, mid-career and established artists. Exhibited artists include: John Copper, Qiang Wu. Average display time 2 weeks. Open all year; Tuesday-Saturday, 10-5:30; weekends 12-4. Located in downtown Victoria, 2 stories of heritage building; professional lighting; 900 sq. ft. Clientele: local community, tourists and upscale. Overall price range: $200-1,000; most work sold at $400.

Media: Considers acrylic, collage, drawing, mixed media, oil, paper, pen & ink, watercolor. Most frequently exhibits watercolor, mixed media on paper, oil. Considers linocuts, lithographs, serigraphs, woodcuts.

Style: Exhibits: imagism, impressionism, realism, oriental style. Genres include florals, landscapes, wildlife.

Terms: Artwork is accepted on consignment (40% commission). Artwork is bought outright for 30% of retail price; net 30 days. Retail price set by the artist. Gallery provides promotion and contract. Accepted work should be framed. Does not require exclusive representation locally.

Submissions: Write to arrange a personal interview to show portfolio of photographs, transparencies. Send artist's statement, bio, brochure, business card, résumé, reviews, SASE. Returns material with SASE. Replies in 1 month. Finds artists through submissions, portfolio reviews, referrals by other artists.

‡❧**AD AXIOM ART WORKS**, 3443 Fairview St., Burlington, Ontario L7N 2R4 Canada. (905)639-6777. Fax: (905)639-4576. E-mail: adaxiom@cgocable.net. Owner: Karen Brouwers. Alternative space. Estab. 1990. Approached by 20 artists a year; represents 30 emerging, mid-career and established artists/year. Exhibited artists include: Peter T. Belkett and Casey McGlynn. Average display time 1 month. Open all year; Monday-Saturday, 9-5. Located on main traffic corridor in Burlington. Clients include: local community. Clientele: 30% corporate collectors. Overall price range: $500-3,500; most work sold at $1,200.

Media: Considers ceramics, collage, drawing, fiber, glass, installation, mixed media, oil, paper, pastel, photography and sculpture. Most frequently exhibits oil, paper and ceramics. Considers all types of prints.

Style: Exhibits: color field, pattern painting, painterly abstraction, primitivism realism and geometric abstraction. Most frequently exhibits painterly abstraction and pattern painting.

Terms: Artwork is accepted on consignment (40% commission) or buys outright for 50% of retail price. Retail price set by the artist. Gallery provides insurance. Requires exclusive representaiton locally. Accepts only artists from Canada.

Submissions: Write to arrange a personal interview to show portfolio of photographs, slides, transparencies; or send query letter with artist's statement, bio, photographs. Returns material with SASE. Replies in 2 weeks. Finds artists through word of mouth, art exhibits, art fairs.

‡❧**BAU-XI GALLERY**, 340 W. Dundas St., Toronto, Ontario M5T 1G5 Canada. (416)977-0600. Fax: (416)977-0625. Assistant Manager: Fran Hill. Commercial art gallery. Estab. 1965. Represents 25 emerging, mid-career and established artists/year. Exhibited artists include: Jack Shadbolt, Ken Lochhead, Roly Fenwick, Lynn Donoghue and David Sorensen. Open all year; Tuesday-Saturday, 10-5:30 or by appointment.

Media: Considers acrylic, collage, drawing, engraving, etching, lithographs, mixed media, oil, paper, pastel, pen & ink, serigraph and watercolor. Most frequently exhibits oil, acrylic and mixed media.

Style: Exhibits all styles and genres. Most frequently exhibits contemporary, abstract and figurative.

Terms: Accepts work on consignment. Retail price set by the artist. Gallery provides insurance and promotion. Prefers artwork framed or unframed paper. Requires exclusive representation locally.

Submissions: Mail portfolio for review with artist's statement, bio, slides and SASE. Returns material with SASE. Replies in 6 months. Finds artists by word of mouth, submissions, portfolio reviews and referrals by other artists.

‡❧**DALES GALLERY**, 537 Fisgard St., Victoria, British Columbia V8W 1R3 Canada. Fax: (250)383-1552. Manager: Sheila Kertesz. Museum retail shop. Estab. 1976. Approached by 6 artists/year; represents 40 emerging, mid-career and established artists/year. Exhibited artists include: Grant Fuller and Graham Clarke. Sponsors 2-3 exhibits/year. Average display time 2 weeks. Open all year; Monday-Saturday, 10-5:30; Sunday, 12-4 in spring and summer. Gallery situated in Chinatown (Old Town); approximately 650 sq. ft. of space—one side brick wall. Clients include: local community, students, tourists and upscale. Overall price range: $100-4,600; most work sold at $350.

Media: Considers most media except photography. Most frequently exhibits oils, etching and watercolor. Considers all types of prints.

Style: Exhibits: expressionism, impressionism, postmodernism, primitivism realism and surrealism. Most frequently exhibits impressionism, realism and expressionism. Genres include figurative, florals, landscapes, humorous whimsical.

Terms: Accepts work on consignment (40% commission) or buys outright for 50% of retail price (net 30 days). Retail price set by both gallery and artist. Gallery provides promotion. Accepted work should be framed by professional picture framers. Does not require exclusive representation locally.

Submissions: Call to arrange a personal interview to show portfolio of photographs or slides or send query letter with photographs. Portfolio should include résumé, reviews, contact number and prices. Replies only if interested within 2-8 weeks. Finds artists through word of mouth, art exhibits, submissions, art fairs, portfolio reviews and referral by other artists.

‡❧**FEDERATION OF CANADIAN ARTISTS**, 1241 Cartwright, Vancouver, British Columbia V6H 4B7 Canada. (604)681-8534. Fax: (604)681-2740. E-mail: fca@istar.ca. Website:http://www.artists.ca. Gallery Manager: Nancy Clayton. Nonprofit membership organization with gallery. Estab. 1995. Approached by 1,200 member artists/year; represents 1,200 member emerging, mid-career, established artists. Exhibited artists include: Ed Loenen, AFCA; Joyce Kamikura, SFCA, NWS; Kiff Holland, SFCA, AWS; and Alan Wylie, SFCA, AWS. Average display time 2-4 weeks. Open Tuesday-

 CANADIAN LISTINGS are marked with a maple leaf.

Sunday, 10-4; mid May to Labor Day 10-5. Federation gallery is located on Granville Island, a specialty shopping district described as the second most popular tourist destination in Vancouver (after Stanley Park). Clientele: local community, students, tourists, upscale, members and other clientele. Overall price range: $150-7,000; most work sold at $1,500.

Media: Considers acrylic, collage, drawing, mixed media, oil, pastel, pen & ink and watercolor. Most frequently exhibits watercolor, oil, acrylic, pastels. Considers engraving, etching, linocut, lithographs, serigraphs, woodcut.

Style: Exhibits: impressionism, surrealism, painterly abstraction. Considers all genres.

Terms: There is a co-op membership fee plus a donation of time and rental fee for space. Retail price set by the artist. Gallery provides promotion. Accepted work should be framed. Does not require exclusive representation locally. Artists must be members.

Submissions: Call or write to arrange jurying of slides. Send artist's statement, bio, résumé, SASE. Portfolio should include photos or slides only. Returns material with SASE. Replies in 2-8 weeks. Files photos and bio. Finds artists through word of mouth, submissions, portfolio reviews, referrals by other artists.

Tips: "Have professional slides taken of your work before submitting to galleries. Using archival-quality materials is very important."

‡❧GALERIE ART & CULTURE, 227 St. Paul O, Old Montreal, Quebec H2Y 2A2 Canada. Phone/fax: (514)843-5980. President: Helen Doucet. Retail gallery. Estab. 1989. Approached by 55 artists/year; represents 30 mid-career and established artists/year. Exhibited artists include: Louise Martineau and Pierre A. Raymond. Sponsors 6 exhibits/year. Average display time 13 days. Open all year; Tuesday-Friday, 10-6; weekends 10-5. Located in the historic area of Old Montreal. St. Paul is the oldest established commercial street in North America. Original brick work and high ceilings fit well for the exhibition of works of art. Clients include: local community, tourists and upscale. 15% corporate collectors. Overall price range: $700-2,500; most work sold at $1,200-1,500.

Media: Considers acrylic, oil, sculpture, watercolor. Most frequently exhibits oil, acrylic, sculpture.

Style: Exhibits: impressionism and postmodernism. Most frequently exhibits figurative works, landscapes, still lifes. Genres include figurative work, florals, landscapes, portraits.

Terms: Accepts work on consignment (50% commission). Retail price set by the gallery and the artist. Gallery provides promotion and contract. Accepted work should be unframed. Does not require exclusive representation locally. Accepts only artists from Canada, United States. Prefers only oils, acrylic.

Submissions: Mail portfolio for review. Send bio, photographs, résumé, reviews. Returns material with SASE. Replies in 1-2 months. Files dossiers of artists, exhibitions, portfolio reviews. Finds artists through submissions, portfolio reviews, referrals by other artists.

Tips: "Artists should present complete dossier of their works including photos of artworks, biographies, expositions, solo or group works, how they started, courses taken, number of years in the profession. As a gallery representative, it helps when selling a work of art that you have as much information on the artist, and when you present not just the work of art, but a complete dossier, it reassures the potential customer."

‡❧GALERIE DART LE JARDIN DE L'OEIL, 413 Racine E., Room 106, Chicoutimi, Quebec G7H 1S8 Canada. (418)545-0898. Fax: (418)543-2733. Co-owner: Richard Giroux. Retail gallery. Estab. 1991. Approached by 10 artists/year; represents or exhibits 4 artists/year. Sponsors 4 exhibits/year. Average display time 3 weeks. Open all year; Monday-Sunday, 9-5; weekends, 1-5. 880 sq. ft. 1 bigger room $15 \times 40'$. 4 smaller rooms $10 \times 8'$. Clients include local community and tourists. 10% of sales are to corporate collectors. Overall price range: $200-2,000; most work sold at $600.

Media: Considers all media. Most frequently exhibits oil paintings, acrylic paintings, watercolors. Considers all types of prints.

Style: Exhibits: expressionism, impressionism, primitivism realism, surrealism. Genres include figurative, florals, landscapes, portraits.

Terms: Artwork is accepted on consignment (40% commission). Retail price set by the artist. Gallery provides insurance, promotion and contract. Accepted work should be framed. Requires exclusive representation locally.

Submissions: Call to arrange a personal interview to show portfolio of photographs or send bio, résumé, press reviews, SASE. Replies in 2 weeks. Files résumés or bios. Finds artists through word or mouth, portfolio reviews, referrals by other artists.

Tips: Artists must show "an up-to-date and impeccable résumé, good photographs and empathic communication."

‡❧HARRISON GALLERIES, 2932 Granville St., Vancouver, British Columbia V6H 3J7 Canada. (604)732-5217. Fax: (604)732-0911. Website: http://www.tourtheworld.com/bc03/bc03008.htm. Director: Chris Harrison. Estab. 1958. Approached by 20 artists/year; represents 25 emerging, mid-career and established artists/year. Exhibited artists include: Nicholas Bott, Kiff Holland, Francine Gravel and Ron Parker. Average display time 3 weeks. Open all year; Monday-Friday, 9:30-5:30; weekends 11-4. Clients include local community, students, tourists and upscale. 30% of sales are to corporate collectors. Overall price range $300-40,000; most work sold at $3,000.

• This gallery is one of Vancouver's oldest and most respected galleries. They have a second location at 1471 Marine Dr. in West Vancouver—same hours.

Media: Considers acrylic, glass, mixed media, oil, sculpture, watercolor. Most frequently exhibits oil, acrylic, watercolor. Considers engraving, etching, lithographs.

Style: Exhibits: conceptualism, imagism, impressionism, landscapes, painterly abstraction, realism. Most frequently

© Gallery Art & Culture

It is always important to carefully read the style and media requirements noted by galleries in their listings. Gallery Art & Culture in Montreal, which often features exhibits of florals, portraits and landscapes, was pleased to show and sell the work of Jean Le Saucier, who approached gallery representative Helene Doucet with *Sur les Flots bleus de l'ete* (On the Blue Water of Summer), and a series of other works, which were in keeping with the gallerey's artistic preferences. "This piece was the master painting for Le Saucier's exhibition done in a romantic style," Doucet says. "When his exhibition opened, this painting was the first one sold."

exhibits realism, impressionis and painterly abstraction. Genres include figurative work, florals, landscapes, western, wildlife, street scenes, cityscapes, still lifes.

Terms: Artwork is accepted on consignment (50% commission). Retail price set by the gallery. Gallery provides insurance, promotion and contract. Usually requires exclusive representation locally.

Submissions: Write to arrange a personal interview to show portfolio of photographs or mail portfolio for review. Portfolio should include query letter with artist's statement, bio, brochure, business card, photographs, résumé, reviews, SASE. Replies only if interested. Finds artists through word of mouth, portfolio reviews, referrals by other artists.

Tips: "To make your gallery submissions professional include digital photos or labelled and backed photos, curriculum vitae and bio. Deliver or mail and retrieve your portfolio on your own volition."

‡✤**HARROP GALLERY & FRAMING WAREHOUSE**, 345 Steeles Ave., Milton, Ontario L9T 3G6 Canada. (905)878-8161. Fax: (905)876-4972. Director: Chris Turk. Estab. 1980. Represents mid-career and established artists.

‡✤**INTRALUX GALLERY**, 227 Carrall St., Vancouver, British Columbia V6B 2J2 Canada. (604)602-0570. Fax: (604)602-7060. E-mail cami@intergate.bc.ca. Website: http://artsource.shinnova.ca. Director: Arvind Thadhani. Alternative space, art consultancy and rental gallery. Estab. 1997. Approached by 120 artists/year; represents 2-4 emerging, mid-career artists/month. Exhibited artists include: Richard Tetrault, Tiko Kerr and Erica Grimm-Vance. Average display time 1-2 months. Open all year; Tuesday-Sunday, 11-6; weekends, 12-5. Located in Gastown/tourist district of Vancouver; 600 sq. ft., wood floors, fireplace, white wall space, 16 ft. ceilings. Clientele: local community, tourists and upscale. 60% corporate collectors. Overall price range: $500-5,000; most work sold at $600.

Media: Considers all media. Most frequently exhibits sculpture, painting, monoprints. Considers all types of prints, not

posters.

Style: Considers all styles except impressionism and postmodern. Most frequently exhibits conceptualism, surrealism and expressionism. Genres include figurative work.

Terms: Artwork is accepted on consignment (50% commission). Retail price set by the gallery and the artist. Gallery provides insurance, promotion and contract. Accepted work should be framed or mounted. Requires exclusive representation locally. Accepts only artists living in Vancouver or British Columbia.

Submissions: Call to arrange a personal interview to show portfolio of photographs, slides, transparencies or send query letter with artist's statement bio, photographs, résumé. Returns material with SASE. Replies in 2-4 weeks. Artist should keep in touch. Files all available material. Finds artists through word of mouth, submissions, portfolio reviews, art exhibits, referrals by other artists, and artists coming into gallery.

‡❧KAMENA GALLERY & FRAMES LTD., 7510 82 Ave., Edmonton, Alberta T6C 0X9 Canada. (403)944-9497. Fax: (403)466-5062. E-mail: kamena@junctionnet.com. Website: http://www.whyte-ave.com/kamena. Assistant Manager: Willie Wong. Retail gallery. Estab. 1993. Approached by 10-20 artists/year; represents 20-25 emerging, mid-career and established artists/year. Exhibited artists include: Ted Harrison and Willie Wong. Sponsors 6-8 exhibits/year. Average display time 30-45 days. Open all year; Monday-Saturday, 10-6; weekends, 10-5. Clientele: local community and tourists. 10% corporate collectors. Overall price range: $150-1,200; most work sold at $300.

• Second location at 9939-170 St., Edmonton .

Media: Considers all media except installation and craft. Most frequently exhibits watercolor, photo and mixed media. Considers etching, linocut, serigraph and woodcut.

Style: Exhibits: color field, conceptualism, expressionism, impressionism and primitivism realism. Most frequently exhibits conceptualism, color field and expressionism. Genres include figurative work, florals, landscapes and wildlife.

Terms: Artwork is accepted on consignment and there is a 35% commission. Retail price set by the artist. Gallery provides insurance and promotion. Accepted work should be framed. Requires exclusive representation locally. Prefers only watercolor, acrylic and photo.

Submissions: Call or write to arrange a personal interview to show portfolio of slides, bio, photographs, SASE. Returns material with SASE. Replies in 2 weeks. Files slides and bio. Finds artists through submissions.

Tips: "Have clean slides or photos, a large volume of reasonably priced work, short bio (one page)."

‡❧MARCIA RAFELMAN FINE ARTS, 10 Clarendon Ave., Toronto, Ontario M4V 1H9 Canada. (416)920-4468. Fax: (416)968-6715. E-mail: mrfa@ican.net. President: Marcia Rafelman. Semi-private gallery. Estab. 1984. Approached by 100s of artists/year. Represents emerging and mid-career artists. Average display time 1 month. Open by appointment except the first 2 days of art openings which is open full days. Centrally located in Toronto's mid-town, 2,000 sq. ft. on 2 floors. Clients include local community, tourists and upscale. 40% of sales are to corporate collectors. Overall price range: $500-30,000; most work sold at $1,500-5,000.

Media: Considers all media. Most frequently exhibits photography, painting and graphics. Considers all types of prints.

Style: Exhibits: geometric abstraction, minimalism, neo-expressionism, primitivism and painterly abstraction. Most frequently exhibits high realism paintings. Considers all genres except southwestern, western and wildlife.

Terms: Artwork is accepted on consignment (50% commission); net 30 days. Retail price set by the gallery and the artist. Gallery provides insurance, promotion and contract. Requires exclusive representation locally.

Submissions: Mail portfolio of photographs, bio and reviews for review. Returns material with SASE if in Canada. Replies only if interested within 1-2 weeks. Files bios and visuals. Finds artists through word of mouth, submissions, art fairs and referrals by other artists.

‡❧SAW GALLERY INC., 67 Nicholas St., Ottawa, Ontario K1N 7B9 Canada. (613)236-6181. Fax: (613)238-4617. E-mail: saw@magi.com. Visual Arts Coordinator: Sue-Ellen Gerritsen. Alternative space. Estab. 1973. Approached by 100 artists/year. Represents 8-30 emerging and mid-career artists. Average display time 4-5 weeks. Open all year; Tuesday-Saturday, 11-5. Clients include local community, students, tourists and other members. Sales conducted with artist directly.

Media: Considers all media. Most frequently exhibits installation, mixed media, media arts (video/film/computer). Considers all types of prints.

Style: Exhibits: cutting edge contemporary art. Most frequently exhibits art attuned to contemporary issues. Considers critical and contemporary (avant-garde art).

Terms: All sales arranged between interested buyer and artist directly. Retail price set by the artist. Gallery provides insurance, promotion and contract. Does not require exclusive representation locally. Accepts only art attuned to contemporary issues.

Submissions: Send artist's statement, bio, résumé, reviews (if applicable), SASE, 10 slides. Returns material with SASE. Replies in 1-6 months. Proposals are reviewed in June and December. Files curriculum vitae. Finds artists through word of mouth, submissions, referrals by other artists, calls for proposals, advertising in Canadian art magazines.

Tips: "Have another artist offer an opinion of the proposal and build on the suggestions before submitting."

‡WHISTLER INUIT GALLERY, 4599 Chateau Blvd., Whistler, British Columbia V0N 1B4 Canada. (604)938-3366. Fax: (604)938-5404. Director: Bill Quinney. Retail gallery. Estab. 1991. Represents 30 emerging, mid-career and established artists/year. Exhibited artists include: Kathyrn Youngs, Joe David and Gloria Masse. Open all year; Monday-

Sunday, 10-10. Clientele: tourists, upscale. 5% corporate collectors. Overall price range: $100-10,000. Most work sold at $1,000.

Media: Considers all media except installation/conceptual. Most frequently exhibits sculpture, oil and prints.

Style: Exhibits all styles. Most frequently exhibits Inuit, Northwest Coast native and contemporary.

Terms: Accepts work on consignment (50% commission). Buys outright for 60% of retail price (net 30 days). Retail price sent by the artist. Gallery provides insurance, promotion and contract. Prefers artwork framed. Requires exclusive representation locally.

Submissions: Call for appointment to show portfolio of photographs or mail portfolio for review with query letter, artist's statement, bio, brochure, photographs, résumé, reviews and SASE. Returns material with SASE. Replies in 1-4 weeks if interested. Files portfolios. Finds artists by word of mouth, submissions, portfolio reviews and newspaper ads.

Tips Artists must include "slides, full supporting bio and list of exhibitions. Works well or tastefully framed, or presented."

International

***ABEL JOSEPH GALLERY**, Avenue Maréchal Foch, 89 Bruxelles Belgique 1030. Phone: 32-2-2456773. Directors: Kevin and Christine Freitas. Commercial gallery and alternative space. Estab. 1989. Represents young and established national and international artists. Exhibited artists include Bill Boyce, Diane Cole, Régent Pellerin and Ron DeLegge. Sponsors 6-8 shows/year. Average display time 6 weeks. Open all year. Located in Brussels. 100% of space for work of gallery artists. Clientele: varies from first time buyers to established collectors. 80% private collectors; 20% corporate collectors. Overall price range: £500-15,000; most work sold at £1,000-8,000.

Media: Considers most media except craft. Most frequently exhibits sculpture, painting/drawing and installation (including active-interactive work with audience—poetry, music, etc.).

Style: Exhibits painterly abstraction, conceptualism, minimalism, post-modern works and imagism. "Interested in seeing all styles and genres." Prefers abstract, figurative and mixed-media.

Terms: Accepts artwork on consignment (50% commission). Retail price set by the gallery with input from the artist. Customer discounts and payment by installments are available. Gallery provides insurance, promotion and contract; shipping costs are shared.

Submissions: Send query letter with résumé, 15-20 slides, bio, SASE and reviews. Portfolio review requested if interested in artist's work. Portfolio should include slides, photographs and transparencies. Replies in 1 month. Files résumé, bio and reviews.

Tips: "Gallery districts are starting to spread out. Artists are opening galleries in their own studios. Galleries have long outlived their status as the center of the art world. Submitting work to a gallery is exactly the same as applying for a job in another field. The first impression counts. If you're prepared, interested, and have any initiative at all, you've got the job."

‡*ADONIS ART, 1B Coleherne Rd., Earl's Court, London S210 9BS United Kingdom. E-mail: adonis@dircon.co.uk. Proprietor: Stewart Hardman. Rental gallery for male figurative art. Estab. 1995. Represents emerging, mid-career and established artists. Exhibited artists include: Cornelius McCarthy, Myles Antony, Ian Spence. Sponsors 12 exhibits/year. Average display time 1 month. Open all year; Monday-Saturday, 10:30-6:30; Sunday, 12-5:30. Located in one of London's central gay areas on 2 floors—a gallery presenting monthly exhibitons—a mixed gallery—sculpture, paintings, drawings. Clientele: local community, students, tourists and upscale. Overall price range: £100-10,000; most work sold at £200-2,000.

Media: Considers acrylic, drawing, mixed media, oil, pastel, pen & ink, photography, sculpture and watercolor. Most frequently exhibits oils, watercolors, photos. Considers all types of prints.

Style: Considers only male figurative or romantic work. Genres include figurative work, portraits.

Terms: Artwork is accepted on consignment and there is a commission. Retail price set by the gallery and the artist. Gallery provides insurance, promotion and contract. Accepted work should be framed, mounted or matted. Requires exclusive representation locally. Subject matter must be male.

Submissions: Call or write to arrange a personal interview to show portfolio. Replies in 2 weeks. Finds artists through word of mouth, submissions, art exhibits, referrals by other artists.

Tips: "Best to contact me by letter; enclose brief résumé and a few photos of your work."

‡*THE ARTIST, 31 High St., Lyndhurst, Hampshire SO43 7BE United Kingdom. Phone: (01703) 283630. E-mail: arichings@wysi.org. Website: http://www.wysi.org. Contact: Sherryl Richings. Alternative space, art consultancy and teaching portrait studio. Estab. 1997. Approached by 110 artists/year. Represents 10 emerging, mid-career and established artists. Exhibited artists include: Allen Richings, Linda Boddy. Average display time 2 months. Open 7 days/week, 10-5. Located in High St. Centre New Forest, shop front, exhibition space according to pictures. Clientele: local community, tourists, upscale. 1% corporate collectors. Overall price range: £750-2,000.

Media: Considers acrylic, collage, drawing, mixed media, oil, pastel, sculpture and watercolor. Most frequently exhibits oils, pastel, mixed media. Considers lithographs.

Style: Exhibits: expressionism, geometric abstraction, impressionism and surrealism. Most frequently exhibits abstracts, classic oils and pastels. Genres include figurative work, florals, landscapes, mainly portraits, wildlife.

Terms: Retail price set by the artist. Gallery provides promotion. Accepted work should be framed or mounted. Requires exclusive representation locally.
Submissions: Call or write to arrange a personal interview to show portfolio of photographs. Send artist's statement. Returns material with SASE. Replies in 1 week. Finds artists through word of mouth, portfolio reviews, art fairs, referrals by other artists.

‡*BAUMKOTTER GALLERY**, 63a Kensington Church St., London W8 4BA United Kingdom. Owner: Love Baumkotter. Estab. 1963. Gallery. Overall price range: £8,000-10,000. Most work sold at £8,000.
Media: Considers oil.

‡*BLACKHEATH GALLERY**, 34a Tranquil Vale, London SE3 0AX United Kingdom. Phone: 0181 8521802. Fax: 01580 291 321. Contact: Mrs. B. Simpson. Private retail gallery. Estab. 1975. Approached by 100 artists/year. Represents 74 emerging, mid-career and established artists. Exhibited artists include: John Sprakes, Alan Forneaux. Average display time 6 weeks. Open Monday-Friday, 10-6; closed Thursday. Located in center of thriving London village (ancient). Adjacent to Greenwich on 2 floors—can hang up to 150 pictures depending on size up to 6×6'. Aspect is modern and white walls. Clientele: local community, students and tourists. 5% corporate collectors. Overall price range: £150-8,000; most work sold at £700.
Media: Considers acrylic, ceramics, collage, drawing, fiber, glass, oil, pastel, pen & ink, photography, sculpture, watercolor. Most frequently exhibits painting, sculpture, glass. Considers engraving, etching, linocut, lithographs, mezzotint, serigraph, engraving and woodcut.
Style: Considers all styles. Most frequently exhibits expressionism, painterly abstraction, color field. Considers all genres.
Terms: Artwork is accepted on consignment (50% commission). Retail price set by the gallery or the artist. Gallery provides burglary insurance, promotion and contract. Accepted work should be framed or mounted. Requires exclusive representation locally.
Submissions: Send artist's statement, photographs, résumé. Returns material with SASE. Replies in 2 weeks. Files biographies and slides (if not needed back). Finds artists through word of mouth, submissions, referrals by other artists, classified and magazine ads.
Tips: "Present good, clear photos or slides with additional information about each item—size, title, media, etc. and date executed. Good curriculum vitae or biography."

‡*CHICHESTER GALLERY**, 8 The Hornet, Chichester, West Sussex PO19 4JG United Kingdom. Phone: 01243-779821. Proprietor: Thomas J.P. McHale. Cooperative period picture gallery/retail. Estab. 1997. Represents established artists. Exhibited artists include: Copley Fielding, George Leonord Lewis, Jessie Mellor. Located in Georgian period building. Interior has undergone careful and sympathetic restoration of cornices, ceiling and arches, shirting and other mouldings. Clientele: local community.
Media: Considers mixed media, oil, pastel, watercolor. Considers etching, engraving, mezzotint, woodcut. Representational painting only.
Style: Genres include florals, landscapes, portraits, wildlife.
Terms: Retail price set by the gallery.
Submissions: Replies in weeks. Finds artists through art exhibits, art fairs, auctions.

‡*DARYL DAVIES FINE ART**, Concept House, Headlands Business Park, Ringwood, Hampshire BH24 3PB United Kingdom. Phone: (011)44 425 477114. Fax: (011)44 425 480822. Licensing Manager: Lawrie Lennie. Wholesale gallery and artist agent for copyright and licensing. Estab. 1965. Approached by 100 artists/year. Represents 60 emerging, mid-career and established artists. Exhibited artists include: E. Hersey, D. Morgan. 50% corporate collectors.
Media: Considers acrylic, mixed media, oil, paper, pastel, watercolor. Most frequently exhibits acrylic, oil.
Style: Considers all styles and genres. Most frequently exhibits landscapes, still life, etc.
Terms: Artwork is accepted on consignment and there is an as agreed upon commission; or artwork is bought outright. Retail price set by the gallery. Gallery provides promotion and contract. Requires exclusive representation locally.
Submissions: Send query letter with bio, photographs. Returns material with SASE. Replies only if interested within 1 month. Finds artists through word of mouth, submissions, portfolio reviews, art exhibits, referrals by other artists.

‡*EGEE ART CONSULTANCY**, 9 Chelsea Manor Studios, Flood St., London SW3 5SR United Kingdom. Phone: (44+)171 351 6818. Fax: (44+)171 376. E-mail: egee.art@btinternet.com. Website: http://www.egeeart.co.uk. Director: Dale Egee. Art Consultant: Kate Brown. Art consultancy. Estab. 1978. Approached by 50 artists/year. Represents 30-40 emerging, mid-career and established artists. Exhibited artists include: Mil Lubroth, Dia Azzawi. Average display time 1 month. Open all year; Monday-Friday, 8:30-5:30; weekends by appointment. Located in a Victorian artists studio just off the King's Rd. in Chelsea, Egee Art Consultancy is based in a light and airy gallery space. Clientele: government, corporate and hospitality. 50% corporate collectors. Overall price range: £100-80,000; most work sold at £1,500.
Media: Considers acrylic, drawing, glass, mixed media, oil, paper, pastel, pen & ink, photography, sculpture, watercolor, engraving, etching, linocut, lithographs, mezzotint, engraving, woodcut. Most frequently exhibits oil, watercolor, prints.
Style: Exhibits: impressionism, orientalism/new orientalism, Middle Eastern and Islamic. Considers all genres as long as Middle Eastern theme.
Terms: Artwork is accepted on consignment; commission varies. Retail price set by the gallery. Gallery provides

insurance, promotion and contract. Prefers exclusive representation locally. Accepts only artists whose work influenced by Middle East.

Submissions: Call or write to arrange a personal interview to show portfolio of photographs of work. Send query letter with bio, photographs, résumé. Don't send original work unless requested. Replies in 1 week. Files archive of artist's photos, slides, frames, bios, articles. Finds artists through word of mouth, submissions, portfolio reviews, art exhibits, art fairs, referrals by other artists, trade directories, Internet.

Tips: "Worthwhile typing CV/résumé. Cover letter should make it clear you want us to represent you, not just any gallery. Also send good clear photos/transparencies and reviews/articles."

‡*GALLERY OF MODERN ART, 9 Barmouth Rd., London SW18 2DT United Kingdom. Phone/fax: 0181 875 1481. Contact: Mrs. Ba'hons Newbery. Art consultancy and gallery. Estab. 1993. Approached by 30 artists/year. Represents 40 mid-career and established artists. Exhibited artists include: Jan Hamilton Finlay, Mary Lloyd Jones. Average display time 2 months. Open all year; Monday-Thursday, 10-4; weekends by appointment. Located near Wandsworth Common on a cul-de-sac out of the way. Overall price range: £300-8,000; most work sold at £400-500.

Media: Considers all media except craft. Most frequently exhibits paintings. Considers all types of prints.

Style: Exhibits: color field, conceptualism, geometric abstraction, minimalism, painterly abstraction. Most frequently exhibits hard-edged, lyrical and color field abstracts; some landscape oriented abstracts. Considers non-figurative work only.

Terms: Artwork is accepted on consignment (33% commission). Retail price set by the artist. Gallery provides insurance, promotion and contract. Accepted work should be framed or mounted. Does not require exclusive representation locally.

Submissions: Write to arrange to show portfolio. Send artist's statement, photographs, résumé. Replies in 1 month. If accepted files artist's work for inquiries.

†*GARDEN SUBURB GALLERY, 16 Arcade House Hampstead Way, London NW11 7TL United Kingdom. Phone/fax: +44 181 455 9132. Website: http://www.hgs.org.uk. Manager: R.J. Wakefield. Nonprofit gallery. Estab. 1995. Approached by 5 artists/year. Represents 32 emerging, mid-career and established artists. Exhibited artists include: Annie Walker, Judy Bermant. Average display time 1 month. Open all year; Monday-Saturday, 10-5. Located in conservation area. Very small utyens summer house; 18×10'. Clientele: local community, tourists. Overall price range: $250. Most work sold at $250.

Media: Considers all media and all types of prints.

Style: Considers all styles. Genres include florals, landscapes, portraits.

Terms: Artwork is accepted on consignment (40% commission). Retail price set by the gallery. Gallery provides insurance and promotion. Accepted work should be framed or mounted.

Submissions: Write to arrange a personal interview to show portfolio. Returns material with SASE. Replies in 2 weeks. Finds artists through word of mouth, submissions, art exhibits and referrals by other artists.

‡*GOLDSMITHS, 3 High St., Lenham, Maidstone, Kent ME17 2QD United Kingdom. Phone: (01622)850011. E-mail: simon4art@aol.com. Manager: Simon Bate. Retail gallery. Estab. 1987. Approached by 4 artists/year. Represents 15 emerging, mid-career and established artists. Exhibited artists include: John Harvey, John Triickett. Sponsors 2 exhibits/year. Open all year; Tuesday-Saturday, 10-5; weekends 9:30-4:30. Located in a medieval village in Kent just off main village square in a mid 19th century building with timber and exposed fireplaces. 500 sq. ft. in 3 rooms. Clientele: local community, tourists and upscale. 20% corporate collectors. Overall price range: £50-120. Most work sold at £70.

Media: Considers all media and all types of prints. Most frequently exhibits watercolor, mixed media and pen & ink.

Style: Considers all styles and genres.

Terms: Artwork is accepted on consignment (40% commission) or is bought outright for 100% of retail price; net 30 days. Retail price set by the gallery or the artist. Gallery provides insurance and promotion. Accepted work should be framed and mounted.

Submissions: Call or write to arrange a personal interview to show portfolio of photographs. Send query letter with artist's statement, bio, brochure, business card, photographs, résumé, reviews and SASE. Returns material with SASE. Replies in 2 weeks. Files catalogs/brochures. Finds artists through word of mouth, submissions, art exhibits and referrals by other artists.

Tips: "Don't frame/mount as this is often done badly by artists. We can discuss this and suggest how it should be done or arrange to have it done. This way applies to inexperienced artists. Established professionals know how to present their work."

‡*HONOR OAK GALLERY, 52 Honor Oak Park, London SE23 1DY United Kingdom. Phone: 0171-291-6094. Contact: Victoria Bull or John Broad. Estab. 1986. Approached by 15 artists/year. Represents 40 emerging, mid-career and established artists. Exhibited artists include: Jenny Devereux, Norman Ackroyd. Sponsors 2 total exhibits/year. Average display time 6 weeks. Open all year; Tuesday-Friday, 9:30-6; Saturday, 9:30-5. Closed 2 weeks at Christmas, New Years and August. Located on a main thoroughfare in South London. Exhibition space of 1 room 12×17'. Clientele: local community and upscale. 2% corporate collectors. Overall price range: £18-2,000; most work sold at £150.

Media: Considers collage, drawing, mixed media, pastel, pen & ink, watercolor, engravings, etchings, linocuts, litho-

graphs, mezzotints, engravings, woodcuts, screenprints, wood engravings. Most frequently exhibits etchings, wood engravings, watercolor.

Style: Exhibits: postmodernism, primitivism, realism, 20th century works on paper. Considers all styles. Most frequently exhibits realism. Genres include figurative work, florals, landscapes, wildlife, botanical illustrations.

Terms: Artwork is accepted on consignment (40% commission). Retail price set by the gallery and the artist. Gallery provides promotion. Does not require exclusive representation locally. Prefers only works on paper.

Submissions: Write to arrange a personal interview to show portfolio of recent original artwork. Send query letter with bio, photographs. Replies in 1 month. Finds artists through word of mouth, submissions, art fairs.

Tips: "Show a varied, but not too large selection of recent work. Be prepared to discuss a pricing policy. Present work neatly and in good condition. As a gallery which also frames work, we always recommend conservation mounting and framing and expect our artists to use good quality materials and appropriate techniques."

‡*INSTITUTE OF FINE ART, 5 Kirby St. Hatton Garden, London EC1N 8TS United Kingdom. Phone: (0171)831 4048. Fax: (0171)405 4448. Contact: Alon Zakaim. Wholesale gallery. Estab. 1990. Approached by 20 artists/year. Represents 50 emerging artists. Exhibited artists include: Derrick Sayer and Althea Wilson. Open all year; Monday-Friday, 10-6. 90% corporate collectors. Overall price range: £1,500-5,000; most work sold at £20,000.

Media: Considers acrylic, collage, drawing, oil, paper, pastel, pen & ink, watercolor and engravings. Most frequently exhibits oil, drawings and watercolor.

Style: Exhibits: conceptualism, expressionism, impressionism, postmodernism and surrealism. Genres include florals and landscapes.

Terms: Retail price set by the gallery. Gallery provides insurance, promotion and contract. Does not require exclusive representation locally.

Submissions: Call or write to arrange a personal interview to show portfolio of photographs and transparencies. Send query letter with brochure and business card. Replies in 1 week.

‡*LE MUR VIVANT, 30 Churton St., London SW1V 2LP United Kingdom. Phone: (0171)821 5555. Contact: Caro Lyle Skyrme. Estab. 1996. Represents 15 established artists. Exhibited artists include: Charles MacQueen, Ron Bolt, Angus McEwan. Sponsors 10 exhibits/year. Average display time 3 weeks. Open Tuesday-Friday, 10-5; and one Saturday/month. Closed Mondays and Friday from noon. Gallery space is 2 connected rooms—each approximately 12×15′. Total 30′ long space. 2 offices in central London—Westminster. High ceilings, Victorian shop. Clientele: local community, tourists, upscale media and theater people. 20% corporate collectors. Overall price range: $500-10,000; most work sold at £1,000.

Media: Considers all media. Most frequently exhibits oil on canvas or board, watercolor, mixed media.

Style: Exhibits: color field, expressionism, imagism, impressionism, neo-expressionism, painterly abstraction, postmodernism and surrealism. Most frequently exhibits abstract expressionism, impressionism, magic realism and surrealism. Considers all genres.

Terms: "We work on flexible percentages depending on standing of artist and potential following. We take smaller percentage from already established artists with excellent C.V. and good client list as we can rely on many sales. Retail price set with collaboration of the artist. Gallery provides contract. Accepted work should be framed or mounted. Requires exclusive representation locally. Prefers only fully professional artists with excellent curriculum vitae.

Submissions: Write to arrange a personal interview to show portfolio of photographs, slides, transparencies. Send query letter with artist's statement, bio, photographs, résumé and SASE. Portfolio should include good photos or slides etc. Full curriculum vitae detailing college and professional experience. Returns material with SASE. Replies only if interested within 1 month. Finds artists through word of mouth, submissions, portfolio reviews, art exhibits, referrals by other artists, Royal Academy exhibitions, public shows and magazines.

Tips: "Send neatly presented details of past work/exhibitions/galleries, good quality transparencies, photos and/or slides."

‡*NEVILL GALLERY, 43 St. Peters St., Canterbury, Kent CT1 2BG United Kingdom. Phone/fax: (01227)765291. Director: Christopher Nevill. Rental gallery. Estab. 1970. Approached by 6 artists/year. Represents 30 emerging, mid-career and established artists. Exhibited artists include: Matthew Alexander and David Napp. Average display time 3 weeks. Open all year; Monday-Saturday, 10-5. Located on High St. in the heart of Canterbury. Clientele: local community, tourists and upscale. Overall price range: £100-5,000.

Media: Considers acrylic, collage, mixed media, oil, paper, pastel, pen & ink, watercolor, engravings, etchings, linocuts, mezzotints and woodcuts. Most frequently exhibits oils, watercolor and pastels.

Style: Exhibits: expressionism, impressionism and painterly abstraction. Genres include abstract, figurative work, florals and landscapes.

Terms: Artwork is accepted on consignment (40% commission). Retail price set by the artist. Gallery provides insurance while on the premises. Accepted work should be framed. Does not require exclusive representation locally.

Submissions: Call or write to arrange a personal interview to show portfolio of photographs, slides, transparencies. Send query letter with photographs and résumé. Return material with SASE. Replies in 2 weeks. Finds artists through word of mouth, submissions, portfolio reviews, art exhibits, art fairs and referrals by other artists.

‡*NORTHCOTE GALLERY, 110 Northcote Rd., London SW11 6QP United Kingdom. Phone/fax: (0171)926 6741. Director: Ali Pettit. Art consultancy, wholesale gallery. Estab. 1992. Approached by 100 artists/year. Represents 30

emerging, mid-career and established artists. Exhibited artists include: Daisy Cook and Robert McKellar. Sponsors 16 exhibits/year. Average display time 3-4 weeks. Open all year; Tuesday-Saturday, 11-7; Sunday, 11-6. Located in south-west London. 1 large exhibition space, 1 smaller space; average of 35 paintings exhibited/time. Clientele: local community and upscale. 50% corporate collectors. Overall price range: £400-12,000; most work sold at £1,500.
Media: Considers acrylic, ceramics, drawing, glass, mixed media, oil, paper, photography, sculpture, watercolor, engravings, etchings and lithographs.
Style: Exhibits: conceptualism, expressionism, impressionism, painterly abstraction and postmodernism. Considers all genres.
Terms: Artwork is accepted on consignment (45% commission). Retail price set by the gallery. Gallery provides promotion. Accepted work should be framed.
Submissions: Send query letter with artist's statement, bio, brochure, photograph, résumé, reviews and SASE. Returns material with SASE. Replies in 4-6 weeks. Finds artists through word of mouth, submissions, portfolio reviews and referrals by other artists.

‡PARK WALK GALLERY, 20 Park Walk, London SW10 AQ United Kingdom. Phone/fax: (0171)351 0410. Gallery Owner: Jonathan Cooper. Gallery. Estab. 1988. Approached by 5 artists/year. Represents 8 mid-career and established artists. Exhibited artists include: Jay Kirkman and Kate Nessler. Sponsors 6 exhibits/year. Average display time 3 weeks. Open all year; Monday-Saturday, 10-6:30; Sunday, 11-4. Located in Park Walk which runs between Fulham Rd. to Kings Rd. Clientele: upscale. 10% corporate collectors. Overall price range: £500-50,000; most work sold at £2,000.
Media: Considers drawing, mixed media, oil, paper, pastel, pen & ink, photography, sculpture, watercolor. Most frequently exhibits watercolor, oil and sculpture.
Style: Exhibits: conceptualism, impressionism. Genres include florals, landscapes, wildlife, equestrian.
Terms: Artwork is accepted on consignment (50% commission). Retail price set by the gallery. Gallery provides promotion. Requires exclusive representation locally.
Submissions: Call to arrange a personal interview to show portfolio. Returns material with SASE. Replies in 1 week. Finds artists through submissions, portfolio reviews, art exhibits, art fairs, referrals by other artists.
Tips: "Include full curriculum vitae and photographs of work."

‡*PEACOCK COLLECTION, The Old Smithy Old Warden, Biggleswade, Belfordshire SG18 9HQ United Kingdom. Phone: (01767)627132. Fax: (01767)627027. E-mail: peacockcol@aol.com. Contact: Elaine Baker. Retail gallery. Estab. 1997. Represents emerging artists. Exhibited artists include: Walasse Ting and Adrian Rigby. Average display time 2 weeks. Open all year; Monday-Friday, 9-5:30; weekends 1-4:30. Located in the beautiful 18th century award winning village of Old Warden. The gallery has 2 rooms both spotlit. Room 1 is 30×20 ft. Room 2 is 15×10 ft. Clientele: local community and tourists. 20% of sales are to corporate collectors. Overall price range: £29-4,500; most work sold at £200.
Media: Considers acrylic, ceramics, craft, drawing, glass, mixed media, oil, pastel, pen & ink, photography, sculpture, watercolor, etchings, linocuts, lithographs and posters. Most frequently exhibits watercolor, ceramics and sculptures.
Style: Considers all styles. Genres include figurative work, florals, landscapes and wildlife.
Terms: Artwork is accepted on consignment (30% commission). Retail price set by gallery. Gallery provides insurance, promotion and contract. Accepted work should be framed or mounted. Requires exclusive representation locally.
Submissions: Write with details and photographic samples. Send query letter with bio and photographs. Returns material with SASE. Replies in 2 weeks. "If we are allowed to keep artists photos we file in specific categories, i.e., sculpture work for future exhibitions, i.e., wildlife exhibition." Finds artists through word of mouth, submissions, art exhibits, referrals by other artists.
Tips: "Good, clear photographs of work with contact details with indication of best times to phone, i.e., day/evening."

‡*THE STUDIO, 20 High St., Otford, Stevenoaks, Kent TN14 5PQ United Kingdom. Phone: 01959 524784. Website: http://www.yell.co.uk/sites/the-studio-otford/. Contact: Wendy Peck. Estab. 1990. Exhibits established artists. Exhibited artists include: Deborah Scaldwell, Abigail Mill. Average display time 1 year. Open Tuesday-Saturday, 10-5:30. High street in picturesque village. The shop is fairly narrow but long—plenty of wall space—along shelving and alcoves for craftwork (16th century building with oak beams). Clientele: local community, tourists and upscale. Overall price range: £5-400; most work sold at £50.
Media: Considers all media except installations. Most frequently exhibits watercolor, bronze resin, ceramics. Considers etchings, linocuts, lithographs, mezzotints, serigraphs, engravings, woodcuts.
Style: Exhibits: color field, conceptualism, expressionism, impressionism, minimalism, pattern painting, painterly abstraction. Most frequently exhibits impressionism, pattern painting, expressionism. Genres include figurative work, florals, portraits, western and wildlife.
Terms: Artwork is accepted on consignment (40% commission) or bought outright for 50% of retail price; net 30 days. Retail price set by gallery. Gallery provides insurance, promotion. Accepted work should be framed or mounted. Does not require exclusive representation locally.
Submissions: Call or write to arrange a personal interview to show portfolio of photographs, slides, transparencies. Send query letter with artist's statement, brochure, business card. Replies in 1 months. Finds artists through word of mouth, art exhibits, art fairs, referrals by other artists.
Tips: "The work must beg a high standard. Framing must beg good quality—with an attractive mounting (not a cheap frame)."

‡***WILL'S ART WAREHOUSE**, Unit 3, Heathmans Rd., London SW6 4TJ United Kingdom. Phone: (0044)171 371 8787. Fax: (0044) 171 371 0066. E-mail: will@willsart.demon.co.uk. Website: http://www.willsart.demon.co.uk. Contact: Will Ramsay. Estab. 1996. Approached by 400 artists/year. Represents 200 emerging artists. Exhibited artists include: Sophie Dickens and Susan Moxley. Average display time 1 month. Open Monday-Thursday, 10:30-8; Friday-Sunday 10:30-6. 3,600 sq. ft.—room for up to 150 pictures. Clientele: local community, tourists and upscale. 5% corporate collectors. Overall price range: £50-2,000; most work sold at £500.
Media: Considers acrylic, ceramics, collage, drawing, oil, paper, pastel, pen & ink, photography, sculpture and watercolor. Most frequently exhibits oil, bronze, prints. Considers all types of prints, styles and genres.
Terms: Retail price set by the artist. Gallery provides insurance, promotion and contract. Accepted work should be framed. Does not require exclusive representation locally.
Submissions: Mail portfolio for review. Send artist's statement, bio, photographs and SASE. Returns material with SASE. Replies in 1 month. Finds artists through word of mouth, submissions, portfolio reviews, art exhibits, art fairs and referrals by other artists.

‡***OSTEN ZEKI GALLERY**, 174 Walton St., London SW3 2JL United Kingdom. Phone: (0171)225-1624 and 225-2899. Contact: Ozten Zeki. Estab. 1991. Approached by 30 artists/year. Represents emerging, mid-career and established artists. Sponsors 5-6 exhibits/year. Open Monday-Saturday, 11-6. Clientele: local community, students, tourists, upscale and banks. 60-70% corporate collectors.
Media: Considers acrylic, ceramics, craft, drawing, glass, mixed media, oil, paper, pastel, pen & ink, watercolor, engravings and etchings.
Style: Styles and genres include abstract, figurative, florals, landscapes, western and wildlife.
Terms: Artwork is accepted on consignment (50% commission). Retail price set by the gallery. Gallery provides insurance, promotion and contract. Accepted work should be framed. Requires exclusive representation locally.
Submissions: Write to arrange a personal interview to show portfolio of photographs. Send artist's statement, brochure, photographs. Returns material with SASE. Replies only if interested within 2 months. Finds artists through word of mouth, submissions, portfolio reviews, art exhibits, art fairs and referrals by other artists.

Syndicates & Cartoon Features

Syndicates are agents who sell comic strips, panels and editorial cartoons to newspapers and magazines. They promote and distribute comic strips and other features in exchange for a cut of the profits.

The syndicate business is one of the hardest to break into. If you know your competition (as you should) you'll realize spaces don't open up often. Newspapers are reluctant to drop long-established strips for new ones. Syndicates look for a "sure thing," a feature they'll feel comfortable investing more than $25,000 in for promotion and marketing.

Work worthy of syndication must be original, saleable and timely, and characters must have universal appeal in order to attract a diversity of readers. To crack this market, you have to be more than a fabulous cartoonist. The art won't sell if the idea isn't there in the first place.

Editorial cartoons

If you're an editorial cartoonist, you'll need to start out selling your cartoons to a base newspaper (probably in your hometown) and build up some clips before approaching a syndicate. Submitting published clips proves to the syndicate that you have a following and are able to produce cartoons on a regular basis. Once you've built up a good collection of clips, submit at least 12 photocopied samples of your published work along with a brief cover letter.

Payment and contracts

If you're one of the lucky few to be picked up by a syndicate, your earnings will depend on the number of publications in which your work appears. It takes a minimum of about 60 interested newspapers to make it profitable for a syndicate to distribute a strip. A top strip such as Garfield may be in as many as 2,000 papers worldwide.

Newspapers pay in the area of $10-15 a week for a daily feature. If that doesn't sound like much, multiply that figure by 100 or even 1,000 newspapers. Your payment will be a percentage of gross or net receipts. Contracts usually involve a 50/50 split between the syndicate and cartoonist. Check the listings for more specific payment information.

Before signing a contract, be sure you understand the terms and are comfortable with them. The most favorable contracts offer:
- Creator ownership of the strip and its characters.
- Periodic evaluation of the syndicate's performance.
- A five-year contract without automatic renewal.
- A percentage of gross, instead of net, receipts.

Self-syndication

Self-syndicated cartoonists retain all rights to their work and keep all profits, but they also have to act as their own salespeople, sending packets to newspapers and other likely outlets. This requires developing a mailing list, promoting the strip (or panel) periodically, and developing a pricing, billing and collections structure. If you have a knack for business and the required time and energy, this might be the route for you. Weekly newspapers are the best bet here (daily

newspapers rarely buy from self-syndicated cartoonists). Read the Insider Report in this section to find out how cartoonist Tim Jackson successfully syndicated his own cartoons.

HOW TO APPROACH A SYNDICATE

Each syndicate has a preferred method for submissions, and most have guidelines you can send for. Availability is indicated in the listings. They're also published in several helpful books, such as *Your Career in the Comics* by Lee Nordling (Andrews and McMeel) and *The Practical Guide for Marketing to Syndicates* by Pasqual Battaglia (Syndicate Publications).

To submit a strip idea, send a brief cover letter (50 words or less is ideal) summarizing your idea, along with a character sheet (the names and descriptions of your major characters), and photocopies of 24 of your best strip samples on 8½×11 paper, six daily strips per page. Sending at least one month of samples, shows that you're capable of producing high-quality humor, consistent artwork and a long lasting idea. Never submit originals; always send photocopies of your work. Simultaneous submissions are acceptable. Response time can take several months. Syndicates understand it would be impractical for you to wait for replies before submitting your ideas to other syndicates.

ALLIED FEATURE SYNDICATE, P.O. Drawer 48, Joplin MO 64802-0048. (417)673-2860. Fax: (417)673-4743. Editor: Robert Blanset. Estab. 1940. Syndicate serving 50 outlets: newspapers, magazines, etc.
- Allied Features is the only agency syndicating cartoons solely geared toward electronics. Also owns separate syndicates for environmental, telecommunications, space and medical instruments fields. The same company also owns *ENN, The Lead Trader* and *Circuit News Digest*, a monthly electronics news magazine.

Needs: Approached by 100 freelancers/year. Buys from 1-10 freelancers/year. Introduces 25 new strips/year. Introductions include *Outer Space* by Ken Muse and *Shuttlebutt* by James Wright. Considers comic strips, gag cartoons, editorial/political cartoons. Considers single or multiple panel, b&w line drawings, with gagline. Prefers creative works geared toward business, the Space Program, electronics, engineering and environmental topics.

First Contact & Terms: Sample package should include cover letter, roughs, photocopies and 3 finished cartoon samples. One sample of each should be included. Samples are filed or are returned by SASE if requested by artist. Reports back within 90 days. Portfolio review requested if interested in artist's work. **Pays on acceptance**; flat fee of $10-50; or 50% of net proceeds. Negotiates rights purchased. Interested in buying second rights (reprint rights) to previously published artwork. Minimum length of contract is 5 years. Freelancer owns original art and the characters. "This is negotiable with artist. We always negotiate."

BLACK CONSCIENCE SYNDICATION, INC., Dept. AGDM, 308A Deer Park Rd., Dix Hills NY 11746. (516)462-3933. Fax: (516)243-3121. President: Clyde R. Davis. Estab. 1987. Syndicate serving 10,000 daily and weekly newspapers, regional magazines, schools and television.

Needs: Considers comic strips, gag cartoons, caricatures, editorial or political cartoons, illustrations and spot drawings. Prefers single, double or multipanel cartoons. "All material must be of importance to the Black community in America and the world." Especially needs material on gospel music and its history. "Our new format is a TV video magazine project. This half hour TV program highlights our clients' material. We are accepting ½" tapes, 2 minutes maximum. Tape must describe the artist's work and provide brief bio of the artist. Mailed to 25 different Afrocentric publications every other month."

First Contact & Terms: Send query letter with résumé, tearsheets and photocopies. Samples are filed or are returned by SASE only if requested by artist. Reports back within 2 months. Portfolio review not required. Pays on publication; 50% of net proceeds. Considers client's preferences when establishing payment. Buys first rights.

Tips: "We need positive Afro-centric information. All material must be inspiring as well as informative. Our main search is for the truth."

ASHLEIGH BRILLIANT ENTERPRISES, 117 W. Valerio St., Santa Barbara CA 93101. (805)682-0531. Art Director: Ashleigh Brilliant. Estab. 1967. Syndicate and publisher. Outlets vary. "We supply a catalog and samples for $2 plus SASE."

Needs: Considers illustrations and complete word and picture designs. Prefers single panel. Maximum size of artwork 5½×3½, horizontal only.

First Contact & Terms: Samples are returned by SASE if requested by artist. Reports back within 2 weeks. **Pays on acceptance**; minimum flat fee of $60. Buys all rights. Syndicate owns original art.

Tips: "Freelancers will be wasting their time and ours unless they first carefully study our catalog."

CARTOON COMEDY CLUB, 560 Lake Forest Dr., Cleveland OH 44140. (216)871-5449. Cartoon Editor: John Shepherd. Estab. 1988. Publisher (syndicated). Guidelines available for #10 SASE.
Needs: Approached by 12-20 cartoonists/year. Considers gag cartoons. Prefers single panel with gagline. Maximum size of artwork 8½×11 or less.
First Contact & Terms: Sample package should include finished cartoons. 6-12 samples should be included. Reports back to the artist only if interested. Pays $5-7 for previously published cartoons and rejects.
Tips: "We seek cartoons of a general nature, family oriented plus other humor cartoons—no blue material."

CATHOLIC NEWS SERVICE, 3211 Fourth St. NE, Washington DC 20017. (202)541-3250. Fax: (202)541-3255. E-mail: cnspix@aol.com. Photos/Graphics Editor: Nancy Wiechec. Estab. 1920. Syndicate serving 160 Catholic newspapers.
Needs: Buys from 3 cartoonists and 3-5 illustrators/year. Considers single panel, editorial political cartoons and illustrations. Prefers religious, church or family themes.
First Contact & Terms: Sample package should include cover letter and roughs. Pays on publication. Rights purchased vary according to project.

CELEBRATION: AN ECUMENICAL RESOURCE, Box 419493, Kansas City MO 64141-6493. (301)681-4927. E-mail: patmarrin@aol.com. Website: http://www.ncrpub.com/celebration/. Editor: Patrick Marrin. Clients: Churches, clergy and worship committees.
Needs: Buys 75 religious theme cartoons/year. Does not run an ongoing strip. Buys cartoons on church themes (worship, clergy, scripture, etc.) with a bit of the offbeat.
First Contact & Terms: No originals returned to artist at job's completion. Payment upon use, others returned. Pays $40/illustration. Pays $30/cartoon.
Tips: "We only use religious themes (black & white). The best cartoons tell the 'truth'—about human nature, organizations, by using humor."

CHRONICLE FEATURES, was purchased by Universal Press Syndicate.

CITY NEWS SERVICE, Box 39, Willow Springs MO 65793. (417)469-2423. E-mail: cns@townsqr.com. President: Richard Weatherington. Estab. 1969. Editorial service providing editorial and graphic packages for magazines.
Needs: Buys from 12 or more freelance artists/year. Considers caricature, editorial cartoons and tax and business subjects as themes; considers b&w line drawings and shading film.
First Contact & Terms: Send query letter with résumé, tearsheets or photocopies. Samples should contain business subjects. "Send 5 or more b&w line drawings, color drawings, shading film or good line drawing editorial cartoons." Does not want to see comic strips. Samples not filed are returned by SASE. Reports within 4-6 weeks. To show a portfolio, mail tearsheets or photostats. Pays 50% of net proceeds; pays flat fee of $25 minimum. "We may buy art outright or split percentage of sales."
Tips: "We have the markets for multiple sales of editorial support art. We need talented artists to supply specific projects. We will work with beginning artists. Be honest about talent and artistic ability. If it isn't there then don't beat your head against the wall."

COMMUNITY PRESS SERVICE, P.O. Box 717, Frankfort KY 40602. (502)223-1736. Fax: (502)223-2679. Editor: Gail Combs. Estab. 1990. Syndicate serving 200 weekly and monthly periodicals.
Needs: Approached by 15-20 cartoonists and 30-40 illustrators/year. Buys from 8-10 cartoonists and 4-5 illustrators/year. Introduces 1-2 new strips/year. Considers comic strips. Prefers single panel b&w line drawings with or without gagline. Maximum size of artwork 8½×11; must be reducible to 50% of original size.
First Contact & Terms: Sample package should include cover letter, finished cartoons, photocopies. 5-10 samples should be included. Samples are filed. Reports back within 2 months. Call for appointment to show portfolio of b&w final art. **Pays on acceptance.** Buys all rights. Offers automatic renewal. Syndicate owns original art; artist owns characters.

CONTINENTAL FEATURES/CONTINENTAL NEWS SERVICE, 501 W. Broadway, Plaza A, Suite 265, San Diego CA 92101. (619)492-8696. Director: Gary P. Salamone. Parent firm established August, 1981. Syndicate serving 3 outlets: house publication, publishing business and the general public through the *Continental Newstime* magazine.
• This syndicate is putting less emphasis on children's material in their mix of cartoon/comic features.
Needs: Approached by 200 cartoonists/year. Number of new strips introduced each year varies. Considers comic strips and gag cartoons. Does not consider highly abstract, computer-produced or stick-figure art. Prefers single panel with gagline. Recent features include *Mick's Nuts* by Mick Williams. Guidelines available for #10 SASE with first-class postage. Maximum size of artwork 8×10, must be reducible to 65% of original size.
First Contact & Terms: Sample package should include cover letter, photocopies (10-15 samples). Samples are filed or are returned by SASE if requested by artist. Reports back within 1 month only if interested and if SASE is received. To show portfolio, mail photocopies and cover letter. Pays 70% of gross income on publication. Rights purchased vary according to project. Minimum length of contract is 1 year. The artist owns the original art and the characters.

Tips: "We need single-panel cartoon and comic strips appropriate for adult readers of *Continental Newstime*. Do not send samples reflecting the highs and lows and different stages of your artistic development. CF/CNS wants to see consistency and quality, so you'll need to send your best samples."

CREATIVE SYNDICATION SUS, Box 40, Eureka MO 63025. (314)587-7126. Website: http://www.the-weekend-workshop.com. Editor: Debbie Holly. C.E.O.: Ed Baldwin. Syndicate serving 400 daily and weekly newspapers.
Needs: Approached by 2-3 illustrators/year. Buys from 2-3 illustrators/year. Prefers double panel b&w line drawings. Maximum size of artwork 8½×11.
First Contact & Terms: Sample package should include roughs. 1-2 samples should be included. Samples are not filed. Reports back within 1 month. Mail appropriate materials. Portfolio should include roughs. Pays on publication; net proceeds. Rights purchased vary according to project. Offers automatic renewal. Syndicate owns original art; artist owns characters.

CREATORS SYNDICATE, INC., 5777 W. Century Blvd., Los Angeles CA 90045. (310)337-7003. E-mail: cre8ors@aol.com. Website: http://www.creators.com. Address work to Editorial Review Board—Comics. President: Richard S. Newcombe. Executive Vice President: Mike Santiago. Vice President/Executive Editor: Katherine Searcy. Editor: Laura Ramm. Estab. 1987. Serves 2,400 daily newspapers, weekly and monthly magazines worldwide. Guidelines available.
Needs: Syndicates 100 writers and artists/year. Considers comic strips, caricatures, editorial or political cartoons and "all types of newspaper columns."
First Contact & Terms: Send query letter with brochure showing art style or résumé and "anything but originals." Samples are not filed and are returned by SASE. Reports back in a minimum of ten weeks. Considers saleability of artwork and client's preferences when establishing payment. Negotiates rights purchased.
Tips: "If you have a cartoon or comic strip you would like us to consider, we will need to see at least four weeks of samples, but not more than six weeks of dailies and two Sundays. If you are submitting a comic strip, you should include a note about the characters in it and how they relate to each other. As a general rule, drawings are most easily reproduced if clearly drawn in black ink on white paper, with shading executed in ink wash or Benday® or other dot-transfer. However, we welcome any creative approach to a new comic strip or cartoon idea. Your name(s) and the title of the comic or cartoon should appear on every piece of artwork. If you are already syndicated elsewhere, or if someone else owns the copyright to the work, please indicate this."

✤FOTO EXPRESSION INTERNATIONAL, Box 1268, Station "Q," Toronto, Ontario M4T 2P4 Canada. (416)299-4887. Fax: (416)299-6442. E-mail: operations@fotopressnews.com. Website: www.fotopressnews.com. Director: M.J. Kubik. Serving 35 outlets.
Needs: Buys from 80 freelancers/year. Considers b&w and color single, double and multiple panel cartoons, illustrations and spot drawings.
First Contact & Terms: Send query letter with brochure showing art style or résumé, tearsheets, slides and photographs. Samples not filed are returned by SASE with Canadian International Reply Coupon, $4 US money order or $4.50 Canadian money order. Reports within 1 month only if postage is included. To show portfolio, mail final reproduction/product and color and b&w photographs. Pays on publication; artist receives 50%. Considers skill and experience of artist and rights purchased when establishing payment. Negotiates rights purchased.

FUTURE FEATURES SYNDICATE, 1923 N. Wickham Rd., Suite 117, Melbourne FL 32935. (407)259-3822. Fax: (407)259-1471. E-mail: jforney@futurefeatures.com. Website: http://www.futurefeatures.com. Creative Director: Jerry Forney. Estab. 1989. Syndicate markets to 1,500 daily/weekly newspapers. Guidelines available for SASE with first-class postage.
• Future Features has a home page on World Wide Web that gives them global exposure with links to various other sites. They hope to market cartoon services this way, in addition to building a subscriber base for their features.
Needs: Approached by 400-500 freelancers/year. Introduces 10-15 new strips/year. Considers comic strips, gag cartoons, editorial/political cartoons and humorous strips with contemporary drawing styles. Recent introductions include *Diaper Dudes* by Walter Storozuk and *Popcorn* by Merritt Hammett. Prefers single, double and multiple panel strips with or without gagline; b&w line drawings. Prefers "unpublished, well designed art, themed for general newspaper audiences." Maximum size of artwork 8½×11 panel, 3½×14 strip: must be reducible to 25% of original size, suitable for scanning purposes.
First Contact & Terms: Sample package should include cover letter, photocopies and a short paragraph stating why you want to be a syndicated cartoonist. 12-36 samples should be included. "We are also interested in cartoons produced on a Macintosh or PC in Illustrator, FreeHand, Photoshop or Ray Dream Designer. We can review files saved as PICT, TIFF, GIF, JPEG or Adobe Acrobat (PDF) files." Samples are filed or are returned only if SASE is included. Reports back within 4-6 weeks. Portfolio review not required, but portfolio should not include original/final art. Pays on publication; 50% of gross income. Buys first rights. Minimum length of contract is 2 years. Artist owns original art; syndicate owns characters (if applicable) upon the death or retirement of the artist.
Tips: "Avoid elaborate résumés; short bio with important career highlights/achievements is preferable. Include clean, clear copies of your best work. Don't send binders or bound collections of features; loose samples on 8½×11 bond paper are preferable. Study the masters. Purchase a good cartoon history book and make it your Bible. Practice drawing, rendering and lettering. It's fine to be influenced by what you like, but avoid imitation. Strive to be polished and original."

Work on good writing. Clean, simple and to the point. Say the most with the least. Avoid overwriting your gags. Always check spelling and grammar. Strive for a high degree of visual and verbal literacy in your work."

GRAHAM NEWS SERVICE, 2770 W. Fifth St., Suite G20, Brooklyn NY 11224. (718)372-1920. Contact: Paula Royce Graham. Syndicates to newspapers and magazines.
Needs: Considers b&w illustrations. Uses freelancers for advertising and graphics.
First Contact & Terms: Send business card and samples to be kept on file. Samples returned by SASE only if requested. Reports within days. Write for appointment to show portfolio. Pays on publication; negotiable. Considers skill of artist, client's preferences and rights purchased when establishing payment. Buys all rights.
Tips: "Keep it simple—one or two samples."

GRAPHIC ARTS COMMUNICATIONS, Box 421, Farrell PA 16121. (412)342-5300. President: Bill Murray. Estab. 1980. Syndicates to 200 newspapers and magazines.
Needs: Buys 400 pieces/year from artists. Humor through youth and family themes preferred for single panel and multipanel cartoons and strips. Needs ideas for anagrams, editorial cartoons and puzzles, and for comic panel "Sugar & Spike." Introductions include "No Whining" by John Fragle and "Attach Cat" by Dale Thompson; both similar to past work—general humor, family oriented.
First Contact & Terms: Query for guidelines. Sample package should contain 5 copies of work, résumé, SASE and cover letter. Reports within 4-6 weeks. No originals returned. Buys all rights. Pays flat fee, $8-50.
Tips: "Inter-racial material is being accepted more."

✔**HISPANIC LINK NEWS SERVICE**, 1420 N St. NW, Washington DC 20005. (202)234-0280. Fax: (202)234-4090. E-mail: zapoteco@aol.com. Editor: Louis Aguilar. Syndicated column service to 70 newspapers and a newsletter serving 1,300 subscribers: "movers and shakers in the Hispanic community in U.S., plus others interested in Hispanics." Guidelines available.
Needs: Buys from 20 freelancers/year. Considers single panel cartoons; b&w, pen & ink line drawings. Work should have a Hispanic angle; "most are editorial cartoons, some straight humor."
First Contact & Terms: Send query letter with résumé and photocopies to be kept on file. Samples not filed are returned by SASE. Reports within 3 weeks. Portfolio review not required. **Pays on acceptance**; $25 flat fee (average). Considers clients' preferences when establishing payment. Buys reprint rights and negotiates rights purchased. "While we ask for reprint rights, we also allow the artist to sell later."
Tips: Interested in seeing more cultural humor. "While we accept work from all artists, we are particularly interested in helping Hispanic artists showcase their work. Cartoons should offer a Hispanic perspective on current events or a Hispanic view of life."

‡**INTERPRESS OF LONDON AND NEW YORK**, 400 Madison Ave., New York NY 10017. (212)832-2839. Editor/Publisher: Jeffrey Blyth. Syndicates to several dozen European magazines and newspapers.
Needs: Buys from 4-5 freelancers/year. Prefers material universal in appeal; no "American only."
First Contact & Terms: Send query letter and photographs; write for artists' guidelines. Samples not kept on file are returned by SASE. Reports within 3 weeks. Purchases European rights. Pays 60% of net proceeds on publication.

JODI JILL FEATURES, 1705 14th St., Suite 321, Boulder CO 80302. (303)786-9401. E-mail: jjillone@aol.com. Art Editor/President: Jodi Jill. Estab. 1983. Syndicate serving 138 newspapers, magazines, publications.
Needs: Approached by 250 freelancers/year. "We try to average ten new strips per year." Considers comic strips, editorial/political cartoons and gag cartoons. "Looking for silly, funny material, not sick humor on lifestyles or ethnic groups." Introductions include *From My Eyes* by Arnold Peters and *Why Now?* by Ralph Stevens. Prefers single, double and multiple panel b&w line drawings. Needs art, photos and columns that are visual puzzles. Maximum size of artwork 8½×11.
First Contact & Terms: Sample package should include cover letter, résumé, tearsheets, finished cartoons and photocopies. 6 samples should be included. Samples are not filed and are returned by SASE if requested by artist. Portfolio review requested if interested in artist's work. Reports back within 1 month. Portfolio should include b&w roughs and tearsheets. **Pays on acceptance**; 50-60% of net proceeds. Negotiates rights purchased. Minimum length of contract is 1 year. The artist owns original art and characters. Finds artists "by keeping our eyes open and looking at every source possible.
Tips: "Would like to see more puzzles with puns in their wording and visual effects that say one thing and look like another. We like to deal in columns. If you have a visual puzzle column we would like to look it over. Some of the best work is unsolicited. Think happy, think positive, and think like a reader. If the work covers the three 'T's we will pick it. Please remember a SASE and remember we are human too. No need to hate us if we return the work, we are doing our job, just like you. Believe in your work, but listen to critiques and criticism. Be patient and think like the reader."

✔**A.D. KAHN, INC.**, 24567 Northwestern, Suite 333, Southfield Hills MI 48075-2412. (248)355-4100. Fax: (248)356-4344. E-mail: kahn@olmarket.com. Website: http://www.artistmarket.com. President/Editor: David Kahn. Estab. 1960. Syndicate serving daily and weekly newspapers, monthly magazines. "Several dozen artists signed."
 • Kahn has marketed on the Internet to editors and Website developers.
Needs: Approached by 24-30 freelancers/month.Considers comic strips, editorial/political cartoons, gag cartoons, puz-

INSIDER REPORT

Turned down by syndicates? Here's how to create your own

If you're like me, you've known the thrill of syndicate rejection—reminiscent of slipping from a cliff you've spent years climbing. But don't despair. You're not alone, and there are ropes at hand.

Selling your work directly to papers has much to recommend it. However, syndicates take 50 percent of the net earnings. When you syndicate your work yourself, the profit is yours, you retain all merchandising rights, and editorial control is entirely in your hands. But it's not easy.

Tim Jackson is one cartoonist who made the decision to climb on his own. "As a child, I never wanted to do anything else but cartoon. It was a single-minded obsession that never allowed me to think it wouldn't work out. 'If only the public got to see my work, they'd love it,' was my belief. Since the national syndicates weren't willing to show it to them,

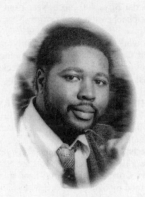

Tim Jackson

it was only natural to do it myself." That belief has delivered his feature, *Things That Make You Go Hmmm . . .* to 11 regular clients and a dozen or so intermittent ones.

Before you begin climbing, however, Jackson suggests you develop certain techniques. In addition to drawing and writing the feature, "you're also the salesperson, marketing director, distributor and accounts receivable. Although many artists lack these skills in the beginning, one learns out of necessity. This is where city college comes in handy." The business section of a library or bookstore is also useful. And if ledger paper and sharp pencils are ill-tokens, consider one of the many software programs designed to track every facet of your business.

After you have your bookkeeping system set up, the next step is identifying your readers. "Research the papers that speak to that audience," Jackson says. "I recommend the National Directory of Publications, which breaks down papers by specialty, state and target audience." And don't limit your options. "My market in the beginning was the black press, but now it includes alternative press and social consciousness publications." Another resource is *Editor & Publisher*, the weekly news magazine for the newspaper industry. They publish an annual listing of papers. If you have online access, check out the Association of Alternative Newspapers site. You'll find a few hundred names and addresses for the top alternative markets.

On your way to the top, keep in mind that every climb has its hazards. Jackson's biggest mistake was trusting the publications to pay for the work they ran. "Many editors seem to be under the impression that cartooning isn't real work, and therefore we shouldn't expect money for it. My favorite comment: 'We don't need a cartoon, but if you want, we can print them to give you exposure.' " Keeping in mind that exposure is often lethal, especially when dangling from a metaphorical cliff, Jackson has spun a safety net. "I've

INSIDER REPORT, *Jackson*

developed such a distinct style that people who are familiar with my comic[s] from legitimate papers will let me know if one shows up [illegally clipped] in some other paper. I plant my name and contact info within the art itself, making it difficult to white-out without leaving an obvious hole in the artwork.''

Promoting your work as a self-syndicator demands the usual routine of phone calls, personal visits (make an appointment, and don't expect a long meeting), and regular mailing of promotional pieces. The goal is to get your work seen. At an annual newspaper convention, says Jackson, "The publisher of the *Madison Times Weekly* . . . [saw] my cartoon in the *Capitol Outlook* from Florida and got my number from the publisher. He has been my most faithful, on-time invoice payer since then." Jackson describes his sales as slow and steady. "People tend to think you're a 'real' cartoonist if your work is seen in more than one paper. Once *Things That Make You Go Hmm . . .* was appearing regularly, I began to get calls and letters about using it."

Another marketing advantage is the Web. Jackson maintains a site that offers a portfolio of everything he creates, from editorial illustration to his panel feature. "With the Internet, I can offer my services via the World Wide Web along with visual samples of the cartoons so [prospective buyers] know what I offer. This saves lots of long-distance calling on both ends. I think all cartoonists should have computer access, if for nothing else but to have e-mail. This is available free at most public libraries."

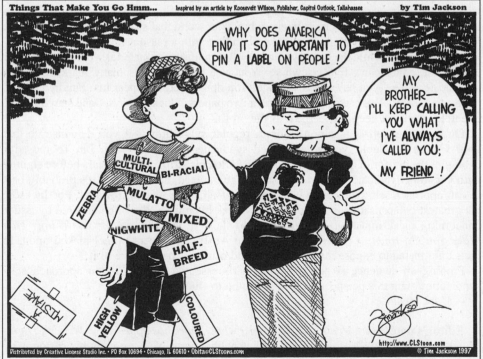

Tim Jackson's syndicated cartoon, *Things That Make You Go Hmm . . .* can be seen in papers around the country. The entrepreneurial cartoonist syndicates his own work, through his company, Creative License Studio Inc. Jackson's work can be found on the World Wide Web at http://www.CLStoons.com.

INSIDER REPORT, *continued*

If you go online, you should be aware of the inevitable piracy (often unintentional; the typical viewer isn't aware of copyright legalities, so it's a good idea to post an explanation of copyright law on your site). Jackson chooses to see the upside of the crime. "In a way, the thieves are giving me more exposure, making it appear that I'm in many more papers than I am." And because Jackson works his e-mail and snail mail address into each cartoon, he'll often hear from a fan who's spotted his work. "If it's a client [paper], fine—if it's not, I send them an invoice, suggesting that running the cartoon without permission is subject to a lawsuit, thus making the busted clipper a client," or compelling the user to pay for the cartoon. Another Internet advantage is the low resolution quality of art on the Web; once downloaded, the image degrades, discouraging illegal print use.

You have several options for distributing your work to clients. Regular mail is fine, if the deadlines aren't too tight. You can phone in your work via e-mail (though that's not always reliable.) The fastest route is the fax machine. Send the art oversize; the client can reduce it and print a clean image that's suitable for newspapers.

Here are more points to keep in mind:

• Persistence. Don't expect an editor to be swayed by your first mailing.

• Appearance. A syndicate package is usually a glossy color folder, offering sharp copies of sample strips and a contact letter. Short of the color artwork (if your budget is tight), your submission should look just as professional.

• Creative billing. Keep in mind that a paper might pay as little as five dollars for a week of *Peanuts*—a common fee for papers with a circulation of 25,000 or less. And since the small papers are the ones most likely to buy your work, that's your competition. Prepare to haggle, beginning with a high quote and ending with a reasonable rate.

• Uniqueness. While the large syndicates offer mainstream material, yours should offer a slant the editor can't find elsewhere. You won't appeal to as many markets, but as asyndicate of one, you have an advantage. You don't need to appear in a hundred papers to be successful. "You can begin with one or two papers," Jackson says, "and start building clientele. And you keep 100 percent of the profit."

On occasion, self-syndication leads to regular syndication—if you demonstrate that your feature is salable, you've addressed syndicates' prime concern. Jim Toomey, for example, the creator of *Sherman's Lagoon*, peddled his strip for a few years before signing with Creators Syndicate. This transition isn't guaranteed, however, and it's probably best if you approach self-syndication as an end in itself, with its own rewards. For Jackson, his greatest compensation is the freedom to speak his mind. "I'm often angered by issues concerning racial injustice, and this tends to show in my editorial feature *Things That Make You Go Hmm* . . . leaving non-African American readers to feel picked upon. In fact, I am trying to expose the issue itself, and offer our perspective of it."

Finding an audience is perhaps the artist's essential dream. If you approach self-syndication with this perspective, you're bound to find success.

—*Mark Heath*

Editor's note: *Mark Heath is a cartoonist whose work has appeared in Writer's Digest Magazine, The Artist's Magazine and other publications. You can view his cartoons by visiting his web page at http://www.reuben.org/heath. He also publishes Encouraging Rejection, a helpful newsletter for cartoonists, and is the author of Drawing Cartoons* (North Light Books). **See Publications of Interest**, page 678 for further information.

zles/games.
First Contact & Terms: Sample package should include material that best represents artist's work. Files samples of interest; others returned by SASE if requested by artist. Pays 50% of net proceeds. Negotiates rights purchased according to project. The artist owns original art and characters.

KING FEATURES SYNDICATE, 235 E. 45th St., New York NY 10017. (212)455-4000. Website: http://KingFeatures.com. Editor-in-Chief: Jay Kennedy. Estab. 1915. Syndicate servicing 3,000 newspapers. Guidelines available for #10 SASE.
● This is one of the oldest, most established syndicates in the business. It runs such classics as *Blondie*, *Hagar*, *Dennis the Menace* and *Beetle Bailey* and such contemporary strips as *Zippy the Pinhead*, *Baby Blues* and *Mutts*. If you are interested in selling your cartoons on an occasional rather than fulltime basis, refer to the listings for The New Breed and Laff-A-Day (also run by King Features).
Needs: Approached by 6,000 freelancers/year. Introduces 3 new strips/year. Considers comic strips and single panel cartoons. Prefers humorous single or multiple panel, and b&w line drawings. Maximum size of artwork 8½×11. Comic strips must be reducible to 6½″ wide; single panel cartoons must be reducible to 3½″ wide.
First Contact & Terms: Sample package should include cover letter, character sheet that names and describes major characters and photocopies of finished cartoons. "Résumé optional but appreciated." 24 samples should be included. Returned by SASE. Reports back within 8 weeks. Pays 50% of net proceeds. Rights purchased vary according to project. Artist owns original art and characters. Length of contract and other terms negotiated.
Tips: "We look for a uniqueness that reflects the cartoonist's own individual slant on the world and humor. If we see that slant, we look to see if the cartoonist is turning his attention to events other people can relate to. We also study a cartoonist's writing ability. Good writing helps weak art, better than good art helps weak writing."

LAFF-A-DAY, ℅ King Features Syndicate, 235 E. 45th St., New York NY 10017. (212)455-4000. Contact: Laff-A-Day Editors. Estab. 1936. Syndicated feature. "Showcases single panel gag cartoons with a more traditional approach."
Needs: Reviews 3,000 cartoons/year. Buys 312 cartoons/year. Maximum size of artwork 8½×11. Must be reducible to 3½″ wide.
First Contact & Terms: "Submissions should include 10-25 single panel cartoons per batch. Cartoons should be photocopied 1 per page and each page should have cartoonist's name and address on back. All submissions must include SASE large enough and with enough postage to return work. No original art." Reports back within 6 weeks. **Pays on acceptance**; flat fee of $50.

LEW LITTLE ENTERPRISES, INC., P.O. Box 47, Bisbee AZ 85603-0047. (520)432-8003. Editor: Lew Little. Estab. 1986. Syndicate serving all daily and weekly newspapers. Guidelines available for legal SASE with first-class postage.
Needs: Approached by 300-400 artists/year. Buys from 1-2 artists/year. Introduces 1-2 new strips/year. Considers comic strips, text features, editorial/political cartoons and gag cartoons. Recent introductions include *Warped*, a new daily and Sunday comic feature, by cartoonist Mike Cavna. Recently completed distribution contract for *Warped* with United Features Syndicate. Prefers single or multiple panel with gagline.
First Contact & Terms: Sample package should include cover letter ("would like to see an intelligent cover letter"), résumé, roughs and photocopies of finished cartoons or text feature samples. Minimum of 12 samples should be included. Samples are not filed and are returned by SASE. Reports back within 6 weeks. Schedule appointment to show portfolio or mail final reproduction/product, b&w roughs, tearsheets and SASE. Pays on publication; negotiable percentage of net proceeds. Negotiates rights purchased. Minimum length of contract 5 years. Offers automatic renewal. Artist owns original art and syndicate owns characters during the contract term, after which rights revert to artist.
Tips: "Get a good liberal arts education. Read *The New York Times* daily, plus at least one other newspaper. Study all comic features carefully. Don't give up; most cartoonists do not make it to syndication until in their 30s or 40s."

LOS ANGELES TIMES SYNDICATE, 218 S. Spring St., Los Angeles CA 90012. (213)237-7969. Promotion Manager: Cathryn Mestas.
Needs: Considers comic strips, panel cartoons and editorial cartoons. "We prefer humor to dramatic continuity and general illustrations for political commentary. We consider only cartoons that run six or seven days/week. Cartoons may be of any size, as long as they're to scale with cartoons running in newspapers." (Strips usually run approximately 6⁷⁄₁₆×2; panel cartoons 3⅛×4; editorial cartoons vary.)
First Contact & Terms: Submit photocopies or photostats of 24 dailies. Submitting Sunday cartoons is optional; if you choose to submit them, send at least four. Reports within 2 months. Include SASE. Finds artists through word of mouth, submissions, newspapers.
Tips: "Don't imitate cartoons that are already in the paper. Avoid linework or details that might bleed together, fade out or reproduce too small to be seen clearly. We hardly ever match artists with writers or vice versa. We prefer people or teams who can do the entire job of creating a feature."

MASTERS AGENCY, 703 Ridgemark Dr., Hollister CA 95023. (408)637-9795. Publisher: George Crenshaw. Estab. 1961. Magazine gag-cartoon publisher.
Cartoons: Buys 100 cartoons/year. Prefers single panel with gagline. Wants finished roughs, accepts previously pub-

Cartoonist Julie Larsen used *Artist's & Graphic Designer's Market* to find markets for her work before hooking up with King Features Syndicate. Larsen mailed samples of earlier comic panels to that company, "and we didn't think they were quite right for syndication," says King representative Jay Kennedy, "but we recognized her considerable talent, and worked with her on development of *The Dinette Set*." Perseverance and exposure are the keys to selling your work, Larsen says: "Our country is so diverse, there is a need for everyone's voice and style."

lished clips. Samples are not filed and are returned by SASE. Reports back within 1 month. Buys reprint rights. Pays $20/cartoon.
Tips: "We carefully review all submissions." Seeks cartoons on the following topics: computers, environment, farm, motor homes and rec vehicles, physical fitness, industrial safety, senior citizens, trucks, ecology, medical, hospitals, women executives, women winning, sales and insurance. Write for additional categories needed.

‡**MIDWEST FEATURES INC.**, P.O. Box 9907, Madison WI 53725-0907. (608)274-8925. Editor/Founder: Mary Bergin. Estab. 1991. Syndicate serving daily/weekly newspapers and other Wisconsin publications.
Needs: Approached by dozens of freelancers/year. Buys from 2-3 freelancers/year. Emphasis on Wisconsin material

is mandatory.
First Contact & Terms: Sample package should include cover letter, résumé, tearsheets and 8½×11 photocopies. "No originals!" 6 samples should be included. Samples are filed. Reports back to the artist only if interested or if artist sends SASE. Pays on publication; 50% of gross income. Rights purchased vary according to project. Minimum length of contract one year for syndication work. Offers automatic renewal. Artist owns original art and characters.
Tips: "Do not send originals. Phone calls are not appreciated. Make it Wisconsin specific and find another home for it for a minimum of one year before peddling it our way."

MINORITY FEATURES SYNDICATE, INC., P.O. Box 421, Farrell PA 16121. (412)342-5300. Fax: (412)342-6244. Editor: Bill Murray. Estab. 1980. Syndicate serving 150 daily newspapers, school papers and regional and national publications. Art guidelines available for #10 SASE.
Needs: Approached by 800 freelance artists/year. Buys from 650 freelancers/year. Introduces 100 new strips/year. Considers comic strips, gag cartoons and editorial/political cartoons. Prefers multiple panel b&w line drawing with gagline. Prefers family-oriented, general humor featuring multicultural, especially Black characters. Maximum size of artwork 8½×11; must be reducible to 65%.
First Contact & Terms: Sample package should include cover letter, tearsheets and photocopies. 5 samples should be included. Samples are filed or returned by SASE. Reports back in 3 months. To show portfolio, mail b&w tearsheets. Pays flat fee of $50-150. Rights purchased vary according to project. No automatic renewal. Syndicate owns original art. Character ownership negotiable.

✓**NATIONAL NEWS BUREAU**, Box 43039, Philadelphia PA 19129. (215)849-9016. Editor: Harry Jay Katz. Syndicates to 300 outlets and publishes entertainment newspapers on a contract basis.
Needs: Buys from 500 freelancers/year. Prefers entertainment themes. Uses single, double and multiple panel cartoons, illustrations; line and spot drawings.
First Contact & Terms: To show portfolio, send samples and résumé. Samples returned by SASE. Reports within 2 weeks. Returns original art after reproduction. Send résumé and samples to be kept on file for future assignments. Negotiates rights purchased. Pays on publication; flat fee of $5-100 for each piece.

THE NEW BREED, %King Features Syndicate, 235 E. 45th St., New York NY 10017. (212)455-4000. Website: http://KingFeatures.com. Contact: *The New Breed* Editors. Estab. 1989. Syndicated feature.
• *The New Breed* showcases single panel gag cartoons done by cartoonists with a contemporary or wild sense of humor. *The New Breed* is a place where people can break into newspaper syndication without making a commitment to producing a comic on a daily basis. The feature is intended as a means for King Features to encourage and stay in touch with promising cartoonists who might one day develop a successful strip for regular syndication.
Needs: Reviews 30,000 cartoons/year. Buys 500 cartoons/year. Maximum size of artwork 8½×11; must be reducible to 3½ wide.
First Contact & Terms: "Submissions should include 10-25 single panel cartoons per batch. The cartoons should be photocopied one per page and each page should have cartoonist's name and address on back. All submissions must include SASE large enough and with enough postage to return work. Do not send originals." Reports back within 2 months. **Pays on acceptance**; flat fee of $50. Buys first worldwide serial rights.

‡**NEW ENGLAND MOTORSPORTS/INTERNATIONAL MOTORSPORTS SYNDICATES**, 27-2 Bay Berry Dr., Shoron MA 02067. Phone/fax: (781)784-7857. Estab. 1988. Syndicate serving 15 daily newspapers, motorsports trade weeklies.
Needs: Considers sports pages material. Prefers single panel, motorsports motif. Maximum size 1 column.
First Contact & Terms: Sample package should include cover letter and 1 sample. Samples are filed. Reports back within 1 week. To show a portfolio, mail original/final art. **Pays on acceptance**; flat fee of $10. Syndicate owns original art and characters.

SAM MANTICS ENTERPRISES, P.O. Box 7727, Menlo Park CA 94026. (415)854-9698. E-mail: corrcook@syndicate.com. Website: http://www.syndicate.com. President: Carey Cook. Estab. 1988. Syndicate serving schools, weekly newspapers.
• Sam Mantics also has a website of grade-level vocabulary puzzles called Vocabulary University at http://www.vocabulary.com.
Needs: Approached by 25-40 artists/year. Considers comic strips, word puzzles, word games and educational text. Prefers multiple panel comic strips and b&w line drawings. Prefers themes relating to educational stimulating, training and vocabulary. Maximum size of artwork 11×17; must be reducible to 65% of original size.
First Contact & Terms: Sample package should include cover letter, photocopies of finished cartoons. 20 samples should be included. Samples not filed and are returned by SASE if requested by artist. Reports back within 1 month. To show portfolio, mail tearsheets. Pays on publication. Rights purchased vary according to project. The artist owns original art and characters. Finds artists through submissions.
Tips: "The World Wide Web and the Internet have become the preferred way to communicate educational ideas. Stimulating products can now be shown on the Internet with instantaneous distribution."

SINGER MEDIA CORP., Seaview Business Park, 1030 Calle Cordillera, Unit #106, San Clemente CA 92673. (714)498-7227. Fax: (714)498-2162. E-mail: singer@deltanet.com. Acquisitions Director: Helen Lee. Syndicates to 300 worldwide magazines, newspapers, book publishers. Geared toward the family, health and fitness, business management. Artists' guidelines $2.
Needs: Syndicates several hundred pieces/year. Considers single panel cartoons targeted at an international reader, mute humor or easily translatable text. No ballooned text, please. Recent features include *Sherlock Holmes' Crime Scene Chronicles* by Jack Harris and Howard Bender and *Oddly Enough* by Russ Miller. Current marketable cartoons are computer-related topics, as well as business, golf, travel, sex or family.
First Contact & Terms: Send query letter with synopsis and or samples, promotional material, photocopies, SASE and tearsheets. Do not send any original work. Show 10-12 samples. Reports within 1 month. Returns cartoons to artist at job's completion if requested at time of submission with SASE. Syndication rights with 50/50 split on all sales. Exceptions can be negotiated.

STATON GRAPHICS/SCRAMBLED EGGS STUDIO, P.O. Box 618, Winterville GA 30683-0618. E-mail: cowlic k@negia.net. Website: http://www.negia.net/~cowlick/statongraphics.html. President ("King"): Bill Staton. Estab. 1991. Syndicates almost exclusively to weekly newspapers. Art guidelines available for #10 SASE, or by e-mail.
Needs: Approached by 300 cartoonists/year. Buys from 10/year. Recently introduced features include *Sweaty Palms*, by Dave Helwig. Considers comic strips and gag cartoons.
First Contact & Terms: Sample package should include minimum of 12 photocopied samples. Samples not filed are returned by SASE. Reports back within 2 weeks. Art director will contact artist for portfolio review if interested. Pays 50% of gross income at time of sale. Rights purchased vary according to project. Artist owns original art and characters. Finds artists through word of mouth, submissions.
Tips: "Don't take your cartooning too seriously . . . (as an artform) . . . it's more of a business these days. At best, you'll get rich and people will tape your work to their refrigerators; at worst, you'll work a day job and you will tape your work to your refrigerator."

‡TEENAGE CORNER INC., 70-540 Gardenia Court, Rancho Mirage CA 92270. President: Mrs. David J. Lavin. Syndicates rights.
Needs: Prefers spot drawings and illustrations.
First Contact & Terms: Send query letter and SASE. Reports within 1 week. Buys 1-time and reprint rights. Negotiates commission. Pays on publication.

TRIBUNE MEDIA SERVICES, INC., 435 N. Michigan Ave., Suite 1500, Chicago IL 60611. (312)222-5998. E-mail: tms@tribune.com. Website: http://www.comicspage.com. Editor: Mark Mathes. Syndicate serving daily domestic and international and Sunday newspapers as well as weeklies and new media services. "All are original comic strips, visually appealing with excellent gags." Art guidelines available for SASE with first-class postage or on website.
 ● Tribune Media Services is a leading provider of Internet and electronic publishing content, including the WebPoint Internet Service.
Needs: Seeks comic strips and newspaper panels, puzzles and word games. Introductions include *Zenon* comic for girls and boys by Roger Bollen and Marilyn Sader; commentary columns by Carl Hiaasen and Leonard Pitts; *Family Doctor Online* by Dr. Allen Doúma; *Rush & Molloy Celebrity Journalism* (NY Daily News); and *Jumble Crosswords* (word game) by David Hoyt. Prefers original comic ideas, with excellent art and timely, funny gags; original art styles; inventive concepts; crisp, funny humor and dialogue.
First Contact & Terms: Send query letter with résumé and photocopies. Sample package should include 2-3 weeks of daily strips or panels. "Interactive submissions invited." Samples not filed are returned only if SASE is enclosed. Reports within 4-6 weeks. Pays 50% of net proceeds.
Tips: "Comics with recurring characters should include a character sheet and descriptions. If there are similar comics in the marketplace, acknowledge them and describe why yours is different."

UNITED FEATURE SYNDICATE/NEWSPAPER ENTERPRISE ASSOCIATION, 200 Madison Ave., New York NY 10016. (212)293-8500. Website: http://www.unitedmedia.com. Contact: Comics Editor. Syndicate serving 2500 daily/weekly newspapers. Guidelines available for #10 SASE.
Needs: Approached by 5,000 cartoonists/year. Buys from 2-3 cartoonists/year. Introduces 2-3 new strips/year. Strips introduced include *Dilbert*, *Over the Hedge*. Considers comic strips, editorial political cartoons and panel cartoons.
First Contact & Terms: Sample package should include cover letter, photocopies of finished cartoons. 18-36 dailies. Samples are returned by SASE if requested by artist. Reports back within 10 weeks.
Tips: "No oversize packages, please."

UNITED MEDIA, 200 Madison Ave., New York NY 10016. Website: http://www.unitedmedia.com. Editorial Director: Diana Loevy. Estab. 1978. Syndicate servicing US and international newspapers. Guidelines for SASE. "United Media consists of United Feature Syndicate and Newspaper Enterprise Association. Submissions are considered for both syndicates. Duplicate submissions are not needed." Guidelines available.
Needs: Introduces 2-4 new strips/year. Considers comic strips and single, double and multiple panels. Recent introductions include *Over the Hedge* by Mike Fry and T. Lewis. Prefers pen & ink..
First Contact & Terms: Send cover letter, résumé, finished cartoons and photocopies. Include 36 dailies; "Sundays

not needed in first submissions." Do not send "oversize submissions or concepts without strips." Samples are not filed and are returned by SASE. Reports back within 3 months. "Does not view portfolios." UFS pays 50% of net proceeds. NEA pays flat fee, $500 and up a week. Buys all rights. Minimum length of contract 5 years and 5 year renewal. Automatic renewal.

Tips: "Send copies, but not originals. Do not send mocked-up licensing concepts." Looks for "originality, art and humor writing. Be aware of long odds; don't quit your day job. Work on developing your own style and humor writing. Worry less about 'marketability'—that's our job."

‡**UNITED NEWS SERVICE**, 48 Scribner Ave., Staten Island NY 10301. (718)981-2365. Fax: (718)981-6292. Assignment Desk: Jane Marie Johnson. Estab. 1936. Syndicate servicing 500 regional newspapers. Considers caricatures, editorial political cartoons, illustrations and spot drawings. Prefers b&w line drawings.

First Contact & Terms: Sample package should include cover letter and résumé. Samples are filed or returned by SASE if requested. Reports back within weeks. Mail appropriate materials. Pays on publication; $50-100. Buys reprint rights. Syndicate owns original art; artist owns characters.

UNIVERSAL PRESS SYNDICATE, 4520 Main St., Suite 700, Kansas City MO 64111. (816)932-6600. Editorial Director: Lee Salem. Syndicate serving 2,750 daily and weekly newspapers.

Needs: Considers single, double or multiple panel cartoons and strips; b&w and color. Requests photocopies of b&w, pen & ink, line drawings.

First Contact & Terms: Reports within 4-6 weeks. To show a portfolio, mail photostats. Send query letter with photocopies.

Tips: "Be original. Don't be afraid to try some new idea or technique. Don't be discouraged by rejection letters. Universal Press receives 100-150 comic submissions a week, and only takes on two or three a year, so keep plugging away. Talent has a way of rising to the top."

WHITEGATE FEATURES SYNDICATE, 71 Faunce Dr., Providence RI 02906. (401)274-2149. Talent Manager: Eve Green. Estab. 1988. Syndicate serving daily newspapers internationally, book publishers and magazines.

Needs: Introduced Dave Berg's *Roger Kaputnik*.Considers comic strips, gag cartoons, editorial/political cartoons, illustrations and spot drawings; single, double and multiple panel. Work must be reducible to strip size. Also needs artists for advertising and publicity. looking for fine artists and illustrators for book publishing projects.

First Contact & Terms: Send cover letter, résumé, tearsheets, photostats and photocopies. Include about 12 strips. Does not return materials. To show portfolio, mail tearsheets, photostats, photographs and slides; include b&w. Pays 50% of net proceeds upon syndication. Negotiates rights purchased. Minimum length of contract 5 years (flexible). Artists owns original art; syndicate owns characters (negotiable).

Tips: Include in a sample package "info about yourself, tearsheets, notes about the strip and enough samples to tell what it is. Don't write asking if we want to see; just send samples." Looks for "good writing, strong characters, good taste in humor. No hostile comics. We like people who have cartooned for a while and are printed. Get published in local papers first."

Stock Illustration & Clip Art Firms

Stock illustration is a nifty concept that has its origins in the photography market. Photographers have been selling previously published photos as "stock" photography for years. They know that reselling photos is a win-win situation for both the photographers who shoot the original assignments and the publishers who purchase rights to reprint photos at reduced rates. Realizing that what works for photographers could work for illustrators, a few enterprising agents and other businesspeople formed agencies to broker illustrations the same way. They promoted the illustrations to art directors through catalogs, brochures and even CD-ROMs. The idea took off. When dealing with tight budgets and time crunches, art directors (already accustomed to using stock photography) quickly adapted to flipping through stock illustration catalogs for their pick of "instant" artwork at reduced prices, while firms split fees with illustrators.

Sell your illustrations and cartoons again and again

There are those who maintain stock illustration hurts freelancers. They say it encourages art directors to choose ready-made artwork from catalogs at reduced rates instead of assigning illustrators for standard industry rates. But just as many insiders observe the practice has helped, not hurt, freelancers because it gives them a vehicle to resell their work. Defenders of stock point out that advertising agencies and major magazines continue to assign original illustrations. Stock just gives them another option.

It's an option illustrators appreciate, too. Wouldn't it be nice to sell an illustration again and again instead of filing it away in a drawer? That illustration can mean extra income for you every time someone chooses it from a stock catalog. But selling previously published illustrations isn't the only way you can work with stock illustration agencies. Because there is a demand from art directors for certain kinds of images, you can create work specifically for the market and do quite well selling it directly to stock illustration agencies. But you'll have to create images agencies want. Stephen Morelock of The Image Bank explains how you can turn your down time into profits through stock illustration work, on page 538.

Stock illustration firms have a reputation for being more high-end than clip art firms. They market to book publishers, advertising agencies, magazines, corporations and other businesses. And the illustrations they show in their catalogs are polished, sophisticated images. Clip art firms, on the other hand, are usually considered a little more "grass roots." When most people think of clip art, they think of booklets of copyright-free graphics and cartoons, the kind used in church bulletins, high school newspapers, club newsletters and advertisments for small businesses. But these days, especially with some of the digital images available on disk and CD-ROMs, perceptions are changing. With the popularity of desktop publishing, newsletters that formerly looked homemade look more professional. And some of the more sophisticated clip art is used by professional designers.

Copyright and payment

Aside from the subtle differences between the "look" of stock illustration as opposed to that of clip art, there is another crucial distinction between the two. That distinction is copyright. Stock illustration firms do not sell illustrations. They license the right to reprint illustrations, working out a "pay-per-use" agreement. Fees charged depend on how many times and for what length of time their clients want to reproduce the artwork. Stock illustration firms generally split their fees 50-50 with artists, and pay the artist every time his image is used.

Clip art, on the other hand, generally implies the buyer has been granted a license for any use. Buyers can use the image as many times as they want, and furthermore, they can alter it, crop it or retouch it to fit their purposes. You might be familiar with the Victorian etching clip art as well as the popular 1940s and 50s clip art. Some clip art firms repackage artwork created many years ago because it is in the public domain, and therefore, they don't have to pay an artist for the use of the work. But in the case of clip art created by living artists, firms will either pay the artists an agreed-upon fee for all rights to the work, or will negotiate a royalty agreement. Keep in mind that if you sell all rights to your work, you will not be compensated each time it is used unless you also negotiate a royalty agreement. And once your work is sold as clip art, the buyer of that clip art can alter your work and resell it without giving you credit or compensation.

How to submit artwork

Companies are identified as either stock illustration firms or clip art firms in the first paragraph of each listing. Some firms, such as Metro Creative Graphics and Dynamic Graphics, seem to be hybrids of clip art firms and stock illustration agencies. Read the information under the "Needs" heading to find out what type of artwork each firm needs. Then check "First Contact & Terms" to find out what type of samples you should send. Most firms accept samples in the form of slides, photocopies and tearsheets. Increasingly, disk submissions are encouraged in this market.

Since this section is new to *Artist's & Graphic Designers's Market*, all stock illustration and clip art firms are not listed. Expect this section to grow in future editions.

✤ADOBE SYSTEMS INCORPORATED, (formerly Image Club Graphics), 833 Fourth Ave., SW, Suite 800, Calgary, Alberta T2P 3T5 Canada. (403)262-8008. Fax: (403)261-7013. E-mail: submissions@adobestudios.com. Website: http://www.adobestudios.com. Estab. 1985. Royalty-free visual content provider with a monthly catalog distribution of 900,000.
Needs: Approached by 1,500 artists/year. Buys from 100 freelancers/year. Considers illustrations, photos, typefaces and spot drawings.
First Contact & Terms: Sample package should include submission form (from Website), tearsheets, slides, photocopies or digital files. 10 samples should be included. Samples are filed or returned by SASE if requested by artist. Reports back within 1 month. Mail appropriate materials. Portfolio should include final reproduction product, tearsheets and slides. **Pays on acceptance.** Buys all rights. Minimum length of contract is indefinite. Offers automatic renewal. Clip art firm owns original art and characters.

AFROCENTREX, 2770 N. Lincoln Ave., Suite A, Chicago IL 60614. (773)463-6269. Fax: (773)404-5599. E-mail: afrocentre@aol.com. Website: http://www.afrocentrex.com. Chief Executive Officer: Keith Coleman. Estab. 1993. Clip art firm. Specializes in multicultural clip art. Recently introduced Hispanic clip art, Asian clip art, multicultural/language websites. Distributes to over 20 outlets, including newspapers, schools and corporate accounts.
Needs: Approached by 2 cartoonists and 4-10 illustrators/year. Buys from 2-4 illustrators/year. Considers caricatures and illustrations. Prefers b&w line drawings and digital art.
First Contact & Terms: Send cover letter with résumé and photocopies or tearsheets and SASE. Include 3-5 samples. Samples are filed. Reports back within 2 weeks. Write for appointment to show portfolio of final art. Pays flat fee; $25-150. **Pays on acceptance.** Negotiates rights purchased. Offers automatic renewal. Clip art firm owns original art and characters.
Tips: Looks for "persistence, professionalism and humbleness."

ART PLUS REPRO RESOURCE, P.O. Box 4710, Sarasota FL 34230-4710. (941)955-2950. Fax: (941)955-5723. E-mail: editor@mml-art.com. Website: http://www.mmi-art.com. Publisher: Wayne Hepburn. Estab. 1983. Clip art firm serving about 6,000 outlets, primarily churches, schools, associations and ministries. Guidelines, catalog and sample available for 9×12 SAE with 4 first-class stamps.
● This clip art firm works one year ahead of publication, pays within 90 days of acceptance, accepts any seasonal material at any time, and has been using more digitized and computer images. They will furnish a list of topics needed for illustration.
Needs: Buys 40-60 cartoons and 500-1,000 freelance illustrations/year. Prefers illustrations and single panel cartoons and b&w line art with gagline. Maximum size is 7×10 and must be reducible to 20% of size without losing detail. "We need very graphic material." Prefers religious, educational and seasonal themes. Accepts camera ready line art or digital files: CDR, CGM, EPS and WMF formats for Windows or Mac if digitized, perfers WMF.
First Contact & Terms: Send photocopies. Samples not filed are returned by SASE. Reports back within 2-3 months.

Portfolio review not required. Pays $15 for cartoons; $20-30 for spot or clip art. Buys all rights. Finds artists through *Artist's & Graphic Designer's Market* listing.

Tips: "All our images are published as clip art to be reproduced by readers in their bulletins and newsletters for churches, schools, associations, etc. We need art for holidays, seasons and activities; new material every three months. We want single panel cartoons, not continuity strips. We're always looking for people images, ethnic and mixed races. No cartoon strips."

‡*ARTBANK ILLUSTRATION LIBRARY, 8 Woodcroft Ave., London NW7 2AG England. Phone: (+44)181 906 2288. Fax: (+44)181 906 2289. E-mail: info@artbank. ltd.uk. Website: http://www.artbank.ltd.uk. Estab. 1989. Picture library. Clients include advertising agencies, businesses, book publishers, calendar companies, greeting card companies and postcard publishers.

Needs: Prefers 4×5 transparencies.

✔CUSTOM MEDICAL STOCK PHOTO, INC., The Custom Medical Building, 3660 W. Irving Park Rd., Chicago IL 60618-4132. (800)373-2677. Fax: (773)248-7427. E-mail: info@cmsp.com. Website: http://www.cmsp.com. Contact: Mike Fisher or Henry Schleichkorn. Estab. 1985. Medical and scientific stock image agency. Specializes in medical photography and illustration for the healthcare industry. Distributes to magazines, advertising agencies and design firms. Clients include: Satchi & Satchi, Foote Cone Belding, Merck, Glaxo, etc. Guidelines available for #10 SASE.

Needs: Approached by 20 illustrators/year. Works with 50+ illustrators/year. Prefers airbrush art, animation, 3-D and soundfiles, clip art, medical and technical illustration, multimedia projects and pen & ink. Themes include healthcare. Knowledge of Adobe Photoshop, Adobe Illustrator and Aldus Freehand helpful.

First Contact & Terms: "Call first to discuss before shipping." Accepts disk submission compatible with Mac or PC; send "low res files for viewing." Reports back within 1 month. Call or write for portfolio review. Pays royalties of 40%. Licenses non-exclusive rights to clients. Finds artists through word of mouth. "Our reputation precedes us among individuals who produce medical imagery. We also advertise in several medical and photographer's publications."

Tips: "Our industry is motivated by current events and issues that affect healthcare—new drug discoveries, advances and F.D.A. approval on drugs and medical devices."

DREAM MAKER SOFTWARE, 925 W. Kenyon Ave., #16, Englewood CO 80110. (303)762-1001. Fax: (303)762-0762. E-mail: david@coolclipart.com. Art Director: David Sutphin. Estab. 1986. Clip art firm, computer software publisher serving homes, schools and businesses.

Needs: Approached by 20-30 freelancers/year. Considers a variety of work including cartoon type and realistic illustrations suitable for publication as clip art with a broad market appeal. Also interested in small water color illustrations in styles suitable for greeting cards.

First Contact & Terms: Sample package should include cover letter. 8-12 samples should be included. Samples are not filed and are returned by SASE. Reports back to the artist in 1-2 months only if interested. Considers both traditional and computer based (Adobe Illustrator) artwork. Does not accept initial samples on disk. Pays $10-50 flat fee on completion of contract. Typical contract includes artist doing 50-150 illustrations with full payment made upon completion and acceptance of work. Rights purchased include assignment of copyright from artist.

DYNAMIC GRAPHICS INC., 6000 N. Forest Park Dr., Peoria IL 61614-3592. (309)688-8800. Art Director: Frank Antal. Distributes to thousands of magazines, newspapers, agencies, industries and educational institutions.

● Dynamic Graphics is a clip art firm and publisher of *Step-by-Step Graphics* magazine. Uses illustrators from all over the world; 99% of all artwork sold as clip art is done by freelancers.

Needs: Works with 30-40 freelancers/year. Prefers illustration, graphic design and elements; primarily b&w, but will consider some 2- and full-color. Recently introduced colorized TIFF and EPS images. "We are currently seeking to contact established illustrators capable of handling b&w and highly realistic illustrations of contemporary people and situations."

First Contact & Terms: Submit portfolio with SASE. Reports within 1 month. **Pays on acceptance.** Negotiates payment. Buys all rights.

Tips: "Concentrate on mastering the basics in anatomy and figure illustration before settling into a 'personal' or 'interpretive' style!"

HEALTH CARE PR GRAPHICS, Division of Solution Resources, Inc., 1121 Oswego St., Suite 1, Liverpool NY 13088. (315)451-9339. E-mail: erobe73423@aol.com. Editor: Eric Roberts. Estab. 1981. Clip art firm. Distributes monthly to hospitals and other health care organizations.

Needs: Uses illustration, drawings and graphic symbols for use in brochures, folders, newsletters, etc. Prefers sensitive line illustrations, spot drawings and graphics related to health care, hospitals, nurses, doctors, patients, technicians and medical apparatus. Also buys cartoons.

First Contact & Terms: Experienced illustrators only, preferably having hospital exposure or access to resource material. Works on assignment only. Send query letter, résumé, photostats or photocopies to be kept on file. "Send 10 to 20 different drawings which are interesting and show sensitive, caring people." Would like to see color illustration. Samples returned by SASE if not kept on file. Reports within 1 month. Original art not returned at job's completion. Buys all rights. **Pays on acceptance;** pays flat rate of $30-100 for illustrations or negotiates payment according to project. Finds artists through submissions, word of mouth.

Tips: "We are looking to establish a continuing relationship with freelance graphic designers and illustrators. Looking for different, 'breakthrough' '90s styles! Send enough samples to show the variety (if any) of styles you're capable of handling. Indicate the length of time it took to complete each illustration or graphic, and/or remuneration required. Practice drawing people's faces. Many illustrators fall short when drawing people."

✔IA USERS CLUB D/B/A GRAPHIC/CORP, 3348 Overland Ave., Los Angeles CA 90034. (800)962-2459. Fax: (310)287-2347. E-mail: heffron_b@earthlink.net. Website: http://www.graphiccorp.com. Contact: Brian Heffron. Estab. 1986. Software company specializing in clip art, photos and fonts for use by computer hardware and software companies.
Needs: Approached by 50 cartoonists and 50 illustrators/year. Buys from 20 cartoonists and 20 illustrators/year. Considers custom created clip art, software, photos, gag cartoons, caricature and illustrations. Prefers single panel. Also uses freelancers for computer illustration.
First Contact & Terms: Sample package should include cover letter, finished clip art in electronic samples. Maximum possible should be included. "GraphicCorp recommends that image submissions: be provided in .WMF and/or .EPS format (preferably both); be provided on floppy diskette or CD-ROM, accompanied by hard copy printout; contain a *minimum* of 50 images; be provided in color (no black & white images, please); and contain the following subject-matter: holidays, borders, greeting card-style, animals, religious, flowers and layouts." Samples are not filed and are returned by SASE if requested by artist. Reports back only if interested. To show portfolio, mail appropriate materials. Portfolio should include final clip art and photographs. Negotiates rights purchased.
Tips: "We prefer prolific artists or artists with large existing collections. Images must be in electronic format. We are not interested in expensive works of art. We buy simple, but detailed, images that can be used by anybody to convey an idea in one look. We are interested in quantity, with some quality."

‡IDEAS UNLIMITED FOR EDITORS, 9700 Philadelphia Court, Lanham MD 20706. (301)731-2024. Fax: (301)731-5203. E-mail: pubeditor@erols.com. Website: http://www.go-nsi.com. Editorial Director: Dave Douglass. Clip art firm serving corporate in-house newsletters. Guidelines not available.
● This new clip art firm is a division of Newsletter Services, Inc., which provides publishing services to corporate newsletter editors. Ideas Unlimited provides clip art in both hard copy and disk form. Check out their website for examples of the type of work they seek from freelancers. Last year, the company acquired Fillers For Publication and Reporter, Your Editorial Assistant, which were listed in the 1998 *AGDM*. If you have previously done work for either of these firms and want to contact them for more work, call Dave Douglass.
Needs: Buys from 2 cartoonists and 5 illustrators/year. Prefers single panel with gagline.
First Contact & Terms: Sample package should include cover letter, tearsheets, résumé and finished cartoons. 10 samples should be included. Samples are filed. Reports back only if interested. Mail final art, photostats and tearsheets. Pays $50-100. **Pays on acceptance.** Buys all rights. Minimum length of contract is 6 months.

‡THE IMAGE BANK INC., 2777 Stemmons Frwy., Suite 600, Dallas TX 75207. (214)863-4900. Fax: (214)863-4860. Website: http://www.theimagebank.com. Director, Artist Relations: Stephen V. Morelock. Also 111 Fifth Ave., 4th Floor, New York NY 10003. (212)539-8300. Fax: (212)539-8391. Also 126 rue Reaumur, Paris 75002 France. Phone: (33)1-53-00-35-60. Fax: (33)1-53-00-35-99. Stock photography, illustration and film agency. Distributes to art directors, designers, editors, producer and publishers. Call or write for guidelines.
● The Image Bank Inc. is the largest stock photography, illustration and film agency in the world, with more than 70 offices in over 35 countries and more than 20 years experience. See the interview with Director of Artist Relations Stephen V. Morelock on page 538.
Needs: Prefers all media. Themes include business, family life, financial, healthcare and restaurant.
First Contact & Terms: Send no more than 200 transparencies and/or 50 prints, along with image submission agreement from guidelines. "Please make sure all images are sleeved. Please do not place your sleeved images in any type of binder, as this slows down the review process." Include self-addressed, pre-paid ("bill recipient") FedEx or DHL airbill.
Tips: "We're looking for artists who have the same passion for great work that we do. Young talent, experienced talent, renowned talent—the adjective doesn't matter, the talent does. The Image Bank seeks artists who are capable of creating distinctive and relevant images on a consistent basis. We are interested in finding and working closely with photographers and illustrators who consistently deliver artistically and technically superb images."

‡INNOVATION MULTIMEDIA, 41 Mansfield Ave., Essex Jet VT 05452. (802)879-1164. Fax: (802)878-1768. E-mail: innovate@ad-art.com. Website: http://www.ad-art.com/innovation. Owner: David Dachs. Estab. 1985. Clip art publisher. Specializes in clip art for publishers, ad agencies, designers. Clients include US West, Disney, *Time* Magazine.
Needs: Prefers clip art, illustration, line drawing. Themes include animals, business, education, food/cooking, holidays, religion, restaurant, schools. 100% of design demands knowledge of Adobe Illustrator.
First Contact & Terms: Send samples and/or Macintosh disks (Adobe Illustrator files). Samples are filed. Reports back only if interested. Pays by the project. Buys all rights.

METRO CREATIVE GRAPHICS, INC., 33 W. 34th St., New York NY 10001. (212)947-5100. Fax: (212)714-9139. Contact: Ann Marie Weiss. Estab. 1910. Creative graphics/art firm. Distributes to 7,000 daily and weekly paid and free circulation newspapers, schools, graphics and ad agencies and retail chains. Guidelines available.
Needs: Buys from 100 freelancers/year. Considers all styles of illustrations and spot drawings; b&w and color. Editorial

INSIDER REPORT

Turn downtime into profits with stock assignments

Most freelance situations involve tight deadlines. But creating illustrations for stock agencies can give an artist an opportunity to work at a more leisurely pace. "This is a quality-oriented business," says Stephen Morelock, Director of Artist Relations for The Image Bank, a Dallas-based stock agency. He points out that creating stock illustration can be a good way to fill in the gaps in your work schedule. "This is something you can do at your own pace," he says. "In a lull you can create something you really want to do and have the potential to market it."

Stephen Morelock

As the world's largest stock photography and illustration agency, much of The Image Bank's success is due to its ability to understand and meet the demand for the kinds of imagery designers and their clients want. "We try to keep our finger on the pulse of popular culture," says Morelock. To anticipate market trends, The Image Bank maintains a database of customer requests, and uses this information to determine what subject matter and stylistic treatments are going to be most sought after. From there, it's Morelock's job to go after photographers and illustrators who can best deliver images that meet this criteria.

"We contract with artists to create images we think will be marketable in the stock industry," he says. These artists can be established illustrators whose work Morelock spots in an annual or another publication, or they may be selected from the many portfolios The Image Bank receives every week.

According to Morelock, prior experience has little to do with whether or not an illustrator's work will sell. "We're looking for talent, even if that person is relatively new and unproven," he says. In fact, Morelock frequently spots potential for stock illustration in the portfolios of emerging artists. "When we see something that's a match with where the market is or where it's going, we'll contract with that artist."

From there, The Image Bank will propose an artist-exclusive contract, so the agency can work with the artist over a period of time to produce a series of images it feels will be most marketable. "The market's going to change," says Morelock. "We want to stay connected with our artists to provide imagery that's going to meet changing demands." In this situation, The Image Bank has an exclusive arrangement with that artist within the stock industry. "Any other aspect of their business is unaffected by our contract," he says.

Morelock says it's common for other stock agencies to offer an image-exclusive contract when a portfolio contains specific images it wants to market. In this situation, the agency has exclusive rights to the marketing of those specific images. "The artist is free to market his other images with any other stock agency they want," Morelock points out.

How does an artist submit a portfolio to The Image Bank? "What often happens is we'll

INSIDER REPORT, *Morelock*

get a call from an artist who says they're interested in submitting a portfolio," says Morelock. "We have a published set of guidelines we send them which include specific instructions for submitting a portfolio." The Image Bank requests that artists limit their portfolio pieces to no more than 200 slides or 50 prints, and send copies rather than original artwork.

When portfolios arrive, they're logged and portfolio samples are distributed among various Image Bank editors. "There's a team responsible for people and lifestyle, one for conceptual, business and industry, medical, etc." says Morelock, who's responsible for circulating and keeping track of all of the portfolio samples the Image Bank receives. The editors judge the work they view by professional quality standards and contemporary style and rate them. If the work receives a favorable response, Morelock contacts the artist and proposes a contract. A contract with The Image Bank gives the agency the right to market the artist's illustrations in exchange for royalties. The agency gives its artists royalty fees that are competitive with the industry standard of 30-50%.

The Image Bank promotes its image library aggressively, distributing hundreds of thousands of catalogs of its photography and illustrations four times a year to ad agencies, publishing houses and design studios all over the world, and reaching millions with its website. Every time a designer or art director sees an illustration they want to use and contracts with the Image Bank for the use of it, the artist receives their royalty share of the usage fee—an arrangement that can provide incremental income over an extended period, long after an illustration has been completed.

—Poppy Evans

Illustrations by Mike Quon (left) and Todd Davidson (right) work perfectly as visuals for The Image Bank's clients. Stephen Morelock anticipates which subjects clients will be looking for.

style art, oil paintings or cartoons for syndication not considered. Special emphasis on computer-generated art for Macintosh. Send floppy disk samples using Adobe Illustrator 5.0. or Adobe Photoshop. Prefers all categories of themes associated with newspaper advertising (retail promotional and classified). Also needs covers for special-interest newspaper, tabloid sections..

First Contact & Terms: Send query letter with brochure, photostats, photocopies, slides, photographs or tearsheets to be kept on file. Accepts submissions on disk compatible with Adobe Illustrator 5.0 and Adobe Photoshop. Send EPS or TIFF files. Samples returned by SASE if requested. Reports only if interested. Works on assignment only. **Pays on acceptance**; flat fee of $25-1,500 (buy out). Considers skill and experience of artist, saleability of artwork and clients' preferences when establishing payment.

Tips: This company is "very impressed with illustrators who can show a variety of styles." They prefer that electronic art is drawn so all parts of the illustration are drawn completely, and then put together. "It makes the art more versatile to our customers."

MILESTONE GRAPHICS, 1093 A1A Beach Blvd., #388, St. Augustine FL 32084. (904)823-9962. E-mail: miles@aug.com. Website: http://www.milestonegraphics.com. Owner: Jill O. Miles. Estab. 1993. Clip art firm providing targeted markets with electronic graphic images.

Needs: Buys from 20 illustrators/year. 50% of illustration demands knowledge of Adobe Illustrator.

First Contact & Terms: Sample package should include non-returnable photocopies or samples on computer disk. Accepts submissions on disk compatible with Adobe Illustrator on the Macintosh. Send EPS files. Interested in b&w and some color illustrations. All styles and media are considered. Macintosh computer drawings accepted (Adobe Illustrator preferred). "Ability to draw people a plus, but many other subject matters needed as well." Reports back to the artist only if interested. Pays flat fee of $25 minimum/illustration, based on skill and experience. A series of illustrations is often needed.

MONOTYPE TYPOGRAPHY, 985 Busse Rd., Elk Grove Village IL 60007. (847)718-0400. Fax: (847)718-0500. E-mail: oem.sales@monotype.com. Website: http://www.monotype.com. Estab. 1897. Font foundry. Specializes in high-quality Postscript and Truetype fonts for graphic design professionals and personal use. Clients include Leo Burnett, Hearst Magazines, Microsoft.

Needs: Approached by 10 designers and 2 illustrators/year. Works with 5 designers and 2 illustrators/year. Prefers clip art, font and logo design, line drawing, multimedia projects, sport illustration. Themes include animals, business, education, holidays, restaurant. Also needs freelancers for design. Freelance work demands knowledge of Adobe Illustrator, Adobe Photoshop, QuarkXPress.

First Contact & Terms: Samples are not filed. Reports back only if interested. Rights purchased vary according to project. Finds artists through word of mouth.

NOVA DEVELOPMENT CORPORATION, 23801 Calabasas Rd., Suite 2005, Calabasas CA 91302-1547. (818)591-9600. Fax: (818)591-8885. E-mail: submit@novadevcorp.com. Website: http://www.novadevcorp.com. Product Development Manager: Lisa Helfstein. Estab. 1983. Computer Software Publisher. Specializes in digital, royalty-free clip art for consumers and small businesses. Distributes to consumers via retail stores.

Needs: Approached by 100 illustrators/year. Works with 20 illustrators/year. Prefers clip art, animation, single panel cartoons, font design, humorous illustration and line drawing in electronic format. Themes include animals, business, current events, education, family life, food/cooking, healthcare, hobbies, holiday, pets, religion, restaurants and schools. Also needs Art Explosion, Web Explosion, Web Animation Explosion, computer animations (GIF, Shockwave), web graphics and photographs. 70% of illustration demands knowledge of Adobe Illustrator 5.0 and Adobe Photoshop 5.0.

First Contact & Terms: Send cover letter and electronic samples. Accepts disk submissions. Prefers EPS/Macintosh format. Will also accept TIFF, WMF, CDR, BMP and others. Samples are filed. Reports back only if interested. Pays royalties of 7-20% of gross income depending on product type. Artist owns original art. Minimum length of contract is 5 years.

Tips: "We prefer collections of 500 illustrations."

ONE MILE UP, INC., 7011 Evergreen Court, Annandale VA 22003. (703)642-1177. Fax: (703)642-9088. Website: http://www.onemileup.com. President: Gene Velazquez. Estab. 1988.

Needs: Approached by 5 cartoonists and 10 illustrators/year. Buys from 5 illustrators/year. Prefers illustration and animation.

First Contact & Terms: Send photostats, résumé and/or diskettes. Include 3-5 samples. Call or mail appropriate materials for portfolio review of final art. Pays flat fee; $30-120. **Pays on acceptance.** Negotiates rights purchased.

✔STOCK ILLUSTRATION SOURCE, 16 W. 19th St., 9th Floor, New York NY 10011. (212)849-2900, (800)4-IMAGES. Fax: (212)691-6609. E-mail: sis@sisstock.com. Website: http://www.sisstock.com. Acquisitions Manager: Barbara Preminger. Estab. 1992. Stock illustration agency. Specializes in illustration for corporate, advertising, editorial, publishing industries. Guidelines available.

Needs: "We deal with 1,200 illustrators." Prefers painterly, conceptual images, including collage and digital works, occasionally humorous and medical illustrations. Themes include corporate, business, education, family life, healthcare, law and environment.

First Contact & Terms: Illustrators send sample work on reprints or digital media. Samples are filed. Reports back

within 1 month. Will do portfolio review. Pays royalties of 50% for illustration sales. Negotiates rights purchased. Finds artists through agents, sourcebooks, on-line services, magazines, word-of-mouth, submissions.

✔STOCKART.COM, (formerly Iconomics), 155 N. College Ave., Suite 225, Ft. Collins CO 80524. (970)493-0087 or (800)297-7658. E-mail: stockart@stockart.com. Website: http://www.stockart.com. Art Manager: Eric Hunter. Estab. 1995. Stock illustration and representative. Specializes in b&w and color illustration for ad agencies, design firms and publishers. Clients include BBDO, Bozell, Pepsi, Chase, Saatchi & Saatchi.
Needs: Approached by 250 illustrators/year. Works with 150 illustrators/year. Themes include business, family life, healthcare, holidays, religion.
First Contact & Terms: Illustrators send at least 5 samples of work. Accepts disk submissions compatible with Photoshop EPS files less than 600k/image. Reports back only if interested. Pays 50% stock royalty, 70% commission royalty (commissioned work-artist retains rights) for illustration. Rights purchased vary according to project. Finds artists through sourcebooks, on-line, word of mouth.
Tips: "We have both high-quality black & white and color illustration."

STOCKWORKS-STOCK ILLUSTRATION, 11936 W. Jefferson Blvd., Suite C, Culver City CA 90230. (310)390-9744. Fax: (310)390-3161. E-mail: stockworks@earthlink.net. Website: http://www.workbook.com. President: Martha Spelman. Estab. 1988. Stock illustration firm. Specializes in stock illustration for corporations, advertising agencies and design firms. Clients include IBM, First Fidelity, Macmillan Publishing, Lexis Nexis. Guidelines available for large SAE with 5 first-class stamps.
Needs: Approached by 100 illustrators/year. Works with 300 illustrators/year. Themes include animals, business, education, healthcare, holidays, conceptual, technology and computers, industry, education.
First Contact & Terms: Illustrators send slides, tearsheets, color copies of available stock work. Samples are filed or are returned with SASE. Reports back only if interested. Call for portfolio review of available stock images and leave behinds. Pays royalties of 50% for illustration. Negotiates rights purchased. Finds artists through *Workbook*, *Showcase, Creative Illustration*, magazines, submissions.
Tips: "Stockworks likes to work with artists to create images specifically for stock. We provide concepts and sometimes rough sketches to aid in the process. Creating or selling stock illustration allows the artist a lot of leeway to create images they like, the time to do them and the possibility of multiple sales. We like to work with illustrators who are motivated to explore an avenue other than just assignment to sell their work."

STUDIO ADVERTISING ART, P.O. Box 43912, Las Vegas NV 89116. (702)641-7041. Fax: (702)641-7001. Director: Rick Barker. Clip art firm. Guidelines available for #10 SASE.
Needs: Approached by 40 freelance artists/year. Buys from 1-3 artists/year. Considers illustrations and spot drawings. Prefers b&w line drawings. Computer (Macintosh/Adobe Illustrator files only).
First Contact & Terms: Sample package should include photocopies *only*. 10-15 samples should be included. Samples are returned by SASE if requested by artist. Reports back to the artist only if interested. To show a portfolio, send photostats. Pays a flat fee of $10. **Pays on acceptance.** Buys all rights.
Tips: "Submit good quality art that can be reused by a large section of the desktop publishing industry."

Animation & Computer Games

Animation is hot! It's no longer limited to Saturday morning cartoons and Disney features. Witness the popularity of *Toy Story*, *Space Jam*, as well as television hits like *The Simpsons*, *South Park* and *King of the Hill*. Special effects in motion pictures, such as *Titanic*, *Men in Black* and *Jurassic Park: The Lost World* are created using animation techniques. Animation enlivens web pages and popular computer games. And animation is flourishing in advertising, too. Surveys show that viewers are less likely to channel surf during commercials featuring innovative animation.

All the growth in the industry has created an increased demand for artists with animation skills. Right now, there are more animation jobs in the industry than there are qualified animators to fill them. Animation graduates are recruited like college athletes. Disney, Nickelodeon, Fox Animation, Broderbund and Pixar take out full page advertisements in *Animation* magazine, urging artists to send résumés and reels. Pixar, the creators of *Toy Story*, even recruits in London, Paris and Munich. Studios are having such a tough time finding competent animators, that a few (Warner Bros., for one) have developed training programs to teach animation skills to artists.

What does it take to break into animation? Dave Master, director of artist development at Warner Bros. Feature Animation, sheds light on the field in an interview on page 550. First, you have to have artistic talent. A background in fine art, with some experience in figure drawing and design is ideal. Next, you'll need basic animation skills. If you don't have them, enroll in animation courses or get accepted to a training program at an animation studio. If you have access to a computer, animation software and tutorials, it's possible to train yourself to create computer animation. Read *So You Want to Be a Computer Animator* by Mike Morrison (Sams Publishing) to find out more about the computer animation field.

How to approach animation and computer game markets

Whether you specialize in hand drawn animation, clay animation or 3D, you'll need to prepare a VHS demo reel, so you can submit it for consideration to animation markets. Your demo tape should be short—three minutes is probably enough. (Sending three minutes worth of work on a 60-minute tape is considered amateurish, so have your tape dubbed professionally on a three-minute VHS tape.) It's helpful to show animated characters of your own creation on your reel. If possible, add a soundtrack that complements those characters and what they are doing. If your characters speak, make sure the voices are in sync with the animation or risk losing points. Be sure your reel has a label on the outside with your name, address and phone number. Attach a spine label so the tape can easily be recognized on a shelf full of tapes. To save money, have about a dozen tapes dubbed at a time. You'll need them eventually as you try to get jobs. Include a one-page résumé that looks professional and emphasizes animation skills and experience.

If studios like your reel, they'll want to see more of your work. So prepare a professional portfolio of your drawings, animation stills and/or sculptures. Since your "book" should be ready to show at any time, it's wise to prepare two or more portfolios. Invest in a couple of simple portfolio binders or boxes of manageable size—something that fits comfortably on art directors' desks. (See What Should I Submit?, page 4, for more advice on portfolios.)

To find out more about the exciting opportunities in this growing industry, check out a few issues of *Animation* magazine or visit their website at www.Animag.com.

FESTIVALS HOOK UP ANIMATORS AND RECRUITERS

Aspiring artists can maximize their chances of getting work, according to Kat Fair, head of recruitment for Nickelodeon Animation Studio, by taking advantage of recruiting opportunities at animation festivals. Fair, who makes the rounds of art schools to recruit new talent, always tells students two things: to keep drawing, and to keep attending festivals. "There are several reasons to go to festivals," says Fair, "but make sure you go to the right festivals, that is, the ones set up for recruitment. The most important reason to go is to get your work seen by recruiters who are out there looking for you." She advises artists to make sure the festival they plan to attend has a recruitment center and is not just a trade show focusing on selling.

Animation festivals also give attendees a chance to meet their peers, who are in similiar situations and who can share with them tips on the job market, find out who's hiring, and learn what kind of work different animation studios are doing. Exhibitors can also give artists valuable information on how and when they recruit. "Recruitment centers usually offer a one-on-one meeting which gives artists a chance to make personal contact with a studio and talk about themselves and their work. It's like a job interview," says Fair.

There are a variety of festivals around the country, including the World Animation Festival in Pasadena, California, in early January, and the Ottawa Festival in Canada held in September. But dates are subject to change, and Fair recommends getting a complete updated festival list from ASIFA (Association Internationale du Film d'Animation), which has branches in major cities, or through the animation departments of local art schools. For more information on ASIFA, write ASIFA-East at 10 Point Crescent, Whitestone, NY 11357. "These festivals are an important resource for anyone interested in breaking into the animation industry."

—*Brooke Comer*

ADDITIONAL ANIMATION LISTINGS

As we prepared this year's *Artist's & Graphic Designer's Market*, we noticed that several advertising and design firms, record labels and other markets also use freelancers for animation. The following companies are listed elsewhere in this book. To read a complete listing, check for page numbers in the General Index beginning on page 691. You can also find more information by visiting a company's website. To submit your animation, send your reel, résumé and query letter to the markets listed below.

Access Inc.
Adfiliation Advertising
Angel Films Company
Bramson & Associates
Creative Connections
John Crowe Advertising
Custom Medical Stock Photo
Norman Diegnan & Assoc.
Films for Christ
Fine Art Productions
Futuretalk Telecommunications Company

Gold & Associates Inc.
GT Group
The Hitchins Company
Image Associates Inc.
Impact Media Group
Instructional Fair-TS Denison
Kaufman Ryan Stral Inc.
KJD Teleproductions
Linear Cycle Productions
McClanahan Graphics Inc.
Media Consultants
One Mile Up

Outside the Box Interactive
Steve Postal Productions
Princeton Direct, Inc.
Rhythms Productions
Sorin Productions Inc.
Take 1 Productions
Tom Thumb Music
UltiTech, Inc.
Walker Design Group
Dana White Productions, Inc.
WP Post & Graphics

ACORN ENTERTAINMENT, 1800 N. Vine, #305, Hollywood CA 90028. (818)340-5272. E-mail: info@acornenterta inment.com. Website: http://www.acornentertainment.com. Development: Bill Hastings. Estab. 1991. Number of employees: varies to 80. Animation studio. Specializes in game design, CD-ROM development, advertising, animation for motion picture industry. Recent clients include Disney, Fox, Interplay. Professional affiliations: ASIFA.

Needs: Approached by 300 animators/year. Works with 150 animators/year. Uses freelancers mainly for storyboard, layout, animation, BG, clean-up. 40% of freelance animation demands knowledge of Softimage, Alias/Wavefront, Prisims, Electric Image.

First Contact & Terms: Send reel, computer disk, résumé. Samples are filed or returned by SASE. Reports back only if interested. Will contact for portfolio review of reel of previous paid work, demo rel, disk of computer animation if interested. Pays by the hour, by the project or by the day. Rights purchased vary according to project.

Tips: "Animators should have over five years experience. Please have materials viewable via Internet if possible."

ANGEL FILMS, 967 Hwy. 40, New Franklin MD 65274-4978 Phone/fax: (573)698-3900. E-mail: angelfilm@aol.com. Vice President: Matthew Eastman. Estab. 1980. Number of employees: 50. Animation studio, AV firm. Specializes in advertising, animation. Recent projects/clients include *The Fairy Bride*.

Needs: Approached by 24 animators/year. Uses freelancers for all areas of animation. 50% of freelance animation demands knowledge of 3-D Studio, Strata Studio Pro.

First Contact & Terms: Send query letter with reel, computer disk, résumé. Accepts IBM compatible 3½ disks. Samples are filed or are returned by SASE. Reports back within 6 weeks. Will contact for portfolio review of reel of previous paid work, disk of computer animation if interested. Pay depends on budget. Finds artists through word of mouth, submissions.

Tips: "Don't copy other work. Computers are the trend. We may hate them but we are stuck with them."

ANIMANICS, INC., 340 S. LaBrea, Los Angeles CA 90036. (213)655-7911. Fax: (213)951-0495. Website: http://www.azproductions.com. President: Alonso Zevallos. Producer: Monica Zevallos. Estab. 1995. Number of employees: 5. Animation studio, AV firm. Specializes in development of hi-end animatics for the advertising industry. Recent clients include General Mills, *Playboy* magazine, Disneyland and Money Gram. Client list available upon request.

Needs: Approached by 13 freelance animators/year. Works with 13 freelance animators/year. Prefers local freelancers with experience in Photoshop, After Effects. Uses freelancers mainly for drawing, design, animation. 100% of freelance animation demands knowledge of Strata Studio Pro.

First Contact & Terms: Send query letter with computer disk, résumé. Accepts disks compatible with Mac OS (Flopy, Zip, Bernoulli, Jazz). Samples are returned. Reports back within 15 days. Wishes to see portfolio only if interested in artist's work. Pays by the project, $1,000-3,000. Buys all rights.

THE AVALON HILL GAME CO., 4517 Harford Rd., Baltimore MD 21214. (410)254-9200. Fax: (410)254-0991. Website: http://www.avalonhill.com. Art Director: Jean Baer. Estab. 1958. "Produces strategy, sports, family, role playing and military strategy, board games and computer games for adults."

● This company also publishes the magazine *Girls' Life*.

Needs: Approached by 30 freelancers/year. Works with 5 freelancers/year. Buys less than 10 designs and illustrations from freelancers/year. Prefers freelancers with experience in realistic military art. Works on assignment only. Uses freelancers mainly for cover and interior art. Considers any media. "The styles we are looking for vary from realistic to photographic."

First Contact & Terms: Send query letter with tearsheets, slides, SASE and photocopies. Samples are filed or returned by SASE if requested by artist. Prefers samples that do not have to be returned. Reports back within 2-3 weeks. If Art Director does not report back, the artist should "wait. We will contact the artist if we have an applicable assignment." Art Director will contact artist for portfolio review if interested. Original artwork is not returned. Sometimes requests work on spec before assigning a job. Pays by the project, $500 average for cover art, according to job specs. Buys all rights. Considers buying second rights (reprint rights) to previously published work. Finds artists through word of mouth and submissions.

‡BIFROST DIGITAL EFFECTS, 6733 Sale Ave., West Hills CA 91307. (818)704-0423. Fax: (818)704-4629. E-mail: howshore@aol.com. President: Howard Shore. Estab. 1982. Number of employees: 2. Animation studio. Specializes in advertising, animation, atmospheric laser effects and other visual effects for film and TV. Recent projects/clients include *Stargate*, *Batman Forever*, *Dark Planet*, *Time Lock*. Client list available upon request.

Needs: Prefers local freelancers with experience in 3D animation. 100% of freelance animation demands skills in Alias/Wavefront, 3-D Studio Max.

First Contact & Terms: Send query letter with résumé. Accepts IBM-compatible disk submissions. Samples are filed. Will contact artist for portfolio review of demo reel if interested.

Tips: "IBM Rules!"

CLASSIC ANIMATION, 1800 S. 35th St., Galesburg MI 49053-9688. (616)665-4800. Creative Director: David Baker. Estab. 1986. AV firm. Specializes in animation—computer (Topas, Lightwave, Wavefront SGI, Rio) and traditional. Current clients include Amway, Upjohn, Armstrong, NBC.

Needs: Approached by 60 freelancers/year. Works with 36 illustrators and 12 designers/year. Prefers artists with experience in animation. Uses freelancers for animation and technical, medical and legal illustration. Also for storyboards, slide illustration, animatics, TV/film graphics and logos. 10% of work is with print ads. 50% of freelance work demands computer skills.

First Contact & Terms: Send query letter with résumé, photocopies and ½" VHS. Samples are filed or are returned by SASE. Reports back within 1 week only if interested. Write for appointment to show portfolio or mail appropriate

materials. Portfolio should include slides and ½″ VHS. Pays for design and illustration by the hour, $25 minimum; or by the project, $250 minimum. Rights purchased vary according to project.

☘**COREL CORPORATION**, 1600 Carling Ave., Ottawa, Ontario K1Z 8R7 Canada. (613)728-3733. Fax: (613)728-9790. E-mail: photos@corel.ca or clipart@corel.ca. Product Manager, Digital Libraries: Katie Gray. Estab. 1985. Clip art firm, software developer.
Needs: Considers illustrations, animations, photos and clip art.
First Contact & Terms: Sample package should include tearsheets, slides and/or roughs. Include electronic samples if possible.

D ANIMATION MULTIMEDIA & WEB DESIGN, 1950 Stemmons Freeway, #2066, Dallas TX 75207. (214)800-1800. Fax: (214)800-1811. Website: http://www.d-animation.com. Vice President: Travis Bittner. Estab. 1991. Number of employees: 8. Multimedia and Internet developers. Specializes in all facets of multimedia and internet (marketing/sales, tracking, entertainment). Recent clients include Justin Boots, JPI, Gaylord Properties, First USA, GTE, Alcon Labs. Client list available upon request.
Needs: Approached by 10-20 freelance animators/year. Works with 1-4 freelance animators/year. Prefers local freelancers with experience in 3D Studio. Uses freelancers mainly for programming, animation. 100% of freelance animation demands knowledge of 3-D Studio 4/Max.
First Contact & Terms: Send query letter with reel, computer disk, résumé. Disks should be PC compatible. If doing multimedia, include small shows in Authorware or Director. Samples are filed. Reports back only if interested. Will contact for portfolio review of reel of previous paid work if interested. Pays by the project. Pay depends on turn-around and experience. Negotiates rights purchased. Finds artists through agents, sourcebooks, trade shows, on-line services, magazines, word of mouth, submissions.
Tips: "Don't be limited to animation. Be open to new software and direction. Enjoy creative corporate applications. Gain experience at school first. We offer internships to give experience and potentially hire."

DELTASOFT, 2137 Renfrew Ave., Elmont NY 11003. (516)775-4381. E-mail: mreiferson@aol.com. Website: http://www.perplexed.com. Contact: Matt Reiferson. Estab. 1996. Number of employees: 2. Entertainment (games) developers. Specializes in game design/development, Web page design, graphics. Recent projects/clients include *Math Wars*, *Do or Die*.
 ● DeltaSoft does not pay for animation but is interested in working with animators who are just beginning their careers. This company might be a good place to start building a portfolio.
Needs: Approached by 4-5 freelance animators/year. Works with 2 freelance animators/year. Prefers local freelancers with experience in Truespace, POVRAY, Poser, Photoshop. Uses freelancers mainly for game graphics. 100% of freelance animation demands knowledge of Softimage, 3-D Studio, Truespace.
First Contact & Terms: Send query letter with computer disk. Submit IBM compatible disks. Samples are filed. Reports back within 3 days only if interested. Artist should follow-up with call for portfolio review of disk of computer animation, any graphics. Pays nothing, "strictly for the sake of making the game." Buys all rights. Finds artists through Internet.
Tips: Game/graphics history recommended. Open to beginning animators. "Learn and have experience in many graphic software programs."

GENE KRAFT PRODUCTIONS, 29 Calvados, Newport Beach CA 92657. (714)721-0609. Producer: Suzanne Stanford. Estab. 1980. Number of employees: 2. Animation studio and design firm specializing in animation production and title design for motion pictures and television. Recent clients include Nickelodeon and Universal Family Entertainment. Member of the Producer's Guild of America.
Needs: Approached by 12 freelance animators/year. Works with 6 freelance animators/year. Uses freelancers for design, illustration and animation. 25% of freelance work demands knowledge of Softimage and Alias/Wavefront.
First Contact & Terms: Send query letter with reel and résumé. Samples are filed. Reports back within 2 weeks. Art director will contact artist for portfolio review of demo reel if interested. Pays by the project, $100-2,500. Buys all rights. Finds artists through agents, word of mouth and submissions.

LUMENI PRODUCTIONS, 1632 Flower St., Glendale CA 91201. (818)956-2200. Fax: (818)956-3298. Art Director: Carla Swanson. Number of employees: 15. Film graphics company. Specializes in animation, graphics, title design for motion picture industry. Recent clients include Disney, Warner Bros., Miramax, MGM/UA. Client list available upon request.
Needs: Approached by 300 freelance animators/year. Works with 3 freelance animators/year. Prefers local freelancers with experience in Alias, Composer. Uses freelancers mainly for animation, title design. 100% of freelance animation demands skills in Alias/Wavefront, Strata Studio Pro, After Effects.
First Contact & Terms: Send reel, résumé. Samples are filed. Reports back only if interested. Will contact for portfolio review of demo reel if interested. Pays by the hour, negotiated. Rights purchased vary according to project. Finds artists through word of mouth.

➤**METAFOR IMAGING**, 3962 Ince Blvd., Culver City CA 90232. (310)287-3777. Fax: (310)287-3778. Website: http://www.metafor.com. Contact: Studio Manager. Estab. 1992. Digital imaging company. Specializes in motion picture

INSIDER REPORT

Jump into the creative frontier of kids' cartoons

When Kat Fair, head of recruitment at Nickelodeon Animation Studio, reviews the 60 or so portfolios she receives each week, she looks for unusual work, a variety of styles and original ideas. "We don't have a house style here at Nickelodeon," says Fair, "so we need people who have a range of styles. I want people who are creative, flexible and diverse."

Fair comes from a background in development, first in theater, then in live-action television and films. She loved the industry, "but my heart was always in animation." She worked at Disney TV as a development executive, where she "developed a good sense of what distinguished good work from bad work." Fair then went on to Rhythm and Hues, where as director of development she increased her knowledge of computer animation and developed an eye for form and character. She then joined the team at Nickelodeon, where

Kat Fair

she's been since July 1997. Nickelodeon offers its employees in-house education programs in work-related areas such as storyboarding, film theory, timing, life drawing and slugging, as well as in time management, financial management, aerobics and yoga. "If we hire you," says Fair, "it means you're good. But once you're hired, we'll make you better."

Freelancers are hired at Nickelodeon "when we're under the gun," says Fair, who notes that the studio prefers to hire staff artists. "And once you're on staff here," she continues, "you won't burn out by doing the same thing over and over, because you'll probably get a chance to try out different styles on different shows. Our cartoons don't have a 'Nick' stamp—they each have their own unique identity because they're creator driven. For instance, *Hey, Arnold!*, which features more realistic kids than some of the other shows, is very different from the mixed-media styles on *Kablam!*. And we're not limited to the styles you see—we love to get ideas from our house staff—which is why we like to hire people who are creative and who draw well."

Because each Nickelodeon show is creator driven, "we're very much hands-off when it comes to production, more so than any other studio," says Fair. "We rely on the creator of each product to see his or her vision through. That way we can be sure we'll get different views, looks and feels to our shows."

The creators of the Nickelodeon shows are able to infuse their shows with a creative style, and the studio is respectful of creative autonomy. *Kablam!* uses mixed media that includes paper cut-outs, computer-generated characters and traditional cel animation and stop motion. *Angry Beavers*, a traditional cel animation show with a lot of special effects, was created by Mitch Shauer, a producer on the show, "who has a lot of control over the series from storyboard on," says Fair. Peter Hannon, who created the traditional cel animation show *CatDogs*, comes from children's book illustration rather than animation, "but

INSIDER REPORT, *Fair*

he also has a lot of involvement in what goes on creatively in his show," Fair notes.

Fair makes regular tours of colleges, art schools and animation conferences to look for new talent. "I'm always looking for colleges with animation programs because there's new talent there." She singles out some of the best programs, at Rhode Island School of Design, Ringling School of Design in Sarasota, and Cal Arts and University of Southern California. The latter two schools have relationships with Nickelodeon; the studio funded Phase II of the Mac Lab at Cal Arts, doubling the school's animation stations. Nickelodeon is also helping to set up an MFA program in experimental animation at USC.

Fair personally looks at every one of the 60 portfolios she receives each week. There is also a review process, and notes are entered into Fair's database. "Everyone gets a response," she says, "yet I'm always surprised how few people call in to get their notes." Prospective artists drop off their portfolios with the receptionist, or mail them in. Each one is logged, then goes through a portfolio review with all five producers who write notes on it. "If someone's portfolio fits in with our needs at that time, we'll contact the artist."

Everyone who submits a portfolio gets a phone call when the portfolio is ready to pick up. If there is no job opening in that area at that time, a polite form letter response will be sent. But those who follow through and call Fair can request that she check her database and read the artist their reviews. "That way you can find out where your portfolio was weak or strong. If you're willing to work on your weak areas, you can resubmit after your portfolio has changed substantially." Fair—who will look at resubmissions a third and even a fourth time if she feels that talent warrants it—finds that it usually takes four to five months for artists to create enough new work to redo their portfolio.

Freelance work is one way to break into a staff position at Nickelodeon. Fair notes that a lot of freelancers don't want to be on staff. She suggests that job applicants stress in their application whether they're interested exclusively in a staff or freelance job, or if they are are willing to freelance until a staff job is available. In addition to looking for artists, Fair also looks for production assistants, runners and administration assistants, all of which are good jobs for aspiring artists. "Once you're on board, and you show how well you can draw, and we see where your talents lie, then you might get clean-up work, which is one way to break in and move up the ranks." In-house promotions are so common at Nickelodeon that receptionists usually don't last more than three months—because they've moved up. "So if you're a talented artist," says Fair, "and you have a kid-cartoony sense of creativity and the freedom to explore that creative frontier, you're the kind of person Nickelodeon is looking for!"

—*Brooke Comer*

One of Nickelodeon's top animated shows is *Hey, Arnold!*, a show about a fourth-grader who lives with his grandparents in a boarding house. The series is the brainchild of animator Craig Bartlett.

key art, advertising. Recent projects/clients include *Devil's Own* key art, Columbia Pictures; Porsche Boxter Ads, *Goodby Silverstein*.

Needs: Approached by 10-15 freelance animators/year. Works with 20 freelance animators/year. Prefers local freelancers with experience in Photoshop Finish. 100% of freelance animation demands skills in Photoshop 4.0.

First Contact & Terms: Send query letter with résumé. Reports back only if interested. Artist should follow-up with call. Pays by the hour, $20-50. Finds artists through agents, word of mouth.

METROLIGHT STUDIOS, INC., 5724 W. Third St., #400, Los Angeles CA 90036. (213)932-0400. Fax: (213)932-8440. E-mail: resumes@metrolight.com. Website: http://www.metrolight.com. Estab. 1987. Number of employees: 65. CGI special effects house. Specializes in special effects, animation and imagery for motion picture industry and commercials, TV. Recent projects include the films *Matilda, McHale's Navy, Leave It To Beaver, Eraser* and *Kull the Conqueror*. Clients include Disney, Warner Bros., Universal, 20th Century Fox.
- Metrolight won an Academy Award for *Total Recall* and Emmys for *ABC World of Discovery* and the *1992 Barcelona Olympics*.

Needs: Approached by hundreds of freelance animators/year. Works with a few freelance animators/year. Prefers freelancers with experience in Alias. 100% of freelance animation demands knowledge of Alias/Wavefront, Prisms, Matador, Renderman.

First Contact & Terms: Send reel, résumé. Samples are not filed and are not returned. Reports back only if interested. Will contact for portfolio review of demo reel if interested. Finds artists through word of mouth.

Tips: "We prefer 2-5 years of production experience in the following software: Alias/Wavefront, Prisms, Renderman, Matador. The best way to get your foot in the door is to have a killer demo reel. Software knowledge is less important than how well you manipulate it."

JAMES MURPHY CONSULTING, INC., 1431 Garland St., Green Bay WI 54301. (920)435-7345. Fax: (920)435-7395. E-mail: murph@virtualpartners.com. Website: http://www.3d4all.com & http://www.virtualpartners.com. President: James M. Murphy. Estab. 1988. Number of employees: 2. Animation studio. Specializes in Web page design/graphics, advertising, animation for motion picture industry. Recent clients include NBC Nightly News, Atlantic Records, McDonnell Douglas Corp., Epic MegaGames, Forensic Media, WFRV-TV, Blur Studios. "We support over 500 animation and graphics houses many of whom have won many awards as a result of our training and support."

Needs: Approached by 75 freelance animators/year. Works with 200 freelance animators/year. Prefers freelancers with experience in architectural and character animation. 100% of freelance animation demands skills in 3-D Studio Max.

First Contact & Terms: Send query letter with reel. Samples are filed. Reports back within 2 weeks. Portfolio should include demo reel. Pays by the project, $500 minimum. Rights purchased vary according to project.

Tips: "Buy, learn and excel in 3-D Studio Max! This is not a 9-to-5 job! Also, sell the talent you have to communicate effectively through graphics. Use a variety of tools best suited to accomplish the job with disregard to platform preferences. Bad business will drive away the good."

❋**NATTER JACK ANIMATION**, 1241 Homer St., Vancouver, British Columbia V6B 2Y9 Canada. (604)669-3689. Fax: (604)669-3489. Website: http://www.natterjack.com. Senior Producer: Colleen Pollock. Estab. 1993. Number of employees: 40. Animation studio. Specializes in feature, television, interactive animation. Professional affiliations: ABCAP.

Needs: Approached by 60 freelance animators/year. Works with 30-50 freelance animators/year. Prefers local freelancers. Uses freelancers mainly for animation, assisting.

First Contact & Terms: Send query letter with reel, résumé. Samples are filed. Reports back within 1 month. Portfolio review required. Request portfolio review in original query and follow-up with call for review of demo reel. Pays biweekly/salaried.

‡**NICKELODEON**, 231 W. Olive Ave., Burbank CA 91502. (818)736-3673 or (818)736-3000. Fax: (818)736-3539. Head of Recruitment: Kat Fair. Estab. 1992. Number of employees: 200. Cable TV network. Specializes in animation for television. Recent projects include *Blue's Clues, Angry Beavers, Hey Arnold!, Oh Yeah!*. Professional affiliations: ASIFFA, ATAS, Women in Animation.
- See the interview with Kat Fair in this section.

Needs: Approached by 1,000 freelance animators/year. Prefers freelancers with experience. 1% of freelance illustration demands skills in Photoshop.

First Contact & Terms: Send portfolio. Samples are filed or returned. Reports back in 2 weeks. Portfolio review required. Portfolios may be dropped off every Monday-Thursday. "Reel is OK, but we're really looking for drawing ability.". Artist should follow up. Pays by the project. Buys all rights. Finds artists through trade shows, word of mouth, submissions.

Tips: "Don't send huge, over-sized portfolios. Get to know Photoshop and animation software."

NOVA DEVELOPMENT CORPORATION, 23801 Calabasas Rd., Suite 2005, Calabasas CA 91302-1547. (818)591-9600. Fax: (818)591-8885. E-mail: submit@novadevcorp.com. Website: http://www.novadevcorp.com. Product Development Manager: Lisa Helfstein. Estab. 1983. Computer Software Publisher. Specializes in web graphics, web animation and clip art packages for the consumer market. Recent products include Web Explosion, Art Explosion and Web Animation Explosion.

Needs: Approached by 15 freelance animators/year. Works with 5 freelance animators/year. Prefers freelancers with experience in GIF and Shockwave animation. Uses freelancers to provide content for consumer software packages. 100% of freelance animation demands computer skills.
First Contact & Terms: Send query letter with computer disk (Macintosh format preferred) or URL for sample page. Samples are filed. Reports back only if interested. Pays royalties based on gross income. Rights purchased vary according to project.

RENEGADE ANIMATION, INC., 204 N. San Fernando Blvd., Burbank CA 91502. (818)556-3395. Fax: (818)556-3398. Executive Producer: Ashley Quinn. Estab. 1992. Number of employees: 8. Animation studio. Specializes in CD-ROM game animation, commercial animation, TV and film animation. Recent projects include Disney *101 Dalmations* CD-ROM game, Carl's Jr. "Tattoo" commercial, Cheeto's commercial, Taco Bell "Nacho & Dog" commercials, etc. Professional affiliations: ASIFA.
Needs: Approached by 15 freelance animators/year. Works with 30 freelance animators/year. Prefers local freelancers with experience in animation. Uses freelancers mainly for animation, asst. animation, fx animation, checking.
First Contact & Terms: Send query letter with reel, résumé. Samples are not filed and are returned. Reports back within 2 weeks. Portfolio review required. Request portfolio review of reel of previous paid work, demo reel, scenes to flip in original query. Pays by the project. Finds artists through word of mouth.

‡R/GREENBERG ASSOCIATES, 350 W. 39th St., New York NY 10018. (212)946-4000. Fax: (212)946-4160. Website: http://www.RGA.com. Executive Producer: Rick Wagonheim. Head of Production: Michael Miller. Estab. 1977. Number of employees: 114. Animation/design firm. Specializes in visual effects and design for film titles, commercials and new media. Recent clients include Pontiac, Dodge, *Night Falls On Manhattan*.
Needs: Approached by 30 freelance animators/year. Works with 25% freelance animators/year. Uses freelancers mainly for graphic design, CG-related work. "Don't bother to come to R/GA unless you have computer skills."
First Contact & Terms: Send query letter with reel and résumé. Samples are filed and are not returned. Reports back only if interested. Portfolio review required for design department, not CD work (reel only). Portfolios may be dropped of every Monday-Friday. Request portfolio review in original query. Artist should follow up with letter after initial query. Art director will contact artist for portfolio review if interested. Portfolio should include your best work. Pay depends on project. Finds artists through agents, trade shows, word of mouth.
Tips: "Don't give up. Be hungry, aggressive and talented."

✔SCULPTURED SOFTWARE STUDIOS, a Kodiak Interactive Company, 4001 S. 700 E., Suite 301 Salt Lake City UT 84107. (801)266-5400. Fax: (801)266-5570. E-mail: mmezo@kodiakgames.com. Website: http://www.kodiakg ames.com. Director of Human Resources: Monique Mezo. Entertainment software developer.
Needs: Computer graphic artists for full-time and contract work with 3D animation skills. Needs 3D animation artists. Should have strong 2D art skills, especially figure drawing, and strong skills in animation programs such as 3D Studio Max, Animator Pro, D Paint.
First Contact & Terms: Send a short reel of animation (especially 3D animation) and graphics on a VHS tape plus slides or photos of 2-D artwork.
Tips: "just include your best work on your VHS tape. Don't make the tape too long. three to five minutes is enough. (Some artists include everything they've ever done and that's too much for us to have time to look at)."

STARTOONS, P.O. Box 1232, Homewood IL 60430. (708)335-3535. Fax: (708)335-3999. General Manager: Terry Hamilton. Estab. 1989. Number of employees: 25. Animation studio. Specializes in advertising, animation for motion picture industry, etc. Recent clients include Warner Bros., Griffin Bacal. Client list available upon request. Professional affiliations: Women in Film.
 ● Startoons has won an Emmy for work on *Animanics* and many awards for the *Dudley the Dinosaur* series.
Needs: Approached by 2 freelance animators/week. Works with 5 freelance animators/year. Prefers local freelancers with experience in traditional animation. Uses freelancers mainly for storyboards.
First Contact & Terms: Send query letter with résumé, life drawing examples. Samples are not filed and are not returned. Reports back within 2 months. Will contact for portfolio review of demo reel if interested. Pays piece rates. Buys all rights. Finds artists through word of mouth, submissions.

♣STUDIO B PRODUCTIONS, 21 Water St., #400, Vancouver, British Columbia Y6B 1A1 Canada. (604)684-2363. Fax: (604)684-7290. E-mail: production@studiobproductions.com. Contact: Kathy Antonsen. Estab. 1987. Number of employees: 45. Animation studio. Specializes in animation for television, animation pre-production. Recent projects/clients include Disney-*Timon & Pumba*, *Jungle Cubs*; DIC Entertainment-*Tex Avery Theater*; Warner Bros.-*Calamity Jane*; Universal-*Savage Dragon Cycle II*. Client list available upon request. Professional affiliations: Association of British Columbia Animation Producers.
Needs: Approached by 85 freelance animators/year. Works with 10 freelance animators/year. Prefers freelancers with experience in animation. Uses freelancers mainly for design, storyboards, slugging, x-sheets, background color keys.
First Contact & Terms: Send query letter with résumé and sample copy of artwork. "Please send copies only as samples are kept on file." Reports back only if interested. Will contact for portfolio review of original or copies of original drawings, painting, storyboards etc. (no reels and disks) if interested. Finds artists through submission, word of mouth.

INSIDER REPORT

Visual virtuosos needed in animation industry

When prospective artists send their portfolios to Warner Bros. Feature Animation Studios, one thing is clear, says Dave Master, director of artist development and training: "These people are not doing enough research on the industry or its needs."

In particular, according to Master, artists should apply for a specific job, be clear about the skill sets required for that job, and make sure the job is available at the time they submit portfolios. Also, they should have realistic expectations in terms of the high level of expertise expected—even from beginners.

Master likes to use the music metaphor "If you want to be hired by an orchestra, do you say in your application that you play a musical instrument, or that you play the cello?"

Dave Master

Master stresses that like a symphony orchestra, Warner Bros. Animation hires artists who have excellent technical skills in specific areas of animation. "Orchestras do not look for 'one-man bands.' Neither do we."

Warner Bros. is looking for visual virtuosos with particular job skills. "When artists send in their portfolios, we may not hire them even if they are good artists. They may not possess a particular skill set we're currently looking for."

Many portfolios Master receives also display a misconception about the level of the artistic ability he's looking for. "People tend to look at a cartoon series or animated film and say, 'I can do that.' But in reality, what we're really looking for are Florentine Renaissance artists who can adapt their skills to fit the artistic needs of a particular production design."

Master doesn't recommend scrutinizing particular TV shows to try to figure out what animation studios need. "A series on TV doesn't always reflect the level of artistic ability that a studio needs from its artists to produce the show."

Even though the industry has grown enormously in the past few years, and now four major feature animation studios turn out work instead of just one, "people think this means there is a plethora of jobs, but there aren't," says Master. "The number of people and the specific talents we require depend on the needs of that production."

Unlike some studios, where freelancers can parlay a temporary job into fulltime work, "in the feature animation industry, freelancers are people who are working between films," says Master, "or who are moonlighting. And these people usually work for smaller commercial houses that contract out their services for a particular project. It may be easier to break in coming from a smaller studio that does advertising, TV, or specials, so keep your ear to the ground and find out which small animation production companies are hiring for short-term projects."

INSIDER REPORT, *Master*

Master emphasizes how very important the research process is. "You need to call the studio and find out what jobs are available. Each studio has a recruiting director and there's usually a hotline as well, and trade associations and unions can also supply information. Different skills are required for different jobs, and the bigger the studio, and the bigger the projects, the more they'll be looking for particular virtuoso skills. You have to be exceptional in one area, i.e., animation, layout, background painting, inbetweening, etc. to get a job at a big studio."

When Master last put out a call for interns—over a year ago—he received 500 portfolios in one week for only 12 available slots. "We only hire interns when the production need arises, and we haven't hired any interns for over a year. Most of the portfolios submitted, unfortunately, were off the mark," he adds.

"You can tell by the portfolios that animation is what these artists have wanted to do all their lives, but they never researched what skills their career target required. Many times artists spend years practicing things we don't look for. Animation provides many visual artists an opportunity to express their talents in a collaborative, orchestrated manner and requires a professional virtuosity, and potential applicants must be self-critically aware of them."

What about the portfolios that do get the job? The interns he does hire (they receive a salary) are those who know what to show in their portfolios. "The portfolios we choose, even at this lowest level, are magnificent," says Master. "Interns must show an extremely proficient level of skills in human anatomy. They must have a good understanding of solidity and weight and balance, as well as 3-D drawing, and be able to capture a key pose with the fewest possible lines. Even if a character is only on screen for a split second, key drawings have to capture a very clear, readable pose."

© 1998 by Warner Bros.

Quest for Camelot is Warner Bros. Feature Animation's first full-length, fully animated feature. You can learn how animators create the characters for Warner Bros. by visiting http://www.quest4camelot.com or http://www.wbanimation.com on the World Wide Web.

INSIDER REPORT, *continued*

Master says that "an animator's sketchbook should show the ability to capture a pose that shows what a character is 'thinking.' We ask for that because animators are artists who can act. They have to be extremely proficient artists, and prolific artists who can draw fast and get something out on paper without a lot of struggle. Half their job is drawing and the other half is acting. You're really acting with your pencil, and if you're struggling over how you're going to draw something, that takes away from the acting. We hire some of best artists on the planet, and on top of their incredible drawing skill, they are actors." So if you are a visual virtuoso who can think like a cartoon character, you've got it made!
—Brooke Comer

✔**TITLE HOUSE DIGITAL EFFECTS**, 738 N. Cahuenga Blvd., Los Angeles CA 90038. (213)469-8171. Fax: (213)469-0377. E-mail: titlehouse@earthlink.net. Digital Effects Producer: Rick Brackmann. Estab. 1962. Number of employees: 20. Animation studio, design firm, digital effects film production studio. Specializes in 3-D animation, 2-D compositing, Wavefront, Cineon, After Effects. Recent projects/clients include "The Arrival," Lawnmower Man III. Client list available upon request.
Needs: Approached by 5 freelancer animators/year. Works with 5 freelancer animators. Prefers local freelancers with experience in Wavefront, Cineon, After Effects. Uses freelancers mainly for animation, compositing, design. 100% of freelance animation demands skills in above software.
First Contact & Terms: Send query letter with résumé. Accepts samples on Mac floppies, zip disks. Samples are filed. Reports back only if interested within 1 week. Artist should call. Will contact for portfolio review of reel of previous paid work, demo reel.

UNITEL INTERACTIVE, 8 W. 38th St., New York NY 10018. (212)944-9090. Fax: (212)840-0217. E-mail: info@uni a.com. Website: http://www.unia.com. Executive Producer: Mike McCall. Estab. 1993. Number of employees: 10. New media developers. Specializes in CD-ROM development, Web page design/graphics and broadcast TV design. Client list available upon request. Professional affiliations: IMA, ITS, Microsoft Solution Provider, Macromedia Development Partner, New York New Media Association.
 • Recently won the ITS Monitor Award-Best Non Commercial CD-ROM and BDA Design award for Website Design.
Needs: Approached by 20 freelance artists/year. Works with 5-10 freelance artist/animators/year. Prefers freelancers with knowledge of Photoshop, Illustrator, After F/X; Director, HTML. Uses freelancers mainly for design, animation, programming. 10% of freelance animation demands knowledge of Softimage.
First Contact & Terms: Send résumé. Samples compatible with Mac or PC are filed. Reports back only if interested. Portfolio review required only if interested in artist's work. Artist should follow-up with call and/or letter after initial query. Portfolio should include disk of computer animation. Pays by the hour, $20-50. Finds artists through word of mouth, NYNMA and school.
Tips: "Start as an intern—for no pay if necessary—and learn, learn, learn! Meanwhile, build a portfolio."

‡**WARNER BROS. FEATURE ANIMATION**, 500 N. Brand Blvd., Suite 1800, Glendale CA 91203. Fax: (818)977-7111. Contact: Recruitment. Estab. 1994. Number of employees: varies by production. Animation studios. Specializes in animation for motion picture industry. Recent projects include Space Jam and Quest for Camelot.
 • See the interview with Director of Artist Development Dave Master in this section.
Needs: Approached by thousands of freelance animators/year. "We hire small studios. A good way to break in is to find small studios who get hired by big studios." Prefers to have previous relationships with freelancers. 100% of freelance animation demands skills in computer animation.
First Contact & Terms: Send query letter with reel, résumé and portfolio. "Identify your position! Don't just say, 'I want a job!' Don't give us too much." Samples are filed briefly or are returned. "Don't send portfolio; send cover letter asking if we are accepting portfolios." Reports back in 2-4 weeks. Portfolio review required "only if we have a job opening. Write first and ask when we are looking at portfolios. But we won't review if we're not looking for this category." Art director will contact artist for portfolio review if interested. Pays by the project. Rights purchased vary according to project. Finds artists through word of mouth
Tips: "Write first. Send query and list the job you want. Call to find out when we're hiring. Then send portfolio."

Advertising, Design & Related Markets

Advertising is the most lucrative market for freelancers, but design firms and related markets have similar needs and pay rates. The firms and agencies in this section vary in size, ranging from two-person operations to huge, international corporations. All, however, rely on freelancers. If you have the required talent and skills, these markets offer a steady stream of assignments.

There are thousands of advertising agencies; public relations, design and marketing firms across the country and around the world. Though we alert you to a number of them, our page-count is limited. So be aware the listings on the following pages are the tip of the proverbial iceberg. Look for additional firms in industry directories, such as *Workbook* (Scott & Daughters Publishing), *Standard Directory of Advertisers* (National Register Publishing) and *The Design Firm Directory* (Wefler & Associates), available in the business section of most large public libraries. Find local firms in the yellow pages and your city's business-to-business directory. You can also pick up leads by reading *HOW, Print, Step-by-Step Graphics, Communication Arts* and other design publications (see addresses in Publications of Interest on page 678).

How to target your market

Read listings for clues that lead you to firms whose clients and specialties are in line with the type of work you create. (You'll find clients and specialties in the first paragraph of each listing.) If you create charts and graphs, contact firms whose clients include financial institutions. Fashion illustrators should approach firms whose clients include department stores and catalog publishers. Sculptors and modelmakers might find opportunities with firms specializing in exhibition design.

Contact local agencies first. Although fax and modem have made it easier for agencies to work with out-of-town illustrators, most prefer to work with local freelancers for design projects. It may take some initial digging to find markets in need of your specialty, but it's worth the effort. When you submit work you enjoy creating, it shows! In the long run your samples will win the kind of assignments you'll enjoy working on and you'll have a more rewarding freelance career.

Bowl them over with your samples!

Once you choose which firms to approach, create samples that will knock their socks off! The art directors and art buyers listed in this section have high standards. Follow these tips to increase your odds of landing assignments:

- Submit samples appropriate to each firm's specialties. Doing so demonstrates you did your homework and gives the impression you'll be just as thorough when tackling assignments. If a firm specializes in package design, for example, and its clients include wineries and coffee companies, a sample showing vineyard or coffee images would be right on target and might prompt them to give you a call. If you are a medical illustrator, skip the firm specializing in packaging and look for firms specializing in pharmaceutical companies. Your best strategy is this: *Don't create work based on the kind of images you think markets want to see. Rather, target design firms (and other markets) who need the type of work you want to specialize in.*
- Postcards or color photocopies work well as samples for illustrators. To save on printing

costs, first narrow your market, then design and print several hundred postcard samples of an image that both represents your style and is appropriate to the listings you have selected for your mailings. Another economical strategy is to design several samples and submit color photocopies or laser prints instead of printed cards. (See What Should I Submit?, page 22.)

- Be sure the style you choose for your sample is one you can easily duplicate, because firms will expect you to create assignments in the style of your sample.
- Illustrators should make sure the *design* elements in their samples—the layout, typography, etc.—are well thought out and clearly show name, address, phone number, fax.
- If you are a designer, remember the stationery you choose for your cover letter is as important as your samples. The layouts (as well as the content) of your cover letter and resume will be scrutinized, along with the fonts and paper grades you choose. If you submit beautiful samples with a poorly designed résumé, you'll be quickly ruled out.
- Consider showcasing your capabilities by designing a brochure or booklet. You can find dozens of examples of creative self-promotional pieces in North Light's *Fresh Ideas* series.
- Mailings have a cumulative effect, so don't give up after one or two mailings. Send a new sample every few months to the same mailing list, adding additional names to the list as you come across them.

WHAT SKILLS ARE NEEDED?

Advertising agencies and design firms hire the following freelance creative talent on a project-by-project basis:

- **Illustrators.** Ad agencies and design firms hire illustrators to provide fresh images and a variety of styles.
- **Design and production freelancers.** Art directors need freelancers who have polished computer skills on Mac graphic programs, who know how to spec type, create layouts and produce charts and graphs. They might hire you to work on a project at home on your Mac, or ask you to work on their premises.
- **Sculptors.** Design firms specializing in exhibit design for museums or trade shows often rely on freelancers with knowledge of sculpture and model-making techniques.
- **Calligraphers, lettering artists and font designers.** Some advertising and design firms turn to freelancers who specialize in attractive or unusual lettering or fonts.
- **Multimedia designers and animators.** There is a growing need for freelancers who can create websites and work on CD-ROM projects.
- **Storyboard artists.** Artists who have experience drawing storyboards pick up assignments from design firms as well as advertising agencies.

WHAT THEY PAY

You will most likely be paid by the hour for work done on the firm's premises (inhouse), and by the project if you take the assignment back to your studio. Most checks are issued 40-60 days after completion of assignments. Fees depend on the client's budget, but most companies are willing to negotiate, taking into consideration the experience of the freelancer, the lead time given, and the complexity of the project. Be prepared to offer an estimate for your services and ask for a purchase order (P.O.) before you begin an assignment.

Some art directors will ask you to provide a preliminary sketch, which, if approved by the client, can land you a plum assignment. If you are asked to create something "on spec," you may not receive payment beyond an hourly fee for your time if the project falls through. So be sure to ask upfront about payment policy before you start an assignment.

If you're hoping to retain usage rights to your work, you'll want to discuss this upfront, too.

Get the 2,000 EDITION at this year's price!

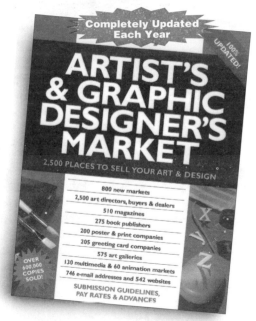

Be among the first to receive next year's edition of *Artist's & Graphic Designer's Market*, completely updated and packed with new markets for your work.

You'll save the frustration of submitting to companies whose addresses have changed, and you'll have first shot at new markets that are hungry for submissions. Best of all, you'll get the 2,000 edition at the 1999 price — delivered to your door as soon as it's off press!

Use the order form below to reserve your copy now.

The 2,000 edition of *Artist's & Graphic Designer's Market* will be published and ready for shipment in September 1999.

More books to help you sell your work

More Great Books to Help You Get Ahead!

Completely Updated!
1999 Children's Writer's & Illustrator's Market
Break into this lucrative field! You'll get the names and addresses of more than 800 buyers of freelance materials, plus information-packed articles written by the experts.
#10582/$19.99/368 pages/pb/Available January, 1999

Getting Started as a Freelance Illustrator or Designer
The basics of self-promotion and assembling your portfolio, plus the ins and outs of working with magazines, newspapers, ad agencies, publishers, greeting card companies and small businesses.
#30200/$16.99/118 pages/pb

NEW!
Art Marketing 101
Sound advice for establishing a lucrative art career, including alternative avenues for selling art, tricks to succeeding without a rep, tips for marketing and publicity, and practical info on taxes, income, pricing, billing and more.
#31231/$24.95/336 pages/pb

The Streetwise Guide to Freelance Design and Illustration
Full of practical business sense to help you succeed on your own. How to buy the proper studio equipment, create a knock-out portfolio, develop relationships with clients, manage your time and much more.
#31111/$24.99/144 pages/pb

Essential
How to Get Started Selling Your Art
Turn your spare-time hobby into a satisfying and profitable career. Carol Katchen offers proven advice on exhibiting, creating a professional image, assembling a portfolio, pricing your work — plus worksheets, success stories and loads of inspiration.
#30814/$17.99/128 pages/pb

The Best Seasonal Promotions
A great idea-starter for your next self-promotion! This book showcases more than 150 clever promotions tied to holidays throughout the year — even Groundhog's Day. Includes info on cost and production specs for each piece.
#30931/$29.99/144 pages

Order these helpful references today from your local bookstore, or use the handy order card on the reverse.

You can generally charge more if the client is requesting a buyout. If research and travel are required, make sure you find out ahead of time who will cover these expenses.

TRADE JOURNALS ALERT YOU TO OPPORTUNITIES

As an illustrator—and savvy self-promoter—you must understand the changes in advertising's landscape and how they impact on your opportunities. You've got to note the trends in your market—and on Madison Avenue—to position yourself for the times. Your livelihood depends on it.

Reading industry trade journals such as *Adweek* and *Advertising Age* can guide you to potential clients—and keep you from approaching the wrong agencies.

For example, agency downsizing is a way of life. New technologies have put ad dollars in new places and smaller shops are emerging as major players. The big budget work is no longer only going to the big agencies. Giants such as MasterCard, IBM, Burger King and Volkswagen, which traditionally looked to the the monolithic agencies as marketing partners, are turning to smaller agencies for fresh creative ideas. While the big agencies will in all likelihood continue to service global clients, the smaller shops are now getting bigger pieces of the $138 billion U.S. advertising pie.

Another telling change is the growing importance of marketing alternatives to traditional advertising. Many clients are turning to cost-effective marketing strategies such as direct mail. If you've never done so before, consider these collateral companies your potential new clients. Design firms, too are emerging as a major source of creative work.

Adweek recently reported that Los Angeles has become "Detroit on the beach"—the L.A. agencies are either doing small-time print campaigns or big-time car accounts. If you don't illustrate cars, you might want to look outside of L.A. for national jobs.

Even such basics as immersing yourself in the advertising trade publications and the business section of the major market newspapers on a regular basis will keep you aware of industry trends and give you the big picture. Networking is also critical to keep you informed of inside news and to alert you when one of "your" art directors makes a career move.

Markets, technologies and consumer trends are changing at a dizzying rate. But the successful artist will keep reading the signs—through research, the media, and even common sense—to keep up with the times.

—*Jo Ann Miller*
American Showcase

Alabama

COMPASS COMMUNICATIONS, 175 Northshore Place, Gulf Shores AL 36542. (334)968-4600. Fax: (334)968-5938. E-mail: awboone@compasspoints.com. Website: http://www.compasspoints.com. Editor: April W. Boone. Estab. 1988. Number of employees: 20. Approximate annual billing: $3 million. Integrated marketing communications agency and publisher. Specializes in tourism products and programs. Product specialties are business and consumer tourism. Current clients include Alabama Bureau of Tourism, Gulf Shores Golf Assoc. and Alabama Gulf Coast CVB. Client list available upon request. Professional affiliations: STS, Mobile 7th Dist. Ad Fed, MCAN and AHA.
Needs: Approached by 2-10 illustrators/year and 5-20 designers/year. Works with 2 illustrators and 4-6 designers/year. Prefers freelancers with experience in magazine work. Uses freelancers mainly for sales collateral, advertising collateral and illustration. 5% of work is with print ads. 100% of design demands knowledge of Adobe Photoshop 3.1 and QuarkXPress. Some illustration demands computer skills.
First Contact & Terms: Designers send query letter with photocopies, résumé and tearsheets. Illustrators send postcard sample of work. Samples are filed and are not returned. Reports back within 1 month. Art director will contact artist for portfolio review of slides and tearsheets if interested. Pays by the project, $100 minimum. Rights purchased vary according to project. Finds artists through sourcebooks, networking and print.

Tips: "Be fast and flexible. Have magazine experience."

A. TOMLINSON ADVERTISING, INC., 201 N. Pine St., Suite 108, Florence AL 35630. (205)766-4222. Fax: (205)766-4106. E-mail: allent2476@aol.com. President: Allen Tomlinson. Estab. 1990. Number of employees: 5. Approximate annual billing: $1.2 million. Ad agency. Specializes in magazine, collateral, catalog—business to business. Product specialties are home building products. Client list available upon request.
Needs: Approached by 20 illustrators and 20 designers/year. Works with 4 illustrators and 4 designers/year. Also for airbrushing, billboards, brochure and catalog design and illustration, logos and retouching. 35% of work is with print ads. 85% of design demands skills in Aldus PageMaker 5.0, Adobe Photoshop, Adobe Illustrator and QuarkXPress 3.2. 85% of illustration demands skills in Aldus PageMaker 5.0, Adobe Photoshop, Adobe Illustrator and QuarkXPress 3.2.
First Contact & Terms: Designers send query letter with brochure and photocopies. Illustrators send send query letter with brochure, photocopies, résumé and transparencies. Samples are filed and are not returned. Does not report back; artist should call. Artist should also call to arrange for portfolio review of color photographs, slides, thumbnails and transparencies. Pays by the project. Rights purchased vary according to project.

Arizona

FILMS FOR CHRIST, 1044 N. Gilbert Rd., Gilbert AZ 85234. E-mail: mail@eden.org. Website: http://www.Christian Answers.net/eden. Contact: Paul S. Taylor. Number of employees: 10. Motion picture producer and book publisher. Audience: educational, religious and secular. Produces and distributes motion pictures, videos and books.
● Design and computer work are done inhouse. Will work with out-of-town illustrators.
Needs: Works with 1-5 freelance illustrators/year. Works on assignment only. Uses illustrators for books, catalogs and motion pictures. Also for storyboards, animation, cartoons, slide illustration and ads.
First Contact & Terms: Send query letter with résumé, photocopies, slides, tearsheets or snapshots. Samples are filed or are returned by SASE. Reports in 1 month. All assignments are on a work-for-hire basis. Originals are not returned. Considers complexity of project and skill and experience of artist when establishing payment.

✔**GODAT/JONCZYK INC.**, 101 W. Simpson St., Tucson AZ 85701-2268. (520)620-6337. E-mail: ken@gojodesign. com. Partners: Ken Godat and Jeff Jonczyk. Estab. 1983. Number of employees: 6. Specializes in corporate identity, annual reports, marketing communications, publication design and signage. Clients: corporate, retail, institutional, public service. Current clients include Weiser Lock, Rain Bird, IBM and University of Arizona. Professional affiliations: AIGA, ACD.
Needs: Approached by 75 freelancers/year. Works with 0-3 freelance illustrators and 2-3 designers/year. Freelancers should be familiar with Aldus PageMaker, Aldus FreeHand, Adobe Photoshop or Adobe Illustrator. Needs technical illustration.
First Contact & Terms: Send query letter with samples. Samples are filed. Request portfolio review in original query. Will contact artist for portfolio review if interested. Pays for design by the hour, $15-40 or by the project. Pays for illustration by the project. Finds artists through sourcebooks.

‡**PAUL S. KARR PRODUCTIONS**, 2925 W. Indian School Rd., Box 11711, Phoenix AZ 85017. Phone/fax: (602)266-4198. Contact: Paul or Kelly Karr. Utah Division: 1024 N. 300 East, Box 1254, Orem UT 84057. Phone/fax: (801)226-3001. Contact: Michael Karr. Film and video producer. Clients: industry, business, education, TV, cable and feature films.
Needs: Occasionally works with freelance filmmakers in motion picture and video projects. Works on assignment only.
First Contact & Terms: Advise of experience, abilities, and funding for project.
Tips: "If you know about motion pictures and video or are serious about breaking into the field, there are three avenues: 1) have relatives in the business; 2) be at the right place at the right time; or 3) take upon yourself the marketing of your idea, or develop a film or video idea for a sponsor who will finance the project. Go to a film or video production company, such as ours, and tell them you have a client and the money. They will be delighted to work with you on making the production work, and approve the various phases as it is being made. Have your name listed as the producer on the credits. With the knowledge and track record you have gained you will be able to present yourself and your abilities to others in the film and video business and to sponsors."

‡**THE M. GROUP GRAPHIC DESIGN**, 2512 E. Thomas Rd., Suite #7, Phoenix AZ 85016. (602)957-7557. Fax: (602)957-7876. E-mail: mail@themgroupinc.com. Website: http://www.themgroupinc.com. President: Gary Miller. Estab. 1987. Number of employees: 7. Approximate annual billing: 1.75 million. Specializes in annual reports; corporate

✠ **MARKETS NEW TO THIS EDITION** are marked with a double dagger.

identity; direct mail and package design; and advertising. Clients: corporations and small business. Current clients include Arizona Public Service, Comtrade, Sager, Dole Foods, Giant Industries, Microchip, Coleman Spas, ProStar, Teksoft and CYMA.

Needs: Approached by 50 freelancers/year. Works with 5-10 freelance illustrators/year. Uses freelancers for ad, brochure, poster and P-O-P illustration. 95% of freelance work demands knowledge of Adobe Illustrator, Adobe Photoshop and QuarkXPress.

First Contact & Terms: Send postcard sample or query letter with samples. Samples are filed or returned by SASE if requested by artist. Reports back to the artist only if interested. Request portfolio review in original query. Artist should follow-up. Portfolio should include b&w and color final art, photographs and transparencies. Rights purchased vary according to project. Finds artists through publications (trade) and reps.

Tips: Impressed by "good work, persistence, professionalism."

✔**MILES ADVERTISING**, (formerly Miles & Associates Advertising), 3661 N. Campbell Ave., #276, Tucson AZ 85719. (520)795-2919. Contact: Bill Miles. Estab. 1973. Number of employees: 2. Approximate annual billing: $750,000. Ad agency. Full-service, multimedia firm. Specializes in local TV advertising, outdoor. Product specialty is automotive. Client list available upon request.

Needs: Approached by 30 freelancers/year. Works with 1 freelance illustrator and 3 designers/year. Prefers local freelancers only. Uses freelancers mainly for newspaper and outdoor design and layout, plus television graphics. Also for signage. 20% of work is with print ads. Needs computer-literate freelancers for design and production.

First Contact & Terms: Send query letter with photocopies. Samples are filed and are not returned. Will contact artist for portfolio review if interested. Portfolio should include b&w and color final art and roughs. Pays for design by the project, $40-2,500. Pays for illustration by the project. Buys all rights.

PAPAGALOS AND ASSOCIATES, 5333 N. Seventh St., Suite 222, Phoenix AZ 85014. (602)279 2933. Fax: (602)277-7448. E-mail: terence@papagalos.com. Website: http://www.papagalos.com. Creative Director: Nicholas Papagalos. Specializes in advertising, brochures, annual reports, corporate identity, displays, packaging, publications and signage. Clients: major regional, consumer and business-to-business.

Needs: Works with 10-20 freelance artists/year. Works on assignment only. Uses artists for illustration, retouching, airbrushing, AV materials, lettering, design and production. Needs computer-literate freelancers for design, illustration and production. 100% of freelance work demands knowledge of Adobe Illustrator, QuarkXPress or Photoshop. Needs editorial illustration.

First Contact & Terms: Send query letter with brochure or résumé and samples. Samples are filed or are returned only if requested. Call or write to schedule an appointment to show a portfolio, which should include thumbnails, roughs, final reproduction/product, photostats and photographs. Pays for design by the hour or by the project. Pays for illustration by the project. Considers complexity of project, client's budget, skill and experience of artist, how work will be used, turnaround time and rights purchased when establishing payment. Rights purchased vary according to project.

Tips: In presenting samples or portfolios, "two or three samples of the same type/style are enough."

✔**TIEKEN DESIGN & CREATIVE SERVICES**, 3838 N. Central Ave., Suite 100, Phoenix AZ 85012. (602)230-0060. Fax: (602)230-7574. E-mail: team@tiekendesign.com. Website: http://www.tiekendesign.com. General Manager: Gail Tieken. Estab. 1980. Specializes in annual reports, corporate identity, package and publication design, signage, multimedia, websites. Clients: corporations and associations. Client list not available.

Needs: Approached by 30-40 freelance artists/year. Works with 3-4 freelance illustrators and 1-2 freelance designers/year. Prefers artists with experience in Macintosh. Works on assignment only.

First Contact & Terms: Send query letter with résumé. Samples are filed. Reports back to the artist only if interested. To show a portfolio, mail thumbnails, roughs and tearsheets. Pay varies by project and artist. Buys all rights.

Tips: It is important for freelancers to have "a referral from an associate and a strong portfolio."

ZEROONE DESIGN, 17435 N. Seventh St. #C1091, Phoenix AZ 85022. E-mail: heldesign@aol.com. Contact: Mark Heideman. Estab. 1985. Specializes in display, direct mail, package and publication design, annual reports, brand and corporate identity, signage, technical illustration, vehicle graphics and web page design. Clients: technical and industrial.

Needs: Works with 2-3 freelance illustrators and 2-3 designers/year. Works on assignment only. Uses freelancers for marker comps, brochure, catalog, P-O-P, and poster illustration. 100% of design demands knowledge of Adobe Illustrator, Adobe Dimensions, QuarkXPress or Adobe Photoshop. Needs editorial illustration and photography.

First Contact & Terms: Send postcard sample or query letter with brochure, résumé, photocopies and tearsheets. Accepts disk submissions. Samples are filed. Will contact artist for portfolio review if interested. Portfolio should include thumbnails, roughs and tearsheets. Pays for design by the project, $100 minimum; pays for illustration by the project, $100-2,000. Considers client's budget, skill and experience of artist and turnaround time when establishing payment. Rights purchased vary according to project.

Arkansas

KIRKPATRICK, WILLIAMS, GURLEY ASSOCIATES, 111½ W. Walnut, Rogers AR 72756. (501)636-4037. Fax: (501)636-9457. Art Director: Laura Denson. Estab. 1960. Ad agency. Full-service, multimedia firm. Specializes in

packaging and print material. Clients include Southern Aluminum, Crane Vending Co., Jack Henry & Associates and town of Eureka Springs.

Needs: Approached by 2-3 freelancers/month. Works with 1-2 illustrators/month. Prefers artists with experience in toys, automotive, military and space products. Works on assignment only. Uses freelancers mainly for illustration for packaging. Also for brochure, catalog and print ad illustration and retouching and posters. Needs computer literate freelancers for design and production. 75% of freelance work demands knowledge of QuarkXPress, Aldus FreeHand, Adobe Illustrator and Photoshop. Needs technical illustration. 8-10% of work is with print ads.

First Contact & Terms: Send query letter with brochure, résumé, photographs and slides. Samples are filed or are returned by SASE only if requested by artist. Does not report back. Artist should "contact by letter." Call for appointment to show portfolio of "whatever best shows the artist's strengths." Pays for design by the hour, $50 maximum. Pays for illustration by the project, $250-3,000. Buys all rights.

✔**McCLANAHAN GRAPHICS, INC.**, 107 W. Main, MGI Bldg., Heber Springs AR 72543. (501)362-4038. Fax: (501)362-5547. E-mail: mgi@arkansas.net. President: K.L. McClanahan. Estab. 1978. Number of employees: 7. Approximate annual billing: $5 million. Ad agency and design firm. Specializes in industrial print advertising, trade ads, design, corporate logos, corporate videos, industrial campaigns, catalogs, retouching, brochures. Client list available upon request.

Needs: Approached by 6 illustrators and 5 designers/year. Works with 2 illustrators and 1 designer/year. Prefers freelancers with experience in illustration. Also for animation, humorous illustration, model making and storyboards. 90% of work is with print ads. 75% of design and illustration demands skills in Adobe Photoshop, Aldus FreeHand and QuarkXPress.

First Contact & Terms: Send postcard sample of work or query letter with brochure and résumé. Send follow-up postcard every 6 months. Accepts disk submissions. Samples are filed. Reports back only if interested. Art director will contact artist for portfolio review of color, final art, photographs, roughs and slides if interested. Payment negotiable. Rights purchased vary according to project. Finds artists through sourcebooks and reps.

Tips: "Perseverance. Diversification. Specialize in what you love to do."

California

THE ADVERTISING CONSORTIUM, 10536 Culver Blvd., Suite D, Culver City CA 90232. (310)287-2222. Fax: (310)287-2227. E-mail: theadco97@earthlink.net. Contact: Kim Miyade. Estab. 1985. Ad agency. Full-service, multimedia firm. Specializes in print, collateral, direct mail, outdoor, broadcast. Current clients include Bernini, American Tower Systems, Davante, Maison D'Optique.

Needs: Approached by 5 freelance artists/month. Works with 1 illustrator and 3 art directors/month. Prefers local artists only. Works on assignment only. Uses freelance artists and art directors for everything (none on staff), including brochure, catalog and print ad design and illustration and mechanicals and logos. 80% of work is with print ads. Also for multimedia projects. 100% of freelance work demands knowledge of Aldus PageMaker, QuarkXPress, Aldus FreeHand, Adobe Illustrator and Adobe Photoshop.

First Contact & Terms: Send postcard sample or query letter with brochure, tearsheets, photocopies, photographs and anything that does not have to be returned. Samples are filed. Write for appointment to show portfolio. "No phone calls, please." Portfolio should include original/final art, b&w and color photostats, tearsheets, photographs, slides and transparencies. Pays for design by the hour, $60-75. Pays for illustration by the project, based on budget and scope.

Tips: Looks for "exceptional style."

ADVERTISING DESIGNERS, INC., 7087 Snyder Ridge Rd., Mariposa CA 95338-9642. (209)742-6704. Fax: (209)742-6314. E-mail: ad@yosemite.net. President: Tom Ohmer. Estab. 1947. Number of employees: 2. Specializes in annual reports, corporate identity, ad campaigns, package and publication design and signage. Clients: corporations. Professional affiliations: LAADC.

Needs: Approached by 50 freelancers/year. Works with 2 freelance illustrators and 2 designers/year. Works on assignment only. Uses freelancers mainly for editorial and annual reports. Also for brochure design and illustration, mechanicals, retouching, lettering, logos and ad design. Needs computer-literate freelancers for design and illustration. 100% of design and 70% of illustration demand skills in PageMaker, Quark XPress, FreeHand, Illustrator and Photoshop.

First Contact & Terms: Send query letter with postcard sample. Samples are filed. Does not report back. Artist should call. Write for appointment to show portfolio. Pays for design by the hour, $35 minimum or by the project, $500-7,500. Pays for illustration by the project, $500-5,000. Rights purchased vary according to project.

‡**ASAP ADVERTISING**, P.O. Box 250, Porterville CA 93258-0250. (209)783-2727. Fax: (209)781-0712. Owner: Brian Dillon. Estab. 1982. Specializes in copywriting and production of print advertising for business-to-business and retail accounts.

Needs: All design and production is currently handled inhouse. Not seeking new outside sources, or full- or part-time or freelance help. Works on assignment only.

BASIC/BEDELL ADVERTISING & PUBLISHING, 600 Ward Dr., Suite H, Box 30571, Santa Barbara CA 93130. President: C. Barrie Bedell. Specializes in advertisements, direct mail and how-to books and manuals. Clients: national

and international newspapers, publishers, direct response marketers, retail stores, hard lines manufacturers, software developers, trade associations, plus extensive self-promotion of proprietary advertising how-to manuals.

• This company's president is seeing "a glut of 'graphic designers,' and an acute shortage of 'direct response' designers."

Needs: Uses artists for publication and direct mail design, book covers and dust jackets and camera-ready computer desktop production. Also interested in hearing from professionals experienced in web page design and in converting printed training materials to electronic media.

First Contact & Terms: Especially wants to hear from publishing and "direct response" pros. Portfolio review not required. Pays for design by the project, $100-2,500 and up; pays for illustration by the project, $100 minimum. Considers client's budget, and skill and experience of artist when establishing payment.

Tips: "There has been a substantial increase in use of freelance talent and increasing need for true professionals with exceptional skills and responsible performance (delivery as promised and 'on target'). It is very difficult to locate freelance talent with expertise in design of advertising and direct mail with heavy use of type. If work is truly professional and freelancer is business-like, contact with personal letter and photocopy of one or more samples of work that needn't be returned."

‡THE BASS GROUP, Dept. AM, 102 Willow Ave., Fairfax CA 94930. (415)455-8090. Producer: Herbert Bass. Number of employees: 2. Approximate annual billing: $300,000. "A multimedia, full-service production company providing corporate communications to a wide range of clients. Specializes in multimedia presentations, video/film, and events productions for corporations."

Needs: Approached by 30 freelancers/year. Works with a variety of freelance illustrators and designers/year. Prefers solid experience in multimedia and film/video production. Works on assignment only. Uses freelancers for logos, charts/graphs and multimedia designs. Needs graphics, meeting theme logos, electronic speaker support and slide design. Needs computer-literate freelancers for design, illustration and production. 90% of freelance work demands knowledge of QuarkXPress, Aldus FreeHand, Adobe Illustrator and Photoshop. Prefers loose or impressionistic style.

First Contact & Terms: Send résumé and slides. Samples are filed and are not returned. Reports back within 1 month if interested. Will contact artist for portfolio review if interested. Sometimes requests work on spec before assigning a job. Pays by the project. Considers turnaround time, skill and experience of artist and how work will be used when establishing payment. Rights purchased vary according to project.

Tips: Finds illustrators and designers mainly through word-of-mouth recommendations. "Send résumé, samples, rates. Highlight examples in speaker support—both slide and electronic media—and include meeting logo design."

✔BERSON, DEAN, STEVENS, 210 High Meadow St., Wood Ranch CA 93065. (818)713-0134. Fax: (818)713-0417. Owner: Lori Berson. Estab. 1981. Specializes in annual reports, brand and corporate identity and display, direct mail, package and publication design. Clients: manufacturers, ad agencies, corporations and movie studios. Professional affiliation: L.A. Ad Club.

Needs: Approached by 50 freelancers/year. Works with 10-20 illustrators and 5 designers/year. Works on assignment only. Uses illustrators mainly for brochures, packaging and comps. Also for catalog, P-O-P, ad and poster illustration; mechanicals retouching; airbrushing; lettering; logos; and model making. 90% of freelance work demands knowledge of Aldus PageMaker, Adobe Illustrator, QuarkXPress, Adobe Photoshop and Aldus FreeHand.

First Contact & Terms: Send query letter with tearsheets and photocopies. Samples are filed. Will contact artist for portfolio review if interested. Pays for design and illustration by the project. Rights purchased vary according to project. Considers buying second rights (reprint rights) to previously published work. Finds artists through word of mouth, submissions/self-promotions, sourcebooks and agents.

BRAINWORKS DESIGN GROUP, INC., 2 Harris Court, #A7, Monterey CA 93940. (408)657-0650. Fax: (408)657-0750. E-mail: brainwks@mbay.net. Website: http://www.brainwks.com. Art Director: Al Kahn. Vice President Marketing: Michele Strub. Estab. 1970. Number of employees: 6. Specializes in ERC (Emotional Response Communications), graphic design, corporate identity, direct mail and publication. Clients: colleges, universities, nonprofit organizations; majority are colleges and universities. Current clients include Marymount College, Union University, Notre Dame College and Xavier University, Cal State University. Client list available upon request.

Needs: Approached by 100 freelancers/year. Works with 4 freelance illustrators and 10 designers/year. Prefers freelancers with experience in type, layout, grids, mechanicals, comps and creative visual thinking. Works on assignment only. Uses freelancers mainly for mechanicals and calligraphy. Also for brochure, direct mail and poster design; mechanicals; lettering; and logos. 100% of design work demands knowledge of Aldus PageMaker, QuarkXPress, Aldus FreeHand and Adobe Photoshop.

First Contact & Terms: Send brochure or résumé, photocopies, photographs, tearsheets and transparencies. Samples are filed. Artist should follow up with call and/or letter after initial query. Will contact artist for portfolio review if

 A CHECKMARK PRECEDING A LISTING indicates a change in either the address or contact information since the 1998 edition.

interested. Portfolio should include thumbnails, roughs, final reproduction/product and b&w and color tearsheets, photostats, photographs and transparencies. Pays for design by the project, $200-2,000. Considers complexity of project and client's budget when establishing payment. Rights purchased vary according to project. Finds artists through sourcebooks and self-promotions.

Tips: "Creative thinking and a positive attitude are a plus." The most common mistake freelancers make in presenting samples or portfolios is that the "work does not match up to the samples they show." Would like to see more roughs and thumbnails.

CLIFF AND ASSOCIATES, 715 Fremont Ave., South Pasadena CA 91030. (818)799-5906. Fax: (818)799-9809. Owner: Greg Cliff. Estab. 1984. Number of employees: 10. Approximate annual billing: $1 million. Specializes in annual reports, corporate identity, direct mail and publication design and signage. Clients: Fortune 500 corporations and performing arts companies. Current clients include Arco, Nissan, Southern California Gas Co. and Kaiser Permanente.

Needs: Approached by 50 freelancers/year. Works with 10 freelance illustrators and 10 designers/year. Prefers local freelancers and Art Center graduates. Uses freelancers mainly for brochures. Also for technical, "fresh" editorial and medical illustration; mechanicals; lettering; logos; catalog, book and magazine design; P-O-P and poster design and illustration; and model making. Needs computer-literate freelancers for design and production. 90% of freelance work demands knowledge of QuarkXPress, Aldus FreeHand or Adobe Illustrator.

First Contact & Terms: Send query letter with résumé and sample of work. Samples are filed. Art director will contact artist for portfolio review if interested. Portfolio should include thumbnails, b&w photostats and printed samples. Pays for design by the hour, $22-30. Pays for illustration by the project, $50-3,000. Buys one-time rights. Finds artists through sourcebooks.

CREATIVE CONNECTIONS, 423 S. Pacific Coast Hwy., Suite 205, Redondo Beach CA 90277. (310)543-4480 or (800)600-1167. Fax: (310)540-5281. President: Cathleen Cunningham. Estab. 1996. Number of employees: 4. Employment service specializing in creative personnel. Specializes in collateral and advertising. Product specialty is consumer. Client list available upon request. Professional affiliations AMA, Ad Club-L.A.

Needs: Approached by 50 illustrators/year and 200 designers/year. Works with 100 freelance illustrators and 300 designers/year. Prefers local freelancers. Also for airbrushing; animation; annual reports; billboards; brochure, catalog and web page design; brochure, catalog, humorous, medical, technical illustration; lettering; logos; mechanical; model making; multimedia projects; posters; retouching; storyboards; TV/film graphics. 50% of work is with print ads. 95% of freelance design demands skills in Aldus FreeHand, Adobe Photoshop, QuarkXpress, Adobe Illustrator, CorelDraw. 10% of freelance illustration demands skills in Adobe Illustrator.

First Contact & Terms: Send query letter with photocopies and résumé. Accepts disk submissions compatible with Adobe Photoshop, QuarkXPress 3.3. Send EPS files. Samples are filed. Portfolio review required. To arrange portfolio review of final art, roughs, tearsheets and thumbnails, follow up with letter. Pays for design by the hour, $15-50. Pays for illustration by the hour, $30-60. Rights purchased vary according to project. Finds artists through classified ads, word of mouth.

Tips: Considers "presentation of book, attitude, availability, client list and rate."

DENTON DESIGN ASSOCIATES, 491 Arbor St., Pasadena CA 91105. (818)792-7141. President: Margi Denton. Estab. 1975. Specializes in annual reports, corporate identity and publication design. Clients: nonprofit organizations and corporations. Current clients include California Institute of Technology, Huntington Memorial Hospital and University of Southern California.

Needs: Approached by 12 freelance graphic artists/year. Works with 4 freelance illustrators and 3 freelance designers/year. Prefers local designers only. "We work with illustrators from anywhere." Works on assignment only. Uses designers and illustrators for brochure design and illustration, lettering, logos and charts/graphs. 100% of design work demands knowledge of QuarkXPress, Adobe Photoshop and Adobe Illustrator.

First Contact & Terms: Send résumé, tearsheets and samples (illustrators just send samples). Samples are filed and are not returned. Reports back to the artist only if interested. Art director will contact artist for portfolio review if interested. Portfolio should include color samples "doesn't matter what form." Pays for design by the hour, $20-25. Pays for illustration by the project, $250-6,500. Rights purchased vary according to project. Finds artists through sourcebooks, AIGA, *Print* and *CA*.

DESIGN AXIOM, 50 B, Peninsula Center Dr., 156, Rolling Hills Estates CA 90274. (310)377-0207. E-mail: tschorer @aol.com. President: Thomas Schorer. Estab. 1973. Specializes in graphic, environmental and architectural design; product development; and signage.

Needs: Approached by 100 freelancers/year. Works with 5 freelance illustrators and 10 designers/year. Works on assignment only. Uses designers for all types of design. Uses illustrators for editorial and technical illustration. 50% of freelance work demands knowledge of Aldus PageMaker or QuarkXPress.

First Contact & Terms: Send query letter with appropriate samples. Will contact artist for portfolio review if interested. Portfolio should include appropriate samples. Pays for design and illustration by the project. Finds artists through word of mouth, self-promotions, sourcebooks and colleges.

EVANS & PARTNERS INC., 55 E. G St., Encinitas CA 92024-3615. (619)944-9400. Fax: (619)944-9422. E-mail: evans-and-partners@worldnet.att.net. Website: http://www.evans-and-partners.com. President/Creative Director: David

Evans. Estab. 1988. Number of employees: 7. Approximate annual billing: $1.5 million. Ad agency. Full-service, multimedia firm. Specializes in marketing communications from strategies and planning through implementation in any media. Product specialties are marketing and graphics design for high-tech, high-tech medical, manufacturing. Current clients include Novus Technologies, Orincon, various credit unions, Argo Scientific, Baxter Healthcare, U.S. Filter Corporation.

● Very interested in CD-ROM combination photography illustration—typographic work.

Needs: Approached by 24-36 freelancers/year. Works with 5-7 freelance illustrators and 4-6 designers/year. Works only with artist reps/illustrators. Prefers local freelancers with experience in listening, concepts, print and collateral. Uses freelancers mainly for comps, design and production (brochure and print ad design and illustration, storyboards, mechanicals, retouching, billboards, posters, TV/film graphics, lettering and logos). Needs editorial, technical and medical illustration. 40% of work is with print ads. 90% of freelance work demands knowledge of Adobe Illustrator, Adobe Photoshop, QuarkXPress or CorelDraw.

First Contact & Terms: Send query letter with brochure, photocopies, résumé, photographs and SASE. "Send samples that have an appreciation for dynamic design but are still reader friendly." Samples are filed. Reports back to the artist only if interested. Will contact artist for portfolio review if interested. Portfolio should include roughs, photostats, tearsheets, transparencies and actual produced pieces. Very rarely may request work on spec. Pays for design by the project, $100-24,000 or by the hour, $90 maximum. Pays for illustration by the project, $100-18,000. Rights purchased vary according to project. Finds artists through word of mouth, magazines, submissions, sourcebooks and agents.

Tips: Looks for "flexible, service-oriented freelancers."

‡EVENSON DESIGN GROUP, 4445 Overland Ave., Culver City CA 90230. (310)204-1995. Fax: (310)204-4879. E-mail: evensoninc@aol.com. Website: http://evensondesign.com. Production Manager: Elisabeth Sanderson. Estab. 1976. Specializes in annual reports, brand and corporate identity, display design, direct mail, package design and signage. Clients: ad agencies, hospitals, corporations, law firms, entertainment companies, record companies, publications, PR firms. Current clients include Warner Bros., The Disney Channel, Mattel Toys, Twentieth Century Fox, MCA/Universal, Price Waterhouse and DayRunner.

Needs: Approached by 75-100 freelance artists/year. Works with 10 illustrators and 15 designers/year. Prefers artists with production experience as well as strong design capabilities. Works on assignment only. Uses illustrators mainly for covers for corporate brochures. Uses designers mainly for logo design, page layouts, all overflow work. Also for brochure, catalog, direct mail, ad, P-O-P and poster design and illustration; mechanicals; lettering; logos; and charts/graphs. 100% of design work demands knowledge of QuarkXPress, Aldus FreeHand, Adobe Photoshop or Adobe Illustrator.

First Contact & Terms: Send query letter with résumé. Also has drop-off policy. Samples are filed. Returned by SASE if requested. Reports back to the artist only if interested. Portfolio should include b&w and color photostats and tearsheets and 4×5 or larger transparencies. All work must be printed or fabricated in form of tearsheets, transparencies or actual piece. Pays for design by the hour, $20-35. Rights purchased vary according to project.

Tips: "Be efficient in the execution of design work, producing quality designs over the quantity of designs. Professionalism, as well as a good sense of humor, will prove you to be a favorable addition to any design team."

‡FREEASSOCIATES, 3728 Hayvenhurst Ave., Encino CA 91436-3844. (818)784-2380. Fax: (818)784-0452. E-mail: freeassocs@aol.com. President: Josh Freeman. Estab. 1974. Number of employees: 4. Design firm. Specializes in marketing materials for corporate clients. Client list available upon request. Professional affiliations: AIGA.

Needs: Approached by 50 illustrators and 20 designers/year. Works with 15 illustrators and 5 designers/year. Prefers freelancers with experience in top level design and advertising. Uses freelancers mainly for design, production, illustration. Also for airbrushing, brochure design and illustration, catalog design and illustration, humorous illustration, lettering, logos, mechanicals, multimedia projects, posters, retouching, signage, storyboards, technical illustration and web page design. 10% of work is with print ads. 90% of design and 50% of illustration demand skills in Aldus PageMaker, Adobe Photoshop, QuarkXPress, Adobe Illustrator.

First Contact & Terms: Designers send query letter with photocopies, photographs, résumé, tearsheets and transparencies. Illustrators send postcard sample of work and/or photographs and tearsheets. Accepts Mac compatible disk submissions to view in current version of major software or self-running presentations. CD-ROM OK. Samples are filed or returned by SASE. Will contact for portfolio review if interested. Pays for design and illustration by the project; negotiable. Rights purchased vary according to project. Finds artists through *LA Workbook*, *CA*, *Print*. *Graphis*, submissions and samples.

Tips: Designers should have their own computer modem. Must have sensitivity to marketing requirements of projects they work on. Deadline commitments are critical.

DENNIS GILLASPY DESIGN/BRANDON TAYLOR DESIGN, 6305 Lusk Blvd., Suite 100, San Diego CA 92121-2752. (619)623-9084. Fax: (619)452-6970. Owner: Dennis Gillaspy. Estab. 1977. Specializes in corporate identity, displays, direct mail, package and publication design and signage. Clients: corporations and manufacturers. Client list available upon request.

Needs: Approached by 20 freelance artists/year. Works with 15 freelance illustrators and 10 freelance designers/year. Prefers local artists. Works on assignment only. Uses freelance illustrators mainly for technical and instructional spots. Uses freelance designers mainly for logo design, books and ad layouts. Also uses freelance artists for brochure, catalog, ad, P-O-P and poster design and illustration, retouching, airbrushing, logos, direct mail design and charts/graphs.

First Contact & Terms: Send query letter with brochure, résumé, photocopies and photostats. Samples are filed. Reports back within 2 weeks. Write to schedule an appointment to show a portfolio or mail thumbnails, roughs, photostats, tearsheets, comps and printed samples. Pays for design by the assignment. Pays for illustration by the project, $400-1,500. Rights purchased vary according to project.

GRAFF ADVERTISING INC., 200 Twin Dolphin Dr. #F, Redwood City CA 94065-1402. (415)637-8200. Fax: (415)637-8311. E-mail: graffad@graffad.com. Website: http://www.graffad.com. Creative Director: Steve Graff. Ad agency. Full-service, multimedia firm. Product specialties are science and medicine, industrial. Current clients include Fuji Medical, Skyway Inc., California Emergency Physicians, Med America, Panasonic Interactive Media, Diasonics and J.H. Baxter. Client list available upon request.
Needs: Approached by 6-10 freelance artists/month. Works with 1-2 freelance illustrators and 2-3 freelance designers/ month. Prefers local artists proficient in electronic production. Works on assignment only. Uses freelance artists mainly for concept through final. Also uses freelance artists for brochure, catalog and print ad design and illustration and storyboards, mechanicals, retouching, model making, billboards, posters, TV/film graphics and logos. 50% of work is with print ads. Needs computer-literate freelancers for design, illustration and production. 90% of freelance work demands knowledge of Adobe Illustrator, QuarkXPress, Adobe Photoshop and/or Aldus FreeHand.
First Contact & Terms: Send query letter with résumé and examples of work. Samples are filed or returned by SASE if requested. Does not report back. Artist should follow-up with call. Portfolio should include thumbnails, roughs and final art. Pays for design and illustration by the project. Rights purchased vary according to project.

GRAFICA DESIGN SERVICE, 7053 Owensmouth Ave., Canoga Park CA 91303. (818)712-0071. Fax: (818)348-7582. E-mail: graficaeps@aol.com. Website: http://www.grafica.com. Designer: Larry Girardi. Estab. 1974. Specializes in corporate identity, package and publication design, signage and technical illustration. Clients: ad agencies, corporations, government and medium-size businesses; majority are high-tech.
Needs: Approached by 25-50 freelance artists/year. Works with 5-10 freelance illustrators and designers/year. Prefers local artists and artists with experience in airbrush and Macintosh computer graphics. Works on assignment only. Uses illustrators mainly for technical, medical and airbrush illustration. Uses designers mainly for design-layout/thumbnails and comps. Also uses artists for brochure design and illustration, catalog design and illustration, mechanicals, retouching, airbrushing, lettering, logos, ad design and illustration, P-O-P illustration, charts/graphs and production. Needs computer-literate freelancers for illustration and production. 90% of freelance work demands computer literacy in QuarkXPress or Adobe Illustrator.
First Contact & Terms: Send query letter with brochure, résumé, SASE, tearsheets, photographs, photocopies, photostats and slides. Samples are filed or are returned by SASE if requested. Reports back only if interested. To show a portfolio, mail thumbnails, roughs, b&w and color photostats, tearsheets, photographs, slides and transparencies. Pays for design by the hour, $10-35; or by the project, $75-5,000. Pays for illustration by the hour, $10-35; or by the project, $50-5,000. "Payment is based on complexity of project, budget and the experience of the artist. Rights purchased vary according to project.
Tips: " 'Doing is honest philosophy.' Get the projects and do as much work as you can. Experience is much more important than money. If your work is good, money will follow. Enjoy what you do and enjoy the people you work with. Too many creatives want to work in an ivory tower. Much like life, being able to adapt to change and transform challenges into success is what happy and fulfilling work is all about."

GRAPHIC DATA, 5111 Mission Blvd., P.O. Box 99991, San Diego CA 92169. Phone/fax: (619)274-4511 (call first before faxing). President: Carl Gerle. Estab. 1971. Number of employees: 3. Specializes in industrial design. Clients: industrial and publishing companies. Client list available upon request. Professional affiliations: IEEE, AGM, NCGA.
Needs: Works with 6 sculptors, 3 freelance illustrators and 3 designers/year. Needs sculptors and designers for miniature figurines. 60% of freelance work demands computer skills.
First Contact & Terms: Send query letter with brochure, résumé or photostats. Samples are returned if SASE included. Sometimes requests work on spec before assigning a job. Pays for design and sculpture by the project, $100-1,000 plus royalties. Rights purchased vary according to project.
Tips: "Know the fundamentals behind your craft. Be passionate about your work; care how it is used. Be professional and business-like."

THE HITCHINS COMPANY, 22756 Hartland St., Canoga Park CA 91307. (818)715-0150. E-mail: hitchins@soca.c om. President: W.E. Hitchins. Estab. 1985. Advertising agency. Full-service, multimedia firm.
Needs: Works with 1-2 illustrators and 3-4 designers/year. Works on assignment only. Uses freelance artists for brochure and print ad design and illustration, storyboards, mechanicals, retouching, TV/film graphics, lettering and logo. Needs editorial and technical illustration and animation. 60% of work is with print ads. 90% of design and 50% of illustration demand knowledge of Aldus PageMaker, Adobe Illustrator, QuarkXPress or Aldus FreeHand.
First Contact & Terms: Send postcard sample. Samples are filed if interested and are not returned. Reports back to the artist only if interested. Call for appointment to show portfolio. Portfolio should include tearsheets. Pays for design and illustration by the project, according to project and client. Rights purchased vary according to project.

‡RUSTY KAY & ASSOC. INC., 2665 Main St., #E, Santa Monica CA 90405. (310)392-4569. Fax: (310)399-3906. E-mail: rustkay@aol.com. Senior Designers: Susan Rogers and Dave Chapple. Estab. 1977. Specializes in annual reports,

brand and corporate identity, package and publication design and signage. Clients: corporations and private businesses. Current clients include Casablanca Fan Co., Lockheed, K&M Company, M.D. Buyline, Bon Lait. Client list available upon request.

Needs: Approached by 200-300 freelance artists/year. Works with 2-5 illustrators and 2-5 designers/year. Prefers artists with computer skills. Works on assignment only. Uses illustrators mainly for publications. Uses designers mainly for corporate identity, publications, packaging. Also for brochure design; brochure and catalog illustration; mechanicals; retouching; airbrushing; lettering; and charts/graphs. Needs computer-literate freelancers for design, illustration and production. 100% of freelance work demands knowledge of Aldus PageMaker, QuarkXPress, Aldus FreeHand, Adobe Illustrator and Photoshop.

First Contact & Terms: Send query letter with brochure, résumé and slides. Samples are filed or are returned by SASE. Reports back only if interested. Drop off policy for all portfolios. Portfolio should include photostats, slides and printed pieces. Pays for design by the hour, $30-75. Pays for illustration by the project, $500-2,000. Rights purchased vary according to project.

Tips: "Freelance must have a creative mind coupled with computer skills."

KVCR-TV RADIO, 701 S. Mount Vernon Ave., San Bernardino CA 92410. (909)888-6511 or 825-3103. General Manager: Lew Warren. Number of employees: 19. Specializes in public and educational radio/TV.

Needs: Approached by 1 freelancer/year. Assigns 1-10 jobs/year. Uses freelancers for graphic/set design and set design painting.

First Contact & Terms: Query and mail photos or slides. Reports in 2 weeks. Samples returned by SASE.

‡LEKASMILLER, 1460 Maria Lane, Suite 260, Walnut Creek CA 94596. (510)934-3971. Fax: (510)934-3978. Production Manager: Ali Gencarelle. Estab. 1979. Specializes in annual reports, corporate identity, advertising, direct mail and brochure design. Clients: corporate and retail. Current clients include CivicBank of Commerce, Tosco Refining Co., Voicepro and Chevron USA.

Needs: Approached by 80 freelance artists/year. Works with 1-3 illustrators and 5-7 designers/year. Prefers local artists only with experience in design and production. Works on assignment only. Uses artists for brochure design and illustration, mechanicals, direct mail design, logos, ad design and illustration. 100% of freelance work demands knowledge of Aldus PageMaker, QuarkXPress, Adobe Photoshop or Adobe Illustrator.

First Contact & Terms: Designers send résumé. Illustrators send postcard samples. Samples are filed or are returned if accompanied by SASE. Reports back only if interested. To show a portfolio, mail thumbnails, roughs, final reproduction/product, tearsheets and transparencies. Considers skill and experience of artist when establishing payment. Negotiates rights purchased.

LINEAR CYCLE PRODUCTIONS, P.O. Box 2608, San Fernando CA 91393-0608. Producer: Rich Brown. Production Manager: R. Borowy. Estab. 1980. Number of employees: 30. Approximate annual billing: $200,000. AV firm. Specializes in audiovisual sales and marketing programs and also in teleproduction for CATV. Current clients include Katz, Inc. and McDave and Associates.

Needs: Works with 7-10 freelance illustrators and 7-10 designers/year. Prefers freelancers with experience in teleproductions (broadcast/CATV/non-broadcast). Works on assignment only. Uses freelancers for storyboards, animation, TV/film graphics, editorial illustration, lettering and logos. 10% of work is with print ads. 25% of freelance work demands knowledge of Aldus FreeHand, Adobe Photoshop or Tobis IV.

First Contact & Terms: Send query letter with résumé, photocopies, photographs, slides, transparencies, video demo reel and SASE. Samples are filed or are returned by SASE if requested by artist. Reports back to the artist only if interested. To show portfolio, mail audio/videotapes, photographs and slides; include color and b&w samples. Pays for design and illustration by the project, $100 minimum. Considers skill and experience of artist, how work will be used and rights purchased when establishing payment. Negotiates rights purchased. Finds artists through reviewing portfolios and published material

Tips: "We see a lot of sloppy work and samples, portfolios in fields not requested or wanted, poor photos, photocopies, graphics, etc. Make sure your materials are presentable."

JACK LUCEY/ART & DESIGN, 84 Crestwood Dr., San Rafael CA 94901. (415)453-3172. Contact: Jack Lucey. Estab. 1960. Art agency. Specializes in annual reports, brand and corporate identity, publications, signage, technical illustration and illustrations/cover designs. Clients: businesses, ad agencies and book publishers. Current clients include U.S. Air Force, TWA Airlines, California Museum of Art & Industry, CNN News, NBC Television News, Lee Books, High Noon Books. Client list available upon request. Professional affiliations: Art Directors Club, Academy of Art Alumni.

Needs: Approached by 20 freelancers/year. Works with 1-2 freelance illustrators/year. Uses mostly local freelancers. Uses freelancers mainly for type and airbrush. Also for lettering for newspaper work.

First Contact & Terms: Query. Prefers photostats and published work as samples. Provide brochures, business card and résumé to be kept on file. Portfolio review not required. Originals are not returned to artist at job's completion. Requests work on spec before assigning a job. Pays for design by the project.

Tips: "Show variety in your work. Many samples I see are too specialized in one subject, one technique, one style (such as air brush only, pen & ink only, etc.). Subjects are often all similar too."

MARKETING BY DESIGN, 2012 19th St., Suite 200, Sacramento CA 95818. (916)441-3050. Creative Director: Joel Stinghen. Estab. 1977. Specializes in corporate identity and brochure design, publications, direct mail, trade show, signage, display and packaging. Client: associations and corporations. Client list not available.
Needs: Approached by 50 freelance artists/year. Works with 6-7 freelance illustrators and 1-3 freelance designers/year. Works on assignment only. Uses illustrators mainly for editorial. Also uses freelance artists for brochure and catalog design and illustration, mechanicals, retouching, lettering, ad design and charts/graphs.
First Contact & Terms: Send query letter with brochure, résumé, tearsheets. Samples are filed or are not returned. Does not report back. Artist should follow up with call. Call for appointment to show portfolio of roughs, b&w photostats, color tearsheets, transparencies and photographs. Pays for design by the hour, $10-30; by the project, $50-5,000. Pays for illustration by the project, $50-4,500. Rights purchased vary according to project. Finds designers through word of mouth; illustrators through sourcebooks.

SUDI MCCOLLUM DESIGN, 3244 Cornwall Dr., Glendale CA 91206. (818)243-1345. Fax: (818)243-1345. Contact: Sudi McCollum. Specializes in corporate identity, publication design and illustration. Majority of clients are small to mid-size businesses. "No specialty in any one industry." Clients: corporations and small businesses.
Needs: Approached by a few graphic designers/year. Works with a couple of freelance illustrators and a couple of freelance designers/year. Works on assignment only. Also uses designers for production.
First Contact & Terms: Send query letter with "whatever you have that's convenient." Samples are filed. Reports back only if interested.

‡MEDIA ENTERPRISES, 1644 S. Clementine St., Anaheim CA 92802. (714)778-5336. Fax: (714)778-6367. Creative Director: John Lemieux Rose. Estab. 1982. Number of employees: 8. Approximate annual billing: $2 million. Integrated marketing communications agency. Specializes in interactive multimedia, CD-ROMs, Internet, magazine publishing. Product specialty high tech. Client list available upon request. Professional affiliations: Orange County Multimedia Users Group (OCMUG), Software Council of Southern California, Association of Internet Professionals.
Needs: Approached by 30 freelance illustrators and 10 designers/year. Works with 8-10 freelance illustrators and 3 designers/year. Also for animation, humorous illustration, lettering, logos, mechanicals, multimedia projects. 30% of work is with print ads. 100% of freelance work demands skills in Aldus PageMaker, Adobe Photoshop, QuarkXPress, Adobe Illustrator, Director.
First Contact & Terms: Send postcard sample and/or query letter with photocopies, photographs or URL. Accepts disk submissions compatible with Mac or PC. Samples are filed. Will contact for portfolio review of color photographs, slides, tearsheets, transparencies and/or disk. Pays by project; negotiated. Buys all rights.

NEW & UNIQUE VIDEOS, 2336 Sumac Dr., San Diego CA 92105. (619)282-6126. Fax: (619)283-8264. E-mail: videos@concentric.net. Website: http://www.concentric.net/~videos. Estab. 1982. Number of employees: 4. AV firm. Full-service, multimedia firm. Specializes in corporate and industrial, special interest video titles—documentaries, how-to's etc. Current clients include Coleman Company, American Express, Fox's Real TV, The Coca-Cola Company. Client list available upon request.
Needs: Approached by dozens of freelancers/year. Works with 1-2 freelance illustrators/year. Prefers freelancers with experience in computer animation. Works on assignment only. Uses freelancers mainly for video animation. Also for video box covers, catalog and print ad design, posters and TV/film graphics. 10% of work is with print ads. 50% of freelance work demands compatability with Macintosh.
First Contact & Terms: Send query letter with brochure, résumé and SASE. Samples are filed or returned by SASE. Reports back in 1 month only if interested. Artist should follow up. Will contact artist for portfolio review if interested. Portfolio should include thumbnails, photographs and tearsheets. Pays for design and illustration by the project (negotiated). Buys one-time rights.

DEBORAH RODNEY CREATIVE SERVICES, 1635 16th St., Santa Monica CA 90404. (310)450-9650. Fax: (310)450-9793. E-mail: darbo4@aol.com. Owner: Deborah Rodney. Estab. 1975. Number of employees: 1. Specializes in advertising design and collateral. Clients: ad agencies and direct clients. Current clients include Vetinary Centers of America, California Casualty Insurance, Long Beach Memorial Medical Center.
Needs: Approached by 30 freelancers/year. Works with 6-10 freelance illustrators and 1-2 designers/year. Prefers local freelancers. Uses illustrators mainly for finished art and lettering. Uses designers mainly for logo design. Also uses freelancers for mechanicals, charts/graphs, ad design and illustration. Especially needs freelancers with Photoshop and digital imaging expertise. 100% of design demands knowledge of QuarkXPress, Adobe Illustrator 6.0 or Adobe Photoshop. Needs production help.
First Contact & Terms: Designers send postcard sample or query letter with brochure, tearsheets and photocopies. Illustrators send postcard samples and tearsheets. Request portfolio review in original query. Portfolio should include final reproduction/product and tearsheets or "whatever best shows work." Accepts disk submissions compatible with Adobe Illustrator 6.0. Send EPS files. Pays for design by the hour, $35-50; by the project; by the day, $100 minimum. Pays for illustration by the project, $200-500; varies. Negotiates rights purchased. Considers buying second rights (reprint rights) to previously published work. Finds artists through sourcebooks and referrals.
Tips: "I do more concept and design work inhouse and hire out production and comps because it is faster, cheaper that way. For illustrators, it helps to be in sourcebooks such as *Workbook*, *Black Book*, *Showcase*, etc." Advice to freelancers who want to get work in advertising/design: "Offer a free trial of your services or offer to intern at an ad agency or

design firm. Decide who you want to work for and design a campaign to get yourself hired."

RUBIN POSTAER & ASSOCIATES, Dept. AM, 1333 Second St., Santa Monica CA 90401. (310)917-2425. Manager, Art Services: Annie Ross. Ad agency. Serves clients in automobile and heavy equipment industries, savings and loans and cable television.
Needs: Works with about 24 freelance illustrators/year. Uses freelancers for all media.
First Contact & Terms: Contact manager of art services for appointment to show portfolio. Selection based on portfolio review. Negotiates payment.
Tips: Wants to see a variety of techniques.

‡EDGAR S. SPIZEL ADVERTISING INC., 2610 Torrey Pines Rd. C-31, La Jolla CA 92037. (415)474-5735. President: Edgar S. Spizel. AV producer. Clients: "Consumer-oriented from department stores to symphony orchestras, supermarkets, financial institutions, radio, TV stations, political organizations, hotels, real estate firms, developers and mass transit, such as BART." Works a great deal with major sports stars and TV personalities. Specializes in marketing to "over-50" age group.
Needs: Uses artists for posters, ad illustrations, brochures and mechanicals.
First Contact & Terms: Send query letter with tearsheets. Provide material to be kept on file for future assignments. No originals returned at job's completion.

JULIA TAM DESIGN, 2216 Via La Brea, Palos Verdes CA 90274. (310)378-7583. Fax: (310)378-4589. E-mail: taandm888@earthlink.net. Contact: Julia Tam. Estab. 1986. Specializes in annual reports, corporate identity, brochures, promotional material, packaging and design. Clients: corporations. Current clients include Southern California Gas Co., *Los Angeles Times*, UCLA. Client list available upon request. Professional affiliations: AIGA.
 • Julia Tam Design won several awards including an American Graphic Design Award, an award of distinction from *Creativity 26*, and inclusion in *American Corporate Identity/12* and *Best of Business Card Design 2*.
Needs: Approached by 10 freelancers/year. Works with 6-12 freelance illustrators 2 designers/year. "We look for special styles." Works on assignment only. Uses illustrators mainly for brochures. Also uses freelancers for brochure design and illustration; catalog and ad illustration; retouching; and lettering. 50-100% of freelance work demands knowledge of QuarkXPress, Adobe Illustrator or Adobe Photoshop.
First Contact & Terms: Designers send query letter with brochure and résumé. Illustrators send query letter with résumé and tearsheets. Samples are filed. Reports back to the artist only if interested. Artist should follow up. Portfolio should include b&w and color final art, tearsheets and transparencies. Pays for design by the hour, $10-20. Pays for illustration by the project. Negotiates rights purchased. Finds artists through *LA Workbook*.

THARP DID IT, 50 University Ave., Suite 21, Los Gatos CA 95030. (Also an office in Portland OR—Tharp and Drummond Did It). Art Director/Designer: Rick Tharp. Estab. 1975. Specializes in brand identity; corporate, noncorporate, and retail visual identity; packaging; and environmental graphic design. Clients: direct and through agencies. Current clients include BRIO Scanditoy (Sweden), Iván Támas Winery, Harmony Foods, Mirassou Vineyards, LeBoulanger Bakeries, Santa Clara Valley Transportation Authority and Time-Warner. Professional affiliations: American Institute of Graphic Arts (AIGA), Society for Environmental Graphic Design (SEGD), Western Art Directors Club (WADC).
 • Tharp Did It won a gold medal in the International Packaging Competition at the 30th Vinitaly in Verona, Italy, for a wine label design. The label also won a Gold Medal in the San Francisco Fair's International Wine Label Competition, a Silver Medal in the Fifth Annual International Brand Packaging Awards, and an award of excellence in the American Graphic Design Awards in New York.
Needs: Approached by 250-350 freelancers/year. Works with 5-10 freelance illustrators and 2 designers/year. Needs advertising/product, food and people illustration. Prefers local designers with experience. Works on assignment only. 50% of freelance design work demands computer skills.
First Contact & Terms: Send query letter with printed promotional material. Samples are filed or are returned by SASE. Will contact artist for portfolio review if interested. "No phone calls please. We'll call you." Pays for design by the project. Pays for illustration by the project, $100-10,000. Considers client's budget and how work will be used when establishing payment. Rights purchased vary according to project. Finds artists through awards annuals, sourcebooks, and submissions/self-promotions.
Tips: Rick Tharp predicts "corporate globalization will turn all flavors of design into vanilla, but globalization is inevitable. Today, whether you go to Mall of America in Minnesota or to the Gamla Stan (Old Town) in Stockholm, you find the same stores with the same interiors and the same products in the same packages. The cultural differences are fading quickly. Environmental and communication graphics are losing their individuality. Eventually we'll have to go to Mars to find anything unique or stimulating. But, as long as the dictum of business is 'grow, grow, grow' there will always be a place for the designer."

TRIBOTTI DESIGNS, 22907 Bluebird Dr., Calabasas CA 91302-1832. (818)591-7720. Fax: (818)591-7910. E-mail: bob4149@aol.com. Contact: Robert Tribotti. Estab. 1970. Number of employees: 2. Approximate annual billing: $200,000. Specializes in graphic design, annual reports, corporate identity, packaging, publications and signage. Clients: PR firms, ad agencies, educational institutions and corporations. Current clients include Southwestern University, Northrup Grumman and city of Calabasas.

Needs: Approached by 8-10 freelancers/year. Works with 2-3 freelance illustrators and 1-2 designers/year. Prefers local freelancers only. Works on assignment only. Uses freelancers mainly for brochure illustration. Also for catalogs, charts/graphs, lettering and ads. Prefers marker, pen & ink and computer illustration. 75% of freelance design and 50% of illustration demand knowledge of Adobe PageMaker, Adobe Illustrator, QuarkXPress, Adobe Photoshop, FreeHand. Needs editorial and technical illustration and illustration for annual reports/brochures.
First Contact & Terms: Send postcard sample or query letter with brochure, photocopies and résumé. Accepts submissions on disk compatible with PageMaker 6.0, Adobe Illustrator or Adobe Photoshop. Send EPS files. Will contact artist for portfolio review if interested. Portfolio should include thumbnails, roughs, original/final art, final reproduction/product and b&w and color tearsheets, photostats and photographs. Pays for design by the hour, $35-85. Pays for illustration by the project, $100-1,000. Rights purchased vary according to project. Finds artists through word of mouth and self-promotion mailings.
Tips: "We will consider experienced artists only. Must be able to meet deadline. Send printed samples. We look for talent and a willingness to do a very good job."

‡**VIRTUAL VINEYARDS**, 3803 E. Bayshore, Palo Alto CA 94303. (800)289-1275. Director of Marketing: Cyndy Ainsworth. Estab. 1994. Number of employees: 20.
Needs: Works with 2 freelance illustrators and 2 designers/year for brochure, catalog and webpage design; brochure and catalog illustration, logos, mechanicals. 100% of freelance design and 60-100% of illustration demand skills in Adobe Photoshop, Adobe Illustrator.
First Contact & Terms: Send query letter with brochure, photocopies, photographs and résumé. Accepts disk submissions compatible with Adobe Photoshop or Illustrator. Samples are not filed. Samples are returned if requested. Follow-up with call and/or letter. Will contact for portfolio review if interested. Pays by the project. Rights purchsed vary according to project.
Tips: Establish your own website.

VISUAL AID/VISAID MARKETING, Box 4502, Inglewood CA 90309. (310)399-0696. Manager: Lee Clapp. Estab. 1961. Number of employees: 3. Distributor of promotion aids, marketing consultant service, "involved in all phases." Specializes in manufacturers, distributors, publishers and graphics firms (printing and promotion) in 23 SIC code areas.
Needs: Approached by 25-50 freelancers/year. Works with 1-2 freelance illustrators and 6-12 designers/year. Uses freelancers for advertising, brochure and catalog design, illustration and layout; product design; illustration on product; P-O-P display; display fixture design; and posters. Buys some cartoons and humorous cartoon-style illustrations. Additional media: fiber optics, display/signage, design/fabrication.
First Contact & Terms: Works on assignment only. Send postcard sample or query letter with brochure, photostats, duplicate photographs, photocopies and tearsheets to be kept on file. Reports back if interested and has assignment. Write for appointment to show portfolio. Pays for design by the hour, $5-75. Pays for illustration by the project, $100-500. Considers skill and experience of artist and turnaround time when establishing payment.
Tips: "Do not say 'I can do anything.' We want to know the best media you work in (pen & ink, line drawing, illustration, layout, etc.)."

DANA WHITE PRODUCTIONS, INC., 2623 29th St., Santa Monica CA 90405. (310)450-9101. E-mail: dwprods @aol.com. Owner/Producer: Dana C. White. AV firm. "We are a full-service audiovisual production company, providing multi-image and slide-tape, video and audio presentations for training, marketing, awards, historical and public relations uses. We have complete inhouse production resources, including computer multimedia, photo digitizing, image manipulation, program assembly, slidemaking, soundtrack production, photography, and AV multi-image programming. We serve major industries, such as GTE, Occidental Petroleum; medical, such as Whittier Hospital, Florida Hospital; schools, such as University of Southern California, Pepperdine University, Clairbourne School; publishers, such as McGraw-Hill, West Publishing; and public service efforts, including fundraising."
Needs: Works with 4-6 freelancers/year. Prefers freelancers local to greater Los Angeles, "with timely turnaround, ability to keep elements in accurate registration, neatness, design quality, imagination and price." Uses freelancers for design, illustration, retouching, characterization/animation, lettering and charts. 50% of freelance work demands knowledge of Adobe Illustrator or Aldus FreeHand.
First Contact & Terms: Send query letter with brochure or tearsheets, photostats, photocopies, slides and photographs. Samples are filed or are returned only if requested. Reports back within 2 weeks only if interested. Call or write for appointment to show portfolio. Pays by the project. Payment negotiable by job.
Tips: "These are tough times. Be flexible. Negotiate. Deliver quality work on time!"

Los Angeles

ART HOTEL INC., 607 Huntley Dr., Los Angeles CA 90069. (310)854-6154. Fax: (310)854-1185. E-mail: owsky@aol .com. Studio Manager: Beth Baran. Estab. 1980. Number of employees: 6. Design firm. Specializes in graphic design, marketing materials, logo developments, signage, packaging for entertainment industry. Current clients include Trimark Pictures, Fox Home Entertainment, GRP Records. Client list not available. Professional affiliations: BMUG/LAMUG, AGIA.

Needs: Approached by hundreds of illustrators and designers/year. Works with 5 illustrators and 10-15 designers/year. Prefers freelancers with experience in meeting deadlines, working within budgets. Uses freelancers mainly for illustration and design. Also for logos, mechanicals, retouching and TV/film graphics. 80% of freelance work is video packaging for the entertainment industry. 95% of design and less than 20% of illustration demand knowledge of Aldus PageMaker, Adobe Photoshop, Adobe Illustrator, Aldus FreeHand and QuarkXPress.

First Contact & Terms: Designers send floppy disks or b&w or color photocopies. Illustrators send disk, 8×10 sheet from sourcebook or color photocopies. "We will accept work compatible with QuarkXPress 7.5/version 3.3 Send EPS file." Uses Macs exclusively. Samples are filed. Reports back only if interested. Prefers portfolios on disk or they may be dropped off every Monday-Thursday, 9-6. Pickup by 6 on Friday. Portfolio should include b&w, color, final art, photographs, photostats, slides and tearsheets. Pays for design by the the hour, $25-40 or by the project, $500-2,500, depending on nature of work. Pays for illustration by the project, $200-2,000, depending on distribution of work. Buys first rights. Finds artists through *Workbook*, agents.

Tips: "Computer skills are the most important thing. Everything is digital these days."

ASHCRAFT DESIGN, 11832 W. Pico Blvd., Los Angeles CA 90064. (310)479-8330. Fax: (310)473-7051. E-mail: info@ashcraftdesign.com. Website: http://www.ashcraftdesign.com. Art Director: Eugene Bustillos. Estab. 1986. Specializes in corporate identity, display and package design and signage. Client list available upon request.

Needs: Approached by 2 freelance artists/year. Works with 1 freelance illustrator and 2 freelance designers/year. Works on assignment only. Uses freelance illustrators mainly for technical illustration. Uses freelance designers mainly for packaging and production. Also uses freelance artists for mechanicals and model making.

First Contact & Terms: Send query letter with tearsheets, résumé and photographs. Samples are filed and are not returned. Reports back to the artist only if interested. To show a portfolio, mail original/final art, tearsheets and 4×5 transparencies. Pays for design and illustration by the project. Rights purchased vary according to project.

BRAMSON (+ ASSOC.), 7400 Beverly Blvd., Los Angeles CA 90036. (213)938-3595. Fax: (213)938-0852. Art Directors: Alex or Gene. Estab. 1970. Number of employees: 12. Approximate annual billing: more than $2 million. Advertising agency. Specializes in magazine ads, collateral, ID, signage, graphic design, imaging, campaigns. Product specialties are healthcare, consumer, business to business. Current clients include Johnson & Johnson, Chiron Vision, Lawry's, IOLAB Corp. and Surgin, Inc.

Needs: Approached by 150 freelancers/year. Works with 10 freelance illustrators, 2 animators and 5 designers/year. Prefers local freelancers. Works on assignment only. Uses freelancers for brochure and print ad design; brochure, technical, medical and print ad illustration; storyboards; mechanicals; retouching; lettering; logos. 30% of work is with print ads. 50% of freelance work "prefers" knowledge of Aldus Pagemaker, Adobe Illustrator, QuarkXPress, Adobe Photoshop, Aldus Freehand or 3-D Studio.

First Contact & Terms: Send query letter with brochure, photocopies, résumé, photographs, tearsheets, SASE. Samples are filed. Will contact artist for portfolio review if interested. Portfolio should include roughs, color tearsheets. Sometimes requests work on spec before assigning job. Pays for design by the hour, $15-25. Pays for illustration by the project, $250-2,000. Buys all rights or negotiates rights purchased. Finds artists through sourcebooks.

Tips: Looks for "very unique talent only." Price and availability are also important.

‡FOOTE, CONE & BELDING, 11601 Wilshire Blvd., 15th Floor, Los Angeles CA 90025-1772. (310)312-7000. Fax: (310)479-1277. Art Buyer: Laura Hanson. Senior Creative Director: Howard Casavant. Estab. 1950. Ad agency. Full-service, multimedia firm. "Impact is the design and sales promotion division for Foote, Cone & Belding." Product specialties are package goods, toys, entertainment and retail. Current clients include Mattel Toys, Sunkist Growers, Universal Studios and Walt Disney Publications.

Needs: Approached by 15-20 freelance artists/month. Works with 3-4 freelance illustrators and 2-3 freelance designers/month. Prefers local artists only with experience in design and sales promotion. Designers must be able to work in-house and have Mac experience. Uses freelance artists for brochure, catalog and print ad design and illustration, storyboards, mechanicals, retouching, lettering, logos and computer (Mac). 30% of work is with print ads.

First Contact & Terms: Designers send query letter with résumé, photocopies and tearsheets. Illustrators send post-card, color photocopies, tearsheets or other non-returnable samples. Samples are filed. Reports back to the artist only if interested. Write to schedule an appointment to show a portfolio. Portfolio should include roughs and color. Pays for design based on estimate on project from concept to mechanical supervision. Pays for illustration per project. Rights purchased vary according to project.

GORDON GELFOND ASSOCIATES, INC., 11500 Olympic Blvd., Los Angeles CA 90064. (310)478-3600. Fax: (310)477-4825. Creative Director: Barry Brenner. Estab. 1967. Ad agency. Full-service multimedia firm. Specializes in print campaigns. Product specialties are financial, general, consumer. Current clients include Long Beach Bank, Century Bank and Deluxe Color Labs.

Needs: Works only with artists reps. Uses freelancers for print ad illustration, mechanicals, retouching and lettering. 95% of work is with print ads.

First Contact & Terms: Send query letter with photostats. Will contact artist for portfolio review if interested. Pays for illustration by the project, $200 minimum. Rights purchased vary according to project.

GRAPHIC DESIGN CONCEPTS, 4123 Wade St., Suite #2, Los Angeles CA 90066. (310)306-8143. President: C. Weinstein. Estab. 1980. Specializes in package, publication and industrial design; annual reports; corporate identity;

displays; and direct mail. "Our clients include public and private corporations, government agencies, international trading companies, ad agencies and PR firms." Current projects include new product development for electronic, hardware, cosmetic, toy and novelty companies.

Needs: Works with 15 illustrators and 25 designers/year. "Looking for highly creative idea people, all levels of experience." All styles considered. Uses illustrators mainly for commercial illustration. Uses designers mainly for product and graphic design. Also uses freelancers for brochure, P-O-P, poster and catalog design and illustration; book, magazine, direct mail and newspaper design; mechanicals; retouching; airbrushing; model making; charts/graphs; lettering; logos. Also for multimedia design, program and content development. 50% of freelance work demands knowledge of Aldus PageMaker, Adobe Illustrator, QuarkXPress, Adobe Photoshop or Aldus FreeHand.

First Contact & Terms: Send query letter with brochure, résumé, tearsheets, photostats, photocopies, slides, photographs and/or transparencies. Accepts disk submissions compatible with Windows on the IBM. Samples are filed or are returned if accompanied by SASE. Reports back within 10 days with SASE. Portfolio should include thumbnails, roughs, original/final art, final reproduction/product, tearsheets, transparencies and references from employers. Pays for design by the hour, $15 minimum; pays for illustration by the hour, $50 minimum. Considers complexity of project, client's budget, skill and experience of artist, how work will be used, turnaround time and rights purchased when establishing payment.

Tips: "Send a résumé if available. Send samples of recent work or *high quality* copies. Everything sent to us should have a professional look. After all, it is the first impression we will have of you. Selling artwork is a business. Conduct yourself in a business-like manner."

‡RHYTHMS PRODUCTIONS, P.O. Box 34485, Los Angeles CA 90034. President: Ruth White. Estab. 1955. AV firm. Specializes in CD-ROM and music production/publication. Product specialty is educational materials for children.

Needs: Works with 2 freelance illustrators and 2 designers/year. Prefers artists with experience in cartoon animation and graphic design. Works on assignment only. Uses freelancers artists mainly for cassette covers, books, character design. Also for catalog design, multimedia, animation and album covers. 2% of work is with print ads. 75% of design and 50% of illustration demand knowledge of Adobe Illustrator, Adobe Photoshop or Macromind Director.

First Contact & Terms: Send query letter with photocopies and SASE (if you want material returned). Samples are returned by SASE if requested. Reports back within 2 months only if interested. Will contact artist for portfolio review if interested. Pays for design and illustration by the project. Buys all rights. Finds artists through word of mouth and submissions.

STUDIO WILKS, 2148-A Federal Ave., Los Angeles CA 90025. (310)478-4442. Fax: (310)478-0013. Estab. 1990. Specializes in print, collateral, packaging, editorial and environmental work. Clients: ad agencies, architects, corporations and small business owners. Current clients include Walt Disney Co., Major League Soccer and Yoga Works.

Needs: Works with 6-10 freelance illustrators and 10-20 designers/year. Uses illustrators mainly for packaging illustration. Also for brochures, print ads, collateral, direct mail and promotions.

First Contact & Terms: Designers send query letter with brochure, résumé, photocopies and tearsheets. Illustrators send postcard sample or query letter with tearsheets. Samples are returned by SASE if requested by artist. Will contact artist for portfolio review if interested. Pays for design by the project. Buys all rights. Considers buying second rights (reprint rights) to previously published work. Finds artists through *The Workbook* and word of mouth.

San Francisco

THE AD AGENCY, P.O. Box 470572, San Francisco CA 94147. Creative Director: Michael Carden. Estab. 1972. Ad agency. Full-service multimedia firm. Specializes in print, collateral, magazine ads. Client list available upon request.

Needs: Approached by 120 freelancers/year. Works with 120 freelance illustrators and designers/year. Uses freelancers mainly for collateral, magazine ads, print ads. Also for brochure, catalog and print ad design and illustration; mechanicals; billboards; posters; TV/film graphics; multimedia; lettering; and logos. 60% of freelance work is with print ads. 50% of freelance design and 45% of illustration demand computer skills.

First Contact & Terms: Send query letter with brochure, photocopies and SASE. Samples are filed or returned by SASE. Reports back in 1 month. Portfolio should include color final art, photostats and photographs. Buys first rights or negotiates rights purchased. Finds artists through word of mouth, referrals and submissions.

Tips: "We are an eclectic agency with a variety of artistic needs."

‡COMMUNICATIONS WEST, 1426 18th St, San Francisco CA 94107. (415)863-7220. Fax: (415)621-2907. E-mail: comwest@comwest.com. Contact: Creative Director. Estab. 1983. Number of employees: 9. Approximate annual billing: $4 million. Ad agency/PR firm. Product specialties are transportation and consumer. Specializes in magazine ads and collateral. Current clients include Blue Star Line, Sector Watches, Marine Terminals, Consolidated Freightways, Redwood Systems, Primo-Angeli, Harbinger.

Needs: Approached by 48 freelancers/year. Works with 2-4 freelance illustrators and 6-8 designers/year. Prefers local freelancers with experience. Works on assignment only. Uses freelancers mainly for brochure and print ad design and illustration, slide illustration, mechanicals, retouching, posters, lettering and logos. 50% of work is with print ads. 50% of freelance work demands knowledge of Adobe Illustrator, QuarkXPress and Adobe Photoshop.

First Contact & Terms: Send query letter with brochure, résumé, photocopies and tearsheets. Samples are filed. Reports back to the artist only if interested. Call for appointment to show portfolio of color tearsheets and finished art samples. Pays for design by the project, $250-5,000. Pays for illustration by the project, $500-2,500. Buys all rights.
Tips: The president of this firm advises freelancers entering the advertising field to "start out small with easy-to-execute, inexpensive work."

✓IMPACT MEDIA GROUP, Mad Avenues Inc., 300 Deharo St., South Train Car, San Francisco CA 94103. (415)865-3700. Fax: (415)865-3704. E-mail: impactmg@aol.com. Website: http://www.impactmg.com. Senior Partner: Garner Moss. Estab. 1993. Number of employees: 10. Approximate annual billing: $1 million. Digital design firm. Specializes in web design and programming, packaging, direct mail, marketing, desktop video and animation, 3D modeling, logos. Product specialty is design. Current clients include: Los Angeles Kings, Sun Microsystems, Kodak, Lucas Film, NHL, NBA, NFL, the AMA. Professional affiliations: AIGS, Art Directors Club, America Advertising Federation, SF Ad Club, Ad2 Club.
Needs: Approached by 10 illustrators and 30 designers/year. Works with 3 illustrators and 5 designers/year. Prefers local designers with experience in QuarkXPress and Adobe Photoshop. Uses freelancers mainly for direct mail, web design. Also for animation, annual reports, billboards, brochure design and illustration, catalog design and illustration, logos, medical illustration, model making, multimedia projects, posters, signage, storyboards, technical illustration, TV/film graphics, web page design, web programers. 50% of work is with print ads. 100% of design and 50% of illustration demand skills in Aldus FreeHand, Adobe Photoshop 4.0, QuarkXPress 3.32, Adobe Illustrator.
First Contact & Terms: Designers send query letter with photocopies, résumé, SASE, tearsheets, samples to keep on file. Illustrators send postcard sample and/or query letter with photocopies, résumé, SASE, tearsheets, samples of brochure or 4-color work. Send follow-up postcard every 2 months. Accepts Mac-compatible disk submissions. Send QuarkXPress files—version 3.2 and above and EPS files. Samples are filed. Will contact artist for portfolio review of b&w, color final art, photographs, photostats, roughs, slides, tearsheets, thumbnails and transparencies if interested. Pays for design by the hour, $10-45. Pays for illustration by the hour, $10-100, or by the project. Flat rates may be applied. Rights purchased vary according to project. Finds artists through ads, word of mouth and referrals.
Tips: "Really know your Quark. Be willing to go overtime on a project. Work on a project like it's a matter of winning an award. Make a portfolio that is interactive and can be seen on a website or floppy disk."

‡ROY RITOLA, INC., 431 Jackson St., San Francisco CA 94111. (415)788-7010. President: Roy Ritola. Specializes in brand and corporate identity, displays, direct mail, packaging, signage. Clients: manufacturers.
Needs: Works with 6-10 freelancers/year. Uses freelancers for design, illustration, airbrushing, model making, lettering and logos.
First Contact & Terms: Send query letter with brochure showing art style or résumé, tearsheets, slides and photographs. Samples not filed are returned only if requested. Reports back only if interested. To show portfolio, mail final reproduction/product. Pays for design by the hour, $25-100. Considers complexity of project, client's budget, skill and experience of artist, turnaround time and rights purchased when establishing payment.

Colorado

BARNSTORM DESIGN/CREATIVE, 2902 W. Colorado Ave., Suite 200, Colorado Springs CO 80904. (719)630-7200. Fax: (719)630-3280. Owner: Douglas D. Blough. Estab. 1975. Specializes in corporate identity, brochure design and publications. Clients: high-tech corporations, nonprofit fundraising, business-to-business and restaurants. Current clients include The Colorado College, USOC, Concept Restaurants, US Swimming, Gray Brewing Co., Sky Sox Baseball Club, General Merchandise Distributors Council.
Needs: Works with 2-4 freelance artists/year. Prefers local, experienced (clean, fast and accurate) artists. Works on assignment only. Uses freelancers mainly for paste-up, editorial and technical illustration and layout. Also uses freelancers for design, mechanicals, retouching and calligraphy. Needs computer-literate freelancers for production. 90% of freelance work demands knowledge of Aldus PageMaker, Adobe Illustrator, QuarkXPress, Photoshop and Macromedia FreeHand.
First Contact & Terms: Send query letter with résumé and samples to be kept on file. Prefers "good originals or reproductions, professionally presented in any form" as samples. Samples not filed are returned by SASE. Reports only if interested. Call or write for appointment to show portfolio. Pays for design by the project, $300-500. Pays for illustration by the project, $100 minimum for b&w; $300 for color. Considers client's budget, skill and experience of artist, and turnaround time when establishing payment.
Tips: "Portfolios should reflect an awareness of current trends. We try to handle as much inhouse as we can, but we recognize our own limitations (particularly in illustration). Do not include too many samples in your portfolio."

‡CINE DESIGN FILMS, Box 6495, Denver CO 80206. (303)777-4222. E-mail: jghusband@aol.com. Producer/Director: Jon Husband. AV firm. Clients: automotive companies, banks, restaurants, etc.
Needs: Works with 3-7 freelancers/year. Works on assignment only. Uses freelancers for layout, titles, animation and still photography. Clear concept ideas that relate to the client in question are important.
First Contact & Terms: Send query letter to be kept on file. Reports only if interested. Write for appointment to

show portfolio. Pays by the project. Considers complexity of project, client's budget and rights purchased when establishing payment. Rights purchased vary according to project.

JO CULBERTSON DESIGN, INC., 1034 Logan St., Denver CO 80203. (303)861-9046. E-mail: joculdes@aol.com. President: Jo Culbertson. Estab. 1976. Number of employees: 1. Approximate annual billing: $200,000. Specializes in direct mail, packaging, publication and marketing design; annual reports; corporate identity; and signage. Clients: corporations, not-for-profit organizations. Current clients include Love Publishing Company, American Cancer Society, Nurture Nature, Clarus Products Intl., Sun Gard Insurance Systems. Client list available upon request.
Needs: Approached by 15 freelancers/year. Works with 2 freelance illustrators/year. Prefers local freelancers only. Works on assignment only. Uses illustrators mainly for corporate collateral pieces, illustration and ad illustration. 50% of freelance work demands knowledge of QuarkXPress, Adobe Photoshop, CorelDraw.
First Contact & Terms: Send query letter with résumé, tearsheets and photocopies. Samples are filed. Reports back to the artist only if interested. Artist should follow up with call. Portfolio should include b&w and color thumbnails, roughs and final art. Pays for design by the project, $250 minimum. Pays for illustration by the project, $100 minimum. Finds artists through file of résumés, samples, interviews.

Connecticut

FORDESIGN GROUP, 87 Dayton Rd., Redding CT 06896. (203)938-0008. Fax: (203)938-0805. E-mail: steven@ford esign-group.com. Website: http://fordesign-group.com. Principal: Steve Ford. Estab. 1990. Specializes in brand and corporate identity, package and publication design and signage. Clients: corporations. Current clients include Black & Decker, Cadbury Beverage, Carrs, MasterCard. Professional affiliations: AIGA, PDC.
Needs: Approached by 100 freelancers/year. Works with 4-6 freelance illustrators and 4-6 designers/year. Uses illustrators mainly for brochures, ads. Uses designers mainly for corporate identity, packaging, collateral. Also uses freelancers for ad and brochure design and illustration, logos. Needs computer-literate freelancers for design, illustration and production. 90% of freelance work demands knowledge of Adobe Illustrator, Adobe Photoshop, FreeHand and QuarkXPress.
First Contact & Terms: Send postcard sample of work or send photostats, slides and transparencies. Samples are filed or returned by SASE if requested by artist. Will contact artist for portfolio review if interested. Portfolio should include b&w and color samples. Pays for design by the hour, $25-75; by the project, $100-5,000. Pays for illustration by the project, $2-3,000.
Tips: "We are sent all *Showcase*, *Workbook*, etc." Impressed by "great work, simply presented." Advises freelancers entering the field to save money on promotional materials by partnering with printers. Create a joint project or tie-in. "Send out samples—good luck!"

FREELANCE EXCHANGE, INC., P.O. Box 1165, Glastonbury CT 06033-6165. (860)633-8116. Fax: (860)633-8106. E-mail: stella1@ix.netcom.com. President: Stella Neves. Estab. 1983. Number of employees: 3. Approximate annual billing: $600,000. Specializes in annual reports; brand and corporate identity; animation; display, direct mail, package and publication design; web page design; illustration (cartoon, realistic, technical, editorial, product and computer). Clients: corporations, nonprofit organizations, state and federal government agencies and ad agencies. Current clients include Lego Systems, Milton Bradley Co., Hartford Courant, Abrams Publishing Co., Otis Elevator, Phoenix Home Life Insurance Co., CIGNA, ABB, The Travelers, The Allied Group. Client list available upon request. Professional affiliations: GAIG, Connecticut Art Directors Club.
Needs: Approached by 350 freelancers/year. Works with 25-40 freelance illustrators and 30-50 designers/year. Prefers freelancers with experience in publications, website design, consumer products and desktop publishing. "Home page and website design are becoming more important and requested by clients." Works on assignment only. Uses illustrators mainly for editorial and computer illustration. Design projects vary. 95% of design and 50% of illustration demand knowledge of Aldus PageMaker, QuarkXPress, Aldus FreeHand, Adobe Illustrator, Adobe Photoshop, Persuasion, Powerpoint, Macromind Director, Page Mill and Hot Metal.
First Contact & Terms: Designers send postcard sample or query letter with résumé, SASE, brochure, tearsheets and photocopies. Illustrators send postcard sample or query letter with résumé, photocopies, photographs, SASE, slides and tearsheets. Samples are filed and are returned by SASE. Call or write for appointment to show portfolio of thumbnails, roughs, final art (if appropriate) and b&w and color photostats, slides, tearsheets, photographs. "We prefer slides and good quality color copies." Pays for design by the project, $500 minimum. Pays for illustration by the project, $300 minimum. Rights purchased vary according to project.
Tips: "Send us one sample of your best work that is unique and special. All styles and media are OK, but we're really interested in computer-generated illustration and websites. If you want to make money, learn to use the new technology. The 'New Media' is where our clients want to be, so adjust your portfolio accordingly. Your portfolio must be spectacular (I don't want to see student work). Having lots of variety and being well-organized will encourage one to take a chance on an unknown artist."

‡FREEMAN DESIGN GROUP, 85 River Rd., #G4, Greenwich CT 06426-1341. (203)968-0026. President: Bill Freeman. Estab. 1972. Specializes in annual reports, corporate identity, package and publication design and signage.

Clients: corporations. Current projects include company magazines. Current clients include Pitney Bowes, Continental Grain Co., IBM Credit, CB Commercial Real Estate. Client list available upon request.
Needs: Approached by 35 artists/year. Works with 5 illustrators and 5 designers/year. Prefers artists with experience in production. Works on assignment only. Uses illustrators for mechanicals, retouching and charts/graphs. Looking for technical illustration and editorial illustration with "montage, minimal statement."
First Contact & Terms: Send query letter with promotional piece showing art style, résumé and tearsheets. Samples are filed or are returned if accompanied by SASE. Does not report back. Call for appointment to show portfolio or mail appropriate materials and tearsheets. Pays for design by the hour, $25 minimum; by the project, $150-3,000.

‡**IDC**, Box 312, Farmington CT 06034. (203)678-1111. Fax: (203)793-0293. President: Dick Russell. Estab. 1960. Number of employees: 6-8. Specializes in industrial design. Clients: corporations. Client list not available.
Needs: Approached by 50 freelance industrial designers/year. Works with 10-15 industrial designers/year. Prefers local freelancers. Uses designers mainly for product design. Also uses freelancers for model making and industrial design. Needs computer-literate freelancers for design. 50% of freelance work demands knowledge of CADKey or AutoCAD.
First Contact & Terms: Send résumé. Reports back only if interested. Designer should follow up with call after initial query. Will contact for portfolio review if interested. Portfolio should include thumbnails and roughs. Pays for design by the hour.

INFOVIEW MARKETING, 124 Farmingdale Rd., Wethersfield CT 06109. Phone/fax: (860)721-0270. E-mail: lbell@ziplink.net. General Manager: Larry Bell. Estab. 1985. Number of employees: 3. Advertising specialties firm. Specializes in personalized products for organization identity—logos on jackets, leather goods and bags.
Needs: Works with 4-5 freelance illustrators/year. Uses freelancers in developing coporate, club and organizational logos.
First Contact & Terms: Send a sample logo for evaluation. Will contact artist for additional photocopies of work. Pays for design by the project. Finds artists through *Artist's & Graphic Designer's Market* listing and agents.

ULTITECH, INC., Foot of Broad St., Stratford CT 06497. (203)375-7300. Fax: (203)375-6699. E-mail: comcowic@meds.com. Website: http://www.meds.com. President: W.J. Comcowich. Estab. 1993. Number of employees: 3. Approximate annual billing: $1 million. Integrated marketing communications agency. Specializes in interactive multimedia, software, online services. Product specialties are medicine, science, technology. Current clients include Glaxo, Smithkline, Pharmacia. Professional affiliation: IMA.
Needs: Approached by 10-20 freelance illustrators and 10-20 designers/year. Works with 2-3 freelance illustrators and 6-10 designers/year. Prefers freelancers with experience in interactive media design and online design. Uses freelancers mainly for interactive media—online design (WWW). Also for animation, brochure and web page design, medical illustration, multimedia projects, TV/film graphics. 10% of work is with print ads. 100% of freelance design demands skills in Adobe Photoshop, QuarkXPress, Adobe Illustrator, 3D packages.
First Contact & Terms: Designers send query letter with résumé. Illustrators send postcard sample and/or query letter with photocopies, résumé, tearsheets. Accepts disk submissions in PC formats. Samples are filed. Reports back only if interested. Request portfolio review in original query. Pays for design by the project or by the day. Pays for illustration by the project. Buys all rights. Finds artists through sourcebooks, word of mouth.
Tips: "Learn design principles for interactive media."

Delaware

‡**ALOYSIUS BUTLER & CLARK (AB&C)**, One Riverwalk Center, Wilmington DE 19801. (302)655-1552. Contact: Tom McGivney. Ad agency. Clients: health care, banks, industry, restaurants, hotels, businesses, government offices.
Needs: Works with 12 or more illustrators and 3-4 designers/year. Uses artists for trade magazines, billboards, direct mail packages, brochures, newspapers, stationery, signage and posters. 95% of design and 15% of illustration demand knowledge of QuarkXPress, Adobe Illustrator or Adobe Photoshop.
First Contact & Terms: Designers send query letter with résumé and photocopies. Illustrators send postcard samples. Samples are filed; except work that is returned only if requested. Reports only if interested. Works on assignment only. Pays for design by the hour, $20-50. Pays for illustration by the hour; or by the project, $250-1,000.

CUSTOM CRAFT STUDIO, 310 Edgewood St., Bridgeville DE 19933. (302)337-3347. Fax: (302)337-3444. AV producer. Vice President: Eleanor H. Bennett.
Needs: Works with 12 freelance illustrators and 12 designers/year. Works on assignment only. Uses freelancers mainly for work on filmstrips, slide sets, trade magazines and newspapers. Also for print finishing, color negative retouching and airbrush work. Prefers pen & ink, airbrush, watercolor and calligraphy. 10% of freelance work demands knowledge of Adobe Illustrator. Needs editorial and technical illustration.
First Contact & Terms: Send query letter with résumé, slides or photographs, brochure/flyer and tearsheets to be kept on file. Samples returned by SASE. Reports back in 2 weeks. Originals not returned. Pays by the project, $25 minimum.

GLYPHIX ADVERTISING, 105 Second St., Lewes DE 19958. (302)645-0706. Fax: (302)645-2726. E-mail: rjundt@shore.intercom.net. Website: http://www.glyphixadv.com. Creative Director: Richard Jundt. Estab. 1981. Number of employees: 2. Approximate annual billing: $200,000. Ad agency. Specializes in collateral and advertising. Current clients include Cytec Industries, CasChem, Lansco Colors. Client list available upon request.
Needs: Approached by 10-20 freelancers/year. Works with 2-3 freelance illustrators and 2-3 designers/year. Prefers local artists only. Uses freelancers mainly for "work I can't do." Also for brochure and catalog design and illustration and logos. 20% of work is with print ads. 100% of freelance work demands knowledge of Adobe Photoshop, QuarkXPress, Adobe Illustrator and Delta Graph.
First Contact & Terms: Send query letter with samples. Reports back within 10 days if interested. Artist should follow-up with call. Portfolio should include b&w and color final art, photographs and roughs. Buys all rights. Finds artists through word of mouth and submissions.

Washington DC

ARNOLD & ASSOCIATES PRODUCTIONS, 1834 Jefferson Place NW, Washington DC 20036. President: John Arnold. AV/video firm.
Needs: Works with 30 artists/year. Prefers local artists, award-winning and experienced. "We're an established, national firm." Works on assignment only. Uses freelancers for multimedia, slide show and staging production.
First Contact & Terms: Send query letter with brochure, tearsheets, slides and photographs to be kept on file. Call for appointment to show portfolio, which should include final reproduction/product and color photographs. Pays for design by the hour, $50-100 or by the project, $500-3,500. Pays for illustration by the project, $500-4,000. Considers complexity of the project, client's budget and skill and experience of artist when establishing payment.

LOMANGINO STUDIO INC., 3209 M St. NW, Washington DC 20007. (202)338-4110. Fax: (202)625-0848. Website: http://www.lomangino.com. President: Donna Lomangino. Estab. 1987. Number of employees: 6. Specializes in annual reports, corporate identity and publication design. Clients: corporations, nonprofit organizations. Client list available upon request. Professional affiliations: AIGA Washington DC.
Needs: Approached by 25-50 freelancers/year. Works with 1 freelance illustrator/year. Uses illustrators and production designers occasionally for publication. Also for multimedia projects. Accepts disk submissions, but not preferable. 99% of design work demands knowledge of Adobe Illustrator, Adobe Photoshop and QuarkXPress.
First Contact & Terms: Send postcard sample of work. Samples are filed. Will contact artist for portfolio review if interested. Pays for design and illustration by the project. Finds artists through sourcebooks, word of mouth and studio files.
Tips: "Please don't call. Send samples for consideration."

Florida

‡AD CONSULTANT GROUP INC., 3111 University Dr., #408, Coral Springs FL 33065. (954)340-0883. Fax: (954)340-0996. President: B. Weisblum. Creative Director: Michael Cadieux. Estab. 1994. Number of employees: 3. Ad agency. Full-service multimedia firm.
Needs: Prefers local artists only. Also uses freelancers for animation, brochure and catalog design and illustration, posters and TV/film graphics. 25% of work is with print ads. Needs computer-literate freelancers for design, illustration, production and presentation. 100% of freelance work demands computer skills.
First Contact & Terms: Send query letter. Samples are filed. Reports back within 1 week. Artist should follow-up with call. Portfolio should include final art. Buys first rights or all rights.

AURELIO & FRIENDS, INC., 14971 SW 43 Terrace, Miami FL 33185. (305)225-2434. Fax: (305)225-2121. E-mail: aurelio97@aol.com. President: Aurelio Sica. Vice President: Nancy Sica. Estab. 1973. Number of employees: 3. Specializes in corporate advertising and graphic design. Clients: corporations, retailers, large companies, hotels and resorts.
Needs: Approached by 4-5 freelancers/year. Works with 1-2 freelance illustrators and 3-5 designers/year. Also uses freelancers for ad design and illustration; brochure, catalog and direct mail design; and mechanicals. 50% of freelance work demands knowledge of Adobe Ilustrator, Adobe Photoshop and QuarkXPress.
First Contact & Terms: Send brochure and tearsheets. Samples are filed. Will contact artist for portfolio review if interested. Portfolio should include b&w and color final art, photographs, roughs and transparencies. Pays for design and illustration by the project. Buys all rights.

‡EXHIBIT BUILDERS INC., Dept. AM, 150 Wildwood Rd., Deland FL 32720. (904)734-3196. Fax: (904)734-9391. E-mail: ebifl@ix.netcom.com. President: Penny D. Morford. Produces themed custom trade show exhibits and distributes modular and portable displays, and sales centers. Clients: museums, primarily manufacturers, government agencies, ad agencies, tourist attractions and trade show participants.

● Looking for freelance trade show designers.

Needs: Works on assignment only. Uses artists for exhibit/display design murals.

First Contact & Terms: Provide résumé, business card and brochure to be kept on file. Samples returned by SASE. Reports back for portfolio review. Considers complexity of project, skill and experience of artist, how work will be used, turnaround time and rights purchased when establishing payment.

Tips: "Wants to see examples of previous design work for other clients; not interested in seeing school-developed portfolios."

✓GOLD & ASSOCIATES INC., 6000-C Sawgrass Village Circle, Ponte Vedra Beach FL 32082. (904)285-5669. Fax: (904)285-1579. Creative Director/President: Keith Gold. Estab. 1988. Full-service multimedia communications firm. Specializes in graphic design and advertising. Product specialties are publishing, entertainment, fashion and tourism. Three locations. Total staff of 50+.

● The president of Gold & Associates believes agencies will offer more services than ever before, as commissions are reduced by clients.

Needs: Approached by 80-100 freelancers/year. Works with 20-30 freelance illustrators and 6-8 freelance designers/ year. Works primarily with artist reps. Works on assignment only. Uses freelancers for brochure, catalog, medical, editorial, technical, slide and print ad illustration; storyboards; animatics; animation; mechanicals. 50% of work is with print ads. 50% of freelance work demands knowledge of Adobe Illustrator, QuarkXPress and Adobe Photoshop.

First Contact & Terms: Contact through artist rep or send query letter with photocopies, tearsheets and capabilities brochure. Samples are filed. Reports back to the artist only if interested. Request portfolio review in original query. Will contact artists for portfolio review if interested. Follow-up with letter after initial query. Portfolio should include tearsheets. Pays for design by the hour, $35-125. "Maximum number of hours is negotiated up front." Pays for illustration by the project, $200-7,500. Buys all rights. Finds artists primarily through sourcebooks and reps.

TOM GRABOSKI ASSOCIATES, INC., 4649 Ponce de Leon Blvd., #401, Coral Gables FL 33146. (305)669-2550. Fax: (305)669-2539. E-mail: tga@gate.net. President: Tom Graboski. Estab. 1980. Specializes in exterior/interior signage, environmental graphics, corporate identity, publication design and print graphics. Clients: corporations, museums, a few ad agencies. Current clients include Universal Studios, Florida, Royal Caribbean Cruise Line, The Equity Group, Disney Development.

Needs: Approached by 50-80 freelance artists/year. Works with approximately 4-8 designers/draftspersons/year. Prefers artists with a background in signage and knowledge of architecture. Freelance artists used in conjunction with signage projects, occasionally miscellaneous print graphics. 100% of design and 10% of illustration demand knowledge of Aldus PageMaker, Adobe Illustrator, QuarkXPress or Aldus FreeHand.

First Contact & Terms: Send query letter with brochure and résumé. "We will contact designer/artist to arrange appointment for portfolio review. Portfolio should be representative of artist's work and skills; presentation should be in a standard portfolio format." Pays by the project. Payment varies by experience and project. Rights purchased vary by project.

Tips: "Look at what type of work the firm does. Tailor presentation to that type of work." For this firm "knowledge of environmental graphics, detailing, a plus."

PETER JAMES DESIGN STUDIO, 7495 NW Fourth St., Mark IV Bldg., Plantation FL 33317. (954)587-2842. Fax: (954)587-2866. Creative Director: Jim Spangler. Estab. 1980. Specializes in business-to-business advertising, package design, direct mail advertising and corporate identity. Clients: manufacturers, corporations and hospitality companies. Client list available upon request.

● Jim Spangler thinks "electronic artwork and design will continue to evolve . . . hopefully to be less mechanical and more inspired."

Needs: Approached by dozens of freelance artists/year. Works with 6 freelance art directors and designers/year. Prefers local artists with 7 years experience minimum in corporate design. Also uses artists for technical, editorial and graphic illustration and mechanicals, retouching, airbrushing, lettering and logo design. Needs computer-literate freelancers for design, illustration and production. Freelance work demands skills in QuarkXPress, Adobe Photoshop or Adobe Illustrator.

First Contact & Terms: Send query letter with samples, tearsheets, photocopies and résumé. Samples are filed or are returned by SASE if requested by artist. Will contact artist for portfolio review if interested. Pays for inhouse design by the hour, $15-50. Pays for illustration by the project, $50-1,500. Rights purchased vary according to project. Considers buying second rights (reprint rights) to previously published work. Finds artists through magazines, artists' submissions/ self-promotions, sourcebooks and agents.

‡KELLY & CO., GRAPHIC DESIGN, INC., Dept. AM, 7490 30 Ave. N., St. Petersburg FL 33710. (813)341-1009. Art Director: Ken Kelly. Estab. 1971. Specializes in print media design, logo design, corporate identity, ad campaigns, direct mail, brochures, publications, signage, architectural and technical illustrations. Clients: industrial, banking, auto, boating, real estate, accounting, furniture, travel and ad agencies. Majority of clients are industrial.

Needs: Works with 2 illustrators and 1 designer/year. Prefers artists with a minimum of 5 years of experience. "Local artists preferred. Must have a good working attitude." Uses artists for design, technical illustration, brochures, catalogs, magazines, newspapers, P-O-P displays, mechanicals, retouching, airbrushing, posters, model making, direct mail pack-

ages, charts/graphs, lettering and logos. 90% of design and 75% of illustration demands knowledge of Aldus PageMaker, QuarkXPress, Aldus FreeHand, Adobe Illustrator or "other programs."

First Contact & Terms: Send query letter with résumé, brochure and photocopies, or "copies of work showing versatility." Accepts submissions on Mac floppy or CD. Samples are filed. Reports back only if interested. Pays for design by the hour, $35-55. Pays for illustration by the hour, $65-95; by the day, $90-110. Buys all rights.

Tips: "Be highly talented in all areas with reasonable rates. Don't oversell yourself. Must be honest with a high degree of integrity and appreciation. Send clean, quality samples and résumé. I prefer to make the contact. Our need for freelancers has been reduced."

STEVE POSTAL PRODUCTIONS, P.O. Box 428, Carraway St., Bostwick FL 32007-0428. (904)325-9356. Website: http://www.caisa.com/worstfilms. Director: Steve Postal. Estab. 1958. Number of employees: 8. Approximate annual billing: $1 million. AV firm. Full-service multimedia firm. Specializes in documentaries, feature films. Product specialty is films and videos. Professional affiliations: Directors Guild of Canada, FMPTA.

Needs: Approached by 150 freelancers/year. Works with 10 freelance illustrators and 5 designers/year. Prefers artists with experience in advertising, animation, design for posters. Works on assignment only. Uses freelancers mainly for films and film ads/VHS boxes. Also for brochure, catalog and print ad design and illustration; animation; TV/film graphics; and lettering. 10% of work is with print ads. 10% of design and 15% of illustration demand knowledge of Aldus FreeHand.

First Contact & Terms: Send query letter with résumé, brochure, photocopies and SASE. Samples are filed. Reports back to the artist only if interested. "Artist should follow-up their mailing with at least two telephone calls within two weeks of mailing." Portfolio should include b&w and color final art, tearsheets and photographs. Pays for design and illustration by the project. Buys all rights. Finds artists through submissions.

Tips: "The one who contacts me the most wins the job!"

PRODUCTION INK, 2826 NE 19th Dr., Gainesville FL 32609. (352)377-8973. Fax: (352)373-1175. E-mail: tun@pro ink.com. Website: http://www.proink.com. President: Terry Van Nortwick. Estab. 1979. Number of employees: 5. Specializes in publications, marketing, healthcare, engineering, development and ads. Professional affiliations: Public Relations Society of America, Society of Professional Journalists, International Association of Business Communicators, Gainesville Advertising Federation, Florida Public Relations Association.

Needs: Works with 6-10 freelancers/year. Works on assignment only. Uses freelancers for brochure illustration, airbrushing and lettering. 80% of freelance work demands knowledge of Aldus PageMaker, Adobe Illustrator, QuarkXPress, Adobe Photoshop or Aldus FreeHand. Needs editorial, medical and technical illustration.

First Contact & Terms: Send résumé, samples, tearsheets, photostats, photocopies, slides and photography. Samples are filed or are returned if accompanied by SASE. Reports back only if interested. Call or write for appointment to show portfolio of original/final art. Pays for design and illustration by the project, $50-500. Rights purchased vary according to project.

‡ROBERTS COMMUNICATIONS & MARKETING, INC., 5405 Cypress Center Dr., Suite 250, Tampa FL 33609-1025. (813)281-0088. Fax: (813)281-0271. Creative Director: Amy Phillips. Estab. 1986. Number of employees: 9. Ad agency, PR firm. Full-service multimedia firm. Specializes in integrated communications campaigns using multiple media and promotion. Professional affiliations: AIGA, PRSA, AAF.

Needs: Approached by 50 freelancers/year. Works with 10 freelance illustrators and designers/year. Prefers local artists with experience in conceptualization and production knowledge. Uses freelancers for billboards, brochure design and illustration, lettering, logos, mechanicals, posters, retouching and signage. 60% of work is with print ads. 95% of freelance work demands knowledge of Adobe Photoshop 2.5, QuarkXPress 3.3 and Adobe Illustrator 5.0.

First Contact & Terms: Send postcard sample or query letter with photocopies, résumé and SASE. Samples are filed or are returned by SASE if requested by artist. Portfolios may be dropped off every Monday. Will contact artist for portfolio review if interested. Portfolio should include b&w and color final art, roughs and thumbnails. Pays for design by the hour, $20-50; by the project, $100 minimum; by the day, $150-500. Pays for illustration by the project, negotiable. Refers to Graphic Arts Guild Handbook for fee structure. Rights purchased vary according to project. Finds artists through agents, sourcebooks, seeing actual work done for others, annuals (*Communication Arts*, *Print*, *One Show*, etc.).

Tips: Impressed by "work that demonstrates knowledge of product, willingness to work within budget, contributing to creative process, delivering on-time. Continuing development of digital technology hand-in-hand with new breed of traditional illustrators sensitive to needs of computer production is good news."

‡VAN VECHTEN BURKE & ASSOCIATES PUBLIC RELATIONS, P.O. Box 99, Boca Raton FL 33429. (561)243-2900. President: Jay Van Vechten. Number of employees: 8. Approximate annual billing: $1.1 million. PR firm. Clients: medical, consumer products, industry. Client list available for SASE.

Needs: Approached by 20 freelancers/year. Works with 8 freelance illustrators and 8 designers/year. Works on assignment only. Uses artists for editorial and medical illustration, consumer and trade magazines, brochures, newspapers, stationery, signage, AV presentations and press releases. 20% of freelance work demands computer skills.

First Contact & Terms: Send query letter with brochure, résumé, business card, photographs or photostats. Samples not returned. Reports back only if interested. Pays for design and illustration by the project. Considers client's budget when establishing payment. Buys all rights.

Tips: Advises freelancers starting out in the field to research agencies. "Find out what clients the agency has. Create

a thumbnail sketch or original idea to get yourself in the door."

‡**MICHAEL WOLK DESIGN ASSOCIATES**, 3841 NE Second Ave., Suite #303, Miami FL 33137. (305)576-2898. President: Michael Wolk. Estab. 1985. Specializes in corporate identity, displays, interior design and signage. Clients: corporate and private. Client list available upon request.
Needs: Approached by 10 freelancers/year. Works with 5 illustrators and 5 freelance designers/year. Prefers local artists only. Works on assignment only. Needs editorial and technical illustration mainly for brochures. Uses designers mainly for interiors and graphics. Also for brochure design, mechanicals, logos and catalog illustration. Needs "progressive" illustration. Needs computer-literate freelancers for design, production and presentation. 75% of freelance work demands knowledge of Aldus PageMaker, QuarkXPress, Aldus FreeHand, Adobe Illustrator or other software.
First Contact & Terms: Send query letter with slides. Samples are not filed and are returned by SASE. Reports back to the artist only if interested. To show a portfolio, mail slides. Pays for design by the hour, $10-20. Rights purchased vary according to project.

Georgia

✔**EJW ASSOCIATES & TRADE PR SERVICE**, Dept. AGDM, 1031 Cambridge Square, Suite D, Alpharetta GA 30004. (770)664-9322. Fax: (770)664-9324. E-mail: emiljw@mindspring.com. Website: http://www.ejwassoc.com. President: Emil Walcek. Estab. 1980. Ad agency. Specializes in magazine ads, collateral and website design. Product specialty is business-to-business.
Needs: Works with 24 freelance illustrators and 12 designers/year. Prefers local freelancers with experience in Mac computer design and illustration and Photoshop expertise. Works on assignment only. Uses freelancers for brochure, catalog and print ad design and illustration; editorial, technical and slide illustration; retouching; and logos. 50% of work is with print ads. Needs computer-literate freelancers for design, illustration, production and presentation. 75% of freelance work demands knowledge of PageMaker, FreeHand or Photoshop.
First Contact & Terms: Send query letter with résumé, photostats and slides. Samples are filed or are returned by SASE if requested by artist. Reports back to the artist only if interested. Write for appointment to show portfolio of thumbnails, roughs, final art, tearsheets. Pays for design by the hour, $15-25; by the day, $85-200; or by the project. Pays for illustration by the project. Buys all rights.
Tips: Looks for "experience in non-consumer, industrial or technology account work. Visit our website first—then e-mail or call."

GRANT/GARRETT COMMUNICATIONS, INC., Box 53, Atlanta GA 30301. (404)755-2513. President: Ruby Grant Garrett. Estab. 1979. Production and placement firm for print media. Specializes in recruitment advertising and graphics. Clients: banks, organizations, products-service consumer. Client list available for SASE.
● Grant/Garrett Communications predicts there will be more small jobs in the future.
Needs: Assigns 24 jobs/year. Works with 2-3 illustrators and 2 designers/year. "Experienced, talented artists only." Works on assignment only. Uses freelancers for billboards, brochures, signage and posters. 100% of work is with print ads. Needs editorial, technical and medical illustration. Especially needs "help-wanted illustrations that don't look like clip art." 30% of freelance work demands knowledge of Aldus PageMaker.
First Contact & Terms: Designers send query letter with résumé to be kept on file. Illustrators send postcard samples and résumé. Reports within 10 days. Will contact artist for portfolio review if interested. Portfolio should include roughs and tearsheets. "Do not send samples or copies of fine art or paintings." Requests work on spec before assigning a job. Pays for design by the hour, $25-35; by the project, $75-3,500. Pays for illustration by the project, $35-2,500. Considers client's budget, skill and experience of artist and turnaround time when establishing payment. Negotiates rights purchased. Finds artists through submissions and sourcebooks.

‡**LORENC DESIGN, INC.**, 724 Longleaf Dr. NE, Atlanta GA 30342-4307. (404)266-2711. Fax: (404)233-5619. E-mail: lorenc@mindspring.com. President: Mr. Jan Lorenc. Specializes in architectural signage design; environmental, exhibit, furniture and industrial design. Clients: corporate, developers, product manufacturers, architects, real estate and institutions. Current clients include Gerald D. Hines Interests, MCI, Georgia-Pacific, IBM, Homart Development, HOH Associates. Client list available upon request.
Needs: Approached by 25 freelancers/year. Works with 5 illustrators and 10 designers/year. Local senior designers only. Uses freelancers for design, illustration, brochures, catalogs, books, P-O-P displays, mechanicals, retouching, airbrushing, posters, direct mail packages, model making, charts/graphs, AV materials, lettering and logos. Needs editorial and technical illustration. Especially needs architectural signage and exhibit designers. 95% of freelance work demands knowledge of QuarkXPress, Adobe Illustrator or Aldus FreeHand.
First Contact & Terms: Send brochure, résumé and samples to be kept on file. Prefers slides as samples. Samples are filed or are returned. Call or write for appointment to show portfolio of thumbnails, roughs, original/final art, final reproduction/product and color photostats and photographs. Pays for design by the hour, $10-50; by the project, $250-20,000; by the day, $80-400. Pays for illustration by the hour, $10-50; by the project, $100-2,000; by the day, $80-400. Considers complexity of project, client's budget, and skill and experience of artist when establishing payment.
Tips: "Sometimes it's more cost-effective to use freelancers in this economy, so we have scaled down permanent staff."

MURRELL DESIGN GROUP, 1280 W. Peachtree #120, Atlanta GA 30309. (404)892-5494. Fax: (404)874-6894. E-mail: murrell@mindspring.com. President: James Murrell. Estab. 1992. Number of employees: 9. Approximate annual billing: $1 million. Specializes in annual reports, brand and corporate identity, package and publication design and signage. Clients: ad agencies and corporations. Current clients include: ACOG, Coca-Cola, Delta. Professional affiliations: AIGA.

Needs: Approached by 100 freelancers/year. Works with 10 freelance illustrators and 25 designers/year. Uses illustrators mainly for high tech work. Uses designers mainly for package design. 75% of freelance work demands knowledge of Adobe Illustrator, Adobe Photoshop and QuarkXPress.

First Contact & Terms: Send postcard sample of work or send photographs, slides or transparencies and résumé. Send follow-up postcard every 6 months. Accepts disk submissions compatible with Adobe Illustrator 6.0. Samples are filed. Request portfolio review in original query. Will contact artist for portfolio review if interested. Portfolio should include b&w and color photocopies and photographs. Pays by the project, $25 minimum. Pays for illustration by the hour, $15-40. Rights purchased vary according to project. Finds artists through sourcebooks, agents and submissions.

Tips: Looks for team players with flexible attitudes who are able to meet tight deadlines.

ROKFALUSI DESIGN, 2953 Crosswycke Forest Circle, Atlanta GA 30319. (404)262-2561. Designer/Owner: J. Mark Rokfalusi. Estab. 1982. Number of employees: 1. Approximate annual billing: $100,000. Specializes in annual reports; display, direct mail, package and publication design; and technical illustration. Clients: ad agencies, direct clients, studios, reps. Current clients include Atlanta Market Center, Hewitt Associates, Stouffer Pine Isle Resort. Professional affiliations: AIGA.

Needs: Approached by 10-20 freelancers/year. Works with 1-5 freelance illustrators/year. Uses illustrators for almost all projects. Also uses freelancers for airbrushing, audiovisual materials, catalog illustration, charts/graphs, model making and retouching. Needs computer-literate freelancers for production and presentation. 50% of freelance work demands knowledge of Adobe Illustrator, Adobe Photoshop, Aldus FreeHand, Aldus PageMaker and QuarkXPress. Send brochure, résumé and tearsheets Samples are filed. Reports back to the artist only if interested. Request portfolio review in original query. Portfolio should include b&w and color final art, photographs, roughs, slides and transparencies. Pays for design and illustration by the project. Rights purchased vary according to project. Finds artists through sourcebooks, other publications, agents, submissions.

Tips: Impressed by "quality work, professional attitude. Do not call every week to see if there is anything coming up. I have a good memory and remember the right talent for the right project."

Hawaii

‡MILICI VALENTI NG PAC, 999 Bishop St., 2nd Floor, Honolulu HI 96813. (808)536-0881. Creative Director: Walter Wanger. Ad agency. Serves clients in food, finance, utilities, entertainment, chemicals and personal care products. Clients include First Hawaiian Bank, Aloha Airlines, Sheraton Hotels.

Needs: Works with 3-4 freelance illustrators/month. Artists must be familiar with advertising demands; used to working long distance through the mail; and be familiar with Hawaii. Uses freelance artists mainly for illustration, retouching and lettering for newspapers, multimedia kits, magazines, radio, TV and direct mail.

First Contact & Terms: Send brochure, flier and tearsheets to be kept on file for future assignments. Pays $200-2,000.

ERIC WOO DESIGN, INC., 733 Bishop St., Suite 1280, Honolulu HI 96813. (808)545-7442. Fax: (808)545-7445. E-mail: woostuff@pixi.com. Principal: Eric. Estab. 1985. Number of employees: 1.5. Approximate annual billing: 500,000. Design firm. Specializes in image development, packaging, print. Specializes in state/corporate. Current clients include BHP Hawaii, State of Hawaii. Client list available upon request.

Needs: Approached by 5-10 illustrators and 10 designers/year. Works with 1-2 illustrators/year. Prefers freelancers with experience in multimedia. Uses freelancers mainly for multimedia projects and lettering. 5% of work is with print ads. 90% of design demands skills in Aldus PageMaker 6.0, Adobe Photoshop, Adobe Illustrator.

First Contact & Terms: Designers send query letter with brochure, photocopies, photographs, résumé, slides and tearsheets. Illustrators send postcard sample of work or query letter with brochure, photocopies, photographs, photostats, résumé, slides, tearsheets, transparencies. Send follow-up postcard samples every 1-2 months. Accepts submissions on disk in above software. Samples are filed. Does not report back. Artist should call. Will contact for portfolio review of final art, photographs, photostats, roughs, slides, tearsheets, thumbnails and transparencies. Pays for design by the hour, $12-25. Pays for illustration by the project. Rights purchased vary according to project.

Tips: "Design and draw constantly. Have a good sense of humor."

Illinois

‡ARTONWEB, P.O. Box 1160, Wayne IL 60184-1160. (630)289-6262. E-mail: sbastian@artonweb.com. Website: http://www.artonweb.com. Owner: Thomas Sebastian. Estab. 1996. Number of employees: 10. Integrated marketing

communications agency and internet service. Specializes in website design and marketing. Current clients include Design Strategies, Creative FX. Client list available upon request.

Needs: Approached by 12 illustrators and 12 designers/year. Works with 2-3 illustrators and 1-2 designers/year. Uses freelancers mainly for design and computer illustration. Also for humorous illustration, lettering, logos and web page design. 5% of work is with print ads. 90% of design and 70% of illustration demands knowledge of Adobe Photoshop, Adobe Illustrator, QuarkXPress.

First Contact & Terms: Send e-mail and follow-up postcard samples every 6 months. Accepts Mac-compatible disk submissions—floppy, Zip disk or CD-ROM. Samples are filed and are not returned. Does not report back. Artist should contact via e-mail. Will contact artist for portfolio review if interested. Pays by the project. Negotiates rights purchased. Finds freelancers through *Black Book*, creative sourcebooks, Web.

‡BEDA DESIGN, 26179 Tarvin Lane, Ingleside IL 60041. Phone/fax: (847)973-1719. President: Lynn Beda. Estab. 1971. Number of employees: 2-3. Approximate annual billing: $250,000. Design firm. Specializes in collateral, P.O.P., publishing, film and video. Product specialties are food and auto industries. Current clients include business to business accounts. Client list available upon request.

Needs: Approached by 6-12 illustrators and 6-12 designers/year. Works with 6 illustrators and 6 designers/year. Prefers local freelancers. Also for retouching, technical illustration and production. 50% of work is with print ads. 75% of design demands skills in Adobe Photoshop, QuarkXPress 3.3, Adobe Illustrator.

First Contact & Terms: Designers send query letter with brochure, photocopies and résumé. Illustrators send postcard samples and/or photocopies. Samples are filed and are not returned. Will contact for portfolio review if interested. Pays $250-1,000. Buys all rights. Finds artists through word of mouth.

BENTKOVER'S DESIGN & MORE, 1222 Cavell, Suite 3C, Highland Park IL 60035. (847)831-4437. Fax: (847)831-4462. Creative Director: Burt Bentkover. Estab. 1989. Number of employees: 2. Approximate annual billing: $100,000. Specializes in annual reports; ads, package and brochure design. Clients: business-to-business, foodservice.

Needs: Works with 3 freelance illustrators/year. Works with artist reps. Prefers local artists only. Uses freelancers for ad and brochure illustration, airbrushing, lettering, mechanicals, retouching and desktop mechanicals. 80% of freelance work demands computer skills.

First Contact & Terms: Send brochure, photocopies and tearsheets. No original art—only disposable copies. Samples are filed. Reports back in 1 week if interested. Request portfolio review in original query. Will contact artist for portfolio review if interested. Portfolio should include b&w and color photocopies. "No final art or photographs." Pays for design and illustration by the project. Rights purchased vary according to project. Finds artists through sourcebooks and agents.

BRAGAW PUBLIC RELATIONS SERVICES, 800 E. Northwest Hwy., Palatine IL 60067. (847)934-5580. Fax: (847)934-5596. Principal: Richard S. Bragaw. Number of employees: 3. PR firm. Specializes in newsletters and brochures. Clients: professional service firms, associations and industry. Current clients include Arthur Andersen, Kaiser Precision Tooling, Inc. and Nykiel-Carlin and Co. Ltd.

Needs: Approached by 12 freelancers/year. Works with 2 freelance illustrators and 2 designers/year. Prefers local freelancers only. Works on assignment only. Uses freelancers for direct mail packages, brochures, signage, AV presentations and press releases. 90% of freelance work demands knowledge of Aldus PageMaker. Needs editorial and medical illustration.

First Contact & Terms: Send query letter with brochure to be kept on file. Reports back only if interested. Pays by the hour, $25-75 average. Considers complexity of project, skill and experience of artist and turnaround time when establishing payment. Buys all rights.

Tips: "We do not spend much time with portfolios."

JOHN CROWE ADVERTISING AGENCY, INC., 2319½ N. 15th St., Springfield IL 62702-1226. Phone/fax: (217)528-1076. President: Bryan J. Crowe. Ad/art agency. Number of employees: 3. Approximate annual billing: $250. Specializes in industries, manufacturers, retailers, banks, publishers, insurance firms, packaging firms, state agencies, aviation and law enforcement agencies. Product specialty is creative advertising. Current clients include US West Direct, Fitness America.

Needs: Approached by 250-300 freelancers/year. Works with 10-15 freelance illustrators and 2-5 designers/year. Works on assignment only. Uses freelancers for color separation, animation, lettering, paste-up and type specing for work with consumer magazines, stationery design, direct mail, slide sets, brochures/flyers, trade magazines and newspapers. Especially needs layout, camera-ready art and photo retouching. Needs technical illustration. Prefers pen & ink, airbrush, watercolor and marker. 75% of freelance design and 25% of illustration demand computer skills.

First Contact & Terms: "Send a letter to us with photocopies of your work regarding available work at agency. Tell us about yourself. We will reply if work is needed and request additional samples of work." Reports back in 2 weeks. Pays for design and illustration by the hour, $15-25. Originals not returned. No payment for unused assigned illustrations.

Tips: "Current works are best. Show your strengths and do away with poor pieces that aren't your stonghold. A portfolio should not be messy and cluttered. There has been a notable slowdown across the board in our use of freelance artists."

‡DESIGN RESOURCE CENTER, 1979 N. Mill, Suite 208, Naperville IL 60565. (708)357-6008. Fax: (708)357-6040. E-mail: drc1@ix.netcom.com. Website: http://designresource.com. President: John Norman. Estab. 1990. Number

of employees: 5. Approximate annual billing: $400,000. Specializes in package design and display, brand and corporate identity. Clients: corporations, manufacturers, private label.

Needs: Approached by 5-10 freelancers/year. Works with 3-5 freelance illustrators and 3-5 designers/year. Uses illustrators mainly for illustrating artwork for scanning. Uses designers mainly for Macintosh or concepts. Also uses freelancers for airbrushing; brochure, poster and P-O-P design and illustration; lettering; logos; and package design. Needs computer-literate freelancers for design, illustration and production. 100% of freelance work demands knowledge of Adobe Illustrator 5.0, Aldus FreeHand 4.0 and QuarkXPress.

First Contact & Terms: Send query letter with brochure, photocopies, photographs and résumé. Samples are filed. Does not report back. Artist should follow up. Portfolio review sometimes required. Portfolio should include b&w and color final art, photocopies, photographs, photostats, roughs and thumbnails. Pays for design by the hour, $10-30. Pays for illustration by the project. Buys all rights. Finds artists through word of mouth, referrals.

‡IDENTITY CENTER, 1350 Remington Rd, Suite A, Schaumburg IL 60173-4822. President: Wayne Kosterman. Number of employees: 3. Approximate annual billing: $250,000. Specializes in brand and corporate identity, print communications and signage. Clients: corporations, hospitals, manufacturers and banks. Professional affiliations: AIGA, American Center for Design, SEGD.

Needs: Approached by 40-50 freelancers/year. Works with 4 freelance illustrators and 4 designers/year. Prefers 3-5 years of experience minimum. Uses freelancers for editorial and technical illustration, mechanicals, retouching and lettering. 50% of freelance work demands knowledge of QuarkXPress, Photoshop and Adobe Illustrator.

First Contact & Terms: Designers send résumé and photocopies. Illustrators send postcard samples, color photocopies or other non-returnable samples. To show a portfolio, send photocopies or e-mail. Do not send samples you need back without checking with us first. Pays for design by the hour, $12-35. Pays for illustration by the project, $200-5,000. Considers client's budget, skill and experience of artist and how work will be used when establishing payment. Rights purchased vary according to project.

Tips: "Not interested in amateurs or 'part-timers.'"

‡INNOVATIVE DESIGN & GRAPHICS, 1234 Sherman Ave., Suite 214, Evanston IL 60202-1375. (847)475-7772. E-mail: idgemail@sprintmail.com. Contact: Tim Sonder. Clients: magazine publishers, corporate communication and marketing departments.

Needs: Works with 1-5 freelance artists/year. Prefers local artists only. Uses artists for editorial and technical illustration and desktop (CorelDraw, FreeHand, Adobe Illustrator).

First Contact & Terms: Send query letter with résumé or brochure showing art style, tearsheets, photostats, slides and photographs. Will contact artist for portfolio review if interested. Pays for design by the hour, $15-35. Pays for illustration by the project, $200-1,000 average. Considers complexity of project, client's budget and turnaround time when establishing payment. Interested in buying second rights (reprint rights) to previously published work.

Tips: "Interested in meeting new illustrators, but have a tight schedule. Looking for people who can grasp complex ideas and turn them into high-quality illustrations. Ability to draw people well is a must. Do not call for an appointment to show your portfolio. Send non-returnable tearsheets or self-promos, and we will call you when we have an appropriate project for you."

QUALLY & COMPANY INC., 2238 Central St., Suite 3, Evanston IL 60201-1457. (847)864-6316. Creative Director: Robert Qually. Specializes in integrated marketing/communication and new product development. Clients: major corporations.

Needs: Works with 20-25 freelancers/year. "Freelancers must have talent and the right attitude." Works on assignment only. Uses freelancers for design, illustration, mechanicals, retouching, lettering and computer graphics.

First Contact & Terms: Send query letter with brochure, résumé, business card and samples. Samples not filed are returned by SASE. Reports back within several days. Call or write for appointment to show portfolio.

Tips: Looking for "talent, point of view, style, craftsmanship, depth and innovation" in portfolio or samples. Sees "too many look-alikes, very little innovation."

Chicago

ACCESS, INC., 1301 W. Chicago Ave., Suite 200, Chicago IL 60622-5706. (312)226-1390. E-mail: pollacks@idt.net. Art Director: Bob Goldberg. Estab. 1991. Number of employees: 7. Approximate annual billing: $2 million. Visual agency. Specializes in film and print ads, image strategy, children's development, animation. Product specialties are auto, children's, consumer/food, beverage, cosmetic, furniture. Current clients include Kraft Foods, American Crew, Creative Balloons, Nickelodeon, Johnson Controls, Novistar.

Needs: Approached by 15 freelance illustrators and 5 designers/year. Works with 6 freelance illustrators and 20 designers/year. Prefers local designers with experience in children and food-related design. Uses freelancers mainly for concept, work in process. Also for animation, brochure design, mechanicals, multimedia projects, retouching, technical illustration, TV/film graphics. 70% of work is with print ads. 100% of design and 30% of illustration demand skills in Photoshop, Quark, Illustrator, SoftImage, Alias, SGI.

First Contact & Terms: Designers send query letter with samples. Illustrators send postcard sample and/or query

letter with photocopies. Accepts disk submissions. Samples are filed or returned by SASE. Will contact for portfolio review if interested. Pays for design by the hour, $15-75. Pays for illustration by the project, $100-2,500. Rights purchased vary according to project. Finds artists through agents, sourcebooks, AIGA.
Tips: "Be innovative, push the creativity, understand the business rationale and accept technology."

‡THE CHESTNUT HOUSE GROUP INC., 1980 Berkeley Rd., Highland Park IL 60035. (847)831-0757. Fax: (847)831-2527. E-mail: chestnuthouse@compuserve.com or mileszim@interaccess.com. Contact: Miles Zimmerman. Clients: major educational publishers.
Needs: Illustration, layout and electronic page production. Needs computer-literate freelancers for production. Uses experienced freelancers only. Freelancers should be familiar with QuarkXPress and various drawing and painting programs for illustrators. Pays for production by the hour. Pays for illustration by the project.
First Contact & Terms: "Illustrators submit samples."

CHICAGO COMPUTER AND LIGHT, INC., 5001 N. Lowell Ave., Chicago IL 60630-2610. (773)283-2749. Fax: (773)283-9972. E-mail: ccl@wwa.com. President: Larry Feit. Estab. 1987. Number of employees: 3. Approximate annual billing: $200,000. Multi-faceted advertising, marketing, design and manufacturing corporation. Product specialty is consumer.
Needs: Approached by 6 illustrators and 6 designers/year. Works with 3 illustrators and 2 designers/year. Uses freelancers mainly for billboards, brochure design and illustration, catalog design and illustration, logos, mechanicals, posters, retouching, signage, web page design. 70% of freelance work demands computer skills.
First Contact & Terms: Send query letter with tearsheets and/or samples. Accepts 3.5″ disk submissions in any viewable IBM format. Samples are filed and are not returned. Will contact for portfolio review of color tearsheets, thumbnails, transparencies if interested. Pays by the project, $30-3,500. Rights purchased vary according to project.
Tips: Looking for simple design that leaves a lasting impression. Likes Rockwell-type illustrations.

DeFRANCESCO/GOODFRIEND, 444 N. Michigan Ave., Suite 1000, Chicago IL 60611. (312)644-4409. Fax: (312)644-7651. E-mail: johnde@dgpr.com. Partner: John DeFrancesco. Estab. 1985. Number of employees: 8. Approximate annual billing: $1 million. PR firm. Full-service multimedia firm. Specializes in marketing, communication, publicity, direct mail, brochures, newsletters, trade magazine ads, AV presentations. Product specialty is consumer home products. Current clients include S-B Power Tool Co., Northern Trust Co., Wells Lamont, Ace Hardware Corp., Promotional Products Association International. Professional affiliations: Chicago Direct Marketing Association, Sales & Marketing Executives of Chicago, Public Relations Society of America, Publicity Club of Chicago.
Needs: Approached by 15-20 freelancers/year. Works with 2-5 freelance illustrators and 2-5 designers/year. Works on assignment only. Uses freelancers mainly for brochures, ads, newsletters. Also for print ad design and illustration, editorial and technical illustration, mechanicals, retouching and logos. 90% of freelance work demands computer skills.
First Contact & Terms: Send query letter with brochure and résumé. Samples are filed. Does not report back. Request portfolio review in original query. Artist should call within 1 week. Portfolio should include printed pieces. Pays for design and illustration by the project, $50 minimum. Rights purchased vary according to project. Finds artists through word of mouth and queries.
Tips: "Many new people are opening shop and you need to keep your name in front of your prospects."

✔DESIGN MOVES, LTD., 660 LaSalle Place, Suite 202, Highland Park IL 60035. (847)433-4313. Fax: (847)433-4314. E-mail: laurie@designmoves.com. Website: http://www.designmoves.com. Principal: Laurie Medeiros Freed. Estab. 1988. Number of employees: 3. Specializes in design for annual reports, corporate literature, corporate identity, packaging, advertising and the World Wide Web. Current clients include Humana Healthcare, Microsoft Corp. and the Chicago Park District. Professional affiliations: AIGA, WID, ACD, NAWBO.
Needs: Approached by 5-10 freelancers/year. Works with 3-5 freelance illustrators and 1-3 designers/year. Works on assignment only. Uses freelancers for lettering, Internet design, poster illustration and design, direct mail design and charts/graphs. Freelance work requires knowledge of HTML Macromedia Director, Adobe Illustrator, QuarkXPress and Adobe Photoshop.
First Contact & Terms: Send query letter with brochure, résumé and tearsheets. Samples are filed or are returned by SASE if requested. Request portfolio review in original query. Reports back to the artist only if interested. Portfolio should include thumbnails, tearsheets, photographs and transparencies. Pays for design by the hour, $20-30. Pays for illustration by the project. Rights purchased vary according to project.

HIRSCH O'CONNOR DESIGN INC., 205 W. Wacker Dr., Suite 622, Chicago IL 60606. (312)329-1500. President: David Hirsch. Number of employees: 11. Specializes in annual reports, corporate identity, publications and promotional literature. Clients: manufacturing, PR, real estate, financial and industrial firms. Professional affiliations: American Center for Design, AIGA and IABC.
Needs: Approached by more than 100 freelancers/year. Works with 6-10 freelance illustrators and 4-8 designers/year. Uses freelancers for design, illustration, brochures, retouching, airbrushing, AV materials, lettering, logos and photography. Freelancers should be familiar with Adobe Photoshop and Adobe Illustrator.
First Contact & Terms: Send query letter with promotional materials showing art style or samples. Samples not filed are returned by SASE. Reports back only if interested. Call for appointment to show portfolio of roughs, final reproduction/product, tearsheets and photographs. Pays for design and illustration by the project. Considers complexity of project,

client's budget and how work will be used when establishing payment. Interested in buying second rights (reprint rights) to previously published work. Finds artists primarly through sourcebooks and self-promotions.
Tips: "We're always looking for talent at fair prices."

HUTCHINSON ASSOCIATES, INC., 1147 W. Ohio, Suite 305, Chicago IL 60622. (312)455-9191. Fax: (312)455-9190. E-mail: hutch@hutchinson.com. Website: http://www.hutchinson.com. Contact: Jerry Hutchinson. Estab. 1988. Number of employees: 3. Specializes in annual reports, corporate identity, multimedia, direct mail, publication design and web page design. Clients: corporations, associations and PR firms. Professional affiliations: AIGA, ACD.
Needs: Approached by 5-10 freelancers/year. Works with 3-10 freelance illustrators and 5-15 designers/year. Uses freelancers mainly for brochure design, illustration, annual reports, multimedia and web designs. Also uses freelancers for ad and direct mail design, catalog illustration, charts/graphs, logos and mechanicals. Also for multimedia projects.
First Contact & Terms: Send postcard sample of work or send query letter with résumé, brochure, photocopies and photographs. Accepts disk submissions compatible with Adobe Illustrator and Director. Samples are filed. Request portfolio review in original query. Artist should follow-up with call. Will contact artist for portfolio review if interested. Portfolio should include transparencies and printed pieces. Pays by the project, $100-10,000. Rights purchased vary according to project. Finds artists through *Creative Illustration, Workbook*, sourcebooks, Illinois reps, submissions.
Tips: "Persistence pays off."

KAUFMAN RYAN STRAL INC., 650 N. Dearborn St., Suite 700, Chicago IL 60610. (312)467-9494. Fax: (312)467-0298. E-mail: big@bworld.com. Website: http://www.bworld.com. President/Creative Director: Robert Ryan. Estab. 1993. Number of employees: 7. Ad agency. Specializes in all materials in print and website development. Product specialty is business-to-business. Client list available upon request. Professional affiliations: BMA, American Israel Chamber of Commerce.
Needs: Approached by 30 freelancers/year. Works with 6 freelance illustrators and 5 designers/year. Prefers local freelancers only. Uses freelancers for design, production, illustration and computer work. Also for brochure, catalog and print ad design and illustration; animation; mechanicals; retouching; model making; posters; lettering; and logos. 30% of work is with print ads. 50% of freelance work demands knowledge of QuarkXPress, html programs FrontPage or Page Mill, Adobe Photoshop or Adobe Illustrator.
First Contact & Terms: Send query letter with résumé and photostats. Samples are filed or returned by SASE. Reports back only if interested. Artist should follow-up with call and/or letter after initial query. Will contact artist for portfolio review if interested. Portfolio should include b&w and color roughs and final art. Pays for design by the hour, $35-75; or by the project. Pays for illustration by the project, $75-8,000. Buys all rights. Finds artists through sourcebooks, word of mouth, submissions.

‡MEYER/FREDERICKS & ASSOCIATES, 333 N. Michigan Ave., #1300, Chicago IL 60601. (312)782-9722. Fax: (312)782-1802. Estab. 1972. Number of employees: 15. Ad agency, PR firm. Full-service, multimedia firm.
Needs: Prefers local freelancers only. Freelancers should be familiar with Adobe Photoshop 3.0, QuarkXPress 3.31 and Adobe Illustrator 5.
First Contact & Terms: Send query letter with samples. Will contact artist for portfolio review if interested.

MSR ADVERTISING, INC., P.O. Box 10214, Chicago IL 60610-0214. (312)573-0001. Fax: (312)573-1907. E-mail: marc@msradv.com. Website: http://msradu.com. President: Marc S. Rosenbaum. Art Director: Margaret Wilkins. Estab. 1983. Number of employees: 6. Approximate annual billing: $2.5 million. Ad agency. Full-service multimedia firm. Specializes in collateral. Product specialties are medical, food, industrial and aerospace. Current clients include Baxter Healthcare, Mama Tish's, Pizza Hut, hospitals, healthcare, Helene Curtis, Colgate-Palmolive.
● MSR opened a Tampa, Florida office at the end of 1996 and has new clients including insurance agencies, law firms and an engineering firm interested in growing their identities in the marketplace.
Needs: Approached by 6-10 freelancers/year. Works with 5-10 freelance illustrators and 5-10 designers/year. Prefers local artists who are "innovative, resourceful and hungry." Works on assignment only. Uses freelancers mainly for creative through boards. Also for brochure, catalog and print ad design and illustration; multimedia; storyboards; mechanicals; billboards; posters; lettering; and logos. 30% of work is with print ads. 75% of design and 25% of illustration demand computer skills.
First Contact & Terms: Send query letter with brochure, photographs, photocopies, slides, SASE and résumé. Accepts submissions on disk. Samples are filed or returned. Reports back within 1-2 weeks. Write for appointment to show portfolio or mail appropriate materials: thumbnails, roughs, finished samples. Artist should follow up with call. Pays for design by the hour, $45-95. Buys all rights. Finds artists through submissions and agents.
Tips: "We maintain a relaxed environment designed to encourage creativity; however, work must be produced timely and accurately. Normally the best way for a freelancer to meet with us is through an introductory letter and a follow-up phone call a week later. Repeat contact every 2-4 months. Be persistent and provide outstanding representation of your work."

THE QUARASAN GROUP, INC., 214 W. Huron St., Chicago IL 60610-3613. (312)787-0750. President: Randi S. Brill. Project Manager: Jean LoGrasso. Specializes in educational products. Clients: educational publishers. Client list not available.
Needs: Approached by 400 freelancers/year. Works with 700-900 illustrators/year. Freelancers with publishing experi-

ence preferred. Uses freelancers for illustration, books, mechanicals, charts/graphs, lettering and production. Needs computer-literate freelancers for illustration. 50% of freelance illustration work demands knowledge of Adobe Illustrator, QuarkXPress, Photoshop or Aldus FreeHand. Needs editorial, technical, medical and scientific illustration.

First Contact & Terms: Send query letter with brochure or résumé and samples addressed to ASD to be circulated and to be kept on file. Prefers "anything that we can retain for our files: photostats, photocopies, tearsheets, disks or dupe slides that do not have to be returned" as samples. Reports only if interested. Pays for illustration by the piece/project, $40-2,000 average. Considers complexity of project, client's budget, how work will be used and turnaround time when establishing payment. "For illustration, size and complexity are the key factors."

Tips: "Our publishers continue to require us to use only those artists willing to work on a work-for-hire basis. This may change in time, but at present, this is a requirement."

TESSING DESIGN, INC., 3822 N. Seeley Ave., Chicago IL 60618. (312)525-7704. Fax: (312)525-7756. E-mail: tess46@aol.com. Principals: Arvid V. Tessing and Louise S. Tessing. Estab. 1975. Number of employees: 2. Specializes in corporate identity, marketing promotions and publications. Clients: publishers, educational institutions and nonprofit groups. Majority of clients are publishers. Professional affiliation: Women in Design.

Needs: Approached by 30-80 freelancers/year. Works with 5 freelance illustrators and 2 designers/year. Works on assignment only. Uses freelancers mainly for publications. Also for book and magazine design and illustration, mechanicals, retouching, airbrushing, charts/graphs and lettering. 90% of design and 75% of illustration demand knowledge of QuarkXPress, Adobe Photoshop or Adobe Illustrator. Needs textbook, editorial and technical illustration.

First Contact & Terms: Designers send query letter with photocopies. Illustrators send postcard samples. Samples are filed and are not returned. Request portfolio review in original query. Artist should follow up with letter after initial query. Will contact artist for portfolio review if interested. Portfolio should include original/final art, final reproduction/product and photographs. Pays for design by the hour, $40-60. Pays for illustration by the project, $100 minimum. Rights purchased vary according to project. Finds artists through word of mouth, submissions/self-promotions and sourcebooks.

Tips: "We prefer to see original work or slides as samples. Work sent should always relate to the need expressed. Our advice for artists to break into the field is as always—call prospective clients, show work and follow up."

‡ZÜNDESIGN INCORPORATED, 520 N. Michigan Ave., #424, Chicago IL 60611. (312)494-7788. Fax: (312)494-9988. E-mail: zun@interaccess.com. Partners: William Ferdinand and David Philmee. Estab. 1991. Number of employees: 5. Specializes in annual reports, brand and corporate identity, capability brochures, package and publication design, electronic and interactive. Clients: from Fortune 500 to new upstart companies. Current clients include Ameritech, Arthur Andersen, Harris Bank, Motorola, Sara Lee and Sears. Client list available upon request. Professional affiliations: AIGA, ACD.

Needs: Approached by 30 freelancers/year. Works with 10-15 freelance illustrators and 15-20 designers/year. Looks for strong personal style (local and national). Uses illustrators mainly for editorial. Uses designers mainly for design and layout. Also uses freelancers for colateral and identity design, illustration; web, video, audiovisual materials; direct mail, magazine design and lettering; logos; and retouching. Needs computer-literate freelancers for design, illustration, production and presentation. 90% of freelance work demands knowledge of Adobe Illustrator, Adobe Photoshop, QuarkXPress and Director.

First Contact & Terms: Send postcard sample of work or send query letter with brochure or résumé. Samples are filed. Reports back to the artist only if interested. Portfolios may be dropped off every Friday. Artist should follow-up. Portfolio should include b&w and color samples. Pays for design by the hour and by the project. Pays for illustration by the project. Rights purchased vary according to project. Finds artists through reference books and submissions.

Tips: Impressed by "to the point portfolios. Show me what you like to do, and what you brought to the projects you worked on. Don't fill a book with extra items (samples) for sake of showing quantity."

Indiana

‡C.R.E. INC., 400 Victoria Centre, 22 E. Washington St., Indianapolis IN 46204. (317)631-0260. Website: http://www.cremarcom.com. VP/Creative Director: Mark Gause. Senior Art Directors: Rich Lunseth and Sean Cunat. Number of employees: 40. Approximate annual billing: $16 million. Ad agency. Specializes in business-to-business, transportation products and services, computer equipment, biochemicals and electronics. Clients: primarily business-to-business.

Needs: Approached by 50 freelancers/year. Works with 15 freelance illustrators and 2 designers/year. Works on assignment only. Uses freelancers for technical line art, color illustrations and airbrushing; also for multimedia, primarily CD-ROM and Internet applications. 100% of freelance design and 25% of illustration demand computer skills.

MARKET CONDITIONS are constantly changing! If you're still using this book and it is 2000 or later, buy the newest edition of *Artist's & Graphic Designer's Market* at your favorite bookstore or order directly from Writer's Digest Books (1-800-289-0963).

First Contact & Terms: Send query letter with résumé and photocopies. Accepts disk submissions. Samples not filed are returned. Reports back only if interested. Call or write for appointment to show portfolio, or mail final reproduction/product and tearsheets. Pays by the project, $100 minimum. Buys all rights.
Tips: "Show samples of good creative talent."

‡CALDWELL VAN RIPER, INC. ADVERTISING-PUBLIC RELATIONS, Dept. AM, 1314 N. Meridian St., Indianapolis IN 46202. (317)632-6501. Creative Director: Brian Hadlock. Ad agency/PR firm. Clients are a "good mix of consumer (banks, furniture, food, etc.) and industrial (chemicals, real estate, insurance, heavy industry)."
Needs: Assigns 100-200 jobs/year. Works with 1-2 illustrators/2 months. Works on assignment only. Uses freelancers for newspaper and magazine ads, billboards, direct mail packages, brochures, catalogs, P-O-P displays, storyboards, AV presentations and posters.
First Contact & Terms: Send query letter with brochure, samples and tearsheets to be kept on file. Call for appointment to show portfolio. Accepts any available samples. Samples not filed are returned by SASE only if requested. Reports only if interested. Pay is negotiated. Buys all rights.
Tips: "Send five samples of best work (copies acceptable) followed by a phone call."

JMH CORPORATION, 921 E. 66th St., Indianapolis IN 46220. (317)255-3400. Website: http://jmhdesign.com. President: J. Michael Hayes. Number of employees: 3. Specializes in annual reports, corporate identity, advertising, collateral, packaging, publications and website development. Clients: publishers, consumer product manufacturers, corporations and institutions. Professional affiliations: AIGA.
Needs: Approached by 30-40 freelancers/year. Works with 5 freelance illustrators and 2 designers/year. Prefers experienced, talented and responsible freelancers only. Works on assignment only. Uses freelancers for advertising, brochure and catalog design and illustration; P-O-P displays; mechanicals; retouching; charts/graphs and lettering. Needs editorial and medical illustration. 100% of design and 30% of illustration demand knowledge of QuarkXPress, Adobe Illustrator or Adobe Photoshop (latest versions).
First Contact & Terms: Send query letter with brochure/flyer, résumé, photocopies, photographs, tearsheets and slides. Accepts disk submissions compatible with QuarkXPress 3.11 and Adobe Illustrator 5.0. Send EPS files. Samples returned by SASE, "but we prefer to keep them." Reporting time "depends entirely on our needs." Write for appointment to show portfolio. Pays for design by the hour, $20-50, or by the project, $100-1,000. Pays for illustration by the project, $300-2,000.
Tips: "Prepare an outstanding mailing piece and 'leave-behind' that allows work to remain on file. Keep doing great work and stay in touch." Advises freelancers entering the field to "send samples regularly. Call to set a portfolio presentation. Do great work. Be persistent. Love what you do. Have a balanced life."

‡OMNI PRODUCTIONS, 12955 Old Meridan St., P.O. Box 302, Carmel IN 46032. (317)848-3456. E-mail: winston @omniproductions.com. Website: http://omniproductions.com. President: Winston Long. Estab. 1987. AV firm. Full-service, multimedia firm. Specializes in video, Intranet, CD-ROM and Internet. Current clients include "a variety of industrial clients, international."
Needs: Works on assignment only. Uses freelancers for brochure design and illustration, storyboards, slide illustration, animation, and TV/film graphics. Needs computer-literate freelancers for design, illustration and production. Most of freelance work demands computer skills.
First Contact & Terms: Send résumé. Samples are filed and are not returned. Artist should follow-up with call and/or letter after initial query. Pays be the project. Finds artists through agents, word of mouth and submissions.

Kansas

AWESOME ADVERTISING & MARKETING, 9875 Widmer, Lenexa KS 66215. (913)888-3466. Fax: (913)888-3467. Executive Director: Elizabeth Allen. Estab. 1994. Approximate annual billing: $500,000. Ad agency, marketing firm. Specializes in collateral, media buying, retail.
Needs: Approached by 75 illustrators and 200 designers/year. Works with 50 illustrators and 50 designers/year. Uses freelancers for all work including billboards, brochure design and illustration, catalog design and illustration, humorous illustration, lettering, logos, mechanicals, model making, multimedia projects, posters, signage, storyboards, technical illustration, TV/film graphics, web page design. 85% of work is with print ads. 100% of freelance work demands knowledge of Aldus PageMaker, Aldus FreeHand, Adobe Photoshop, Adobe Illustrator, QuarkXPress.
First Contact & Terms: Designers send query letter with brochure, photocopies and résumé. Illustrators send postcard sample of work. Samples are filed and are not returned. Reports back only if interested. Art director will contact designer for portfolio review of b&w, color, final art, thumbnails if interested. Payment depends on the project and the type of designer. Rights purchased vary according to project.
Tips: "Artists should have flexible attitudes, pay prompt attention to deadlines."

GRETEMAN GROUP, 142 N. Mosley, 3rd Floor, Wichita KS 67202-4617. (316)263-1004. Fax: (316)263-1060. E-mail: greteman@gretemangroup.com. Website: http://www.gretemangroup.com. Owner: Sonia Greteman. Estab. 1989. Number of employees: 9. Approximate annual billing: $2.1 million. Design firm. Specializes in corporate identity,

annual reports, signage, website design, interactive media, brochures, collateral. Professional affiliations: AIGA.
Needs: Approached by 2 illustrators and 10-20 designers/year. Works with 2 illustrators and 2 designers/year. Also for brochure illustration. 10% of work is with print ads. 100% of design demands skills in Aldus PageMaker, Aldus FreeHand, Adobe Photoshop, QuarkXPress, Adobe Illustrator. 30% of illustration demands computer skills.
First Contact & Terms: Send query letter with brochure and résumé. Accepts disk submissions. Send EPS files. Samples are filed. Will contact for portfolio review of b&w and color final art and photostats if interested. Pays for design by the hour. Pays for illustration by the project. Rights purchased vary according to project.

WP POST & GRAPHICS, 228 Pennsylvania, Wichita KS 67214-4149. (316)263-7212. Fax: (316)263-7539. E-mail: wppost@aol.com. Art Director: Bob Abraham. Estab. 1968. Number of employees: 4 full- and 2 part-time. Ad agency, design firm, video production/animation. Specializes in TV commercials, print advertising, animation, web design, packaging. Product specialties are automative, broadcast, furniture, restaurants. Current clients include Rusty Eck Ford, The Wichita Eagle, Dick Edwards Auto Plaza, Samantha's Home Ideas, Turner Tax Wise. Client list available upon request. Professional affiliations: Advertising Federation of Wichita.
 • Recognized by the American Advertising Federation of Wichita for excellence in advertising.
Needs: Approached by 2 illustrators and 10 designers/year. Works with 1 illustrator and 2 designers/year. Prefers local designers with experience in Macintosh production, video and print. Uses freelancers mainly for overflow work. Also for animation, brochure design and illustration, catalog design and illustration, logos, TV/film graphics, web page design and desktop production. 10% of work is with print ads. 100% of freelance work demands knowledge of Adobe Photoshop, Aldus FreeHand and QuarkXPress.
First Contact & Terms: Designers send query letter with résumé and self-promotional sheet. Illustrators send postcard sample of work or query letter with résumé. Send follow-up postcard samples every 3 months. Accepts disk submissions if compatible with Macintosh formatted, Photoshop 4.0, FreeHand 7.0, or an EPS file. Samples are filed and are not returned. Reports back only if interested. Art director will contact artist for portfolio review of b&w, color, final art, illustration if interested. Pays by the project. Rights purchased vary according to project and are negotiable. Finds artists through local friends and coworkers.
Tips: "Be creative, be original, and be able to work with different kinds of people."

Kentucky

HAMMOND DESIGN ASSOCIATES, INC., 206 W. Main, Lexington KY 40507. (606)259-3639. Fax: (606)259-3697. Vice-President: Mrs. Kelly Johns. Estab. 1986. Specializes in direct mail, package and publication design and annual reports, brand and corporate identity, display and signage. Clients: corporations, universities and medical facilities.
Needs: Approached by 35-50 freelance/year. Works with 5-7 illustrators and 5-7 designers/year. Works on assignment only. Uses freelancers mainly for brochures and ads. Also for editorial, technical and medical illustration; airbrushing; lettering; P-O-P and poster illustration; and charts/graphs. 100% of design and 50% of illustration require computer skills.
First Contact & Terms: Send postcard sample or query letter with brochure or résumé. "Sample in query letter a must." Samples are filed or returned by SASE if requested by artist. Reports back only if interested. Will contact artist for portfolio review if interested. Sometimes requests work on spec before assigning job. Pays by the project, $100-10,000. Rights negotiable.

MENDERSON & MAIER, INC., 1001 Second Ave., Dayton KY 41074-1205. (606)491-2880. Fax: (606)491-7980. E-mail: menderson@fuse.net. Website: http://home.fuse.net/menderson. Art Director: Barb Phillips. Estab. 1954. Number of employees: 5. Full-service ad agency in all aspects of media. Professional affiliations: Cincinnati Ad Club.
 • This art director predicts there will be more catalog and brochure work.
Needs: Approached by 15-30 freelancers/year. Works with 5-10 freelance illustrators and 5-10 designers/year. Prefers local artists only. Uses freelancers mainly for editorial, technical, fashion and general line illustrations and production. Also for brochure, catalog and print ad design and illustration; slide illustration; mechanicals; retouching; and logos. Prefers mostly b&w art, line or wash. 85% of freelance work demands knowledge of Aldus PageMaker 6.0, Photoshop 3.0, Aldus FreeHand 5.0 or 7.0 and Word 5.0. 50% of work is with print ads.
First Contact & Terms: Contact only through artist rep. Send résumé and photocopies. Samples are filed and are not returned. Will contact artist for portfolio review if interested. Artist should follow up with call. Portfolio should include b&w and color photostats, tearsheets, final reproduction/product and photographs. Sometimes requests work on spec before assigning a job. Pays for design by the hour, or by the project. Pays for illustration by the project. Considers complexity of project and client's budget when establishing payment. Buys all rights. Finds artists through résumés and word of mouth.
Tips: The most effective way for a freelancer to get started in advertising is "by any means that build a sample portfolio. Have a well-designed résumé and nice samples of work whether they be illustrations, graphic design or logo design."

WILLIAMS McBRIDE DESIGN, INC., 344 E. Main St., Lexington KY 40507. (606)253-9319. Fax: (606)233-0180. Partners: Robin Williams Brohm and Kimberly McBride. Estab. 1988. Number of employees: 13. Design firm specializing in annual reports, corporate identity and publications. Clients: health care, manufacturing, software. Client list available upon request.

Needs: Approached by 7-10 freelance artists/year. Works with 4 illustrators and 2 designers/year. Prefers freelancers with experience in corporate design, branding. Works on assignment only. Uses designers mainly for concept sketches. Uses illustrators for annual reports, brochure design and illustration, logos, mechnicals and technical illustrations. Needs computer-literate freelancers for design and illustration. 50% of freelance design work demands knowledge of QuarkXPress, Adobe Photoshop and Adobe Illustrator.

First Contact & Terms: Designers send query letter with résumé, tearsheets or photocopies. Illustrators send postcard sample of work. Accepts disk submissions compatible with Macintosh QuarkXPress 3.32 V5, EPS or TIFF. PC also acceptable. Samples are filed. Reports back only if interested. Pays for design by the hour, $25-60. Pays for illustration by the project, $100-3,500. Rights purchased vary according to project. Finds artists through submissions, word of mouth, *Creative Black Book*, *Workbook* and *American Showcase*.

Tips: "Keep our company on your mailing list; remind us that you are out there, and understand the various rights that can be purchased."

Louisiana

ANTHONY DI MARCO, 301 Aris Ave., New Orleans LA 70005. (504)833-3122. Creative Director: Anthony Di Marco. Estab. 1972. Number of employees: 1. Specializes in illustration, sculpture, costume design and art photo restoration and retouching. Current clients include Audubon Institute, Louisiana Nature and Science Center, Fair Grounds Race Course, City of New Orleans, churches, agencies. Client list available upon request. Professional affiliations: Art Directors, Designers Association; Energy Arts Council; Louisiana Crafts Council; Louisiana Alliance for Conservation of Arts.

● Anthony DiMarco recently completed the re-creation of a 19th century painting, *Life on the Metairie*, for the Fair Grounds racetrack. The original painting was destroyed by fire in 1993.

Needs: Approached by 50 or more freelancers/year. Works with 5-10 freelance illustrators and 5-10 designers/year. Seeks "local freelancers with ambition. Freelancers should have substantial portfolios and an understanding of business requirements." Uses freelancers mainly for fill-in and finish: design, illustration, mechanicals, retouching, airbrushing, posters, model making, charts/graphs. Prefers highly polished, finished art in pen & ink, airbrush, charcoal/pencil, colored pencil, watercolor, acrylic, oil, pastel, collage and marker. 25% of freelance work demands computer skills.

First Contact & Terms: Send query letter with résumé, business card, slides, brochure, photocopies, photographs, transparencies and tearsheets to be kept on file. Samples not filed are returned by SASE. Reports back within 1 week if interested. Call or write for appointment to show portfolio. Pays for illustration by the hour or by the project, $100 minimum.

Tips: "Keep professionalism in mind at all times. Put forth your best effort. Apologizing for imperfect work is a common mistake freelancers make when presenting a portfolio. Include prices for completed works (avoid overpricing). Three-dimensional works comprise more of our total commissions than before."

PETER O'CARROLL ADVERTISING, 710 W. Prien Lake Rd., Suite 209, Lake Charles LA 70601. (318)478-7396. Fax: (318)478-0503. E-mail: ocarroll@laol.net. Website: http://www.ocarroll.com. Art Director: Kathlene Deaville. Estab. 1978. Ad agency. Specializes in newspaper, magazine, outdoor, radio and TV ads. Product specialty is consumer. Current clients include Players Island Casino, First Federal Savings, Lake Charles Ice Pirates and Cellular One. Client list available upon request.

Needs: Approached by 1 freelancer/month. Works with 1 illustrator every 3 months. Prefers freelancers with experience in computer graphics. Works on assignment only. Uses freelancers mainly for time-consuming computer graphics. Also for brochure and print ad illustration and storyboards. 65% of work is with print ads. 50% of freelance work demands knowledge of Adobe Illustrator and Adobe Photoshop.

First Contact & Terms: Send query letter with résumé, transparencies, photographs, slides and tearsheets. Samples are filed or returned by SASE if requested. Reports back to the artist only if interested. Will contact artist for portfolio review if interested. Portfolio should include color roughs, final art, tearsheets, slides, photostats and transparencies. Pays for design by the project, $30-300. Pays for illustration by the project, $50-275. Rights purchased vary according to project. Find artists through viewing portfolios, submissions, word of mouth, American Advertising district conferences and conventions.

Maine

THE DW COMMUNICATIONS GROUP, (formerly Designwrights Inc.), P.O. Box 1150 Main St., Blue Hill ME 04614-1150. (207)374-5400. Fax: (207)374-2417. E-mail: kmurphy@dwgroup.com. Creative Director: Kyle C. Murphy. Estab. 1985. Number of employees: 12. Approximate annual billing: $2 million. Integrated marketing communications agency. Product specialties are healthcare, education and banking. Current clients include Outward Bound and Harvard. Professional affiliations: G.A.G., Portland Art Director Club, Boston Ad Club and Portland Ad Club.

Needs: Approached by 10 illustrators and 10 designers/year. Works with 5 illustrators and 2 designers/year. Uses freelancers mainly for illustration. Also for airbrushing, catalog, humorous, medical and technical illustration, model

making, multimedia projects, signage, storyboards, signage and TV/film graphics. 25% of work is with print ads. 100% of design demands skills in Adobe Photoshop, Adobe Illustrator and QuarkXPress.

First Contact & Terms: Designers send query letter with brochure, photographs, résumé, slides, tearsheets and transparencies. Illustrators send postcard sample and query letter with brochure, photographs, résumé, slides, tearsheets and transparencies. Send follow-up postcard every 6 months. Accepts disk submissions compatible with Mac formats. Samples are filed. Reports back only if interested. Art director will contact artist for portfolio review of b&w and color photographs, roughs, slides, tearsheets and transparencies if interested. Pays for design by the hour, $35-55; pays for illustration by the project, $50-2,500. Rights purchased vary according to project. Finds artists through word of mouth.

MICHAEL MAHAN GRAPHICS, 48 Front, P.O. Box 642, Bath ME 04530-0642. (207)443-6110. Fax: (207)443-6085. E-mail: m2design@ime.net. Contact: Linda Delorme. Estab. 1986. Number of employees: 5. Approximate annual billing: $400,000. Design firm. Specializes in publication design—catalogs and direct mail. Product specialties are furniture, fine art and high tech. Current clients include Bowdoin College, Bath Iron Works and Newport Data. Client list available upon request. Professional affiliations: G.A.G., AIGA and Art Director's Club-Portland, ME.

Needs: Approached by 5-10 illustrators and 10-20 designers/year. Works with 2 illustrators and 2 designers/year. Uses freelancers mainly for production. Also for brochure, catalog and humorous illustration and lettering. 5% of work is with print ads. 100% of design demands skills in Adobe Photoshop and QuarkXPress.

First Contact & Terms: Designers send query letter with photocopies and résumé. Illustrators send query letter with photocopies. Accepts disk submissions. Samples are filed and are not returned. Reports back only if interested. Art director will contact artist for portfolio review of final art roughs and thumbnails if interested. Pays for design by the hour, $15-40. Pays for illustration by the hour, $18-60. Rights purchased vary according to project. Finds artists through word of mouth and submissions.

Maryland

‡AVRUM I. ASHERY—GRAPHIC DESIGNER, 5901 Montrose Rd., #S-1101, Rockville MD 20852. (301)984-0142. Estab. 1968. Number of employees: 2 (part time). Specializes in brand identity, corporate identity (logo), exhibit, publication design and signage. "Specialty is Judaic design for synagogues, Jewish organizations/institutions." Current clients include U.S. Committee for Sports in Israel, Temple Emanuel Hebrew Day Institute, Jewish federations (many cities), Washington Hebrew Confederation, Masorti (conservative movement in Israel), Embassy of Israel, B'nai B'rith International. Professional affiliations: Federal Design Council, Artsites Guild for Judaic Arts.

Needs: Approached by 2-3 freelancers/year. Works with 2-3 freelance illustrators and 2-3 designers/year. Prefers artists with experience in "all around illustration." Uses designers mainly for work overload (logos). Also uses freelancers for brochure design, logos and model making. Needs computer-literate freelancers for production. 20% of freelance work demands knowledge of Adobe Illustrator, Adobe Photoshop and Aldus PageMaker.

First Contact & Terms: Send postcard sample of work or send tearsheets. Samples are filed. Will contact artist for portfolio review if interested. Portfolio should include b&w and color final art and thumbnails. Pays for design and illustration by the hour or by the project. Rights purchased vary according to project. Finds artists through word of mouth.

Tips: Does not want a "trendy designer/illustrator. Have a specialty or developing interest in Judaic themes for design." Advises freelancers entering the field to "have a healthy ego. Make sure you know what constitutes good, effective, well-balanced, readable visuals. Knowing many software packages does not make a professional designer."

‡SAM BLATE ASSOCIATES, 10331 Watkins Mill Dr., Montgomery Village MD 20886-3950. (301)840-2248. Fax: (301)990-0707. E-mail: samblate@bellatlantic.net. President: Sam Blate. Number of employees: 2. Approximate annual billing: $90,000. AV and editorial services firm. Clients: business/professional, US government, some private.

Needs: Approached by 6-10 freelancers/year. Works with 1-5 freelance illustrators and 1-2 designers/year. Only works with freelancers in the Washington DC metropolitan area. Works on assignment only. Uses freelancers for cartoons (especially for certain types of audiovisual presentations), editorial and technical illustrations (graphs, etc.) for 35mm slides, pamphlet and book design. Especially important are "technical and aesthetic excellence and ability to meet deadlines." 80% of freelance work demands knowledge of CorelDraw, Aldus PageMaker, Powerpoint or Harvard Graphics for Windows.

First Contact & Terms: Send query letter with résumé and tearsheets, brochure, photocopies, slides, transparencies or photographs to be kept on file. Accepts disk submissions compatible with CorelDraw and Aldus PageMaker. IBM format only. "No original art." Samples are returned only by SASE. Reports back only if interested. Pays by the hour, $20-40. Rights purchased vary according to project, "but we prefer to purchase first rights only. This is sometimes not possible due to client demand, in which case we attempt to negotiate a financial adjustment for the artist."

Tips: "The demand for technically oriented artwork has increased."

✔DEVER DESIGNS, INC., 1056 West St., Laurel MD 20707. (301)776-2812. Fax: (301)953-1196. President: Jeffrey Dever. Estab. 1985. Number of employees: 8. Approximate annual billing: $450,000. Specializes in annual reports, corporate identity and publication design. Clients: corporations, museums, government agencies, associations, nonprofit organizations. Current clients include Population Reference Bureau, University of Maryland, McGraw-Hill, National

Gallery of Art, American Institute of Architects, Washington Post. Client list available upon request.
● Dever Designs won 18 awards for Graphic Design in 1997 and the studio has won over 260.
Needs: Approached by 100 freelancers/year. Works with 30-50 freelance illustrators and 1-2 designers/year. Prefers artists with experience in editorial illustration. Uses illustrators mainly for publications. Uses designers mainly for on-site help when there is a heavy workload. Also uses freelancers for brochure illustration, charts/graphs and in-house production. 100% of design demands knowledge of QuarkXPress.
First Contact & Terms: Send postcard, samples or query letter with photocopies, résumé and tearsheets. Accepts disk submissions compatible with Adobe Illustrator or QuarkXPress, but prefers hard copy samples which are filed. Will contact artist for portfolio review if interested. Portfolio should include b&w and/or color photocopies for files. Pays for design and illustration by the project. Rights purchased vary according to project. Finds artists through referrals.
Tips: Impressed by "uniqueness and consistant quality."

DIRECT SOURCE ADVERTISING, (formerly Gerew Graphic Design), 4403 Wickford Rd., Baltimore MD 21210. (410)366-5424. Fax: (410)366-6123. Owner: Cynthia Gerew-Serfas. Estab. 1988. Number of employees: 3. Specializes in direct mail design. Clients: financial and insurance corporations.
Needs: Approached by 10-15 freelancers/year. Works with 4 freelance illustrators and 4 designers/year. Prefers artists with experience in drawing realistic people/family situations. Uses illustrators mainly for brochure illustration. Uses designers mainly for direct mail. Also uses freelancers for ad illustration, brochure design and illustration, charts/graphs, direct mail design, lettering, logos and mechanicals. Needs computer-literate freelancers for design, illustration and production. 90% of freelance work demands knowledge of Adobe Illustrator, Adobe Photoshop and QuarkXPress. "Very interested in finding graphic artists with direct mail experience—familiar with full-package design."
First Contact & Terms: Send postcard sample of work or send query letter. Will contact artist for portfolio review if interested. Portfolio should include color final art, photocopies, photographs, photostats and transparencies. Pays for design by the hour, $25-30. Pays for illustration by the project. Negotiates rights purchased. Finds artists through sourcebooks and local referrals.
Tips: Impressed by freelancers "who are not only talented, but also dependable."

NORTH LIGHT COMMUNICATIONS, 7100 Baltimore Ave., #307, College Park MD 20740. (301)864-2626. Fax: (301)864-2629. E-mail: brands@nlightcom.com. President: Bill Briggs. Vice President: Hal Kowenski. Estab. 1989. Number of employees: 12. Approximate annual billing: $15 million. Ad agency. Product specialties are business-to-business and consumer durables. Current clients include Egg Harbor Yachts, US Air, US Navy, Pacific Industries, American Institute of Physics, Chemical Manufacturing Assoc., Bruning Paint Co.
Needs: Approached by 6 freelancers/year. Works with 4 freelance illustrators and 6 designers/year. Prefers artists with agency background and experience in collateral. Uses freelancers for annual reports, brochure design and illustration, mechanicals, posters and signage. 20% of work is with print ads. 100% of design and 50% of illustration demand knowledge of Adobe Photoshop, QuarkXPress and Adobe Illustrator.
First Contact & Terms: Designers send query letter with brochure, photocopies, résumé and SASE. Illustrators send query letter with photocopies and SASE. Samples are filed are returned by SASE if requested by artist. Will contact artist for portfolio review if interested. Portfolio should include: b&w and color final art, tearsheets and thumbnails. Pays for design by the hour, $20-60 or by the day, $150-800. Pays for illustration by the project. Buys all rights. Finds artists through *Black Book*, *Sourcebook*, classified ads.

‡**PICCIRILLI GROUP**, 502 Rock Spring Rd., Bel Air MD 21014. (410)879-6780. Fax: (410)879-6602. E-mail: info@picgroup.com. Website: http://www.picgroup.com. President: Charles Piccirilli. Executive Vice President: Micah Piccirilli. Art Director: Bob Coe. Estab. 1974. Specializes in design and advertising; also annual reports, advertising campaigns, direct mail, brand and corporate identity, displays, packaging, publications and signage. Clients: recreational sport industries, fleet leasing companies, technical product manufacturers, commercial packaging corporations, direct mail advertising firms, realty companies, banks, publishers and software companies.
Needs: Works with 4 freelance designers/year. Works on assignment only. Mainly uses freelancers for layout or production. Prefers local freelancers. 75% of design demands knowledge of Adobe Illustrator 5.5 and QuarkXPress 3.3.
First Contact & Terms: Send query letter with brochure, résumé and tearsheets; prefers originals as samples. Samples returned by SASE. Reports on whether to expect possible future assignments. To show a portfolio, mail roughs and finished art samples or call for an appointment. Pays for design and illustration by the hour, $20-45. Considers complexity of project, client's budget, and skill and experience of artist when establishing payment. Buys one-time or reprint rights; rights purchased vary according to project.
Tips: "Portfolios should include work from previous assignments. The most common mistake freelancers make is not being professional with their presentations. Send a cover letter with photocopies of work."

✔**MARC SMITH CO., INC.**, 10 Luna Lane, Severna Park MD 21146. (410)647-2606. Art/Creative Director: Ed Smith. Number of employees: 3. Ad agency. Clients: consumer and industrial products.
Needs: Approached by 12 freelancers/year. Works with 3 freelance illustrators and 3 designers/year. Prefers local artists only. Uses freelancers for layout, lettering, technical art, type specing, paste-up and retouching. Also for illustration and design of direct mail, slide sets, brochures/flyers, trade magazines and newspapers; design of film strips, stationery, multimedia kits. Occasionally buys humorous and cartoon-style illustrations. Needs computer-literate freelancers for design, illustration and production. 50% of freelance work demands computer skills.

First Contact & Terms: Send query letter with brochure showing art style or tearsheets, photostats, photocopies, slides or photographs. Keeps file on artists. Originals not returned. Negotiates payment.

Tips: "More sophisticated techniques and equipment are being used in art and design. Our use of freelance material has intensified. Project honesty, clarity and patience."

✔**SPIRIT CREATIVE SERVICES INC.**, 3157 Rolling Rd., Edgewater MD 21037. (410)956-1117. Fax: (410)956-1118. E-mail: spiritcs@annapinfi.net. Website: http://www.annapinfi.net/~spiritcs/. President: Alice Yeager. Estab. 1992. Number of employees: 2. Approximate annual billing: $90,000. Specializes in annual reports; brand and corporate identity; display, direct mail, package and publication design; web page design; technical and general illustration; copywriting; photography and marketing; catalogs; signage; books. Clients: associations, corporations, government. Client list available upon request.

Needs: Approached by 5-10 freelancers/year. Works with 3-4 freelance illustrators and 4-5 designers/year. Prefers local designers. Uses freelancers for ad, brochure, catalog, poster and P-O-P design and illustration; book direct mail and magazine design; audiovisual materials; crafts/graphs; lettering; logos; mechanicals. Also for multimedia and Internet projects. 100% of design and 10% of illustration demand knowledge of Adobe Illustrator, Adobe Photoshop, and Adobe PageMaker. Also HTML coding for Web design.

First Contact & Terms: Send 2-3 samples of work with résumé. Accepts disk submissions compatible with Adobe Illustrator 5.0 to 6.0. Send EPS files. Samples are filed. Reports back within 1-2 weeks if interested. Request portfolio review in original query. Artist should follow-up with call and/or letter after initial query. Portfolio should include b&w and color final art, tearsheets, sample of comping ability. Pays for design by the project, $50-6,000. Pays for illustration by the project, $50 minimum. Rights purchased vary according to project.

Tips: "Paying attention to synchronicity and intuition is vital."

Massachusetts

‡**A.T. ASSOCIATES**, 63 Old Rutherford Ave., Charlestown MA 02129. (617)242-6004. Fax: (617)242-0697. Partner: Annette Tecce. Estab. 1976. Specializes in annual reports; industrial, interior, product and graphic design; model making; corporate identity; signage; display; and packaging. Clients: nonprofit companies, corporate clients, small businesses and ad agencies. Client list available upon request.

Needs: Approached by 20-25 freelance artists/year. Works with 3-4 freelance illustrators and 2-3 freelance designers/year. Prefers local artists; some experience necessary. Uses artists for posters, model making, mechanicals, logos, brochures, P-O-P display, charts/graphs and design.

First Contact & Terms: Send résumé and nonreturnable samples. Samples are filed or are returned by SASE if requested by artist; Reports back only if interested. Call to schedule an appointment to show a portfolio, which should include a "cross section of your work." Pays for design and illustration by the hour or by the project. Rights purchased vary according to project.

RICHARD BERTUCCI/GRAPHIC COMMUNICATIONS, 3 Juniper Lane, Dover MA 02030-2146. (508)785-1301. Fax: (500)785-2072. Owner: Richard Bertucci. Estab. 1970. Number of employees: 2. Approximate annual billing: $1 million. Specializes in annual reports; corporate identity; display, direct mail, package design, print advertising, collateral material. Clients: companies and corporations. Professional affiliations: AIGA.

Needs: Approached by 12-24 freelancers/year. Works with 6 freelance illustrators and 3 designers/year. Prefers local artists with experience in business-to-business advertising. Uses illustrators mainly for feature products. Uses designers mainly for fill-in projects, new promotions. Also uses freelancers for ad, brochure and catalog design and illustration; airbrushing; direct mail, magazine and newpaper design; logos; and mechanicals. 50% of design and 25% of illustration demand knowledge of Aldus FreeHand, Adobe Illustrator, CorelDraw and QuarkXPress.

First Contact & Terms: Send postcard sample of work or send query letter with brochure and résumé. Samples are filed. Will contact artist for portfolio review if interested. Portfolio should include b&w and color roughs. Pays for design by the project, $500-5,000. Pays for illustration by the project, $250-2,500. Rights purchased vary according to project.

Tips: "Send more information, not just postcard with no written information." Chooses freelancers based on "quality of samples, turn-around time, flexibility, price, location."

FLAGLER ADVERTISING/GRAPHIC DESIGN, Box 280, Brookline MA 02146. (617)566-6971. Fax: (617)566-0073. President/Creative Director: Sheri Flagler. Specializes in corporate identity, brochure design, ad campaigns and package design. Clients: finance, real estate, high-tech and direct mail agencies, infant/toddler manufacturers.

Needs: Works with 10-20 freelancers/year. Works on assignment only. Uses freelancers for illustration, photography, retouching, airbrushing, charts/graphs and lettering.

First Contact & Terms: Send résumé, business card, brochures, photocopies or tearsheets to be kept on file. Call or write for appointment to show portfolio. Samples not filed are not returned. Reports back only if interested. Pays for design and illustration by the project, $150-2,500. Considers complexity of project, client's budget and turnaround time when establishing payment.

Tips: "Send a range and variety of styles showing clean, crisp and professional work."

DAVID FOX (PHOTOGRAPHER), (formerly Foremost Communications), 59 Fountain St., Framingham MA 01701. (508)820-1130. Fax: (508)820-0558. E-mail: davidfox@virtmall.com. Website: http://www.virtmall.com/Davidfoxphotographer. President: David Fox. Estab. 1983. AV firm. Full-service photography and video firm. Specializes in training, marketing, sales, education and industrial. Product specialties are corporate and consumer. Current clients include Harlem Rockers, Staples, Inc., Laidlaw, American Heart Association.
- Even though this market accepts mostly photography, President David Fox remains interested in illustration for the growing needs of his company.

Needs: Approached by 0-1 freelancer/month. Works with 1-2 freelance illustrators and 1-2 designers/month. Works on assignment only. Uses freelancers mainly for logo designs and image presentation. Also for brochure, catalog and print ad design and illustration; storyboards; multimedia; animation; retouching. 10-20% of work is with print ads. 90% of freelance work demands knowledge of Adobe Illustrator and Photoshop.

First Contact & Terms: Send postcard sample or query letter with brochure, tearsheets, photographs, slides, transparencies and SASE. Accepts disk submissions compatible with Mac. Samples are filed. Does not report back. Artist should follow up. Call or write for appointment to show portfolio or mail b&w and color photographs and slides. Pays for design and illustration by the project. Buys all rights.

Tips: "Do not send original promos, slides, etc. We would prefer copies or dupes only. Work tends to be by assignment only. Most work we handle inhouse but occasionally use subcontractors."

DONYA MELANSON ASSOCIATES, 437 Main St., Boston MA 02129. Fax: (617)241-5199. E-mail: dma7300@aol.com. Contact: Donya Melanson. Advertising agency. Number of employees: 5. Clients: industries, institutions, education, associations, publishers, financial services and government. Current clients include: US Geological Survey, Mannesmann, Massachusetts Turnpike Authority, Security Dynamics, Writings of Mary Baker Eddy, Cambridge College, American Psychological Association and US Dept. of Agriculture. Client list available upon request.

Needs: Approached by 30 artists/year. Works with 3-4 illustrators/year. Most work is handled by staff, but may occasionally use illustrators and designers. Uses artists for stationery design, direct mail, brochures/flyers, annual reports, charts/graphs and book illustration. Needs editorial and promotional illustration. 50% of freelance work demands knowledge of Adobe Illustrator, QuarkXPress, Adobe Photoshop or Aldus FreeHand.

First Contact & Terms: Query with brochure, résumé, photostats and photocopies. Provide materials (no originals) to be kept on file for future assignments. Originals returned to artist after use only when specified in advance. Call or write for appointment to show portfolio or mail thumbnails, roughs, final art, final reproduction/product and color and b&w tearsheets, photostats and photographs. Pays for design and illustration by the project, $100 minimum. Considers complexity of project, client's budget, skill and experience of artist and how work will be used when establishing payment.

Tips: "Be sure your work reflects concept development. We would like to see more electronic design and illustration capabilities."

‡STEWART MONDERER DESIGN, INC., 10 Thacher St., Suite 112, Boston MA 02113. (617)720-5555. Senior Designer: Joe LaRoche. Estab. 1982. Specializes in annual reports, corporate identity, package and publication design, employee benefit programs, corporate cabability brochures. Clients: corporations (hi-tech, industry, institutions, healthcare, utility, consulting, service). Current clients include Aspen Technology, Vivo Software, Voicetek Corporation, Pegasystems and Millipore. Client list not available.

Needs: Approached by 200 freelancers/year. Works with 5-10 freelance illustrators and 1-5 designers/year. Works on assignment only. Uses illustrators mainly for corporate communications. Uses designers for design and production assistance. Also uses freelancers for mechanicals and illustration. Needs computer-literate freelancers for design, illustration and production. 50% of freelance work demands knowledge of Aldus PageMaker, Adobe Illustrator, QuarkXPress, Photoshop or Aldus FreeHand. Needs editorial and corporate illustration.

First Contact & Terms: Send query letter with brochure, tearsheets, photographs and photocopies. Samples are filed. Will contact artist for portfolio review if interested. Portfolio should include b&w and color-finished art samples. Sometimes requests work on spec before assigning a job. Pays for design by the hour, $10-25; by the project. Pays for illustration by the project, $250 minimum. Negotiates rights purchased. Finds artists through submissions/self-promotions and sourcebooks.

THE PHILIPSON AGENCY, 241 Perkins St., Suite B201, Boston MA 02130. (617)566-3334. Fax: (617)566-3363. E-mail: tpa@ziplink.net. President and Creative Director: Joe Philipson. Marketing design firm. Specializes in packaging, collateral, P-O-P, corporate image, sales presentations, direct mail, business-to-business and high-tech.

Needs: Approached by 3-4 freelancers/month. Works with 4 illustrators and 3 designers/month. Prefers freelancers with experience in design, illustration, comps and production. Works on assignment only. Uses freelancers mainly for overflow and special jobs. Also for brochure, catalog and print ad design and illustration; packaging, multimedia, mechanicals, retouching, posters, lettering and logos. Needs editorial illustration. 65% of work is with print ads. 100% of design and 50% of illustration demand knowledge of PageMaker, Illustrator, QuarkXPress, Aldus FreeHand or Adobe Photoshop.

First Contact & Terms: Send postcard sample, query letter with brochure, tearsheets, photocopies, SASE, résumé. Samples are filed or are returned by SASE. Reports back to the artist only if interested. To show a portfolio, mail roughs, photostats, tearsheets, photographs and slides. Pays by the project. Buys all rights.

PRECISION ARTS ADVERTISING INC., 2 Narrows Rd., Suite 201, Westminster MA 01473-0740. (978)874-9944. Fax: (978)874-9943. E-mail: designs@paadv.com. Website: http://www.paadv.com. President: Terri Adams. Estab. 1985. Number of employees: 5. Ad agency. Specializes in trade ads, public relations, media marketing, web page design. Product specialty is industrial. Client list available upon request.
Needs: Approached by 5 freelance illustrators and 5 designers/year. Works with 1 freelance illustrator and 1 designer/year. Prefers local freelancers. 40% of work is with print ads. 50% of freelance work demands knowledge of Adobe Photoshop 4, QuarkXPress, 4, Adobe Illustrator 6.0.
First Contract & Terms: Send query letter with photocopies and résumé. Accepts disk submissions. Samples are not filed and are returned by SASE. Reports back only if interested.

RUBY SHOES STUDIO, INC., 12A Mica Lane, Wellesley MA 02181-1702. (617)431-8686. Website: http://www.ru byshoes.com. Creative Director: Susan Tyrrell Donelan. Estab. 1984. Number of employees: 12. Specializes in corporate identity, direct mail, website design, package and publication design. Client list available upon request.
Needs: Approached by 150-300 freelancers/year. Works with 10-20 freelance illustrators and 10-20 designers/year. Uses freelance illustrators mainly for brochure illustration. Uses freelance designers mainly for ad design and mechanicals. Also uses freelancers for brochure and P-O-P design and illustration, 3-D design, mechanicals, airbrushing, lettering, logos, poster and direct mail design and graphs. Freelancers should be familiar with Adobe Illustrator, Photoshop, QuarkXPress, and/or 3-D Design.
First Contact & Terms: Send query letter with nonreturnable samples, such as tearsheets and résumé. Samples are filed or are returned by SASE. Reports back to the artist only if interested. To show a portfolio, mail roughs, original/final art, b&w and color tearsheets and slides. Pays for design by the hour, $20-30; by the project, $150-1,500. Pays for illustration by the project. Buys first or one-time rights.

‡TR PRODUCTIONS, 1031 Commonwealth Ave., Boston MA 02215. (617)783-0200. Fax: (617)783-4844. Creative Director: Cary M. Benjamin. Estab. 1947. Number of employees: 12. AV firm. Full-service multimedia firm. Specializes in slides, collateral, AV shows and video.
Needs: Approached by 15 freelancers/year. Works with 5 freelance illustrators and 5 designers/year. Prefers local freelancers with experience in slides and collateral. Works on assignment only. Uses freelancers mainly for slides, collateral. Also for brochure and print ad design and illustration, slide illustration, animation and mechanicals. 25% of work is with print ads. Needs computer-literate freelancers for design, production and presentation. 95% of work demands knowledge of Aldus FreeHand, Adobe Photoshop, Microsoft Powerpoint, Aldus Persuasion, QuarkXPress or Adobe Illustrator.
First Contact & Terms: Send query letter. Samples are filed. Does not report back. Artist should follow-up with call. Will contact artist for portfolio review if interested. Rights purchased vary according to project.

‡TVN-THE VIDEO NETWORK, 31 Cutler Dr., Ashland MA 01721-1210. (508)881-1800. E-mail: tvnvideo@aol.c om. Website: http://www.tvnvideo.com. Producer: Gregg McAllister. Estab. 1986. AV firm. Full-service multimedia firm. Specializes in video production for business, broadcast and special events. Product specialties "cover a broad range of categories." Current clients include Marriott, Digital, IBM, Waters Corp., National Park Service.
Needs: Approached by 1 freelancer/month. Works with 1 illustrator/month. Prefers freelancers with experience in Mac/NT, Amiga PC, The Video Toaster, 2D and 3D programs. Works on assignment only. Uses freelancers mainly for video production, technical illustration, flying logos and 3-D work. Also for storyboards, animation, TV/film graphics and logos.
First Contact & Terms: Send query letter with videotape or computer disk. Samples are filed or are returned. Reports back within 2 weeks. Will contact artist for portfolio review if interested. Portfolio should include videotape and computer disk (Amiga). Pays for design by the hour, $50; by the project, $1,000-5,000; by the day, $250-500. Buys all rights. Finds artists through word of mouth, magazines and submissions.
Tips: Advises freelancers starting out in the field to find a company internship or mentor program.

WEYMOUTH DESIGN, INC., 332 Congress St., Boston MA 02210-1217. (617)542-2647. Fax: (617)451-6233. E-mail: weymouth@usa1.com. Website: http://www.weymouth@USA1.com. Office Manager: Judith Bentari. Estab. 1973. Number of employees: 16. Specializes in annual reports, corporate collateral, designing home pages, CD-ROMs and miscellaneous multimedia. Clients: corporations and small businesses. Client list not available. Professional affiliation: AIGA.
Needs: Approached by "tons" of freelancers/year. Works with 3-5 freelance illustrators/year. 100% of design demands knowledge of QuarkXPress. Prefers freelancers with experience in corporate annual report illustration. Works on assignment only. Needs editorial, medical and technical illustration mainly for annual reports. Also uses freelancers for brochure and poster illustration and multimedia projects.
First Contact & Terms: Send query letter with résumé or illustration samples and/or tearsheets. Samples are filed or are returned by SASE if requested by artist. Will contact artist for portfolio review if interested. Pays for design by the hour, $30. Pays for illustration by the project; "artists usually set their own fee to which we do or don't agree." Rights purchased vary according to project. Finds artists through magazines and agents.
Tips: "Freelancers we use are for mechanicals and typesetting on Quark. It's all production—so skills are essentially important whether you're a beginner or not."

Michigan

‡**BIGGS GILMORE COMMUNICATIONS**, Suite 300, 100 W. Michigan Ave., Kalamazoo MI 49007. (616)349-7711. Fax: (616)349-3051. Website: http://www.biggs-gilmore.com. Creative Department Coordinator: Launa Rogers. Estab. 1973. Ad agency. Full-service, multimedia firm. Specializes in magazine and newspaper ads and collateral. Product specialties are consumer, business-to-business, marine and healthcare.
 • This is one of the largest agencies in southwestern Michigan. Clients include Upjohn, Sea Ray Boats and Kellogg.
Needs: Approached by 10 artists/month. Works with 1-3 illustrators and designers/month. Works both with artist reps and directly with artist. Prefers artists with experience with client needs. Works on assignment only. Uses freelancers mainly for completion of projects needing specialties. Also for brochure, catalog and print ad design and illustration, storyboards, slide illustration, animatics, animation, mechanicals, retouching, billboards, posters, TV/film graphics, lettering and logos.
First Contact & Terms: Send query letter with brochure, photocopies and résumé. Samples are filed. Reports back to artists only if interested. Call for appointment to show portfolio. Portfolio should include all samples the artist considers appropriate. Pays for design and illustration by the hour and by the project. Rights purchased vary according to project.

‡**LEO J. BRENNAN, INC. Marketing Communications**, Suite 300, 2359 Livernois, Troy MI 48083-1692. Phone/fax: (810)362-3131. E-mail: vjanusis@ljbrennan.com or lbrennan@ljbrennan.com. Website: http://www.ljbrennan.com. Vice President: Virginia Janusis. Estab. 1969. Ad agency, PR and marketing firm. Clients: industrial, electronics, robotics, automotive, banks and CPAs.
Needs: Works with 2 illustrators and 2 designers/year. Prefers experienced artists. Uses freelancers for design, technical illustration, brochures, catalogs, retouching, lettering, keylining and typesetting. Also for multimedia projects. 50% of work is with print ads. 100% of freelance work demands knowledge of IBM software graphics programs.
First Contact & Terms: Send query letter with résumé and samples. Samples not filed are returned only if requested. Reports back to artist only if interested. Call for appointment to show portfolio of thumbnails, roughs, original/final art, final reproduction/product, color and b&w tearsheets, photostats and photographs. Payment for design and illustration varies. Buys all rights.

‡**COMMUNICATIONS ELECTRONICS, INC.**, Dept AM, Box 2797, Ann Arbor MI 48106-2797. (734)996-8888. E-mail: ken@cyberspace.org. Editor: Ken Ascher. Estab. 1969. Number of employees: 38. Approximate annual billing: $2 million. Manufacturer, distributor and ad agency (13 company divisions). Specializes in marketing. Clients: electronics, computers.
Needs: Approached by 500 freelancers/year. Works with 40 freelance illustrators and 40 designers/year. Uses freelancers for brochure and catalog design, illustration and layout; advertising; product design; illustration on product; P-O-P displays; posters; and renderings. Needs editorial and technical illustration. Prefers pen & ink, airbrush, charcoal/pencil, watercolor, acrylic, marker and computer illustration. 30% of freelance work demands knowledge of Aldus PageMaker or QuarkXPress.
First Contact & Terms: Send query letter with brochure, résumé, business card, samples and tearsheets to be kept on file. Samples not filed are returned by SASE. Reports within 1 month. Will contact artist for portfolio review if interested. Pays for design and illustration by the hour, $10-120; by the project, $10-15,000; by the day, $40-800.

CREATIVE HOUSE ADVERTISING INC., Suite 301, 30777 Northwestern Hwy., Farmington Hills MI 48334. (248)737-7077. E-mail: washburn@creativechai.com. Executive Vice President/Creative Director: Robert G. Washburn. Estab. 1964. Advertising/marketing/promotion graphics/display/art firm. Clients: residential and commercial construction, land development, consumer, retail, finance, manufacturing.
Needs: Assigns 20-30 jobs; buys 10-20 illustrations/year. Works with 6 illustrators and 4 designers/year. Prefers local artists. Uses freelancers for work on filmstrips, consumer and trade magazines, multimedia kits, direct mail, television, slide sets, brochures/flyers and newspapers. Most of work involves illustration, design and comp layouts of ads, brochures, catalogs, annual reports and displays. 50-60% of work is with print ads.
First Contact & Terms: Query with résumé, business card and brochure/flier to be kept on file. Artist should follow up with call. Samples returned by SASE. Reports in 2 weeks. Originals not returned. Call or write for appointment to show portfolio of originals, reproductions and published pieces. Pays for design by the hour, $25-45; by the day, $240-400; or by the project. Pays for illustration by the project, $200-50,000. Considers complexity of project, client's budget and rights purchased when establishing payment. Reproduction rights are purchased as a buy-out.
Tips: "Flexibility is a necessity; do not send too much of the same style or technique. Have an outgoing friendly attitude. Provide quality, service and price."

VARON & ASSOCIATES, INC., 31333 Southfield, Beverly Hills MI 48025. (248)645-9730. Fax: (248)642-1303. President: Shaaron Varon. Estab. 1963. Specializes in annual reports; brand and corporate identity; display, direct mail and package design; and technical illustration. Clients: corporations (industrial and consumer). Current clients include Dallas Industries Corp., Enprotech Corp., FEC Corp., Johnstone Pump Corp., Microphoto Corp., PW & Associates. Client list available upon request.
Needs: Approached by 20 freelancers/year. Works with 7 illustrators and 7 designers/year. Prefers local freelancers

only. Works on assignment only. Uses freelancers mainly for brochure, catalog, P-O-P and ad design and illustration; direct mail design; mechanicals; retouching; airbrushing; audiovisual materials; and charts/graphs. Needs computer-literate freelancers for design, illustration and presentation. 70% of freelance work demands knowledge of Aldus Page-Maker, QuarkXPress, Aldus FreeHand or Adobe Illustrator.

First Contact & Terms: Send brochure, samples, slides and transparencies. Samples are filed. Reports back to the artist only if interested. Portfolios may be dropped off every Monday-Friday. Portfolio should include color thumbnails, roughs, final art and tearsheets. Buys all rights. Finds artists through submissions.

Minnesota

LUIS FITCH DESIGN, 3131 Excelsior Blvd., Suite 206, Minneapolis MN 55416. (612)929-1439. E-mail: luis@fitchd esign.com. Website: http://www.fitchdesign.com. Creative Director: Luis Fitch. Estab. 1990. Number of employees: 6. Approximate annual billing: $890,000. Specializes in brand and corporate identity; display, package and retail design; and signage. Clients: Latin American corporations, retail. Current clients include MTV Latino, Target, Mervyn's, 3M, Daytons. Client list available upon request. Professional affiliations: AIGA, GAG.

Needs: Approached by 33 freelancers/year. Works with 40 freelance illustrators and 20 designers/year. Works only with artists reps. Prefers local artists with experience in retail design, graphics. Uses illustrators mainly for packaging. Uses designers mainly for retail graphics. Also uses freelancers for ad and book design; brochure, catalog and P-O-P design and illustration; audiovisual materials; logos and model making. Also for multimedia projects (Interactive Kiosk, CD-Educational for Hispanic Market). 60% of design demands computer skills in Adobe Illustrator, Adobe Photoshop, Aldus FreeHand and QuarkXPress.

First Contact & Terms: Designers send postcard sample, brochure, résumé, photographs, slides, tearsheets and transparencies. Illustrators send postcard sample, brochure, photographs, slides and tearsheets. Accepts disk submissions compatible with Adobe Illustrator, Adobe Photoshop, Aldus FreeHand. Send EPS files. Samples are filed. Will contact artist for portfolio review if interested. Portfolio should include color final art, photographs and slides. Pays for design by the project, $500-6,000. Pays for illustration by the project, $200-20,000. Rights purchased vary according to project. Finds artists through artist reps, *Creative Black Book* and *Workbook*.

Tips: It helps to be bilingual and to have an understanding of Hispanic cultures.

PATRICK REDMOND DESIGN, P.O. Box 75430-AGDM, St. Paul MN 55175-0430. (612)646-4254. Designer/Owner/President: Patrick M. Redmond, M.A. Estab. 1966. Number of employees: 1. Specializes in book and/or book cover design; logo and trademark design; brand and corporate identity; package, publication and direct mail design; design consulting and education; and posters. Has provided design services for more than 120 clients in the following categories: publishing, advertising, marketing, retail, financial, food, arts, education, computer, manufacturing, small business, health care, government and professions. Recent clients include: Norwest, Mid-List Press, Hauser Artists, Bend & Ellingson and others.

Needs: Approached by 300 freelancers/year. Works with 2-4 freelance illustrators and 2-4 designers/year (some years more of both, depending on client needs). Uses freelancers mainly for editorial and technical illustration, publications, books, brochures and newsletters. Also for multimedia projects. 70% of freelance work demands knowledge of Macintosh, QuarkXPress, Adobe Photoshop, Adobe Illustrator, Aldus FreeHand (latest versions).

First Contact & Terms: Send postcard sample, brochure, and/or photocopies. Also "send us quarterly mailings/updates; a list of three to four references; a rate sheet/fee schedule." Samples not filed are thrown away. No samples returned. Reports back only if interested. "Artist will be contacted for portfolio review if work seems appropriate for client needs. Patrick Redmond Design will not be responsible for acceptance of delivery or return of portfolios not specifically requested from artist or rep. Samples must be presented in person unless other arrangements are made. Unless specifically agreed to in writing in advance, portfolios should not be sent unsolicited." Pays for design and illustration by the project. Rights purchased vary according to project. Considers buying second rights (reprint rights) to previously published work. Finds artists through word of mouth, magazines, submissions/self-promotions, exhibitions, competitions, CD-ROM, sourcebooks, agents and WWW. Provide e-mail address and URL.

Tips: "I see trends toward more use of WWW and a broader spectrum of approaches to images, subject matter and techniques. Clients also seem to have increasing interest in digitized, copyright-free stock images of all kinds." Advises freelancers starting out in the field to "create as much positive exposure for your images or design examples as possible. Make certain your name and location appear with image or design credits. Photos, illustrations and design are often noticed with serendipity. For example, your work may be just what a client needs—so make sure you have name credit."

TAKE I PRODUCTIONS, 5325 W. 74th St., Minneapolis MN 55439. (612)831-7757. Fax: (612)831-2193. Producer: Rob Hewitt. Estab. 1985. Number of employees: 10. Approximate annual billing: $800,000. AV firm. Full-service multimedia firm. Specializes in video and multimedia production. Specialty is industrial. Current clients include 3M, NordicTrack and Kraft. Client list available upon request. Professional affiliations: ITVA, SME, IICS.

Needs: Approached by 100 freelancers/year. Works with 10 freelance illustrators/year. Prefers freelancers with experience in video production. Uses freelancers for graphics, sets. Also for animation, brochure design, logos, model making, signage and TV/film graphics. 2% of work is with print ads. 90% of freelance work demands knowledge of Adobe Photoshop and Lightwave.

First Contact & Terms: Send query letter with video. Samples are filed. Will contact artist for portfolio review if interested. Pays for design and illustration by the hour or by the project. Rights purchased vary according to project. Finds artists through sourcebooks, word of mouth.
Tips: "Tell me about work you have done with videos."

Missouri

ANGEL FILMS COMPANY, 967 Hwy. 40, New Franklin MO 65274-9778. Phone/fax: (573)698-3900. E-mail: angelfilm@aol.com. Vice President of Marketing/Advertising: Linda G. Grotzinger. Estab. 1980. Number of employees: 9. Approximate annual billing: more than $10 million. Ad agency, AV firm, PR firm. Full-service multimedia firm. Specializes in "all forms of television and film work plus animation (both computer and art work)." Product specialties are feature films, TV productions, cosmetics. Current clients include Azian, Mesn, Angel One Records.
Needs: Approached by 100 freelancers/year. Works with 10 freelance illustrators and 10 designers/year. Prefers freelancers with experience in graphic arts and computers. Works on assignment only. Uses freelancers mainly for primary work ("then we computerize the work"). Also for brochure and print ad design and illustration, storyboards, animation, model making, posters and TV/film graphics. 45% of work is with print ads. 50% of freelance work demands knowledge of Adobe Illustrator, Adobe Photoshop or CorelDraw.
First Contact & Terms: Send query letter with résumé and SASE. Samples are filed. Reports back within 6 weeks. Will contact artist for portfolio review if interested. Portfolio should include b&w and color slides and computer disks (IBM). Pays for design and illustration by the hour, $9 minimum. Buys all rights.
Tips: "You can best impress us with what you can do now not what you did ten years ago. Times change; the way people want work done changes also with the times. Disney of today is not the same as Disney of ten or five years ago."

INTELPLEX, 12215 Dorsett Rd., Maryland Heights MO 63043. (314)739-9996. Owner: Alan E. Sherman. Estab. 1953. Specializes in corporate identity, display design and package design and signage. Clients: manufacturers. Client list not available.
Needs: Works with 3 freelance designers/year. "We prefer persons with a good grasp of technical issues." Works on assignment only. Uses illustrators mainly for product illustration. Also uses freelance artists for catalog design and illustration, mechanicals, airbrushing, logos and ad design. Needs computer-literate freelancers for design and production. 50% of freelance work demands knowledge of QuarkXPress or AutoCAD.
First Contact & Terms: Send query letter. Samples are filed or are returned. Does not report back. Will contact artist for portfolio review if interested. Portfolio should include final art. Pays for design and illustration by the project. Buys all rights. Finds artists through submissions and references.

MEDIA CONSULTANTS, P.O. Box 130, Sikeston MO 63801. (314)472-1116. Fax: (314)472-3299. E-mail: media@1 dd.net. President: Rich Wrather. Estab. 1981. Number of employees: 10. Ad agency, AV and PR firm. Full-service multimedia firm. Specializes in print, magazines, AV. Product specialty is business-to-business. Client list not available.
Needs: Appoached by 25 freelancers/year. Works with 10-15 freelance illustrators and 5-10 designers/year. Works on assignment only. Uses freelancers mainly for layout and final art. Also for brochure, catalog and print ad design and illustration; storyboards; animation; billboards; TV/film graphics; and logos. 40% of work is with print ads. Needs computer-literate freelancers for design, illustration, production and presentation. 100% of freelance work demands knowledge of Aldus PageMaker, Aldus FreeHand or Adobe Photoshop.
First Contact & Terms: Send query letter with brochure, résumé, photocopies, photographs, SASE and tearsheets. Samples are filed. Will contact artist for portfolio review if interested. Portfolio should include b&w and color roughs, final art, tearsheets, photostats and photographs. Pays for design by the project, $150-1,000. Pays for illustration by the project, $25-250. Buys all rights. Finds artists through word of mouth.
Tips: Advises freelancers starting out to "accept low fees first few times to build a rapport. Put yourself on the buyer's side."

‡PHOENIX FILMS, 2349 Chaffee Dr., St. Louis MO 63146. (314)569-0211. E-mail: phoenixfilms@worldnet.att.net. President: Heinz Gelles. Vice President: Barbara Bryant. Number of employees: 50. Clients: libraries, museums, religious institutions, US government, schools, universities, film societies and businesses. Produces and distributes educational films.
Needs: Works with 1-2 freelance illustrators and 2-3 designers/year. Prefers local freelancers only. Uses artists for motion picture catalog sheets, direct mail brochures, posters and study guides. Also for multimedia projects. 85% of freelance work demands knowledge of Aldus PageMaker and QuarkXPress.
First Contact & Terms: Send postcard sample and query letter with brochure (if applicable). Send recent samples of artwork and rates to director of promotions. "No telephone calls please." Reports if need arises. Buys all rights. Keeps all original art "but will loan to artist for use as a sample." Pays for design and illustration by the hour or by the project. Rates negotiable. Free catalog upon written request.

SIGNATURE DESIGN, 2101 Locust, St. Louis MO 63103. (314)621-6333. Fax: (314)621-0179. Owner: Therese McKee. Estab. 1988. Specializes in graphic and exhibit design. Clients: museums, nonprofit institutions, corporations,

government agencies, botanical gardens. Current clients include Missouri Botanical Garden, U.S. Army Corps of Engineers, Monsanto Corporation, United States Post Office. Client list available upon request.
Needs: Approached by 15 freelancers/year. Works with 1-2 illustrators and 1-2 designers/year. Prefers local freelancers only. Works on assignment only. 50% of freelance work demands knowledge of Aldus PageMaker, QuarkXPress, Adobe Illustrator or Adobe Photoshop.
First Contact & Terms: Send query letter with résumé, tearsheets and photocopies. Samples are filed. Reports back to the artist only if interested. Artist should follow up with letter after initial query. Portfolio should include "whatever best represents your work." Pays for design by the hour. Pays for illustration by the project.

Montana

✔**WALKER DESIGN GROUP**, 47 Dune Dr., Great Falls MT 59404. (406)727-8115. Fax: (406)791-9655. President: Duane Walker. Number of employees: 6. Design firm. Specializes in annual reports and corporate identity. Professional affiliations: AIGA and Ad Federation.
Needs: Uses freelancers for animation, annual reports, brochure, medical and technical illustration, catalog design, lettering, logos and TV/film graphics. 80% of design and 90% of illustration demand skills in Aldus PageMaker, Adobe Photoshop and Adobe Illustration.
First Contact & Terms: Send query letter with brochure, photocopies, photographs, résumé, slides and/or tearsheets. Accepts disk submissions. Samples are filed and are not returned. Reports back only if interested. To arrange portfolio review, artist should follow-up with call or letter after initial query. Portfolio should include color photographs, photostats and tearsheets. Pays by the project; negotiable. Finds artists through *Workbook*.
Tips: "Stress customer service and be very aware of time lines."

Nebraska

✔**IDEA BANK MARKETING**, (formerly Portwood Martin Jones Advertising & Marketing, Inc.), 701 W. Second St., Hastings NE 68902-2117. (402)463-0588. Fax: (402)463-2187. E-mail: mail@ideabankmarketing.com. Website: http://www.ideabankmarketing.com. Creative Director: Sherma Jones. Estab. 1982. Number of employees: 7. Approximate annual billing: $1,000,000. Ad agency. Specializes in print materials, direct mail. Product specialty is manufacturers. Client list available upon request. Professional affiliations: Advertising Federation of Lincoln.
Needs: Approached by 2 illustrators/year. Works with 2 illustrators and 2 designers/year. Prefers local designers only. Uses freelancers mainly for illustration. Also for airbrushing, catalog and humorous illustration, lettering. 30% of work is with print ads. 75% of design demands knowledge of Adobe Photoshop, Adobe Illustrator, Aldus FreeHand. 60% of illustration demands knowledge of Aldus FreeHand, Adobe Photoshop, Adobe Illustrator.
First Contact & Terms: Designers and illustrators send query letter with brochure. Send follow-up postcard samples every 6 months. Accepts disk submissions compatible with original illustration files or Photoshop files. Samples are filed or returned by SASE. Reports back only if interested. Will contact artist for portfolio review of b&w, color, final art, tearsheets if interested. Pays by the project. Rights purchased vary according to project and are negotiable. Finds artists through word of mouth.

STUDIO GRAPHICS, 7337 Douglas St., Omaha NE 68114. (402)397-0390. Fax: (402)558-3717. Owner: Leslie Hanson. Number of employees: 1. Approximate annual billing: $85,000. Specializes in corporate identity, displays, direct mail, packaging, publications and signage. Clients: agencies, corporations, direct with print advertisers, marketing organizations and restaurant chains.
Needs: Approached by 20 freelancers/year. Works with 2 freelance illustrators and 2 designers/year. Works on assignment only. Uses freelancers for illustration, retouching, airbrushing and AV materials. 25% of freelance work demands knowledge of QuarkXPress, Adobe Photoshop and Adobe Illustrator.
First Contact & Terms: Send postcard sample or query letter with brochure. Samples are filed or are returned by SASE if requested. Reports back only if interested. Write for an appointment to show portfolio. Pays for design and illustration by the project, $100 minimum. Considers complexity of project and client's budget when establishing payment. Negotiates rights purchased.

SWANSON RUSSELL ASSOCIATES, 9140 W. Dodge Rd., #402, Omaha NE 68114. (402)393-4940. Fax: (402)393-6926. E-mail: paul_b@oma.sramarketing.com. Website: http://www.sramarketing.com. Associate Creative Director: Paul Berger. Estab. 1963. Number of employees: 70. Approximate annual billing: $40 million. Integrated marketing communications agency. Specializes in collateral, catalogs, magazine and newspaper ads, direct mail. Product specialties are healthcare, pharmaceuticals, agriculture. Current clients include Schering-Plough Animal Health, Alegent Health, AGP Inc. Professional affiliations: 4A's, PRSA, AIGA, Ad Club.
Needs: Approached by 12 illustrators and 3-4 designers/year. Works with 5 illustrators and 2 designers/year. Prefers freelancers with experience in agriculture, pharmaceuticals, human and animal health. Uses freelancers mainly for collateral, ads, direct mail, storyboards. Also for brochure design and illustration, humorous and technical illustration,

lettering, logos, mechanicals, posters, storyboards. 10% of work is with print ads. 90% of design demands knowledge of Adobe Photoshop 7.0, Aldus FreeHand 5.0, QuarkXPress 3.3. 30% of illustration demands knowledge of Adobe Photoshop, Adobe Illustrator, Aldus FreeHand.

First Contact & Terms: Designers send query letter with photocopies, photographs, photostats, SASE, slides, tearsheets, transparencies. Illustrators send query letter with SASE. Send follow-up postcard samples every 3 months. Accepts Mac compatible disk submissions. Send self expanding archives and player for multimedia, or JPEG, EPS and TIFFs. Software: Quark, FreeHand or Adobe. Samples are filed or returned by SASE. Reports back only if interested within 2 weeks. Art director will contact artist for portfolio review of final art, photographs, photostats, transparencies if interested. Pays for design by the hour, $50-65; pays for illustration by the project, $250-3,000. Rights purchased vary according to project. Finds artists through agents, submissions, word of mouth, *Laughing Stock, American Showcase.*

New Jersey

‡**AM/PM ADVERTISING INC.**, 196 Clinton Ave., Newark NJ 07108. (201)824-8600. Fax: (201)824-6631. President: Bob Saks. Estab. 1962. Number of employees: 130. Approximate annual billing: $24 million. Ad agency. Full-service multimedia firm. Specializes in national TV commercials and print ads. Product specialties are health and beauty aids. Current clients include J&J, Bristol Myers, Colgate Palmolive. Client list available upon request. Professional affiliations: AIGA, Art Directors Club, Illustration Club.

Needs: Approached by 35 freelancers/year. Works with 3 freelance illustrators and designers/month. Works only with artist reps. Works on assignment only. Uses freelancers mainly for illustration and design. Also for brochure and print ad design and illustration, storyboards, slide illustration, animation, mechanicals, retouching, model making, billboards, posters, TV/film graphics, lettering and logos and multimedia projects. 30% of work is with print ads. 50% of work demands knowledge of Aldus PageMaker, QuarkXPress, Aldus FreeHand, Adobe Illustrator or Adobe Photoshop.

First Contact & Terms: Send postcard sample and/or query letter with brochure, résumé and photocopies. Samples are filed or returned. Reports back within 10 days. Portfolios may be dropped off every Friday. Artist should follow up after initial query. Portfolio should include b&w and color thumbnails, roughs, final art, tearsheets, photographs and transparencies. Pays for design by the hour, $35-100; by the project, $300-5,000; or by the day, $150-700. Pays for illustration by the project, $500-10,000. Rights purchased vary according to project.

Tips: "When showing work, give time it took to do job and costs."

‡**BLOCK ADVERTISING & MARKETING, INC.**, 3 Clairidge Dr., Verona NJ 07044. (973)857-3900. Fax: (973)857-4041. Senior VP/Creative Director: Karen DeLuca. Estab. 1939. Number of employees: 25. Approximate annual billing: $8 million. Product specialties are electronics, finance, home fashion, healthcare and industrial manufacturing. Professional affiliations: Ad Club of New Jersey.

Needs: Approached by 100 freelancers/year. Works with 25 freelance illustrators and 25 designers/year. Prefers to work with "freelancers with at least 3-5 years experience as mac comp artists and 'on premises' work as Mac artists." Uses freelancers for "consumer friendly" technical illustration, layout, lettering, mechanicals and retouching for ads, annual reports, billboards, catalogs, letterhead, brochures and corporate identity. Needs computer-literate freelancers for design and presentation. 90% of freelance work demands knowledge of QuarkXPress, Adobe Illustrator, Type-Styler and Photoshop.

First Contact & Terms: To show portfolio, mail appropriate samples and follow up with a phone call. Include SASE. Reports in 2 weeks. Pays for design by the hour, $20-50. Pays for illustration by the project, $150-5,000.

Tips: "Please send some kind of sample of work. If mechanical artist, send line art printed sample. If layout artist, send composition of some type and photographs or illustrations. We are fortunately busy—we use four to six freelancers daily."

CUTRO ASSOCIATES, INC., 47 Jewett Ave., Tenafly NJ 07670. (201)569-5548. Fax: (201)569-8987. E-mail: ronalddc@aol.com. Manager: Ronald Cutro. Estab. 1961. Number of employees: 2. Specializes in annual reports; corporate identity; direct mail, fashion, package and publication design; technical illustration; and signage. Clients: corporations, business-to-business, consumer.

Needs: Approached by 5-10 freelancers/year. Works with 2-3 freelance illustrators and 2-3 designers/year. Prefers local artists only. Uses illustrators mainly for wash drawings, fashion, specialty art. Uses designers for comp layout. Also uses freelancers for ad and brochure design and illustration, airbrushing, catalog and P-O-P illustration, direct mail design, lettering, mechanicals, and retouching. Needs computer-literate freelancers for design, illustration and production. 98% of freelance work demands knowledge of Adobe Illustrator, QuarkXPress and Adobe Photoshop.

First Contact & Terms: Send postcard sample of work. Samples are filed. Will contact artist for portfolio review if interested. Portfolio should include final art and photocopies. Pays for design and illustration by the project. Buys all rights.

NORMAN DIEGNAN & ASSOCIATES, 3 Martens Rd., Lebanon NJ 08833. (908)832-7951. President: N. Diegnan. Estab. 1977. Number of employees: 5. Approximate annual billing: $1 million. PR firm. Specializes in magazine ads. Product specialty is industrial.

Needs: Approached by 10 freelancers/year. Works with 20 freelancers illustrators/year. Works on assignment only.

Uses freelancers for brochure, catalog and print ad design and illustration; storyboards; slide illustration; animatics; animation; mechanicals; retouching; and posters. 50% of work is with print ads. Needs editorial and technical illustration.
First Contact & Terms: Send query letter with brochure and tearsheets. Samples are filed and not returned. Reports back within 1 week. To show portfolio, mail roughs. Pays for design and illustration by the project. Rights purchased vary according to project.

JANUARY PRODUCTIONS, INC., 210 Sixth Ave., Hawthorne NJ 07507. (201)423-4666. Fax: (201)423-5569. E-mail: awpeller@worldnet.att.net. Art Director: Karen Sigler. Estab. 1973. Number of employees: 12. AV producer. Serves clients in education. Produces children's educational materials—videos, sound filmstrips, read-along books, cassettes and CD-ROM.
Needs: Works with 1-2 freelance illustrators/year. "While not a requirement, a freelancer living in the same geographic area is a plus." Works on assignment only, "although if someone had a project already put together, we would consider it." Uses freelancers mainly for illustrating children's books. Also for artwork for filmstrips, sketches for books and layout work. 50% of freelance work demands knowledge of QuarkXPress, Aldus FreeHand and Adobe Photoshop.
First Contact & Terms: Send query letter with résumé, tearsheets, SASE, photocopies and photographs. Will contact artist for portfolio review if interested. "Include child-oriented drawings in your portfolio." Requests work on spec before assigning a job. Pays for design and illustration by the project, $20 minimum. Originals not returned. Buys all rights. Finds artists through submissions.

LARRY KERBS STUDIOS, 215 Rutgers St., Maplewood NJ 07040. (201)378-9366. Fax: (201)378-9286. Contact: Larry Kerbs. Specializes in sales promotion design, ad work and placement, annual reports, corporate identity, publications and technical illustration. Clients: industrial, chemical, medical devices, insurance, travel, PR, over-the-counter specialties.
 • Also has Western branch at 320 Galisteo St., Suite 305, Santa Fe NM 87501, (505)989-9551, Fax: (505)989-9552.
Needs: Works with 2 illustrators and 1 designer/month. Prefers New York, New Jersey and Connecticut artists (also Northern NM). Uses artists for direct mail, layout, illustration, technical art, retouching for annual reports, trade magazine ads, product brochures and direct mail. Combines traditional and computer art. Needs computer-literate freelancers, prefers those with strong design training. Needs editorial and technical illustration. Looks for realistic editorial illustration, montages, 2-color and 4-color.
First Contact & Terms: Mail samples or call for interview. Prefers b&w line drawings, roughs and previously published work as samples. Provide brochures, business card and résumé to be kept on file for future assignments. No originals returned at job's completion. Pays by the hour, negotiates payment by the project.
Tips: "Strengthen typographic knowledge and application; know computers, production and printing in depth to be of better service to yourself and to your clients."

KJD TELEPRODUCTIONS, 30 Whyte Dr., Voorhees NJ 08043. (609)751-3500. Fax: (609)751-7729. E-mail: mactoday@earthlink.net. President: Larry Scott. Estab. 1989. Ad agency/AV firm. Full-service multimedia firm. Specializes in magazine, radio and television. Current clients include ICI America's and Taylors Nightclub.
Needs: Works with 20 freelance illustrators and 12 designers/year. Prefers freelancers with experience in TV. Works on assignment only. Uses freelancers for brochure and print ad design and illustration, storyboards, animatics, animation, TV/film graphics. 70% of work is with print ads. Also for multimedia projects. 90% of freelance work demands knowledge of QuarkXPress, Adobe Illustrator 6.0, Aldus PageMaker and Aldus FreeHand.
First Contact & Terms: Send query letter with brochure, photographs, slides, tearsheets or transparencies and SASE. Samples are filed or are returned by SASE. Accepts submissions on disk from all applications. Send EPS files. Reports back to the artist only if interested. To show portfolio, mail roughs, photographs and slides. Pays for design and illustration by the project; rate varies. Buys first rights or all rights.

‡MURRAY MULTI MEDIA, P.O. Box M, Blairstown NJ 07825. (908)362-8174. Fax: (908)362-5446. Services Manager: Alice Frable. Estab. 1972. Number of employees: 11. Design/multimedia firm. Specializes in collateral and presentation. Product specialty is corporate. Current clients include J&J, Schering, Roche, WL, ADT, ADP. Client list available upon request. Professional affiliations: IABC.
Needs: Approached by 10 illustrators and 15 designers/year. Works with 5 illustrators and 2 designers/year. Prefers local designers. Also for animation; brochure, catalog and web page design; brochure, humorous, medical and technical illustration; multimedia projects; and TV/film graphics. 1% of work is with print ads. 100% of design demands skills in Aldus FreeHand, Adobe Photoshop, QuarkXPress, Adobe Illustrator. 50% of illustration demands skills in Aldus FreeHand, Adobe Photoshop, Adobe Illustrator, Painter.
First Contact & Terms: Send query letter with photocopies and résumé. Accepts disk submissions compatible with Mac or PC. Samples are filed. Will contact for portfolio review of b&w and color final art, photographs, photostats, roughs, slides, tearsheets, thumbnails or transparencies. Pays for design by the hour, $12-50. Pays for illustration by the project, $75-10,000. Finds artists through yearly portfolio review, word of mouth.
Tips: Looks for advanced technology and good design.

PRINCETON DIRECT, INC., 5 Vaughn Dr., Princeton NJ 08540. (609)520-8575. Fax: (609)520-0695. E-mail: renee@princetondirect.com. Website: http://www.princetondirect.com. Creative Director: Reneé Hobbs. Estab. 1987.

Number of employees: 10. Approximate annual billing: $8 million. Ad agency. Specializes in direct mail, multimedia, web sites. Product specialties are financial, computer. Current clients include HIP of New Jersey, Summit Bank, Unisys. Client list available upon request.

Needs: Approached by 12 freelance illustrators and 25 designers/year. Works with 6 freelance illustrators and 10 designers/year. Prefers local designers with experience in Macintosh. Uses freelancers for airbrushing, animation, brochure design and illustration, multimedia projects, retouching, technical illustration, TV/film graphics. 10% of work is with print ads. 90% of design demands skills in Adobe Photoshop, QuarkXPress, Adobe Illustrator, Macromedia Director. 50% of illustration demands skills in Adobe Photoshop, Adobe Illustrator.

First Contact & Terms: Send query letter with résumé, tearsheets, video or sample disk. Send follow-up postcard every 6 months. Accepts disk submissions compatible with QuarkXPress, Adobe Photoshop. Send EPS, PICT files. Samples are filed. Reports back only if interested. Pay negotiable. Rights purchased vary according to project.

‡RPD GROUP/RICHARD PUDER DESIGN, 2 W. Blackwell St., P.O. Box 1520, Dover NJ 07802-1520. (973)361-1310. Fax: (973)361-1663. E-mail: strongtype@aol.com. Website: http://www.strongtype.com. Estab. 1985. Number of employees: 3. Approximate annual billing: $300,000. Specializes in annual reports, direct mail and publication design, technical illustration. Current clients include AT&T, R.R. Bowker, Scholastic, Simon & Schuster, Warner Lambert. Professional affiliation: Type Directors Club.

Needs: Approached by 60 freelancers/year. Works with 20 freelance illustrators and 5 designers/year and some interns. Prefers artists with experience in anatomy, color, perspective—many illustrative styles; prefers artists without reps. Uses illustrators mainly for publishing clients. Uses designers mainly for corporate, publishing clients. Also uses freelancers or ad and brochure design and illustration; book, direct mail, magazine and poster design; charts/graphs; lettering; logos; mechanicals; and retouching. 80% of freelance work demands knowledge of Illustrator, Photoshop, Acrobat FreeHand 4.0, XPress, Director 4.0, and web developing.

First Contact & Terms: Send postcard sample of work or send résumé and tearsheets. Samples are filed. Will contact artist for portfolio review if interested. Portfolio should include b&w and color photocopies, photographs, roughs and thumbnails. Pays for design by the hour, $10-45. Pays for illustration by the job. Buys first rights or rights purchased vary according to project. Finds artists through sourcebooks (e.g., *American Showcase* and *Workbook*) and by client referral.

Tips: Impressed by "listening, problem-solving, speed, technical competency and creativity."

SMITH DESIGN ASSSOCIATES, 205 Thomas St., Box 190, Glen Ridge NJ 07028. (201)429-2177. Fax: (201)429-7119. E-mail: assoc@smithdesign.com. Website: http://www.smithdesign.com. Vice President: Larraine Blauvelt. Clients: cosmetics firms, toy manufacturers, life insurance companies, office consultants. Current clients: Popsicle, Good Humor, Breyer's and Schering Plough. Client list available upon request.

Needs: Approached by more than 100 freelancers/year. Works with 10-20 freelance illustrators and 2-3 designers/year. Requires quality and dependability. Uses freelancers for advertising and brochure design, illustration and layout; interior design; P-O-P; and design consulting. 90% of freelance work demands knowledge of Adobe Illustrator, QuarkXPress, Adobe Photoshop and Painter. Needs children's, packaging and product illustration.

First Contact & Terms: Send query letter with brochure showing art style or résumé, tearsheets and photostats. Samples are filed or are returned only if requested by artist. Reports back within 1 week. Call for appointment to show portfolio of color roughs, original/final art and final reproduction. Pays for design by the hour, $25-100; by the project, $175-5,000. Pays for illustration by the project, $175-5,000. Considers complexity of project and client's budget when establishing payment. Buys all rights. Also buys rights for use of existing non-commissioned art. Finds artists through word of mouth, self-promotions/sourcebooks and agents.

Tips: "Know who you're presenting to, the type of work we do and the quality we expect. We use more freelance artists not so much because of the economy but market for diverse styles."

SORIN PRODUCTIONS INC., 919 Hwy. 33, Suite 46, Freehold NJ 07728. (732)462-1785. E-mail: mail@sorinvideo.com. Website: http://www.sorinvideo.com. President: David Sorin. Estab. 1982. AV firm. Full-service multimedia firm. Specializes in corporate video, web, audio. Current clients include AT&T, First Fidelity Bank, J&J. Client list available upon request.

Needs: Approached by 2-3 freelance artists/month. Works with 1 freelance illustrator and designer/month. Prefers local artists only with experience in graphics for video and web. Works on assignment only. Uses artists for storyboards, animation, and TV/film graphics. 5% of work is with print ads. 75% of freelance work demands knowledge of Photoshop, QuarkXPress, Fractal Paint, Infini-D, After Effects.

First Contact & Terms: Send query letter with brochure. Samples are not filed and are returned by SASE if requested. Reports back to the artist only if interested. Will contact artist for portfolio review if interested. Pays for design and illustration by the project. Buys all rights.

‡VIDEO PIPELINE INC., 16 Haddon Ave., Haddonfield NJ 08083. (609)427-9799. President: Jed Horovitz. Estab. 1985. Number of employees: 9. Approximate annual billing: $1 million. Point of purchse firm. Specializes in video and interactive display. Product specialties are movies, music, CD-ROM, video games. Current clients include Blockbuster.

Needs: Approached by 2 freelance illustrators and 1 designer/year. Works with 1 freelance illustrator and 1 designer/year. Prefers experienced freelancers. Uses freelancers mainly for fliers, ads, logos. Also for brochure illustration, catalog and web page design, TV/film graphics. 25% of work is with print ads. 100% of freelance work demands skills in Aldus

PageMaker, Aldus FreeHand, Adobe Photoshop, QuarkXPress, Adobe Illustrator, CorelDraw.
First Contact & Terms: Send query letter with résumé. Accepts disk submissions. Send EPS files. Samples are filed. Will contact for portfolio review if interested. Pays by the project. Buys all rights.

New Mexico

‡R H POWER AND ASSOCIATES, INC., 6616 Gulton Court, NE, Albuquerque NM 87109. (505)761-3150. Fax: (503)761-3153. E-mail: rhpower@aol.com. Art Director: Mark Hellyer. Estab. 1989. Number of employees: 12. Ad agency. Full-service, multimedia firm. Specializes in TV, magazine, billboard, direct mail, newspaper, radio. Product specialties are recreational vehicles and automotive. Current clients include Holiday RV Super Stores, Venture Out RV, Valley Forge RV Show. Client list available upon request.
Needs: Approached by 10-50 freelancers/year. Works with 5-10 freelance illustrators and 5-10 designers/year. Prefers freelancers with experience in retail automotive layout and design. Uses freelancers mainly for work overload, special projects and illustrations. Also for annual reports, billboards, brochure and catalog design and illustration, logos, mechanicals, posters and TV/film graphics. 50% of work is with print ads. 100% of design demands knowledge of Adobe Photoshop, CorelDraw 5.0, Ventura Publisher and QuarkXPress.
First Contact & Terms: Send query letter with photocopies or photographs and résumé. Accepts disk submissions compatible with CorelDraw or QuarkXPress. Send PC EPS files. Samples are filed and are not returned. Will contact artist for portfolio review if interested. Portfolio should include b&w and color final art, roughs and thumbnails. Pays for design and illustration by the hour, $8 minimum; by the project, $50 minimum. Buys all rights.
Tips: Impressed by work ethic and quality of finished product. "Deliver on time and within budget. Do it until it's right without charging for your own corrections."

New York

ALBEE SIGN CO., 561 E. Third St., Mt. Vernon NY 10553. (914)668-0201. President: William Lieberman. Produces interior and exterior signs and graphics. Clients are banks and real estate companies.
Needs: Works with 6 freelance artists per year for sign design, 6 for display fixture design, 6 for P-O-P design and 6 for custom sign illustration. Prefers local artists only. Works on assignment only.
First Contact & Terms: Send query letter with samples, SASE, résumé and business card to be kept on file. Pays by job. Previous experience with other firms preferred. Reports within 2-3 weeks. Samples are not returned. Reports back as assignment occurs.

‡AUTOMATIC MAIL SERVICES, INC., 30-02 48th Ave., Long Island City NY 11101. (212)361-3091. Fax: (718)937-8568. E-mail: autoonline@aol.com. Contact: Michael Waskover. Manufacturer and service firm. Provides printing Internet sites and direct mail advertising. Clients: publishers, banks, stores, clubs, businesses.
Needs: Works with 5-10 artists/year. Uses freelancers for advertising, brochure and catalog design, illustration and layout.
First Contact & Terms: Send business card and photostats to be kept on file. Call for appointment to show portfolio. Samples not kept on file are returned if requested. Works on assignment only. Pays by the project, $10-1,000 average. Considers skill and experience of artist and turnaround time when establishing payment.

‡BOXER DESIGN, 548 State St., Brooklyn NY 11216-1619. (718)802-9212. Fax: (718)802-9213. E-mail: eboxcr@thorn.net. Contact: Eileen Boxer. Estab. 1986. Approximate annual billing: $250,000. Design firm. Specializes in brochures, announcements, conceptual, video, exhibits. Product specialties are cultural institutions/misc. corp. Current clients include Knoll, Ubu Gallery, Brooklyn Museum, Chase, Sotheby's. Client list available upon request. AIGA award of excellence (Graphic Design USA) 1997.
Needs: 10% of work is with print ads. Design work demands knowledge of Adobe Photoshop, Adobe Illustrator, QuarkXPress.
First Contact & Terms: Send query letter with photographs, résumé, slides, tearsheets. Accepts disk submissions compatible with Quark 3.32, Photoshop 3., Illustrator 6, all Mac, Zip or SyQuest. Samples are filed or returned on request. Reports back within 3 weeks if interested in artist's work. Artist should follow-up with call after initial query. Pays by the project. Rights purchased vary according to project.

‡CHANNEL ONE PRODUCTIONS, INC., 82-03 Utopia Pkwy., Jamaica Estates NY 11432. (718)380-2525. E-mail: bmp.emht@lx.netcom.com. President: Burton M. Putterman. AV firm. "We are a multimedia, film and video production company for broadcast, image enhancement and P-O-P displays." Clients: multi-national corporations, recreational industry and PBS.
Needs: Works with 25 freelancers/year. Assigns 100 jobs/year. Prefers local freelancers. Works on assignment only. Uses freelancers mainly for work on brochures, catalogs, P-O-P displays, animation, direct mail packages, motion pictures, logos and advertisements. Needs technical illustration. 100% of freelance work demands knowledge of Aldus PageMaker, Aldus FreeHand or Adobe Illustrator.

First Contact & Terms: Send query letter with résumé, slides and photographs. Samples are not filed and are returned by SASE. Reports back within 2 weeks only if interested. Call to schedule an appointment to show a portfolio of original/final art, final reproduction/product, slides, video disks and videotape. Pays for design by the project, $400 minimum. Considers complexity of project and client's budget when establishing payment. Rights purchased vary according to project.
Tips: "Our freelance needs have increased."

DALOIA DESIGN, 149-30 88 St., Howard Beach NY 11414. (718)835-7641. Owner/Designer: Peter Daloia. Estab. 1983. Number of employees: 2. Approximate annual billing: $100,000. Design firm. Specializes in stationery, novelty and gift products design. Product specialties are magnets, photo frames, coasters, bookmarks, framed mirrors, etc.
Needs: Works with 1 illustrator and 1 designer/year. Prefers local freelancers with experience in consumer products. Uses freelancers mainly for art and/or design for retail products. Also for airbrushing, brochure and catalog design, humorous illustration, mechanicals, model making, posters, signage, design for stationery, novelties and gift products. Freelancers must know software appropriate for design or production of project including PageMaker, FreeHand, Photoshop, QuarkXPress, Illustrator or "whatever is necessary."
First Contact & Terms: Designers send query letter with b&w or color photocopies, photographs, résumé. Illustrators send query letter with photocopies, photographs, résumé or laser color copies. Samples are filed and are not returned. Reports back only if interested. Will contact artist for portfolio review of b&w, color, final art, roughs, thumbnails and design showing use of type. Payment "depends on project and use." Negotiates rights purchased. Finds artists through *Creative Black Book*, *RSVP*, etc.
Tips: "Keep an open mind, strive for excellence, push limitations."

FINE ART PRODUCTIONS, RICHIE SURACI PICTURES, MULTIMEDIA, INTERACTIVE, 67 Maple St., Newburgh NY 12550-4034. Phone/fax: (914)561-5866. E-mail: rs7.fap@mhv.net. or richie.suraci@bbs.mhv.net. Websites: http://www.audionet.com/books/, http://www.mhv.net/~rs7.fap/networkerotica.html, http://www.audiohwy.com, http://www.woodstock69.com, http://indyjones.simplenet.com/kunda.htm. Contact: Richie Suraci. Estab. 1990. Ad agency, AV and PR firm. Full-service multimedia firm. Specializes in film, video, print, magazine, documentaries and collateral. "Product specialties cover a broad range of categories."
● Fine Art Productions is looking for artists who specialize in science fiction and erotic art for upcoming projects.
Needs: Approached by 288 freelancers/year. Works with 12-48 freelance illustrators and 12-48 designers/year. "Everyone is welcome to submit work for consideration in all media." Works on assignment only. Uses freelancers for brochure, catalog and print ad design and illustration; storyboards; slide illustration; animatics; animation; mechanicals; retouching; billboards; posters; TV/film graphics; lettering; and logos. Also for multimedia projects. Needs editorial, technical, science fiction, jungle, adventure, children's, fantasy and erotic illustration. 20% of work is with print ads. 50% of freelance work demands knowledge of "all state-of-the-art software."
First Contact & Terms: Send query letter with brochure, photocopies, résumé, photographs, tearsheets, photostats, slides, transparencies and SASE. Accepts submissions on disk compatible with Macintosh format. Samples are filed or returned by SASE if requested by artist. Reports back in 4-6 months if interested. Will contact artist for portfolio review if interested. Portfolio should include thumbnails, roughs, b&w and color photostats, tearsheets, photographs, slides and transparencies. Requests work on spec before assigning a job. Pays for design and illustration by the project; negotiable. Rights purchased vary according to project.
Tips: "We need more freelance artists. Submit your work for consideration in field of interest specified."

‡GARRITY COMMUNICATIONS, INC., 217 N. Aurora St., Ithaca NY 14850. (607)272-1323. Creative Director: Michael Mayhew. Estab. 1978. Ad agency, AV firm. Specializes in trade ads, newspaper ads, annual reports, video, etc. Product specialties are financial services, industrial.
Needs: Approached by 8 freelance artists/month. Works with 2 freelance illustrators and 1 freelance designer/month. Works on assignment only. Uses freelance artists mainly for work overflow situations; some logo specialization. Also uses freelance artists for brochure design and illustration, print ad illustration, TV/film graphics and logos. 40% of work is with print ads. 90% of freelance work demands knowledge of Aldus PageMaker (IBM) or Corel.
First Contact & Terms: Send query letter with brochure and photocopies. Samples are filed and are not returned. Reports back to the artist only if interested. Will contact artist for portfolio review if interested. Pays for design by the hour, $15-50. Pays for illustration by the project, $150-500. Rights purchased vary according to project. Finds artists through sourcebooks, submissions.

‡HUMAN RELATIONS MEDIA, 175 Tompkins Ave., Pleasantville NY 10570. (914)769-6900. E-mail: hrm@aol.com. Editor-in-Chief, President: Anson W. Schloat. Number of employees: 18. Approximate annual billing: $5 million. AV firm. Clients: junior and senior high schools, colleges.
Needs: Approached by 25 freelancers/year. Works with 10-15 freelance illustrators/year and 10-15 designers/year. Prefers local freelancers. Uses artists for illustration for print, video and advertising. Computer graphics preferred for video. Increasing need for illustrators.
First Contact & Terms: Send query letter with résumé and samples to be kept on file. Samples not filed are returned by SASE. Reports back only if interested. Call for appointment to show portfolio of videotape, slides or tearsheets. Pays for illustration by the project, $65-15,000. Rights purchased vary according to project.
Tips: "We're looking for talented artists, illustrators, CD-ROM developers and graphics arts personnel with experience."

‡**LEONE DESIGN GROUP INC.**, 7 Woodland Ave., Larchmont NY 10538. President: Lucian J. Leone. Specializes in corporate identity, publications, signage and exhibition design. Clients: nonprofit organizations, museums, corporations, government agencies. Client list not available. Professional affiliations: AAM, SEGD, MAAM, AASLH, NAME.
Needs: Approached by 30-40 freelancers/year. Works with 10-15 freelance designers/year. Uses freelancers for exhibition design, brochures, catalogs, mechanicals, model making, charts/graphs and AV materials. Needs computer-literate freelancers for design and presentation. 100% of freelance work demands knowledge of QuarkXPress, Photoshop, Illustrator.
First Contact & Terms: Send query letter with résumé, samples and photographs. Samples are filed unless otherwise stated. Samples not filed are returned only if requested. Reports back within 2 weeks. Write for appointment to show portfolio of thumbnails, b&w and color original/final art, final reproduction/product and photographs. Pays for design by the hour, $20-45 or on a project basis. Considers client's budget and skill and experience of artist when establishing payment.

McANDREW ADVERTISING, 1 Mountain View Knolls, Route 82, Fishkill NY 12524. Phone/fax: (914)897-2405. Art/Creative Director: Robert McAndrew. Estab. 1961. Number of employees: 3. Approximate annual billing: $225,000. Ad agency. Clients: industrial and technical firms. Current clients include Yula Corp. and Electronic Devices, Inc.
Needs: Approached by 20 freelancers/year. Works with 3 freelance illustrators and 5 designers/year. Uses mostly local freelancers. Uses freelancers mainly for design, direct mail, brochures/flyers and trade magazine ads. Needs technical illustration. Prefers realistic, precise style. Prefers pen & ink, airbrush and occasionally markers. 50% of work is with print ads. 5% of freelance work demands computer skills.
First Contact & Terms: Query with photocopies, business card and brochure/flier to be kept on file. Samples not returned. Reports in 1 month. Originals not returned. Will contact artist for portfolio review if interested. Portfolio should include roughs and final reproduction. Pays for illustration by the project, $35-300. Pays for design by the project. Considers complexity of project, client's budget and skill and experience of artist when establishing payment. Finds artists through sourcebooks, word of mouth and business cards in local commercial art supply stores.
Tips: Artist needs "an understanding of the product and the importance of selling it."

MIRANDA DESIGNS INC., 745 President St., Brooklyn NY 11215. (718)857-9839. President: Mike Miranda. Estab. 1970. Number of employees: 3. Approximate annual billing: $350,000. Solves marketing problems, specializes in "giving new life to old products, creating new markets for existing products, and creating new products to fit existing manufacturing/distribution facilities." Clients: agencies, manufacturers, PR firms, corporate and retail companies. Professional affiliation: Art Directors Club.
Needs: Approached by 80 freelancers/year. Works with 6 freelance illustrators and 10 designers/year; at all levels, from juniors to seniors, in all areas of specialization. Works on assignment only. Uses freelancers for editorial, food, fashion, product illustration, design; and mechanicals. Also for catalog design and illustration; brochure, ad, magazine and newspaper design; mechanicals; model making; direct mail packages and multimedia projects. 60% of freelance work demands knowledge of Aldus PageMaker, QuarkXPress, Adobe Photoshop or Adobe Illustrator.
First Contact & Terms: Send postcard sample. Samples are filed and are not returned. Will contact artist for portfolio review if interested. Portfolio should include thumbnails, roughs, original/final art and final reproduction/product. Pays for design and illustration by the project, "whatever the budget permits." Considers complexity of project, client's budget and skill and experience of artist when establishing payment. Rights purchased vary according to project. Considers buying second rights (reprint rights) to previously published work; depends on clients' needs. Finds artists through submissions/self-promotions, sourcebooks and agents.
Tips: "Don't call, persevere with mailings. Show a variety of subject material and media."

MITCHELL STUDIOS DESIGN CONSULTANTS, 1111 Fordham Lane, Woodmere NY 11598. (516)374-5620. Fax: (516)374-6915. E-mail: msdcdesign@aol.com. Principals: Steven E. Mitchell and E.M. Mitchell. Estab. 1922. Specializes in brand and corporate identity, displays, direct mail and packaging. Clients: major corporations.
Needs: Works with 5-10 freelance designers and 20 illustrators/year. "Most work is started in our studio." Uses freelancers for design, illustration, mechanicals, retouching, airbrushing, model making, lettering and logos. 100% of design and 50% of illustration demand knowledge of Adobe Illustrator 7.0, Adobe Photoshop 4.0 and QuarkXPress 3.3. Needs technical illustration and illustration of food, people.
First Contact & Terms: Send query letter with brochure, résumé, business card, photographs and photocopies to be kept on file. Accepts non-returnable disk submissions compatible with Adobe Illustrator, QuarkXPress, Aldus FreeHand and Adobe Photoshop. Reports only if interested. Call or write for appointment to show portfolio of roughs, original/final art, final reproduction/product and color photostats and photographs. Pays for design by the hour, $25 minimum; by the project, $250 minimum. Pays for illustration by the project, $250 minimum.
Tips: "Call first. Show actual samples, not only printed samples. Don't show student work. Our need has increased—we are very busy."

JACK SCHECTERSON ASSOCIATES, 5316 251 Place, Little Neck NY 11362. (718)225-3536. Fax: (718)423-3478. Principal: Jack Schecterson. Estab. 1967. Ad agency. Specializes in packaging, product marketing, graphic design and new product introduction.
Needs: Works direct and with artist reps. Prefers local freelancers only. Works on assignment only. Uses freelancers for package and product design and illustration, brochures, catalogs, retouching, lettering, logos. 100% of design and

40% of illustration demand skills in Adobe Illustrator, Adobe Photoshop and QuarkXPress.

First Contact & Terms: Send query letter with brochure, photocopies, tearsheets, résumé, photographs, slides, transparencies and SASE; "whatever best illustrates work." Samples not filed are returned by SASE only if requested by artist. Request portfolio review in original query. Will contact artist for portfolio review if interested. Portfolio should include roughs, b&w and color—"whatever best illustrates creative abilities/work." Pays for design and illustration by the project; depends on budget. Buys all rights.

‡SCHROEDER BURCHETT DESIGN CONCEPTS, 104 Main St., RR 1 Box 5A, Unadilla NY 13849-9703. (607)369-4709. Designer & Owner: Carla Schroeder Burchett. Estab. 1972. Specializes in packaging, drafting and marketing. Clients: manufacturers.

Needs: Works on assignment only. Uses freelancers for design, mechanicals, lettering and logos. 20% of freelance work demands knowledge of Aldus PageMaker or Adobe Illustrator. Needs technical and medical illustration.

First Contact & Terms: Send résumé. "If interested, we will contact artist or craftsperson and will negotiate." Write for appointment to show portfolio of thumbnails, final reproduction/product and photographs. Pays for illustration by the project. Pays for design by the hour, $15 minimum. "If it is excellent work the person will receive what he asks for!" Considers skill and experience of artist when establishing payment.

Tips: "Creativity depends on each individual. Artists should have a sense of purpose and dependability and must work for long and short range plans. Have perseverance. Top people still get in any agency. Don't give up."

‡VISUAL HORIZONS, 180 Metro Park, Rochester NY 14623. (716)424-5300. Fax: (716)424-5313. E-mail: slides1@aol.com. or info@visualhorizons.com. Website: http://www.visualhorizons.com. Estab. 1971. AV firm. Full-service multimedia firm. Specializes in presentation products. Current clients include US government agencies, corporations and universities.

Needs: Works on assignment only. Uses freelancers mainly for slide illustration. 10% of work is with print ads. 100% of freelance work demands knowledge of Aldus PageMaker, Aldus FreeHand, Adobe Illustrator or Arts and Letters.

First Contact & Terms: Send query letter with tearsheets. Samples are not filed and are not returned. Reports back to the artist only if interested. Portfolio review not required. Pays for design and illustration by the hour or project, negotiated. Buys all rights.

New York City

BBDO NEW YORK, 1285 Avenue of the Americas, New York NY 10019-6095. (212)459-5000. Fax: (212)459-6645. Estab. 1891. Ad agency. Full-service multimedia firm. Studio Manager: Richard Raskov.

● BBDO Art Director Richard Raskov told our editors he is always open to new ideas and maintains an open drop-off policy. If you call and arrange to drop off your portfolio, he'll review it and you can pick it up in a couple days.

BARRY DAVID BERGER & ASSOCIATES, INC., 54 King St., New York NY 10014. (212)255-4100. Senior Industrial Designer: Robert Ko. Senior Graphic Designer: Heidi S. Broecking. Number of employees: 5. Approximate annual billing: $500,000. Specializes in brand and corporate identity, P-O-P displays, product and interior design, exhibits and shows, corporate capability brochures, advertising graphics, packaging, publications and signage. Clients: manufacturers and distributors of consumer products, office/stationery products, art materials, chemicals, healthcare, pharmaceuticals and cosmetics. Current clients include Dennison, Timex, Sheaffer, Bausch & Lomb and Kodak. Professional affiliations IDSA, AIGA, APDF.

Needs: Approached by 12 freelancers/year. Works with 5 freelance illustrators and 7 designers/year. Uses artists for advertising, editorial, medical, technical and fashion illustration; mechanicals; retouching; direct mail and package design; model making; charts/graphs; photography; AV presentations; and lettering. Needs computer-literate freelancers for illustration and design. 50% of freelance work demands computer skills.

First Contact & Terms: Send query letter, then call for appointment. Works on assignment only. Send "whatever samples are necessary to demonstrate competence" including multiple roughs for a few projects. Samples are filed or returned. Reports immediately. Provide brochure/flyer, résumé, business card, tearsheets and samples to be kept on file for possible future assignments. Pays for design by the project, $1,000-10,000. Pays for illustration by the project.

Tips: Looks for creativity and confidence.

ANITA HELEN BROOKS ASSOCIATES, PUBLIC RELATIONS, 155 E. 55th St., New York NY 10022. (212)755-4498. President: Anita Helen Brooks. PR firm. Specializes in fashion, "society," travel, restaurant, political and diplomatic and publishing. Product specialties are events, health and health campaigns.

Needs: Works on assignment only. Uses freelancers for consumer magazines, newspapers and press releases. "We're currently using more abstract designs."

First Contact & Terms: Send query letter with résumé. Call for appointment to show portfolio. Reports back only if interested. Considers client's budget and skill and experience of artist when establishing payment.

Tips: "Artists interested in working with us must provide rate schedule, partial list of clients and media outlets. We look for graphic appeal when reviewing samples."

CANON & SHEA ASSOCIATES, INC., 224 W. 35th St., Suite 1500, New York NY 10001. (212)564-8822. E-mail: canonshea@aol.com. Website: http://members.aol.com/canonshea. Art Buyer: Sal Graci. Estab. 1978. Print, Internet, multimedia, advertising/PR/marketing firm. Specializes in business-to-business and financial services.
Needs: Works with 20-30 freelance illustrators and 2-3 designers/year. Mostly local freelancers. Uses freelancers mainly for design and illustrations. 100% of freelance work demands knowledge of QuarkXPress, Adobe Illustrator, Adobe Photoshop, Director, Pagemill or FrontPage.
First Contact & Terms: Send postcard sample and/or query letter with résumé, photocopies and tearsheets. Accepts submissions on disk. Will contact artist for portfolio review if interested. Pays by the hour: $15-35 for design, annual reports, catalogs, trade and consumer magazines; $25-50 for packaging; $50-250 for corporate identification/graphics; $10-45 for layout, lettering and paste-up. Pays for illustration by the hour, $10-20. Finds artists through art schools, design schools and colleges.
Tips: "Artists should have business-to-business materials as samples and should understand the marketplace. Do not include fashion or liquor ads. Common mistakes in showing a portfolio include showing the wrong materials, not following up and lacking understanding of the audience."

COUSINS DESIGN, 599 Broadway, New York NY 10012. (212)431-8222. President: Michael Cousins. Number of employees: 4. Specializes in packaging and product design. Clients: marketing and manufacturing companies. Professional affiliation: IDSA.
Needs: Works with freelance designers. Prefers local designers. Works on assignment only. Uses artists for design, illustration, mechanicals, retouching, airbrushing, model making, lettering and logos.
First Contact & Terms: Send query letter with brochure or résumé, tearsheets and photocopies. Samples are filed or are returned, only if requested. Reports back within 2 weeks only if interested. Write for appointment to show portfolio of roughs, final reproduction/product and photostats. Pays for design by the hour or flat fee. Considers skill and experience of artist when establishing payment. Buys all rights.
Tips: "Send great work that fits our direction."

D&B GROUP, 386 Park Ave. S., New York NY 10016. (212)532-3884. Fax: (212)532-3921. E-mail: moca@lava.net. Website: http://www.hss.hawaii.edu/artwcb/. Acting Coordinator: J.P. Orias. Estab. 1956. Number of employees: 3. Approximate annual billing: $500,000. Advertising art studio. Specializes in direct mail response advertising, annual reports, brand and corporate identity and publications. Clients: ad agencies, PR firms, direct response advertisers and publishers.
Needs: Approached by 30-40 freelancers/year. Works with 8-10 freelance illustrators and 2 designers/year. Prefers local freelancers only. Uses freelancers mainly for video wraps and promotion. Also for consumer magazines, direct mail, brochures/flyers, newspapers, layout, technical art, type spec, paste-up, lettering and retouching. Needs technical and product illustration. Prefers pen & ink, airbrush, watercolor and oil. Needs computer-literate freelancers for production. 60% of freelance work demands knowledge of Adobe Illustrator, Photoshop or QuarkXPress.
First Contact & Terms: Call for interview or send brochure showing art style, fliers, business card, résumé and tearsheets to be kept on file. Originals are not returned. Call for appointment to show portfolio of thumbnails, roughs, 8×10 chromes, original/final art and final reproduction/product. Pays for design by the hour, $25-50 or by the project, $200-1,500. Pays for illustration by the project, $75-800. Considers complexity of project and client's budget when establishing payment.
Tips: "We foresee a need for direct-response art directors. Clients are more careful as to price and quality of work."

DE FIGLIO DESIGN, 11 W. 30th St., Suite 6, New York NY 10001-4405. (212)695-6109. Fax: (212)695-4809. Creative Director: R. De Figlio. Estab. 1981. Number of employees: 2. Design firm. Specializes in magazine ads, annual reports, collateral, postage stamps and CD albums. Specializes in postage stamps.
Needs: Approached by 10 illustrators and 10 designers/year. Works with 4 illustrators and 10 designers/year. Prefers local designers with experience in Mac-based programs. Illustrators can be "from anywhere." Uses freelancers mainly for mechanicals on the Mac. Also for airbrushing, annual reports, brochure design and illustration, logos, posters, retouching and web page design. 80% of design and 25% of illustration demand knowledge of latest versions of Adobe Photoshop, QuarkXPress and Adobe Illustrator. Illustrators can use any version that works for project.
First Contact & Terms: Designers send photocopies and résumé. Illustrators send postcard sample or photocopies and résumé. Samples are filed. Does not report back. Payment negotiable. Finds artists through submissions and networking.

DLS DESIGN, (formerly David Schiffer Design, Inc.), 156 Fifth Ave., New York NY 10010. (212)255-3464. E-mail: dsdesign@interport.net. Website: http://www.dlsdesign.com. President: David Schiffer. Estab. 1986. Number of employees: 4. Approximate annual billing: $150,000. Graphic design firm. Specializes in high-end corporate websites, logo and corporate identity materials, some annual reports, collateral and book jackets. Product specialties are corporate, publishing, nonprofit, entertainment. Current clients include The Foundation Center, Disney Magazine Publishing, American Management Association, Timex Watchbands, Newcastle/Acoustone Fabrics and many others. Professional affiliation: WWWAC (World Wide Web Artists' Consortium).
Needs: "Over 50% of our work is high-end corporate websites. Work is clean, but can also be high in the 'delight factor.'" Requires designers and illustrators fluent in Photoshop and Illustrator for original website art, including splash screens, banners, GIF animations and interactive banners. Other essential programs include BBEdit, GIF Builder,

DeBabelizer. Also uses freelancers fluent in clean, intermediate to advanced HTML, as well as an understanding of Javascript and CGI.

First Contact & Terms: E-mail is acceptable, but unsolicited attached files will be rejected. "Please wait until we say we are interested, or direct to your URL to show us samples." Uses some hourly freelance help in website authoring; rarely needs editorial illustrations in traditional media.

GT GROUP, a division of Griffith & Tekushan, Inc., 630 Ninth Ave., #1000, New York NY 10036. (212)246-0154. Fax: (212)581-4827. E-mail: gtgroupny@aol.com. Website: http://www.grgroupnyc.com. Estab. 1985. Full-service multimedia firm. Specializes in TV, video, advertising, design and production of promos, show openings and graphics. Current clients include ESPN and CBS.

Needs: Prefers freelancers with experience in television or advertising production. Works on assignment only. Uses freelancers mainly for design production. Also for animation, TV/film graphics and logos. Needs computer-literate freelancers for design, production and presentation.

First Contact & Terms: Send query letter with résumé and demo reels. Samples are filed. Coordinating Producer will contact artist for portfolio review if interested. Portfolio should include 3/4" video or VHS. Pays for design by the hour, $25-50. Finds artists through word of mouth.

Tips: Considers "attitude (professional, aggressive and enthusiastic, not cocky), recommendations and demo sample."

‡HILL AND KNOWLTON, INC., Dept. AGDM, 466 Lexington Ave., New York NY 10017. (212)885-0300. E-mail: maldinger@hillandknowlton.com. Website: http://www.hillandknowlton.com. Corporate Design Group: Michael Aldinger. Estab. 1927. Number of employees: 1,200 (worldwide). PR firm. Full-service multimedia firm. Specializes in annual reports, collateral, corporate identity, advertisements.

Needs: Works with 0-10 freelancers illustrators/month. Works on assignment only. Uses freelancers for editorial, technical and medical illustration. Also for storyboards, slide illustration, animatics, mechanicals, retouching and lettering. 10% of work is with print ads. Needs computer-literate freelancers for illustration. Freelancers should be familiar with QuarkXPress, Aldus FreeHand, Adobe Illustrator, Photoshop or Delta Graph.

First Contact & Terms: Send query letter with promo and samples. Samples are filed. Does not report back, in which case the artist should "keep in touch by mail—do not call." Call and drop-off only for a portfolio review. Portfolio should include dupe photographs. Pays for illustration by the project, $250-5,000. Negotiates rights purchased.

Tips: Looks for "variety; unique but marketable styles are always appreciated."

JEWELITE SIGNS, LETTERS & DISPLAYS, INC., 106 Reade St., New York NY 10013. (212)233-1900. Fax: (212)233-1998. E-mail: jewelite@eclipse.net. Website: http://www.jewelite.com. Vice President: Bobby Bank. Produces signs, letters, silk screening, murals, handlettering, displays and graphics. Current clients include Transamerica, Steve Horn and MCI.

Needs: Approached by 15 freelancers/year. Works with 12 freelancers/year. Works on assignment only. Uses freelancers for handlettering, walls, murals, signs, interior design, architectural renderings, design consulting and model making. 80% of freelance work demands computer skills. Prefers airbrush, lettering and painting.

First Contact & Terms: Call or send query letter. Call for appointment to show portfolio of photographs. Pays for design and illustration by the project, $75 and up. Considers complexity of project and skill and experience of artist when establishing payment.

‡HOWARD LEVY DESIGN, 145 E. 29th St., Suite 4D, New York NY 10016. (212)532-4072. Art Director: Howard Levy. Estab. 1991. Number of employees: 2. Specializes in corporate marketing and communication design: identities, brochures, annual reports, magazines, books and promotion. Professional affiliation: AIGA.

Needs: Approached by 50 freelancers/year. Works with 20 freelance illustrators and 15 designers/year. Prefers artists with experience in QuarkXPress, Adobe Illustrator and Adobe Photoshop. Uses designers and illustrators mainly for magazines, annual reports, brochure and catalog design and illustration, lettering, logos, mechanicals, posters and retouching. 80% of freelance work demands knowledge of Adobe Photoshop, QuarkXPress and Adobe Illustrator.

First Contact & Terms: Send query letter with brochure, photocopies, photographs, résumé, SASE, slides, tearsheets and transparencies. Reports back to the artist only if interested. Pays for design by the hour, $15-20; by the day, $100-150; or by the project, $500-5,000. Pays for illustration by the day, $400-1,000 for color inside; or by the project, $500-2,000 for 2-page spreads. Finds artists through creative sourcebooks and submissions.

Tips: "We are seeking illustrators with strong conceptual skills for editorial illustration in conservation magazine. Also seeking local designers for Macintosh design and production as well as a local Macintosh consultant."

LUBELL BRODSKY INC., 21 E. 40th St., Suite 1806, New York NY 10016. (212)684-2600. Art Directors: Ed Brodsky and Ruth Lubell. Number of employees: 5. Specializes in corporate identity, direct mail, promotion and packaging. Clients: ad agencies and corporations. Professional affiliations: ADC, TDC.

Needs: Approached by 100 freelancers/year. Works with 10 freelance illustrators and 1-2 designers/year. Works on assignment only. Uses freelancers for illustration, mechanicals, retouching, airbrushing, charts/graphs, AV materials and lettering. 100% of design and 30% of illustration demand knowledge of Adobe Photoshop.

First Contact & Terms: Send postcard sample, brochure or tearsheets to be kept on file. Reports back only if interested.

Tips: Looks for unique talent.

JODI LUBY & COMPANY, INC., 808 Broadway, New York NY 10003. (212)473-1922. Fax: (212)473-2858. E-mail: jodi.luby@worldnet.att.net. President: Jodi Luby. Estab. 1983. Specializes in corporate identity, promotion and direct mail design. Clients: magazines, corporations.
Needs: Approached by 10-20 freelance artists/year. Works with 5-10 illustrators/year. Prefers local artists only. Uses freelancers for brochure and catalog illustration, mechanicals, retouching and lettering. 80% of freelance work demands computer skills.
First Contact & Terms: Send postcard sample or query letter with résumé and photocopies. Samples are not filed and are not returned. Will contact artist for portfolio review if interested. Portfolio should include thumbnails, roughs, b&w and color printed pieces. Pays for design by the hour, $25 minimum; by the project, $100 minimum. Pays for illustration by the project, $100 minimum. Rights purchased vary according to project. Finds artists through word of mouth.

LOUIS NELSON ASSOCIATES INC., 80 University Place, New York NY 10003. (212)620-9191. Fax: (212)620-9194. E-mail: lnanyc@aol.com. President: Louis Nelson. Estab. 1980. Number of employees: 6. Approximate annual billing: $750,000. Specializes in environmental, interior and product design and brand and corporate identity, displays, packaging, publications, signage, exhibitions and marketing. Clients: nonprofit organizations, corporations, associations and governments. Current clients include Korean War Veterans Memorial, Port Authority of New York & New Jersey, Richter+Ratner Contracting Corporation, Central Park Conservancy, Steuben, MTA and NYC Transit. Professional affiliations: IDSA, AIGA, SEGD, APDF.
Needs: Approached by 30-40 freelancers/year. Works with 30-40 designers/year. Works on assignment only. Uses freelancers mainly for specialty graphics and 3-dimensional design. Also for design, mechanicals, model making and charts/graphs. 100% of design demands knowledge of Aldus PageMaker, QuarkXPress, Adobe Photoshop, Velum or Adobe Illustrator. Needs editorial illustration.
First Contact & Terms: Send postcard sample or query letter with résumé. Accepts disk submissions compatible with Adobe Illustrator 5.0 or Adobe Photoshop 2.5.1. Send EPS files. Samples are returned only if requested. Reports within 2 weeks. Write for appointment to show portfolio of roughs, color final reproduction/product and photographs. Pays for design by the hour, $15-25 or by the project, negotiable. Less need for illustration.
Tips: "I want to see how the artist responded to the specific design problem and to see documentation of the process—the stages of development. The artist must be versatile and able to communicate a wide range of ideas. Mostly, I want to see the artist's integrity reflected in his/her work."

‡NEWMARK, POSNER & MITCHELL, INC., 300 E. 42nd, New York NY 10017. E-mail: rlcposner@npm.com. Website: http://www.npm.com. Contact: VP/Creative Director. Estab. 1959. AD agency. Full-service multimedia firm. Specializes in ads, collaterals, packaging, outdoor. Product specialties are healthcare, real estate, consumer business to business, corporate.
Needs: Approached by 25 freelance aritsts/month. Works with 1-3 illustrators and 5 designers/month. Prefers local artists only with traditional background with experience in computer design. Uses freelancers mainly for graphic design, production, illustration. 80% of work is with print ads. Needs computer-literate freelancers for design, illustration and production. 90% of freelance work demands knowledge of Adobe Illustrator, QuarkXPress, Photoshop or Aldus FreeHand.
First Contact & Terms: Send query letter with photocopies or disk. Samples are filed. Reports back only if interested. Write for appointment to show portfolio. Portfolio should include thumbnails, roughs, b&w and color tearsheets, printed pieces. Pays for design by the hour, $15-35 or by the project, $300-2,000. Pays for illustration by the project, $300-2,000. Negotiates rights purchased.
Tips: Advises freelancers starting out in advertising field to offer to intern at agencies for minimum wage.

NICOSIA CREATIVE EXPRESSO LTD., 16 W. 56th St., New York NY 10019. (212)489-6423. Fax: (212)265-5422. E-mail: info@niceltd.com. Website: http://www.niceltd.com. President/Creative Director: Davide Nicosia. Estab. 1993. Number of employees: 16. Specializes in graphic design, annual reports, corporate/brand identity, brochures, promotional material, packaging, signage, marketing and website design. Current clients include Calvin Klein, Victoria's Secret, Elizabeth Arden, Tiffany & Co. and Bath & Body Works.
Needs: Approached by 70 freelancers/year. Works with 6 freelance illustrators and 8 designers/year. Works by assignment only. Uses illustrators, designers, 3-dimensional comp artists and computer artists familiar with Adobe Illustrator, Adobe Photoshop, QuarkXPress and Macromedia Director.
First Contact & Terms: Send query letter and résumé. Reports back to artist for portfolio review only if interested. Pays for design by the hour. Pays for illustration by the project. Rights purchased vary according to project.
Tips: Looks for "promising talent and an adaptable attitude."

NOVUS VISUAL COMMUNICATIONS, INC., 18 W. 27th St., New York NY 10001. (212)689-2424. Fax: (212)696-9676. E-mail: novuscom@aol.com. President: Robert Antonik. Estab. 1984. Creative marketing and communications firm. Specializes in advertising, annual reports, brand and corporate identity; display, direct mail, fashion, package and publication design; technical illustration; and signage. Clients: healthcare, telecommunications, consumer products companies. Client list available upon request.
Needs: Approached by 12 freelancers/year. Works with 2-4 freelance illustrators and 2-6 designers/year. Works with artist reps. Prefers local artists only. Uses freelancers for ad, brochure, catalog, poster and P-O-P design and illustration;

airbrushing; audiovisual materials; book, direct mail, magazine and newpaper design; charts/graphs; lettering; logos; mechanicals; and retouching. 75% of freelance work demands knowledge of Adobe Illustrator, Adobe Photoshop, Aldus FreeHand, Aldus PageMaker and QuarkXPress.

First Contact & Terms: Contact only through artist rep. Send postcard sample of work. Samples are filed. Reports back ASAP. Follow-up with call. Pays for design by the hour, $15-75; by the day, $200-300; by the project, $200-1,500. Pays for illustration by the project, $150-1,750. Rights purchased vary according to project. Finds artists through *Creative Illustration, Workbook*, agents and submissions.

Tips: "First impressions are important, a portfolio should represent the best, whether it's 4 samples or 12." Advises freelancers entering the field to "always show your best creation. You don't need to overwhelm your interviewer and it's always a good idea to send a thank you or follow-up phone call."

OUTSIDE THE BOX INTERACTIVE, 133 W. 19th, Suite 10B, New York NY 10011-4117. (212)463-7160. Fax: (212)463-9179. E-mail: theoffice@outboxin.com. Website: http://www.outboxin.com. Design Manager: Lauren Schwartz. Estab. 1995. Number of employees: 5. Integrated marketing communications agency. Specializes in multimedia and integrated digital marketing, online and web content development. Product specialty is business-to-business. Professional affiliations: NY New Media Assoc., Assoc. of Internet Users, Harvestworks/Digital Media.

Needs: Approached by 30-40 freelance illustrators and 30-40 designers/year. Works with 8-10 freelance illustrators and 8-10 designers/year. Prefers freelancers with experience in computer arts. Also for airbrushing, animation, brochure and humorous illustration, logos, model making, multimedia projects, posters, retouching, storyboards, TV/film graphics, web page design. 30% of work is with print ads. 90% of design demands skills in Adobe Photoshop 3, QuarkXPress 3.2, Adobe Illustrator 5, Director HTML, Java Script and any 3D program. 60% of illustration demands skills in Adobe Photoshop 3, QuarkXPress 3.2, Adobe Illustrator 5, any animation and 3D program.

First Contact & Terms: Send query letter with brochure, photocopies, photographs, photostats, résumé, SASE, slides, tearsheets, transparencies. Send follow-up postcard every 3 months. Accepts disk submissions compatible with Power PC. Samples are filed and are returned by SASE. Will contact for portfolio review of b&w, color, final art, photographs, roughs, tearsheets, thumbnails, transparencies if interested. Pays by project. Rights purchased vary according to project.

Tips: "Be able to think on your feet, and to test your limits."

‡PRO/CREATIVES COMPANY, 25 W. Burda Place, New York NY 10956-7116. President: D. Rapp. Estab. 1986. Ad agency and marketing/promotion PR firm. Specializes in direct mail, ads, collateral. Product specialties are consumer/trade, goods/services.

Needs: Works on assignment only. Uses freelancers for brochure and print ad design and illustration. 30% of work is with print ads.

First Contact & Terms: Samples are filed and are returned by SASE. Portfolio review not required. Pays for design and illustration by the project.

‡QUADRANT COMMUNICATIONS CO., INC., 137 Varick St., Third Floor, New York NY 10013. (212)352-1400. Fax: (212)352-1411. E-mail: quadcom@aol.com. President: Robert Eichinger. Number of employees: 4. Approximate annual billing: $850,000. Estab. 1973. Specializes in annual reports, corporate identity, direct mail, publication design and technical illustration. Clients: corporations. Current clients include AT&T, Citibank, Dean Witter Reynolds, Chase Manhattan Bank, Federal Reserve Bank and Polo/Ralph Lauren. Client list available upon request.

Needs: Approached by 100 freelancers/year. Works with 6 freelance illustrators and 4 designers/year. Prefers freelancers with experience in publication production. Works on assignment only. Uses freelancers mainly for publications, trade show collateral and direct mail design. Also for brochure, magazine Internet and intranet design; and charts/graphs. Needs computer-literate freelancers for design and production. 80% of freelance work demands knowledge of QuarkXPress, Aldus FreeHand or Adobe Illustrator and Photoshop.

First Contact & Terms: Send query letter with résumé. Samples are filed. Reports back only if interested. Call for appointment to show portfolio of tearsheets and photographs. Pays for design by the hour, $25-35. Pays for illustration by the project, $400-1,200. Rights purchased vary according to project.

Tips: "We need skilled people. There's no time for training."

MIKE QUON/DESIGNATION INC., (formerly Mike Quon Design Office, Inc.), 53 Spring St., New York NY 10012. (212)226-6024. Fax: (212)219-0331. E-mail: mikequon@aol.com. Website: http://www.mikequondesign.com. President: Mike Quon. Estab. 1982. Number of employees: 3. Specializes in corporate identity, displays, direct mail, packaging, publications and technical illustrations. Clients: corporations (fashion, beauty, financial) and ad agencies. Current clients include Pfizer, Bristol-Myers Squibb, American Express, Chase Manhattan Bank, Bell Atlantic, AT&T. Client list available upon request. Professional affiliations: AIGA, Society of Illustrators, Graphic Artists Guild.

Needs: Approached by 100 illustrators and 100 designers/year. Works with 10 freelance illustrators and 15 designers/year. Prefers local freelancers. Works by assignment only. Prefers graphic style. Uses artists for brochures, design and catalog illustration, P-O-P displays, logos, mechanicals, model making, charts/graphs and lettering. Especially needs computer artists with knowledge of QuarkXPress, Adobe Illustrator, Adobe Photoshop and Dimensions 3.0.

First Contact & Terms: Send query letter with résumé and photocopies. Samples are filed or are returned if accompanied by SASE. Reports back only if interested. Portfolio may be dropped off Monday-Friday. Pays for design by the hour, $20-45. Pays for illustration by the project, $100-500. Buys first rights.

Tips: "Do good work and continually update art directors with mailed samples."

GERALD & CULLEN RAPP, INC., 108 E. 35th St., New York NY 10016. (212)889-3337. Fax: (212)889-3341. E-mail: john@rappart.com. Website: www.theispot.com/rep/rapp. Number of employees: 10. Approximate annual billing: $3.5 million. Associate: John Knepper. Estab. 1944. Clients: ad agencies, coporations and magazines. Client list not available. Professional affiliations: GAG, SPAR, S.I.

Needs: Approached by 500 freelance artists/year. Works with 40 exclusive freelance illustrators. Works on assignment only. Uses freelance illustrators for editorial advertising and corporate illustration. Also uses freelancers for brochure and poster design and illustration, ad and direct mail design, mechanicals, retouching, airbrushing, lettering, and P-O-P illustration.

First Contact & Terms: Send query letter with tearsheets and SASE. Samples are filed or returned by SASE if requested by artist. Reports back within 2 weeks. Call or write for appointment to show portfolio or mail appropriate materials. Pays for illustration by the project, $500-40,000. Negotiates rights purchased.

‡PETER ROTHHOLZ ASSOCIATES INC., 355 Lexington Ave., 17th Floor, New York NY 10017. (212)687-6565. E-mail: pr4pr@aol.com. President: Peter Rothholz. PR firm. Specializes in government (tourism and industrial development), publishing, pharmaceuticals (health and beauty products) and business services.

Needs: Works with 24 freelance illustrators and 24 designers/year. Works on assignment only. Needs editorial illustration.

First Contact & Terms: Call for appointment to show portfolio of résumé or brochure/flyer to be kept on file. Samples are returned by SASE. Reports back in 2 weeks. Assignments made based on freelancer's experience, cost, style and whether he/she is local. Originals are not returned. Sometimes requests work on spec before assigning a job. Negotiates payment based on client's budget. Finds artists through word of mouth and submissions.

‡SAATCHI & SAATCHI ADVERTISING WORLDWIDE, 375 Hudson St., New York NY 10014-3620. (212)463-2000. Fax: (212)463-9855. Senior Art Buyer: Francis Timoney. Full service advertising agency. Clients include: Delta Airlines, Eastman Kodak, General Mills and Procter & Gamble.

- Saatchi & Saatchi is a London-based ad agency with offices all over the globe. Art Buyer Francis Timoney discusses his agency's use of freelancers on page 606.

Needs: Approached by 50-100 freelancers/year. Works with 1-5 designers and 15-35 illustrators/year. Uses freelancers mainly for illustration and advertising graphics. Prefers freelancers with knowledge of electronic/digital delivery of images.

First Contact & Terms: Send query letter and nonreturnable samples or postcard sample. Prefers illustrators' sample postcards or promotional pieces to show "around a half a dozen illustrations," enough to help art buyer determine illustrator's style and visual vocabulary. Files interesting promo samples for possible future assignments. Pays for design and illustration by the project.

✔TONI SCHOWALTER DESIGN, 1133 Broadway, Suite 1610, New York NY 10010. (212)727-0072. Fax: (212)727-0071. E-mail: tonidesign@aol.com or tonidesign@earthlink.net. Website: http://home.earthlink.net/~tonidesign/. Office Manager: Dawn Cavalieri. Estab. 1986. Number of employees: 4. Approximate annual billing: $500,000. Specializes in corporate identity, publication design and sales promotion brochures. Clients: architects, furniture industry, technology, healthcare, management consultants, law firms, financial investments firms. Client list available upon request. Professional affiliations: AIGA, SMPS.

Needs: Approached by 25 freelancers/year. Works with 25 freelance illustrators and 10 designers/year. Prefers artists with experience in illustration and photography. Uses illustrators and designers mainly for publications. Also uses freelancers for brochure design and illustration, charts/graphs, lettering, logos and poster illustration. Needs computer-literate freelancers for design and production. 100% of freelance design work demands knowledge of Adobe Illustrator, Adobe Photoshop and QuarkXPress.

First Contact & Terms: Send postcard sample of work or send query letter with brochure, résumé and tearsheets. Samples are filed. Does not report back. Request portfolio review in original query. Artist should follow-up with call. Portfolio should include b&w and color final art. Pays for design by the hour, $20-45 or by the project, $200-2,000. Pays for illustration by the project, $200-1,000. Negotiates rights purchased. Finds artists through sourcebooks and awards books.

Tips: Looks for a unique portfolio. Send a résumé and 3 color prints of samples, with a cover letter

‡STRATEGIC COMMUNICATIONS, 276 Fifth Ave., New York NY 10001. (212)779-7240. Fax: (212)779-7248. Estab. 1981. PR firm. Specializes in corporate and press materials, World Wide Web-based environments, VNRs and presentation materials. Specializes in service businesses.

Needs: Approached by 3-4 freelancers/month. Works with 3 illustrators and 4 designers/month. Prefers local freelancers only. Works on assignment only. Uses freelancers for brochure design and illustration, slide illustration, mechanicals, posters, computer-mediated communications, lettering, logos, corporate ID programs, annual reports, collateral and press materials.

First Contact & Terms: Send query letter with brochure, résumé, photographs and nonreturnable samples only. Samples are filed. Does not report back, in which case the artist should send follow-up communication every 6-9 months to keep file active. Portfolio should include original, final art. Pays for design and illustration by the project. Rights purchased vary according to project.

Tips: "Send relevant work samples and pricing information based on 'needs.' When I receive irrelevant samples, I

INSIDER REPORT

Fast turn-around, electronic delivery give you extra edge with top agencies

Most young illustrators and designers assume that, without prior experience, it's hard to get freelance assignments from advertising agencies that handle national and global accounts. But this isn't necessarily the case. "You don't have to have a portfolio full of tearsheets to get a big job and command a competitive rate for your work. You just have to prove to the art buyer that you're professional," says Francis Timoney, senior art buyer for Saatchi & Saatchi, a London-based ad agency with offices all over the globe.

Francis Timoney

Timoney says illustrators can get their foot in the door by sending a self-promotional mailer that demonstrates their proficiency. "I like it when an artist produces a self-promotional piece that shows half a dozen illustrations. That allows me to understand their style and visual vocabulary and see the level of execution in their work. It's like a mini-portfolio."

Timoney advises newcomers to study how illustrations are used in advertising, and include samples in their self promotion that exhibit the degree of finish expected of professional illustrators. "Look at advertising. Understand the way images are used in advertising. Understand how advertising works. There are some illustrators who have very successful careers in advertising. They're the ones who understand the concerns of marketers and advertising agencies."

The work included in the self promotion should show the illustrator's ability to enhance a product or complement the attitude that might surround a product. "It can be very conservative, or very funky," says Timoney. He also advises illustrators to recognize that commercial illustration is directed to a much more conservative market than editorial illustration. "Don't develop a self promotion that's so wacky and wild that you alienate the mainstream of advertising," he warns, adding that a collection of samples directed at editorial illustration probably won't strike the right chord with an ad agency.

Timoney says he opens every self-promotional mailer he receives. If it demonstrates professional capability, it gets filed into an extensive library of illustration and design samples he's accumulated over five years at Saatchi & Saatchi's New York office. "If somebody tells me they need someone who does caricature, I have a file called 'humorous illustration.' Within that file I have a subcategory for caricatures. I've collected about a dozen promos from illustrators across the country who do just that."

Let's assume Timoney has pulled your self promotion from his files and wants to give you an illustration assignment. Be prepared to follow through on a professional level, producing a piece that's on par with the work you've shown in your self promotion. And, expect to work around the clock, if necessary, to meet "real world" deadlines. "In advertising we have wicked time lines. We're often given just a few days to produce art,"

INSIDER REPORT, *Timoney*

says Timoney, adding that illustration assignments typically need to be turned around anywhere from one day to one week.

Along with speedy turn around times comes the need to expedite sketches and sometimes final artwork electronically. At the very least, Timoney says, illustrators should be equipped with fax machines for sending and receiving sketches and other communication, and be prepared to Fed Ex final art. He points out that many illustrators are gaining an edge on the competition because they can communicate with clients instantaneously by scanning their work and e-mailing the digital files to their clients for approval. E-mail also has the advantage of letting the art buyer see the illustration in color, and allows the electronic files to be sent by modem as soon as the work is approved. "It has nothing to do with aesthetics—it's the convenience factor," says Timoney. "I called an illustrator the other day and he did an ad illustration for me within an hour. He zapped it over to us via e-mail, and it was printed that night."

Timoney notes that less-experienced illustrators generally charge a lower fee than their more-experienced counterparts. Since agencies are very anxious to meet the bottom line, your slightly lower fee could give you an edge over big-name illustrators. So he encourages newcomers to send self-promotional material to art buyers at top agencies. "As an art buyer, my job is to be liaison to the talent that exists in the outside world," he says. "You don't have to have published work to get work. I hire up-and-comers all the time. Giving someone a break is one of the fun parts of my job, and my clients are pleased, because we're getting the work at a great price."

—*Poppy Evans*

© C.F. Payne

Advertising agencies need skilled illustrators to bring ad campaigns to life. Here, Timoney chose illustrator C.F. Payne, whose talents can make even orange juice seem captivating.

immediately assume the sender does not understand my business and would not be someone we are likely to engage. We toss all extraneous material and don't have time to separate a portfolio. We expect the artist to have some judgment."

TALCO PRODUCTIONS, 279 E. 44th St., New York NY 10017. (212)697-4015. Fax: (212)697-4827. President: Alan Lawrence. Number of employees: 5. TV/film producer. Specializes in nonprofit organizations, industry, associations and PR firms. Produces videotapes, motion pictures and some filmstrips and sound-slide sets. Professional affiliation: DGA.
Needs: Works with 1-2 freelance illustrators and 1-2 designers/year. Prefers local freelancers with professional experience. 15% of freelance work demands knowledge of Aldus FreeHand or Adobe Illustrator.
First Contact & Terms: Send query letter with résumé, brochure and SASE. Reports back only if interested. Portfolio should include roughs, final reproduction/product, and color photostats and photographs. Payment varies according to assignment. Pays on production. Originals sometimes returned at job's completion. Buys all rights. Considers complexity of project, client's budget and rights purchased when establishing payment.

North Carolina

‡BARRINGER & ASSOCIATES, LTD., P.O. Box 2525, 224 Third Ave. NW, Hickory NC 28603. (828)322-5550. Fax: (704)327-8440. Art Director: Brad Metzgar. Estb. 1979. Number of employees: 7. Approximate annual billing: $5 million. Ad agency. Full-service, multimedia firm. Specializes in magazine ads and collateral for business-to-business and industrial corporations. Client list available upon request.
Needs: Approached by 30 freelancers/year. Works with 6 freelance illustrators and 2 designers/year. Prefers freelancers with experience in computer illustration, airbrush, pastel. Uses freelancers mainly for ads, brochures. Also for catalog illustration and retouching. 40% of work is with print ads. Needs computer-literate freelancers for design and illustration. 80% of freelance work demands knowledge of Adobe Photoshop, QuarkXPress, Adobe Illustrator, Ray Dream Designer and Adobe Dimensions.
First Contact & Terms: Send query letter with brochure, photographs and tearsheets. Samples are filed. Reports back only if interested. Request portfolio review in original query. Artist should follow-up with call after initial query. Portfolio should include b&w and color final art, photostats and tearsheets. Pays for design by the hour, $20-35. Pays for illustration by the project, $300-4,000. Negotiates rights purchased. Rights purchased vary according to project.
Tips: Finds artists through CD-ROM and stock houses (catalogs). Not interested in retail (i.e. fashion). "Airbrush artists for photo retouching are history. Professional comprehensive artists with no computer skills are history. Any artists without computer skills are on the endangered species list."

BOB BOEBERITZ DESIGN, 247 Charlotte St., Asheville NC 28801. (704)258-0316. E-mail: bbd@buncombe.main.nc.us. Website: http://buncombe.main.nc.us/~bobb. Owner: Bob Boeberitz. Estab. 1984. Number of employees: 1. Approximate annual billing: $80,000. Specializes in graphic design, corporate identity and package design. Clients: retail outlets, hotels and restaurants, textile manufacturers, record companies, publishers, professional services. Majority of clients are business-to-business. Current clients include Para Research Software, Blue Duck Music, Laurens County Chamber of Commerce, Owen Manufacturing Co., Cross Canvas Co. and High Windy Audio. Professional affiliations: AAF, Asheville Chamber, NARAS, Asheville Freelance Network.
• Owner Bob Boeberitz predicts "everything in art design will be done on computer; more electronic; more stock images; photo image editing and conversions will be used; there will be less commissioned artwork."
Needs: Approached by 50 freelancers/year. Works with 5 freelance illustrators/year. Works on assignment only. Uses freelancers primarily for technical illustration and comps. Prefers pen & ink, airbrush and acrylic. 50% of freelance work demands knowledge of Adobe PageMaker, Adobe Illustrator, Adobe Photoshop or CorelDraw.
First Contact & Terms: Send query letter with résumé, brochure, SASE, photographs, slides and tearsheets. "Anything too large to fit in file" is discarded. Accepts disk submissions compatible with IBM PCs. Send AI-EPS and TIFF files. Samples are returned by SASE if requested. Reports only if interested. Will contact artist for portfolio review if interested. Portfolio should include thumbnails, roughs, final art, b&w and color slides and photographs. Sometimes requests work on spec before assigning a job. Pays for design and illustration, by the project, $50 minimum. Rights purchased vary according to project. Will consider buying second rights to previously published artwork. Finds artists through word of mouth, submissions/self-promotions, sourcebooks, agents.
Tips: "Show sketches—sketches help indicate how an artist thinks. The most common mistake freelancers make in presenting samples or portfolios is not showing how the concept was developed, what their role was in it. I always see the final solution, but never what went into it. In illustration, show both the art and how it was used. Portfolios should be neat, clean and flattering to your work. Show only the most memorable work, what you do best. Always have other stuff, but don't show everything. Be brief. Don't just toss a portfolio on my desk; guide me through it. A 'leave-behind' is helpful, along with a distinctive-looking résumé. Be persistent but polite. Call frequently. I don't recommend cold calls (you rarely ever get to see anyone) but it is an opportunity for a 'leave behind.' I recommend using the mail. I like postcards. They get noticed, maybe even kept. They're economical. And they show off your work. And you can do them more frequently. Plus you'll have a better chance to get an appointment. After you've had an appointment send a thank you note. Say you'll keep in touch and do it!"

IMAGE ASSOCIATES INC., 4909 Windy Hill Dr., Raleigh NC 27609. (919)876-6400. Fax: (919)876-7064. E-mail: dc@imageassociates.com. Website: http://www.imageassociates.com. President: David Churchill. Estab. 1984. Number of employees: 35. AV firm. "Visual communications firm specializing in computer graphics and AV, multi-image, interactive multimedia, Internet development, print and photographic applications.
Needs: Approached by 10 freelancers/year. Works with 4 freelance illustrators and 4 designers/year. Prefers freelancers with experience in high-tech orientations and computer graphics. Works on assignment only. Uses freelancers mainly for brochure design and illustration. Also for print ad design and illustration, slide illustration, animation and retouching. 25% of work is with print ads. 90% of freelance work demands knowledge of Aldus FreeHand, Adobe Photoshop and Macromind Director.
First Contact & Terms: Send query letter with brochure, résumé and tearsheets. Samples are filed or are returned by SASE if requested by artist. Reports back to the artist only if interested. To show portfolio, mail roughs, finished art samples, tearsheets, final reproduction/product and slides. Pays for design and illustration by the project, $100 minimum. Considers complexity of project, client's budget and how work will be used when establishing payment. Rights purchased vary according to project.

North Dakota

‡FLINT COMMUNICATIONS, 101 Tenth St. N., Fargo ND 58102. (701)237-4850. Fax: (701)234-9680. Art Director: Gerri Lien. Estab. 1947. Number of employees: 25. Approximate annual billing: $9 million. Ad agency. Full-service, multimedia firm. Product specialties are agriculture, manufacturing, healthcare, insurance and banking. Client list available upon request. Professional affiliations: AIGA.
Needs: Approached by 50 freelancers/year. Works with 6-10 freelance illustrators and 3-4 designers/year. Uses freelancers for annual reports, brochure design and illustration, lettering, logos and TV/film graphics. 40% of work is with print ads. 20% of freelance work demands knowledge of Aldus PageMaker, Adobe Photoshop, QuarkXPress and Adobe Illustrator.
First Contact & Terms: Send postcard-size sample of work and query letter. Samples are filed. Will contact artist for portfolio review if interested. Pays for illustration by the project, $100-2,000. Rights purchased vary according to project.

‡INK INC., P.O. Box 11384, Fargo ND 58106. (701)241-9204. Contact: Mike Stevens. Number of employees: 11. Approximate annual billing: $600,000. Newsletter printer and publisher. Full-service multimedia firm. Specializes in direct mail advertising and newsletters. "We produce industry-specific newsletters that local printers re-sell to small businesses in their area." Current clients include more than 700 printers nationwide. Client list not available.
Needs: Approached by 12-15 freelancers/year. Works with 5 freelance illustrators and 4 designers/year. Uses freelancers mainly for illustration and line art. Also for brochure design and illustration, lettering and logos. 80% of work is with newsletter design and advertisements. Knowledge of Aldus PageMaker and Adobe Photoshop helpful but not necessary.
First Contact & Terms: Send query letter with photocopies. Samples are filed. "Will return if necessary." Reports back within 1 month. Portfolio review not required. Pays for design and illustration by the project. Rights purchsed vary according to project.
Tips: "Do good work, be friendly, meet deadlines, and charge small town prices. We can't afford New York City rates. We buy lots of artwork and design. Our artists love us because we're easy to work with and pay fast!"

Ohio

BARON ADVERTISING, INC., Hanna Bldg., Suite 645, 1422 Euclid Ave., Cleveland OH 44115-1901. (216)621-6800. Fax: (216)621-6806. President: Selma Baron. Estab. 1956. Ad agency. Specializes in magazine ads and collateral. Product specialties are business-to-business, food, building products, technical products, industrial food service.
Needs: Approached by 30-40 freelance artists/month. Prefers artists with experience in food and technical equipment. Works on assignment only. Uses freelance artists mainly for specialized projects. Also uses freelance artists for brochure, catalog and print ad illustration and retouching. 90% of work is with print ads. Freelancers should be familiar with Aldus PageMaker, QuarkXPress, Aldus FreeHand, Adobe Illustrator or Adobe Photoshop.
First Contact & Terms: Send query letter with résumé and photocopies. Samples are filed and are not returned. Does not report back. "Artist should send only samples or copies that do not need to be returned." Will contact artist for portfolio review if interested. Portfolio should include final art and tearsheets. Pay for design depends on style. Pay for ilustration depends on technique. Buys all rights. Finds artists through agents, sourcebooks, word of mouth and submissions.

‡BELDON/FRENZ/LEHMAN, INC., 24500 Center Ridge Rd., Westlake OH 44145. (216)835-4000. Fax: (216)835-9641. President: Dennis Pavan. Estab. 1955. Number of employees: 12. Approximate annual billing: $6.5 million. Marketing communications firm. Full-service, multimedia firm. Specializes in new product marketing, Internet website design, interactive media. Product specialty is consumer home products. Client list available upon request. Professional affiliations: North American Advertising Agency Network, BPAA.

Needs: Approached by 20 freelancers/year. Works with 5 freelance illustrators and 5 designers/year. Prefers freelancers with experience in advertising design. Uses freelancers mainly for graphic design, illustration. Also for brochure and catalog design and illustration, lettering, logos, model making, posters, retouching, TV/film graphics. 80% of work is with print ads. Needs computer-literate freelancers for design, illustration, production and presentation. 50% of freelance work demands knowledge of Aldus FreeHand, Adobe Photoshop, QuarkXPress, Adobe Illustrator.

First Contact & Terms: Send postcard-size sample of work or send query letter with brochure, photostats, tearsheets, photocopies, résumé, slides and photographs. Samples are filed or returned by SASE. Reports back within 2 weeks. Artist should follow-up with call and/or letter after initial query. Will contact artist for portfolio review if interested. Portfolio should include b&w and color final art, photographs, photostats, roughs, slides and thumbnails. Pays by the project, $200 minimum.

Tips: Finds artists through *Creative Black Book, Illustration Annual, Communication Arts,* local interviews. "Seeking specialist in Internet design, CD-ROM computer presentations and interactive media."

✔FIREHOUSE 101 ART + DESIGN INC., 641 N. High St., Columbus OH 43215. (614)464-0928. Fax: (614)464-0200. E-mail: fh101@eenet.com. Creative Director: Kirk Richard Smith. Estab. 1990. Number of employees: 2. Approximate annual billing: $250,000. Design studio. Specializes in CD packaging, book cover, brochure, poster, logo identity, illustration. Product specialties are entertainment, software, retail fashion. Current clients include CompuServe, Structure, Sony Music, Nickelodeon, Levi Strauss & Co., MCA Records, Arista Records, Locomotion Channel. Client list available upon request. Professional affiliations: CSCA (Columbus Society of Communicating Arts).

 • Firehouse 101 has won many awards. Look for work in *Graphis Poster, Print Regional, Graphis Logo, HOW International Annual* and *Graphic Design America: 2.*

Needs: Approached by 40 illustrators and 50 designers/year. Works with 5 illustrators and 12 designers/year. Uses freelancers mainly for design production. Also for lettering, mechanicals and marketing/proposals. 5% of work is with print ads. 80% of design demands skills in Aldus PageMaker 5, Adobe Photoshop 3, QuarkXPress 3.3. 30% of illustration demands skills in Adobe Photoshop.

First Contact & Terms: Designers send query letter with brochure, photocopies, résumé and tearsheets. Illustrators send postcard sample of work. Accepts submissions on disk compatible with QuarkXPress 3.3. Send EPS files. Samples are filed and are not returned. Reports back only if interested. Request portfolio review in original query. Portfolio should include tearsheets and transparencies. Pays for design by the hour, $20-45. Pays for illustration by the project, $200-2,000. Buys one-time or all rights. Finds artists through postcard mailings, *Print, Graphis, HOW* and *Eye.*

Tips: "Be open to working hard and learning new methodologies. Stay informed of the industry and art world."

‡HOLLAND ADVERTISING, 252 Ludlow Ave., Cincinnati OH 45220. (513)221-1252. Fax: (513)221-0758. E-mail: holland@eos.net. Estab. 1937. Number of employees: 8. Approximate annual billing: $7 million. Ad agency. Full-service, multimedia firm. Professional affiliation: TAAN.

Needs: Approached by 6-12 freelancers/year. Works with 5-10 freelance illustrators and 2-3 designers/year. Prefers artists with experience in Macintosh. Uses freelancers for brochure illustration, logos, retouching and TV/film graphics. 100% of freelance work demands knowledge of Aldus PageMaker, Aldus FreeHand, Adobe Photoshop, QuarkXPress and Adobe Illustrator.

First Contact & Terms: Send query letter with photocopies and résumé. Accepts submissions on disk. Samples are filed and are not returned. Will contact artist for portfolio review if interested. Portfolio should include b&w and color final art, photographs, roughs, tearsheets and thumbnails. Pays for design by the hour, by the project and by the day. Pays for illustration by the project. Rights purchased vary according to project.

‡INSTANT REPLAY, Dept. AM, 1349 E. McMillan, Cincinnati OH 45206. (513)569-8600. Fax: (513)569-8608. President: Terry Hamad. Estab. 1977. AV/Post Production/Graphic Design firm. "We are a full-service film/video production and video post production house with our own sound stage. We also do traditional animation, paintbox animation with Harry, and 3-D computer animation for broadcast groups, corporate entities and ad agencies. We do many corporate identity pieces as well as network affiliate packages, car dealership spots and general regional and national advertising for TV market." Current clients include Procter and Gamble, General Electric, NBC, CBS, ABC and FOX affiliates.

Needs: Works with 1 designer/month. Prefers freelancers with experience in video production. Works on assignment only. Uses freelancers mainly for production. Also use freelancers for storyboards, animatics, animation and TV/film graphics.

First Contact & Terms: Send query letter with résumé, photocopies, slides and videotape. "Interesting samples are filed." Samples not filed are returned by SASE only if requested. Reports back only if interested. Call for appointment to show slide portfolio. Pays by the hour, $25-50 or by the project and by the day (negotiated by number of days.) Pays for production by the day, $75-300. Considers complexity of project, client's budget and turnaround time when establishing payment. Buys all rights.

‡LIGGETT-STASHOWER, 1228 Euclid Ave., Cleveland OH 44115. (216)348-8500. Fax: (216)736-8113. Art Buyer: Kelly McNamara. Estab. 1940. Ad agency. Full-service multimedia firm. Works in all formats. Handles all product categories. Current clients include Sears Optical, Babcock & Wilson and Evenflo.

Needs: Approached by 120 freelancers/year. Works with 12 freelance illustrators and 12 designers/year. Prefers local freelancers. Works on assignment only. Uses freelancers mainly for brochure, catalog and print ad design and illustration;

storyboards; slide illustration; animatics; animation; mechanicals; retouching; billboards; posters; TV/film graphics; lettering; and logos. Needs computer-literate freelancers for illustration and production. 30% of freelance work demands knowledge of Aldus PageMaker, QuarkXPress, Aldus FreeHand, Photoshop or Adobe Illustrator.

First Contact & Terms: Send query letter. Samples are filed. Reports back to the artist only if interested. To show portfolio, mail tearsheets and transparencies. Pays for design and illustration by the project. Negotiates rights purchased.

LOHRE & ASSOCIATES, 2330 Victory Parkway, Suite 701, Cincinnati OH 45206. (513)961-1174. E-mail: sales@loh re.com. Website: http://www.lohre.com. President: Chuck Lohre. Number of employees: 8. Approximate annual billing: $1 million. Ad agency. Specializes in industrial firms. Professional affiliation: BMA.

Needs: Approached by 24 freelancers/year. Works with 10 freelance illustrators and 10 designers/year. Works on assignment only. Uses freelance artists for trade magazines, direct mail, P-O-P displays, multimedia, brochures and catalogs. 100% of freelance work demands knowledge of Aldus PageMaker, Aldus FreeHand, Adobe Photoshop and Illustrator.

First Contact & Terms: Send postcard sample. Accepts submissions on disk, any Mac application. Pays for design and illustration by the hour, $10 minimum.

Tips: Looks for artists who "have experience in chemical and mining industry, can read blueprints and have worked with metal fabrication. Needs Macintosh-literate artists who are willing to work at office, during day or evenings."

‡CHARLES MAYER STUDIOS INC., 168 E. Market St., Akron OH 44308. (216)535-6121. President: C.W. Mayer, Jr. AV producer. Estab. 1934. Number of employees: 65. Approximate annual billing: $2 million. Clients: mostly industrial. Produces film and manufactures visual aids for trade show exhibits.

Needs: Uses illustrators for catalogs, filmstrips, brochures and slides. Also for brochures/layout, photo retouching and cartooning for charts/visuals. In addition, has a large gallery and accepts paintings, watercolors, etc. on a consignment basis, 33%-40% commissions.

First Contact & Terms: Send slides, photographs, photostats or b&w line drawings or arrange interview to show portfolio. Samples not filed are returned by SASE. Reports back in 1 week. Provide résumé and a sample or tearsheet to be kept on file. Originals returned to artist at job's completion. Negotiates payment.

ART MERIMS COMMUNICATIONS, Bank One Center, Suite 1300, 600 Superior Ave., Cleveland OH 44114-2650. (216)522-1909. Fax: (216)479-6801. E-mail: amerims@hqcon.com. President: Arthur M. Merims. Number of employees: 4. Approximate annual billing: $800,000. Ad agency/PR firm. Current clients include Ohio Pest Control Association, HQ Business Centers, Patrick Douglas, Inc., Woodruff Foundation, Associated Builders and Contractors, Inc., Cleveland Marshall Law Alumni Assn., Cleveland World Trade Assn.

Needs: Approached by 10 freelancers/year. Works with 1-2 freelance illustrators and 3 designers/year. Prefers local freelancers. Works on assignment only. Uses freelancers mainly for work on trade magazines, brochures, catalogs, signage, editorial illustrations and AV presentations. 20% of freelance work demands computer skills.

First Contact & Terms: Send query letter with samples to be kept on file. Call for appointment to show portfolio of "copies of any kind" as samples. Sometimes requests work on spec before assigning a job. Pays for design and illustration by the hour, $20-60, or by the project, $300-1,200. Considers complexity of project, client's budget and skill and experience of artist when establishing payment. Finds artists through contact by phone or mail.

Tips: When reviewing samples, makes decisions based on "subjective feeling about abilities and cost if budget is low."

‡PARKER ADVERTISING COMPANY, 3445 S. Dixie Dr., Dayton OH 45439. (937)293-3300. Fax: (937)293-7423. Estab. 1925. Number of employees: 10. Ad agency. Specializes in magazine ads, annual reports, spec sheets and catalogs. Product specialty is industrial. Client list not available.

Needs: Approached by 10 freelancers/year. Works with 4 freelance illustrators and 2 designers/year. Prefers artists with experience in industrial advertising. Uses freelancers for brochure and catalog illustration. 60% of work is with print ads. Needs computer-literate freelancers for production. Freelancers should be familiar with Aldus PageMaker, Adobe Photoshop and QuarkXPress.

First Contact & Terms: Send postcard-size sample of work. Samples are filed and are not returned. Does not report back. Portfolio review not required. Pays for design and illustration by the project. Buys all rights.

‡TRIAD (Terry Robie Industrial Advertising, Inc.), 7654 W. Bancroft St., Toledo OH 43617-1656. (419)841-2272. E-mail: jrobie@terryrobie.com. Website: http://www.terryrobie.com. President/Creative Director: Janice Robie. Ad agency specializing in graphics, promotions and electronic media. Product specialties are industrial, consumer.

Needs: Assigns 30 freelance jobs/year. Works with 5 illustrators/year and 20 designers/year. Works on assignment only. Uses freelancers for consumer and trade magazines, brochures, catalogs, P-O-P displays, AV presentations, posters and illustrations (technical and/or creative). 100% of design and 50% of illustration require computer skills. Also needs freelancers experienced in electronic authoring, animation, web design, programming and design.

First Contact & Terms: Send query letter with résumé and slides, photographs, photostats or printed samples. Accepts disk submissions compatible with Mac or Windows. Samples returned by SASE if not filed. Reports only if interested. Write for appointment to show portfolio, which should include roughs, finished art, final reproduction/product and tearsheets. Pays by the hour, $10-60 or by the project, $25-2,500. Considers client's budget and skill and experience of artist when establishing payment. Negotiates rights purchased.

Tips: "We are interested in knowing your specialty."

‡**WATT, ROOP & CO.**, 1100 Superior Ave., Suite 1350, Cleveland OH 44114. (216)566-7019. Fax: (216)566-0857. Vice President Design: Tom Federico. Estab. 1981. Number of employees: 30. Approximate annual billing: $3 million. Integrated marketing communications agency. Specializes in annuals, sales literature, ads. Product specialties are manufacturing, high tech, healthcare. Current clients include NCR, RPM, TRW, AT&T. Professional affiliations: AIGA, Cleveland Ad Club.

Needs: Approached by 30 freelance illustrators and 20 designers/year. Works with 3 freelance illustrators and 6 designers/year. Prefers local freelancers. Uses freelancers mainly for overflow. Also for animation; humorous, medical and technical illustration; lettering, mechanicals, model making, multimedia projects, storyboards, TV/film graphics. 10% of work is with print ads. 100% of design demands skills in Aldus PageMaker, Aldus FreeHand, Adobe Photoshop, QuarkXPress, Adobe Illustrator. 50% of illustration demands skills in Aldus FreeHand, Adobe Photoshop, Adobe Illustrator.

First Contact & Terms: Designers send query letter with photocopies. Illustrators send postcard sample of work. Accepts disk submissions compatible with QuarkXPress 7.5/version 3.3. Send EPS files. Samples are filed. Reports back only if interested. Portfolio of color, final art, photographs may be dropped off. Pays for design by the hour, $30-50. Pays for illustration by the project. Buys all rights. Finds artists through word of mouth, creative outlet books.

Tips: "Be flexible and fast."

‡**WILDER-FEARN & ASSOC., INC.**, 2035 Dunlap St., Cincinnati OH 45214. (513)621-5237. Fax: (513)621-4880. E-mail: wildfearn@aol.com. President: Gary Fearn. Estab. 1946. Number of employees: 7. Specializes in annual reports; brand and corporate identity; and display, package and publication design. Clients: ad agencies, corporations, packaging. Current clients include Jergens Co., Kenner Toys, Kroger and Kraft. Client list available upon request. Professional affiliation: Art Directors Club of Cincinnati.

Needs: Approached by 20-25 freelancers/year. Works with 5-10 freelance illustrators and 2-5 designers/year. Prefers freelancers with experience in packaging and illustration comps. Uses freelance illustrators mainly for comps and finished art on various projects. Needs editorial illustration. Uses freelance designers mainly for packaging and brochures. Freelancers should be familiar with QuarkXPress, Adobe Illustrator, Aldus FreeHand, Adobe Photoshop, Adobe Streamline and O-Photo-Scan.

First Contact & Terms: Send query letter with photocopies, résumé and slides. Accepts disk submissions compatible with Adobe Illustrator. Send EPS files. Samples are filed or are returned by SASE if requested by artist. Reports back to the artist only if interested. Call for appointment to show portfolio of roughs, original/final art and color tearsheets and slides. Payment for design and illustration is based upon talent, client and project. Rights purchased vary according to project.

Oklahoma

KIZER PAGE ADVERTISING AND COMM.'S, 6440 Avondale, #200, Oklahoma City OK 73116. (405)843-3020. Fax: (405)843-3017. Principal: William Kizer. Estab. 1995. Number of employees: 6. Ad agency. Specializes in magazine ads, annual reports, collateral. Professional affiliations: GLS, OKC Ad Club, AMA.

Needs: Approached by 10 illustrators/year. Works with 3 illustrators and 3 designers/year. 75% of work is with print ads. 100% of design demands knowledge of Aldus PageMaker, Aldus FreeHand, Adobe Photoshop. 50% of illustration demands knowledge of Aldus FreeHand, Adobe Photoshop.

First Contact & Terms: Designers send query letter. Illustrators send query letter with samples. Accepts disk submissions compatible with FreeHand 5.5 or Photoshop EPS. Samples are filed and are not returned. Reports back only if interested. To show portfolio, artist should follow-up with call. Portfolio should include "your best work." Pays by the project. Rights purchased vary according to project. Finds artists through agents, sourcebooks, on-line services, magazines, word of mouth, artist's submissions.

Oregon

ADFILIATION ADVERTISING, 323 W. 13th Ave., Eugene OR 97401. (541)687-8262. Fax: (541)687-8576. E-mail: vip@adfiliation.com. Website: http://www.adfiliation.com. President/Creative Director: Gary Schubert. Media Director/VP: Gwen Schubert. Estab. 1976. Ad agency. "We provide full-service advertising to a wide variety of regional and national accounts. Our specialty is print media, serving predominantly industrial and business-to-business advertisers." Product specialties are forest products, heavy equipment, software, sporting equipment, food and medical.

Needs: Works with approximately 4 freelance illustrators and 2 designers/year. Works on assignment only. Uses freelancers mainly for specialty styles. Also for brochure and magazine ad illustration (editorial, technical and medical), retouching, animation, films and lettering. 80% of work is with print ads. 80% of freelance work demands knowledge of Adobe Illustrator, QuarkXPress, Aldus FreeHand, MultiMedia, Director, 3D Renderman or Adobe Photoshop.

First Contact & Terms: Send query letter, brochure, résumé, slides and photographs. Samples are filed or are returned by SASE only if requested. Reports back only if interested. Write for appointment to show portfolio. Pays for design and illustration and by the hour, $25-100. Rights purchased vary according to project.

Tips: "We're busy. So follow up with reminders of your specialty, current samples of your work and the convenience of dealing with you. We are looking at more electronic illustration. Find out what the agency does most often and produce a relative example for indication that you are up for doing the real thing! Followup after initial interview of samples. Do not send fine art, abstract subjects."

‡**CREATIVE COMPANY, INC.**, Dept. AM, 3276 Commercial St. SE, Salem OR 97302. (503)363-4433. E-mail: jlmorrow@creativeco.com. Website: http://www.creativeco.com. President/Owner: Jennifer Larsen Morrow. Specializes in marketing-driven corporate identity, collateral, direct mail, packaging and P-O-P displays. Product specialties are food, garden products, financial services, colleges, pharmaceutical, medical, technical instruments, franchises, transportation programs.
Needs: Works with 3-7 freelance designers and 3-7 illustrators/year. Prefers local artists. Works on assignment only. Uses freelancers for design, illustration, computer production (Mac), retouching and lettering. "Looking for clean, fresh designs!" 100% of design and 60% of illustration demand skills in QuarkXPress, Aldus Pagemaker, Aldus FreeHand, Adobe Illustrator and Adobe Photoshop.
First Contact & Terms: Send query letter with brochure, résumé, business card, photocopies and tearsheets to be kept on file. Samples returned by SASE only if requested. Will contact for portfolio review if interested. "We require a portfolio review. Years of experience not important if portfolio is good. We prefer one-on-one review to discuss individual projects/time/approach." Pays for design by the hour or project, $50-90. Pays for illustration by the project. Considers complexity of project and skill and experience of artist when establishing payment.
Tips: Common mistakes freelancers make in presenting samples or portfolios are: "1) poor presentation, samples not mounted or organized; 2) not knowing how long it took them to do a job to provide a budget figure; 3) not demonstrating an understanding of the audience, the problem or printing process and how their work will translate into a printed copy; 4) just dropping in without an appointment; 5) not following up periodically to update information or a résumé that might be on file."

‡**OAKLEY DESIGN STUDIOS**. 519 SW Park Ave., Suite 521, Portland OR 97205. (503)241-3705. Fax: (503)241-3812. E-mail: oakleyds@teleport.com or oakleyds@aol.com. Creative Director: Tim Oakley. Estab. 1992. Number of employees: 3. Specializes in brand and corporate identity; display, package and publication design; and advertising. Clients: ad agencies, record companies, surf apparel manufacturers, mid-size businesses. Current clients include Safari Motorcoaches, Bratwear, Judan Records, Amigo Records, Jantzen, Inc., Triad Pools, Wells Fargo Bank, Paragon Cable, Mira Mobile Television, Mira Creative Group. Professional affiliations OMPA, AIGA, PDXAD and PAF.
Needs: Approached by 5-10 freelancers/year. Works with 3 freelance illustrators and 2 designers/year. Prefers local artists with experience in technical illustration, airbrush. Also for multimedia projects. Uses illustrators mainly for advertising. Uses designers mainly for logos. Also uses freelancers for ad and P-O-P illustration, airbrushing, catalog illustration, lettering and retouching. 60% of design and 30% of illustration demand knowledge of Adobe Illustrator, Adobe Photoshop and QuarkXPress.
First Contact & Terms: Contact through artist rep or send query letter with brochure, photocopies, photographs, résumé and tearsheets. Accepts disk submissions compatible with Adobe Illustrator 5.0. Send EPS files. Samples are filed or returned by SASE if requested by artist. Reports back within 4-6 weeks. Request portfolio review in original query. Will contact artist for portfolio review if interested. Portfolio should include b&w and color final art, photocopies, photostats, roughs and slides. Pays for design by the project, $200 minimum. Pays for illustration by the project. Rights purchased vary according to project. Finds artists through design workbooks.
Tips: "Be yourself. No phonies. Be patient and have a good book ready."

SULLIVAN PATTISON CLEVENGER, 219 SW Stark St., #200, Portland OR 97204-2602. (503)226-4553. Fax: (503)273-8052. E-mail: hpattison@eugene.spcadvertising.com. or kfinstad@portland.spcadvertising.com. Partner/Senior Art Director: Kirsten Finstad. Partner/Creative Director: Harry Pattison. Estab. 1988. Number of employees: 12. Approximate annual billing: $8-10 million. Ad agency, PR firm. Full-service multimedia firm. Specializes in print, broadcast and PR. Product specialties are healthcare, resort, restaurant, real estate, high-tech industries. Client list available upon request. Professional affiliations: PAF, PAAA, AIGA.
Needs: Approached by over 100 freelancers/year. Works with 10-20 freelance illustrators/year. Also Uses freelancers for billboards, brochure and catalog illustration, retouching and TV/film graphics. 80% of work is with print ads/collateral work. 50% of freelance work demands knowledge of Adobe Photoshop, QuarkXPress and FreeHand.
First Contact & Terms: Send postcard-size sample of work, photocopies and tearsheets. Will contact artist for portfolio review if interested. Portfolio should include "anything in a good creative presentation." Payment for illustration depends on the project. Rights purchased vary according to project. Finds artists through *Creative Black Book*, *Workbook*, magazines, word of mouth, submissions.
Tips: Impress art director "with intelligence, open-minded attitude, creative break-through work only; and flexibility with budget."

WISNER ASSOCIATES, Advertising, Marketing & Design, 2237 NE Wasco, Portland OR 97232. (503)228-6234. Creative Director: Linda Wisner. Estab. 1979. Number of employees: 1. Specializes in brand and corporate identity, book design, direct mail, packaging and publications. Clients: small businesses, manufacturers, restaurants, service businesses and book publishers.

Needs: Approached by 2-3 freelancers/year. Works with 3-5 freelance illustrators/year. Prefers experienced freelancers and "fast, clean work." Works on assignment only. Uses freelancers for technical and fashion illustration and some Windows-based computer work. Knowledge of QuarkXPress, CorelDraw, Adobe Photoshop, Adobe Illustrator and other Windows-compatible software required.
First Contact & Terms: Send query letter with résumé, photocopies and tearsheets. Prefers "examples of completed pieces which show the fullest abilities of the artist." Samples not kept on file are returned by SASE only if requested. Will contact artist for portfolio review if interested. Portfolio should include thumbnails, roughs and final reproduction/product. Pays for illustration by the hour, $20-45 average or by the project, by bid. Pays for computer work by the hour, $15-25.
Tips: "Bring a complete portfolio with up-to-date pieces."

Pennsylvania

‡ADVERTEL, INC., (formerly Bellmedia Corp.), P.O. Box 18053, Pittsburgh PA 15236. (888)ADVERTEL. Fax: (412)469-8244. Full-service multimedia firm. Product specialty is business-to-business telephonic production.
Needs: Prefers local artists only. Uses freelance artists mainly for print ad, brochure and logo design. Also uses freelance artists for catalog and print ad design. 90% of freelance work demands knowledge of Aldus PageMaker.
First Contact & Terms: Send query letter with brochure and résumé. Accepts submissions on disk. Samples are filed. Reports back to the artist only if interested. Artist should follow up with call. Portfolio should include thumbnails, roughs, final art and mechanicals. Pays for design and illustration by the hour or by the project. Buys reprint rights or all rights. Finds artists through word of mouth, submissions.

‡THE BALL GROUP, 1689 Crown Ave., Lancaster PA 17601. (717)299-1598. Fax: (717)299-9690. Creative Director: Marlin Miller. Estab. 1985. Number of employees: 7. Approximate annual billing: $5 million. Integrated marketing communications agency. Specializes in new market development. Professional affiliation: Central Pennsylvania Ad Club, American Marketing Assoc., Baltimore Chapter.
● The Ball Group received four Addy Awards in the 1996 Baltimore Addy competition.
Needs: Approached by 5 freelance illustrators and 5 designers/year. Works with 5 freelance illustrators and 5 designers/year. Uses freelancers mainly for illustration. Also for animation; brochure, catalog, technical illustration; logos; multimedia projects; retouching; signage; storyboards; TV/film graphics; web page design. 20% of work is with print ads. 80% of design demands skills in Aldus PageMaker, Aldus FreeHand, Adobe Photoshop.
First Contact & Terms: Designers send query letter with photocopies, résumé. Illustrators send query letter with photocopies, photographs. Accepts disk submissions compatible with Aldus PageMaker 6.5, Aldus FreeHand 7.0 or Adobe Photoshop 4.0. Samples are filed. Will contact for portfolio review of final art, photographs if interested. Pays for design by the hour, $15-35. Pays for illustration by the project. Rights purchased vary according to project. Finds artists through agents, direct mail, sourcebooks.

THE CONCEPTS CORP., Dept. AM, 120 Kedron Ave., Holmes PA 19043. (610)461-1600. Fax: (610)461-1650. President: James Higgins. Estab. 1962. AV firm. Full-service, multimedia firm. Specializes in design, collateral, location and studio photography, computer graphics and special effects photography. Product specialties are computer, medical and industrial. Current clients include GE, Acts, Inc., Chilton Publishing, Herr's Foods, Ply-Gem Mfg., Arlo Chemical, Georgetown Yacht Basin.
Needs: Approached by 2-4 artists/month. Works with 1 illustrator and 1 designer/month. Prefers local artists with experience in collateral and AV design, type-spec, layout, comps and client contact. Uses freelancers mainly for fill-in for overflow and special design illustrator talent. Also for brochure, catalog and print ad design and illustration; storyboards; multimedia; mechanicals; and TV/film graphics. 90% of work is with print ads. 10% of design and 90% of illustration demand computer skills.
First Contact & Terms: Send query letter with résumé. Samples are filed or are returned. Reports back to the artist only if interested. Write for appointment to show portfolio of thumbnails, roughs, tearsheets and slides. Pays for design and illustration by the hour, $20-75. Buys first rights.
Tips: "Be at the right place at the right time and network as much as possible. Learn 'new technologies' and utilize them."

‡CROSS KEYS ADVERTISING & MARKETING, INC., 329 S. Main St., Doylestown PA 18901. (215)345-5435. Fax: (215)345-4570. President: Laura T. Barnes. Estab. 1981. Number of employees: 10. Approximate annual billing: $2 million. Ad agency.
Needs: Approached by 30 freelancers/year. Works with 4 freelance illustrators and 5 designers/year. Prefers local

SASE MEANS SELF-ADDRESSED, STAMPED ENVELOPE. Send SASEs when requesting return of your samples.

freelancers. Uses freelancers for design and illustration, logos, mechanicals and retouching. 80% of work is with print ads. 50% of freelance work demands knowledge of Adobe Photoshop, QuarkXPress and Adobe Illustrator on Mac.

First Contact & Terms: Send query letter with photocopies and résumé. "We will accept work in Adobe Illustrator or as EPS files and in QuarkXPress." Samples are filed. Will contact artist for portfolio review if interested. Portfolio should include b&w and color final art, roughs. Pays for design and illustration by the project. Rights purchased vary according to project.

DESIGN & MARKET RESEARCH LABORATORY, 1035 Longford Rd., Oaks PA 19456. (215)935-4114. Fax: (215)935-4051. Director: M. Ryan. Estab. 1945. Number of employees: 19. Approximate annual billing: $3 million. Specializes in package design. Clients: corporations. Client list available upon request. Professional affiliations: AIGA, IOPP, Art Directors Club.

Needs: Approached by 40 freelancers/year. Works with 10 freelance illustrators and 20 designers/year. Prefers local freelancers only. Uses freelancers mainly for packaging. Also for brochure and P-O-P illustration and design, mechanicals, retouching, airbrushing, lettering and logos. Needs computer-literate freelancers for design and production. 60% of freelance work demands knowledge of QuarkXPress (mostly), Adobe Illustrator or Adobe Photoshop.

First Contact & Terms: Send query letter with brochure and résumé. Samples are filed. Reports back to the artist only if interested. Request portfolio review in original query. Portfolio should include b&w and color thumbnails, final art and slides. Pays for design by the hour, rate negotiable. Pays for illustration by the project. Buys all rights.

DLD ADVERTISING, (formerly Dave Loose Design, Inc.), 620 E. Oregon Rd., Lititz PA 17543. (717)569-6568. Fax: (717)569-7410. Director of Operations: Lynn Ritts. Estab. 1986. Number of employees: 9. Design firm. Specializes in capabilities brochures, corporate ID. Client list available upon request.

Needs: Approached by 2 illustrators and 4 designers/year. Works with 2 illustrators/year. Uses freelancers mainly for illustration. Also for animation; catalog, humorous and technical illustration; TV/film graphics. 10% of work is with print ads. 50% of design demands skills in Adobe Photoshop, QuarkXPress, Adobe Illustrator.

First Contact & Terms: Designers send query letter with photocopies, résumé and tearsheets. Illustrators send postcard sample of work. Accepts disk submissions compatible with QuarkXPress 7.5/version 3.3. Send EPS files. Samples are filed. Reports back only if interested. Artist should follow-up with call. Portfolio should include color final art, roughs and tearsheets. Pays for design and illustration by the project. Buys all rights. Finds artists through *American Showcase*, postcard mailings, word of mouth.

Tips: "Be conscientious of deadlines, willing to work with hectic schedules."

‡FULLMOON CREATIONS INC., 81 S. Main St., Doylestown PA 18901. (215)345-1233. Fax: (215)348-5378. E-mail: rkl@fullmooncreations.com. Website: http://www.fullmooncreations.com. Contact: Art Director. Estab. 1986. Number of employees: 5. Approximate annual billing: $300,000. Specializes in brand and corporate identity; packaging design; corporate literature systems; new brand and new product development. Clients: Fortune 500 corporations. Current clients include M&M Mars, CHR, Hansen Bio-Systems, Educom.

Needs: Approached by 100-120 freelancers/year. Works with 5-15 freelance illustrators and 10-20 designers/year. Uses freelancers for ad, brochure and catalog design and illustration; airbrushing; audiovisual materials; book, direct mail and magazine design; logos; mechanicals; poster and P-O-P illustration. Needs computer-literate freelancers for design, illustration and production. 50% of freelance work demands knowledge of Adobe Illustrator, Adobe Photoshop 2.51 or 3.0, Aldus FreeHand 4.0 and QuarkXPress 3.31.

First Contact & Terms: Send postcard sample of work, photocopies, résumé and 1.44MB diskette/floppies. Samples are filed. Reports back within 1 month with SASE. Will contact artist for portfolio review if interested. Portfolio should include b&w and color roughs, thumbnails and transparencies. Pays for design by the hour, $10-40. Pays for illustration by the project, $150-1,500. Rights purchased vary according to project. Finds artists through sourcebooks, submissions and art schools.

Tips: "Send samples every three months."

L D & B ADVERTISING INC., (formerly Letven/Diccicco & Battista Advertising Inc.), Dept. AM, 655 Business Center Dr., Horsham PA 19044. (215)957-0300. Website: http://www.ldb.com. Contact: Executive Art Director. Estab. 1967. Full-service, multimedia, business-to-business ad agency. "High Creative." Specializes in food and business-to-business. Current clients include Hatfield Meats, Primavera, Hallowell and Caulk Dental Supplies.

Needs: Works with 10 freelance illustrators and 25 freelance designers/month. Uses freelance artists mainly for paste-up and mechanicals, illustration, photography and copywriting. Also uses artists for brochure design, slides, print ads, animatics, animation, retouching, TV/film grapics, lettering and logos. 60% of work is with print ads.

First Contact & Terms: Send query letter with brochure, résumé, tearsheets, photostats, photocopies, photographs, slides and SASE. Samples are filed or are returned by SASE only if requested by artist. Reports back to the artist only if interested. Write to schedule an appointment to show a portfolio, which should include roughs, original/final art, tearsheets, final reproduction/product, photographs, slides; include color and b&w samples. Pays for design by the hour, $15-50. Pays for illustration by the project. Rights purchased vary according to project.

Tips: "Not everything they've had printed is worth showing—good ideas and good executions are worth more than mediocre work that got printed. Check on agency's client roster in the Red Book—that should tell you what style or look they'll be interested in."

LECHNER & BENSON ADVERTISING DESIGN, 4014 Wood St., Erie PA 16509. Phone/fax: (814)864-5043. Partners: Chuck Benson and Bill Lechner. Estab. 1992. Number of employees: 3. Approximate annual billing: $150,000. Ad agency/design firm. Specializes in collateral, magazine ads, sales promotion and logo design. Product specialties are consumer and industrial. Current clients include Reed Manufacturing, United Refining and Lord Corp. Client list not available. Professional affiliation: Erie Ad Club.

Needs: Approached by 3-5 freelancers/year. Works with 3 freelance illustrators and 2 designers/year. Uses freelancers for brochure design and illustration, catalog design, mechanicals, retouching and signage. 20% of work is with print ads. Needs computer-literate freelancers for design, illustration and production. 80% of freelance work demands knowledge of Adobe PageMaker, Aldus FreeHand, Adobe Photoshop, QuarkXPress and Adobe Illustrator.

First Contact & Terms: Send postcard-size sample of work or send query letter with brochure, photocopies and tearsheets. Samples are filed or returned by SASE if requested by artist. Reports back to the artist only if interested. Artist should follow-up. Portfolio should include b&w and color roughs, tearsheets and thumbnails. Pays for design by the hour, $50 minimum or by the project, $1,000-3,000. Pays for illustration by the hour, $50-80 or by the project, $100-2,000. Buys all rights or negotiates rights purchased. Finds artists through submissions, word of mouth.

Tips: "Try to be versatile. When you're first starting out, you have to be a 'jack of all trades,' until you find your specialty."

‡MINKUS & ASSOCIATES, 100 Chetwynd Dr., Suite 200, Rosemont PA 19010. (610)525-6769. Fax: (610)525-6829. President: Bob Minkus. Estab. 1985. Number of employees: 5. Specializes in package design, brand and corporate identity, annual reports, display design and signage. Clients: corporations. Current clients include Borden, Inc., AT&T, Confab Companies and Boiron International. Client list available upon request. Professional affiliations: AIGA, International Trademark Center and Package Design Council.

Needs: Approached by 50-100 freelancers/year. Works with 5-10 freelance illustrators and 10-15 designers/year. Uses designers mainly for computer rendering and mechanicals; some traditional design. Also uses freelancers for airbrushing, brochure design and illustration, logos and mechanicals (computer). Needs computer-literate freelancers for design, illustration, production and presentation. 98% of freelance work demands knowledge of Adobe Illustrator 5.5, Adobe Photoshop 3.0 and QuarkXPress 3.31. "Must be very familiar—no time to train."

First Contact & Terms: Send query letter with brochure and résumé. Samples are filed "if liked." Reports back to the artist only if interested. Artist should follow-up with call. Pays for design by the hour, $15 minimum. Pays for illustration depending on project budget.

Tips: Finds designers through portfolio reviews at local schools and résumés received. Finds illustrators through sourcebooks and artist reps we have on file. Impressed by "clever and unusual solutions to problems; clean and clear idea presentation."

THE NEIMAN GROUP, Harrisburg Transportation Center, Fourth and Chesnut St., Harrisburgh PA 19101. (717)232-5554. Fax: (717)232-7998. E-mail: neimangrp@aol.com. Senior Art Director: Sandra Dwyer. Estab. 1978. Full-service ad agency specializing in print collateral and ad campaigns. Product specialties are healthcare, banks, retail and industry.

Needs: Works with 5 illustrators and 4 designers/month. Prefers local artists with experience in comps and roughs. Works on assignment only. Uses freelancers mainly for advertising illustration and comps. Also uses freelancers for brochure design, mechanicals, retouching, lettering and logos. 50% of work is with print ads. 3% of design and 1% of illustration demand knowledge of Adobe Illustrator and Adobe Photoshop.

First Contact & Terms: Designers send query letter with résumé. Illustrators send postcard sample, query letter and tearsheets. Samples are filed. Will contact artist for portfolio review if interested. Portfolio should include color and b&w samples, thumbnails, roughs, original/final art, photographs. Pays for design and illustration by the project, $300 minimum. Buys all rights. Finds artists through sourcebooks and workbooks.

Tips: "Everybody looks great on paper. Try to get a potential client's attention with a novel concept. Never, ever, miss a deadline. Enjoy what you do. There will be a need for more multimedia and electronic design. We are moving in that direction gradually."

PERCEPTIVE MARKETERS AGENCY LTD., 1100 E. Hector St., Suite 301, Conshohocken PA 19428-2394. (610)825-8710. Fax: (610)825-9186. E-mail: perceptmkt@aol.com. Creative Director: Jason Solovitz. Estab. 1972. Number of employees: 8. Approximate annual billing: $4 million. Ad agency. Product specialties are communications, sports, hospitals, health care consulting, computers (software and hardware), environmental products, automotive, insurance, financial, food products and publishing. Professional Affiliation: Philadelphia Ad Club, Philadelphia Direct Marketing Association, AANI, Second Wind Network.

Needs: Approached by 50 freelancers/year. Works with 6 freelance illustrators and 8 designers/year. Uses 80% local talent. In order of priority, uses freelancers for computer production, photography, illustration, comps/layout and design/art direction. Also for multimedia. "Concepts, dynamic design, ability to follow instructions/layouts and precision/accuracy are important." 100% of design and 50% of illustration demand knowledge of QuarkXPress, Adobe Illustrator or Adobe Photoshop. 50% of work is with print ads.

First Contact & Terms: Send résumé and photostats, photographs and tearsheets to be kept on file. Accepts as samples "whatever best represents artist's work—but preferably not slides." Accepts submissions on disk. Samples not filed are returned by SASE only. Reports back only if interested. Graphic designers call for appointment to show portfolio. Pays for design by the hour or by the project. Pays for illustration by the project, up to $3,500. Considers complexity of the project, client's budget and turnaround time when establishing payment. Buys all rights.

Tips: "Freelance artists should approach us with unique, creative and professional work. And it's especially helpful to followup interviews with new samples of work (i.e., to send a month later a 'reminder' card or sample of current work to keep on file)."

WILLIAM SKLAROFF DESIGN ASSOCIATES, 124 Sibley Ave., Ardmore PA 19003. (610)649-6035. Fax: (610)649-6063. E-mail: wsklaroff@aol.com. Design Director: William Sklaroff. Estab. 1956. Specializes in display, interior, package and publication design and corporate identity and signage. Clients: contract furniture, manufacturers, health care corporations. Current clients include: Kaufman, Halcon Corporation, L.U.I. Corporation, McDonald Products, Smith Metal Arts, Baker Furniture, Novikoff and Metrologic Instruments. Client list available upon request.
Needs: Approached by 2-3 freelancers/year. Works with 2-3 freelance illustrators and 2-3 designers/year. Works on assignment only. Uses freelancers mainly for assistance on graphic projects. Also for brochure design and illustration, catalog and ad design, mechanicals and logos.
First Contact & Terms: Send query letter with brochure, résumé and slides to Lori L. Minassian, PR Coordinator. Samples are returned. Reports back within 3 weeks. To show portfolio, mail thumbnails, roughs, finished art samples and color slides and transparencies. Pays for design by the hour. Rights purchased vary according to project. Finds artists through word of mouth and submissions.

‡SPENCER ZAHN & ASSOCIATES, 2015 Sansom St., Philadelphia PA 19103. (215)564-5979. Fax: (215)564-6285. Business Manager: Brian Zahn. Estab. 1970. Number of employees: 10. Specializes in brand and corporate identity, direct mail design, marketing and retail advertising. Clients: corporations.
Needs: Approached by 100 freelancers/year. Works with freelance illustrators and designers. Prefers artists with experience in Macintosh computers. Uses freelancers for ad, brochure and poster design and illustration; direct mail design; lettering; and mechanicals. Needs computer-literate freelancers for design, illustration and production. 80% of freelance work demands knowledge of Adobe Illustrator, Adobe Photoshop, Aldus FreeHand and QuarkXPress.
First Contact & Terms: Send query letter with samples. Samples are not filed and are returned by SASE if requested by artist. Reports back to the artist only if interested. Artist should follow-up with call. Portfolio should include final art and printed samples. Buys all rights.

Rhode Island

✔MARTIN THOMAS, INC., 334 County Rd., Barrington RI 02806-4108. (401)245-8500. Fax: (401)245-1242. Production Manager: Brenda L. Pottle. Estab. 1987. Number of employees: 12. Approximate annual billing: $7 million. Ad agency, PR firm. Specializes in industrial, business-to-business. Product specialties are plastics, medical and automotive. Professional affiliations: American Association of Advertising Agencies, Boston Ad Club.
Needs: Approached by 10-15 freelancers/year. Works with 6 freelance illustrators and 10-15 designers/year. Prefers freelancers with experience in business-to-business/industrial. Uses freelancers mainly for design of ads, literature and direct mail. Also for brochure and catalog design and illustration. 85% of work is print ads. 70% of design and 40% of illustration demand knowledge of QuarkXPress.
First Contact & Terms: Send query letter with brochure and résumé. Samples are filed and are returned. Reports back within 3 weeks. Will contact artist for portfolio review if interested. Portfolio should include b&w and color final art. Pays for design and illustration by the hour and by the project. Buys all rights. Finds artists through *Creative Black Book*.
Tips: Impress agency by "knowing industries we serve."

‡SILVER FOX ADVERTISING, 11 George St., Pawtucket RI 02860. (401)725-2161. Fax: (401)726-8270. E-mail: silfoxadv@aol.com. President: Fred Marzocchi, Jr. Estab. 1979. Number of employees: 6. Approximate annual billing: $1 million. Specializes in annual reports; brand and corporate identity; display, package and publication design; and technical illustration. Clients: corporations, retail. Client list available upon request.
Needs: Approached by 16 freelancers/year. Works with 6 freelance illustrators and 12 designers/year. Works only with artist reps. Prefers local artists only. Uses illustrators mainly for cover designs. Also for multimedia projects. 50% of freelance work demands knowledge of Adobe Illustrator, Adobe Photoshop, Aldus PageMaker and QuarkXPress.
First Contact & Terms: Send query letter with résumé and photocopies. Accepts disk submissions compatible with Adobe Photoshop 3.0 or Adobe Illustrator 5.5. Samples are filed. Does not report back. Artist should follow-up with call and/or letter after initial query. Portfolio should include final art, photographs, photostats, roughs and slides.

Tennessee

AB STUDIOS INC., 807 Third Ave. S., Nashville TN 37210. (615)256-3393. Fax: (615)256-3464. E-mail: abinfo@abs tudios.com. Website: http://www.abstudios.com. President: Rick Arnemann. General Manager: Dan Kellerby. Estab. 1988. Number of employees: 20. Approximate annual billing: $2.5 million. Specializes in brand identity, display and direct mail design and signage. Clients: ad agencies, corporations, mid-size businesses. Current clients include Best

Products, Service Merchandise, WalMart, Hartmann Luggage. Client list available upon request. Professional affiliations: Creative Forum.

Needs: Approached by 20 freelancers/year. Works with 4-5 freelance illustrators and 2-3 designers/year. Uses illustrators mainly for P-O-P. Uses designers mainly for fliers and catalogs. Also uses freelancers for ad, brochure, catalog, poster and P-O-P design and illustration; logos; magazine design; mechanicals; and retouching. 85% of freelance work demands knowledge of Adobe Illustrator 5.5, Adobe Photoshop 3.0 and QuarkXPress 3.31.

First Contact & Terms: Send photographs, résumé, slides and transparencies. Samples are filed. Will contact artist for portfolio review if interested. Portfolio should include color final art, roughs, slides and thumbnails. Pays for design and illustration by the project. Rights purchased vary according to project. Finds artists through sourcebooks and portfolio reviews.

ANDERSON STUDIO, INC., 2609 Grissom Dr., Nashville TN 37204. (615)255-4807. Fax: (615)255-4812. Contact: Andy Anderson. Estab. 1976. Number of employees: 13. Approximate annual billing: $1.6 million. Specializes in T-shirts (designing and printing of art on T-shirts for retail/wholesale market). Clients: business, retail, catalog and gift stores.

Needs: Approached by 20 freelancers/year. Works with 1-2 freelance illustrators and 1-2 designers/year. "We use freelancers with realistic (photorealistic) style or approach to various subjects, animals and humor. Also contemporary design and loose film styles accepted." Works on assignment only. Needs freelancers for retail niche markets, resorts, theme ideas, animals, zoos, educational, science, American motorcycle v-twin art, hip kid art (skateboarder/BMX bike type art for T's), humor-related themes and hot rod art. Also creative graphic work for above. Catchy marketable ideas welcome. Educational and science art needed.

First Contact & Terms: Send postcard sample or query letter with color copies, brochure, photocopies, photographs, SASE, slides, tearsheets and transparencies. Samples are filed and are returned by SASE if requested by artist. Portfolio should include slides, color tearsheets, transparencies and color copies. Sometimes requests work on spec before assigning a job. Pays for design and illustration by the project, $300-1,000 or in royalties per piece of printed art. Negotiates rights purchased. Considers buying second rights (reprint rights) to previously published work.

Tips: "We're looking for fresh ideas and solutions for art featuring animals, zoos, science, humor and education. We need work that is marketable for specific tourist areas—state parks, beaches, islands; also for women's markets. Be flexible in financial/working arrangements. Most work is on a commission or flat buy out. We work on a tight budget until product is sold. Art-wise, the more professional the better." Advises freelancers entering the field to "show as much work as you can. Even comps or ideas for problem solving. Let art directors see how you think. Don't send disks. Takes too long to review. Most art directors like hard copy art."

McCLEAREN DESIGN, 3901 Brush Hill Rd., Nashville TN 37216. (615)859-4550. Fax: (615)859-3988. E-mail: mcclearen@aol.com. Owner: Brenda McClearen. Estab. 1987. Number of employees: 3. Specializes in display, music, package and publication design.

Needs: Approached by 5-10 freelancers/year. Works with 2-5 freelance illustrators and designers/year. Prefers local artists only. Uses freelancers for ad design and illustration, model making and poster design. Needs computer-literate freelancers for design and illustration. 50% of freelance work demands knowledge of QuarkXPress and Macintosh.

First Contact & Terms: Samples are filed. Will contact artist for portfolio review if interested. Portfolio should include b&w and color final art, photographs and roughs. Pays be the project.

✔MEDIA GRAPHICS, 717 Spring St., P.O. Box 820525, Memphis TN 38182-0525. (901)324-1658. Fax: (901)323-7214. E-mail: devkinney@worldnet.att.net. CEO: J.D. Kinney. Estab. 1973. Integrated marketing communications agency. Specializes in all visual communications. Product specialties are financial, fundraising, retail, business-to-business. Client list available upon request. Professional affiliations: Memphis Area chamber, B.B.B.

• This firm reports they are looking for top illustrators only. When they find illustrators they like, they generally consider them associates and work with them on a continual basis.

First Contact & Terms: Send query letter with résumé and tearsheets. Accepts disk submissions compatible with Mac or PC. Send EPS file. Also CD-ROM. Samples are filed and are not returned. Will contact for portfolio review if interested. Rights purchased vary according to project.

Tips: Chooses illustrators based on "portfolio, availability, price, terms and compatibility with project."

THE TOMBRAS GROUP, 630 Concord St., Knoxville TN 37919. (423)524-5376. Fax: (423)524-5667. E-mail: mmccampbell@tombras.com. Website: http://www.tombras.com. Creative Director: Mitch McCampbell. Estab. 1946. Number of employees: 50. Approximate annual billing: $21 million. Ad agency. Full-service multimedia firm. Specializes in full media advertising, collateral, PR. Current clients include PHP Cariten Healthcare and Eastman Chemical. Client list available upon request. Professional affiliations: AAAA, 3AI, PRSA.

Needs: Approached by 20-25 freelancers/year. Works with 5-10 freelance illustrators and 2-5 designers/year. Uses freelancers mainly for illustration. Also for brochure design and illustration, model making and retouching. 60% of work is with print ads. Needs computer-literate freelancers for design and presentation. 25% of freelance work demands knowledge of Aldus FreeHand, Adobe Photoshop and QuarkXPress.

First Contact & Terms: Send query letter with photocopies and résumé. Samples are filed. Will contact artist for portfolio review if interested. Portfolio should include b&w and color samples. Pays for design by the hour, $25-40; by the project, $250-2,500. Pays for illustration by the project, $100-10,000. Rights purchased vary according to project.

North Light Art School offers you...

The Convenience of Home Study

- Get professional guidance throughout your workshop without leaving your home or studio.
- Work at your own pace...on your own schedule...when *you* have time for your art!

Personal, Professional Feedback

- Your work gets the personal attention of professional artists who have years of teaching experience.
- As you progress in your workshop, you'll receive individual, one-on-one critiques of up to 12 artworks.

The Satisfaction of Success

- Professional instruction tailored to *your* level of skill and experience.
- See your artwork improve after your very first personal critique!

Get custom critiques of your artwork in your choice of format—tracing paper overlay or VHS videotape.

For FREE information on how the experts at North Light Art School can help you enhance your art, simply fill out this card and mail today!

Tips: "Stay in touch with quality promotion. 'Service me to death' when you get a job."

Texas

DYKEMAN ASSOCIATES INC., 4115 Rawlins, Dallas TX 75219. (214)528-2991. Fax: (214)528-0241. E-mail: adykeman@airmail.net. Website: http://dykemanassoc.com. Contact: Alice Dykeman. PR/marketing firm. Specializes in business, industry, hospitality, sports, environmental, energy, health.
Needs: Works with 12 illustrators and designers/year. Local freelancers only. Uses freelancers for editorial and technical illustration, brochure design, exhibits, corporate identification, POS, signs, posters, ads and all design and finished artwork for graphics and printed materials.
First Contact & Terms: Request portfolio review in original query. Pays by the project, $250-3,000. "Artist makes an estimate; we approve or negotiate."
Tips: "Be enthusiastic. Present an organized portfolio with a variety of work. Portfolio should reflect all that an artist can do. Don't include examples of projects for which you only did a small part of the creative work. Have a price structure but be willing to negotiate per project. We prefer to use artists/designers/illustrators who will work with barter (trade) dollars and join one of our associations. We see steady growth ahead."

FUTURETALK TELECOMMUNICATIONS COMPANY, INC., P.O. Box 270942, Dallas TX 75227-0942. Website: http://www.tel3.com, then type in under sponsor #FU515092 to access system and services accounts. Contact: Marketing Department Manager. Estab. 1993. Ad agency and PR firm. Full-service multimedia firm and telecommunications company. Current clients include small to medium businesses and individuals, and 9.9¢ long distance, pagers, phone cards.
Needs: Approached by 20-30 freelancers/year. Works with 10-15 illustrators and 2-3 designers/year. Prefers freelancers with experience in computer graphics. Works on assignment only. Uses freelancers mainly for promotional projects. Also for brochure and catalog illustration, storyboards, animation, model making, billboards and TV/film graphics. 20% of work is with print ads. 60% of freelance work demands computer skills.
First Contact & Terms: Send query letter with résumé, photocopies, photographs and SASE. Samples are filed or are returned by SASE if requested by artist. Reports back within 3 weeks. Art Director will contact artist for portfolio review if interested. Portfolio should include b&w and color final art, tearsheets and photostats. Pays for design by the hour, $10-25; by the project, $250-2,500; by the day, $250-2,500. Pays for illustration by the hour, $20-40; by the project, $250-2,500; by the day, $250-2,500. Rights purchased vary according to project. Finds artists through sourcebooks, word of mouth and artists' submissions.
Tips: "This year Futuretalk will be also seeking an artist to develop a cartoon book to sell our 9.9¢/minute NeTel long distance service. Artist's abilities must be very professional, but not overly expensive, pay cash and artist credits will be compensation. Send $3 for 'outline sheets' which explain project 'before' submitting prospective ideas and samples."

HEPWORTH ADVERTISING COMPANY, 3403 McKinney Ave., Dallas TX 75204. (214)526-7785. Manager: S.W. Hepworth. Full-service ad agency. Clients: finance, consumer and industrial firms.
Needs: Works with 3-4 freelancers/year. Uses freelancers for brochure and newspaper ad design, direct mail packages, magazine ad illustration, mechanicals, billboards and logos.
First Contact & Terms: Send a query letter with tearsheets. Samples are not filed and are returned by SASE only if requested by artist. Does not report back. Portfolio should include roughs. Pays for design and illustration by the project. Considers client's budget when establishing payment. Buys all rights.
Tips: Looks for variety in samples or portfolio.

ZIERHUT DESIGN STUDIOS, INC., 2014 Platinum St., Garland TX 75042. (972)276-1722. Fax: (972)272-5570. E-mail: zierhut@ont.com. Website: http://www.zierhut.com. Owner: Kathleen Zierhut. Estab. 1955. Specializes in display, product and package design and corporate identity. Clients: corporations, museums, individuals. Client list not available.
Needs: Works with 1-2 freelance graphic artists and 3-4 freelance designers/year. Works on assignment only. Uses designers mainly for renderings and graphics. Also uses freelance artists for illustration, mechanicals, retouching, airbrushing and model making. Needs computer-literate freelancers for design. 100% of freelance work demands knowledge of CAD and/or Pro Engineering.
First Contact & Terms: Send query letter with résumé. Samples are filed. Reports back to the artist only if interested. Will contact artist for portfolio review if interested. Porfolio should include b&w and color final art and photographs. Pays for design by the hour, $15-50, by the project or by direct quote. Buys all rights. Finds artists through sourcebooks and word of mouth.
Tips: "Be computer-literate and persistent."

Vermont

‡HARRY SPRUYT DESIGN, 451 Jacksonville Stage Rd., Brattleboro VT 05301-6909. Specializes in design/invention of product, package and device; design counseling service shows "in-depth concern for environments and human

factors with the use of materials, energy, time; product design evaluation and layout." Clients: product manufacturers, design firms, consultants, ad agencies, other professionals and individuals. Client list available.
Needs: Works on assignment only.

Virginia

‡**VIVID IMAGES PRESS, INC.**, 8907 Necessary Rd., #100, Wise VA 24293. (864)461-4117. E-mail: jcallio@juno.com. Website: http://www.vipinc.net. President: Jacqueline C. Allio. Estab. 1975. Specializes in webpages. Product specialties motorsports. Professional affiliations: AARWBA, AICPA, ABBSA, AMA, HTML Writer's Guild.
Needs: Approached by 5 freelance illustrators and 5 designers/year. Works with 10 freelance illustrators and 10 designers/year. Prefers freelancers with experience in HTML. Uses freelancers mainly for contract jobs. Also for brochure and technical illustration, logos, multimedia projects, posters, TV/film graphics, web page design. 80% of work is with print ads. 25% of freelance work demands skills in Aldus PageMaker, Adobe Photoshop.
First Contact & Terms: Send query letter with photocopies, résumé, SASE. Send follow-up postcard every 4 months. Accepts disk submissions compatible with DOS and Windows on 3.5 or 5.25 disks. Samples are filed or returned by SASE. Reports back within 15 days. Portfolios may be dropped off every Tuesday. Will contact for portfolio review of photostats, diskettes if interested. Pays by the hour, $10 minimum; by the project, $50 minimum. Negotiates rights purchased. Rights purchased vary according to project. Finds artists through word of mouth, submissions, agents.
Tips: "We welcome new talent. Check our online client list and suggest better illustrations than what is currently shown."

Washington

BELYEA DESIGN ALLIANCE, 1809 Seventh Ave., Suite 1007, Seattle WA 98101. (206)682-4895. Fax: (206)623-8912. Website: http://www.belyea.com. Estab. 1980. Specializes in annual reports; brand and corporate identity; marketing materials; in-store P-O-P; direct mail, package and publication design. Clients: corporate, manufacturers, retail. Current clients include Weyerhaeuser and Princess Tours. Client list available upon request.
Needs: Approached by 20-30 freelancers/year. Works with 10 freelance illustrators and 3-5 designers/year. Prefers local design freelancers only. Works on assignment only. Uses illustrators for "any type of project." Uses designers mainly for overflow. Also uses freelancers for brochure, catalog, poster and ad illustration; and lettering. 100% of design and 70% of illustration demand knowledge of QuarkXPress, Aldus FreeHand or Adobe Photoshop.
First Contact & Terms: Send postcard sample and résumé. Accepts disk submissions. Samples are filed. Reports back to the artist only if interested. Pays for illustration by the project, $125-1,000. Rights purchased vary according to project. Finds artists through submissions by mail and referral by other professionals.
Tips: "Designers must be computer-skilled. Illustrators must develop some styles that make them unique in the marketplace. When pursuing potential clients, "send something (one or more) distinctive. Follow up. Be persistent (it can take one or two years to get noticed) but not pesky. Get involved in local AIGA. Always do the best work you can—exceed everyone's expectations."

✔**DAIGLE DESIGN INC.**, 180 Olympic Dr. SE, Bainbridge Island WA 98110. (206)842-5356. Fax: (206)780-2526. Website: http://www.daigle.com. Creative Director: Candace Daigle. Estab. 1987. Number of employees: 4. Approximate annual billing: $600,000. Design firm. Specializes in brochures, catalogs, logos, magazine ads, trade show display and web pages. Product specialties are communication, restaurant and automotive. Current clients include AT&T Wireless Services, Tollycraft and Wells Manufacturing. Professional affiliations: AIGA.
Needs: Approached by 20 illustrators and 40 designers/year. Works with 5 illustrators and 10 designers/year. Prefers local designers with experience in Adobe Photoshop, Adobe Illustrator and Aldus PageMaker. Uses freelancers mainly for concept and production. Also for airbrushing, brochure design and illustration, lettering, logos, multimedia projects, signage, technical illustration and web page design. 15% of work is with print ads. 90% of design demands skills in Aldus PageMaker 6.0, Adobe Photoshop 3.0, Adobe Illustrator 6.0 and Aldus FreeHand 5.0. 50% of illustration demands skills in Adobe Illustrator 6.0 and Aldus FreeHand 5.0.
First Contact & Terms: Designers send query letter with résumé. Illustrators send query letter with photocopies. Accepts disk submissions compatible with Photoshop 3.0 and Pagemaker 6.0. Send EPS files. Samples are filed and are not returned. Reports back only if interested. Will contact for portfolio review of b&w, color, final art, slides and tearsheets if interested. Pays for design by the hour, $25-50; pays for illustration by the project, $100-1,000. Buys all rights. Finds artists through submissions, reps, temp agencies and word of mouth.

DITTMANN DESIGN, P.O. Box 31387, Seattle WA 98103-1387. (206)523-4778. E-mail: danditt@aol.com. Owner/Designer: Martha Dittmann. Estab. 1981. Number of employess: 2. Specializes in brand and corporate identity, display and package design and signage. Clients: corporations. Client list available upon request. Professional affiliations: AIGA.
Needs: Approached by 50 freelancers/year. Works with 5 freelance illustrators and 2 designers/year. Uses illustrators mainly for corporate collateral and packaging. Uses designers mainly for color brochure layout and production. Also

uses freelancers for brochure and P-O-P illustration, charts/graphs and lettering. Needs computer-literate freelancers for design, illustration, production and presentation. 75% of freelance work demands knowledge of Adobe Illustrator, Photoshop, PageMaker, Persuasion, FreeHand and Painter.

First Contact & Terms: Send postcard sample of work or brochure and photocopies. Samples are filed. Will contact artist for portfolio review if interested. Portfolio should include final art, roughs and thumbnails. Pays for design by the hour, $35-100. Pays for illustration by the project, $250-5,000. Rights purchased vary according to project. Finds artists through sourcebooks, agents and submissions.

Tips: Looks for "enthusiasm and talent."

EMMAL BUTLER CREATIVES, 1735 Westlake N. #207, Seattle WA 98109. (206)283-7223. Fax: (206)284-9362. E-mail: cemmal@aol.com. Contact Cheryl Butler. Estab. 1989. Number of employees: 1. Approximate annual billing: 150,000. Integrated marketing communications agency/broker of art talent. Specializes in print and web design.

Needs: Approached by 50 illustrators and 50 designers/year. Works with 10 illustrators and 10 designers/year. Uses freelancers mainly for print/web design. Also for airbrushing, annual reports, billboards, brochure and catalog design and illustration, humorous illustration, lettering, logos, multimedia projects, posters, retouching, signage, storyboards, signage, technical illustration and web page design. 25% of work is with print ads. 95% of design demands skills in Adobe Photoshop, Adobe Illustrator, Aldus FreeHand, QuarkXPress and Web software. 50% of illustration demands skills in Adobe Photoshop, Adobe Illustrator and Aldus FreeHand.

First Contact & Terms: Designers and illustrators send examples of work (any form). Send follow-up every 6 months. Accepts digital portfolios and e-mail queries with links to websites. Samples are filed and are not returned. Does not report back. Artist should check in. To arrange portfolio review, follow-up with call. Payment determined by value of work. Rights purchased vary according to project. Finds artists through word of mouth and submissions.

Tips: "Specialize—become known for one area of expertise. Be persistent or get a good rep."

LEIMER CROSS DESIGN, 140 Lakeside Ave., Seattle WA 98122. (206)325-9504. Fax: (206)329-9891. Partner: Dorothy Cross. Estab. 1983. Specializes in annual reports, publication design, marketing brochures. Clients: corporations and service companies. Client list not available.

Needs: Approached by 75 freelance artists/year. Works with 4-5 illustrators and 6-8 designers/year. Prefers artists with experience in working for corporations. Uses freelance illustrators mainly for annual reports, lettering and marketing materials. Uses freelance designers mainly for "layout per instructions," production. Also for brochure illustration, mechanicals, charts/graphs. "Mac/Aldus Pagemaker expertise a must."

First Contact & Terms: Send query letter with résumé, tearsheets and photographs. Samples are filed. Reports back to the artist only if interested. To show a portfolio, mail thumbnails, roughs, tearsheets and photographs. Pays for design by the hour or by the project. Pays for illustration by the project. Rights purchased vary according to project.

TED MADER ASSOCIATES, INC. (TMA), 2562 Dexter Ave. N., Seattle WA 98109. (206)270-9360. Also 280 Euclid Ave., Oakland, CA. E-mail: info@tmadesign.com. Website: http://www.tmadesign.com. Principal: Ted Mader. Number of employees: 12. Specializes in corporate and brand identity, displays, direct mail, fashion, packaging, publications, signage, book covers, interactive media and CD-ROM. Client list available upon request.

Needs: Approached by 150 freelancers/year. Works with 25 freelancer illustrators and 10-20 designers/year. Uses freelancers for illustration, retouching, electronic media, production and lettering. Freelance work demands knowledge of QuarkXPress, Macromedia FreeHand, Adobe Illustrator, Photoshop, Macromedia Director or HTML programming.

First Contact & Terms: Send postcard sample or query letter with résumé and samples. Accepts disk submissions compatible with Mac. Samples are filed. Write or call for an appointment to show portfolio. Pays by the project. Considers skill and experience of freelancer and project budget when establishing payment. Rights purchased vary according to project.

‡JERI McDONALD & ASSOC., INC., 2200 Sixth Ave., #430, Seattle WA 98275 (206)728-8570. Fax: (206)728-7109. E-mail: jerimcd@aol.com. Art Director: Tami Taylor. Estab. 1979. Number of employees: 4. Ad agency, PR firm. Full-service multimedia firm. Specializes in collateral, print ads and video. Product specialties are consumer, food and travel. Current clients include Tillicum, Village & Tours, Washington Newspaper Association, Tule Art Gallery. Client list available upon request. Professional affiliations: PRSA, SKUCCB, BVCB.

Needs: Approached by 6-12 freelancers/year. Works with 1-3 freelance illustrators/year. Uses freelancers mainly for special needs of clients, work overload. Also for brochure design, logos and TV/film graphics. 5% of work is with print ads. Needs computer-literate freelancers for design and production. 100% of freelance work demands knowledge of Aldus PageMaker, Aldus FreeHand and Adobe Photoshop.

First Contact & Terms: Send postcard-size sample of work or query letter with résumé and samples. Will contact artist for portfolio review if interested. Pays for design and illustration by the project depending on need. Buys all rights.

Tips: Finds artists through professional networking. "Keep in touch by sending postcards showing samples of work."

‡PARALLEL COMMUNICATIONS, 8195 166th Ave. NE, Suite 200, Redmond WA 98052. E-mail: parallel@parallel.comm.com. Website: http://www.parallel-comm.com/. Creative Director: Alan Kawashima. Estab. 1984. Number of employees: 27. Approximate annual billing: $20 million. Ad agency. Full-service advertising, web design and multimedia firm. Product specialties are high tech, software and game companies. Professional affiliations: MIT, WSA, AMA, AAF, IICS.

Needs: Approached by 200-400 freelancers/year. Works with 30-50 freelance illustrators and 2-5 designers/year. Designers must work inhouse. Uses freelancers mainly for handling overflow. Also for annual reports, brochure design and illustration, logos, mechanicals and model making. 25% of work is with print ads. Needs computer-literate freelancers for design, illustration, production and presentation. 99% of freelance work demands knowledge of Aldus FreeHand, Adobe Photoshop, QuarkXPress, Illustrator and new media software.

First Contact & Terms: Send query letter with brochure, photocopies, photographs, photostats, résumé, slides, tearsheets and transparencies. Samples are not filed. Portfolios may be dropped off Monday-Friday. Will contact artist for portfolio review if interested. Portfolio should include b&w and color final art, photographs, photostats, roughs, slides, tearsheets, thumbnails and transparencies. Pays for design by the hour, $25-100; or by the project; $500-5,000. Pays for illustration by the project, $900-2,500. Rights purchased vary according to project. Finds artists through agents, sourcebooks (*Creative Black Book*, *Workbook*), magazines, word of mouth and artists' submissions.

Tips: Impress creative director by being multi-dimensional. "We are looking for freelancers with experience in traditional print and new media design."

‡SAM PAYNE & ASSOCIATES, 1471 Elliott Ave. W., Suite A, Seattle WA 98119. (206)285-2009. Fax: (206)285-2948. Owner: Sam Payne. Estab. 1979. Specializes in brand and corporate identity; direct mail, package and publication design; and signage. Clients: food companies, corporations, small to medium-sized businesses and packaging companies.

Needs: Approached by 10-12 freelance artists/year. Works with 2-3 freelance illustrators/year. Prefers local artists with experience in food. Works on assignment only. Uses freelance illustrators mainly for packaging and miscellaneous publications. Also uses freelance artists for ad, brochure, editorial, food, catalog and P-O-P illustration and retouching, airbrushing and lettering. Also for multimedia projects. 100% of design demands knowledge of QuarkXPress, Adobe Photoshop, Aldus FreeHand and Adobe Illustrator.

First Contact & Terms: Send query letter with résumé, color photocopies and SASE. Samples are filed or are returned by SASE if requested by artist. Will contact artist for portfolio review if interested. Portfolio should include color slides, photographs and finished printed pieces. Pays for design and illustration by the project, $50-5,000. Rights purchased vary according to project. Considers buying second rights (reprint rights) to previously published work.

Wisconsin

AGA COMMUNICATIONS, 2557 C. N. Terrace Ave., Milwaukee WI 53211-3822. (414)962-9810. E-mail: agacom @juno.com. CEO: Art Greinke. Estab. 1984. Number of employees: 8. Marketing communications agency (includes advertising and public relations). Full-service multimedia firm. Specializes in special events (large display and photo work), print ads, TV ads, radio, all types of printed material (T-shirts, newsletters, etc.). Current clients include Great Circus Parade, Circus World Museum, GGS, Inc., IBM, Universal Savings Bank and Landmark Theatre Chain. Also sports, music and entertainment personalities. Professional affiliations: PRSA, IABC, NARAS.

 • AGA also has audio recording and video facilities.

Needs: Approached by 125 freelancers/year. Works with 25 freelance illustrators and 25 designers/year. Uses freelancers for "everything and anything"—such as brochure and print ad design and illustration, storyboards, slide illustration, retouching, model making, billboards, posters, TV/film graphics, lettering and logos. Also for multimedia projects. 40% of work is with print ads. 75% of freelance work demands knowledge of PageMaker, Illustrator, Quark, Photoshop, FreeHand or Powerpoint.

First Contact & Terms: Send postcard sample and/or query letter with brochure, résumé, photocopies, photographs, SASE, slides, tearsheets, transparencies. Accepts disk submissions compatible with BMP files, PageMaker, Quark and Illustrator. Samples are filed and are not returned. Reports back only if interested. Will contact artists for portfolio review if interested. Portfolio should include b&w and color thumbnails, roughs, final art, tearsheets, photographs, transparencies, etc. Pays by personal contract. Rights purchased vary according to project. Finds artists through submissions and word of mouth.

Tips: "We look for stunning, eye-catching work—surprise us! Fun and exotic illustrations are key!"

HANSON/DODGE DESIGN, 301 N. Water St., Milwaukee WI 53202. (414)347-1266. Fax: (414)347-0493. Website: http://www.hanson-dodge.com. CEO: Ken Hanson. Estab. 1980. Number of employees: 40. Approximate annual billing: $4.6 million. Specializes in integrated design, brand and corporate identity; catalog, display, direct mail and package design; signage; websites and digital publishing systems. Clients: corporations, agencies. Current clients include Miller Brewing, Trek Bicycle, Timex, Warburg Pincus Funds, S.C. Johnson Wax. Client list available upon request. Professional affiliations: AIGA, APDF, ACD.

Needs: Approached by 30 freelancers/year. Works with 2-3 freelance illustrators, 2-3 designers and 5-8 production artists/year. Needs computer-literate freelancers for design, illustration and production. 90% of freelance work demands knowledge of Adobe Illustrator, Adobe Photoshop and QuarkXPress.

First Contact & Terms: Send letter of introduction and position sought with résumé and non-returnable samples to Hanson/Dodge Design, Attn: Susan Begel or e-mail postmaster@hanson-dodge.com. Résumés and samples are kept on file for 6 months. Reports back within 2 weeks. Artist should follow-up with call. Pays for design and illustration by the hour. Finds artists through word of mouth, submissions.

HARE STRIGENZ DESIGN, INC., 306 N. Milwaukee St., Milwaukee WI 53202. (414)272-0072. Fax: (414)291-7990. E-mail: hsnet@execpc.com. Website: http://www.hare-strigen2.com. Owner/Creative Director: Paula Hare. Estab. 1986. Number of employees: 9. Specializes in packaging, annual reports, collateral, corporate communications. Clients: manufacturers, retail, agricultural, electronics industries. Client list available upon request.
Needs: Approached by 12-18 freelancers/year. Works with 10-12 freelance illustrators and 12-15 designers/year. Prefers local illustrators but uses national designers. 100% of freelance work demands knowledge of Adobe Photoshop, QuarkXPress and Adobe Illustrator.
First Contact & Terms: Send query letter with brochure and tearsheets. Samples are filed. Reports back to the artist only if interested. Portfolios may be dropped off every Monday. Artist should follow-up with letter after initial query. Buys all rights.

IMAGINASIUM DESIGN STUDIO, INC., 1240 Main St., Suite 2, Green Bay WI 54302-1307. (920)431-7872. Fax: (920)431-7875. E-mail: inquire@imaginasium.com. Website: http://www.imaginasium.com. Creative Director: Joe Bergner. Estab. 1991. Number of employees: 5. Approximate annual billing: $600,000. Design firm. Specializes in corporate identity, collateral. Product specialties are industrial, business to business. Current clients include Georgia Pacific, Schneider National. Client list available upon request. Professional affiliation: Green Bay Advertising Federation.
Needs: Approached by 10 illustrators and 15 designers/year. Works with 10 illustrators and 2 designers/year. Prefers local designers. Uses freelancers mainly for overflow. Also for brochure illustration and lettering. 15-20% of work is with print ads. 100% of design and 10-20% of illustration demand skills in Adobe Photoshop 4.0, QuarkXPress 3.3 and Adobe Illustrator 7.0.
First Contact & Terms: Designers send query letter with brochure, photographs and tearsheets. Illustrators send postcard sample of work with follow-up postcard every 6 months. Accepts Macintosh disk submissions of above programs. Samples are filed and are not returned. Will contact for portfolio review of color tearsheets, thumbnails and transparencies if interested. Pays for design by the hour, $20-40. Pays for illustration by the project. Rights purchased vary according to project. Finds artists through submissions, word of mouth.

UNICOM, 9470 N. Broadmoor Rd., Bayside WI 53217. (414)352-5070. Fax: (414)352-4755. Senior Partner: Ken Eichenbaum. Estab. 1974. Specializes in annual reports; brand and corporate identity; display, direct, package and publication design; and signage. Clients: corporations, business-to-business communications, and consumer goods. Client list available upon request.
Needs: Approached by 15-20 freelancers/year. Works with 1-2 freelance illustrators/year. Works on assignment only. Uses freelancers for brochure, book and poster illustration.
First Contact & Terms: Send query letter with brochure. Samples not filed or returned. Does not report back; send nonreturnable samples. Write for appointment to show portfolio of thumbnails, photostats, slides and tearsheets. Pays by the project, $200-6,000. Rights purchased vary according to project.

Record Labels

The recording industry is an exciting place for artists and designers. You will enjoy relative freedom to create work that excites you. But though you'll be free to push the envelope, you'll still work within parameters. Your designs and illustrations must capture the attention of music buyers while conveying the mood of the music and the vision of the musician. Your interpretation of this vision must satisfy the art director, the producer, the recording artist and the record company.

Record labels use freelance artists for more than just CD covers. In addition to retail budgets for packaging, each CD release has budgets for promotion and merchandising, too. You could be hired to design store displays, promotional materials, T-shirts or posters. Since each project must have a consistent visual image, art directors generally carryover the CD cover art to all the product and promotional aspects of the project.

Your greatest challenge will be working within the size constraints of CD and cassette covers. The dimensions of a CD cover are 4¾ × 4¾ inches, packaged in a 5 × 5 inch jewel box. Inside each CD package is a 4-5 panel fold-out booklet, inlay card and CD. If you are assigned to design an inside booklet, your design must be economical. Photographs of the recording artist, illustrations, liner notes, titles, credit lines and lyrics all must be placed into that relatively small format. Because the space is so small, artwork must be all the more compelling. Art and typography choices are perhaps more crucial than they were in the days of 12 × 12 inch album covers.

Important projects on major labels may have extra budgets to produce lavish limited-edition versions of the same release. Expensive touches such as clipcases and wood boxes make these special editions impractical to sell to the general public. But the impressive CDs which are shipped to influential radio stations, the press and industry movers and shakers help generate the necessary "buzz" record labels create surrounding a new project. Several examples of elaborate promotional CDs are featured in *CD Packaging & Graphics* by Ken Pfeifer, a Rockport Book.

The recording industry is dominated by a handful of major labels, but there are thousands of independent labels. Some are thriving, others struggling, but they are a big part of the industry. And you'll find indies are great places to start when looking for freelance assignments.

LANDING THE ASSIGNMENT

Submit your work to record labels the same way you would approach any market. Check the listings in the following section to see how the art director prefers to be approached and what type of samples to send. Check also to see what type of music they produce. If the company produces classical recordings, don't send images more appropriate to a heavy metal band. Assemble a portfolio of your best work in case an art director wants to see more of your work.

Be sure your portfolio includes quality samples. It doesn't matter if the work is of a different genre—quality is key. If you don't have any experience in the industry create your own CD package, featuring one of your favorite recording artists or groups.

Get the name of the art director or creative director from the listings in this section and send a cover letter that asks for a portfolio review. If you are not contacted within a couple of weeks, make a polite follow-up call to the office manager. (Most art directors prefer not to be called directly. If they are interested, they will call.)

Another route of entry is through management companies who work for recording artists. They represent musicians in the many facets of their business, one being control over the artwork used in releases. Follow the steps already listed to get a portfolio review. Lists of management

companies can be found in *Songwriter's Market* published by Writer's Digest Books and the *Recording Industry Sourcebook* published by Ascona Group, Inc.

Once you nail down an assignment, get an advance and a contract. Independent labels usually provide an advance and payment in full when a project is done. When negotiating a contract, ask for a credit line on the finished piece and samples for your portfolio.

You don't have to live in one of the recording capitals to land an assignment, but it does help to familiarize yourself with the business. Visit record stores and study the releases of various labels. Ask to see any catalogs or promotional materials the store may have received from the companies you're interested in. Read music industry trade magazines, like *Spin*, *Rolling Stone*, *Vibe*, *Ray Gun* and *Billboard*. For further information about CD design read *Rock Art*, by Spencer Drate (PBC International).

MORE INDUSTRY TIPS

As a freelancer in the recording industry, it is important to pay attention to record sales. When sales are running high, labels are more likely to have the budgets to initiate new projects. When sales are slow, budgets will be tighter. Right now, analysts say the industry is going through a recovery mode. Sluggish sales cause record companies to cut overhead and reduce budgets. But all it takes is a new sound to explode on the scene for sales to climb.

You should also pay attention to sales figures of individual labels. The industry regularly reports on "the big six," the six major labels that dominate the industry. They include Polygram NV, Warner Music, Sony Corp., Universal Music Group and Bertelsmann AG and EMI Group.

You can keep track of how the major labels and "indies" are doing by reading *Billboard* and other music industry publications. Each year around February, the Recording Industry Association of America releases sales figures for the industry. The RIAA's report also gives the latest trends on packaging and format, and music sales by genre. To request the most recent report, call the RIAA at (202)775-0101.

A&R RECORDS/RDS PROMOTIONS, 900 19th Ave. S., Suite 207, Nashville TN 37212. (615)329-9127. E-mail: ruanst@aol.com. Website: http://www.interlog.com/mladent. President: Ruth Steele. Estab. 1986. Produces CDs and tapes: folk, gospel, country/western, alternative by solo artists and groups. Recent releases: *Work Hard, Play Hard*, by Ty Saunder; *Big Wheels—Life of a Trucker*, by David Steele.
Needs: Works with 2 freelancers/year. Prefers local artists only. Uses freelancers for CD cover, tape cover, advertising and brochure design and illustration; direct mail packages; posters; multimedia projects. 90% of freelance work demands computer skills.
First Contact & Terms: Send query letter with brochure, photocopies, résumé and photographs. Accepts disk submissions. Samples are filed or returned by SASE if requested by artist. May not report back. Artist should re-submit in 6 months. Art Director will contact artist for portfolio review if interested. Portfolio should include b&w and color final art, photocopies and photographs. Pays by the project. Rights purchased vary according to project.
Tips: "Contact everyone—study industry directories/lists and do a blanket mailing. Be flexible with charges."

‡ACE LABELS, 2121 Hepburn, Suite 708, Houston TX 77054. (713)594-0372. Fax: (713)787-6999. E-mail: ace_labels @yahoo.com. CEO: Fred McGhee. Estab. 1995. Produces albums, CDs, cassettes: jazz, bob, progressive, R&B, rap, rock and soul by soloists and groups. Recent releases: "Vexx Files," by Vexx; "Adriann," by Adriann Hammett.
Needs: Produces 3 releases/year. Works with 1-2 freelancers/year. Prefers designers who own IBM-compatible PCs. Uses freelancers for album, cassette and cover design and poster design. Also for brochures, catalogs, direct mail and magazines. 85% of illustration demands knowledge of Aldus PageMaker, Adobe Illustrator, Adobe Photoshop, MS Publisher.
First Contact & Terms: Send postcard sample and/or query letter with brochure. Accepts IBM-compatible disk submissions. Samples are filed. Will contact for portfolio review of b&w, color photocopies, photographs if interested. Pays by the project. Rights purchased vary according to project. Finds artists through magazines, reps, word of mouth.

‡ADVANCE CYBERTECH ENTERPRISES & X:TREME RECORDS, INC., 800 E. Broward, Suite 700, Ft. Lauderdale FL 33301. (954)522-3900. Fax: (954)522-0280. E-mail: mlabate@xtreme1.com. Art Director: Michael La-

bate. Estab. 1990. Produces CDs, CD-ROMs, cassettes, software games. Produces compilations, techno, New Age by solo artists and groups. Recent releases: *Fresh Summer Mix*, *Absolute Dance Mix*.
Needs: Produces 50 releases/year. Works with 7 freelancers/year. Prefers local freelancers who own Mac/IBM computers with experience in 3-D animation, modeling, TV, radio, design. "Interns are welcome as well." Uses freelancers for album cover design and illustration; animation; cassette cover design and illustration; CD booklet design and illustration; CD cover design and illustration; CD-ROM design and packaging; poster design; web page design and packaging design for software i.e. game boxes. 90% of freelance design and 10% of illustration demands knowledge of Adobe Illustrator, QuarkXPress, Adobe Photoshop, Aldus FreeHand, 3D Studio Max, Light Wave or Adobe Premier.
First Contact & Terms: Send or e-mail postcard sample and/or query letter with résumé. Accepts disk submissions in IBM format (Zip, 3.5″, CD). Samples are filed. Reports back within 30 days. Will contact for portfolio review if interested. Portfolio should include b&w, color, final art, slides, thumbnails, transparencies or CD-ROM. Pays by the hour, $100-150 depending on complexity. Buys all rights. Finds artists through local art college like International Fine Arts College in Miami.
Tips: "Don't stop; continue networking yourself, your ideas. Don't take no for an answer! I look for flawless work, with a not so conservative style. Prefer wild, flashy, distorted, fun designs."

‡AFFINITY MUSIC GROUP, P.O. Box 1522, Goodletsville TN 37070. (615)622-2004. Fax: (615)672-8626. E-mail: donreed@donreed.com. Website: http://donreed.com. President: Don Reed. Estab. 1957. Produces albums and cassettes: country, gospel, pop, R&B, rock. Recent releases: *The Boat*, by Frank Mabry and *Song Titles* by Thrish Kelly Knight.
Needs: Produces 2 releases/year. Works with 10 freelancers/year. Uses freelancers for advertising, animation, CD booklet design and poster design. 90% of design and 95% of illustration demands knowledge of Aldus PageMaker and Adobe Photoshop.
First Contact & Terms: Send query letter with brochure, photocopies and résumé. samples are filed or are returned. Reports back only if interested. Art director will contact artist for portfolio review of color photographs if interested. Pays by the project. Negotiates rights purchased. Finds artists through advertising.

‡AFTERSCHOOL PUBLISHING COMPANY, P.O. Box 14157, Detroit MI 48214. (313)571-0363. President: Herman Kelly. Estab. 1978. Produces CDs and tapes: rock, jazz, rap, R&B, soul, pop, classical, folk, educational, country/western, dance and new wave. Recent releases: *Emotional Love Maintenance*, *Tell You What You're Going To Do* and *Love Letter*.
Needs: Produces 1 solo artist/year. Works with 10 freelance designers and 10 illustrators/year. Prefers professional artists with experience in all forms of the arts. Uses artists for CD cover design, tape cover and advertising design and illustration, brochure design, multimedia projects and posters. 10% of freelance work demands computer skills.
First Contact & Terms: Send query letter with brochure, résumé, SASE, bio, proposal and appropriate samples. Samples are filed or are returned by SASE. Reports back within 2-4 weeks. Requests work on spec before assigning a job. To show portfolio, mail roughs, printed samples, b&w/color tearsheets, photographs, slides and transparencies. Pays by the project. Negotiates rights purchased. Interested in buying second rights (reprint rights) to previously published work. Finds artists through Michigan Council for the Arts' Artist Directory and Detroit Arts Council.
Tips: "Be on a local or national artist roster to work outside your hometown."

‡AIRWAX RECORDS, Box 288291, Chicago IL 60628. (773)779-2384. Fax: (773)779-7898. President: Casey Jones. Estab. 1983. Produces CDs, tapes and albums: rhythm and blues, soul and blues. Recent releases: *On My Way to Chicago*, by Casey Jones and *100% Chicago Style Blues*, by various artists.
Needs: Produces 2 soloists and 2 groups/year. Works with 5 visual artists/year. Prefers artists with experience in the performing circuit. Works on assignment only. Uses artists for posters.
First Contact & Terms: Send query letter with brochure. Samples are not filed and are returned. Reports back only if interested. To show a portfolio, mail b&w material. Pays by the project. Rights purchased vary according to project.

‡ALBATROSS RECORDS/R&D PRODUCTIONS, 2405 Wentworth St., Houston TX 77004. (713)521-2616. Fax: (713)529-4914. Art Director: Darin Gates. Estab. 1987. Produces CDs, cassettes: country, jazz, R&B, rap, rock by solor artists and groups. Recent releases: *Judgment Day*, by H.E.A.T.
Needs: Produces 22 releases/year. Works with 3 freelancers/year. Prefers freelancers with experience in QuarkXPress, Aldus Freelance. Uses freelancers for cassette cover design and illustration; CD booklet design; CD cover design and illuatraion; poster design; Web page design. Also for advertising design/illustration. 70% of freelance work demands knowledge of QuarkXPress, Aldus FreeHand, Adobe Photoshop.
First Contact & Terms: Send postcard sample of work. Samples are filed and not returned. Will contact for portfolio review of b&w and color final art if interested. Pays for design by the project, $600 maximum. Pays for illustration by the project, $250 maximum. Buys all rights. Finds freelancers through word of mouth.

ALIAS RECORDS, 2815 W. Olive Ave., Burbank CA 91505. (818)566-1034. Fax: (818)566-6623. E-mail: ink19cole@aol.com. Art Director: Cole Gerst. Estab. 1989. Produces albums, CDs, cassettes and videos: pop, progressive and rock by solo artists and groups. Recent releases: *All the Nations Airports*, by Archers of Loaf; and *Day Three of My New Life*, by Knapsack.
Needs: Produces 20 releases/year. Works with 5-10 freelancers/year. Prefers local designers and illustrators who own Macs. Uses freelancers for album/cassette/CD cover design and illustration, CD booklet design and illustration, poster

and World Wide Web page design and stickers. 50% of design demands knowledge of Aldus PageMaker 5, Adobe Illustrator 5, QuarkXPress 3.3, Adobe Photoshop 3.0 and Aldus FreeHand 5.0.

First Contact & Terms: Send postcard sample and brochure, tearsheets, résumé and photographs. Accepts disk submissions compatible with Zip or Syquest for large files. EPS preferred. Samples filed. Report back to artist only if interested. Will contact for portfolio review of b&w, color, final art and tearsheets if interested. Pays by the project for design, $500-2,000; for illustration, $50-1,000. Buys all rights. Finds artists through submissions.

Tips: "We look for something new, different and fresh in portfolios."

‡**ALJONI MUSIC CO.**, P.O. Box 52417, Jacksonville FL 32201. (904)564-4297. E-mail: hall_a2@popmail.firn.edu. Production Manager: Al Hall, Jr. Estab. 1971. Produces albums, CDs, cassettes, videos: classical, country, gospel, jazz, R&B, rap, rock, soul, world by solo artists and groups. Recent releases: *Buffalo Soldier Suite*, by Cosmos Dwellers.

Needs: Produces 4-6 releases/year. Works with minimum of 2 freelancers/year. Uses freelancers for album cover design and illustration; animation; cassette cover design and illustration; CD booklet design and illustration; CD cover design and illustration; poster design, web page design. 50% of freelance work demands computer skills.

First Contact & Terms: Send postcard sample or query letter with brochure, résumé, photographs, SASE. Samples are filed or returned by SASE if requested by artist. Reports back to the artist only if interested. Portfolio review not required. Pays for design by the project; negotiable. Negotiates rights purchased. Rights purchased vary according to project.

Tips: "Be bold, different. Make your work 'jump out!!' at the viewer—I keep my eyes open for Great Stuff!!"

‡**AMERICAN MUSIC NETWORK INC.**, P.O. Box 7018, Warner Robins GA 31095. (912)953-2800. Estab. 1986. Produces albums, CDs, cassettes, videos: country, folk, gospel, jazz, pop, progressive, R&B, rock, soul by solo artists and groups. Recent releases: "One Man's Junk," by Wayne Little; "Pots & Pans," by Theresa Justus.

Needs: Produces 12 releases/year. Works with 6 freelancers/year. Uses freelancers for album cover design and illustration; cassette cover design and illustration; CD booklet design and illustration; CD cover design and illustration; poster design. 50% of freelance design and illustration demands knowledge of Aldus PageMaker, Adobe Illustrator, QuarkXPress, Adobe Photoshop or Aldus FreeHand.

First Contact & Terms: Send query letter with résumé. Samples are filed or returned by SASE if requested by artist. Reports back within 4 months. Portfolio review not required. Pays by the project, $50-500. Negotiates rights purchased.

Tips: Looks for "originality and inventiveness."

‡**AMERICATONE INTERNATIONAL—U.S.A.**, 1817 Loch Lomond Way, Las Vegas NV 89102-4437. (702)384-0030. Fax: (702)382-1926. President: Joe Jan Jaros. Estab. 1983. Produces CDs and tapes: rock & roll, jazz, pop, progressive, classical, country/western and rap by solo artists and groups. Recent releases: *Modern Loneliness*, by Carol Martini; *After All These Years*, by Brent Blount; and *Peace Pipe*, by Heavenly Hash.

Needs: Produces 10 solo artists and 3 groups/year. Uses artists for direct mail packages and posters.

First Contact & Terms: Samples are returned by SASE. Reports back to artist within 2 months only if interested. To show a portfolio, mail appropriate materials.

ANGEL RECORDS, (formerly Angel/EMI Records), 304 Park Ave S., New York NY 10010.
 • Angel Records merged with Blue Note. See listing for Blue Note in this section.

✦**AQUARIUS RECORDS/TACCA MUSIQUE**, 1445 Lambert-Closse, Suite 200, Montreal, Quebec H3H 1Z5 Canada. (514)939-3775. Fax: (514)939-2778. E-mail: aquerec@cam.org. Production Manager: Rene LeBlanc. Estab. 1970. Produces CDs, cassettes and CD-ROMs: folk, pop, progressive and rock by solo artists and groups. Recent releases: *Present*, by Sass Jordan; *I Bificus*, by Bif; and *The Sound and the Jerry*, by Jerry Jerry.

Needs: Produces 2-8 releases/year. Works with 4 freelancers/year. Prefers designers who own IBM PCs. Uses freelancers for album, cassette and CD cover design and illustration; CD booklet design and illustration; CD-ROM design and packaging; poster design; advertising and brochure. 90% of freelance work demands knowledge of Adobe Photoshop, Adobe Illustrator and QuarkXPress.

First Contact & Terms: Send postcard sample of work or query letter with brochure, résumé and photographs. Samples are filed and are not returned. Will contact for portfolio review of b&w and color photocopies and photographs if interested. Pays for design and illustration by the project. Rights purchased vary according to project. Finds artists through word of mouth.

Tips: "Be creative. Understand that each project is different and unique. Stay away from generics!"

‡**ARIANA RECORDS**, 1336 S. Avenida Polar, Tucson AZ 85710. (520)790-7324. E-mail: tomdukes@concentric.net. President: Jim Gasper. Estab. 1980. Produces albums, CDs, CD-ROMs, cassettes: folk, pop, progressive and rock by solo artists and groups. Recent releases: "I'm A Tree," by Jtiom; "Love's a Mess," The Rakeheads.

Needs: Produces 5 releases/year. Works with 2 freelancers/year. Prefers freelancers with experience in cover design. Uses freelancers for album cover design and illustration; cassette cover design and illustration; CD cover design and illustration and multimedia projects. 70% of design and 50% of illustration demands computer skills.

First Contact & Terms: Send postcard sample of work. Samples are filed or returned by SASE if requested by artist. Reports back within 1 month. Portfolio review not required. Pays by the project.

ARISTA RECORDS, 6 W. 57th St., 11th Floor, New York, NY 10019. (212)489-7400. Senior Design Director: Mark Burdett. Senior Art Director: Sheri G. Lee. Produces CDs and LPs: all types.
Needs: Uses designers and illustrators for music packaging, advertising, broadcast, promotion and P.O.P.
First Contact & Terms: Call or write for appointment to show portfolio or drop off portfolio Monday-Friday, 10:30-5:30. Call back after 2 days to arrange pick up of portfolio. Payment varies. Rights purchased vary according to project.

ART ATTACK RECORDINGS/MIGHTY FINE RECORDS, 3305 N. Dodge Blvd., Tucson AZ 85716. (602)881-1212. President: William Cashman. Produces rock, country/western, jazz, pop, R&B; solo artists.
Needs: Produces 12 albums/year. Works with 1-2 freelance designers and 1-2 illustrators/year. Uses freelancers for CD/album/tape cover design and illustration; catalog design and layout; advertising design, illustration and layout; posters; multimedia projects.
First Contact & Terms: Works on assignment only. Send postcard sample or brochure to be kept on file. Samples not filed are returned by SASE only if requested. Reports back only if interested. Write for appointment to show portfolio. Original artwork is not returned. Pays for design by the hour, $15-25 or by the project, $100-500. Pays for illustration by the project, $100-500. Considers complexity of project and available budget when establishing payment. Buys all rights. Sometimes interested in buying second rights (reprint rights) to previously published artwork.

ATLAN-DEC/GROOVELINE RECORDS, 2529 Green Forest Ct., Snellville GA 30278. (770)985-1686. E-mail: lyye71a@prodigy.com. Website: http://gemm.com/s.cgi/atlandec. Art Director: Wileta J. Hatcher. Estab. 1994. Produces CDs and cassettes: gospel, jazz, pop, R&B, rap artists and groups. Recent releases: *Ace On Top*, by BlackJack.
Needs: Produces 2-4 releases/year. Works with 1-2 freelancers/year. Prefers freelancers with experience in CD and cassette cover design. Uses freelancers for alblum cover, cassette cover, CD booklet and poster design. 80% of of freelance work demands knowledge of Adobe Photoshop.
First Contact & Terms: Send postcard sample of work or query letter with brochure, photocopies, photograhs and tearsheets. Samples are filed. Will contact for portfolio review of b&w, color, final art if interested. Pays for design by the project, negotiable. Negotiates rights purchased. Finds artists through submissions.

BABY FAZE RECORDS & TAPES, 45 Pearl St., San Francisco CA 94103. (415)495-5312. E-mail: bfaze tapes@aol.c om. Owner: G. Miller Marlin. Estab. 1989. Produces tapes and vinyl: rock, jazz, pop, R&B, soul, progressive, classical, folk, country/western, rap, industrial. Recent releases: *I Am the Edison Phonograph*, by Cat Howdy; *Slowdown*, by LMNOP.
Needs: Produces 24 releases/year.
First Contact & Terms: Send query letter with brochure, tearsheets, SASE, photocopies and photographs. Accepts disk submissions compatible with Adobe Photoshop and Adobe Illustrator, in Mac format. Send PICT files. Samples are filed and are not returned. Reports back to the artist only if interested. Portfolio should include b&w and color final art, photographs. No payment—credit line given. Negotiates rights purchased. Finds artists through submissions.
Tips: Impressed by "talent and a willingness to work easily for exposure. Don't expect too much, too soon in the record business."

‡BACKWORDS RECORDINGS, P.O. Box 1103, Mishawaka IN 46546. E-mail: briantimothybacker@attworldnet.n et. Owner: Tim Backer. Produces CDs and cassettes: classical, progressive, rock, composer-rock and performed literature. Recent releases: *The Subtle Dawn* by Tim Backer.
Needs: Works with 1 freelancer/year. Prefers designers who own Mac computers with experience in Quark XPress and SyQuest. Uses freelancers for cassette cover illustration and design, CD booklet design and illustration, CD cover design and illustration, poster design and World Wide Web page design. "Need freelancers in poster design and World Wide Web page design for future releases." 100% of design and 65% of illustration demands knowledge of Quark XPress, Adobe Photoshop and SyQuest.
First Contact & Terms: Send postcard sample of work and send query letter with résumé, photostats, photographs and "statement of vision." Samples are filed or are returned by SASE if requested by artist. Reports back only if interested. Art director will contact artist for portfolio review of b&w and color photocopies, photographs, photostats and thumbnails if interested. Pays by the project; "freelancers must submit a bid." Rights purchased vary according to project.

‡BAL RECORDS, Box 369, LaCanada CA 91012. (818)548-1116. Website: http://www.busdir.com/balmusic/index.ht ml. President: Adrian P. Bal. Estab. 1965. Produces 4-6 rpm (singles): rock & roll, jazz, R&B, pop, country/western and church/religious. Recent releases include: *Special Day, what's the matter with me* and *Lord You've Been So Good To Me*, by Rhonda Johnson.
Needs: Produces 2-4 soloists and 1 or 2 groups/year. Uses 1-3 artists/year for direct mail packages.
First Contact & Terms: Samples are not filed and are returned by SASE. Reports back ASAP. Portfolio review requested if interested in artist's work. Sometimes requests work on spec before assigning a job.
Tips: Finds new artists through submissions. "I don't like the abstract designs."

***BIG BEAR RECORDS**, P.O. Box, Birmingham B16 8UT England. (021)454-7020. Fax: (21)454-9996. Managing Director: Jim Simpson. Produces CDs and tapes: jazz, R&B. Recent releases: *Let's Face the Music*, by Bruce Adams/

Alan Barnes Quintet and *Blues & Rhythm, Volume One*, by King Pleasure & The Biscuit Boys; and *The Boss Is Home*, by Kenny Bakers Dozen.
Needs: Produces 8-10 records/year. Works with 4-6 illustrators/year. Uses freelancers for album cover design and illustration. Needs computer-literate freelancers for illustration.
First Contact & Terms: Works on assignment only. Send query letter with photographs or photocopies to be kept on file. Samples not filed are returned only by SAE (nonresidents include IRC). Negotiates payment. Considers complexity of project and how work will be used when establishing payment. Buys all rights. Interested in buying second rights (reprint rights) to previously published work.

‡**BIG TIME RECORDS/BIG TIME SURF SHOP**, 2888 Mission Blvd., San Diego CA 92109. (619)539-3989.
President: Mark Whitney Mehran. Produces albums and CDs: rock. Recent releases: "Know My Name" by Antie Pete and *M.T.G.* by The Green Leaf.
Needs: Produces 2-7 releases/year. Works with 3 freelancers/year. Prefers local artists. Uses freelancers for CD booklet design, CD cover illustration, poster design, negative prep and shooting.
First Contact & Terms: Send query letter and postcard with sample of work. Samples are not filed and are not returned. Reports back only if interested. Art director will contact artist for portfolio review if interested. Pays by the project. Buys all rights.

‡**BLACK DIAMOND RECORDS INCORPORATED**, P.O. Box 8073, Pittsburg CA 94565. (510)980-0893. Fax: (510)432-4342. Art Management: B.D.R. Art Dept. Estab. 1988. Produces tapes, CDs and vinyl 12-inch and 7-inch records: jazz, pop, R&B, soul, rap by solo artists and groups. Recent releases: "Can't Do Without My Baby," by Deanna Dixon; "So Hard to Leave Without U," by Proper J; and "Something, Somethin," by 3-Part.
Needs: Produces 2 solo artists and 3 groups/year. Works with 2 freelancers/year. Prefers freelancers with experience in album cover and insert design. Uses freelancers for CD/tape cover and advertising design and illustration; direct mail packages; and posters. Needs computer-literate freelancers for production. 85% of freelance work demands knowledge of Aldus PageMaker, Aldus FreeHand.
First Contact & Terms: Send query letter with résumé. Samples are filed and are returned. Reports back within 3 months. Write for appointment to show portfolio of b&w roughs and photographs. Pays for design by the hour, $100; by the project, $100. Rights purchased vary according to project.
Tips: "Be unique, simple and patient. Most of the time success comes to those whose artistic design is unique and has endured through rejection after rejection."

BLASTER BOXX HITS, 519 N. Halifax Ave., Daytona Beach FL 32118. (904)252-0381. Fax: (904)252-0381. C.E.O.: Bobby Lee Cude. Estab. 1978. Produces CDs, tapes and albums: rock, R&B. Releases: *In and Out Urge*; *Don't Stop*, by Zonky-Honky Man; and *Get Down*, *Doctor of Love*, *Bitch It Up*, *Hollywood Kisses* and *Get In Line* all by Punk-John.
Needs: Approached by 15 designers and 15 illustrators/year. Works with 3 designers and 3 illustrators/year. Produces 6 CDs and tapes/year. Works on assignment only. Uses freelancers for CD cover design and illustration.
First Contact & Terms: Send query letter with appropriate samples. Samples are filed. Reports back within 1 week. To show portfolio, mail thumbnails. Sometimes requests work on spec before assigning a job. Pays by the project. Buys all rights.

‡**BLUE NOTE AND ANGEL RECORDS**, 304 Park Ave. S., New York NY 10010. (212)253-3000. Fax: (212)253-3170. Website: http://www.bluenote.com. Creative Director: Darcy Cloutier-Fernald. Estab. 1939. Produces albums, CDs, cassettes, advertising and point-of-purchase materials. Produces classical, jazz, pop, and world music by solo artists and groups. Recent releases by Cassandra Wilson, Vanessa May, Itzhak Perlman, Holly Cole, Mose Allison, Richard Elliot.
Needs: Produces qpproximately 200 releases in US/year. Works with about 10 freelancers/year. Prefers designers with experience in QuarkXPress, Adobe Illustrator, Adobe Photoshop who own Macs. Uses freelancers for album cover design and illustration; cassette cover design and illustration; CD booklet and cover design and illustration; poster design. Also for advertising. 100% of design demands knowledge of Adobe Illustrator, QuarkXPress, Adobe Photoshop (most recent versions on all).
First Contact & Terms: Send postcard sample of work. Samples are filed. Reports back to the artist only if interested. Portfolios may be dropped off every Thursday and should include b&w and color final art, photographs and tearsheets. Pays for design by the hour, $12-20; by the project, $1,000-5,000. Pays for illustration by the project, $750-2,500. Rights purchased vary according to project. Finds artists and designers through submissions, portfolio reviews, networking with peers.

✔**BOUQUET-ORCHID ENTERPRISES**, P.O. Box 1335, Norcross GA 30091. (770)814-2420. President: Bill Bohannon. Estab. 1972. Produces CDs and tapes: rock, country, pop and contemporary Christian by solo artists and groups. Releases: *Blue As Your Eyes*, by Adam Day; and *Take Care Of My World*, by Bandoleers.
Needs: Produces 6 solo artists and 4 groups/year. Works with 8-10 freelancers/year. Works on assignment only. Uses freelancers for CD/tape cover and brochure design; direct mail packages; advertising illustration. 25% of freelance work demands knowledge of Aldus PageMaker, Adobe Illustrator and QuarkXPress.
First Contact & Terms: Send query letter with brochure, SASE, résumé and samples. "I prefer a brief but concise

overview of an artist's background and works showing the range of his talents." Include SASE. Samples are not filed and returned by SASE if requested by artist. Reports within 1 month. To show a portfolio, mail b&w and color tearsheets and photographs. Pays for design by the project, $100-500. Rights purchased vary according to project.

Tips: "Study current packaging design on cassette and CD releases. Be creative and willing to be different with your approach to design."

BRIARHILL RECORDS, 3484 Nicolette Dr., Crete IL 60417. (708)672-6457. Fax: (708)672-1277. President/A&R Director: Danny Mack. Estab. 1984. Produces tapes, CDs and records: pop, gospel, country/western, polka, Christmas by solo artists and groups. Recent releases: *Ordinary People* and *The Ballad of Paul Bunyan*, by Danny Mack; *Sad State of Affairs*, by Rebecca Thompson.

Needs: Produces 2-5 solo artists/year. Approached by 30 designers and 30 illustrators/year. Works with 4 designers and 4 illustrators/year. Prefers artists with experience in album covers. Works on assignment only. Uses freelancers for CD/tape cover design and illustration; brochure design and advertising illustration.

First Contact & Terms: Send postcard sample with brochure, photographs and SASE. Samples are filed and are not returned. Reports back within 3 weeks. To show portfolio, mail photostats. Pays for design by the project, $100 minimum. Buys all rights.

Tips: "Especially for the new freelance artist, get acquainted with as many recording studio operators as you can and show your work. Ask for referrals. They can be a big help in getting you established locally. When sending samples for submission, always include illustrations that relate in some way to the types of music we produce as listed. This is the best way to receive consideration for upcoming projects. We keep on file only those who have done similar work."

‡BRIGHT GREEN RECORDS, P.O. Box 24, Bradley IL 60915. E-mail: bgrecords@aol.com. Website: http://members.aol.com/bgrecords/bgr.html. Contact: Mykel Boyd. Art Director: Scott McGuire. Estab. 1989. Produces albums, CDs, CD-ROMs, cassettes and vinyl: classical, folk, jazz, pop, progressive, rap, rock, experimental and electronic music by solo artists and groups. Recent releases: "Super God," by Angry Red Planet; "The Sin Eaters," by E.A. Zann.

Needs: Produces 10 releases/year. Works with 10 freelancers/year. Looking for creative art. Uses freelancers for cover design and illustration; cassette cover design and illustration; CD booklet design and illustration; CD cover design and illustration; CD-ROM design and packaging and poster design. Freelancers should be familiar with Aldus PageMaker, Adobe Illustrator, QuarkXPress, Adobe Photoshop, Aldus FreeHand.

First Contact & Terms: Send query letter with brochure, résumé, photostats, transparencies, photocopies, photographs, slides, SASE, tearsheets. Accepts disk submissions. Samples are filed or returned by SASE if requested by artist. Reports back within 3 months. Will contact artist for portfolio review of b&w and color final art, photocopies, photographs, photostats, roughs, slides, tearsheets, thumbnails and transparencies, if interested. Pays by the project. Negotiates rights purchased. Finds artists through word of mouth.

Tips: "Work cheap. Send something that catches my eye. We like *Raygun* and *Emigré* styled layout."

‡BROADLAND INTERNATIONAL, 50 Music Sq. W., Suite 407, Nashville TN 37203. (615)327-3410. Fax: (615)327-3571. A&R Director: Gary Buck. Estab. 1975. Produces CDs, cassettes: country and gospel. Recent releases: "Again," by Johnny Duncan; "Can't Get Enough," by Gunslinger.

Needs: Produces 15-20 releases/year. Works with 3-4 freelancers/year. Prefers designers who own computers. Uses freelancers for album cover design and illustration; cassette cover design and illustration; CD booklet design and illustration; CD cover design and illustration; poster design. Also for in-store promotional posters. 80% of freelance work demands computer skills.

First Contact & Terms: Send query letter with brochure, résumé, photocopies, photographs, tearsheets. Accepts disk submissions (Windows). Samples are filed or returned by SASE if requested by artist. Will contact artist for portfolio review of b&w, color photocopies, photographs, tearsheets if interested. Pays by the project; negotiable. Rights purchased vary according to project.

‡BROKEN NOTE RECORDS, P.O. Box 131444, Houston TX 77219. Phone/fax: (713)943-3336. E-mail: bknote@aol.com. Owner: Tony Aviata. Estab. 1994. Produces CDs, cassettes: jazz, pop, rap and rock by solo artists and groups. Recent releases: *The Regal Beagle*, by I-45; *The Sultry Sounds of Collision*, by Cult Ceavers.

Needs: Produces 8 releases/year. Works with 2 freelancers/year. Prefers designers who own IBM-compatible PCs with experience in music. Uses freelancers for album cover design and illustration; cassette cover design and illustration; CD booklet design and illustration; CD cover design and illustration; Web page design. 100% of freelance work demands knowledge of Adobe Photoshop 4.0.

First Contact & Terms: Send postcard sample or query letter with brochure and SASE. Accepts disk submissions. Samples are not filed and are returned by SASE if requested by artist. Reports back only if interested. Artist should follow-up with call after initial query. Pays by the project, $50 minimum. Rights purchsed vary according to project. Finds artists through the Web.

BSW RECORDS, Box 2297, Universal City TX 78148. (210)659-2338. Fax: (210)659-2557. E-mail: bsw18@txdirect.net. President: Frank Willson. Estab. 1987. Produces tapes and albums: rock, country/western by solo artists. Releases 8 CDs/tapes each year. Recent releases: *Down Town Austin*, by Marion Randall; and *Only The Dead Are Free*, by Larry Butler.

Needs: Produces 25 solo artists and 5 groups/year. Works with 4-5 freelance designers, 4-5 illustrators/year. Uses 3-4

freelancers/year for CD cover design; album/tape cover, advertising and brochure design and illustration; direct mail packages; and posters. 25% of freelance work demands knowledge of Aldus FreeHand.
First Contact & Terms: Send postcard sample and brochure. Samples are filed. Reports back within 1 month. To show portfolio, mail photographs. Requests work on spec before assigning a job. Pays by the project. Buys all rights. Sometimes interested in buying second rights (reprint rights) to previously published work. Finds new artists through submissions and self-promotions.

‡C.P.R. RECORD COMPANY, 4 West St., Massapequa Park NY 11762. (516)797-1995. Fax: (516)367-4481. E-mail: sandrina@earthink.net. President: Denise Thompson. Estab. 1996. Produces CDs, CD-ROMs, cassettes: R&B, rap, rock, soul by solo artists and groups.
 ● As *AGDM* went to press, this label was in the process of launching a website.
Needs: Produces 3-4 releases/year. Works with 5 freelancers/year. Prefers local freelancers who own IBM-compatible PCs. Uses freelancers for album cover design and illustration; animation; cassette cover design; CD booklet design and illustration; CD cover design and illustration; CD-ROM design and packaging and multimedia projects. Design demands knowledge of Aldus PageMaker, Aldus FreeHand, Adobe Photoshop.
First Contact & Terms: Send postcard sample or query letter with photocopies, tearsheets, résumé, photographs and photostats. Samples are filed or returned by SASE if requested by artist. Reports back within 6 weeks. Will contact artist for portfolio review of b&w, color photocopies, photographs if interested. Pays for design by the project; negotiable. Pays for illustration by the project, $500-5,000. Rights purchased vary according to project; negotiable. Finds artists through *Black Book* and *Workbook*.
Tips: "Be original. We always look for new and fresh material with a new twist. Don't be scared of rejection. It's the only way you learn, and always be positive! Be professional, be flexible, work hard and never stop learning."

CAPITOL RECORDS, 1750 N. Vine St., Hollywood, CA 90028-5274. (213)462-6252. Website: http://www.hollywoo dandvine.com. Art Director: Tommy Steele. Produces CDs, tapes and albums. Recent releases include *Romeo & Juliet* (soundtrack) and Losing by Less Than Jake.
 ● Art Director Tommy Steele was featured in an Insider Report in *AGDM*'s 1998 edition. Capitol also has offices in New York at 304 Park Ave. S. New York, NY 10010. (212)253-3000.
Needs: Uses freelance designers and illustrators for CD projects. Works on assignment only.
First Contact & Terms: Send non-returnable samples. Reports back only if interested. If you are planning a visit to Los Angeles or New York, call to make arrangements to drop off your portfolio.

CASH PRODUCTIONS, INC. (Recording Artist Development Corporation), 744 Joppa Farm Rd., Joppa-towne MD 21085. Phone/fax: (410)679-2262. President/CEO: Ernest W. Cash. Estab. 1987. Produces CDs and tapes: country/western by solo artists and groups. Releases: *Family Ties*, by The Short Brothers.
Needs: Produces 20-30 releases/year. Works with 10-12 freelancers/year. Works only with artist reps. Works on assignment only. Uses artists for cassette, album and CD cover design and illustration; animation and World Wide Web page design. 50% of freelance work demands computer skills.
First Contact & Terms: Send query letter with brochure, photographs, résumé and SASE. Samples are filed. Reports back to the artist only if interested. Will contact for portfolio review of b&w and color final art if interested. Pays for design by the project. "Price will be worked out with rep or artist." Buys all rights.

‡CEDAR CREEK RECORDS®, 44 Music Square E., Suite #503, Nashville TN 37203. (615)252-6916. Fax: (615)327-4204. Interstate Records, Affiliated Company Website: www.lynnguyo.com. President: Larry Duncan. Estab. 1992. Produces albums, CDs, cassettes: country, gospel, pop, r&b and light by solo artists. Recent releases: "Love at First Sound," by Lynn Guyo; "Be True to Yourself," by Lynn Guyo.
Needs: Produces 20 singles, 5 CDs/LPs/year. Works with 3 freelancers/year. Prefers local designers who own IBM-compatible PCs. Uses freelancers for album cover design and illustration; cassette cover design and illustration; CD booklet design and illustration; CD cover design and illustration; Web page design. Also for brochure and advertising design and illustration. 50% of freelance work demands knowledge of Aldus PageMaker, Adobe Illustrator, Adobe Photoshop.
First Contact & Terms: Send query letter with brochure, photocopies. Samples are filed. Reports back within 2 months. Will contact artist for portfolio review of b&w and color photocopies if interested. Pays by the project. Buys all rights. Finds artists through Yellow Pages, magazines, sourcebooks and submissions.
Tips: There is a trend towards multimedia, CD-ROMs and interactive media. Looks for good ideas or concepts for album covers for our recording artists on our record label.

CHERRY STREET RECORDS, INC., P.O. Box 52681, Tulsa OK 74152. (918)742-8087. E-mail: cherryst@msn.c om. Website: http://www.cherrystreetrecords.com. President: Rodney Young. Estab. 1991. Produces CDs and tapes: rock, R&B, country/western, soul, folk by solo and group artists. Recent releases: *Land of the Living*, by Richard Elkerton; *Find You Tonight*, by Brad Absher; and *Rhythm Gypsy*, by Steve Hardin.
Needs: Produces 2 solo artists/year. Approached by 10 designers and 25 illustrators/year. Works with 2 designers and 2 illustrators/year. Prefers freelancers with experience in CD and cassette design. Works on assignment only. Uses freelancers for CD/album/tape cover design and illustration; catalog design; multimedia projects; and advertising illustration. 100% of design and 50% of illustration demand knowledge of Adobe Illustrator and CorelDraw for Windows.

Persistence and timing lead to success in music business

There are several different routes to success in record label design, according to Stefan Sagmeister of New York City-based Sagmeister, Inc. "You can try to get a job in a record label's in-house design department, work for a design firm that has music industry clients, or you can go out on your own."

After learning his craft as a staffer at different design firms, the Austrian-born designer chose the path less taken—he works in his own New York studio as an independent designer, where he has the freedom to remain true to the unique vision that distinguishes him in the business. He also has found success. His innovative designs are sought after by the likes of the Rolling Stones, Lou Reed and David Byrne—all creative icons in their own right.

Stefan Sagmeister

If you want to break into record label design or illustration, Sagmeister recommends you pay close attention to the kind of work individual record labels or design firms turn out before offering your services. "Make sure the companies you apply to are doing the kind of work that suits your particular esthetic."

He also advises artists to visit record stores and make note of the companies who produce the artwork they like most, "then go to the label that matches your own vision."

It's not easy to break into recording design work, and you can't always pick and choose your first opportunities, says Sagmeister. If landing a job as an in-house designer at a label is your goal, you may find you have to start out as a freelancer until you get your foot in the door. On the other hand, if your dream is opening your own design studio, you might move toward your goal by working on staff at a record label or design firm with music clients until you accumulate enough experience and contacts to strike out on your own.

If you can't get a job with a record label—or prefer not to—Sagmeister recommends a two-fold plan of action to gain experience and make contacts as a freelancer. "When I was starting out," he recalls, "I approached bands directly, and I also approached their managers. If you don't have any work to show them, create something relevant. Put together a CD cover for a band, but choose an unknown act rather than someone like Pink Floyd. Everyone already has an image in their head of *Dark Side of the Moon*."

Sagmeister, who studied at the University of Applied Arts in Vienna and then at New York's Pratt Institute, always knew he wanted to design record covers. As a child in a small Austrian town, he spent hours in record stores, mesmerized by the work of the London-based design firm Hypnosis, creators of cover art for Pink Floyd, Led Zeppelin and XTC. "They did such great work and they had no house style whatsoever; everything was different and visually unique," Sagmeister recalls. He went to London at age 19 hoping to get a job at Hypnosis, "but the company had just closed." He spent time in

INSIDER REPORT, *Sagmeister*

Hong Kong, where he worked on staff and helped open The Design Group, a division of Leo Burnett advertising agency. Working with The Design Group was "unbelievably hard work, mostly commercial, for large clients," but the stint in advertising gave him exposure to the world of market research, and an entree into music. While at The Design Group, Sagmeister created an album cover for a European jazz group.

When Sagmeister returned to America, he worked for M & Co., the design firm responsible for many Talking Heads albums. When the company relocated to Europe, Sagmeister started out on his own. He had a friend in the music world, a musician in the New York band H.P. Zinker. Sagmeister designed a cover for the act's CD, *Mountains of Madness*, on Energy Records. At first glance, the CD cover shows the peaceful face of an old man. As the booklet is pulled out of the case, however, the old man's expression transforms into a terrifying grimace before the viewer's eyes. "The concept behind the design was that fine line between madness and sanity," says Sagmeister. The design won Sagmeister a Grammy nomination.

Once he won the nomination, Sagmeister says, "I began to get more attention. When I called record labels, they'd finally take my call." But until that point, the designer points out, he had a long, uphill road to climb. "In this kind of business, you need complete persistence. And you have to realize the situation at record labels: they get many portfolios and many calls from designers. But timing is everything. Just because you don't get a response, don't give up." They may not need the particular look you've presented right away, but when they do, you might get a call.

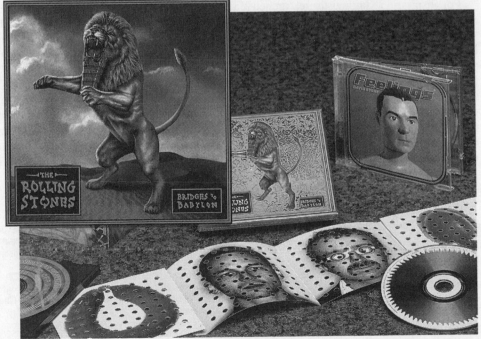

© Sagmeister Inc.

Pictured above are CD packages designed by Sagmeister Inc., including *Bridges to Babylon* by the Rolling Stones; *Feelings* by David Byrne and *Fantastic Spikes Through Balloon* by Skeleton Key.

INSIDER REPORT, *continued*

Sagmeister's reputation began to grow, but he continued to focus on every aspect of the design process from a creative and marketing standpoint. "I spent a lot of time in record stores conducting informal market research studies," he explains. He was familiar with the market research process from his days at Leo Burnett in Hong Kong, and realized that often research results are not as accurate as they could be because of the disparity between people's responses and the way the responses are analyzed. Sagmeister simplified the process by streamlining the research technique. He asked music buyers what they thought of certain covers and what aspects of the artwork intrigued them.

It is part of Sagmeister's work ethic to stay as close to his projects as possible. He works with the help of one other designer, Iceland-born Hjalti Karlsson, and an intern. "I go to all my meetings myself. I don't even employ an accounts servicing person, because you can get stuck in your studio thinking that people will understand your design when in fact most of the population doesn't." He also points out the challenge of designing covers for bands with enormous followings, like the Rolling Stones. "David Byrne has a more closely knit audience, but the Stones' audience is basically all of America."

When Mick Jagger requested a meeting with Sagmeister to discuss his group's upcoming recording, the mega-star established one ground rule: the design had to relate to the band's latest tour, which would coincide with the release of the CD. Sagmeister did his homework by listening to all the Stones' previous recordings and watching their performance videos. Halfway through his research he got a call from the band, telling him the recording/tour title: *Bridges to Babylon*. "I'd been going in a more baroque direction visually," Sagmeister recalls, "and I had to start from scratch."

For inspiration, Sagmeister researched Babylonian art at the British Museum. While walking the galleries, he spotted a large sculpture of an Assyrian lion with a man's head which provided a symbol not only for the CD cover but for the entire tour. The silver curtain which covered the stage was transformed into a slipcover for the CD case; when you slide it out, you see the lion in the desert. "The lion is also a British heraldic image," Sagmeister observes. "And Mick Jagger's sun sign is Leo."

Sagmeister's Stones project established the already-renowned designer in the music design hall of fame. Now that their work is in demand, Sagmeister and Karlsson "only take jobs where we are responsible for initiating the creative concept. If it's just a question of a layout, if the photo shoot's been done, we're not interested." Sagmeister, Inc. is not in this business strictly for money. "We want the creative challenge."
—*Brooke Comer*

First Contact & Terms: Send postcard sample or query letter with photocopies and SASE. Accepts disk submissions compatible with Windows '95 in above programs. Samples are filed or are returned by SASE. Reports back only if interested. Write for appointment to show portfolio of printed samples, b&w and color photographs. Pays by the project, up to $1,250. Buys all rights.

Tips: "Compact disc covers and cassettes are small—your art must get consumer attention. Be familiar with CD and cassette music layout on computer in either Adobe or Corel. Be familiar with UPC bar code portion of each program. Be under $500 for layout to include buyout of original artwork and photographs. Copyright to remain with Cherry Street—no reprint rights or negatives retained by illustrator, photographer or artist."

***COMMA RECORDS & TAPES**, Box 2148, D-63243, Neu Isenburg, Germany. 06102-52696. Fax: 06102-52696. Contact: Marketing Department. Estab. 1972. Produces CDs, tapes and albums: rock, R&B, classical, country/western, soul, folk, dance, pop by group and solo artists.

Needs: Produces 70 solo artists and 40 groups/year. Uses 10 freelancers/year for CD/album/tape cover and brochure design and illustration; posters.

First Contact & Terms: Send query letter with brochure, résumé, tearsheets, slides, photographs, SASE, photocopies

and transparencies. Samples are not filed and are returned by SASE if requested by artist. Reports back to the artist only if interested and SASE enclosed. To show portfolio, mail copies of final art and b&w photostats, tearsheets, photographs and transparencies. Payment negotiated. Buys first rights and all rights.

‡**CRANK! A RECORD COMPANY**, 1223 Wilshire Blvd., Suite 823, Santa Monica CA 90403. (310)264-0439. Fax: (310)264-0539. E-mail: fanecrankthis.com. Website: http://www.crankthis.com. Indian Chief: Jeff Matlow. Estab. 1994. Produces albums, CDs 7″, 10″: rock and indie/alternative by solo artists and groups. Recent releases: "The Power of Failing," by Mineral; *Posthumous*, by Vitreous Humor.
Needs: Produces 10 releases/year. Works with 3 freelancers/year. Prefers local designers. Uses freelancers for album cover design and illustration; CD booklet design and illustration; CD cover design and illustration; poster design; Web page design. Also for advertising and catalogs. 100% of freelance design and 30% of illustration demands knowledge of Aldus PageMaker, Adobe Illustrator, QuarkXPress, Adobe Photoshop, Aldus FreeHand.
First Contact & Terms: Send query letter with photocopies. Samples are filed. Reports back to the artist only if interested. Artist should follow-up with call and/or letter after initial query. Portfolio should include b&w, color, final art, photocopies, photographs and tearsheets. Rights purchased vary according to project.

‡**CREEK RECORDS/CREEKER MUSIC PUB.**, Box 1946, Cave Creek AZ 85327. (602)488-8132. Junior Vice President: Jeff Lober. Estab. 1996. Produces albums, CDs, CD-ROMs, cassettes: classical, country, folk, jazz, pop, progressive, R&B, rock, soul, Latin-Spanish and Middle Eastern by solor artists and groups. Recent releases: "Rescue Me," by Chrissy Williams; "30 Second Dream," by Richard Towers.
Needs: Produces 30-35 releases/year. Works with 5-6 freelancers/year. Uses freelancers for album cover design and illustration; cassette cover design and illustration; CD booket design and illustration; CD cover design and illustration; CD-ROM design and packaging. 50% of freelance work demands knowledge of QuarkXPress, Adobe Photoshop, Aldus FreeHand.
First Contact & Terms: Send query letter with brochure and photostats. Accepts Mac-compatible disk submissions. Samples are filed or returned by SASE. Will contact artist for portfolio review of b&w, color art if interested. Pays by the project, $200-1,000. Buys all rights.
Tips: Look at CD covers in stores and use your own ideas from there. Looks for "something that will sell the CD besides the music."

CRESCENT RECORDING CORPORATION, P.O. Box 520195, Bronx NY 10452. (212)462-9202. Fax: (718)716-2963. Operations Officer: Leon G. Pinkston. Produces albums, CDs and cassettes: pop, R&B, rap, rock, soul. Recent releases: *Crazytown*, by Dodging Reality; and *Something On My Mind*, by Camille Watson.
Needs: Produces 1-3 releases/year. Works with 2-5 freelance artists/year. Prefers designers who own Mac/IBM computers with experience in QuarkXPress, FreeHand, Illustrator, etc. Uses freelancers for album cover design and illustration, cassette cover design and illustration, CD booklet design and illustration, CD cover design and illustration, poster and World Wide Web page design. Also for advertising, mail packages, brochure design/illustration. 75% of design and illustration demands knowledge of Adobe Illustrator, Adobe Photoshop, Aldus FreeHand, Aldus PageMaker, QuarkX-Press.
First Contact & Terms: Send postcard sample of work or query letter with résumé. Samples are filed and are not returned. Reports back with 2-3 months only if interested. Will contact for portfolio review of b&w, color, final art if interested. Pays for design by the project, $750-1,000; pays for illustration by the project, $400-700. Negotiates rights purchased. Finds artists "mainly through artists' submissions. Sometimes we use artists' reps and the WWW."
Tips: "Continue to grow and to reinvent your skills within the scope of the art industry. Keep up with the changing packaging and technological trends."

‡**CRS ARTISTS**, 724 Winchester Rd., Broomall PA 19008. (215)544-5920. Fax: (215)544-5921. E-mail: crsnews@erols.com. Website: http://www.erols.com/crsnews. Administrative Assistant: Caroline Hunt. Estab. 1981. Produces CDs, tapes and albums: jazz and classical by solo artists and compilations. Recent releases: *Excursions* and *Albumleaf*.
Needs: Produces 20 CDs/year. Works with 4 designers and 5 illustrators/year on assignment only. Also uses freelancers for multimedia projects. 50% of freelance work demands knowledge of Word Perfect and Wordstar.
First Contact & Terms: Send query letter with brochure, résumé, SASE and photocopies. Samples are filed or are returned by SASE if requested by artist. Reports back within 1 month only if interested. Call for appointment to show portfolio or mail roughs, b&w tearsheets and photographs. Requests work on spec before assigning a job. Pays by the project. Buys all rights; negotiable. Finds new artists through *Artist's and Graphic Designer's Market*.

‡**DAPMOR PUBLISHING COMPANY**, 3031 Acorn St., Kenner LA 70065. (504)468-9820. Fax: (504)466-2896. Owner: Kelly Jones. Estab. 1977. Produces CDs, cassettes: country, jazz, pop, R&B, rap, rock and soul by solo artists and groups.
First Contact & Terms: Send postcard sample of work. Samples are not filed and not returned. Reports back within 1 month.

‡*DEMI MONDE RECORDS & PUBLISHING**, Foel Studio, Llanfair Caereinion, Powys SY21 ODS Wales. Phone: (44)1938-810758. Fax: (44)1938-810758. E-mail: demi.monde@dial.pipex.com. Managing Director: Dave Anderson. Estab. 1984. Produces albums and cassettes: pop, progressive, R&B and rock by solo artists and groups.

Needs: Produces 12 releases/year. Works with 5-10 freelancers/year. Prefers designers who own Macs or PCs. Uses freelancers for album cover design and illustration; cassette cover illustration and design; CD booklet design and illustration; CD cover design and illustration; CD cover design and illustration; poster design; web page design. 100% of freelance work demands knowledge of Adobe Illustrator, QuarkXPress, Adobe Photoshop.
First Contact & Terms: Send postcard sample, brochure or photocopies. Accepts PC-compatible disk submissions. Samples are filed. Reports back within 6 weeks if interested. Buys all rights.

✔DIRECT FORCE PRODUCTIONS, Box 120817, Brooklyn NY. (718)346-3991. President: Ronald Amedee. Estab. 1989. Produces CDs and tapes: rock and roll, jazz, rap, rhythm and blues, soul, pop, hip hop by group and solo artists. Recent releases: *One Love*, by Sheila Stone; and *All of Me* by Kim Fields.
 ● Direct Force has doubled their pay for freelance design and illustration.
Needs: Produces 25 albums/year; soloists and groups. Works with 6 freelance designers and 28 freelance illustrators/year. Prefers artists with experience in the music field. Uses artists for CD cover design; album/tape cover design and illustration; advertising design; posters. 25% of design and 50% of illustration demand computer literacy in QuarkXPress or Adobe Illustrator.
First Contact & Terms: Send query letter with brochure, SASE, photocopies and photographs. Samples are filed or are returned. Reports back within 15 days. Call to schedule an appointment to show a portfolio or mail appropriate materials: original/final art and b&w and color samples. Sometimes requests work on spec before assigning a job. Pays for design and illustration by the project, $3,000 minimum. Rights purchased vary according to project.

‡DRIVE ENTERTAINMENT, 10351 Santa Monica Blvd., Suite 404, Los Angeles CA 90025. (310)553-3490. Fax: (310)553-3373. E-mail: drive@earthlink.net. Production Coordinator: Priscilla Sanchez. Estab. 1991. Produces albums, CDs, cassettes, videos: country, folk, jazz, big band by solo artists and groups. Recent releases: albums by Sara Vaughn and Don Redman All Stars.
Needs: Produces 48 releases/year. Works with 3-6 freelancers/year. Prefers local designers who own Mac computers and are able to give first drafts. Uses freelancers for album cover design, cassette cover illustration and design, CD booklet design, CD cover design and poster design. 100% of design demands knowledge of Quark XPress and Adobe Photoshop.
First Contact & Terms: Send postcard sample of work and send query letter with brochure, photocopies, tearsheets and résumé. Accepts Mac-compatible disk submissions. Samples are filed or are returned by SASE if requested by artist. Reports back only if interested. Art director will contact artist for portfolio review of b&w and color final art, photocopies, photographs, photostats, roughs, slides, tearsheets, thumbnails and transparencies if interested. Pays for design by the project; $700-820/CD (design and film). Buys all rights. Finds artists through word of mouth and submissions.
Tips: "Send postcards, samples to all companies. Basically, advertise! Any samples are acceptable—classy designs, professional, beautiful colors, eye-catching designs."

‡EARACHE RECORDS, 295 Lafayette, Suite 915, New York NY 10012. (212)343-9090. Fax: (212)343-9244. E-mail: earacherec@aol.com. Website: http://www.earache.com. Product Manager: Peter Tsakiris. Art & Multimedia Manager: Antz White. Estab. 1993. Produces albums, CDs, CD-ROMs, cassettes, 7" and 10" vinyl: rock, industrial, heavy metal techno, death metal, grind core. Recent releases: *Napalm Death*, by Napalm Death and *Formulas Fatal to the Flesh*, by Morbid Angel.
Needs: Produces 12 releases/year. Works with 4-6 freelancers/year. Prefers designers with experience in music field who own Macs. Uses freelancers for album cover design; cassette cover illustration; CD booklet design and illustration; CD cover design and illustration; CD-ROM design. Also for advertising and catalog design. 90% of freelance work demands knowledge of Adobe Illustrator 7.0, QuarkXPress 3.3, Adobe Photoshop 4.0, Aldus FreeHand 7.
First Contact & Terms: Send postcard sample of work. Samples are filed and not returned. Does not report back. Artist should follow-up with call and/or letter after initial query. Will contact artist for portfolio review of color, final art, photocopies, photographs if interested. Pays by the project. Buys all rights.
Tips: "Know the different packaging configurations and what they are called. You must have a background in music production/manufacturing."

EMF RECORDS & AFFILIATES, 633 Post St., #145, San Francisco CA 94109. (415)263-5727. Fax: (415)752-2442. Sales & Marketing Director: Mark Jarvis. Estab. 1994. Produces CDs, CD-ROMs, cassettes: classical, country, jazz, pop, progressive, R&B, rock, soul, urban, dance, Latin, new age. Recent releases: *Like The Mist That Lingers*, by Joe Tsongo (vol. 1, 2 and 3); and *Hot On The Groove*, by Slam Jam.
Needs: Produces 7 releases/year. Works with 1 freelance artist/year. Prefers designers who own Mac/IBM computers with experience in cover designing. Uses freelancers for cassette cover design and illustration, CD booklet design and illustration, CD cover design and illustration, poster design. Also for advertising design, catalog design, direct mail packages, multimedia projects. 70-80% of design and illustration demands knowledge of Adobe Illustrator, Adobe Photoshop.
First Contact & Terms: Send query letter with brochure, photocopies, photographs, résumé. Accepts disk submissions. Samples are filed or are returned by SASE if requested by artist. Reports back with 2 months. Will contact for portfolio review of b&w, color, final art, photocopies, photographs, photostats. Pays for design and illustration by the project. Rights purchased vary according to project. Finds artists through submissions and sourcebooks.

∠ETHEREAN MUSIC/ELATION ARTISTS, 12640 W. Cedar Dr., #300, Lakewood CO 80228. (303)973-8291. Fax: (303)973-8499. E-mail: etherean@etherean.com. Website: http://www.etherean.com. Contact: Chad Darnell. Estab. 1988. Produces 4 CDs and tapes/year: jazz and New Age/Native American. Recent releases: *Sons of Somerled*, by Steve McDonald; and *Twelve Twelve*, by Kenny Passarelli.

Needs: Produces 2 soloists and 2 groups/year. Works with 1 designer and 1 illustrator/year for CD and tape cover design and illustration. Needs computer-literate freelancers for illustration. 80% of freelance work demands knowledge of Director 5.0 or 6.0, QuarkXPress, Adobe Illustrator and Photoshop.

First Contact & Terms: Send query letter with brochure, résumé, photostats and photocopies. "No original artwork." Samples are filed or are returned by SASE if requested. Reports back only if interested. Write for appointment to show portfolio. Sometimes requests work on spec before assigning a job. Pays for design by the project, $200-1,000. Pays for illustration by the hour, $100-500. Rights purchased vary according to project.

‡FIRST POWER ENTERTAINMENT GROUP, 15801 Riverdale Rd., Suite 105, Riverdale MD 20737. (301)277-1671. Fax: (301)277-0173. E-mail: powerpla@mail.erols.com. Vice President: Adrianne Harris. Estab. 1992. Produces albums, CDs, cassettes and *Street Jam* magazine: classical, gospel, R&B, rap, rock, soul, dance, alternative. Recent releases: "Set it Out" and *Do the Lasso* by Da Foundation.

Needs: Produces 2-4 releases/year. Works with 3-6 freelancers/year. Prefers local freelancers with experience in Adobe PageMaker, Photoshop, Extreme 3D. Uses freelancers for album cover design and illustration, animation, cassette cover design, CD booklet design and illustration, CD cover design and illustration, CD-ROM design, poster design, multimedia projects, *Street Jam* magazine. 100% of design and illustration work demands knowledge of Adobe Illustrator, Adobe Photoshop and Adobe PageMaker.

First Contact & Terms: Send brochure, résumé, photostats, photocopies, photographs, tearsheets, SASE. Samples are filed or are returned by SASE if requested. Reports back only if interested. Request portfolio review of b&w and color photographs ("whatever you have available; work samples") in original query. Artist should follow-up with call. Pays by the project. Buys all rights. Finds artists through advertising and word of mouth.

Tips: "Trends are always changing. The current ones (listed above) and the DVD formats are what's currently in demand. Know your business and get all the experience you can. However, don't just follow trends. Be creative, break barriers and present yourself and your work as something unique."

‡FOREFRONT RECORDS/EMI CHRISTIAN MUSIC GROUP, 201 Seaboard Lane, Franklin TN 37067. (615)771-2900. Fax: (615)771-2901. E-mail: f2creative@aol.com. Website: http://www.forefrontrecords.com. Creative Services Manager: Cindy Simmons. Estab. 1988. Produces CDs, CD-ROMs, cassettes: Christian alternative rock by solo artists and groups. Recent releases: *Jesus Freak*, by dc Talk; *Some Kind of Zombie*, by Audio Adrenaline.

Needs: Produces 15-20 releases/year. Works with 5-10 freelancers/year. Prefers designers who own Macs with experience in cutting edge graphics and font styles/layout, ability to send art over e-mail, and attention to detail and company spec requirements. Uses freelancers for cassette cover design and illustration; CD booklet design and illustration; CD cover design and illustration; CD-ROM design and packaging; poster design. 100% freelance design and 50% of illustration demands knowledge of Adobe Illustrator, QuarkXPress, Adobe Photoshop.

First Contact & Terms: Send postcard sample or query letter with résumé, photostats, transparencies, photocopies, photographs, slides, SASE, tearsheets. Accepts disk submissions compatible with Mac/Quark, Adobe Photoshop or Illustrator, EPS files. Samples are filed or returned by SASE if requested by artist. Reports back to the artist only if interested. Portfolios may be dropped every Tuesday and Wednesday. Will contact artist for portfolio review if interested. Payment depends on each project's budgeting allowance. Negotiates rights purchased. Finds artists through artist's submissions, sourcebooks, web pages, reps, word-of-mouth.

Tips: "I look for cutting edge design and typography along with interesting use of color and photography. Illustrations must show individual style and ability to be conceptual."

∠GEFFEN RECORDS, 9130 Sunset Blvd., Los Angeles CA 90069. (310)285-2780. Website: http://www.geffen.com. Contact: Susan Horton. Produces progressive, R&B and rock music. Recent releases include *Plastic Seat Sweat*, by Southern Culture On the Skids; *Firecracker*, by Lisa Loeb; and *Vegas*, by the Crystal Method.

● Geffen's four art directors also create CD packages for Almo Sounds, Outpost Recordings and Dreamworks. They "rarely" use freelance illustrators because most of the covers feature photography.

Tips: "The art department and creative services love to see truly original work. Don't be too conservative, but do create a portfolio that's consistent. Don't be afraid to push the limits."

‡GLASS HOUSE PRODUCTIONS, P.O. Box 602, Columbus IN 47202. (812)375-9362. Fax: (812)372-3985. E-mail: glasshouse@ghp.net. Website: http://www.ghp.net/glasshouse. Executive Producer: S. Glass. Estab. 1989. Produces CDs, cassettes: classical, country, folk, pop, progressive, rock by solo artists and groups. Recent releases: *Turn It Around*, by Sacred Project; *Suzanne Glass*, by Suzanne Glass.

Needs: Produces 2-10 releases/year. Works with 5 freelancers/year. Prefers local designers with experience in Quark, PageMaker. Uses freelancers for cassette cover design and illustration; CD booklet design and illustration; CD cover design and illustration; poster design. Also for multimedia. 95% of design and 50% of illustration demands knowledge of Aldus PageMaker, Adobe Illustrator, QuarkXPress, Adobe Photoshop.

First Contact & Terms: Send postcard sample. Samples are filed. Will contact artist for portfolio review if interested. Pays for design by the project, $300-2,000. Negotiates rights purchsed. Finds artists through word of mouth, submissions.

Tips: "Be willing to do 'generic' design for independent artists. There is a great demand and should lead to more creative work."

‡GRAY DOT, INC., 1979 S. Cobb Dr., Marietta GA 30060. (770)384-0001. Fax: (770)384-0002. E-mail: david@grayd ot.com. Website: http://www.graydot.com. Art Director: David Vanderpoel. Estab. 1990. Produces CDs, cassettes: gospel, pop, rock by solo artists and groups. Recent releases: *Fight the System,* by Squad Five-O; *The Truth,* Age of Faith.
Needs: Produces 18 releases/year. Works with 4 freelancers/year. Prefers local designers and illustrators. Uses freelancers for album cover design and illustration; animation; cassette cover design and illustration; CD booklet design and illustration; CD cover design and illustration; poster design; World Wide Web page design. 90% of design and illustration demands knowledge of Adobe Illustrator, QuarkXPress, Adobe Photoshop.
First Contact & Terms: Send query letter with résumé, slides, tearsheets. Accepts disk submissions compatible with Macintosh only. Samles are filed. Reports back within 2 weeks. Request portfolio review of final art in original query. Pays for design and illustration by the project; negotiable. Buys all rights. Finds artists through direct submissions, referrals, competitor's products, magazines.
Tips: Sees a trend in "packages shrinking—layouts need to be more direct and clean." Recommends doing "gratis work for indie bands—treat them as major projects." Looking for "new approach, sense of taste, ability to modify to please client."

HARD HAT RECORDS AND CASSETTE TAPES, 519 N. Halifax Ave., Daytona Beach FL 32118-4017. (904)252-0381. Fax: (904)252-0381. E-mail: hardhat@kspace.com. Website: http://www.kspace.com/hardhat. CEO: Bobby Lee Cude. Produces rock, country/western, folk and educational by group and solo artists. Publishes high school/college marching band arrangements. Recent releases include: *Broadway USA* CD series (a 3 volume CD program of new and original music); and *Times-Square Fantasy Theatre* (CD release with 46 tracks of new and original Broadway style music).
 • Also owns Blaster Boxx Hits.
Needs: Produces 6-12 records/year. Works with 2 designers and 1 illustrator/year. Works on assignment only. Uses freelancers for album cover design and illustration; advertising design; and sheet music covers. Prefers "modern, up-to-date, on the cutting edge" promotional material and cover designs that fit the music style. 60% of freelance work demands knowledge of Adobe Photoshop.
First Contact & Terms: Send query letter with brochure to be kept on file one year. Samples not filed are returned by SASE. Reports within 2 weeks. Write for appointment to show portfolio. Sometimes requests work on spec before assigning a job. Pays by the project. Buys all rights.

✔❖HICKORY LANE RECORDS, Box 2275, Vancouver, British Columbia V6B 3W5 Canada. (604)945-4746. Fax: (604)987-0616. E-mail: chrismichaels1@msn. President: Chris Michaels. A&R Manager: David Rogers. Estab. 1985. Produces CDs and tapes: country/western. Recent releases: *All Fired Up and Country,* by Chris Urbanski.
Needs: Produces 5 solo artists and 2 groups/year. Approached by 15 desginers and 15 illustrators/year. Works with 2 designers and 2 illustrators/year. Works on assignment only. Uses freelancers for CD/tape cover, brochure and advertising design and illustration; and posters. 25% of freelance work demands knowledge of Aldus PageMaker, Adobe Illustrator, QuarkXPress, Adobe Photoshop, Aldus FreeHand.
First Contact & Terms: Send query letter with brochure, résumé, photostats, transparencies, photocopies, photographs, SASE and tearsheets. Samples are filed and are returned by SASE if requested by artist. Reports back within 6 weeks. Call or write for appointment to show portfolio of b&w and color roughs, final art, tearsheets, photostats, photographs, transparencies and computer disks. Pays for design by the project, $250-650. Negotiates rights purchased.
Tips: "Keep ideas simple and original. If there is potential in the submission we will contact you. Be patient and accept criticism. Send us samples via email."

✔HIGHWAY ONE MEDIA ENTERTAINMENT, 2950 31st St., Suite 376, Santa Monica CA 90405. (310)664-6686. Fax: (310)664-6685. E-mail: hwyone@aol.com or highway1@earthlink.net. Website: http://www.highway1media. com. President: Ken Caillat. Estab. 1994. Produces CD-ROMs, DVD-ROMs and enhanced music CDs: pop and rock by solo artists and groups. Recent releases: *Electric Barbarella,* by Duran Duran; *Sock It 2 Me/The Rain (Supa Dupa Fly),* by Missy Elliott; *Classics For Dummies* series; and *Razorblade Suitecase,* by Bush.
Needs: Produces 6-10 releases/year. Works with 10-20 freelancers/year. Prefers local designers who own computers. Uses freelancers for CD booklet and cover design and illustration; CD-ROM design and packaging. 100% of freelance work demands knowledge of Adobe illustrator, QuarkXPress, Adobe Photoshop.
First Contact & Terms: Fulltime positions may be available. Send query letter with brochure, photocopies, tearsheets, résumé. Accepts disk submissions. Samples are filed. Reports back within 2 weeks. Will contact for portfolio review of color photocopies if interested. Pays by the project, $200-6,000. Send to attention of Anna Rambo.

HOTTRAX RECORDS, 1957 Kilburn Dr., Atlanta GA 30324. (770)662-6661. E-mail: hotwax@hottrax.com. Website: http://www.hottrax.com. Publicity and Promotion: Teri Blackman. Estab. 1975. Produces CDs and tapes: rock, R&B, country/western, jazz, pop and blues/novelties by solo and group artists. Recent releases: *Real Time,* by Sheffield-Webb; *Live From The Eye Of The Storm,* by Roger Hurricane Wilson; and *Blue in Dixieland,* by Bob Page.
Needs: Produces 2 soloists and 4 groups/year. Approached by 90-100 designers and 60 illustrators/year. Works with 6 designers and 6 illustrators/year. Prefers freelancers with experience in multimedia—mixing art with photographs—and

caricatures. Uses freelancers for CD/tape cover, catalog and advertising design and illustration; and posters. 25% of freelance work demands knowledge of Aldus PageMaker, Adobe Illustrator and Photoshop.

First Contact & Terms: Send postcard samples. Accepts disk submissions compatible with Adobe Illustrator and CorelDraw. Some samples are filed. If not filed, samples are not returned. Reports back only if interested. Pays by the project, $150-1,250 for design and $1,000 maximum for illustration. Buys all rights.

Tips: "We file all samples that interest us even though we may not respond until the right project arises. We like simple designs for blues and jazz, including cartoon/caricatures, abstract for New Age and fantasy for heavy metal and hard rock."

‡**IGUANA RECORDS,** 110 Greene St., #702, New York NY 10012. (212)226-0300. Fax: (212)226-8996. E-mail: carl@guana-records.com. Website: http://www.iguana-records.com. Director of Marketing: Carl Parcaro. Estab. 1991. Produces albums, CDs, cassettes and posters: progressive, rock. Recent releases: *Vibrolush* by Vibrolush and *I Think Too Much* by Settie.

Needs: Produces 6 releases/year. Works with 4 freelancers/year. Prefers designers who own Mac computers. Uses freelancers for album cover design and illustration, cassette cover illustration and design, CD booklet design and illustration, CD cover design and illustration, poster design and World Wide Web page design. 100% of design and illustration demands computer skills.

First Contact & Terms: Send postcard sample of work and query letter with brochure, résumé, photostats, transparencies, photocopies, photographs, slides, tearsheets. Accepts Mac-compatible disk submissions. Samples are filed. Reports back only if interested. Pay varies.

✔**ISLANDLIFE,** (formerly Island Records), 4 Columbus Circle, New York NY 10019. (212)506-5841. Fax: (212)506-5849. Studio Manager: Sandi Tansky. Estab. 1959. Produces films, albums, CDs, CD-ROMs, cassettes, LPs: folk, gospel, pop, progressive, R&B, rap and rock by solo artists and groups.

Needs: Works with 15 freelancers/year. Prefers designers who own Mac computers. Uses freelancers for album, cassette and CD cover design and illustration; CD booklet design and illustration; and poster design; advertising; merchandising. 99% of design and 20% of illustration demand knowledge of Adobe Illustrator, QuarkXPress, Adobe Photoshop and Aldus FreeHand.

First Contact & Terms: Send postcard sample and or query letter with tearsheets. Accepts disk submissions. Samples are filed. Portfolios of b&w and color final art and tearsheets may be dropped off Monday through Thursday. Pays for design by the project, $50-5,000; pays for illustration by the project, $500-5,000. Rights purchased vary according to project. Finds artists through submissions, word of mouth and sourcebooks.

Tips: "Have a diverse portfolio."

JAY JAY, NE 35 62nd St., Miami FL 33138. (305)758-0000. President: Walter Jagiello. Produces CDs and tapes: country/western, jazz and polkas. Recent releases: *Jolly Times* and *Feel Good Music Instrumental*, by Li'l Wally.

Needs: Produces 7 CDs, tapes and albums/year. Works with 3 freelance designers and 2 illustrators/year. Works on assignment only. Uses freelancers for album cover design and illustration; brochure design; catalog layout; advertising design, illustration and layout; and posters. Sometimes uses freelancers for newspaper ads. Knowledge of MIDI-music lead sheets helpful for freelancers.

First Contact & Terms: Send brochure and tearsheets to be kept on file. Call or write for appointment to show portfolio. Samples not filed are returned by SASE. Reports within 2 months. Requests work on spec before assigning a job. Pays for design by the project, $20-50. Considers skill and experience of artist when establishing payment. Buys all rights.

✔**LITTLE RICHIE JOHNSON AGENCY,** 2125 Willowmere Dr., Des Moines IA 50321. General Manager: Tony Palmer. Produces tapes and albums: country/western. Recent release: *Moonlight Wine & Roses*, by Gabe Nieto.

Needs: Produces 5 soloists and 2 groups/year. Works with "a few" freelance designers and illustrators/year on assignment only. Prefers local artists. Uses freelancers for album/tape cover design and advertising design.

First Contact & Terms: Send query letter with brochure showing art style or photographs. Samples are filed or are returned by SASE only if requested. Reports back only if interested. To show portfolio, mail photographs. Pays for design and illustration by the project. Considers complexity of project and available budget when establishing payment. Rights purchased vary according to project.

‡✤**K.S.M. RECORDS,** 2305 Vista Court, Coquitlam, British Columbia V3J 6W2 Canada. (604)671-0444. Fax: (604)469-9359. E-mail: ksmrecords@infomatch.com. Website: http://www.infomatch.com/~KSM records. Art Director: David London. Estab. 1991. Produces CDs: alternative. Recent releases: *Gala*, by DAED21; and *Rain Creature*, by Colour Clique, Red Sector 1, X-Drone, etc.

Needs: Produces 2-5 releases/year. Works with 2-5 freelancers/year. Prefers artists with experience in surrealism. Uses freelancers for CD covers and advertising design and illustration; and posters.

First Contact & Terms: Send query letter with résumé, photographs. Samples are filed or returned. Reports back within 1 month only if interested. Art Director will contact artist for portfolio if interested. Portfolio should include b&w and color samples. Pays for illustration by the project, negotiable. Buys one-time rights.

Tips: Finds artists through artists' submissions. Impressed by Salvador Dali influence in an artist's work.

‡**KAT RECORDS/LIQUID MEAT RECORDINGS**, P.O. Box 460692, Escondido CA 929046. Fax: (760)942-8228. E-mail: liqmeat@netcom. Website: http://www.junkdealer.com. A&R Director: Mollie Ehn. Estab. 1993. Produces albums & CDs: pop, punk-pop, EMD and hardcore music by solo artists and groups. Recent releases: *Half Fiction*, by Discount; *Give Kids Candy*, by Hemlock.
Needs: Produces 2-4 releases/year. Works with 1-4 freelancers/year. Works only with artist reps. Prefers local designers. Uses freelancers for album cover design and illustration; CD booklet design and illustration; and poster design. Also for catalog and brochure design. 100% of freelance design demands knowledge of Aldus PageMaker 6.0, Adobe Illustrator 6.0, QuarkXPress 3.32, Adobe Photoshop.
First Contact & Terms: Send postcard sample. Samples are filed. Will contact artist for portfolio review of b&w, final, photocopies if interested. Pays by the project; negotiable. Rights purchased vary according to project.

KIMBO EDUCATIONAL, 10 N. Third Ave., Long Branch NJ 07740. E-mail: kimboed@aol.com. Website: http://www.kimboed.com. Production Manager: Amy Laufer. Educational record/cassette company. Produces 8 cassettes and compact discs/year for schools, teacher supply stores and parents. Primarily early childhood/physical fitness, although other materials are produced for all ages.
Needs: Works with 3 freelancers/year. Prefers local artists on assignment only. Uses artists for CD/cassette/covers; catalog and flier design; and ads. Helpful if artist has experience in the preparation of CD covers jackets or cassette inserts.
First Contact & Terms: "It is very hard to do this type of material via mail." Send letter with photographs or actual samples of past work. Reports only if interested. Pays for design and illustration by the project, $200-500. Considers complexity of project and budget when establishing payment. Buys all rights.
Tips: "The jobs at Kimbo vary tremendously. We produce material for various levels—infant to senior citizen. Sometimes we need cute 'kid-like' illustrations and sometimes graphic design will suffice. We are an educational firm so we cannot pay commercial record/cassette/CD art prices."

♣**L.A. RECORDS**, P.O. Box 1096, Hudson, Quebec J0P 1H0 Canada. (514)869-3236. Fax: (514)458-2819. E-mail: larecord@total.net. Website: http://www.radiofreedom.com. Manager: Tina Sexton. Estab. 1991. Produces CD and tapes: rock, pop, R&B, alternative; solo artists and groups. Recent releases: *Paradigm*, by Golden Mea; and *Tempted*, by Freeland.
Needs: Produces 8-12 releases/year. Works with 2-5 freelancers/year. Prefers local freelancers. Uses freelancers for CD/tape cover, brochure and advertising design and illustration. Needs computer-literate freelancers for design and illustration. 80% of freelance work demands computer skills.
First Contact & Terms: Send postcard sample of work or query letter with brochure, résumé, photostats, photocopies, photographs and SASE. Samples are filed. Art Director will contact artist for portfolio review if interested. Portfolio should include color photocopies and photographs. Pays for design and illustration by the project. Rights purchased vary according to project. Finds artists through word of mouth.
Tips: "Make an emotional impact."

‡♣**LCDM ENTERTAINMENT**, Box 79564, 1995 Weston Rd., Weston, Ontario M9N 3W9 Canada. (416)242-7391. Fax: (416)743-6682. E-mail: guitarbabe@hotmail.com. or jameson@yorku.ca. Website: http://www.canmusic.com. Publisher: L.C. DiMarco. Estab. 1991. Produces CDs, tapes, publications (quarterly): pop, folk, country/western and original. Recent releases: "Glitters & Tumbles," by Liana; and *Indie Tips & the Arts* (publication).
Needs: Prefers local artists but open to others. Uses freelancers for CD cover design, brochure illustration, posters and publication artwork. Needs computer-literate freelancers for production, presentation and multimedia projects.
First Contact & Terms: Send query letter with brochure, résumé, photocopies, photographs, SASE, tearsheets, terms of renumeration (i.e., pay/non-pay/alternative). Samples are filed. Art Director will contact artist for portfolio review if interested. Pays for design and illustration by the project. Rights purchased vary according to project.
Tips: "The best experience is attainable through indie labels. Ensure that the basics (phone/fax/address) are on all of your correspondence. Seldom do indie labels return long distance calls. Include SASE in your mailings always. Get involved and offer to do work on a volunteer or honorarium basis. The best chance to be hired is the second time around when approaching."

PATTY LEE RECORDS, 6034½ Graciosa Dr., Hollywood CA 90068. (213)469-5431. Contact: Susan Neidhart. Estab. 1986. Produces CDs and tapes: New Orleans rock, jazz, folk, country/western, cowboy poetry and eclectic by solo artists. Recent releases: *Return to BeBop*, by Jim Sharpe; *Alligator Ball*, by Armand St. Martin; and *Afternoon Candy*, by Angelyne.
Needs: Produces 4-5 soloists/year. Works with 1 designer and 2 illustrators/year. Works on assignment only. Uses freelancers for CD/tape cover, sign and brochure design; and posters.
First Contact & Terms: Send postcard sample. Samples are filed or are returned by SASE. Reports back only if interested. "Please do not send anything other than an introductory letter or card." Payment varies. Rights purchased vary according to project. Finds new artists through word of mouth, magazines, submissions/self-promotional material, sourcebooks, agents and reps and design studios.
Tips: "Our label is small. The economy does not affect our need for artists. Sending a postcard representing your 'style' is very smart. It's inexpensive and we can keep the card on file. We are 'mom and pop' and have limited funds so if you don't hear back from us, it is not a reflection on your talent. Keep up the good work."

‡**LIVING MUSIC**, P.O. Box 72, Litchfield CT 06759. (860)567-8796. Fax: (860)567-4276. E-mail: pwclmr@aol.com. Website: http://www.livingmusic.com. Director of Communications: Kathi Fragione. Estab. 1980. Produces CDs and tapes: classical, jazz, folk, progressive, world, New Age. Recent releases: *Pete*, by Pete Seeger; *Celtic Soul*, by Noirin Ni Riain; and *Canyon Lullaby*, by Paul Winter.
Needs: Produces 1-3 releases/year. Works with 1-5 freelancers/year. Uses freelancers for CD/tape cover and brochure design and illustration; direct mail packages; advertising design; catalog design, illustration and layout; and posters. 70% of freelance work demands knowledge of Aldus PageMaker, Adobe Illustrator, QuarkXPress, Adobe Photoshop, Aldus FreeHand.
First Contact & Terms: Send postcard sample of work or query letter with brochure, transparencies, photographs, slides, SASE, tearsheets. Samples are filed or returned by SASE if requested by artist. Reports back to the artist only if interested. Art Director will contact artist for portfolio review of b&w and color roughs, photographs, slides, transparencies and tearsheets. Pays for design by the project. Rights purchased vary according to project.
Tips: "We look for distinct 'earthy' style; sometimes look for likenesses."

‡**LUCIFER RECORDS, INC.**, Box 263, Brigantine NJ 08203. (609)266-2623. President: Ron Luciano. Produces pop, dance and rock.
Needs: Produces 2-12 records/year. Prefers experienced freelancers. Works on assignment only. Uses freelancers for album cover and catalog design; brochure and advertising design, illustration and layout; direct mail packages; and posters.
First Contact & Terms: Send query letter with résumé, business card, tearsheets, photostats or photocopies. Reports only if interested. Original art sometimes returned to artist. Write for appointment to show portfolio, or mail tearsheets and photostats. Pays by the project. Negotiates pay and rights purchased.

METAL BLADE RECORDS, INC., 2828 Cochran St., Suite 302, Simi Valley CA 93065. (805)522-9111. Fax: (805)522-9380. E-mail: mtlbldrcds@aol.com. Website: http://www.iuma.com/metal_blade or http://home.earthlink.net/~metal_blade/. Vice President/General Manager: Tracy Vera. Estab. 1982. Produces CDs and tapes: rock by solo artists and groups. Recent releases: *Carnival of Chaos*, by Gwar; and *A Pleasant Shade of Gray*, by Fates Warning.
Needs: Produces 10-20 releases/year. Approached by 10 designers and 10 illustrators/year. Works with 1 designer and 1 illustrator/year. Prefers freelancers with experience in album cover art. Uses freelancers for CD cover design and illustration. Needs computer-literate freelancers for design and illustration. 80% of freelance work demands knowledge of Aldus PageMaker, Adobe Illustrator, QuarkXPress, Adobe Photoshop.
First Contact & Terms: Send postcard sample of work or query letter with brochure, résumé, photostats, photocopies, photographs, SASE, tearsheets. Samples are filed or returned by SASE if requested by artist. Reports back to the artist only if interested. Art Director will contact artist for portfolio review if interested. Portfolio should include b&w and color, final art, photocopies, photographs, photostats, roughs, slides, tearsheets. Pays for design and illustration by the project. Buys all rights. Finds artists through *Black Book*, magazines and artists' submissions.
Tips: "Please send samples of work previously done. We are interested in any design."

MIGHTY RECORDS, Rockford Music Publishing Co.—BMI, Stateside Music Publishing Co.—BMI, Stateside Music Co.—ASCAP, 150 West End Ave., Suite 6-D, New York NY 10023. (212)873-5968. Manager: Danny Darrow. Estab. 1958. Produces CDs and tapes: jazz, pop, country/western; by solo artists. Releases: *Falling In Love*, by Brian Dowen; and *A Part of You*, by Brian Dowen/Randy Lakeman.
Needs: Produces 1-2 solo artists/year. Works on assignment only. Uses freelancers for CD/tape cover, brochure and advertising design and illustration; catalog design and layout; and posters.
First Contact & Terms: Send query letter with SASE. Samples are not filed and are returned by SASE if requested by artist. Reports back within 1 week. To show portfolio, mail photocopies with SASE. Pays for design by the project. Rights purchased vary according to project.

‡**MOJO RECORDS**, 1749 14th St., Suite 201, Santa Monica 90404. (310)260-3181. Fax: (310)314-3699. Website: http://www.mojorecords.com. Art Director: Jenny O'Callaghan. Produces CDs, cassettes, ECD: pop by solo artists and groups. Recent releases: *Turn the Radio Off*, by Reel Big Fish; *Zoot Suit Riot*, by Cherry Poppin' Daddies.
Needs: Produces 5 releases/year. Works with 5 freelancers/year. Prefers local designers and illustrators who own Macs. Uses freelancers for album cover design and illustration; casseette cover design and illustration; CD booklet design and illustration; CD cover design and illustration; poster design. 90% of design and 70% of illustration demands knowledge of Adobe Illustrator, QuarkXPress, Adobe Photoshop.
First Contact & Terms: Send postcard sample of work. Samples are filed or returned by SASE if requested by artist. Reports back within 1 month. Will contact artist for portfolio review if interested. Pays for design and illustration by the project. Negotiates rights purchased. Finds artists through word of mouth, sourcebooks, World Wide Web, etc.
Tips: "We really review portfolios on a project by project basis with the objective of matching the illustrator's style to the band's album."

‡**MUSIC MIND ENTERTAINMENT LTD.**, P.O. Box 803213, Chicago IL 60680. E-mail: etaylor950@aol. Vice Presidents: Eric C. Taylor and Ivan Ray. Estab. 1996. Produces CDs, cassettes, video: gospel, pop, R&B, rap, soul by solo artists and groups. Recent releases: "Climbing Up," by Sister Susie; "Shake," by The Fortress.
Needs: Produces 3 releases/year. Works with 2 freelancers/year. Prefers designers who own Macs. Uses freelancers

for album cover design and illustration; Cassette cover design and illustration; CD booklet design and illustration; CD cover design and illustration; poster design Web page design. 70% of design and 70% of illustration demands knowledge of Adobe Illustrator, Adobe Photoshop, Aldus FreeHand.

First Contact & Terms: Send query letter with brochure, résumé, photocopies, slides. Accepts disk submissions compatible with Mac. Samples are filed or returned by SASE if requested by artist. Reports back within 1 month. Art Director will contact artist for portfolio review or b&w, color, final art, photocopies, thumbnails if interested. Pays for design and illustration by the project; negotiable. Rights purchased vary according to project. Finds artists through *Black Book* and magazines.

Tips: "Record companies are always looking for a new hook so be creative. Keep your price negotiable. I look for creative and professional-looking portfolio."

***NERVOUS RECORDS**, 7-11 Minerva Rd., London NW10 6HJ England. (01)963-0352. Fax: (01)963-1170. E-mail: 100613.3456@compuserve.com. Website: http://www.nervous.co.uk. Contact: R. Williams. Produces CDs, tapes and albums: rock and rockabilly. Recent releases: *Slimline Daddy*, by Bill McElroy; and *Back to the Beat*, by The Backbeats.

Needs: Produces 9 albums/year. Approached by 4 designers and 5 illustrators/year. Works with 3 designers and 3 illustrators/year. Uses freelancers for album cover, brochure, catalog and advertising design and multimedia projects. 50% of design and 75% of illustration demand knowledge of Page Plus II and Microsoft Word 6.0.

First Contact & Terms: Send query letter with postcard samples; material may be kept on file. Write for appointment to show portfolio. Accepts disk submissions compatible with PagePlus and Microsoft Word. Samples not filed are returned by SAE (nonresidents include IRC). Reports only if interested. Original art returned at job's completion. Pays for design by the project, $50-200. Pays for illustration by the project, $10-100. Considers available budget and how work will be used when establishing payment. Buys first rights.

Tips: "We have noticed more imagery and caricatures in our field so fewer actual photographs are used." Wants to see "examples of previous album sleeves, keeping with the style of our music. Remember, we're a rockabilly label."

‡NEURODISC RECORDS, INC., 4592 N. Hiatus, Ft. Lauderdale FL 33351. (954)572-0289. Fax: (954)572-2874. E-mail: neurodisc@aol.com. Website: http://www.neurodisc.com. Contact: John Wai and Tom O'Keefe. Estab. 1990. Produces albums, CDs, cassettes: pop, progressive, rap and electronic. Recent releases: "The Chemical Box," Trip Hop Nation; "Holiday Mood Acid Breaks & Beats" and Spasmik.

Needs: Produces 10 releases/year. Works with 5 freelancers/year. Prefers designers with experience in designing covers. Uses freelancers for album cover design and illustration; animation; cassette cover design and illustration; CD booklet design and illustration; cover design and illustration; poster design; Web page design. Also for print ads. 100% of freelance work demands computer skills.

First Contact & Terms: Send postcard sample or query letter with brochure, photocopies and tearsheets. Samples are not filed and are returned by SASE if requested by artist. Will contact artist for portfolio review if interested. Pays by the project. Buys all rights.

‡NEW EXPERIENCE RECORDS/GRAND SLAM RECORDS, P.O. Box 683, Lima OH 45802. President: James Milligan. Estab. 1989. Produces tapes, CDs and records: rock, jazz, pop, R&B, soul, folk, gospel, country/western, rap by solo artists and groups. Recent releases: "You Promise Me Love," by The Impressions; and "He'll Steal Your Heart," by Barbara Lomus/BT Express.

Needs: Produces 5-10 solo artists and 4-6 groups/year. Works with 2-3 freelancers/year. Works with artist reps. Prefers freelancers with experience in album cover design. "Will consider other ideas." Works on assignment only. Uses freelancers for CD/tape cover design and illustration; brochure and advertising design; catalog layout; posters. 50% of freelance work demands knowledge of Aldus PageMaker.

First Contact & Terms: Send query letter with brochure, résumé, photocopies and photographs. Samples are filed. Reports back within 6 weeks. Artist should follow up with letter or phone call. Call or write for appointment to show portfolio of b&w roughs, final art and photographs. Pays for design by the project, $250-500. Buys one-time rights or reprint rights.

NUCLEUS RECORDS, Box 282, 885 Broadway, Bayonne NJ 07002. President: Robert Bowden. Produces albums and tapes: country/western, folk and pop. Recent releases: *4 O'clock Rock* and *Always*, by Marco Sission.

Needs: Produces 2 records/year. Artists with 3 years' experience only. Works with 1 freelance designer and 2 illustrators/year on assignment only. Uses freelancers for album cover design. 25% of design and 20% of illustration demand knowledge of Adobe Illustrator and Adobe Photoshop.

First Contact & Terms: Send query letter with résumés, SASE, printed samples and photographs. Write for appointment to show portfolio of photographs. Accepts disk submissions. Samples are returned. Sometimes requests work on spec before assigning a job. Pays for design by the project, $200-300; pays for illustration by the project, $300-400. Reports within 1 month. Originals returned at job's completion. Considers skill and experience of artist when establishing payment. Buys all rights. Finds new artists through submissions and design studios.

‡OMNI 2000, INC., 413 Cooper St., Camden NJ 08102. (609)963-6400. Fax: (609)964-3291. E-mail: omniplex@erols. .com. Website: http://www.omniplex413.com. President: Michael Nise. Estab. 1995. Produces albums, CDs, CD-ROMs, cassettes: classical, country, folk, gospel, jazz, pop, progressive, R&B, rap, rock, soul. Recent releases: *Created the Destroyer*, by various artists (dramatized book on tape).

Needs: Prefers designers who own Macs. Uses freelancers for album cover design and illustrations; animation; cassette cover design and illustration; CD booklet design and illustration; CD cover design and illustration; CD-ROM design and packaging; poster design; Web page design. Also for multimedia and brochures. 100% of freelance work demands knowledge of Aldus PageMaker 6.5, QuarkXPress 4.0, Adobe Photoshop 4.0.
First Contact & Terms: Send query letter with brochure, résumé, photocopies, photographs, SASE, tearsheets. Accepts Mac-compatible disk submissions. Samples are returned by SASE. Will contact for portfolio review of b&w, color, final art, photocopies, photographs, photostats, roughs, slides, tearsheets if interested. Pays by the project. Buys all rights. Finds artists through referrals and portfolios.
Tips: "Be willing to be flexible to gain credits and contacts."

‡ONEPLUS DESIGNS, 215 Chestnut Lake, Lake Jackson TX 77566. (409)297-5646. Fax: (409)297-5646. E-mail: aggravat@yahoo.com. Website: http://www.aggravated.com. Contact: John Hernandez. Estab. 1995. Produces CDs, cassettes: R&B and rap by solo artists and groups. Recent releases: "Aggravated State of Mind," and "Accept," by Agravated.
Needs: Produces 4 releases/year. Works with 2 freelancers/year. Works only with artist reps. Uses freelancers for album cover design and illustration; cassette cover design and illustration; CD booklet design and illustration; CD cover design and illustration; poster design. 100% of freelance work demands knowledge of QuarkXPress 4, Adobe Photoshop 4.
First Contact & Terms: Send query letter brochure, résumé. Accepts disk subissions. Send EPS files. Samples are filed. Reports back within 1 month. Will contact artist for portfolio review of b&w, color, final art. Pays by the hour. Buys first rights. Finds artists through World Wide Web.

‡OREGON CATHOLIC PRESS, 5536 NE Hassalo, Portland OR 97230. (503)281-1191. Fax: (503)282-3486. E-mail: jeang@ocp.org. Website: http://www.ocp.org/. Art Director: Jean Germano. Estab. 1934. Produces liturgical music CDs, cassettes, songbooks, missalettes books. Recent releases: *Ubi Caritas*, by Bob Hord; *Celtic Mass*, by Christopher Walker.
Needs: Produces 10 collections/year. Works with 5 freelancers/year. Uses freelancers for cassette cover design and illustration; CD booklet illustration; CD cover design and illustration. Also for spot illustration.
First Contact & Terms: Send query letter with brochure, transparencies, photocopies, photographs, slides, tearsheets and SASE. Samples are filed or returned by SASE. Reports back within 2 weeks. Will contact artist for portfolio review if interested. Pays for illustration by the project, $35-500. Finds artists through submissions and the Web.
Tips: Looks for attention to detail.

‡ORINDA RECORDS, P.O. Box 838, Orinda CA 94563. (510)441-1300. A&R Director: H. Balk. Produces CDs and tapes: jazz, pop, classical by solo artists and groups.
Needs: Works with 6 visual artists/year. Works on assignment only. Uses artists for CD cover design and illustration; tape cover design and illustration.
First Contact & Terms: Send postcard sample or query letter with photocopies. Samples are filed and are not returned. Reports back to the artist only if interested. Write for appointment to show portfolio of b&w and color photographs. Pays for design by the project. Rights purchased vary according to project.

‡PARALLAX RECORDS, 14110 N. Dallas Pkwy., Suite 130, Dallas TX 75240. (972)726-9203. Fax: (972)726-7749. E-mail: parallax@airmail.net. Website: http://parallaxrecords.com. Art Director: Jason Abbott. Estab. 1995. Produces albums, CDs, cassettes: pop, R&B, rap, rock. by solo artists and groups. Recent releases: *Pawn Shop from Heaven*, by Junky Southern; *Hellafied Funk Crew*, by Hellafied Funk Crew.
Needs: Produces 2-3 releases/year. Works with 3 freelancers/year. Uses freelancers for album cover design and illustration; cassette cover design and illustration; CD booklet design and illustration; CD cover design and illustration; poster design. 75% of freelance work demands knowledge of Aldus PageMaker, Adobe Illustrator, QuarkXPress, Adobe Photoshop, Aldus FreeHand, Corel 7-8.
First Contact & Terms: Send query letter with brochure, résumé, photographs, tearsheets. Samples are filed. Portfolios may be dropped off every Tuesday. Will contact artist for portfolio review of final art, photocopies and photographs if interested. Pays for design by the project, $200-2,500. Pays for illustration by the hour. Buys all rights.

‡PPI ENTERTAINMENT GROUP, 88 St. Francis St., Newark NJ 07105. (201)344-4214. Creative Director: Dave Hummer. Estab. 1923. Produces CDs and tapes: rock and roll, dance, soul, pop, educational, rhythm and blues; aerobics and self-help videos; group and solo artists. Also produces children's books, cassettes and CD-ROMs. Recent releases: *The Method," by Denise Austin.*
Needs: Produces 200 records and videos/year. Works with 10-15 freelance designers/year and 10-15 freelance illustrators/year. Uses artists for album cover design and illustration; brochure, catalog and advertising design, illustration and layout; direct mail packages; posters; and packaging.
First Contact & Terms: Works on assignment only. Send query letter with samples to be kept on file; call or write for appointment to show portfolio. Prefers photocopies or tearsheets as samples. Samples not filed are returned only if requested. Reports only if interested. Original artwork returned to artist. Pays by the project. Considers complexity of project and turnaround time when establishing payment. Purchases all rights.

‡PPL ENTERTAINMENT GROUP, P.O. Box 8442, Universal City CA 91618. (818)506-8533. Fax: (818)506-8534. E-mail: pplzmi@aol.com. Website: http://www.pplzmi. Art Director: Kaitland Diamond. Estab. 1979. Produces albums,

CDs, cassettes: country, pop, R&B, rap, rock and soul by solo artists and groups. Recent releases: "Shake Down," The Band AKA; "Change of Heart," by Jay Sattiewhite.

Needs: Produces 12 releases/year. Works with 2 freelancers/year. Prefers designers who own Mac or IBM computers. Uses freelancers for album cover design and illustration; cassette cover design and illustration; CD booklet design and illustration; CD cover design and illustration; CD-ROM design and packaging; poster design; Web page design. Freelance work demands knowledge of Aldus PageMaker, Adobe Illustrator, Adobe Photoshop.

First Contact & Terms: Send query letter with brochure, photocopies, tearsheets, résumé, photographs, photostats, slides, transparencies and SASE. Accepts disk submissions. Samples are filed or returned by SASE if requested by artist. Reports back within 2 months. Request portfolio review in original query. Pays by the project, monthly.

‡QUALITY RECORDS, 15260 Ventura Blvd., Suite 980, Sherman Oaks CA 91403. (818)905-9250. Fax: (818)905-7533. Director of Creative Services: Sarajane Smith. Estab. 1990. Produces CDs and tapes: rock & roll, R&B, pop and rap; solo and group artists. Recent releases: *Jointz From Back in da Day Vol. 2*, *Dance Mix USA*, Vol. 7. and *ZIN Only*, by Jonny 2.

Needs: Produces 5 soloists and 3 groups/year. Works with 3-5 visual artists/year. Uses artists for CD cover, tape cover and advertising design and illustration and posters. 90% of freelance work demands knowledge of Adobe Illustrator and Adobe Photoshop.

First Contact & Terms: Send query letter with brochure, tearsheets and photographs. Samples are filed or returned by SASE if requested. Does not report back, in which case the artist should call. Call for appointment to show portfolio, which should include final art and b&w and color tearsheets and photographs. Pays by the project. Buys all rights.

R.E.F. RECORDING CO./FRICK MUSIC PUBLISHING CO., 404 Bluegrass Ave., Madison TN 37115. (615)865-6380. Contact: Bob Frick. Produces CDs and tapes: country/western and gospel. Recent releases: *I Found Jesus in Nashville*, by Bob Scott Frick; and *He Sat Where You Sit*, by Teresa Ford.

Needs: Produces 30 records/year. Works with 10 freelancers/year on assignment only.

First Contact & Terms: Send résumé and photocopies to be kept on file. Write for appointment to show portfolio. Samples not filed and returned by SASE. Reports within 10 days only if interested.

‡*RED-EYE RECORDS, Wern Fawr Farm, Pencoed CF3 56NB Wales. 01656 860041. Managing Director: Mike Blanche. Estab. 1980. Produces albums, CDs, cassettes: gospel, pop, progressive, R&B, rock, soul by solo artists, groups. Recent releases: *Time is Ticking*, by Cadillacs; *Night Thoughts*, by Cadillacs.

Needs: Produces 3-4 releases/year.

First Contact & Terms: Send query letter with photocopies. Reports back to the artist on if interested.

‡REGO IRISH RECORDS & TAPES, INC., 64 New Hyde Park Rd., Garden City NY 11530. (516)328-7800. Fax: (516)354-7768. E-mail: kellmus@pipeline.com. Website: http://www.regorecords.com. Managing Director: Thomas Horan. Estab. 1969. Produces CDs, cassettes: Celtic.

Needs: Produces 12 releases/year. Works with 2 freelancers/year. Prefers local designers. Uses freelancers for cassette cover design; CD booklet and cover design and illustration; poster design. 100% of illustration demands computer skills.

First Contact & Terms: Send query letter with brochure, résumé, tearsheets. Samples are filed. Will contact artist for portfolio review of final art, tearsheets and transparencies. Pays by the project, $2,500 maximum. Buys all rights.

RHYTHMS PRODUCTIONS/TOM THUMB MUSIC, Box 34485, Los Angeles CA 90034-0485. President: R.S. White. Estab. 1955. Produces CDs, cassettes of children's music.

Needs: Works on assignment only. Works with 3-4 freelance artists/year. Prefers Los Angeles artists who have experience in advertising, catalog development and cover illustration/design. Uses freelance artists for album, cassette and CD cover design and illustration; animation; CD booklet design and illustration; CD-ROM packaging. Also for catalog development. 95% of design and 50% of illustration demand knowledge of QuarkXPress and Adobe Photoshop.

First Contact & Terms: Send query letter photocopies and SASE. Samples are filed or are returned by SASE if requested. Reports within 1 month. "We do not review portfolios unless we have seen photocopies we like." Pays by the project. Buys all rights. Finds artists through submissions and recommendations.

Tips: "We like illustration that is suitable for children. We find that cartoonists have the look we prefer. However, we also like art that is finer and that reflects a 'quality look' for some of our more classical publications. Our albums are for children, and are usually educational. We don't use any violent or extreme art which is complex and distorted."

ROCK DOG RECORDS, P.O. Box 3687, Hollywood CA 90028-9998. (213)661-0259. E-mail: rockdogrec@aol.com. Website: http://members.aol.com/empathcd/web/index.htm. President, A&R and Promotion: Gerry North. Estab. 1987. Produces CDs and tapes: rock, R&B, dance, New Age, contemporary instrumental, ambient and music for film, TV and video productions. Recent releases: *Variations on a Dream*, by Brainstorm; *Circadian Breath*, by Elijah; and *Abduction*, by Empath.

• This company has a second location at P.O. Box 884, Syosset, NY 11791-0899. (516)544-9596. Fax: (516)364-1998. E-mail: rockdogrec@aol.com. A&R, Promotion and distribution: Maria Cuccia.

Needs: Produces 2-3 solo artists and 2-3 groups/year. Approached by 50 designers and 200 illustrators/year. Works with 5-6 designers and 25 illustrators/year. Prefers freelancers with experience in album art. Uses artists for CD album/

tape cover design and illustration, direct mail packages, multimedia projects, ad design and posters. 95% of design and 75% of illustration demand knowledge of Print Shop or Adobe Photoshop.

First Contact & Terms: Send postcard sample or query letter with photographs, SASE and photocopies. Accepts disk submissions compatible with Windows '95. Send Bitmap, TIFF, GIF or JPG files. Samples are filed or are returned by SASE. Reports back within 2 weeks. To show portfolio, mail photocopies. Sometimes requests work on spec before assigning a job. Pays for design by the project, $50-500. Pays for illustration by the project, $50-500. Interested in buying second rights (reprint rights) to previously published work. Finds new artists through submissions from artists who use *Artist's & Graphic Designer's Market.*

Tips: "Be open to suggestions; follow directions. Don't send us pictures, drawings (etc.) of people playing an instrument. Usually we are looking for something abstract or conceptual. We look for prints that we can license for limited use."

ROWENA RECORDS & TAPES, 195 S. 26th St., San Jose CA 95116. (408)286-9840. Owner: Jeannine O'Neal. Estab. 1967. Produces CDs, tapes and albums: rock, rhythm and blues, country/western, soul, rap, pop and New Age; by groups. Recent releases: *I Know That I Know*, by Jeannine O'Neal (contemporary Christian); *Palomite Triste*, by Jaque Lynn (Mexican music); and *Visions of Chance*, by Sharon Roni Greer (hi-energy contemporary pop).

Needs: Produces 20 solo artists and 5 groups/year. Uses freelancers for CD/album/tape cover design and illustration and posters.

First Contact & Terms: Send query letter with brochure, résumé, SASE, tearsheets, photographs, photocopies and photostats. Samples are filed or are returned by SASE. Reports back within 1 month. To show a portfolio, mail original/ final art. "Artist should submit prices."

RRRECORDS, 23 Central St., Lowell MA 01852. (508)454-8002. Contact: Ron. Estab. 1984. Produces CDs, tapes and albums: experimental, electronic and avant-garde.

Needs: Produces 30-40 releases/year. Uses 5-6 artists/year for CD and album/tape cover design and illustration; and CD booklet design and illustration.

First Contact & Terms: Send query letter with résumé, SASE and appropriate samples. Samples are filed. Reports back only if interested. To show a portfolio, mail thumbnails, roughs, final art and b&w and color photostats. Pays by the project, negotiable. Buys first rights.

‡SAHARA RECORDS AND FILMWORKS ENTERTAINMENT, 4475 Allisonville Rd., 8th Floor, Indianapolis IN 46205-2466. (317)546-2912. Fax: (317)546-2912. Marketing Director: Dwayne Woolridge. Estab. 1981. Produces CDs, cassettes: jazz, pop, R&B, rap, rock, soul, TV-film music by solo artists and groups. Recent releases: "Moments," by Steve Lynn and "Games," by D'von Edwards.

Needs: Produces 10 releases/year. Works with 2 illustrators and 2 designers/year. Prefers freelancers with experience in pop/rock art, commercial ad designs and layouts. Uses freelancers for album cover design and illustration; cassette cover design and illustration; CD booklet design and illustration; CD cover design and illustration; poster design. 50% of freelance work demands knowledge of Aldus PageMaker, Adobe Illustrator, QuarkXPress, Adobe Photoshop, Aldus FreeHand.

First Contact & Terms: Send postcard sample of work. Samples are filed and not returned. Reports back to the artist only if interested. Will contact for portfolio review of b&w, color, final art, photocopies, photographs. Pays for design and illustration by the project, $500-2,500. Buys all rights. Finds artists through word of mouth and sourcebooks.

***SCOTDISC B.G.S. PRODUCTIONS LTD.**, Newtown St., Kilsyth, Glasgow G65 0JX Scotland. 01236-821081. E-mail: nscott@scotdisc.co.uk. Website: http://www.scotdisc.co.uk. Director: Dougie Stevenson. Produces rock and roll, country, jazz and folk; solo artists. Recent releases: *The Big Country Line Dance Party*, by Sydney Devine; *Tommy Scott's Street Party* by Tommy Scott.

Needs: Produces 15-20 records/videos per year. Approached by 3 designers and 2 illustrators/year. Works with 1 designer and 2 illustrators/year for album cover design and illustration; brochure design, illustration and layout; catalog design, illustration and layout; advertising design, illustration and layout; posters.

First Contact & Terms: Send postcard sample or brochure, résumé, photocopies and photographs to be kept on file. Call or write for appointment to show portfolio. Accepts disk submissions compatible with Adobe Illustrator 3.2 or Aldus FreeHand 3.0. Send Mac formatted EPS files. Samples not filed are returned only if requested. Reports only if interested. Pays by the hour, $20 average. Considers available budget when establishing payment. Buys all rights.

‡SCRUTCHINGS MUSIC, 429 Homestead St., Akron OH 44306. (330)773-8529 or (330)724-6940. Owner/President: Walter Scrutchings. Estab. 1980. Produces CDs, tapes and albums: gospel music (black). Recent releases: *He Keeps Blessing Me*, by The Arch Angel Concert Choir; *You're Worthy of All The Praise*, by Elvin Dent Jr. and the United Voices; and *Just Call on Jesus*, by Walter Scrutchings and Company.

Needs: Produces 2-5 solo artists and 2-5 groups/year. Works with 2-3 freelancers/year. Prefers freelancers with experience in jacket and cover design. Works on assignment only. Uses artists for CD/album/tape cover and brochure design, direct mail packages and posters.

First Contact & Terms: Send query letter with résumé. Samples are filed or are returned by SASE if requested by artist. Reports back only if interested. To show portfolio, mail b&w and color photographs. Pays by the project, $200-2,000. Buys all rights.

†SELECT RECORDS, 16 W. 22nd St., 10th Floor, New York NY 10010. (212)691-1200. Fax: (212)691-3375. Art Director: Ian Thornell. Produces CDs, tapes, 12-inch singles and marketing products: rock, R&B, rap and comedy solo artists and groups. Recent releases: *Jerky Boys II*, by Jerky Boys; and *To the Death*, by M.O.P.

Needs: Produces 6-10 releases/year. Works with 6-8 freelancers/year. Prefers local freelancers with experience in computer (Mac). Uses freelancers for CD/tape cover design and illustration, brochure design, posters. 70-80% of freelance work demands knowledge of Adobe Illustrator, QuarkXPress, Adobe Photoshop and Aldus FreeHand.

First Contact & Terms: Send postcard sample of work or query letter with photostats, transparencies, slides and tearsheets. Samples are not filed or returned. Portfolios may be dropped off Monday-Friday. Art Director will contact artist for portfolio review if interested. Portfolio should include slides, transparencies, final art and photostats. Payment depends on project and need. Rights purchased vary according to project. Finds artists through submissions, *Black Book*, agents.

Tips: Impressed by "good creative work that shows you take chances; clean presentation."

‡SHAOLIN COMMUNICATIONS, P.O. Box 900457, San Diego CA 92190. Phone/fax: (801)595-1123. E-mail: taichiyouth@worldnet.att.net. Vice President of A&R: Don DeLaVega. Estab. 1984. Produces albums, CDs, CD-ROMs, cassettes, books and videos: folk, pop, progressive, rock, Chinese meditation music by solo artists and groups. Recent releases: *Level 1*, by American Zen; *Tai Chi Magic*, by Master Zhen.

Needs: Produces 14 releases/year. Works with 4 freelancers/year. Prefers local freelancers who own Macs. Uses freelancers for album cover design and illustration; animation; cassette cover design and illustration; CD booklet design and illustration; CD cover design and illustration; CD-ROM design and packaging; poster design; Web page design. Also for multimedia, brochures and newsletter: *Shaolin Zen* . 80% of design and 20% of illustration demands knowledge of QuarkXPress, Adobe Photoshop.

First Contact & Terms: Send query letter with brochure, résumé, SASE. Samples are filed or returned by SASE if requested by artist. Reports back within 6 weeks if interested. Will contact for portfolio review if interested. Pays for design and illustration by the hour, $15-25; by the project, $250-500. Buys all rights. Finds artists through submissions and social contacts.

Tips: "Find projects to do for friends, family . . . to build your portfolio and experience. A good designer must have some illustration ability and a good illustrator needs to have design awareness—so usually our designer is creating a lot of artwork short of a photograph or piece of cover art."

‡SILENT RECORDS/PULSE SONIQ DISTRIBUTION, 340 Bryant St., 3rd Floor E., San Francisco CA 94107. (415)957-1320. Fax: (415)957-0779. E-mail: silent@sirius.com. Website: http://www.silent.org. A&R: Matt Valenzuela. Estab. 1987. Produces albums, CDs and 12″ singles: rap, electronica, trip hop, techno, house, drum & bass. Recent releases: *Confessions of a Selector* by Tim 'Love' Lee and *Big Shots* by various artists.

Needs: Produces 20 releases/year. Works with 10-12 freelancers/year. Prefers local designers who own Mac computers and have experience in Photoshop, Quark and photography. Uses freelancers for album cover design and illustration, CD booklet design and illustration, CD cover design and illustration, poster design, advertising and catalog design. 100% of design and illustration demands knowledge of Adobe Illustrator, Quark XPress and Adobe Photoshop.

First Contact & Terms: Send query letter with résumé, photocopies and photographs. Accepts Mac-compatible disk submissions. Send EPS files. Samples are filed. Reports back in 1 week. Portfolio of color final art may be dropped off every Wednesday. Artist should follow up with call. Pay depends on project and budget. Rights purchased vary according to project.

Tips: "Try and do work for a label, even if it's on a donation basis." Looks for ″talent, minimalism, individuality."

‡SILVER WAVE RECORDS, 2475 Broadway, Suite 300, Boulder CO 80304. (303)443-5617. Fax: (303)443-0877. E-mail: valerie@silverwave.com. Website: http://www.silverwave.com. Art Director: Valerie Sanford. Estab. 1986. Produces CDs, cassettes: Native American and World by solo artists and groups. Recent releases: *The Offering*, by Mary Youngblood; *Matriarch*, by Joanne Shenandoah.

Needs: Produces 4 releases/year. Works with 6 freelancers/year. Prefers local designers. Illustrators need not be local. Uses illustrators for CD booklet and cover illustration. 100% of freelance design demands knowledge of Adobe Illustrator, QuarkXPress, Adobe Photoshop.

First Contact & Terms: Send postcard sample or query letter with 2 or 3 samples. Samples are filed. Will contact for portfolio review if interested. Pays by the hour or by the project. Rights purchased vary according to project.

Tips: "Try to work with someone at first and get some good samples and experience. Many artists I've hired are local. Word of mouth is effective. I also look for artists at Native American 'trade shows'. I look at *Workbook* and other sourcebooks but haven't hired from there yet. We will call if we like work or need someone. We're a small company and I don't have enough man/woman power to receive lots of calls. We're a small company." When hiring freelance designers, looks for "level of professionalism, good design, do they understand technical, i.e. printers, separations etc." When hiring freelance illustrators, looks for style for a particular project."

JERRY SIMS RECORDS, Box 648, Woodacre CA 94973. (415)789-8322. Owner: Jerry Sims. Estab. 1984. Produces vinyl albums, CDs and cassettes: rock, R&B, classical, Celtic. Recent releases: *Viaggio* and *December Days*, by Coral; and *King of California*, by Chuck Vincent.

Needs: Produces 5-6 releases/year. Works with 2-3 freelancers/year. Prefers local artists who own Mac computers and

Personal contacts led graphic designer Susan Wasinger to this project illustrating the cover of the CD *Under the Green Corn Moon: Native American Lullabies*. Silver Wave Records representative Valerie Sanford says she has turned to Wasinger for three CD illustration projects because of her "graphic, playful style." Although she primarily concentrates on graphic design, "sometimes I shamelessly assign myself the illustration job on a project if I think I have the appropriate style," Wasinger says. "Apply your aesthetic everywhere," she advises, "gardening, wrapping presents, choosing your socks—watch for interaction of texture and color. Inspiration and education are everywhere your eyes are."

have experience in album cover art. Uses freelancers for album, cassette and CD cover design. 30% of design and 40% of illustration demand knowledge of QuarkXPress and Adobe Photoshop.

First Contact & Terms: Send postcard sample of work or query letter with brochure and résumé. Samples are filed. Art Director will contact artist for portfolio review if interested. Portfolio should include photocopies and roughs. Pays for design and illustration by the project. Rights purchased vary according to project. Finds artists through submissions, word of mouth.

Tips: "Try to develop local clientele as well as clients out of your area."

SIRE RECORDS GROUP, (formerly Discovery Records), 2034 Broadway, Santa Monica CA 90404. (310)828-1033. Fax: (310)828-1584. Art Director: John Ayers. Produces CDs: jazz, pop, progressive, R&B and rock by solo artists and groups.

Needs: Prefers local designers and illustrators who own Mac computers with experience in traditional/electronic art. Uses freelancers for CD booklet and cover design, poster and World Wide Web page design. 100% of design and 50%

of illustration demand knowledge of Adobe Illustrator, QuarkXPress and Adobe Photoshop.

First Contact & Terms: Send postcard sample and/or query letter with brochure. Accepts disk submissions compatible with Mac. Samples are filed. Reports back to artist only if interested. Will contact for portfolio review if interested. Rights purchased vary according to project. Finds artists through submissions, *Creative Illustration*, *Black Book*, *Workbook*, magazines, World Wide Web and artists' reps.

‡**SOLITUDES**, 1131A Leslie St, Suite 500, Toronto, Ontario M3C 318 Canada. (416)510-2800. Fax: (416)510-3070. E-mail: solitudes@solitudes.com. Website: http://www.solitudes.com. Art Director: Elliot Lahman. Estab. 1994. Produces CDs, cassettes and enhanced CDs: classical, country, folk, jazz, New Age by solo artists and groups. Recent releases: "The Elegance of Pachelbel," by Michael Maxwell; "Natural Stress Relief," by David Bradstreet.

Needs: Produces 30 releases/year. Works with 5 freelancers/year. Prefers local freelancers who own Mac computers with experience in illustration and photography. Uses freelancers for album cover and cassette illustration; CD booklet design; web page design. 80% of design demands knowledge of Adobe Illustrator, QuarkXPress, Adobe Photoshop.

First Contact & Terms: Send query letter with résumé, transparencies, photographs. Accepts Mac-compatible disk submissions. Samples are filed or returned. Reports back to the artist only if interested. Art Director will contact artist for portfolio review of final art, photocopies, photographs, roughs, transparencies. Pays for design and illustration by the project. Negotiates rights purchased. Finds artists through word of mouth; other designers may refer.

‡**SUGAR BEATS ENTERTAINMENT**, 301 E. 64th St., Suite 4D, New York NY 10021. (212)737-5737. Fax: (212)535-0741. Website: http://www.sugar-beats. com. Vice President Marketing: Bonnie Gallanter. Estab. 1993. Produces CDs, cassettes: children's music by groups. Recent releases: "Back to the Beat" and "Everybody is a Star," by Sugar Beats.

Needs: Produces 1 release/year. Works with 1-2 freelancers/year. Prefers local freelancers who own Macs with experience in QuarkXPress, Photoshop, Adobe Illustrator and web graphics. Uses freelancers for album cover design; cassette cover design and illustration; CD booklet design and illustration; CD cover design and illustration; poster design; Web page design. Also for ads, sell sheets and postcards. 100% of freelance design demands knowledge of Adobe Illustrator, QuarkXPress, Adobe Photoshop, Aldus FreeHand.

First Contact & Terms: Send postcard sample or query letter with brochure, tearsheets, résumé and photographs. Accepts Mac-compatible disk submissions. Will contact artist for portfolio review of b&w and color art. Pays by the project. Rights purchased vary according to project. Finds freelancers through referrals.

‡*****SWOOP RECORDS**, White House Farm, Shropshire, TF9 4HA United Kingdom. Phone: 01630-647374. Fax: 01630-647612. A&R International Manager: Xavier Lee. Estab. 1971. Produces albums, CDs, cassettes and video: classical, country, folk, gospel, jazz, pop, progressive, R&B, rap, rock, soul by solo artists and groups. Recent releases: "Latin," by Emmitt Till; "The Old Days," by Groucho.

Needs: Produces 40 releases/year. Works with 6 freelancers/year. Prefers album cover design and illustration; cassette cover design and illustration; CD booklet design and illustration; CD cover design and illustration; poster design.

First Contact & Terms: Send postcard sample of work with SASE. Samples are not filed and are returned by SASE. Reports back within 6 weeks. Payment negotiated. Buys all rights. Finds artists through submissions.

‡**T.B.S. RECORDS**, 611 N. Main St., Sweetwater TN 37874. (423)337-SONG. Fax: (423)337-7664. President of A&R: Thomas B. Santelli. Produces CDs, CD-ROMs, cassettes: country, folk, pop, R&B, rock, bluegrass. Recent releases: "Written in the Stars," by Tommy Santelli and "My Life," by Marc Santelli.

Needs: Produces 4 releases/year. Works with 6 freelancers/year. Prefers local designers and illustrators. Uses freelancers for album cover design and illustration; cassette cover design and illustration; CD booklet design and illustration; CD cover design and illustration; poster design. 100% of freelance work demands knowledge of Corel Draw and others.

First Contact & Terms: Send postcard sample of work. Samples are filed and are not returned. Reports back in 3 months. Will contact for portfolio review of b&w and color samples if interested. Pays by the project. Buys all rights. Finds artists through artists' reps.

‡**TANGENT RECORDS**, 1888 Century Park E., Suite 1900, Los Angeles CA 90067. (310)204-0388. Fax: (310)204-0995. E-mail: tangent@ix.netcom.com. President: Andrew J. Batchelor. Estab. 1986. Produces CDs, CD-ROMs, cassettes, videos: classical, gospel, jazz, pop, progressive, rock, electronic and New Age fusion. Recent releases: "Moments Edge," by Andrew Batchelor.

Needs: Produces 20 releases/year. Works with 5 freelancers/year. Prefers local illustrators and designers who own computers. Uses freelancers for album cover design and illustration; cassette design and illustration; CD booklet design and illustration; CD cover design and illustration; CD-ROM design and packaging; poster design; Web page design. Also for advertising and brochure design/illustration and multimedia projects. 70% of freelance work demands knowledge of Adobe Illustrator, QuarkXPress, Adobe Photoshop, Aldus FreeHand.

First Contact & Terms: Send postcard sample or query letter with brochure, photocopies, tearsheets, résumé, photographs. Accepts IBM-compatible disk submissions. Send JPG file on 3.5″ diskette. Samples are filed and not returned. Will contact artist for portfolio review of b&w, color, final art, photocopies, photographs, photostats, slides, tearsheets, thumbnails, transparencies if interested. Pays by the project. "Amount varies by the scope of the project." Negotiates rights purchased. Finds artists through College Art Programs and referrals.

Tips: Looks for creativity and innovation.

‡THUNDERDOG MUSIC, 315 E. 86th St., Suite 6FE, New York NY 10028. (212)534-8641. Fax: (212)534-0271. E-mail: thunderdog1@juno.com. Website: http://www.crownjewelsnyc.com. President: Steven Conte. Estab. 1995. Produces CDs: rock by groups. Recent release: "Spitshine," by Crown Jewel.
Needs: Produces 1 release/year. Works with 1-2 freelancers/year. Prefers local designers with experience in website design. Uses freelancers for album cover design; CD booklet design; poster design; web page design. 60% of freelance design demands knowledge of QuarkXPress or Adobe Photoshop.
First Contact & Terms: Send postcard sample or query letter with photocopies. Samples are filed. Reports back to the artist only if interested. Request portfolio review in original query. Portfolio should include b&w, color, photocopies. Pays by the project; negotiable. Negotiates rights purchased. Finds artists/designers through word of mouth.
Tips: "Work a lot and cheaply until you're known." Looks for "originality, excellence (technically), eye for beauty. . . ."

TOM THUMB MUSIC, (division of Rhythms Productions), Box 34485, Los Angeles CA 90034. President: Ruth White. Record and book publisher for children's market.
Needs: Works on assignment only. Prefers Los Angeles freelancers with cartooning talents and animation background. Uses freelancers for catalog cover and book illustration, direct mail brochures, layout, magazine ads, multimedia kits, paste-up and album design. Needs computer-literate freelancers for animation. Artists must have a style that appeals to children.
First Contact & Terms: Buys 3-4 designs/year. Send query letter with brochure showing art style or résumé, tearsheets and photocopies. Samples are filed or are returned by SASE. Reports back within 3 weeks. Pays by the project. Considers complexity of project, available budget and rights purchased when establishing payment. Buys all rights on a work-for-hire basis.
Tips: "You need to be up to date with technology and have a good understanding of how to prepare art projects that are compatible with printers' requirements."

‡TOPNOTCH® ENERTAINMENT CORP., Sanibel Island Rd., Box 1515, Sanibel FL 33957-1515. (941)982-1515. Fax: (941)472-5033. E-mail: wolanin@earthlink.net. President/CEO: Vincent M. Wolanin. Estab. 1973. Produces albums, CDs, CD-ROMs, tour merchandise, cassettes: pop, progressive, R&B, rock, soul by solo artists and groups. Recent releases: "Angry Room," by Lyndal's Burning and "Lingerie," by Natalia.
Needs: Produces 6-8 releases/year. Works with 3-6 freelancers/year. Prefers designers who own IBM computers. Uses freelancers for album cover design and illustration; animation; cassette cover deisgn and illustration; CD booklet design and illustration; CD cover design and illustration; CD-ROM design and packaging; poster design; web page design. Also for outside entertainment projects like Superbowl related events. 90% of design and illustration demands knowledge of Aldus PageMaker, Adobe Illustrator, QuarkXPress, Adobe Photoshop, Aldus FreeHand, Corel.
First Contact & Terms: Send query letter with brochure, résumé, photostats, transparencies, photocopies, photographs, slides, SASE, tearsheets. Accepts disk submissions compatible with IBM. Samples are filed. Does not report back. Artist should contact again in 4-6 months. Request portfolio review in original query. Artist should follow-up with letter after initial query. Portfolio should include color, final art, photographs, slides, tearsheets. Pays for design and illustration by the project. Buys all rights.
Tips: "We look for new ways, new ideas, eye catchers—let me taste the great wine right away. Create great work and be bold. Don't get discouraged."

‡TOUCHWOOD RECORDS, 1650 Broadway, Suite 1210, New York NY 10019. (212)977-7800. Fax: (212)977-7963. E-mail: tchwd@touchwood.com. Website: http://www.touchwood.com. Director Artist Development: John Stix. Estab. 1995. Produces albums, CDs and cassettes: jazz, pop, progressive, R&B, rap, rock, cabaret by solo artists. Recent releases: *The Erratics*, by The Errataics; *Love Is Good*, by Christine Andreas.
Needs: Produces 10-15 releases/year. Works with 5-10 freelancers/year. Uses freelancers for album cover design and illustration; cassette cover design and illustration; CD booklet design and illustration; CD cover design and illustration; web page design. Also for advertising. 95% of freelance design demands computer skills.
First Contact & Terms: Send query letter with brochure, résumé, photostats, photographs. Samples are filed. Will contact artist for portfolio review of b&w, color, final art, photographs if interested. Buys all rights. Finds artists through submissions, sourcebooks, web, artists' reps.
Tips: Being aware of trends and contemporary designs is of utmost importance in the music business. Looks for "imaginative and innovative concepts that are on the leading edge of current fashion."

‡TROPIKAL PRODUCTIONS/WORLD BEATNIK RECORDS, 516 Storrs, Rockwall TX 75087. Phone/fax: (972)771-3797. E-mail: tropikalproductions@juno.com. Website: http://www.rockwall.net/tropikal. Contact: Ana Towry. Estab. 1981. Produces albums, CDs, cassettes: gospel, jazz, pop, R&B, rap, rock, sould, and reggae/world. Recent releases: *Cool Runner*, by Watusi; *Playa*, Wave.
Needs: Produces 5-10 releases/year. Works with 5-10 freelancers/year. Prefers freelancers with experience in CD/album covers, animation and photography. Uses freelancers for album cover design and illustration; animation; cassette cover design and illustration; CD booklet design and illustration; CD cover design and illustration; poster design. 50% of freelance work demands knowledge of Adobe Illustrator, Adobe Photoshop.
First Contact & Terms: Send postcard or query letter with brochure, résumé, photostats, photocopies, photographs, tearsheets. Accepts Mac or IBM-compatible disk submissions. Send EPS files. Samples are filed or returned by SASE if requested by artist. Reports back within 15 days. Will contact for portfolio review of b&w, color, final art, photocopies,

photographs, roughs if interested. Pays by the project; negotiable. Rights purchased vary according to project; negotiable. Finds artists through referrals, submissions.
Tips: "Show versatility; create theme connection to music."

‡28 RECORDS, 19700 NW 86 Court, Miami FL 33015. (305)829-8142. Fax: (305)829-8142. E-mail: rec28@aol.com. President/CEO: Eric Diaz. Estab. 1994. Produces CDs: pop, rock, alternative, metal, punk by solo artists and groups. Recent releases: "Near Life Experience," by Eric Knight and *Julian Day*, by Hell Town's Infamous Vandal.
Needs: Produces 4 releases/year. Works with 2 freelancers/year. Prefers designers who own Macs. Uses freelancers for CD booklet design and illustration; CD cover design and illustration; poster design, web page design. 80% of freelance work demands knowledge of QuarkXPress, Adobe Photoshop.
First Contact & Terms: Send query letter with résumé, photocopies. Samples are filed and not returned. Reports back to the artist only if interested. Artist should follow-up with call and/or letter after initial query. Pays by the project, $300-700. Buys all rights. Finds artists through word of mouth.
Tips: "Get out there and sell yourself. Get multiple portfolios out there to everyone you can." Looks for cutting edge and original design.

‡TWILIGHT SOULS MUSIC, 264 S. La Cienega Blvd., Beverly Hills CA 90211. (213)656-1394. Director of Promotions: Michael Parker. Estab. 1992. Produces CDs and cassettes: pop, adult contemporary, inspirational and metaphysical by solo artists and groups. Recent release: Michael Poss.
Needs: Produces 1-2 releases/year. Works with 1-2 freelancers/year. Prefers local freelancers. Uses freelancers for cassette cover design and illustration; CD booklet design and illustration; CD cover design and illustration; poster design. 100% of design and 50% of illustration demands knowledge of Adobe Illustrator, Adobe Photoshop, Aldus FreeHand.
First Contact & Terms: Send postcard sample. Samples are filed and not returned. Will contact artist for portfolio review of b&w and color tearsheets and thumbnails. Pays for design by the hour; pays for illustration by the project. Buys all rights. Finds artists through music trade magazines.
Tips: "We are a new company on a shoe-string budget."

‡VALARIEN PRODUCTIONS, 16036 Temecula St., Pacific Palisades CA 90272. (310)454-2620. Fax: (310)454-2970. E-mail: valarien@gte.net. Owner: Eric Reyes. Estab. 1990. Produces CDs, cassettes: progressive, New Age, ambient, acoustic, film scores by solo artists. Recent releases: "In Paradise," by Valarien.
Needs: Produces 1-4 releases/year. Works with 1-2 freelancers/year. Prefers local freelancers who own Macs. Uses freelancers for album cover design and illustration; animation; cassette cover design and illustration; CD booklet design and illustration; CD cover design and illustration. Also for ads. 100% of freelance work demands knowledge of Adobe Illustrator, QuarkXPress.
First Contact & Terms: Send postcard sample of work. Samples are filed and not returned. Will contact artist for portfolio review of b&w, color, final art if interested. Pays by the project. Rights purchased vary according to project. Finds artists through word of mouth, submissions, sourcebooks.

‡VAN RICHTER RECORDS, 100 S. Sunrise Way, Suite 219, Palm Springs CA 92262. (760)320-5577. Fax: (760)320-4474. E-mail: vrichter@netcom.com. Website: http://vr.dv8.net. Label Manager: Paul Abramson. Estab. 1993. Produces CDs: rock, industrial. Recent releases: *MMMYAOOOO*, by Testify; *Nachtstran*, by Sielwole.
Needs: Produces 3-4 releases/year. Works with 2-3 freelancers/year. Prefers freelancers with experience in production design. Uses freelancers for CD booklet design and illustration; CD cover design and illustration; posters/pop. 100% of freelance work demands knowledge of Adobe Illustrator, QuarkXPress, Adobe Photoshop.
First Contact & Terms: Send postcard sample or query letter with brochure, tearsheets, photographs, print samples. Accepts Mac-compatible disk submissions. Samples are not filed and are returned by SASE if requested by artist. Will contact artist for portfolio review of final art if interested. Payment negotiable. Buys all rights. Finds artists through World Wide Web and submissions.
Tips: "You may have to work for free until you prove yourself/make a name."

‡VERVE RECORDS, 825 Eighth Ave., 26th Floor, New York NY 10019. (212)333-8150. Fax: (212)445-3472. E-mail: plie@earthlink.net. Website: http://www.verveinteractive.com. Creative Director: Patricia Lie. Produces albums, CDs: jazz, progressive by solo artists and groups. Recent releases: *New Standard*, by Herbie Hancock; *Readings*, by Jack Kerovac.
Needs: Produces 120 releases/year. Works with 20 freelancers/year. Prefers local designers with experience in CD cover design who own Macs. Uses freelancers for album cover design and illustration; CD booklet design and illustration; CD cover design and illustration. 100% of freelance design demands computer skills.
First Contact & Terms: Send postcard sample of work. Samples are filed or returned by SASE if requested by artist. Does not report back. Portfolios may be dropped off every Monday through Friday. Will contact artist for portfolio review if interested. Pays for design by the project, $1,500 minimum; pays for illustation by the project, $2,000 minimum. Buys all rights.

‡V2 RECORDS, 14 E. Fourth, Suite 3, New York NY 10012. (212)320-8588. Fax: (212)320-8600. E-mail: davidcalderley@v2music. Head of Design: David Calerley. Estab. 1996. Produces albums, CDs, cassettes: gospel, pop, progressive,

R&B, rap, rock, soul, hip hop and dance by solo artists and groups. Recent releases: "Pick, the Sickle and the Shovel," by Gravedigger. "Word Gets Around," by Stereophonics.
Needs: Produces 15 releases/year. Works with 3 freelancers/year. Prefers local designers with experience in music packaging and typography who own Macs. Uses freelancers for album cover design and illustration; CD booklet design and illustration; CD cover design and illustration and poster design. 100% of freelance design and 50% of illustration demands knowledge of Adobe Illustrator, QuarkXPress, Adobe Photoshop, Strata.
First Contact & Terms: Send postcard sample or query letter with brochure and tearsheets. Samples are returned by SASE if requested by artist. Reports back within 4 days if interested. Request portfolio review of photographs, roughs and tearsheets in original query. Pays for design by the project, $75-7,000; pays for illustration by the project, $200-2,000. Buys all rights. Finds artists through submissions, sourcebooks, magazines, Web, artists' reps.
Tips: "Some CD-ROMs are starting to appear as samples. It can be irritating to stop work to load in a portfolio. Show as near to what is final (i.e. real print) as possible—create own briefs if necessary. We look for originality, playfullness and confidence."

✔WARLOCK RECORDS, INC., 122 E. 25th St., 6th and 7th Floors, New York NY 10010. (212)673-2700. Fax: (212)673-2700. Art Director: Mark Pessoni. Estab. 1986. Produces CDs, tapes and albums: rhythm and blues, jazz, rap and dance. Recent releases: *I Need Your Lovin'*, by The Cover Girls; *Traffic Jams*, by DJ Skribble; and *The Other Side*, by The Outhere Brothers.
Needs: Produces 5 soloists and 12-15 groups/year. Approached by 30 designers and 75 illustrators/year. Works with 3 designers and 4 illustrators/year. Prefers artists with experience in record industry graphic art and design. Works on assignment only. Uses artists for CD and album/cassette cover design; posters; and advertising design. Seeking artists who both design and produce graphic art, to "take care of everything, including typesetting, stats, etc." 99% of freelance work demands knowledge of Adobe Illustrator 6.0, Quark XPress 4.0, Adobe Photoshop 4,0, Flight Check 3.2.
First Contact & Terms: Send query letter with brochure, résumé, photocopies and photostats. Samples are filed and are not returned. "I keep information on file for months." Reports back only if interested; as jobs come up. Call to schedule an appointment to show a portfolio, or drop off for a day or half-day. Portfolio should include photostats, slides and photographs. Pays for design by the project, $50-1,000; pays for illustration by the project, $50-1,000. Rights purchased vary according to project. Finds artists through submissions.
Tips: "Create better design than any you've ever seen and never miss a deadline—you'll be noticed. Specialize in excellence."

WARNER BROS. RECORDS, 3300 Warner Blvd., Burbank CA 91505. (818)953-3361. Fax: (818)953-3232. Art Dept. Assistant: Michelle Barish. Produces the artwork for CDs, tapes and sometimes albums: rock, jazz, hip hop, alternative, rap, R&B, soul, pop, folk, country/western by solo and group artists. Releases include: *This Fire*, by Paula Cole; and *Jagged Little Pill*, by Alanis Morrissette. Releases approximately 300 total packages/year.
Needs: Works with freelance art directors, designers, photographers and illustrators on assignment only. Uses freelancers for CD and album tape cover design and illustration; brochure design and illustration; catalog design, illustration and layout; advertising design and illustration; and posters. 100% of freelance work demands knowledge of QuarkXPress, Aldus FreeHand, Adobe Illustrator or Adobe Photoshop.
First Contact & Terms: Send query letter with brochure, tearsheets, résumé, slides and photographs. Samples are filed or are returned by SASE if requested by artist. Reports back to the artist only if interested. Submissions should include roughs, printed samples and b&w and color tearsheets, photographs, slides and transparencies. "Any of these are acceptable." Do not submit original artwork. Pays by the project.
Tips: "Send a portfolio—we tend to use artists or illustrators with distinct/stylized work—rarely do we call on the illustrators to render likenesses; more often we are looking for someone with a conceptual or humorous approach."

WATCHESGRO MUSIC, BMI—INTERSTATE 40 RECORDS, 9208 Spruce Mountain Way, Las Vegas NV 89134. (702)363-8506. President: Eddie Lee Carr. Estab. 1975. Produces CDs, tapes and albums: rock, country/western and country rock. Releases include: *What About Us*, by Scott Ellison; *Eldorado*, by Del Reeves; and *Yellow Elephant*, by Robert Forman.
 • Watchesgro Music has placed songs in two feature films, *Conair* starring Nicolas Cage and *Top of the World* starring Dennis Hopper.
Needs: Produces 8 solo artists/year. Works with 3 freelancers/year for CD/album/tape cover design and illustration; and videos.
First Contact & Terms: Send query letter with photographs. Samples are filed or are returned by SASE. Reports back within 1 week only if interested. To show portfolio, mail b&w samples. Pays by the project. Negotiates rights purchased.

‡WATERDOG/WHITEHOUSE/ABSOLUTE RECORDS, P.O. Box 18439, Chicago IL 60618. (773)421-7499. E-mail: wthouse@housedog.com. Website: http://www.housedog.com. Label Manager: Rob Gillis. Estab. 1991. Produces CDs: folk, pop, progressive, rock, spoken word by solo artists and groups. Recent releases: "Too Much Light Makes the Baby Go Blind," by The Neo-Futurists; "The Two-Meter Sessions," by The Bad Examples.
Needs: Produces 4-6 releases/year. Works with 2-3 freelancers/year. Prefers local freelancers with experience in CD design who own Macs. Uses freelancers for album cover design and illustration; CD booklet design and illustration; CD cover design and illustration; poster design. 100% of design and 50% of illustration demands knowledge of QuarkXPress.

First Contact & Terms: Send postcard sample or query letter with brochure, résumé. Samples are not filed. Portfolio review not required. Pays by the project. Buys all rights. Finds artists through referrals.

‡WIND-UP ENTERTAINMENT, 72 Madison Ave., 8th Floor, New York NY 10016. (212)251-9665. Fax: (212)251-0779. E-mail: mdroescher@wind-up.com. Website: http://www.wind-up.com. Creative Director: Mark Droescher. Estab. 1997. Produces CDs, cassettes, music videos and TV commercials: pop, R&B, rock by solo artists and groups. Recent releases: *My Own Prison,* by Creed; *You and I,* by Teddy Pendergrass.
Needs: Produces 8 releases/year. Works with 8-10 freelancers/year. Prefers local freelancers who own Macs. Uses freelancers for album cover design and illustration; cassette cover design and illustration; CD booklet design and illustration; CD cover design and illustration; poster design and web page design. 100% of design and 50% of illustration demands knowledge of QuarkXPress 3.3 or 4, Adobe Photoshop 4.
First Contact & Terms: Send query letter with brochure, résumé, photostats, transparencies, photocopies, photographs, slides, SASE, tearsheets. Accepts disk submissions compatible with Mac. Samples are filed or returned by SASE if requested by artist. Will contact artist for portfolio review if interested. Pays for design by the hour, $25-50. Finds artists through word of mouth, magazines, reps, directories.
Tips: "Work should be as personal as possible."

‡WORD ENTERTAINMENT INC., 3319 West End, Suite 200, Nashville TN 37203. (615)457-1077. Fax: (615)457-1099. E-mail: mlee@wordentertainment.com. Art Director: Beth Lee. Produces albums, CDs, CD-ROMs, cassettes, videotapes: classical, gospel, pop, progressive, R&B, rock by solo artists and groups. Recent releases: *Sixpence None the Richer,* by Sixpence None the Richer; *Am I Pretty?,* by Skypark.
Needs: Produces 80 releases/year. Works with lots of freelancers/year. Prefers designers who own Macs with experience in the music industry. Uses freelancers for album cover design and illustration; cassette cover design and illustration; CD booklet design and illustration; CD cover design and illustration. 100% of freelance design demands knowledge of QuarkXPress (current), Adobe Photoshop (current).
First Contact & Terms: Send postcard sample of work. Send query letter with appropriate samples. Samples are filed. Reports back to the artist only if interested. Will contact artist for portfolio review if interested. Pays by the project. Buys all rights. Finds artists through wide net of local artists and people who call us.
Tips: "I like current, not copycat, work. Be original. Keep trying, and pay attention. Appropriateness to our needs and goals, quality and freshness are important."

Resources
Artists' Reps

Many artists find leaving promotion to a rep allows them more time for the creative process. In exchange for actively promoting an artist's career, the representative receives a percentage of sales (usually 25-30%). Reps concentrate on either the commercial or fine art markets, rarely both. Very few reps handle designers.

Two types of reps

- **Fine art reps** promote the work of fine artists, sculptors, craftspeople and fine art photographers to galleries, museums, corporate art collectors, interior designers and art publishers.
- **Commercial reps** help illustrators obtain assignments from advertising agencies, publishers, magazines and other art buyers.

What reps do

- Work with you to bring your portfolio up-to-speed.
- Recommend advertising in one of the many creative directories such as *American Showcase* or *Creative Illustration* so that your work will be seen by hundreds of art directors. (Expect to make an initial investment in costs for duplicate portfolios and mailings).
- Negotiate contracts, handle billing and collect payments.

Getting representation isn't as easy as you might think. Reps are choosy about who they represent, not just in terms of talent, but in terms of marketability and professionalism. A rep will only take on talent she knows will sell.

WHAT TO SEND

Once you've narrowed down a few choices, contact them with a brief query letter and direct mail piece. If you do not have a flier or brochure, send photocopies or (duplicate) slides along with a self-addressed, stamped envelope. Check the listings for specific information.

The Society of Photographers and Artists Representatives (SPAR) is an organization for professional representatives. SPAR members are required to maintain certain standards and follow a code of ethics. For more information, write to SPAR, 60 E. 42nd St., Suite 1166, New York NY 10165, phone (212)779-7464.

‡**ADMINISTRATIVE ARTS, INC.**, P.O. Box 547935, Orlando FL 32854-1266. (407)849-9744. E-mail: mangoarts@worldnet.att.net. President: Brenda B. Harris. Fine art advisor. Estab. 1983. Registry includes 1,000+ fine artists (includes fine art crafts). Markets include: architects; corporate collections; developers; private collections; public art.
- This company develops and distributes software, Mango Arts Management System™, for artists, art organizations, consultants and advisors that focus on project and inventory management, marketing (for artists), presentation development and registry management. They analyze artistic growth, experience record and conduct an interview with the artist to determine the artist's professional management skills in order to advise artists on career growth.

Handles: Fine art. "We prefer artists with established regional and national credentials. We also review and encourage emerging talent."

Terms: "Trade discount requested varies from 15-50% depending on project and medium. "

How to Contact: "For first contact, submissions must include: 1) complete résumé; 2) artist's statement or brief

profile; 3) labeled slides (artist's name, title of work, date, medium, image size and *retail price*); 4) availability of works submitted."SASE. Reports in 1-4 weeks.

Tips: "Artists are generally referred by their business or art agent, another artist or art professional, educators, or art editors who know our firm. A good impression starts with a cover letter and a well organized, typed résumé. *Always place your name and slide identification on each slide.* Make sure that slides are good representations of your work. Know your retail and net pricing and the standard industry discounts. Invite the art professional to visit your studio. To get placements, be cooperative in getting art to the art professional when and where it's needed."

AIR STUDIO, INC., The Illustrators' Representative, 203 E. Seventh St., Cincinnati OH 45202. (513)721-1193. Fax: (513)721-1202. Website: http://www.airstudio.com. Illustrator's Rep.: Gregg Martini. Commercial illustration representative. Estab. 1982. Markets include: advertising agencies, corporations/client direct, design firms, editorial/magazines, publishing/books, packaging.
Handles: Illustration.
Terms: Rep receives 30% commission. Advertising costs are split: 70% paid by talent; 30% paid by representative. For promotional purposes, "talent must provide original art that we shoot to 4×5 transparencies and participate in yearly promotional book and website."
How to Contact: For first contact, send query letter. Reports back within 15 days. After initial contact, call to schedule an appointment for portfolio review. Portfolio should include original art, tearsheets, slides, photographs.
Tips: "I look for strong ethical guidelines, communication skills, work ethic and, above all, talent with a specific, recognizable style in work."

ANNE ALBRECHT AND ASSOCIATES, 405 N. Wabash, Suite 4410, Chicago IL 60611. E-mail: aaartagent@aol.com. Agent: Anne Albrecht. Commercial illustration, photography representative. Estab. 1991. Member of Chicago Artist Representatives. Represents 7 illustrators, 3 photographers. Markets include advertising agencies, corporations/client direct, design firms, editorial/magazines.
Handles: Illustration, photography.
Terms: Rep receives 25% commission. Exclusive area representation is required. For promotional purposes, talent must provide a presentation portfolio and advertise in a national sourcebook. Advertises in *American Showcase*, *The Workbook*.
How to Contact: For first contact, send direct mail flier/brochure, tearsheets. Reports back within 2 days. After initial contact, drop off or mail in appropriate materials. Portfolio should include tearsheets, slides, photographs.
Tips: Looks for artists who are "motivated, easy to work with, and have great and unique portfolios."

ALBRECHT & JENNINGS ART ENTERPRISES, 3546 Woodland Trail, Williamsburg MI 49690. (616)938-2163. E-mail: tctomkaren@aol.com. Contact: Tom Albrecht. Fine art representative. Estab. 1991. Represents 60 fine artists (includes 15 sculptors). Staff includes Tom Albrecht, Karen Jennings. Specializes in Michigan and Midwest art, especially by emerging artists. Markets include: corporate collections; private collections.
Handles: Fine art.
Terms: Agent receives 40% commission. Advertising costs are paid by representative. For promotional purposes, talent must provide slides and photographs of artwork, and up-to-date résumés.
How to Contact: For first contact, send query letter, résumé, bio, slides, photographs and SASE. Reports in 2 weeks. After initial contact, call for appointment to show portfolio of slides and photographs. Obtains talent "by referral from other artists, looking at galleries, and solicitation."

FRANCE ALINE ASSOCIATES, 1076 S. Ogden Dr., Los Angeles CA 90019. (213)933-2500. Fax: (213)933-2081. E-mail: francealine@aol.com. Owner: France Aline. Commercial illustration, photography and graphic design representative. Represents illustrators, photographers, designers. Specializes in advertising. Markets include: advertising, corporations, design firms, movie studios, record companies.
Handles: Illustration, photography.
Terms: Rep receives 25% commission. Exclusive area representation is required. Advertises in *American Showcase*, *The Workbook*.
How to Contact: For first contact, send tearsheets. Reports back within a few days. Mail in appropriate materials. Portfolio should include tearsheets, photographs.
Tips: "Send promotions. No fashion."

‡AMERICAN ARTISTS, REP. INC., 353 W. 53rd St., #1W, New York NY 10019. (212)582-0023. Fax: (212)582-0090. E-mail: amerart@aol.com. Commercial illustration representative. Estab. 1930. Member of SPAR. Represents 30 illustrators. Markets include: advertising agencies; corporations/client direct; design firms; editorial/magazines; paper products/greeting cards; publishing/books; sales/promotion firms.
Handles: Illustration, design.
Terms: Rep receives 30% commission. "All portfolio expenses billed to artist." Advertising costs are split: 70% paid by talent; 30% paid by representative. "Promotion is encouraged; portfolio must be presented in a professional manner—8×10, 4×5, tearsheets, etc." Advertises in *American Showcase*, *Black Book*, *RSVP*, *The Workbook*, medical and Graphic Artist Guild publications.
How to Contact: For first contact, send query letter, direct mail flier/brochure, tearsheets. Reports in 1 week if

interested. After initial contact, drop off or mail appropriate materials for review. Portfolio should include tearsheets, slides.

Tips: Obtains new talent through recommendations from others, solicitation, conferences.

JACK ARNOLD FINE ART, 5 E. 67th St., New York NY 10021. (212)249-7218. Fax: (212)249-7232. E-mail: jackald@mail.idt.net. Contact: Jack Arnold. Fine art representative. Estab. 1979. Represents 15 fine artists. Specializes in contemporary graphics and paintings. Markets include: galleries; museums; private collections; corporate collections.

Handles: Looking for contemporary impressionists and realists.

Terms: Agent receives 50% commission. Exclusive area representation preferred. No geographic restrictions. To be considered, talent must provide color prints or slides.

How to Contact: For first contact, send bio, photographs, retail prices and SASE. Reports in days. After initial contact, drop off or mail in portfolios of slides, photographs.

Tips: Obtains new talent through referrals.

THE ART AGENCY, 2405 N.W. Thurman St., Portland OR 97210. (503)203-8300. (503)203-8301. Owner/Representative: Cindy Lommasson. Commercial illustration, photography and graphic design representative. Estab. 1993. Member of the Society of Children's Book Writers and Illustrators. Represents 15 illustrators, 2 photographers and 1 designer. Markets include advertising agencies, design firms, editorial/magazines and publishing/books.

Handles: Illustration, photography and design. "Styles created digitally are a plus."

Terms: Agent receives 25% commission. Charges for postage, list purchase and direct mail. Requires exclusive area representation. Advertising costs are split; 75% paid by the talent, 25% paid by the representative. Artists must provide 2 compact (mailable) portfolios and one direct mail piece or photocopies to leave with clients. Advertises in *Creative Black Book*. For first contact, send bio, direct mail flier/brochure, tearsheets, photocopies and SASE. Reports back within 1 month if interested. Call to schedule an appointment to show portfolio of orignal art, tearsheets and photocopies.

Tips: "Artist must have a minimum of five years professional experience. I prefer artists who have been self-representing at least three years. Style must be unique and consistent. Must work well with a wide range of clients. Prefers artists living in (or planning to move to) the Pacific Northwest."

‡ART SOURCE L.A., INC., 11901 Santa Monica Blvd., Suite 555, Los Angeles CA 90025. (310)479-6649. Fax: (310)479-3400. E-mail: ellmanart@aol.com. Website: http://www.artsourcela.com. Contact: Francine Ellman. Fine art representative. Estab. 1980. Represents artists in all media in fine art and accessories. Specializes in fine art consulting and curating worldwide. Markets include: architects; corporate collections; developers; hospitality public space; interior designers; private collections and government projects.

Handles: Fine art in all media, including a broad array of accessories handmade by American artists.

Terms: Agent receives commission, amount varies. Exclusive area representation required in some cases. No geographic restrictions. "We request artists submit a minimum of 10 slides/visuals, résumé and SASE." Advertises in *Art News*, *Artscene*, *Art in America*, *Blue Book*, *Gallery Guide*, *Visions*, *Art Diary*, *Art & Auction*, *Guild*, and *Internet*.

How to Contact: For first contact, send résumé, bio, slides or photographs and SASE. Reports in 1-2 months. After initial contact, "we will call to schedule an appointment" to show portfolio of original art, slides, photographs. Obtains new talent through recommendations, artists' submissions and exhibitions.

Tips: "Be professional when submitting visuals. Remember—first impressions can be critical! Have a body of work that is consistent and of the highest quality. Work should be in excellent condition and already photographed for your records. Framing does not enhance the presentation to a dealer."

✔ARTISAN CREATIVE, INC., 1950 S. Sawtelle Blvd., Suite 320, Los Angeles CA 90025. (310)312-2062. Fax: (310)312-0670. E-mail: info@cre8art.com. Website: http://www.cre8art.com. Creative Recruiter: Christine Roth. Estab. 1996. Represents creative directors, art directors, graphic designers, illustrators, animators (3D and 2D), storyboarders, packaging designers, photographers, web designers, broadcast designers and multimedia designers. Markets include: advertising agencies, corporations/client direct, design firms, entertainment industry.

 • Artisan Creative has a second location at 850 Montgomery, Suite C-50, San Francisco CA 94133. (415)362-2699. Fax: (415)362-2698. Contact: Colleen Connery.

Handles: Illustration, photography, design, multimedia and production. Looking for web, traditional and multimedia-based graphic designers.

Terms: 100% of advertising costs paid by the representative. For promotional purposes, talent must provide 8½×11 color photocopies in a mini-portfolio and six samples scanned on disk. Advertises in magazines for the trade, direct mail and the internet.

How to Contact: For first contact, send résumé and samples. Call in to schedule a portfolio review. Portfolio should include roughs, tearsheets, photographs, or color photos of your best work.

Tips: "Have at least two years working experience and a great portfolio."

ARTISTS ASSOCIATES, 4416 La Jolla Dr., Bradenton FL 34210-3927. (941)756-8445. Fax: (941)727-8840. Contact: Bill Erlacher. Commercial illustration representative. Estab. 1964. Member of Society of Illustrators, Graphic Artists Guild, AIGA. Represents 11 illustrators. Markets include: advertising agencies; corporations/client direct; design firms; editorial/magazines; paper products/greeting cards; publishing/books; sales/promotion firms.

Handles: Illustration, fine art, design.

Terms: Rep receives 25% commission. Advertises in *American Showcase*, *RSVP*, *The Workbook*, *Society of Illustrators Annual*.
How to Contact: For first contact, send direct mail flier/brochure.

‡**ARTISTS INTERNATIONAL**, 320 Bee Brook Rd., Washington CT 06777-1911. (860)868-1011. Fax: (860)868-1272. Contact: Michael Brodie. Commercial illustration representative. Estab. 1970. Represents 20 illustrators. Specializes in children's books. Markets include: advertising agencies; design firms; editorial/magazines; licensing.
Handles: Illustration.
Terms: Rep receives 30% commission. No geographic restrictions. Advertising costs are split: 70% paid by talent; 30% paid by representative. "We have our own full-color brochure, 24 pages, and featured in *Picture Book '97*."
How to Contact: For first contact, send slides, photocopies and SASE. Reports in 1 week.
Tips: Obtains new talent through recommendations from others, solicitation, conferences, *Literary Market Place*, etc. "SAE with example of your work; no résumés please."

ARTREPS, 20929 Ventura Blvd., Suite 47, Woodland Hills CA 91364. (818)992-4278. Fax: (818)992-6040. Art Director: Phoebe Batoni. Fine art representative. Estab. 1993. Represents fine artists. Specializes in getting artists published. Markets include: art publishers; corporate collections; galleries; interior decorators.
Handles: Fine art.
Terms: Handled on a individual basis. For promotional purposes, talent must provide adequte materials.
How to Contact: For first contact, send query letter with résumé, bio, either direct mail flier/brochure, tearsheets, slides, photographs, photocopies or photostats and SASE. Reports in 10 days.
Tips: "Looks for high quality, universally appealing fine art presented in a professional manner."

ARTVISIONS, 12117 SE 26th St., Suite 202A, Bellevue WA 98005-4118. (425)746-2201. E-mail: neilm@artvisions.com. Owner: Neil Miller. Estab. 1993. Markets include publishers, manufacturers and others who may require fine art.
Handles: Fine art licensing.
Terms: Rep receives 40% for licenses. "We produce highly targeted direct marketing programs focused on opportunities to license art. Fees for promotional materials vary for each artist, but are strictly cost reimbursement for time and materials with no profit added." Requires exclusive world-wide representation for licensing (the artist is free to market his work via other means).
How to Contact: Send slides/photos/tearsheets/brochures via mail, with SASE for return. ALWAYS label your materials. "We cannot respond to inquiries that do not include examples of your art. We do not see drop-ins. Phone calls will only be returned if not busy with other work."
Tips: "We do not buy art, we are a licensing agent for artists.. We derive our income from commissions, so, if you don't make money, neither do we. We are very careful about selecting artists for our service. Our way of doing business is very labor intensive and each artist's market plan is unique. Be prepared to invest in yourself."

CAROL BANCROFT & FRIENDS, 121 Dodgingtown Rd., P.O. Box 266, Bethel CT 06801. (203)748-4823. Fax: (203)748-4581. Owner: Carol Bancroft. Illustration representative for children's publishing. Estab. 1972. Member of SPAR, Society of Illustrators, Graphic Artists Guild. Represents 40 illustrators. Specializes in illustration for children's publishing—text and trade; any children's-related material. Clients include Scholastic, Houghton Mifflin, Franklin Mint. Client list available upon request.
Handles: Illustration for children of all ages. Seeking multicultural and fine artists.
Terms: Rep receives 25-30% commission. Advertising costs are split: 75% paid by talent; 25% paid by representative. For promotional purposes, talent must provide "flat copy (not slides), tearsheets, promo pieces, good color photocopies, etc.; 6 pieces or more is best; narrative scenes and children interacting." Advertises in *RSVP*.
How to Contact: For contact, "call for information or send samples and SASE." Reports in 1 month.
Tips: "We're looking for artists who can draw animals and people well. They need to show characters in an engaging way with action in situational settings. Must be able to take a character through a story."

CECI BARTELS ASSOCIATES, 3286 Ivanhoe, St. Louis MO 63139. (314)781-7377. Fax: (314)781-8017. E-mail: ceciba@stinet.com. Contact: Ceci Bartels. Commercial illustration and photography representative. Estab. 1980. Member of SPAR, Graphic Artists Guild, ASMP. Represents 20 illustrators and 3 photographers. "My staff functions in sales, marketing and bookkeeping. There are 7 of us. We concentrate on advertising agencies and sales promotion." Markets include: advertising agencies; corporations/client direct; design firms; publishing/books; sales/promotion firms.
Handles: Illustration, photography. "Illustrators capable of action with a positive (often realistic) orientation interest us as well as conceptual styles."
Terms: Rep receives 30% commission. Advertising costs are paid by talent. "We welcome 6 portfolios/artist. Artist is advised not to produce multiple portfolios or promotional materials until brought on." Advertises in *American Showcase*, *The Workbook*.
How to Contact: For first contact, send query letter, direct mail flier/brochure, tearsheets, slides, SASE, portfolio with SASE or promotional materials. Reports if SASE enclosed. After initial contact, drop off or mail appropriate

materials for review. Portfolio should include tearsheets, slides, photographs, 4×5 transparencies. Obtains new talent through recommendations from others; "I watch the annuals and publications."

Tips: "We are interested in artists who are committed intellectually and financially to the advancement of their careers nationally."

BERENDSEN & ASSOCIATES, INC., 2233 Kemper Lane, Cincinnati OH 45206. (513)861-1400. Fax: (513)861-6420. Website: http://www.theispot.com. President: Bob Berendsen. Commercial illustration, photography, artists' representative. Incorporated 1986. Represents 25 illustrators, 1 photographer. Specializes in "high-visibility consumer accounts." Markets include: advertising agencies; corporations/client direct; design firms; editorial/magazines; paper products/greeting cards; publishing/books; sales/promotion firms. Clients include Disney, CNN, Pentagram, F&W Publications. Client list available upon request.

Handles: Illustration, photography. "We are always looking for illustrators who can draw people, product and action well. Also, we look for styles that are unique."

Terms: Rep receives 25% commission. Charges "mostly for postage but figures not available." No geographic restrictions. Advertising costs are split: 75% paid by talent; 25% paid by representative. For promotional purposes, "artist must co-op in our direct mail promotions, and sourcebooks are recommended. Portfolios are updated regularly." Advertises in *RSVP*, *Creative Illustration Book* and *American Showcase*.

How to Contact: For first contact, send query letter, résumé, and any nonreturnable tearsheets, slides, photographs or photocopies. Follow up with a phone call.

Tips: Artists should have a "proven style with at least ten samples of that style."

BERNSTEIN & ANDRIULLI INC., 60 E. 42nd St., New York NY 10165. (212)682-1490. Fax: (212)286-1890. Website: artinfo@ba-reps.com or photoinfo@ba-reps.com. Contact: Sam Bernstein. Commercial illustration and photography representative. Estab. 1975. Member of SPAR. Represents 54 illustrators, 16 photographers. Staff includes Anthony Andriulli; Howard Bernstein; Sam Bernstein; Gregg Lhotsky; Cleo Johnson; Melanie Spiegel; Molly Birenbaum; Ivy Glick; Fran Rosenfeld. Markets include: advertising agencies; corporations/client direct; design firms; editorial/magazines; paper products/greeting cards; publishing/books; sales/promotion firms.

Handles: Illustration and photography.

Terms: Rep receives a commission. Exclusive career representation is required. No geographic restrictions. Advertises in *American Showcase*, *Black Book*, *The Workbook*, *New York Gold*, *Bernstein & Andriulli International Illustration*, *CA Magazine*, *Archive*.

How to Contact: For first contact, send query letter, direct mail flier/brochure, tearsheets, slides, photographs, photocopies. Reports in 1 week. After initial contact, drop off or mail appropriate materials for review. Portfolio should include tearsheets, slides, photographs.

PEMA BROWNE LTD., HCR Box 104B, Pine Rd., Neversink NY 12765. (914)985-2936. Fax: (914)985-7635. Contact: Pema Browne or Perry Browne. Commercial illustration representative. Estab. 1966. Represents 10 illustrators. Specializes in general commercial. Markets include: all publishing areas; children's picture books; collector plates and dolls; advertising agencies. Clients include HarperCollins, Thomas Nelson, Bantam Doubleday Dell, Hyperion, Bradford Exchange. Client list available upon request.

Handles: Illustration. Looking for "professional and unique" talent.

Terms: Rep receives 30% commission. Exclusive area representation is required. For promotional purposes, talent must provide color mailers to distribute. Representative pays mailing costs on promotion mailings.

How to Contact: For first contact, send query letter, direct mail flier/brochure and SASE. If interested will ask to mail appropriate materials for review. Portfolios should include tearsheets and transparencies or good color photocopies, plus SASE. Obtains new talent through recommendations and interviews (portfolio review).

Tips: "We are doing more publishing—all types—less advertising." Looks for "continuity of illustration and dedication to work."

✓SID BUCK SVORA TECHNIQUES CORP., 481 Eighth Ave., New York NY 10001. (212)631-0009. Fax: (212)631-0715. E-mail: andi9@aol.com. President: Sid Buck. Commercial illustration representative. Estab. 1964. Markets include: advertising agencies; corporations/client direct; design firms; editorial/magazines; paper products/greeting cards; publishing/books; fashion.

Handles: Illustration, fashion.

Terms: Rep receives 25% commission. Exclusive area represention is required. Advertising costs are split: 75% paid by talent; 25% paid by representative. Advertises in *American Showcase*, *Black Book*, *The Workbook*.

How to Contact: For first contact, send photocopies, photostats. Reports in 1 week. After initial contact, call to schedule an appointment for portfolio review. Portfolio should include photostats, photocopies.

WOODY COLEMAN PRESENTS INC., 490 Rockside Rd., Cleveland OH 44131. (216)661-4222. Fax: (216)661-2879. E-mail: woody@portsort.com. Website: http://www.portsort.com. Contact: Woody. Creative services representative. Estab. 1978. Member of Graphic Artists Guild. Specializes in illustration. Markets include: advertising agencies; corporations/client direct; design firms; editorial/magazines; paper products/greeting cards; publishing/books; sales/promotion firms; public relations firms.

Handles: Illustration.

CECI BARTELS
ASSOCIATES

3286 Ivanhoe
St.Louis MO 63139

Telephone
314.781.7377

Facsimile
314.781.8017

Chicago
312.786.1560

New York
212.912.1877

debbie
PALEN

cecicba@stlnet.com

"Try to get your work seen by as many people as possible. Make self-promotion part of your job," says illustrator Debbie Palen, creator of these lovably contorted characters. Through Ceci Bartels Associates in St. Louis, Palen had this promotional piece created, which has "reached many more art directors than I could have reached without representation," Palen says. Bartels says the response to Palen's "hip and funky, engaging and dynamic" characters has been very positive. Advises Palen: "Don't take yourself too seriously."

Terms: Rep receives 25% commission. If chosen—will place free 12-image portfolio on Internet Database (see www.p-ortsort.com). For promotional purposes, talent must provide "all 12 or more image portfolios in 4 × 5 transparencies as well as 12 scans." Advertises in *American Showcase*, *Black Book*, *The Workbook*, other publications.
How to Contact: For first contact, send query letter, tearsheets, slides, SASE. Reports in 30 days, only if interested. Portfolio should include tearsheets, 4 × 5 transparencies.
Tips: "Solicitations are made directly to our agency. Concentrate on developing 12 specific examples of a single style exhibiting work aimed at a particular specialty, such as fantasy, realism, Americana or a particular industry such as food, medical, architecture, transportation, film, etc."

JAN COLLIER REPRESENTS, INC., P.O. Box 470818, San Francisco CA 94147. (415)383-9026. E-mail: jan@collierreps.com. Website: http://www.collierreps.com. Contact: Leah. Commercial illustration representative. Estab. 1978. Represents 15 illustrators. Markets include: advertising agencies; design firms and editorial.
Handles: Illustration.
Terms: Rep receives 25% commission. Exclusive area representation is required. Advertising costs are split: 75% paid by talent; 25% paid by representative. Advertises in *American Showcase*, *The Workbook*.
How to Contact: For first contact, send tearsheets, slides and SASE. Reports in 5 days, only if interested. After initial contact, call for appointment to show portfolio of slides.

CORNELL & MCCARTHY, LLC, 2-D Cross Hwy., Westport CT 06880. (203)454-4210. Fax: (203)454-4258. Contact: Merial Cornell. Children's book illustration representative. Estab. 1989. Member of SCBWI and Graphic Artists Guild. Represents 30 illustrators. Specializes in children's books: trade, mass market, educational.
Handles: Illustration.
Terms: Agent receives 25% commission. Advertising costs are split: 75% paid by talent; 25% paid by representative. For promotional purposes, talent must provide 10-12 strong portfolio pieces relating to children's publishing.
How to Contact: For first contact, send query letter, direct mail flier/brochure, tearsheets, photocopies and SASE. Reports in 1 month. After initial contact, call for appointment or drop off or mail appropriate materials for review. Portfolio should include original art, tearsheets, photocopies. Obtains new talent through recommendations, solicitation, conferences.
Tips: "Work hard on your portfolio."

✔CORPORATE ART PLANNING, 27 Union Square W., Suite 407, New York NY 10003. (212)242-8995. Fax: (212)242-9198. E-mail: virtual2ads@infohouse.com. Principal: Maureen McGovern. Fine art exhibitors, virtual entities. Estab. 1986. Represents 2 illustrators, 2 photographers, 5 fine artists (includes 1 sculptor). Guidelines available for #10 SASE. Markets include: advertising agencies; corporations/client direct; design firms; editorial/magazines; publishing/books; architects; art publishers; corporate collections; private collections.
Handles: Fine art only.
Terms: Consultant receives 15%. Advertising costs are split: 50% paid by talent; 50% paid by representative. For promotional purposes, prefers all artists have museum connections and professional portfolios. Advertises in *Creative Black Book*, *The Workbook*, *Art in America*.
How to Contact: Reports back in 15 days. After initial contact, write to schedule an appointment for portfolio review. Portfolio should include color photocopies only (non-returnable).

CREATIVE ARTS OF VENTURA, P.O. Box 684, Ventura CA 93002. Owners: Don and Lamia Ulrich. Representative not currently seeking new talent. Clients include Tempe Arts Center, Arizona; Beverly Hills Recreation Parks Dept.; U.S. Embassy in Panama/U.S. State Dept.
Tips: "High quality photographic imagery of artist's art form or product is most important. Lengthy résumés are of secondary value to us."

‡CREATIVE FREELANCERS MANAGEMENT, INC., 99 Park Ave., #210A, New York NY 10016. (800)398-9544. Fax: (203)532-2927. Website: http://www.freelancers.com. Contact: Marilyn Howard. Commercial illustration representative. Estab. 1988. Represents 30 illustrators. "Our staff members have art direction, art buying or illustration backgrounds." Specializes in children's books, advertising, architectural, conceptual. Markets include: advertising agencies; corporations/client direct; design firms; editorial/magazines; paper products/greeting cards; publishing/books; sales/promotion firms.
Handles: Illustration. Artists must have published work.
Terms: Rep receives 30% commission. Exclusive area representation is preferred. Advertising costs are split: 75% paid by talent; 25% paid by representative. For promotional purposes, talent must provide "printed pages to leave with clients. Co-op advertising with our firm could also provide this. Transparency portfolio preferred if we take you on but we are flexible." Advertises in *American Showcase*, *Workbook*.
How to Contact: For first contact, send tearsheets or "whatever best shows work." Reports back only if interested.
Tips: Looks for experience, professionalism and consistency of style. Obtains new talent through "word of mouth and website."

‡LINDA DE MORETA REPRESENTS, 1839 Ninth St., Alameda CA 94501. (510)769-1421. Fax: (510)521-1674. Contact: Linda de Moreta. Commercial illustration and photography representative; also portfolio and career consultant.

Estab. 1988. Represents 9 illustrators, 4 photographers. Markets include: advertising agencies; design firms; corporations/client direct; editorial/magazines; paper products/greeting cards; publishing/books; sales/promotion firms.

Handles: Illustration, lettering/title design, photography.

Terms: Rep receives 25% commission. Exclusive representation requirements vary. Advertising costs are according to individual agreements. Materials for promotional purposes vary with each artist. Advertises in *The Workbook*, *Black Book*, *The Creative Illustration Book*, *American Showcase*.

How to Contact: For first contact, send direct mail flier/brochure, tearsheets, slides, photocopies, photostats and SASE. "Please do *not* send original art. SASE for any items you wish returned." Responds to any inquiry in which there is an interest. Portfolios are individually developed for each artist and may include transparencies, prints or tearsheets.

Tips: Obtains new talent through client and artist referrals primarily, some solicitation. "I look for great creativity, a personal vision and style of illustration or photography combined with professionalism, maturity and a willingness to work hard."

DWYER & O'GRADY, INC., Mountain Rd., P.O. Box 239, East Lempster NH 03605. (603)863-9347. Fax: (603)863-9346. Contact: Elizabeth O'Grady. Agents for children's picture book artists and writers. Estab. 1990. Member of Society of Illustrators, SCBWI, ABA. Represents 22 illustrators and 12 writers. Staff includes Elizabeth O'Grady, Jeffrey Dwyer. Specializes in children's picture books (middle grade and young adult). Markets include: publishing/books.

Handles: Illustrators and writers of children's books. "Favor realistic and representational work for the older age picture book. Artist must have full command of the figure and facial expressions."

Terms: Receives 15% commission domestic, 20% foreign. Additional fees are negotiable. Exclusive representation is required (world rights). Advertising costs are paid by representative. For promotional purposes, talent must provide both color slides and prints of at least 20 sample illustrations depicting the figure with facial expression.

How to Contact: When making first contact, send query letter, slides, photographs and SASE. Reports in 1½ months. After initial contact, call for appointment and drop off or mail in appropriate materials for review. Portfolio should include slides, photographs.

FREELANCE ADVANCERS, INC., 420 Lexington Ave., Suite 2007, New York NY 10170. (212)661-0900. Fax: (212)661-1883. President: Gary Glauber. Commercial illustration, graphic design, freelance artist representative. Estab. 1987. Member of Society of Illustrators. Represents 150 illustrators, 250 designers. Specializes in freelance project work. Markets include: advertising agencies; corporations/client direct; design firms; editorial/magazines; publishing/books.

Handles: Illustration, design. Looks for artists with Macintosh software and multimedia expertise.

Terms: Rep receives 20% commission. 100% of advertising costs are paid by the representative. Advertises in *Art Direction*, *Adweek*.

How to Contact: For first contact, send query letter, résumé, tearsheets. Reports back within 1 week. After initial contact, call to schedule an appointment.

Tips: Looking for "talent, flexibility and reliability" in an artist. "Always learn, but realize you are good enough now."

‡FREELANCE HOTLINE, INC., 110 W. Grant St., Suite 29H, Minneapolis MN 55403. (612)341-4411. Fax: (612)341-0229. E-mail: frelancers@aol.com. Website: http://freelancehotline.com. Contact: Ben M. Rangel. Commercial illustration, graphic design, desktop, HTML Programmers, multimedia developers and keyline artists representative. Estab. Chicago 1987, Minneapolis 1992. Member of AIGA and the Greater Minneapolis Chamber of Commerce. Specializes in desktop and keyline artists, and HTML programmers and multimedia developers. Markets include: advertising agencies; corporations/client direct; design firms; sales/promotion firms.

Handles: Illustration, design, desktop publishing/graphic arts, HTML/multimedia. Artists should have "Two years professional desktop and/or keylining experience (Mac, IBM platforms)."

Terms: Have set fee and pay rate. Exclusive area representation is required in Twin Cities Metro and surrounding areas. Independent contractor pays no fees. "All talents have their own portfolios, etc. Freelance Hotline also has a portfolio." Advertises in *Creative Black Book*, *Gold Book*, magazines, newspapers, *MacChicago*, *Computer User Format*, *Format*, *Digital Chicago*.

How to Contact: For first contact, send query letter, résumé, bio, direct mail flier/brochure (samples not necessary). Reports in 2 weeks (always contacted, qualified or not). After initial contact, Freelance Hotline calls to set up appointment to test desktop/keyline skills, followed by portfolio review. Portfolio should include thumbnails, roughs, original art, tearsheets, slides, photographs, photostats, photocopies (variety of materials, concept to print). After testing and portfolio review, 3 professional references are checked.

Tips: Obtains new talent through Yellow Pages, magazines, newspapers, conferences, seminars, Macshows, *Gold/Black Books*, etc. "We represent artists who meet our minimum requirement of at least two years professional experience with degree or five years professional experience without degree. They must also pass our test."

ROBERT GALITZ FINE ART/ACCENT ART, 166 Hilltop Court, Sleepy Hollow IL 60118. (847)426-8842. Fax: (847)426-8846. Contact: Robert Galitz. Fine art representative. Estab. 1985. Represents 100 fine artists (includes 2 sculptors). Specializes in contemporary/abstract corporate art. Markets include: architects; corporate collections; galleries; interior decorators; private collections.

Handles: Fine art.

Terms: Agent receives 25-40% commission. No geographic restrictions; sells mainly in Chicago, Illinois, Wisconsin, Indiana and Kentucky. For promotional purposes talent must provide "good photos and slides." Advertises in monthly art publications and guides.

How to Contact: For first contact, send query letter, slides, photographs. Reports in 2 weeks. After initial contact, call for appointment to show portfolio of original art. Obtains new talent through recommendations from others, solicitation, conferences.

Tips: "Be confident, persistent. Never give up or quit."

RITA GATLIN REPRESENTS, 83 Walnut Ave., Corte Madera CA 94925. (415)924-7881. Fax: (415)924-7891. E-mail: gatlin@ritareps.com. Website: http://www.ritareps.com. Agent: Rita Gatlin. Commercial illustration. Estab. 1991. Member of Society of Illustrators. Represents 12 illustrators. Markets include: advertising agencies; corporations/client direct; design firms; editorial/magazines; paper products/greeting cards; publishing/books.

Handles: Commercial illustrators only.

Terms: Rep receives 25% commission. Charges fees for portfolio materials (mounting and matting); postage for yearly direct mail divided among artists. Advertising costs are split: 75% paid by talent; 25% paid by representative. For promotional purposes, talent must provide at least one 8½×11 printed page. Prefers portfolios in transparency form. Advertises in *American Showcase*, *The Workbook*, *Creative Illustration*.

How to Contact: For first contact, send query letter and tearsheets. Reports back within 5 days. After initial contact, call to schedule an appointment for portfolio review. Portfolio should include tearsheets, slides.

Tips: "Artists must have a minimum of five years experience as commercial illustrators." When asked what their illustration style is, artists should never say they can do all styles—it's "a sign of a beginner."

DENNIS GODFREY REPRESENTING ARTISTS, 201 W. 21st St., Suite 10G, New York NY 10011. Phone/fax: (212)807-0840. E-mail: dengodfrey@aol.com. Contact: Dennis Godfrey. Commercial illustration representative. Estab. 1985. Represents 7 illustrators. Specializes in publishing and packaging. Markets include: advertising agencies; corporations/client direct; design firms; publishing/books. Clients include Putnam Berkley, Dell, Avon, Ogilvy & Mather, Oceanspray, Tropicana, Celestial Seasonings.

Handles: Illustration.

Terms: Rep receives 25% commission. Prefers exclusive area representation in NYC/Eastern US. Advertising costs are split: 75% paid by talent; 25% paid by representative. For promotional purposes, talent must provide mounted portfolio (at least 20 pieces), as well as promotional pieces. Advertises in *The Workbook*, *American Showcase*.

How to Contact: For first contact, send tearsheets. Reports in 2 weeks, only if interested. After initial contact, write for appointment to show portfolio of tearsheets, slides, photographs, photostats.

BARBARA GORDON ASSOCIATES LTD., 165 E. 32nd St., New York NY 10016. (212)686-3514. Fax: (212)532-4302. Contact: Barbara Gordon. Commercial illustration and photography representative. Estab. 1969. Member of SPAR, Society of Illustrators, Graphic Artists Guild. Represents 9 illustrators, 1 photographer. "I represent only a small, select group of people and therefore give a great deal of personal time and attention to the people I represent."

Terms: No information provided. No geographic restrictions in continental US.

How to Contact: For first contact, send direct mail flier/brochure. Reports in 2 weeks. After initial contact, drop off or mail appropriate materials for review. Portfolio should include tearsheets, slides, photographs; "if the talent wants materials or promotion piece returned, include SASE." Obtains new talent through recommendations from others, solicitation, conferences, etc.

Tips: "I do not care if an artist or photographer has been published or is experienced. I am essentially interested in people with a good, commercial style. Don't send résumés and don't call to give me a verbal description of your work. Send promotion pieces. *Never* send original art. If you want something back, include a SASE. Always label your slides in case they get separated from your cover letter. And always include a phone number where you can be reached."

‡ANITA GRIEN—REPRESENTING ARTISTS, 155 E. 38th St., New York NY 10016. E-mail: agrien@aol.com. Representative not currently seeking new talent.

CAROL GUENZI AGENTS, INC., 865 Delaware St., Denver CO 80210. (303)820-2599. E-mail: cgaiart@aol.com. Website: http://www.artagent.com. Contact: Carol Guenzi. Commercial illustration, film and animation representative. Estab. 1984. Member of Denver Advertising Federation and Art Directors Club of Denver. Represents 26 illustrators, 5 photographers, 4 computer illustrators, 3 multimedia developers and 1 animator. Specializes in a "wide selection of talent in all areas of visual communications." Markets include: advertising agencies; corporations/client direct; design firms; editorial/magazine, paper products/greeting cards, sales/promotions firms. Clients include The Integer Group, Karsh & Hagan, BB00, DDB Needham. Partial client list available upon request.

Handles: Illustration, photography. Looking for "unique style application."

Terms: Rep receives 25% commission. Exclusive area representative is required. Advertising costs are split: 75% paid by talent; 25% paid by the representation. For promotional purposes, talent must provide "promotional material after six months, some restrictions on portfolios." Advertises in *American Showcase*, *Black Book*, *Rocky Mountain Sourcebook*, *The Workbook*, "periodically."

How to Contact: For first contact, send direct mail flier/brochure. Reports in 2-3 weeks, only if interested. Call or write for appointment to drop off or mail in appropriate materials for review, depending on artist's location. Portfolio

should include tearsheets, slides, photographs. Obtains new talent through solicitation, art directors' referrals, an active pursuit by individual artist.

Tips: "Show your strongest style and have at least 12 samples of that style, before introducing all your capabilities. Be prepared to add additional work to your portfolio to help round out your style. Have a digital background."

‡GUIDED IMAGERY PRODUCTIONS, 2995 Woodside Rd., #400, Woodside CA 94062. (650)324-0323. Fax: (650)324-9962. Owner/Director: Linda Hoffman. Fine art representative. Estab. 1978. Member of Hospitality Industry Association. Represents 2 illustrators, 12 fine artists. Specializes in large art production—perspective murals (trompe l'oeil); unusual painted furniture/screens. Markets include: design firms; interior decorators; hospitality industry.

Handles: Looking for "mural artists (realistic or trompe l'oeil) with good understanding of perspectives."

Terms: Rep receives 33% commission. 100% of advertising costs paid by representative. For promotional purposes, talent must provide a direct mail piece to preview work, along with color copies of work (SASE too). Advertises in *The Workbook*.

How to Contact: For first contact, send query letter, résumé, photographs, photocopies and SASE. Reports in 2-3 weeks. After initial contact, drop off or mail appropriate materials. Portfolio should include photographs.

Tips: Wants artists with talent, references and follow-through. "Send color copies of original work that show your artistic style. Never send one-of-a-kind artwork or snapshots. My focus is 3-D murals. References from previous clients very helpful."

PAT HACKETT/ARTIST REPRESENTATIVE, 1809 Seventh Ave., Suite 1710, Seattle WA 98101. (206)447-1600. Fax: (206)447-0739. E-mail: pathackett@aol.com. Contact: Pat Hackett. Commercial illustration and photography representative. Estab. 1979. Represents 29 illustrators, 3 photographers. Markets include: advertising agencies; corporations/client direct; design firms; editorial/magazines.

Handles: Illustration.

Terms: Rep receives 25-33% commission. Exclusive area representation is required. No geographic restrictions, but sells mostly in Washington, Oregon, Idaho, Montana, Alaska and Hawaii. Advertising costs are split: 75% paid by talent; 25% paid by representative. For promotional purposes, talent must provide "standardized portfolio, i.e., all pieces within the book are the same format. Reprints are nice, but not absolutely required." Advertises in *American Showcase*, *The Workbook*.

How to Contact: For first contact, send direct mail flier/brochure. Reports in 1 week, only if interested. After initial contact, drop off or mail in appropriate materials: tearsheets, slides, photographs, photostats, photocopies. Obtains new talent through "recommendations and calls/letters from artists moving to the area."

Tips: "We prefer to handle artists who live in the area unless they do something that is not available locally." Looks for "experience in the *commercial* art world, professional presentation in both portfolio and person, cooperative attitude and enthusiasm."

‡HALL & ASSOCIATES, 606 N. Larchmont Blvd., Suite 4C, Los Angeles CA 90004. (213)962-2500. Fax: (213)962-5759. Contact: Marni Hall. Commercial illustration and photography representative. Estab. 1983. Member of SPAR, SILA, APA. Represents 10 illustrators and 5 photographers. Markets include: advertising agencies; design firms. Member agent: Lisa Ellison (artist representative).

Handles: Illustration, photography.

Terms: Rep receives 30% commission. Exclusive area representation is desired. No geographic restrictions. Advertising costs are paid by talent. For promotional purposes, talent must advertise in "1 or 2 national source books a year (double page), provide 2 direct mail pieces and 1 specific, specialized mailing. No specific portfolio requirement except that it be easily portable." Advertises in *Creative Black Book*, *The Workbook*.

How to Contact: For first contact, send direct mail flier/brochure. Reports in 5 days. After initial contact, drop off or mail in appropriate materials for review. Portfolios should include tearsheets, transparencies, prints (8×10 or larger).

Tips: Obtains new talent through recommendations from clients or artists' solicitations. "Show work that you are passionate about and make sure the work in your presentation has consistency. If using tearsheets or printed material from jobs executed, only put in tearsheets of great ads regardless of the client."

HANKINS & TEGENBORG, LTD., 60 E. 42nd St., Suite 1940, New York NY 10165. (212)867-8092. Fax: (212)949-1977. E-mail: dhlt@aol.com. Website: http://www.ht-ltd.com. Commercial illustration representative. Estab. 1980. Member of Society of Illustrators, Graphic Artists Guild. Represents 65 illustrators. Specializes in realistic and digital illustration. Markets include; advertising agencies; publishing/book covers/promotion.

Handles: Illustration, computer illustration.

Terms: Rep receives 25% commission. "All additional fees are charged per job if applicable." Exclusive area representation is required. Advertising costs are split: 75% paid by talent; 25% paid by representative. For promotional purposes, talent must provide 8×10 transparencies or digital files. Advertises in *American Showcase* "and own promotion book."

How to Handle: For first contact, send query letter, direct mail flier/brochure, tearsheets and SASE. Reports back if interested. Portfolio can be dropped off and should include original art, if possible, tearsheets or slides.

‡BARB HAUSER, ANOTHER GIRL REP, P.O. Box 421443, San Francisco CA 94142-1443. (415)647-5660. Fax: (415)546-4180. Estab. 1980. Represents 11 illustrators. Markets include: primarily advertising agencies and design firms; corporations/client direct.

Handles: Illustration.
Terms: Rep receives 25-30% commission. Exclusive representation in the San Francisco area is required. No geographic restrictions.
How to Contact: For first contact, send direct mail flier/brochure, tearsheets, slides, photographs, photocopies and SASE. Reports in 3-4 weeks. Call for appointment to show portfolio of tearsheets, slides, photographs, photostats, photocopies.

‡JOANNE HEDGE/ARTIST REPRESENTATIVE, 1415 Garden St., Glendale CA 91201. (818)244-0110. Fax: (818)244-0136. Contact: J. Hedge. Commercial illustration representative. Estab. 1975. Member of Graphic Artists Guild. Represents 14 illustrators. Specializes in "high-quality, painterly and realistic illustration and lettering." Markets include advertising agencies, design firms, movie studios, package design firms.
Handles: Illustration. Seeks established realists in airbrush, painting. Also quality computer-generated art suppliers.
Terms: Rep receives 30% commission. Artist pays quarterly portfolio maintenance expenses. Advertising costs are split: 75% paid by talent; 25% paid by representative. For promotional purposes, talent should provide "ad reprint flyer, 4×5 or 8×10 copy transparencies, matted on 11×14 laminate mattes." Advertises in *The Workbook*.
How to Contact: For first contact, send query letter with direct mail flier/brochure, 35mm slides OK with SASE. Reports in 1 week, if interested. After initial contact, call or write for appointment to show portfolio of tearsheets (laminated), photocopies, 4×5 or 8×10 transparencies.
Tips: Obtains new talent after talent sees workbook directory ad, or through referrals from art directors or other talent. "Have as much experience as possible and zero or one other rep. That, and a good looking $8\frac{1}{2} \times 11$ flier!"

HK PORTFOLIO, 666 Greenwich St., New York NY 10014. (212)675-5719. E-mail: hkpfolio@aol.com. Website: http://www.hkportfolio.com. Contact: Harriet Kasak or Mela Bolinao. Commercial illustration representative. Estab. 1986. Member of SPAR. Represents 42 illustrators. Specializes in illustration for juvenile markets. "Sub-agent for Peters, Fraser & Dunlop (London). Affiliated with Creatif Licensing Corporation." Markets include: advertising agencies; editorial/magazines; publishing/books.
Handles: Illustration.
Terms: Rep receives 25% commission. No geographic restrictions. Advertising costs are split: 75% paid by talent; 25% paid by representative. Advertises in *American Showcase*, *Picture Book*.
How to Contact: No geographic restrictions. For first contact, send query letter, direct mail flier/brochure, tearsheets, slides, photographs, photostats and SASE. Reports in 1 week. After initial contact, drop off or mail in appropriate materials for review. Portfolio should include tearsheets, slides, photographs, photostats, photocopies.
Tips: Leans toward highly individual personal styles.

‡MARY HOLLAND & COMPANY, INC., 6638 N. 13th St., Phoenix AZ 85014. (602)263-8990. Fax: (602)277-0680. Owner: Mary Holland. Assistant: Holly Heath. Commercial illustration, photography representative. Estab. 1984. Member of SPAR, Graphic Artists Guild. Represents 18 illustrators, 2 photographers. Markets include: advertising agencies; corporations/client direct; design firms; editorial/magazines; paper products/greeting cards; publishing/books.
Handles: Illustration, photography.
Terms: Rep receives 25% commission. Advertising costs are split: 75% paid by talent; 25% paid by representative. For promotional purposes, talent must provide direct mail piece, tearsheets or promotional material. Advertises in *American Showcase*, *Southwest Portfolio*, *Workbook*.
How to Contact: For first contact, send query letter, direct mail flier/brochure, tearsheets, photocopies. Reports back within 3 weeks. After initial contact, call to schedule an appointment. Portfolio should include tearsheets, photographs.
Tips: Looking for "good conceptual styles."

MELISSA HOPSON REPRESENTING, 1605C Stemmons Freeway, Dallas TX 75207. (214)747-3122. Fax: (214)720-0080. Owner: Melissa Hopson. Commercial illustration, digital/computer representative. Estab. 1982. Member of Society of Illustrators. Represents 6 illustrators. Specializes in comps/presentations and high-end computer illustration.
Handles: Traditional illustrators, digital illustrators, specializing in photo manipulating, 3-D illustration and animation.
Terms: Rep receives 25-30% commission. Exclusive area representation is required. Advertising costs are split: 75% paid by talent; 25% paid by representative. For promotional purposes, requires ads in national books, leave behinds and 2 full portfolios.
How to Contact: For first contact, send query letter, tearsheets and slides. Reports in 1-2 weeks, only if interested. After initial contact, call to schedule an appointment. Portfolio should include transparencies of work (mounted).
Tips: Impressed by "upbeat personality, willingness to work hard, friendliness—does not mind client changes—professional appearance, professionally put together portfolio."

SCOTT HULL ASSOCIATES, 68 E. Franklin S., Dayton OH 45459. (937)433-8383. Fax: (937)433-0434. E-mail: scott@scotthull.com. Website: http://www.scotthull.com. Contact: Scott Hull or Frank Sturges. Commercial illustration representative. Estab. 1981. Represents 20 plus illustrators.
 • This rep showcases his illustrators periodically in imaginative promotional projects. Hull was featured in the 1997 *AGDM*.
Terms: No information provided.
How to Contact: Contact by sending slides, tearsheets or appropriate materials for review. Follow up with phone

INSIDER REPORT

Streetwise talk about hiring a rep

Curtis Parker is a well-known freelance illustrator whose work has appeared in *U.S. News & World Report* and *Atlantic Monthly*. Working out of his studio in Tempe, Arizona, Parker has been freelancing for more than ten years.

Following his graduation from Arizona State University, Parker was hired as a graphic designer for a small design studio in Phoenix. After three years, he started his own studio. "At the beginning, you have to establish yourself with lower rates. When you start out, you take jobs for a modest fee to get your foot in the door and to get images in your portfolio. Eventually you can command higher and higher fees," he says.

Curtis Parker

As a beginning illustrator, you may be used to taking every job that comes your way—regardless of how much it pays—just for the work. However, when your career begins to take off, even slightly, that can catch up with you. Suddenly you find yourself at a turning point in your career—a point where you must make wise choices about which jobs to take and which to turn down. You also need to find the courage to raise your rates and start going after those high-paying clients. You're at a point where marketing, invoicing and collecting take too much time away from your creative work. That's the turning point when many illustrators, like Parker, decide to hire one or more reps to take them to the next level—and keep them there.

In the helpful book *The Streetwise Guide to Freelance Design and Illustration* (North Light Books), author Theo Stephan Williams interviewed freelance illustrators and designers about the business aspects of their careers. Here's what Curtis Parker had to say about working with art reps:

What kind of representation arrangement do you have?

I have two reps, one in Phoenix and one in the Midwest. One mainly handles the local business area and the other takes care of national business.

What's so great about having a rep?

In some situations, one of the biggest keys to negotiating is having a third party do it. You can feel self-conscious about negotiating for your own work. When there is a third party, he can tell clients all the good things about your work, how valuable it is and what a valuable person you are. Your art rep says all the stuff you would never say about yourself. Another reason to have a rep is to keep yourself from getting locked into too severe a deadline and too low prices. Most reps have a pretty good feel for the right pricing structure [to charge].

Why do you have two reps?

By having two reps, when one is a bit slow, the other seems to kick in, and [the work] balances out very nicely. But when you have more than one rep, you have to be aware of the issue of exclusive rights. You have to be careful not to give a rep every exclusive situation.

INSIDER REPORT, *Parker*

What advice can you give about choosing a rep?

The most crucial thing in the world is getting someone reputable. I was involved with a rep who left town with over $5,000 of my money. Finding someone reputable was as big a concern as how many doors he could get me into—[I had to find out] how ethical he was and how easy he was to work with.

Other key things to look for in a rep are what kind of talent the other artists they represent have and what kind of promotion the rep believes in.

I found a goldmine in Scott Hull. I chose him after calling the artists he worked with and asking them the key things: how his billing schedule is and how soon the artists get paid on projects.

How is billing handled?

Clients should be billed the day after you finish a job, because a lot of clients pay 30 to 45 days after receiving an invoice. The longer you postpone it, the harder it is to collect. My reps do about 90 percent of my invoicing. I send invoices myself only for jobs I get on my own, without my agent's assistance. When my one of my reps originated the job and does the invoicing, I get paid by him.

What kind of a contract do you and your reps have?

Right now I'm in a very informal contract with my reps. I'm more of a handshake and deal kind of guy, even though we do have a signed contract.

Condensed from The Streetwise Guide to Freelance Design and Illustration *by Theo Stephan William (North Light Books). To order, fill out the bind-in card in this book or call 1-800-289-0963.*

© Curtis Parker

Curtis Parker's unique style is in demand thanks to his marvelous imagination and drawing skills—not to mention the diligence of his art reps.

call. Reports within 2 weeks.

Tips: Looks for "an interesting style and a desire to grow, as well as a marketable portfolio."

‡INDUSTRY ARTS, P.O. Box 1737, Beverly Hills CA 90213. (310)302-0088. Fax: (310)305-7364. E-mail: tocker@in dustryarts.com. Website: http://www.industryarts.com. Agent/Broker: Marc Tocker. Commercial illustration, photography, graphic design representative and copywriters. Estab. 1997. Member of California Lawyers for the Arts. Represents 1 copywriter, 1 illustrator, 1 photographer, 1 designer. Specializes in clever cutting edge design. Markets include: advertising agencies, corporations/client direct, design firms.

Handles: Illustration, photography, design, Web design/programming. "We are looking for design mindful people who create cutting edge work that challenges dominant cultural paradigms."

Terms: Rep receives 20-25% commission. Exclusive area representation is required. Advertising costs are paid by talent. For promotional purposes, portfolio should be adapted to digital format for website presentation. Advertises in *The Workbook*.

How to Contact: For first contact, send query letter, bio, direct mail flier/brochure, tearsheets, photocopies and SASE. Reports in 2 weeks. Call to schedule an appointment. Portfolio should include original art, tearsheets, slides, photographs.

Tips: Looks for artists with an awareness of the cutting edge in contemporary design.

INTERPRESS WORLDWIDE, P.O. Box 8374, Los Angeles CA 91618-8374. (213)876-7675. E-mail: email@interpr essww.com. Website: http://www.interpressww.com. Rep Coordinator: Ellen Bow. Commercial and fashion illustration, photography, fine art, graphic design, actor, make-up artist, musician representative; make-up artists; hairstylists. Estab. 1989. Represents 2 illustrators, 10 photographers, 6 make-up artists, 4 hairstylists, 20 models, 15 musicians, 4 actors, 2 designers, 5 fine artists. Specializes in subsidiaries worldwide. Markets include advertising agencies; corporations/client direct; editorial/magazines; movie industry; art publishers; galleries; private collections; publishing/books; music industry.

Handles: Illustration, photography, fine art, graphic arts; commercial, A/V productions; television, movie.

Terms: Rep receives 30% commission. Charges for postage and initial rep fee. Exclusive area representation is required. Advertising costs are split: 80% paid by talent; 20% paid by the representative. For promotional purposes, talent must provide 2 show portfolios, 6 traveling portfolios. Advertises in *Red Book*, *Production-Creation*.

How to Contact: For first contact, send query letter, résumé, bio, direct mail flier/brochure, tearsheets, slides, photographs and photostats. Reports in 45-60 days. After initial contact, write to schedule an appointment, mail in appropriate materials. Portfolio should include thumbnails, roughs, original art, tearsheets, slides, photographs, photostats, E-folio (Mac).

Tips: Obtains new talent through recommendations from others and the extraordinary work, personality and talent of the artist. "Try as hard as you can and don't take our 'no' as a 'no' to your talent."

‡THE IVY LEAGUE OF ARTISTS, 18 W. 21st St., 7th Floor, New York NY 10010. (212)243-1333. E-mail: ilartists@ aol.com. Graphic design representative, illustration or photography broker. Commercial illustration, photography, fine art, graphic design representative. Estab. 1985. Represents 5 illustrators, 2 designers. Staff includes sales and graphic designers. Specializes in graphic design, illustration representatives. Markets include: advertising agencies, corporations/clients direct, publishing/books.

Will Handle: Interested in reviewing illustration, design.

Terms: Rep receives 30% commission.

How to Contact: For first contact, send tearsheets. Reports in 2 weeks. Portfolio should include prints, tearsheets.

Tips: "At this point, we are not looking for new talent."

‡JEDELL PRODUCTIONS, INC., 370 E. 76th St., New York NY 10021. (212)861-7861. Contact: Joan Jedell. Commercial photography representative. Estab. 1969. Member of SPAR. Specializes in photography. Markets include: advertising agencies.

Handles: Photography, fine art.

How to Contact: After initial contact, drop off or mail in portfolio of photographs. For returns, include SASE or Federal Express number.

JOHNSON REPRESENTS, 1643 W. Swallow Rd., Fort Collins CO 80526. (303)223-3027. Contact: Sally Johnson. Commercial illustration representative. Estab. 1992. Represents 5 illustrators. Markets include: advertising agencies; corporations/client direct; design firms; editorial/magazines.

Handles: Illustration.

Terms: Rep receives 25% commission. Exclusive area representation is required. For promotional purposes, talent must provide promo piece with current images.

How to Contact: For first contact, send query letter, direct mail flier/brochure and tearsheets. Reports in 1 month only if interested. Portfolio should include tearsheets, transparencies.

Tips: "An artist is ready for representation if his/her work is good and he/she is able to meet deadlines. (I rarely represent new artists, though.)"

‡TANIA KIMCHE, 137 5th Ave., 11th Floor, New York NY 10010. (212)529-3556. Fax: (212)353-0831. Contact: Tania. Commercial illustration representative. Estab. 1981. Member of SPAR. Represents 9 illustrators. "We do every-

thing, a lot of design firm, corporate/conceptual work." Markets include: advertising agencies; corporations/client direct; design firms; editorial/magazines; publishing books; sales/promotion firms.

Handles: Illustration. Looking for "conceptual/corporate work."

Terms: Rep receives 25% commission if the artist is in town; 30% if the artist is out of town. Splits postage and envelope expense for mailings with artists. Advertising costs are split: 75% paid by the talent; 25% paid by the representative. For promotional purposes, talent "must go into *American Showcase* each year." Advertises in *American Showcase*.

How to Contact: For first contact, send bio, tearsheets, slides. Reports in months, only if interested. After initial contact, drop off or mail in appropriate materials for review. Portfolio should include tearsheets, slides, photostats.

Tips: Obtains new talent through recommendations from others or "they contact me. Do not call. Send promo material in the mail. Don't waste time with a résumé—let me see the work."

KIRCHOFF/WOHLBERG, ARTISTS REPRESENTATION DIVISION, 866 United Nations Plaza, #525, New York NY 10017. (212)644-2020. Fax: (212)223-4387. Director of Operations: John R. Whitman. Estab. 1930s. Member of SPAR, Society of Illustrators, AIGA, Associaton of American Publishers, Bookbuilders of Boston, New York Bookbinders' Guild. Represents over 50 illustrators. Artist's Representative: Elizabeth Ford. Specializes in juvenile and young adult trade books and textbooks. Markets include: publishing/books.

Handles: Illustration and photography (juvenile and young adult).

Terms: Rep receives 25% commission. Exclusive representation to book publishers is usually required. Advertising costs paid by representative ("for all Kirchoff/Wohlberg advertisements only"). "We will make transparencies from portfolio samples; keep some original work on file." Advertises in *American Showcase*, *Art Directors' Index*, *Society of Illustrators Annual*, children's book issue of *Publishers Weekly*.

How to Contact: Please send all correspondence to the attention of Elizabeth Ford. For first contact, send query letter, "any materials artists feel are appropriate." Reports in 4-6 weeks. "We will contact you for additional materials." Portfolios should include "whatever artists feel best represents their work. We like to see children's illustration in any style."

KLIMT REPRESENTS, 15 W. 72nd St., 7-U, New York NY 10023. (212)799-2231. Contact: Bill or Maurine. Commercial illustration representative. Estab. 1978. Member of Society of Illustrators, Graphic Artists Guild. Represents 14 illustrators. Specializes in paperback covers, young adult, romance, science fiction, mystery, etc. Markets include: advertising agencies; corporations/client direct; design firms; editorial/magazines; paper products/greeting cards; publishing/books; sales/promotion firms.

Handles: Illustration.

Terms: Rep receives 25% commission, 30% commission for "out of town if we do shoots. The artist is responsible for only his own portfolio. Exclusive area representation is required. Advertising costs are split: 75% paid by talent; 25% paid by representative. For promotional purposes, talent must provide 4×5 or 8×10 mounted transparencies. Advertises through direct mail.

How to Contact: For first contact, send direct mail flier/brochure, and "any image that doesn't have to be returned unless supplied with SASE." Reports in 5 days. After initial contact, call for appointment to show portfolio of professional, mounted transparencies.

ELLEN KNABLE & ASSOCIATES, INC., 1233 S. LaCienega Blvd., Los Angeles CA 90035. (310)855-8855. (310)657-0265. E-mail: pearl2eka@aol.com. Contact: Ellen Knable. Commercial illustration, photography and commercial production representative. Estab. 1978. Member of SPAR, Graphic Artists Guild. Represents 2 illustrators, 4 photographers. Markets include: advertising agencies; corporations/client direct; design firms. Clients include Chiat/Day, BBDO, J.W. Thompson/SF, Ketchum/SF. Client list available upon request.

Terms: Rep receives 25-30% commission. Exclusive West Coast/Southern California representation is required. Advertising costs split varies. Advertises in *The Workbook*.

How to Contact: For first contact, send query letter, direct mail flier/brochure and tearsheets. Reports within 2 weeks. Call for appointment to show portfolio. Obtains new talent from creatives/artists.

Tips: "Have patience and persistence!"

CLIFF KNECHT–ARTIST REPRESENTATIVE, 309 Walnut Rd., Pittsburgh PA 15202. (412)761-5666. Fax. (412)761-4072. E-mail: artrep1@aol.com. Website: http://www.artrep1.com. Contact: Cliff Knecht. Commercial illustration representative. Estab. 1972. Represents 20 illustrators. Markets include: advertising agencies; corporations/client direct; design firms; editorial/magazines; paper products/greeting cards; publishing/books; sales/promotion firms.

Handles: Illustration.

Terms: Rep receives 25% commission. No geographic restrictions. Advertising costs are split: 75% paid by the talent; 25% paid by representative. For promotional purposes, talent must provide a direct mail piece. Advertises in *Graphic Artists Guild Directory of Illustration*.

How to Contact: For first contact, send résumé, direct mail flier/brochure, tearsheets, slides. Reports in 1 week. After initial contact, call for appointment to show portfolio of original art, tearsheets, slides, photographs. Obtains new talent directly or through recommendations from others.

‡ANN KOEFFLER ARTIST REPRESENTATION, 5015 Clinton St., #306, Los Angeles CA 90004. (213)957-2327. Fax: (213)957-1910. Owner/Operator: Ann Koeffler. Commercial illustration representative. Estab. 1983. Member

of Society of Illustrators. Represents 20 illustrators. Markets include: advertising agencies, corporations/client direct, design firms, editorial/magazines, paper products/greeting cards, publishing/books, individual small business owners.
Will Handle: Interested in reviewing illustration. Looking for artists who are digitally adept.
Terms: Rep receives 25-30% commission. Advertising costs 100% paid by talent. For promotional purposes, talent must provide an initial supply of promotional pieces and a committment to advertise regularly. Advertises in *The Workbook.*
How to Contact: For first contact, send tearsheets. Reports in 1 week. Portfolio should include photocopies, 4×5 chromes.
Tips: "I only carry artists who are able to communicate clearly and in an upbeat and professional manner."

‡**MARY LAMONT**, 56 Washington Ave., Brentwood NY 11717. Representative not currently seeking new talent.

✒**LANGLEY ARTIST REPRESENTATIVE**, 111 E. Wacker Dr., 26th Floor, Chicago IL 60601. (312)540-9420. Fax: (312)540-9421. E-mail: artrepsjl@aol.com. Contact: Sharon Langley. Commercial illustration representative. Estab. 1988. Member of CAR (Chicago Artists Representatives). Represents 21 illustrators. Markets include: advertising agencies; corporations/client direct; design firms; editorial/magazines; publishing/books; sales/promotion firms. Clients include Leo Burnett Advertising, Davidson Marketing, Kemper Insurance Co.
Handles: Illustration. Although representative prefers to work with established talent, "I am always receptive to reviewing illustrators' work."
Terms: Rep receives 25% commission. Exclusive area representation is preferred. Advertising costs are split: 75% paid by talent; 25% paid by representative. For promotional purposes, talent must provide printed promotional piece, well organized portfolio. Advertises in *The Workbook, Blackbook Illustration.*
How to Contact: For first contact, send printed promotional piece. Reports in 3 weeks if interested. After initial contact, call for appointment to show portfolio of tearsheets, transparencies. Obtains new talent through art directors, clients, referrals.
Tips: "When an artist starts freelancing it's a good idea to represent yourself for a while. Only then are you able to appreciate a professional agent. Don't be discouraged when one rep turns you down. Contact the next one on your list!"

‡**LEIGHTON & COMPANY**, 7 Washington St., Beverly MA 01915. (978)921-0887. Fax: (978)921-0223. E-mail: leighton@leightonreps.com. Website: http://www.leightonreps.com. Contact: Leighton O'Connor. Commercial illustration and photography representative. Estab. 1986. Member of Graphic Artists Guild, ASMP. Represents 8 illustrators and 3 photographers. Markets include: advertising agencies; corporations/clients direct; design firms; editorial/magazines; publishing/books.
Handles: Illustration, photography. "Looking for photographers and illustrators who can create their work on computer."
Terms: Rep receives 25% commission. Advertising costs are split: 75% paid by talent; 25% paid by representative. For promotional purposes, "talent is required to supply me with 6×9 color mailer(s) and laminated portfolios as well as two 4×5 color transparency portfolios." Advertises in *Creative Illustration, Graphic Artist Guild Directory of Illustration.*
How to Contact: For first contact, send query letter, direct mail flier/brochure, tearsheets and SASE. Reports in 1 week if interested. After initial contact, drop off or mail in appropriate materials with SASE for review. Portfolio should include tearsheets, slides, photographs.
Tips: "My new talent is almost always obtained through referrals. Occasionally, I will solicit new talent from direct mail pieces they have sent to me. It is best to send work first, i.e., tearsheet or direct mail pieces. Only send a portfolio when asked to. If you need your samples returned, always include a SASE. Follow up with one phone call. It is very important to get the correct spelling and address of the representative. Also, make sure you are financially ready for a representative, having the resources available to create a portfolio and direct mail campaign."

LESLI ART, INC., Box 6693, Woodland Hills CA 91364. (818)999-9228. Fax: (818)999-0833. Contact: Stan Shevrin. Fine art agent, publisher and advisor. Estab. 1965. Represents emerging, mid-career and established artists. Specializes in artists painting in oil or acrylic, in traditional subject matter in realistic or impressionist style. Also represents illustrators who want to establish themselves in the fine art market. Sells to leading art galleries throughout the US.
Terms: Receives 50% commission. Pays all expenses including advertising and promotion. Artist pays one-way shipping. All artwork accepted unframed. Exclusives preferred. Contract provided.
How to Contact: For first contact, send either color prints or slides with short bio and SASE. Material will be filed if SASE is not included. Reports in 30 days. Obtains new talent through "reviewing portfolios."
Tips: "Artists should show their most current works and state a preference for subject matter and medium."

MARKET CONDITIONS are constantly changing! If you're still using this book and it is 2000 or later, buy the newest edition of *Artist's & Graphic Designer's Market* at your favorite bookstore or order directly from Writer's Digest Books (1-800-289-0963).

LULU CREATIVES, 4645 Colfax Ave. S., Minneapolis MN 55409. Phone/fax: (612)825-7564. Creative Representative: Lulu Zabowski. Commercial illustration representative. Estab. 1983. Represents 12 illustrators. Markets include: advertising agencies; corporations/client direct; design firms; editorial/magazines; paper products/greeting cards; publishing/books.
Handles: Illustration.
Terms: Rep receives 25% commission. Exclusive area representation is required. Advertising costs are split: 75% paid by talent; 25% paid by representative. For promotional purposes, talent must provide yearly national advertising, direct mailers (2 to 3 times yearly). Advertises in *American Showcase*, *Black Book*, *The Workbook*.
How to Contact: For first contact, send tearsheets. Reports immediately if interested. After initial contact, call to schedule an appointment.
Tips: Artists must have "good communication skills, conceptual thinking."

MARLENA AGENCY, 278 Hamilton Ave., Princeton NJ 08540. (609)252-9405. E-mail: marzena@bellatlantic.net. Artist Rep: Marlena Torzecka. Commercial illustration representative. Estab. 1990. Member of Art Directors Club of New York. Represents 14 illustrators. Specializes in conceptual illustration. Markets include: advertising agencies; corporations/client direct; design firms; editorial/magazines; publishing/books; theaters.
Handles: Illustration, fine art.
Terms: Rep receives 30% commission. Costs are shared by all artists. Exclusive area representation is required. Advertising costs are split: 70% paid by talent; 30% paid by representative. For promotional purposes, talent must provide slides (preferably 8×10 framed); direct mail piece helpful. Advertises in *American Showcase*, *Black Book*, *Illustrators 35* (New York City), *Workbook*, *Alternative Pick*.
How to Contact: For first contact send tearsheets. Reports back within 1 week only if interested. After initial contact, drop off or mail appropriate materials. Portfolio should include tearsheets.
Tips: Wants artists with "talent, good concepts—intelligent illustration, promptness in keeping up with projects, deadlines, etc."

MARTHA PRODUCTIONS, INC., 11936 W. Jefferson, Suite C, Culver City CA 90230. (310)390-8663. Fax: (310)390-3161. E-mail: marthaprod@earthlink.net. Contact: Martha Spelman. Commercial illustration and graphic design representative. Estab. 1978. Member of Graphic Artists Guild. Represents 25 illustrators. Staff includes Annie Gregory (artist representative), Martha Spelman (artist representative), Shannon Tinker (artist representative). Specializes in b&w and 4-color illustration. Markets include: advertising agencies; corporations/client direct; design firms; editorial/magazines; paper products/greeting cards.
Handles: Illustration.
Terms: Rep receives 30% commission. Exclusive area representation is required. No geographic restrictions. Advertising costs are split: 70% paid by talent; 30% paid by representative. For promotional purposes, talent must provide "a minimum of 12 images, 4×5 transparencies of each. (We put the transparencies into our own format.) In addition to the transparencies, we require 4-color promo/tearsheets and participation in the biannual Martha Productions brochure." Advertises in *The Workbook*, *Single Image*.
How to Contact: For first contact, send query letter, direct mail flier/brochure, tearsheets, slides and SASE (if materials are to be returned). Reports only if interested. After initial contact, drop off or mail in appropriate materials for review. Portfolio should include tearsheets, slides, photographs, photostats. Obtains new talent through recommendations and solicitation.
Tips: "Artists should have a style we feel would sell and does not compete with those artists we are currently representing, as well as a solid body of consistent (in style and execution) work that includes a variety of topics (i.e., people, landscape, product concept, etc.). We'll often work with the artist on a job-to-job basis prior to representation to see how competent the artist is and how smooth the working relationship will be."

‡**MASON ILLUSTRATION**, 3646 47th Ave. S, Minneapolis MN 55406. (612)729-1774. Fax: (612)729-0133. Creative Rep/Owners: Marietta and Jerry Mason. Commercial illustration representative. Estab. 1984. Represents 10 illustrators. Markets include advertising agencies; corporations/client direct; design firms; editorial/magazines; publishing/books; sales; promotion; incentives.
Handles: Illustration.
Terms: Rep receives 25% commission. Exclusive area representation is required. Advertising costs are split: 75% paid by talent; 25% paid by representative. For promotional purposes, talent must provide 2 complete portfolios of transparencies or reflective samples, "unmounted as we mount to coordinate as group."
How to Contact: For first contact, send query letter, bio, direct mail flier/brochure, tearsheets, slides, photocopies and SASE. Reports in 1 month. After initial contact, drop off or mail in appropriate materials. Portfolio should include tearsheets, slides, photocopies, 4×5 transparencies.
Tips: Artist must have "good communication/visual/verbal skills."

‡**MENDOLA ARTISTS**, 3227 S.E. Anthony, Portland OR 97214. (212)986-5680. Fax: (212)818-1246. Contact: Tim Mendola. Commercial illustration representative. Estab. 1961. Member of Society of Illustrators, Graphic Artists Guild. Represents 60 or more illustrators, 3 photographers. Markets include: advertising agencies; corporations/client direct; design firms; editorial/magazines; sales/promotion firms.
Handles: Illustration. "We work with the top agencies and publishers. The calibre of talent must be in the top 5%."

Terms: Rep receives 25% commission. Artist pays for all shipping not covered by client and 75% of promotion costs. Exclusive area representation is sometimes required. Advertising costs are split: 75% paid by talent; 25% paid by representative. For promotional purposes, talent must provide 8×10 transparencies and usually promotion in at least one sourcebook. Advertises in *American Showcase, Black Book, RSVP, The Workbook*.

How to Contact: For first contact, send direct mail flier/brochure, tearsheets, slides. Reports in 1 week. After initial contact, drop off or mail in appropriate materials for review. Portfolio should include original art, tearsheets, slides, photographs.

✔**MONTAGANO & ASSOCIATES**, 11 E. Hubbard, 11th Floor, Chicago IL 60611. (312)527-3283. Fax: (312)527-2108. E-mail: dmontag@aol.com. Contact: David Montagano. Commercial illustration, photography and television production representative and broker. Estab. 1983. Represents 7 illustrators, 1 photographer. Markets include: advertising agencies; corporations/client direct; design firms; editorial/magazines; paper products/greeting cards.

Handles: Illustration, photography, design.

Terms: Rep receives 30% commission. No geographic restrictions. Advertises in *American Showcase, The Workbook, CIB*.

How to Contact: For first contact, send direct mail flier/brochure, tearsheets, photographs. Portfolio should include original art, tearsheets, photographs.

VICKI MORGAN ASSOCIATES, 194 Third Ave., New York NY 10003. (212)475-0440. E-mail: vmartrep@aol.com. Website: http://www.spar.org. Partners: Vicki Morgan and Gail Gaynin. Commercial illustration representative. Estab. 1974. Member of SPAR, Graphic Artists Guild, Society of Illustrators. Represents 16 illustrators. Markets include: advertising agencies; corporations/client direct; design firms; editorial/magazines; paper products; publishing/books; sales/promotion firms.

Handles: Illustration. "Fulltime illustrators only."

Terms: Rep receives 30% commission. Exclusive area representation is required. No geographic restrictions. Advertising costs are split: 70% paid by talent; 30% paid by representative. "We require samples for three duplicate portfolios; the presentation form is flexible." Advertises in *American Showcase*, other directories and individual promotions.

How to Contact: For first contact, send any of the following: direct mail flier/brochure, tearsheets, slides with SASE. "If interested, we keep on file and consult these samples first when considering additional artists. No drop-off policy." Obtains new talent through "recommendations from artists I represent and mail solicitation."

Tips: "Reuse of existing work and stock illustration are being requested more often than before!"

THE NEWBORN GROUP, 270 Park Ave. S., Apt. 8E, New York NY 10010-6105. (212)260-6700. Fax: (212)260-9600. Website: http://www.zaks.com/illustrators/newborn. Owner: Joan Sigman. Commercial illustration representative. Estab. 1964. Member of SPAR, Society of Illustrators, Graphic Artists Guild. Represents 12 illustrators. Markets include: advertising agencies; design firms; editorial/magazines; publishing/books. Clients include Leo Burnett, Berkley Publishing, Weschler Inc.

Handles: Illustration.

Terms: Rep receives 25% commission. Exclusive area representation is required. Advertising costs are split: 75% paid by talent; 25% paid by representative. Advertises in *American Showcase, The Workbook, Directory of Illustration*.

How to Contact: "Not reviewing new talent."

Tips: Obtains new talent through recommendations from other talent or art directors.

✔**LORI NOWICKI AND ASSOCIATES**, 37 W. 20th St., Suite 902, New York NY 10011. E-mail: lori@lorinowicki.com. Artist Representative: Lori Nowicki. Commercial illustration representative. Estab. 1993. Represents 13 illustrators. Markets include: advertising agencies; design firms; editorial/magazines; publishing/books.

Handles: Illustration.

Terms: Rep receives 25-30% commission. Cost for direct mail promotional pieces is paid by illustrator. Exclusive area representation is required. Advertising costs are split: 75% paid by talent; 25% paid by representative. Advertises in *American Showcase, The Workbook, Black Book*.

How to Contact: For first contact, send query letter, résumé, tearsheets. Samples are not returned. "Do not phone, will contact if interested." Wants artists with consistent style.

100 ARTISTS, 4170 S. Arbor Circle, Marietta GA 30066. (770)924-4793. Fax: (770)924-7174. Owner: Brenda Bender. Commercial illustration, photography, graphic design representative. Estab. 1990. Member of Society of Illustration, Graphic Artists Guild. Represents 40 illustrators, 8 photographers, 8 designers. Markets include: advertising agencies; corporations/client direct; design firms; editorial/magazines; publishing/books.

Handles: Illustration, photography.

Terms: Rep receives 30% commission. $30-50 is added to all out-of-town projects for miscellaneous expenses, i.e. long distance calls, fax, etc. Exclusive area representation is required. Advertising costs are split: 70% paid by talent; 30% paid by representative. For promotional purposes, talent must provide direct mail/self-mailer (no overlarge or bulky promos), new material every 3 months. Advertises in *American Showcase, The Workbook*.

How to Contact: For first contact, send query letter, direct mail flier/brochure or tearsheets. Reports back within 1 month weeks if interested. SASE or postcard required for replies or return of material. After initial contact, call to

schedule an appointment or drop off or mail in appropriate materials. Portfolio should include roughs, tearsheets, slides or photographs.

Tips: Needs artists with "originality who do not conflict with talent we already represent."

‡JOANNE PALULIAN, 18 McKinley St., Rowayton CT 06853. (203)866-3734 or (212)581-8338. Fax: (203)857-0842. Commercial illustration representative. Estab. 1976. Member of SPAR. Represents 10 illustrators. Markets include: advertising agencies; corporations/client direct; design firms; editorial/magazines; broadcast/animation; sales/promotion firms.

Handles: Illustration.

Terms: Rep receives 30% commission. Exclusive area representation is required. Advertising costs are split: 75% paid by talent; 25% paid by representative. For promotional purposes, talent must provide portfolio and promotional materials. Advertises in *American Showcase, Black Book, Workbook, Graphic Artist Guild Illustration Book, Single Image.*

How to Contact: For first contact, send direct mail flier/brochure. Reports in 2 days, only if interested. After initial contact, drop off or mail in appropriate materials for review. Portfolio should include tearsheets, transparencies (4×5 or 8×10) of original art.

Tips: "Talent usually contacts me, follows up with materials that I can keep. If interest is there, I interview. Do not send materials without my consent. Include return packaging with necessary postage. Be courteous and friendly. You are asking someone to give you his or her time and attention for your benefit."

✔RANDY PATE & ASSOCIATES, 2510G Las Pasas Rd., Camarillo CA 93010. (888)484-8111. Fax: (805)384-9087. E-mail: rp@patecompany.com. Website: http://www.patecompany.com. Commercial illustration representative. Estab. 1979. Member of Society of Illustrators, Graphic Artists Guild. Represents 9 illustrators, 2 designers. Markets include: advertising agencies; corporations/client direct; design firms; sales/promotion firms; children's book publishers.

Handles: Illustration.

Terms: Rep receives 25% commission. Occasionally charges other fee; "this varies." Exclusive area representation is required. Advertising costs are split: 75% paid by talent; 25% paid by representative. For promotional purposes, talent should provide "a full page in *The Workbook*, and at least 2 portfolios (8×10 transparencies or 11×14 print/tearsheets preferred)." Advertises in *The Workbook*.

How to Contact: For first contact, send query letter, direct mail flier/brochure, tearsheets and SASE. Reports in 2 weeks, only if interested. If interested, will call for appointment to show portfolio of tearsheets, transparencies (4×5 or 8×10). Obtains new talent through recommendations from others.

‡CHRISTINE PRAPAS/ARTIST REPRESENTATIVE, 12480 SE Wiese Rd., Boring OR 97009. (503)658-7070. Fax: (503)658-3960. E-mail: cprapas@teleport.com. Contact: Christine Prapas. Commercial illustration and photography representative. Estab. 1978. Member of AIGA. "Promotional material welcome."

PUBLISHERS' GRAPHICS, 251 Greenwood Ave., Bethel CT 06801. (203)797-8188. Fax: (203)798-8848. Commercial illustration representative for juvenile markets. Estab. 1970. Member of Society of Children's Book Writers and Illustrators, Author's Guild Inc. Staff includes Paige C. Gillies (President, selects illustrators, develops talent). Specializes in children's book illustration. Markets include: design firms; editorial/magazines; paper products/greeting cards; publishing/books; sales/promotion firms.

Handles: Illustration.

Terms: Rep receives 25% commission. Exclusive area representation is required. For promotional purposes, talent must provide original art, proofs, photocopies "to start. The assignments generate most sample/promotional material thereafter unless there is a stylistic change in the work." Advertises in *Literary Market Place*.

How to Contact: For first contact, send résumé, photocopies and SASE. Reports in 6 weeks. After initial contact, "We will contact them. We don't respond to phone inquiries." Portfolios should include original art, tearsheets, photocopies. Obtains new talent through "clients recommending our agency to artists. We ask for referrals from our illustrators. We receive submissions by mail."

GERALD & CULLEN RAPP, INC., 108 E. 35th St., New York NY 10016. (212)889-3337. Fax: (212)889-3341. E-mail: gerald@rappart.com. Website: http://www.theispot.com/rep/rapp. Contact: John Knepper. Commercial illustration representative. Estab. 1944. Member of SPAR, Society of Illustrators, Graphic Artists Guild. Represents 40 illustrators. Markets include: advertising agencies; corporations/client direct; design firms; editorial/magazines; paper products/greeting cards; publishing/books; sales/promotion firms.

Handles: Illustration.

Terms: Rep receives 25-30% commission. Exclusive area representation is required. No geographic restrictions. Split of advertising costs is negotiated. Advertises in *American Showcase, The Workbook, Graphic Artists Guild Directory* and *CA, Print, Art Direction* magazines. "Conducts active direct mail program and advertises on the internet."

How to Contact: For first contact, send query letter, direct mail flier/brochure. Reports in 1 week. After initial contact, call for appointment to show portfolio of tearsheets, slides. Obtains new talent through recommendations from others, solicitations.

‡JODI RAPPAPORT, 6305 Yucca St. #600, Los Angeles CA 90028-5093. (213)464-4481. Fax: (213)464-5030. Commercial photography, graphic design, stylist and art director representative. Estab. 1987. Member of SPAR. Represents

4 photographers, 2 designers. Markets include: advertising agencies; corporations/client direct; design firms; editorial/magazines; sales/promotion firms. Clients include galleries.
Handles: Photography, design.
Terms: Rep receives 25% commission. Charges for messengers and air courier per charges incurred. Exclusive area representation is required. Advertising costs are paid by talent. For promotional purposes, talent must provide direct mail pieces, professional portfolio presentation.
How to Contact: For first contact, send direct mail flier/brochure. Reports in 1 week, only if interested. After initial contact, drop off portfolio for review. "If interested, I will call to set up meeting. Portfolio content depends upon the client and what presentation form is appropriate for the work."
Tips: "I generally only take meeting with photographers who are recommended to me. Otherwise, I keep promos on file. Books are seen on a drop-off basis only. Any photographer interested in seeking representation should research the talent the rep is working with so they have an idea if the rep is appropriate for their needs. They should be clear about their focus and direction, and know what venues they would like to explore. They should have a great, strong presentation."

REDMOND REPRESENTS, 4 Cormer Court, #304, Timonium MD 21093. (410)560-0833. E-mail: sony@erols.com. Contact: Sharon Redmond. Commercial illustration and photography representative. Estab. 1987. Markets include: advertising agencies; corporations/client direct; design firms.
Handles: Illustration, photography.
Terms: Rep receives 30% commission. Exclusive area representation is required. No geographic restrictions. Advertising costs and expenses are split: 50% paid by talent; 50% paid by representative. For promotional purposes, talent must provide a small portfolio (easy to Federal Express) and at least 6 direct mail pieces (with fax number included). Advertises in *American Showcase, Black Book*.
How to Contact: For first contact, send photocopies. Reports in 2 weeks if interested. After initial contact, representative will call talent to set an appointment.
Tips: "Even if I'm not taking in new talent, I do want *photocopies* sent of new work. You never know when an ad agency will require a different style of illustration/photography and it's always nice to refer to my files."

‡KERRY REILLY: REPS, 1826 Asheville Place, Charlotte NC 28203. Phone/fax: (704)372-6007. Contact: Kerry Reilly. Commercial illustration and photography representative. Estab. 1990. Represents 16 illustrators, 3 photographers. Markets include: advertising agencies; corporations/client direct; design firms; editorial/magazines. Clients include Paramount Parks, Price/McNabb Advertising, Indigo Design.
Handles: Illustration, photography. Looking for computer graphics: Adobe Photoshop, Adobe Illustrator, Aldus Free-Hand, etc.
Terms: Rep receives 25% commission. Exclusive area representation is required. No geographic restrictions. Advertising costs are split: 75% paid by talent; 25% paid by representative. For promotional purposes, talent must provide at least 2 pages printed leave-behind samples. Preferred format is 9×12 pages, portfolio work on 4×5 transparencies. Advertises in *American Showcase, The Workbook*.
How to Contact: For first contact, send direct mail flier/brochure or samples of work. Reports in 2 weeks. After initial contact, call for appointment to show portfolio or drop off or mail tearsheets, slides, 4×5 transparencies.
Tips: "Have printed samples—a lot of printed samples."

REPERTOIRE, 2029 Custer Pkwy., Richardson TX 75080. (972)761-0500. Fax: (972)761-0501. E-mail: rprtoire@onramp.net. Contact: Larry Lynch (photography) or Andrea Lynch (illustration). Commercial illustration and photography representative and broker. Estab. 1974. Member of SPAR. Represents 12 illustrators and 6 photographers. Specializes in "importing specialized talent into the Southwest." Markets include advertising agencies, corporations/client direct, design firms, editorial/magazines.
Handles: Illustration, photography, design.
Terms: Rep receives 25-30% commission. Exclusive area representation is required. Advertising costs are split; printing costs are paid by talent; distribution costs are paid by representative. Talent must provide promotion, both direct mail and a national directory. Advertises in *The Workbook*.
How to Contact: For first contact, send direct mail flier/brochure, tearsheets. Reports in 1 month. After initial contact, write for appointment or drop off or mail portfolio of tearsheets, slides, photographs. Obtains new talent through referrals, solicitations.
Tips: Looks for "sense of humor, honesty, maturity of style, ability to communicate clearly and relevance of work to our clients."

‡THE ROLAND GROUP, 4948 St. Elmo Ave., Suite #201, Bethesda MD 20814. (301)718-7955. Fax: (301)718-7958. E-mail: npnrolgp@erols.com. Commercial illustration and photography representative. Estab. 1988. Member of SPAR, Society of Illustrators, Ad Club, Production Club. Represents 20 illustrators, and over 200 photographers. Markets include: advertising agencies; corporations/client direct; design firms; editorial/magazines; paper products/greeting cards; publishing books.
Handles: Illustration and photography.
Terms: Rep receives 35% commission. Exclusive area representation is required. Also work with artists on a project-

by-project basis. For promotional purposes, talent must provide 8½ × 11 promo sheet. Advertises in *American Showcase, The Workbook, Sourcebook, International Creative Handbook.*

How to Contact: For first contact, send query letter, tearsheets and photocopies. Reports back, if interested. Portfolio should include nonreturnable tearsheets, photocopies.

‡ROSENTHAL REPRESENTS, 3850 Eddington Ave., Calabasas CA 91302. (818)222-5445. Fax: (818)222-5650. Commercial illustration representative and licensing agent for artists who do advertising, entertainment, action/sports, children's books, giftware, collectibles, figurines, children's humorous, storyboard, animal, graphic, floral, realistic, impressionistic and game packaging art. Estab. 1979. Member of SPAR, Society of Illustrators, Graphic Artists Guild, Women in Design and Art Directors Club. Represents 100 illustrators, 2 designers and 5 fine artists. Specializes in game packaging, personalities, licensing, merchandising art and storyboard artists. Markets include: advertising agencies; corporations/client direct; paper products/greeting cards; sales/promotion firms; licensees and manufacturers.

Handles: Illustration.

Terms: Rep receives 25-30% as a rep; 40% as a licensing agent. Exclusive area representation is required. No geographic restrictions. Advertising costs are paid by talent. For promotion purposes, talent must provide 1-2 sets of transparencies (mounted and labeled), 10 sets of slides of your best work (labeled with name on each slide), 1-3 promos. Advertises in *American Showcase* and *The Workbook.*

How to Contact: For first contact, send direct mail flier/brochure, tearsheets, slides, photocopies, photostats and SASE. Reports in 1 week. After initial contact, call for appointment to show portfolio of tearsheets, slides, photographs, photocopies.

Tips: Obtains new talent through seeing their work in an advertising book or at an award show.

‡S.I. INTERNATIONAL, 43 E. 19th St., New York NY 10003. (212)254-4996. Fax: (212)995-0911. E-mail: hspiers-@tiac.net. Website: http://www.si-i.com. Commercial illustration representative. Estab. 1983. Member of SPAR, Graphic Artists Guild. Represents 50 illustrators, 1 photographer. Specializes in license characters, educational publishing and children's illustration, mass market paperbacks. Markets include design firms; publishing/books; sales/promotion firms; licensing firms.

Handles: Illustration. Looking for artists "who have the ability to do children's illustration and to do license characters."

Terms: Rep receives 25-30% commission. Advertising costs are split: 70% paid by talent; 30% paid by representative. "Contact agency for details. Must have mailer." Advertises in *Showcase.*

How to Contact: For first contact, send query letter, tearsheets. Reports in 3 weeks. After initial contact, write for appointment to show portfolio of tearsheets, slides.

‡JOAN SAPIRO ART CONSULTANTS, 4750 E. Belleview Ave., Littleton CO 80121. (303)793-0792. Contact: Joan Sapiro. Art consultant. Estab. 1980. Specializes in "corporate art with other emphasis on hospitality, health care and art consulting/advising to private collectors."

Handles: All mediums of artwork and all prices if applicable for clientele.

Terms: "50/50. Artist must be flexible and willing to ship work on consignment. Also must be able to provide sketches, etc. if commission piece involved." No geographic restrictions.

How to Contact: For first contact, send résumé, bio, direct mail flier/brochure, tearsheets, slides, photographs, price list—net (wholesale) and SASE. Reports in 2 weeks. After initial contact, drop off or mail in appropriate materials for review. Portfolios should include tearsheets, slides, price list and SASE.

Tips: Obtains new talent through recommendations, publications, travel, research, university faculty.

‡FREDA SCOTT, INC., 1015 Battery St., Suite #B, San Francisco CA 94111. (415)398-9121. Fax: (415)398-6136. Contact: Melinda Meinke or Freda Scott. Commercial illustration and photography representative. Estab. 1980. Member of SPAR. Represents 10 illustrators, 6 photographers. Markets include: advertising agencies; corporations/client direct; design firms; editorial/magazines; paper products/greeting cards; publishing/books; sales/promotion firms. Clients include Saatchi & Saatchi, Young & Rubicam, J. Walter Thompson, Anderson & Lembke, *Smart Money, Travel & Leisure,* Oracle Corp., Sun Microsystems. Client list available upon request.

Handles: Illustration, photography.

Terms: Rep receives 25% commission. No geographic restrictions. Advertising costs are split: 75% paid by talent; 25% paid by representative. For promotional purposes, talent must provide "promotion piece and ad in a directory. I also need at least three portfolios." Advertises in *American Showcase, Black Book, The Workbook.*

How to Contact: For first contact, send direct mail flier/brochure, tearsheets and SASE. If you send transparencies, reports in 1 week, if interested. "You need to make follow up calls." After initial contact, call for appointment to show portfolio of tearsheets, photographs, 4 × 5 or 8 × 10.

Tips: Obtains new talent sometimes through recommendations, sometimes solicitation. "If you are seriously interested in getting repped, keep sending promos—once every six months or so. Do it yourself a year or two until you know what you need a rep to do."

‡FRAN SEIGEL, ARTIST REPRESENTATIVE, 160 W. End Ave., #23-S, New York NY 10023. (212)486-9644. Fax: (212)486-9646. Commercial illustration. Estab. 1982. Member of SPAR, Graphic Artists Guild. Represents 10 illustrators. Specializes in "stylized realism leaning toward the conceptual." Markets include advertising agencies; corporations/client direct; design firms; editorial/magazines; paper products/greeting cards; publishing/books.

Handles: Illustration, fine art. "Artists in my group must have work applicable to wide commercial market; a unique marketable style for book jackets and/or corporate and packaging is a plus."

Terms: Rep receives 30% commission. Exclusive national representation is required. Advertising costs are split: 70% paid paid by talent; 30% paid by representative. "First promotion is designed by both of us paid for by talent; subsequent promotion costs are split." Advertises in *American Showcase, Graphic Artists Guild Directory of Illustration*.

How to Contact: For first contact, send 12-20 images, direct mail flier/brochure, tearsheets, slides and SASE. Reports in 2 weeks only if SASE is included.

Tips: Looking for artists with " 'uniquely wonderful' artwork, vision and energy, market-oriented portfolio, and absolute reliability and professionalism."

SIMPATICO ART & STONE, 1221 Demaret Lane, Houston TX 77055-6115. (713)467-7123. Contact: Billie Blake Fant. Fine art broker/consultant/exhibitor. Estab. 1973. Specializes in unique fine art, sculpture and Texas domestic stone furniture, carvings, architectural elements. Market includes: corporate; institutional and residential clients.

Handles: Looking for unique fine art and sculpture not presently represented in Houston, Texas.

Terms: Standard commission. Exclusive area representation required.

How to Contact: For first contact, send query letter, résumé, slides. Obtains new talent through travel, publications, exhibits and referrals.

‡**STORYBOARDS**, 1426 Main St., #F, Venice CA 90291. (310)305-1998. Fax: (310)305-1810. Contact: Jennifer Morrison. Commercial illustration representative and storyboard artists for advertising, commercial production and feature films. Estab. 1979. Represents 40 storyboard artists. Markets include: advertising agencies; commercial productions; feature films.

Handles: Illustration, set design.

Terms: Rep receives 25% commission. Exclusive area representation is required. Advertising costs are split: 75% paid by talent; 25% paid by representative. "Talent and agency work together on promo." Advertises in *The Workbook*.

How to Contact: For first contact, send non-returnable samples or portfolio drop off and SASE. Reports in 5 days. Drop off or mail in appropriate samples for review. Portfolio should include storyboards/comp samples.

Tips: Obtains new talent through referrals.

SULLIVAN & ASSOCIATES, 3805 Maple Court, Marietta GA 30066. (770)971-6782. Fax: (770)973-3331. E-mail: sullivan@atlcom.net. Contact: Tom Sullivan. Commercial illustration, commercial photography and graphic design representative. Estab. 1988. Member of Creative Club of Atlanta, Atlanta Ad Club. Represents 14 illustrators, 7 photographers and 7 designers, including those with computer graphic skills in illustration/design/production and photography. Staff includes Tom Sullivan (sales, talent evaluation, management); Debbie Sullivan (accounting, administration). Specializes in "providing whatever creative or production resource the client needs." Markets include: advertising agencies, corporations/client direct; design firms; editorial/magazines; publishing/books; sales/promotion firms.

Handles: Illustration, photography. "Open to what is marketable; computer graphics skills."

Terms: Rep receives 25% commission. Exclusive area representation in Southeastern US is required. Advertising costs are split: 75-100% paid by talent; 0-25% paid by representative. "Negotiated on individual basis depending on: (1) length of time worked with; (2) area of representation; (3) scope of exclusive representation." For promotional purposes, talent must provide "direct mail piece, portfolio in form of 8½×11 (8×10 prints) pages in 22-ring presentation book." Advertises in *American Showcase, The Workbook*.

How to Contact: For first contact, send bio, direct mail flier/brochure; "follow up with phone call." Reports in 2 weeks if interested. After initial contact, call for appointment to show portfolio of tearsheets, photographs, photostats, photocopies, "anything appropriate in nothing larger than 8½×11 print format." Obtains new talent through referrals and direct contact from creative person.

Tips: "Have direct mail piece or be ready to produce it immediately upon reaching an agreement with a rep. Be prepared to immediately put together a portfolio based on what the rep needs for that specific market area."

✔**SUSAN AND CO.**, 5002 92nd Ave. SE, Mercer Island WA 98040. (206)232-7873. Fax: (206)232-7908. Owner: Susan Trimpe. Commercial illustration, photography representative. Estab. 1979. Member of SPGA. Represents 19 illustrators, 2 photographers. Specializes in commercial illustrators and photographers. Markets include advertising agencies; corporations/client direct; design firms; publishing/books.

Handles: Illustration, photography. Looks for "computer illustration, corporate, conceptual."

Terms: Rep receives 30% commission. Charges postage if portfolios are shipped out of town. Exclusive area representation is required. Advertising costs are split: 70% paid by talent; 30% paid by representative. "Artists must take out a page in a publication, i.e., *American Showcase, CIB, The Workbook* with rep."

How to Contact: For first contact, send query letter and direct mail flier/brochure. Reports back within 2 weeks only if interested. After initial contact, call to schedule an appointment. Portfolio should include tearsheets, slides, photographs, photostats, photocopies.

Tips: Wants artists with "unique well-defined style and experience."

TRADITIONAL FINE ARTS ONLINE, INC., 8502 E. Chapman, Suite 392, Orange CA 92869. (714)997-8500. Fax: (714)997-0937. E-mail: publisher@tfaoi.com. Website: http://www.tfaoi.com. President: John P. Hazeltine. Fine art representative. "Traditional Fine Arts Online, Inc. is a California corporation, providing selection and convenience

to purchasers of American traditional original art and service to those who wish to sell their art. We also inform and provide education through our online magazine. The company actively supports museums and art organizations throughout the United States." Estab. 1996. Represents 40 fine artists (includes 5 sculptors). Art guidelines available on website. Specializes in American representational paintings and sculpture. Markets include architects, interior decorators, museums, corporate and private collectors, developers and galleries.

Handles: Fine art valued over $3,000.

Terms: Agent receives 0-15% commission (sliding scale). Exclusive representation not required. Advertises in several publications.

How to Contact: Send query letter. Reports back within 2 weeks. To show portfolio, mail in appropriate materials and SASE. Portfolio should include slides or photographs.

JOSEPH TRIBELLI DESIGNS, LTD., 254-33 Iowa Rd., Great Neck NY 11020. (516)482-2699. Contact: Joseph Tribelli. Representative of textile designers only. Estab. 1988. Member of Graphic Artists Guild. Represents 9 designers. Specializes in textile surface design for apparel (women and men). "All designs are on paper."

Handles: Textile design for apparel and home furnishings.

Terms: Rep receives 40% commission. Exclusive area representation is required.

How to Contact: "Telephone first." Reports back in 2 weeks. After initial contact, drop off or mail appropriate materials. Portfolio should include original art. Obtains new talent through placing ads, recommendations.

Tips: "I am interested in only textile designers who can paint on paper. Do not apply unless you have a flair for fashion."

‡T-SQUARE, ETC., 1426 Main St., Venice CA 90291. (310)826-7033. Fax: (310)826-7133. E-mail: tsquare@pacificn et.net. Managing Director: Diane Pirritino. Graphic design representative. Estab. 1990. Member of Advertising Production Association of California, Ad Club of LA. Represents 50 illustrators, 100 designers. Specializes in computer graphics. Markets include advertising agencies; corporations/client direct; design firms; editorial/magazines.

Handles: Design.

Terms: Rep receives 25% commission. Advertising costs are split: 25% paid by talent; 75% paid by representative. For promotional purposes, talent must provide samples from their portfolio (their choice).

How to Contact: For first contact, send résumé. Reports back within 5 days. After initial contact, call to schedule an appointment. Portfolio should include thumbnails, roughs, original art, tearsheets, slides.

Tips: Artists must possess "good design, computer skills, flexibility, professionalism."

CHRISTINA A. TUGEAU: ARTIST AGENT, 110 Rising Ridge Rd., Ridgefield CT 06877. (203)438-7307. Fax: (203)438-7060. Owner: Chris Tugeau. Children's market illustration representative. Estab. 1994. Member of Graphic Artists Guild, SPAR, SCBWI. Represents 20 illustrators. Specializes in children's book publishing and educational market and related areas.

Handles: Illustration. Must be proficient at illustrating children and animals in a variety of interactive situations, in real space, full color/b&w, and with a strong narrative sense.

Terms: Rep receives 25% commission. Exclusive area representation is required (self-promotion is OK). Advertising costs are split: 80% paid by the talent; 20% paid by the representative. For promotional purposes, talent must provide a direct mail promo piece, 8-10 good "back up" samples (multiples), 3 strong portfolio (8×10 or printed pieces). Advertises in *RSVP* and *GAG Directory of Illustration*, *Showcase*, *Picturebook*.

How to Contact: For first contact call, then send direct mail flier/brochure, tearsheets, photographs, photocopies, SASE, "prefer no slides!" Reports in 1-2 weeks. Call to schedule an appointment. Portfolio should include tearsheets, photocopies, "no originals."

Tips: "You should have a style uniquely and comfortably your own and be great with deadlines. I've taken on young, new artists with great potential and desire, as well as published, more experienced illustrators."

‡VARGO BOCKOS, 211 E. Ohio St., Apt. 2404, Chicago IL 60611. (312)661-1717. Fax: (312)661-0043. Partners: Julie Vargo, Patrice Bockos. Commercial illustration, photography, film production representative. Estab. 1994. Member of CAR (Chicago Artists Reps). Represents 3 photographers. Markets include: advertising agencies, design firms.

Handles: Illustration, photography and film.

Terms: Rep receives 30% commission. Advertising costs are split: 70% paid by talent; 30% paid by representative. "Direct mail pieces are great bonuses. The portfolio must be professionally presented." Advertises in *The Workbook*.

How to Contact: For first contact, send query letter and direct mail flier/brochure. Reports back within 2 days if interested. After initial contact, call to schedule an appointment. Portfolio should include original art, tearsheets, photographs.

‡JAE WAGONER, ARTIST REPRESENTATIVE, Unit #C, 654 Pier Ave., Santa Monica CA 90405. (310)392-4877. Website: http://jaewagoner.com. Contact: Jae Wagoner "by mail only—send copies or tear sheets only for us to keep—do not call!" Commercial illustration representative. Estab. 1975. Represents 12 illustrators. Markets include: advertising agencies; corporations/client direct; design firms; editorial/magazines; paper products/greeting cards; publishing/books; sales/promotion firms.

Handles: Illustration.

Terms: Agent receives 25% commission locally; 30% outside of Los Angeles. Exclusive area representation required.

ANN BARROW
Represented by:
Christina A. Tugeau
110 Rising Ridge Road
Ridgefield, CT 06877
TEL (203) 438-7307

Client list:
Atheneum
Scholastic
Cricket Magazine
Hallmark Cards
Peachtree Publishers
McClanahan Book Company
Jamestown Publishers

Spider Magazine
Thomas Nelson Gifts
Children's Writer's &
Illustrator's Market
Modern Curriculum Press
D.C. Heath
Britannica
Member—SCBWI

Christina A. Tugeau 203•438•7307

© 1997 Ann Barrow

This promotional piece was created for Ann Barrow to show her range and depth as a portrait artist, and has appeared in several sourcebooks. "I wanted to show a lot of contrast in the color pieces, and wanted to showcase my children's book illustrations as well," says Barrow, who has used *Artist's & Graphic Designer's Market* in the past to find assignments. "Within the first month of publication, this promotional piece brought me an assignment that more than paid the price of the ad," Barrow says. "Find a good agent you can develop a partnership with, and be open to his advice, instincts and business savvy."

Advertising costs depend. For promotional purposes talent must advertise once a year in major promotional book (ex: Workbook) exclusively with us. "Specifications and details are handled privately." Advertises in *American Showcase* and *The Workbook*.

How to Contact: When making first contact, send: query letter (with other reps mentioned), photocopies ("examples to keep only. No unsolicited work returned.") Reports back in weeks only if interested. After initial contact, talent should wait to hear from us.

Tips: "We select first from 'keepable' samples mailed to us. The actual work determines our interest, not verbal recommendation or résumés. Sometimes we search for style we are lacking. It is *not* a good idea to call a rep out of the blue. You are just another voice on the phone. What is important is your work, *not* who you know, where you went to school, etc. Unsolicited work that needs to be returned creates a negative situation for the agent. It can get lost, and the volumn can get horrendous. Also—do your homework—do not call and expect to be given the address by phone. It's a waste of the reps time and shows a lack of effort. Be brief and professional." Sometimes, even if an artist can't be represented, Jae Wagoner provides portfolio reviews, career counseling and advice for an hourly fee (with a 5 hour minimum fee). If you are interested in this service, please request this in your cover letter.

WARNER & ASSOCIATES, 1425 Belleview Ave., Plainfield NJ 07060. (908)755-7236. E-mail: bwarnet@sci-image makers.com. Website: http://www.sci-imagemakers.com. Contact: Bob Warner. Commercial illustration and photography representative. Estab. 1986. Represents 4 illustrators, 4 photographers. "My specialized markets are advertising agencies that service pharmaceutical, medical, health care clients."

Handles: Illustration, photography. Looking for medical illustrators: microscope photographers (photomicrography), science illustrators, special effects photographers.

Terms: Rep receives 25% commission. "Promo pieces and portfolios obviously are needed; who makes up what and at what costs and to whom, varies widely in this business."

How to Contact: For first contact send query letter "or phone me." Reports back in days. Portfolio should include "anything that talent considers good sample material." Obtains new talent "by hearsay and recommendations. Also, specialists in my line of work often hear about my work from art directors and they call me."

WASHINGTON-ARTISTS' REPRESENTATIVE INC. (II), 22727 Cielo Vis #2, San Antonio TX 78255-9501. (210)698-1409. Fax: (210)698-1603. Website: http://www.uscreative.com. Contact: Dick Washington. Commercial illustration representative. Estab. 1983. Member of CASSA. Represents 12 illustrators.

Terms: No information provided.

How to Contact: For first contact, send tearsheets. Reports in 2 weeks, only if interested. After initial contact, call for appointment to show portfolio of original art, tearsheets, slides. Usually obtains, new talent through recommendations and solicitation.

Tips: "Make sure that you are ready for a real commitment and relationship. It's an important step for an artist, and should be taken seriously."

DAVID WILEY REPRESENTS, 94 Natoma St., Suite 200, San Francisco CA 94105. (415)442-1822. Fax: (415)442-1823. E-mail: david@dwrepresents.com. Website: http://www.dwrepresents.com. Contact: David Wiley. Commercial illustration and photography representative. Estab. 1984. Member of AIP (Artists in Print). Represents 8 illustrators and 1 photographer. Specializes in "being different and effective!" Clients include Coke, Pepsi, '96 Summer Olympics, Disney Co., Bank of America, NHL, US Open. Client list available upon request.

Terms: Advertises in *American Showcase* and *Creative Illustration Book*, *Workbook*.

How to Contact: For first contact, send 1-2 direct mail samples, tearsheets, slides, photographs, and SASE ("very important"). Will call back, if interested, within 48 hours. After initial contact, call for appointment or drop off appropriate materials. Portfolio should include, personal, commissioned jobs and tearsheets.

DEBORAH WOLFE LTD., 731 N. 24th St., Philadelphia PA 19130. (215)232-6666. Fax: (215)232-6585. Contact: Deborah Wolfe. Commercial illustration representative. Estab. 1978. Represents 25 illustrators. Markets include: advertising agencies; corporations/client direct; design firms; editorial/magazines; publishing/books.

Handles: Illustration.

Terms: Rep receives 25% commission. Advertises in *American Showcase* and *Black Book*.

How to Contact: For first contact, send direct mail flier/brochure, tearsheets, slides. Reports in 3 weeks. "Artists usually contact us through mail or drop off at our office. If interested, we ask to see more work (including originals)."

Publications of Interest

The following publications will help you keep up with market trends and provide additional leads. A few offer advertising opportunities for artists. Most are available in libraries or book-stores or from the publisher.

DIRECTORIES

AMERICAN SHOWCASE, *915 Broadway, 14th Floor, New York NY 10010. (212)673-6600. Annual hardcover directory of illustrators. Most often used by art directors and artist representatives to find new talent.*

ART NOW GALLERY GUIDE, *97 Grayrock Rd., P.O. Box 5541, Clinton NJ 08809. (908)638-5255. Monthly guide listing galleries by region. Also publishes international guide.*

AUDIO VISUAL MARKETPLACE, *R.R. Bowker, A Reed Reference Publishing Co., 121 Chanlon Rd., New Providence NJ 07974. (908)464-6800. Annual directory listing audiovisual companies and related services.*

BLACK BOOK ILLUSTRATION, *(same as* Creative Illustration), *The Black Book, 10 Astor Place, 6th Floor, New York NY 10003. (800)841-1246. Annual directory listing illustrators, photographers, printers and service houses. Also publishes regional directories.*

GRAPHIC ARTISTS GUILD'S DIRECTORY OF ILLUSTRATION, *Serbin Communications, 511 Olive St., Santa Barbara CA 93101. (805)963-0439. Annual directory of illustration.*

LITERARY MARKET PLACE, *R.R. Bowker, A Reed Reference Publishing Co., 121 Chanlon Rd., New Providence NJ 07974. (908)464-6800. Annual directory listing book publishers and related services.*

RSVP, *The Directory of Illustration and Design, P.O. Box 050314, Brooklyn NY 11205. (718)857-9267. Annual directory in which designers and illustrators can advertise their services. Most often used by art directors seeking new talent.*

STANDARD DIRECTORY OF ADVERTISING AGENCIES (The Redbook), *National Register Publishing, A Reed Reference Publishing Co., 121 Chanlon Rd., New Providence NJ 07974. (908)464-6800. Annual directory listing advertising agencies.*

STANDARD RATE AND DATA SERVICE (SRDS), *1700 E. Higgins Rd., Des Plains IL 60018. (847)375-5000. Monthly directory listing magazines, plus their advertising rates and related information.*

MAGAZINES

ADVERTISING AGE, *Crain Communications, 740 N. Rush St., Chicago IL 60611-2590. (312)649-5200. Weekly trade tabloid covering the ad industry.*

ADWEEK, *Adweek Magazines, 1515 Broadway, New York NY 10036-8986. (212)536-5336. Weekly advertising and marketing magazine. Also publishes annual directory of ad agencies.*

AMERICAN ARTIST, *P.O. Box 1944, Marion OH 43305. (800)745-8922.*

ART BUSINESS NEWS, *270 Madison Ave., New York NY 10016. (212)951-6600. Monthly magazine covering business issues in the art industry.*

ART CALENDAR, *P.O. Box 199, Upper Fairmount MD 21867-0199. (410)651-9150. Monthly magazine listing galleries, juried shows, percent-for-art programs, scholarships and art colonies, plus other art-related articles.*

ART IN AMERICA, *Brant Publications, Inc., 575 Broadway, New York NY 10012. (212)941-2800. Monthly magazine covering national and international news and issues relating to the fine art world. Also publishes annual guide to museums, galleries and artists (August issue).*

THE ARTIST'S MAGAZINE, *F&W Publications, Inc., 1507 Dana Ave., Cincinnati OH 45207. (513)531-2690. Monthly magazine for fine artists, illustrators and cartoonists. Features how-to articles on techniques and business issues. Subscription services: P.O. Box 2120, Harlan IA 51593. (800)333-0444.*

ARTNEWS, *ARTnews Associates, 48 W. 38th St., New York NY 10018. (212)398-1690. Magazine published 11 times/*

year covering the latest issues in national and international fine art, plus reviews and other feature articles.

ARTWEEK, *2149 Paragon Dr., Suite 100, San Jose CA 95131-1312. (408)441-7065. Monthly magazine covering fine art issues, galleries and other events on the West Coast.*

BILLBOARD, *1515 Broadway, 15th Floor, New York NY 10036. (212)764-7300. Weekly magazine covering the music industry.*

COMMUNICATION ARTS, *410 Sherman Ave., Box 10300, Palo Alto CA 94303. (650)326-6040. Magazine published 8 times/year covering design, illustration and photography.*

DECOR, *Commerce Publishing Co., 330 N. Fourth St., St. Louis MO 63102. (314)421-5445. Monthly trade magazine for gallery owners and gallery directors. Also publishes an annual buyers' guide directory.*

EDITOR & PUBLISHER, *The Editor & Publisher Co. Inc., 11 W. 19th St., New York NY 10011. (212)675-4380. Weekly magazine covering latest developments in journalism and newspaper production. Publishes annual directory issue listing syndicates and another directory listing newspapers.*

ENCOURAGING REJECTION, *Box 750, Intervale NH 03845 (603)356-9910. Quarterly newsletter for professional cartoonists.*

FOLIO, *Cowles Business Media, 11 Riverbend Dr. S., Box 4272, Stamford CT 06907-0272. (203)358-9900. Biweekly magazine featuring trends in magazine circulation, production and editorial.*

GIFTWARE NEWS, *20 N. Wacker Dr., Suite 1865, Chicago IL 60606. (800)229-1967 ext. 50. Monthly trade magazine covering the giftware and paper products industry.*

GREETINGS TODAY, *810 E. Tenth St., Lawrence KS 66044. (800)627-0932. Quarterly trade magazine covering the greeting card and stationery industry.*

HOW, *F&W Publications, Inc., 1507 Dana Ave., Cincinnati OH 45207. (513)531-2690. Monthly magazine for graphic design professionals.*

PARTY & PAPER RETAILER, *4Ward Corp., 70 New Canaan Ave., Norwalk CT 06850. (203)845-8020. Monthly magazine covering the giftware and paper products industry.*

PRINT, *RC Publications, 104 Fifth Ave., 19th Floor, New York NY 10011. (212)463-0600. Bimonthly magazine focusing on creative trends and technological advances in illustration, design, photography and printing. Also publishes* Regional Design Annual *featuring the year's best in design and illustration.*

PUBLISHERS WEEKLY, *Cahners Publishing Co., 249 W. 17th St., New York NY 10011. (212)645-9700. Weekly trade magazine covering industry trends and news in book publishing, book reviews and interviews.*

SOUTHWEST ART, *Cowles Magazines, 5444 Westheimer, Suite 1440, Houston TX 77056. (713)296-7900. Monthly magazine covering fine arts in the Southwest.*

STEP-BY-STEP GRAPHICS, *Dynamic Graphics Inc., 6000 N. Forest Park Dr., Peoria IL 61614. (800)255-8800. Bimonthly magazine featuring step-by-step demonstrations for designers and illustrators.*

UPPER & LOWER CASE (U & lc), *International Typeface Corp., 228 E. 45th St., New York NY 10017. (212)949-8072. Quarterly publication covering the latest in typography and issues relating to type designers.*

Internet Resources

BY MEGAN LANE

The Internet is becoming an important resource for artists. Web pages offer valuable, instant information about art buyers. Galleries, large and small, are also constructing websites to better market their artists' work, and artists are marketing their own work on personal sites and on group sites of electronic portfolios. If you don't have access to the web at home or at work, try your local library. Surfing time is often limited on these public computers, but a carefully planned search can yield excellent results.

Surf the Web for leads

The first step to making the most of your time online is to know where you want to go. Magazines including *Yahoo Internet Life*, *NetGuide*, *Website* and *the net* offer reviews of web pages usually categorized under specific subject headings, i.e. art. The market has also been flooded with Internet directories in book form—yellow pages for the Web. Website addresses, or URLs, change frequently however, and only the most recent directories will be of any help. While Internet search engines don't offer site reviews, they do provide the most accurate, up-to-date URLs with some descriptive information. Try a few of these.
- http://www.yahoo.com
- http://guide-p.infoseek.com
- http://query.webcrawler.com

Use key words like *greeting card* or *graphic design* to generate a list of potential sites or try a company's name for more specific information. We've included URLs following each listing's address whenever possible, and many listings indicated they had pages in the works. Use the following URLs as a starting place for your explorations in cyberspace.

Greeting Cards, Gifts & Products
- Greeting Card Association—http://www.greetingcard.org
- Hallmark Cards—http://www.hallmark.com
- *Party & Paper* magazine—http://www.partypaper.com

Magazines
- Electronic Journal—http://www.edoc.com
- Electronic Newsstand—http://www.enews.com

Posters & Prints
- The Art & Framing Headquarters—http://www.artframing.com
- ArtCatalogue.com—http://www.artcatalog.com
- SDESIGNET—http://www.isdesignet.com/Directory/Art.html

Book Publishers
- Bookwire—http://www.bookwire.com
- Publisher's Catalogues Home Page—http://www.lights.com/publisher/index.html
- Publishers on the Internet—http://www.faxon.com/html/it_pl_am.html

Galleries
- Art Dealers Association of America—http://www.artdealers.org
- Art Links—http://www.fine-art.com/link.html
- GenArt—http://www.genart.org
- Doubletake Gallery—http://www.DoubletakeArt.com.

Syndicates & Cartoon Features
- Cartoonists at Large—http://www.cyberenet.net/~jasper/cal_home.html
- Professional Cartoonists Index—http://www.inet1.com/Toons/true/art/ToonLinks.html
- Stu's Comic Strip Connection—http://www.stus.com/1public.htm

Stock Illustration & Clip Art Firms
- Custom Medical Stock—http://www.cmsp.com
- Image Club Graphics—http://www.imageclub.com
- Nova Development Corporation—http://www.novadevcorp.com

Animation & Computer Games
- International Animation Association—http://www.swcp.com/~asifa/
- Quickdraw Animation Society—http://www.smithy.net/qas/home
- Women in Animation—http://women.in.animation.org/

Advertising, Design & Related Markets
- Eloquent Interface—http://www.ozemail.com.au/~pharmofs/design/index.htm
- Graphic Arts Guild—http://www.gag.org
- *HOW* magazine—http://www.howdesign.com/

Record Labels
- Arista Records—http://www.artistarec.com
- Capitol Records—http://www.hollywoodandvine.com
- Geffen Records—http://www.geffen.com

Contests
- The Art Deadlines List—http://www.3dsite.com/3dsite/cgi/publications/adl/adl-sept-96.html

Cyber-marketing

If you're considering posting your art on-line in an electronic portfolio, check out these sites. They may give you ideas about creating your own web page or offer you the opportunity to post your work through an established site.
- Art on the Net Index—http://www.art.net/
- Artisan's Corner—http://www.esinet.net/ac.html
- ArtNet—http://www.arnet.com
- Art Net Web—http://artnetweb.com
- Arts Online—http://www.arts-online.com
- Art Scope—http://www.artscope.com
- On Line Gallery—http://www.OnLineGallery.com
- Designlink—http://www.designlink.com
- Kaleidospace—http://www.kspace.com
- Pure Art Mkt.—http://www.PureArtMkt.com

Let your fingers do the typing

Quite possibly the most valuable resources the Internet has to offer artists are electronic yellow pages. Using these sites, artists can generate long lists of potential markets in their regions. Searching for all the galleries or greeting card publishers in the U.S. will yield more information than is helpful or can possibly be used by one person. However, searching for all the galleries in your city and surrounding area can lead to an effective submission strategy. Although there are many online address directories, we've found these to be the most helpful.
- GTE SuperPages—http://yp.gte.net
- Worldpages—http://www.bigbook.com.
- Big Book—http://www.bigbook.com.

Keep in mind that a carefully planned, well-researched self-promotion campaign will always be more successful than a blind mass mailing. Use the vast resources of the Internet to become a more effective marketer of yourself and of your artwork.

Glossary

Acceptance (payment on). An artist is paid for his work as soon as a buyer decides to use it.

Adobe Illustrator®. Drawing and painting computer software.

Adobe Photoshop®. Photo manipulation computer program.

Advance. Amount paid to an artist before beginning work on an assigned project. Often paid to cover preliminary expenses.

Airbrush. Small pencil-shaped pressure gun used to spray ink, paint or dye to obtain gradated tonal effects.

Aldus FreeHand. Illustration computer software.

Aldus PageMaker. Page layout computer software.

Art director. In commercial markets, the person responsible for choosing and purchasing artwork and supervising the design process.

Biannually. Occurring twice a year.

Biennially. Occurring once every two years.

Bimonthly. Occurring once every two months.

Biweekly. Occurring once every two weeks.

Book. Another term for a portfolio.

Buy-out. The sale of all reproduction rights (and sometimes the original work) by the artist; also subcontracted portions of a job resold at a cost or profit to the end client by the artist.

Calligraphy. The art of fine handwriting.

Camera-ready. Art that is completely prepared for copy camera platemaking.

Capabilities brochure. A brochure, similar to an annual report, outlining for prospective clients the nature of a company's business and the range of products or services it provides.

Caption. See gagline.

CD-ROM. Compact disc read-only memory; non-erasable electronic medium used for digitized image and document storage and retrieval on computers.

Collateral. Accompanying or auxiliary pieces, such as brochures, especially used in advertising.

Color separation. Photographic process of separating any multi-color image into its primary component parts (cyan, magenta, yellow and black) for printing.

Commission. 1) Percentage of retail price taken by a sponsor/salesman on artwork sold. 2) Assignment given to an artist.

Comprehensive. Complete sketch of layout showing how a finished illustration will look when printed; also called a comp.

Copyright. The exclusive legal right to reproduce, publish and sell the matter and form of a literary or artistic work.

Consignment. Arrangement by which items are sent by an artist to a sales agent (gallery, shop, sales rep, etc.) for sale with the understanding the artist will not receive payment until work is sold. A commission is almost always charged for this service.

Direct-mail package. Sales or promotional material that is distributed by mail. Usually consists of an outer envelope, a cover letter, brochure or flier, SASE, and postpaid reply card, or order form with business reply envelope.

Dummy. A rough model of a book or multi-page piece, created as a preliminary step in determining page layout and length. Also, a rough model of a card with an unusual fold or die cut.

Edition. The total number of prints published of one piece of art.

Elhi. Abbreviation for elementary/high school used by publishers to describe young audiences.

Environmental graphic design (EGD). The planning, designing and specifying of graphic elements in the built and natural environment; signage.

EPS files. Encapsulated PostScript—a computer format used for saving or creating graphics.

Estimate. A ballpark figure given to a client by a designer anticipating the final cost of a project.

Etching. A print made by the intaglio process, creating a design in the surface of a metal or other plate with a needle and using a mordant to bite out the design.

Exclusive area representation. Requirement that an artist's work appear in only one outlet within a defined geographical area.

Finished art. A completed illustration, mechanical, photo, or combination of the three that is ready to go to the printer. Also called camera-ready art.

Gagline. The words printed with a cartoon (usually directly beneath); also called a caption.

Giclée Method of creating limited and unlimited edition prints using computer technology in place of traditional methods of reproducing artwork. Original artwork or transparency is digitally scanned, and the stored information is manipulated on screen using computer software (usually Photoshop). Once the image is refined on screen, it is printed on an Iris printer, a specialized ink-jet printer designed for making giclée prints.

Gouache. Opaque watercolor with definite, appreciable film thickness and an actual paint layer.

Halftone. Reproduction of a continuous tone illustration with the image formed by dots produced by a camera lens screen.

IRC. International Reply Coupon; purchased at the post office to enclose with artwork sent to a foreign buyer to cover his postage cost when replying.

New! From the publishers of *The Artist's Magazine* and *Artist's & Graphic Designer's Market*

Now there's a magazine devoted exclusively to water-based media, and it's packed with step-by-step instruction and new techniques to try. You'll find helpful advice on topics like choosing a palette and framing your work, and everything in between:

- how to electrify your paintings with light
- how to layer with acrylics for watercolor effects
- how to choose and cut mats for your work
- 6 tips for well-placed focal points
- how to achieve dramatic contrasts of light and dark
- how to create texture with pen & ink and watercolor

See for yourself how *Watercolor Magic* can enhance your painting skills and make you a better artist. Mail the card below to start your subscription today!

Iris print. Limited and unlimited edition print or giclée output on an Iris or ink-jet printer (named after Iris Graphics of Bedford, Massachusetts, a leading supplier of ink-jet printers).

JPEG files. Joint Photographic Experts Group—a computer format used for saving or creating graphics.

Keyline. Identification of the positions of illustrations and copy for the printer.

Kill fee. Portion of an agreed-upon payment an artist receives for a job that was assigned, started, but then canceled.

Layout. Arrangement of photographs, illustrations, text and headlines for printed material.

Licensing. The process whereby an artist who owns the rights to his or her artwork permits (through a written contract) another party to use the artwork for a specific purpose for a specified time in return for a fee and/or royalty.

Lithography. Printing process based on a design made with a greasy substance on a limestone slab or metal plate and chemically treated so image areas take ink and non-image areas repel ink.

Logo. Name or design of a company or product used as a trademark on letterhead, direct mail packages, in advertising, etc., to establish visual identity.

Mechanicals. Paste-up or preparation of work for printing.

Multimedia. A generic term used by advertising, public relations and audiovisual firms to describe productions involving more than one medium to create a variety of visual effects. Also, a term used to reflect the varied inhouse capabilities of an agency.

Naif. Native art of such cultures as African, Eskimo, Native American, etc., usually associated with daily life.

Offset. Printing process in which a flat printing plate is treated to be ink-receptive in image areas and ink-repellent in non-image areas. Ink is transferred from the printing plate to a rubber plate, and then to the paper.

Overlay. Transparent cover over copy, on which instruction, corrections or color location directions are given.

Panel. In cartooning, the boxed-in illustration; can be single panel, double panel or multiple panel.

Paste-up. Procedure involving coating the backside of art, type, photostats, etc., with rubber cement or wax and adhering them in their proper positions to the mechanical board. The boards are then used as finished art by the printer.

Photostat. Black & white copies produced by an inexpensive photographic process using paper negatives; only line values are held with accuracy. Also called stat.

PMT. Photomechanical transfer; photostat produced without a negative.

P-O-P. Point-of-purchase; in-store marketing display that promotes a product.

Print. An impression pulled from an original plate, stone, block screen or negative; also a positive made from a photographic negative.

Production artist. In the final phases of the design process, the artist responsible for mechanicals, paste up, and sometimes the overseeing of printing.

QuarkXPress. Page layout computer program.

Query. Letter to an art director or buyer eliciting interest in a work an artist wants to illustrate or sell.

Quotation. Set fee proposed to a client prior to commencing work on a project.

Rendering. A drawn representation of a building, interior, etc., in perspective.

Retail. The sale of goods in small quantities directly to the consumer.

Roughs. Preliminary sketches or drawings.

Royalty. An agreed percentage paid by a publisher to an artist for each copy of a work sold.

SASE. Self-addressed, stamped envelope.

Self-publishing. In this arrangement, an artist coordinates and pays for printing, distribution and marketing of his/her own artwork and in turn keeps all ensuing profits.

Semiannual. Occuring twice a year.

Semimonthly. Occurring twice a month.

Semiweekly. Occuring twice a week.

Serigraph. Silkscreen; method of printing in which a stencil is adhered to a fine mesh cloth stretched over a wooden frame. Paint is forced through the area not blocked by the stencil.

Simultaneous submissions. Submission of the same artwork to more than one potential buyer at the same time.

Speculation. Creating artwork with no assurance that a potential buyer will purchase it or reimburse expenses in any way; referred to as work on spec.

Spot drawing. Small illustration used to decorate a page of type, or to serve as a column ending.

Storyboard. Series of panels that illustrate a progressive sequence or graphics and story copy of a TV commercial, film or filmstrip. Serves as a guide for the eventual finished product.

Tabloid. Publication whose format is an ordinary newspaper page turned sideways.

Tearsheet. Published page containing an artist's illustration, cartoon, design or photograph.

Thumbnail. A rough layout in miniature.

TIFF files. Tagged Image File Format—a computer format used for saving or creating graphics.

Transparency. A photographic positive film such as a color slide.

Type spec. Type specification; determination of the size and style of type to be used in a layout.

Velox. Photoprint of a continuous tone subject that has been transformed into line art by means of a halftone screen.

VHS. Video Home System; a standard videotape format for recording consumer-quality videotape, most commonly used in home videocassette recording and portable camcorders.

Video. General category comprised of videocassettes and videotapes.

Wash. Thin application of transparent color or watercolor black for a pastel or gray tonal effect.

Wholesale. The sale of commodities in large quantities usually for resale (as by a retail merchant).

Special Markets Index

The following indexes can help you find the most appropriate listings for the kind of artwork you create. Check the individuals listings for specific information about submission requirements. The double-dagger (‡) before a listing indicates that it is new to the book.

General Index

A double-dagger (‡) precedes listings that are new to this edition. Companies or galleries that appeared in the 1998 edition but do not appear in this edition are identified by a two-letter code explaining why the market was omitted: (**ED**)—Editorial Decision, (**NS**)—Not Accepting Submissions (**NR**)—No (or late) Response to Listing Request, (**OB**)—Out of Business, (**RR**)—Removed by Market's Request, (**UC**)Unable to Contact.

More Great Books for Artists!

Graphic Artist's Guild Handbook of Pricing & Ethical Guidelines, 9th Edition—Over 100,000 copies sold! The latest, essential information on business, pricing and ethical standards for nearly every discipline in the visual communications industry—from advertising to publishing to corporate markets. *#30896/ $29.95/328 pages/paperback*

Art Marketing 101: A Handbook for the Fine Artist, Updated Version—This user-friendly and up-to-date handbook takes new and professional artists through the basics of creating a successful business. Learn alternative avenues for selling your art, how to market it, how to navigate legal issues and more. *#31231/$24.95/336 pages/paperback*

How to Draw and Sell Comic Strips for Newspapers and Comic Books, Revised Edition—More than 70 comic strips from such well-known artists as Matt Groening of *The Simpsons* and Todd McFarlane of *Spawn*, illustrate each step of the creative process—from scripting and storyline to inking and lettering. Includes updated information on the latest industry trends. *#31213/$22.99/144 pages/10 4-color and 160 2-color illus./hardcover*

The Streetwise Guide to Freelance Design and Illustration——Get the inside scoop from successful freelancers: How to set up your own studio, promote yourself, manage your time, negotiate a fair price, get clients and keep them. *#31111/$24.99/144 pages/66 color illus./paperback*

How to Get Started Selling Your Art—Drawing on her 30 years of experience, Carole Katchen offers you surefire methods and expert advice on how to turn your art into a satisfying and profitable career. *#30814/$17.99/128 pages/paperback*

Fresh Ideas Series—This series shows some of the most innovative, quality work being done in graphic design today. Work from various designers and studios is reproduced large and in full color and features inside information on each project—including concept, production techniques, and cost-saving strategies. Each hardcover book is 144 pages long.

 Fresh Ideas in Limited Budget Design—*#31112/$29.99/221 color illus.*
 Fresh Ideas in Photoshop—*#31114/$29.99/209 color illus.*
 Fresh Ideas in Brochure Design—*#30929/$31.99/160 pages/298 color illus.*
 Fresh Ideas in Letterhead & Business Card Design 3—*#30885/$29.99/400 color illus.*

Computer Animation: A Whole New World—This showcase presents you with work from twelve top international computer animators and takes you inside their studios to see the animators' inspiration and creative processes first-hand. *#31154/$29.99/144 pages/250 color illus./hardcover*

The Best Music CD Art & Design—Dozens of the latest CD packaging designs are accompanied by comments from the designers, the art directors, and event the music artists themselves, telling the ideas and inspiration behind each piece. *#30991/$34.99/160 pages/300 color illus./hardcover*